ART HISTORY

A View of the West

ART HISTORY

A View of the West

THIRD EDITION

VOLUME TWO

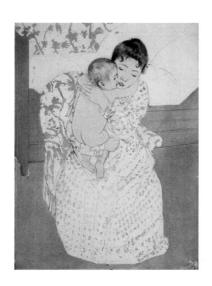

MARILYN STOKSTAD

Judith Harris Murphy Distinguished Professor of Art History Emerita

The University of Kansas

CONTRIBUTORS

Patrick Frank and D. Fairchild Ruggles

Upper Saddle River, New Jersey 07458

Library of Congress Cataloging-in-Publication Data

Stokstad, Marilyn,

Art History: A View of the West / Marilyn Stokstad. —3rd ed.

Stokstad, Marilyn

p. cm.

Includes bibliographical references and index.

ISBN 0-13-156577-X (alk. paper)

1. Art—History. I. Title.

N5300.S923 2008

709-dc22

2006052795

Editor-in-Chief: Sarah Touborg Sponsoring Editor: Helen Ronan Editorial Assistant: Jacqueline Zea

Editor in Chief, Development: Rochelle Diogenes

Development Editors: Jeannine Ciliotta, Margaret Manos,

Teresa Nemeth, and Carol Peters

Media Editor: Anita Castro

Director of Marketing: Brandy Dawson

Executive Marketing Manager: Marissa Feliberty

AVP, Director of Production and Manufacturing: Barbara Kittle

Senior Managing Editor: Lisa Iarkowski Production Editor: Barbara Taylor-Laino Production Assistant: Marlene Gassler Manufacturing Manager: Nick Sklitsis Manufacturing Buyer: Sherry Lewis Creative Design Director: Leslie Osher

Art Director: Amy Rosen

Interior and Cover Design: Anne DeMarinis

Layout Artist: Gail Cocker-Bogusz

Line Art and Map Program Management: Gail Cocker-Bogusz,

Maria Piper

Line Art Studio: Peter Bull Art Studio

Cartographer: DK Education, a division of Dorling Kindersley, Ltd. Pearson Imaging Center: Corin Skidds, Greg Harrison, Robert Uibelhoer, Ron Walko, Shayle Keating, and Dennis Sheehan

Site Supervisor, Pearson Imaging Center: Joe Conti

Photo Research: Laurie Platt Winfrey, Fay Torres-Yap, Mary Teresa Giancoli, and Christian Peña, Carousel Research, Inc.

Director, Image Resource Center: Melinda Reo Manager, Rights and Permissions: Zina Arabia Manager, Visual Research: Beth Brenzel

Manager, Cover Visual Research and Permissions: Karen Sanatar

Image Permission Coordinator: Debbie Latronica Manager, Cover Research and Permissions: Rita Wenning

Copy Editor: Stephen Hopkins

Proofreaders: Faye Gemmellaro, Margaret Pinette, Nancy Stevenson,

and Victoria Waters

Composition: Prepare, Inc.

Cover Printer: Phoenix Color Corporation

Printer/Binder: R. R. Donnelley

Maps designed and produced by DK Education, a division of Dorling Kindersley, Limited, 80 Strand London WC2R 0RL. DK and the DK logo are registered trademarks of Dorling Kindersley Limited.

Credits and acknowledgements borrowed from other sources and reproduced, with permission, in this textbook appear on the appropriate page within text or on the credit pages in the back of this book.

Cover Photo:

Mary Cassatt MATERNAL CARESS

c. 1891. Drypoint, soft-ground etching, and aquatint on paper, $14\frac{7}{4} \times 10\frac{7}{4}$ " (37.5 × 27.3 cm), (Matthews and Shapiro 1989 12.vi/vi), 1963.10.255 (B-22323). Photo by Dean Beasom. Chester Dale Collection © Board of Trustees, National Gallery of Art, Washington, D.C.

Copyright © 2008, 2005 by Pearson Education, Inc., Upper Saddle River, New Jersey, 07458. All rights reserved. Printed in the United States of America. This publication is protected by copyright, and permission should be obtained from the publisher prior to any prohibited reproduction, storage in a retrieval system, or transmission in any form or by any means, electronic, mechanical, photocopying, recording, or likewise. For information regarding permission(s), write to: Rights and Permissions Department.

Pearson Prentice HallTM is a trademark of Pearson Education, Inc.

Pearson® is a registered trademark of Pearson plc

Prentice Hall® is a registered trademark of Pearson Education, Inc.

Pearson Education LTD.

Pearson Education Australia PTY, Limited

Pearson Education Singapore, Pte. Ltd

Pearson Education North Asia Ltd

Pearson Education, Canada, Ltd

Pearson Educación de Mexico, S.A. de C.V

Pearson Education—Japan

Pearson Education Malaysia, Pte. Ltd

10 9 8 7 6 5 4 3 2

ISBN 0-13-156577-X

ISBN 978-0-13-156577-7

BRIEF CONTENTS

CONTENTS vii

PREFACE xi

WHAT'S NEW xi

TOOLS FOR UNDERSTANDING ART HISTORY xiv

FACULTY AND STUDENT RESOURCES FOR ART HISTORY xxi

ACKNOWLEDGEMENTS xxiii

USE NOTES xxv

STARTER KIT xxvi
INTRODUCTION xxxiii

- 12 FOURTEENTH-CENTURY ART IN EUROPE 422
- 13 FIFTEENTH-CENTURY ART IN NORTHERN EUROPE AND THE IBERIAN PENINSULA 452
- 14 renaissance art in fifteenthcentury italy 488
- 15 sixteenth-century art in Italy $_{528}$
- 16 SIXTEENTH-CENTURY ART IN NORTHERN EUROPE AND THE IBERIAN PENINSULA 576

- 17 BAROQUE ART 612
- 18 EIGHTEENTH-CENTURY ART IN EUROPE AND THE AMERICAS 678
- 19 NINETEENTH-CENTURY ART IN EUROPE AND THE UNITED STATES 722
- $20 \begin{array}{l} {}_{\rm AMERICAS,\ 1900-1945 \quad 802}^{\rm MODERN\ ART\ IN\ EUROPE\ AND\ THE} \end{array}$
- THE INTERNATIONAL SCENE SINCE 1945 862

CONTENTS

Preface xi

What's New xii

Tools for Understanding Art History xiv

Faculty and Student Resources for Art History xxi

Acknowledgements xxiii

Use Notes xxv

Starter Kit xxvi

Introduction xxxii

12

FOURTEENTH-CENTURY ART IN EUROPE 422

EUROPE IN THE FOURTEENTH CENTURY 424

ITALY 427

Florentine Architecture and Sculpture 427 Florentine Painting 429 Sienese Painting 437

FRANCE 442

Manuscript Illumination 442

Sculpture 443

ENGLAND 445

Embroidery: Opus Anglicanum 445

Architecture 446

THE HOLY ROMAN EMPIRE 448

The Supremacy of Prague 448 Mysticism and Suffering 450

IN PERSPECTIVE 452

TIMELINE 453

BOXES

THE **OBJECT SPEAKS** The Triumph of Death 426

■ TECHNIQUE

Cennino Cennini (c. 1370–1440) on Painting 434 Buon Fresco 439

ART AND ITS CONTEXT

A New Spirit in Fourteenth-Century Literature 431

13

FIFTEENTH-CENTURY ART IN NORTHERN EUROPE AND THE IBERIAN PENINSULA 454

HUMANISM AND THE NORTHERN RENAISSANCE 456 ART FOR THE FRENCH DUCAL COURTS 457

Painting and Sculpture for the Chartreuse de Champmol 458 Manuscript Illumination 460 The Fiber Arts 464

PAINTING IN FLANDERS 466

The Founders of the Flemish School 466
Painting at Midcentury: The Second Generation 474

EUROPE BEYOND FLANDERS 479

France 479
Spain and Portugal 481
Germany and Switzerland 483

THE GRAPHIC ARTS 484

Single Sheets 484
Printed Books 485

IN PERSPECTIVE 486

TIMELINE 487

BOXES

THE DBJECT SPEAKS Hans Memling's Saint Ursula Reliquary 478

■ TECHNIQUE

Woodcuts and Engraving on Metal 485

ART AND ITS CONTEXT

Altars and Altarpieces 461
Women Artists in the Late Middle Ages and the Renaissance 462

14

RENAISSANCE ART IN FIFTEENTH-CENTURY ITALY 488

HUMANISM AND THE ITALIAN RENAISSANCE 490

FLORENCE 491

Architecture 493
Sculpture 498
Painting 504

Mural Painting in Florence after Masaccio 508

ITALIAN ART IN THE SECOND HALF OF THE FIFTEENTH CENTURY 510

Urbino 510 Mantua 514

Rome 517

The Later Fifteenth Century in Florence 518

Venice 523

IN PERSPECTIVE 525

TIMELINE 527

BOXES

THE **OBJECT SPEAKS** The Foundling Hospital 496

■ TECHNIQUE

Brunelleschi, Alberti, and Renaissance Perspective 492 Ceramics 504

ART AND ITS CONTEXT

The Printed Book 522

vii

15 SIXTEENTH-CENTURY ART IN ITALY 528

EUROPE IN THE SIXTEENTH CENTURY 530 ITALY IN THE EARLY SIXTEENTH CENTURY: THE HIGH

RENAISSANCE 532

Three Great Artists of the Early Sixteenth Century 532
Architecture and Painting in Northern Italy 550
Venice and Veneto 552

ART AND THE COUNTER-REFORMATION 557

Art and Architecture in Rome and the Vatican 558

MANNERISM 562

Painting 563
Manuscripts and Miniatures 566
Late Mannerism 568

LATER SIXTEENTH-CENTURY ART IN VENICE AND THE VENETO 569

Oil Painting 569
Architecture: Palladio 573
IN PERSPECTIVE 574
TIMELINE 575

BOXES

THE DBJECT SPEAKS Veronese Is Called Before the Inquisition 570

■ ELEMENTS OF ARCHITECTURE The Grotto 547

Saint Peter's Basilica 549

■ ART AND ITS CONTEXT
Women Patrons of the Arts 558

■ DEFINING ART
The Vitruvian Man 535

SIXTEENTH-CENTURY
ART IN NORTHERN
EUROPE AND THE
IBERIAN PENINSULA 576

THE REFORMATION AND THE ARTS 578

EARLY SIXTEENTH-CENTURY ART IN GERMANY 579

Sculpture 579 Painting 581

RENAISSANCE ART IN FRANCE 590

The Introduction of Italian Art 590 Art in the Capital 592

RENAISSANCE ART IN SPAIN AND PORTUGAL 595

Architecture 595 Painting 595

RENAISSANCE PAINTING IN THE NETHERLANDS 598

Art for Aristocratic and Noble Patrons 598
Antwerp 601

RENAISSANCE ART IN ENGLAND 604

Artists for the Tudor Court 605

Architecture 608

IN PERSPECTIVE 610

TIMELINE 611

BOXES

THE OBJECT SPEAKS Sculpture for the Knights of Christ at Tomar 594

■ TECHNIQUE

German Metalwork: A Collaborative Venture 684

ART AND ITS CONTEXT

Armor for Royal Games 607 Chenonceau: The Castle of the Ladies 592

17

BAROQUE ART 612

THE BAROQUE PERIOD 614

ITALY 615

Architecture and Sculpture in Rome 615 Painting 624

THE HABSBURG LANDS 634

Painting in Spain's Golden Age 634 Architecture in Spain and Austria 640

FLANDERS AND THE NETHERLANDS 642

Flanders 644 The Dutch Republic 649

FRANCE 663

Architecture and Its Decoration at Versailles 663
Painting 667

ENGLAND 671

Architecture and Landscape Design 671 English Colonies in North America 675

IN PERSPECTIVE 676

TIMELINE 677

BOXES

THE DBJECT SPEAKS Brueghel and Rubens's Allegory of Sight 650

■ ELEMENTS OF ARCHITECTURE French Baroque Garden Design 666

DEFINING ART

Grading the Old Masters 669

■ SCIENCE AND TECHNOLOGY

Science and the Changing Worldview 616

18

EIGHTEENTH-CENTURY ART IN EUROPE AND THE AMERICAS 678

THE ENLIGHTENMENT AND ITS REVOLUTIONS 680
THE ROCOCO STYLE IN EUROPE 681

Architecture and Its Decoration in Germany and Austria 682 Rococo Painting and Sculpture in France 684

ITALY AND THE CLASSICAL REVIVAL 689

Italian Portraits and Views 690

Neoclassicism in Rome: The Albani-Winckelmann Influence 692

REVIVALS AND ROMANTICISM IN BRITAIN 694

Classical Revival in Architecture and Landscaping 694
Gothic Revival in Architecture and Its Decoration 697
Neoclassicism in Architecture and the Decorative Arts 697
Painting 699

LATER EIGHTEENTH-CENTURY ART IN FRANCE 707

Architecture 707

Painting and Sculpture 708

EIGHTEENTH-CENTURY ART OF THE AMERICAS 715

New Spain 715 North America 717

IN PERSPECTIVE 720

TIMELINE 721

BOXES

THE DBJECT SPEAKS Georgian Silver 700

- ELEMENTS OF ARCHITECTURE Iron as a Building Material 705
- ART AND ITS CONTEXT
 Women and Academies 690
- DEFINING ART
 Academies and Academy Exhibitions 686

NINETEENTH-CENTURY
ART IN EUROPE
AND THE
UNITED STATES 722

EUROPE AND THE UNITED STATES IN THE NINETEENTH CENTURY 724

EARLY NINETEENTH-CENTURY ART: NEOCLASSICISM AND ROMANTICISM 725

Neoclassicism and Romanticism in France 726
Romantic Sculpture in France and Beyond 735
Romanticism in Spain: Goya 736
Romantic Landscape Painting 738
Orientalism 743

Revival Styles in Architecture before 1850 745

ART IN THE SECOND HALF OF THE NINETEENTH CENTURY 747

Early Photography in Europe 748

New Materials and Technology in Architecture at Midcentury 750

French Academic Art and Architecture 751

Realism 753

Late Nineteenth-Century Art in Britain 761 Impressionism 764

THE BIRTH OF MODERN ART 776

Post-Impressionism 776
Symbolism in Painting 785
Late Nineteenth-Century French Sculpture 789
Art Nouveau 791
Late-Century Photography 795
Architecture 796

IN PERSPECTIVE 800

TIMELINE 801

BOXES

THE DBJECT SPEAKS Raft of the "Medusa" 730

ELEMENTS OF ARCHITECTURE

The City Park 797

■ TECHNIQUE

Lithography 732

How to be a Famous Artist in the Nineteenth Century 754

ART AND ITS CONTEXT

Modern Artists and World Culture 782

DEFINING ART

Art on Trial in 1877 763

MODERN ART IN EUROPE AND THE AMERICAS, 1900–1945 802

EUROPE AND THE AMERICAS IN THE EARLY TWENTIETH CENTURY 804

EARLY MODERN ART IN EUROPE 805

The Fauves: Wild Beasts of Color 805
"The Bridge" and Primitivism 808
Independent Expressionists 810
Spiritualism of the Blue Rider 811
Cubism in Europe: Exploding the Still Life 814
Extensions of Cubism 820
Toward Abstraction in Sculpture 824
Dada 826

EARLY MODERN ART IN THE AMERICAS 829

Modernist Tendencies in the United States 829 Modernism Breaks out of Latin America 834 Canada 836

EARLY MODERN ARCHITECTURE 838

European Modernism 838 American Modern Architecture 839

ART BETWEEN THE WARS 843

Utilitarian Art Forms in Russia 843
Rationalism in the Netherlands 845
Bauhaus Art in Germany 848
Art and Politics 849
Surrealists Rearrange Our Minds 857

IN PERSPECTIVE 860

TIMELINE 861

BOXES

THE DIJECT SPEAKS Portrait of a German Officer 832

■ ELEMENTS OF ARCHITECTURE

The Skyscraper 842
The International Style 847

ART AND ITS CONTEXT

Federal Patronage for American Art During the Depression 854

DEFINING ART

Suppression of the Avant-Garde in Nazi Germany 850

THE INTERNATIONAL SCENE SINCE 1945 862

THE WORLD SINCE 1945 864 POSTWAR EUROPEAN ART 866

Figural Artist 866 Abstraction and Art Informel 867

ABSTRACT EXPRESSIONISM 869

The Formative Phase 869
Action Painting 871
Color Field Painting 875
Sculpture of the New York School 876

EXPERIMENTS WITH FORM IN BUENOS AIRES 879

Concrete-Invention 880 Madí 880

POSTWAR PHOTOGRAPHY 880

New Documentary Slants 881
The Modernist Heritage 883

MOVING INTO THE REAL WORLD 883

Assemblage 883 Happenings 886 Pop Art 888

THE FINAL ASSAULT ON CONVENTION, 1960-1975 892

Op Art and Minimal Art 892 Arte Povera: Impoverished Art 896 Conceptual and Performance Art 898
Earthworks and Site-Specific Sculpture 899
Feminist Art 901

ARCHITECTURE: FROM MODERN TO POSTMODERN 905

Midcentury Modernist Architecture 905 Postmodern Architecture 908

POSTMODERN ART 909

The Critique of Originality 910
Telling Stories with Paint 912
Finding New Meanings in Shapes 917
High Tech and Deconstructive Architecture 920
New Statements in New Media 922

IN PERSPECTIVE 928

TIMELINE 929

BOXES

THE DIJECT SPEAKS The Dinner Party 906

■ DEFINING ART
Recent Controversies over Public Funding for the Arts 921

Contemporary World Map 932 Glossary 933

Bibliography 940 Credits 948 Index 950

PREFACE

believe that the first goal of an introductory art history course is to create an educated, enthusiastic public for the inspired, tangible creations of human skill and imagination that make up the visual arts—and I remain convinced that every student can and should enjoy her or his introduction to this broad field of study.

This book balances formalist analysis with contextual art history to support the needs of a diverse and fast-changing student population. Throughout the text, the visual arts are treated within the real-world contexts of history, geography, politics, religion, economics, and the broad social and personal aspects of human culture.

So . . . What's New in This Edition?

A Major Revision

I strongly believe that an established text should continually respond to the changing needs of its audience. With this in mind, the Third Edition has been revised in several major ways.

A View of the West: For the first time, this western-only version of the text is offered in response to requests from instructors teaching general survey courses confined to European-based traditions. The text of each of its chapters is identical to the western chapters found in the global version of the new Third Edition of *Art History*.

Significant Restructuring and Rewriting: In response to the evolving requirements of the text's audience—both students and educators—the changes implemented in this edition result in greater depth of discussion, and for

some specific cultures and time periods, a broader scope. I also revamped a number of chapters and sections in a continuing effort to better utilize chapter organization as a foundation for understanding historic periods and to help explain key concepts.

Improved Student Accessibility: New pedagogical features make this book even more readable and accessible than its previous incarnations. Revised maps and chronologies, for example, anchor the reader in time and place, while the redesigned box program provides greater detail about key contextual and technical topics. At the same time, I have worked to maintain an animated and clear narrative to engage the reader. Incorporating feedback from our many users and reviewers, I believe we have succeeded in making this edition the most student-accessible art history survey available.

Enhanced Image Program: Every image that could be obtained in color has been acquired. Older reproductions of uncleaned or unrestored works also have been updated when new and improved images were available. In some instances, details have also been added to allow for closer inspection. (See, for example, figs. 13–21 and 14–37.) The line art program has been enhanced with color for better readability, and there is a new series of color reconstructions and cutaway architectural images. To further assist both students and teachers, we have sought permission for electronic educational use so that instructors who adopt *Art History* will have access to an extraordinary archive of high quality digital images for classroom use. (SEE P. XXI FOR MORE DETAILS ABOUT THE PRENTICE HALL DIGITAL ART LIBRARY).

WHAT'S NEW

Chapter by Chapter Revisions

Chapter 1 includes a focus on the arts and daily life in prehistoric Europe with enhanced coverage of Neolithic paintings and the village of *Skara Brae*.

Chapter 2 is reorganized to follow a chronological sequence, and the focus on the arts and daily life in this chapter incorporates the sites of *Jericho* and *Catal Huyuk*.

Chapter 3 features an aerial view and reconstruction drawing of Karnak, as well as expanded coverage of Abu Simbel.

Chapter 4 now offers aerial views combined with reconstruction drawings for the sites of Knossos and Mycenae, and the "Object Speaks" highlights the Lions' Gate at Mycenae.

Chapter 5 is enhanced by the addition of Exekias' vase, Ajax and Achilles Playing a Dice Game. There also is a clarification of the ownership status of the Death of Sarpedon vase by Euphronios.

Chapter 6 is reorganized to follow a chronological sequence rather an organization by medium. The addition of more "natural" busts such as Pompey and a Middle-aged Flavian Woman broadens the discussion of Roman portrait. A colorized reproduction of the Augustus of Prima Porta is included in a discussion of the use of color in ancient sculpture.

Chapter 7 includes new images of the Old St. Peter's interior and the Hosios Lukas exterior. New examples of Early Christian sculpture are a sarcophagus with Christian themes, and the carved doors of the church of Santa Sabina.

Chapter 8 heightens its emphasis on the exchanges within the Islamic world and between Islam and its neighbors. A new section on the "Five Pillars" of Islamic religious observance is incorporated. Coverage is extended into the modern period.

Chapter 9 is reorganized to clarify the complex styles of migrating peoples in the fifth through seventh centuries as well as the contributions of the Vikings in sculpture and architecture. To allow for a more cohesive discussion, eleventh-and twelfth-century work in wood has been moved to this chapter.

Chapter 10 is reorganized chronologically rather than regionally or by medium. It includes a new focus on secular architecture and Dover Castle. In sculpture, there is enhanced coverage of cloister reliefs, historiated capitals, and bronze work.

Chapter 11 is reorganized in several significant ways. The chapter incorporates early and high Gothic art

and ends at about 1300. The origins and development of Gothic art in France have been reworked, the "hall" church has been reinstated, and the coverage of secular architecture continues with Stokesay Castle in England.

Chapter 12 is a new chapter that permits a discussion of the fourteenth century as it unfolded across Europe. An aerial view and illustrated drawing of the Cathedral in Florence have been added. A new section on Bohemian art is included.

Chapters 13–16 are a result of a major restructuring. The two chapters formerly devoted to the fifteenth and sixteenth centuries each have been divided into four chapters.

Chapter 13 continues some of the themes and traditions of Gothic and fourteenth-century art outside Italy. The Ghent Altarpiece has been reinstated with open and closed views. A closed view of Rogier van der Weyden's Last Judgment Altarpiece also is added.

Chapter 14 is devoted to Italian fifteenth-century art. Donatello's St. George is now incorporated, as is the Triumph of Federico and Battista da Montefeltro. The art and architecture of Venice are given greater emphasis.

Chapter 15 features sixteenth-century Italian art. The sculpture discussion is broadened. Illustrations from The Farnese Hours emphasize the continuing tradition of the illuminated manuscript.

Chapter 16 deals with the sixteenth century outside Italy. The "Object Speaks" focuses on Portuguese sculpture and the great Window at Tomar. Secular architecture is expanded to include the Château of Chenonceau and Tudor Hardwick Hall.

Chapter 17 remains regionally organized, but is slightly reordered for better clarity. Spanish colonial sculpture and architecture are moved to chapter 29.

Chapter 18 includes more historical context in the discussion of artists and works. Colonial Latin American objects are moved to this chapter.

Chapter 19 features a section on Orientalism. The interaction of French political history and art is explored in

greater detail, and the discussion relating to the definition and causes of Modern art is rewritten and expanded.

Chapter 20 includes an increased exploration of Primitivism in relation to several movements. There is a key new section on Latin American early Modern art, and the segments relating to Kandinsky's abstract art, Dada, and Surrealism are rewritten.

Chapter 21 has a new discussion of cultural factors such as existentialism, John Cage, and the influence of mass media. There is increased coverage of postwar European art and Latin American art. An expanded discussion of the end of Modernism and the beginnings of Postmodernism is incorporated, as well as new sections relating to some dominant trends in Postmodernism.

Tools for Understanding Art History: A View of the West

Art History: A View of the West offers the most student-friendly, contextual, and inclusive survey of art history.

he text provides students with essential historical, social, geographical, political, and religious contexts. It anchors works of art and architecture in time and place to foster a better understanding of their creation and influence. Marilyn Stokstad takes students on a unique journey through the history of art, illustrating the rich diversity of artists, media, and objects.

Key Features of Every Chapter

Art History has always been known for superb pedagogical features in every chapter, many of which have been enhanced for this new edition. These include:

Chapter openers quickly immerse the reader in time and place and set the stage for the chapter. Clear, engaging prose throughout the text is geared to student comprehension.

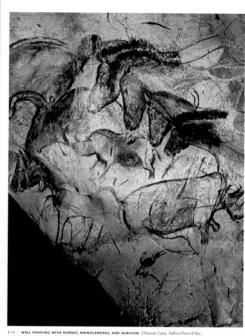

I-I | WALL PAINTING WITH HORSES, RHINOCEROSES, AND AUI Ardèche Gorge, France, c. 30,000-28,000 acs. Paint on limestone

CHAPTER ONE

PREHISTORIC ART IN EUROPE

that defining mement, people were carving and other structures. In fact, much of what we leave about probative people is based on the art they pro-duced. These works are factivating because they are supermely beautiful and because of what they till in about those who make them. The sheer artney and investeday of the images we are these tools appear too. The creation of the images we are

ten records link us to those who came later.

The first contemporary people to explore the paint vet Cave, located in a gorge in the Ardiche region of south- image makers. eastern France (ri.G. 1-1) images of hoves, (dec., riammoths, aurochs (extinct ane estors of oxen), and other animas that lived prehistoric art storside a significant clue—along with founk, prehistoric art storside a significant clue—along with founk, turing the essence of well-observed arimals-meat-bearing structures that survive are only a tiny fraction of what must have

every aspect of material culture, while art his

left by our early ancestors connect us to them as surely as writteday on the walls of the Chauvet Cave must have seemed a ted day survival. They were often painted in areas far from the cove of France and Spain entered an almost usimaginably ancient word. Handreds of youth from the entrances and accreed though long, narrow underground passages, what they found attounded them and still fact native in the Chamber of the control of

30,000 years ago exert the walls and cedings. Feet forms pollen, and artifacts—to understanding early human life and bulge and seem to d iff and move. The images are early identifiable for the painters have transformed their memories of when and how these works were created, they may never be until charmony in specimen continue and season terms of the finite for the punters have transformed their insenses of active, three-dimensional figures into two dimensions by capacities, three-dimensional figures into two dimensions by capacities that the first punters have transformed the scripture, paintings, and able to tell us why they were made. The scripture, paintings, and flinks, powerful legs, and dangerous horns or trake. Using only
the fermal language of line and color, shading, and contour, prehistoric art one of the most speculative areas of art history.

Chapter-at-a-glance feature allows students to see how the chapter will unfold.

God by the biblical patriarch Abraham and long the focus of pilgrimage and poly-heistic worship. He emptied the shrine, repu duting its accumulated pagan idols, while preserving the enigmatic cubical structure inelf and dedicting it to God.

The Kaaba is the symbolic center of the Islamic world, the place to which all Muslim prayer is directed and the ultimate

nation of Islam's obligatory pilgrimage, the Haji. Each year, huge numbers of Muslims from all over the world travel to Mecca to circumambulate the Kaaba during the month of pilgrimage. The exchange of ideas that occurs during the inten-gling of these diverse groups of pilgrims has been a primary source of Islamic art's cultural eelectricism.

- ART DURING THE EARLY CALIPHATES Architecture Calligraphy Ceramics and Textiles ■ LATER ISLAMIC ART | Architecture | Portable Arts | Manuscripts and Painting

- IN PERSPECTIVE

SOCIETY

Seemingly out of nowhere, Islam assee in seventh-century
Archiu, a land of desert once with no enter of great stre,
sparsely inhabited by milds nomank Nrt, under the leadership
of in founder, the Propher Muhammad in CS-2 for SOC 2012, and
his successors, Islam upered rapidly throughout nominers
Africa, southern and centern Emproye, and much of Asia, grant
had no successors, Islam upered rapidly throughout nominers
Africa, southern and centern Emproye, and much of Asia, grant
had no successors, Islam upered rapidly throughout nominers
had no successors and a season of the control of the Charles
had no successors and the season of the Charles
had no successors and the season of the control of the Charles
ferror techniques and sleet as bout at and architecture. The
result was a remarkable extercious and artistic explositacition.
Mandium date their history as beginning with the high
("migration"), the flight of the Propher Muhammad had succeeded in uniting the warring class of Arriba under
the humer of Hadin. Following his dead acide Muhammad
had succeeded in uniting the warring class of Arriba under
the humer of Hadin. Following his dead acide Muhammad
had succeeded in uniting the warring class of Arriba under
the humer of Hadin. Following his dead folds—following
the continued the financient concept of anticions'
(outcomes)".

The accessing viewnos with listed successors from
the continued the financient concept of anticions'
(orthogones) and the representation of
figures, particularly in religious controls, Intead, Islamic
artists, claborated a rich wockshulty of monfigural oranneurs,
including complete geometric designs and seconding views

284. CHAPTER EIGHT ISSAMIC ART

284 CHAPTER EIGHT ISLAMIC ART

Africa and Spain, and penetrated France to within 100 miles of Davis before being turner, back (\$400.8—8-1), in these newly considered from the treatment of Christians and Jews who conquered lands, the treatment of Christians and Jews who did not connect to Islam was not consistent, but in general, as "People of the Book,"—Globbers of a monotheticin religion based on a revealed scripture—they enjoyed a protected state. However, they were also subject to a special test and retrictions on dress and employment.

ART DURING THE EARLY CALIPHATES

ART DURING THE EARLY CALIPHATES 285

Easy-to-read color maps use modern country names for ease of reference and point to the sites and locations mentioned in the chapter.

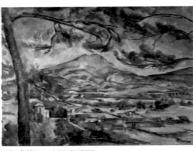

Mini chronologies

provide small in-text sequencing charts related to historic events and works of art.

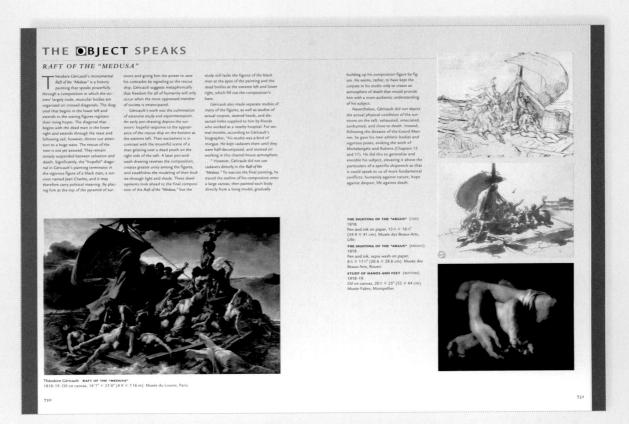

The Object Speaks boxes provide in-depth insights on topics such as authenticity, patronage, and artistic intention.

Box program brings an added layer of understanding to the contextual and technical aspects of the discipline:

- The Object Speaks
- Elements of Architecture
 - Technique
 - Defining Art
- Science and Technology
- Religion and Mythology
 - Art and Its Context

Art and Its Context WOMEN AND ACADEMIES

Inhough womal women were made members of whe European scadewise of are before the eightmore than honorary recognition of their authorities of the American Committee of the American Committee of the Foral Academy that is interest on was to resured all words are supported to the Foral Academy to the words are supported to the Committee of Face, women gained the tide of Academican between 1648 women gained the tide of Academican to women the support of the Academy to women women to the support of the support of the Academy to Academy to the time the animate of the cademy by 1779, who the in emition conversor, and declared flow women members to the lens that only the time to the cademy clark of the academy stress of the academy to the lens that only the cademy to admitted to the academy clark of our allowed to compete for academy prices of the time to the academy to the cademy to admitted to the academy clark of the academy to the cademy to the the cademy to the cademy to the cademy to the the cademy to the the cademy to the the cademy to the cademy to the cademy to the cademy to the the cademy to the cademy to the cademy to the cademy to the the cademy to the cademy to the cademy to the cademy to the the cademy to the cademy to the cademy to the cademy to t

Worne fired erw wore at Loncor's Royal Academy. After the Swiss juniors May Motor and Angleia Kauffmans were named as founding members in 1768, no other women were instituted until 1922, and then only as associates, Johann Zeiffley's 1971-172 portrait of the Lonon azademicans show the men grouped around a male node model, along with the academy's study collection of classical states are abletted opening with the previous diseased states are all deliver copies. Progrego probibited the previous of women in this setting (women were not allowed to get one wife from the mall much), so Zeiflay allowed to get one wife from the mall much), so Zeiflay allowed to get one wife from the mall much), so Zeiflay allowed to get one wife from the mall much), so Zeiflay allowed to get one wife from the mall much), so Zeiflay allowed to get one wife from the mall much) when the form the properties of the searching, however, the two women were informed and the academy, however, the two women were informed and the searching however, the

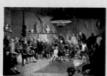

Johann Zoffany ACADEMICIANS OF THE ROYAL ACADEMY 1771-72. Oil on canvas, 47% × 59 % (120.6 > 151.2 cm). The Royal Collection,

or woman began in Den, mored on to southern. Ennec to vivia a number of well-preserved Kroman baldings and moni-unsents there, then headed to Venice, Bornece, Nigles, and Rome As repository of the classical and the Reminance pass, lady was the focus of the Grant of Tour and provided imputation for the most characteristic splee to presult during the English embers, Newclassicson, Needsasicson (nos means "new") present classical spleet matter—applyshaged of historical—and spleet of method of the control of the co

and tentre to minut mose trunce.

Beginning in 1780, extraodinary archaeological discoverics made at two uses nor Nepiles also excited renewed interest
in classical art and artifacts. Heroidnessman and Prospers, two
prosperson Roman town barrela in 79 c.1 by the suddern solcame cruption of Montal Vension, afford sensitional new
material for study and speculation. Numerous illustrated books
on these discoveries circulated throughout Europe and America, Inefing public facination with the ancient world and conrobusting to a tast for the Necclinacia [197].

Italian Portraits and Views

Most educated Europeans regarded Italy as the wellspring of Western culture, where Roman and Renaissance art flourished in the past and a great many artists still practiced. The studios of important Italian artists were required stops on the Grand Tour, and collectors avidly bought portraits and landscapes the could bear on Islaid.

CARRELA. Wealthy northern European visitors to Italy offers at size personals by Italian arrives. Resulta Carrera (1675–1573), the leading the first positive during the first positive during the first positive during the first positive for the properties of the properties of the first positive persons on the group late pattern and painting ministure portrain on the group late of surfaces, by the early eighteent century the was making portrain with pastels, exposs of pulverteed pigment bound to a challs but by weak gam water. A versule modelm, pastel can be employed in a sketchy manner to create a visicious and fleeting effect or can be belieded through rubbing to produce a highly finished image. Carriera's parche area of the produce of the produc

18-13 | Rosalba Carriesa CHARLES SACKVILLE, 2ND DUKE OF DORSET c. 1730. Pastel on paper, 25 × 19" (63.5 × 48.3 cm).

18-14 Canaletto SANTI GIOVANNI E PAOLO AND THE MONUMEN
C. 1735-38. Oil on carvas. 18 % × 30% (46 × 78 4 cm). The Royal Col

In Perspective is a concluding synthesis of essential ideas in the chapter.

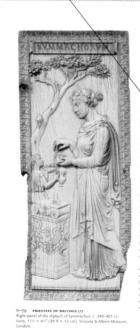

pagan practices. As a result, stories of the ancient gods and heroes entered the secular realm as lively, visually delightful, and even crotic decorative elements.

The style and subject matter of the art reflect a societ in transition, for even as Roman authority gave way to loc, calle by powerful "barbarian" in these in much of the West many people continued to appreciate classical learning to resaure Greek and Roman art. In the East, classical train tions and styles endured to become an important element of Neuratine art.

IN PERSPECTIVE

The Roman, who supplanted the Erruscan and the Greek appreciated the callet and other people and adapted in their own uses, but they also had their own strengths, such a efficiency and a perical agrain for organization. As spinit ideated would propagated, Roman art served the state an the empire. Creating both official images and representation of private individuals, Roman acultors entitled and sleet open data and organization. As spinit are supplied as a spinit propagation of private individuals, Roman sculptors entitled and sleet open data and organization. The spinit propagation of private individuals are considered contemporary historical events on commemorative arches, column and musuodenum.

and manoteums. Roman artists covered the walls of private homes wit paintings, too. Sometimes fantastic urban panoramas ur round a room, or painted columns and corniecs, swingin garlands, and unches make a wall seem to dissolve. Some artist cereated the flusion of being on a porth or in a pavilion look ing out into an extensive landscape. Such painted surfaces as often like backdrops for a theartist set.

Roman architects relied heavily on the round arch an masonry vaulting. Beginning in the second century itex, the abor brieful increasingly on a new building material concrete in contrast to stone, the components of concrete arc cheapinght, and easily transported. Imposing and Isating concret structures could be built by a large, semiskilled work foro

directed by one or two trained and experienced upervisors. Drawing artistic impairton from their Errucan and Greek predecessors and combining this with their own raditions, Roman artists made a distinctive contribution to the history of air, creating works that formed an enduring lade of excellence in the Wext. And as Roman authority gave way to local rule, the newly powerful "Databarian" rubes continue to appreciate and even treasure the Classical learning and art the Roman left below.

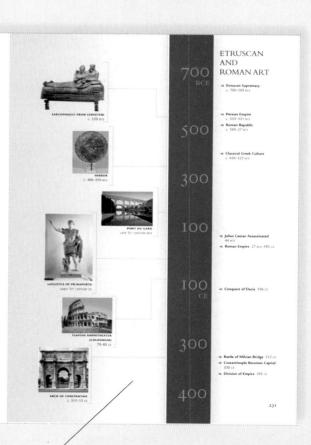

Timelines provide an overview of the chapter time frame.

Elements of Architecture THE SKYSCRAPER The evolution of the skyscraper depended on the development of the structural majority in deal beam and goden for the structural majority of t

which is intended to facilitate contemplation of the specturular view aross the cargor. The rootine of the structure is also irregular, like the surrounding cargon wall. Inside, the used large have logo for most of the structural superior, between raw stone walls. All of these features can also be found in Hopa substituting. The sole concessions to most found in Hopa substitution. The sole concessions to most the stone foundation. Her work on borders and railors we then some foundation. Her work on borders and railors we tions throughout the Southwest helped to establish a distinctive identity for architecture of that region.

THE AMERICAN SKYSCRAFER. After 1900, New York City assumed leadership in the development of the skyscraper, whose soaring height was made possible by the use of the steel-frame skeleton for structural support and other advances in engineering and technology (see "The Skyscraper," above).

342 CHAPTER TWENTY MODERN ART IN EUROPE AND THE AMERICAS, 1900-194

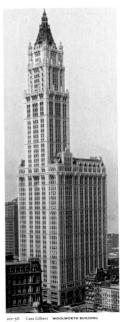

20–56 | Cass Gilbert WOOLWORTH BUILDIN New York, 1911–13.

New York clients rejected the innovative style of Louis Sulfivan and other Chicago architects for the historicist approach still in Kern in the East, seem in the worknown approach will in Kern in the East, seem in the worknown of Gelbert (1889–1984). When completed, a '170 Feet and Softwork (1882–1984). When completed, a '170 Feet and Softwork is worked to the complete style in the state of the complete style in the contract details, in good to the contract details, in significant will will be supported by the state of the contract of t

ART BETWEEN THE WARS

World War I had a profound effect on Europe's arms and architects. While the Dadius responded curasticilly to the unprecedented destruction, some sought in the wark albeit the basis for a new, more secure (withstim). The onese of the Great Depression in 1929 also motivated many arisis to try to find ways to serve society. In general, great ded of are produced between 1919 and 1939 in Europe and North America is connected in some way with the hope for a better and more just world, rather than primarily serving selfegoression or the inventogrant of a serving selfegoression or the inventogrant of a self-

Utilitarian Art Forms in Russi

In the 1917 Russian Revolution, the radical socialist Bolsheviks overthrew the czar, took Russia out of the world war, and turned to winning an internal civil war that lasted until 1920, Most of the Russian avant-garde enthusiastically supnorted the Bolsheviks, who in turn supported them.

Constructions. The case of Aleksandr Rockbenho (1891— 1996) in fairly representative. An early associate of Malevich and Dopose (3st 1918, 20-22), 20-31). Rockbenko initially used drafting took to make abstract densing. The Supermatist phase of his career culminated in a 1921 echibition where he showed three large flat, monochromotic panels painted in reed, yellow, and blue, which he titled Last Plusting (they are motivaturely tool). After making this work, he renounced a painting as a busically selfols activity and condemned selfergression as oscilly irreposable.

In the same year he helped launch a group known as the Constructivities, who were committed to quitting the studie and going "into the factory, where the real body of life in made." In place of arms dedicated to expressing themselve or exploring aesthetic issues, policitally committed arms would create useful objects and promote the aims of society Rodchenko came to believe that patienting and sculpture of not contribute enough to practical needs, so after 1921 he began to make photographs, posters, books, teralles, and the are sets that would promote the egalization ends of the neeforest proceive.

SETWEEN THE WARS 84

Diagrams make difficult concepts related to architecture and materials and techniques accessible to students.

VALUE OF FRONT

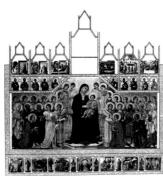

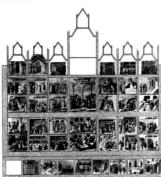

Creating this altarpiece was an audious undertaking. The central panel alone was 7 by 13.5 feer, and it had to be pieced on both from and back, because it was meant to be seen from both ades. The main altar for which it was designed stoud beneath the done in the center of the sun taury. Inscribed on Mary's thones are the words, "Hob Mother of Godb ee thou the cause of peace for Sieran and because he painted there thus, of life for Discioi" (cited in

Altur and Wilkins 4.2, page 104).
May and Christ, adored by angels and the four parson
same of Sensa—Ansams, Serium, Crescertins, and Victor—
American from eff. file barge central panel. This Topia and
Child in Neutry represents both the Church and no specific
consolidamen/Sensa Cardhedl. Narrawe even from the early
life of the VipiQ, and the infrarcy of the Churc Child appear
below the central Senger. The predict (the lower zone of the
altarpeacy was entitled to the control of the control of the
distripancy was entitled to the control of the control
of the Church with the infrared control
of the Church with the control of the control
of the Church with the control of the control
of the Church with the control of the control
of the Church with the control of the Church
of the Church with the Church with the Church
of the Church with the Church with the Church
of the Church with the Church with the Church
of the Church with the Church with the Church
of the Church with the Church with the Church
of the Church with the Church with the Church
of the Church with the Church with the Church
of the Church with the Church with the Church
of the Church with the Church with the Church
of the Church with the Church with the Church
of the Church with the Church with the Church
of the Church with the Church with the Church
of the Church with the Church with the Church
of the Church with the Church with the Church
of the Church with the Church with the Church
of the Church with the Church with the Church
of the Church with the Church with the Church
of the Church with the Church with the Church
of the Church with the Church with the Church
of the Church with the Church with the Church
of the Church with the Church with the Church with the Church
of the Church with the Church with the Church with the Church
of the Church with the Church with the Church with the Church
of the Church with the Church wi

Duese created a personal style that combines a softened latel by parame figure per with with the execution related to the latel and their personal related to the personal rel

on the during of the state of t

Technique BUON FRESCO

.....

buen ("true") Fresco ("fresh"), in which paint is applied with water-based paints on wer plaster, and fresco secce ("dry"), in which paint is applied to a dry plastered wall. The two methods can be used on the sams wall painting.

The advantage of buen fresco is its durability. A chemi-

The adventage of how flevio is its durability. A chemical relation course as the painted plates dries, which bonds the pigments into the wall surface. In femio sens, by contrast, the colde onto not become given of the wall and tends to false of flower time. The chief disadvantage of the surface is the configuration of the surface of the surface is the completed in a day, in tally, each we technic is called agivenate, or day is vow. The size of a generate voice is according to the completed in a day, in tally, each we technic is called agivenate, or day is vow. The size of a generate voice is according to the completed or the painting within it. A face, for instance, can encopy an enter of key, whereas

large areas of sky can be painted quite rapidly.

In medical and Remanance Islay, and the of frenceed was from prepared with a rough, thick understat of particular for prepared with a rough, thick understat of parties of the painters of composition once a with charact. The artist made any necessary adjustments. These drawings, known as skepts, have an immediately and fortheres lost in the finished passings. Work proceeded in reregularly shaped accessor, conforming to the contension of large figures and when the size of the north of the painter figures with which the size of the north of the painter worked with pigments mixed with water. Palarest over the inlepit, and when this was "act "but north of the parties worked from the top down so that duty of the our furnished points. Some areas requiring pigments such as also assured to the parties of the

438 CHAPTER TWELVE FOURTEENTH-CENTURY ART IN EUROPE

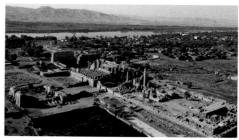

3-22 | THE RUINS OF THE GREAT TEMPLE OF AMUN AT KARNAK, EGYP

hall and sanctuary. The design was symmetrical and axial that is, all of its separate elements are symmetrically arranged along a dominant center line, creating a processional path. The rooms became smaller, darker, and more exclusive as they neared the sanctuary. Only the pharaoh and the priests

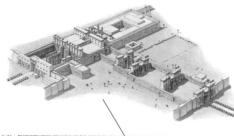

3-23 | RECONSTRUCTION DRAWING OF THE GREAT TEMPLE OF MUN AT KARNAK, EGYPT New Kingdom, c. 1579-1075 BCE.

68 CHAPTER THREE ART OF ANCIENT EGY

Two temple districts consecrated primarily to the worship of An'un Mut, and Khons arose near Thebes—a huge complex at Karnak to the north and, joined to it by an avenue of sphinxes a more compact temple at Luzor to the south.

KABMAK. At KATHAL temples were bult and rebuilt for over 1,500 years, and the remains of the New X ingulom additions to the Grest Temple of Amun still dominate the landscape (106.3–22). Over the nearly \$500 years of the New Kingdom, successive Thing removated and expanded the Amun temples until the complex covered about \$60 xers, an area as large as a dozen foodball fields (106.3–231).

Access to the heart of the semple, a successary contained the state of An mouse from the west per held wise of the reconstruct on drawing through a pericipal coursyste, hyposyste ball, and a number of musher halls and course places of the season of the s

In the sun turn, the priests washed the goft statue ever morning and dothed it in a new garmer. Became the got was though to derive nourishment from the spiri of food, it was provided with tempting meals two ces 2 day, which the priests then removed and at: themselves Ordinary people centered the temple precisior cely as far as the forecours of the hypostyc balls, where they found themselves surrounded by interpress and images of king and the god on column and walls. Furing religious foctoals, however, they lined the waterways, Johny which statues of the gols were carried in ceremonal work, and were per-nitted to submit pertitions to the priests for requests they will well the gols to grant.

THE GRAY HALL AY KANNAC. Between Pylons III and IIII at Karrak Starks the enormous hypoxyle hall exected in the reigns of the Nineteenth Dynasy rulers Sey I (ruled c. 1290–1279 Euc) and his son Ramese III (ruled c. 1290–1279 Euc) and his son Ramese III (ruled c. 1290–1279 in the House of Amama," it may have been used for royal coronation ceremonics. Ruraese II referred to it as "the place where the common people exat of the name of

An office of the state of the s

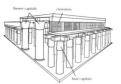

3—24 RECONSTRUCTION DRAWING OF THE HYPOSTYLI HALL, GREAT TEMPLE OF AMUN AT KARNAK

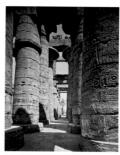

3-25 | FLOWER AND BUD COLUMNS, HYPOSTYLE H

THE NEW KINGDOM, c. 1539-1075 acr

Reconstructions bring partially destroyed and no longer extant sites to life.

The Camerana. In Florence, the cathedral demonst (prec. 12-24, 12-34) has 3 long and complex, hintory. The origina plan, by Arnolfo th Cambao (c. 1245-1302), was approved 12-284 has political unsers in the 1335 could make in the 1450 counter to a half until 1357. Several modifications of the deign resumment, and the cathedral was we tought between 1357 and 1378. (The figade was given its veneer of which and green mathed in the numerical terminy no condinate is with the per of the building and the nearby Buptary of San (Grossma).

Sculptors and painters rather than masons were ofter responsible for designing Italian architecture, and as the Florence Cathedral reflects, they tended to be more concerned with pure design than with engineering. The long, squarebased nave ends in an octagonal domed crossine, as wide a the naw and tide aides. Three pelygonal apies, each with fiveradiating chaples, surround the carried paice. This system, of the Dome of Heaven, where the mais after is Goard, stands apart from the swindly realin of the congregation in the navidation the great ribbed dome, so fundamental to the planners' conception, was not beginn until 120, when the architecture ippo Brunelleschi (1377–1446) solved the engineering problems involved in its construction (see Chapter 14).

THE BAPTISTRY DOORS. In 1330, Andrea Pisane (c.1290–1348) was awarded the prestigious commission for a pair of gilded bronze doors for the Florent ne Baptistry of San Giovanni. (Although his name means "from Pisa," Andrea was not related to Nicola and Giovanni Pisano.) The

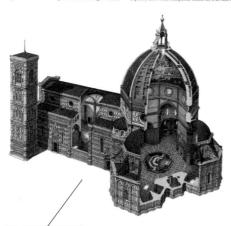

12—3 FLORENCE CATHEDRAL (DUOMO)
Plan 1294, costruction begun 1296, redisegned 1357 and 1366, drum and dome 1420-36.

Matrazion by Philipe Bland in Guide Californat Florence © Californat Lowins.

428 CHAPTER TWELVE FOURTEENTH-CENTURY ART IN EUROPE

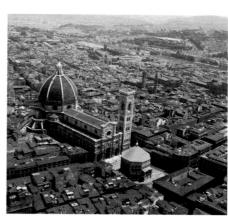

12–4 | Arnolfo di Camilio, Francesco Talenti, Andrea Orcagna, and others | FLORENCE CATHEDRAL (DUOM 1296-1378; drum and dome by Brunelleschi, 1420-36; bell tower (Campanile) by Giotto, Andrea Pisano, and Francesco Talenti, c. 1334-50.

The Romanesque Baptistry of San Giovanni stands in front of the Dwome

twenty scenes from the life of John the Baptits (San Giovanni) est above eight personification of the Viruso (San Lis-y). The relefs are framed by quartefuls, the four-lobed decorative frames turnsheade at the Calhedal of Amiens in Frame (Bit Fig. 11-22). The figures within the quarteful star the mountained, clausizing yells emported by Giotte on the mountained, clausizing yells emported by Giotte on the construction of the properties of the contraction of the properties of the contraction of the contrac dimensional and decorative, and emphasizes the solidity of the doors. The bronze vine scrolls filled with flowers, fruits, and birds on the lintel and jambs framing the door were

Florentine Painting

Florence and Siena, rivals in so many ways, each st poported flourishing school of painting in the fourteenth century. Bot grew out of the Italo-Byzantine style of the thirteenth cent tury, modified by local traditions and by the presence of individual artists of genius. The Byzantine influence, also referre to as the maniera genta ("Greek manner"), was characterize to as the maniera genta ("Greek manner"), was characterized.

ITALY 429

Cutaways assist students in understanding the design and engineering of major buildings.

FACULTY AND STUDENT RESOURCES FOR ART HISTORY: A VIEW OF THE WEST

rentice Hall is pleased to present an outstanding array of high quality resources for teaching and learning with Stokstad's Art History: A View of the West.

DIGITAL & VISUAL RESOURCES

The Prentice Hall Digital Art Library: Instructors who adopt Stokstad's Art History: A View of the West are eligible to receive this unparalleled resource. Available in a two-DVD set (ISBN 0-13-232211-0) or a 16-CD set (ISBN 0-13-156321-1), The Prentice Hall Digital Art Library contains every image in Art History: A View of the West in the highest resolution (300-400 dpi) and pixellation (up to 3000 pixels) possible for optimal projection and one-click download. Developed with input from a panel of instructors and visual resource curators, this resource features over 1,200 illustrations in jpeg and in PowerPoint, an instant download function for easy import into any presentation software, along with a zoom feature, and a compare/contrast function, both of which are unique and were developed exclusively for Prentice Hall.

VangoNotes: Students can study on the go with VangoNotes—chapter reviews from the text in downloadable mp3 format. Each chapter review contains: Big Ideas—Your "need to know" for each chapter; Key Terms: audio "flashcards" to help you review key concepts and terms; and Rapid Review: A quick drill session—use it right before your test. Visit www.vango.com.

OneKey is Prentice Hall's exclusive course management system that delivers all student and instructor resources in one place.

Powered by WebCT and Blackboard, OneKey offers an abundance of online study and research tools for students and a variety of teaching and presentation resources for instructors, including an easy-to-use gradebook and access to many of the images from the book.

Art History Interactive CD-ROM: 1,000 Images for Study & Presentation is a powerful study tool for students. Images are viewable by title, by period, or by artist. Students can quiz them-

selves in flashcard mode or by answering any number of short answer and compare/contrast questions.

Classroom Response System (CRS) In Class Questions: Get instant, class-wide responses to beautifully illustrated chapter-specific questions during a lecture to gauge student comprehension—and keep them engaged. Visit www.prenhall.com/art.

Companion Website: Visit www.prenhall.com/ stokstad for a comprehensive online resource featuring a variety of learning and teaching modules, all correlated to the chapters of Art History: A View of the West.

Prentice Hall Test Generator is a commercial-quality computerized test management program available for both Microsoft Windows and Macintosh environments.

PRINT RESOURCES

TIME Special Edition, Art: Featuring stories such as "The Mighty Medici," "When Henri Met Pablo," and "Redesigning America," Prentice Hall's TIME Special Edition contains thirty articles and exhibition reviews on a wide range

of subjects, all illustrated in full color. This is the perfect complement for discussion groups, in-class debates, or writing assignments. With TIME Special Edition, students also receive a 3-month pass to the TIME archive, a unique reference and research tool.

Understanding the Art Museum by Barbara Beall-Fofana: This handbook gives students essential museum-going guidance to help them make the most of their experience seeing art outside of the classroom. Case studies are incorporated into the text, and a list of major museums in the United States and key cities across the world is included. (0-13-195070-3)

OneSearch with Research Navigator helps students with finding the right articles and journals in art history.

Students get exclusive access to three research databases: The New York Times Search by Subject Archive, ContentSelect Academic Journal Database, and Link Library.

Instructor's Manual & Test Item File is an invaluable professional resource and reference for new and experienced faculty, containing sample syllabi, hundreds of sample test questions, and guidance on incorporating media technology into your course. (0-13-232214-5)

To find your Prentice Hall representative, use our rep locator at www.prenhall.com.

ACKNOWLEDGEMENTS AND GRATITUDE

Dedicated to my sister, Karen L. S. Leider, and to my niece, Anna J. Leider

preface gives the author yet another opportunity to thank the many readers, faculty members, and students who have contributed to the development of a book. To all of you who have called, written, e-mailed, and just dropped by my office in the Art History Department or my study in the Spencer Research Library at the University of Kansas, I want to express my heartfelt thanks. Some of you worried about pointing out defects, omissions, or possible errors in the text or picture program of the previous edition. I want to assure you that I am truly grateful for your input and that I have made all the corrections and changes that seemed right and possible. (I swear the Weston photograph in the Introduction is correctly positioned in this edition, and that, no, I was not just being witty by showing only the Gallic trumpeter's back side in Chapter 5—that slip has been corrected!)

Art History: A View of the West represents the cumulative efforts of a distinguished group of scholars and educators. Single authorship of a work such as this is no longer viable. Patrick Frank has reworked the modern material previously contributed by David Cateforis and Bradford R. Collins. Dede Ruggles (Islamic) also hs contributed to the third edition.

As ever, this edition has benefited from the assistance and advice of scores of other teachers and scholars who have generously answered my questions, given recommendations on organization and priorities, and provided specialized critiques. I want to especially thank the anonymous reviewers for their advice about reorganizing and revising individual chapters.

In addition, I want to thank University of Kansas colleagues Sally Cornelison, Amy McNair, Marsha Haufler, Charles Eldredge, Marni Kessler, Susan Earle, John Pulz, Linda Stone Ferrier, Stephen Goddard, and Susan Craig for their insightful suggestions and intelligent reactions to revised material. I want to mention, gratefully, graduate students who also helped: Stephanie Fox Knappe, Kate Meyer, and Emily Stamey.

I am additionally grateful for the detailed critiques that the following readers across the country prepared for this third edition: Charles M. Adelman, University of Northern Iowa; Fred C. Albertson, University of Memphis; Frances Altvater, College of William and Mary; Michael Amy, Rochester Institute of Technology; Jennifer L. Ball, Brooklyn College, CUNY; Samantha Baskind, Cleveland State University; Tracey Boswell, Johnson County Community College; Jane H. Brown, University of Arkansas at Little Rock; Roger J. Crum, University of Dayton; Brian A. Curran, Penn State University; Michael T. Davis, Mount Holyoke College; Juilee Decker, Georgetown College; Laurinda Dixon, Syracuse University;

Laura Dufresne, Winthrop University; Dan Ewing, Barry University; Arne Flaten, Coastal Carolina University; John Garton. Cleveland Institute of Art; Rosi Gilday, University of Wisconsin, Oshkosh; Eunice D. Howe, University of Southern California; Phillip Jacks, George Washington University; William R. Levin, Centre College; Susan Libby, Rollins College; Henry Luttikhuizen, Calvin College; Lynn Mackenzie, College of DuPage; Dennis McNamara, Triton College; Gustav Medicus, Kent State University; Lynn Metcalf, St. Cloud State University; Jo-Ann Morgan, Coastal Carolina University; Beth A. Mulvaney, Meredith College; Dorothy Munger, Delaware Community College; Bonnie Noble, University of North Carolina at Charlotte; Leisha O'Quinn, Oklahoma State University; Willow Partington, Hudson Valley Community College; Martin Patrick, Illinois State University; Albert Reischuck, Kent State University; Jeffrey Ruda, University of California, Davis; Diane Scillia, Kent State University;. Stephanie Smith, Youngstown State University; Janet Snyder, West Virginia University; James Terry, Stephens College; Michael Tinkler, Hobart and William Smith Colleges; Reid Wood, Lorain County Community College. I hope that these readers will recognize the important part they have played in this new edition of Art History: A View of the West and that they will enjoy the fruits of all our labors. Please continue to share your thoughts and suggestions with me.

Many people reviewed the original edition of Art History and have continued to assist with its revision. Every chapter was read by one or more specialists. For work on the original book and assistance with subsequent editions my thanks go to: Barbara Abou-el-Haj, SUNY Binghamton; Roger Aiken, Creighton University; Molly Aitken; Anthony Alofsin, University of Texas, Austin; Christiane Andersson, Bucknell University; Kathryn Arnold; Julie Aronson, Cincinnati Art Museum; Michael Auerbach, Vanderbilt University; Larry Beck; Evelyn Bell, San Jose State University; Janetta Rebold Benton, Pace University; Janet Berlo, University of Rochester; Sarah Blick, Kenyon College; Jonathan Bloom, Boston College; Suzaan Boettger; Judith Bookbinder, Boston College; Marta Braun, Ryerson University; Elizabeth Broun, Smithsonian American Art Museum; Glen R. Brown, Kansas State University; Maria Elena Buszek, Kansas City Art Institute; Robert G. Calkins; Annmarie Weyl Carr, Southern Methodist University; April Clagget, Keene State College; William W. Clark, Queens College, CUNY; John Clarke, University of Texas, Austin; Jaqueline Clipsham; Ralph T. Coe; Robert Cohon, The Nelson-Atkins Museum of Art;

Bradford Collins, University of South Carolina; Alessandra Comini; Charles Cuttler; James D'Emilio, University of South Florida; Walter Denny, University of Massachusetts, Amherst; Jerrilyn Dodds, City College, CUNY; Lois Drewer, Index of Christian Art; Joseph Dye, Virginia Museum of Art; James Farmer, Virginia Commonwealth University; Grace Flam, Salt Lake City Community College; Mary D. Garrard; Paula Gerson, Florida State University; Walter S. Gibson; Dorothy Glass; Oleg Grabar; Randall Griffey, The Nelson-Atkins Museum of Art; Cynthia Hahn, Florida State University; Sharon Hill, Virginia Commonwealth University; John Hoopes, University of Kansas; Carol Ivory, Washington State University; Reinhild Janzen, Washburn University; Alison Kettering, Carleton College; Wendy Kindred, University of Maine at Fort Kent; Alan T. Kohl, Minneapolis College of Art; Ruth Kolarik, Colorado College; Carol H. Krinski, New York University; Aileen Laing, Sweet Briar College; Janet Le Blanc, Clemson University; Charles Little, The Metropolitan Museum of Art; Laureen Reu Liu, McHenry County College; Loretta Lorance; Brian Madigan, Wayne State University; Janice Mann, Bucknell University; Judith Mann, St. Louis Art Museum; Richard Mann, San Francisco State University; James Martin,; Elizabeth Parker McLachlan, Rutgers University; Tamara Mikailova, St. Petersburg, Russia, and Macalester College: Anta Montet-White; Anne E. Morganstern, Ohio State University; Winslow Myers, Bancroft School; Lawrence Nees, University of Delaware; Amy Ogata, Cleveland Institute of Art; Judith Oliver, Colgate University; Edward Olszewski, Case Western Reserve University; Sara Jane Pearman; John G. Pedley, University of Michigan; Michael Plante, Tulane University; Eloise Quiñones-Keber, Baruch College and the Graduate Center, CUNY; Virginia Raguin, College of the Holy Cross; Nancy H. Ramage, Ithaca College; Ann M. Roberts, Lake Forest College; Lisa Robertson, The Cleveland Museum of Art; Barry Rubin; Charles Sack, Parsons, Kansas; Jan Schall, The Nelson-Atkins Museum of Art; Tom Shaw, Kean College; Pamela Sheingorn, Baruch College, CUNY; Raechell Smith, Kansas City Art Institute; Lauren Soth; Anne R. Stanton, University of Missouri, Columbia; Michael Stoughton; Thomas Sullivan, OSB, Benedictine College (Conception Abbey); Pamela Trimpe, University of Iowa; Richard Turnbull, Fashion Institute of Technology; Elizabeth Valdez del Alamo, Montclair State College; Lisa Vergara; Monica Visoná, University of Kentucky; Roger Ward, Norton Museum of Art; Mark Weil, Washington University, St. Louis; David Wilkins; Marcilene Wittmer, University of Miami

My thanks also to additional expert readers for this new edition including Susan Cahan, University of Missouri-St. Louis; David Craven, University of New Mexico; Marian Feldman, University of California, Berkeley; Dorothy Johnson, University of Iowa; Genevra Kornbluth, University of Maryland; Patricia Mainardi, City University of New York; Clemente Marconi, Columbia University, Tod Marder, Rutgers University; Mary Miller, Yale University; Elizabeth Penton, Durham Technical Community College; Catherine B. Scallen, Case Western University; Kim Shelton, University of California, Berkeley.

I also want to thank Saralyn Reese Hardy, William J. Crowe, Richard W. Clement, and the Kenneth Spencer Research Library and the Helen F. Spencer Museum of Art of the University od Kansas.

Again I worked with my editors at Prentice Hall, Sarah Touborg and Helen Ronan, to create a book that would incorporate effective pedagogical features into a narrative that explores fundamental art historical ideas. Helen Ronan, Barbara Taylor-Laino, Assunta Petrone, and Lisa Iarkowski managed the project. I am grateful for the editing of Jeannine Ciliotta, Margaret Manos, Teresa Nemeth, and Carol Peters. Peter Bull's drawings have brought new information and clarity to the discussions of architecture. Designer Anne Demarinis created the intelligent, approachable design of this book; she was supported by the masterful talents of Amy Rosen and Gail Cocker-Bogusz. Much appreciation goes to Brandy Dawson, Marissa Feliberty, and Sasha Anderson-Smith in marketing and Sherry Lewis the manufacturing buyer, as well as the entire Humanities and Social Sciences team at Prentice Hall.

I hope you will enjoy this third edition of *Art History:* A View of the West and, as you have done so generously and graciously over the past years, will continue to share your responses and suggestions with me.

Marilyn Stokstad
 Lawrence, Kansas

USE NOTES

he various features of this book reinforce each other, helping the reader to become comfortable with terminology and concepts that are specific to art history.

Starter Kit and Introduction The Starter Kit is a highly concise primer of basic concepts and tools. The Introduction is an invitation to the many pleasures of art history.

Captions There are two kinds of captions in this book: short and long. Short captions identify information specific to the work of art or architecture illustrated:

artist (when known)
title or descriptive name of work
date
original location (if moved to a museum or other site)
material or materials a work is made of
size (height before width) in feet and inches, with meters
and centimeters in parentheses
present location

The order of these elements varies, depending on the type of work illustrated. Dimensions are not given for architecture, for most wall paintings, or for most architectural sculpture. Some captions have one or more lines of small print below the identification section of the caption that gives museum or collection information. This is rarely required reading.

Long captions contain information that complements the narrative of the main text.

Definitions of Terms You will encounter the basic terms of art history in three places:

IN THE TEXT, where words appearing in boldface type are defined, or glossed, at their first use. Some terms are boldfaced and explained more than once, especially those that experience shows are hard to remember.

IN BOXED FEATURES, on technique and other subjects, where labeled drawings and diagrams visually reinforce the use of terms.

IN THE GLOSSARY, at the end of the volume, which contains all the words in boldface type in the text and boxes. The Glossary begins on page 933, and the outer margins are tinted to make it easy to find.

Maps and Timelines At the beginning of each chapter you will find a map with all the places mentioned in the chapter. At the end of each chapter, a timeline runs from the earliest through the latest years covered in that chapter.

Boxes Special material that complements, enhances, explains, or extends the text is set off in three types of tinted boxes. Elements of Architecture boxes clarify specifically architectural features, such as "Space-Spanning Construction Devices" in the Starter Kit (page xxvi). Technique boxes (see "Lost-Wax Cast-

ing," page xxx) amplify the methodology by which a type of artwork is created. Other boxes treat special-interest material related to the text.

Bibliography The bibliography at the end of this book beginning on page 940 contains books in English, organized by general works and by chapter, that are basic to the study of art history today, as well as works cited in the text.

Dates, Abbreviations, and Other Conventions This book uses the designations BCE and CE, abbreviations for "Before the Common Era" and "Common Era," instead of BC ("Before Christ") and AD ("Anno Domini," "the year of our Lord"). The first century BCE is the period from 99 BCE to 1 BCE; the first century CE is from the year 1 CE to 99 CE. Similarly, the second century CE is the period from 199 BCE to 100 BCE; the second century CE extends from 100 CE to 199 CE.

Circa ("about" or "approximately") is used with dates, spelled out in the text and abbreviated to "c." in the captions, when an exact date is not yet verified.

An illustration is called a "figure," or "fig." Thus, figure 6–7 is the seventh numbered illustration in Chapter 6. Figures 1 through 23 are in the Introduction. There are two types of figures: photographs of artworks or of models, and line drawings. Drawings are used when a work cannot be photographed or when a diagram or simple drawing is the clearest way to illustrate an object or a place.

When introducing artists, we use the words *active* and *documented* with dates, in addition to "b." (for "born") and "d." (for "died"). "Active" means that an artist worked during the years given. "Documented" means that documents link the person to that date.

Accents are used for words in French, German, Italian, and Spanish only.

With few exceptions, names of museums and other cultural bodies in Western European countries are given in the form used in that country.

Titles of Works of Art Most paintings and works of sculpture created in Europe and North America in the past 500 years have been given formal titles, either by the artist or by critics and art historians. Such formal titles are printed in italics. In other traditions and cultures, a single title is not important or even recognized. In this book we use formal descriptive titles of artworks where titles are not established. If a work is best known by its non-English title, such as Manet's Le Déjeuner sur l'Herbe (The Luncheon on the Grass), the original language precedes the translation.

STARTER KIT

rt history focuses on the visual arts—painting, drawing, sculpture, graphic arts, photography, decorative arts, and architecture. This Starter Kit contains basic information and addresses concepts that underlie and support the study of art history. It provides a quick reference guide to the vocabulary used to classify and describe art objects. Understanding these terms is indispensable since you will encounter them again and again in reading, talking, and writing about art, and when experiencing works of art directly.

Let us begin with the basic properties of art. A work of art is a material object having both form and content. It is also described and categorized according to its style and medium.

FORM

Referring to purely visual aspects of art and architecture, the term form encompasses qualities of *line, shape, color, texture, space, mass* and *volume,* and *composition*. These qualities all are known as *formal elements*. When art historians use the term formal, they mean "relating to form."

Line and shape are attributes of form. Line is a form—usually drawn or painted—the length of which is so much greater than the width that we perceive it as having only length. Line can be actual, as when the line is visible, or it can be implied, as when the movement of the viewer's eyes over the surface of a work follows a path determined by the artist. Shape, on the other hand, is the two-dimensional, or flat, area defined by the borders of an enclosing outline, or contour. Shape can be geometric, biomorphic (suggesting living things; sometimes called organic), closed, or open. The outline, or contour, of a three-dimensional object can also be perceived as line.

Color has several attributes. These include *hue, value,* and *saturation*.

Hue is what we think of when we hear the word color, and the terms are interchangeable. We perceive hues as the result of differing wavelengths of electromagnetic energy. The visible spectrum, which can be seen in a rainbow, runs from red through violet. When the ends of the spectrum are connected through the hue red-violet, the result may be diagrammed as a color wheel. The *primary hues* (numbered 1) are red, yellow, and blue. They are known as primaries because all other colors are

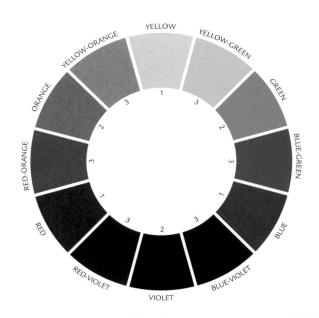

made of a combination of these hues. Orange, green, and violet result from the mixture of two primaries and are known as secondary hues (numbered 2). *Intermediate hues, or tertiaries* (numbered 3), result from the mixture of a primary and a secondary. *Complementary colors* are the two colors directly opposite one another on the color wheel, such as red and green. Red, orange, and yellow are regarded as warm colors and appear to advance toward us. Blue, green, and violet, which seem to recede, are called cool colors. Black and white are not considered colors but neutrals; in terms of light, black is understood as the absence of color and white as the mixture of all colors.

Value is the relative degree of lightness or darkness of a given color and is created by the amount of light reflected from an object's surface. A dark green has a deeper value than a light green, for example. In black-and-white reproductions of colored objects, you see only value, and some artworks—for example, a drawing made with black ink—possesses only value, not hue or saturation.

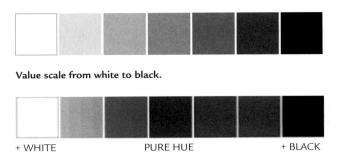

Value variation in red.

Saturation, also sometimes referred to as intensity, is a color's quality of brightness or dullness. A color described as highly saturated looks vivid and pure; a hue of low saturation may look a little muddy or dark.

Intensity scale from bright to dull.

Texture, another attribute of form, is the tactile (or touch-perceived) quality of a surface. It is described by words such as *smooth*, *polished*, *rough*, *grainy*, or *oily*. Texture takes two forms: the texture of the actual surface of the work of art and the implied (illusionistically depicted) surface of the object that the work represents.

Space is what contains objects. It may be actual and threedimensional, as it is with sculpture and architecture, or it may be represented illusionistically in two dimensions, as when artists represent recession into the distance on a wall or canvas.

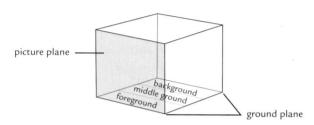

Mass and volume are properties of three-dimensional things.

Mass is matter—whether sculpture or architecture—that takes up

space. Volume is enclosed or defined space, and may be either solid or hollow. Like space, mass and volume may be illusionistically represented in two dimensions.

Composition is the organization, or arrangement, of form in a work of art. Shapes and colors may be repeated or varied, balanced symmetrically or asymmetrically; they may be static or dynamic. The possibilities are nearly endless and depend on the time and place where the work was created as well as the personal sensibility of the artist. *Pictorial depth* (spatial recession) is a specialized aspect of composition in which the three-dimensional world is represented in two dimensions on a flat surface, or *picture plane*. The area "behind" the picture plane is called the *picture space* and conventionally contains three "zones": *foreground, middle ground*, and *background*.

Various techniques for conveying a sense of pictorial depth have been devised by artists in different cultures and at different times. A number of them are diagrammed below. In Western art, the use of various systems of *perspective* has created highly convincing illusions of recession into space. In other cultures, perspective is not the most favored way to treat objects in space.

CONTENT

Content includes *subject matter*, which is what a work of art represents. Not all works of art have subject matter; many buildings, paintings, sculptures, and other art objects include no recognizable

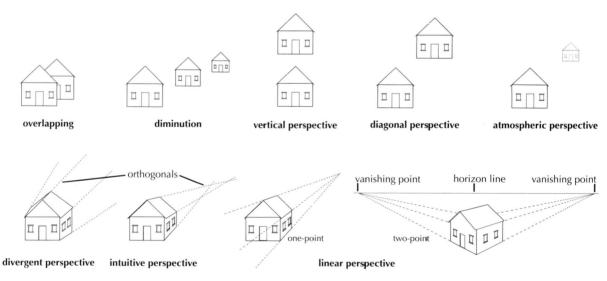

PICTORAL DEVICES FOR DEPICTING RECESSION IN SPACE

The top row shows several comparatively simple devices, including overlapping, in which partially covered elements are meant to be seen as located behind those covering them, and diminution, in which smaller elements are to be perceived as being farther away than larger ones. In vertical and diagonal perspective, elements are stacked vertically or diagonally, with the higher elements intended to be perceived as deeper in space. Another way of suggesting depth is through atmospheric perspective, which depicts objects in the far distance, often in bluish gray hues, with less clarity than nearer

objects and treats sky as paler near the horizon than higher up. In the lower row, divergent perspective, in which forms widen slightly and lines diverge as they recede in space, was used by East Asian artists. Intuitive perspective, used in some late medieval European art, takes the opposite approach: forms become narrower and converge the farther they are from the viewer, approximating the optical experience of spatial recession. Linear perspective, also called scientific, mathematical, one-point, and renaissance perspective, is an elaboration and standardization of intuitive perspective and was developed

in fifteenth-century Italy. It uses mathematica formulas to construct illusionistic images in which all elements are shaped by imaginary lines called *orthogonals* that converge in one or more vanishing points on a *horizon line*. Linear perspective is the system that most people living in Western cultures think of as perspective. Because it is the visual code they are accustomed to reading, they accept as "truth" the distortions it imposes. One of these distortions is *foreshortening*, in which, for instance, the soles of the feet in the foreground are the largest elements of a figure lying on the ground.

imagery but feature only lines, colors, masses, volumes, and other formal elements. However, all works of art—even those without recognizable subject matter—have content, or meaning, insofar as they seek to convey feelings, communicate ideas, or affirm the beliefs and values of their makers and, often, the people who view or use them.

Content may comprise the social, political, religious, and economic *contexts* in which a work was created, the *intention* of the artist, the *reception* of the work by the beholder (the audience), and ultimately the meanings of the work to both artist and audience. Art historians applying different methods of interpretation often arrive at different conclusions regarding the content of a work of art.

The study of subject matter is *iconography* (literally, "the writing of images"). The iconographer asks, What is the meaning of this image? Iconography includes the study of *symbols* and *symbolism*—the process of representing one thing by another through association, resemblance, or convention.

STYLE

Expressed very broadly, *style* is the combination of form and composition that makes a work distinctive. *Stylistic analysis* is one of art history's most developed practices, because it is how art historians recognize the work of an individual artist or the characteristic manner of several artists working in a particular time or place. Some of the most commonly used terms to discuss *artistic styles* include *period style, regional style, representational style, abstract style, linear style,* and *painterly style*.

Period style refers to the common traits detectable in works of art and architecture from a particular historical era. For instance, Roman portrait sculpture created at the height of the Empire is different from sculpture made during the late imperial period, but it is recognizably Roman. It is good practice not to use the words style and period interchangeably. Style is the sum of many influences and characteristics, including the period of its creation. An example of proper usage is "an American house from the Colonial period built in the Georgian style."

Regional style refers to stylistic traits that persist in a geographic region. An art historian whose specialty is medieval art can recognize French style through many successive medieval periods and can distinguish individual objects created in medieval France from other medieval objects that were created in, for example, the Low Countries.

Representational styles are those that create recognizable subject matter. *Realism, naturalism,* and *illusionism* are representational styles.

REALISM AND NATURALISM are terms often used interchangeably, and both describe the artist's attempt to describe the observable world. *Realism* is the attempt to depict objects accurately and objectively. *Naturalism* is closely linked to realism but often implies a grim or sordid subject matter.

IDEAL STYLES strive to create images of physical perfection according to the prevailing values of a culture. The artist may work in a representational style or may try to capture an underlying or expressive reality. The *Medici Venus* (see Introduction, fig. 7) is *idealized*.

ILLUSIONISM refers to a highly detailed style that seeks to create a convincing illusion of reality. *Flower Piece with Curtain* is a good example of this trick-the-eye form of realism (see Introduction, fig. 2).

IDEALIZATION strives to realize an image of physical perfection according to the prevailing values of a culture. The *Medici Venus* is idealized, (see Introduction, fig. 7).

Abstract styles depart from literal realism to capture the essence of a form. An abstract artist may work from nature or from a memory image of nature's forms and colors, which are simplified, stylized, distorted, or otherwise transformed to achieve a desired expressive effect. Georgia O'Keeffe's *Red Canna* is an abstract representation of nature (see Introduction, fig. 5). *Nonrepresentational art* and *expressionism* are particular kinds of abstract styles.

NONREPRESENTATIONAL (OR NONOBJECTIVE) ART is a form that does not produce recognizable imagery. *Cubi XIX* is nonrepresentational (see Introduction, fig. 6).

EXPRESSIONISM refers to styles in which the artist uses exaggeration of form to appeal to the beholder's subjective response or to project the artist's own subjective feelings. Munch's *The Scream* is expressionistic (see fig 19–71).

Linear describes both style and techniques. In the linear style the artist uses line as the primary means of definition, and modeling—the creation of an illusion of three-dimensional substance, through shading. It is so subtle that brushstrokes nearly disappear. Such a technique is also called "sculptural." Raphael's *The Small Cowper Madonna* is linear and sculptural (fig. 15–5).

Painterly describes a style of painting in which vigorous, evident brushstrokes dominate and shadows and highlights are brushed in freely. Sculpture in which complex surfaces emphasize moving light and shade is called "painterly." Claudel's *The Waltz* is painterly sculpture (see fig. 19–75).

MEDIUM

What is meant by medium or mediums (the plural we use in this book to distinguish the word from print and electronic news media) refers to the material or materials from which a work of art is made.

Technique is the process used to make the work. Today, literally anything can be used to make a work of art, including not only traditional materials like paint, ink, and stone, but also rubbish, food, and the earth itself. Various techniques are explained throughout this book in Technique boxes. When several mediums are used in a single work of art, we employ the term *mixed mediums*. Two-dimensional mediums include painting, drawing, prints, and photography. Three-

dimensional mediums are sculpture, architecture, and many so-called decorative arts.

Painting includes wall painting and fresco, illumination (the decoration of books with paintings), panel painting (painting on wood panels) and painting on canvas, miniature painting (small-scale painting), and handscroll and hanging scroll painting. Paint is pigment mixed with a liquid vehicle, or binder.

Graphic arts are those that involve the application of lines and strokes to a two-dimensional surface or support, most often paper. Drawing is a graphic art, as are the various forms of printmaking. Drawings may be sketches (quick visual notes made in preparation for larger drawings or paintings); studies (more carefully drawn analyses of details or entire compositions); cartoons (full-scale drawings made in preparation for work in another medium, such as fresco); or complete artworks in themselves. Drawings are made with such materials as ink, charcoal, crayon, and pencil. Prints, unlike drawings, are reproducible. The various forms of printmaking include woodcut, the intaglio processes (engraving, etching, drypoint), and lithography.

Photography (literally "light writing") is a medium that involves the rendering of optical images on light-sensitive surfaces. Photographic images are typically recorded by a camera.

Sculpture is three-dimensional art that is *carved, modeled, cast,* or *assembled*. Carved sculpture is subtractive in the sense that the image is created by taking away material. Wood, stone, and ivory are common materials used to create carved sculptures. Modeled sculpture is considered additive, meaning that the object is built up from a material, such as clay, that is soft enough to be molded and shaped. Metal sculpture is usually cast (see "Lost-Wax Casting," page xxx) or is assembled by welding or a similar means of permanent joining.

Sculpture is either freestanding (that is, not attached) or in relief. Relief sculpture projects from the background surface of which it is a part. High relief sculpture projects far from its background; low relief sculpture is only slightly raised; and sunken relief, found mainly in Egyptian art, is carved into the surface, with the highest part of the relief being the flat surface.

Ephemeral arts include processions and festival decorations and costumes, performance art, earthworks, cinema, video art, and some forms of digital and computer art. All have a central temporal aspect in that the artwork is viewable for a finite period of time and then disappears forever, is in a constant state of change, or must be replayed to be experienced again.

Architecture is three-dimensional, highly spatial, functional, and closely bound with developments in technology and materials. An example of the relationship among technology, materials, and function can be seen in "Space-Spanning Construction Devices" (page xxxi). Several types of two-dimensional schematic drawings are commonly used to enable the visualization of a building. These architectural graphic devices include plans, elevations, sections, and cutaways.

PLANS depict a structure's masses and voids, presenting a view from above—as if the building had been sliced horizontally at about waist height.

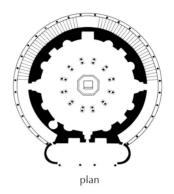

ELEVATIONS show exterior sides of a building as if seen from a moderate distance without any perspective distortion.

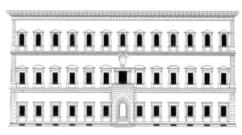

elevation

SECTIONS reveal a building as if it had been cut vertically by an imaginary slicer from top to bottom.

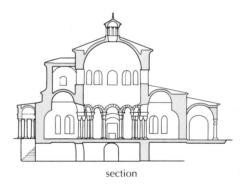

CUTAWAYS show both inside and outside elements from an oblique angle.

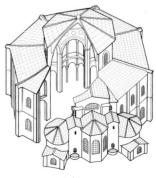

cutaway

Technique

LOST-WAX CASTING

he lost-wax process consists of a core on which the sculptor models the image in wax. A heat-resistant mold is formed over the wax. The wax is melted and replaced with metal, usually bronze or brass. The mold is broken away and the piece finished and polished by hand.

The usual metal for this casting process was bronze, an alloy of copper and tin, although sometimes brass, an alloy of copper and zinc, was used. The progression of drawings here shows the steps used by the Benin sculptors of Africa. A heat-resistant "core" of clay approximating the shape of the sculpture-to-be (and eventually becoming the hollow inside the sculpture) was covered by a layer of wax having the thickness of the final sculpture. The sculptor carved or modeled the details in the wax. Rods and a pouring cup made of wax were attached to the model. A thin layer of fine, damp sand was pressed very firmly

into the surface of the wax model, and then model, rods, and cup were encased in thick layers of clay. When the clay was completely dry, the mold was heated to melt out the wax. The mold was then turned upside down to receive the molten metal, which is heated to the point of liquification. The cast was placed in the ground. When the metal was completely cool, the outside clay cast and the inside core were broken up and removed, leaving the cast brass sculpture. Details were polished to finish the piece of sculpture, which could not be duplicated because the mold had been destroyed in the process.

In lost-wax casting the mold had to be broken and only one sculpture could be made. In the eighteenth century a second process came into use—the piece mold. As its name implies, the piece mold could be removed without breaking allowing sculptors to make several copies (editions) of their work.

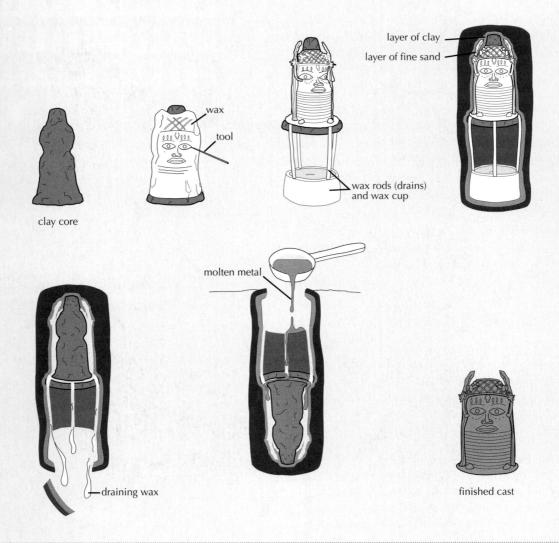

Elements of Architecture

SPACE-SPANNING CONSTRUCTION DEVICES

ravity pulls on everything, presenting great challenges to architects and sculptors. Spanning elements must transfer weight to the ground. The simplest space-spanning device is **post-and-lintel** construction, in which uprights are spanned by a horizontal element. However, if not flexible, a horizontal element over a wide span may break under the pressure of its own weight and the weight it carries.

Corbeling, the building up of overlapping stones, is another simple method for transferring weight to the ground. Arches, round or pointed, span space. Vaults, which are essentially extended arches, move weight out from the center of the covered space and down through the corners. The cantilever is a

variant of post-and-lintel construction. Suspension works to counter the effect of gravity by lifting the spanning element upward. Trusses of wood or metal are relatively lightweight spanners but cannot bear heavy loads. Large-scale modern construction is chiefly steel frame and relies on steel's properties of strength and flexibility to bear great loads. When concrete is reinforced with steel or iron rods, the inherent brittleness of cement and stone is overcome because of metal's flexible qualities. The concrete can then span much more space and bear heavier loads. The balloon frame, an American innovation, is based on post-and-lintel principles and exploits the lightweight, flexible properties of wood.

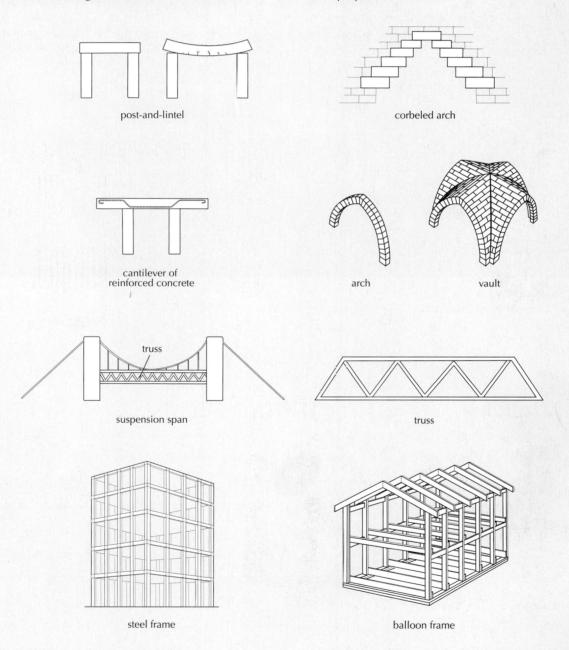

THE GREAT SPHINX, Giza, Egypt Dynasty 4, c. 2613–2494 BCE. Sandstone, height approx. 65' (19.8 m).

INTRODUCTION

Crouching in front of the pyramids of Egypt and carved from the living rock of the Giza plateau, the **GREAT SPHINX** is one of the world's best-known monuments (FIG. 1). By placing the head of the ancient Egyptian king Khafre on the body of a huge lion, the sculptors merged human intelligence and animal strength in a single image to evoke the superhuman power of the ruler. For some 4,600 years, the Sphinx has defied the desert sands; today it also must withstand the sprawl of greater Cairo and the impact of air pollution. In its majesty, the Sphinx symbolizes mysterious wisdom and dreams of per-

manence, of immortality. But is such a monument a work of art? Does it matter that the people who carved the Sphinx—unlike today's independent, individualistic artists—obeyed formulaic conventions and followed the orders of priests? No matter what the ancient Egyptians may have called it, today most people would say, "Certainly, it is art." Human imagination conceived this creature, and human skill gave it material form. Combining imagination and skill, the creators have conceived an idea of awesome grandeur and created a work of art. But we seldom stop to ask: What is art?

WHAT IS ART?

At one time the answer to the question "What is art?" would have been simpler than it is today. The creators of the *Great Sphinx* demonstrate a combination of imagination, skill, training, and observation that appeal to our desire for order and harmony—perhaps to an innate aesthetic sense. Yet, today some people question the existence of an aesthetic faculty, and we realize that our tastes are products of our education and our experience, dependent on time and place. Whether acquired at home, in schools, in museums, or in other public places, our responses are learned—not innate. Ideas of truth and falsehood, of good and evil, of beauty and ugliness are influenced as well by class, gender, race, and economic status. Some historians and critics even go so far as to argue that works of art are mere reflections of power and privilege.

Even the idea of "beauty" is questioned and debated today. Some commentators find discussions of aesthetics (the branch of philosophy concerned with The Beautiful) too subjective and too personal, and they dismiss the search for objective criteria that preoccupied scholars in the eighteenth and nineteenth centuries. As traditional aesthetics come under challenge, we can resort to discussing the authenticity of expression in a work of art, even as we continue to analyze its formal qualities. We can realize that people at different times and in different places have held different values. The words "art history" can be our touchstone. Like the twofold term itself, this scholarly discipline considers both art and history—the work of art as a tangible object and as part of its historical context. Ultimately, because so-called objective evaluations of beauty seem to be an impossibility, beauty again seems to lie in the eye of the beholder.

Today's definition of art encompasses the intention of the creator as well as the intentions of those who commissioned the work. It relies, too, on the reception of the artwork by society—both today and at the time when the work was made. The role of art history is to answer complex questions: Who are these artists and patrons? What is this thing they have created? When and how was the work done? Only after we have found answers to practical questions like these can we acquire an understanding and appreciation of the artwork and, answering our earlier question, we can say, yes, this is a work of art.

ART AND NATURE

The ancient Greeks enjoyed the work of skillful artists. They especially admired the illusionistic treatment of reality in which the object represented appears to actually be present. The Greek penchant for realism is illustrated in a story from the late fifth century BCE about a rivalry between two painters named Zeuxis and Parrhasios as to whom was the better painter. First, Zeuxis painted a picture of grapes so accurately that birds flew down to peck at them. But, when Parrhasios

2 Adriaen van der Spelt and Frans van Mieris **FLOWER PIECE WITH CURTAIN** 1658. Oil on panel, $18\% \times 25\%$ (46.5 \times 64 cm). The Art Institute of Chicago.

Wirt D. Walker Fund. (19 4 9.585). Photograph © 2005 The Art Institute of Chicago. All rights reserved

took his turn, and Zeuxis asked his rival to remove the curtain hanging over his rival's picture, Parrhasios pointed out with glee that the "curtain" was his painting. Zeuxis had to admit that Parrhasios had won the competition since he himself had fooled only birds, while Parrhasios had deceived a fellow artist.

In the seventeenth century, the painters Adriaen van der Spelt (1630-73) and Frans van Mieris (1635-81) paid homage to the story of Parrhasios's curtain in a painting of blue satin drapery drawn aside to show a garland of flowers. We call the painting simply FLOWER PIECE WITH CURTAIN (FIG. 2). The artists not only re-created Parrhasios's curtain illusion but also included a reference to another popular story from ancient Greece, Pliny's anecdote of Pausias and Glykera. In his youth, Pausias had been enamored of the lovely flowerseller Glykera, and he learned his art by persistently painting the exquisite floral garlands that she made, thereby becoming the most famously skilled painter of his age. The seventeenthcentury people who bought such popular still-life paintings appreciated their classical allusions as much as the artists' skill in drawing and painting and their ability to manipulate colors on canvas. But, the reference to Pausias and Glykera also raised the conuncrum inherent in all art that seeks to make an unblemished reproduction of reality: Which has the greater beauty, the flower or the painting of the flower? And which is the greater work of art, the garland or the painting of the garland? So then, who is the greater artist, the garland maker or the garland painter?

MODES OF REPRESENTATION

Many people think that the manner of Zeuxis and Parrhasios, and of van der Spelt and van Mieris—the manner of representation that we call **naturalism**, or **realism**—the mode of

3 CORINTHIAN CAPITAL FROM THE THOLOS AT EPIDAURUS c. 350 BCE. Archaeological Museum, Epidaurus, Greece.

interpretation that seeks to record the visible world—represents the highest accomplishment in art, but not everyone agrees. Even the ancient Greek philosophers Aristotle (384–322 BCE) and Plato (428–348/7 BCE), who both considered the nature of art and beauty in purely intellectual terms, arrived at divergent conclusions. Aristotle believed that works of art should be evaluated on the basis of mimesis ("imitation"), that is, on how well they copy definable or particular

aspects of the natural world. This approach to defining "What is art?" is a realistic or naturalistic one. But, of course, while artists may work in a naturalistic style, they also can render lifelike such fictions as a unicorn, a dragon, or a sphinx by incorporating features from actual creatures.

In contrast to Aristotle, Plato looked beyond nature for a definition of art. In his view even the most naturalistic painting or sculpture was only an approximation of an eternal ideal world in which no variations or flaws were present. Rather than focus on a copy of the particular details that one saw in any particular object, Plato focused on an unchangeable ideal—for artists, this would be the representation of a subject that exhibited perfect symmetry and proportion. This mode of interpretation is known as **idealism**. In a triumph of human reason over nature, idealism wishes to eliminate all irregularities, ensuring a balanced and harmonious work of art.

Let us consider a simple example of Greek idealism from architecture: the carved top, or capital, of a Corinthian column, a type that first appeared in ancient Greece during the fourth century BCE. The Corinthian capital has an inverted bell shape surrounded by acanthus leaves (FIG. 3). Although the acanthus foliage was inspired by the appearance of natural vegetation, the sculptors who carved the leaves eliminated blemishes and irregularities in order to create the Platonic ideal of the acanthus plant's foliage. To achieve Plato's ideal images and represent things "as they ought to be" rather than as they are, classical sculpture and painting established ideals that have inspired Western art ever since.

4 Edward Weston

SUCCULENT

1930. Gelatin silver print,

7½ × 9½" (19.1 × 24 cm).

Center for Creative Photography, The University of Arizona,

Tucson.

Like ancient Greek sculptors, Edward Weston (1886–1958) and Georgia O'Keeffe (1887–1986) studied living plants. In his photograph **succulent**, Weston used straightforward camera work without manipulating the film in the darkroom in order to portray his subject (FIG. 4). He argued that although the camera sees more than the human eye, the quality of the image depends not on the camera, but on the choices made by the photographer-artist.

When Georgia O'Keeffe painted RED CANNA, she, too, sought to capture the plant's essence, not its appearance—although we can still recognize the flower's form and color (FIG. 5). By painting the canna lily's organic energy rather than the way it actually looked, she created a new abstract beauty, conveying in paint the pure vigor of the flower's life force. This abstraction—in which the artist appears to transform a visible or recognizable subject from nature in a way that suggests the original but purposefully does not record the subject in an entirely realistic or naturalistic way—is another manner of representation.

Furthest of all from naturalism are pure geometric creations such as the polished stainless steel sculpture of David Smith (1906–65). His Cubi works are usually called nonrepresentational art—art that does not depict a recognizable subject. With works such as CUBI XIX (FIG. 6), it is important to distinguish between subject matter and content. Abstract art like O'Keeffe's has both subject matter and content, or meaning. Nonrepresentational art does not have subject matter but it does have content, which is a product of the interaction between the artist's

6 David Smith **CUBI XIX** 1964. Stainless steel, $9'5\%'' \times 1'9\%'' \times 1'8''$ (2.88 x .55 \times .51 m). Tate Gallery, London.

© Estate of David Smith/Licensed by VAGA, New York, NY

intention and the viewer's interpretation. Some viewers may see the Cubi works as robotic plants sprung from the core of an unyielding earth, a reflection of today's mechanistic society that challenges the natural forms of trees and hills.

At the turn of the fifteenth century, the Italian master Leonardo daVinci (1452–1519) argued that observation alone produced "mere likeness" and that the painter who copied the external forms of nature was acting only as a mirror. He believed that the true artist should engage in intellectual activity of a higher order and attempt to render the inner life—the energy and power—of a subject. In this book we will see that artists have always tried to create more than a superficial likeness in order to engage their audience and express the cultural contexts of their particular time and place.

5 Georgia O'Keeffe RED CANNA

1924. Cil on canvas mounted on Masonite, $36\times29\%$ " (91.44 \times 75.88 cm). Collection of the University of Arizona Museum of Art, Tucson.

© 2007 The Georgia O Keeffe Foundation/Artists Rights Society (ARS), New York

Beauty and the Idealization of the Human Figure

Ever since people first made what we call art, they have been fascinated with their own image and have used the human body to express ideas and ideals. Popular culture in the twenty-first century continues to be obsessed with beautiful people—with Miss Universe pageants and lists of the Ten

7 THE MEDICI VENUSRoman copy of a 1st-century BCE Greek statue.
Marble, height 5' (1.53 m) without base. Villa
Medici, Florence, Italy.

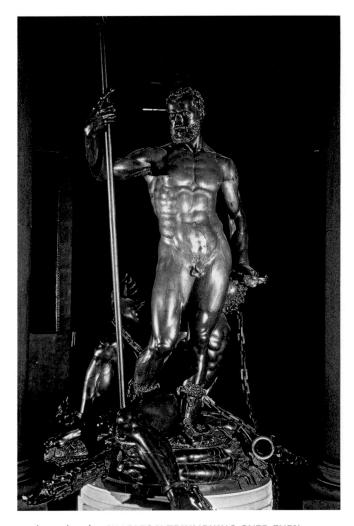

8 Leone Leoni **CHARLES V TRIUMPHING OVER FURY, WITHOUT ARMOR** c. 1549–1555. Bronze, height to top of head 5'8" (1.74 m). Museo Nacional del Prado, Madrid.

Best-Dressed Women and the Fifty Sexiest Men, just to name a few examples. Today the **MEDICI VENUS**, with her plump arms and legs and sturdy body, would surely be expected to slim down, yet for generations such a figure represented the peak of female beauty (FIG. 7).

This image of the goddess of love inspired artists and those who commissioned their work from the fifteenth through the nineteenth century. Clearly, the artist had the skill to represent a woman as she actually appeared, but instead he chose to generalize her form and adhere to the classical canon (rule) of proportions. In so doing, the sculptor created a universal image, an ideal rather than a specific woman.

The *Medici Venus* represents a goddess, but artists also represented living people as idealized figures, creating symbolic portraits rather than accurate likenesses. The sculptor Leone Leoni (1509–90), commissioned to create a monumental bronze statue of the emperor Charles V (ruled 1519–56), expressed the power of this ruler of the Holy

Roman Empire just as vividly as did the sculptors of the Egyptian king Khafre, the subject of the *Great Sphinx* (SEE FIG. 1). Whereas in the sphinx, Khafre took on the body of a vigilant lion, in **CHARLES V TRIUMPHING OVER FURY**, the emperor has been endowed with the muscular torso and proportions of the classical ideal male athlete or god (FIG. 8). Charles does not inhabit a fragile human body; rather, in his muscular nakedness, he embodies the idea of triumphant authoritarian rule. (Not everyone approved. In fact, a full suit of armor was made for the statue, and today museum officials usually exhibit the sculpture clad in armor rather than nude.)

Today, when images—including those of great physical and spiritual beauty—can be captured with a camera, why should an artist draw, paint, or chip away at a knob of stone? Does beauty even play a significant role in our world? Attempting to answer these and other questions that consider the role of art is a branch of philosophy called *aesthetics*, which considers the nature of beauty, art, and taste as well as the creation of art.

Laocoön: A Meditation on Aesthetics

Historically, the story of Laocoön has focused attention on the different ways in which the arts communicate. In the *Iliad*, Homer's epic poem about the Trojan War, Laocoön was the priest who forewarned the Trojans of an invasion by the Greeks. Although Laocoön spoke the truth, the goddess Athena, who took the Greeks' side in the war, dispatched serpents to strangle him and his sons. His prophecy scorned, Laocoön represents the virtuous man tragically destroyed by unjust fate. In a renowned ancient sculpture, his features twist in agony, and the muscles of his and his sons' torsos and arms extend and knot as they struggle (FIG. 9). When this sculpture was discovered in Rome in 1506, Michelangelo rushed to watch it being excavated, an astonishing validation of his own ideal, heroic style coming straight out of the earth. The pope acquired it for the papal collection, and it can be seen today in the Vatican Museum.

Like other learned people in the eighteenth century, the German philosopher Lessing knew the story of Laocoön and admired the sculpture as well. In fact, he titled his study of the relationship between words and images "Laocoon: An Essay upon the Limits of Painting and Poetry" (1766). Lessing saw literary pursuits such as poetry and history as arts of time, whereas painting and sculpture played out in a single moment in space. Using words, writers can present a sequence of events, while sculptors and painters must present a single critical moment. Seen in this light, the interpretation of visual art depends upon the viewer who must bring additional knowledge in order to reconstitute the narrative, including events both before and after the depicted moment. For this reason, Lessing argued for the primacy of literature over the visual arts. The debate over the comparative virtues of the arts has been a source of excited argument and even outrage among critics, artists, philosophers, and academics ever since.

Underlying all our assumptions about works of art—whether in the past or the present—is the idea that art has meaning, and that its message can educate and move us, that it can influence and improve our lives. But what gives art its meaning and expressive power? Why do images fascinate and inspire us? Why do we treasure some things but not others? These are difficult questions, and even specialists disagree about the answers. Sometimes even the most informed people must conclude, "I just don't know."

Studying art history, therefore, cannot provide us with definitive answers, but it can help us recognize the value of asking questions as well as the value of exploring possible answers. Art history is grounded in the study of material objects that are the tangible expression of the ideas—and ideals—of a culture. For example, when we become captivated by a striking creation, art history can help us interpret its particular imagery and meaning. Art history can also illuminate the cultural context of the work—that is, the social, economic, and political situation of the historical period in which it was produced, as well as its evolving significance through the passage of time.

Exceptional works of art speak to us. However, only if we know something about the **iconography** (the meaning and interpretation) of an image can its larger meaning become clear. For example, let's look again at *Flower Piece with*

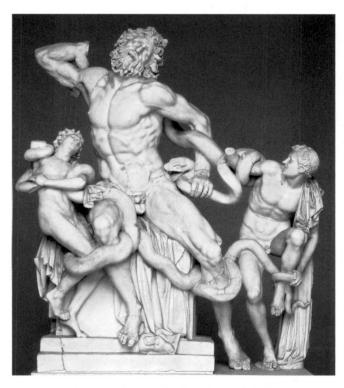

9 Hagesandros, Polydoros, and Athanadoros of Rhodes LAOCOÖN AND HIS SONS

As restored today. Probably the original of 1st century CE or a Roman copy of the 1st century CE. Marble, height 8' (2.44 m). Musei Vaticani, Museo Pio Clementino, Cortile Ottagono, Rome, Italy.

Curtain (SEE FIG. 2). The brilliant red and white tulip just to the left of the blue curtain was the most desirable and expensive flower in the seventeenth century; thus, it symbolizes wealth and power. Yet insects creep out of it, and a butterfly—fragile and transitory—hovers above it. Consequently, here flowers also symbolize the passage of time and the fleeting quality of human riches. Informed about its iconography and cultural context, we begin to fathom that this painting is more than a simple still life.

WHY DO WE NEED ART?

Before we turn to Chapter 1—before we begin to look at, read about, and think about works of art and architecture historically, let us consider a few general questions that studying art history can help us answer and that we should keep in mind as we proceed: Why do we need art? Who are artists? What role do patrons play? What is art history? and What is a viewer's role and responsibility? By grappling with such questions, our experience of art can be greatly enhanced.

Biologists account for the human desire for art by explaining that human beings have very large brains that demand stimulation. Curious, active, and inventive, we humans constantly explore, and in so doing we invent things that appeal to our senses—fine art, fine food, fine scents, fine fabrics, and fine music. Ever since our prehistoric ancestors developed their

ability to draw and speak, we have visually and verbally been communicating with each other. We speculate on the nature of things and the meaning of life. In fulfilling our need to understand and our need to communicate, the arts serve a vital function. Through art we become fully alive.

Self-Expression: Art and the Search for Meaning

Throughout history art has played an important part in our search for the meaning of the human experience. In an effort to understand the world and our place in it, we turn both to introspective personal art and to communal public art. Following a personal vision, James Hampton (1909-64) created profoundly stirring religious art. Hampton worked as a janitor to support himself while, in a rented garage, he built THRONE OF THE THIRD HEAVEN OF THE NATIONS' MILLENNIUM GENERAL ASSEMBLY (FIG. 10), his monument to his faith. In rising tiers, thrones and altars have been prepared for Jesus and Moses. Placing New Testament imagery on the right and Old Testament imagery on the left, Hampton labeled and described everything. He even invented his own language to express his visions. On one of many placards he wrote his credo: "Where there is no vision, the people perish" (Proverbs 29:18). Hampton made this fabulous assemblage out of discarded furniture, flashbulbs, and all sorts of refuse tacked together and wrapped in gold and

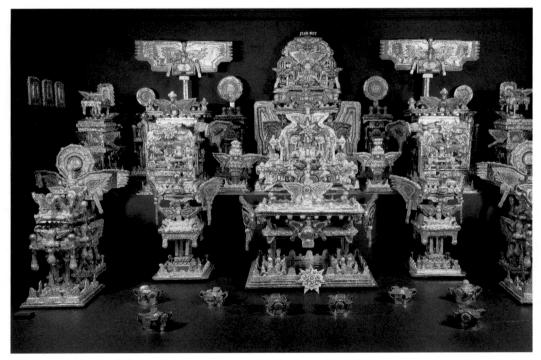

10 James Hampton THRONE OF THE THIRD HEAVEN OF THE NATIONS'
MILLENNIUM GENERAL ASSEMBLY

c. 1950–1964. Gold and silver aluminum foil, colored Kraft paper, and plastic sheets over wood, paperboard, and glass, $10'6'' \times 27' \times 14'6'' (3.2 \times 8.23 \times 4.42 \text{ m})$. Smithsonian American Art Museum, Smithsonian Institution, Washington, D.C.

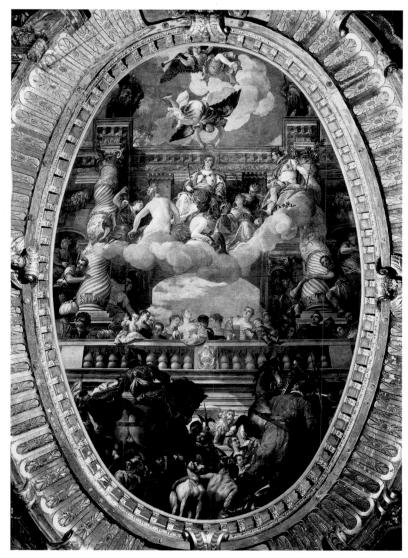

11 Veronese THE TRIUMPH OF VENICE Ceiling painting in the Council Chamber, Palazzo Ducale, Venice, Italy. c. 1585. Oil on canvas, $29'8'' \times 19' (9.04 \times 5.79 \text{ m})$.

silver aluminum foil and purple tissue paper. How can such worthless materials turn into an exalted work of art? Art's genius transcends material.

In contrast to James Hampton, whose life's work was compiled in private and only came to public attention after his death, most artists and viewers participate in more public expressions of art and belief. Nevertheless, when people employ special objects in their rituals, such as statues, masks, and vessels, these pieces may be seen as works of art by others who do not know about their intended use and original significance.

Social Expression: Art and Social Context

The visual arts are among the most sophisticated forms of human communication, at once shaping and being shaped by their social context. Artists may unconsciously interpret their times, but they also may be enlisted to consciously serve social ends in ways that range from heavy-handed propaganda (as seen earlier in the portrait of Charles V, for example) to subtle suggestion. From ancient Egyptian priests to elected officials today, religious and political leaders have understood the educational and motivational value of the visual arts.

Governments and civic leaders use the power of art to strengthen the unity that nourishes society. In sixteenth-century Venice, for example, city officials ordered Veronese (Paolo Caliari, 1528–88) to fill the ceiling in the Great Council Hall with a huge and colorful painting, **THE TRIUMPH OF VENICE** (FIG. 11). Their contract with the artist survives as evidence of their intentions. They wanted a painting that showed their beloved Venice surrounded by peace, abundance, fame, happiness, honor, security, and freedom—all in vivid colors and idealized forms. Veronese and his assistants complied by painting the city personified as a mature, beautiful, and splendidly robed woman enthroned between the towers of the Arsenal, a build-

ing where ships were built for worldwide trade, the source of the city's wealth and power. Veronese painted enthusiastic crowds of cheering citizens, together with personifications of Fame blowing trumpets and of Victory crowning Venice with a wreath. Supporting this happy throng, bound prisoners and trophies of armor attest to Venetian military prowess. The Lion of Venice—the symbol of the city and its patron, Saint Mark—oversees the triumph. Although Veronese created this splendid propaganda piece to serve the purposes of his patrons, his artistic vision was as individualistic as that of James Hampton, whose art was purely self-expression.

Social Criticism: Uncovering Sociopolitical Intentions

Although powerful patrons have used artworks throughout history to promote their political interests, modern artists are often independent-minded and astute critics of the powers that be. For example, among Honoré Daumier's most trenchant comments on the French government is his print RUE TRANSON-AIN, LE 15 AVRIL 1834 (FIG. 12). During a period of urban unrest, the French National Guard fired on unarmed citizens, killing fourteen people. For his depiction of the massacre, Daumier used lithography—a cheap new means of illustration. He was not thinking in terms of an enduring historical record, but rather of a medium that would enable him to spread his message as widely as possible. Daumier's political commentary created such horror and revulsion among the public that the government reacted by buying and destroying all the newspapers in which the lithograph appeared. As this example shows, art historians sometimes need to consider not just the historical context of a work of art but also its political content and medium to have a fuller understanding of it.

Another, more recent, work with a critical message recalls how American citizens of Japanese ancestry were removed from their homes and confined in internment camps during World War II. In 1978, Roger Shimomura (b. 1939) painted **DIARY**, which illustrates his grandmother's account of the family's experience in one such camp in Idaho (FIG. 13). Shimomura has painted his grandmother writing in her diary, while he (the toddler) and his mother stand by an open door—a door that does not signify freedom but opens on to a field bounded by barbed wire. In this commentary on discrimination and injustice, Shimomura combines two stylistic traditions—the Japanese art of the color woodblock print and American Pop art of the 1960s—to create a personal style that expresses his own dual culture.

WHO ARE THE ARTISTS?

We have focused so far mostly on works of art. But what of the artists who make them? How artists have viewed themselves and have been viewed by their contemporaries has

12 Honoré Daumier RUE TRANSONAIN, LE 15 AVRIL 1834 Lithograph, $11'' \times 17\%''$ (28×44 cm). Bibliothèque Nationale, Paris

changed over time. In Western art, painters and sculptors were at first considered artisans or craftspeople. The ancient Greeks and Romans ranked painters and sculptors among the skilled workers; they admired the creations, but not the creators. The Greek word for art, *tekne*, is the source for the English word "technique," and the English words *art* and *artist* come from the Latin word *ars*, which means "skill." In the Middle Ages, people sometimes went to the opposite extreme and attributed especially fine works of art not to human artisans, but to supernatural forces, to angels, or to Saint Luke. Artists continued to be seen as craftspeople—admired, often prosperous, but not particularly special—until the Renaissance, when artists such as Leonardo da Vinci proclaimed themselves to be geniuses with "divine" abilities.

13 Roger Shimomura

DIARY (MINIDOKA SERIES #3)

1078 Aprilia on compact 4/11//

1978. Acrylic on canvas, $4'11\%'' \times 6'$ (1.52 \times 1.83 m). Spencer Museum of Art, The University of Kansas, Lawrence. Museum purchase, (1979.51)

Soon after the Renaissance, the Italian painter Guercino (Giovanni Francesco Barbieri, 1591-1666) combined the idea that saints and angels have miraculously made works of art with the concept that human painters have special, divinely inspired gifts. In his painting SAINT LUKE DISPLAYING A PAINTING OF THE VIRGIN (FIG. 14), Guercino portrays the Evangelist who was regarded as the patron saint of artists. Christians widely believed that Luke had painted a portrait of the Virgin Mary holding the Christ Child. In Guercino's painting, Luke, seated before just such a painting and assisted by an angel, holds his palette and brushes. A book, a quill pen, and an inkpot decorated with a statue of an ox (Saint Luke's symbol) rest on a table, reminders of his status as the author of a gospel. Guercino seems to say that if Saint Luke is a divinely endowed artist, then surely all other artists share in this special power and status. This image of the artist as an inspired genius has persisted.

Even after the idea of "specially endowed" creators emerged, numerous artists continued to conduct their work as craftspeople leading workshops, and oftentimes artwork continued to be a team effort. Nevertheless, as the one who conceives the work and controls its execution—the artist is the "creator," whose name is associated with the final product.

This approach is evident today in the glassworks of American artist Dale Chihuly (b. 1941). His team of artist-craftspeople is skilled in the ancient art of glass-making, but Chihuly remains the controlling mind and imagination behind the works. Once created, his multipart pieces may be transformed when they are assembled for display; they can take on a new life in accordance with the will of a new owner, who may arrange the pieces to suit his or her own preferences. The viewer/owner thus becomes part of the creative team. Originally fabricated in 1990, VIOLET PERSIAN SET WITH RED LIP WRAPS (FIG. 15) has twenty separate pieces, but the person who assembles them determines the composition.

How Does One Become an Artist?

Whether working individually or communally, even the most brilliant artists spend years in study and apprenticeship and continue to educate themselves throughout their lives. In his painting **THE DRAWING LESSON**, Dutch artist Jan Steen (1626–79) takes us into a well-lit artist's studio. Surrounded by the props of his art—a tapestry backdrop, an easel, a stretched canvas, a portfolio, musical instruments, and decorative *objets d'art*—a painter instructs two youngsters—a boy apprentice at a drawing board, and a young woman in an elegant armchair (FIG. 16). The artist's pupil has been drawing from sculpture and plaster casts because women were not permitted to work from nude models. *The Drawing Lesson* records contemporary educational practice and is a valuable record of an artist's workplace in the seventeenth century.

14 Guercino SAINT LUKE DISPLAYING A PAINTING OF THE VIRGIN 1652-1653. Oil on canvas, $7'3'' \times 5'11''$ (2.21×1.81 m). The Nelson-Atkins Museum of Art, Kansas City, Missouri. Purchase (F83-55)

15 Dale Chihuly VIOLET PERSIAN SET WITH RED LIP WRAPS 1990. Glass, $26 \times 30 \times 25''$ ($66 \times 76.2 \times 63.5$ cm). Spencer Museum of Art, The University of Kansas, Lawrence Museum Purchase: Peter T. Bohan Art Acquisition Fund, 1992.2

Even the most mature artists learn from each other. In the seventeenth century, Rembrandt van Rijn carefully studied Leonardo's painting of THE LAST SUPPER (FIG. 17). Leonardo had turned this traditional theme into a powerful drama by portraying the moment when Christ announces that one of the assembled apostles will betray him. Even though the men react with surprise and horror to this news, Leonardo depicted the scene in a balanced symmetrical composition typical of the Italian Renaissance of the fifteenth and early sixteenth centuries, with the apostles in groups of three on each side of Christ. The regularly spaced tapestries and ceiling panels lead the viewers' eyes to Christ, who is silhouetted in front of an open window (the door seen in the photograph was cut through the painting at a later date).

Rembrandt, working 130 years later in the Netherlands—a very different time and place—knew the Italian master's painting from a print, since he never went to Italy. Rembrandt copied THE LAST SUPPER in hard red chalk (FIG. 18). Then he reworked the drawing in a softer chalk, assimilating Leonardo's lessons but revising the composition and changing the mood of the original. With heavy overdrawing he recreated the scene, shifting Jesus's position to the left, giving Judas more emphasis. Gone are the wall hangings and ceiling, replaced by a huge canopy. The space is undetermined and expansive rather than focused. Rembrandt's drawing is more

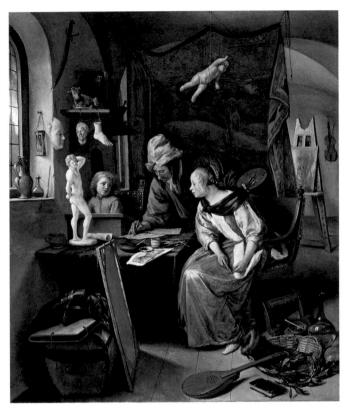

16 Jan Steen **THE DRAWING LESSON** 1665. Oil on wood, $19\% \times 16\%$ (49.3×41 cm). The J. Paul Getty Museum, Los Angeles, California.

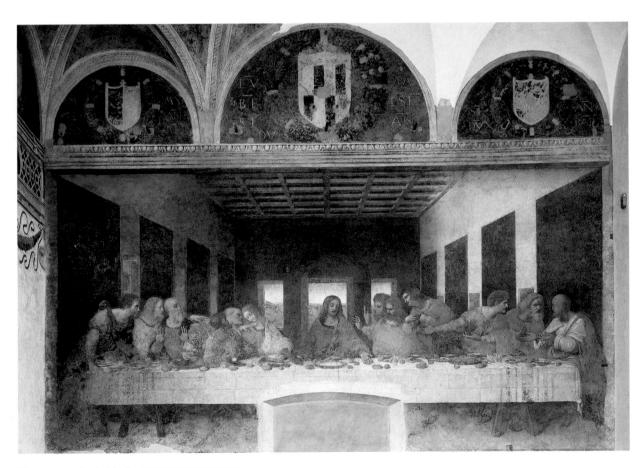

17 Leonardo da Vinci THE LAST SUPPER Wall painting in the refectory, Monastery of Santa Maria delle Grazie, Milan, Italy. 1495–1498. Tempera and oil on plaster, $15'2'' \times 28'10''$ (4.6 \times 8.8m).

than an academic exercise; it is also a sincere tribute from one great master to another. The artist must have been pleased with his version of Leonardo's masterpiece because he signed his drawing boldly in the lower right-hand corner.

WHAT ROLE DO PATRONS AND COLLECTORS PLAY?

As we have seen, the person or group who commissions or supports a work of art—the patron—can have significant impact on it. The *Great Sphinx* (SEE FIG. 1) was "designed" following the conventions of priests in ancient Egypt; the monumental statue of *Charles V* was cast to glorify absolutist rule (SEE FIG. 8); the content of Veronese's *Triumph of Venice* (SEE FIG. 11) was determined by that city's government officials; and Chihuly's glassworks (SEE FIG. 15) may be reassembled according to the collector's wishes or whims.

The civic sponsorship of art is epitomized by fifth-century BCE Athens, a Greek city-state whose citizens practiced an early form of democracy. Led by the statesman and general Pericles, the Athenians defeated the Persians, and then rebuilt Athens's civic and religious center, the Acropolis, as a tribute to the goddess Athena and a testament to the glory of Athens. In FIGURE 19, a nineteenth-century British artist, Sir Lawrence Alma-Tadema, conveys the accomplishment of the

Athenian architects, sculptors, and painters, who were led by the artist Phidias. Alma-Tadema imagines the moment when Phidias showed the carved and painted frieze at the top of the wall of the Temple of Athena (the Parthenon) to Pericles and a group of Athenian citizens—his civic sponsors.

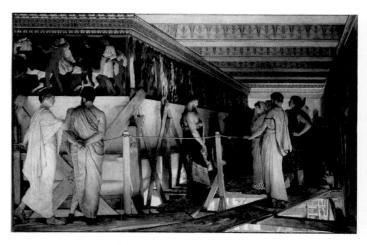

19 Lawrence Alma-Tadema PHIDIAS AND THE FRIEZE OF THE PARTHENON, Athens 1868. Oil on canvas, $29\% \times 42\%$ (75.3 \times 108 cm). Birmingham City Museum and Art Gallery, England

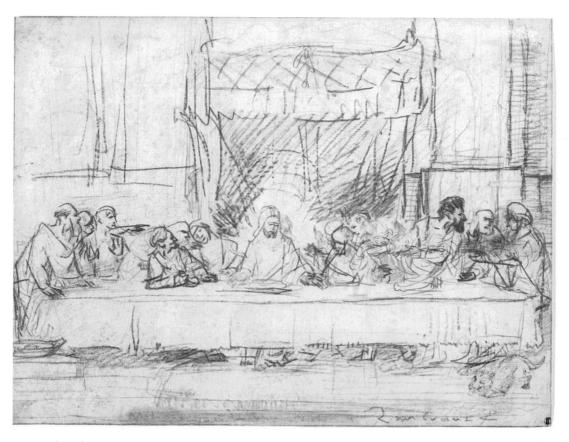

18 Rembrandt van Rijn **THE LAST SUPPER** After Leonardo da Vinci's fresco. Mid-1630s. Drawing in red chalk, $14\% \times 18\%$ (36.5 \times 47.5 cm). The Metropolitan Museum of Art, New York Robert Lehman Collection, 1975 (1975.1.794)

THE OBJECT SPEAKS

THE VIETNAM VETERANS MEMORIAL

attle die. Kinfolk die. We all die. Only fame lasts," said the Vikings. Names remain. Flat, polished stone walls inscribed with thousands of names reflect back the images of the living as they contemplate the memorial to the Vietnam War's (1964-75) dead and missing veterans. The idea is brilliant in its simplicity. The artist Maya Ying Lin (b. 1959) combined two basic ideas: the minimal grandeur of long, black granite walls and row upon row of engraved namesthe abstract and the intimate conjoined. The power of Lin's monument lies in its understatement. The wall is a statement of loss, sorrow, and the futility of war, and the names are so numerous that they lose individuality and become a surface texture. It is a timeless monument to suffering humanity, faceless in sacrifice. Maya Lin said, "The point is to see yourself reflected in the names."

The VIETNAM VETERANS MEMORIAL, now widely admired as a fitting testament to the Americans who died in that conflict, was the subject of public controversy when it was first proposed due to its severely Minimalist style. In its request for proposals for the design of the monument, the Vietnam Veterans Memor-

ial Fund—composed primarily of veterans themselves-stipulated that the memorial be without political or military content, that it be reflective in character, that it harmonize with its surroundings, and that it include the names of the more than 58,000 dead and missing. They awarded the commission to Maya Lin, then an undergraduate studying in the architecture department at Yale University. Her design called for two 200-foot long walls (later expanded to 246 feet) of polished black granite to be set into a gradual rise in Constitution Gardens on the Mall in Washington, D.C., meeting at a 136 degree angle at the point where the walls and slope would be at their full 10-foot height. The names of the dead were to be incised in the stone in the order in which they died, with only the dates of the first and last deaths to be recorded.

The walls also reflect more than visitors. One wall faces and reflects the George Washington Monument (constructed 1848-84). Robert Mills, the architect of many public buildings at the beginning of the nineteenth century, chose the obelisk, a time-honored Egyptian sun symbol, for his memorial to the nation's founder. The other wall leads the

eye to the Neoclassical-style Lincoln Memorial. By subtly incorporating the Washington and Lincoln monuments into the design, Lin's *Vietnam Veterans Memorial* reminds the viewer of sacrifices made in defense of liberty throughout the history of the United States.

Until the modern era, most public art celebrated political and social leaders and glorified aspects of war in large, freestanding monuments. The motives of those who commissioned public art have ranged from civic pride and the wish to honor heroes to political propaganda and social intimidation. Art in public places may engage our intellect, educating or reminding us of significant events in history. Yet the most effective memorials also appeal to our emotions. Public memorials can provide both a universal and intimate experience, addressing subjects that have entered our collective conscious as a nation, yet remain highly personal. Lin's memorial in Washington, D.C., to the American men and women who died in or never returned from the Vietnam War is among the most visited works of public art of the twenty-first century and certainly among the most affecting war monuments ever conceived.

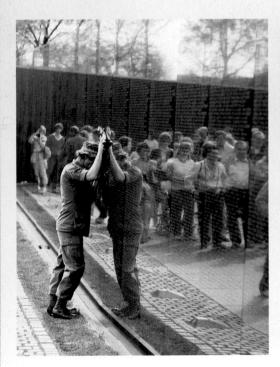

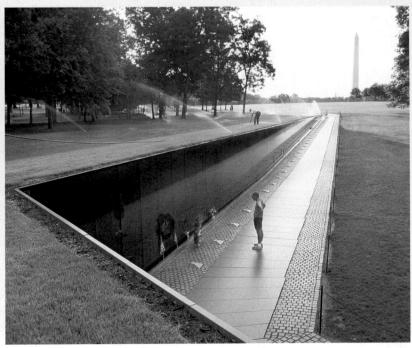

Maya Ying Lin VIETNAM VETERANS MEMORIAL 1982. Black Granite, length 500' (152 m). The Mall, Washington, D.C.

Although artists sometimes work speculatively, hoping afterwards to sell their work on the open market, throughout history interested individuals and institutions have acted as patrons of the arts. During periods of great artistic vigor, enlightened patronage has been an essential factor. Today, museums and other institutions, such as governmental agencies (for example, in the United States, the National Endowment for the Arts), also provide financial grants and support for the arts.

Individual Patrons

People who are not artists often want to be involved with art, and patrons of art constitute a very special audience for artists. Many collectors truly love works of art, but some collect art only to enhance their own prestige, to give themselves an aura of power and importance. Patrons can vicariously participate in the creation of a work by providing economic support to an artist. Such individual patronage can spring from a cordial relationship between a patron and an artist, as is evident in an early fifteenth-century manuscript illustration in which the author, Christine de Pisan, presents her work to her patron Isabeau, the Queen of France (FIG. 20). Christine—a widow who supported her family by writing-hired painters and scribes to copy, illustrate, and decorate her books. She especially admired the painting of a woman named Anastaise, whose work she considered unsurpassed in the city of Paris. While Queen Isabeau was Christine's patron, Christine in turn was Anastaise's patron; and all the women seen in the painting were patrons of the brilliant textile workers who supplied the brocades for their gowns, the tapestries for the wall, and the embroideries for the bed. Such networks of patronage shape a culture.

Relations between artists and patrons are not always necessarily congenial. Patrons may change their minds or fail to pay their bills. Artists may ignore their patron's wishes, or exceed the scope of their commission. In the late nineteenth century, for example, the Liverpool shipping magnate Frederick Leyland asked James McNeill Whistler (1834–1903), an American painter living in London, what color to paint the shutters in the dining room where he planned to hang Whistler's painting *The Princess from The Land of Porcelain* (FIG. 21).

The room had been designed by Thomas Jeckyll with embossed and gilded leather on the walls and finely crafted shelves to show off Leyland's collection of blue and white Chinese porcelain. While Leyland was away, Whistler, inspired by the Japanese theme of his own painting as well as by the porcelain, painted the window shutters with splendid turquoise and gold peacocks, the walls and ceiling with peacock feathers, and then he gilded the walnut shelves. When Leyland, shocked and angry at what seemed to him to be wanton destuction of the room, paid him less than half the agreed on price, Whistler added a painting of himself and Leyland as fighting peacocks. Whistler called the room HARMONY IN BLUE AND GOLD: THE PEACOCK ROOM.

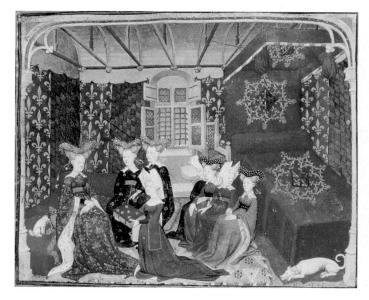

20 CHRISTINE DE PISAN PRESENTING HER BOOK TO THE QUEEN OF FRANCE 1410–15. Tempera and gold on vellum, image approx. $5\% \times 6\%$ " (14 \times 17 cm). The British Library, London.

MS. Harley 4431, folio 3

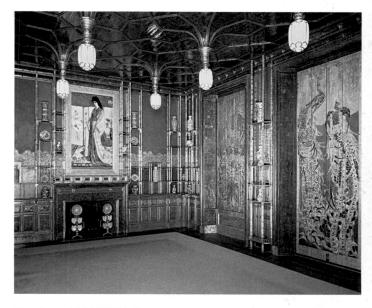

21 James McNeill Whistler HARMONY IN BLUE AND GOLD: THE PEACOCK ROOM northeast corner, from a house owned by Frederick Leyland, London. 1876–1877. Oil paint and metal leaf on canvas, leather, and wood, $13'11\%'' \times 33'2'' \times 19'11\%''$ (4.26 \times 10.11 \times 6.83 m). Over the fireplace, Whistler's *The Princess from The Land of Porcelain*. Freer Gallery of Art, Smithsonian Institut on, Washington, D.C. Gift of Charles Lang Freer, (F1904.61)

Luckily, Leyland did not destroy the Peacock Room. After Leyland's death, Charles Lang Freer (1854–1919) purchased the room and the painting of *The Princess*. Freer reinstalled the room in his home in Detroit, Michican, and filled the delicate gold shelves with his own collection of porcelain. When Freer died in 1919, the Peacock Room was moved to the Freer

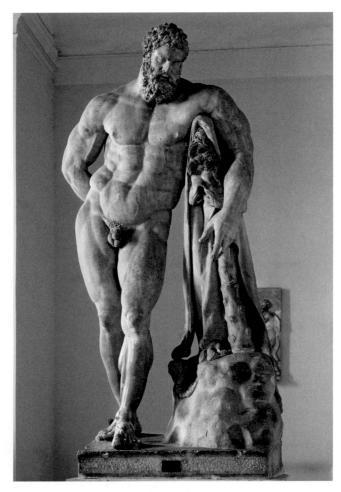

22 THE FARNESE HERCULES3rd century BCE. Copy of *The Weary Hercules* by Lysippos. Found in the Baths of Caracalla in 1546; exhibited in the Farnese Palace until 1787. Marble, $10\frac{1}{2}$ (3.17 m). Signed "Glykon" on the rock under the club. Left arm restored.

Gallery of Art, which he had founded in Washington D.C., where it remains as an extraordinary example of interior design and late nineteenth-century patronage.

Collectors and Museums

From the earliest times, people have collected and kept precious objects that convey the idea of power and prestige. Today both private and public museums are major patrons, collectors, and preservers of art. Curators of such collections acquire works of art for their museums and often assist patrons in obtaining especially desirable pieces, although the idea of what is best and what is worth collecting and preserving often changes from one generation to another.

Charles Lang Freer, mentioned on the previous page, is another kind of patron—one who was a sponsor of artists, a collector, and the founder of the museum that bears his name. Freer was an industrialist in Detroit—the manufacturer of rail—way cars—who was inspired by the nineteenth-century ideal of art as a means of achieving universal harmony and of the philosophy "Art for Art's Sake." The leading American exponent of

this philosophy was James McNeill Whistler. On a trip to Europe in 1890, Freer met Whistler, who inspired him to collect Asian art as well as the art of his own time. Freer became an avid collector and supporter of Whistler, whom he saw as a person who combined the aesthetic ideals of both East and West. Freer assembled a large and distinguished collection of American and Asian art, including the *Peacock Room*. (SEE FIG. 21). In his letter written at the founding the Freer Gallery, donating his collection to the Smithsonian Institution and thus to the American people, he wrote of his desire to "elevate the human mind."

WHAT IS ART HISTORY?

Art history became an academic field of study relatively recently. Many art historians consider the first art history book to be the 1550 publication *Lives of the Most Excellent Italian Architects, Painters, and Sculptors*, by the Italian artist and writer Giorgio Vasari. As the name suggests, art history combines two studies—the study of individual works of art outside time and place (formal analysis and theory) and the study of art in its historical and cultural context (contextualism), the primary approach taken in this book. The scope of art history is immense. As a result, art history today draws on many other disciplines and diverse methodologies.

Studying Art Formally and Contextually

The intense study of individual art objects is known as connoisseurship. Through years of close contact with artworks and through the study of the formal qualities that compose style in art (such as the design, the composition, and the way materials are manipulated)—an approach known as formalism—the connoisseur learns to categorize an unknown work through comparison with related pieces, in the hope of attributing it to a period, a place, and sometimes even a specific artist. Today such experts also make use of the many scientific tests—such as x-ray radiography, electron microscopy, infrared spectroscopy, and x-ray diffraction—but ultimately connoisseurs depend on their visual memory and their skills in formal analysis.

As a humanistic discipline, art history adds theoretical and contextual studies to the formal and technical analyses of connoisseurship. Art historians draw on biography to learn about artists' lives; on social history to understand the economic and political forces shaping artists, their patrons, and their public; and on the history of ideas to gain an understanding of the intellectual currents influencing artists' works. Some art historians are steeped in the work of Sigmund Freud (1856–1939), whose psychoanalytic theory addresses creativity, the unconscious mind, and art as an expression of repressed feelings. Others have turned to the political philosopher Karl Marx (1818–83) who saw human beings as the products of their economic environment and art as a reflection of humanity's excessive concern with material val-

ues. Some social historians see the work of art as a status symbol for the elite in a highly stratified society.

Art historians also study the history of other arts including music, drama, and literature—to gain a fuller sense of the context of visual art. Their work results in an understanding of the iconography (the narrative and allegorical significance) and the context (social history) of the artwork. Anthropology and linguistics have added yet another theoretical dimension to the study of art. The Swiss linguist Ferdinand de Saussure (1857-1913) developed structuralist theory, which defines language as a system of arbitrary signs. Works of art can be treated as a language in which the marks of the artist replace words as signs. In the 1960s and 1970s structuralism evolved into other critical positions, the most important of which are semiotics (the theory of signs and symbols) and deconstruction. To the semiologist, a work of art is an arrangement of marks or "signs" to be decoded, and the artist's meaning or intention holds little interest. Similarly the deconstructionism of the French philosopher Jacques Derrida (1930-2004) questions all assumptions including the idea that there can be any single correct interpretation of a work of art. So many interpretations emerge from the creative interaction between the viewer and the work of art that in the end the artwork is "deconstructed."

The existence of so many approaches to a work of art may lead us to the conclusion that any idea or opinion is equally valid. But art historians, regardless of their theoretical stance, would argue that the informed mind and eye are absolutely necessary.

As art historians study a wider range of artworks than ever before, many have come to reject the idea of a fixed canon of superior pieces. The distinction between elite fine arts and popular utilitarian arts has become blurred, and the notion that some mediums, techniques, or subjects are better than others has almost disappeared. This is one of the most telling characteristics of art history today, along with the breadth of studies it now encompasses and its changing attitude to challenges such as preservation and restoration.

WHAT IS A VIEWER'S ROLE AND RESPONSIBILITY?

As viewers we enter into an agreement with artists, who in turn make special demands on us. We re-create the works of art for ourselves as we bring to them our own experiences, our intelligence, our knowledge, and even our prejudices. Without our participation, artworks are merely chunks of stone or flecks of paint. But remember, all is change. From extreme realism at one end of the spectrum to entirely non-representational art at the other, artists have worked with varying degrees of naturalism, idealism, and abstraction. For students of art history, the challenge is to discover not only how those styles evolved, but also why they changed, and

ultimately what significance these changes hold for us, for our humanity, and for our future.

Our involvement with art can be casual or intense, naive or sophisticated. At first we may simply react instinctively to a painting or a building or a sculpture (FIG. 22), but this level of "feeling" about art—"I know what I like"—can never be fully satisfying. Like the sixteenth-century Dutch visitors to Rome (FIG. 23), we too can admire and ponder the ancient marble FARNESE HERCULES, and we can also ponder Hendrick Goltzius's engraving that depicts his Dutch friends as they ponder, and we can perhaps imagine an artist depicting us as our glance leaps backwards and forwards pondering art history. Because as viewers we participate in the re-creation of a work of art, its meaning changes from individual to individual, from era to era.

Once we welcome the arts into our lives, we have a ready source of sustenance and challenge that grows, changes, mellows, and enriches our daily experience. This book introduces us to works of art in their historical context, but no matter how much we study or read about art and artists, eventually we return to the contemplation of an original work itself, for art is the tangible evidence of the ever-questing human spirit.

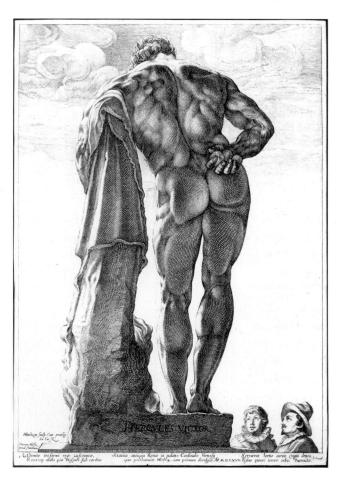

23 Hendrick Goltzius DUTCH VISITORS TO ROME LOOKING AT THE FARNESE HERCULES c. 1592. Engraving, $16 \times 11 \%$ (40.5 x 29.4 cm). After Goltzius returned from a trip to Rome in 1591–1592, he made engravings based on his drawings. The awe-struck viewers have been identified as two of his Dutch friends.

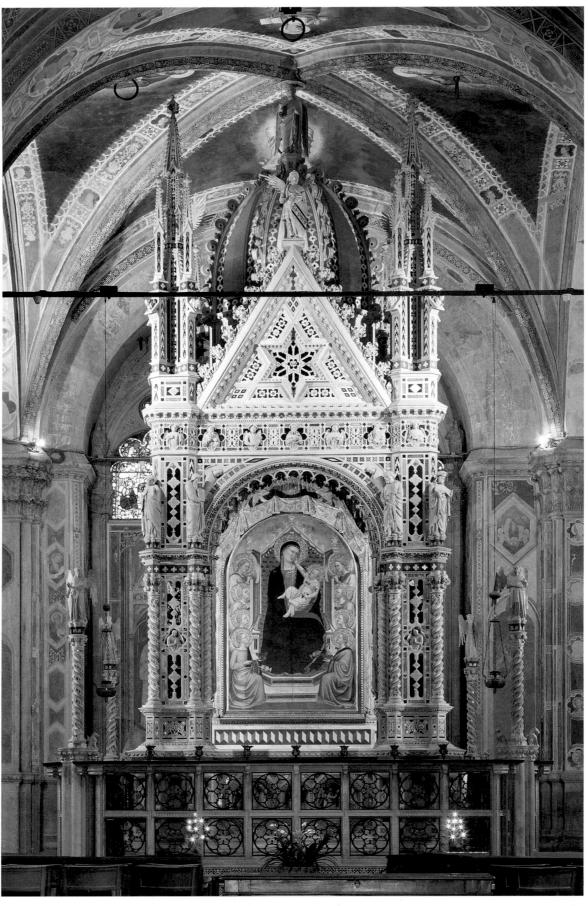

12-I Andrea Orcagna Marble, mosaic, gold, lapis lazuli.
 Bernardo Daddi MADONNA AND CHILD 1346-7. Tempera and gold on wood panel.

CHAPTER TWELVE

FOURTEENTH-CENTURY ART IN EUROPE

One of the many surprises greeting the modern visitor to Florence is a curious blocky building with statue-filled niches. Originally a **loggia** (a covered, open-air gallery), today its dark interior is dominated by a huge and ornate taberna-

cle built to house the important **MADONNA AND CHILD** (FIG. 12–1) by Bernardo Daddi. Daddi was commissioned to create this painting in 1346/47, just before the Black Death swept through the city in the summer of 1348.

Daddi's painting was the second replacement of a late thirteenth-century miracle-working image of the Madonna and Child. The original image had occupied a simple shrine in the central grain market, known as *Orsanmichele* (Saint Michael in the Garden). The original painting may have been irreparably damaged in the fire of 1304 that also destroyed the first market loggia, built at the end of the thirteenth century. A second painting, also lost, was made sometime later, but it was believed that the healing power of the image passed from painting to painting with continued potency.

Florence grew rapidly in the late Middle Ages. By the fourteenth century two-thirds of the city's grain supply had to be imported. The central grain market and warehouse established at Orsanmichele, as insurance against famine, made that site the economic center of the city. The Confraternity (charitable society) of Orsanmichele was created to honor the image of the Madonna and Child and to collect and distribute alms to needy citizens. In 1337 a new leggia

was built to protect the miracle-working image, and two upper stories were added to the loggia to store the city's grain reserves.

Orsanmichele remained Florence's central grain market for about ten years after Daddi

painted the newest miracle-working *Madonna and Child* in 1346/47. As a reflection of its wealth and piety, the Confraternity of Orsanmichele commissioned Andrea di Cione, better known as Orcagna (active c. 1343–68), to create a new and rich tabernacle for Daddi's painting. A member of the stone- and woodworkers guild, Orcagna was in charge of building and decorating projects at Orsanmichele. To protect and glorify the *Madonna and Child*, he created a tour-de-force of architectural sculpture in marble, encrusted with gold and glass mosaics. In Orcagna's shrine, Daddi's *Madonna and Child* seems to be revealed by a flock of angels drawing back carved curtains. Sculpted saints stand on the pedestals against the piers, and reliefs depicting the life of the Madonna occupy the structure's base. The tabernacle was completed in 1359, and a protective railing was added in 1366.

Orsanmichele answered practical economic and social needs (granary and distribution point for alms), as well as religious and spiritual concerns (a shrine to the Virgin Mary), all of which characterized the complex society of the fourteenth century. In addition, Orsanmichele was a civic rallying point for the city's guilds. The significance of the guilds in the life of cities in the later Middle Ages cannot be overestimated. In

Florence, guild members were not simple artisans; the major guilds, composed of rich and powerful merchants and entrepreneurs, dominated the government and were key patrons of the arts. For example, the silk guild oversaw the construction of Orsanmichele. In 1380, the arches of the loggia were walled up. At that time, fourteen of the most important Florentine guilds were each assigned an exterior niche on the ground level in which to erect an image of their patron saint.

The cathedral, the Palazzo della Signoria, and Orsanmichele, three great buildings in the city center, have come to symbolize power and patronage in the Florentine Republic. But of the three, the miraculous Madonna in her shrine at Orsanmichele witnessed the greatest surge of interest in the years following the Black Death. Pilgrims flocked to Orsanmichele, and those who had died during the plague left their estates in their wills to the shrine's confraternity. On August 13, 1365, the Florentine government gathered the people together to proclaim the Virgin of Orsanmichele the special protectress of the city.

CHAPTER-AT-A-GLANCE

- EUROPE IN THE FOURTEENTH CENTURY
- ITALY | Florentine Architecture and Sculpture | Florentine Painting | Sienese Painting
- FRANCE | Manuscript Illumination | Sculpture
- ENGLAND Embroidery: Opus Anglicanum Architecture
- THE HOLY ROMAN EMPIRE | The Supremacy of Prague | Mysticism and Suffering
- IN PERSPECTIVE

EUROPE IN THE FOURTEENTH CENTURY

By the middle of the fourteenth century, much of Europe was in crisis. Earlier prosperity had fostered population growth, which by about 1300 had begun to exceed food production. A series of bad harvests then meant that famines became increasingly common. To make matters worse, a prolonged conflict known as the Hundred Years' War (1337–1453) erupted between France and England. Then, in the middle of the fourteenth century, a lethal plague known as the Black Death swept across Europe, wiping out as much as 40 percent of the population (see "The Triumph of Death," page 426). By depleting the labor force, however, the plague gave surviving peasants increased leverage over their landlords and increased the wages of artisans.

The papacy had emerged from its conflict with the Holy Roman Empire as a significant international force. But its temporal success weakened its spiritual authority and brought it into conflict with growing secular powers. In 1309, after the election of a French pope, the papal court moved from Rome to Avignon, in southern France. Italians disagreed, and during the Great Schism from 1378 to 1417, there were two popes, one in Rome and one in Avignon, each claiming legitimacy. The Church provided some solace but little leadership, as rival popes in Rome and Avignon excommunicated each other's followers. Secular rulers took sides: France, Scotland, Aragon, Castile, Navarre, and Sicily supported the

pope in Avignon; England, Flanders, Scandinavia, Hungary, and Poland supported the pope in Rome. Meanwhile, the Church experienced great strain from challenges from reformers like John Hus (c. 1370–1415) in Bohemia. The cities and states that composed present-day Germany and the Italian Peninsula were divided among different factions.

The literary figures Dante, Petrarch, and Boccaccio (see "A New Spirit in Fourteenth-Century Literature," page 431) and the artists Cimabue, Duccio, and Giotto fueled a cultural explosion in fourteenth-century Italy. In literature, Petrarch (Francesco Petrarca, 1304–74) was a towering figure of change, a poet whose love lyrics were written not in Latin but in Italian, marking its first use as a literary language. A similar role was played in painting by the Florentine Giotto di Bondone (c. 1277–1337). In deeply moving mural paintings, Giotto not only observed the people around him, he ennobled the human form by using a weighty, monumental style, and he displayed a new sense of dignity in his figures' gestures and emotions

This new orientation toward humanity, combined with a revived interest in classical learning and literature, we now designate as *humanism*. Humanism embodied a worldview that focused on human beings; an education that perfected individuals through the study of past models of civic and personal virtue; a value system that emphasized personal effort and responsibility; and a physically active life that was directed toward the common good as well as individual

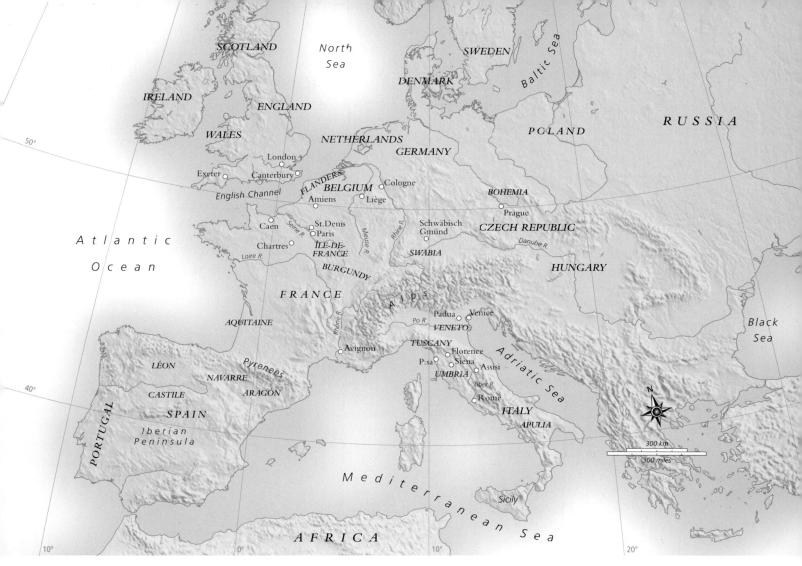

MAP 12-1 | Europe in the Fourteenth Century

Avignon in Southern France, Prague in Bohemia, and Exeter in Southern England joined Paris, Florence, and Siena as centers of art patronage in the late Gothic period.

nobility. For Petrarch and his contemporaries an appreciation of Greek and Roman writers became the defining element of the age. Humanists mastered the Greek and Latin languages so that they could study the classical literature—including newly rediscovered works of history, biography, poetry, letters, and orations.

In architecture, sculpture, and painting, the Gothic style—with its soaring vaults, light, colorful glass, and linear qualities—persisted in the fourteenth century, with regional variations. Toward the end of the century, devastation from the Hundred Years' War and the Black Death meant that large-scale construction gradually ceased, ending the great age of cathedral building. The Gothic style continued to develop, however, in smaller churches, municipal and commercial buildings, and private residences. Many churches were modernized or completed in this late Gothic period.

From the growing middle class of artisans and merchants, talented and aggressive leaders assumed economic and in some places political control. The artisan guilds—organized by occupation—exerted quality control among members and supervised education through an apprenticeship sys-

tem. Admission to the guild came after examination and the creation of a "masterpiece"—literally, a piece fine enough to achieve master's status. The major guilds included cloth finishers, wool merchants, and silk manufacturers, as well as pharmacists and doctors. Painters belonged to the pharmacy guild, perhaps because they used mortars and pestles to grind their colors. Their patron saint, Luke, who was believed to have painted the first image of the Virgin Mary (see Chapter 7, page 266), was also a physician—or so they thought. Sculptors who worked in wood and stone had their own guild, while those who worked in metals belonged to another guild. Guilds provided social services for their members, including care of the sick and funerals for the deceased. Each guild had its patron saint and maintained a chapel and participated in religious and civic festivals.

Complementing the economic power of the guilds was the continuing influence of the Dominican and Franciscan religious orders (see Chapter 11), whose monks espoused an ideal of poverty, charity, and love and dedicated themselves to teaching and preaching. The new awareness of societal needs manifested itself in the

THE OBJECT SPEAKS

THE TRIUMPH OF DEATH

he Four Horsemen of the Apocalypse—Plague, War, Famine, and Death—stalked the people of Europe during the fourteenth century. France, England, and Germany pursued their seemingly endless wars, and roving bands of soldiers and brigands looted and murdered unprotected peasants and villagers. Natural disasters—fires, droughts, floods, and wild storms—took their toll. Disease spread rapidly through a population already weakened by famine and physical abuse.

Then a deadly plague, known as the Black Death, spread by land and sea from Asia. The plague soon swept from Italy and France across the British Isles, Germany, Poland, and Scandinavia. Half the urban population of Florence and Siena—some say 80 percent—died in the summer of 1348. To people of the time the Black Death seemed to be an act of divine wrath against sinful humans.

In their panic, some people turned to escapist pleasures; others to religious fanaticism. Andrea Pisano and Ambrogio Lorenzetti were probably among the many victims of the Black Death. But the artists who survived had work to do—chapels and hospitals, altarpieces and votive statues. The sufferings of Christ, the sorrows as well as the joys of the Virgin, the miracles of the saints, and new themes—"The Art of Dying Well," and "The Triumph of Death"—all carried the message "Remember, you too will die." An unknown artist, whom we call the Master of the Triumph of Death, painted such a theme in the cemetery of Pisa (Camposanto).

The horror and terror of impending death are vividly depicted in the huge mural, THE TRIUMPH OF DEATH. In the center of the wall dead people lie in a heap while devils and angels carry their souls to hell or heaven. Only the hermits living in the wilderness escape the holocaust. At the right, wealthy young people listen to music under the orange trees, unaware of Death flying toward them with a scythe. At the left of the painting, a group on horseback who have ridden out into the wilderness discover three open coffins. A woman recoils at the sight of her dead counterpart. A courtier covers his nose, gagging at the smell,

while his wild-eyed horse is terrified by the bloated, worm-riddled body in the coffin. The rotting corpses remind them of their fate, a medieval theme known as "The Three Living and the Three Dead."

Perhaps the most memorable and touching images in the huge painting are the crippled beggars who beg Death to free them from their earthly miseries. Their words appear on the scroll: "Since prosperity has completely deserted us, O Death, you who are the medicine for all pain, come to give us our last supper!"* The painting speaks to the viewer, delivering its message in words and images. Neither youth nor beauty, wealth nor power, but only piety like that of the hermits provides protection from the wrath of God.

Strong forces for change were at work in Europe. For all the devastation caused by the Four Horsemen, those who survived found increased personal freedom and economic opportunity.

* Translated by John Paoletti and Gary Radke, Art in Renaissance Italy, 3rd ed. Upper Saddle River, New Jersey. Pearson Prentice Hall, 2005. p. 154.

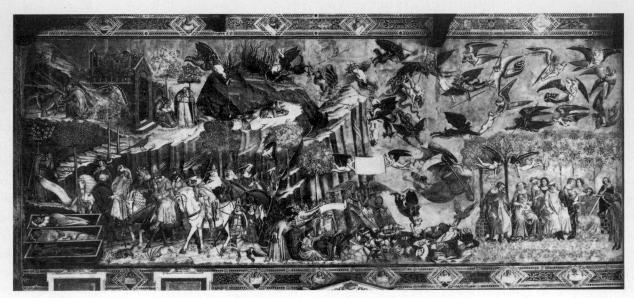

Master of the Triumph of Death (Buffalmacco?) THE TRIUMPH OF DEATH Camposanto, Pisa. 1330s. Fresco, $18'6'' \times 49'2''$ (5.6 × 15 m).

Reproduced here in black and white, photo taken before the fresco was damaged by American shells during World War II.

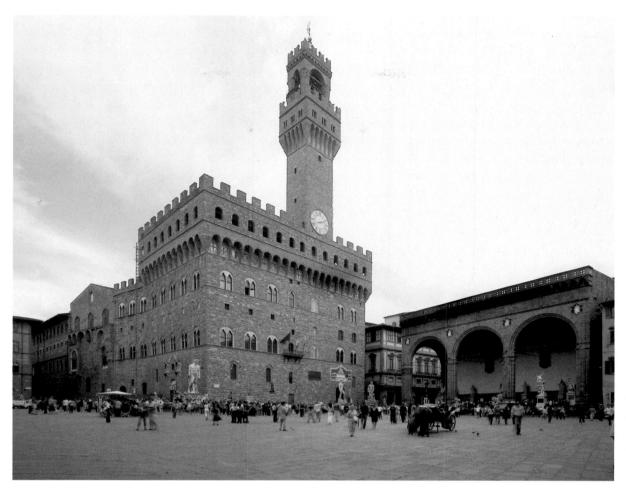

12–2 | PIAZZA DELLA SIGNORIA WITH PALAZZO DELLA SIGNORIA (TOWN HALL)
1299–1310 and LOGGIA DEI LANZI (LOGGIA OF THE LANCERS)

Florence. 1376-82. Speakers' platform and since the sixteenth century a guard station and sculpture gallery.

architecture of churches designed for preaching as well as liturgy, and in new religious themes that addressed personal or sentimental devotion.

ITALY

Great wealth and a growing individualism promoted art patronage in northern Italy. Artisans began to emerge as artists in the modern sense, both in their own eyes and in the eyes of patrons. Although their methods and working conditions remained largely unchanged, artisans in Italy contracted freely with wealthy townspeople and nobles and with civic and religious bodies. Their ambition and self-confidence reflect their economic and social freedom.

Florentine Architecture and Sculpture

The typical medieval Italian city was a walled citadel on a hilltop. Houses clustered around the church and an open city square. Powerful families added towers to their houses both for defense and out of family pride. In Florence, by contrast, the ancient Roman city—with its rectangular plan, major north—south and east—west streets, and city squares—remained the foundation for civic layout. The cathedral stood northeast of the ancient forum. The north—south street joining the cathedral and the Piazza della Signoria followed the Roman line.

THE PALAZZO DELLA SIGNORIA. The governing body of the city (the Signoria) met in the PALAZZO DELLA SIGNORIA, a massive fortified building with a tall bell tower 300 feet (91 m) high (FIG. 12–2). The building faces a large square, or piazza, which became the true civic center. Town houses often had seats along their walls to provide convenient public seating. In 1376 (finished in 1381/82), a huge loggia was built at one side to provide a covered space for ceremonies and speeches. After it became a sculpture gallery and guard station in the sixteenth century, the loggia became known as the LOGGIA OF THE LANCERS. The master builders were Berici di Cione and Simone Talenti. Michelangelo's *David* (SEE FIG. 15–10) once stood in front of the Palazzo della Signoria facing the loggia (it is replaced today by a modern copy).

THE CATHEDRAL. In Florence, the cathedral (duomo) (FIGS. 12–3, 12–4) has a long and complex history. The original plan, by Arnolfo di Cambio (c. 1245–1302), was approved in 1294, but political unrest in the 1330s brought construction to a halt until 1357. Several modifications of the design were made, and the cathedral we see today was built between 1357 and 1378. (The façade was given its veneer of white and green marble in the nineteenth century to coordinate it with the rest of the building and the nearby Baptistry of San Giovanni.)

Sculptors and painters rather than masons were often responsible for designing Italian architecture, and as the Florence Cathedral reflects, they tended to be more concerned with pure design than with engineering. The long, squarebayed nave ends in an octagonal domed crossing, as wide as the nave and side aisles. Three polygonal apses, each with five radiating chapels, surround the central space. This symbolic Dome of Heaven, where the main altar is located, stands apart from the worldly realm of the congregation in the nave. But the great ribbed dome, so fundamental to the planners' conception, was not begun until 1420, when the architect Filippo Brunelleschi (1377–1446) solved the engineering problems involved in its construction (see Chapter 14).

THE BAPTISTRY DOORS. In 1330, Andrea Pisano (c.1290–1348) was awarded the prestigious commission for a pair of gilded bronze doors for the Florentine Baptistry of San Giovanni. (Although his name means "from Pisa," Andrea was not related to Nicola and Giovanni Pisano.) The Baptistry doors were completed within six years and display

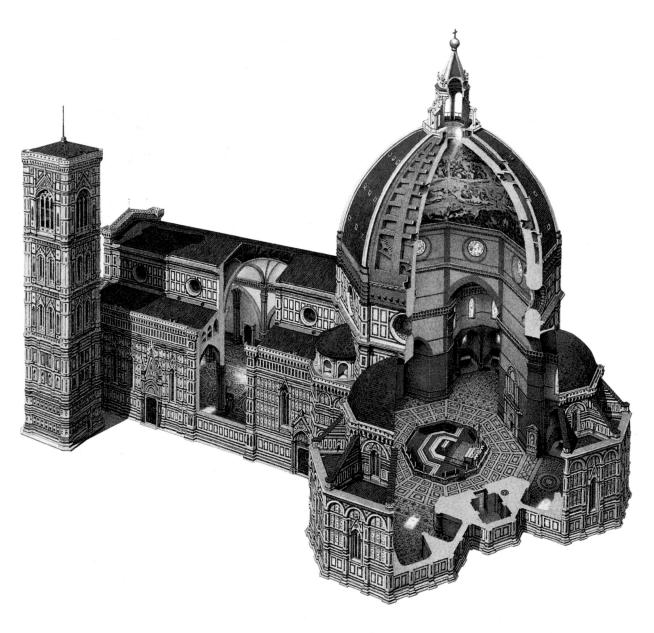

12-3 FLORENCE CATHEDRAL (DUOMO)

Plan 1294, costruction begun 1296, redisegned 1357 and 1366, drum and dome 1420–36. Illustration by Philipe Biard in Guide Gallimard Florence © Gallimard Loisirs.

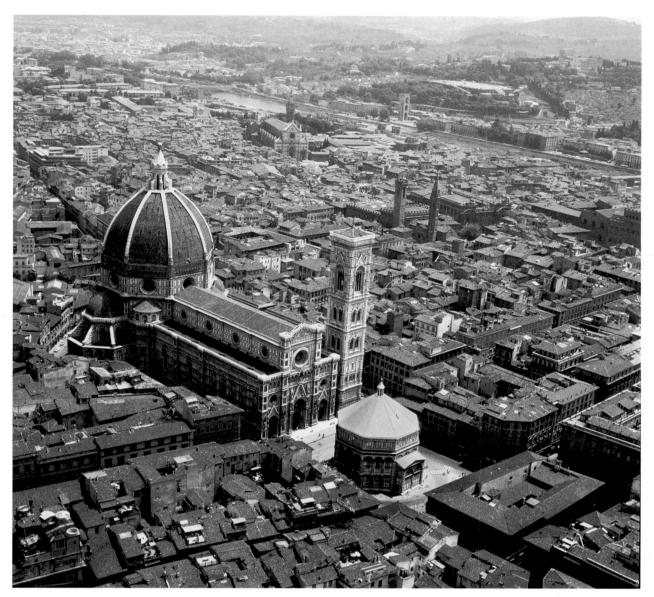

12–4 | Arnolfo di Cambio, Francesco Talenti, Andrea Orcagna, and others FLORENCE CATHEDRAL (DUOMO) 1296-1378; drum and dome by Brunelleschi, 1420–36; bell tower (Campanile) by Giotto, Andrea Pisano, and Francesco Talenti, c. 1334–50.

The Romanesque Baptistry of San Giovanni stands in front of the Duomo.

twenty scenes from the life of John the Baptist (San Giovanni) set above eight personifications of the Virtues (FIG. 12–5). The reliefs are framed by quatrefoils, the four-lobed decorative frames introduced at the Cathedral of Amiens in France (SEE FIG. 11–21). The figures within the quatrefoils are in the monumental, classicizing style inspired by Giotto then current in Florentine painting, but they also reveal the soft curves of northern Gothic forms in their gestures and draperies, and a quiet dignity of pose particular to Andrea. The individual scenes are elegantly natural. The figures' placement, on shelflike stages, and their modeling create a remarkable illusion of three-dimensionality, but the overall effect created by the repeated barbed quatrefoils is two-

dimensional and decorative, and emphasizes the solidity of the doors. The bronze vine scrolls filled with flowers, fruits, and birds on the lintel and jambs framing the door were added in the mid-fifteenth century.

Florentine Painting

Florence and Siena, rivals in so many ways, each supported a flourishing school of painting in the fourteenth century. Both grew out of the Italo-Byzantine style of the thirteenth century, modified by local traditions and by the presence of individual artists of genius. The Byzantine influence, also referred to as the *maniera greca* ("Greek manner"), was characterized by dramatic pathos and complex iconography and showed

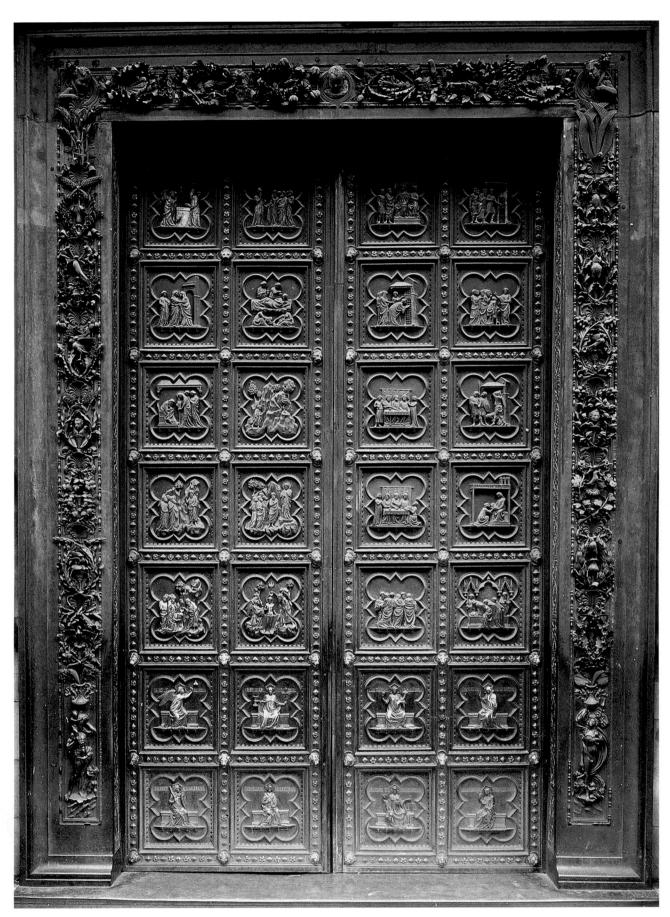

12–5 | Andrea Pisano LIFE OF JOHN THE BAPTIST South doors, Baptistry of San Giovanni, Florence. 1330–36. Gilded bronze, each panel $19\% \times 17''$ (48×43 cm). Frame, Ghiberti workshop, mid-15th century.

itself in such elements as elongated figures, often exaggerated, iconic gestures, stylized features including the use of gold for drapery folds, and striking contrasts of highlights and shadows in the modeling of individual forms. By the end of the fourteenth century, the painter and commentator Cennino Cennini (see "Cennino Cennini [c. 1370–1440] on Painting," page 434) would be struck by the accessibility and modernity of Giotto's art, which, though it retained traces of the "Greek manner," was moving toward the depiction of a humanized world anchored in three-dimensional form.

CIMABUE. In Florence, the transformation of the Italo-Byzantine style began a little earlier than in Siena. About 1280, a painter named Cenni di Pepi (active c. 1272–1302), better known by his nickname "Cimabue," painted the VIR-GIN AND CHILD ENTHRONED (FIG. 12–6), perhaps for the main altar of the Church of Santa Trinita in Florence. At almost 12 feet tall, this enormous panel painting set a new precedent for monumental altarpieces. Cimabue uses the traditional Byzantine iconography of the "Virgin Pointing the Way," in which Mary holds the infant Jesus in her lap and points to him as the path to salvation. Mother and child are surrounded by saints, angels, and Old Testament prophets.

A comparison with a Byzantine icon (SEE FIG. 7-51) shows that Cimabue employed Byzantine formulas in determining the proportions of his figures, the placement of their schematic features, and even the tilt of their haloed heads. Mary's huge throne, painted to resemble gilded bronze with inset enamels and gems, provides an architectural framework for the figures. To render her drapery and that of the infant Jesus, Cimabue used the Italo-Byzantine technique of highlighting drapery with thin lines of gold to indicate divinity. The viewer seems suspended in space in front of the image, simultaneously looking down on the projecting elements of the throne and Mary's lap, while looking straight ahead at the prophets at the base of the throne and the angels at each side. These spatial ambiguities, the subtle asymmetries within the centralized composition, the Virgin's thoughtful gaze, and the individually conceived faces of the old men enliven the picture with their departure from Byzantine tradition. Cimabue's concern for spatial volumes, solid forms delicately modeled in light and shade, and warmly naturalistic human figures contributed to the course of later Italian painting.

GIOTTO DI BONDONE. Compared to Cimabue's Virgin and Child Enthroned, Giotto's painting of the same subject (FIG. 12–7), done about 1310 for the Church of the Ognissanti (All Saints) in Florence, exhibits a groundbreaking spatial consistency and sculptural solidity while retaining some of Cimabue's conventions. The central and overtly symmetrical composition and the position of the figures reflect Cimabue's influence. Gone, however, are Mary's modestly inclined head and the delicate gold folds in her drapery. Instead, her face is

Art and Its Context

A NEW SPIRIT IN FOURTEENTH-CENTURY LITERATURE

or Petrarch and his contemporaries—Boccaccio, Chaucer, Christine de Pizan—the essential qualifications for a writer were an appreciation of Greek and Roman authors and an ability to observe and appreciate people from every station in life. Although fluent in Latin, they chose to write in the language of their own daily life—Italian, English, French. Leading the way was Dante Alighieri (1265–1321), who wrote *The Divine Comedy*, his great summation of human virtue and vice, and ultimately human destiny, in Italian. Dante established the Italian language as worthy of great themes in literature.

Francesco Petrarca, called simply Petrarch (13C4-74), raised the status of secular literature with his sonnets (love lyrics) to his unobtainable, beloved Laura; his histories and biographies; and his discovery of the ancient Roman writings on the joys of country life. Petrarch's imaginative updating of classical themes in a work called *The Triumphs*—which examines the themes of Chast ty triumphant over Love, Death over Chastity, Fame over Death, Time over Fame, and Eternity over Time—provided later Renaissance poets and painters with a wealth of allegorical subject matter.

More earthy, Giovanni Boccaccio (1313-75) perfected the art of the short story in *The Decameron*, a collection of amusing and moralizing tales told by a group of young Florentines who moved to the countryside to escape the Black Death. With wit and sympathy, Boccaccio presents the full spectrum of daily life in Italy. Such secular literature, including the discovery and translation of ancient authors (for some of the tales had a long lineage), written in Italian as it was then spoken in Tuscany, provided a foundation for the Renaissance of the fifteenth century.

In England. Geoffrey Chaucer (c. 1342-1400) was inspired by Boccaccio to write his own series of snort stories, *The Canterbury Tales*, told by pilgrims traveling to the shrine of Saint Thomas à Becket (1118?-1170) in Canterbury. Observant and witty, Chaucer depicted the pretensions and foibles, as well as the virtues, of humanity.

Christine ce Pizan (1364–c. 1431), born in Venice but living and writing at the French court, became an author out of necessity when she was left a widow with three young children and an aged mother to support. Among her many works are a poem in praise of Joan of Arc and a history of famous women—including artists—from antiquity to her own time. In *The Book of the City of Ladies* she defended women's abilities and argued for women's rights and status. These writers, as surely as Giotto, Duccio, Peter Parler, and Master Theodoric, led the way into a new era.

individualized, and her action—holding her child's leg instead of merely pointing to him—seems entirely natural. This colossal Mary seems too large for the slender Gothic tabernacle, where figures peer through the openings and haloes overlap the faces. In spite of the formal, enthroned image and flat, gold background, Giotto renders the play of light and shadow across these substantial figures to create a sense that they are fully three-dimensional beings inhabiting real space. Details of the Virgin's solid torso can be glimpsed under her thin tunic, and Giotto's angels, unlike those of Cimabue, have ample wings that fold over in a resting position.

According to the sixteenth-century chronicler Vasari, "Giotto obscured the fame of Cimabue, as a great light out-

shines a lesser." Vasari also credited Giotto with "setting art upon the path that may be called the true one [for he] learned to draw accurately from life and thus put an end to the crude Greek [i.e., Italo-Byzantine] manner" (translated by J. C. and P. Bondanella).

Giotto may have collaborated on murals at the prestigious Church of Saint Francis in Assisi (see "The Church of Saint Francis at Assisi," page 416). Certainly he worked for the Franciscans in Florence and reacted to their teaching. Saint Francis's message of simple, humble devotion, direct experience of God, and love for all creatures was gaining followers throughout Western Europe, and it had a powerful impact on thirteenth- and fourteenth-century Italian literature and art.

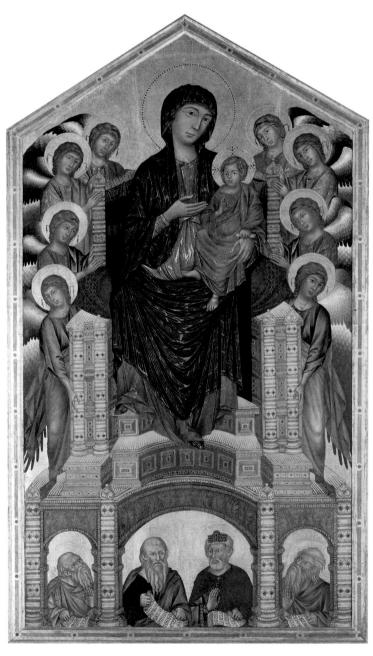

12–6 | Cimabue **VIRGIN AND CHILD ENTHRONED** Most likely painted for the high altar of the Church of Santa Trinita, Florence. c. 1280. Tempera and gold on wood panel, $12'17'' \times 7'$ 4" $(3.53 \times 2.2 \text{ m})$. Galleria degli Uffizi, Florence.

Early in the fourteenth century Giotto traveled to northern Italy. While working at the Church of Saint Anthony in Padua, he was approached by a local banker, Enrico Scrovegni, to decorate a new family chapel. He agreed, and the **SCROVEGNI CHAPEL** was dedicated in 1305 to the Virgin of Charity and the Virgin of the Annunciation. (The chapel is also called the "Arena Chapel" because it and the family palace were built on and in the ruins of an ancient Roman arena.) The building is a simple, barrel-vaulted room (FIG. 12–8). As viewers look toward the altar, they see the story of Mary and Jesus unfolding before them in a series of rectangular panels. On the entrance wall Giotto painted the Last Judgment.

Sequencing Events MARCH OF THE BLACK DEATH

1346	Plague enters the Crimian Peninsula
1347	Plague arrives in Sicily
1348	Plague reaches port cities of Genoa, Italy, and Marseilles, France
1349	First recorded cases of plague in Cologne and Vienna
1350	Plague reaches Bergen, Norway, via England

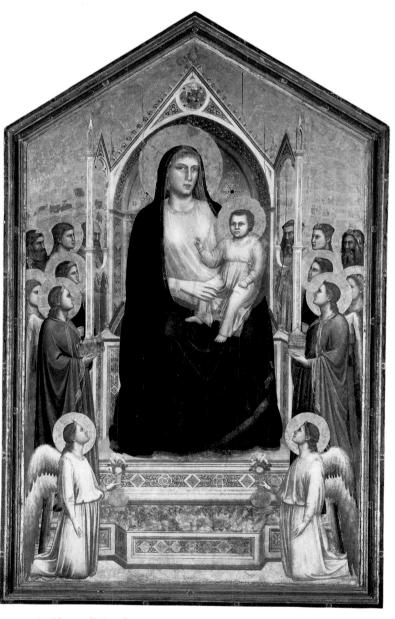

12–7 | Giotto di Bondone VIRGIN AND CHILD ENTHRONED Most likely painted for the high altar of the Church of the Ognissanti (All Saints), Florence. 1305–10. Tempera and gold on wood panel, $10'8'' \times 6' \ 8 \ \%'' \ (3.53 \times 2.05 \ m)$. Galleria degli Uffizi, Florence.

Technique

CENNINO CENNINI (c. 1370-1440) ON PAINTING

ennino Cennini's *Il Libro dell' Arte (The Book of Art)* is a handbook of Florentine and north Italian painting techniques from about 1400. Cennini includes a description of the artist's life as well as step-by-step painting instructions.

"You, therefore, who with lofty spirit are fired with this ambition, and are about to enter the profession, begin by decking yourselves with this attire: Enthusiasm, Reverence, Obedience, and Constancy. And begin to submit yourself to the direction of a master for instruction as early as you can, and do not leave the master until you have to" (Chapter III).*

The first step in preparing a panel for painting is to cover its surface with clean white linen strips soaked in a **gesso** made from gypsum. Gesso provides a ground, or surface, on which to paint. Cennini specified that at least nine layers of gesso should be applied. The gessoed surface should then be burnished until it resembles ivory. The artist can now sketch the composition of the work with charcoal. At this point, advised Cennini, "When you have finished drawing your figure, especially if it is in a very valuable [altarpiece], so that you are counting on profit and reputation from it, leave it alone for a few days, going back to it now and then to look it over and improve it wherever it still needs something . . . (and bear in mind that you may copy and examine things done by other good masters; that it is no shame to you). The final version of the design should be inked in with a

fine squirrel-hair brush, and the charcoal brushed off with a feather. Gold leaf should be affixed on a humid day, the tissuethin sheets carefully glued down with a mixture of fine powdered clay and egg white, on the reddish clay ground (called bole). Then the gold is burnished with a gemstone or the tooth of a carnivorous animal. Punched and incised patterning should be added to the gold leaf later."*

Italian painters at this time worked in **tempera** paint, powdered pigments mixed most often with egg yolk, a little water, and an occasional touch of glue.

Cennini specified a detailed and highly formulaic painting process. Faces, for example, were always to be done last, with flesh tones applied over two coats of a light greenish pigment and highlighted with touches of red and white. The finished painting was to be given a layer of varnish to protect it and enhance its colors. An elaborate frame, which included the panel or panels on which the painting would be executed, would have been produced by a specialist according to the painter's specifications and brought fully assembled to the studio.

Cennini claimed that panel painting was a gentleman's job, but given its laborious complexity, that was wishful thinking. The claim does, however, reflect the rising social status of painters.

* Cennino Cennini, *The Craftsman's Handbook (Il Libro dell' Arte)*. Trans. by Daniel V. Thompson. New York: Dover, 1960. pp. 3, 16, 75.

A base of faux marble and allegorical *grisaille* (gray monochrome) paintings of the Virtues and Vices support vertical bands painted to resemble marble inlay and carved relief and containing quatrefoil portrait medallions. The central band of medallions spans the vault, crossing a brilliant, lapis blue, star-spangled sky in which large portrait disks float like glowing moons. Set into this framework are the rectangular narrative scenes juxtaposing the life of the Virgin with that of Jesus (FIG. 12–9).

Both the individual scenes and the overall program display Giotto's genius for distilling a complex narrative into a coherent visual experience. The life of the Virgin Mary begins the series and fills the upper band of images. Following in historical sequence, events in the life and ministry of Jesus circle the chapel in the middle band, while scenes of the Passion (the arrest, trial, and Crucifixion of Jesus) fill the lowest band. Read vertically, however, each set of three scenes foreshadows or comments on the others.

The first miracle, when Jesus changes water to wine during the wedding feast at Cana, recalls that his blood will become the wine of the Eucharist, or Communion. The raising of Lazarus becomes a reference to Jesus's Resurrection. Below, the Lamentation over the body of Jesus by those closest

to him leads to the Resurrection, indicated by angels at the empty tomb and his appearance to Mary Magdalen in the *Noli Me Tangere* ("Do not touch me"). The juxtaposition of dead and live trees in the two scenes also becomes a telling detail of death and resurrection. Giotto used only a few large figures and essential props in settings that never distract the viewer by their intricate detail. The scenes are reminiscent of *tableaux vivants* ("living pictures"), in which people dressed in costume re-created poses from familiar works of art—scenes that were played out in the city square in front of the chapel in Padua.

Among Giotto's achievements was his ability to model form with color. He rendered his bulky figures as pure color masses, painting the deepest shadows with the most intense hues and highlighting shapes with lighter shades mixed with white. These sculpturally modeled figures enabled Giotto to convey a sense of depth in landscape settings without relying on the traditional convention of an architectural framework.

In one of the most moving works, **LAMENTATION** (FIG. 12–10), in the lowest **register** (horizontal band) of the Arena Chapel, Giotto focused the composition off center for maximum emotional effect, concentrating on the faces of Mary and the dead Jesus. A great downward-swooping ridge—its barrenness emphasized by a single dry tree, a medieval symbol of

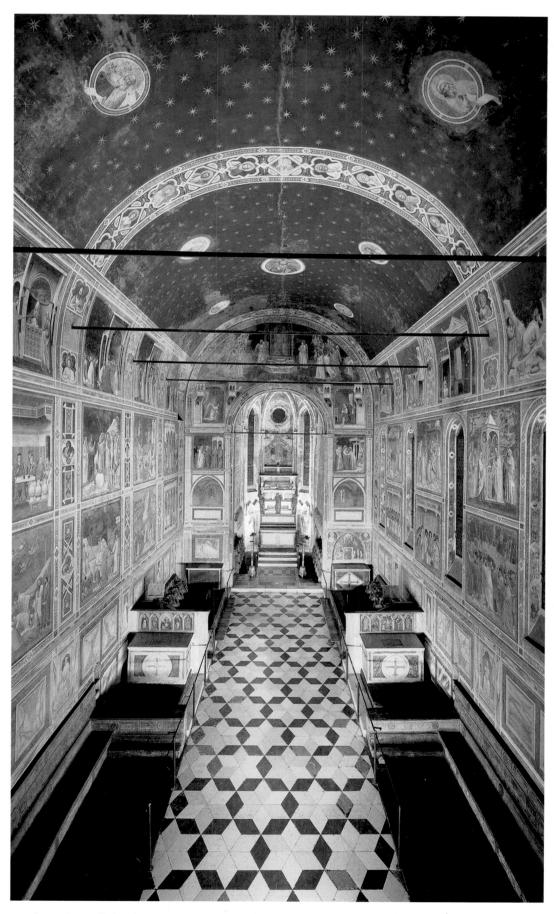

12–8 | Giotto di Bondone **SCROVEGNI (ARENA) CHAPEL,** Frescoes, Padua. 1305–6. View toward east wall.

12–9 | Giotto di Bondone
MARRIAGE AT CANA,
RAISING OF LAZARUS,
RESURRECTION, and NOLI ME
TANGERE and LAMENTATION
Frescoes on north wall of
Scrovegni (Arena) Chapel,
Padua. 1305–6. Each scene
approx. 6'5" × 6' (2 × 1.85 m).

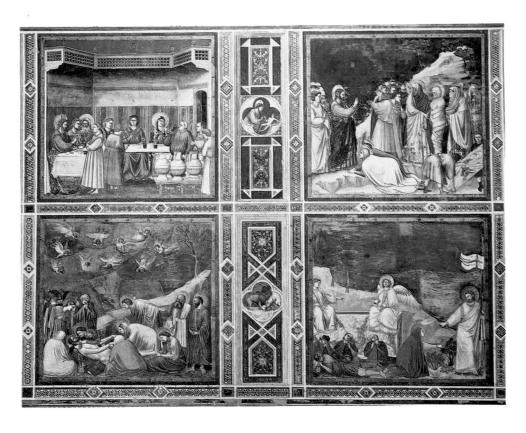

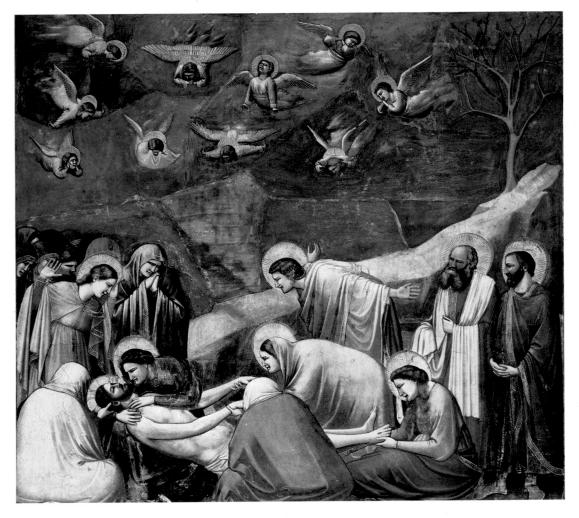

12−10 | Giotto di Bondone LAMENTATION Fresco in the Scrovegni (Arena) Chapel, Padua. 1305-6. Approx. 6'5" × 6' (2 x 1.85 m).

death—carries the psychological weight of the scene to its expressive core. Mourning angels hovering overhead mirror the anguish of Jesus's followers. The stricken Virgin communes with her dead son with mute intensity, while John the Evangelist flings his arms back in convulsive despair and other figures hunch over the corpse. Instead of symbolic sorrow, more typical of art from the early Middle Ages, Giotto conveys real human suffering, drawing the viewer into the circle of personal grief. The direct, emotional appeal of his art, as well as its deliberate plainness, seems to embody Franciscan values.

BERNARDO DADDI. Giotto dominated Florentine painting in the first half of the fourteenth century. His combination of humanism and realism was so memorable that other artists' work paled beside his. The artists who worked in his studio picked up the mannerisms but not the essence of his style. Bernardo Daddi (active c. 1312–48), who painted the *Madonna and Child* in Orsanmichele (SEE FIG. 12–1), typifies the group with his personal reworking of Giotto's powerful figures. Daddi's talent lay in the creation of sensitive, lyrical images rather than the majestic realistic figures. He may have

been inspired by courtly French art, which he would have known from luxury goods, such as imported ivory carvings. The artists of the school of Giotto were responsible for hundreds of panel paintings. They also frescoed the walls of chapels and halls (see "Buon Fresco," page 439).

Sienese Painting

Like their Florentine rivals, the Sienese painters at first worked in a strongly Byzantine style. Sienese painting continued to emphasize abstract decorative qualities and a love of applied gold and brilliant colors. Consequently, Sienese art often seems slightly conservative.

DUCCIO DI BUONINSEGNA. Siena's foremost painter in the later Gothic period was Duccio di Buoninsegna (active 1278–1318). Duccio knew thirteenth-century Byzantine art, with its elongated figures, stacks of angels, patterned textiles, and lavish use of gold. Between 1308 and 1311, Duccio painted a huge altarpiece for the high altar of Siena Cathedral. The **MAESTÀ (MAJESTY)** was dedicated, like the town itself, to the Virgin (FIGS. 12–11, 12–12).

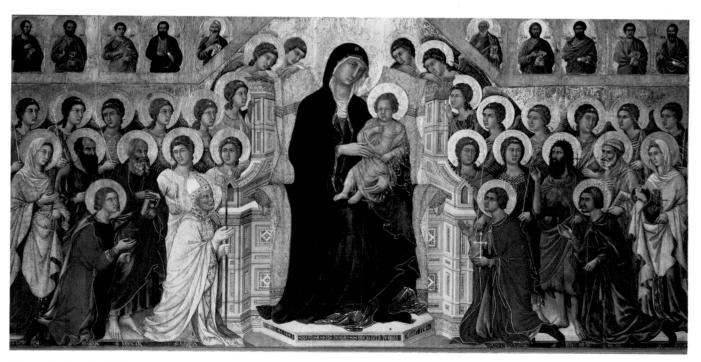

12–11 Duccio di Buoninsegna **VIRGIN AND CHILD IN MAJESTY,** Central Panel from Maestà Altarpiece Siena Cathedral. 1308–11. Tempera and gold on wood panel, $7' \times 13'6''$ (2.13 \times 3.96 m). Museo dell'Opera del Duomo, Siena.

"On the day that it was carried to the [cathedral] the shops were shut, and the bishop conducted a great and devout company of priests and friars in solemn procession, accompanied by . . . all the officers of the commune, and all the people, and one after another the worthiest with lighted candles in their hands took places near the picture, and behind came the women and children with great devotion. And they accompanied the said picture up to the [cathedral], making the procession around the Campo [square], as is the custom, all the bells ringing joyously, out of reverence for so noble a picture as is this" (Holt, page 69).

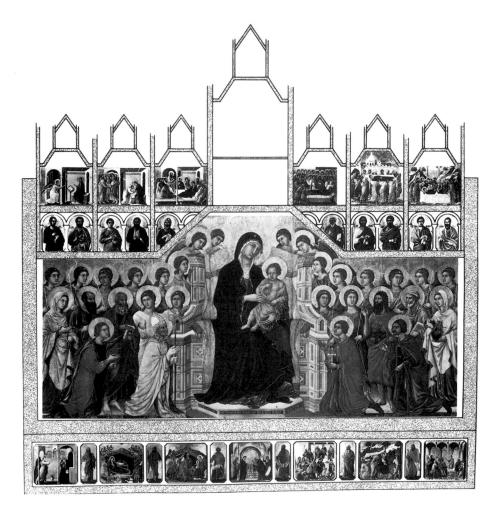

I2-I2 | PLAN OF FRONT AND BACK OF THE MAESTÀ ALTARPIECE

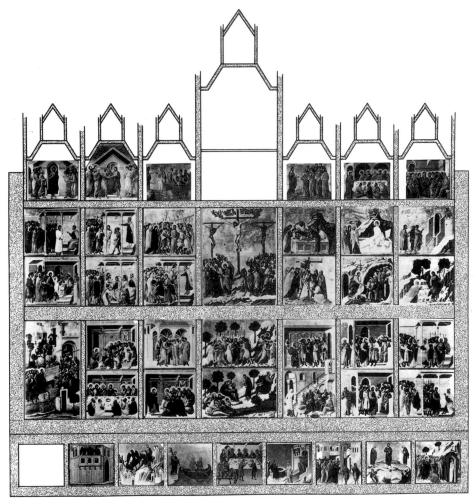

Creating this altarpiece was an arduous undertaking. The central panel alone was 7 by 13 ½ feet, and it had to be painted on both front and back, because it was meant to be seen from both sides. The main altar for which it was designed stood beneath the dome in the center of the sanctuary. Inscribed on Mary's throne are the words, "Holy Mother of God be thou the cause of peace for Siena and, because he painted thee thus, of life for Duccio" (cited in Hartt and Wilkins 4.2, page 104).

Mary and Christ, adored by angels and the four patron saints of Siena—Ansanus, Savinus, Crescentius, and Victor—kneeling in front, fill the large central panel. This *Virgin and Child in Majesty* represents both the Church and its specific embodiment, Siena Cathedral. Narrative scenes from the early life of the Virgin and the infancy of the Christ Child appear below the central image. The **predella** (the lower zone of the altarpiece) was entirely painted with the events in the childhood of Jesus. The back of this immense work was dedicated to scenes of his adult life and the miracles. The entire composition was topped by pinnacles—on the front, angels and the later life of the Virgin, and on the back, events after the Passion.

Duccio created a personal style that combines a softened Italo-Byzantine figure style with the linear grace and the easy relationship between figures and their settings characteristic of French Gothic. This subtle blending of northern and southern elements can be seen in the haloed ranks of angels around Mary's architectonic throne. The central, most holy figures retain a solemnity and immobility with some realistic touches, such as the weighty figure of the child; the adoring saints reflect a more naturalistic, courtly Gothic style that became the hallmark of the Sienese school for years to come. The brilliant palette, which mingles pastels with primary hues, the delicately patterned textiles that shimmer with gold, and the ornate punchwork—tooled designs in gold leaf on the haloes—are characteristically Sienese.

In 1771 the altarpiece was broken up, and individual panels were sold. One panel—the NATIVITY WITH PROPHETS ISAIAH AND EZEKIEL—is now in Washington, D.C. Duccio represented the Nativity in the tradition of Byzantine icons. Mary lies on a fat mattress within a cave hollowed out of a jagged, stylized mountain (FIG. 12-13). Jesus appears twice: first lying in the manger and then with the midwife below. However, Duccio followed Western tradition by placing the scene in a shed. Rejoicing angels fill the sky, and the shepherds and sheep add a realistic touch in the lower right corner. The light, intense colors, the calligraphic linear quality, even the meticulously rendered details recall Gothic manuscripts (see Chapter 11). The tentative move toward a defined space in the shed as well as the subtle modeling of the figures point the way toward future development in representing people and their world. Duccio's graceful, courtly art contrasts with Giotto's austere monumentality.

Technique BUON FRESCO

he two techniques used in mural painting are buon ("true") fresco ("fresh"), in which paint is applied with water-based paints on wet plaster, and fresco secco ("dry"), in which paint is applied to a dry plastered wall. The two methods can be used on the same wall painting.

The advantage of buon fresco is its durability. A chemical reaction occurs as the painted plaster dries, which bonds the pigments into the wall surface. In fresco secco, by contrast, the color does not become part of the wall and tends to flake off over time. The chief disadvantage of buon fresco is that it must be done quickly without mistakes. The painter plasters and paints only as much as can be completed in a day. In Italy, each section is called a giornata, or day's work. The size of a giornata varies according to the complexity of the painting within it. A face, for instance, can occupy an entire day, whereas large areas of sky can be painted quite rapidly.

In medieval and Renaissance Italy, a wall to be frescoed was first prepared with a rough, thick undercoat of plaster. When this was dry, assistants copied the master painter's composition onto it with charcoal. The artist made any necessary adjustments. These drawings, known as sinopia, have an immediacy and freshness lost in the finished painting. Work proceeded in irregularly shaped sections conforming to the contours of major figures and objects. Assistants covered one section at a time with a fresh, thin coat of very fine plaster over the sinopia, and when this was "set" but not dry, the artist worked with pigments mixed with water. Painters worked from the top down so that drips fell on unfinished portions. Some areas requiring pigments such as ultramarine blue (which was unstable in buon fresco), as well as areas requiring gilding, would be added after the wall was dry using the fresco secco method.

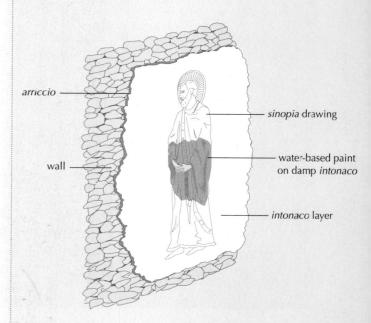

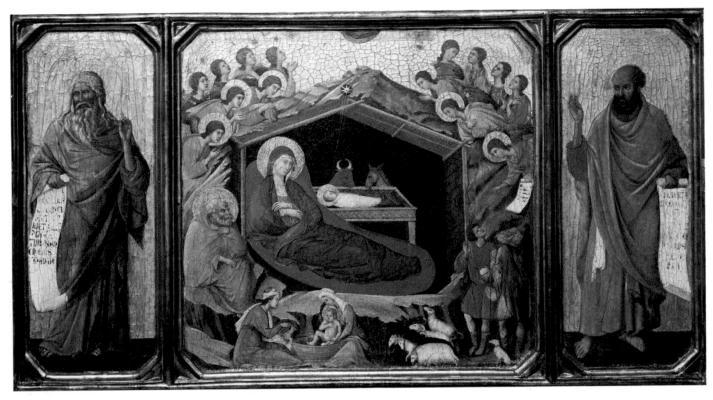

12–13 | Duccio di Buoninsegna NATIVITY WITH PROPHETS ISAIAH AND EZEKIEL Predella of the Maestà Altarpiece, $17\times17\%''$ (44×45 cm); Prophets, $17\%''\times6\%''$ (44×16.5 cm). National Gallery, Washington, D.C.

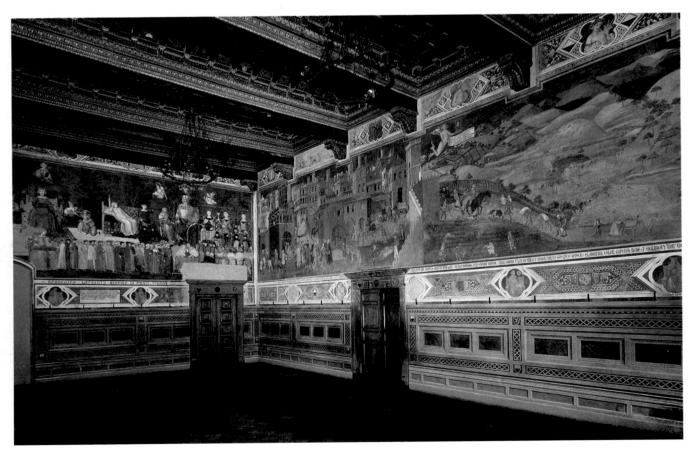

12–14 Ambrogio Lorenzetti **FRESCO SERIES OF THE SALA DELLA PACE, PALAZZO PUBBLICO** Siena city hall, Siena, Italy. 1338–40. Length of long wall about 46′ (14 m).

AMBROGIO LORENZETTI. In Siena, a strain of seemingly native realism also began to emerge. In 1338, the Siena city council commissioned Ambrogio Lorenzetti to paint in fresco the council room of the Palazzo Pubblico (city hall) known as the **SALA DELLA PACE (CHAMBER OF PEACE)** (FIG. 12–14). The murals were to depict the results of good and bad government. On the short wall Ambrogio painted a figure symbolizing the Commune of Siena, enthroned like an emperor holding an orb and scepter and surrounded by the Virtues. Justice, assisted by Wisdom and Concord, oversees the local magistrates. Peace lounges on a bench against a pile

of armor, having defeated War. The figure is based on a fragment of a Roman sarcophagus still in Siena.

Ambrogio painted the results of both good and bad government on the two long walls. For the ALLEGORY OF GOOD GOVERNMENT, and in tribute to his patrons, Ambrogio created an idealized but recognizable portrait of the city of Siena and its immediate environs (FIG. 12–15). The cathedral dome and the distinctive striped campanile (see Chapter 16) are visible in the upper left-hand corner; the streets are filled with productive citizens. The Porta Romana, Siena's gateway leading to Rome, divides the city from the country. Over the portal

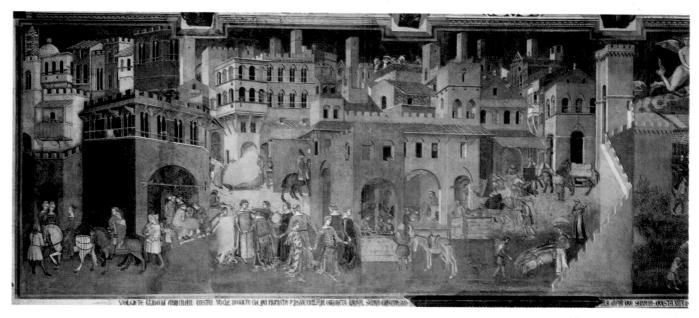

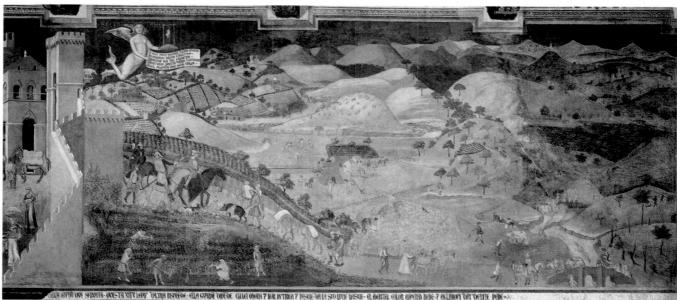

12–15 Ambrogio Lorenzetti **ALLEGORY OF GOOD GOVERNMENT IN THE CITY AND IN THE COUNTRY** Sala della Pace, Palazzo Pubblico, Siena, Italy. 1338–40. Fresco, total length about 46′ (14 m).

stands the statue of the wolf suckling Romulus and Remus, the legendary founders of Rome. Representations of these twin boys were popular in Siena because of the legend that Remus's son Senus founded Siena. Hovering above outside the gate is a woman clad in a wisp of transparent drapery, a scroll in one hand and a miniature gallows complete with a hanged man in the other. She represents Security, and her scroll bids those entering the city to come in peace. The gallows is a sharp reminder of the consequences of not doing so.

Ambrogio's achievement in this fresco was twofold. First, despite the shifts in vantage point and scale, he maintained an overall visual coherence and kept all parts of the flowing composition intelligible. Second, he maintained a natural relationship between the figures and the environment. Ambrogio conveys a powerful vision of an orderly society, of peace and plenty, from the circle of young people dancing to a tambourine outside a shoemaker's shop to the well-off peasants tending fertile fields and lush vineyards. Sadly, plague struck in the next decade. Famine, poverty, and disease overcame Siena just a few years after this work was completed.

The world of the Italian city-states—which had seemed so full of promise in Ambrogio Lorenzetti's *Good Government* fresco—was transformed into uncertainty and desolation by epidemics of the plague. Yet as dark as those days must have seemed to the men and women living through them, beneath the surface profound, unstoppable changes were taking place. In a relatively short span of time, the European Middle Ages gave way to what is known as the Renaissance.

FRANCE

At the beginning of the fourteenth century the royal court in Paris was still the arbiter of taste in Western Europe, as it had been in the days of Saint Louis. During the Hundred Years' War, however, the French countryside was ravaged by armed struggles and civil strife. The power of the old feudal nobility, weakened significantly by warfare, was challenged by townsmen, who took advantage of new economic opportunities that opened up in the wake of the conflict. Leadership in the arts and architecture moved to the duchy of Burgundy, to England, and—for a brief golden moment—to the court of Prague.

Gothic sculptors found a lucrative new outlet for their work in the growing demand among wealthy patrons for religious art intended for homes as well as churches. Busy urban workshops produced large quantities of statuettes and reliefs in wood, ivory, and precious metals, often decorated with enamel and gemstones. Much of this art was related to the cult of the Virgin Mary. Architectural commissions were smaller—chapels rather than cathedrals, and additions to already existing buildings, such as towers, spires, and window tracery.

In the second half of the thirteenth century, architects working at the royal court in Paris (see Chapter 11) introduced a new style, which continued into the first part of the fourteenth century. Known as the French Court style, or Rayonnant style or Rayonnant Gothic in France, the art is characterized by elegance and refinement achieved through extraordinary technical virtuosity. In sculpture and painting, elegant figures move gracefully through a narrow stage space established by miniature architecture and elements of landscape. Sometimes a focus on the details of nature suggests the realism that appears in the fourteenth century.

Manuscript Illumination

By the late thirteenth century, literacy had begun to spread among laypeople. Private prayer books became popular among those who could afford them. Because they contained special prayers to be recited at the eight canonical "hours" between morning and night, an individual copy of one of these books came to be called a Book of Hours. Such a book included everything the lay person needed—psalms, prayers to the Virgin and the other saints, a calendar of feast days, the office of the Virgin, and even the offices of the dead. During the fourteenth century, a richly decorated Book of Hours was worn or carried like jewelry and was among a noble person's most important portable possessions.

THE BOOK OF HOURS OF JEANNE D'EVREUX. Shortly after their marriage in 1325, King Charles IV gave his queen, Jeanne d'Evreux, a tiny, exquisite BOOK OF HOURS, the work of the illuminator Jean Pucelle (FIG. 12–16). This book was precious to the queen, who mentioned it in her will. She named its illuminator, Jean Pucelle, an unusual tribute.

In this manuscript, Pucelle worked in the *grisaille* technique—monochromatic painting in shades of gray with faint touches of color (here, blue and pink). The subtle shades emphasized his accomplished drawing. Queen Jeanne appears in the initial below the *Annunciation*, kneeling before a lectern and reading, perhaps, from her Book of Hours. This inclusion of the patron in prayer within a scene conveyed the idea that the scenes were visions inspired by meditation rather than records of historical events. In this case, the young queen would presumably have identified with Mary's joy at Gabriel's message.

Jeanne d'Evreux's Book of Hours combines two narrative cycles in its illuminations. One, the Hours of the Virgin, juxtaposes scenes from the Infancy and Passion of Christ, a form known as the Joys and Sorrows of the Virgin. The other is dedicated to the recently canonized king, Saint Louis. In the opening shown here, the joy of the *Annunciation* on the

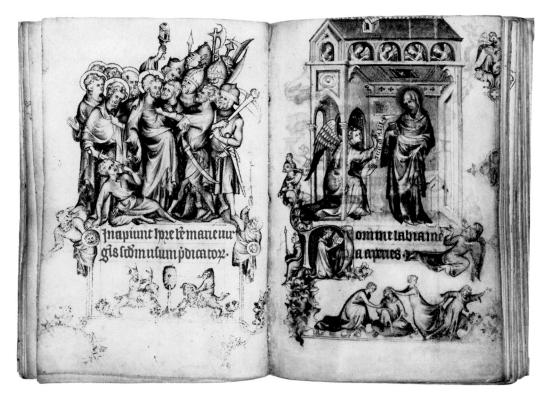

12–16 | Jean Pucelle PAGES WITH BETRAYAL AND ARREST OF CHRIST, folio 15v. (left), and ANNUNCIATION, folio 16r. (right), BOOK OF HOURS OF JEANNE D'EVREUX
Paris c. 1325–28. *Grisaille* and color on vellum, each page $3\frac{1}{2} \times 2\frac{1}{4}$ " (8.9 × 6.2 cm). The Metropolitan Museum of Art, New York. The Cloisters Collection 1954 (54.1.2).

right is paired with the "sorrow" of the Betrayal and Arrest of Christ on the left. In the Annunciation, Mary is shown receiving the archangel Gabriel in a Gothic building, while rejoicing angels look on from windows under the eaves. The group of romping children at the bottom of the page (known as the bas-de-page in French) at first glance seems to echo the joy of the angels. They might be playing "love tag," which would surely relate to Mary as the chosen one of the Annunciation. Folklorists have suggested, however, that the children are playing "froggy in the middle," or "hot cockles," games in which one child was tagged by the others. To the medieval reader the game symbolized the mocking of Christ or the betrayal of Judas, who "tags" his friend, and it evokes a darker mood by foreshadowing Jesus's death even as his life is beginning. In the Betrayal on the opposite page, Judas Iscariot embraces Jesus, thus identifying him to the Roman soldiers. The traitor sets in motion the events that lead to the Crucifixion. Saint Peter, on the left, realizing the danger, draws his sword to defend Jesus and slices off the ear of the high priest's servant Malchus. The bas-de-page on this side shows knights riding goats and jousting at a barrel stuck on a pole, a spoof of the military that may comment on the lack of valor of the soldiers assaulting Jesus.

Pucelle's work represents a sophisticated synthesis of contemporary French, English, and Italian art. From English illuminators he borrowed the merging of Christian narrative with allegory, the use of foliate borders filled with real and grotesque creatures (instead of the standard French vine scrolls), and his lively bas-de-page illustrations. His presentation of space, with figures placed within coherent architectural settings, suggests a firsthand knowledge of Sienese art: The small angels framed by the rounded arches of the attic are reminiscent of the half-length saints who appear above the front panel of Duccio's Maestà. Pucelle also adapted to manuscript illumination the Parisian Court style in sculpture, with its softly modeled, voluminous draperies gathered around tall, elegantly curved figures with curly hair and delicate features.

Sculpture

Sculpture in the fourteenth century is exemplified by its intimate character. Religious subjects became more emotionally expressive. In the secular realm, the cult of chivalry was revived just as the era of the knight on horseback was being rendered obsolete. Tales of love and valor were carved on luxury items to delight the rich, middle class, and aristocracy alike. Precious metals—gold, silver, and ivory—were preferred.

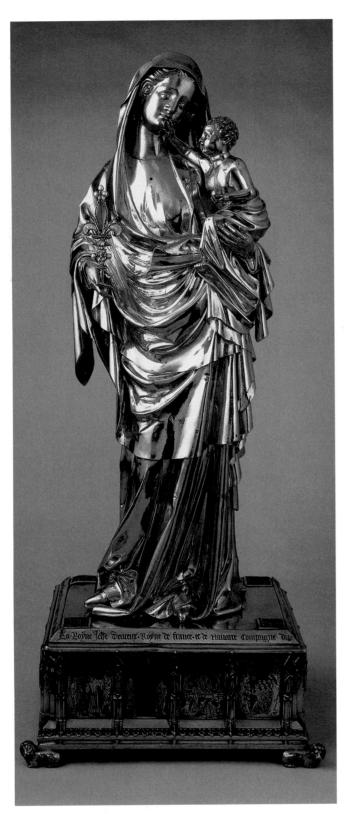

12–17 VIRGIN AND CHILD
c. 1339. Silver gilt and enamel, height 27 1/8" (69 cm).
Musée du Louvre, Paris.

Given by Jeanne d'Evreux to the Abbey Church of Saint-Denis, France.

THE VIRGIN AND CHILD FROM SAINT-DENIS. A silver-gilt image of a standing virgin and child (FIG. 12-17) was once among the treasures of the Abbey Church of Saint-Denis (see Chapter 11). An inscription on the base bears the date 1339 and the donor's name, Queen Jeanne d'Evreux. The Virgin holds Jesus in her left arm, her weight on her left leg, creating the graceful S-curve pose that became characteristic of the period. Fluid drapery, suggesting the consistency of heavy silk, covers her body. She originally wore a crown, and she holds a scepter topped with a large enameled and jeweled fleur-de-lis, the heraldic symbol of French royalty. The scepter served as a reliquary for a few strands of Mary's hair. The Virgin's sweet, youthful face and simple clothing, although based on thirteenth-century sculpture, anticipate the so-called Beautiful Mother imagery of fourteenth-century Prague (SEE FIG. 12-25), Flanders, and Germany. The Christ Child reaching out to touch his mother's lips is babylike in his proportions and gestures, a hint of realism. The image is not entirely joyous, however; on the enameled base, scenes of Christ's Passion remind us of the suffering to come.

COURTLY LOVE: AN IVORY BOX. A strong market also existed for personal items like boxes, mirrors, and combs with secular scenes inspired by popular literature and folklore. A box—perhaps a gift from a lover—made in a Paris workshop around 1330–50 provides a delightful example of such a work (FIG. 12–18). In its ivory panels, the God of Love shoots his arrows; knights and ladies throw flowers as missiles and joust with flowers. The subject is the ATTACK ON THE CASTLE OF LOVE, but what the owner kept in the box—jewelry? love tokens?—remains a mystery.

A tournament takes place in front of the Castle of Love. The tournament—once a mock battle, designed to keep knights fit for war—has become a lovers' combat. In the center panel, women watch jousting knights charge to the blare of the heralds' trumpets. In the scene on the left, knights use crossbows and a catapult to hurl roses at the castle, while the God of Love helps the women by aiming his arrows at the attackers. The action concludes in the scene on the right, where the tournament's victor and his lady love meet in a playful joust of their own.

Unlike the aristocratic marriages of the time, which were essentially business contracts based on political or financial exigencies, romantic love involved passionate devotion. Images of gallant knights serving ladies, who bestowed tokens of affection on their chosen suitors or cruelly withheld their love on a whim, captured the popular imagination. Tales of romance were initially spread by the musician-poets known as troubadours. Twelfth-century troubadour poetry marked a shift away from the usually negative way in which women had previously been portrayed as sinful daughters of Eve.

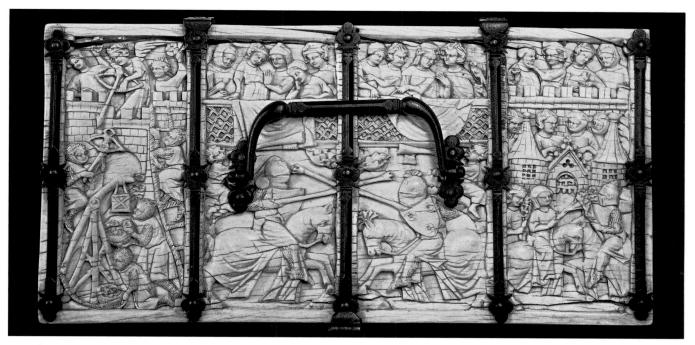

12–18 | ATTACK ON THE CASTLE OF LOVE Lid of a box. Paris. c. 1330–50. Ivory box with iron mounts, panel $4\frac{1}{2} \times 9^{\frac{11}{16}}$ (11.5 × 24.6 cm). The Walters Art Museum, Baltimore.

ENGLAND

Fourteenth-century England prospered in spite of the ravages of the Black Death and the Hundred Years' War with France. Life in medieval England is described in the rich store of Middle English literature. The brilliant social commentary of Geoffrey Chaucer in the *Canterbury Tales* (see "A New Spirit in Fourteenth-Century Literature," page 431) includes all classes of society. The royal family, especially Edward I—the castle builder—and many of the nobles and bishops were generous patrons of the arts.

Embroidery: Opus Anglicanum

An English specialty, pictorial needlework in colored silk and gold thread, gained such fame that it came to be called *opus anglicanum (English work)*. Among the collectors of this luxurious textile art were the popes, who had more than 100 pieces in the Vatican treasury. The names of several prominent embroiderers are known, but few names can be connected to specific pieces.

Opus anglicanum was employed for court dress, banners, cushions, bed hangings, and other secular items, as well as for the vestments worn by the clergy to celebrate the Mass (see Introduction Fig. 21, Christine de Pisan Presenting a Book to the Queen of France). Few secular pieces survive, since clothing and furnishings were worn out and discarded when fashions changed. But some vestments have survived, stored in church treasuries.

A liturgical vestment (that is, a special garment worn by the priest during mass), the red velvet **CHICHESTER-CONSTABLE** **CHASUBLE** (FIG. 12–19) was embroidered with colored silk, gold threads forming the images as subtly as painting. Where gold threads were laid and couched (tacked down with colored silk), the effect resembles the burnished gold-leaf backgrounds of manuscript illuminations. The Annunciation, the Adoration of the Magi, and the Coronation of the Virgin are set in cusped, crocketed **ogee** (S-shaped) arches amid twisting branches sprouting oak leaves, seed-pearl acorns, and animal masks. Because the star and crescent moon in the Coronation of the Virgin scene are heraldic emblems of Edward III (ruled 1327–77), perhaps he or a family member ordered this luxurious vestment.

During the celebration of the Mass, garments of *opus* anglicanum would have glinted in the candlelight amid treasures on the altar. Court dress was just as rich and colorful, and at court such embroidered garments established the rank and

Sequencing Events		
c. 1307-21	Dante writes The Divine Comedy	
1309–77	Papacy transferred from Rome to Avignon	
1348	Arrival of Black Death on European mainland	
1378–1417	Great Schism in Catholic Church	
1396	Greek studies instituted in Florence; beginning of the revival of Greek literature	

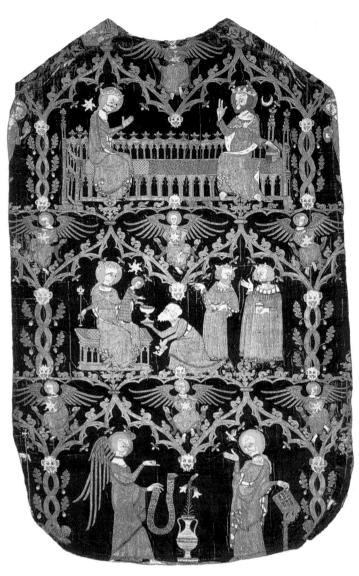

12-19 LIFE OF THE VIRGIN, BACK OF THE CHICHESTER-CONSTABLE CHASUBLE

From a set of vestments embroidered in opus anglicanum from southern England. 1330-50. Red velvet with silk and metallic thread and seed pearls; length 4'3" (129.5 cm), width 30" (76 cm). The Metropolitan Museum of Art, New York. Fletcher Fund, 1927 (27 162.1).

status of the wearer. So heavy did such gold and bejeweled garments become that their wearers often needed help to move.

Architecture

In the later years of the thirteenth century and early years of the fourteenth, a distinctive and influential style, popularly known as the "Decorated style," which corresponded to the Rayonnant style in France (see Chapter 11), developed in England. This change in taste has been credited to Henry III's ambition to surpass his brother-in-law, Saint Louis (Louis IX) of France, as a royal patron of the arts.

THE DECORATED STYLE AT EXETER. The most complete Decorated style building is the **EXETER CATHEDRAL**. Thomas of Witney began work at Exeter in 1313 and was the master

mason from 1316 until 1342. He supervised construction of the nave and redesigned upper parts of the choir. He left the towers of the original Norman cathedral but turned the interior into a dazzling stone forest of colonnettes, moldings, and vault ribs (FIG. 12-20). From diamond-shaped piers covered with colonnettes rise massed moldings that make the arcade seem to ripple. Bundled colonnettes spring from sculptured corbels (supporting brackets that project from a wall) between the arches to support conical clusters of thirteen ribs that meet at the summit of the vault, a modest 69 feet above the floor. The basic structure here is the four-part vault with intersecting cross-ribs, but the designer added additional ribs, called tiercerons, to create a richer linear pattern. Elaborately carved bosses (decorative knoblike elements) cover the intersections where ribs meet. Large clerestory windows with bartracery mullions (slender vertical elements dividing the windows into subsections) illuminate the 300-foot-long nave. Unpolished gray marble shafts, yellow sandstone arches, and a white French stone, shipped from Caen, used in the upper walls add subtle graduations of color to the many-rayed space.

Detailed records survive for the building of Exeter Cathedral. They extend over the period from 1279 to 1514, with only two short breaks. Included is such mundane information as where the masons and carpenters were housed (in a hostel near the cathedral) and how they were paid (some by the day with extra for drinks, some by the week, some for each finished piece); how materials were acquired and transported (payments for horseshoes and fodder for the horses); and of course payments for the building materials (not only stone and wood but rope for measuring and parchment on which to draw forms for the masons). The bishops contributed generously to the building funds. Building was not an anonymous labor of love as imagined by romantic nineteenth-century historians.

Thomas of Witney also designed the bishop's throne. Richard de Galmeton and Walter of Memburg led a team of a dozen carpenters to build the throne and the intricate canopy, 57 feet high. The canopy is like a piece of embroidery translated into wood, revealing characteristic forms of the Decorated style: S-curves, nodding arches (called "nodding ogee arches" because they curve outward—and nod—as well as upward) lead the eye into a maze of pinnacles, bursting with leafy crockets and tiny carved animals and heads. To finish the throne in splendor, Master Nicolas painted and gilded the wood. When the bishop was seated on his throne wearing embroidered vestments like the Chichester-Constable Chasuble, he must have resembled a golden image in a shrine rather than a living man. Enthroned, he represented the power and authority of the Church.

THE PERPENDICULAR STYLE AT EXETER. During years following the Black Death, work at Exeter Cathedral came to a

I2–20 | **EXETER CATHEDRAL**Exeter, Devon, England. Thomas of Witney, Choir, 14th century and Bishop's Throne, 1313–17; Robert Lesyngham, East Window, 1389–90.

standstill. The nave had been roofed but not vaulted, and the windows had no glass. When work could be resumed, taste had changed. The exuberance of the Decorated style gave way to an austere style in which rectilinear patterns and sharp angular shapes replaced intricate curves, and luxuriant foliage gave way to simple stripped-down patterns. This phase is known as the Perpendicular style.

In 1389–90, well-paid master mason Robert Lesyngham rebuilt the great East Window (FIG. 12–20), and he designed the window tracery in the new Perpendicular style. The window fills the east wall of the choir like a glowing altarpiece. A single figure in each light stands under a tall painted canopy that flows into and blends with the stone tracery. The Virgin with the Christ Child stands in the center over the high altar,

with four female saints at the left and four male saints, including Saint Peter, to whom the church is dedicated, on the right. At a distance the colorful figures silhouetted against the silver *grisaille* glass become a band of color, reinforcing the rectangular pattern of the mullions and transoms. The combination of *grisaille*, silver stain (creating shades of gold), and colored glass produces a cool silvery light.

The Perpendicular style produces a decorative scheme that heralds the Renaissance style (see Chapter 14) in its regularity, its balanced horizontal and vertical lines, and its plain wall or window surfaces. When Tudor monarchs introduced Renaissance art into the British Isles, builders did not have to rethink the form and structure of their buildings; they simply changed the ornament from the pointed cusped and

crocketed arches of the Gothic style to the round arches and ancient Roman columns and capitals of the classical era. The Perpendicular style, used throughout the Late Gothic period in the British Isles, became England's national style. It remains popular today in the United States for churches and college buildings.

THE HOLY ROMAN EMPIRE

By the fourteenth century, the Holy Roman Empire existed more as an ideal fiction than a fact. The Italian territories had established their independence, and in contrast to England and France, Germany had become further divided into multiple states with powerful regional associations and princes. The Holy Roman Emperors, now elected by Germans, concentrated on securing the fortunes of their families. They continued to be patrons of the arts, promoting local styles.

I2-2I | Heinrich and Peter Parler | CHURCH OF THE HOLY CROSS

Schwäbisch Gmünd, Germany. Interior. Begun in 1317 by Henrich Parler; choir by Peter Parler begun in 1351; vaulting completed 16th century.

The Supremacy of Prague

Charles IV of Bohemia (ruled 1346–75), whose admiration for the French king Charles IV was such that he changed his own name from Wenceslas to Charles, had been raised in France. He was officially crowned king of Bohemia in 1347 and Holy Roman Emperor in 1355.

Charles established his capital in Prague, which, in the view of its contemporaries, replaced Constantinople as the "New Rome." Prague had a great university, a castle, and a cathedral overlooking a town that spread on both sides of a river joined by a stone bridge, a remarkable structure itself.

When Pope Clement VI made Prague an archbishopric in 1344, construction began on a new cathedral in the Gothic style—to be named for Saint Vitus—which would also serve as the coronation church and royal pantheon. At Charles's first coronation, however, the choir remained unfinished. Charles, deeply involved in his projects, brought Peter Parler from Swabia to complete the building. Peter came from a distinguished family of architects.

THE PARLER FAMILY. In 1317 Heinrich Parler, a former master of works on the Cologne Cathedral, designed and began building the CHURCH OF THE HOLY CROSS in Schwäbisch Gmünd, in southwest Germany. In 1351, his son Peter (c. 1330–99), the most brilliant architect of this talented family, joined the shop. Peter designed the choir (FIG. 12–21) in the manner of a hall church in which a triple-aisled form was enlarged by a ring of deep chapels between the buttresses

12–22 | PLAN OF CHURCH OF THE HOLY CROSS
Schwäbisch Gmünd.

of the choir. The unity of the entire space was enhanced by the complex net vault—a veritable web of ribs created by eliminating transverse ribs and ridge ribs. Seen clearly in the plan (FIG. 12–22), the contrast between Heinrich's nave and Peter's choir illustrates the increasing complexity of rib patterns, a complexity that in fact finally led to the unified interior space of the Renaissance.

Called by Charles IV to Prague in 1353, Peter turned the unfinished Saint Vitus Cathedral into a "glass house," adding a vast clerestory and glazed triforium supported by double flying buttresses, all covered by net vaults that created a continuous canopy over the space. Photos do not do justice to the architecture; but the small, gilded icon shrine suggests the richness and elaborateness of Peter's work. The shrine stands in the reliquary chapel of Saint Wenceslas (FIG. 12–23)—once a freestanding Romanesque chapel, now incorporated into the cathedral—on the south side of the church. The chapel itself, with walls encrusted with semiprecious stones, recalls a reliquary (c. 1370–71).

Peter, his family, and heirs became the most successful architects in the Holy Roman Empire. Their concept of space, luxurious decoration, and intricate vaulting dominated central European architecture for three generations.

Sequencing Works of Art		
c. 1330	Vesperbild, Germany	
1330-36	Andrea Pisano, Life of Saint John the Baptist, Baptistry, Florence	
1338-40	Ambrogio Lorenzetti, <i>Allegory of Good Government</i> , Sala della Pace, Palazzo Pubblico, Siena	
1330-50	Life of the Virgin, Chichester-Constable Chasuble	
1339	Virgin and Child, Jeanne d'Evreux, France	

MASTER THEODORIC AND THE "BEAUTIFUL STYLE." At Karlstejn Castle, a day's ride from Prague, the emperor built another chapel and again covered the walls with gold and precious stones as well as with paintings. One hundred thirty paintings of the saints also served as reliquaries, for they had relics inserted into their frames. Master Theodoric, the court painter, provided drawings on the wood panels, and he painted about thirty images himself (FIG. 12–24). These figures are crowded into—and even extend over—the frames,

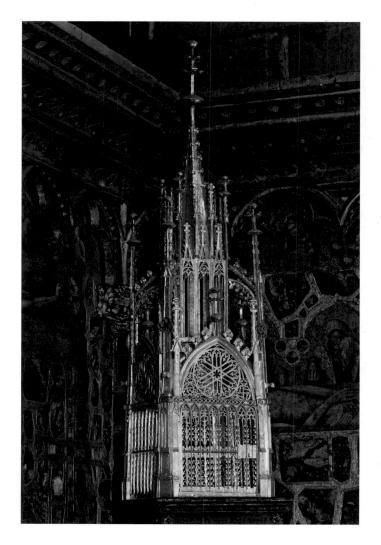

12–23 | Peter Parler and workshop SAINT WENCESLAS CHAPEL, CATHEDRAL OF SAINT VITUS

Prague. Begun 1356. In 1370-71, the walls were encrusted with slabs of jasper, amethyst, and gold, forming crosses. Tabernacle, c. 1375: gilded iron. Height 81%" (208 cm).

The spires, pinnacles, and flying buttresses of the tabernacle may have been inspired by Peter Parler's drawings for the cathedral.

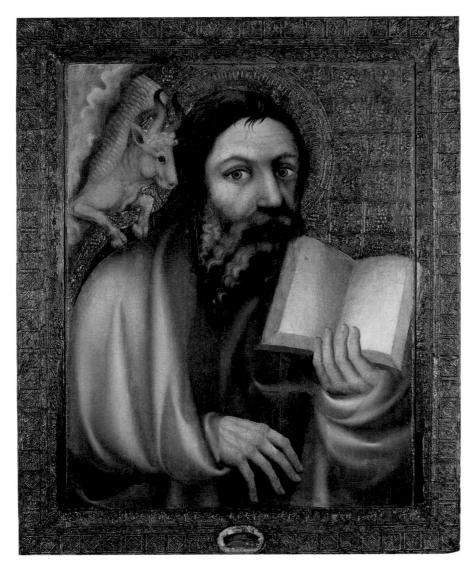

Theodoric SAINT LUKE
Holy Cross Chapel, Karlstejn Castle, near Prague.
1360-64. Paint and gold on panel. 45¼ × 37″
(115 × 94 cm).

emphasizing their size and power. Master Theodoric was head of the Brotherhood of Saint Luke, the patron saint of painters, and his painting of **SAINT LUKE**, accompanied by his symbol, the ox, looks out at the viewer, suggesting that this may really be a self-portrait of Master Theodoric. Master Theodoric's personal style—heavy bodies, oversized heads and hands, dour and haunted faces, and soft, deeply modeled drapery—merged with the French Gothic style to become what is known as the Beautiful style of the end of the century. The chapel, consecrated in 1365, so pleased the emperor that in 1367 he gave the artist a farm in appreciation for his work.

Like the architecture of the Parler family, the style created by Master Theodoric spread through central and northern Europe. Typical of this Beautiful style is the sweet-faced Virgin and Child, as seen in the "BEAUTIFUL" VIRGIN AND CHILD (FIG. 12–25), engulfed in swaths of complex drapery.

Cascades of V-shaped folds and clusters of vertical folds ending in rippling edges surround a squirming infant to create the feeling of a fleeting movement. Emotions are restrained, and grief as well as joy become lost in a naive piety. Yet, this art emerges against a background of civil and religious unrest. The Beautiful style seems like an escape from the realities of fourteenth-century life.

Mysticism and Suffering

The ordeals of the fourteenth century—famines, wars, and plagues—helped inspire a mystical religiosity that emphasized both ecstatic joy and extreme suffering. Devotional images, known as *Andachtsbilder* in German, inspired the worshiper to contemplate Jesus's first and last hours, especially during evening prayers, or vespers (giving rise to the term *Vesperbild* for the image of Mary mourning her son).

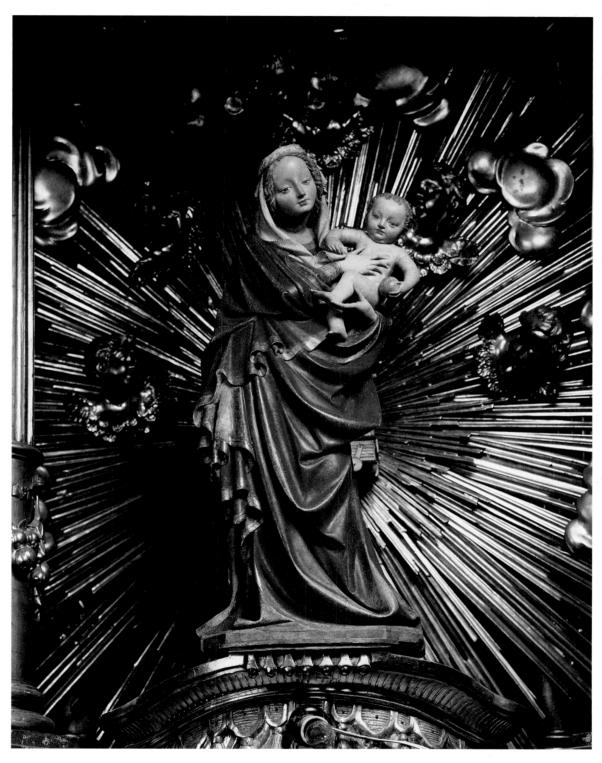

12-25 "BEAUTIFUL" VIRGIN AND CHILD Probably from the Church of Augustinian Carons, Sternberk. c. 1390. Limestone with original paint and gilding; height 33 1/8" (84 cm).

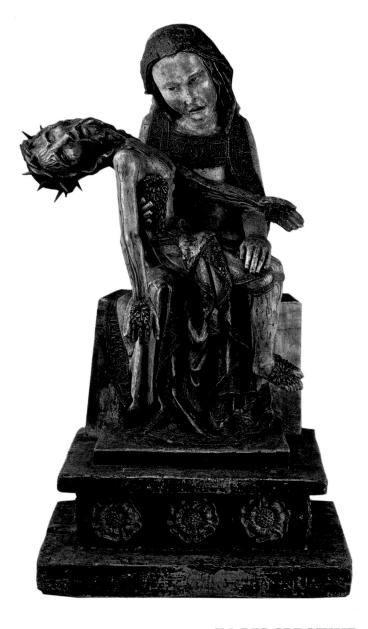

12–26 | VESPERBILD From Middle Rhine region, Germany. c. 1330. Wood, height 34½" (88. 4 cm). Landesmuseum, Bonn.

Through such religious exercises, worshipers hoped to achieve understanding of the divine and union with God. In the well-known example shown here (FIG. 12–26), blood gushes from the hideous rosettes that are the wounds of an emaciated Jesus. The Virgin's face conveys the intensity of her ordeal, mingling horror, shock, pity, and grief. Such images had a profound impact on later art, both within Germany and beyond.

Prague and the Holy Roman Empire under Charles IV had become a multicultural empire where people of different religions (Christians and Jews) and ethnic heritage (German and Slav) lived side by side. Charles died in 1378, and without his strong central government, political and religious dissent overtook the empire. Jan Hus, dean of the philosophy faculty at Prague University and a powerful reforming preacher, denounced the immorality he saw in the Church. He was burned at the stake, becoming a martyr and Czech national hero. The Hussite Revolution in the fifteenth century ended Prague's—and Bohemia's—leadership in the arts.

IN PERSPECTIVE

The emphasis on suffering and on supernatural power inspired many artists to continue the formal, expressive styles of earlier medieval and Byzantine art. At the same time, the humanism emerging in the paintings of Giotto and his school at the beginning of the fourteenth century could not be denied. Painters began to combine the flat, decorative, linear quality of Gothic art with the new representation of forms defined by light and space. In Italy they created a distinctive new Gothic style that continued through the fourteenth century. North of the Alps, Gothic elements survived in the arts well into the fifteenth century.

The courtly arts of manuscript illumination, embroidery, ivory carving, and of jewel, enamel, gold, and silver work flour-ished, becoming ever richer, more intricate and elaborate. Stained glass filled the ever-larger windows, while paintings or tapestries covered the walls. In Italy, artists inspired by ancient Roman masters and by Giotto looked with fresh eyes at the natural world. The full impact of their new vision was not fully assimilated until the beginning of the fifteenth century.

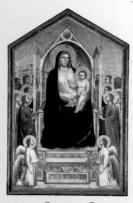

GIOTTO DI BONDONE VIRGIN AND CHILD ENTHRONED 1305-10

AMBROGIO LORENZETTI.

ALLEGORY OF GOOD GOVERNMENT IN THE CITY

AND IN THE COUNTRY

SALA DELLA PACE, PALAZZO PUBBLICO, SIENA, ITALY

1338-40

LIFE OF THE VIRGIN

BACK OF THE
CHICHESTER-CONSTABLE CHASUBLE,

SOUTHERN ENGLAND

1330–50

PETER PARLER AND WORKSHOP.

ST. WENCESLAS CHAPEL

BEGUN 1356

MASTER THEODORIC **ST. LUKE** 1360-64

FOURTEENTH-CENTURY ART IN EUROPE

■ Papacy resides in Avignon 1309-77

■ Hundred Years' Wars 1337-1453

■ Black Death begins 1348

■ Boccaccio begins writing

The Decameron 1349–51

■ Great Schism 1378-1417

Chaucer starts work on
 The Canterbury Tales 1387

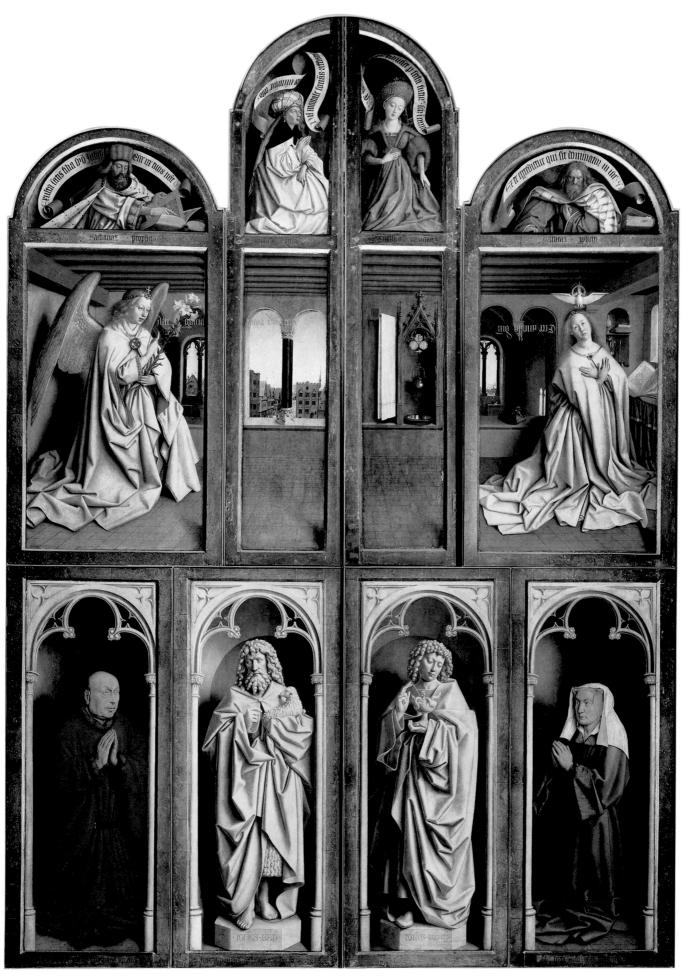

13–1 $\,^{\dagger}$ Jan and Hubert van Eyck $\,^{\dagger}$ GHENT ALTARPIECE (CLOSED). ANNUNCIATION WITH DONORS Completed 1432. Oil on panel, height 11′5″. Cathedral of Saint Bavo. Ghent.

CHAPTER THIRTEEN

FIFTEENTH-CENTURY ART IN NORTHERN EUROPE AND THE IBERIAN PENINSULA

When Philip the Good, duke of Burgundy, entered Ghent in 1458, the entire Flemish city turned out. Townspeople made elaborate decorations and presented theatrical events, and local artists designed banners and made sets for

13

Below, the donors are portrayed beside statues of the church's patron saints, Saint John the Baptist and Saint John the Evangelist, who, although painted to represent stone, seem to acknowledge the presence of their supplicants

performances. That day in Ghent became an especially matic and fascinating example of the union of visual arts it was at Easter time, it signals the new interests of the fifteenth century: the intellectual change from religious symbolism to secular and ancient learning, a formal change to detailed realism and awareness of the world, and a social and economic change to middle-class power and patronage.

The vision of the Annunciation takes place in a domes-

The vision of the Annunciation takes place in a domestic interior, and a prosperous Flemish city can be seen through the open windows. We are at once made aware of the remarkable rise of the middle class to wealth, power, and patronage. The donors are represented by true-to-life portraits, and the patron saints are sculptured figures on pedestals in niches, not visions. In fact, the two Saint Johns do not present the donors to God. Instead, the donors Jodocus Vijd and Elizabeth Borluut kneel in prayer, just as they must have knelt in front of the altarpiece in life.

Because of its monumental scale, complex iconography, and masterly painting techniques, the *Ghent Altarpiece* has continued to be one of the most studied and respected works of the early Renaissance in Europe since its creation in the early fifteenth century.

the performances. That day in Ghent became an especially dramatic and fascinating example of the union of visual arts and performance, as groups of citizens welcomed Philip with tableaux vivants ("living pictures"). They dressed in costume and stood "absolutely frozen, like statues" to re-create scenes from their town's most celebrated work of art, Jan and Hubert van Eyck's Ghent Altarpiece (SEE FIG. 13-11), completed twenty-six years earlier. The altarpiece had an enthroned figure of God, seated between the Virgin Mary and John the Baptist and flanked by angel musicians. Below, a depiction of the Communion of Saints, based on the biblical passage Revelation 14:1, described the Lamb of God receiving the veneration of a multitude of believers. The church fathers, prophets, martyrs, and other saints depicted in the altarpiece were among those scenes staged that day to greet Philip.

Closed, as we see it here (FIG. 13–1), the wings of the altarpiece present the **ANNUNCIATION**, with Gabriel and the Virgin on opposite sides of an upper room that overlooks a city. In panels above them, Old Testament prophets and seers from the ancient classical world foretell the coming of Christ.

- HUMANISM AND THE NORTHERN RENAISSANCE
- **ART FOR THE FRENCH DUCAL COURTS** Painting and Sculpture for the Chartreuse de Champmol Manuscript Illumination
 The Fiber Arts
- PAINTING IN FLANDERS | The Founders of the Flemish School | Painting at Midcentury: The Second Generation
- EUROPE BEYOND FLANDERS | France | Spain and Portugal | Germany and Switzerland
- THE GRAPHIC ARTS | Single Sheets | Printed Books
- IN PERSPECTIVE

HUMANISM AND THE NORTHERN RENAISSANCE

Revitalized civic life and economic growth in the late four-teenth century gave rise to a prosperous middle class of artisans, merchants, and bankers who attained their place in the world through personal achievement, not inherited wealth. This newly rich middle class supported scholarship, literature, and the arts. Their patronage resulted in the explosion of learning and creativity known as the Renaissance. Though the actual term *Renaissance* (French for "rebirth") was applied by later historians, the characterization has its origins in the thinking of Petrarch and other fourteenth-century scholars, who believed in *humanism*—the power and potential of human beings.

Humanism is also fundamentally tied to the revival of classical learning and literature that appeared in fourteenth-century Italy with Petrarch, Boccaccio, and others (see "A New Spirit in Fourteenth-Century Literature," page 431). Beginning with Petrarch, humanists of the later fourteenth and fifteenth centuries looked back at the thousand years extending from the collapse of the Roman Empire to their own time, and they determined that human achievement of the ancient classical world was followed by a period of decline (a "middle age" or "dark age"). The third period—their own era—saw a revival, a rebirth, a renaissance, when humanity began to emerge from an intellectual and cultural stagnation and scholars again appreciated the achievements of the ancients.

Humanists extended education to the laity, investigated the natural world, and subjected philosophical and theological positions to logical scrutiny. They constantly invented new ways to extend humans' intellectual and physical reach. For all our differences, we still live in the modern era envisioned by these Renaissance thinkers—a time when human beings, their deeds, and their beliefs have primary importance.

The rise of humanism did not signify a decline in the importance of Christian belief, however. An intense Christian spirituality continued to inspire and pervade most European art. But despite the enormous importance of Christian faith, the established Western Church was plagued with problems. Its hierarchy was bitterly criticized for a number of practices, including a perceived indifference to the needs of common

people. Strains within the Western Church exemplified the skepticism of the Renaissance mind. In the next century, these strains would give birth to the Protestant Reformation.

The new intense interest in the natural world manifested itself in the detailed observation and recording of nature. Artists depicted birds, plants, and animals with breathtaking accuracy. They looked at people and objects, and they modeled these forms with light and shadow, giving them three dimensions. In the north, artists such as Jan van Eyck (FIGS. 13–1, 13–11, 13–12, 13–13), Dirck Bouts (FIG. 13–19), and Hugo van der Goes (FIG. 13-20) used an intuitive perspective in order to approximate the appearance of things growing smaller and closer together in the distance. They coupled it with a masterful use of atmospheric or aerial perspective. This technique—applied to the landscape scenes that were a northern specialty—was based on observation that distant elements appear less distinct and less colorful than things close by: The sky becomes paler near the horizon and the distant landscape turns bluish-gray.

Along with the desire for accurate depiction of the world came a new interest in individual personalities. Fifteenth-century portraits have an astonishingly lifelike quality, combining careful—sometimes even unflattering—description with an uncanny sense of vitality. Indeed, the individual becomes important in every sphere. More names of artists survive from the fifteenth century, for example, than in the entire span from the beginning of the Common Era to the year 1400.

The new power of cities in the Flanders region and the greater Low Countries (present-day Belgium, Luxembourg, and the Netherlands; SEE MAP 13–1) provided a critical tension and balance with the traditional powers of royalty and the Church. Increasingly, the urban lay public sought to express personal and civic pride by sponsoring secular architecture, sculptured monuments, or paintings directed toward the community. The common sense values of the merchants formed a solid underpinning for humanist theories and enthusiasms.

But if the *Ghent Altarpiece* donors Jodocus Vijd and Elizabeth Borluut represent the new influence of the middle class, this influence nevertheless remained intertwined with the continuing power of the Church and the royal and noble

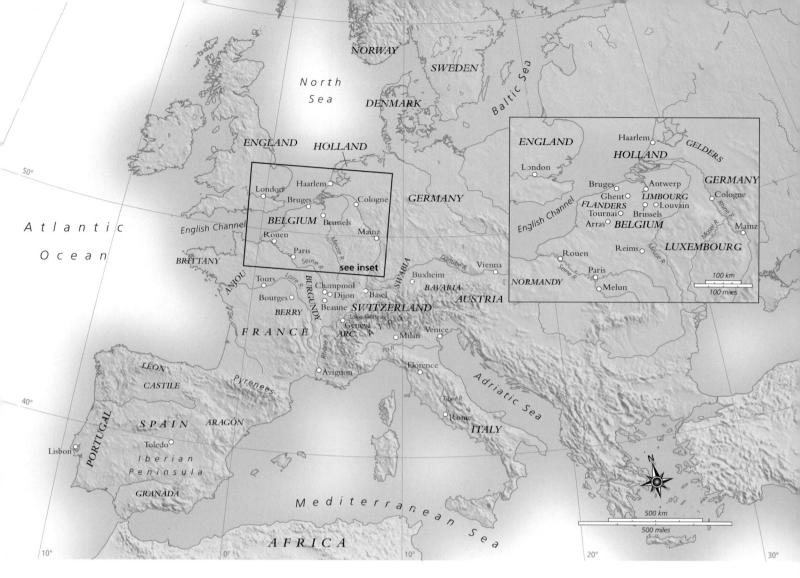

MAP 13-1 | FIFTEENTH-CENTURY NORTHERN EUROPE AND THE IBERIAN PENINSULA

The dukes of Burgundy, whose territory included much of present-day Belgium and Luxembourg, the Netherlands, and eastern France, became the cultural and political leaders of Western Europe. Their major cities of Bruges (Belgium) and Dijon (France) were centers of art and industry as well as politics.

courts. Like other wealthy individuals, Jodocus and Elizabeth sought eternal salvation with their donation to the Church; and though Jodocus eventually became the mayor of Ghent, he also served as a high official to the Burgundian duke Philip the Good (ruled 1419–67).

ART FOR THE FRENCH DUCAL COURTS

The dukes of Burgundy were the most powerful rulers in northern Europe for most of the fifteenth century, and a primary reason for this was their control not only of Burgundy but also of Flemish and Netherlandish centers of finance and trade, including the thriving cities of Ghent, Bruges, Tournai, and Brussels (FIG. 13–2). The major seaport, Bruges, was the commercial center of northern Europe and the rival of the Italian city-states of Florence, Milan, and Venice. In the late fourteenth century, Philip the Good's predecessor Philip the Bold (ruled 1363–1404) had acquired territory in the Nether-

lands—including the politically desirable region of Flanders—by marrying the daughter of the Flemish count. Though dukes Philip the Bold of Burgundy, John of Berry, and Louis of Anjou were brothers of King Charles V of France, their interests rarely coincided. Even the threat of a common enemy, England, during the Hundred Years' War was not a strong unifying factor. Burgundy and England were often allied because of common financial interests in Flanders.

While the French king held court in Paris, the dukes held even more splendid courts in their own cities. The dukes of Burgundy (including present-day east-central France, Belgium, Luxembourg, and the Netherlands) and Berry (central France), not the king in Paris, were arbiters of taste. The painting of the Duke of Berry in his great hall (FIG. 13–3), from an illuminated manuscript, which we will take up in more detail later, shows us how the dukes collected splendid robes and jewels, tapestry, goldsmithing, and monumental stone sculpture. Painting on panel also gained a place of importance, with early enthusiasm appearing in the ducal

13-2 Robert Campin A FLEMISH CITY

Detail of right wing of the Mérode Altarpiece (Triptych of the Annunciation), fig. 13-10. c. 1425-28. Oil on wood panel, wing approx. $25\frac{3}{8} \times 10\frac{3}{4}$ " (64.5 × 27.3 cm). The Metropolitan Museum of Art, New York

The Cloisters Collection, 1956 (56.70)

The windows in Joseph's carpentry shop open onto a view of a prosperous Flemish city. Tall, well-kept houses crowd around churches, whose towers dominate the skyline. People gather in the open market square, walk up a major thoroughfare, and enter the shops, whose open doors and windows suggest security as well as commercial activity—an ideal to be sure.

courts under Philip the Bold. The duke commissioned many works from Flemish and Netherlandish painters. Those that survive show a debt to the International Gothic style.

A new, composite style emerged in the late fourteenth century from the papal court in Avignon in the south of France, where artists from Italy, France, and Flanders worked side by side. The International Gothic style, the prevailing manner of the late fourteenth century, is characterized by slender, gracefully posed figures whose delicate features are framed by masses of curling hair and extraordinarily complex headdresses. Noble men and women wear rich brocaded and embroidered fabrics and elaborate jewelry. Landscape and architectural settings are miniaturized; however, details of nature—leaves, flowers, insects, birds—are rendered with nearly microscopic detail. Spatial recession is represented by rising tiled floors in buildings open at the front like stage sets, by fanciful mountains and meadows having high horizon lines, and some diminution in size of objects and lightening of color near the horizon. Artists and patrons alike preferred light, bright colors and a liberal use of gold in manuscript and panel paintings, tapestries, and polychromed sculpture. The International Gothic was so appealing that patrons throughout Europe continued to commission such works well into the fifteenth century.

Painting and Sculpture for the Chartreuse de Champmol

One of Philip the Bold's most lavish projects was the Carthusian monastery, or chartreuse ("chartrehouse"), at Champmol, near Dijon, his Burgundian capital city. Land was acquired in 1377 and 1383 and construction began in 1385. The monastic

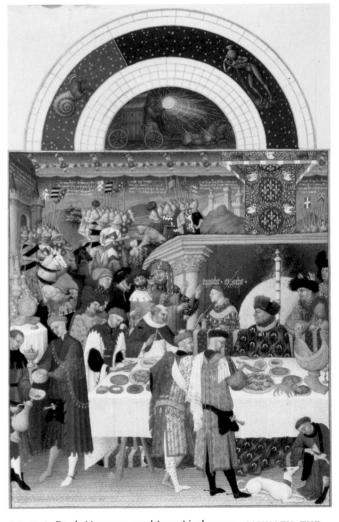

13-3 Paul, Herman, and Jean Limbourg JANUARY, THE DUKE OF BERRY AT TABLE. TRÈS RICHES HEURES 1411-16. Colors and ink on parchment, $8\% \times 5\%$ (22.5 × 13.7 cm). Musée Condé, Chantilly, France.

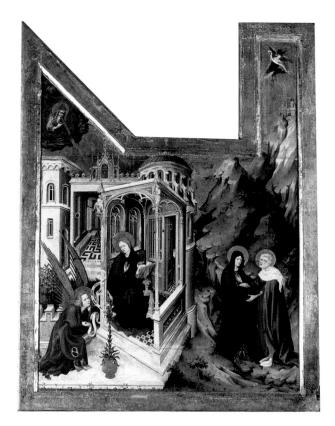

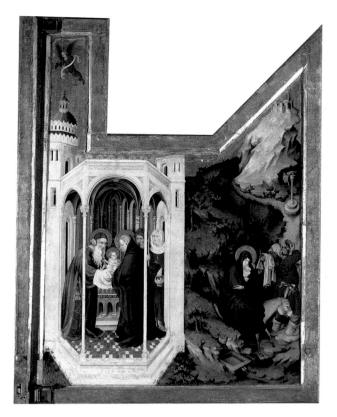

13–4 Melchior Broederlam **CHAMPMOL ALTARPIECE**Wings of the altarpiece for the Chartreuse de Champmol. 1393–99. Oil on wood panel, 5′5½″ × 4′1½″ (1.67 × 1.25 m). Musée des Beaux-Arts, Dijon.

The paintings depict the Annunciation and Visitation at the left and the Presentation in the Temple and Flight into Egypt on the right. The irregular shape of the paintings was determined by the sculpture they were meant to protect.

church was intended to house the family's tombs, and the monks were expected to pray continuously for the souls of Philip and his family. A Carthusian monastery was particularly expensive to maintain because the Carthusian monks did not provide for themselves by farming or other physical work but were dedicated to prayer and solitary meditation. In effect, Carthusians were a brotherhood of hermits.

MELCHIOR BROEDERLAM. The duke ordered a magnificent carved and painted altarpiece for the Chartreuse de Champmol (see "Altars and Altarpieces," page 461). The altarpiece, of gilded wood carved by Jacques de Baerze, depicts scenes of the Crucifixion flanked by the Adoration of the Magi and the Entombment. The primary interest today, however, is in the protective shutters, painted by Melchior Broederlam (active 1381–1410) with scenes from the life of the Virgin and the infancy of Christ (FIG. 13–4). In a personal style that carries the budding realism of the International Style further toward a faithul rendering of the natural world, Broederlam creates tangible figures in fanciful miniature architectural and landscape settings. Christian religious symbolism is present everywhere.

Under the benign eyes of God, the archangel Gabriel greets Mary with the news of her impending motherhood. A door leads into the dark interior of the tall pink rotunda meant

to represent the Temple of Jerusalem, a symbol of the Old Law. According to legend, Mary was an attendant in the Temple prior to her marriage to Joseph. The tiny enclosed garden and a pot of lilies are symbols of Mary's virginity. In International Gothic fashion, both the interior and exterior of the building are shown, and the floors are tilted up to give clear views of the action. Next, in the Visitation, just outside the temple walls, the now-pregnant Mary greets her older cousin Elizabeth, who is also pregnant and will soon give birth to John the Baptist.

On the right shutter, in the Presentation in the Temple, Mary and Joseph have brought the newborn Jesus to the temple for the Jewish purification rite. The priest Simeon takes him in his arms to bless him (Luke 2:25–32). At the far right, the Holy Family flees to Egypt to escape King Herod's order that all Jewish male infants be killed. The family travels along treacherous terrain similar to that in the Visitation scene. The landscape has been arranged to lead the eye up from the foreground and into the distance along a rising ground plane. Despite the imaginative architecture, fantastic mountains, miniature trees, and solid gold sky, the artist has created a sense of light and air around solid figures. Reflecting a new realism creeping into art, a hawk flies through the golden sky, and Joseph drinks from a flask and carries the family belongings in a satchel over his shoulder. The statue of

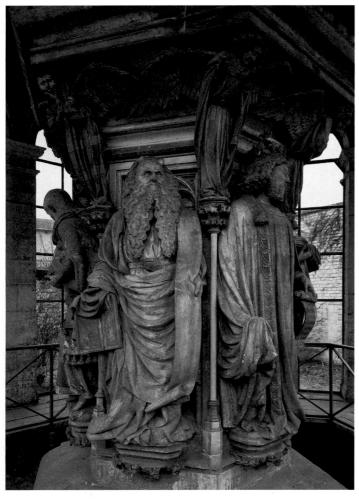

13-5 | Claus Sluter WELL OF MOSES, DETAIL OF MOSES AND DAVID

The Chartreuse de Champmol, Dijon, France. 1395–1406. Limestone with traces of paint, height of figures about 5'8" (1.69 m).

The sculpture's original details included metal used for buckles and even eyeglasses. It was also painted: Moses wore a gold mantle with a blue lining over a red tunic; David's gold mantle had a painted lining of ermine, and his blue tunic was covered with gold stars and wide bands of ornament.

a pagan god, visible at the upper right, breaks and tumbles from its pedestal as the Christ Child approaches. A new era dawns and the New Law replaces the Old.

CLAUS SLUTER. Philip the Bold commissioned the Flemish sculptor Jean de Marville (active 1366–89) to direct the decoration of the monastery. When Jean died in 1389, he was succeeded by his assistant Claus Sluter (c. 1360–1406), from Haarlem, in Holland. Although the Chartreuse and its treasures were nearly destroyed during the French Revolution, the distinctive character of Sluter's work can still be seen in the surviving parts of a monumental well in the main cloister (FIG. 13–5). Begun in 1395, the **WELL OF MOSES** was unfinished at Sluter's death.

The concept of the *Well of Moses* is complex. A pier rose from the water and supported large freestanding figures of Christ on the cross mourned by the Virgin Mary, Mary Magdalen, and John the Evangelist. Forming a pedestal for this Crucifixion group are life-size stone figures of Old Testament men who foretold the coming of Christ: Moses (prophet and lawgiver), David (king of Israel and an ancestor of Jesus), and the prophets Jeremiah, Zachariah, Daniel, and Isaiah. These images and their texts may have been inspired by contemporary mystery plays such as *The Trial of Jesus* and *The Procession of Prophets*, in which prophets foretell and explain events of the Passion. *Meditations on the Life of Christ*, written between 1348 and 1368, by Ludolph of Saxony, provides another source.

Sluter depicted the Old Testament figures as physically and psychologically distinct individuals. Moses's sad old eyes blaze out from a memorable face entirely covered with a fine web of wrinkles. Even his horns—traditionally given to him because of a mistranslation in the Latin Bible—are wrinkled. A mane of curling hair and a beard cascade over his heavy shoulders and chest, and an enormous cloak envelops his body. Beside him stands David, in the voluminous robes of a medieval king, the personification of nobility.

Sluter looked at the human figure in a new way—as a ponderous mass defined by voluminous drapery. Drapery lies in deep folds falling in horizontal arcs and cascading lines; its heavy sculptural masses both conceal and reveal the body, creating strong highlights and shadows. With these vigorous, imposing, and highly individualized figures of the *Well of Moses*, Sluter introduced a radically new style in northern sculpture. He abandoned the idealized faces, elongated figures, and vertical drapery of the International Gothic style for surface realism and the broad horizontal movement of forms. Nevertheless, Sluter retained the detailed naturalism and rich colors (now almost lost but revealed in recent cleaning) and surfaces preferred by his patrons.

Manuscript Illumination

Of all the family, the duke of Burgundy's older brother Jean, duke of Berry, was the most enthusiastic art collector and bibliophile. In addition to commissioning religious art works for personal salvation and public devotion, he collected illuminated manuscripts, which signified both his worldly status and a commitment to learning.

Besides religious texts, wealthy patrons treasured richly illuminated secular writings such as herbals (encyclopedias of plants), health manuals, and both ancient and contemporary works of history and literature. Workshops in France and the Netherlands produced outstanding manuscripts to fill the demand. A typical manuscript page might have leafy tendrils framing the text, decorated opening initials, and perhaps a small inset picture, such as the illustration of Thamyris in Boccaccio's *Concerning Famous Women* (see "Women Artists

Art and Its Context

ALTARS AND ALTARPIECES

he altar in a Christian church symbolizes both the table of Jesus's Last Supper and the tombs of Christ and the saints. The front surface of a block altar is the *ante-pendium*. Relics of the church's patron saint may be placed in a reliquary on the altar, beneath the floor on which the altar rests, or even within the altar itself.

Altarpieces are painted or carved constructions placed at the back or behind the altar in a way that makes altar and altar-

piece appear to be visually joined. The altarpiece evolved into a large and elaborate architectural structure filled with images and protected by movable wings that function like shutters. An altarpiece may have a firm base, called a **predella**. A winged altarpiece can be a **diptych**, in which two panels are hirged together (SEE FIG. 13–22); a **triptych**, in which two wings fold over a center section (SEE FIG. 13–21); or a **polyptych**, consisting of many panels (SEE FIG. 13–16 AND 13–17).

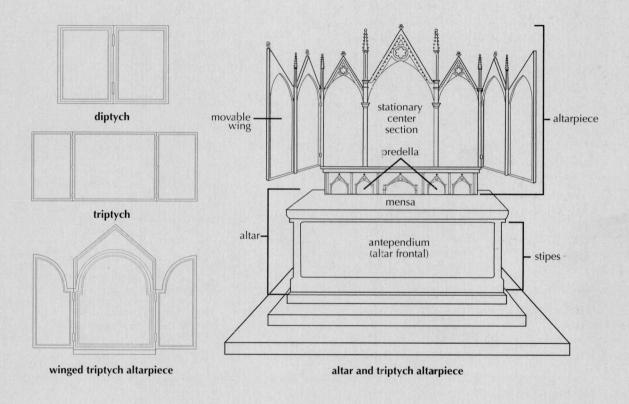

in the Late Middle Ages and the Renaissance," page 462). The illustrations for the books made for the royal family might be large and lavish, as we see in the detail of the page where Christine de Pizan presents her work to the queen of France (Fig. 21, Introduction). Here the glimpse into the queen's private room displays tapestries on the walls and embroidered bed coverings.

The Flemish style that would influence all of fifteenthcentury Europe originated in manuscript illumination of the late fourteenth century, when artists began to create full-page scenes set off with frames that functioned almost as windows looking into rooms or out onto landscapes with distant horizons. Painters in the Netherlands and Burgundy were especially skilled at creating an illusion of reality.

THE LIMBOURG BROTHERS. Among the finest Netherlandish illuminators at the beginning of the century were three brothers—Paul, Herman, and Jean Limbourg—commonly known as the Limbourg brothers, probably referring to their home region.

About 1404 the brothers entered the service of Duke John of Berry (1340–1416), for whom they produced their major work, the so-called *Très Riches Heures (Very Samptuous Book of Hours)*, between 1413 and 1416 (see figs. 13–3, 13–6). A Book of Hours was a selection of prayers and readings to be

Art and Its Context

WOMEN ARTISTS IN THE LATE MIDDLE AGES AND THE RENAISSANCE

edieval and Renaissance women artists typically learned to paint from their husbands and fathers because formal apprenticeships were not open to them. Noblewomen, who were often educated in convents, learned to draw, paint, and embroider. One of the earliest examples of a signed work by a woman painter is a tenth-century manuscript of the Apocalypse illustrated in Spain by a woman named Ende (SEE FIG. 9–10), who describes herself as "painter and helper of God." In Germany, women began to sign their work in the twelfth century. A collection of sermons was decorated by a nun named Guda (SEE FIG. 10–37), who not only signed her work but also included a self-portrait, one of the earliest in Western art.

Examples abound of women artists in the fourteenth and fifteenth centuries. In the fourteenth century, Jeanne de Montbaston and her husband, Richart, worked together as book illuminators under the auspices of the University of Paris. After Richart's death, Jeanne continued the workshop and, following the custom of the time, was sworn in as a *libraire* (publisher) by the university in 1353. In the fifteenth century, women could be admitted to the guilds in some cities, including the Flemish towns of Ghent, Bruges, and Antwerp, and by the 1480s one-quarter of the members of the painters' guild of Bruges were female.

Particularly talented women received major commissions. Bourgot, the daughter of the miniaturist Jean le Noir, illuminated books for King Charles V of France and Jean, duke of Berry. Christine de Pizan (1365–c. 1430), a well-known writer patronized by Philip the Bold of Burgundy and Queen Isabeau of France, described the work of an illuminator named Anastaise, "who is so learned and skillful in painting manuscript borders and miniature backgrounds that one cannot find an artisan . . . who can surpass her . . . nor whose work is more highly esteemed" (*Le Livre de la Cité des Dames*, I.41.4, translated by Earl J. Richards).

In a French edition of a book by the Italian author Boccaccio entitled *Concerning Famous Women*, the anonymous illuminator shows Thamyris, an artist of antiquity, at work in her studio. She is depicted in fifteenth-century dress, painting an image of the Virgin and Child. At the right, an assistant grinds and mixes the colors Thamyris will need to complete her painting. In the foreground, her brushes and paints are laid out conveniently on a table.

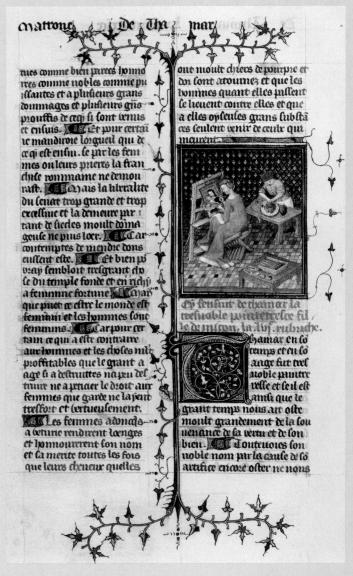

PAGE WITH THAMYRIS

From Giovanni Boccaccio's *De Claris Mulieribus (Concerning Famous Women)*. 1402. Ink and tempera on vellum. Bibliothèque Nationale de France, Paris.

used in daily prayer and meditation, and it included a calendar of holy days. The Limbourgs created full-page illustrations for the calendar in the International Gothic style, with subjects including both peasant labors and aristocratic pleasures. Like most European artists of the time, the Limbourgs showed the laboring classes in a light acceptable to aristocrats—that is, happily working for the nobles' benefit. But they also showed peasants enjoying their own pleasures.

In the **FEBRUARY** page (FIG. 13–6), farm people relax cozily before a blazing fire. This farm looks comfortable and well maintained, with timber-framed buildings, a row of beehives, a sheepfold, and tidy woven wattle fences. In the distance are a village and church. Most remarkably, the artists convey the feeling of cold winter weather: the breath of the bundled-up worker turning to steam as he blows on his hands, the leaden sky and bare trees, the snow covering the

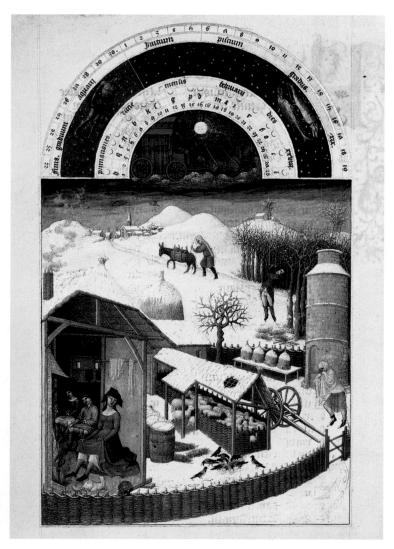

13–6 | Paul, Herman, and Jean Limbourg FEBRUARY, LIFE IN THE COUNTRY. TRÈS RICHES HEURES 1411–16. Colors and ink on parchment, $8\% \times 5\%$ (22.5 \times 13.7 cm). Musée Condé, Chantilly, France.

landscape, and the comforting smoke curling from the farm-house chimney. The painting employs several International Gothic conventions: the high placement of the horizon line, the small size of trees and buildings in relation to people, and the cutaway view of the house showing both interior and exterior. The muted palette is sparked with touches of yellowish-orange, blue, and a patch of bright red on the man's turban at the lower left. The landscape recedes continuously from foreground to middle ground to background. An elaborate calendar device, with the chariot of the sun and the zodiac symbols, fills the upper part of the page.

In contrast, the illustration for the other winter month— January—depicts an aristocratic household (SEE FIG. 13–3). The Duke of Berry sits behind a table laden with food and rich tableware, including a huge gold standing salt. A second

Sequencing Events THE DUKES OF BURGUNDY (VALOIS)

1363-1404	Philip the Bold (acquires Flanders through marriage)
1404-19	John the Fearless
1419-67	Philip the Good; patron of Jan van Eyck
1467-77	Charles the Bold
1477	Mary of Burgundy inherits Burgundy and marries Habsburg heir Maximilian of Austria

table or buffet holds his collection of gold vessels. His chamberlain invites courtiers to approach (the words written overhead say "approach"). John is singled out visually by the red "cloth of honor" with his heraldic arms—swans and the lilies of France—and by a large fire screen that circles his head like a secular halo. Tapestries with battle scenes cover the walls and are rolled up around the fireplace. Rich clothing and jewels, embroidered fabrics and brocades, turbans, golden collars and chains attest to the wealth and lavish lifestyle of this great patron of the arts and brother of King Charles V.

THE MARY OF BURGUNDY PAINTER. By the end of the century, each scene on a manuscript page was a tiny image of the world rendered in microscopic detail. Complex compositions and ornate decorations were commonplace, with framed images surrounded by a fantasy of vines, flowers, insects, animals, shellfish, or other objects painted as if seen under a magnifying glass. Christine de Pizan's preferred artist, Anastaise, probably worked in this mode (see Fig. 21, Introduction).

One of the finest later painters was the anonymous artist known as the Mary of Burgundy Painter—so called because he painted a Book of Hours for Mary of Burgundy, daughter of Charles the Bold. Mary married the Habsburg heir, Maximilian of Austria, in 1477, and her grandson became both King of Spain as Charles I and Holy Roman Emperor as Charles V (see Chapter 15 and Introduction Fig. 8).

Within an illumination in a book only 7½ by 5¼ inches, reality and vision have been rendered equally tangible (FIG. 13–7). The painter has attained a new complexity in treating pictorial space. We look not only through the "window" of the illustration's frame but through another window in the wall of the room depicted in the painting. The spatial recession leads the eye into the far reaches of the church interior, past the Virgin and the gilded altarpiece in the sanctuary to two people conversing in the far distance.

Mary of Burgundy appears twice: once seated in the foreground by a window, reading from her Book of Hours; and again in the background, perhaps in a vision inspired by her reading. She kneels with attendants and angels in front of the Virgin and Child. On the window ledge is an exquisite

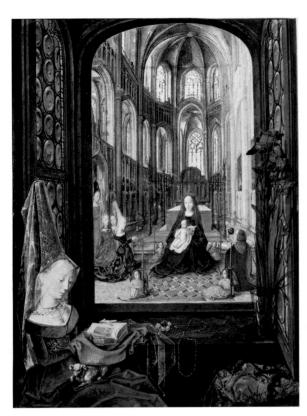

I3–7 | Mary of Burgundy Painter MARY AT HER DEVOTIONS, HOURS OF MARY OF BURGUNDY Before 1482. Colors and ink on parchment, size of image $7\frac{1}{2} \times 5\frac{1}{4}$ " (19.1 \times 13.3 cm). Österreichische Nationalbibliothek, Vienna.

still life—a rosary (symbol of Mary's devotion), carnations (flowers symbolizing the nails of the Crucifixion), and a glass vase holding purple irises, representing the Virgin Mary's sorrows over the sacrifice of Christ (SEE FIG. 13–21). The artist has skillfully executed the filmy veil covering Mary's steeple headdress, the transparent glass vase, and the glass of the window (circular panes whose center "lump" was formed by the glassblower's pipe).

The Fiber Arts

The lavish detail with which textiles are depicted in Flemish manuscripts and paintings reflects their great importance in fifteenth-century society. In the fifteenth and sixteenth centuries, Flemish tapestry making was the finest in Europe. Major weaving centers at Brussels, Tournai, and Arras produced these intricately woven wall hangings for royal and aristocratic patrons, important church officials, and even town councils. Among the most common subjects were foliage and flower patterns, scenes from the lives of the saints, and themes from classical mythology and history, such as the Battle of Troy seen hanging on the Duke of Berry's walls. Tapestries provided both insulation and luxurious decoration for the stone walls of castle halls, churches, and municipal buildings.

Often they were woven for specific places or for festive occasions such as weddings, coronations, and other state events. Many were given as diplomatic gifts, and the wealth of individuals can often be judged by the number of tapestries listed in their household inventories.

The price of a tapestry depended on the work required and the materials used. Rarely was a fine, commissioned series woven only with wool; instead, tapestry producers enhanced the weaving with silk, silver, and gold threads. The richest kind of tapestry was made almost entirely of silk and gold. Because silver and gold threads were made of silk wrapped with real metal, people later burned many tapestries to retrieve the precious materials. As a result, few royal tapestries in France survived the French Revolution. Many existing works show obvious signs, however, that the metallic threads were painstakingly pulled out in order to get the gold but preserve the tapestries.

THE UNICORN TAPESTRY. Tapestries often formed series. One of the best-known surviving tapestry series is the *Hunt of the Unicorn*. Each piece exhibits many people and animals in a dense field of trees and flowers, with a distant view of a castle, as in the UNICORN IS FOUND AT THE FOUNTAIN (FIG. 13–8). The unusually fine condition of the tapestry allows us to appreciate its rich colors and the subtlety in modeling the faces, the tonal variations in the animals' fur, and even the depiction of reflections in the water. The unicorn, a mythical horselike animal with cloven hooves, a goat's beard, and a single long twisted horn, was said to be supernaturally swift and, in medieval belief, could only be captured by a virgin, to whom it came willingly. Thus, the unicorn became a symbol of the Incarnation (Christ is the unicorn captured by the Virgin Mary) and also a metaphor for romantic love.

Because of its religious connotations, the unicorn was an important animal in the medieval **bestiary**, an encyclopedia of real and imaginary animals that gave information of both moral and practical value. For example, the unicorn's horn (in fact, the narwhal's horn) was thought to be an antidote to poison. In the tapestry, the unicorn purifies the water by dipping its horn into the stream. This beneficent act, resulting in the capture and killing of the unicorn, was equated with Christ's death on the cross to save humanity. The prominence of the red roses (symbols both of the Passion and of Mary) growing behind the unicorn suggests that the tapestries may have celebrated Christian doctrine, but they could also have been a wedding gift.

All the woodland creatures included in the tapestry have symbolic meanings. For instance, lions, ancient symbols of power, represent valor, faith, courage, and mercy, and even—because they breathe life into their cubs—the Resurrection of Christ. The stag is another symbol of the Resurrection (it sheds and grows its antlers) and a protector against poisonous serpents and evil in general. Even today

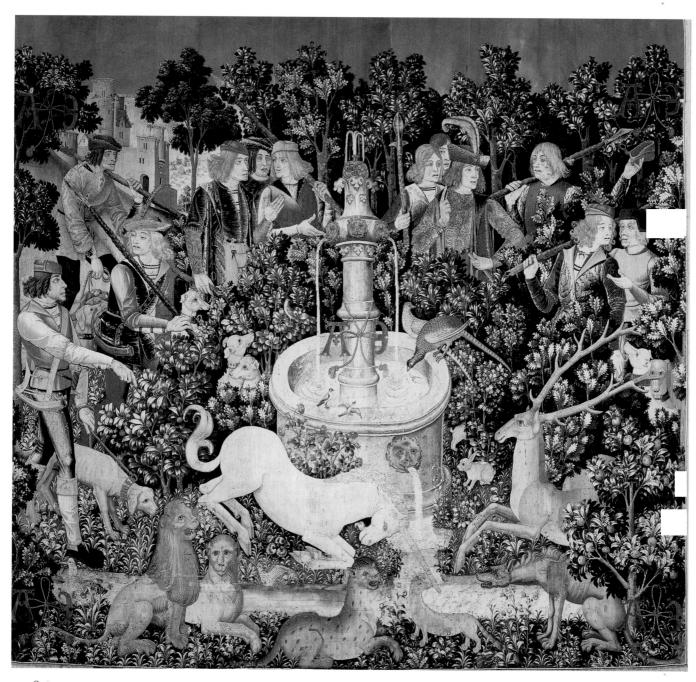

13–8 † **UNICORN IS FOUND AT THE FOUNTAIN**From the *Hunt of the Unicorn* tapestry series.
c. 1495–1505. Wool, silk, and silver- and gilt-wrapped thread (13–21 warp threads per inch), $12'1'' \times 12'5''$ (3.68 \times 3.78 m). The Metropolitan Museum of Art, New York.
Gift of John D. Rockefeller Jr., the Cloisters Collection, 1937 (37.80.2)

we expect the rabbits to symbolize fertility, and the dogs, fidelity. The pair of pheasants is an emblem of human love and marriage, and the goldfinch is another symbol of fertility and also of the Passion of Christ. Only the ducks swimming away have no apparent message.

The flowers and trees in the tapestry, identifiable from their botanically correct depictions, reinforce the theme of protective and curative powers. Each has both religious and secular meanings—as explained in herbals (encyclopedias of plants, their uses and significance)—but the theme of mar-

riage, in particular, is referred to by the presence of such plants as the strawberry, a common symbol of sexual love; the pansy, a symbol for remembrance; and the periwinkle, a cure for spiteful feelings and jealousy. The trees include oak for fidelity, beech for nobility, holly for protection against evil, hawthorn for the power of love, and pomegranate and orange for fertility. The parklike setting with its prominent fountain was inspired by the biblical love poem the Song of Songs (4:12, 13, 15–16): "You are an enclosed garden, my sister, my bride, an enclosed garden, a fountain sealed."

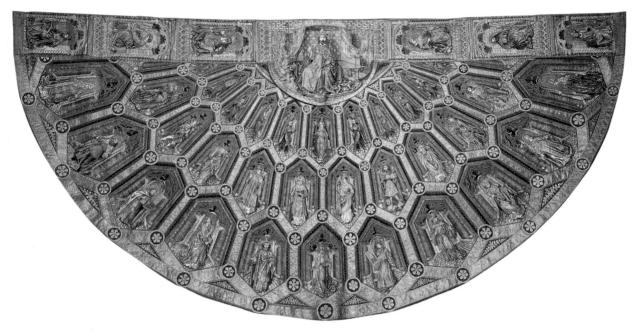

13–9 | COPE OF THE ORDER OF THE GOLDEN FLEECE Flemish, mid-15th century. Cloth with gold and colored silk embroidery, $5'4\%'' \times 10'9\%''$ (1.64 \times 3.3 m). Imperial Treasury, Vienna.

COPE OF THE ORDER OF THE GOLDEN FLEECE. Remarkable examples of the Flemish fiber arts are the vestments of the Order of the Golden Fleece. The Order of the Golden Fleece was an honorary fraternity founded by Duke Philip the Good of Burgundy in 1430 with twenty-three knights chosen for their moral character and bravery. Religious services were an integral part of the order's meetings, and opulent liturgical and clerical objects were created for the purpose.

The surface of the sumptuous cope (cloak) in FIGURE 13–9 is divided into compartments filled with the standing figures of saints. At the top of the neck edge, as if presiding over the company, is an enthroned figure of Christ, flanked by scholar-saints in their studies. The embroiderers worked with great precision to create illusionistic effects of contemporary Flemish painting. The particular stitch used here is known as couching, that is, gold threads are tacked down using unevenly spaced colored silk threads to create images and an iridescent effect. (For the effect of a cope when worn, see the angels in the center panel of the *Portinari Alta*rpiece, FIG. 13–20.)

PAINTING IN FLANDERS

A strong economy based on wool, the textile industry, and international trade provided stability and money for the arts to flourish. Civic groups, town councils, and wealthy merchants were also important patrons in the Netherlands, where the cities were self-governing and largely independent of the landed nobility. Guilds oversaw nearly every aspect of their members' lives, and high-ranking guild members served on

town councils and helped run city governments. Even experienced artists who moved from one city to another usually had to work as assistants in a local workshop until they met the requirements for guild membership.

The diversity of clientele encouraged artists to experiment with new types of images—with outstanding results. Throughout most of the fifteenth century, Flemish art and artists were greatly admired; artists from abroad studied Flemish works, and their influence spread throughout Europe, including Italy. Only at the end of the fifteenth century did a general preference for the Netherlandish painting style give way to a taste for the new styles of art and architecture developing in Italy.

The Founders of the Flemish School

Flemish artists were known for their exquisite illuminated manuscripts, tapestries, and stained glass. For works ranging from enormous altarpieces to small portraits, Flemish painters perfected the technique of painting with an oil medium rather than the tempera paint preferred by the Italians. Oil paint provided more flexibility: Slow to dry, it permitted artists to make changes as they worked. Most important, it had a luminous quality. Oil paint applied in thin glazes produced luminous effects that enabled the artists to capture rich jewel-like colors and subtle changes in textures and surfaces. Like manuscript illuminations, the panel paintings provided a window onto a scene, which fifteenth-century Flemish painters typically rendered with keen attention to individual

features—whether of people, objects, or the natural world—in works laden with symbolic meaning.

ROBERT CAMPIN. One of the first outstanding exponents of the new Flemish style was Robert Campin (active 1406–44). His paintings reflect the Netherlandish taste for lively narrative and a bold three-dimensional treatment of figures reminiscent of the sculptural style of Claus Sluter. About 1425–28, Campin painted an altarpiece now known as the MÉRODE ALTARPIECE from the name of later owners (FIG. 13–10). Slightly over 2 feet tall and about 4 feet wide with the wings open, it was probably made for a small private chapel.

By depicting the Annunciation inside a Flemish home, Campin turned common household objects into religious symbols. The treatment is often referred to as "hidden symbolism" because objects are treated as an ordinary part of the scene, but their religious meanings would have been widely understood by contemporary people. The lilies in the majolica (glazed earthenware) pitcher on the table, for example, symbolize Mary's virginity, and were a traditional element of Annunciation imagery. The white towel and hanging waterpot in the niche symbolize Mary's purity and her role as the vessel for the Incarnation of God. Unfortunately, the precise meanings are not always clear today. The central panel may simply portray Gabriel telling Mary that she will be the Mother of Christ. Another interpretation suggests that the painting shows the moment immediately following Mary's

acceptance of her destiny. A rush of wind riffles the book pages and snuffs the candle as a tiny figure of Christ carrying a cross descends on a ray of light. Having accepted the miracle of the Incarnation (God assuming human form), Mary reads her Bible while sitting humbly on the footrest of the long bench. Her position becomes a symbol of her submission to God's will. But another interpretation of the scene suggests that it represents the moment just prior to the Annunciation. In this view, Mary is not yet aware of Gabriel's presence, and the rushing wind is the result of the angel's rapid entry into the room, where he appears before her, half kneeling and raising his hand in salutation.

The complex treatment of light in the *Mérode Altarpiece* is another Flemish innovation. Campin combines natural and supernatural light, with the strongest illumination coming from an unseen source at the upper left in front of the picture plane. The sun seems to shine through a miraculously transparent wall that allows the viewer to observe the scene. In addition, a few rays enter the round window at the left as the vehicle for the Christ Child's descent. More light comes from the window at the rear of the room, and areas of reflected light can also be detected, such as the right side of the brass waterpot.

Campin maintained some of the conventions typical of the International Gothic style: the abrupt recession of the bench toward the back of the room, the sharply uplifted floor and tabletop, and the disproportionate relationship between the figures and the architectural space. In an otherwise

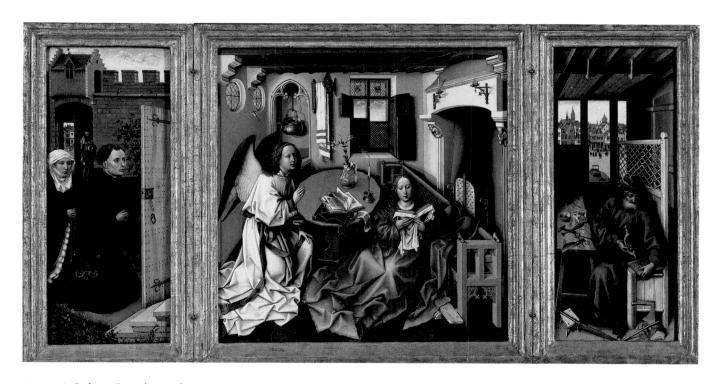

13–10 Robert Campin MÉRODE ALTARPIECE (TRIPTYCH OF THE ANNUNCIATION) (OPEN) c. 1425–28. Oil on wood panel, center $25\frac{1}{4} \times 24\frac{1}{8}$ " (64.1 \times 63.2 cm); each wing approx $25\frac{1}{8} \times 10\frac{1}{4}$ " (64.5 \times 27.6 cm). The Metropolitan Museum of Art, New York. The Cloisters Collection, 1956 (56.70)

intense effort to mirror the real world, this treatment of space may be a conscious remnant of medieval style, serving the symbolic purpose of visually detaching the religious realm from the world of the viewers. Unlike figures by such International Gothic painters as the Limbourg brothers (SEE FIGS. 13-3, 13-6), the Virgin and Gabriel are massive rather than slender, and their abundant draperies increase the impression of material weight.

Although in the biblical account Joseph and Mary were not married at the time of the Annunciation, this house clearly belongs to Joseph, who is shown in his carpentry shop. A prosperous Flemish city can be seen through the shop window, with people going about their business unaware of the drama taking place inside the carpenter's home (SEE FIG. 13–2). One clue indicates that this is not an everyday scene: the shop, displaying wooden wares-mousetraps, in this case—would have been on the ground floor, but Campin has the window apparently opening from the second floor. Furthermore, the significance of the mousetraps would have been recognized by knowledgeable people. They could refer to Saint Augustine's reference to Christ as the bait in a trap set by God to catch Satan. Joseph is drilling holes in a small board used as a drainboard for wine making, which would have been understood as symbolic of the Eucharistic wine and Christ's Passion.

Joseph's house has a garden planted with a rosebush; roses allude to both the Virgin and the Passion. Perhaps the man standing behind the open entrance gate, clutching his hat in one hand and a document in the other, is a self-portrait of the artist, but he has also been called the prophet Isaiah. Kneeling in front of the open door to the house are the donors of the altarpiece, Peter Inghelbrecht and his wife. Although they could observe the Annunciation through the door their eyes seem unfocused. Perhaps the scene of the Annunciation is a vision induced by their prayers.

JAN VAN EYCK. Campin's contemporary Jan van Eyck (active 1420s-41) was a trusted official as well as painter in the court of Philip the Good. His influence would extend through ducal Burgundy and into France, Spain, and Portugal, where he traveled on diplomatic missions for the duke. Duke Philip alluded to Jan's remarkable technical skills in a letter of 1434-35, saying that he could find no other painter equal to his taste or so excellent in art and science. Part of the secret of Jan's "science" was his technique of painting with oil glazes on wood panel. So brilliant were the results of his experiments that Jan has been mistakenly credited with being the inventor of oil painting. Actually, the medium had been known for several centuries, and medieval painters had used oil paint to decorate stone, metal, and occasionally plaster walls. Jan perfected the medium by building up his images in very thin transparent oil layers. This technique permitted a

precise, objective description of what he saw, with tiny, carefully applied brushstrokes so well blended that they are only visible at very close range.

The GHENT ALTARPIECE (FIG. 13-11), which we have already seen in closed form, presents questions of authorship. An inscription on the frame identifies both Jan and Hubert van Eyck as artists, but Hubert died in 1426. Perhaps Hubert left several unfinished panels in his studio when he died and Jan assembled them, repainting and adding to them to bring them into harmony. In addition to the visual evidence, modern scientific analysis—X-ray, infrared reflectography, and chemical analysis—supports this theory.

Dominating the altarpiece by size, central location, and brilliant red and gold color is the enthroned figure of God, wearing the triple crown of Saint Peter (the papal crown) and having an earthly crown at his feet. He is joined in his golden shrine by the Virgin Mary and John the Baptist, each enthroned and holding an open book. This divine trio (in Byzantine art, known as the Deësis) is flanked first by angel musicians and then by Adam and Eve. Van Eyck emphasizes humanity's fall from grace by depicting the murder of Abel by Cain, in the upper lunette (semicircular wall area), and Eve, who holds the forbidden fruit. In the upper register, each of the three themes-God with Mary and John, musical angels, and Adam and Eve-is represented in a different space and at a different scale. Angels stand on a tiled floor but against a blue sky. Adam and Eve stand in shallow stone niches.

The five lower panels present a unified field—a vast landscape with meadows, woods, and distant cities against a continuous horizon. All saints—apostles, martyrs, confessors and virgins, hermits, pilgrims, warriors, and judges-gather to adore the Lamb of God as described in the Book of Revelation. The Lamb stands on an altar, blood flowing into a chalice, ultimately leading to the fountain of life.

The three-dimensional mass of the figures, the voluminous draperies as well as the remarkable surface realism, even the faux sculpture, recall the art of Claus Sluter for the Burgundian court in Dijon. The extraordinary painting of brocades and jewels, the facial expressions (especially of the angels), the detailed rendering of plants, including Mediterranean palms and orange trees, and the concern with atmospheric perspective—all suggest Jan's unique contribution. Jan's technique is firmly grounded in the terrestrial world despite his visionary subject.

The portrait of a man in a red turban of 1433 (FIG. 13-12) projects a strong sense of personality, and the signed and dated frame also bears Jan's personal motto, in Flemish, "As I can" ("The best that I am capable of doing"). This motto, derived from classical sources and written here in Greek letters, is a telling illustration of the humanist spirit of the age and the confident expression of an artist who

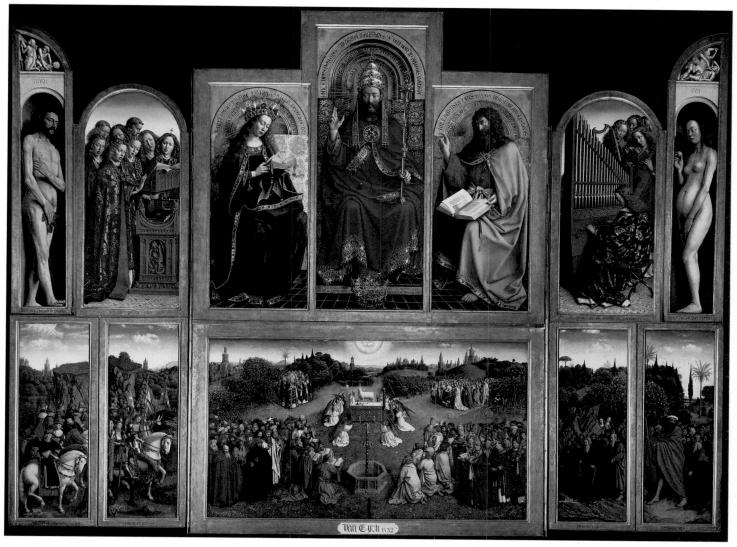

I3–II Jan and Hubert van Eyck GHENT ALTARPIECE (OPEN), ADORATION OF THE MYSTIC LAMB Completed 1432. Oil on panel, $11'5\%'' \times 15'1\%'' (3.5 \times 4.6 \text{ m})$. Cathedral of Saint Bavo, Ghent.

On the frame of the altarpiece was written, "The painter Hubert van Eyck, greater than whom no one was found, began [this work]; and Jan, his brother, second in art, having carried through the task at the expense of Jodocus Vijd, invites you by this verse, on the sixth of May, to look at what has been done." (Translation by L. Silver)

knows his capabilities and is proud to display them. The *Man in a Red Turban* is a portrait in which the physical appearance seems recorded in a magnifying mirror. We see every wrinkle and scar, the stubble of a day's growth of beard on his chin and cheeks, and the tiny reflections of light from a studio window in the pupils of the eyes. The outward gaze of the subject is new in portraiture, and it suggests the subject's increased sense of self-confidence as he catches the viewer's eye.

Jan's best-known painting today is an elaborate portrait of a man and woman traditionally identified as **GIOVANNI ARNOLFINI AND HIS WIFE, GIOVANNA CENAMI** (FIG. 13–13). This fascinating work continues to be subject to a number of interpretations, most of which suggest that it represents a wedding or betrothal. One remarkable detail is the artist's inscription above the mirror on the back wall: *Johannes de eyck fuit hic* 1434 ("Jan van Eyck was present, 1434"). Normally, a work of art in fifteenth-century Flanders would have been signed "Jan

I3–I2 | Jan van Eyck | MAN IN A RED TURBAN 1433. Oil on wood panel, $13\%\times10\%$ (33.3 \times 25.8 cm). The National Gallery, London.

On the frame is written, "Als ich Kan. Joh. de Eyck me Fecit," Jan's personal motto, which translates "As I can."

van Eyck made this." The wording is that of a witness to a legal document, and indeed, two witnesses to the scene are reflected in the mirror, a man in a red turban—perhaps the artist—and one other. The man in the portrait, identified by early sources as Giovanni Arnolfini, a member of an Italian merchant family living in Flanders, holds the hand of the woman and raises his right hand before the two witnesses. In the fifteenth century, a marriage was rarely celebrated with a religious ceremony. The couple signed a legal contract before two witnesses, after which the bride's dowry might be paid and gifts exchanged. However, it has been suggested that the painting might be a pictorial "power of attorney," giving the woman the right to act in her husband's absence. The recent discovery of a document showing that Arnolfini married in 1447, six years after Jan's death, adds to the mystery.

Whatever event or situation the painting depicts, the artist has juxtaposed secular and religious themes in a work that seems to have several levels of meaning. On the man's side of the painting, the room opens to the outdoors, the external "masculine" world, while the woman is silhouetted against a domestic interior, with its allusions to the roles of wife and mother. The couple is surrounded by emblems of

wealth, piety, and married life. The convex mirror reflecting the entire room and its occupants is a luxury object, but it may also symbolize the all-seeing eye of God. The roundels decorating its frame depict the Passion of Christ, a reminder of Christian redemption.

Many other details suggest the piety of the couple: the crystal prayer beads on the wall; the image of Saint Margaret, protector of women in childbirth, carved on the top of a high-backed chair next to the bed; and the single burning candle in the chandelier, a symbol of Christ's presence. The fruits shown at the left, seemingly placed there to ripen in the sun, may allude to fertility in a marriage, and also to the Fall of Adam and Eve in the Garden of Eden. The small dog may simply be a pet, but it serves also as a symbol of fidelity, and its rare breed—affenpinscher—suggests wealth.

The woman wears an aristocratic fur-lined overdress with a long train. Fashion dictated that the robe be gathered up and held in front of the abdomen, giving an appearance of pregnancy. This ideal of feminine beauty emphasized women's potential fertility. The merchant class copied the fashions of the court, and a beautifully furnished room containing a large bed hung with rich draperies was often a home's primary public space, not a private retreat.

Jan delighted in complex symbolism in the guise of ordinary objects. The paintings of his contemporaries and followers seem relatively straightforward by comparison.

ROGIER VAN DER WEYDEN. Little as we know about Jan van Eyck, we know less about the life of Rogier van der Weyden. Not a single existing work of art bears his name. He may have studied under Robert Campin, but this relationship is not altogether certain. At the peak of his career, Rogier maintained a large workshop in Brussels, where he was the official city painter. Apprentices and shop assistants came from as far away as Italy to study with him, adding to modern scholars' difficulties.

To establish the thematic and stylistic characteristics for Rogier's art, scholars have turned to a painting of the **DEPOSITION** (FIG. 13–14), an altarpiece commissioned by the Louvain Crossbowmen's Guild sometime before 1443, the date of the earliest known copy of it by another artist. The copy has wings painted with the four evangelists—Matthew, Mark, Luke, and John—and Christ's Resurrection. Perhaps the *Deposition* was once a triptych too.

The Deposition was a popular theme in the fifteenth century, in part because of its dramatic, emotionally moving nature. Rogier set the act of removing Jesus's body from the cross on a shallow stage closed off by a wooden backdrop that has been covered with a thin overlay of gold like a carved and painted altarpiece. The ten solid, three-dimensional figures seem to press forward into the viewer's space, forcing the viewer to identify with the grief of Jesus's friends—made palpably real by their portraitlike faces and elements of contem-

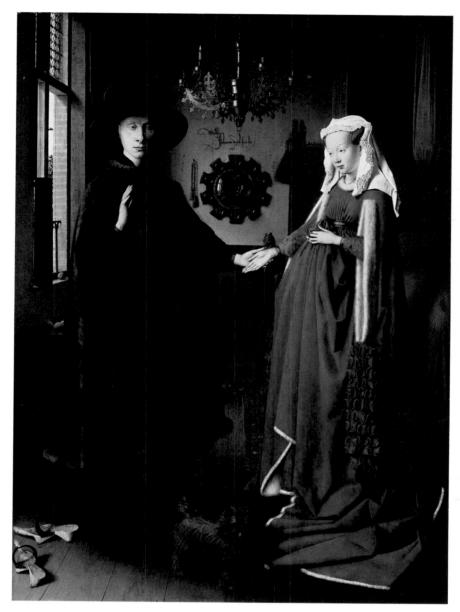

I3–I3 † Jan van Eyck **DOUBLE PORTRAIT; TRADITIONALLY KNOWN AS GIOVANNI ARNOLFINI AND HIS WIFE, GIOVANNA CENAMI** 1434. Oil on wood panel, $33\times22\%$ ($83.8\times57.2~\mathrm{cm}$). The National Gallery, London.

"Johannes de eyck fuit hic [was present]." According to a later inventory, the original frame was inscribed with a quotation from Ovid, a Roman poet known for his celebration of romantic love.

porary dress—as they tenderly and sorrowfully remove his body from the cross for burial. Rogier has arranged Jesus, the life-size corpse at the center of the composition, in a graceful curve that is echoed in angular fashion by the fainting Virgin, thereby increasing the emotional identification between the Son and the Mother. The artist's compassionate sensibility is especially evident in the gestures of John the Evangelist, who supports the Virgin at the left, and Jesus's friend Mary Magdalen, who wrings her hands in anguish at the right. Rogier's

emotionalism links the Gothic past with the fifteenthcentury humanistic concern for individual expressions of emotion. Although united by their sorrow, the mourning figures react in personal ways.

Rogier's choice of color and pattern balances and enhances his composition. For example, the complexity of the gold brocade worn by Joseph of Arimathea, who offered his new tomb for the burial, and the contorted pose and vivid dress of Mary Magdalen increase the visual impact of the

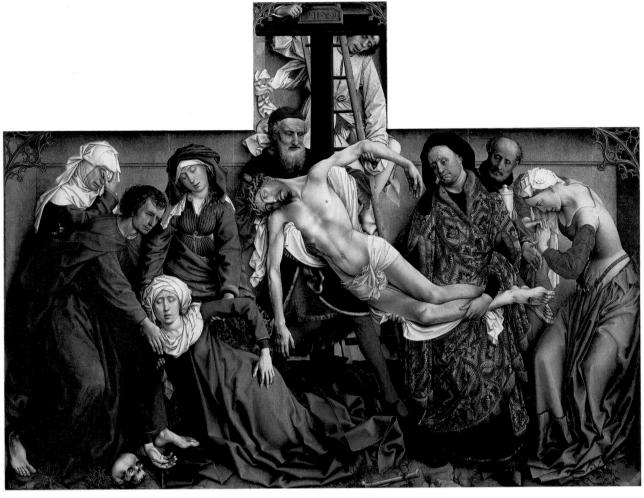

13-14 Rogier van der Weyden DEPOSITION

From an altarpiece commissioned by the Crossbowmen's Guild, Louvain, Belgium. Before 1443, possibly c. 1435-38. Oil on wood panel, 7'2%" × 8'7%" (2.2 × 2.62 m). Museo del Prado, Madrid.

right side of the panel and counter the pictorial weight of the larger number of figures at the left. The palette of subtle, slightly muted colors is sparked with red and white accents that focus the viewer's attention on the main subject. The whites of the winding cloth and the tunic of the youth on the ladder set off Jesus's pale body, as the white turban and shawl emphasize the ashen face of Mary.

Rogier painted his largest and most elaborate work, the altarpiece of the LAST JUDGMENT, for the hospital in Beaune, founded by the chancellor of the Duke of Burgundy, Nicolas Rolin (FIGS. 13–15, 13–16). Whether Rogier painted this altarpiece before or after he made a trip to Rome for the Jubilee of 1450 is debated by scholars. He would have known the iconography of the Last Judgment from medieval church tympana, but he could also have been inspired by the paintings and mosaics of the theme in Rome. The tall, straight figure of the archangel Michael, dressed in a white robe and cope, dominates the center of

the wide polyptych as he weighs souls under the direct order of God, who sits on the arc of a giant rainbow above him. The Virgin Mary and John the Baptist kneel at either end of the rainbow. Behind them on each side, six apostles and a host of saints (men at the right side of Christ and women at the left) witness the scene. The cloudy gold background serves, as it did in medieval art, to signify events in the heavenly realm or in a time remote from that of the viewer.

The bodily resurrection takes place on a narrow, barren strip of earth that runs across the bottom of all but the outer panels. Men and women climb out of their tombs, turning in different directions as they react to the call to Judgment. The scales of justice held by Michael tip in an unexpected direction; instead of Good outweighing Bad, the saved soul has become pure spirit and rises, while the damned soul sinks, weighed down by unrepented sins. The damned throw themselves into the flaming pit of hell—no demons drag them

down; the saved greet the archangel Gabriel at the shining gate of heaven, depicted as a Gothic portal.

When the altarpiece's shutters are closed, they show Rogier's debt to Jan and the *Ghent Altarpiece*. The donors, Nicolas Rolin and Guigone de Salins, kneel in prayer before sculptures of the patron saints of the hospital chape. Saint Sebastian and Saint Anthony. On the upper level the angel Gabriel greets the Virgin Mary, in yet another version of the Annunciation. The high status of the donors is indicated by their coats of arms and the gold brocade on the walls of their room. In contrast, the central images of Mary, Gabriel, and the

two saints are represented in *grisaille* as unpainted stone sculpture set in shallow niches. As on the wings of the *Ghent Altarpiece*, the contrast of living and carved figures is dramatic and interactive. The popularity of *grisaille* in fifteenth-century northern panel painting goes back to Giotto's use of frescoed *grisaille* figures on the fictive marble base of the Arena Chapel (SEE FIG. 12–8), and is at odds with the actual fifteenth-century practice of adding polychromy to stone sculpture before it left the workshop. For Rogier (as for Jan van Eyck), perhaps leaving the stone "unfinished" was more effective and illusionary than depicting painted sculpture.

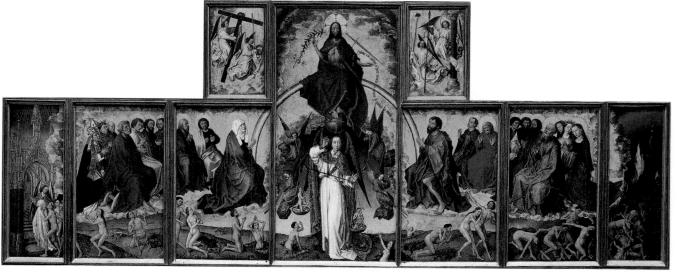

13–15 | Rogier van der Weyden **LAST JUDGMENT ALTARPIECE (OPEN)** After 1443, c. 1445–48. Oil on wood panel, open: $7'4\%'' \times 17'11''$ (2.25 × 5.46 m). Musée de l'Hôtel-Dieu, Beaune, France.

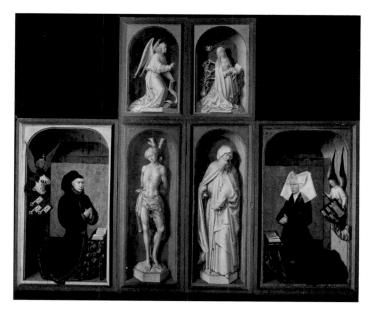

13–16 $\ \ \$ Rogier van der Weyden LAST JUDGMENT ALTARPIECE (CLOSED) Oil on panel, height 7'4%" (2.28 m). Donors: Nicolas Rolin and Guigone de Salins.

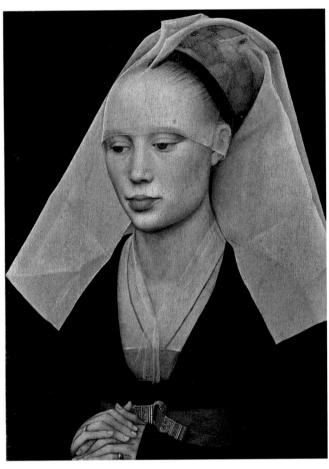

13–17 | Rogier van der Weyden PORTRAIT OF A LADY c. 1455. Oil and tempera on wood panel, $14\frac{1}{16} \times 10\frac{3}{8}$ " (37 × 27 cm). National Gallery of Art, Washington, D.C. Andrew W. Mellon Collection (1937.1.44)

In his portraits, Rogier balanced a Flemish love of individual detail with a flattering idealization of the features of men and women. In portrait of a LADY (FIG. 13-17), painted after his return from Italy, Rogier transformed the young woman into a vision of exquisite but remote beauty. Her long, almond-shape eyes, regular features, and smooth translucent skin appear in many portraits of women attributed to Rogier. He popularized the half-length pose that includes the woman's high waistline and clasped hands. Images of the Virgin and Child often formed diptychs with small portraits of this type. The woman is pious and humble, wealthy but proper and modest; nevertheless, her tense fingers convey a sense of inner controlled emotion. The portrait expresses the complex and often contradictory attitudes of both aristocratic and middle-class patrons of the arts, who balanced pride in their achievements with appropriate modesty.

Painting at Midcentury: The Second Generation

The extraordinary accomplishments of Robert Campin, Jan van Eyck, and Rogier van der Weyden attracted many followers in Flanders. The work of this second generation of Flemish painters was simpler, more direct, and easier to understand than that of their predecessors. These artists produced high-quality work of great emotional power, and they were in large part responsible for the rapid spread of the Flemish style throughout Europe.

PETRUS CHRISTUS. Among the most interesting of the second-generation painters was Petrus Christus (active 1444–c. 1475/76). He came from Holland, but nothing is known of his life before 1444, when he became a citizen of Bruges. He signed and dated six paintings.

In 1449 Christus painted a goldsmith, perhaps Saint Eligius, in his shop (FIG. 13–18). According to Christian tradition, Eligius, a seventh-century ecclesiastic, goldsmith, and mintmaster for the French court, used his wealth to ransom Christian captives. He became the patron saint of metalworkers. Here he weighs a jeweled ring, as a handsome couple looks on. The man wears a badge identifying him as a member of the court of the duke of Gelders; the young woman, dressed in Italian gold brocade, wears a jeweled double-horned headdress fashionable at midcentury (worn by Christine de Pizan and the ladies of the queen of France; see Fig. 21, Introduction).

The counter and shelves hold a wide range of metalwork and jewelry. The coins are Burgundian gold ducats and gold "angels" of Henry VI of England (ruled 1422-61, 1470-71), and on the bottom shelf are a box of rings, two bags with precious stones, and pearls. Behind them stands a crystal reliquary with a gold dome and a ruby and amethyst pelican. Many of the objects on the shelves had a protective function—for example, the red coral and the serpents' tongues (actually fossilized sharks' teeth) hanging above the coral could ward off the evil eye, and the coconut cup at the left neutralized poison. Slabs of porphyry and rock crystal were "touchstones," used to test gold and precious stones, such as the pendant and two brooches of gold with pearls and precious stones pinned to a dark fabric. Rosary beads and a belt end hang from the top shelf, where two silver flagons and a covered cup stand. A bridal belt, similar to the one worn in Rogier's Portrait of a Lady, curls across the counter. Such a combination of pieces suggests that the painting expresses the hope for health and well-being for the couple whose betrothal or wedding portrait this may be. Or perhaps the painting simply advertises the guild's wares.

As in Jan's Giovanni Arnolfini and his Wife Giovanna Cenami, a convex mirror extends the viewer's field of vision, in this instance to the street outside, where two men appear. One is stylishly dressed in red and black, and the other holds a falcon, another indication of high status since only the nobility hunted with falcons. Whether or not the reflected image has symbolic meaning, the mirror has a practical value in allowing the goldsmith to observe the approach of a potential customer.

DIRCK BOUTS. Dirck Bouts (active c. 1444–75) is the best storyteller among the Flemish painters, skillful in direct narration rather than complex symbolism. The two remaining panels (FIG. 13-19) from a set of four on the subject of justice illustrate this skill. The town council of Louvain, for whom Bouts was the official painter, ordered these huge paintings for the city hall to be examples and warnings to city officials. The paintings depict an early moral tale, the wrongful **EXECUTION OF THE COUNT.** The empress, seen standing with Emperor Otto III in her palace garden, falsely accuses a count of a sexual impropriety. Otto III has the count beheaded and the countess receives her husband's head, in the presence of the councilors. In the second panel, the countess successfully endures a trial by ordeal to prove her husband's innocence. Unscathed and still holding her husband's head, she lifts up a glowing iron bar before the shocked and repentant emperor. In the far distance, justice is done and the evil empress is executed by burning at the stake.

Dirck Bouts's paintings are notable for his use of spacious outdoor settings and his inclusion of contemporary portraits.

Sequencing Works of Art		
	1432	Jan van Eyck, Ghent Altarpiece
	c. 1450	Jean Fouquet, Étienne Chevalier and Saint Stephen, Melun Diptych
	c. 1460	Rogier van der Weyden, Portrait of a Lady
	c. 1465-67	Nuno Gonçalves, Saint Vincent and the

Portuguese Royal Family

Hugo van der Goes, Portinari Altarpiece

c. 1474-76

He is the first to create an illusion of space that recedes continuously and gradually from the picture plane to the far horizon. To achieve this effect, he employed devices such as walkways, walls, and winding roads along which characters in the scene are placed. His use of atmospheric perspective can be seen in the gradual lightening of the sky and the smoky blue hills at the horizon. Bouts is also credited with inventing

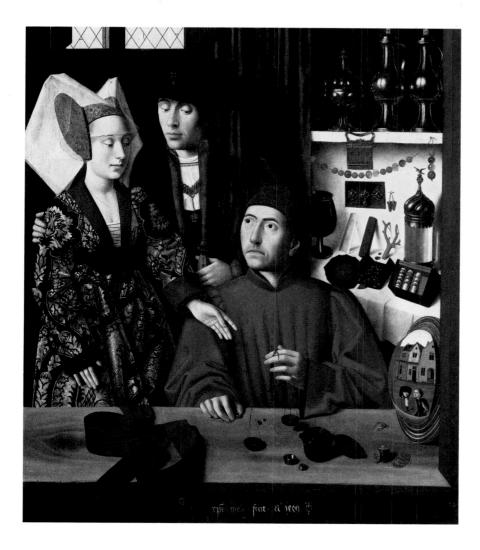

I3-I8 | Petrus Christus

A GOLDSMITH (SAINT ELIGIUS?)
IN HIS SHOP 1449. Oil on oak
panel, 38 % × 33 ½" (98 × 85 cm).
The Metropolitan Museum of Art,
New York.

Robert Lehman Collection, 1975. (1975.1.110)

The artist signed and dated his work on the house reflected in the mirror.

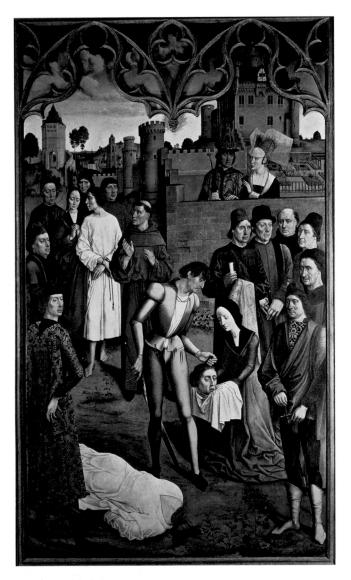

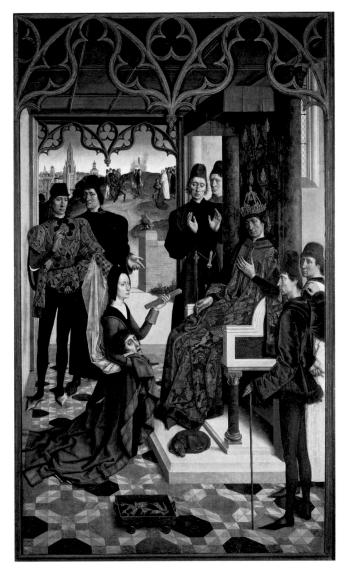

13–19 | Dirck Bouts | WRONGFUL EXECUTION OF THE COUNT (LEFT), JUSTICE OF OTTO III (RIGHT) 1470–75. Oil on wood panel, each $12'11'' \times 6'7 \%'' (3.9 \times 2 \text{ m})$. Musées Royaux des Beaux-Arts de Belgique, Brussels, Belgium-Koninklijke Musea voor Schone Kunsten van Belgie, Brussels.

the official group portrait in which living individuals are integrated into a narrative scene along with fictional or religious characters. In the Louvain justice panels, the men observing the execution may have been members of the town council. Their impassive faces are realistic but their figures are impossibly tall and slender.

Hugo Van DER GOES. Hugo van der Goes (c. 1440–82), dean of the painters guild in Ghent (1468–75), united the intellectual prowess of Jan van Eyck and the emotional sensitivity of Rogier van der Weyden. Hugo's major work was a large altarpiece of the Nativity (FIG. 13–20). The altarpiece was commissioned by Tommaso Portinari, head of the Medici bank in Bruges. Painted probably between 1474 and 1476, the triptych was sent to Florence and installed in 1483 in the Portinari fam-

ily chapel in the Church of Sant'Egidio. It had a noticeable impact on Florentine painters such as Ghirlandaio, whose own altarpiece in the Sassetti Chapel in the Church of Santa Trinita (SEE FIG. 14–35) reflects his study of Hugo's painting. Tommaso, his wife Maria Baroncelli, and their three oldest children are portrayed kneeling in prayer on the wings. On the left wing, looming larger than life behind Tommaso and his son Antonio, are the saints for whom they are named, Saint Thomas and Saint Anthony. The younger son, Pigello, born in 1474, was apparently added after the original composition was set. On the right wing, Maria and her daughter Margherita are presented by the saints Mary Magdalen and Margaret.

The theme of the altarpiece is the Nativity as told by Luke (2:10–19). The central panel represents the Adoration of the newborn Christ Child by Mary and Joseph, a host of

angels, and the shepherds who have rushed in from the fields. In the middle ground of the wings are scenes invented by Hugo, a part of his personal vision. Winding their way through the winter landscape are two groups headed for Bethlehem. On the left wing, Mary and Joseph travel to their native city to take part in a census ordered by the region's Roman ruler, King Herod. Near term in her pregnancy, Mary has dismounted from her donkey and staggers, supported by Joseph. On the right wing, a servant of the three Magi, who are coming to honor the awaited Savior, asks directions from a peasant. The continuous landscape across the wings and central panel is the finest evocation of cold, barren winter since the Limbourg brothers' February (SEE FIG. 13–6).

Hugo's technique is firmly grounded in the terrestrial world despite the visionary subjects. Meadows and woods are painted meticulously. Like Bouts (SEE FIG. 13–19) and many other northern artists at this time, he used atmospheric perspective to approximate distance in the landscape. Although Hugo's brilliant palette and meticulous accuracy recall Jan van Eyck, and although the intense but controlled emotions he depicts suggest the emotional content of Rogier van der Weyden's works, the composition and interpretation of the altarpiece are entirely his own. He shifts figure size for emphasis: The huge figures of Joseph, Mary, and the shepherds are the same size as the patron saints on the wings, in contrast to the much smaller *Portinari* family and still smaller angels. Hugo also uses color, as well as the gestures and gazes of the figures, to focus our eyes on the center panel where the mystery of

the Incarnation takes place. Instead of lying swaddled in a manger or in his mother's arms, Jesus rests naked and vulnerable on the barren ground. Rays of light emanate from his body. The source of this image was the visionary writing of the Swedish mystic Saint Bridget (who composed her work c. 1360–70), which describes Mary kneeling to adore the Christ Child immediately after giving birth.

Hugo was also a master of disguised symbolism (FIG. 13-21). In the foreground the ceramic pharmacy jar (albarello), glass, flowers, and wheat have multiple meanings. The wheat sheaf refers both to the location of the event at Bethlehem, which in Hebrew means "house of bread," and to the Host, or bread, at Communion, which represents the Body of Christ. The majolica albarello is decorated with vines and grapes, alluding to the wine of Communion at the Eucharist, which represents the Blood of Christ. It holds a red lily for the Blood of Christ and three irises—white for purity and purple for Christ's royal ancestry. Every little flower has a meaning. The three irises may refer to the Trinity of Father (God), Son (Jesus), and Holy Ghost. The iris, or "little sword," also refers to Simeon's prophetic words to Mary at the Presentation in the Temple: "And you yourself a sword will pierce so that the thoughts of many hearts may be revealed" (Luke 2:35). The glass vessel symbolizes Mary and the entry of the Christ Child into the Virgin's womb, the way light passes through glass without breaking it. The seven blue columbines in the glass remind the viewer of the Virgin's future sorrows, and scattered on the ground are violets, symbolizing humility.

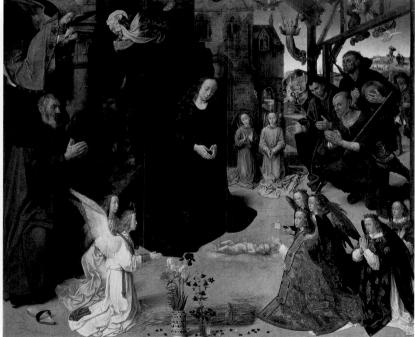

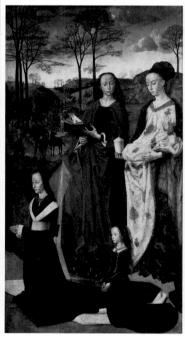

13–20 | Hugo van der Goes PORTINARI ALTARPIECE (OPEN) c. 1474–76. Tempera and oil on wood panel; center $8'3\frac{1}{2}'' \times 10'$ (2.53 \times 3.01 m), wings each $8'3\frac{1}{2}'' \times 4'7\frac{1}{2}''$ (2.53 \times 1.41 m). Galleria degli Uffizi, Florence.

THE OBJECT SPEAKS

HANS MEMLING'S SAINT URSULA RELIQUARY

mong the works securely assigned to Memling is the reliquary of Saint Ursula, a container in the form of a Gothic chapel, made in 1489 for the Hospital of Saint John in Bruges. According to legend, Ursula, the daughter of the Christian king of Brittany, was betrothed to a pagan English prince. She requested a three-year delay in the marriage to travel to Rome, during which time her husband-to-be was to convert to Christianity. On the trip home, she stopped in Cologne, which had been taken over by Attila the Hun and his nomadic warriors from Central Asia. When Ursula rejected an offer of marriage, they killed her with an arrow through the heart and also murdered her companions. The story of Ursula is told on the six side panels of the reliquary. Visible in the illustration are the pope bidding Ursula goodbye in Rome; the murder of her female companions in Cologne harbor; and Ursula's own death. On the reliquary's "roof" are roundels with musical angels flanking the Coronation of the Virgin. At the corners are carved saints, and on the end is Saint Ursula in the doorway of the "chapel," sheltering her followers under her mantle. In early stories, Ursula was accompanied on her trip by ten maidens. By the tenth century, however, she had become the leader of 11,000 young virgin martyrs.

Although the events supposedly took place in the fourth century, Memling has set them in contemporary Cologne: the city's Gothic cathedral, under construction (with the huge lifting wheel still visible), looms in the background of the Martyrdom panel. Memling created this deep space as a foil for his idealized female martyr, a calm aristocratic figure amid menacing men-at-arms. The surface pattern and intricately arranged folds of the drapery draw our attention to her.

Saints continued to play a role in the pre-Reformation Church although the need for personal intercessors began to be questioned by reformers. The possession of relics (remains) of the saints was an important source of prestige for a church, and relics attracted offerings from petitioners. The reliquary was commissioned presumably by the two women dressed in the white habits and black hoods worn by hospital sisters and depicted on the end of the reliquary not visible in the illustration. One hypothesis is that they are Jossine van Dudzeele and Anna van den Moortele, two nuns who were administrators of the hospital of Saint John in the fifteenth century. The reliquary of Saint Ursula, for all the beauty and interest of its paintings, is not a gold and jewel bedecked casket but a simple wooden shrine, an appropriate gift from the women who led the community and the hospital they served.

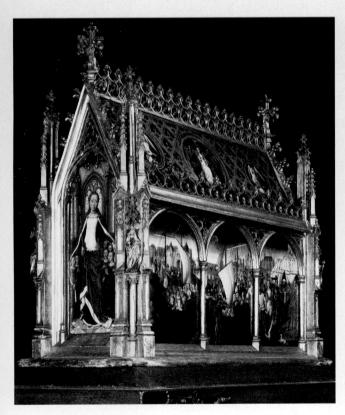

Hans Memling SAINT URSULA RELIQUARY 1489. Painted and gilded oak, $34 \times 36 \times 13''$ ($86.4 \times 91.4 \times 33$ cm). Memling Museum, Hospital of Saint John, Bruges, Belgium.

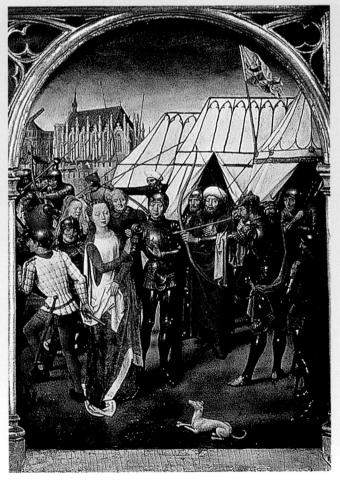

Hans Memling MARTYRDOM OF SAINT URSULA Detail of the Saint Ursula Reliquary. Panel $13\frac{3}{4} \times 10^{\prime\prime}$ (35×25.3 cm).

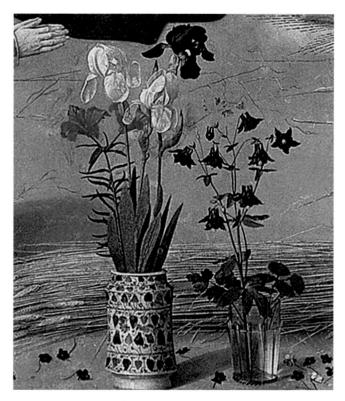

13-21 | Hugo van der Goes DETAIL OF STILL LIFE FROM THE CENTER PANEL OF THE PORTINARI ALTARPIECE

Hugo's artistic vision goes far beyond this formal religious symbolism. For example, the shepherds, who stand in unaffected awe before the miraculous event, are among the most sympathetically rendered images of common people to be found in the art of any period. The portraits of the children are among the most sensitive studies of children's features.

HANS MEMLING. The artist who summarizes and epitomizes the end of the era in Flanders is Hans Memling (1430/35–94). Memling combines the intellectual depth and virtuoso rendering of his predecessors with a delicacy of feeling and exquisite grace. A German from the nearby Rhineland, Memling may have worked in Rogier van der Weyden's Brussels workshop in the 1460s, since Rogier's style remained the dominant influence on his art. Soon after Rogier's death in 1464, Memling moved to Bruges, where he developed an international clientele. In 1489 he produced the reliquary of Saint Ursula for the Hospital of Saint John (see "Hans Memling's Saint Ursula Reliquary," page 478). It has the form of a basilican church, and instead of gold, silver, and enamels, it is made of painted wood, modest materials in keeping with a commission from the nuns of the hospital.

EUROPE BEYOND FLANDERS

Flemish art—its complex symbolism, its realism and atmospheric space, its brilliant colors and sensuous textures—delighted wealthy patrons and well-educated courtiers both

inside and outside of Flanders. At first, Flemish artists worked in foreign courts; later, many artists went to study in Flanders. Flemish manuscripts, tapestries, altarpieces, and portraits appeared in palaces and chapels throughout Europe. Soon local artists learned Flemish oil painting techniques and emulated the Flemish style. By the end of the fifteenth century, distinctive regional variations of Flemish art could be found throughout Europe, from the Atlantic Ocean to the Danube.

France

The centuries-long struggle for power and territory between France and England continued well into the fifteenth century. When King Charles VI of France died in 1422, England claimed the throne for the king's nine-month-old grandson, Henry VI of England. The plight of Charles VII, the late French king's son, inspired Joan of Arc to lead a crusade to return him to the throne. Thanks to Joan's efforts Charles was crowned at Reims in 1429. Although Joan was burned at the stake in 1431, the revitalized French forces drove the English from French lands. In 1461, Louis XI succeeded his father, Charles VII, as king of France. Under his rule the French royal court again became a major source of patronage for the arts.

JEAN FOUQUET. The leading court artist of the period in France, Jean Fouquet (c. 1420–81), was born in Tours and may have trained in Paris as an illuminator. He may have visited Italy in about 1445–47, but by about 1450 he was back in Tours, a renowned painter. Fouquet adapted contemporary Italian classical motifs in architectural decoration, and he was also strongly influenced by Flemish realism. He painted Charles VII, the royal family, and courtiers, and he illustrated manuscripts and designed tombs.

Among the court officials Fouquet painted is Étienne Chevalier, the treasurer of France under Charles VII. Fouquet painted a diptych showing Chevalier praying to the Virgin and Child (FIG. 13–22). According to an inscription, the painting was made to fulfill a vow made by Chevalier to the king's much-loved and respected mistress, Agnès Sorel, who died in 1450. Agnès Sorel, whom contemporaries described as a highly moral, extremely pious woman, was probably the model for the Virgin; her features were taken from her death mask, which is still preserved. Fouquet paints the figures of Virgin and angels as stylized, simplified forms, reducing the color to near-grisaille, then surrounds them with amazing jewels in the crown and the throne. The brilliant red and blue cherubs form a tapestrylike background.

In the other wing of the diptych, Fouquet uses a realistic style. Étienne Chevalier, who kneels in prayer with clasped hands and a meditative gaze, is presented to the Virgin by his name saint, Stephen (Étienne in French). Fouquet has followed the Flemish manner in depicting the courtier's ruddy features with a mirrorlike accuracy that is confirmed by other known portraits. Saint Stephen's features are also distinctive enough to

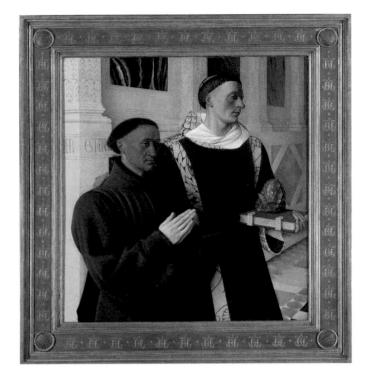

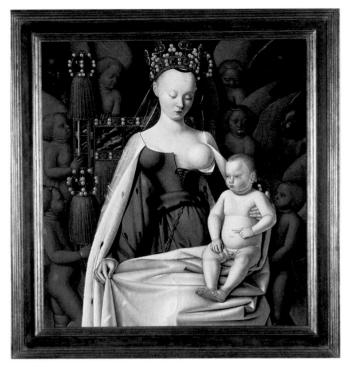

13–22 | Jean Fouquet ÉTIENNE CHEVALIER AND SAINT STEPHEN Left wing of the Melun Diptych c. 1450. Oil on wood panel, $36\frac{1}{2} \times 33\frac{1}{2}$ " (92.7 × 85.5 cm). Staatliche Museen zu Berlin, Preussischer Kulturbesitz, Gemäldegalerie. VIRGIN AND CHILD Right wing of the Melun Diptych c. 1451. Oil on wood panel, $37\frac{1}{4} \times 33\frac{1}{2}$ " (94.5 × 85.5 cm). Koninklijk Museum voor Schone Kunsten, Antwerp, Belgium.

The diptych was separated long ago and the two paintings went to collections in different countries. They are reunited on this page. The original frame was of blue velvet embroidered with pearls and gold and silver thread.

have been a portrait. According to legend and biblical accounts, Stephen, a deacon in the early Christian Church in Jerusalem, was the first Christian martyr, stoned to death for defending his beliefs. Here the saint wears liturgical, or ritual, vestments and carries a large stone on a closed Gospel book as evidence of his martyrdom. A trickle of blood can be seen on his tonsured head (male members of religious orders shaved their heads as a sign of humility). The two figures are shown in a hall decorated with the kind of marble paneling and classical architectural decoration Fouquet could have seen in Italy. Fouquet arranged the figures in an unusual spatial setting; the diagonal lines of the wall and uptilted tile floor recede toward an unseen vanishing point at the right. Despite his debt to Flemish realism and his nod to Italian architectural forms and to linear perspective (discussed in Chapter 14), Fouquet's austere geometric style is uniquely his own.

THE FLAMBOYANT STYLE. The great age of cathedral building that had begun about 1150 was over by the end of the fourteenth century, but the growing urban population needed houses, city halls, guild halls, and more parish churches. The richest patrons commissioned master masons

to build light-filled spacious halls and sculptors to cover their buildings with elaborate Gothic architectural decoration. Like painters, sculptors also turned to the realistic depiction of nature, and they covered capitals and moldings with ivy, hawthorn leaves, and other vegetation. Called the Flamboyant style (meaning "flaming" in French) because of its repeated, twisted, flamelike tracery, this intricate, elegant decoration was used to cover new buildings and was added to older buildings being modernized with spires, porches, or window tracery. The forms often recall the earlier English Decorated style (see Chapter 12).

The **CHURCH OF SAINT-MACLOU** in Rouen, which was begun after a fund-raising campaign in 1432 and dedicated in 1521, is an outstanding example of the Flamboyant style (FIG. 13–23). It may have been designed by the Paris architect Pierre Robin. A projecting porch bends to enfold the façade of the church in a screen of tracery. Sunlight on the flame-shaped openings casts ever-changing shadows across the intentionally complex surface. Crockets—small, knobby leaflike ornaments that line the steep gables and slender buttresses—break every defining line. In the Flamboyant style, decoration sometimes seems divorced from structure. The strength of load-bearing

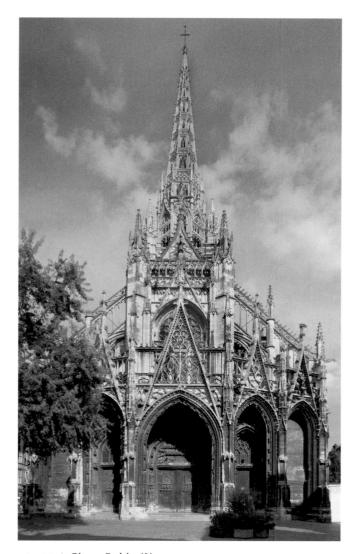

13–23 | Pierre Robin (?)

CHURCH OF SAINT-MACLOU, ROUEN

Normandy, France. West façade, 1432–1521; façade
c. 1500–14.

walls and buttresses is often disguised by an overlay of tracery; and traceried pinnacles, gables, and S-curve moldings combine with a profusion of ornament in geometric and natural shapes, all to dizzying effect. The interior of such a church, filled with light from huge windows, can be seen in the *Bcok of Hours of Mary of Burgundy* (SEE FIG. 13–7).

The **HOUSE OF JACQUES COEUR**, the fabulously wealthy merchant in Bourges, reflects the popularity of the Flamboyant style for secular architecture (FIG. 13–24). Built at great expense between 1443 and 1451, it survives almost intact, although it has been stripped of its rich furnishings. The rambling, palatial house is built around an irregular open courtyard, with spiral stairs in octagonal towers giving access to the rooms. Tympana over doors indicate the function of the rooms within; for example, over the door to the kitchen a cook stirs the contents of a large bowl. Flamboyant decoration enriches the cornices, balustrades, windows, and gables.

Sequencing Events		
1416	Death of Jean, Duke of Berry	
1431	Joan of Arc burned at the stake in Rouen	
1455	Gutenberg prints the Bible	
1453	Hundred Years' War ends	

Columbus reaches the West Indies and

Among the carved decorations are puns on the patron's surname, *Coeur* (meaning "heart" in French). The house was also Jacques Coeur's place of business, so it had large storerooms for goods and a strong room for treasure. (A well-stocked but lesser merchant's shop can be seen in the painting of Petrus Christus, *A Goldsmith in His Shop*; SEE FIG. 13–18.)

North America

Spain and Portugal

1492

Many Flemish and French artists traveled to Spain and Portugal, where they were held in high esteem. Queen Isabella of Castile, for example, assembled a large collection of Flemish paintings and illuminated manuscripts as well as a collection of tapestries, jewels, and gold- and silversmith's work. She was also a patron of architecture. In Toledo,

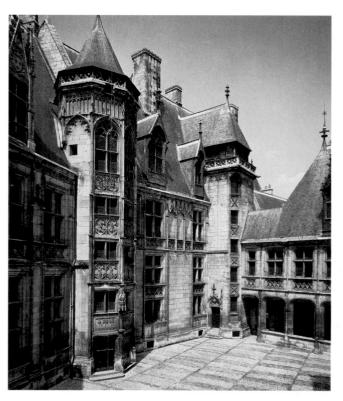

I3-24 | HOUSE OF JACQUES COEUR Bourges. France. Interior courtyard, 1443-51.

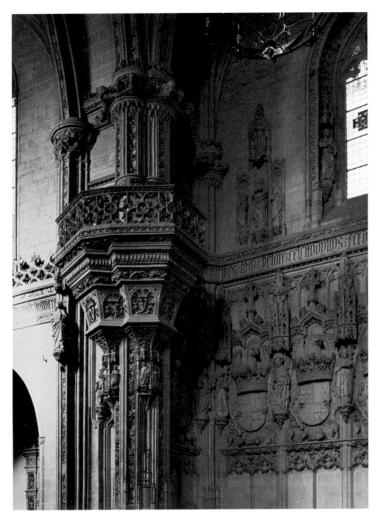

13–25 | Juan Güas SAN JUAN DE LOS REYES Interior, wall with carved coats-of-arms and saints. Toledo, Spain. Begun 1477.

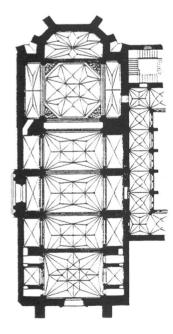

13−26 | Juan Güas PLAN OF SAN JUAN DE LOS REYES Begun 1477.

Isabella built a church for the Franciscans, which she intended to be the royal burial chapel.

SAN JUAN DE LOS REYES. Founded in 1477, SAN JUAN DE LOS REYES (Saint John of the Kings) was never used as intended, since the conquest of Granada in 1492 permitted Ferdinand and Isabella to build their pantheon in the former Moorish capital rather than in Toledo. Nevertheless, the church in Toledo established a new church type known as "Isabellan" (FIGS. 13-25, 13-26). The church had a single nave flanked by lateral chapels built between the wall buttresses, a raised choir over the western entrance (Spanish churches usually had the choir in the nave), and raised pulpits at the crossing. The transept did not extend beyond the line of the buttresses and chapels. A low lantern tower over the crossing focused the light on the space reserved for the tombs, which were never built. This simple compact design allowed ample space for the congregation, and the expanses of wall could be used for educational paintings, sculptures, or tapestries.

Lavish sculptural decoration at San Juan de los Reyes honored Ferdinand and Isabella. Heraldry—an art form in itself—became a major decorative feature in the fifteenth century. Huge shields with the royal coat of arms (chains and bars for King Ferdinand's Aragon and Catalunya and lions and castles for Queen Isabella's Leon and Castile) are held by the gigantic eagles of Saint John. They are flanked by saints standing on pedestals under flamboyant canopies. On moldings and piers the artists, led by Juan Güas, carved plants, insects, and animals as avidly and accurately as painters of manuscripts. Friezes with inscriptions mimic Moorish architectural inscriptions, and the luxurious surface decoration may also reflect the Moorish taste with which the Christians were well informed.

Isabellan art has a special relevance for the Americas. In 1492, when Isabella and Ferdinand entered the Moorish capital city of Granada in triumph, Spanish ships reached the Americas. Soon missionaries were sent to the New World, where they built churches in the Isabellan style, using local materials and workmen. The Mission style of California and the American Southwest (SEE FIG. 18–46) is a simplified version of the Isabellan style of San Juan de los Reyes.

Nuño Gonçalves. Local painters and sculptors quickly absorbed the Flemish style. They could have had firsthand experience, since Jan van Eyck, among others, visited Spain and Portugal. Jan was sent by the Duke of Burgundy to paint the portrait of a Portuguese princess who was a candidate for marriage to the duke. A little later Nuño Gonçalves (active 1450–71) painted the members of the Portuguese royal family. Gonçalves reflects Jan's influence in his monumental figures and intense interest in surfaces and rich colors, although the severity of the portraits recalls Dirck Bouts. Perhaps as early as 1465–67, Gonçalves painted a large multipanel altar-

piece for the Convent of Saint Vincent de Fora in Lisbon (FIG. 13–27). The paintings are filled with remarkable portraits of people from all walks of life—the royal family, Cistercians, businessmen, fishermen—most of whom are identifiable. The central panel with the royal family holds a special interest for Americans. Here the painter has included a portrait of Prince Henry the Navigator, the man who inspired and financed Portuguese exploration. Prince Henry sent ships down the west coast of Africa and out into the Atlantic, but he died before Columbus's ships reached the Americas. Dressed in black, he kneels behind his nephew, King Alfonso V.

Saint Vincent, magnificent in red and gold vestments, stands in a tightly packed group of people, with members of the royal family at the front and courtiers forming a solid block across the rear. With the exception of the idealized features of the saint, all are portraits: At the right, King Alfonso V kneels before Saint Vincent, while his young son and his deceased uncle, Henry the Navigator, look on. Alfonso and his son rest their hands on their swords; Henry's hands are tented in prayer. At the left, Alfonso's deceased wife and mother hold rosaries. The appearance of Saint Vincent is clearly a vision, brought on by the intense prayers of the individuals around him.

Germany and Switzerland

Present-day Germany and Switzerland were situated within the Holy Roman Empire, a loose confederation of primarily German-speaking states. Industries, especially metalworking, developed in the Rhine Valley and elsewhere, and the artisan guilds grew powerful. Trade flourished under the auspices of the Hanseatic League, an association of cities and trading outposts, and both trade and manufacture were stimulated by the financial acumen of the rising merchant class. The Fugger family began their spectacular rise from simple textile workers and linen merchants to bankers for the Habsburgs and the popes. The Holy Roman Emperor and the pope continued their disputes, although a church council, held in Constance (1414-18), temporarily settled some of the problems of church-state relations. These problems would resurface, however, and lead to the Protestant Reformation in the next century.

Germanic artists worked in two very different styles. Some, working around Cologne, continued the International Gothic style with increased prettiness, softness, and sweetness of expression. The "Beautiful Style" of the fourteenth century continued, especially in the Rhineland, where artists perfected a soft, lyrical style. Other artists began an intense investigation and detailed description of the physical world. The major exponent of the latter style was Konrad Witz (active 1434–46). Witz, a native of Swabia in southern Germany, moved to Basel (in present-day Switzerland), where he found a rich source of patronage in the Church.

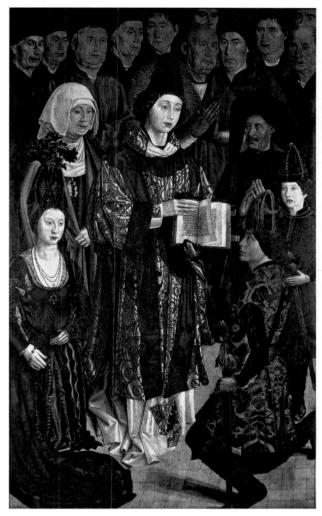

13–27 Nuño Gonçalves SAINT VINCENT WITH THE PORTUGUESE ROYAL FAMILY
Panel from the Altarpiece of Saint Vincent. c. 1465–67.
Oil on wood panel, $6'9\frac{1}{4}'' \times 4'2\frac{1}{6}''$ (2.07 × 1.28 m). Museu Nacional de Arte Antiga, Lisbon.

Witz's last large commission before his early death in 1446 was an altarpiece dedicated to Saint Peter for the Cathedral of Saint Peter in Geneva. Witz signed and dated his work in 1444. In the MIRACULOUS DRAFT OF FISHES (FIG. 13-28), a scene from the altarpiece which depicts Jesus's calling of the fishermen Peter and Andrew, Witz painted Lake Geneva, not Galilee. He has gone beyond the generic realism of the Flemings to paint a realistic portrait of a specific landscape: the dark mountain (the Mole) rising on the far shore of Lake Geneva and the snow-covered Alps shining in the distance. Witz records every nuance of light and water—the rippling surface, the reflections of boats, figures, and buildings, even the lake bottom. Peter's body and legs, visible through the water, are distorted by the refraction. The floating clouds above create shifting light and dark passages over the water. Perhaps for the first time in European art, the artist captures both the appearance and spirit of nature.

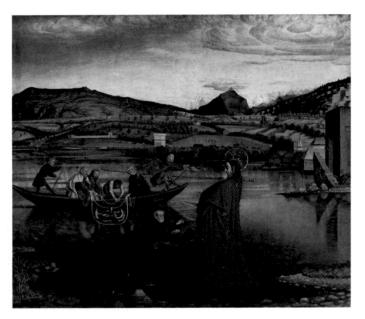

I3–28 | Konrad Witz MIRACULOUS DRAFT OF FISHES From an altarpiece from the Cathedral of Saint Peter, Geneva, Switzerland. 1444. Oil on wood panel, $4'3'' \times 5'1''$ (1.29 \times 1.55 m). Musée d'Art et d'Histoire, Geneva.

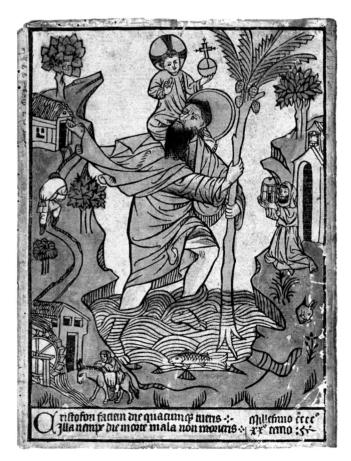

13–29 | **THE BUXHEIM SAINT CHRISTOPHER** 1423. Hand-colored woodcut, $11\% \times 8\%$ " (28.85 \times 20.7 cm). Courtesy of the Director and Librarian, the John Rylands University Library, the University of Manchester, England.

The Latin verse reads, "Whenever you look at the face of Christopher, in truth, you will not die a terrible death that day." "1423"

THE GRAPHIC ARTS

Printmaking emerged in Europe at the end of the four-teenth century with the development of printing presses and the increased local manufacture and wider availability of paper. The techniques used by printmakers during the fifteenth century were woodcut and engraving (see "Woodcuts and Engravings on Metal," page 485). Woodblocks cut in relief had long been used to print designs on cloth, but only in the fifteenth century did the printing of images and texts on paper and the production of books in multiple copies of a single edition, or version, begin to replace the copying of each book by hand. Both handwritten and printed books were often illustrated, and printed images were sometimes hand colored.

Single Sheets

Single-sheet prints in the woodcut and engraving techniques were made in large quantities in the early decades of the fifteenth century. Initially, woodcuts were made primarily by woodworkers with no training in drawing, but soon artists began to draw the images for them to cut from the block.

THE BUXHEIM SAINT CHRISTOPHER. Devotional images were sold as souvenirs to pilgrims at holy sites. The BUXHEIM **SAINT CHRISTOPHER** was found in the Carthusian Monastery of Buxheim, in southern Germany, glued to the inside of the back cover of a manuscript (FIG. 13-29). Saint Christopher, patron saint of travelers, carries the Christ Child across the river. His efforts are witnessed by a monk holding out a light to guide him to the monastery door, but ignored by the hardworking millers on the opposite bank. Both the cutting of the block and the quality of the printing are very high. The artist and cutter vary the width of the lines to strengthen major forms. Delicate lines are used for inner modeling (facial features) and short parallel lines to indicate shadows (the inner side of draperies). Since the date 1423 is cut into the block, the print was thought to be among the earliest to survive. Recent studies have determined that the date refers to some event and the print was made at midcentury.

MARTIN SCHONGAUER. Engraving may have originated with goldsmiths and armorers, who recorded their work by rubbing lampblack into the engraved lines and pressing paper over the plate. German artist Martin Schongauer (c. 1435–91), who learned engraving from his goldsmith father, was an immensely skillful printmaker who excelled both in drawing and in the difficult technique of shading from deep blacks to faintest grays using only line. He was also a skilled painter. In **DEMONS TOR-MENTING SAINT ANTHONY**, engraved about 1470–75 (FIG. 13–30), Schongauer illustrated the original biblical meaning of temptation as a physical assault rather than a subtle inducement. Wildly acrobatic, slithery, spiky demons lift

Technique

WOODCUTS AND ENGRAVINGS ON METAL

oodcuts are made by drawing on the smooth surface of a block of fine-grained wood, then cutting away all the areas around the lines with a sharp tool called a *gouge*, leaving the lines in high relief. When the block's surface is inked and a piece of paper pressed down hard on it, the ink on the relief areas transfers to the paper to create a reverse image. The effects can be varied by making thicker and thinner lines, and shading can be achieved by placing the lines closer or farther apart. Sometimes the resulting black-and-white images were then painted by hand.

Engraving on metal requires a technique called *intaglio*, in which the lines are cut into the plate with tools called *gravers* or burins. The engraver then carefully burnishes the plate to ensure a clean, sharp image. Ink is applied over the whole plate and forced down into the lines, then the plate's surface is carefully wiped clean of the excess ink. When paper and plate are held tightly together by a press, the ink in the lines transfers to the paper.

Woodblocks and metal plates could be used repeatedly to make nearly identical images. If the lines of the block or plate wore down, the artists could repair them. Printing large numbers of identical prints of a single version, called an *edition*, was usually a team effort in a busy workshop. One artist would make the drawing. So metimes it was drawn directly on the block or plate with ink, in reverse of its printed direction, sometimes on paper to be transferred in reverse onto the plate or block by another person, who then cut the lines. Others would ink and print the images.

In the illustration of books, the plates or blocks would be reused to print later editions and even adapted for use in other books. A set of blocks or plates for illustrations was a valuable commodity and might be sold by one workshop to another. Early in publishing, there were no copyright laws, and many entrepreneurs simply had their workers copy book illustrations onto woodblocks and cut them for their own publications.

Anthony up off the ground to torment and terrify him in midair. The engraver intensified the horror of the moment by condensing the action into a swirling vortex of figures beating, scratching, poking, tugging, and no doubt shrieking at the stoical saint, who remains impervious to all by reason of his faith.

Printed Books

The explosion of learning in Europe in the fifteenth century encouraged experiments in faster and cheaper ways of producing books than by hand-copying them. The earliest printed books were block books, for which each page of text, with or without illustrations, was cut in relief on a single block of wood. Movable-type printing, in which individual letters could be arranged and locked together, inked, and then printed onto paper, was first achieved in the workshop of Johann Gutenberg in Mainz, Germany. More than forty copies of Gutenberg's Bible, printed around 1455, still exist. As early as 1465, two German printers were working in Italy, and by the 1470s there were presses in France, Flanders, Holland, and Spain. With the invention of this fast way to make a number of identical books, the intellectual and spiritual life of Europe—and with it the arts—changed forever.

WILLIAM CAXTON. England got its first printing press as the result of a second career launched by a former English cloth merchant, William Caxton (active c. 1441–91). Caxton had lived for thirty years in Bruges, where he came in contact with the humanist community as well as with local printing ventures. In 1476 Caxton moved back to London, where he

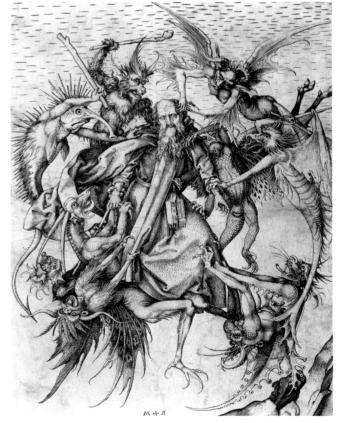

I3-3I \mid Page with Pilgrims at table, prologue to Canterbury tales

By Geoffrey Chaucer, published by William Caxton, London, 1484 (second edition, the first with illustrations). Woodcut, $4\frac{1}{16} \times 4\frac{1}{18}$ " (10.2 \times 12 cm). The Pierpont Morgan Library, New York.

established the first English publishing house. He printed eighty books in the next fourteen years, including works by the fourteenth-century author Geoffrey Chaucer (see "A New Spirit in Fourteenth-Century Literature," page 431).

In the second edition of Chaucer's *Canterbury Tales*, published in 1484, Caxton added woodblock illustrations by an unknown artist (FIG. 13–31). The assembled pilgrims journeying to the shrine of Saint Thomas à Becket are seated around a table. Included in the group of storytellers is an engaging woman, Alice, the Wife of Bath. Some critics see the Wife of Bath as an example of a woman who good women should avoid, but Chaucer put words in the lively

Alice's mouth that are well understood by many women today. Simple woodcut illustrations such as this are typical of the popular art of the time.

New techniques for printing illustrated books in Europe at the end of the fiftheenth century held great promise for the spread of knowledge and ideas in the following century.

IN PERSPECTIVE

The fifteenth century marks the end of the Middle Ages and the beginning of the modern world, our own era. The period has been called the Renaissance, for some people saw it as a period of "rebirth," but in fact Western Europeans built on the accomplishments of the twelfth century—a renaissance in its own right—and on the achievements of the thirteenth and fourteenth centuries. By the fifteenth century thoughtful people focused their attention on human beings and their accomplishments, on life in this world as well as the next. They held a sense of human history, including a new respect for ancient learning.

The fifteenth century saw the growth of a secular spirit, related to the growth of towns into cities where the stimulating hurly-burly of urban life encouraged verbal and intellectual exchange. Whereas towns had once revolved around a court or cathedral, the new cities were industrial and commercial centers. Business joined religion and politics as a powerful motivating force. While the church continued to be a major patron of the arts and architecture, new sources of patronage emerged in the cities.

Architects followed the basic Gothic principles and methods of construction, but they added increasingly elaborate carved decoration that turned solid stone into lacy confections. Sculpture was freed from architecture, and free-standing figures gave the impression of life, vitality, and even possibility of movement. This realism extended into all the arts. Painters and tapestry makers, like writers and sculptors, included images from daily life.

By the middle of the century, a new medium—the graphic arts—came into being. The rapid dissemination of information both in words and pictures now available through the printing press allowed people to read—and see—for themselves. The new empirical frame of mind that characterized the fifteenth century gave rise in the sixteenth century to an explosion of inquiry and new ways of looking at the world.

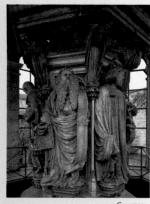

SLUTER.

WELL OF MOSES,
THE CHARTREUSE DE CHAMPMOL, DIJON
1395–1406

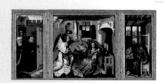

CAMPIN. **MÉRODE ALTARPIECE**C. 1425–28

HOUSE OF JACQUES COEUR
BOURGES
1443–51

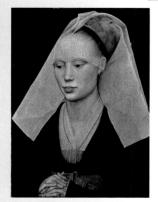

ROGIER VAN DER WEYDEN.

PORTRAIT OF A LADY

C. 1455

MARTIN SCHONGAUER

DEMONS TORMENTING SAINT ANTONY

C. 1480-90

HUNT OF THE UNICORN TAPESTRY SERIES C. 1495–1505

1400

1420

1440

1460

1480

1500

FIFTEENTHCENTURY ART IN NORTHERN EUROPE AND THE IBERIAN PENINSULA

Great (Western) Schism Ends 1417

 Duke Philip The Good of Burgundy Founds The Order of the Golden Fleece 1430

Habsburgs Begin Rule of Holy
 Roman Empire 1452

■ Hundred Year's War Ends 1453

■ Gutenberg Prints Bible 1455

William Caxton Establishes First
 English Publishing House 1476

Columbus Reaches the West Indies
1492

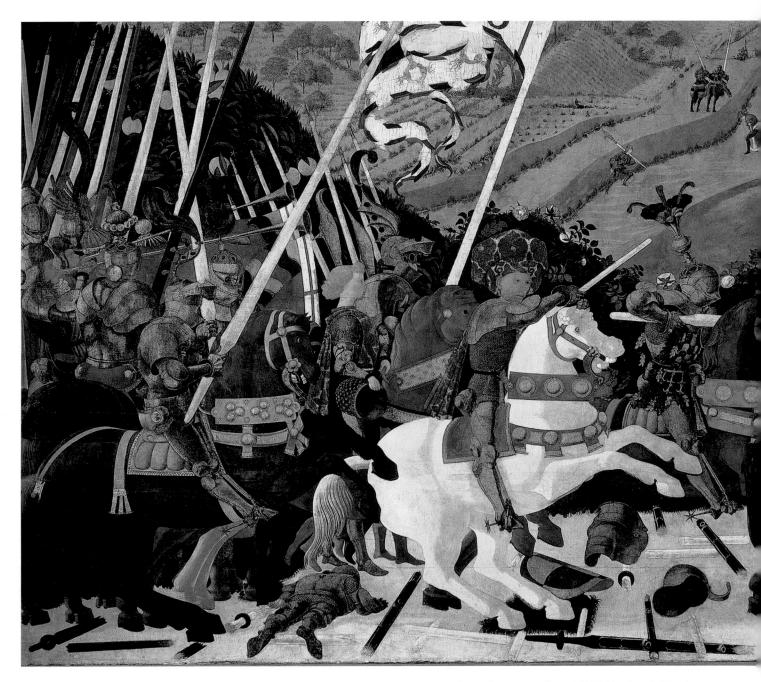

14–1 | Paolo Uccello | **THE BATTLE OF SAN ROMANO** | 1438–40. Tempera on wood panel, approx. $6' \times 10' \ 7'' \ (1.83 \times 3.23 \ m)$. National Gallery, London.

Reproduced by courtesy of the Trustees

RENAISSANCE ART IN FIFTEENTH-CENTURY ITALY

14

The ferocious but bloodless battle we see in FIGURE 14–1 could take place only in our dreams. Under an elegantly fluttering banner, the Florentine general Niccolò da Tolentino leads his men

against the Sienese at the Battle of San Romano, which took place on June 1, 1432. In the center foreground, Niccolò holds aloft a baton of command, the sign of his authority. His bold gesture, together with his white horse and fashionable crimson and gold damask hat, ensure that he dominates the scene. The general's knights charge into the fray, and when they fall, like the soldier at the lower left, they join the many broken lances on the ground—all arranged in conformity with the new mathematical depiction of space, one-point (linear) perspective.

The battle rages across a shallow stage defined by the debris of warfare arranged in a neat pattern on a pink ground and backed by a hedge of blooming orange trees and rosebushes. In the cultivated hills beyond, crossbowmen prepare their lethal bolts. A Florentine painter nicknamed Paolo Uccello ("Paul Bird"), whose given name was Paolo di Dono (c. 1397–1475), created this panel painting, housed today in London's National Gallery. It is one of three panels now separated; the other two are hanging in major museums in Florence and Paris.

The complete history of these paintings has only recently come to light. Lionardo Bartolini Salimbeni (1404–79), who led the Florentine city government during the war against Lucca and Siena, probably commissioned the paintings. Uccello's remarkable accuracy when depicting armor from the 1430s, heraldic banners, and even fashionable fabrics and crests surely would have appealed to civic pride.

The hedges of oranges, roses, and pomegranates—all ancient fertility symbols—make a tapestry-like background for the action. Lionardo and his wife Maddalena had six sons, two of whom inherited the paintings. According to a complaint brought by one of the heirs, Damiano, Lorenzo de' Medici, the powerful de facto ruler of Florence, "forcibly removed" the paintings from Damiano's house. The paintings were never returned, and Uccello's masterpieces are recorded in a 1492 inventory as hanging in Lorenzo's private chamber in the Medici palace. Perhaps Lorenzo, who was called "the Magnificent," saw Uccello's heroic pageant as a trophy worthy of a Medici merchant prince.

In the sixteenth century, the artist, courtier, and historian Giorgio Vasari devoted a chapter to Paolo Uccello in his book *The Lives of the Most Excellent Italian Architects, Painters, and Sculptors.* He described Uccello as a man so obsessed with the study of perspective that he neglected his painting, his family, and even his beloved birds, until he finally became "solitary, eccentric, melancholy, and impoverished" (Vasari, page 79). His wife "used to declare that Paolo stayed at his desk all night, searching for the vanishing points of perspective, and when she called him to bed, he dawdled, saying: 'Oh, what a sweet thing this perspective is!'" (Vasari, page 83; translation by J. C. and P. Bondanella, Oxford, 1991). Such passion for science is typical of fifteenth-century artists, who were determined to capture the appearance of the material world and to subject it to overriding human logic. Thus a battle scene becomes a demonstration of the science of perspective.

CHAPTER-AT-A-GLANCE

- HUMANISM AND THE ITALIAN RENAISSANCE
- FLORENCE | Architecture | Sculpture | Painting | Mural Painting in Florence After Masaccio
- ITALIAN ART IN THE SECOND HALF OF THE FIFTEENTH CENTURY | Urbino | Mantua | Rome | The Later Fifteenth Century in Florence | Venice
- IN PERSPECTIVE

HUMANISM AND THE ITALIAN RENAISSANCE

By the end of the Middle Ages, the most important Italian cultural centers lay north of Rome in the cities of Florence, Milan, and Venice, and in the smaller duchies of Mantua, Ferrara, and Urbino. In the south, Naples, Apulia, and Sicily were under French and then Aragonese control. Much of the power and influential art patronage was in the hands of wealthy families: the Medici in Florence, the Montefeltro in Urbino, the Gonzaga in Mantua, the Visconti and Sforza in Milan, and the Este in Ferrara. Cities grew in wealth and independence as people moved to them from the countryside in unprecedented numbers. Commerce became increasingly important. In some of the Italian states a noble lineage was not necessary for-nor did it guarantee-political and economic success. Money conferred status, and a shrewd business or political leader could become very powerful. The period saw the rise of mercenary armies led by entrepreneurial (and sometimes brilliant) military commanders called condottieri. Unlike the knights of the Middle Ages, they owed allegiance only to those who paid them well; their employer might be a city-state, a lord, or even the pope. Some condottieri, like

Niccolò da Tolentino, became rich and famous. Others, like Federico da Montefeltro (SEE FIG. 14–29), were lords or dukes themselves, with their own territories in need of protection. Patronage of the arts was an important public activity with political overtones. As one Florentine merchant, Giovanni Rucellai, succinctly noted, he supported the arts "because they serve the glory of God, the honour of the city, and the commemoration of myself" (cited in Baxandall, page 2).

Like their northern counterparts (see Chapter 13), Italian humanists had a new sense of the importance of human thought and action, and they looked to the accomplishments of ages past for inspiration and instruction. For Italians, though, this had added significance. Although politically divided into many small entities, and therefore not resembling the country we know today, Italy existed as a geographic unit with a common heritage descended from ancient Rome. Ancient Rome therefore provided not only a unifying ideal of power and wealth but also a unifying culture based on ethical principles. Humanists sought the physical and literary records of the ancient world—assembling libraries, collecting sculpture and fragments of architecture, and beginning archaeological investigations of ancient Rome. They imagined a golden age of

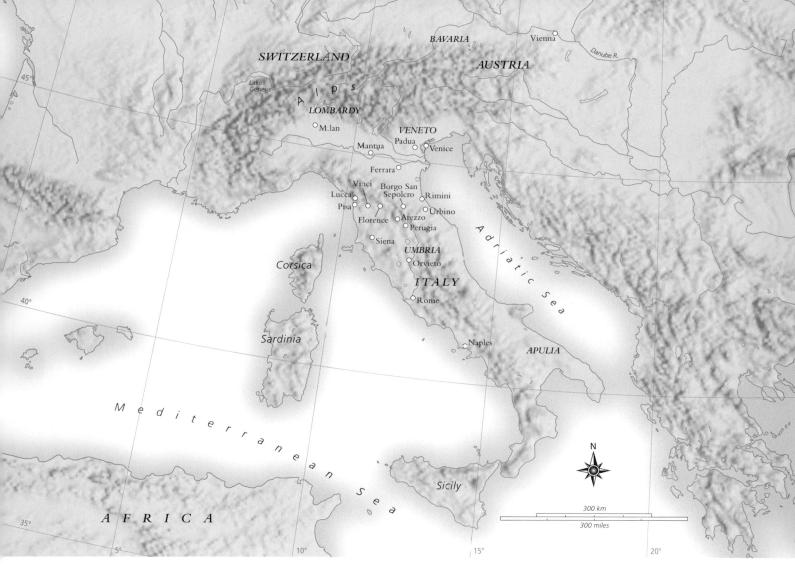

MAP 14-1 Fifteenth-century Italy

Powerful families divided the Italian peninsula into city-states—the Medici in Florence, the Visconti and Sforza in Milan, the Montefeltro in Urbino, the Gonzaga in Mantua, and the Este in Ferrara. After 1420 the popes ruled Rome, while in the south Naples and Sicily were French and then Spanish (Aragonese) territories. Venice maintained her independence as a republic.

philosophy, literature, and the arts, which they hoped to recapture. Their aim was to live a rich, noble, and productive life—usually within the framework of Christianity but always adhering to a school of philosophy as a moral basis.

Artists, like the humanist scholars, turned to classical antiquity for inspiration even as they continued to fulfill commissions for predominantly Christian subjects. Secular works other than portraits do not survive in great numbers until the second half of the century. Much has been lost, especially painted home furnishings such as birth trays and marriage chests. Allegorical and mythological themes appeared, as patrons began to collect art for their personal enjoyment. Because few examples of ancient Roman painting were known in the fifteenth century, Renaissance painters looked to Roman sculpture and to literature. The male nude became an acceptable subject in Renaissance art, often justified as a religious image—Adam, Jesus on the cross, and martyrdoms of saints such as Sebastian. Other than representations of Eve or an occasional allegorical or mythological figure such as Venus, female nudes were rare until the end of the century.

Like the Flemish artists, Italian painters and sculptors moved gradually toward a greater precision in rendering the illusion of physical reality. They did so in a more analytical way than the northerners had, with the goal of achieving correct but perfected figures set within a rationally, rather than visually, defined space. Painters and sculptors developed a mathematical system called *linear perspective*, which achieved the illusion of a measured and continuously receding space (see "Brunelleschi, Alberti, and Renaissance Perspective," page 492). Italian architects also came to apply abstract, mathematically derived design principles to the plans and elevations of the buildings.

FLORENCE

In seizing Uccello's battle painting (SEE FIG. 14–1), Lorenzo de' Medici was asserting the role his family had come to play in the history of Florence. The fifteenth century witnessed the rise of the Medici from among the most successful of a newly rich middle class (comprising primarily merchants and

Technique

BRUNELLESCHI, ALBERTI, AND RENAISSANCE PERSPECTIVE

A rtists such as Jan van Eyck refined intuitive perspective in order to approximate the appearance of things growing smaller and closer together in the distance, coupling it with atmospheric, or aerial, perspective. In Italy, the humanists' study of the natural world and their belief that "man is the measure of all things" led to the invention of a system of perspective that enabled artists to represent the visible world in a convincingly illusionistic way. This system—known variously as mathematical, linear, or one-point perspective—was first demonstrated by the architect Filippo Brunelleschi about 1420.

Brunelleschi's biographer, writing in the 1480s, describes two perspective panels that the architect created. One of them depicted the front of the Florentine Baptistry as if it were seen by someone standing three *braccia* inside the front door of the cathedral—a total of 60 *braccia* from the Baptistry. (In Florence, a *braccia*—meaning "arm," in Italian—measured about 2 feet.) To obtain this illusion, Brunelleschi pierced a hole in the back of the panel at the center point of the composition and placed a mirror one *braccia* length in front of it. Viewers could peep through the hole and see a reflection of the Baptistry that could be understood in actual space. The illusion was made even more striking

by Brunelleschi's use of a burnished silver background, which reproduced real weather conditions.

Leon Battista Alberti developed and codified Brunelleschi's rules of perspective into a mathematical system for representing three dimensions on a twodimensional surface in his treatise, in Latin, De pictura (On Painting) in 1435. A year later he published an Italian version, Della pittura, making a standardized, somewhat simplified method available to a larger number of draftspeople, painters, and relief sculptors. The goal he articulated is to make an image resemble a "view through a window," the view being the image represented, and the window, the picture plane.

In this highly artificial Italian system, the picture's surface was a flat plane that intersected the viewer's field of vision at a right angle. The system is based on a one-eyed viewer standing a prescribed distance from a

work, dead center. From this fixed vantage point everything would appear to recede into the distance at the same rate, following imaginary lines called **orthogonals** that met at a single **vanishing point** on the horizon. Using orthogonals as a guide, artists could **foreshorten** objects, replicating the effect of perspective on individual objects. Despite its limitations, mathematical perspective seems to extend pictorial space into real space, providing the viewer with a direct, almost physical connection to the picture. It creates a compelling, even exaggerated sense of depth.

Early Renaissance artists relied on a number of mechanical methods. Many constructed devices with peepholes through which they sighted the figure or object to be represented. They used mathematical formulas to translate three-dimensional forms onto the picture plane, which they overlaid with a grid to provide reference points, or they emphasized the orthogonals created by tiled floors or buildings in the composition. As Italian artists became more comfortable with mathematical perspective over the course of the fifteenth century, they came to rely less on peepholes and formulas. Many artists adopted multiple vanishing points, which gave their work a more relaxed, less tunnel-like feeling.

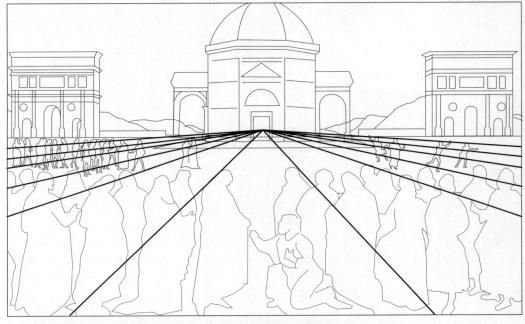

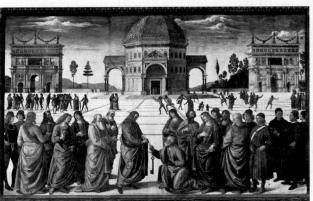

(ABOVE) Perugino THE DELIVERY OF THE KEYS TO SAINT PETER: SCHEMATIC DRAWING SHOWING THE ORTHOGONALS AND VANISHING POINT

(LEFT) Perugino THE DELIVERY OF THE KEYS TO SAINT PETER
Fresco on the right wall of the Sistine Chapel, Vatican, Rome. 1481. 11'5½" × 18' 8½" (3.48 × 5.70 m).

bankers) to become the city's virtual rulers. Unlike hereditary aristocracy, the Medici rose up from obscure roots to make their fortune in banking. The competitive Florentine atmosphere that had fostered mercantile success and civic pride also cultivated competition in the arts and encouraged an interest in the ancient literary texts. These factors have led observers to consider Florence the cradle of the Italian Renaissance. Under Cosimo the Elder (1389–1464), the Medici became leaders in intellectual and artistic patronage. They sponsored philosophers and other scholars who wanted to study the classics, especially the works of Plato and his followers, the Neoplatonists. Neoplatonism distinguished between the spiritual (the ideal or Idea) and the physical (Matter) and encouraged artists to represent ideal figures. Writers, philosophers, and musicians dominated the Medici Neoplatonic circle. Few architects, sculptors, or painters were included, because most of them had learned their craft in apprenticeships and were considered little more than manual laborers. Nevertheless, interest in the ancient world rapidly spread beyond the Medici circle to artists and craftspeople, who sought to reflect the new interests of their patrons in their work. Gradually, artists began to see themselves as more than artisans, and society eventually recognized their best works as achievements of a very high order.

Although the Medici were the de facto rulers, Florence was considered to be a republic. The Council of Ten (headed for a time by Salimbeni, who commissioned Uccello's *Battle of San Romano*) was a kind of constitutional oligarchy where wealthy men formed the government. At the same time, the various guilds wielded tremendous power, and evidence of this is the fact that guild membership was a prerequisite for holding government office. Consequently, artists could look to the church and the state and civic groups—the city and the guilds—as well as private individuals for patronage, and the patrons expected the artists to reaffirm and glorify their achievements.

Architecture

The defining civic project of the early years of the fifteenth century was the completion of the Florence Cathedral with a magnificent dome over the high altar. The construction of the cathedral had begun in the late thirteenth century and had continued intermittently during the fourteenth century (see Chapter 12). As early as 1367, the builders had envisioned a very tall dome to span the huge interior space of the crossing, but they lacked the engineering know-how to construct it. When interest in completing the cathedral revived, around 1407, the technical solution was proposed by a young sculptor-turned-architect, Filippo Brunelleschi.

FILIPPO BRUNELLESCHI. Filippo Brunelleschi (1377–1446), whose father had been involved in the original plans for the cathedral 'dome in 1367, achieved what many considered impossible: He solved the problem of the dome. Brunelleschi originally had trained as a goldsmith. To further his education

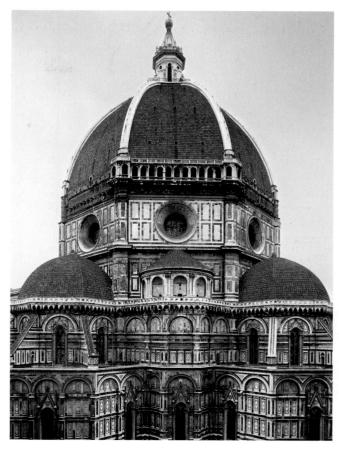

I4−2 | Filippo Brunelleschi DOME OF FLORENCE CATHEDRAL

1417-36; lantern completed 1471; the gallery, 1515.

The cathedral dome was a source of immense local pride. Renaissance architect and theorist Leon Battista Alberti described it as rising "above the skies, large enough to cover all the peoples of Tuscany with its shadow."

he traveled to Rome, probably with his friend, the sculptor Donatello. In Rome he studied ancient Roman sculpture and architecture. On his return to Florence, he tackled the problem of the cathedral. First he advised constructing a tall octagonal drum, as a base. The drum was finished in 1412, and in 1417, Brunelleschi was ready to design the dome itself (FIG. 14-2). From 1420 until 1436, workers built the dome. A revolutionary feat of engineering, the dome is a double shell of masonry 138 feet across. The octagonal outer shell is supported on eight large and sixteen lighter ribs. Instead of using a costly and even dangerous scaffold and centering, Brunelleschi devised a system in which temporary wooden supports were cantilevered out from the drum. He moved these supports up as building progressed. As the dome was built up course by course, each portion of the structure reinforced the next one. Vertical marble ribs interlocked with horizontal sandstone rings, connected and reinforced with iron rods and oak beams. The inner and outer shells were linked internally by a system of arches. When completed, this self-buttressed unit required no external support to keep it standing. Unsure of Brunelleschi's still theoretical approach to building, the men responsible for

I4–3 | Filippo Brunelleschi OLD SACRISTY, CHURCH OF SAN LORENZO, FLORENCE 1421–28, approx. $38 \times 38'$ (11.6 \times 11.6 m). Sculpture by Donatello.

Brunelleschi wanted simple architecture and protested the addition of sculpture.

the cathedral also appointed a respected master mason to assist with practical details of construction.

An oculus (round opening) in the center of the dome was surmounted by a lantern designed in 1436. After Brunelleschi's death, this crowning structure, made up of Roman architectural forms, was completed by another Florentine architect, Michelozzo di Bartolomeo (1396–1472). The final touch—a gilt bronzed ball—was added in 1468–71.

Other commissions came quickly after the cathedral dome project, as Brunelleschi's innovative designs were well received by Florentine patrons. From about 1418 until his death in 1446, Brunelleschi was involved in a series of influential projects. In 1419 he designed a foundling hospital for the city (see "The Foundling Hospital," page 496). For the Medici's parish church of San Lorenzo, he designed a sacristy (a room where ritual attire and vessels are kept), which also served as a burial chapel for Giovanni di Bicci de' Medici, who established the Medici fortune, and his wife (FIG. 14-3). Completed in 1428, it is called the **OLD SACRISTY** to distinguish it from the one built in the sixteenth century that lies opposite it on the other side of the church's choir. The Old Sacristy has a centralized plan, like a martyr's shrine in the Early Christian period. Later, Leon Battista Alberti, in his treatise on architecture (see page 492), wrote of the central plan as an ideal, derived from the humanist belief that the circle was a symbol of divine perfection and that both the circle inscribed in a square and the cross inscribed in a circle were symbols of the cosmos.

The present church of San Lorenzo replaced an eleventh-century basilica. Brunelleschi conceived plans for the new church during the time that he designed and built the sacristy, that is, between 1421 and 1428, but Michelozzo, whose name appears in the construction documents, finished the building after Brunelleschi's death. The façade was never built.

The **church of san Lorenzo** has a basilican plan with a long nave flanked by side aisles that open into shallow lateral chapels (FIG. 14-4). A short transept and square crossing lead to a square sanctuary flanked by additional chapels opening off the transept. Projecting from the left transept, as one faces the altar, are Brunelleschi's sacristy and the older Medici tomb. The Church of San Lorenzo is notable for its mathematical regularity. Brunelleschi based his plan on a square module—a basic unit of measure that could be multiplied or divided and applied to every element of the design. Medieval builders had used modular plans, but Brunelleschi applied the module with greater consistency, and the result was a series of clear, harmonious spaces (FIG. 14-5). Ornamental details, all in a classical style, were carved in pietra serena, a grayish stone that became synonymous with Brunelleschi's interiors. Below the plain clerestory (upper-story wall of windows) with its unobtrusive openings, the arches of the nave arcade are carried on tall, slender Corinthian columns made even taller by the insertion of an impost block between the column capital and the springing of the round arches—one of Brunelleschi's favorite details. Flattened architectural forms in pietra serena repeat the arcade in the outer walls of the side aisles, and each bay is covered by its own shallow domical

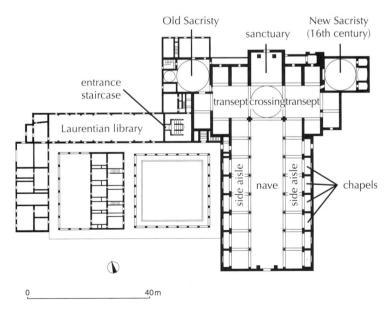

14–4 | Filippo Brunelleschi PLAN OF THE CHURCH OF SAN LORENZO, FLORENCE Includes later additions and modifications.

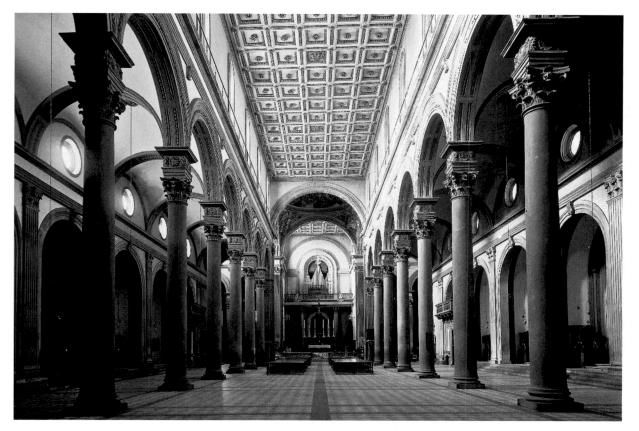

I4–5 | Filippo Brunelleschi; continued by Michelozzo di Bartolomeo NAVE, CHURCH OF SAN LORENZO, FLORENCE c. 1421–28, nave (designed 1434?) 1442–70.

vault. The square crossing is covered by a hemispherical dome; the nave and transept by flat ceilings. Brunelleschi's rational approach, unique sense of order, and innovative incorporation of classical motifs inspired later Renaissance architects, many of whom learned from his work firsthand by completing his unfinished projects.

THE MEDICI PALACE. Brunelleschi may have been involved in designing the nearby Medici Palace (now known as the PALAZZO MEDICI-RICCARDI) in 1446. According to sixteenth-century gossip recorded by Giorgio Vasari, Cosimo de' Medici the Elder rejected Brunelleschi's model for the palazzo as too grand (any large house was called a "palace"—palazzo). The courtyards of both buildings were the work of Michelozzo, whom many scholars have accepted as the designer of the building (FIG. 14–6). The austere exterior was in keeping with the republican political climate and Florentine religious attitudes, imbued with the Franciscan ideals of

14–6 | Attributed to Michelozzo di Bartolomeo **FAÇADE, PALAZZO MEDICI-RICCARDI, FLORENCE** Begun 1446.

For the palace site, Cosimo de' Medici the Elder chose the Via de' Gori at the corner of the Via Larga, the widest city street at that time. Despite his practical reasons for constructing a large residence and the fact that he chose simplicity and austerity over grandeur in the exterior design, his detractors commented and gossiped. As one exaggerated: "[Cosimo] has begun a palace which throws even the Colosseum at Rome into the shade."

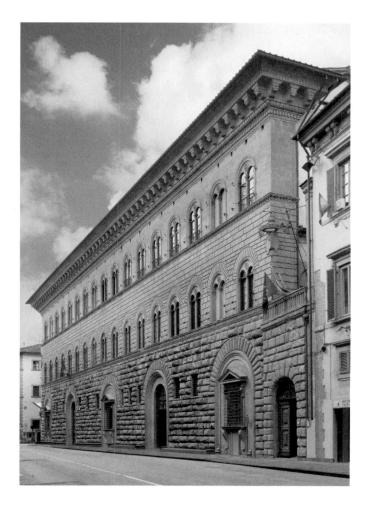

THE OBJECT SPEAKS

THE FOUNDLING HOSPITAL

n 1419 the Guild of Silk Manufacturers and Goldsmiths in Florence undertook a significant public service: It established a large public orphanage and commissioned the brilliant young architect Filippo Brunelleschi to build it next to the Church of the Santissima Annunziata ("Most Holy Annunciation"), which housed a miracle-working painting of the Annunciation. Completed in 1444, the Foundling Hospital, the Ospedale degli Innocenti, was unprecedented in terms of scale and design innovation.

In the Foundling Hospital, Brunelleschi created a building that paid homage to traditional forms while introducing what came to be known as the Italian Renaissance style. Traditionally, a charitable foundation's building had a portico open to the street to provide shelter. Brunelleschi built an arcade of hitherto unimagined lightness and elegance, using smooth round columns and richly carved capitals-his own interpretation of the classical Corinthian order. The underlying mathematical basis for his design creates a sense of classical harmony. Each bay of the arcade encloses a cube of space defined by the 10-braccia (20-foot) height of the columns and the diameter of the arches. Hemispherical pendentive domes, half again as high as the columns, cover the cubes. The bays at the end of the arcade are slightly larger than the rest, creating a subtle frame for the composition. Brunelleschi defined the perfect squares and circles of his building with dark gray stone (pietra serena) against plain white walls. His training as a goldsmith and sculptor served him well as he led his artisans to carve crisp, elegantly detailed capitals and moldings for the open, covered gallery.

A later addition to the building seems eminently suitable: About 1487, Andrea della Robbia, who had inherited the family firm and its secret glazing formulas from his uncle Luca (see "Ceramics," page 504), created blue-and-white glazed terra-cotta medallions that signified the building's function. The babies in swaddling clothes, one in each medallion, are among the most beloved images of Florence.

The medallions seem to embody the human side of Renaissance humanism, reminding viewers that the city's wealthiest guild cared for the most helpless members of society. Perhaps the Foundling Hospital spoke to fifteenth-century Florentines of an increased sense of social responsibility. Or perhaps, by so publicly demonstrating social concerns, the wealthy guild that sponsored it solicited the approval and support of the lower classes in the cutthroat power politics of the day.

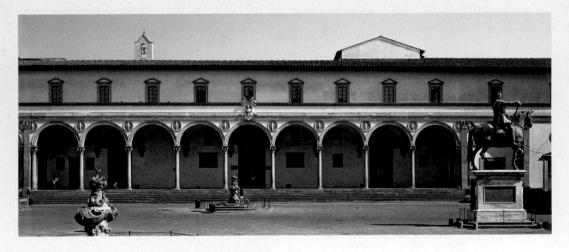

(ABOVE) Filippo Brunelleschi FOUNDLING HOSPITAL, FLORENCE Italy. Designed 1419; built 1421–44.

(LEFT) Andrea della Robbia

DETAIL OF TERRA-COTTA MEDALLION

poverty and charity. Like many other European cities, Florence had sumptuary laws, which forbade ostentatious displays of wealth—but they were often ignored. For example, private homes were supposed to be limited to a dozen rooms; Cosimo, however, acquired and demolished twenty small houses to provide the site for his new residence. The house was more than a dwelling place; it was his place of business, company headquarters. The *palazzo* symbolized the family and underscored the family's place in society. The building is linked to the seat of government, the Palazzo della Signoria (SEE FIG. 12–2), logistically by means of a straight line of connecting streets and symbolically through its imposing massiveness.

Huge in scale (each story is more than twenty feet high—today's builders calculate ten feet per story), the building has harmonious proportions and elegant, classically inspired details. On one side, the ground floor originally opened through large, round arches onto the street, creating in effect a loggia that provided space for the family business. These arches were walled up in the sixteenth century and given windows designed by Michelangelo. The façade of large, rusticated stone blocks—that is, blocks with their outer faces left rough, typical of Florentine town house exteriors—was derived from fortifications. On the façade, the stories are clearly set off from each other by the change in the stone surfaces from very rough at the ground level to almost smooth on the third.

The builders followed the time-honored tracition of placing rooms around a central courtyard. Unlike the still-medieval plan of the House of Jacques Coeur (SEE FIG. 13–24), however, the MEDICI PALACE COURTYARD is square in plan with rooms arranged symmetrically (FIG. 14–7). Round arches on slender columns form a continuous arcade and support an enclosed second story. Tall windows in the second story match the exterior windows. Disks bearing the Medici arms surmount each arch in a frieze decorated with swags in sgraffito work (tinted and engraved plaster). Such classical elements, inspired by the study of Roman ruins, gave the great house an aura of dignity and stability and undoubtedly enhanced the status of its owners. The Medici Palace inaugurated a new monumentality and regularity of plan in residential urban architecture. Wealthy Florentine families soon copied it in their own houses.

LEON BATTISTA ALBERTI. The relationship of the façade to the body of the building behind it was a continuing challenge for Italian Renaissance architects. Early in his architectural career, Leon Battista Alberti (1404–72), a lawyer turned humanist, architect, and author, devised a façade to be the unifying front for a planned merger of eight adjacent houses in Florence acquired by Giovanni Rucellai (FIG. 14–8). Work began about 1455, but the house was never finished, as is obvious on the right side of the view seen here. It has been suggested that Alberti designed a five-bay façade with a central door and that Bernardo Rossellino (1409–64), the builder on record, added two more bays and began the eighth but was unable to finish

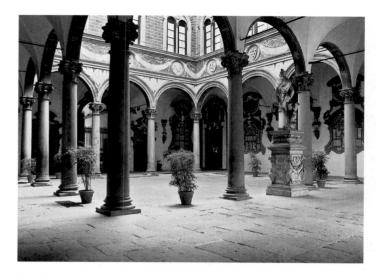

14-7 COURTYARD WITH SGRAFFITO DECORATION, PALAZZO MEDICI-RICCARDI, FLORENCE Begun 1446.

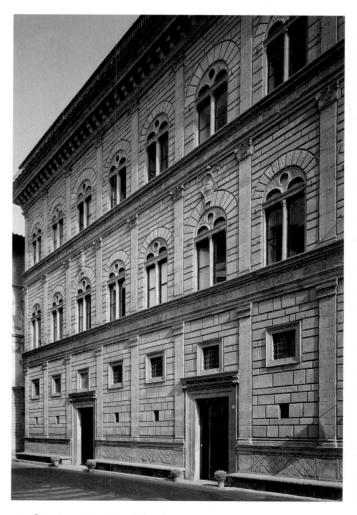

14–8 Leon Battista Alberti PALAZZO RUCELLAI, FLORENCE Left five bays 1455–58; later extended but never finished.

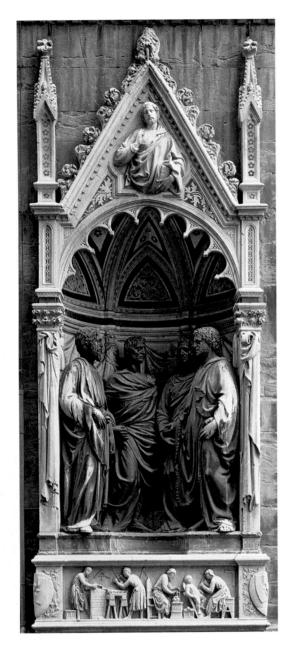

14–9 Nanni di Banco THE FOUR CROWNED MARTYRS c. 1409–17. Marble, height of figures 6' (1.83 m). Orsanmichele, Florence (photographed before removal of figures to museum). The sculpture has been cleaned and restored.

the façade because Rucellai could not acquire the additional land. Alberti's design, influenced in its basic approach by the Palazzo Medici, was a simple rectangular front suggesting a coherent, cubical three-story building capped with an overhanging cornice, the heavy, projecting horizontal molding at the top of the wall. The double windows under round arches were a feature of Michelozzo's Palazzo Medici, but other aspects of the façade were entirely new. Inspired by the ancient Colosseum in Rome, Alberti created systematic divisions on the surface of the lightly rusticated wall with a horizontal-vertical pattern of pilasters and architraves. He superimposed the classically inspired orders on three levels: a novel type of the Doric on the ground floor (the first time this order is employed in Renaissance architecture), a modified version of

the Corinthian on the second floor, and a standard Corinthian on the third. The **PALAZZO RUCELLAI** provided a visual lesson for local architects in the use of classical elements and mathematical proportions, and Alberti's enthusiasm for classicism and his architectural projects in other cities were catalysts for the spread of the Renaissance movement.

Sculpture

The new architectural language inspired by ancient classical form was accompanied by a similar impetus in sculpture. By 1400, Florence had enjoyed internal stability and economic prosperity for over two decades. However, until 1428, the city and its independence were challenged by two great antirepublican powers: the Duchy of Milan and the Kingdom of Naples. In an atmosphere of wealth and civic patriotism, Florentines turned to commissions that would express their self-esteem and magnify the importance of their city. A new attitude toward realism, space, and the classical past set the stage for more than a century of creativity.

In the early fifteenth century the two principal sculptural commissions in Florence included the new set of bronze doors for the Baptistry of Florence Cathedral and the exterior niche decorations of Orsanmichele. Individual commissions for the Orsanmichele sculptures were awarded to a number of different artists. The competitive and distinctive nature of the works produced reveals a great deal about the artistic climate of early Renaissance Florence.

ORSANMICHELE. In the fourteenth century, the city's fourteen most powerful guilds had been assigned the ground floor niches that decorated the exterior of Orsanmichele and were asked to fill them with images of their patron saints (SEE FIG. 12–1). By 1400, only three had fulfilled this responsibility. In the new climate of republicanism and civic pride, the government pressured the guilds to furnish their niches with statuary. The assignment, with some replacements, took almost a century to reach its conclusion. In the meantime, Florence witnessed a dazzling sculptural exposition. Among the most important examples were two early commissions given to the sculptors Nanni di Banco and Donatello.

Nanni di Banco (c. 1385–1421), son of a sculptor in the Florence Cathedral workshop, produced statues for three of Orsanmichele's niches in his short but brilliant career. **THE FOUR CROWNED MARTYRS** was commissioned about 1409 by the stone carvers' and woodworkers' guild, to which Nanni himself belonged (FIG. 14–9). These martyrs, according to tradition, were third-century Christian sculptors who were executed for refusing to make an image of a pagan Roman god. Although the architectural setting resembles a small-scale Gothic chapel, Nanni's figures—with their solid bodies; heavy, form-revealing togas; stylized hair and beards; and naturalistic features—reveal Nanni's interest in ancient Roman sculpture, particularly portraiture, and are testimony to his role in the

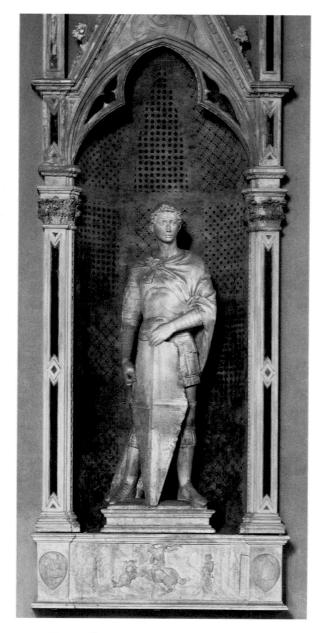

14–10 | **Donatello SAINT GEORGE** 1415–17. Marble, height 6′5″ (1.95 m). Bargello, Florence. Formerly Orsanmichele, Florence.

revival of classicism. The saints convey a new spatial relationship to the building and to the viewer. They stand in a semicircle with forward feet and drapery protruding beyond the floor of the niche. The saints appear to be four individuals talking together, in an open arrangement that involves the passerby. Nanni's sense of a unified geometric composition is based on a circle completed in the space beyond the niche. In the relief panel below the niche, showing the four sculptors at work, Nanni has given the forms a similar solid vigor. He achieved this by deeply undercutting both figures and objects to cast shadows and enhance the illusion of three-dimensionality.

Another sculptor to receive guild commissions for the niches at Orsanmichele was Donatello (Donato di Niccolò di Betto Bardi, c. 1386/87–1466), the great genius of early Italian

Sequencing Events THE MEDICI OF FLORENCE

1360-1429	Giovanni di Bicci de' Medici founded family fortune
1389-1464	Cosimo de' Medici; later known as Pater Patriae ("Father of the Florentine state")
1416-69	Piero the Gouty
1449-92	Lorenzo the Magnificent
1471-1503	Piero the Unfortunate; driven out of Florence by Savonarola in 1494

Renaissance sculpture and one of the most influential figures of the century in Italy. A member of the guild of stone carvers and woodworkers, he worked in both mediums. During his long and productive career, he rethought and executed each commission as if it were a new experiment. Donatello took a remarkably pictorial approach to relief sculpture. He developed a technique for creating the impression of very deep space by improving on the ancient Roman technique of varying heights of relief—high relief for foreground figures and very low relief, sometimes approaching engraving, for the background.

Commissioned by one of Florence's lesser guilds—the armorers and sword makers—to carve their patror saint for their niche, Donatello created a marble figure of **SAINT GEORGE** (FIG. 14–10). As originally conceived, Saint George would have been a standing advertisement for the guild. The figure carried a sword in his right hand and probably wore a metal helmet, a sword belt, and a sheath. The figure is remarkably successful even without these accoutrements. Saint George holds his shield squarely in front of his braced legs; he seems alert and ready as he turns to meet any challenge, yet the expression on his face is tense and worried. His rather sensitive features and wrinkled brow contrast with the serene confidence of medieval knights or aggressive *condottieri* (SEE FIG. 14–1).

The base of the niche, where Saint George is seen slaying a dragon to save the princess, is a remarkable feat of low-relief carving. The contours of the foreground figures are slightly undercut to emphasize their mass, while the landscape and architecture are in progressively lower relief until they are barely incised rather than carved. The result is a spatial setting in relief sculpture as believable as any illusionistic painting.

GATES OF PARADISE. In 1401, a competition was announced in order to determine who would design bronze relief panels for a new set of doors for the east—and most important—side of the Baptistry of San Giovanni. These doors faced the main entrance to the cathedral, and the commission carried enormous prestige—and expense. The commission was awarded to Lorenzo Ghiberti (1381?–1455), a young artist trained as a goldsmith, at the very beginning of

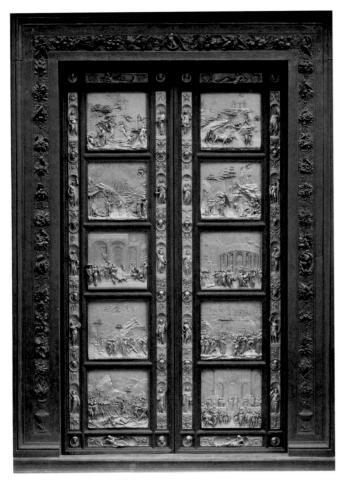

14–11 | Lorenzo Ghiberti GATES OF PARADISE (EAST DOORS), BAPTISTRY OF SAN GIOVANNI, FLORENCE 1425–52. Gilt bronze, height 15′ (4.57 m). Museo dell'Opera del Duomo, Florence.

Ghiberti, whose bust portrait appears at the lower right corner of Jacob and Esau, wrote in his *Commentaries* (c. 1450-55): "I strove to imitate nature as clearly as I could, and with all the perspective I could produce, to have excellent compositions with many figures."

his career. His rival was none other than Brunelleschi, who claimed the competition ended in a tie.

Ghiberti's doors were such a success that in 1425 he was awarded the commission for the third set of doors for the east side of the baptistry, and his first set was moved to the north side. The door panels, commissioned by the Wool Manufacturers' Guild, were a significant conceptual leap from the older schemes of twenty-eight small scenes employed for Ghiberti's earlier doors and those of Andrea Pisano in the fourteenth century (SEE FIG. 12-5). The chancellor of Florence expressed the desire for a magnificent and memorable work. Ghiberti responded to the challenge by departing entirely from the old arrangement: He produced a set of ten Old Testament scenes, from the Creation to the reign of Solomon. Michelangelo reportedly said that those doors, installed in 1452, were worthy of being the GATES OF PARADISE (FIG. 14-11). Overall gilding unites the ten large, square reliefs. Ghiberti organized the space either by a system of linear perspective, with obvious orthogonal lines approximating the system described by Alberti in his 1435 treatise on painting (see "Brunelleschi, Alberti, and Renaissance Perspective," page 492) or sometimes more intuitively by a series of arches or rocks or trees leading the eye into the distance. Foreground figures are grouped in the lower third of the panel, while the other figures decrease gradually in size, suggesting deep space. The use of a system of perspective, with background and foreground clearly marked, also helped the artist to combine a series of related events within only one frame. In some panels, the tall buildings suggest ancient Roman architecture and illustrate the emerging antiquarian tone in Renaissance art.

The story of Jacob and Esau (Genesis 25 and 27) forms the relief in the center panel of the left door. Ghiberti creates a coherent and measurable space peopled by graceful, idealized figures (FIG. 14-12). He unifies the composition by paying careful attention to one-point perspective in the architectural setting. Squares marked out in the pavement establish the lines of the orthogonals that recede to a central vanishing point under the loggia, and towering arches supported on piers with Corinthian pilasters define the space above the figures. The story from Genesis unfolds in a series of individual episodes and begins in the background. On the rooftop (upper right) Rebecca stands, listening to God, who warns of her unborn sons' future conflict; under the left-hand arch she gives birth to the twins. The adult Esau sells his rights as oldest son to Jacob, and when he goes hunting (center right), Rebecca and Jacob plot against him. Finally, in the

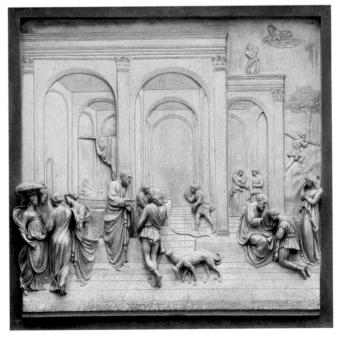

I4–I2 | Lorenzo Ghiberti JACOB AND ESAU, PANEL OF THE GATES OF PARADISE (EAST DOORS)
Formerly on the Baptistry of San Giovanni, Florence. c. 1435. Gilded bronze, 31¼" (79 cm) square. Museo dell'Opera del Duomo, Florence.

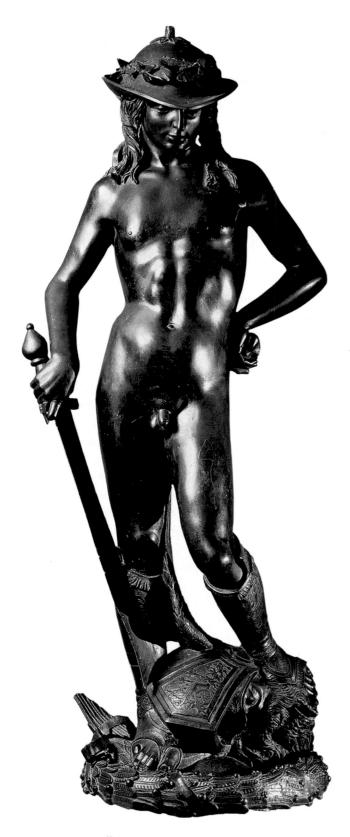

I4–I3 | Donatello **DAVID** c. 1446–60(?). Bronze, height 5′ 2¼″ (1.58 m). Museo Nazionale del Bargello, Florence.

While still in the Medici courtyard, the base was inscribed: "The victor is whoever defends the fatherland.
All-powerful God crushes the angry enemy.
Behold, a boy overcomes the great tyrant.
Conquer, O citizens!"

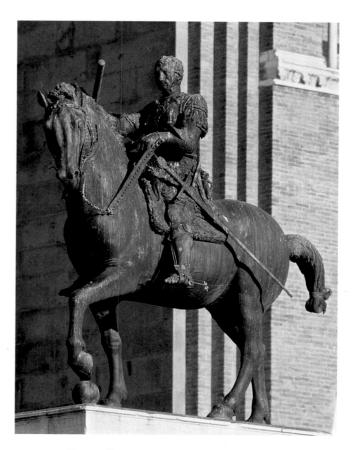

I4—I4 Donatello **EQUESTRIAN MONUMENT OF ERASMO DA NARNI (GATTAMELATA)**Piazza del Santo, Padua. 1443–53. Bronze, height approx. 12'2" (3.71 m).

right foreground, Jacob receives Isaac's blessing, while in the center, Esau faces his father.

In the Renaissance interpretation, Esau symbolized the Jews and Jacob the Christians. The story explains conflict between the two religions and compositionally balances the panel on the opposite door valve. The vanishing point lies between the two panels. Therefore Jacob, who occupies the right foreground, is near the center of interest for the doors as a whole. Esau and his faithful hound complete the beautiful curve of figures that begins with the trio of women at the far left and shows Ghiberti's debt to the International Gothic. In the spirit of Renaissance individuality, Ghiberti not only signed his work, but also included his self-portrait in the medallion beside the lower right-hand corner of the panel.

DONATELLO: NEW EXPRESSIVENESS. Donatello excelled for three reasons: his constant exploration of human emotions and expressions; his vision and insight in representing the formal problems inherent in his subjects; and his ability to solve the technical problems posed by various mediums, from bronze and marble to polychromed wood. In bronze sculpture, he produced the first life-size male nude, **DAVID** (FIG. 14–13); one of the first life-size bronze equestrian portraits, **GATTAME-LATA** (FIG. 14–14); and the first statuettes since antiquity.

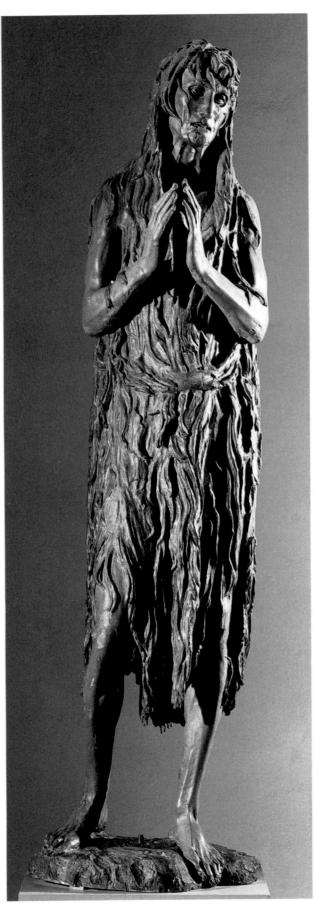

14–15 | Donatello MARY MAGDALEN 1450s(?). Polychromy and gold on wood, height 6'1" (1.85 m). Museo dell'Opera del Duomo, Florence.

Since nothing is known about the circumstances of its creation, the sculpture of the David has been the subject of continuous inquiry and speculation. Although the statue clearly draws on the classical tradition of heroic nudity, this sensuous, adolescent boy in a jaunty laurel-trimmed shepherd's hat and boots has long piqued interest in its meaning. In one interpretation, the boy's angular pose, his underdeveloped torso, and the sensation of his wavering between childish interests and adult responsibility heighten his heroism in taking on the giant and destroying him. With Goliath's severed head now under his feet, David seems to have lost interest in warfare and now seems to be retreating into his dreams. The sculpture is first recorded in 1469 in the courtyard of the Medici palace, where it stood on a base engraved with an inscription extolling Florentine heroism and virtue. This inscription supports the suggestion that the sculpture celebrated the triumph of the Florentines over the Milanese in 1425. A peace treaty was signed in 1428. It ended the struggle with the despots of Milan, which had endured for over a quarter of a century, and helped give Florence a vision of itself as a strong, virtuous republic.

In 1443, Donatello was probably called to Padua to execute the equestrian statue commemorating the Paduan general of the Venetian army, Erasmo da Narni, nicknamed "Gattamelata" (meaning "Honeyed Cat"—a reference to his mother, Melania Gattelli). If one image were to characterize the selfmade men of the Italian Renaissance, surely the most appropriate examples would be the *condottieri*—the brilliant generals (such as Tolentino, from Uccello's *Battle of San Romano*) who organized the armies and fought for any city-state willing to pay. The very word *chivalry* with all its connotations of honor, courage, and courtesy comes from the French word for "horse"—*cheval*. Italian Renaissance *condottieri* may have seen themselves as chivalric, as guardians of the state, although they were in fact tough, opportunistic mercenaries. But they, too, subscribed to an ideal of military and civic virtue.

Donatello's sources for this statue were two surviving Roman bronze equestrian portraits, one (now lost) in the north Italian city of Pavia, the other of the emperor Marcus Aurelius, which the sculptor certainly saw and probably sketched during his stay in Rome. Equestrian monuments of ancient Roman emperors demonstrated their virtues of bravery, nobility, and authority. Horsemanship was more than a necessary skill before the age of automobiles: It had symbolic meanings. The horse, a beast of enormous brute strength, symbolized the passions and man's physical animal nature. Consequently, skilled horsemanship demonstrated physical and intellectual control—self-control, as well as control of the animal—the triumph of the intellect, of "mind over matter."

Viewed from a distance, Donatello's man-animal juggernaut, installed on a high marble base in front of the Church of Sant'Antonio in Padua, seems capable of thrusting forward at the first threat. Seen up close, however, the man's sunken cheeks, sagging jaw, ropy neck, and stern but sad expression suggest a warrior grown old and tired from the constant need for military vigilance and rapid response.

During the decade that he remained in Padua, Donatello executed other commissions for the Church of Sant'Antonio. including a bronze crucifix and reliefs for the high altar and pulpits. His presence in the city introduced Renaissance ideas to northeastern Italy and gave rise to a new Paduan school of painting and sculpture. The expressionism of Donatello's late work inspired some artists to add psychological intensity even in public monuments. His MARY MAGDALEN, traditionally dated about 1455 (although it may have been executed before his stay in Padua), shows the saint, known for her physical beauty, as an emaciated, vacant-eved hermit clothed by her own hair (FIG. 14-15). Few can look at this figure without a wrenching reaction to the physical deterioration caused by age and years of self-denial. Nothing is left for her but an ecstatic vision of the hereafter, and yet that is everything. Despite Donatello's total rejection of the classical ideal form in this figure, the powerful force of the Magdalen's personality makes this a masterpiece of Renaissance imagery.

VERROCCHIO'S CONDOTTIERE. In the early 1480s, the Florentine painter and sculptor Andrea del Verrocchio (1435–88) was commissioned by the government to produce an equestrian monument honoring the Venetian army general Bartolommeo Colleoni (d. 1475), who left money for a memorial to himself (FIG. 14–16). In contrast to the thoughtful and even tragic over-

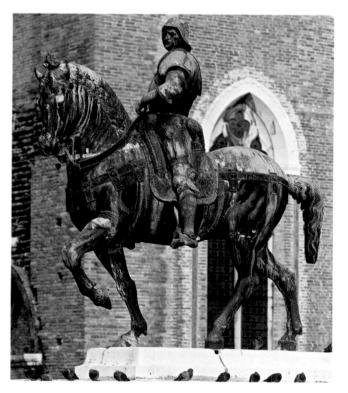

I4−I6 | Andrea del Verrocchio EQUESTRIAN MONUMENT OF BARTOLOMMEO COLLEONI, CAMPO SANTI GIOVANNI E PAOLO, VENICE

Clay model 1486-88; cast after 1490; placed 1496. Bronze, height approx. 13' (4 m). Bronze cast by Alessandro Leopardi.

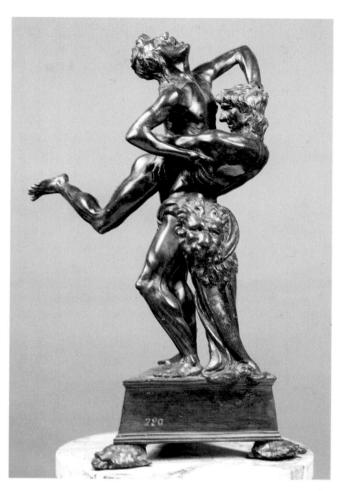

14–17 | Antonio del Pollaiuolo HERCULES AND ANTAEUS c. 1475. Bronze, height with base 18" (45.7 cm). Museo Nazionale del Bargello, Florence.

tones communicated by Donatello's *Gattamelata*, the impression conveyed by the tense forms of Verrocchio's equestrian monument is one of vitality and brutal energy. The general's ferocious determination is expressed in his clenched jaw and staring eyes. The taut muscles of the horse, the fiercely erect posture of the rider, and the complex interaction of the two make this image of will and domination a singularly compelling monument. It still presides over the square of Santi Giovanni e Paolo in Venice.

POLIAIUOLO. Sculptors in the fifteenth century worked not only on a monumental scale for the public sphere; they also created small works, each designed to inspire the mind and delight the eye of its private owner (see "Ceramics," page 504). The enthusiasm of European collectors in the latter part of the fifteenth century for small, easily transported bronzes contributed to the spread of classical taste. Antonio del Pollaiuolo, ambitious and multitalented—a goldsmith, embroiderer, printmaker, sculptor, and painter—came to work for the Medici family in Florence about 1460. His sculptures were mostly small bronzes; his HERCULES AND ANTAEUS of about 1475 is one of the largest (FIG. 14–17). This study of complex interlocking figures has an explosive energy that can best be appreciated by viewing it from every angle.

Technique

CERAMICS

talian sculptors did not limit themselves to the traditional materials of wood, stone and marble, and bronze. They also returned to **terra cotta**, a clay medium whose popularity in Italy went back to Etruscan and ancient Roman times. Techniques of working with and firing clay had been kept alive by the ceramics industry and by a few sculptors, especially in northern Italy.

Typical of Renaissance ceramics in shape and decoration is the albarello, a jar designed especially for pharmacies: The tall concave shape made it easy to remove from a line of jars on pharmacy shelves, and the lip at the rim helped secure the cord that tied a parchment cover over the mouth. Sometimes the name of the owner or the contents of the jar were inscribed on a band around the center (the jar shown held syrup of lemon). The jars were glazed white and decorated in deep, rich colored enamel—orange, blue, green, and purple. The technique for making this lustrous, tin-glazed earthenware had been developed by Islamic potters and then by Christian potters in Spain. It spread to Italy from the Spanish island of Mallorca—known in Italian as Maiorca, which gave rise to the term maiolica to describe such wares. The painted decoration of broad scrolling leaves seen here is characteristic of the fifteenth century.

Ceramics were also used to supply the ever-increasing demand for architectural sculpture. Luca della Robbia (1399/1400-1482), although an accomplished sculptor in marble, began to experiment in 1441-42 with tin glazing to make his ceramic sculpture both weatherproof and decorative. As his inexpensive and rapidly produced sculpture gained an immediate popularity, he added color to the traditional white glaze. His

workshop even made molds so that a particularly popular work could be replicated many times. The elegant and lyrical della Robbia style was continued by Luca's nephew Andrea and his children long after Luca's death (see "The Foundling Hospital," page 496).

ALBARELLO

Cylindrical pharmacy jar, from Faenza. c. 1480. Glazed ceramic, height 12 ½" (31.5 cm). Getty Museum, Los Angeles. Getty .84.DE.104

Statuettes of religious subjects were still popular, but humanist art patrons began to collect bronzes of Greek and Roman subjects. Many sculptors, especially those trained as goldsmiths, began to cast small copies after well-known classical works. Some artists also executed original designs all'antica ("in the antique style"). Although there were outright forgeries of antiquities at this time, works in the antique manner were intended simply to appeal to a cultivated humanist taste. Hercules was always a popular figure, as a patron of Florence. He was even used on the city seal. Among the many courageous acts by which Hercules gained immortality was the slaying of the evil Antaeus in a wrestling match by lifting him off the earth, the source of the giant's great physical power. Hercules had been attacked by Antaeus, the son of the earth goddess Ge (or Gaia), on his search for a garden that produced pure gold apples.

An engraving by Pollaiuolo, **THE BATTLE OF THE NUDES** (FIG. 14–18), reflects the interests of Renaissance scholars—the study of classical sculpture and the anatomical research

that leads to greater realism—as well as the artist's technical skill in fine work on a metal plate. Pollaiuolo may have intended this, his only known—but highly influential—print, as a study in composition involving the human figure in action. The naked men, fighting each other ferociously against a tapestry-like background of foliage, seem to have been drawn from a single model in a variety of poses, many of which were taken from classical sources. Like the artist's *Hercules and Antaeus*, much of the engraving's fascination lies in how it depicts muscles of the male body reacting under tension.

Painting

Italian patrons generally commissioned murals and large altarpieces for their local churches and smaller panel paintings for their private chapels. Artists experienced in fresco, mural painting on wet plaster, were in great demand and traveled widely to execute wall and ceiling decorations. At first the Italians showed little interest in oil painting, for the most part

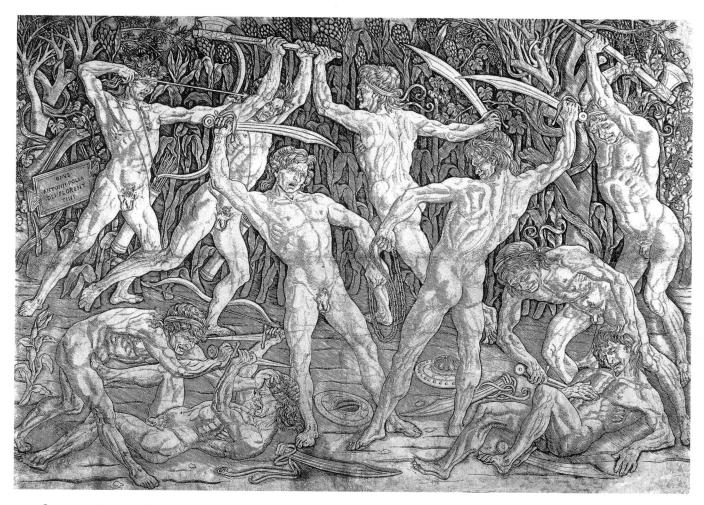

using tempera even for their largest works. But, in the last decades of the century, Venetians began to use the oil medium for major panel paintings.

MASACCIO. The most innovative of the early Italian Renaissance painters was Tommaso di Ser Giovanni di Mone Cassai (1401–28/29?), nicknamed "Masaccio." In his short career of less than a decade, he established a new direction in Florentine painting, much as Giotto had a century earlier. Masaccio rejected the International Gothic style in favor of monumental forms that occupy rationally defined and unified space. Masaccio's interest in one-point perspective, the new architectural style, and classical sculpture allies him, especially, with his older contemporary Brunelleschi. Masaccio's fresco of the Trinity in the Church of Santa Maria Novella in Florence must have been painted around 1426, the date on the Lenzi family tombstone that was once in front of the fresco (FIG. 14–19). The TRINITY was meant to give the illusion of a stone funerary monument and altar table set below

a deep *aedicula* (framed niche) in the wall. The praying donors in front of the pilasters may be members of the Lenzi family. The red robes of the male donor at the left signify that he was a member of the governing council of Florence.

Masaccio created the unusual *trompe l'oeil* ("fcol-the-eye") effect of looking up into a barrel-vaulted niche, made plausible through precisely rendered linear perspective. The eye and level of an adult viewer determined the horizon line on which the vanishing point was centered, just above the base of the cross. The painting demonstrates Masaccio's intimate knowledge of both Brunelleschi's perspective experiments and his architectural style (SEE FIG. 14–5). The painted architecture is an unusual combination of classical orders; on the wall surface, Corinthian pilasters support a plain architrave below a cornice, while inside the niche Renaissance variations on Ionic columns support arches on all four sides. The Trinity is represented by Jesus on the cross, the dove of the Holy Spirit poised in downward flight above his tilted halo, and God the Father, who stands behind the cross on a

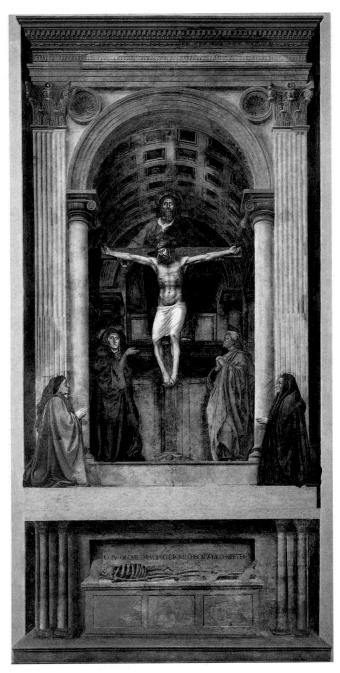

14–19 | Masaccio TRINITY WITH THE VIRGIN, SAINT JOHN THE EVANGELIST, AND DONORS Church of Santa Maria Novella, Florence. c. 1425-27/28. Fresco $21' \times 10'5''$ (6.4×3.2 m).

high platform apparently supported on the rear columns. The "source" of the consistent illumination modeling the figures with light and shadow lies in front of the picture, casting reflections on the coffers, or sunken panels, of the ceiling. As in many scenes of the Crucifixion, Jesus is flanked by the Virgin Mary and John the Evangelist, who contemplate the scene. Mary gazes calmly out at us, her raised hand presenting

the Trinity. Below, in an open sarcophagus, is a skeleton, a grim reminder that death awaits us all and that our only hope is redemption and life in the hereafter through Christian belief. The skeleton represents Adam, on whose tomb the cross was thought to have been set. The inscription above the skeleton reads: "I was once that which you are, and what I am you also will be."

THE BRANCACCI CHAPEL. Masaccio's brief career reached its height in his collaboration with another painter, Masolino (1383–c. 1440), on the fresco decoration of the BRANCACCI CHAPEL in the Church of Santa Maria del Carmine in Florence (FIG. 14–20). The project was ill-fated, however: The painters never finished their work—Masolino traveled to Hungary in 1425–27, and the two painters went to Rome in 1428. Masaccio died in Rome in 1428 or 1429. Felice Brancacci, the patron, was exiled in 1435. Eventually, another Florentine painter, Filippino Lippi, finished painting the chapel in the 1480s. The chapel was dedicated to Saint Peter, and the frescoes illustrate events in his life.

Masaccio combined a study of the human figure with an intimate knowledge of ancient Roman sculpture. In THE EXPULSION FROM PARADISE, he presented Adam and Eve as monumental nude figures (FIG. 14-21). In contrast to Flemish painters, who sought to record every visible hair or scratch (compare Adam and Eve from the Ghent Altarpiece, FIG. 13-11), Masaccio focused on the mass of bodies formed by the underlying bone and muscle structure to create a new realism. He used a generalized light shining on the figures from a single source and further emphasized their tangibility with cast shadows. Ignoring earlier interpretations of the event that emphasized wrongdoing and the fall from grace, Masaccio was concerned with the psychology of individual humans who have been cast mourning and protesting out of Paradise, and he captured the essence of humanity thrown naked into the world.

Adam and Eve lead to THE TRIBUTE MONEY (FIG. 14-22). The painting was done in thirty-one working days. Completed about 1427, it was rendered in a continuous narrative of three scenes within one setting (a medieval compositional technique). The painting illustrates an incident in which a collector of the Jewish temple taxes (the "tribute money") demands payment from Peter, shown in the central group with Jesus and the other disciples (Matt. 17:24-27). Saying "Render unto Caesar that which is Caesar's," Jesus instructs Peter to "go to the sea, drop in a hook, and take the first fish that comes up," which Peter does at the far left. In the fish's mouth is a coin worth twice the tax demanded, which Peter gives to the tax collector at the far right. The tribute story was especially significant for Florentines because in 1427, to raise money for defense against military aggression, the city enacted a graduated tax, based on the value of one's personal property.

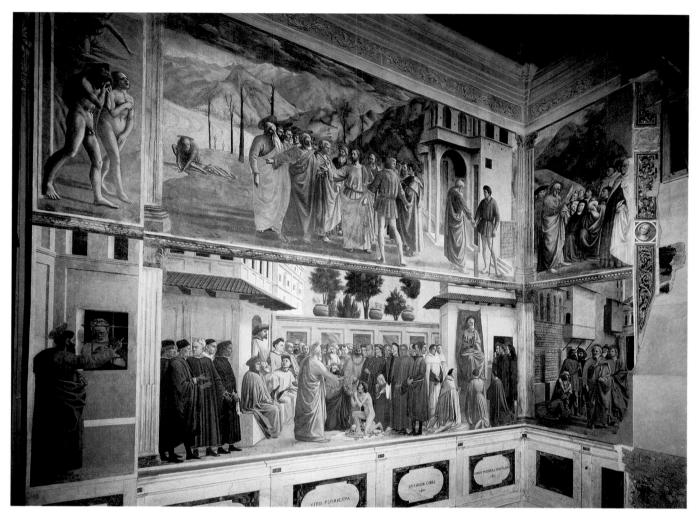

14–20 | INTERIOR OF THE BRANCACCI CHAPEL, CHURCH OF SANTA MARIA DEL CARMINE, FLORENCE Frescoes by Masaccio and Masolino (1426–27) and Filippino Lippi (lower register) (c. 1482–84).

The Tribute Money is remarkable for its integration of figures, architecture, and landscape into a consistent scene. The group of Jesus and his disciples forms a clear central focus, from which the landscape seems to recede naturally into the far distance. To create this illusion, Masaccio used linear perspective in the depiction of the house and then reinforced it by diminishing the sizes of the trees and reducing Peter's size at the left. At the vanishing point established by the lines of the house is the head of Jesus. A second vanishing point determines the steps and stone rail at the right. Masaccic used atmospheric perspective as well as linear perspective in the distant landscape, where mountains fade from grayish green to grayish white and the houses and trees on their slopes are loosely sketched. Green leaves were painted on the branches al secco (meaning "on the dry plastered wall"; see Chapter 12, "Buon Fresco," page 439).

Masaccio modeled the foreground figures with strong highlights and cast their long shadows on the ground toward

the left, implying a light source at the far right, as if the scene were lit by the actual window in the rear wall of the Brancacci Chapel. Not only does the lighting give the forms sculptural definition, but the colors vary in tone according to the strength of the illumination. Masaccio used a wide range of hues—pale pink, mauve, gold, blue green, apple green, peach-and a sophisticated color technique in which Andrew's green robe is shaded with red instead of darker green. All of the figures in The Tribute Money, except those of the temple tax collector, originally had gold-leaf halos, several of which had flaked off before the painting underwent restoration (1982-90). Rather than silhouette the heads against flat gold circles in the medieval manner, Masaccio conceived of the halo as a gold disk hovering in space above each head, and he subjected it to perspective foreshortening shortening the lines of forms seen head-on to align them with the overall perspectival system—depending on the position of the figure.

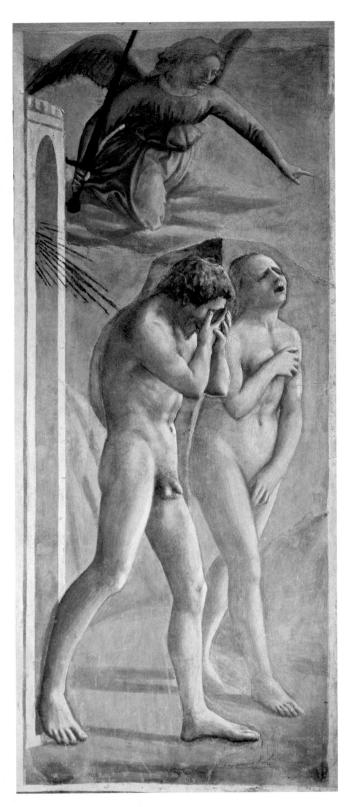

I4–2I | Masaccio THE EXPULSION FROM PARADISE Brancacci Chapel. c. 1427. Fresco, $7' \times 2'$ 11" (214 \times 90 cm).

Cleaning and restoration of the Brancacci Chapel paintings revealed the remarkable speed and skill with which Masaccio worked. He painted Adam and Eve in four *giornate* (each *giornata* of fresh plaster representing a day's work). Working from the top down and left to right, he painted the angel on the first day; on the second day, only the portal; the magnificent figure of Adam on the third day; and Eve on the fourth day.

Stylistic innovations take time to be fully accepted, and Masaccio's genius for depicting weight and volume, consistent lighting, and spatial integration was best appreciated by a later generation. Many important sixteenth-century Italian artists, including Michelangelo, studied and sketched from Masaccio's Brancacci Chapel frescoes. In the meantime, painting in Florence after Masaccio's death developed along lines somewhat different from that of *The Tribute Money* or *Trinity*, as other artists such as Paolo Uccello experimented in their own ways of conveying the illusion of a believably receding space (SEE FIG. 14–1).

Mural Painting in Florence After Masaccio

The tradition of covering walls with paintings in fresco continued through the fifteenth century. Walls of churches and chapels provided space for painters to combine Christian themes with local incidents and realistic portraits. Between 1438 and 1445, the decoration of the Dominican Monastery of San Marco in Florence, where Fra Angelico lived, was one of the most extensive projects.

FRA ANGELICO. Guido di Piero da Mugello (c. 1395/1400–55), known as Fra Giovanni da Fiesole, earned the designation "Fra Angelico" ("Angelic Brother") through his piety as well as his painting. He was beatified, the first step toward sainthood, in 1984. He is first documented as a painter in Florence in 1417–18, and he continued to be a very active painter after taking his vows as a Dominican monk (see "The Mendicant Orders," page 394).

Between 1438 and 1445, in the Monastery of San Marco, Fra Angelico and his assistants created a painting to inspire meditation in each monk's cell (forty-four in all), and they also added paintings to the chapter house (meeting room) and the corridors. The paintings were probably commissioned by Cosimo de' Medici. At the top of the stairs in the north corridor Fra Angelico painted the scene of the ANNUNCIATION (FIG. 14-23). Here the monks were to pause for prayer before going to their individual cells. The illusion of space created by the careful linear perspective seems to extend the stair and corridor out into a second cloister, the Virgin's home and verdant enclosed garden, where the angel Gabriel greets the modest, youthful Mary. The slender, graceful figures wearing flowing draperies assume modest poses. The natural light falling from the left models their forms and casts an almost supernatural radiance over their faces and hands. The scene is a vision that welcomes the monks to the most private areas of the monastery and prepares them for their meditations.

CASTAGNO. Another notable Florentine fresco, THE LAST SUPPER, is the work of Andrea del Castagno (c. 1417/14–57), painted for a convent of Benedictine nuns in 1447 (FIG. 14–24). The Last Supper was often painted in monastic refectories (dining halls) to remind the monks or nuns of

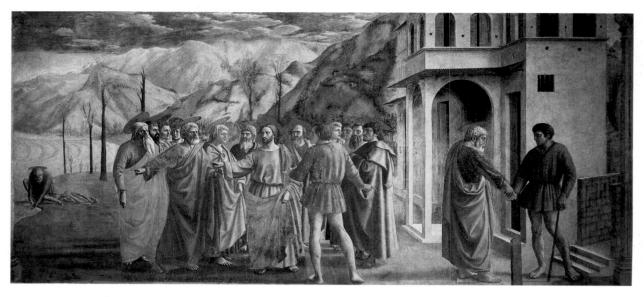

14–22 | Masaccio **THE TRIBUTE MONEY** Brancacci Chapel. c. 1427. Fresco, $8'1'' \times 19'7''$ (1.87 \times 1.57 m).

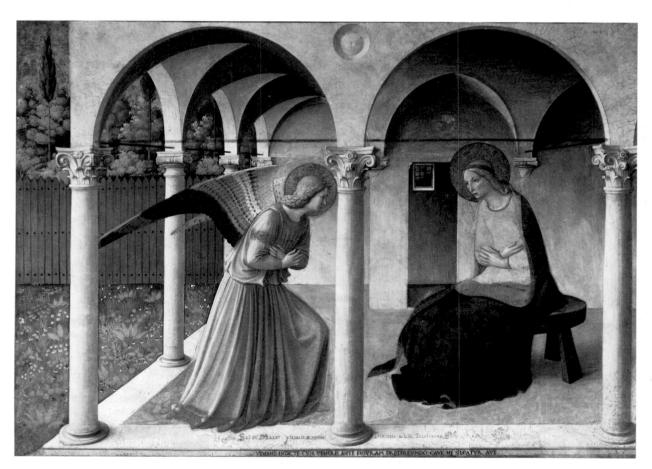

I4–23 | Fra Angelico Annunciation North Corridor, monastery of san Marco, florence c. 1438–45. Fresco, $7' \frac{1}{2}'' \times 19'6''$ (230 × 297 m).

The shadowed vault of the portico is supported by a wall on one side and by slender lonic and Corinthian columns on the other, a new building technique being used by Brunelleschi in the very years when the painting was being created.

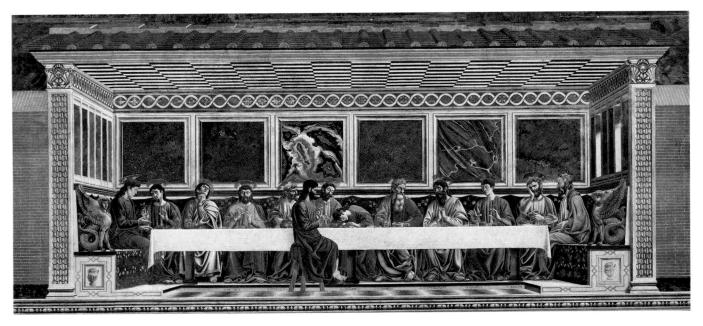

14–24 Andrea del Castagno **THE LAST SUPPER** Refectory, Convent of Sant'Apollonia, Florence. 1447. Fresco, width approx. $16 \times 32'$ (4.6 \times 9.8 m).

Christ's sacrifice and of the bread and wine as his Body and Blood. Here the scene takes place in the "upper room"—the biblical setting—but the humble house described in the Bible has become a great palace with sumptuous marble panels. A brilliantly colored and wildly patterned marble panel frames the heads of Christ and Judas. Judas is separated from the apostles and sits on the viewer's side of the table. Saint John sleeps, head on the table. The strong perspective lines of floor tiles, ceiling rafters, and paneled walls draw the viewer into the scene. The religious would have seen the painting as an extension of their hall. At first, the lines of the orthogonals seem to follow Alberti's perfect logic, but close examination reveals that only the lines of the ceiling converge, below the hands of Saint John; consequently, an uneasy situation is established, and we do not know why. Two windows light the room from the direction of the actual windows, further unifying the painted and actual spaces, and Castagno paints his figures in solid sculptured fashion with clear outlines and strong highlights. He worked quickly, completing the huge mural in at most thirty-two days.

ITALIAN ART IN THE SECOND HALF OF THE FIFTEENTH CENTURY

In the second half of the fifteenth century, the ideas and ideals of artists like Brunelleschi, Donatello, and Masaccio began to spread from Florence to the rest of Italy, combining with local styles. Artists who trained or worked in Florence then traveled to other cities to work, either temporarily or perma-

nently, carrying the style with them. Northern Italy embraced the new classical ideas swiftly, with the ducal courts at Mantua and Urbino taking the lead. The Republic of Venice and the city of Padua, which Venice had controlled since 1405, also emerged as innovative art centers in the last quarter of the century.

Urbino

East of Florence lay another outstanding cultural center, Urbino, where Count (later, in 1474, Duke) Federico da Montefeltro attracted writers, philosophers, and the finest artists of the day to his court. The palace at Urbino would have made a glorious backdrop for the courtly pageantry. The Renaissance book of manners, *The Book of the Courtier*, by Baldassare Castiglione, was written there.

THE PALACE AT URBINO. Construction of Federico's palace had begun about 1450, and in 1468 Federico hired Luciano Laurana (c. 1420/25–1479), who had been an assistant on the project, to direct the work. Among Laurana's major contributions to the palace were closing the courtyard with a fourth wing and redesigning the courtyard façades (FIG. 14–25). The result is a superbly rational solution to the problems of courtyard elevation design, particularly the awkward juncture of the arcades at the four corners. The ground-level portico on each side has arches supported by columns; the corner angles are bridged with piers having engaged columns on the arcade sides and pilasters facing the courtyard. This arrangement avoided the awkward visual effect of two arches springing

from a single column and gave the corner a greater sense of stability. A variation of the composite capital (a Corinthian capital with added Ionic volutes) was used, perhaps for the first time, on the ground level. Corinthian pilasters flank the windows in the story above, forming divisions that repeat the bays of the portico. (The two short upper stories were added later.) The plain architrave was engraved with inscriptions lauding Federico's many virtues. Not visible in the photograph is an exceptionally magnificent monumental staircase leading from the courtyard to the main floor.

The interior of the Urbino palace likewise reflected its patron's embrace of new Renaissance ideas and interest in classical antiquity, seen in carved marble fireplaces and window and door surrounds. In creating luxurious home furnishings and interior decorations for educated clients such as Federico, Italian craft artists found freedom to experiment with new subjects, treatments, and techniques. Among these was the creation of *trompe l'oeil* effects, which had become more convincing with the development of linear perspective. *Trompe l'oeil*, commonly used in painting, was carried to its

ultimate expression in **intarsia** (wood inlay) decoration, exemplified by the walls of Federico da Montefeltro's "**STUDIOLO**," or study, a room for private conversation and the collection of fine books and art objects (FIG. 14–26). The work was probably done by the architect and woodworker Giuliano da Maiano (1432–90) and carries a date of 1476.

The elaborate scenes in the small room are created entirely of wood inlaid on flat surfaces with scrupulously applied linear perspective and foreshortening. Each detail is rendered in *trompe l'oeil*: the illusionistic pilasters, carved cupboards with latticed doors, niches with statues, paintings, and built-in tables. Prominent in the decorative scheme is the prudent and industrious squirrel, a Renaissance symbol of the ideal ruler: in other words, of Federico da Montefeltro. A large window looks out onto an elegant marble loggia with a distant view of the countryside through its arches; and the shelves, cupboards, and tables are filled with all manner of fascinating things—scientific instruments, books, even the Duke's armor hanging like a suit in a closet. On the walls above were paintings of great scholars (whose books Federico

I4–25 | Luciano Laurana COURTYARD, DUCAL PALACE, URBINO Italy. Courtyard c. 1467–72; palace begun c. 1450.

The inscription extolling Federico's virtues—Justice, Clemency, Liberality, and Religion—was added in 1476 when he was made Duke of Urbino.

14–26 | STUDIOLO OF FEDERICO DA MONTEFELTRO, DUCAL PALACE, URBINO
1476 | Intersia | height 7'3" (2.21 m) | Woodwork probab

1476. Intarsia, height 7'3'' (2.21 m). Woodwork probably by Giuliano da Maiano (1432–90).

owned) by Pedro Berruguete from Spain and Justus of Ghent from Flanders.

In 1472 Federico's wife Battista died, shortly after the birth of her ninth child, a son who would inherit the duchy. She was only 26, and Federico was disconsolate. Leaving the palace unfinished, he turned to building a funeral chapel, the church of San Bernardino, on a neighboring hilltop. The church can be seen in the background of Raphael's *Madonna and Child* (FIG. 15–5).

PIERO DELLA FRANCESCA. One artist Federico brought to Urbino was Piero della Francesca (c. 1415–92). Piero had worked in Florence in the 1430s before settling down in his native Borgo Sansepulcro, a Tuscan hill town under papal control. He knew current thinking in art and art theory—including Brunelleschi's system of spatial illusion and linear perspective, Masaccio's powerful modeling of forms and atmospheric perspective, and Alberti's theoretical treatises. Piero was one of the few practicing artists who also wrote about his own theories. Not surprisingly, in his treatise on perspective he emphasized the geometry and the volumetric construction of forms and spaces that were so apparent in his own work. He traveled widely—to Rome, to the Este court in Ferrara, and especially to Urbino.

From about 1454 to 1458, Piero was in Arezzo, where he decorated the Bacci Chapel of the Church of San Francesco

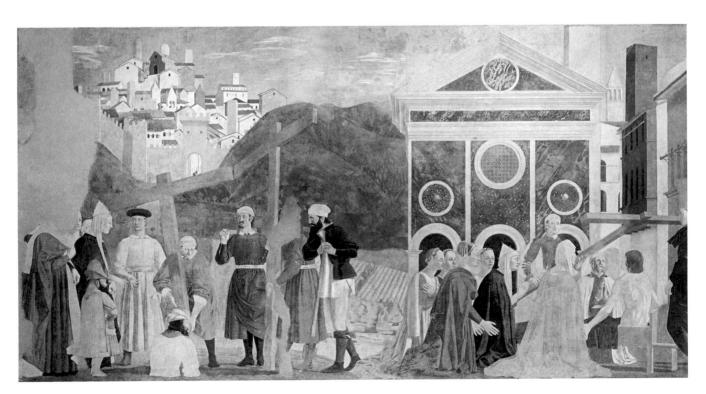

I4–27 | Piero della Francesca RECOGNITION AND PROVING OF THE TRUE CROSS San Francesco, Arezzo. 1450s. Fresco, $11'8'' \times 24'6''$ (3.56 \times 7.47 m).

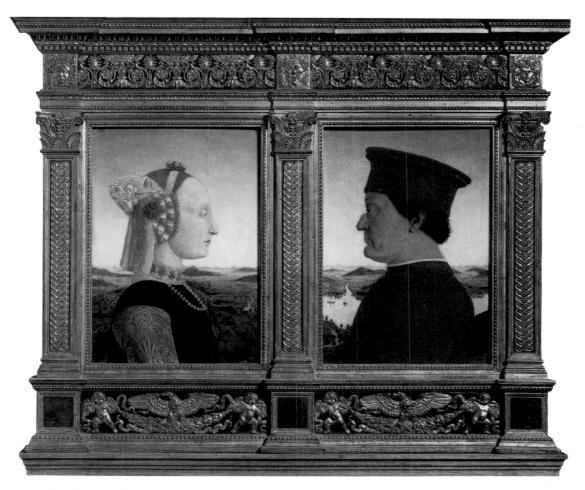

14–28 | Piero della Francesca BATTISTA SFORZA AND FEDERICO DA MONTEFELTRO c. 1474. Oil on wood panel, each $18\frac{7}{2} \times 13''$ (47 \times 33 cm). Galleria degli Uffizi, Florence.

with a cycle of frescoes illustrating the legend of the True Cross, the cross on which Jesus was crucified. The Cross was buried after the Crucifixion, but Helena (the mother of Constantine, who was believed to be the first Christian Roman emperor) discovered and proved the authenticity of the cross when its touch brings to life a man being carried to his tomb.

In the RECOGNITION AND PROVING OF THE TRUE CROSS, (FIG. 14–27), Piero's analytical modeling and perspectival projection result in a highly believable illusion of space around his monumental figures. He reduced his figures to cylindrical and ovoid shapes and established a geometric patterned setting in marble veneered buildings. The building that forms a background is a brilliant example of the ideal Renaissance façade as designed by Alberti. Few such façades were ever finished. Particularly remarkable are the foreshortening of figures and objects such as the cross at the right and the anatomical accuracy of the revived youth's nude figure. Unlike many of his contemporaries, however, Piero gave his figures no expression of human emotion. They observe the miracle with an indifference born of complete confidence.

In about 1474 Piero painted the portraits of Federico and his recently deceased wife, Battista Sforza (FIG. 14–28). The

small panels, painted in tempera in light colors, resemble Flemish painting in their detail and luminosity, their record of surfaces and textures, and their vast landscapes. In the traditional Italian fashion, the figures are portrayed in strict profile, as remote psychologically from the viewer as icons. The profile format also allowed for an accurate recording of Federico's likeness without emphasizing two disfiguring scars—the loss of his right eye from a sword blow and his broken nose. His good left eye is shown, and the angular profile of his nose seems like a distinctive family trait. Typically, Piero emphasized the underlying geometry of the forms. Dressed in the most elegant fashion (Federico wears his red ducal robe), Battista and Federico are silhouetted against a distant view recalling the hilly landscape around Urbino. The influence of Flemish art (which Piero would have known from Flemish and Spanish painters working with him in Urbino) is also strong in the careful record of Battista's jewels and in the well-observed atmospheric perspective, making the landscape as subtle and luminous as any Flemish panel or manuscript. Piero used another northern European device in the harbor view near the center of Federico's panel: The water narrows into a river that leads the eye into the distant landscape.

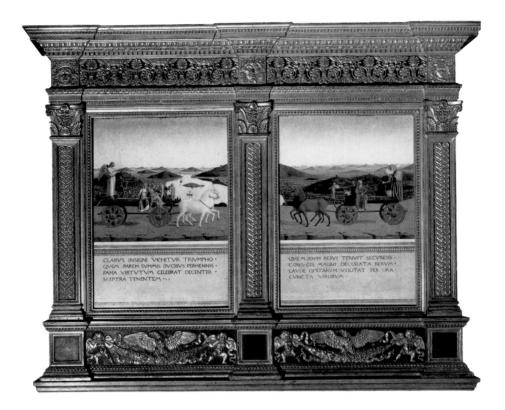

14–29 | Piero della Francesca TRIUMPH OF FEDERICO AND BATTISTA Reverse of FIGURE 14–28.

Federico's inscription can be translated, "He that the perennial fame of virtues rightly celebrates holding the scepter, equal to the highest dukes, the illustrious, is borne in outstanding triumph." Battista had been dead two years when hers was written: "She that kept her modesty in favorable circumstances, flies on the mouths of all men, adorned with the praise of the acts of her great husband." (Translated by John Paolitti and Gary Radke, *Art in Renaissance Italy*. Prentice Hall, 2002, p. 288.)

The painting on the reverse of the portraits reflects the humanist interests of the court (FIG. 14-29). Engraved on the fictive parapets in letters inspired by ancient Roman inscriptions are stanzas praising the couple's respective virtues—Federico's moderation and the fame of his virtue; and Battista's restraint, shining in the reflected glory of her husband. Behind these laudatory inscriptions a wide landscape of hills and valleys appears to be nearly continuous across the two panels. Across the flat top of a jagged cliff in the foreground, triumphal carts roll, and we catch a glimpse of the kind of pageantry and spectacle that must have been enacted at court. The Triumphs of Petrarch—poetic allegories of love, chastity, fame, time, eternity (Christianized as Divinity), and death (see "A New Spirit in Fourteenth-Century Literature," page 431)—inspired many of these extravaganzas. White horses pull Federico's wagon. The Duke is crowned by a winged figureeither Victory or Fortune-and accompanied by personifications of Justice, Prudence, Fortitude, and Temperance. Battista's cart is controlled by a winged putto (nude little boy) driving a team of unicorns. The virtues standing behind her may be personifications of Chastity and Modesty. Seated in front of her are Faith and Charity, who holds a pelican. This bird, believed to feed its young from its own blood, may symbolize the recently deceased Battista's maternal sacrifices.

Mantua

Lodovico Gonzaga, the Marquis of Mantua, ruled a territory that lies on the north Italian plain between Venice and Milan. Like Federico, he made his fortune as a *condottiere*. Lodovico was schooled by humanist teachers and created a court where humanist ideas flourished in art as well as in literature. His relationship with Cosimo de' Medici led to a connection with Florentine artists and architects, including Alberti.

ALBERTI. The spread of Renaissance architectural style beyond Florence was due in significant part to Leon Battista Alberti, who traveled widely, wrote on architecture, and expounded his views to potential patrons. In 1470 Ludovico Gonzaga commissioned Alberti to enlarge the small **CHURCH**

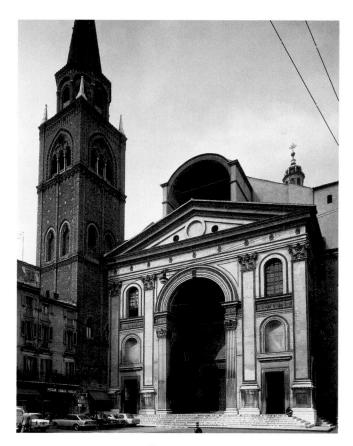

I4–30 | Leon Battista Alberti
FAÇADE, CHURCH OF SANT'ANDREA, MANTUA
Designed 1470, begun 1472.

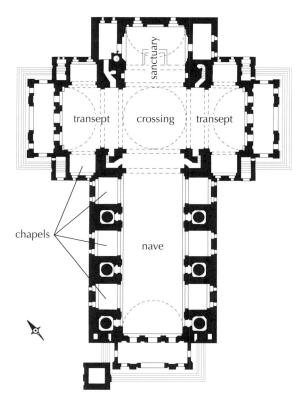

I4–3I | Leon Battista Alberti PLAN OF THE CHURCH OF SANT'ANDREA, MANTUA
Designed 1470.

Sequencing Works of Art 1470-72 Leon Battista Alberti, Church of Sant'Andrea, Mantua 1476 Giuliano da Maiano, intarsia decoration of the studiolo, ducal palace, Mantua c. 1480 Giovanni Bellini, Saint Francis in Ecstasy 1481 Perugino, Delivery of the Keys to Saint Peter, Sistine Chapel, Vatican 1500 Botticelli, The Mystic Nativity

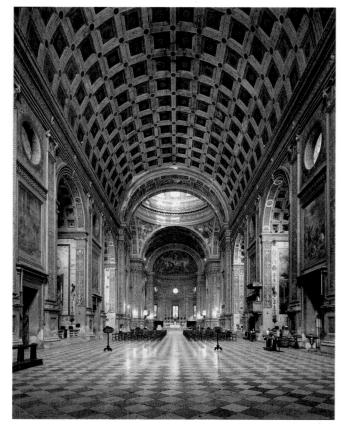

14–32 | **NAVE, CHURCH OF SANT'ANDREA, MANTUA** Designed 1470. Vault width 60′ (18.3 m).

OF SANT'ANDREA, which housed a sacred relic believed to be the actual blood of Christ (FIG. 14–30). To satisfy his patron's desire for a sizable building to handle crowds coming to see the relic, Alberti proposed to build an "Etruscan temple." Work began on the new church in 1472, but Alberti died that summer. Construction went forward slowly, at first according to his original plan, but it was finally completed only at the end of the eighteenth century. Thus, it is not always clear which elements belong to Alberti's original design.

The Church of Sant' Andrea follows the Latin-cross plan, in which the transept intersects the nave high above the

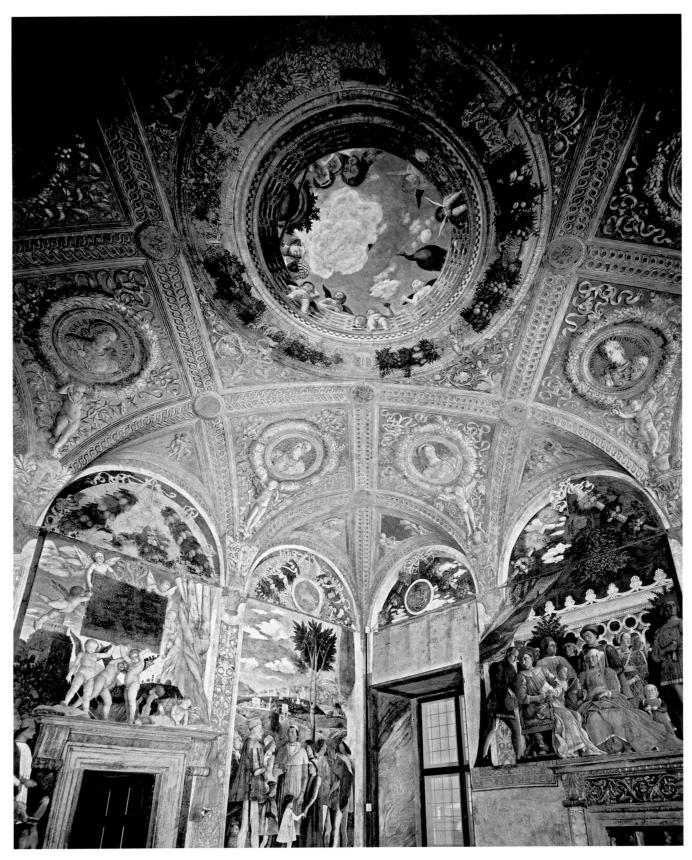

14–33 | Andrea Mantegna CAMERA PICTA, DUCAL PALACE, MANTUA 1465–74. Frescoes. Diameter of false oculus 8'9'' (2.7 m); room 62' 6'' square (8×5 m square).

midpoint of the church. Here, the nave, nearly 60 feet wide, meets a transept of equal width at a square, domed crossing (FIGS. 14–31, 14–32). A rectangular sanctuary on axis with the nave is certainly in keeping with Alberti's ideas. Alberti was responsible, too, for the barrel-vaulted chapels at right angles to the nave that give the appearance of an arcade. Low chapel niches are carved out of the huge piers supporting the barrel vault of the nave. Light enters from chapel windows.

Alberti's design for the façade of Sant'Andrea (SEE FIG. 14–30) integrates two classical forms—a temple front and a triumphal arch with two sets of colossal Corinthian pilasters. The façade now has a clear volume of its own, which sets it off visually from the building behind. Pilasters flanking the barrel-vaulted triumphal-arch entrance are two stories high, whereas the others, raised on pedestals, run through three stories to support the entablature and pediment of the temple form. The arch itself has lateral barrel-vaulted spaces opening through two-story arches on the left and right.

Neither the simplicity of the plan nor the complexity of the façade hints at the grandeur of Sant'Andrea's interior. Its immense barrel-vaulted nave, extended on each side by tall chapels, was inspired by the monumental interiors of such ancient ruins as the Basilica of Maxentius and Constantine in the Roman Forum (SEE FIG. 6–75). This clear reference to Roman imperial art is put to Christian use. Alberti created a building of such colossal scale, spatial unity, and successful expression of Christian humanist ideals that it affected architectural design for centuries.

MANTEGNA. Andrea Mantegna (1431–1506) also worked at the court of Mantua. Mantegna, a painter, was trained in Padua and profoundly influenced by the sculptor Donatello, who arrived in Padua in 1443 and worked there for a decade. Mantegna absorbed such techniques as the Florentine linear perspective system, which Mantegna pushed to its limits with experiments in radical perspective views and foreshortenings. In 1460 Mantegna went to work for Ludovico Gonzaga, and he continued to work for the Gonzaga family for the rest of his life.

Mantegna's mature style is characterized by a virtuoso use of perspective, the skillful integration of figures into their settings, and a love of naturalistic details. His finest works are the frescoes of the CAMERA PICTA ("Painted Room"), a tower chamber in Ludovico Gonzaga's palace, which Mantegna decorated between 1465 and 1474 (FIG. 14–33). Around the walls the family receives its returning cardinal in scenes set in landscapes and loggias. (Ludovico's son, Cardinal Francesco, was head of the Church of Sant'Andrea; SEE FIG. 14–30). The paintings create a continuous scene with figures and countryside behind a fictive arcade. The people are all recognizable portraits of the family and court. On the domed ceiling, the artist painted a tour de force of radical perspective, a tech-

nique called *di sotto in sù* ("from below upwards"). The room appears to be open to a cloud-filled sky through a large oculus in a simulated marble– and mosaic–covered vault. On each side of a precariously balanced planter, three young women and an exotically turbaned African man peer over a marble balustrade into the room below. A fourth young woman in a veil looks dreamily upward. Joined by a large peacock, several *putti* play around the balustrade. The ceiling began a long tradition of illusionistic ceiling painting that culminated in the seventeenth century.

Although Mantegna made trips to Florence and Pisa in the 1460s and to Rome in 1488–90, he spent most of his time in Mantua. There he became a member of the humanist circle, whose interests in classical literature and archaeology he shared. He often signed his name using Greek letters.

Rome

Rome's establishment as a Renaissance center of the arts was enhanced by Pope Sixtus IV's decision to call to the city the best artists he could find to decorate the walls of his newly built chapel, named the Sistine Chapel after him. The resolution in 1417 of the Great Schism in the Western Church had secured the papacy in Rome, precipitating the restoration of not only the Vatican but the city as a whole.

PERUGINO. Among the artists who went to Rome was Pietro Vannucci, called "Perugino" (c. 1445–1523). Originally from near the town of Perugia in Umbria, Perugino worked for a while in Florence and by 1479 was in Rome. Two years later, he was working on the Sistine murals. One of his contributions, **DELIVERY OF THE KEYS TO SAINT PETER** (FIG. 14–34), portrayed the event that provided biblical support for the supremacy of papal authority, Christ's giving the keys of the kingdom of heaven to the apostle Peter (Matt. 16:19), who became the first bishop (pope) of Rome.

Delivery of the Keys is a remarkable work. Its carefully studied linear perspective reveals much about Renaissance ideals. In a light-filled piazza in which banded paving stones provide a geometric grid for perspectival recession, the figures stand like chess pieces on the squares, scaled to size according to their distance from the picture plane and modeled by a consistent light source from the upper left. The composition is divided horizontally between the lower frieze of massive figures and the band of widely spaced buildings above. Vertically, it is divided by the open space at the center between Christ and Peter and by the symmetrical architectural forms on each side of this central axis. Triumphal arches inspired by ancient Rome frame the church and focus the attention on the center of the composition, where the vital key is being transferred. The carefully calibrated scene is softened by the subdued colors, the distant idealized landscape and cloudy skies, and the variety of the

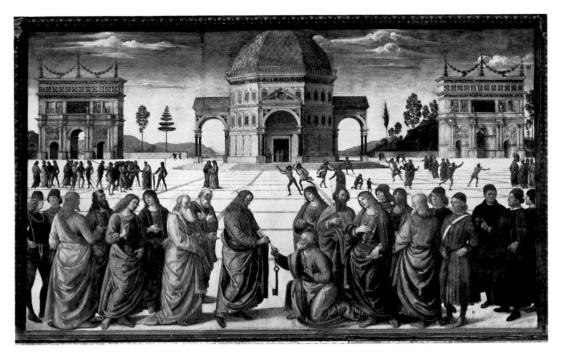

14–34 | Perugino DELIVERY OF THE KEYS TO SAINT PETER Fresco on the right wall of the Sistine Chapel, Vatican City, Rome. 1481. $11'5\%'' \times 18'8\%'' (3.48 \times 5.70 \text{ m})$.

figures' positions. Perugino's painting is, among other things, a representation of Alberti's ideal city, described in his treatise on architecture as having a "temple" (that is, a church) at the very center of a great open space raised on a dais and separate from any other buildings that might obstruct its view. His ideal church had a central plan, illustrated here as a domed octagon.

The Later Fifteenth Century in Florence

In the final decades of the fifteenth century, Florentine painting was characterized on one hand by a love of material opulence and an interest in describing the natural world, and on the other by a poetic, mystical spirit. The first trend was encouraged by the influence of Netherlandish art and the patronage of citizens who sought to advertise their wealth and position, the second by philosophic circles surrounding the Medici and the religious fervor that arose at the very end of the century.

GHIRLANDAIO. In Florence, the most prolific painting workshop of the later fifteenth century was that of the painter Domenico di Tommaso Bigordi (1449–94), known as Domenico "Ghirlandaio" ("Garland Maker"), a nickname adopted by his father, who was a goldsmith noted for his floral wreaths. A skilled painter of narrative cycles, Ghirlandaio reinterpreted the art of earlier fifteenth-century painters into a popular visual language of great descriptive immediacy.

I4-35 Domenico Ghirlandaio VIEW OF THE SASSETTI CHAPEL, CHURCH OF SANTA TRINITA, FLORENCE Frescoes of scenes from the Legend of Saint Francis; altarpiece with Nativity and Adoration of the Shepherds. 1483-86. Chapel: 12'2" deep × 17'2" wide (3.7 × 5.25 m).

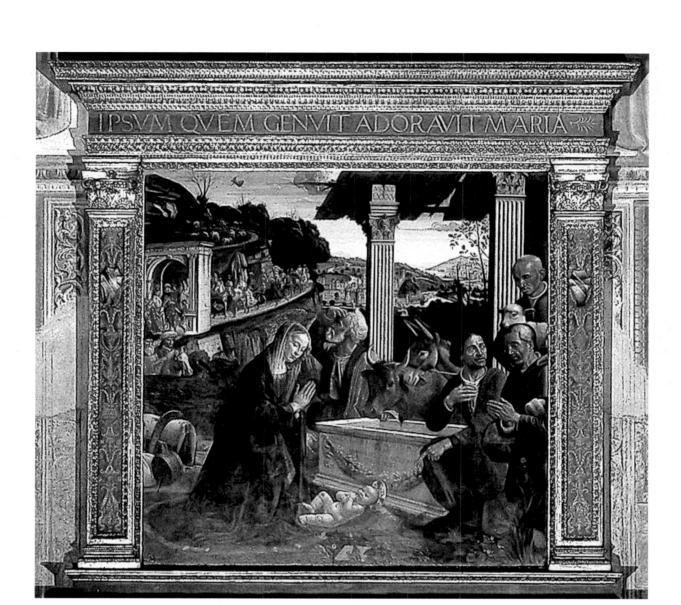

14–36 | Domenico Ghirlandaio NATIVITY AND ADORATION OF THE SHEPHERDS, SASSETTI CHAPEL PANEL, ALTARPIECE, SANTA TRINITÀ, FLORENCE 1485. 65%" square (1.67 m square).

The taste for Flemish painting in Florence grew noticeably after about 1450, and works such as Hugo van der Goes's *Portinari Altarpiece* (SEE FIG. 13–20), which Tommaso Portinari had sent home to Florence from Bruges in 1483, had considerable impact on Ghirlandaio's style.

Among Ghirlandaio's most effective narrative programs were frescoes of the life of Saint Francis created between 1483 and 1486 for the Sassetti family burial chapel in the Church of Santa Trinita, Florence (FIG. 14–35). In the uppermost tier of the paintings, Pope Honorius confirms the Franciscan order. The Loggia of the Lancers (see Chapter 12, FIG. 12–2) and the Palazzo della Signoria can be seen in the background. All the figures, including those coming up the stairs, are portraits of well-known Florentines. In the middle register, a small boy who has fallen from an upper window is resurrected by Saint Francis. The miracle is witnessed by contemporary Florentines, including members of the Sassetti family, and the scene takes place in the piazza outside the actual church. Thus, Ghirlandaio transferred the events of the traditional story from thirteenth-century

Rome to the Florence of his own day, painting views of the city and portraits of Florentines, taking delight in local color and anecdotes. Perhaps Renaissance painters represented events from the distant past in contemporary terms to emphasize their current relevance, or perhaps they and their patrons simply enjoyed seeing themselves in their fine clothes acting out the dramas in the cities of which they were justifiably proud.

The Sassetti Chapel altarpiece, **NATIVITY AND ADORA- TION OF THE SHEPHERDS** (FIG. 14–36), is still in its original frame and in the place for which it was painted. Ghirlandaio clearly was inspired by Hugo's *Portinari Altar- piece* (SEE FIG. 13–20), which had been placed on the high altar of the church of Sant'Egidio two years earlier in 1483. As in Hugo's painting, Domenico's Christ Child lies on the

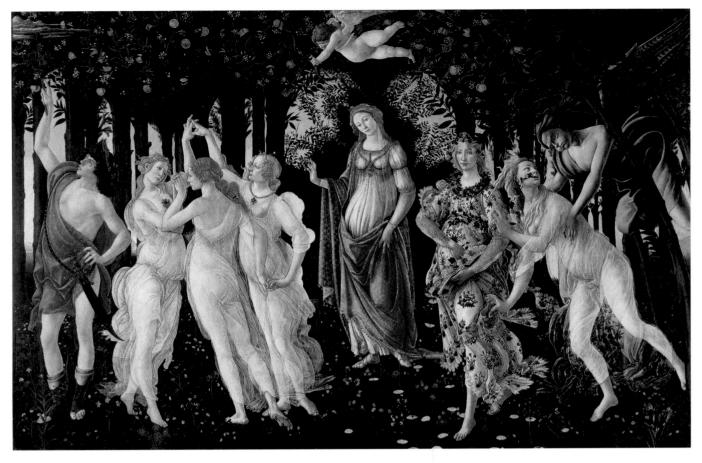

14–37 | Sandro Botticelli PRIMAVERA c. 1482. Tempera on wood panel, $6'8'' \times 10'4''$ (2.03 \times 3.15 m). Galleria degli Uffizi, Florence.

ground, adored by the Virgin while shepherds-rugged countrymen-kneel at the right. He even copies some of Hugo's flowers—although here the iris, a symbol of the Passion, springs not from a vase, but from the earth in the lower right corner. Instead of elaborate late-medieval symbolism. Ghirlandaio includes references to classical Rome. First to catch the eye are the two classical pilasters with Corinthian capitals, one of which has the date 1485. The manger is an ancient sarcophagus with an inscription that promises resurrection (as in the fresco directly above the altarpiece where Saint Francis is reviving a child); and in the distance a classical arch inscribed with a reference to the Roman general Pompey the Great frames the road along which the Magi travel. Domenico replaces the psychological intensity of Hugo's figures with weighty, restrained actors. His mastery of linear perspective is revealed in the manner in which the diagonally placed wooden planks that support the thatched roof of the shed organize the space. A clear foreground, middle ground, and background are joined together in part by the road and in part by aerial perspective, which creates a seamless transition of color, from the sharp details and primary hues of the Adoration to the soft gray mountains in the distance.

BOTTICELLI. Like most artists in the second half of the fifteenth century, Sandro Botticelli (1445–1510) learned to draw and paint sculptural figures that were modeled by light from a consistent source and placed in a setting rendered with strict linear perspective. An outstanding portraitist, he, like Ghirlandaio, often included recognizable contemporary figures among the saints and angels in religious paintings. He worked in Florence, often for the Medici, then was called to Rome in 1481 by Pope Sixtus IV to help decorate the new Sistine Chapel along with Ghirlandaio, Perugino, and other artists.

Botticelli returned to Florence that same year and entered a new phase of his career. Like other artists working for patrons steeped in classical scholarship and humanistic speculation, he was exposed to a philosophy of beauty—as well as to the examples of ancient art in his employers' collections. For the Medici, Botticelli produced secular paintings of mythological subjects inspired by ancient works and by contemporary Neoplatonic thought, including **PRIMAVERA**, or **SPRING** (FIG. 14–37), and *Birth of Venus* (SEE FIG. 14–38).

The overall appearance of *Primavera* recalls Flemish tapestries, which were popular in Italy at the time. The decorative quality of the painting is deceptive, however, for it is a highly complex **allegory** (a symbolic illustration of a concept

or principle), interweaving Neoplatonic ideas with esoteric references to classical sources. In simple terms, Neoplatonic philosophers and poets conceived of Venus, the goddess of love, as having two natures. The first ruled over earthly, human love and the second over universal divine love. In this way the philosophers could argue that Venus was a classical equivalent of the Virgin Mary. Primavera was painted at the time of the wedding of Lorenzo di Pierfrancesco de' Medici and Semiramide d'Appiano in 1482. The theme suggests love and fertility in marriage and provides in the image of Venus a model of the ideal woman. Venus is silhouetted and framed by an arching view through the trees. She is flanked by Flora, the Roman goddess of flowers and fertility, and by the Three Graces. Her son, Cupid, hovers above, playfully aiming an arrow at the Graces. At the far right is the wind god, Zephyr, in pursuit of the nymph Chloris, his breath causing her to sprout flowers from her mouth. At the far left, the messenger god, Mercury, uses his characteristic snake-wrapped wand, the caduceus, to dispel a patch of gray clouds drifting in Venus's direction. He is the sign of the month of May, and he looks out of the painting and onto summer. Venus, clothed in contemporary costume and wearing a marriage wreath on her head, here represents her terrestrial nature, governing wedded love. She stands in a grove of orange trees (a Medici

Sequencing Events		
1402	Death of Gian Galeazzo, Duke of Milan; stronghold on Florence and other Italian cities broken	
1420	Pope returns to Rome from Avignon	
1464	First printing press in Italy	
1496-98	Savonarola in power in Florence	
1499	France captures Milan	

symbol) weighted down with lush fruit, suggesting human fertility; Cupid also embodies romantic desire. As practiced in central Italy in ancient times, the goddess Flora's festival had definite sexual overtones.

Several years later, some of the same mythological figures reappeared in Botticelli's **BIRTH OF VENUS** (FIG. 14–38), in which the central image represents the Neoplatonic idea of divine love and is based on an antique statue type known as the "modest Venus." The classical goddess of love and beauty, born of sea foam, floats ashore on a scallop shell, gracefully arranging her hands and hair to hide—or enhance—her sexuality. Her hair is highlighted with gold. Blown by the

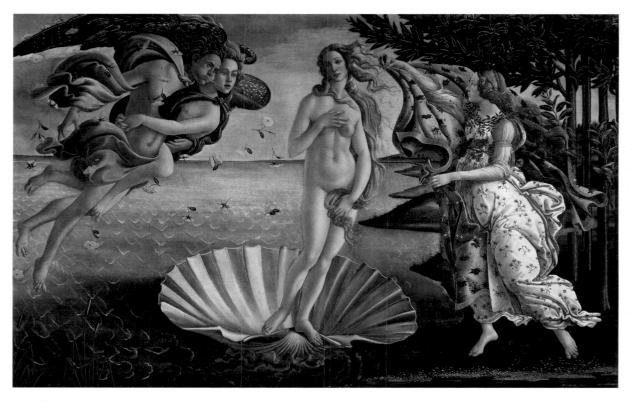

14–38 | Sandro Botticelli BIRTH OF VENUS c. 1484–86. Tempera and gold on canvas, $5'8\%'' \times 9'1\%''$ (1.8 × 2.8 m). Galleria degli Uffizi, Florence.

Art and Its Context

THE PRINTED BOOK

book entitled Hypnerotomachia Poliphili (The Love-Dream Struggle of Poliphilo) tells of the search of Poliphilo through exotic places for his lost love, Polia. The book, written in the 1460s or 1470s by Fra Francesco Colonna, was published in 1499 by the noted Venetian printer Aldo Manuzio (Aldus Manutius in Latin), who had established a press in Venice in 1490 (known today as the Aldine Press). Many historians of the printed book consider Aldo's Hypnerotomachia to be the most beautiful book ever produced, from the standpoint of type and page design. The woodcut illustrations in the Hypnerotomachia incorporate pseudoclassical structures that would influence future architects and garden designers. The Garden of Love, illustrated here, provides a setting for music, story telling, and romance, while Venus as a fountain discreetly turns her back.

Although woodcuts, constantly refined and increasingly complex, would remain a popular medium of book illustration for centuries to come, books also came to be illustrated with engravings. The innovations in printing at the end of the 1400s held great promise for the spread of knowledge and ideas in the following century.

Fra Francesco Colonna PAGE WITH GARDEN OF LOVE, HYPNEROTOMACHIA POLIPHILI

Published by Aldo Manuzio (Aldus Manutius), Venice, 1499. Woodcut, image $5\% \times 5\%$ " (13.5 \times 13.5 cm). The Pierpont Morgan Library, New York. PML 373.

wind, Zephyr (and his love, the nymph Chloris), Venus arrives at her earthly home. She is welcomed by a devotee—sometimes identified as one of the Hours—who holds a garment embroidered with flowers. The circumstances of this commission are uncertain. It is painted on canvas, which suggests that it is a banner or a painted tapestry-like wall hanging. The birth of Venus has been interpreted as the birth of the idea of beauty.

Botticelli's later career was affected by a profound spiritual crisis. While the artist was creating his mythologies, a Dominican monk, Fra Girolamo Savonarola (active in Florence 1490–98), had begun to preach impassioned sermons denouncing the worldliness of Florence. Many Florentines reacted with orgies of self-recrimination, and processions of weeping penitents wound through the streets. Botticelli, too, fell into a state of religious fervor. In a dramatic gesture of repentance, he burned many of his earlier paintings and began to produce highly emotional pictures pervaded by an intense religiosity.

In 1500, when many people feared that the end of the world was imminent, Botticelli painted MYSTIC nativity (FIG. 14-39) his only signed and dated painting. The Nativity takes place in a rocky, forested landscape in which the cave-stable follows the tradition of the Eastern Orthodox (Byzantine) Church, while the timber shed in front recalls the Western iconographic tradition (SEE FIG. 12-13). In the center of the painting, the Virgin Mary kneels in adoration of the Christ Child, who lies on the earth, as recorded in the vision of the fourteenth-century mystic Saint Bridget. Joseph crouches and hides his face, while the ox and the ass bow their heads to the Holy Child. The shepherds at the right and the Magi at the left also kneel before the Holy Family. A circle of singing angels holding golden crowns and laurel branches flies jubilantly above the central scene. Tiny devils, vanquished by the coming of Christ, try to escape from the bottom of the picture.

The most unusual element of the painting is the frieze of wrestling figures below the Holy Family. The men are

ancient classical philosophers, who ceremonially struggle with angels. Each of the three pairs holds an olive branch, a symbol of peace, and a scroll—as do the angels circling above, whose scrolls are inscribed (in Greek) with the words: "Glory to God in the Highest; peace on earth to men of good will." (Palm Sunday in fifteenth-century Florence was called Olive Sunday, and olive branches, symbols of peace, rather than palms were carried in processions.) The inscription at the top of the painting (in Greek) begins: "I Alessandro made this picture..." and goes on to reference the Book of Revelation, Chapter 11, which describes woes to come, and Chapter 12, which includes the vision of a woman crowned with stars and clothed by the sun (the woman of Revelations was interpreted by Christians as a portrayal of the Virgin Mary) and the description of the defeat of Satan. Thus, in spite of the troubles Botticelli saw all around him, he believed that Christ would come to save humankind.

Venice

In the last quarter of the fifteenth century, Venice emerged as a major Renaissance art center. Venice was an oligarchy (government by a select few) with an elected duke (doge in the Venetian dialect). The city government was founded at the end of the Roman empire and survived until the Napoleonic era. In building their city the Venetians had turned marshes into a commercial seaport, and they saw the sea as a resource, not a threat. They depended on naval power and on their lagoons rather than city walls. The city turned toward the east, especially after the Crusaders' conquest of Constantinople in 1204. Even earlier the Venetians were investing the Church of Saint Mark, a great Byzantine-inspired building, with the rich color of mosaics and gold liturgical decorations from the Eastern Christian empire. They excelled in the arts of textiles, gold and enamel, glass and mosaic, and fine printing (see "The Printed Book," facing page), as well as book binding.

THE VENETIAN PALACE. Venice was a city of waterways with few large public spaces. Even palaces had only small interior courtyards and tiny gardens, and were separated by narrow alleys. They faced out on canals, whose waters gave protection and permitted the owners to build houses with large portals, windows, and loggias. This presented a sharp contrast to the fortresslike character of most Italian townhouses. But, as with the Florentine great houses, their owners combined in these structures a place of business with a dwelling.

The CA D'ORO (HOUSE OF GOLD), the home of the wealthy nobleman Marino Contarini, has a splendid front with three superimposed loggias facing the Grand Canal (FIG. 14–40). The house was constructed between 1421 and 1437, and its asymmetrical elevation is based on a traditional Byzantine plan. A wide central hall ran from front to back all the way through the building to a small inner courtyard with

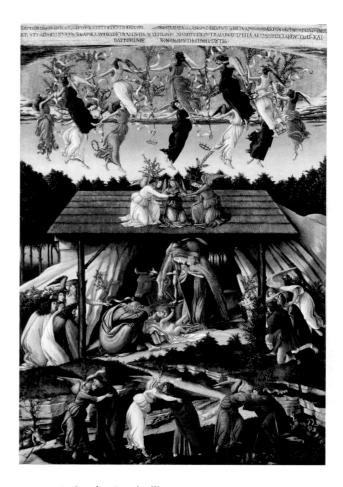

14–39 | Sandro Botticelli MYSTIC NATIVITY 1500. Oil on canvas, $42\times29\%$ (106.7 \times 74.9 cm). The National Gallery, London.

This is the only work signed and dated by Botticelli; translated from the Greek, his inscription reads: "I Alessandro made this picture at the conclusion of the 1500th year" (National Gallery, London, files).

a well and garden. An outside stair led to the main floor on the second level. The entrance on the canal permitted goods to be delivered directly into the warehouse that constituted the ground floor. The principal floor, on the second level. had a salon and reception room opening on the richly decorated loggia. It was filled with light from large windows, and more light reflected off the polished terrazzo floor. Private family rooms filled the upper stories. In contrast to the massive stone façades of Florentine palaces (SEE FIGS. 14-6, 14-8), Contarini's instructions to his contractors and workers specified that the façade was to be painted with white enamel and ultramarine blue and that the red stones in the patterned wall should be oiled to make them even brighter. Details of carving, such as coats of arms and balls on the crest at the roof line, were to be gilded. Beautiful as the palace is today (it is now an art museum), in the fifteenth and sixteenth centuries it must have been truly spectacular.

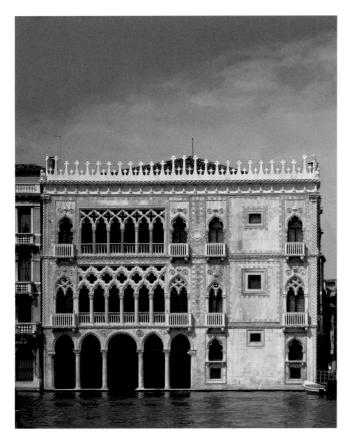

THE BELLINI BROTHERS. The domes of the Church of Saint Mark dominated the city center, and the rich colors of its glowing mosaics captured painters' imaginations. The love of color encouraged the use of the oil medium. Venetian painters eagerly embraced the oil paint technique for both panel and canvas painting.

The most important Venetian artists of this period were two brothers, Gentile (c. 1429–1507) and Giovanni (c. 1430–1516) Bellini, whose father, Jacopo (c. 1400–70), had also been a central figure in Venetian art. Andrea Mantegna was also part of this circle, for he had married Jacopo's daughter in 1453.

Gentile Bellini celebrated the daily life of the city in large, lively narratives, such as the **PROCESSION OF THE RELIC** OF THE TRUE CROSS BEFORE THE CHURCH OF SAINT MARK (FIG. 14–41). Every year on the Feast of Saint Mark (April 25) the Confraternity of Saint John the Evangelist carried the miracle-working Relic of the True Cross in a procession through the square in front of the church. Bellini's painting of 1496 depicts an event that had occurred in 1444: the miraculous recovery of a sick child whose father, the man in red kneeling to the right of the relic, prayed for help as the relic passed by. Gentile has rendered the cityscape with great accuracy and detail. The mosaic-encrusted Byzantine Church of Saint Mark (SEE ALSO FIG. 7-44) forms a backdrop for the procession, and the doge's palace and base of the bell tower can be seen at the right. The relic, in a gold reliquary under a canopy, is surrounded by marchers with giant candles, led by a choir and followed at the far right by the doge and other officials. The procession and spectators bring the huge piazza to life.

Gentile's brother, Giovanni, amazed and attracted patrons with his artistic virtuosity for almost sixty years. The **VIRGIN**

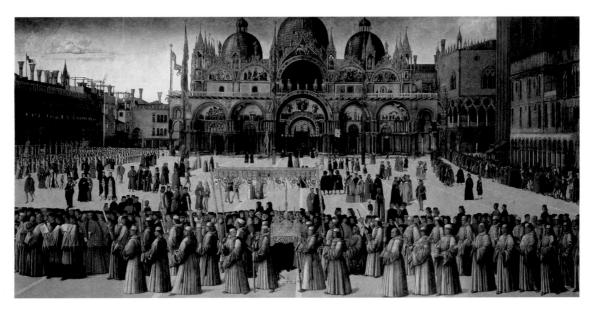

14-41 | Gentile Bellini PROCESSION OF THE RELIC OF THE TRUE CROSS BEFORE THE CHURCH OF SAINT MARK

1496. Oil on canvas, $12' \times 24'5''$ (3.67 \times 7.45 m). Galleria dell'Accademia, Venice.

AND CHILD ENTHRONED WITH SAINTS FRANCIS, JOHN THE BAP-TIST, JOB, DOMINIC, SEBASTIAN, AND LOUIS OF TOULOUSE (FIG. 14-42), painted about 1478 for the Chapel of the Hospital of San Giobbe (Saint Job), exhibits a dramatic perspectival view up into a vaulted apse. Certainly, Giovanni knew his father's perspective drawings well, and he may also have been influenced by his brother-in-law Mantegna's early experiments in radical foreshortening and the use of a low vanishing point. In Giovanni's painting, the vanishing point for the rapidly converging lines of the architecture lies at the center, on the feet of the lute-playing angel. Giovanni has placed his figures in a classical architectural interior with a coffered barrel vault, reminiscent of Masaccio's Trinity (SEE FIG. 14-19). The gold mosaic, with its identifying inscription and stylized seraphim (angels of the highest rank), recalls the art of the Byzantine Empire in the eastern Mediterranean and the long tradition of Byzantineinspired painting and mosaics produced in Venice.

Giovanni Bellini also demonstrates the intense investigation and recording of nature associated with the early Renaissance. His early painting of saint francis in ecstasy (FIG. 14-43), painted in the 1470s, illustrates his command of an almost Flemish realism. The saint stands in communion with nature, bathed in early morning sunlight, his outspread hands showing the stigmata. Francis had moved to a cave in the barren wilderness in his search for communion with God, but in this landscape, the fields blossom and flocks of animals graze. The grape arbor over his desk and the leafy tree toward which he directs his gaze add to an atmosphere cf sylvan delight. True to fifteenth-century religious art, however, Bellini unites Old and New Testament themes to associate Francis with Moses and Christ: The tree symbolizes the burning bush; the stream, the miraculous spring brought forth by Moses; the grapevine and the stigmata, Christ's sacrifice. The crane and donkey represent the monastic virtue of patience. The detailed realism, luminous colors, and symbolic elements suggest Flemish art, but the golden light suffusing the painting is associated with Venice, a city of mist, reflections, and above all, color.

Giovanni's career spanned the second half of the fifteenth century, but he produced many of his greatest paintings in the early years of the sixteenth, when his work matured into a grand, simplified, idealized style. It seems fitting to end our consideration of the first phase of Renaissance painting in Italy with Giovanni Bellini as an important and influential bridge to the future.

IN PERSPECTIVE

In many people's minds the Renaissance and Italy are synonymous—the Renaissance is the Italian Renaissance. Florence is its home, and the Medici family, its patrons. As we have seen, however, the fifteenth century witnessed changes throughout Western Europe—in Bruges as well as Florence.

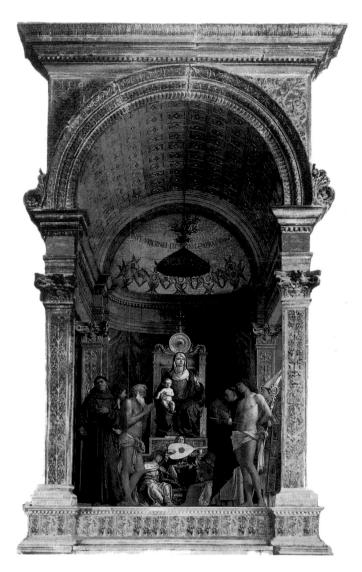

I4-42 | Giovanni Bellini VIRGIN AND CHILD ENTHRONED WITH SAINTS FRANCIS, JOHN THE BAPTIST, JOB, DOMINIC, SEBASTIAN, AND LOUIS OF TOULOUSE

(computer reconstruction) Commissioned for the Chapel of the Hospital of San Giobbe, Venice. c. 1478. Oil on wood panel, $15'4'' \times 8'4''$ (4.67 \times 2.54 m). Galleria dell'Accademia, Venice. The original frame is in the Chapel of the Hospital of San Giobbe, Venice. c. 1478.

Art historians have given the special name sacra conversazione ("holy conversation") to this type of composition that shows saints, angels, and sometimes even the painting's donors in the same pictorial space with the enthroned

Virgin and Child. Despite the name, no "conversation" or other interaction among the figures takes place in a literal sense. Instead, the individuals portrayed are joined in a mystical and eternal communion occurring outside of time.

The art of the fifteenth century reflects the values and worldview of the new social order. A spirit of inquiry was fueled by the study of classical texts begun in the four-teenth century. The kind of logical discourse formerly reserved for theological debate now was applied to the material world. Theories based on the close observation of

I4–43 | Giovanni Bellini SAINT FRANCIS IN ECSTASY c. 1470's. Oil and tempera on wood panel, $49 \times 55\%$ " (125 \times 142 cm). The Frick Collection, New York. Copyright the Frick Collection, New York.

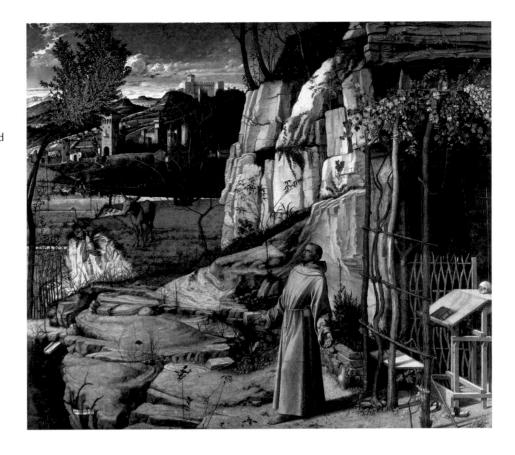

phenomena were put forth to be challenged and defended. During this time individuals gained importance, not only as inquiring minds but as the subject of inquiry. Artists, too, emerged from anonymity and were recognized as distinct personalities.

Patrons wanted to see themselves and their possessions depicted as they were. Fifteenth-century portraits have an uncanny sense of vitality, in part because of their careful, even unflattering, representations of individuals. The patrons' desire for realism extended to their surroundings; they wanted identifiable views of the buildings and countryside where they worked and played, fought and died. Artists tacitly agreed to follow new ways of representing space and visually organizing a scene using linear and atmospheric perspective. By the end of the fifteenth century, the visual mastery of the material

world seemed complete; rational and scientific thought had triumphed in both secular and religious art.

Power was no longer the prerogative of divinely sanctioned elites; it now also lay in the hands of commoners—the merchants and bankers, the leaders of the major guilds and professions. The arts flourished as patronage extended beyond the church and the court to civic, mercantile, and religious associations, as well as to families grown powerful through business and banking.

The last decade of the century saw a sudden reversal of artistic fortunes as the fiery preacher Savonarola spread the fear of damnation and inspired a need for repentance. In great "bonfires of the vanities" people destroyed their finery and great works of art as well. The furor was brief but devastating, a dramatic prelude to the tumultuous sixteenth century.

Nanni di Banco **FOUR CROWNED MARTYRS** C. 1409-17

MASACCIO EXPULSION FROM PARADISE, BRANCACCI CHAPEL C. 1427

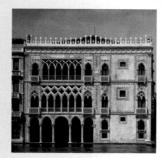

CA D'ORO, VENICE 1421-37

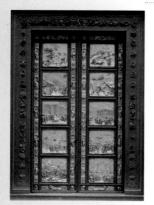

GHIBERTI
EAST DOORS, FLORENCE
BAPTISTRY COMPLETED
1452

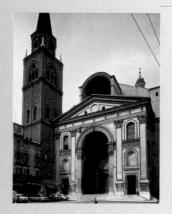

CHURCH OF SANT'ANDREA DESIGNED
1470

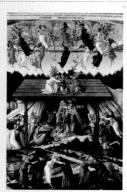

BOTTICELLI
MYSTIC NATIVITY

500

RENAISSANCE ART IN FIFTEENTH-CENTURY ITALY

⋖ Great Schism Ends 1417

■ Alberti Writes De Pictura (On Painting) 1435

■ Ghiberti Writes Commentaries c. 1450–55

■ Lorenzo de' Medici Rules Florence 1469-92

■ Savonarola Executed 1498

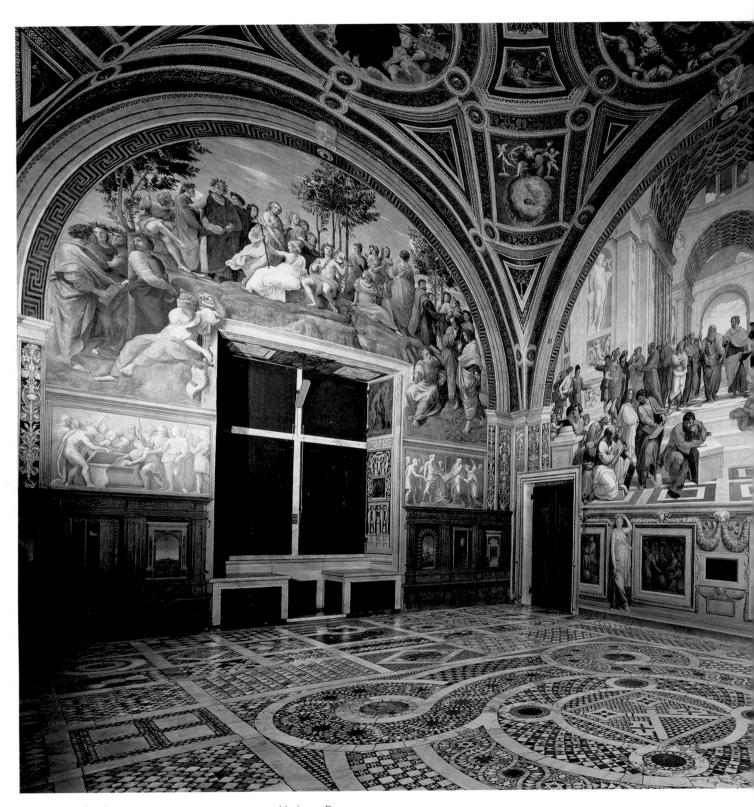

I5-I | Raphael STANZA DELLA SEGNATURA Vatican, Rome. Fresco in the left lunette, *Parnassus*; in the right lunette, *School of Athens*. 1510-11. *School of Athens*, $19 \times 27'$ (5.79 \times 8.24 m).

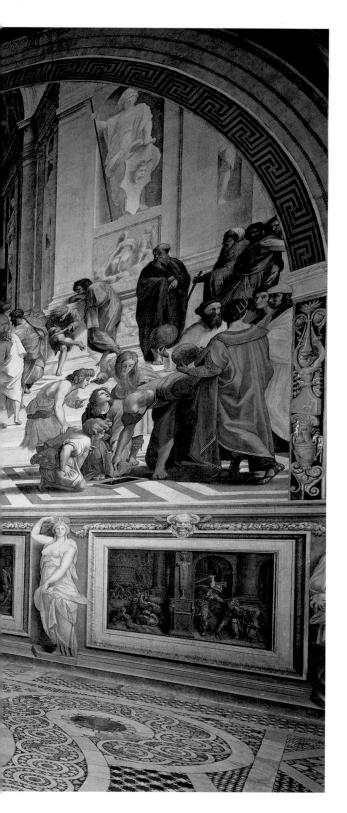

CHAPTER FIFTEEN

SIXTEENTH-CENTURY ART IN ITALY

15

Two young artists—Raphael (Raffaello Santi) and Michelangelo Buonarroti—although rivals in every sense, were both in the service of Pope Julius II in the early years of the sixteenth century. Raphael was

painting the pope's private library (1509–11) while nearby Michelangelo painted the ceiling of his chapel (1508–12). The pope demanded an art that reflected his imperial vision of a new, worldwide Church based on humanistic ideas. In fulfilling this demand, Raphael and Michelangelo brought early Renaissance principles of harmony and balance together with a new monumentality based on classical ideals, and they knit these separate elements into a dynamic and synthetic whole. Together with the architect Donato Bramante and the multifaceted genius Leonardo da Vinci, they created a style we now think of as the High Renaissance.

Pope Julius II (ruled 1503–13) intended the STANZA DELLA SEGNATURA, or Room of the Signature, to be his library and study (FIG. 15–1). In painting the all-encompassing iconographic program we see here, Raphael created an ideal setting for the activities of a pope who believed that all human knowledge existed under the power of divine wisdom. Raphael based his mural program on the traditional organization of a library into divisions of theology, philosophy, the arts, and justice; and he created allegories to illustrate these themes. On one wall, churchmen discussing the sacraments represent theology, while across the room ancient philosophers debate in the School of Athens, led by Plato and Aristotle. Plato holds his book Timaeus, in which creation is seen in terms of geometry, and in which humanity encompasses and explains the universe. Aristotle holds his Nicomachean Ethics, a decidedly human-centered book concerned with

relations between people. Ancient representatives of the academic curriculum—Grammar, Rhetoric, Dialectic, Arithmetic, Music, Geometry, and Astronomy—surround them. On a window wall, Justice, holding a sword and scales, assigns each his due. Across the room, Poetry and the Arts are represented by Apollo and the Muses, and the poet Sappho reclines against the fictive frame of an actual window. Raphael included his own portrait among the onlookers on the extreme lower right in the *School of Athens* and signed the painting with his initials—a signal that artists were increasingly aware of their individual significance.

Raphael achieved a lofty style in keeping with the papal ideals of classical grandeur, faith in human rationality and perfectibility, and the power of the pope as God's earthly administrator. But when Raphael died at the age of 37 on April 6, 1520, the grand moment was already passing: Luther and the Protestant Reformation were challenging papal authority.

CHAPTER-AT-A-GLANCE

- EUROPE IN THE SIXTEENTH CENTURY
- ITALY IN THE EARLY SIXTEENTH CENTURY: THE HIGH RENAISSANCE | Three Great Artists of the Early Sixteenth Century | Architecture in Rome and the Vatican | Architecture and Painting in Northern Italy | Venice and the Veneto
- ART AND THE COUNTER-REFORMATION | Art and Architecture in Rome and the Vatican
- MANNERISM | Painting | Manuscripts and Miniatures | Late Mannerism
- LATER SIXTEENTH-CENTURY ART IN VENICE AND THE VENETO | Oil Painting | Architecture: Palladio
- **IN PERSPECTIVE**

EUROPE IN THE SIXTEENTH CENTURY

The sixteenth century was an age of social, intellectual, and religious ferment that transformed European culture. It was also marked by continual warfare triggered by the expansionist ambitions of the continent's various rulers. The humanism of the fourteenth and fifteenth centuries, with its medieval roots and its often uncritical acceptance of the authority of classical texts, slowly developed a critical spirit that led Europeans to further their exploration of new ideas, nature, and lands. New methods in cartography that took account of the earth's curvature and the degrees of distance undermined traditional views of the world and led to a more accurate understanding of Europe's distinct place in it. The use of the printing press caused an explosion in the number of books available, spreading new ideas through the translation and publication of ancient and contemporary texts, broadening the horizons of educated Europeans and encouraging more people to learn to read. Travel became more common than in earlier centuries; artists and their work became mobile; consequently, artistic styles became less regional and more international.

At the start of the sixteenth century, England, France, and Portugal were nation-states under strong monarchs. Central Europe (Germany) was divided into dozens of principalities, counties, free cities, and other small territories. But even states as powerful as Saxony and Bavaria acknowledged the ovérlordship of the Habsburg (Holy Roman) Empire—in

theory the greatest power in Europe. Charles V, elected Holy Roman Emperor in 1519, also inherited Spain, the Netherlands, and vast territories in the Americas. Italy, which was divided into many small states, was a diplomatic and military battlefield where, for much of the century, the Italian citystates, Habsburg Spain, France, and the papacy fought each other in shifting alliances. The popes themselves behaved like secular princes, using diplomacy and military force to regain control over central Italy and in some cases to establish family members as hereditary rulers. The popes' incessant demands for money, to finance the rebuilding of Saint Peter's as well as their self-aggrandizing art projects and luxurious lifestyles, aggravated the religious dissent that had long been developing, especially north of the Alps. Early in the century, religious reformers within the established Church challenged beliefs and practices—especially Julius II's sale of indulgences, which entailed a financial contribution to the Church in return for forgiveness of sins and insurance of salvation. Because they protested, these northern European reformers came to be called Protestants. Their demand for reform gave rise to a movement called the Reformation.

Although Italy remained staunchly Catholic, the Reformation had profound repercussions there. It drove the Catholic church not only to launch a fight against Protestantism but also to seek internal reform and renewal—a movement that became known as the Counter–Reformation. The Counter–Reformation would have a profound effect on artists and the works they created.

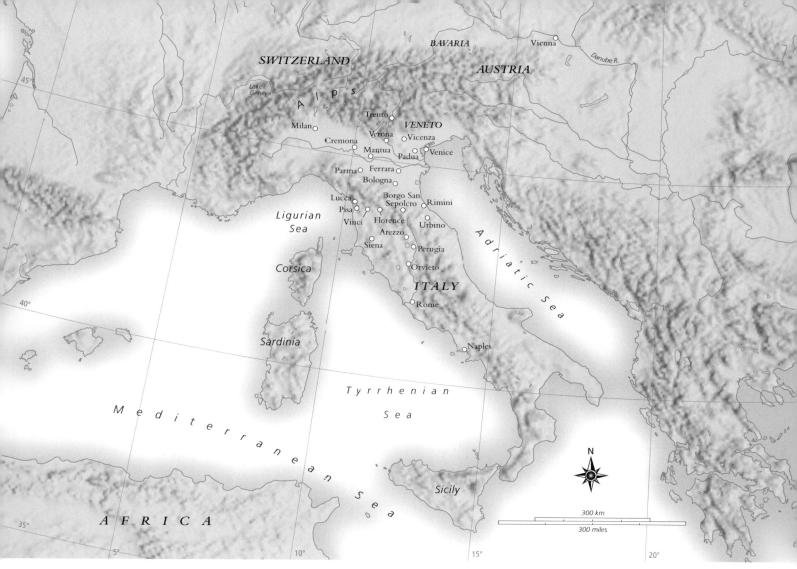

MAP 15-1 SIXTEENTH-CENTURY ITALY

In the 16th century Italy remained a peninsula divided into city-states in the north and the Papal States in the center. In the south Naples and Sicily were part of the vast and powerful Hasburg domains.

The political maneuvering of Pope Clement VII (papacy 1523–34) led to a direct clash with Holy Roman Emperor Charles V. In May 1527, Charles's German mercenary troops attacked Rome, beginning a six-month orgy of killing, looting, and burning. The Sack of Rome, as it is called, shook the sense of stability and humanistic confidence that until then had characterized the Renaissance, and it sent many artists fleeing from the ruined city. Nevertheless, Charles saw himself as the leader of the Catholic forces—and he was the sole Catholic ally Clement had at the time. In 1530 Clement VII crowned Charles emperor in Bologna.

Sixteenth-century patrons valued artists highly and rewarded them well, not only with generous commissions but sometimes even with high social status. Charles V, for example, knighted the painter Titian. Some painters and sculptors became entrepreneurs, selling prints of their works on the side. The sale of prints was a means by which reputations and styles became widely known, and a few artists of stature became international celebrities. With their new fame and independence, the most successful artists could decide which commissions to accept or reject.

Many artists recorded their activities in private diaries, notebooks, and letters that have come down to us. In addition, contemporary writers reported on everything about artists, from their physical appearance to their personal reputation. In 1550, Giorgio Vasari wrote the first survey of Italian art history, Lives of the Best Architects, Painters, and Sculptors. Vasari included more than simple biographical details; he made value judgments on work, commented on the role of patrons, and argued that art had become more realistic and more beautiful over time. He described the art of his own age as the culmination of historical processes, with its fulfillment in the life and work of Michelangelo. From his characterization, in part, stems our notion of this time period as the High Renaissance—that is, as a high point in art since Cimabue and Giotto that marks a balanced synthesis of classical ideals and an ordered naturalism.

During this period, the fifteenth-century humanists' argument that the conception of a painting, sculpture, or work of architecture was not a manual art but a liberal (intellectual) art, which therefore required education in the classics and mathematics, became a topic of intense interest. The

artist could express as much through painted, sculptural, and architectural forms as the poet could with words or the musician with melody. The myth of the divinely inspired creative genius—which arose during the Renaissance—is still with us today.

As with the business side of artistic production, however, the newly elevated status to which artists aspired favored men. Although few artists of either sex had access to the humanist education required for the sophisticated, often esoteric, subject matter used in paintings (most artists depended on outside sources for this aspect of their work), women were denied even the studio practice necessary to draw nude figures in foreshortened poses. Furthermore, it was almost impossible for an artist to achieve international status without traveling extensively and frequently relocating to follow commissions—something most women could not do. Still, women artists were active in European cultural life despite the obstacles to their entering any profession.

ITALY IN THE EARLY SIXTEENTH CENTURY: THE HIGH RENAISSANCE

Italian art from the 1490s to about the time of the Sack of Rome in 1527 has been called the "High Renaissance," the "Imperial style," and the "classical phase" of the Renaissance. It is characterized by a sense of gravity, a complex but balanced relationship of individual parts to the whole, and a deeper understanding of humanism and of ancient classical art than in the previous century. As before, outstanding Italian artists practicing in Rome, Florence, and other Italian cities spread this Italian Renaissance style throughout Europe.

Two important practical developments at the turn of the sixteenth century affected the arts in Italy: Technically, the use of tempera gave way to the more flexible oil medium in painting; and economically, commissions from private sources increased. Artists no longer depended so exclusively on the patronage of the Church, the aristocracy, or civic associations. Some members of the middle class in Italy and other European countries amassed wealth and became avid collectors of classical antiquities, paintings, and small bronzes, as well as coins, minerals, and fossils from the natural world.

Three Great Artists of the Early Sixteenth Century

Florence's renowned artworks and tradition of arts patronage attracted a stream of young artists to that city. The frescoes in the Brancacci Chapel there (SEE FIG. 14–20) inspired young artists, who went to study Masaccio's solid, monumental figures and eloquent facial features, poses, and gestures. For example, the young Michelangelo's sketches of the chapel frescoes clearly show the importance of Masaccio to his developing style. Michelangelo, Leonardo, and Raphael—the three leading artists of the classical phase of the Italian

Renaissance—all began their careers in Florence, although they soon moved to other centers of patronage and their influence spread far beyond that city.

LEONARDO DA VINCI. Leonardo da Vinci (1452–1519) was twelve or thirteen when his family moved to Florence from the Tuscan village of Vinci. He was an apprentice in the shop of the painter and sculptor Verrocchio until about 1476. After a few years on his own, Leonardo traveled to Milan in 1481 or 1482 to work for the ruling Sforza family.

Leonardo spent much of his time in Milan on military and civil engineering projects, including both urbanrenewal and fortification plans for the city, but he also created one of the key monuments of Renaissance art there: At Duke Ludovico Sforza's request, Leonardo painted THE LAST SUPPER (FIG. 15-2, AND Fig. 18, Introduction) in the refectory, or dining hall, of the Monastery of Santa Maria delle Grazie in Milan between 1495 and 1498. In fictive space defined by a coffered ceiling and four pairs of tapestries that seem to extend the refectory into another room, Jesus and his disciples are seated at a long table placed parallel to the picture plane and to the living diners seated in the hall. The stagelike space recedes from the table to three windows on the back wall, where the vanishing point of the one-point perspective lies behind Jesus's head. Jesus forms an equilateral pyramid at the center, his arms uniting the twelve disciples, who are grouped in four interlocking sets of three. As a narrative, the scene captures the moment when Jesus tells his companions that one of them will betray him. They react with shock, disbelief, and horror. Judas recoils, clutching his money bag in the shadows to the left of Jesus. Leonardo was an acute observer of human beings and his art vividly expressed human emotions.

On another level, The Last Supper is a symbolic evocation of both Jesus's coming sacrifice for the salvation of humankind and the institution of the ritual of the Mass. Breaking with traditional representations of the subject, such as the one by Andrea del Castagno (SEE FIG. 14-25), Leonardo placed the traitor Judas in the first triad to the left of Jesus, with the young John the Evangelist and the elderly Peter, rather than isolating him on the opposite side of the table. Judas, Peter, and John were each to play an essential role in Jesus's mission: Judas to set in motion the events leading to Jesus's sacrifice; Peter to lead the Church after Jesus's death; and John, the visionary, to foretell the Second Coming and the Last Judgment in the Apocalypse. By arranging the disciples and architectural elements into four groups of three, Leonardo incorporated a medieval tradition of numerical symbolism. He eliminated another symbolic element—the halo-and substituted the natural light from a triple window framing Jesus's head (compare Rembrandt's reworking of the composition, Fig. 19, Introduction).

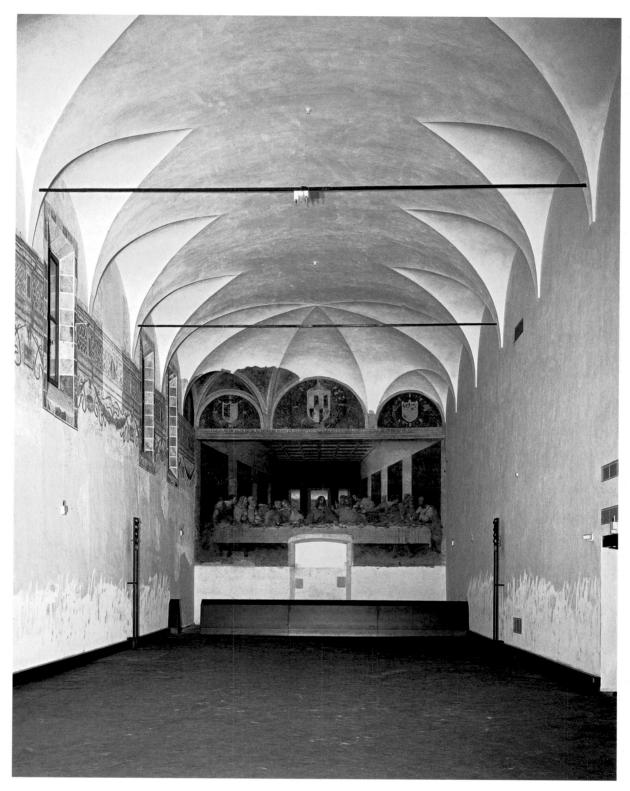

I5-2 | Leonardo THE LAST SUPPER Wall painting in the refectory of the Monastery of Santa Maria delle Grazie, Milan, Italy. 1495-98. Tempera and o I on plaster, $15'2'' \times 28'10''$ ($4.6 \times 8.8 \text{ m}$). See Introduction, Fig. 18.

Instead of painting in fresco, Leonardo devised an experimental technique for this mural. Hoping to achieve the freedom and flexibility of painting on wood panel, he worked directly on dry *intonaco*—a thin layer of smooth plaster—with an oil-and-tempera paint for which the formula is unknown. The result was disastrous. Within a short time, the painting began to deterorate, and by the middle of the sixteenth century its figures could be seen only with difficulty. In the seventeenth century, the monks saw no harm in cutting a doorway through the lower center of the composition. Since then the work has barely survived, despite many attempts to halt its deterioration and restore its original appearance. The painting narrowly escaped complete destruction in World War II, when the refectory was bombed to rubble around its heavily sandbagged wall. The coats of arms at the top are those of patron Ludovico Sforza, the Duke of Milan (ruled 1494–99), and his wife, Beatrice.

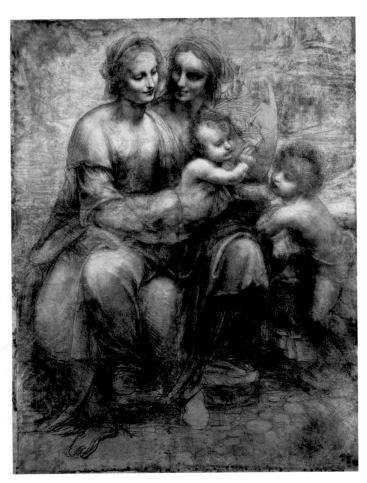

15–3 | Leonardo **VIRGIN AND SAINT ANNE WITH THE CHRIST CHILD AND THE YOUNG JOHN THE BAPTIST** c. 1500. Charcoal heightened with white on brown paper, $55\frac{1}{2} \times 41$ " (141.5 \times 104.6 cm). The National Gallery, London.

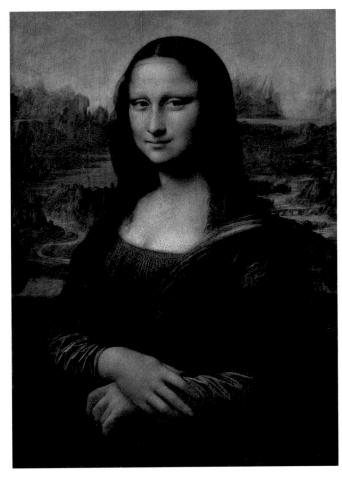

I5–4 | Leonardo MONA LISA c. 1503. Oil on wood panel, $30\% \times 21''$ (77 \times 53 cm). Musée du Louvre, Paris.

The painting's careful geometry, the convergence of its perspective lines, the stability of its pyramidal forms, and Jesus's calm demeanor at the mathematical center of all the commotion together reinforce the sense of gravity, balance, and order. The work's qualities of stability, calm, and timelessness, coupled with the established Renaissance forms modeled after those of classical sculpture, characterize the art of the Renaissance at the beginning of the sixteenth century.

Leonardo returned to Florence in 1500, after the French, who had invaded Italy in 1494, claimed Milan. (They defeated Leonardo's Milanese patron, Ludovico Sforza, who remained imprisoned until his death in 1508.) Upon his return, Leonardo produced a large drawing of the **VIRGIN AND SAINT ANNE WITH THE CHRIST CHILD AND THE YOUNG JOHN THE BAPTIST** (FIG. 15–3). This work may be a full-scale model, called a **cartoon**, for a major painting, but no known painting can be associated with it. Scholars today believe it to be a finished work—perhaps one of the drawings artists often made as gifts. Mary sits on the knee of her mother, Anne, and turns to the right to hold the Christ Child, who strains away from her to reach toward his cousin, the young John the Bap-

tist. Leonardo created the illusion of high relief by modeling the figures with strongly contrasted light and shadow, a technique called **chiaroscuro** (Italian for "light-dark"). Rather than a central focus, carefully placed highlights create interlocking circular movements that activate the composition; they underscore the individual importance of each figure while making each of them an integral part of the whole. This effect emphasizes the figures' complex interactions, which are suggested by their exquisitely tender expressions, particularly those of Saint Anne and the Virgin.

Between about 1503 and 1506, Leonardo painted the renowned portrait known as MONA LISA (FIG. 15–4). The subject may have been 24-year-old Lisa Gherardini del Giocondo, the wife of a prominent merchant in Florence. Leonardo never delivered the painting and kept it with him for the rest of his life. Remarkably for the time, the young woman is portrayed without any jewelry, not even a ring. The solid pyramidal form of her half-length figure—a significant departure from the traditional portraits, which stopped at the upper torso—is silhouetted against distant mountains, whose desolate grandeur reinforces the painting's mysterious atmosphere.

Defining Art

THE VITRUVIAN MAN

rtists throughout history have turned to geometric shapes and mathematical proportions to seek the ideal representation of the human form. Leonardo da Vinci, and before him Vitruvius, equated the ideal man with both circle and square. Ancient Egyptian artists laid out square grids as aids to design. Medieval artists adapted a variety of figures, from triangles to pentagrams. The Byzantines used circles centered on the bridge of the nose to create face, head, and halo.

The first-century BCE Roman architect and engineer Vitruvius, in his ten-volume *De architectura* (*On Architecture*), wrote: "For if a man be placed flat on his back, with his hands and feet extended, and a pair of compasses centered at his navel, the fingers and toes of his two hands and feet will touch the circumference of a circle described therefrom. And just as the human body yields a circular outline, so too a square figure may be found from it. For if we measure the distance from the soles of the feet to the top of the head, and then apply that measure to the outstretched arms, the breadth will be found to be the same as the height" (Book III, Chapter 1, Section 3). Vitruvius determined that the body should be eight heads high. Leonardo added his own observations in the reversed writing he always used for his notebooks when he created his well-known diagram for the ideal male figure, called the VITRUVIAN MAN.

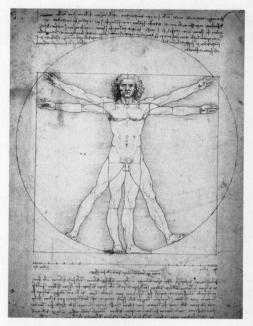

Leonardo VITRUVIAN MAN c. 1490. Ink, $13\% \times 9\%$ (34.3 \times 24.5 cm). Galleria dell'Accademia, Venice.

Mona Lisa's expression has been called enigmatic because her gentle smile is not accompanied by the warmth one would expect to see in her eyes. The contemporary fashion for plucked eyebrows and a shaved hairline to increase the height of the forehead adds to her arresting appearance. Perhaps most unsettling is the bold and slightly flirtatious way her gaze has shifted toward the right to look straight out at the viewer. The implied challenge of her direct stare, combined with her apparent serenity and inner strength, has made the *Mona Lisa* one of the most haunting and consequently one of the most popular and best-known works in the history of art.

A fiercely debated topic in Renaissance Italy was the question of the superiority of painting or sculpture. Leonardo insisted on the supremacy of painting as the best and most complete means of creating an illusion of the natural world, while Michelangelo argued for sculpture. Yet in creating a painted illusion, Leonardo considered color to be secondary to the depiction of sculptural volume, which he achieved through his virtuosity in highlighting and shading. He also unified his compositions by covering them with a thin, lightly tinted varnish, which resulted in a smoky overall haze called *sfumato*. Because early evening light tends to produce a similar effect naturally, Leonardo considered dusk the finest time of day and recommended that painters set up their

studios in a courtyard with black walls and a linen sheet stretched overhead to reproduce twilight.

Leonardo's fame as an artist is based on only a few works, for his many interests took him away from painting. Unlike his humanist contemporaries, he was not particularly interested in classical literature or archaeology. Instead, his passions were mathematics, engineering, and the natural world. He compiled volumes of detailed drawings and notes on anatomy, botany, geology, meteorology, architectural design, and mechanics. In his drawings of human figures, he sought not only the precise details of anatomy but also the geometric basis of perfect proportions (see "The Vitruvian Man," above). Leonardo's searching mind is evident in his drawings, not only of natural objects and human beings, but also of machines. His drawings are so clear and complete that modern engineers have been able to construct working models from them. He designed flying machines, a sort of automobile, a parachute, and all sorts of military equipment, including a mobile fortress. His imagination outran his means to bring his creations into being. For one thing, he lacked a source of power other than men and horses. For another, he may have lacked focus and follow-through: His contemporaries complained that he never finished anything and that his inventions distracted him from his painting.

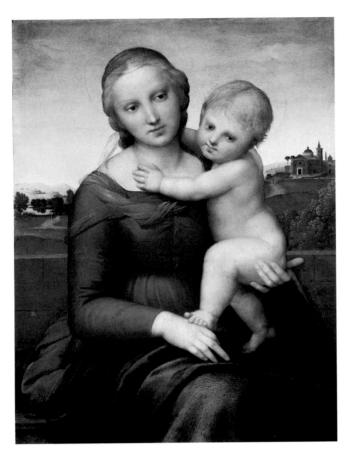

15–5 | Raphael THE SMALL COWPER MADONNA c. 1505. Oil on wood panel, $23\% \times 17\%$ (59.5 \times 44.1 cm). National Gallery of Art, Washington, D.C. Widener Collection (1942.9.57)

RAPHAEL. About 1505, Raphael (Raffaello Santi or Sanzio, 1483-1520) arrived in Florence from his native Urbino. He had studied in Perugia with the leading artist of that city, Perugino (SEE FIG. 14-34). Raphael quickly became successful in Florence, especially with paintings of the Virgin and Child, such as THE SMALL COWPER MADONNA (named for a modern owner) of about 1505 (FIG. 15-5). Already a superb painter technically, the youthful Raphael shows his indebtedness to his teacher in the delicate tilt of the figures' heads and the tranquil, even mood that pervades the painting. But Raphael must have studied Leonardo's work to achieve the simple grandeur created by these monumental shapes, the pyramid activated by the spiraling movement of the child, and the figure-enhancing draperies of the Virgin. The solidly modeled forms are softened by the clear, even light of the outdoor setting.

In the distance on a hilltop, Raphael has painted a scene he knew well from his childhood, the domed Church of San Bernardino, two miles outside Urbino. The church contains the tombs of the dukes of Urbino, Federico and Guidobaldo da Montefeltro, and their wives (SEE FIG. 14–28). Donato Bramante, whose architecture was key in establishing the High Renaissance style (see page 547), may have designed the church.

Raphael left Florence about 1508 for Rome, where Pope Julius II put him to work almost immediately decorating rooms (stanze, singular stanza) in the papal apartments. In the Stanza della Segnatura—the papal library, which we saw at the beginning of the chapter (SEE FIG. 15–1)—Raphael painted the four branches of knowledge as conceived in the sixteenth century: Religion (the Disputà, depicting the disputation over the true presence of Christ in the Host, the Communion bread), Philosophy (the School of Athens), Poetry (Parnassus, home of the Muses), and Law (the Cardinal Virtues under Justice). The shape of the walls and vault of the room itself inspired the composition of the paintings—for example, the receding arches and vaults in the School of Athens, or the inclusion of the window as part of the rocky mountain in Parnassus.

Raphael's most outstanding achievement in the papal rooms was the **school of athens**, painted about 1510–11 **(FIG. 15–6)**. Here, the painter seems to summarize the ideals of the Renaissance papacy in his grand conception of harmoniously arranged forms in a rational space, as well as in the calm dignity of its figures. The learned Julius II may have actually devised the subjects painted; he certainly must have approved them.

Viewed through a trompe l'oeil arch, the Greek philosophers Plato and Aristotle—placed to the right and left of the compositional vanishing point—are silhouetted against the sky (the natural world) and command our attention. At the left, Plato gestures upward, indicating the "ideal" as impossible to attain on earth. Aristotle, with his outstretched hand palm down, seems to emphasize the importance of gathering empirical knowledge from observing the material world. Looking down from niches in the walls are sculptures of Apollo, the god of sunlight, rationality, poetry, music, and the fine arts; and Minerva, the goddess of wisdom and the mechanical arts. Around Plato and Aristotle are mathematicians, naturalists, astronomers, geographers, and other philosophers debating and demonstrating their theories to onlookers and to each other. The scene, flooded with a clear, even light from a single source, takes place in an immense barrel-vaulted interior, possibly inspired by the new design for Saint Peter's, under construction at the time. The grandeur of the building is matched by the monumental dignity of the philosophers themselves, each of whom has a distinct physical and intellectual presence. The sweeping arcs of the composition are activated by the variety and energy of the poses and gestures of these striking individuals. Such dynamic unity is an expression of the High Renaissance style.

Raphael continued to work for Julius II's successor, Leo X (papacy 1513–21), as director of all archaeological and architectural projects in Rome. Leo was born Giovanni de' Medici, the son of Lorenzo the Magnificent, and his driving ambition was the advancement of the Medici family—who had been exiled from Florence in 1494 and only returned to power there in 1512. Raphael's portrait of Leo X is, in effect,

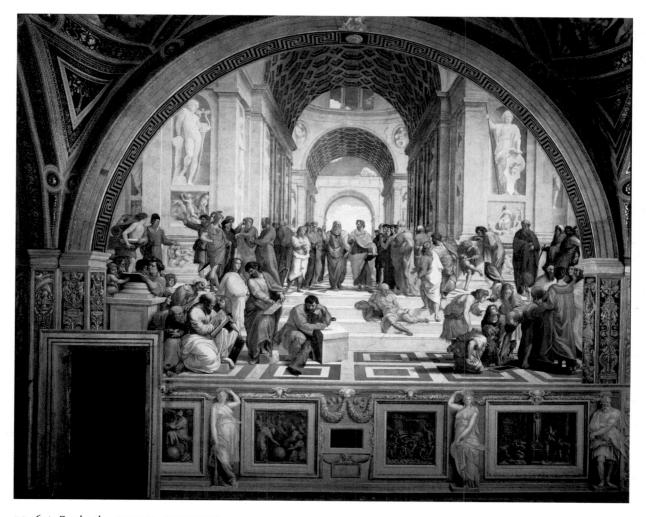

15–6 | Raphael school of Athens Fresco in the Stanza della Segnatura, Vatican, Rome. c. 1510–11. 19 \times 27′ (5.79 \times 8.24 m).

Raphael gave many of the figures in his imaginary gathering of philosophers the features of his friends and colleagues. It is speculated that Plato, standing immediately to the left of the central axis and pointing to the sky, was modeled after Leonardo da Vinci; Euclid, shown inscribing a slate with a compass at the lower right, was, according to Vasari, a portrait of Raphael's friend the architect Donato Bramante. Michelangelo, who was at work on the Sistine Chapel ceiling, only steps away from the stanza where Raphael was painting his fresco, may be the solitary figure at the lower left center, leaning on a block of marble and sketching, in a pose reminiscent of the figures of the sibyls and prophets on his great ceiling. Raphael's own features are represented on the second figure from the front group at the far right, as the face of a young man listening to a discourse by the astronomer Ptolemy.

a dynastic group portrait (FIG. 15–7). Facing the pope at the left is his cousin Giulio, Cardinal de' Medici, who governed Florence from 1519 to 1523 and then became Pope Clement VII (papacy 1523–34). Behind Pope Leo stands Luigi de' Rossi, a nephew whom he made a cardinal. Dressed in splendid brocades and enthroned in a velvet chair, the pope looks up from a richly illuminated fourteenth–century manuscript that he has been examining with a magnifying glass. He seems to stare into space, and, curiously, none of the three men look at each other. The mood seems uneasy, disconnected. Raphael carefully depicted the contrasting textures and surfaces in the picture, including the visual distortion caused by the magnifying glass on the book page. The polished brass knob on the

pope's chair reflects the window and the painter himself. In these telling details, Raphael acknowledges his debt—despite great stylistic differences—to fifteenth-century Flemish artists such as Jan van Eyck.

How could a man—even a brilliant artist—accomplish so much? Raphael was only 37 when he died. The answer lies partly in Raphael's genius for organizing his studio, which enabled him to accept numerous commissions. Retaining a flexible method, Raphael was able to assign assistants wherever he felt it was appropriate, even if that meant finishing major figures in a painting or making preparatory drawings—work generally assumed by the master. Raphael thus freed himself to concentrate on what he considered most necessary at any given

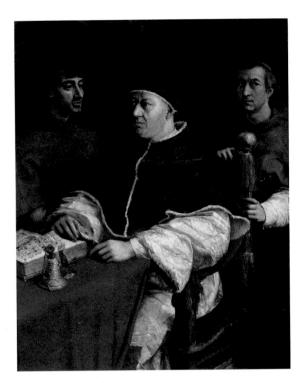

15-7 | Raphael POPE LEO X WITH CARDINALS GIULIO DE' MEDICI AND LUIGI DE' ROSSI c. 1517. Oil on wood panel, 5'\%" \times 3'10\%" (1.54 \times 1.19 m). Galleria degli Uffizi, Florence.

time. This method sometimes resulted in uneven products, especially toward the end of the artist's short life, when he was overwhelmed with work. Yet, even then, Raphael's major pieces show his contribution to be the dominant one.

In 1515–16, Raphael and his shop provided cartoons on themes from the Acts of the Apostles to be made into tapestries to cover the wall below the fifteenth-century wall paintings of the Sistine Chapel (FIG. 15–8). This commission must have suited Raphael's method, accustomed as he was to teamwork. For the production of tapestries, which were woven in workshops in Flanders, artists made full-scale charcoal drawings, then painted over them with glue-based colors for the weavers to match. Pictorial weaving was the most prestigious and expensive kind of wall decoration. With murals by the leading painters of the fifteenth century above and Michelangelo circling over all, Raphael must have felt the challenge. The pope had given him the place of honor among the artists in the papal chapel.

The first tapestry in Raphael's series was the **MIRACULOUS DRAFT OF FISHES** on the Sea of Galilee (Matt. 4:18–22). The fisherman Simon, whom Christ called to be his first apostle, Peter, became the cornerstone on which the papal claims to authority rested. Andrew, James, and John would also become apostles. The two boats establish a friezelike composition, and

15-8 | Shop of Pieter van Aelst, Brussels, after cartoons by Raphael and assistants MIRACULOUS DRAFT OF FISHES

1515–16. From the nine-piece set, the *Acts of the Apostles* series; lower border, two incidents from the life of Giovanni de' Medici, later Pope Leo X. Woven 1517, installed 1519 in the Sistine Chapel. Wool and silk with silver-gilt wrapped threads, $16'1'' \times 21' (4.9 \times 6.4 \text{ m})$. Musei Vaticani, Pinacoteca, Rome.

Raphael's Acts of the Apostles cartoons were used as the models for several sets of tapestries woven in van Aelst's Brussels shop, including one for Francis I of France and another for Henry VIII of England. In 1630, the Flemish painter Peter Paul Rubens (Chapter 17) discovered seven of the ten original cartoons in the home of a van Aelst heir and convinced his patron Charles I of England to buy them. Still part of the British royal collection today, they are exhibited at the Victoria & Albert Museum in London. The original tapestries were stolen during the Sack of Rome in 1527, returned in the 1530s, taken to Paris by Napoleon in 1798, purchased by a private collector in 1808, and returned to the Vatican as a gift that year. They are now displayed in the Raphael Room of the Vatican Painting Gallery.

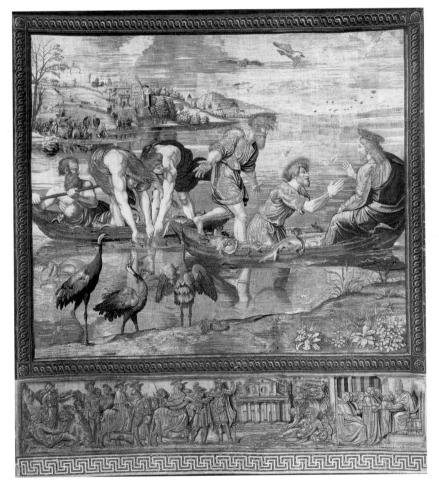

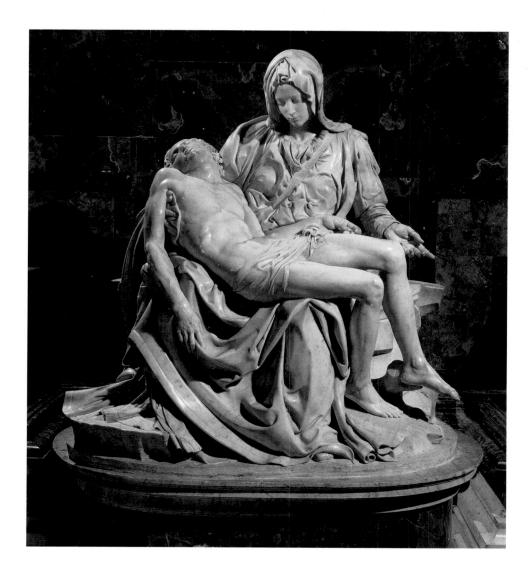

15–9 | Michelangelo PIETÀ c. 1500. Marble, height 5′8½″ (1.74 m). Saint Peter's, Vatican, Rome.

the huge straining figures remind us that Raphael felt himself in clear competition with Michelangelo, whose Sistine ceiling had been completed only three years earlier. Raphael studied not only his contemporaries' paintings, but also antique sources in his efforts to achieve both monumentality and realism. For example, he copied the face of Christ from a fifteenth-century bronze copy of an ancient emerald cameo, which at the time was thought to be the true portrait of Jesus. The panoramic landscape behind the fishermen includes a crowd on the shore, and the city of Rome with its walls and churches. The three cranes in the foreground were not a simple pictorial device; in the sixteenth century they symbolized the ever-alert and watchful pope. The cranes proved to be a timely addition. When the tapestries were first displayed in the Sistine Chapel on December 26, 1519, papal authority was already being challenged by reformers like Martin Luther in Germany (see Chapter 16).

MICHELANGELO'S EARLY WORK. Michelangelo Buonarroti (1475–1564) was born in the Tuscan town of Caprese into an impoverished Florentine family that laid claim to nobility: a claim the artist carefully advanced throughout his life. He

grew up in Florence, and spent his long career working there and in Rome. At thirteen, he was apprenticed to Ghirlandaio (SEE FIG. 14-36), in whose workshop he learned the rudiments of fresco painting and studied drawings of classical monuments. Soon the talented youth joined the household of Lorenzo the Magnificent, head of the ruling Medici family, where he came into contact with the Neoplatonic philosophers and studied sculpture with Bertoldo di Giovanni, a pupil of Donatello. Bertoldo worked primarily in bronze, and Michelangelo later claimed that he had taught himself to carve marble by studying the Medici collection of classical statues. After Lorenzo died in 1492, Michelangelo traveled to Venice and Bologna, then returned to Florence, where he fell under the spell of the charismatic preacher Fra Girolamo Savonarola (see Chapter 14). The preacher's execution for heresy in 1498 had a traumatic effect on Michelangelo, who said in his old age that he could still hear the sound of Savonarola's voice.

Michelangelo's major early work at the turn of the century was a pietà marble sculpture group, commissioned by a French cardinal and installed as a tomb monument in the Vatican basilica of Saint Peter (FIG. 15–9). The pietà—in

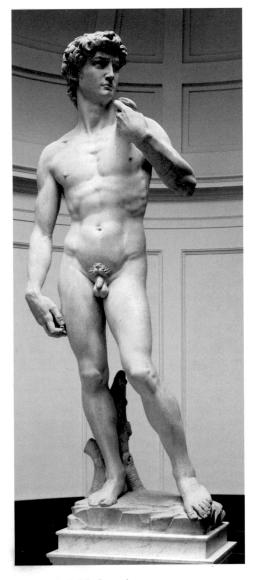

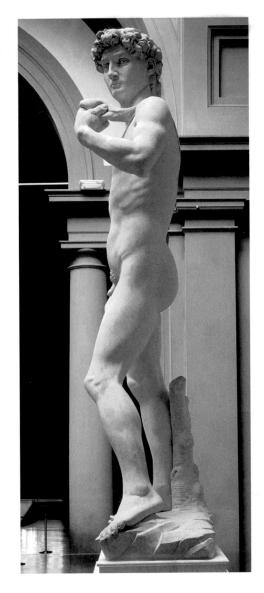

15−10 | Michelangelo **DAVID** 1501-04. Marble, height 17′ (5.18 m) without pedestal. Galleria dell'Accademia, Florence.

Michelangelo's most famous sculpture was cut from an 18-foot-tall marble block. The sculptor began with a small model in wax, then sketched the contours of the figure as they would appear from the front on one face of the marble. Then, according to his friend and biographer Vasari, he chiseled in from the drawn-on surface, as if making a figure in very high relief. The completed statue took four days to move on tree-trunk rollers down the narrow streets of Florence from the premises of the cathedral shop where he worked to its location outside the Palazzo della Signoria (SEE FIG. 12-2). In 1504, the Florentines gilded the tree stump and added a gilded wreath to the head and a belt of twenty-eight gilt-bronze leaves, since removed. In 1873 the statue was replaced by a copy, and the original was moved into the museum of the Florence Academy.

which the Virgin supports and mourns the dead Jesus—had long been popular in northern Europe but was an unusual theme in Italian art at the time. Michelangelo traveled to the marble quarries at Carrara in central Italy himself to select the block from which to make this large work, a practice he was to follow for nearly all of his sculpture. His choice of stone was important, for Michelangelo envisioned the statue as already existing within the marble and needing only to be "set free" from it. Michelangelo was a poet as well as an artist, and later wrote in his Sonnet 15:

"The greatest artist has no conception which a single block of marble does not potentially contain within its mass, but only a hand obedient to the mind can penetrate to this image" (1536–47).

Michelangelo's *Pietà* is a very young Virgin of heroic stature holding the lifeless, smaller body of her grown son. The seeming inconsistencies of age and size are forgotten in contemplating the sweetness of expression, the finely finished surfaces, and the softly modeled forms. Michelangelo's compelling vision of beauty is meant to be seen up close, from

directly in front of the statue and on the statue's own level, so that the viewer can look into Jesus's face. The 25-year-old artist is said to have slipped into the church at night to sign the finished sculpture, to answer the many questions about its creator. It is the only signature of Michelangelo's that has not been disputed.

In 1501, Michelangelo accepted a commission for a statue of one of the symbols of Florence, the biblical DAVID (FIG. 15-10), to be placed high atop a buttress of the Cathedral. When it was finished in 1504, the David was so admired that the city council instead placed it at eye-level in the square next to the Palazzo Vecchio, the seat of Florence's government. There it stood as a reminder of Florence's republican status, which was briefly reinstated after the expulsion of the powerful Medici oligarchy in 1494. Although, in its muscular nudity, Michelangelo's David embodies the athletic ideal of antiquity—particularly of Hellenistic sculptures of Hercules (another symbol of Florence)—the emotional power of its expression and its concentrated gaze is entirely new. Unlike Donatello's bronze David (SEE FIG. 14–13), this is not a triumphant hero with the head of the giant Goliath under his feet. Instead, slingshot over his shoulder and a rock in his right hand, Michelangelo's David frowns and stares into space, seemingly preparing himself psychologically for the danger ahead, a mere youth confronting a gigantic experienced warrior. Here the male nude implies heroic or even divine qualities, as it did in classical antiquity. Traditionally no match for his opponent in experience, weaponry, or physical strength, Michelangelo's powerful David represents the supremacy of right over might—a perfect emblematic figure for the Florentines, who recently had fought the forces of Milan, Siena, and Pisa and still faced political and military pressure.

THE SISTINE CHAPEL. Despite Michelangelo's contractual commitment to the Florence Cathedral for statues of the apostles, in 1505 Pope Julius II, who saw Michelangelo as an ideal collaborator in the artistic aggrandizement of the papacy, arranged for him to come to Rome to work on the spectacular tomb-monument Julius planned for himself. Michelangelo began the new project, but two years later in 1506 the pope put this commission aside and ordered him to paint the SISTINE CHAPEL CEILING instead (FIG. 15–11).

Michelangelo considered himself a sculptor, but the strong-minded pope wanted his chapel painted and paid Michelangelo well for the work, which began in 1508. Michelangelo complained bitterly in a sonnet to a friend: "This miserable job has given me a goiter . . . The force of it has jammed my belly up beneath my chin. Beard to the sky . . . Brush splatterings make a pavement of my face . . . I'm not a painter." Despite his physical misery as he stood on a scaffold, painting the ceiling just above him, he achieved the

Sequencing Events Reigns of the Great Papal Patrons of the Sixteenth Century

1492-1503	Alexander VI (Borgia)
1503-13	Julius II (della Rovere)
1513-21	Leo X (Medici)
1523-34	Clement VII (Medici)
1534-49	Paul III (Farnese)
1585-90	Sixtus V (Peretti)

desired visual effects for viewers standing on the floor far below. His Sistine Chapel ceiling frescoes established a new and extraordinarily powerful style in Renaissance painting.

Julius's initial order for the ceiling was simple: trompe l'oeil coffers to replace the original star-spangled blue ceiling. Later he wanted the twelve apostles seated on thrones to be painted in the triangular walls between the lunettes framing the windows. According to Michelangelo, when he objected to the limitations of Julius's plan, the pope told him to paint whatever he liked. This Michelangelo presumably did, although a commission of this importance probably involved an adviser in theology. Certainly it required the pope's approval. Then, as master painter, Michelangelo assembled a team of expert assistants, who probably continued to work with him under close supervision.

In Michelangelo's final composition, illusionistic marble architecture establishes a framework for the figures on the vault of the chapel (FIG. 15-12). Running completely around the ceiling is a painted cornice with projections supported by short pilasters decorated with putti. Set within this frame are figures of Old Testament prophets and classical sibyls (female prophets) who were believed to have foretold Jesus's birth. Seated on the fictive cornice are heroic figures of nude young men, called ignudi (singular, ignudo), holding sashes attached to large gold medallions. Rising behind the ignudi, shallow bands of fictive stone span the center of the ceiling and divide it into compartments in which are painted scenes of the Creation, the Fall, and the Flood. The narrative sequence begins over the altar and ends near the chapel entrance (FIG. 15-13). God's earliest acts of creation are therefore closest to the altar, the Creation of Eve at the center of the ceiling, followed by the imperfect actions of humanity: the Temptation, the Fall, the Expulsion from Paradise, and God's eventual destruction of all people except Noah and his family by the Flood. The triangular spandrels contain paintings of the ancestors of Jesus; each is flanked by mirror-image nudes in reclining and seated poses.

According to discoveries during the most recent restoration, Michelangelo worked on the ceiling in two

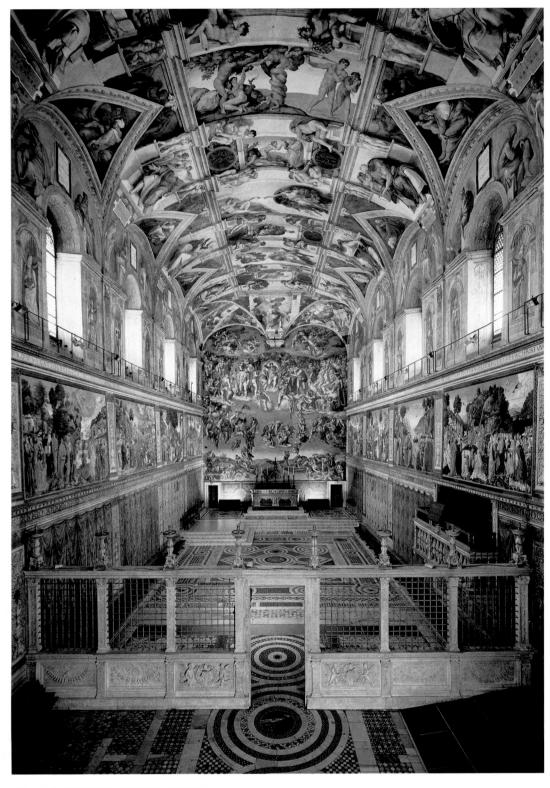

15–11 | **INTERIOR, SISTINE CHAPEL** Vatican, Rome. Built 1475–81; ceiling painted 1508–12; end wall, 1536–41. The ceiling measures $45 \times 128'$ (13.75 \times 39 m).

Named after its builder, Pope Sixtus (Sisto) IV, the chapel is slightly more than 130 feet long and about 143½ feet wide, approximately the same measurements recorded in the Old Testament for the Temple of Solomon. The floor mosaic was recut from the colored stones used in the floor of an earlier papal chapel. The walls were painted in fresco between 1481 and 1483 with scenes from the lives of Moses and Jesus by Perugino (SEE FIG. 14–34), Botticelli, Ghirlandaio, and others. Below these are *trompe l'oeil* painted draperies, where Raphael's tapestries illustrating the Acts of the Apostles once hung (SEE FIG. 15–8). Michelangelo's famous ceiling frescoes begin with the lunette scenes above the windows. On the end above the altar is his *Last Judgment* (SEE FIG. 15–28).

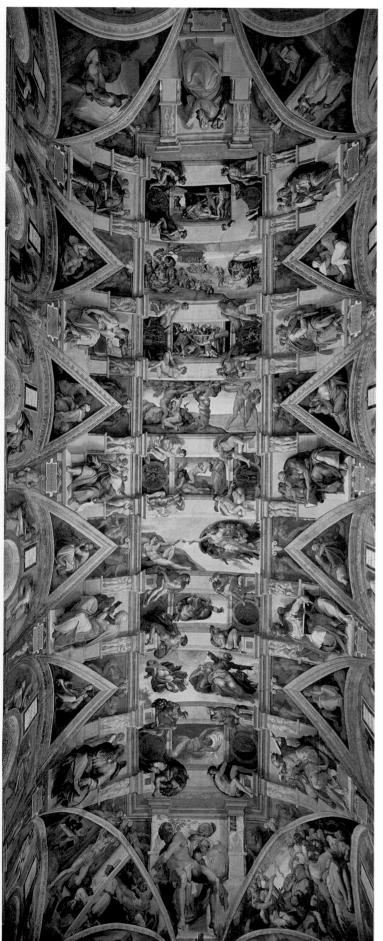

15–12 | Michelangelo **VIEW OF THE SISTINE CHAPEL CEILING FRESCOES** Vatican, Rome. 1508–12. $45' \times 128'$ (13.75 \times 39 m). Commissioned by Pope Julius II.

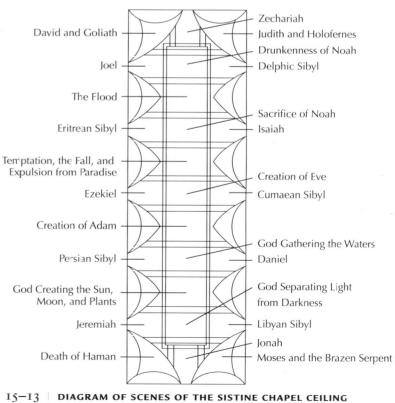

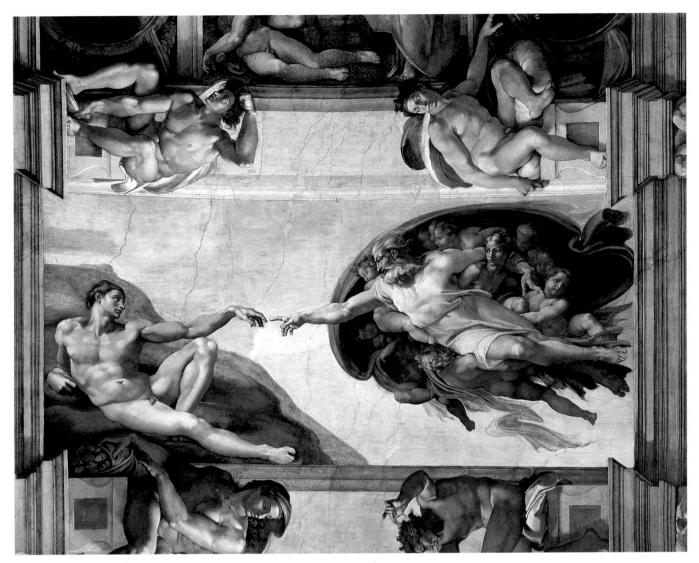

15–14 | Michelangelo CREATION OF ADAM, SISTINE CHAPEL CEILING 1511–12.

The *Creation of Adam*, which opens the second stage of Michelangelo's fresco cycle, has the simplified background and the powerful male figures, and nude youths twisting into contrapposto poses characteristic of this phase of his work. Stylus marks above Adam's head show where the artist transferred his design onto the wet plaster.

stages, beginning in the late summer or fall of 1508 and moving from the chapel's entrance toward the altar, in reverse of the narrative sequence. The first half of the ceiling up to the Creation of Eve was unveiled in August 1511 and the second half in October 1512. His style became broader and the composition simpler as he progressed.

Perhaps the most familiar scene on the ceiling is the **CREATION OF ADAM** (FIG. 15–14). Here Michelangelo depicts the moment when God charges the languorous Adam with the spark of life. As if to echo the biblical text, Adam's

heroic body and pose mirror those of God, in whose image he has been created. Directly below Adam is an *ignudo* grasping a bundle of oak leaves and giant acorns, which refer to Pope Julius's family name (della Rovere, or "of the oak") and possibly also to a passage in the Old Testament prophecy of Isaiah (61:3): "They will be called oaks of justice, planted by the Lord to show his glory."

MICHELANGELO'S LATER SCULPTURE. Michelangelo's first papal sculpture commission, the tomb of Julius II, still incomplete at

Julius's death in 1513, was to plague him and his patrons for forty years. In 1505, he had presented his first designs to the pope for a huge freestanding structure crowned by the pope's sarcophagus and covered with more than forty statues and reliefs in marble and bronze. But Julius had halted the tomb project to divert money toward other ends. After Julius died, his heirs soon began to cut back on the expense and size of the tomb. At this time, between 1513 and 1516, and again from 1542 to 1545, Michelangelo worked on the figure of MOSES (FIG. 15-15), the only sculpture from the original design to be incorporated into the final, much-reduced monument to Julius II. No longer an actual tomb-Julius was buried elsewhere—the monument was installed in 1545, after decades of wrangling, in the Church of San Pietro in Vincoli, Rome, where Julius had been the cardinal. In the original design, Moses was to have been one of four seated figures; in the final configuration, however, Moses becomes the focus of the monument and a stand-in for the long-dead pope.

Moses is an inspired figure, a prophet holding the tablets of the Law, which he has just received from God on Mount Sinai. Like the prophets on the Sistine Chapel ceiling, his gigantic muscular figure, swathed in great sheets of drapery, is seated in a restless contrapposto that seems to strain the confines of the niche. Moses's beard is an extraordinary curling, flowing mass that covers his chest. Michelangelo's carving of this beard as it is drawn aside by a finger is a tour de force of marble sculpture.

After the Medici regained power in Florence in 1512, and Leo X succeeded Julius in 1513, Michelangelo became chief architect for Medici family projects at the Church of San Lorenzo in Florence—including a new chapel for the tombs of Lorenzo the Magnificent, his brother Giuliano, and two younger dukes, also named Lorenzo and Giuliano, ordered in 1519. The older men's tombs were never built to Michelangelo's designs, but the unfinished tombs for the younger relatives were placed on opposite side walls of the so-called New Sacristy (FIG. 15–16). The Old Sacristy, by Filippo Brunelleschi, is at the other end of the transept (SEE FIG. 14–3).

In the New Sacristy, each of the two monuments consists of an idealized portrait of the deceased, who turns to face the family's unfinished ancestral tomb. The men are dressed in a sixteenth-century interpretation of classical armor and seated in niches above pseudoclassical sarcophagi. Balanced precariously atop the sarcophagi are male and female figures representing the times of day. Their positions would not seem so unsettling had reclining figures of river gods been installed below them, as originally planned. Giuliano represents the Active Life, and his sarcophagus figures are allegories of Night and Day. Night is accompanied by her symbols: a star and crescent moon on her tiara; poppies, which induce sleep; and an owl under the arch of her leg. The huge mask at her back may allude to Death, since Sleep and Death were said to be the children of Night. Lorenzo, representing the

Sequencing Events GREAT SECULAR PATRONS OF THE SIXTEENTH CENTURY

1452-1508	Ludovico Sforza, Duke of Milan
1474-1539	Isabella d'Este, Marchesa of Mantua
1494-1547	Francis I (Valois), King of France
1500-40	Federigo II Gonzaga, Fifth Marchese and First Duke of Mantua
1500-58	Charles V (Habsburg), King of Spain and Holy Roman Emperor
1519-74	Cosimo I de' Medici, Duke of Florence and Grand Duke of Tuscany

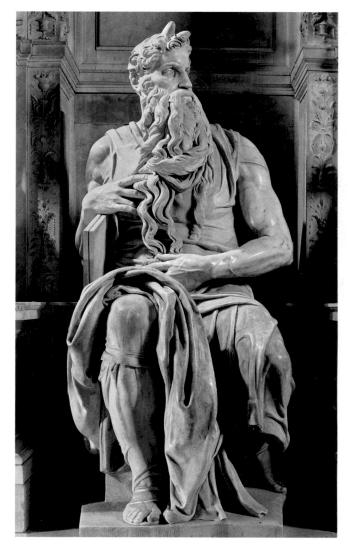

I5-I5 | Michelangelo MOSES
Tomb of Julius II. 1513-16, 1542-45. Marble, height 7'8½"
(2.35 m). Church of San Pietro in Vincoli, Rome.

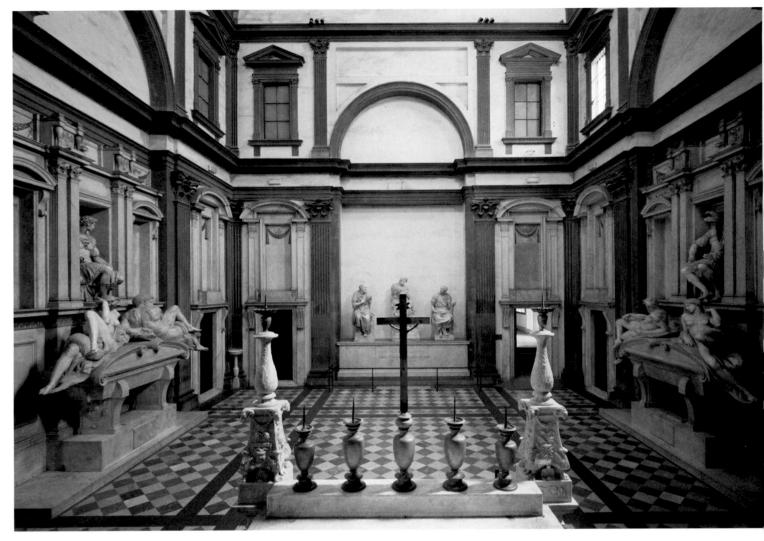

15–16 | Michelangelo NEW SACRISTY (MEDICI CHAPEL) 1519–34. Church of San Lorenzo, Florence.

Looking from the altar, we see on the left the tomb of Giuliano de' Medici, with Giuliano seated in the niche and personifications of Day and Night reclining on the pseudo-classical sarcophagus; on the right, the tomb of Lorenzo with the personifications of Dusk and Dawn. Facing the altar is the unfinished tomb of Lorenzo the Magnificent with the "Medici Madonna" in the center and the Medici patron saints, Sts. Cosmas and Damian, at each side.

Contemplative Life, is supported by Dawn and Evening. The allegorical figures for the empty niches that flank the tombs were never carved. The walls of the sacristy are articulated with Brunelleschian *pietra serena* pilasters and architraves in the Corinthian order.

Ongoing political struggles in Florence interrupted Michelangelo's work. In 1534, detested by the new Duke of Florence and fearing for his life, Michelangelo returned to Rome, where he settled permanently. He had left the Medici chapel unfinished. Many years later, in 1545, his students assembled the tomb sculptures, including unfinished figures of the times of day, into the composition we

see today. The figures of the dukes are finely finished, but the times of day are notable for their contrasting areas of rough unfinished and polished marble. These are the only unfinished sculptures Michelangelo may have permitted to be put in place, and we do not know what his reasons were. Michelangelo specialists call this his *nonfinito* ("unfinished") quality, suggesting that he had begun to view his artistic creations as symbols of human imperfection. Indeed, Michelangelo's poetry often expressed his belief that humans could achieve perfection only in death. The lack of finish may also reflect his belief that the block of marble held the image prisoner within it. Some of

Michelangelo's unfinished sculptures were placed in the Great Grotto of the Boboli Gardens in Florence (see "The Grotto," right).

Michelangelo's style continued to evolve throughout his career in sculpture, painting, and architecture, and he produced significant works until his death in 1564. We will return to him later in this chapter to examine his further development and his direct influence on artists of the later sixteenth century.

Architecture in Rome and the Vatican

The election of Julius II as pope in 1503 crystallized a resurgence of the papal power. France, Spain, and the Holy Roman Empire all had designs on Italy. The political turmoil that beset Florence, Milan, and other northern cities left Rome as Italy's most active artistic and intellectual center. During the ten years of his reign, Julius fought wars and formed alliances to consolidate his power. And in addition to commissioning large painting programs and sculpture projects, he also enlisted the artists Bramante, Raphael, and Michelangelo as architects to carry out his vision of revitalizing Rome and the Vatican, the pope's residence, as the center of a new Christian art based on classical forms and principles.

Inspired by the achievements of their fifteenth-century predecessors as well as the monuments of antiquity, architects working in Rome created a new ideal classical style typified by the architecture of Bramante. The first-century Roman architect and engineer Vitruvius wrote a treatise on classical architecture (see "The Vitruvian Man," page 535) that became an important source for sixteenth-century Italian architects. Although most commissions were for churches, opportunities also arose to build urban palaces and country villas.

BRAMANTE. Donato Bramante (1444–1514) was born near Urbino and trained as a painter, but turned to architectural design early in his career. Earlier in this chapter, we saw a church attributed to him, the Church of San Bernardino near Urbino, in the landscape background of Raphael's Small Cowper Madonna (SEE FIG. 15-5). About 1481, he became attached to the Sforza court in Milan, where he would have known Leonardo da Vinci. In 1499, Bramante settled in Rome, but work came slowly. The architect was nearing sixty when, according to a dedicatory inscription, the Spanish rulers Queen Isabella and King Ferdinand commissioned a small shrine over the spot in Rome where the apostle Peter was believed to have been crucified (FIG. 15-17). In this tiny building, known as the **TEMPIETTO** ("Little Temple"), Bramante combined his interpretation of the principles of Vitruvius and the fifteenth-century architect Leon Battista Alberti, from the stepped base to the Doric columns and frieze (Vitruvius had advised that the Doric order be used for temples to gods of particularly forceful character) to the elegant balustrade. The centralized plan and the tall drum, or

Elements of Architecture THE GROTTO

f all the enchanting features of Renaissance gardens, none is more intriguing than a grotto, a recess typically constructed of irregular stones and shells and covered with fictive foliage and slime to suggest a natural cave. The fancifully decorated grotto usually included a spring, pool, fountain, or other waterworks. Sculpture of earth giants might support its walls, and depictions of nymphs might suggest the source of the water that nourished the garden. Great Renaissance gardens had at least one grotto where one could commune with nymphs and Muses and escape the summer heat. Alberti recommended that the contrived grotto be covered "with green wax, in imitation of mossy Slime which we always see in moist grottoes" (Alberti, On Architecture, 9.4).

The Great Grotto of the Boboli Gardens of the Pitti Palace in Florence, designed by Bernardo Buontalenti in 1583 and constructed in 1587–93, contained four marble captives (originally conceived for the tomb of Pope Julius II) carved by Michelangelo and, in its inner cave, a 1592 copy of Astronomy (or Venus Urania by Giovanni da Bologna (SEE FIG. 15–41). Flowing water operated fountains, hydraulic organs, and other devices, such as mechanical birds that fluttered their wings and chirped or sang, filling the grotto with noise, if not music. Water jets concealed in the floor, stairs, or crevasses in the rockwork could be turned on by the owner to drench his guests, to the great amusement of all.

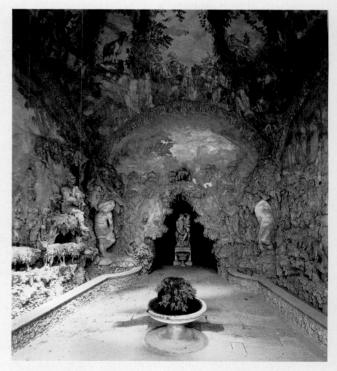

Bernardo Buontalenti THE GREAT GROTTO, BOBOLI GARDENS, PITTI PALACE, FLORENCE
1583–93. Sculpture by Michelangelo.

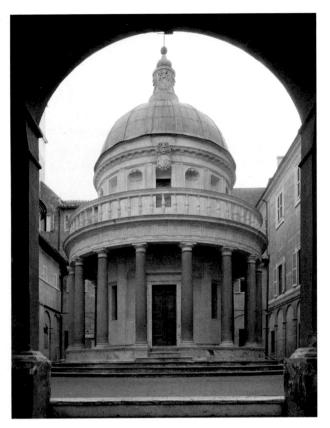

15–17 | Donato Bramante | TEMPIETTO, CHURCH OF SAN PIETRO IN MONTORIO

Rome. 1502-10; dome and lantern were restored in the 17th century.

circular wall, supporting a hemispheric dome recall early Christian shrines built over martyrs' relics, as well as ancient Roman circular temples. Especially notable is the sculptural effect of the building's exterior, with its deep wall niches creating contrasts of light and shadow, and the Doric frieze of carved papal emblems. Bramante's design called for a circular cloister around the church, but the cloister was never built.

Shortly after Julius II's election as pope, he commissioned Bramante to renovate the Vatican Palace. Julius also appointed him chief architect of a project to replace Saint Peter's Basilica (see "Saint Peter's Basilica," right).

THE ROMAN PALACE. Sixteenth-century Rome was more than a city of churches and public monuments. Wealthy families, many of whom had connections with the pope or the cardinals—the "princes of the church"—commissioned architects to design residences to enhance their prestige. For example, Cardinal Alessandro Farnese (who became Pope Paul III in 1534) set Antonio da Sangallo the Younger (1484–1546) the task of rebuilding the PALAZZO FARNESE into the largest, finest palace in Rome (FIG. 15–18). The main façade of the great rectangular building faces a public square—which was created by tearing down blocks of

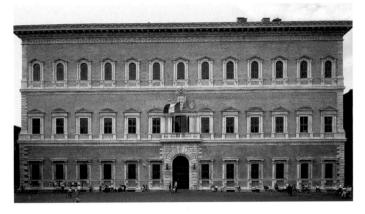

15–18 | Antonio da Sangallo the Younger and Michelangelo PALAZZO FARNESE, ROME

1517-50. When Sangallo died in 1546, Michelangelo added the third floor and cornice.

houses. The massive central door is emphasized by elaborate rusticated stonework (as are the building's corners, where the shaped stones are known as quoins) and is surmounted by a balcony suitable for ceremonial appearances, over which is set the cartouche (a decorative plaque) with the Farnese coat of arms—lilies. The palace's three stories are clearly defined by two horizontal bands of stonework, or stringcourses. Windows are treated differently on each story: on the ground floor, the twelve windows sit on supporting brackets. The story directly above is known in Italy as the piano nobile, or first floor (Americans would call it the second floor), which contains large and richly decorated reception rooms. Its twelve windows are decorated with alternating triangular and arched pediments supported by pairs of engaged halfcolumns in the Corinthian order. The second floor (or American third floor) has windows all with triangular pediments whose supporting Ionic half columns are set on brackets echoing those under the windows on the ground floor. At the back, a loggia overlooks a garden and the Tiber River. Annibale Carracci painted the loggia in 1597-1601 (SEE FIG. 17-13). When Sangallo died, the pope turned work on the palace over to Michelangelo, who added focus to the building by emphasizing the portal and gave it added dignity by increasing the height of the top story, capping the building with a magnificent cornice.

Great patrons of the arts were also great collectors of antiquities, none greater than Farnese, and none more generous to artists wanting to study. The Farnese *Hercules* stood in the courtyard, to impress visitors with the extensive collection of antiquities—and the erudition—of the owner (Figs. 23, 24, Introduction). Imagine walking into the Farnese Palace; then identify with the two "tourists" who come upon the colossal figure. The Farnese *Hercules*, along with the *Laocoön* and other discoveries by sixteenth-century art excavators, created new

Elements of Architecture SAINT PETER'S BASILICA

he history of Saint Peter's in Rome is an interesting case of the effects of individual and institutional demands on the practical congregational needs of a major religious building. The original church, now referred to as Old Saint Peter's, was built in the fourth century CE by Constantine, the first Christian Roman emperor, to mark the grave of the apostle Peter, the first bishop of Rome and therefore the first pope. Because the site was considered the holiest in Europe, Constantine's architect had to build a structure large enough to house Saint Peter's tomb and to accommodate the crowds of pilgrims who came to visit it. To provide a platform for the church, a huge terrace was cut into the side of the Vatican Hill, across the Tiber River from the city. Here Constantine's architect erected a basilica, with a new feature, a transept, to allow large numbers of visitors to approach the shrine at the front of the apse. The rest of the church was, in effect, a covered cemetery, carpeted with the tombs of believers who wanted to be buried near the apostle's grave. When it was built, Constantine's basilica, as befitted an imperial commission, was one of the largest buildings in the world (interior length 368 feet; width 190 feet), and for more than a thousand years it was the most important pilgrim shrine in Europe.

In 1506, Pope Julius II made the astonishing decision to demolish the Constantinian basilica, which had fallen into disrepair, and to replace it with a new building. That anyone, even a pope, had the nerve to pull down such a venerated building is an indication of the extraordinary sense of assurance of the age—and of Julius himself. To design and build the new church, the pope appointed Donato Bramante. Bramante envisioned

the new Saint Peter's as a central-plan building, in this case a Greek cross (with four arms of equal length) crowned by an enormous dome. This design was intended to continue the tradition of domed and round *martyria* (martyrs' shrines). In Renaissance thinking, the central plan and dome symbolized the perfection of God.

The deaths of pope and architect in 1513 and 1514 put a temporary halt to the project. Successive plans by Raphael, Antonio da Sangallo, and others changed the Greek cross to a Latin cross (with three shorter arms and one long one) to provide the church with a full-length nave. However, when Michelangelo was appointed architect in 1546, he returned to the Greekcross plan. Michelangelo simplified Bramante's design to create a single, unified space covered with a hemispherical dome. The dome was finally completed some years after Michelangelo's death by Giacomo della Porta, who retained Michelangelo's basic design but gave the dome a taller profile (SEE FIG. 15–29).

During the Counter-Reformation, the Church emphasized congregational worship, so more space was needed to house the congregation and allow for processions. To expand the church—and to make it more closely resemble Old Saint Peter's—Pope Paul V in 1606 commissioned the architect Carlo Maderno to change Michelangelo's Greek-cross plan to a Latin-cross plan. Maderno extended the nave to its final length of slightly more than 636 feet and added a new façade, thus completing Saint Peter's as it is today. Later in the seventeenth century, the sculptor and architect Gianlorenzo Bernini changed the approach to the basilica by creating an enormous piazza. In the twentieth century a wide avenue was built joining the piazza and the Tiber River.

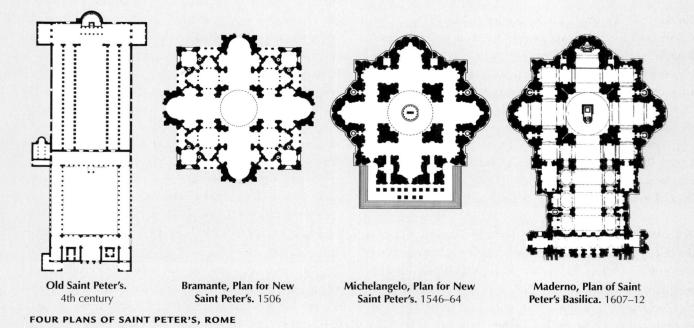

ideals for the contemporary artists. Like our two gentlemen, once having seen these extraordinary muscle men their view of art would be forever changed. Who could return to the bony figure of Jan van Eyck's Adam?

Architecture and Painting in Northern Italy

While Rome ranked as Italy's preeminent arts center at the beginning of the sixteenth century, wealthy and powerful families elsewhere in Italy also patronized the arts and letters, just as the Montefeltro had in Urbino and the Gonzaga had in Mantua during the fifteenth century. Their architects created fanciful structures and their painters developed a new colorful, illusionistic style—witty, elegant, and finely executed art designed to appeal to the jaded taste of the intellectual elite of Mantua, Parma, and Venice.

GIULIO ROMANO. In Mantua, Federigo II Gonzaga (ruled 1519-40) continued the family tradition of patronage when in 1524 he lured a Roman architect and follower of Raphael, Giulio Romano (c. 1499-1546), to Mantua to build a pleasure palace. The PALAZZO DEL TÈ (FIG. 15-19) is not "serious" architecture and was never meant to be. Giulio Romano devoted more space in his design to gardens, pools, and stables than he did to rooms for living—and partying. Federigo and his erudite friends would have known classical orders and proportions so well that they could appreciate this travesty of classical ideals—visual jokes such as lintels masquerading as arches and dropped triglyphs. The building itself is skillfully constructed. Later architects and scholars have studied the palace, with its sophisticated humor and exquisite craft, as a precursor to Mannerism or as Mannerist itself (see page 562).

Giulio Romano continued his witty play on the classics in the decoration of the two principal rooms. One, dedicated to the loves of the gods, depicted the marriage of Cupid and Psyche. The other room is a remarkable feat of *trompe l'oeil* painting in which the entire building seems to be collapsing about the viewer as the gods defeat the giants (FIG. 15–20). Here, Giulio Romano accepted the challenge Andrea Mantegna had laid down in the Camera Picta of the Gonzaga palace (SEE FIG. 14–33), painted for Federigo's grandfather. Like the building itself, the mural paintings display brilliant craft in the service of lighthearted, even superficial, goals: to distract, amuse, and enchant the viewer.

CORREGGIO. At about the same time that Giulio Romano was building and decorating the Palazzo del Tè in Mantua, in nearby Parma an equally skillful master, Correggio, was creating just as theatrical effects through dramatic foreshortening in the Parma Cathedral dome. In his brief but prolific career, Correggio (Antonio Allegri, c. 1489–1534) produced most of his work for patrons in Parma and Mantua. Correggio's great work, the **ASSUMPTION OF THE VIRGIN** (FIG. 15–21),

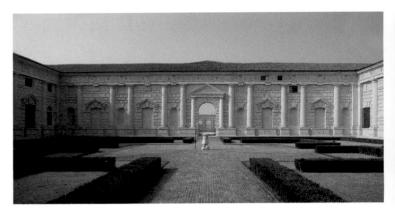

15–19 | Giulio Romano COURTYARD FAÇADE, PALAZZO DEL TÈ, MANTUA 1527–34.

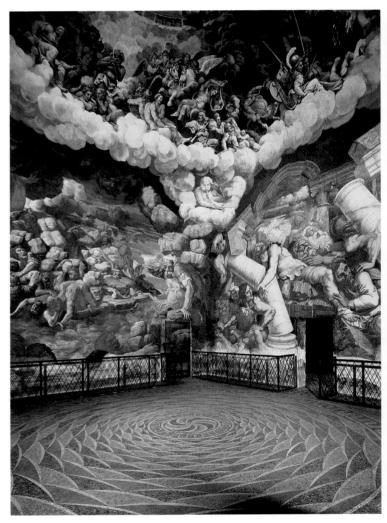

15–20 | Giulio Romano FALL OF THE GIANTS
Fresco in the Sala dei Giganti, Palazzo del Tè. 1530–32.

a fresco painted between 1526 and 1530 in the dome of Parma Cathedral, distantly recalls the illusionism of Mantegna's ceiling in the Gonzaga palace. But Leonardo da Vinci also clearly inspired Correggio's use of softly modeled forms,

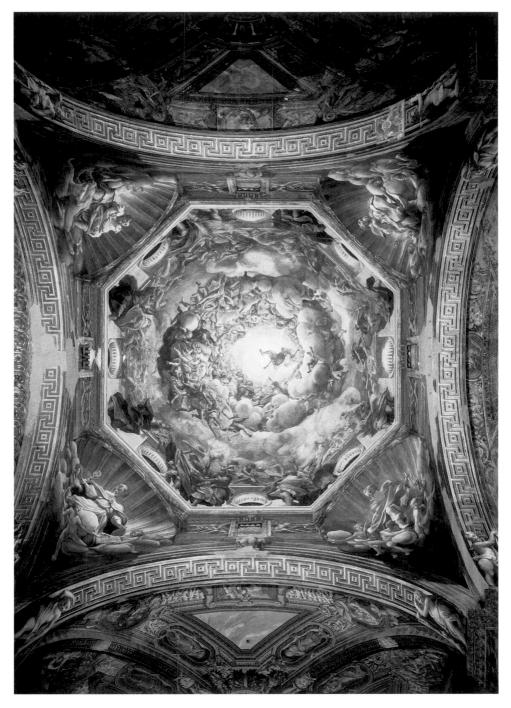

spotlighting effects of illumination, and a slightly hazy overall appearance (sfumato). Correggio also assimilated Raphael's idealism into his personal style. In the Assumption, Correggio created a dazzling illusion: The architecture of the dome seems to dissolve and the forms seem to explode through the building, drawing the viewer up into the swirling vortex of saints and angels who rush upward, amid billowing clouds, to accompany the Virgin as she soars into heaven. Correggio's

painting of the sensuous flesh and clinging draperies of the figures contrasts with the spirituality of the theme (the Virgin's miraculous transport to heaven at the moment of her death). The viewer's strongest impression is of a powerful, spiraling upward motion of alternating cool clouds and warm, sensuous figures. Illusionistic painting directly derived from this work became a hallmark of ceiling decoration in Italy in the following century.

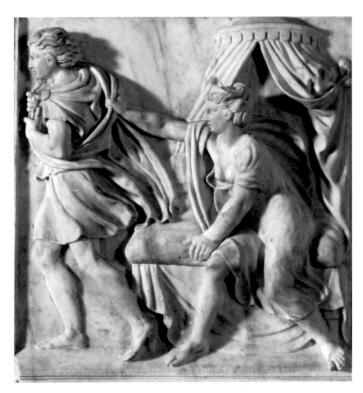

15–22 | Properzia de' Rossi JOSEPH AND POTIPHAR'S WIFE San Petronio, Bologna. 1525–26. Marble, $1'9'' \times 1'11''$ (54 × 58 cm). Museo de S. Petronio, Bologna.

PROPERZIA DE' ROSSI. Very few women had the opportunity or inclination to become sculptors. Properzia de' Rossi (c. 1490-1529/30), who lived in Bologna, was an exception. She mastered many arts, including engraving, and was famous for her miniature carvings, including an entire Last Supper carved on a peach pit! She carved several pieces in marble two sibyls, two angels, and this relief of JOSEPH AND POTIPHAR'S WIFE—for the cathedral of San Petronio in Bologna (FIG. 15-22). The contemporary historian Vasari wrote that a rival male sculptor prevented her from being paid fairly and from getting more commissions. This particular relief, according to Vasari, was inspired by her own love for a young man, which she got over by carving this panel. Joseph escapes, running, as the partially clad seductress snatches at his cloak. Properzia is the only woman Vasari includes in the 1550 edition of the Lives.

Venice and the Veneto

In the sixteenth century the Venetians did not see themselves as rivals of Florence and Rome, but rather as superiors. Their city was the greatest commercial sea power of the Mediterranean; they had challenged Byzantium and now they confronted the Muslim Turks. Favored by their unique geographical situation—protected by water and controlling sea routes in the Adriatic Sea and the eastern Mediter-

ranean—the Venetians became wealthy and secure patrons of the arts. Their Byzantine heritage, preserved by their natural conservatism, encouraged an art of rich patterned surfaces emphasizing light and color.

The idealized style and oil painting technique initiated by the Bellini family in the late fifteenth century (see Chapter 14) were developed further by sixteenth-century painters in Venice and the Veneto region, the part of northeastern Italy ruled by Venice. Venetians were the first Italians to use oils for painting on both wood panel and canvas. Possibly because they were a seafaring people accustomed to working with large sheets of canvas, and possibly because of humidity problems in their walls, the Venetians were also the first to use large canvas paintings instead of frescoes. Because oils dried slowly, errors could be corrected and changes made easily during the work. The flexibility of the canvas support, coupled with the radiance and depth of oil-suspended color pigments, eventually made oil painting an almost universally preferred medium. Oil paint was particularly suited to the rich color and lighting effects employed by Giorgione and Titian, two of the city's major painters of the sixteenth century. (Two others, Veronese and Tintoretto, will be discussed later in this chapter.)

GIORGIONE. The career of Giorgione (Giorgio da Castelfranco, c. 1475–1510) was brief—he died from the plague—and most scholars accept only four or five paintings as entirely by his hand. Nevertheless, his importance to Venetian painting is critical, as he introduced new, enigmatic pastoral themes, known as *poesie* (or painted poems), that were inspired by the contemporary literary revival of ancient pastoral poetry. He is significant for his sensuous nude figures, and, above all, an appreciation of nature in his landscape painting. His early life and training are undocumented, but his work suggests that he studied with Giovanni Bellini. Perhaps Leonardo da Vinci's subtle lighting system and mysterious, intensely observed landscapes also inspired him.

Giorgione's most famous work, called today THE TEM-PEST (FIG. 15-23), was painted shortly before his death. It is an example of the imaginative and sensual (rather than historical and intellectual) aspects of the poesie. Simply trying to understand what is happening in the picture piques our interest. At the right, a woman is seated on the ground, nude except for the end of a long white cloth thrown over her shoulders. Her nudity seems maternal rather than erotic as she nurses the baby at her side. Across the dark, rock-edged spring stands a man wearing the uniform of a German mercenary soldier. His head is turned toward the woman, but he appears to have paused for a moment before continuing to turn toward the viewer. X-rays of the painting show that Giorgione altered his composition while he was still at work on it—the soldier replaces a second woman. Inexplicably, a spring gushes forth between the figures to feed a lake surrounded by

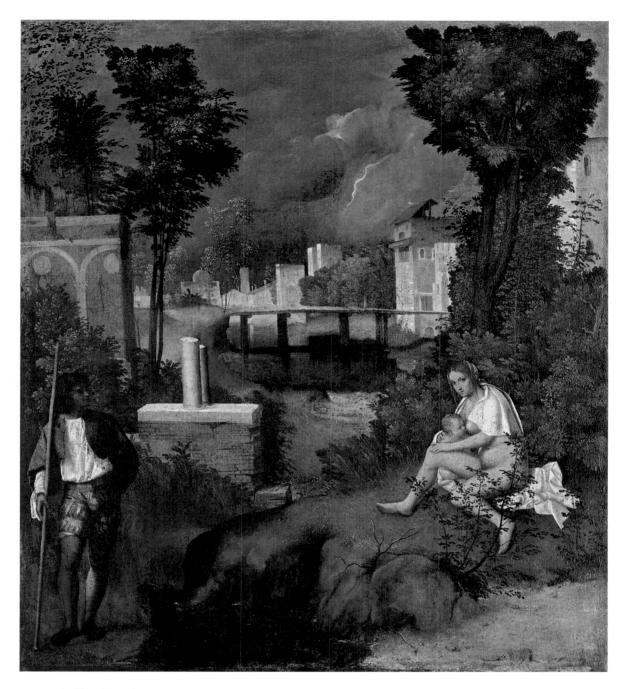

15–23 | Giorgione THE TEMPEST c. 1506. Oil on canvas, $32\times28\%''$ (82×73 cm). Galleria dell'Accademia, Venice.

The subject of this enigmatic picture preoccupied twentieth-century art historians, many of whom came up with well-reasoned possible solutions to the mystery. However, the painting's subject seems not to have particularly intrigued sixteenth-century observers, one of whom described it in 1530 simply as a small landscape in a storm with a gypsy woman and a soldier.

substantial houses, and in the far distance a bolt of lightning splits the darkening sky. Indeed, the artist's attention seems focused on the landscape and the unruly elements of nature rather than on the figures. By making the landscape central to the composition, Giorgione gave nature an importance that is new in Western painting.

Although he may have painted *The Tempest* for purely personal reasons, most of Giorgione's known works were of

traditional subjects, produced on commission for clients: portraits, altarpieces, and paintings on the exteriors of Venetian buildings. When commissioned in 1507 to paint the exterior of the Fondaco dei Tedeschi, the warehouse and effices of German merchants in Venice, Giorgione hired Titian (Tiziano Vecellio, c. 1489–1576) as an assistant. For the next three years, before Giorgione's untimely death, the two artists' careers were closely bound together.

15–24 | Titian THE PASTORAL CONCERT OR ALLEGORY ON THE INVENTION OF PASTORAL POETRY c. 1510. Oil on canvas, $41\% \times 54\%''$ (105 \times 136.5 cm). Musée du Louvre, Paris.

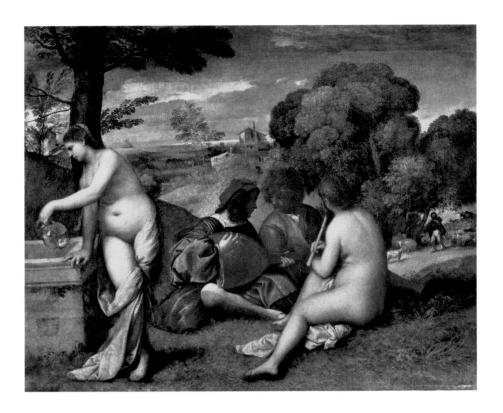

The painting known as THE PASTORAL CONCERT (FIG. 15-24) has been attributed to both Giorgione and Titian, although today scholarly opinion favors Titian. As in Giorgione's The Tempest, the idyllic, fertile landscape, here bathed in golden, hazy late-afternoon sunlight, seems to be the true subject of the painting. In this mythic world, two men—an aristocratic musician in rich red silks and a barefoot, singing peasant in homespun cloth—turn toward each other, ignoring the two women in front of them. One woman plays a pipe and the other pours water into a well, oblivious of the swaths of white drapery sliding to the ground that enhance rather than hide their nudity. Are they the musicians' muses? Behind the figures the sunlight illuminates another shepherd and his animals near lush woodland. The painting evokes a mood, a golden age of love and innocence recalled in ancient Roman pastoral poetry. In fact, the painting is now interpreted as an allegory on the invention of poetry. The Pastoral Concert had a profound influence on later painters—even into the nineteenth century, when Édouard Manet (SEE FIG. 19-49) reinterpreted it.

TITIAN. Everything about Titian's early life is obscure, including his birth, probably about 1489. He supposedly began an apprenticeship as a mosaicist, then studied painting under Gentile and Giovanni Bellini (see page 524). He was about 20 when he began work with Giorgione, and whatever Titian's early work had been, he had completely absorbed Giorgione's style by the time Giorgione died two years later. Titian completed paintings that they had worked on together, and when Giovanni Bellini died in 1516, Titian became the official painter to the Republic of Venice.

In 1519, Jacopo Pesaro, commander of the papal fleet that had defeated the Turks in 1502, commissioned Titian to commemorate the victory in a votive altarpiece for a side-aisle chapel in the Franciscan Church of Santa Maria Gloriosa dei Frari in Venice. Titian worked on the painting for seven years and changed the concept three times before he finally came up with a revolutionary composition—one that complemented the viewer's approach from the left: He created an asymmetrical setting of huge columns on high bases soaring right out of the frame (FIG. 15-25). Into this architectural setting, he placed the Virgin and Child on a high throne at one side and arranged saints and the Pesaro family at the sides and below on a diagonal axis, crossing at the central figure of Saint Peter (a reminder of Jacopo's role as head of the papal forces in 1502). The red of Francesco Pesaro's brocade garment and of the banner diagonally across sets up a contrast of primary colors against Saint Peter's blue tunic and yellow mantle and the red and blue draperies of the Virgin. Saint Maurice (behind Jacopo at the left) holds the banner with the coat of arms of the pope, and a cowering Turkish captive reminds the viewer of the Christian victory. Light floods in from above, illuminating not only the faces, but also the great columns, where putti in the clouds carry a cross. Titian was famous for his mastery of light and color even in his own day, but this altarpiece demonstrates that he also could draw and model as solidly as any Florentine. The composition, perfectly balanced but built on diagonals instead of a vertical and horizontal grid, looks forward to the art of the seventeenth century.

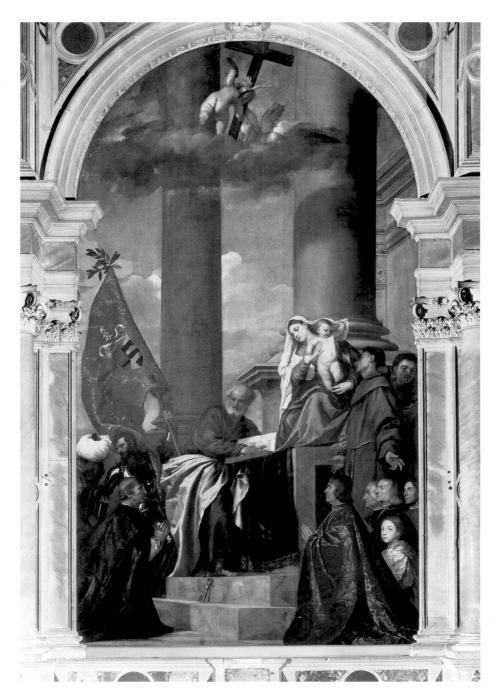

15–25 † Titian PESARO MADONNA 1519–26. Oil on canvas, 16' \times 8'10" (4.9 \times 2.7 m). Side-aisle altarpiece, Santa Maria Gloriosa dei Frari, Venice.

In 1529, Titian, who was well-known outside Venice, began a long professional relationship with Emperor Charles V, who vowed to let no one else paint his portrait. Charles ennobled Titian in 1533. The next year Titian was commissioned to paint a portrait of Isabella d'Este (see "Women Patrons of the Arts," page 558). Isabella was past 60 when Titian portrayed her in 1534–36, but she asked to appear as she had in her twenties. A true magician of portraiture, Titian was able to satisfy her wish by referring to an early portrait by another artist while also conveying the mature Isabella's strength, self-confidence, and energy.

No photograph can convey the vibrancy of Titian's paint surfaces, which he built up in layers of pure colors, chiefly red, white, yellow, and black. A recent scientific study of Titian's paintings revealed that he ground his pigments much finer than had earlier wood-panel painters. The complicated process by which he produced many of his works began with a charcoal drawing on the prime coat of lead white that was used to seal the pores and smooth the surface of the rather coarse Venetian canvas. The artist then built up the forms with fine glazes of different colors, sometimes in as many as ten to fifteen layers. Titian and others had the

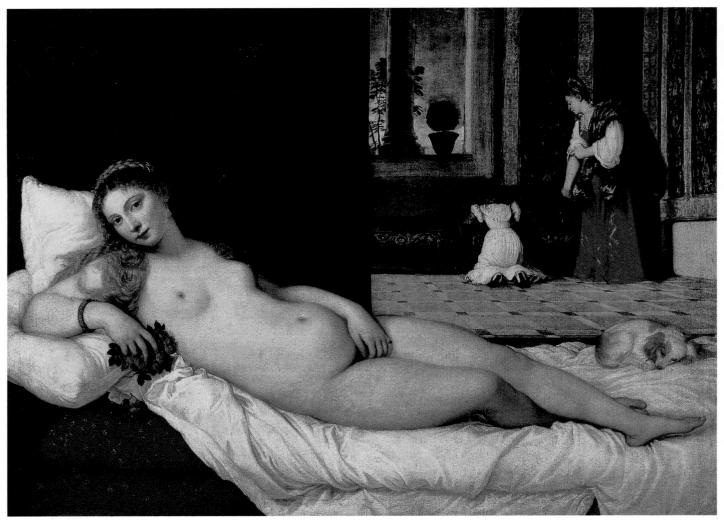

15–26 | Titian VENUS OF URBINO c. 1538. Oil on canvas, $3'11'' \times 5'5''$ (1.19 \times 1.65 m). Galleria degli Uffizi, Florence.

advantage of working in Venice, the first place to have professional retail "color sellers." These merchants produced a wide range of specially prepared pigments, even mixing their oil paints with ground glass to increase its glowing transparency. Not until the second half of the sixteenth century did color sellers open their shops in other cities.

According to a contemporary, Titian could make "an excellent figure appear in four brushstrokes." His technique was admirably suited to the creation of female nudes, whose flesh seems to glow with an incandescent light. Paintings of nude reclining women became especially popular in sophisticated court circles, where male patrons could enjoy and appreciate the "Venuses" under the cloak of respectable classical mythology. Typical of such paintings is the Venus Titian painted about 1538 for the Duke of Urbino (FIG. 15–26). The sensuous quality of this work suggests that Titian was as inspired by flesh-and-blood beauty as by any source from mythology or the history of art. Here, a beautiful Venetian courtesan—whose gestures seem deliberately provocative—

stretches languidly on her couch in a spacious palace, white sheets and pillows setting off her glowing flesh and golden hair. A spaniel, symbolic of fidelity, sleeping at her feet and maids assembling her clothing in the background lend a comfortable domestic air. The **VENUS OF URBINO** inspired artists as distant in time as Manet (SEE FIG. 19–50).

Over the course of his lengthy career, Titian continued to explore art's expressive potential. In his late work he sought the essence of the form and idea, not the surface perfection of his youthful works. Beset by failing eyesight and a trembling hand, Titian left the PIETA he was painting for his tomb unfinished at his death in 1576 (FIG. 15–27). Against a monumental arched niche, the Virgin mourns her son. Titian painted himself as Saint Jerome kneeling before Christ. The figures emerge out of darkness, their forms defined by the broken brushstrokes that activate the dynamic diagonal of the composition. Titian, like Michelangelo, outlived the classical phase of the Renaissance and his new style profoundly influenced Italian art of the later years of the sixteenth century.

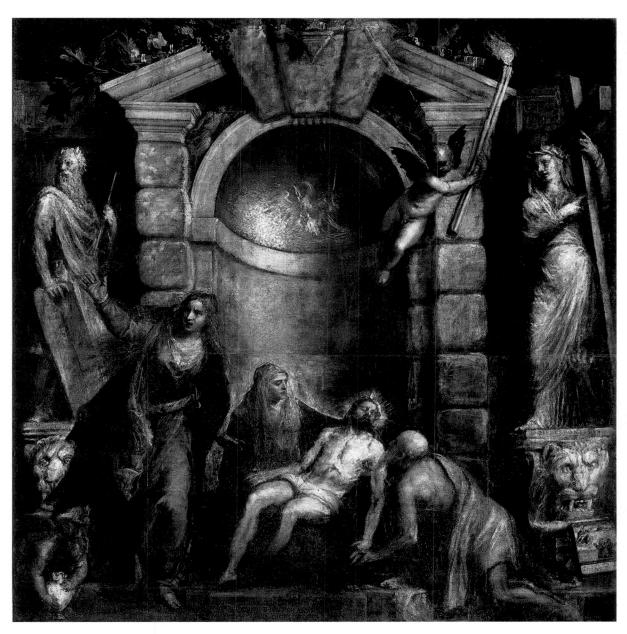

15–27 \perp Titian (finished by Palma Giovane) **PIETÀ** c. 1570–76. Oil on canvas, 11'6" \times 12'9" (3.5 \times 3.9 m). Galleria dell'Accademia, Venice.

ART AND THE COUNTER-REFORMATION

Pope Clement VII, whose miscalculations had spurred Emperor Charles V to attack and destroy Rome in 1527, also misjudged the threat to the Church and to papal authority posed by the Protestant Reformation. His failure to address the issues raised by the reformers enabled the movement to spread. His successor, the rich and worldly Roman noble Alessandro Farnese, who was elected Pope Paul III (papacy 1534–49), was the first pope to grapple directly with the rise of Protestantism and vigorously pursue Church reform. In 1536, he appointed a commission to investigate charges of corruption within the Church. He convened the Council of

Trent (1545–63) to define Catholic dogma, initiate disciplinary reforms, and regulate the training of clerics.

Pope Paul III also addressed Protestantism through repression and censorship. In 1542, he instituted the Inquisition, a papal office that sought out heretics for interrogation, trial, and sentencing. The enforcement of religious unity extended to the arts. Traditional images of Christ and the saints continued to be used to inspire and educate, but art was scrutinized for traces of heresy and profanity. Guidelines issued by the Council of Trent limited what could be represented in Christian art and led to the destruction of some works. At the same time, art became a powerful weapon of propaganda, especially in the hands of members of the Society of Jesus, a new religious order

Art and Its Context

WOMEN PATRONS OF THE ARTS

n the sixteenth century, many wealthy women, from both the aristocracy and the merchant class, were enthusiastic patrons of the arts. The Habsburg princesses Margaret of Austria and Mary of Hungary presided over brilliant humanist courts. The Marchesa of Mantua, Isabella d'Este (1474-1539), became a patron of painters, musicians, composers, writers, and literary scholars. Married to Francesco II Gonzaga at age 15, she had great beauty, great wealth, and a brilliant mind that made her a successful diplomat and administrator. A true Renaissance woman, her motto was the epitome of rational thinking-"Neither through Hope nor Fear." An avid collector of manuscripts and books, she sponsored the publication of an edition of Virgil while still in her twenties. She also collected ancient art and objects, as well as works by contemporary Italian artists such as Mantegna, Leonardo, Perugino, Correggio, and Titian. Her study in the Mantuan palace was a veritable museum for her collections. The walls above the storage and display cabinets were painted in fresco by Mantegna, and the carved wood ceiling was covered with mottoes and visual references to Isabella's impressive literary interests.

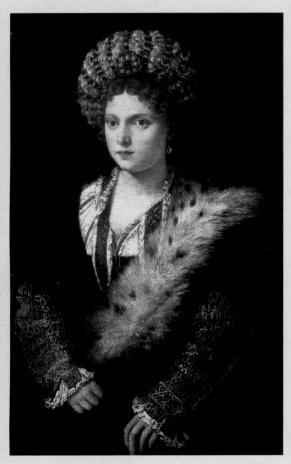

Titian ISABELLA D'ESTE 1534–36. Oil on canvas, $40\% \times 25\%$ " (102 \times 64.1 cm). Kunsthistorisches Museum, Vienna.

founded by the Spanish nobleman Ignatius of Loyola (1491–1556) and confirmed by Paul III in 1540. The Jesuits, dedicated to piety, education, and missionary work, spread worldwide from Il Gesù, their headquarters church in Rome (SEE FIG. 15–31). They came to lead the Counter–Reformation movement and the revival of the Catholic Church.

The Reformation and Counter-Reformation inspired the papacy to promote the Church's preeminence by undertaking an extensive program of building and art commissions. Under such patronage, religious art of the Italian late Renaissance flourished in the second half of the sixteenth century.

Art and Architecture in Rome and the Vatican

To restore the heart of the city of Rome, Paul III began rebuilding the Capitoline Hill as well as continuing work on Saint Peter's. His commissions include some of the finest art and architecture of the late Italian Renaissance. His first major commission brought Michelangelo, after a quarter of a century, to the Sistine Chapel.

MICHELANGELO'S LATE WORK. In his early sixties, Michelangelo complained bitterly of feeling old, but he nonetheless began the important and demanding task of painting the LAST JUDGMENT on the 48-foot-high end wall above the chapel altar (FIG. 15–28).

Abandoning the clearly organized medieval conception of the Last Judgment, in which the saved are neatly separated from the damned, Michelangelo painted a writhing swarm of rising and falling humanity. At the left (the right side of Christ), the dead are dragged from their graves and pushed up into a vortex of figures around Christ, who wields his arm like a sword of justice. The shrinking Virgin represents a change from Gothic tradition, where she sat enthroned beside, and equal in size to, her son. To the right of Christ's feet is Saint Bartholomew, who in legend was martyred by being skinned alive. He holds his flayed skin, the face of which may be painted with Michelangelo's own distorted features. Despite the efforts of several saints to save them at the last minute, the rejected souls are plunged toward hell on the right, leaving the elect and still-unjudged in a dazed, almost uncomprehending state. On the lowest level of the mural is the gaping, fiery entrance to hell, toward which Charon, the ferryman of the dead to the underworld, propels his craft. Conservative clergy criticized the painting for its nudity, and after Michelangelo's death they ordered bits of drapery to be added. The painting was long interpreted as a grim and constant reminder to the celebrants of the Massthe pope and his cardinals—that ultimately they would be judged for their deeds. However, the brilliant colors revealed by recent cleaning contrast with the grim message.

Another of Paul III's ambitions was to complete the new Saint Peter's, a project that had been under way for forty years (see "Saint Peter's Basilica," page 549). Michelangelo was well

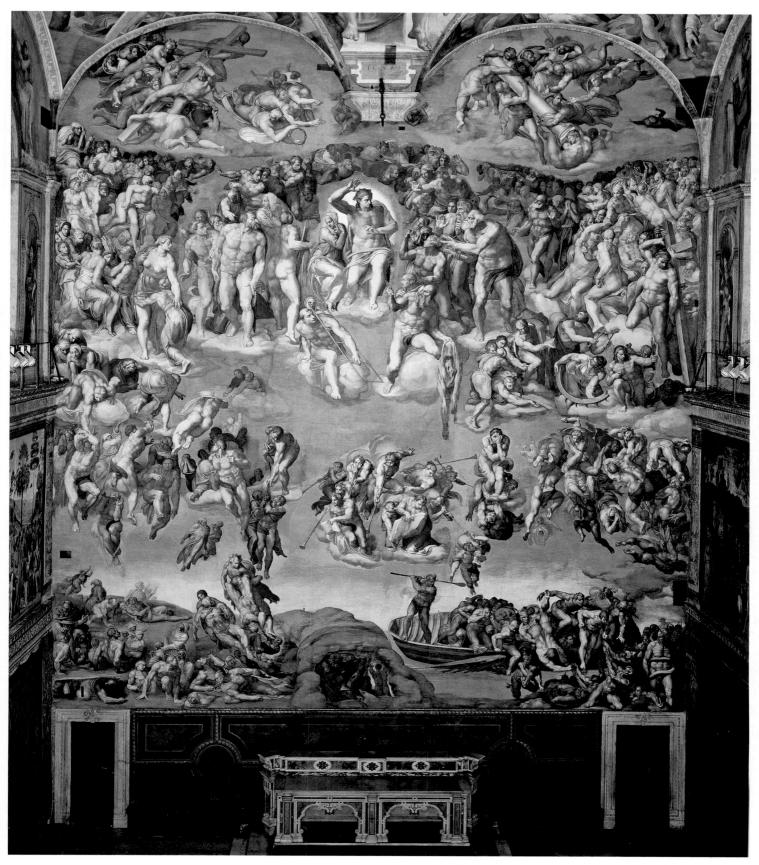

15–28 \perp Michelangelo LAST JUDGMENT, SISTINE CHAPEL 1536–41 (cleaning finished 1994). Fresco, $48 \times 44' (14.6 \times 13.4 \text{ m})$.

Dark, rectangular patches left by the restorers (visible, for example, in the upper left and right corners) contrast with the vibrant colors of the chapel's frescoes. These dark areas show just how dirty the walls had become over the centuries before their recent cleaning.

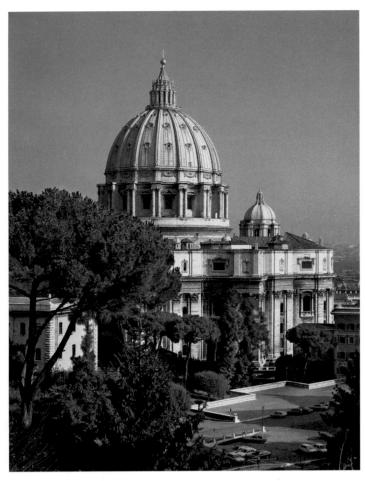

15–29 | Michelangelo SAINT PETER'S BASILICA, VATICAN c. 1546–64; dome completed 1590 by Giacomo della Porta; lantern 1590–93. View from the west.

aware of the work done by his predecessors—from Bramante to Raphael to Antonio da Sangallo the Younger. The 71-yearold sculptor, confident of his architectural expertise, demanded the right to deal directly with the pope, rather than through a committee of construction deputies. Michelangelo further shocked the deputies—but not the pope—by tearing down or canceling parts of Sangallo's design and returning to Bramante's central plan, long associated with Christian martyr shrines. Although seventeenth-century additions and renovations dramatically changed the original plan of the church and the appearance of its interior, Michelangelo's SAINT PETER'S BASILICA (FIG. 15-29) still can be seen in the contrasting forms of the flat and angled walls and the three hemicycles (semicircular structures), in which colossal pilasters, blind windows (having no openings), and niches form the sanctuary of the church. The level above the heavy entablature was later given windows of a different shape. The dome that was erected by Giacomo della Porta in 1588-90 retains Michelangelo's basic design: a segmented dome with regularly spaced openings, resting on a high drum with pedimented windows between paired columns, and surmounted by a tall lantern reminiscent of Bramante's Tempietto (SEE FIG. 15-17). Della Porta's major changes were raising the dome

height, narrowing its segmental bands, and changing the shape of its openings.

Michelangelo—often described by his contemporaries as difficult and even arrogant—alternated between periods of depression and frenzied activity. Yet he was devoted to his friends and helpful to young artists. He believed that his art was divinely inspired; later in life, he became deeply absorbed in religion and dedicated himself to religious works.

Michelangelo's last days were occupied by an unfinished sculpture now known, from the name of a modern owner, as the **RONDANINI PIETÀ** (FIG. 15–30). The *Rondanini Pietà* is the final artistic expression of a lonely, disillusioned, and physically debilitated man who struggled to end his life as he had lived it—working. In his youth, the stone had released the *Pietà* in Saint Peter's as a perfect, exquisitely finished work (SEE FIG. 15–9), but this block resisted his best efforts to shape it. He was still working on the sculpture six days before his death. The ongoing struggle between artist and medium is nowhere more apparent than in this moving example of Michelangelo's *nonfinito* creations. In his late work, Michelangelo subverted Renaissance ideals of human perfectability and denied his own youthful idealism, uncovering new forms that mirrored the tensions in Europe during the second half of the sixteenth century.

15–30 | Michelangelo PIETÀ (KNOWN AS THE RONDANINI PIETÀ)

1559–64. Marble, height 5'3% (1.61 m). Castello Sforzesco, Milan. Intended for his own tomb.

Shortly before his death in 1564, Michelangelo resumed work on this sculpture group, which he had begun some years earlier. He cut down the massive figure of Jesus, merging the figure's now elongated form with that of the Virgin, who seems to carry her dead son upward toward heaven.

The elderly artist Michelangelo, like Titian, secure in the techniques gained over decades of masterful craft, could abandon the knowledge of a lifetime as he attempted to express ultimate truths through art. In his late work, he discovered new stylistic directions that would inspire succeeding generations of artists.

VIGNOLA. Michelangelo alone could not satisfy the demand for architects. One young artist who helped meet the need for new churches was Giacomo Barozzi (1507–73), known as Vignola after his native town. He worked in Rome in the late 1530s surveying ancient Roman monuments and providing illustrations for an edition of Vitruvius. From 1541 to 1543 he was in France with Francesco Primaticcio at the Château of Fontainebleau (see Chapter 16). After returning to Rome, he secured the patronage of the Farnese family.

Vignola profited from the Counter-Reformation program of church building. The Church's new emphasis on individual, emotional participation brought a focus on sermons and music. It also required churches to have wide naves and unobstructed views of the altar instead of the complex interiors of medieval and earlier Renaissance churches. Ignatius of Loyola was determined to build the Jesuit head-quarters church in Rome under these precepts, although he did not live to see his church finished (FIG. 15–34). The cornerstone was laid in 1540, but construction of the **CHURCH OF IL GESÙ** did not begin until 1568, as the Jesuits had to raise considerable funds. Cardinal Alessandro Farnese (Paul III's namesake and grandson) donated funds to the project in 1561 and selected Vignola as architect. After Vignola died in 1573, Giacomo della Porta finished the dome and façade.

Il Gesù was admirably suited for its congregational purpose. Vignola designed a wide, barrel-vaulted nave, shallow connected side chapels but not aisles, and short transepts that

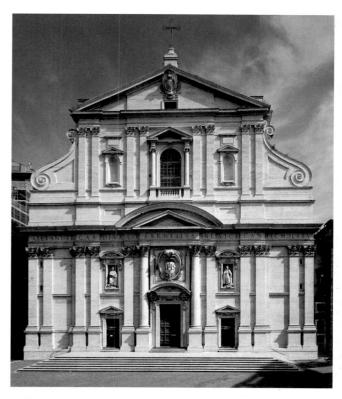

15–31 | Giacomo della Porta **FAÇADE OF THE CHURCH OF IL GESÙ, ROME** c. 1573–84.

did not extend beyond the line of the outer walls—enabling all worshipers to gather in the central space. A single huge apse and dome over the crossing (FIG. 15–32) directed their attention to the altar. The building fit compactly into the city block—a requirement that now often overrode the desire to orient a church along an east-west axis. The façade design emphasized the central portal with classical pilasters, engaged

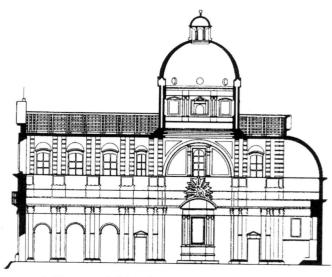

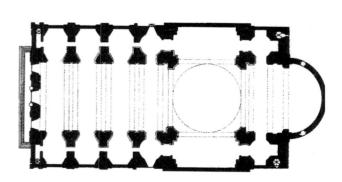

15–33 CAPPONI CHAPEL, CHURCH OF SANTA FELICITÀ, FLORENCE Chapel by Filippo Brunelleschi for the Barbadori family, 1419–23; acquired by the Capponi family, who ordered paintings by Pontormo, 1525–28.

One of the few surviving early Mannerist interiors—fresco, stained-glass window, and altarpiece in an early Renaissance structure.

columns and pediments, and volutes scrolling out to hide the buttresses of the central vault and to link the tall central section with the lower sides.

As finally built by Giacomo della Porta, the design, in its verticality and centrality, would have significant influence on church design well into the next century. The façade abandoned the early Renaissance grid of classical pilasters and entablatures for a two-story design of paired colossal order columns that reflected and tied together the two stories of the nave elevation. Each of these stories was further subdivided by moldings, niches, and windows. The entrance of the church, with its central portal and tall window, became the focus of the composition. Pediments at every level break into the level above, leading the eye upward to the cartouches

with coats of arms. Both Cardinal Farnese, the patron, and the Jesuits (whose arms entail the initials IHS, the monogram of Christ) are commemorated here on the façade.

MANNERISM

A word that has inspired controversy—sometimes even rancorous debate—among historians of Italian art is *Mannerism*. The term comes from the Italian word *maniera*, used in the sixteenth century to suggest self-aware elegance and grace to the point of artifice. When modern critics began to use the term, some defined it as a style opposed to the principles of High Renaissance art; others treated it as an historical period in art between the early sixteenth-century High Renais-

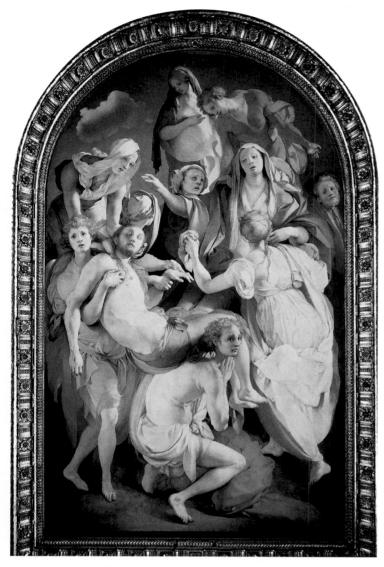

I5–34 Pontormo **ENTOMBMENT** 1525–28. Oil and tempera on wood panel, $10'3'' \times 6'4''$ (3.1 \times 1.9 m). Altarpiece in Capponi Chapel, Church of Santa Felicità, Florence.

sance and the seventeenth-century Baroque. Today many critics would like to drop the term altogether, but it has entered the standard art historical vocabulary. Certainly one can agree that different styles existed at the same time in sixteenth-century Italy.

Today, in the visual arts, Mannerism has come to mean intellectually intricate subjects, highly skilled techniques, and art concerned with beauty for its own sake. Mannerism is an attitude, a point of view, as much as a "style." Certain characteristics do occur regularly: extraordinary virtuosity; intricate compositions; sophisticated, elegant figures; and fearless manipulations or distortions of accepted formal conventions. Some artists and patrons favored obscure, unsettling, and often erotic imagery; unusual colors and juxtapositions; and

Sequencing Works of Art ITALIAN RENAISSANCE ART IN THE 1530s

1530-32	Giulio Romano, <i>Fall of the Giants</i> , Palazzo del Tè, Mantua
1534-36	Titian, Portrait of Isabella d'Este
c. 1538	Titian, Venus of Urbino
1534-40	Parmigianino, Madonna with the Long Neck
1536-41	Michelangelo, Last Judgment, Sistine Chapel, Vatican

unfathomable secondary scenes. Mannerist artists admired the great artists of the earlier generation, and the late styles of Michelangelo and Titian also became a source of inspiration.

Elements of Mannerism, stimulated and supported by aristocratic, sophisticated, and courtly patrons, began to appear in Florence and Rome at the height of the High Renaissance around 1510. The term has been interpreted as an artistic expression of the unsettled political and religious conditions in Europe. Furthermore, a formal relationship between new art styles and aesthetic theories began to appear at this time—especially the elevation of "grace" as an ideal.

Painting

Examples of early Mannerism are the frescoes and altarpieces painted between 1525 and 1528 by Jacopo da Pontormo (1494–1557) for the hundred-year-old CAPPONI CHAPEL in the Church of Sanza Felicità in Florence (FIG. 15-33). Open on two sides, the chapel forms an interior loggia. The altarpiece depicts the ENTOMBMENT (FIG. 15-34), and frescoes depict the Annunciation. The Virgin accepts the angel's message, but the juxtaposition with the altarpiece also seems to present her with a vision of her future sorrow, as she sees her son's body lowered from the cross. Pontormo's ambiguous composition in the altarpiece enhances the visionary quality of the painting. The bare ground and cloudy sky give little sense of physical location. Some figures press into the viewer's space, while others seem to levitate or stand on the smooth boulders. Pontormo chose a moment just after Jesus's removal from the cross, when the youths who have lowered him have paused to regain their hold. The emotional atmosphere of the scene is expressed in the odd poses, and drastic shifts in scale, but perhaps most poignantly in the use of secondary colors and colors shot through with contrasting colors, like iridescent silks. The palette is predominantly blue and pink with accents of olive green, gray, scarlet, and creamy white. The overall tone of the picture is set by the color treatment of the crouching youth, whose skintight bright pink shirt is shaded in iridescent, pale gray-green.

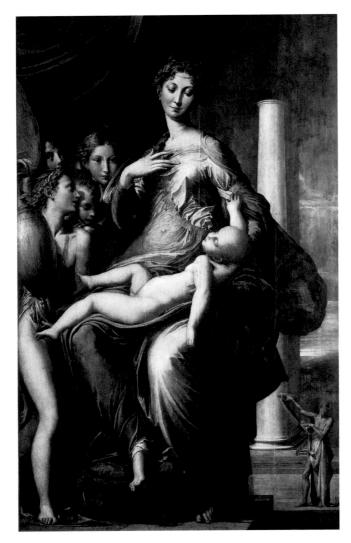

15–35 | Parmigianino MADONNA WITH THE LONG NECK 1534–40. Oil on wood panel, $7'1'' \times 4'4''$ (2.16 \times 1.32 m). Galleria degli Uffizi, Florence.

Parmigianino. Parmigianino (Francesco Mazzola, 1503–40) created equally intriguing variations on the classical style. Until he left his native Parma in 1524 for Rome, the strongest influence on his work had been Correggio. In Rome, Parmigianino met Giulio Romano, and he also studied the work of Raphael and Michelangelo. He assimilated what he saw into a distinctive style of Mannerism, calm but strangely unsettling. After the Sack of Rome in 1527, he moved to Bologna and then back to Parma.

Left unfinished at the time of his early death is a painting known as the MADONNA WITH THE LONG NECK (FIG. 15–35). The elongated figure of the Madonna, whose massive legs and lower torso contrast with her narrow shoulders and long neck and fingers, resembles the large metal vase inexplicably being carried by the youth at the left. The sleeping Christ Child recalls the pose of the pietà, and in the background Saint Jerome unrolls a scroll beside tall white columns that

have no more substance than theater sets in the middle distance. Like Pontormo, Parmigianino presents a well-known image in a manner calculated to unsettle viewers. The painting challenges the viewer's intellect while it exerts its strange appeal to aesthetic sensibility.

BRONZINO. Agnolo di Cosimo (1503–72), whose nickname of "Bronzino" means "Copper-colored" (just as we might call someone "Red"), was born near Florence. About 1522, he became Pontormo's assistant. (He probably helped with the tondos in the corners of the Capponi Chapel.) In 1530, he established his own workshop, though he continued to work occasionally with Pontormo on large projects. In 1540, Bronzino became the court painter to the Medici. Although he was a versatile artist who produced altarpieces, fresco decorations, and tapestry designs over his long career, he is best known today for his courtly portraits. Bronzino's virtuosity in rendering costumes and settings creates a rather cold and formal effect, but the self-contained demeanor of his subjects admirably conveys their haughty personalities. The PORTRAIT

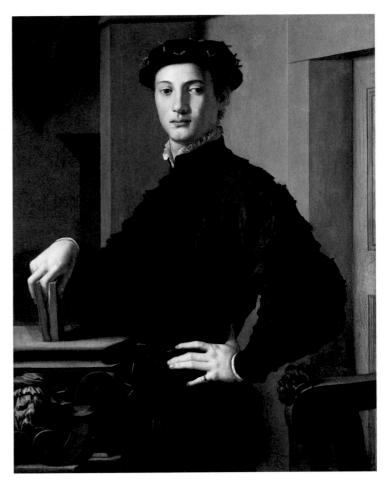

15–36 † Bronzino PORTRAIT OF A YOUNG MAN c. 1540–45. Oil on wood panel, $37\%\times29\%''$ (95.5 \times 74.9 cm). The Metropolitan Museum of Art, New York.

The H. O. Havemayer Collection (29.100.16).

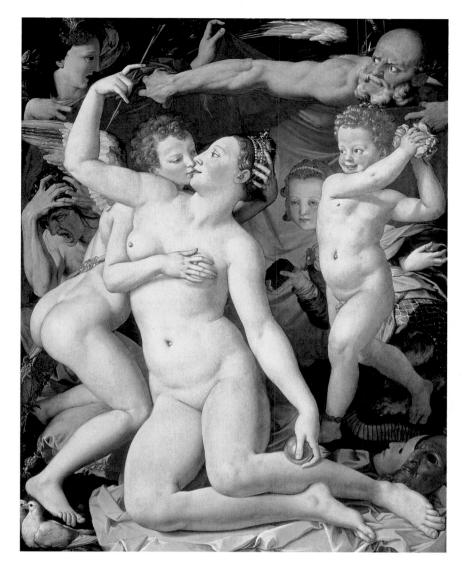

I 5–37 | Bronzino ALLEGORY WITH VENUS AND CUPID Mid-1540s. Oil on panel, $57\% \times 46\%$ (1.46 \times 1.16 m). National Gallery, London. Reproduced by courtesy of the Trustees of the National Gallery, London.

OF A YOUNG MAN (FIG. 15–36) demonstrates Bronzino's characteristic portrayal of his subjects as intelligent, aloof, elegant, and self-assured. The youth toys with a book, suggesting his scholarly interests, but his walleyed stare creates a slightly unsettling effect and seems to associate his portrait with the carved masks surrounding him.

Bronzino's **ALLEGORY WITH VENUS AND CUPID**, one of the strangest paintings in the sixteenth century, contains all the formal, iconographical, and psychological characteristics of Mannerist art (FIG. 15–37). The painting could stand alone as a summary of the period. Seven figures, two masks, and a dove interweave in an intricate formal composition pressed breathlessly into the foreground plane. Taken as individual images, they display the apparent ease of execution and grace of form, ideal perfection of surface and delicacy of color that characterize Mannerist art. Together they become a disturbingly erotic and inexplicable composition.

The painting defies easy explanation for it is one of the complex allegories that delighted the sophisticated courtiers

who enjoyed equally esoteric wordplay and classical references. Nothing is quite what it seems. Venus and her son Cupid engage in lascivious dalliance, encouraged by a putto representing Folly, Jest, or Playfulness, who is about to throw pink roses at them. Cupid kisses his mother and squeezes her breast and nipple while Venus lifts up an arrow from Cupid's quiver, leading some scholars to suggest that the painting's title should be "Venus Disarming Cupid." Venus holds the golden apple of discord given to her by Paris; her dove seems to support Cupid's feet, while a pair of ugly red masks lying at her feet reiterates the theme of duplicity. An old man, Time or Chronos, assisted by an outraged Truth, pulls back a curtain to expose the couple. Lurking just behind Venus a monstrous serpent with a lion's legs and claws and the head of a beautiful young girl crosses her hands to hold a honeycomb and scorpion's stinger. She has been called Inconstancy and Fraud but also Pleasure. In the shadows a screaming head tears its hair—if female, she is Jealousy or Envy, but if male, he would be Pain. The complexity of the painting and the

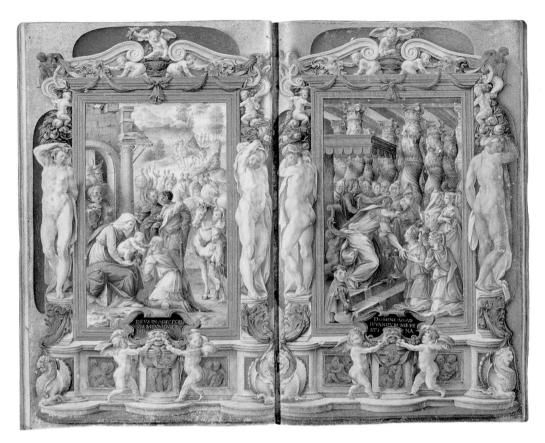

15–38 | Giulio Clovio (Jura Klovic, born in Croatia) | THE FARNESE HOURS: ADORATION OF THE MAGI AND THE MEETING OF SOLOMON AND THE QUEEN OF SHEBA 1546. Vellum, each folio $6 \times 4''$ (17.3 \times 11 cm). The Pierpont Morgan Library, New York. M69 fl 380-3912

possibilities for multiple meanings are typical of the games enjoyed by sixteenth-century intellectuals. Perhaps the allegory tells of the impossibility of constant love and the folly of lovers, which will become apparent in time. But perhaps it is an allegory on sin and a condemnation of vice. In any event, Duke Cosimo ordered the painting himself, and he presented it to King Francis I of France.

Manuscripts and Miniatures

THE FARNESE HOURS. In spite of the increasing use of the printing press (see Chapter 19), luxury manuscripts continued to be made by hand. THE FARNESE HOURS, a book of hours commissioned by Cardinal Alessandro Farnese from Guilio Clovio (1498–1578), is a masterpiece among Italian Renaissance manuscripts (FIG. 15–38). The colophon (at the end of the manuscript) dates it at 1546, and the contemporary historian Giorgio Vasari wrote that Giulio worked for nine years painting the miniatures. Vasari perceptively calls him a "new, if small, Michelangelo." Small indeed, each page measures only 7 by 4 inches, but the paintings encompass every aspect of Mannerist art—the "serpentine figures" in graceful poses and the elongated proportions so noticeable in the nudes support the frames and the extraordinarily elongated figures in the narra-

tives. Brilliant colors combine with pale atmospheric space. The Old Testament supports the New, in a way typical of medieval manuscripts. Thus the Queen of Sheba's visit and homage to Solomon prefigures the Magi's journey with gifts for the Christ Child. King Solomon has the features of the patron, Cardinal Farnese, and beside him is a dwarf in painter's clothes making a typical sixteenth-century visual pun—he is a small man, a "miniature" painter.

ANGUISSOLA. Northern Italy, more than any other part of the peninsula, produced a number of gifted women artists. Sofonisba Anguissola (c. 1532–1625), born into a noble family in Cremona, was unusual as a woman artist in that she was not the daughter of an artist. Her father gave all his children a humanistic education and encouraged them to pursue careers in literature, music, and especially painting. He consulted Michelangelo about Sofonisba's artistic talents in 1557, asking for a drawing that she might copy and return to be critiqued. Michelangelo evidently obliged because Sofonisba Anguissola's father wrote an enthusiastic letter of thanks.

Anguissola was also skilled at miniatures and portraits, an important kind of painting in the sixteenth century, when people had few means of recording a lover, friend, or family

15–39 | Sofonisba Anguissola SELF-PORTRAIT c. 1552. Oil on parchment on cardboard, $2\frac{1}{2} \times 3\frac{1}{4}$ " (6.4 \times 8.3 cm). Museum of Fine Arts, Boston. Emma F. Munroe Fund (60.155)

member's features. Anguissola painted herself holding a medallion, the border of which spells out her name and home town, Cremona (FIG. 15–39). Such visual and verbal games delighted sixteenth-century viewers. The interlaced letters at the center of the medallion are a riddle; they seem to form a monogram with the first letters of her sisters' names: Minerva, Europa, Elena. Such names are further evidence of the Anguissola family's enthusiasm for the classics.

Contemporaries especially admired Sofonisba Anguissola's self-portraits. One wrote that he liked to show off her painting as "two marvels, one the work, the other the artist" (quoted in Hartt/Wilkins, page 629). In 1560, Anguissola accepted the invitation of the queen of Spain to become a lady-in-waiting and court painter, a post she held for twenty years. In a 1582 Spanish inventory, Anguissola is described as "an excellent painter of portraits above all the painters of this time"—extraordinary praise in a court that patronized Titian.

Cellini (1500–71), who wrote a dramatic—and scandalous—autobiography and a practical handbook for artists, worked in the French court at Fontainebleau, where he made the famous **SALTCELLAR OF KING FRANCIS I** (FIG. 15–40)—a table accessory transformed into an elegant sculptural ornament by fanciful imagery and superb execution. In gold and enamel, the Roman sea god Neptune, representing the source of salt, sits next to a tiny boat-shaped container that carries the seasoning, while a personification of Earth guards the plant-derived

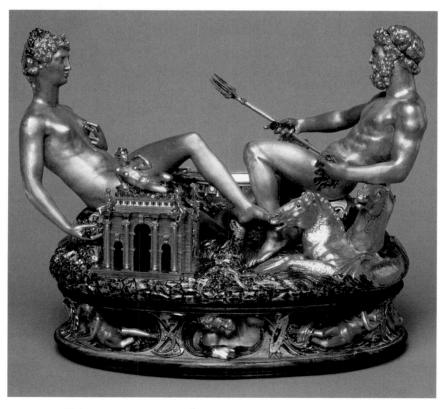

15–40 | Benvenuto Cellini SALTCELLAR OF KING FRANCIS I OF FRANCE 1540–43. Gold and enamel, $10\frac{1}{2} \times 13\frac{1}{8}$ " (26.67 \times 33.34 cm). Kunsthistorisches Museum, Vienna.

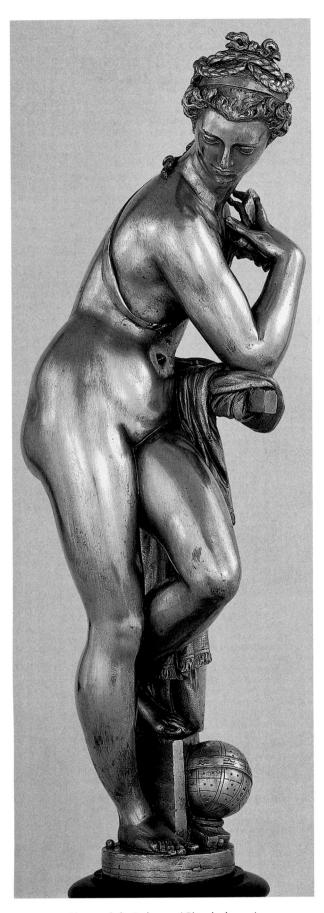

15–41 | Giovanni da Bologna (Giambologna) **ASTRONOMY,** or **VENUS URANIA**c. 1573. Bronze gilt, height 15½" (38.8 cm). Kunsthistorisches Museum, Vienna.

pepper, contained in the triumphal arch to her right. Representations of the seasons and the times of day on the base refer to both daily meal schedules and festive seasonal celebrations. The two main figures, their poses mirroring each other with one bent and one straight leg, lean away from each other at impossible angles yet are connected and visually balanced by glances and gestures. Their supple, elongated bodies and small heads reflect the Mannerist conventions of artists like Parmigianino. Cellini wrote, "I represented the Sea and the Land, both seated, with their legs intertwined just as some branches of the sea run into the land and the land juts into the sea. . ." (quoted in Hartt/Wilkins, page 669).

Late Mannerism

In the second half of the sixteenth century, probably the most influential sculptor in Italy was Jean de Boulogne, better known by his Italian name, Giovanni da Bologna or Giambologna (1529-1608). Born in Flanders, he settled by 1557 in Florence, where both the Medici family and the sizable Netherlandish community there were his patrons. He not only influenced a later generation of Italian sculptors, he also spread the Mannerist style to the north through artists who came to study his work. Although inspired by Michelangelo, Giovanni was more concerned with graceful forms and poses, as in his gilded-bronze **ASTRONOMY**, or **VENUS URANIA** (FIG. 15-41) of about 1573. The figure's identity is suggested by the astronomical device on the base of the plinth. Designed with a classical prototype of Venus in mind, the sculptor twisted Venus's upper torso and arms to the far right and extended her neck in the opposite direction so that her chin was over her right shoulder, straining the limits of the human body. Consequently, Giambologna's statuette may be seen from any viewpoint. The elaborate coiffure of tight ringlets and the detailed engraving of drapery texture contrast strikingly with the smooth, gleaming flesh of Venus's body. Following the common practice for cast-metal sculpture, Giambologna replicated this statuette several times for different patrons.

The northern Italian city of Bologna was especially hospitable to accomplished women. In the latter half of the sixteenth century it boasted of some two dozen women painters and sculptors, as well as a number of women scholars who lectured at the university. There, Lavinia Fontana (1552–1614) learned to paint from her father. By the 1570s, her success was so well rewarded that her husband, the painter Gian Paolo Zappi, gave up his own painting career to care for their large family and help his wife with the technical aspects of her work, such as framing. In 1603 Fontana moved to Rome as an official painter to the papal court. She also soon came to the attention of the Habsburgs, who became major patrons of her work.

While still in her twenties, Fontana painted the **NOLI ME TANGERE** (FIG. 15–42), illustrating the biblical story of Christ

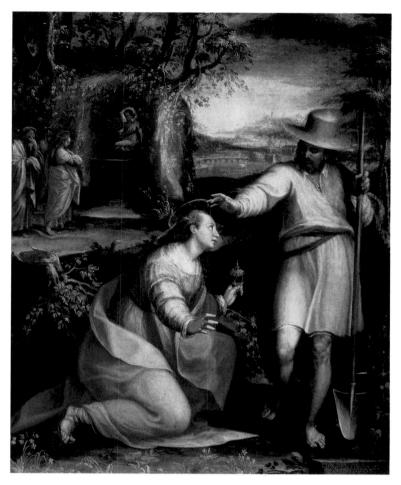

15–42 | Lavinia Fontana NOLI ME TANGERE 1581. Oil on canvas, $47\% \times 36\%''$ (120.3 \times 93 cm). Galleria degli Uffizi, Florence.

revealing himself before his Ascension to Mary Magdalen and warning her not to touch him (John 20:17). Christ's costume refers to the passage in the Gospel of John that tells us that Mary Magdalen at first thought Christ was the gardener.

Christ steps forward like a classical god—but dressed in a short tunic and wearing a gardener's hat. His graceful gesture echoes that of the Magdalen. In the middle distance a second confrontation is taking place: the earlier meeting of the women with the angel at the empty tomb. Like a medieval artist, Fontana ignores the sequence of earthly time and contrasts the large foreground figures with the tiny figures at the tomb, creating a striking plunge into depth. This unsettling spatial and temporal disconnect is a typical Mannerist conceit.

LATER SIXTEENTH-CENTURY ART IN VENICE AND THE VENETO

By the second half of the sixteenth century, Venice ruled supreme as "Queen of the Adriatic." Her power was not, however, unchallenged, and the Turks remained a threat to commerce. In 1571, allied with Spain and the pope, the Christian fleet with Venetian ships defeated the Turkish fleet at the Battle of Lepanto and so established Christian power for future generations. Victorious and wealthy Venetians entered on a lavish lifestyle, building palaces and villas, which they hung with lush oil paintings. The *Triumph of Venice* (see Fig. 12, Introduction), commissioned by the city government from the artist Veronese for the Hall of the Great Council in the Doge's palace, captures the splendor of Venice.

Oil Painting

Rather than the cool, formal, technical perfection sought by the Mannerists, painters in Venice expanded upon the techniques initiated there by Giorgione and Titian, concerning themselves above all with color, light, and expressively loose brushwork.

VERONESE. Paolo Caliari (1528–88) took his nickname—"Veronese"—from his hometown, Verona, but he worked mainly in Venice. His paintings are nearly synonymous today with the popular image of Venice as a splendid city of

THE OBJECT SPEAKS

VERONESE IS CALLED BEFORE THE INQUISITION

esus among his disciples at the Last Supper was an image that spoke powerfully to believers during the sixteenth century. So it was not unusual when, in 1573, the highly esteemed painter Veronese revealed an enormous canvas that seemed at first glance to depict this scene. The Church officials of Venice were shocked and offended by the impiety of placing near Jesus a host of extremely unsavory characters. Veronese was called before the Inquisition to explain his painting.

Venice, July 18, 1573. The minutes of the session of the Inquisition Tribunal of Saturday, the 18th of July, 1573. . . . *

- Q: What picture is this of which you have spoken?
- A: This is a picture of the Last Supper that Jesus Christ took with His apostles in the house of Simon . . .
- Q: At this supper of Our Lord have you painted other figures?
- A: Yes, milords.
- Q: Tell us how many people and describe the gestures of each.

(Veronese describes the painting.)

- Q: What is the significance of those armed men dressed as Germans, each with a halberd in his hand?
- A: We painters take the same license the poets and the jesters take and I have represented these two hal-

berdiers, one drinking and the other eating nearby on the stairs. They are placed there so that they might be of service because it seemed to me fitting, according to what I have been told, that the master of the house, who was great and rich, should have such servants.

- Q: And that man dressed as a buffoon with a parrot on his wrist, for what purpose did you paint him on that canvas?
- A: For ornament, as is customary . . .
- Q: Who do you really believe was present at that Supper?
- A: I believe one would find Christ with His Apostles. But if in a picture there is some space to spare I enrich it with figures according to the stories.
- Q: Did anyone commission you to paint Germans, buffoons, and similar things in that picture?
- A: No, milords, but I received the commission to decorate the picture as I saw fit. It is large and, it seemed to me, it could hold many figures.
- Q: Are not the decorations which you painters are accustomed to add to paintings or pictures supposed to be suitable and proper to the subject and the principal figures or are they for pleasure—simply what comes to

- your imagination without any discretion or judiciousness?
- A: I paint pictures as I see fit and as well as my talent permits.
- Q: Does it seem fitting at the Last Supper of the Lord to paint buffoons, drunkards, Germans, dwarfs, and similar vulgarities?
- A: No, milords . . .

(The questions continue in this vein.)

The judges decreed that Veronese must change the painting within three months or be liable to penalties. Veronese changed the picture's title so that it referred to another banquet, given by the tax collector Levi. The "buffoons, drunkards . . . and similar vulgarities" remained, and Veronese noted his new source-Luke 5-on the balustrade. That Gospel reads that "Levi gave a great banquet for him [Jesus] in his house, and a large crowd of tax collectors and others were at table with them" (Luke 5:29). In changing the declared subject of the painting, Veronese also had modest revenge on the Inquisitors: When Jesus was criticized for associating with such people, he replied, "I have not come to call the righteous to repentance but sinners" (Luke

* E. G. Holt, *Literary Sources of Art History*. Princeton, NJ: Princeton University Press, 1947. pp. 245–48.

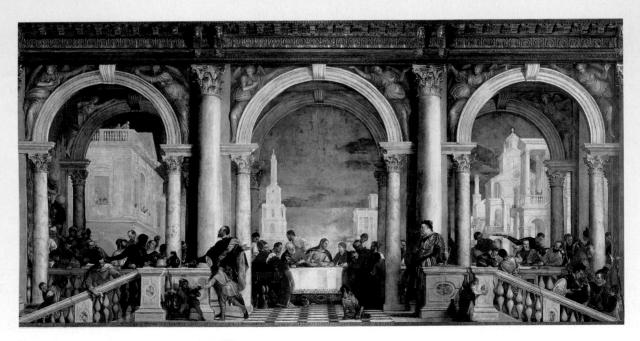

Veronese FEAST IN THE HOUSE OF LEVI

From the refectory of the Dominican Monastery of Santi Giovanni e Paolo, Venice. 1573. Oil on canvas, $18'3'' \times 42'$ (5.56 \times 12.8 m). Galleria dell'Accademia, Venice.

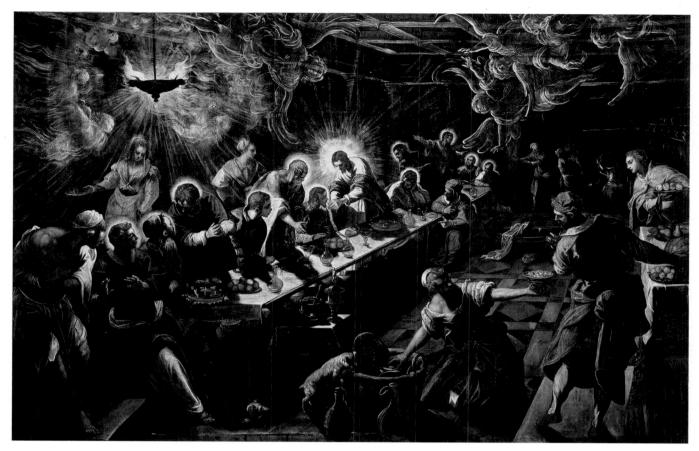

15–43 | Tintoretto THE LAST SUPPER 1592–94. Oil on canvas, $12' \times 18'8''$ (3.7×5.7 m). Church of San Giorgio Maggiore, Venice.

Tintoretto, who had a large workshop, often developed a composition by creating a small-scale model like a miniature stage set, which he populated with wax figures. He then adjusted the positions of the figures and the lighting until he was satisfied with the entire scene. Using a grid of horizontal and vertical threads placed in front of this model, he could easily sketch the composition onto squared paper for his assistants to copy onto a large canvas. His assistants also primed the canvas, blocking in the areas of dark and light, before the artist himself, free to concentrate on the most difficult passages, finished the painting. This efficient working method allowed Tintoretto to produce a large number of paintings in all sizes.

pleasure and pageantry sustained by a nominally republican government and great mercantile wealth. Veronese's elaborate architectural settings and costumes, still lifes, anecdotal vignettes, and other everyday details, often unconnected with the main subject, proved immensely appealing to Venetian patrons. His vision of the glorious Venice reached an apogee in the ceiling of the council chamber in the ducal palace (Fig. 12, Introduction).

Veronese's most famous work is a Last Supper that he renamed **FEAST IN THE HOUSE OF LEVI** (see opposite), painted in 1573 for the Dominican Monastery of Santi Giovanni e Paolo. At first glance, the subject of the painting seems to be architecture and only secondarily Christ seated at the table. An enormous loggia framed by colossal triumphal arches and reached by balustraded stairs symbolizes Levi's house. Beyond the loggia an imaginary city of white marble gleams. Within this grand setting, realistic figures in splendid costumes assume exaggerated, theatrical poses. The huge size of the painting

allowed Veronese to include the sort of anecdotal vignettes beloved by the Venetians—the parrots, monkeys, and Germans—but detested by the Church's Inquisitors, who saw in them profane undertones.

TINTORETTO. Another Venetian master, Jacopo Robusti (1518–94), called "Tintoretto" ("Little Dyer," because his father was a dyer), worked in a style that developed from, and exaggerated, the techniques of Titian, in whose shop he reportedly apprenticed. Tintoretto's goal, declared on a sign in his studio, was to combine Titian's color with the drawing of Michelangelo. Like Veronese, Tintoretto often received commissions to decorate huge interior spaces. He painted THE LAST SUPPER (FIG. 15–43) for the choir of the Church of San Giorgio Maggiore, a building designed by Palladio (SEE FIG. 15–44). Comparison with Leonardo da Vinci's painting of almost a century earlier is instructive (see Figs. 15–2 and fig. 18, Introduction). Instead of Leonardo's closed

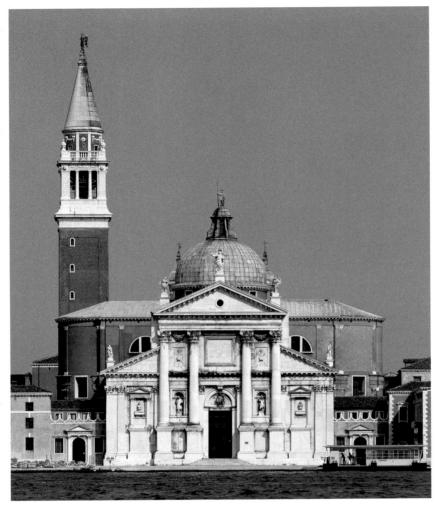

15–44 | Palladio CHURCH OF SAN GIORGIO MAGGIORE, VENICE Plan 1565; construction 1565–80; façade, 1597–1610; campanile 1791. Finished by Vincenzo Scamozzi following Palladio's design.

and logical space with massive figures reacting in individual ways to Jesus's statement, Tintoretto's view is from a corner, with the vanishing point on a high horizon line at the far right side. The table, coffered ceiling, and inlaid floor all seem to plunge dramatically into the distance. The figures, although still large bodies modeled by flowing draperies, turn and move in a continuous serpentine line that unites apostles, servants, and angels. Tintoretto used two light sources: one real, the other supernatural. Light streams from the oil lamp flaring dangerously over the near end of the table; angels seem to swirl out from the flame and smoke. A second light emanates from Jesus himself and is repeated in the glow of the apostles' halos. The mood of intense spirituality is enhanced by deep colors flashed with bright highlights, as well as by the elongated figures—treatments that reflect both the Byzantine art of Venice and the Mannerist aesthetic. The still lifes on the tables and the homey detail of a cat and basket emphasize the reality of the viewers' experience. At the same time, the deep chiaroscuro and brilliant dazzling lights catching forms in near-total darkness enhance the convincingly otherworldly atmosphere. The

interpretation of *The Last Supper* also has changed—unlike Leonardo's more secular emphasis on personal betrayal, Tintoretto has returned to the religious institution of the Eucharist: Jesus offers bread and wine, a model for the priest administering the sacraments at the altar next to the painting.

The speed with which Tintoretto drew and painted was the subject of comment in his own time, and the brilliance and immediacy so admired today (his slashing brushwork was fully appreciated by the gestural painters of the twentieth century) were derided as evidence of carelessness. His rapid production may be attributed to the efficiency of his working methods: Tintoretto had a large workshop of assistants and he usually provided only the original conception, the beginning drawings, and the final brilliant touches on the finished painting. Tintoretto's workshop included members of his family—of his eight children, four became artists. His oldest daughter, Marietta Robusti, worked with him as a portrait painter, and two or perhaps three of his sons also joined the shop. So skillfully did Marietta capture her father's style and technique that today art historians cannot identify her work in the shop.

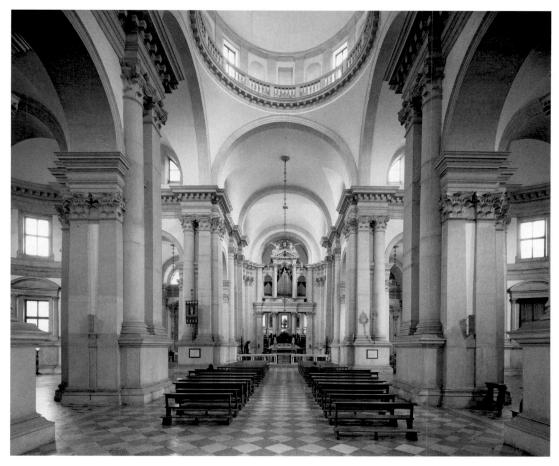

15–45 □ **NAVE, CHURCH OF SAN GIORGIO MAGGIORE, VENICE** Begun 1566. Tintoretto's *Last Supper* (not visible) hangs to the left of the altar.

Architecture: Palladio

Just as Veronese and Tintoretto expanded upon the rich Venetian tradition of oil painting established by Giorgione and Titian, Andrea Palladio dominated architecture during the second half of the century by expanding upon principles of Alberti and of ancient Roman architecture. His work—whether a villa, palace, or church—was characterized by harmonious symmetry and a rejection of ornamentation. Over the years, Palladio became involved in several publishing ventures, including a guide to Roman antiquities, an illustrated edition of Vitruvius, and books on architecture that for centuries would be valuable resources for architectural design.

Born Andrea di Pietro della Gondola (1508–80), probably in Padua, Palladio began his career as a stonecutter. After moving to Vicenza, he was hired by the nobleman, humanist scholar, and amateur architect Giangiorgio Trissino. Trissino gave him the nickname "Palladio" for the Greek gocdess of wisdom, Pallas Athena, and the fourth-century Roman writer Palladius. Palladio learned Latin at Trissino's small academy and accompanied his benefactor on three trips to Rome, where he made drawings of Roman monuments.

SAN GIORGIO MAGGIORE. By 1559, when he settled in Venice, Palladio was one of the foremost architects of Italy. In

1565, he undertook a major architectural commission: the monastery CHURCH OF SAN GIORGIO MAGGIORE (FIG. 15-44). His design for the Renaissance façade to the traditional basilica-plan elevation—a wide lower level fronting the nave and side aisles surmounted by a narrower front for the nave clerestory—is ingenious. Inspired by Alberti's solution for Sant'Andrea in Mantua (SEE FIG. 14-31), Palladio created the illusion of two temple fronts of different heights and widths, one set inside the other. At the center, colossal columns on high pedestals, or bases, support an entablature and pediment that front the narrower clerestory level of the church. The lower temple front, which covers the triple-aisle width and slanted side-aisle roofs, consists of pilasters supporting an entablature and pediment running behind the columns of the taller clerestory front. Palladio retained Alberti's motif of the triumphal-arch entrance. Although the façade was not built until after the architect's death, his original design was followed.

The interior of San Giorgio (FIG. 15–45) is a fine example of Palladio's harmoniously balanced geometry, expressed here in strong verticals and powerful arcs. The tall engaged columns and shorter pairs of pilasters of the nave arcade echo the two levels of orders on the façade, thus unifying the building's exterior and interior.

THE VILLA ROTONDA. Palladio's versatility can best be seen in numerous villas built early in his career. In the 1560s, he started his most famous and influential villa just outside Vicenza (FIGS. 15–46, 15–47). Although traditionally villas were working farms, Palladio designed this one as a retreat for relaxation (a party house). To afford views of the countryside on each face of the building, he placed a porch, with four columns, arched openings in the walls, and a wide staircase. The main living quarters are on this second level, as is usual

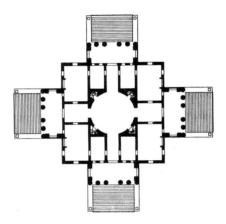

15–46 | Plan of the Villa Rotonda c. 1550.

Palladio was a scholar and an architectural theorist as well as a designer of buildings. His books on architecture provided ideal plans for country estates, using proportions derived from ancient Roman structures. Despite their theoretical bent, his writings were often more practical than earlier treatises. Perhaps his early experience as a stonemason provided him with the knowledge and self-confidence to approach technical problems and discuss them as clearly as he did theories of ideal proportion and uses of the classical orders. By the eighteenth century, Palladio's Four Books of Architecture had been included in the library of most educated people. Thomas Jefferson had one of the first copies in America.

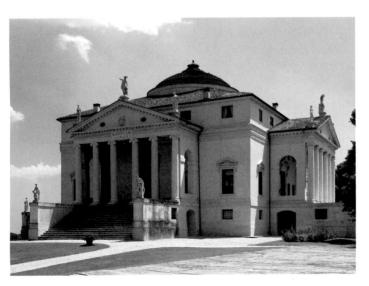

15–47 | Palladio VILLA ROTONDA (VILLA CAPRA), VICENZA Italy. Begun, 1560s.

in European palace architecture, and the lower level is reserved for the kitchen, storage, and other utility rooms. Upon its completion in 1569, the villa was dubbed the VILLA ROTONDA because it had been inspired by another round hall, the Roman Pantheon. After its purchase in 1591 by the Capra family, it became known as the Villa Capra. The villa's plan shows the geometric clarity of Palladio's conception: a circle inscribed in a small square inside a larger square, with symmetrical rectangular compartments and identical rectangular projections from each of its faces. The use of a central dome on a domestic building was a daring innovation that effectively secularized the dome. The Villa Rotonda was the first of what was to become a long tradition of domed country houses, particularly in England and the United States.

IN PERSPECTIVE

In spite of ongoing struggles between the Holy Roman emperor and the pope, and in spite of the scandals beginning to envelop the Church, the early sixteenth century emerged as a golden age for the arts. As sixteenth-century artists built on the past, they carried the investigation of nature, classics, and humanistic learning further than their fifteenth-century predecessors. Art went beyond realism to idealism. Artists not only reproduced the surface appearances, they sought underlying forms. In painting a figure, for example, their study of anatomy had to be more than skin deep; their knowledge of the skeletal and muscular structure of the human body was on display, and the observation of a face led to the study of a personality. The ideal of the dignity of all human beings as creatures made by God, expounded by the philosophers and forcefully elucidated in Michelangelo's paintings in the Sistine Chapel, informed the art of this period.

As classicists, their fascination with the tangible remains of ancient Rome—inscriptions, fragments of architecture and sculpture—turned into full-scale archaeological excavation and the discovery of major pagan artworks such as the *Laocoön*. Like the ancient Greeks (whose sculpture they knew only in Roman copies), the Italian painters of the High Renaissance sought perfection. They, too, developed an ideal canon of proportions and a kind of spiritual geometry that underlies their painting and sculpture. This classical equilibrium in the arts, balancing physical and spiritual forces, proved to be fleeting.

By 1530 change was in the air, and an anticlassical style emerged in works of art that later critics defined as "Mannerist." A high level of technical skill could be assumed and was used to achieve dazzling displays of grace, elegance, and "manner." As complex in their compositions as they were in their subjects, the Mannerist artworks stimulate an uneasy imagination, and today they often defy analysis or explication. Social institutions might be crumbling but artists, secure in their technical achievements and admired by their patrons, continued to paint, carve, and build.

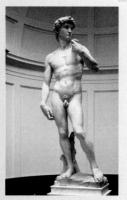

MICHELANGELO

DAVID

1501-4

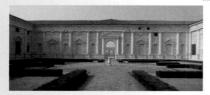

GIULIO ROMANO

COURTYARD FAÇADE , PALAZZO DEL TÈ, MANTUA

1527-34

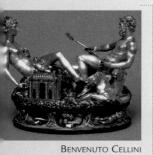

ALTCELLAR OF KING FRANCIS I

OF FRANCE

1540-43

Sofonisba Anguissola **SELF PORTRAIT** C. 1552

TINTORETTO
THE LAST SUPPER
1592-94

SIXTEENTH-CENTURY ART IN ITALY

- Luther Officially Protests Church's Sale of Indulgences 1517
- Charles V Holy Roman Emperor 1519-56
- Charles V Orders Sack of Rome 1527
- Jesuit Order Confirmed 1540
- Pope Paul III Institutes Inquisition 1542
- Council of Trent 1545-63
- Vasari's Lives Published 1550
- Veronese Appears Before the Inquisition 1573

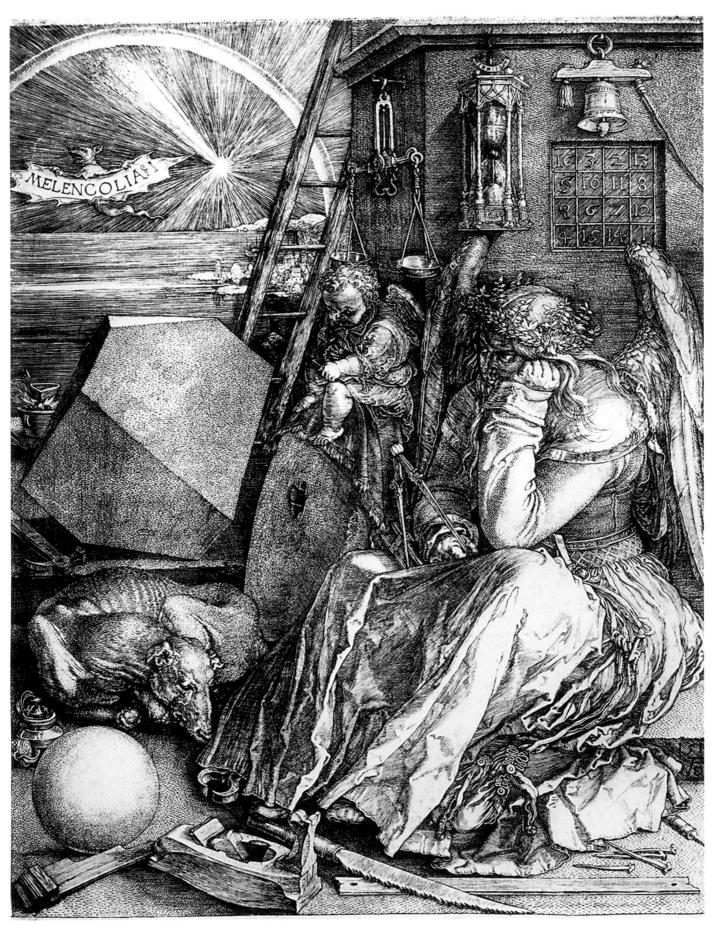

16–1 | Albrecht Dürer | MELENCOLIA I | 1514. Engraving, $9\% \times 7\%$ (23.8 \times 18.9 cm). Victoria & Albert Museum, London.

CHAPTER SIXTEEN

Automobile Property

SIXTEENTH-CENTURY ART IN NORTHERN EUROPE AND THE IBERIAN PENINSULA

A bat inscribed "Melencolia I" flits through the sky. The flashing light of a comet illuminates a huge winged creature seated below, who seems lost in thought and whose body expresses weariness and even despair, a mood reflected in the

ness and even despair, a mood reflected in the curled figure of a starving dog. Piled on the ground and hanging on the wall is a striking collection of objects, some associated with the mechanical arts and crafts—builders' tools such as a ladder, hammer, spikes, saw, and a plane—and others with intellectual activity—compasses, scales, an hourglass, and a measuring stick, all instruments used to describe the world in terms of geometry. A winged child scribbles mindlessly, but the adult figure seems to have created a perfect sphere, a truncated polyhedron, and a magic number square. Now, though, she sits in an attitude of defeat and frustration. What does this all mean? In his groundbreaking study, the scholar Erwin Panofsky identified the image as the "spiritual self-portrait" of its creator, the artist Albrecht Dürer.

A skilled graphic artist with a brilliant mind, Dürer was a leading figure in the German Renaissance. He was also a social and professional success in Italy, where he traveled in 1494 and 1505. There, he must have noted a certain distinction: Artists like Michelangelo could claim to be divinely inspired creators, but in Dürer's Germany artists were still considered artisans—craftsmen and manual laborers. They were not "humanists," not "intellectuals"; they were skilled and valued members of society, to be sure, but nevertheless people who

16

worked with their hands. Dürer, caught up in the humanist spirit of Renaissance Italy, may have identified with his creation in **MELENCOLIA I** (FIG. 16—1): a superhuman, listlessly brooding figure surrounded by tools and symbols of the arts

and humanities but still unable to act.

The ideas behind Dürer's image seem strange to us today. Renaissance scholars believed that the planets influenced human destiny. Artists, it was thought, were born under the distant and dark planet Saturn (the dog and bat are creatures of Saturn). From Saturn came a divine frenzy that inspired artistic creativity. If that frenzy was not kept in balance with what the discipline of art could reasonably accomplish, however, artists were led to frustration and ultimately inaction. In short, the creative genius was prone to melancholy and despair. Also, according to the Renaissance theory of the four humors (bodily fluids that determined human personality and temperament), the melancholy person had an excess of black bile. Black bile was associated with things dry and cold, with the earth, with endings-evening, autumn, age-and with the vices of greed and despair. As if to reinforce the identification with the melancholy humor, Dürer's winged figure wears a wreath of watercress and ranunculus, plants thought to cure the dryness caused by melancholy. The figure's rumpled purse lies on the ground, perhaps signifying the craving for—but absence of—wealth.

But what is the meaning of the roman numeral "I" after the word "Melencolia"? According to the belief of the time, melancholy took three forms, conceived of as "limitations" that varied by profession. Scientists and physicians, for example, were "limited" by the second form of melancholy, reason; theologians were limited by intuition, the third form. Artists suffered from limitation by imagination, the first form—hence, Melencolia I. We are watching an artist struggling with the burden of the creative imagination.

The other two engravings Dürer made between 1513 and 1514 illustrate the active life—a knight defying death and the devil—and the contemplative life—the scholar Saint Jerome at work in his study. *Melencolia I*, however, shows us a secular genius and reflects the philosophical and social conflict that beset Dürer and many other thoughtful artists, especially in Protestant lands, in the early years of the sixteenth century. In its melancholy, the engraving also foreshadows the effects of the religious turmoil, social upheaval, and civil war soon to sweep northern Europe.

CHAPTER-AT-A-GLANCE

- THE REFORMATION AND THE ARTS
- EARLY SIXTEENTH-CENTURY ART IN GERMANY | Sculpture | Painting
- RENAISSANCE ART IN FRANCE | The Introduction of Italian Art | Art in the Capital
- RENAISSANCE ART IN SPAIN AND PORTUGAL | Architecture | Painting
- RENAISSANCE PAINTING IN THE NETHERLANDS | Art for Aristocratic and Noble Patrons | Antwerp
- RENAISSANCE ART IN ENGLAND | Artists in the Tudor Court | Architecture
- **IN PERSPECTIVE**

THE REFORMATION AND THE ARTS

In spite of dissident movements that challenged the Christian Church through the centuries, the authority of the Church and the pope ultimately prevailed—until the sixteenth century. Then, against a backdrop of broad dissatisfaction with financial abuses and lavish lifestyles among the clergy (see Chapter 20), religious reformers within the established Church challenged practices and went on to challenge beliefs.

Two of the most important reformers in the early sixteenth century were themselves Catholic priests and trained theologians: Desiderius Erasmus of Rotterdam (1466?-1536) in Holland who tried to reform the Roman Catholic Church from within, and Martin Luther (1483–1546) in Germany who eventually broke with the Church. Indeed, the Reformation may be said to begin in 1517, when Luther issued his Ninety-Five Theses calling for Church reform. Among Luther's concerns were the practice of selling indulgences (the forgiveness of sins and the assurance of salvation) and the excessive veneration of saints and their relics, which he considered superstitious. Luther and others emphasized individual faith and regarded the Bible as the ultimate religious authority. As they challenged the pope's supremacy, it became clear that the Protestants had to break away from Rome. The Church condemned Luther in 1521.

Increased literacy and the widespread use of the printing press aided the reformers and allowed scholars throughout

Europe to debate religious matters and to influence many people. In Germany the wide circulation of Luther's writings—especially his German translation of the Bible and his works maintaining that salvation comes through faith alone—eventually led to the establishment of the Protestant (Lutheran) Church there. In Switzerland, John Calvin (1509–64) led an even more austere Protestant revolt, and in England, King Henry VIII (ruled 1509–47) also broke with Rome in 1534. By the end of the sixteenth century, some form of Protestantism prevailed throughout northern Europe.

Leading the Catholic cause was Holy Roman Emperor Charles V (see Chapter 15). Europe was wracked by religious war from 1546 to 1555 as Charles battled the Protestant forces in Germany. During this turbulent time, the Italian Leone Leoni (1509-90), working for the emperor in Spain, created a life-size bronze sculpture of Charles V Triumphing over Fury (see Fig. 8, Introduction). Yet Leone's portrayal of a victorious Charles proved premature. At a meeting of the provincial legislature of Augsburg in 1555, the emperor was forced to accommodate the Protestant Reformation in his lands. By the terms of the peace, local rulers selected the religion of their subjects— Catholic or Protestant. Tired of the strain of government and prematurely aged, Charles abdicated in 1556 and retired to a monastery in Spain, where he died in 1558. His son Philip II inherited Spain and the Spanish colonies; his brother Ferdinand led the Austrian branch of the Habsburg dynasty.

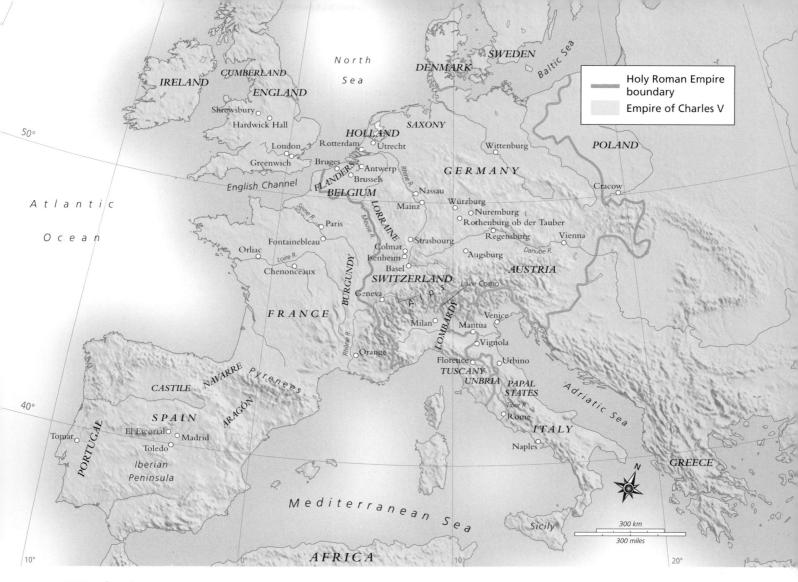

MAP 16-I Northern europe and the iberian peninsula in the sixteenth century

The 16th century saw Europe divided between Protestant and Catholic countries. While France, Spain, Flanders, Belgium, and Italy remained Catholic, Switzerland, the northern Netherlands (the United Provinces), and England became Protestant. By 1555 Emperor Charles V had to permit rulers in his German lands to follow their own religious beliefs.

The years of political and religious strife had a grave impact on artists. Some artists found their careers at an end because of their sympathies for rebels and reformers. Then as Protestantism gained ascendancy, artists who supported the Roman Catholic Church had to leave their homes to seek patronage abroad.

A tragic consequence of the Reformation was the destruction of religious art. In some places, Protestant zealots smashed sculpture and stained-glass windows and destroyed or whitewashed religious paintings to rid the churches of what they considered to be idolatrous images—though Luther, who understood the educational value of art, never directly supported iconoclasm (the smashing of religious images). With the sudden loss of patronage for religious art in the newly Protestant lands, many artists had to find new patrons and new themes. They turned to portraiture and other secular subjects, including moralizing depictions of human folly and weaknesses. Still-life (that is, the painting of objects alone) and landscape painting began to appear. The popularity of these themes stimulated a free art market, centered in Antwerp.

EARLY SIXTEENTH-CENTURY ART IN GERMANY

In German regions the arts flourished until religious upheavals and iconoclastic purges of religious images took a toll at midcentury. The German cities had strong business and trade interests and their merchants and bankers accumulated self-made, rather than inherited, wealth. They ordered portraits of themselves and fine furnishings for their large, comfortable houses. Entrepreneurial artists, like Albrecht Dürer, became major commercial successes.

Sculpture

At the end of the fifteenth century, sculpture gradually changed from the late Gothic to Renaissance style with an increased interest in naturalism. Although, like the Italians, German sculptors worked in stone and bronze, they produced their most original work in wood, especially fine-grained limewood. They gilded and painted these wooden images, until Tilman Riemenschneider began to use natural wood finishes.

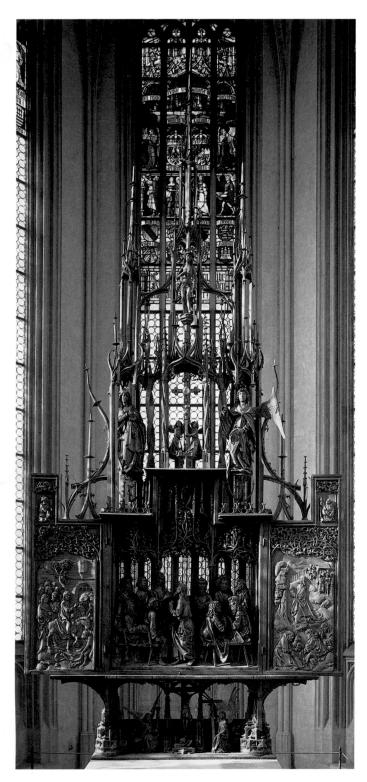

16−2 | Tilman Riemenschneider ALTARPIECE OF THE HOLY BLOOD (WINGS OPEN)

Center, Last Supper. c. 1499-1505. Limewood, glass, height of tallest figure 39" (99.1 cm); height of altar 29'6" (9 m). Sankt Jakobskirche, Rothenburg ob der Tauber, Germany.

TILMAN RIEMENSCHNEIDER. Tilman Riemenschneider (c. 1460–1531) became a master in 1485 and soon had the largest workshop in Würzburg. His shop included specialists in both wood and stone sculpture. Riemenschneider attracted patrons from other cities, and in 1501 he signed a contract with the Church of Saint James in Rothenburg, where a relic said to be a drop of Jesus's blood was preserved. The ALTARPIECE OF THE HOLY BLOOD (FIG. 16–2) is a spectacular limewood construction standing nearly 30 feet high. A specialist in architectural shrines had begun work on the elaborate Gothic frame in 1499. The frame cost fifty florins. Riemenschneider was commissioned to provide the figures and scenes to be placed within this frame, and Riemenschneider was paid sixty florins for the sculpture (a suggestive commentary on the value assigned the work by the patrons).

In the main scene of the altarpiece, the *Last Supper*, Riemenschneider depicted the moment when Christ revealed that one of his followers would betray him. Unlike Leonardo da Vinci, who chose the same moment (see Introduction, Fig. 18), Riemenschneider made Judas the central figure in the composition and placed Jesus off-center at the left. The disciples sit around the table. As the event is described in the Gospel of John (13:21–30), Jesus extends a morsel of food to Judas, signifying that Judas will be the traitor who sets in motion the events leading to the Crucifixion. An apostle points down, a strange gesture until one realizes that he points to the Crucifix in the predella, to the relic of Christ's blood, and to the altar table, the symbolic representation of the table of the Last Supper and the tomb of Christ.

Rather than creating individual images in his sculptures, Riemenschneider repeated a limited number of facial types. In this way he could make effective use of his workshop. His figures have large heads, prominent features, sharp cheekbones, sagging jowls, baggy eyes, and elaborate hair with thick wavy locks and deeply drilled curls. The muscles, tendons, and raised veins of hands and feet are also especially lifelike. His assistants and apprentices copied these faces and figures, either from drawings or from three-dimensional models made by the master. In the altarpiece, deeply hollowed folds and active patterned draperies create strong highlights and dark shadows that unite the figures with the intricate carving of the framework. In the Last Supper the scene is set in a real room with actual benches for the figures, with windows in the back wall glazed with bull's-eye glass. Natural light shining through both the church and altarpiece windows illuminates the scene, creating changing effects depending on the time of day and the weather.

In addition to producing an enormous number of religious images for churches, Riemenschneider was politically active in the city's government, and he even served as mayor in 1520. His career ended during the Peasants' War (1524–26), an early manifestation of the Protestant movement. His support for the peasants led to a fine and imprisonment in 1525, and he died in 1531.

VEIT STOSS. Riemenschneider's contemporary Veit Stoss (1450–1533) spent his early years (1477–96) in Cracow.

Poland, where he became wealthy from his sculpture and architectural commissions, as well as from financial investments. After returning to his native Nuremberg, he too began to specialize in limewood sculpture, probably because established artists already dominated commissions in other mediums. He had a small shop whose output was characterized by an easily recognizable realistic style. Following the lead of Riemenschneider and others, Stoss shows in his unpainted limewood sculptures a special appreciation for the wood itself, which he exploited for its inherent colorations, grain patterns, and range of surface finishes.

Stoss carved the **ANNUNCIATION AND VIRGIN OF THE ROSARY** (FIG. 16–3) for the choir of the Church of Saint Lawrence in Nuremberg in 1517–18. Gabriel's greeting to Mary takes place within a wreath of roses symbolizing the prayers of the rosary, which was being popularized by the Dominicans. Disks are carved with scenes of the Joys of the Virgin, to which are added her death (Dormition) and Coronation. Mary and Gabriel are adored and supported by angels. Their dignified figures are encased in elaborate crinkled and fluttering drapery that seems to blend with the delicate angels and to cause the entire work to float like an apparition in the upper reaches of the choir. The sculpture continues the expressive, mystical tradition prevalent since the Middle Ages in the art of Germany, where the recitation of prayers to the Virgin (the rosary) had become an important part of personal devotion.

NIKOLAUS HAGENAUER. Prayer was also the principal source of solace and relief to the ill before the advent of modern medicine. About 1505, the Strasbourg sculptor Nikolaus Hagenauer (active 1493–1530s) carved an altarpiece for the Abbey of Saint Anthony in Isenheim near Colmar (FIG. 16–4). The Abbey's hospital specialized in the care of patients with skin diseases, including the plague, leprosy, and Saint Anthony's Fire (a terrible disease caused by eating rye and other grains infected with the ergot fungus). The shrine includes images of Saint Anthony, Saint Jerome, and Saint Augustine. Three men kneel at the feet of the saints: the donor, Jean d'Orliac, and two men offering a rooster and a piglet. The three are tiny figures, as befits their subordinate status.

In the predella below, Jesus and the apostles bless the altar, Host, and assembled patients in the hospital. The limewood sculpture was painted in lifelike colors, and the shrine itself was gilded to enhance its resemblance to a precious reliquary. Later, Matthias Grünewald painted wooden shutters to cover the shrine (SEE FIGS. 16–5, 16–6).

Painting

German art during the first decades of the sixteenth century was dominated by two very different artists, Matthias Grünewald and Albrecht Dürer. Grünewald's unique style expressed the

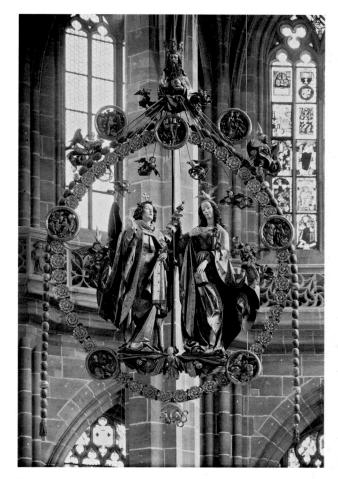

16-3 | Veit Stoss ANNUNCIATION AND VIRGIN
OF THE ROSARY

1517-18. Painted and gilt limewood, $12'2'' \times 10'6''$ (3.71 \times 3.20 m). Church of Saint Lawrence, Nuremberg.

continuing currents of medieval German mysticism and emotional spirituality, while Dürer's intense observation of the natural world represented the scientific Renaissance interest in empirical observation, including mathematical perspective to create the illusion of space, and the use of a reasoned canon of proportions for depicting the human figure.

MATTHIAS GRÜNEWALD. As an artist in the court of the archbishop of Mainz, Matthias Grünewald (Matthias Gothart Neithart, c. 1470/75–1528) was a man of many talents, who worked as an architect and hydraulic engineer as well as a painter. He is best known today for painting the wings of the ISENHEIM ALTARPIECE (SEE FIGS. 16–5, 16–6), built to protect the shrine carved by Nikolaus Hagenauer. In his realism and intensity of feeling, Grünewald may have been inspired by the visions of Saint Bridget of Sweden, a fourteenth-century mystic whose works were published in Germany beginning in 1492. She described the Crucifixion in morbid detail.

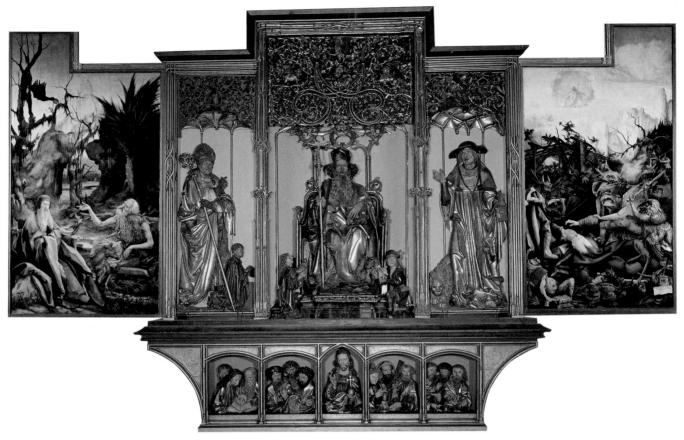

16–4 Nikolaus Hagenauer SAINT ANTHONY ENTHRONED BETWEEN SAINTS AUGUSTINE AND JEROME, SHRINE OF THE ISENHEIM ALTARPIECE (OPEN, SHOWING GRÜNEWALD WINGS.) From the Community of Saint Anthony, Isenheim, Alsace, France. c. 1500. Painted and gilt limewood, center panel $9'9'2'' \times 10'9''$ (2.98 \times 3.28 m); predella $2'5'2'' \times 11'2''$ (0.75 \times 3.4 m). Wings $8'2'2'' \times 3'2'' \times (2.49 \times 0.93 \text{ m})$. Predella: Christ and the Apostles. Wings Saint Anthony and Saint Paul (left); The Temptation of

The altarpiece is impressive in size and complexity. Grünewald painted one set of fixed wings and two sets of movable ones, plus one set of sliding panels to cover the predella. The altarpiece could be exhibited in different configurations depending upon the Church calendar. The wings and carved wooden shrine complemented one another, the inner sculpture seeming to bring the surrounding paintings to life, and the painted wings protecting the precious carvings.

Saint Anthony (right). 1510-15. Musée d'Unterlinden, Colmar, France.

On weekdays, when the altarpiece was closed, viewers saw a shocking image of the Crucifixion in a darkened landscape, a Lamentation below it on the predella, and life-size figures of Saints Sebastian and Anthony Abbot—saints associated with the plague—standing on *trompe l'oeil* pedestals on the fixed wings (FIG. 16–5). Grünewald represented in the most horrific details the tortured body of Jesus, covered with gashes from being beaten and pierced by the thorns used to form a crown for his head. His ashen body, open mouth, and blue lips indicate that he is dead. In fact, he appears already to be decaying, an effect enhanced by the palette of putrescent green, yellow, and purplish red—all described by Saint Bridget; she wrote, "The color of death spread through his flesh. . ." A ghostlike Virgin Mary has collapsed in the arms of an emaciated John the Evangelist, and Mary Magdalen has fallen in anguish to her knees; her

clasped hands with outstretched fingers seem to echo Jesus's fingers, cramped in rigor mortis. At the right John the Baptist points at Jesus and repeats his prophecy, "He shall increase." The Baptist and the lamb, holding a cross and bleeding from its breast into a golden chalice, allude to baptism, the Eucharist, and to Christ as the sacrificial Lamb of God (recalling the *Ghent Altarpiece*; SEE FIG. 13–12). In the predella below, Jesus's bereaved mother and friends prepare his body for burial—an activity that must have been a common sight in the abbey's hospital.

In contrast to these grim scenes, the first opening displays events of great joy—the Annunciation, the Nativity, and the Resurrection—appropriate for Sundays and Church festivals (FIG. 16–6). Praying in front of these images, the patients hoped for miraculous recovery. Unlike the awful darkness of the Crucifixion, the inner scenes are illuminated with clear natural daylight, phosphorescent auras and halos, and the glitter of stars in a night sky. Fully aware of contemporary formal achievements in Italy, Grünewald created the illusion of three-dimensional space and volumetric figures, and he simplified and idealized the forms. Underlying this attempt to arouse a sympathetic emotional response in the viewer is a complex religious symbolism, undoubtedly the result of close collaboration with his monastic patrons.

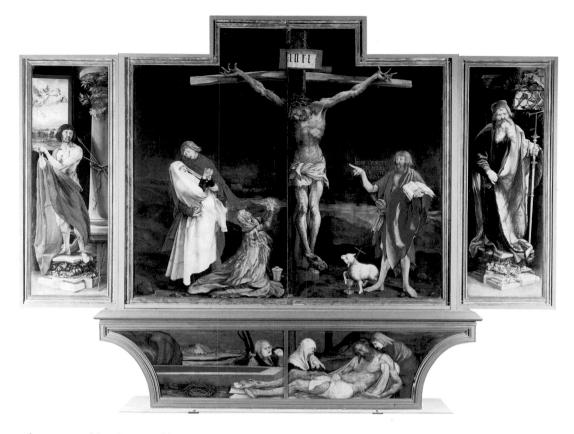

16–5 | Matthias Grünewald ISENHEIM ALTARPIECE (CLOSED)

From the Community of Saint Anthony, Isenheim, Alsace, France. Center panels: *Crucifixion*; predella: *Lamentation*; side panels: *Saints Sebastian* (left) and *Anthony Abbot* (right). c. 1510–15. Date 1515 on ointment jar. Oil on wood panel, center panels $9'9\frac{y_2''}{2} \times 10'9''$ (2.97 \times 3.28 m) overall; each wing $8'2\frac{y_2''}{2} \times 3'\frac{y_2''}{2} \times 3'\frac{y_2''}{2} \times 11'2''$ (0.75 \times 3.4 m). Musée d'Unterlinden, Colmar, France.

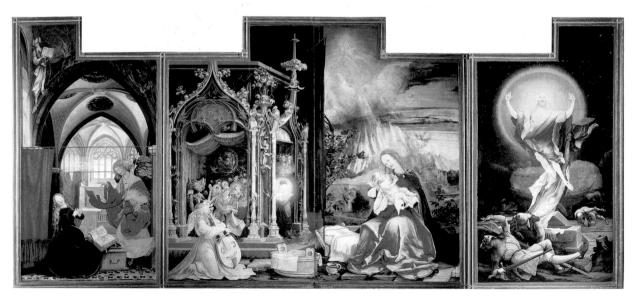

Materials and Techniques

GERMAN METALWORK: A COLLABORATIVE VENTURE

n Nuremberg, a city known for its master metalsmiths, Hans Krug (d. 1519) and his sons Hans the Younger and Ludwig were among its finest gold- and silversmiths. They created marvelous display pieces for the wealthy, such as this silver-gilt apple cup. Made about 1510, a gleaming apple, in which the stem forms the handle of the lid, balances on a leafy branch that forms its base.

The Krug family was responsible for the highly refined casting and finishing of the final product, but several artists worked together to produce such pieces—one drawing designs, another making the models, and others creating the final piece in metal. A drawing by Dürer may have been the basis for the apple cup. Though we know of no piece of goldwork by the artist himself, Dürer was a major catalyst in the growth of Nuremberg as a key center of German goldsmithing. He accomplished this by producing designs for metalwork throughout his career, evidence of the essential role of designers in the metalwork process. With design in hand, the model maker created a wooden form for the goldsmith to follow. The result of this artistic collaboration was a technical tour de force, an intellectual conceit, and a very beautiful object.

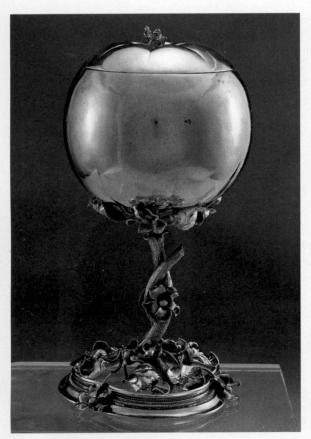

Workshop of Hans Krug (?) APPLE CUP c. 1510–15. Gilt silver, height 8½" (21.5 cm). Germanisches Nationalmuseum, Nuremberg.

The Annunciation on the left wing may have been inspired by a special liturgy called the Golden Mass, which celebrated the divine motherhood of the Virgin. The Mass included a staged reenactment of the angel's visit to Mary, as well as readings from the story of the Annunciation (Luke 1:26–38) and the Old Testament prophecy of the Savior's birth (Isaiah 7:14–15), which is inscribed in Latin on the pages of the Virgin's open book.

The central panels show the heavenly and earthly realms joined in one space. In a variation on the northern European visionary tradition, the new mother adores her miraculous Christ Child while envisioning her own future as Queen of Heaven amid angels and cherubs. Grünewald portrayed three distinct types of angels in the foreground—young, mature, and a feathered hybrid with a birdlike crest on its human head—and a range of ethnic types in the heavenly realm. Perhaps this latter was intended to emphasize the global dominion of the Church, whose missionary efforts were expanding as a result of European exploration. Saint Bridget describes the jubilation of the angels as "the glowing flame of love."

The panels are also filled with traditional imagery of the Annunciation: Marian symbols such as the enclosed garden, the white towel on the tub, and the clear glass cruet behind it, which signify Mary's virginity; the water pot next to the tub, which alludes both to purity and to childbirth; and the fig tree in the background, suggesting the Virgin Birth, since figs were thought to bear fruit without pollination. The bush of red roses at the right alludes not only to Mary but also to the Passion of Jesus, thus recalling the Crucifixion on the outer wings and providing a transition to the Resurrection on the right wing. There, the shock of Christ's explosive emergence from his stone sarcophagus tumbles the guards about, and his new state of being—no longer material but not yet entirely spiritual—is vibrantly evident in his dissolving, translucent figure.

The second opening of the altarpiece (SEE FIG. 16–4) reveals Hagenauer's sculpture and was reserved for the special festivals of Saint Anthony. The wings in this second opening show Saint Anthony attacked by horrible demons—perhaps inspired by the horrors of the diseased patients—and the meeting of Saint Anthony with the hermit Saint Paul. The meeting of the two hermits in the desert glorifies the monastic life, and in the wilderness Grünewald depicts medicinal plants used in the hospital's therapy. Grünewald painted his self-portrait as the face of Saint Paul, and Saint Anthony is a portrait of the donor and administrator of the hospital, the Italian Guido Guersi, whose coat of arms Grünewald painted on the rock.

Like Riemenschneider, Grünewald's career may have been damaged by his active support of the peasants in the Peasants' War. He left Mainz and spent his last years in Frankfurt and then Halle.

ALBRECHT DÜRER. Studious, analytical, observant, and meticulous—and as self-confident as Michelangelo—

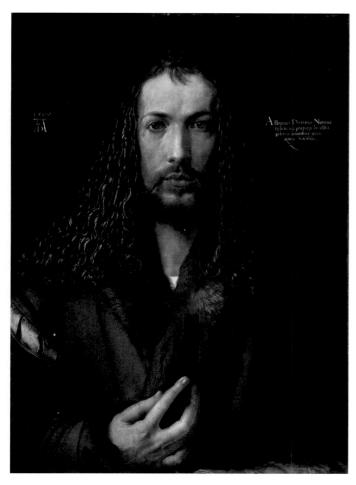

16–7 | Albrecht Dürer SELF-PORTRAIT 1500. Signed "Albrecht Dürer of Nuremberg...age 28." Oil on wood panel, $26\%\times19\%$ " (66.3 \times 49 cm). Alte Pinakothek, Munich.

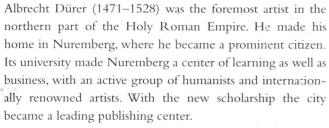

Dürer's father was a goldsmith and must have expected his son to follow in his trade. Dürer did complete an apprentice-ship in goldworking, as well as in stained-glass design, painting, and the making of woodcuts, but it was ultimately as a painter and graphic artist that he found his artistic fame (see "German Metalwork: A Collaborative Venture," facing page).

In 1490, Dürer began traveling to extend his education. He went to Basel, Switzerland, hoping to meet Martin Schongauer, but arrived after the master's death. Dürer remained in Basel until 1494, providing drawings for woodcut illustrations for books. His first trip to Italy (1494–95) introduced him to Italian Renaissance ideas and attitudes and, as we considered at the beginning of this chapter, to the concept of the artist as an inde-

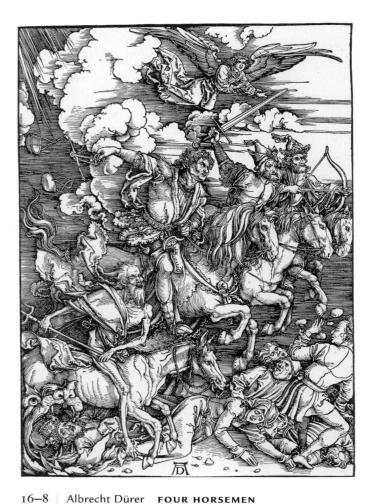

OF THE APOCALYPSE
From The Apocalypse. 497–98. Woodcut, 15½ × 11½"
(39.4 × 28.3 cm). The Metropolitan Museum of Art, New York.
Gift of Junius S. Morgan, 1919 (19.73.209)

pendent creative genius. In the **SELF-PORTRAIT** of 1500 (FIG. 16–7), Dürer represents himself as an idealized, almost Christlike, figure in a severely frontal pose, like an icon. He stares directly at the viewer. His rich fur-lined robes and flowing locks create an equilateral triangle, the timeless symbol of unity.

On his return to Nuremberg, Dürer began to publish his own prints to bolster his income, and ultimately the prints, not his paintings, made his fortune. His first major publication, *The Apocalypse*, appeared simultaneously in German and Latin editions in 1497–98. It consisted of a woodcut title page and fourteen full-page illustrations with the text printed on the back of each. The best-known of the woodcuts is the **FOUR HORSE-MEN OF THE APOCALYPSE** (FIG. 16–8), based on figures described in Revelation 6:1–8: a crowned rider, armed with a bow, on a white horse (Conquest); a rider with a sword, on a red horse (War); a rider with a set of scales, on a black horse (Plague and Famine); and a rider on a sickly pale horse (Death). Earlier artists had simply lined up the horsemen in the land-scape. Dürer created a compact overlapping group of wild riders charging across the land and trampling the cowering men.

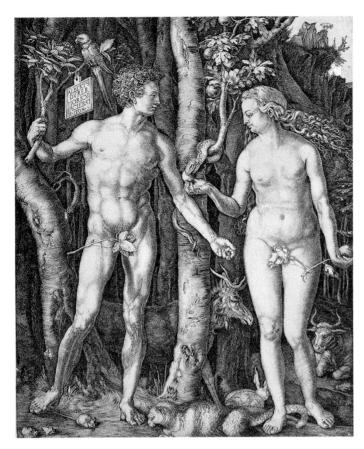

16–9 | Albrecht Dürer **ADAM AND EVE** 1504. Engraving, $9\% \times 7\%$ " (25.1 \times 19.4 cm). Philadelphia Museum of Art.

Dürer probably did not cut his own woodblocks but employed a skilled carver who followed his drawings faithfully. Dürer's dynamic figures show affinities with Schongauer's *Temptation of Saint Anthony* (SEE FIG. 13–30). He adapted Schongauer's metal engraving technique to the woodcut medium, using a complex pattern of lines to model the forms. Dürer's early training as a goldsmith is evident in his meticulous attention to detail, and in his decorative cloud and drapery patterns. He fills the foreground with large, active figures just as late

fifteenth-century artists had done.

Perhaps as early as the summer of 1494, Dürer began to experiment with engravings, cutting the metal plates himself with artistry equal to Schongauer's. His growing interest in Italian art and his theoretical investigations are reflected in his 1504 engraving ADAM AND EVE (FIG. 16–9), which represents his first documented use of ideal human proportions based on Roman copies of ancient Greek sculpture. He may have seen figures of Apollo and Venus in Italy, and he would have known ancient sculpture from contemporary prints and drawings. But behind his idealized human figures he represents plants and animals with typically northern European naturalistic detail.

Dürer embedded the landscape with symbolic content reflecting the medieval theory that after Adam and Eve disobeyed God, they and their descendants became vulnerable to imbalances in the body fluids that controlled human temperament. As we saw in Melencolia I (FIG. 15-1), an excess of black bile from the liver produced melancholy, despair, and greed. Yellow bile caused anger, pride, and impatience; phlegm in the lungs resulted in lethargy and disinterest; and an excess of blood made a person unusually optimistic but also compulsively interested in pleasures of the flesh. These four human temperaments, or personalities, are symbolized here by the melancholy elk, the choleric cat, the phlegmatic ox, and the sensual rabbit. The mouse is a symbol of Satan (see the mousetrap in FIG. 13-2), whose earthly power, already manifest in the Garden of Eden, was capable of bringing perfect human beings to a life of woe through their own bad choices. The parrot may symbolize false wisdom, since it can only repeat mindlessly what it hears. Dürer's pride in his engraving can be seen in the prominence of his signature—a placard bearing his full name and date hung on a branch of the tree of life.

Dürer's familiarity with Italian art was greatly enhanced by a second, leisurely trip over the Alps in 1505–06. Thereafter, he seems to have resolved to reform the art of his own country by publishing theoretical writings and manuals that discussed Renaissance problems of perspective, ideal human proportions, and the techniques of painting. Between 1513 and 1515, Dürer used images, not words, to define a philosophy of Christian life. He created what are known today as his master prints—three engravings having profound themes, but also demonstrating his skill as a graphic artist who could imply color, texture, and space by black lines alone.

Dürer admired Martin Luther, but they never met. In 1526, the artist openly professed his Lutheranism in a pair of inscribed panels, the FOUR APOSTLES (FIG. 16-10). On the left panel, the elderly Peter, who normally has a central position as the first pope, has been displaced by Luther's favorite evangelist, John, who holds an open Gospel that reads "In the beginning was the Word," reinforcing the Protestant emphasis on the Bible. On the right panel, Mark stands behind Paul, whose teachings and epistles were particularly admired by the Protestants. A long inscription on the frame warns the viewer not to be led astray by "false prophets" but to heed the words of the New Testament as recorded by these "four excellent men." Below each figure are excerpts from their letters and from the Gospel of Mark warning against those who do not understand the true word of God. In the inscriptions, Dürer used Luther's German translation of the New Testament. The paintings were surely meant to demonstrate that a Protestant art was possible.

Dürer presented the panels to the city of Nuremberg, which had already adopted Lutheranism as its official religion. Dürer wrote, "For a Christian would no more be led to superstition by a picture or effigy than an honest man to commit murder because he carries a weapon by his side. He must

indeed be an unthinking man who would worship picture, wood, or stone. A picture therefore brings more good than harm, when it is honourably, artistically, and well made" (cited in Snyder, 2nd ed., page 333).

LUCAS CRANACH THE ELDER. One of Dürer's friends, and Martin Luther's favorite painter, Lucas Cranach the Elder (1472–1553), had moved his workshop to Wittenberg in 1504, after a number of years in Vienna. In addition to the humanist milieu of its university and library, Wittenberg offered the patronage of the Saxon court. Appointed court painter to Elector Frederick the Wise, Cranach created woodcuts, altarpieces, and many portraits.

At the humanistic court Cranach met Italian artists who evidently inspired him to paint female nudes himself. Just how far the German artist's style and conception of the figure differ from Italian Renaissance idealism is easily seen in his NYMPH OF THE SPRING, a painting that characterizes the Renaissance in the north (FIG. 16–11; compare Titian's Venus of Urkino, FIG. 15–26). The sleeping nymph was a Renaissance theme, not an ancient one. Cranach was inspired by a fifteenth-century inscription on a fountain beside the Danube. Translated from the Latin, the text reads, "I am the nymph of the sacred font. Do not interrupt my sleep for I am at peace." Cranach records the Danube landscape with northern fidelity and turns his nymph into a highly provocative young woman, who glances

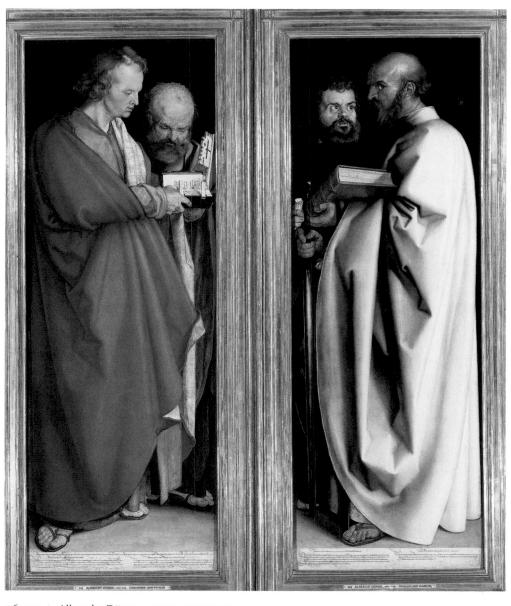

16–10 | Albrecht Dürer FOUR APOSTLES 1526. Oil on wood panel, each panel $7'\%'' \times 2'6''$ (2.15 \times 0.76 m). Alte Pinakothek, Munich.

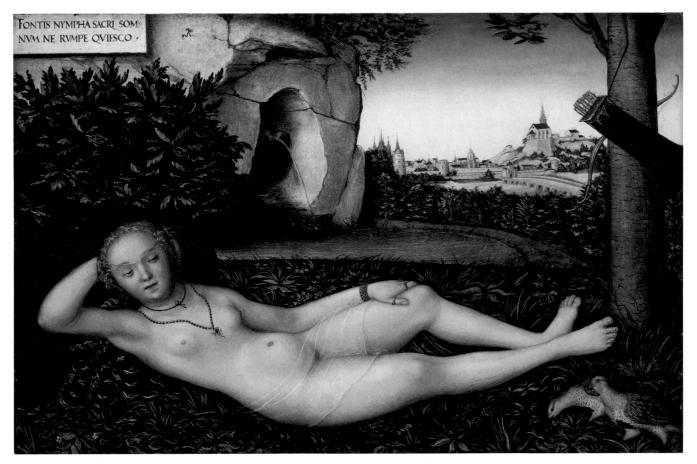

16–11 Lucas Cranach the Elder **NYMPH OF THE SPRING** c. 1537. Oil on panel, $19 \times 28 \%$ " (48.5 \times 72.9 cm). National Gallery of Art, Washington, D.C.

In 1537 Cranach adopted as his device a dragon with folded wings, seen on the rock above the fountain.

slyly out at the viewer through half-closed eyes. She has cast aside a fashionable red velvet gown, but still wears her jewelry, which together with her transparent veil enhances rather than conceals her nudity. Unlike other artists working for Protestant patrons, many of whom looked on earthly beauty as a sinful vanity, Cranach seems delighted by earthly things—the lush foliage that provides the nymph's couch, the pair of partridges (symbols of Venus and married love), and Cupid's bow and quiver of arrows hanging on the tree. The *Nymph of the Spring* seems to depict a beauty from the Wittenburg court rather than a follower of the classical Venus.

ALBRECHT ALTDORFER. Landscape, with or without figures, became a popular theme in the sixteenth century. In the fifteenth century, northern artists had examined and recorded nature with the care and enthusiasm of biologists, but they painted their landscapes as backgrounds for figural compositions, usually with religious themes. In the 1520s, however, religious art found little favor among Protestants. Landscape painting, on the other hand, had no overt religious imagery, although

it could be seen as a reflection or even glorification of God's works on earth. The most accomplished German landscape painter of the period was Albrecht Altdorfer (c. 1480–1538).

Altdorfer probably received his early training in Bavaria from his father; he then became a citizen in 1505 of the city of Regensburg in the Danube River valley. He remained there painting the Danube Valley for the rest of his life. The DANUBE LANDSCAPE of about 1525 (FIG. 16-12) is an early example of pure landscape painting—one without a narrative subject or human figures, and with no religious significance. A small work on vellum laid down on a wood panel, the landscape seems to be a minutely detailed view of the natural terrain, but the forest seems far more poetic and mysterious than Dürer's or Cranach's carefully observed views of nature. The low mountains, gigantic lacy pines, neatly contoured shrubberies, and fairyland castle with red-roofed towers at the end of a winding path announce a new sensibility. The eerily glowing yellowwhite horizon below moving gray and blue clouds in a sky that takes up more than half the composition foretell the Romanticism that will characterize later German landscape painting.

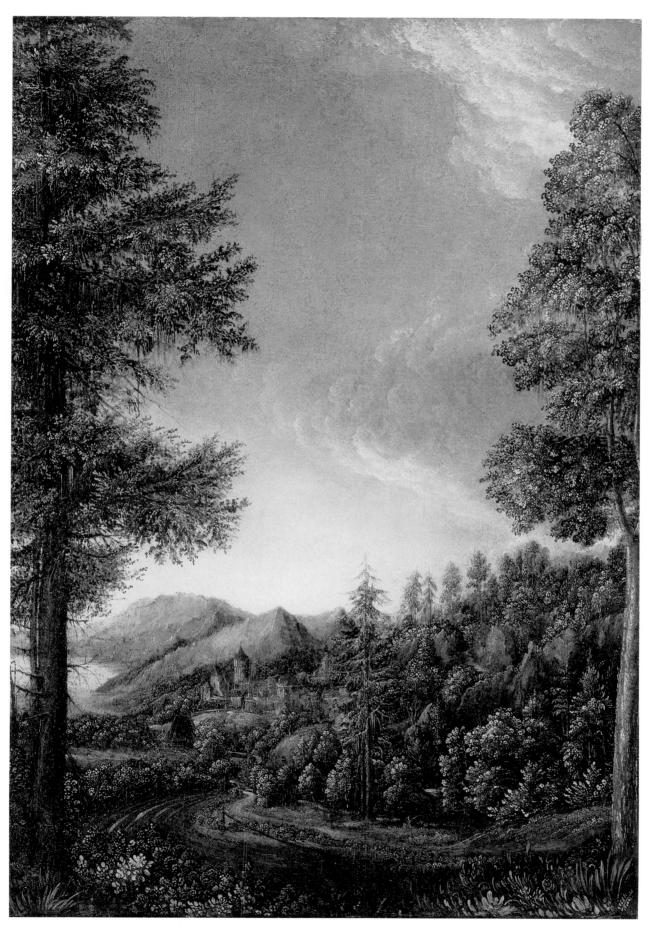

16–12 | Albrecht Altdorfer **DANUBE LANDSCAPE** c. 1525. Oil on vellum on wood panel, $12 \times 8\frac{1}{2}$ " (30.5 \times 22.2 cm). Alte Pinakothek, Munich.

RENAISSANCE ART IN FRANCE

France in the early sixteenth century took a different road than did Germany. Pope Leo X came to an agreement with the French king Francis I (ruled 1515–47) in 1519 that spared the country the turmoil suffered in Germany. Furthermore, whereas Martin Luther had devoted followers among the political leaders as well as the people, the French reformer John Calvin (1509–64) fled to Switzerland in 1534, where he led a theocratic state in Geneva. Nevertheless, wars of religion between political factions favoring either Catholics or Huguenots (Protestants), who each wished to exert power over the French crown, also devastated France in the second half of the century.

In 1560, the devoutly Catholic Catherine de' Medici, widow of Henry II (ruled 1547–59), became regent for her young son, Charles IX. She tried, but failed, to balance the warring factions, and her machinations ended in religious polarization and a bloody conflict that began in 1562. Her successor and third son Henry III (ruled 1574–89) was murdered by a fanatical Dominican friar, and his Protestant cousin, Henry, king of Navarre, the first Bourbon king, inherited the throne. Henry converted to Catholicism and ruled as Henry IV. Backed by a country sick of bloodshed, he quickly settled the religious question by granting toleration to Protestants in the Edict of Nantes in 1598.

The Introduction of Italian Art

The greatest French patron of Italian artists was King Francis I. Immediately after his ascent to the throne, Francis showed his desire to "modernize" the French court by acquiring the versatile talents of Leonardo da Vinci. Leonardo moved to France in 1516, officially to advise the king on royal architectural projects and, the king said, for the pleasure of his conversation. Francis continued to support the arts throughout his reign despite the distraction of continual wars against his brother–in-law, Emperor Charles V. Under his patronage, an Italian–inspired Renaissance blossomed in France.

JEAN CLOUET. The Flemish artist Jean Clouet (c. 1485–c. 1540) found great favor as the royal portrait painter. Clouet was in France as early as 1509, and in 1527 he moved to Paris as principal court painter. In his official portrait of the king (FIG. 16–13), Clouet created a flattering image by modeling Francis's distinctive features with subtle shading, a technique that may have been partially inspired by exposure to the work of Leonardo. At the same time he created an image of pure power. The depiction of the king's thick neck and huge body seems at odds with the nervous movement of his fingers. Elaborate, puffy sleeves broadened his shoulders to more than fill the panel, much as parade armor turned scrawny men into giants. The delicately worked costume of silk, satin, velvet, jewels, and gold embroidery could be painted separately from

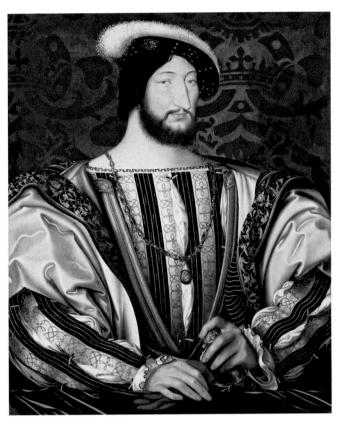

16–13 | Jean Clouet FRANCIS I 1525–30. Oil and tempera on wood panel, $37\frac{1}{4} \times 29\frac{1}{8}$ " (95.9 × 74 cm). Musée du Louvre, Paris.

the portrait itself. The clothing was often loaned to the artist or modeled by a servant to spare the "sitter" the boredom of posing. In creating such official portraits, the artist sketched the subject, then painted a prototype that, upon approval, was the model for numerous replicas made for diplomatic and family purposes.

THE CHÂTEAU OF CHENONCEAU. With the enthusiasm of Francis for things Italian and the widening distribution of Italian books on architecture, the Italian Renaissance style soon appeared in French architecture. Builders of elegant rural palaces, called châteaux, were quick to introduce Italianate decoration to otherwise Gothic buildings, but French architects soon adapted classical principles of building design as well.

One of the most beautiful of these Renaissance palaces was not built as a royal residence, although it soon became one. In 1512 Thomas Bohier, a royal tax collector, bought the castle of Chenonceau on the River Cher, a tributary of the Loire River (FIG. 16–14). He demolished the old castle, leaving only a tower. Using the piers of a water mill on the river bank as part of the foundations, he and his wife erected a new Renaissance home. The plan reflects the classical principles of geometric

regularity and symmetry—a rectangular building with rooms arranged on each side of a wide central hall. Only the library and chapel, which are corbelled out over the water, break the line of the walls. In the upper story, the builders used traditional features of medieval castles—battlements, corner turrets, steep roofs, and dormer windows. The château was finished in 1521. When the owners died soon after, their son gave the château to the king, who turned it into a hunting lodge (see "Chenonceau: The Castle of the Ladies," p. 592).

Later, the foremost French Renaissance architect, the Roman-trained Philibert de l'Orme (d. 1570), designed a gallery on a bridge across the river for Catherine de' Medici. The extension was completed about 1581 and incorporated contemporary Italianate window treatments, wall molding, and cornices that harmonized almost perfectly with the forms of the original turreted building. Chenonceau remains today one of the most important—and beautiful—examples of classical influence on French Renaissance architecture.

FONTAINEBLEAU. Francis I also began renovating royal properties. Having chosen as his primary residence the medieval hunting lodge at Fontainebleau, Francis began transforming it into a grand palace. Most of the exterior structure was altered or destroyed by later renovations, but parts of the interior decoration, the work of artists and artisans from Italy, have been preserved and restored. The first artistic director at

Sequencing Events KEY EVENTS IN THE PROTESTANT REFORMATION

1517	Martin Luther propounds his Ninety- Five Theses at Wittenberg.
1534	Henry VIII of England breaks from Rome; founds Church of England.
1555	Lutheranism recognized in Germany by the Holy Roman Emperor at the Peace of Augsburg.

Fontainebleau, the Mannerist painter Rosso Fiorentino (d. 1540), arrived in 1530. Francesco Primaticcio (1504–70), who had worked with Giulio Romano in Mantua (SEE FIG. 15–19), joined Rosso in 1532 and succeeded him in 1540. Primaticcio worked on the decoration of Fontainebleau from 1532 until his death in 1570. During that time, he also commissioned and imported a large number of copies and casts of criginal Roman sculpture, from the newly discovered *Laocoön* (see Introduction, Fig. 10) to the relief decoration on the Column of Trajan. These works provided an invaluable visual source of figures and techniques for the northern European artists employed on the Fontainebleau project.

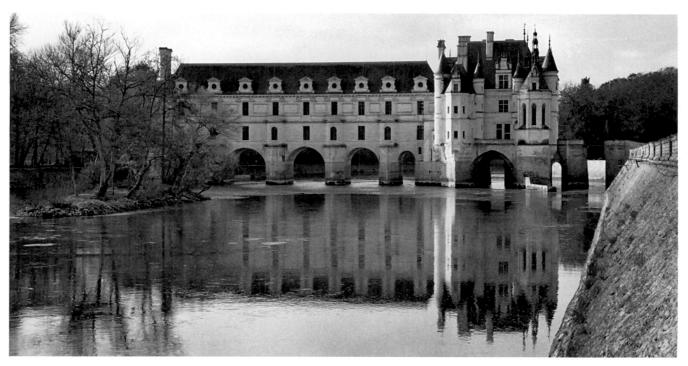

16–14 ↑ **château of Chenonceau**Touraine, France. 1513–21; gallery on bridge, finished c. 1581.

Art and Its Context

CHENONCEAU: THE CASTLE OF THE LADIES

omen played an important role in the patronage of the arts during the Renaissance. Nowhere is their influence stronger than in the castle-palaces (châteaux) built in the Loire River valley. At Chenonceau, built beside and literally over the River Cher, a tributary of the Loire, women built, saved, and restored the château. Catherine Briconnet and her husband Thomas Bohier originally acquired the property, including a fortified mill, on which they built their country residence. Catherine supervised the construction, which included such modern conveniences as a straight staircase (an Italian and Spanish feature) instead of traditional medieval spiral stairs, and a kitchen inside the château instead of in a distant outbuilding. When Thomas died in 1524 and Catherine in 1526, their son gave Chenonceau to King Francis I.

King Henry II, Francis's son, gave Chenonceau to his mistress Diane de Poitiers in 1547. She managed the estate astutely, increased revenue, developed the vineyards, added intricately planted gardens in the Italian style, and built a bridge across the Cher. When Henry died in a tournament, the queen Catherine de' Medici (1519–89) appropriated the château for herself.

Catherine, like so many of her family a great patron of the arts, added the two-story gallery to the bridge at Chenonceau, as well as outbuildings and additional formal gardens. Her parties were famous—mock naval battles on the river, fireworks, banquets, dances, and on one occasion two choruses of young women dressed as mermaids in the moat and nymphs in the shrubbery—who were then chased about by young men costumed as satyrs! When Catherine's third son became king as Henry III in 1574, she gave Chenonceau to his wife, Louise of Lorraine.

Louise of Lorraine lived in mourning at Chenonceau after Henry III was assassinated in 1589. She wore only white and covered the walls, windows, and furniture in her room with black velvet and damask. She gave Chenonceau to her niece when she died.

In the eighteenth and nineteenth centuries the ladies continued to determine the fate of Chenonceau. During the French Revolution (1789-93) the owner, Madame Dupin, was so beloved by the villagers that they protected her and saved her home. Then in 1864 Madame Pelouze bought Chenonceau and restored it by removing Catherine de' Medici's Italian "improvements."

Chenonceau continued to play a role in the twentieth century. During World War I it was used as a hospital. During the German occupation in World War II (1940-42), when the River Cher formed the border with Vichy "Free" France, the gallery bridge at Chenonceau became an escape route. In 2000 the Valley of the Loire and its châteaux became a UNESCO World Heritage site.

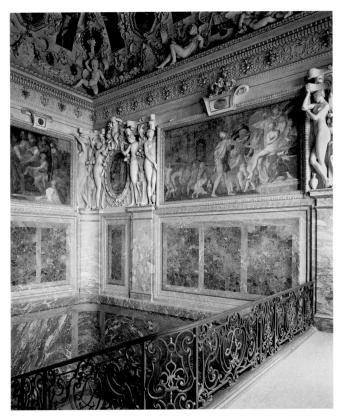

16–15 | Primaticcio STUCCO AND WALL PAINTING, CHAMBER OF THE DUCHESS OF ÉTAMPES, CHÂTEAU OF FONTAINEBLEAU

France. 1540s.

Following ancient tradition, the king maintained an official mistress—Anne, the duchess of Étampes, who lived at Fontainebleau. Among Primaticcio's first projects was the redecoration of Anne's rooms (FIG. 16–15). The artist combined woodwork, stucco relief, and fresco painting in his complex but lighthearted and graceful interior design. The lithe figures of stucco nymphs, with their long necks and small heads, recall Parmigianino's paintings (see fig. 15–35). Their spiraling postures are playfully sexual. The wall surface is almost overwhelmed with garlands, mythological figures, and Roman architectural ornament, yet the visual effect is extraordinarily confident and joyous. The first School of Fontainebleau, as this Italian phase of the palace decoration is called, established a tradition of Mannerism in painting and interior design that spread to other centers in France and into the Netherlands.

Art in the Capital

Before the defeat of King Francis I at Pavia by the Holy Roman Emperor Charles V, and the king's subsequent imprisonment in Spain in 1525, the French court was a mobile unit, and the locus of French art resided outside of Paris in the Loire valley. After 1525, Francis made Paris his bureaucratic seat; and the capital and region around it—the Île de France—took the artistic lead with an attendant shift in style.

16–16 | Pierre Lescot WEST WING OF THE COUR CARRÉ, PALAIS DU LOUVRE Paris. Begun 1546.

RENOVATING THE LOUVRE. Paris saw the birth of a French classical style when the kings Francis I and Henry II decided to modernize the medieval castle of the Louvre. The work began in 1546, with the replacement of the west wing of the square court, the cour carré (FIG. 16-16), by the architect Pierre Lescot (c. 1510-78). Working with the sculptor Jean Goujon (1510-68), Lescot designed a building incorporating Renaissance ideals of balance and regularity with classical architectural details and rich sculptural decoration. The irregular roof lines of a château, such as at Chenonceau, gave way to discreetly rounded arches and horizontal balustrades. Classical pilasters and entablatures replaced Gothic buttresses and stringcourses. Pediments topped a round-arched arcade on the ground floor, suggesting an Italian loggia. The sumptuous decoration recalls the French medieval Flamboyant style, but with classical pilasters and acanthus replacing Gothic colonnettes and cusps.

FRENCH GARDENS AND GROTTOS. Gardens played an important role in architectural designs, usually intended to be viewed from the owners' rooms on the principal (second) floor. Elaborate flower beds bordered with clipped evergreen yews were planted in generally symmetrical patterns. Long avenues enlivened by sculpture and sculptured fountains led to witty surprises such as trick waterworks and grottos. One of the most brilliant must have been the grotto created by Bernard Palissy for the Tuileries Palace facing the Louvre.

Bernard Palissy (1510–90) created a false earthenware grotto made of glazed ceramic rocks and shells, to which he added crumbling statues, a cat stalking birds, ferns, garlands of fruits and vegetation, fish and crayfish seeming to swim in the pool, and reptiles slithering or creeping over mossy rocks—all of which glistened with water and surely achieved Alberti's

16–17 | Attributed to Bernard Palissy

OVAL PLATE IN "STYLE RUSTIQUE"

1570-80/90 (?). Polychromed tin and glazed earthenware, length 20/2" (52 cm). Musée du Louvre, Paris.

ideal Slime (see "The Grotto," page 547). Reportedly, he made all the figures from casts of actual animals and plants. In 1563, Palissy had been appointed the court's "inventor of rustic figurines." A Protestant, he was repeatedly arrested during periods of persecution, and he died in prison. Although his Tuileries grotto was destroyed, we can imagine its appearance from the distinctive ceramic designs attributed to him (FIG. 16–17). Platters decorated in high relief with plants, reptiles, and insects resemble descriptions of the grotto. Existing examples are best called "Palissy-style" works, because their authenticity is nearly impossible to prove.

THE OBJECT SPEAKS

SCULPTURE FOR THE KNIGHTS OF CHRIST AT TOMAR

ne of the strangest-and in its own way most beautifulsixteenth-century sculptures in Portugal seems to float over the cloisters of the Convent of Christ in Tomar. Unexpectedly, in the heart of the castlemonastery complex, one comes face to face with the Old Man of the Sea. He supports on his powerful shoulders an extraordinary growth-part roots and trunk of a gnarled tree, part tangled mass of seaweed, algae, ropes, and anchor chains. Barnacle- and coral-encrusted piers lead the eye upward, revealing a large lattice-covered window, the great west window of the Church of the Knights

When in 1314 Pope Clement V disbanded the Templars (a monastic order of knights founded in Jerusalem in 1118 after the First Crusade), King Dinis of Portugal offered them a renewed existence as the Knights of Christ. In 1356, they made the former Templar castle and monastery in Tomar their headquarters. When Prince Henry the Navigator (1394–1460) became the Grand Master of the Order, he invested their funds in the exploration of the African coast and the Atlantic Ocean. The Templar insignia, the squared cross, became the emblem used on the sails of Portuguese ships.

King Manuel I of Portugal (ruled 1495-1521) commissioned the present church, with its amazing sculpture from Diogo de Arruda, in 1510. It reflects the wealth and power of sixteenth-century Portugal and the Knights of Christ. So distinctive is the style developed under King Manuel by artists like the Arruda brothers, Diogo (active 1508-31) and Francisco (active 1510-47), that Renaissance art in Portugal is called "Manueline." Architecture became more and more sculptural; piers and columns were carved to resemble twisted ropes; vaulting ribs multiplied into treelike branches. In the window of Tomar, Manueline sculpture reached the pinnacle of

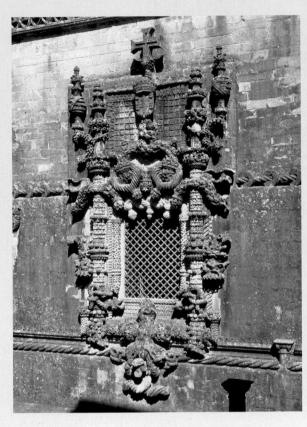

Diogo de Arruda
WEST WINDOW,
CHURCH IN THE CONVENT
OF CHRIST
Tomar, Portugal. c. 1510.
Commissioned by
King Manuel I of Portugal.

complexity. Every surface is carved with architectural and natural detail associated with the sea. Twisted ropes form the corners of the window; the coral pillars support great swathes of seaweed. Chains and cables drop through the watery depths to the place where the head of a man-some see him as the Old Man of the Sea; others see a self-portrait of Diogo de Arruda-emerges from the roots of a tree. Trees with generations of ancestors seated in their branches became an important theme in Portuguese art. Here, the idea of a male figure as the foundation block recalls the biblical Tree of Jesse.

Above the window more ropes, cables, and seaweed support the emblems of the patron—the armillary spheres and the coat of arms of Manuel I with its Portuguese castles framing the five wounds of Christ.

Topping the composition is the square cross of the Order of Christ—clearly delineated against the wall of the chapel.

The armillary sphere became a symbol of the era. This complex form of celestial globe, with the sun at the center surrounded by rings marking the paths of the planets, acknowledges the new scientific theory that the sun, not the earth, is the center of the solar system. (Copernicus, teaching in Germany at this time, only published his theories in 1531 and 1543.) Although the armillary sphere had no practical value in navigation, it was a teaching device, a way to demonstrate and learn astronomy. King Manuel's continued use of the armillary sphere as his emblem indicates his determination to make Portugal the leader in the exploration of the sea. Indeed, in Manuel's reign the Portuguese reached India and Brazil.

RENAISSANCE ART IN SPAIN AND PORTUGAL

The sixteenth century saw the high point of Spanish political power. The country had been united in the fifteenth century by the marriage of Isabella of Castile and Ferdinand of Aragon. Only Navarre (in the Pyrenees) and Portugal remained outside the union of the crowns (see "Sculpture for the Knights of Christ at Tomar," facing page).

When Isabella and Ferdinand's grandson Charles V abdicated in 1556, his son Philip II (1556–98) became the king of Spain, the Netherlands, and the Americas, as well as ruler of Milan, Burgundy, and Naples. Philip made Spain his permanent residence. From an early age, Philip was a serious art collector, and for more than half a century, he supported artists in Spain, Italy, and the Netherlands. His navy, the famous Spanish Armada, halted the advance of Islam in the Mediterranean and secured control of most American territories. Despite enormous effort and wealth, however, Philip could not suppress the revolt of the northern provinces of the Netherlands, nor could he prevail in his war against the English, who destroyed his navy in 1588. He was able to gain control of the entire Iberian Peninsula, however, by claiming Portugal when the king died in 1580. Portugal remained part of Spain until 1640.

Architecture

Philip built **EL ESCORIAL** (FIG. 16–18), the great monastery-palace complex outside Madrid, partly to comply with his father's direction to construct a "pantheon" in which all Spanish kings might be buried and partly to house his court and government. To build the palace, in 1559 Philip summoned from Italy Juan Bautista de Toledo (d. 1567), who had been Michelangelo's

supervisor of work at Saint Peter's from 1546 to 1548. Juan Bautista's design reflected his indoctrination in Bramante's classical principles in Rome, but the king himself dictated the severity and size of the structure. El Escorial's grandeur comes from its overwhelming size, fine proportions, and excellent masonry. The complex includes not only the royal residence but also the Royal Monastery of San Lorenzo, a school, a library, and a church, its crypt serving as the royal burial chamber. The plan was said to resemble a gridiron, the instrument of martyrdom of its patron saint, Lawrence, who was roasted alive.

In 1572, Juan Bautista's assistant, Juan de Herrera, was appointed architect, and he immediately changed the design, adding second stories on all wings and breaking the horizontality of the main façade with a central frontispiece that resembled superimposed temple fronts. Before beginning the church in the center of the complex, Philip solicited the advice of Italian architects—including Vignola and Palladio (see p. 561 and p. 573). The final design combined ideas that Philip approved and Herrera carried out. Although not a replica of any Italian design, the building embodies Italian classicism in its geometric clarity and symmetry and the use of superimposed orders on the temple-front façade. In its sober and severe character, however, it embodies the austere and deeply religious spirit of the Spanish Philip II.

Painting

The arts continued to be sponsored by the Church and the nobles. Pageantry—including the sign language of heraldry, luxurious armor, and textiles—answered the aesthetic desires of the patrons. Philip II was a great patron of the Venetian painter Titian, and he collected Netherlandish artists such as Bosch (see page 598).

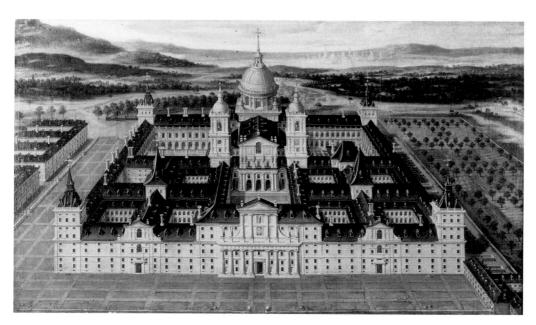

16–18 | Juan Bautista de Toledo and Juan de Herrera EL ESCORIAL Madrid. 1563–84. Detail from an anonymous 18thcentury painting.

EL GRECO. Today the most famous Spanish painter from the last quarter of the sixteenth century is Domenikos Theotokopoulos (1541-1614), who arrived in Spain in 1577 after working for ten years in Italy. "El Greco" ("The Greek"), as he is called, was trained as an icon painter in the Byzantine manner in his native Crete, then under Venetian rule. In about 1566, he went to Venice and entered Titian's studio, where he also studied the paintings of Tintoretto and Veronese. From about 1570 to 1577, he worked in Rome, apparently without finding sufficient patronage, although he lived for a time in the Farnese Palace. Probably encouraged by Spanish Church officials whom he met in Rome, El Greco settled in Toledo, Spain, the seat of the archbishop. He had apparently hoped for a court appointment, but Philip II disliked the painting he had commissioned from El Greco for El Escorial and never gave him work again.

In Toledo, El Greco joined the circle of humanist scholars. His annotations in his own copies of Vitruvius and Vasari demonstrate his concern with the issues of the day. He wrote that the artist's goal should be to copy nature, that Raphael relied too heavily on the ancients, and that the Italians' use of mathematics to achieve ideal proportions hindered their painting of nature. At the same time an intense religious revival was under way in Spain, expressed in the impassioned preaching of Ignatius of Loyola, as well as in the poetry of the two great Spanish mystics: Saint Teresa of Ávila (1515-82), founder of the Discalced ("unshod") Carmelites, and her follower Saint John of the Cross (1542-91). El Greco's style-rooted in Byzantine icon painting and strongly reflecting Venetian artists' rich colors and loose brushwork-expressed in paint the intense spirituality of these mystics.

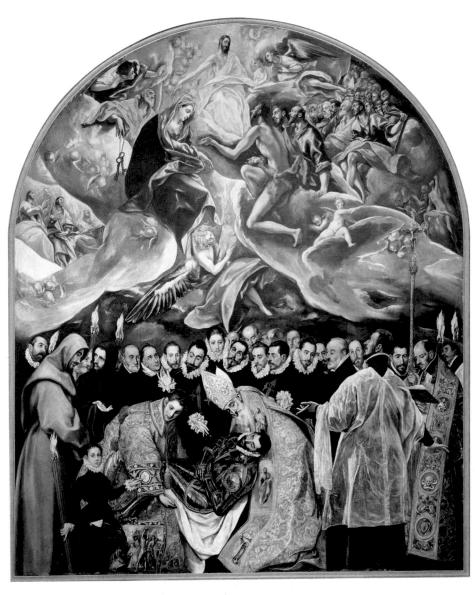

16–19 El Greco BURIAL OF COUNT ORGAZ 1586. Oil on canvas, 16' × 11'10" (4.88 × 3.61 m). Church of Santo Tomé, Toledo, Spain.

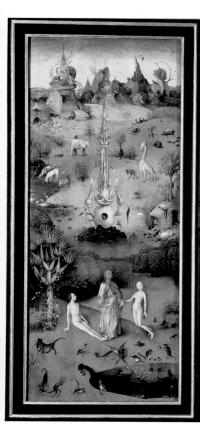

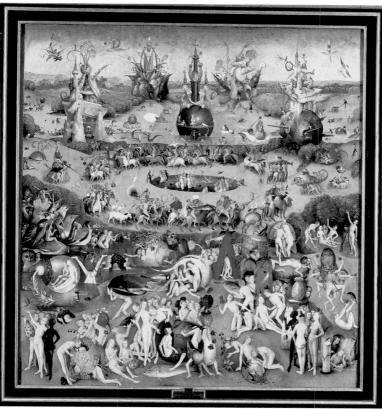

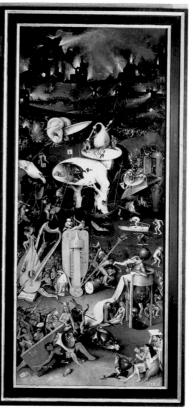

16–21 | Hieronymus Bosch GARDEN OF EARTHLY DELIGHTS c. 1505–15. Oil on wood panel, center panel $7'2\frac{1}{2}''\times6'4\frac{1}{4}''$ (2.20 \times 1.95 m), each wing $7'2\frac{1}{2}''\times3'2''$ (2.20 \times 0.97 m). Museo del Prado, Madrid.

world of fire and ice. A creature with stump legs balanced unsteadily on rowboats watches his own stomach, filled with lost souls in the proverbial "tavern on the road to hell."

One scholar has proposed that the central panel is a parable on human salvation in which the practice of alchemy—the process that sought to turn common metals into gold—parallels Christ's power to convert human dross into spiritual gold. In this theory, the bizarre fountain at the center of the lake in the middle distance can be seen as an alchemical "marrying chamber," complete with the glass vessels for collecting the vapors of distillation. Others see the theme known as "the power of women." In this interpretation the central pool is the setting for a display of seductive women and sex-obsessed men. Women frolic alluringly in the pool while men dance and ride in a mad circle trying to attract them. In this strange garden, men are slaves to their own lust. Yet another critic focused on the fruit, writing (c. 1600) that the triptych was known as The Strawberry Plant because it represented the "vanity and glory and the passing taste of strawberries or the strawberry plant and its pleasant odor that is hardly remembered once it has passed." Luscious fruits having sexual symbolism—strawberries, cherries, grapes, and pomegranates—appear everywhere in the

Garden, serving as food, as shelter, and even as a boat. Is human life as fleeting and insubstantial as the taste of a strawberry? Meaning clearly lies in the eye of the beholder of these very private paintings.

The Garden of Earthly Delights was commissioned by an aristocrat (probably Count Hendrick III of Nassau) for his Brussels town house, and the artist's choice of a triptych format, which suggests an altarpiece, may have been an understated irony. In a private home the painting may have inspired lively discussion and even ribald comment, much as it does today in its museum setting. Despite—or perhaps because of—its bizarre subject matter, the triptych was copied in 1566 into tapestry versions, one for a cardinal (now in the Escorial) and another for the French king Francis I. At least one painted copy was made as well. Bosch's original triptych was sold at the onset of the Netherlands revolt and sent in 1568 to Spain, where it entered the collection of Philip II.

JAN GOSSAERT. In contrast to the private visions of Bosch, Jan Gossaert (c. 1478–c. 1533) took a conservative line in subject matter and also embraced the new classical art of Italy. Gossaert (who later called himself "Mabuse" after his native

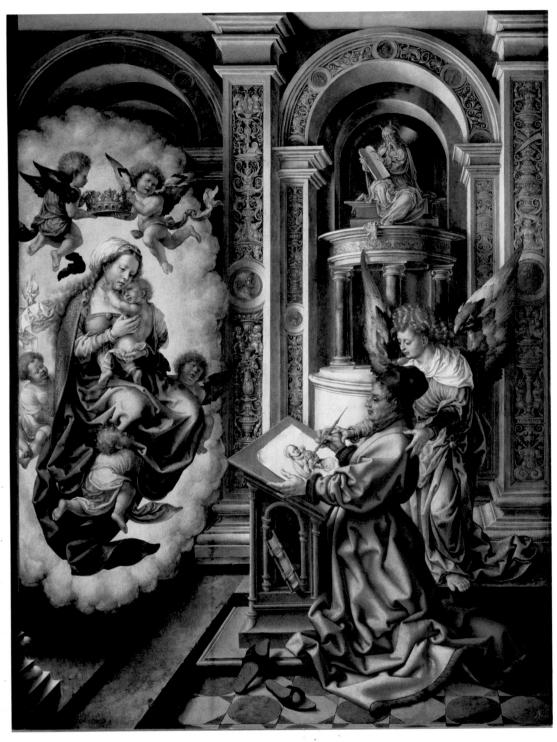

16–22 | Jan Gossaert SAINT LUKE PAINTING THE VIRGIN MARY 1520. Oil on panel, $43\% \times 32\%''$ (110.2 \times 81.9 cm). Kunsthistorisches Museum, Vienna.

city Maubeuge) entered the service of Philip, the illegitimate son of the Duke of Burgundy. In 1508 he traveled to Italy with Philip, and on their return Gossaert continued to work for Philip—who became archbishop of Utrecht in 1517.

After a period when he had been influenced by Jan van Eyck, Gossaert settled into what has been called a "Romanizing" style, inspired by Italian Mannerist paintings with a strong interjection of decorative details based on ancient Roman art.

In **SAINT LUKE PAINTING THE VIRGIN MARY** (FIG. 16–22), the artist's studio is an extraordinary structure of barrel vaults and classical piers and arches, which are carved with a dense ornament of foliage and medallions. Mary and the Christ Child appear to Saint Luke in a vision of golden light and clouds. The saint kneels at a desk, drawing, his hand guided by an angel. Luke's crumpled red robe recalls fifteenth-century drapery conventions. Behind the saint, seated on a round, columnar

structure, Moses holds the tablets of the Law, having seen the burning bush (which, as with Mary's virginity, was not consumed) on Mount Sinai. Moses removed his shoes in the presence of God's manifestation and so has Saint Luke in the presence of his vision. In short, the artist is divinely inspired. Gossaert, like Dürer before him, emphasizes the divine inspiration of the artist.

Antwerp

In the sixteenth century the city of Antwerp was the commercial and artistic center of the southern Netherlands. Antwerp's deep port made it an international center of trade (it was one of the European centers for trade in spices), and it was the financial center of Europe. Painting, printmaking, and book production flourished in this environment, attracting artists and craftsmen from all over Europe. The demand for luxury goods (including art) fostered the birth of the art market, in which art was transformed into a commodity both for local and international consumption. In responding to this market, many artists became specialists in one area, such as portraiture or landscape. Eventually, art dealers emerged as middlemen, further shaping the nascent art market and the professions it includes.

Sequencing Works of Art THE CLASSICIZING INFLUENCE

1504	Albrecht Dürer, Adam and Eve
1520	Jan Gossaert, Saint Luke Painting the Virgin Mary
1546	Pierre Lescot, west wing of the Cour Carré, Louvre, Paris, begun
1563-84	Juar Bautista de Toledo and Juan de Herrera, El Escorial, Madrid, Spain
1591-97	Robert Smythson, Hardwick Hall, Shrewsbury, England

MARINUS VAN REYMERSWAELE. In contrast to Gossaert's inspired Saint Luke, Marinus van Reymerswaele from Zeeland (c. 1493–after 1567) painted "Everyman" going about his daily affairs. In his popular Antwerp workshop he produced secular panel paintings featuring such characters as the universally despised money-lenders and tax collectors. THE BANKER AND HIS WIFE (FIG. 16–23), painted in 1540, is

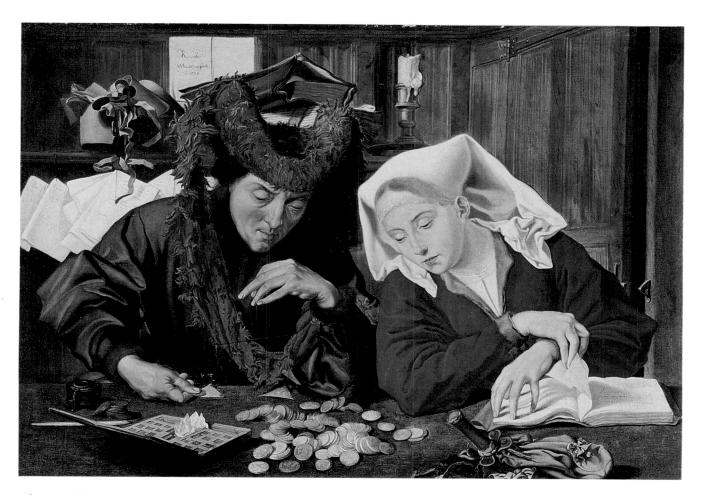

16–23 | Marinus van Reymerswaele | THE BANKER AND HIS WIFE 1540. Oil on panel, 33¾ × 45¾" (85.7 × 116.5 cm). Museo Nazionale del Bargello, Florence.

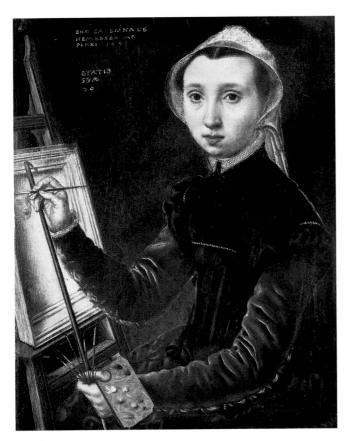

16–24 Caterina van Hemessen **SELF-PORTRAIT** 1548. Oil on wood panel, $12\frac{1}{4} \times 9\frac{1}{4}$ " (31.1 \times 23.5 cm). Öffentliche Kunstsammlung, Basel, Switzerland.

The panel on the easel already has its frame. Caterina holds a small palette and brushes and steadies her right hand with a mahlstick, an essential tool for an artist doing fine, detailed work.

almost a caricature of A Goldsmith (Saint Eligius?) in His Shop by Petrus Christus (SEE FIG. 13–18). In contrast to the pious saint, the banker greedily counts coins, avidly watched by his young wife, whose thin, clawlike fingers turn the pages of the account book. Two other popular themes emerge: "the power of women," a variation of "the world turned upside down," and the "mismatched couple"—the old man with a young wife. Virtuoso painting technique has been applied to a less-than-worthy subject, but the artist probably intended more than mere illustration. The painting recalls the sins of lust and greed—the folly of ill-matched lovers, and the sin caused by the love of money. The cluttered table and filled shelves suggest the emerging specialty of still-life painting—which, along with landscape painting, will become an important theme in the art of the next century.

CATERINA VAN HEMESSEN. As religious art declined in the face of Protestant disapproval, portraits became a major source of work for artists. Caterina van Hemessen (1528–87)

of Antwerp had an illustrious international reputation as a portraitist. She had learned to paint from her father, the Flemish Mannerist Jan Sanders van Hemessen, but her quiet realism and skilled rendering also had its roots in the Italian High Renaissance, whose ideas were brought back to the Netherlands by painters who had visited Italy. To maintain the focus on the foreground subject, van Hemessen painted her portraits against even, dark-colored backgrounds, on which she identified the sitter by name and age, signing and dating each work. The inscription in her **SELF-PORTRAIT** (FIG. 16–24) reads: "I Caterina van Hemessen painted myself in 1548. Her age 20." In delineating her own features, van Hemessen presented a serious young person without personal vanity yet seemingly already self-assured about her artistic abilities.

During her early career in Antwerp, van Hemessen became a favored court artist to Mary of Hungary, sister of Emperor Charles V and regent of the Netherlands, for whom she painted not only portraits but also religious works. In 1554, Caterina married the organist of Antwerp Cathedral, and when Mary ceased to be regent in 1556 (at the time of Charles's abdication), the couple accompanied Mary to Spain.

PIETER BRUEGEL THE ELDER. So popular did the works of Hieronymus Bosch remain that, nearly half a century after his death, Pieter Bruegel (c. 1525-69) began his career by imitating them. Fortunately, Bruegel's talents went far beyond those of an ordinary copyist. Like Bosch he often painted large narrative works crowded with figures, and he chose moralizing or satirical subject matter. He traveled throughout Italy, but, unlike many Renaissance artists, he did not record the ruins of ancient Rome or the wonders of the Italian cities. Instead, he seems to have been fascinated by the landscape, particularly the formidable jagged rocks and sweeping panoramic views of Alpine valleys, which he recorded in detailed drawings. Back home in his studio, he made an impressive leap of the imagination as he painted the flat and rolling lands of Flanders as broad panoramas, even adding imaginary mountains on the horizon (SEE FIG. 16–26).

In 1563, after his first career as a draftsman for the engravers in At the Four Winds publishing house, he moved to Brussels. Bruegel's style and subjects found great favor with local scholars, merchants, and bankers, who appreciated the beautifully painted, artfully composed works that also reflected contemporary social, political, and religious conditions. Bruegel visited country fairs to sketch the farmers and townspeople who became the focus of his paintings, whether religious or secular. He depicted characters not as unique individuals but as well-observed types, whose universality makes them familiar even today. Bruegel presented Flemish farmers vividly and sympathetically while also exposing their very human faults.

Clearly Bruegel knew the classics; he had been a member of the humanistic circles in Antwerp. He could only have

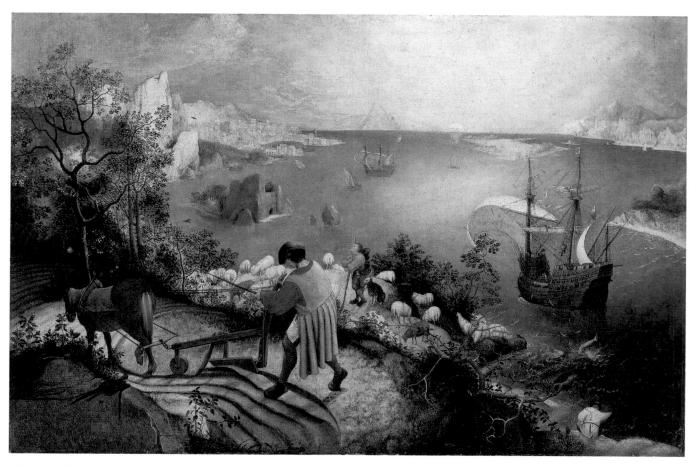

16–25 | Pieter Bruegel the Elder | THE FALL OF ICARUS c. 1555–56. Oil on panel transferred to canvas. $29 \times 44 \%$ (73.6 \times 112 cm). Konenklijke Musea voor Schone Kunsten van Belgie, Brussels.

painted **THE FALL OF ICARUS** (FIG. 16–25) after reading Ovid, so closely does he follow the ancient Roman's description of Icarus's fall. Icarus—thrilled by the experience and filled with exuberant self-confidence—ignored his father's warning and flew too near the sun, melting his wings of feathers and wax. As Ovid tells the story, in Book 8 of his *Metamorphoses*, no one noticed as the youth plunged into the sea—neither the fisherman, the shepherd, nor the plowman. Bruegel's painting of these workers indicates a very close observation of real people going about their normal activities. That he was as aware of local folklore as he was of the classics is demonstrated by his inclusion of a half-hidden corpse in the underbrush. A Flemish proverb says, "No plow stops at the death of any man."

But where is Icarus, the fallen hero? Amid rippling waves near the shore two tiny legs thrash madly as the boy plunges to his death. Man's great achievement—flight—and man's pride in accomplishment—and death because of this pride—all are irrelevant to the simple people whose goal is day-to-day survival in the continuous cycle of nature.

Bruegel was not only a great landscape painter, he could depict nature in all seasons and in all moods. His RETURN OF THE HUNTERS (FIG. 16–26) is one of a cycle of six panels, each representing two months of the year. In this December-January scene, Bruegel has captured the atmosphere of the damp, cold winter, with its early nightfall, in the same way that his compatriots the Limbourgs did 150 years earlier in the February calendar illustration (see fig. 13-6). At first, the Hunters appears neutral and realistic, but the sharp plunge into space, the juxtaposition of near and far without middle ground, is a typically sixteenth-century device. The viewer seems to hover with the birds slightly above the ground, looking down first on the busy foreground scene, then suddenly across the valley to the snow-covered village and frozen ponds. The main subjects of the painting, the hunters, have their backs turned and do not reveal their feelings as they slog through the snow, trailed by their dogs. They pass an inn, at the left, where a worker moves a table to receive a pig that others are singeing in a fire. But this is clearly not an accidental image; it is a slice of everyday life

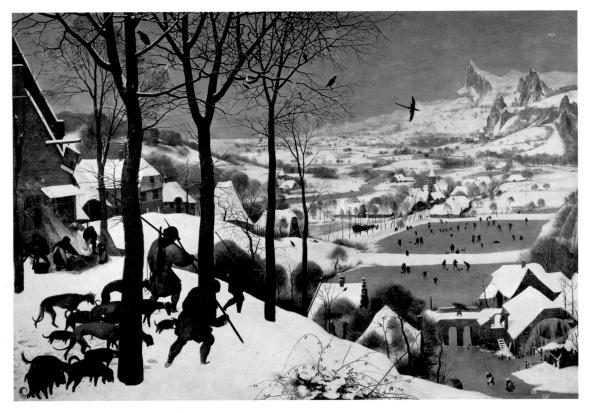

16–26 | Pieter Bruegel the Elder RETURN OF THE HUNTERS
1565. Oil on wood panel, 3'10½" × 5'3¾" (1.18 × 1.61 m). Kunsthistorisches Museum, Vienna.

faithfully reproduced within the carefully calculated composition. The sharp diagonals sweeping into space are countered by the pointed gables and roofs at the lower right as well as by the jagged mountain peaks along the right edge. Their rhythms are deliberately slowed and stabilized by a balance of vertical tree trunks and horizontal rectangles of water frozen over in the distance. As a depiction of Netherlandish life, this scene represents a relative calm before the storm. Three years after it was painted, the anguished struggle of the northern provinces for independence from Spain began.

Pieter the Elder died in 1569, leaving two children, Pieter the Younger and Jan, both of whom became successful painters in the next century. The dynasty continued with Jan's son, Jan the Younger. In the seventeenth century, the spelling of the family name was changed from Bruegel to Brueghel.

RENAISSANCE ART IN ENGLAND

England, although facing the disruption of the Reformation, was economically and politically stable enough to provide sustained support for architecture and the decorative arts during the Tudor dynasty. Music and literature also flourished, but painting was left to foreigners. Henry VIII was known for his love of music (he was himself a composer of considerable

accomplishment), and he also hoped to compete with the wealthy, sophisticated court of Francis I in the visual arts.

As a young man Henry VIII (ruled 1509-47) was loyal to the Church. When he wrote a book attacking Luther in 1520, the pope declared him "Defender of the Faith." But when the pope refused to annul his marriage to Catherine of Aragon, Henry broke with Rome. By action of Parliament in 1534 he became the "Supreme Head on earth of the Church and Clergy of England." He ordered an English translation of the Bible to be put in every church. In 1536 and 1539, he went further and dissolved the monasteries, confiscating their great wealth and rewarding his followers with monastic lands and buildings. Henry's need for money had disastrous effects on the arts as his men stripped shrines and altars of their jewels and precious metals. The final blow to religious art came during the reign of Henry's son Edward VI when in 1548 all images were officially prohibited and two years later altars were replaced by wooden tables.

During the brief reign of Mary (ruled 1553–58), England officially returned to Catholicism, but the accession of Elizabeth in 1558 confirmed England as a Protestant country. So effective was Elizabeth, who ruled until 1603, that the last decades of the sixteenth century in England are called the Elizabethan Age.

Artists in the Tudor Court

Religious painting had no place in England, but a remarkable record of the appearance of Tudor monarchs survives in portraiture. Because direct contacts with Italy became difficult after Henry's break with the Roman Catholic Church, the Tudors favored Netherlandish and German artists. Thus, it was a Germanborn painter, Hans Holbein the Younger (c. 1497–1543), who shaped the taste of the English court and upper classes, and a Flemish artist who held the title of "King's Painter."

HANS HOLBEIN. Holbein first visited London from 1526 to 1528 and was introduced by the Dutch scholar Erasmus to the humanist circle around the statesman Thomas More. He returned to England in 1532 and was appointed court painter to Henry VIII about four years later. One of Holbein's official portraits of Henry (FIG. 16–27), shown at age 49 according to the inscription on the dark blue-green background, was painted in 1540, although the king's appearance had already been established in an earlier prototype. Henry, who envied the

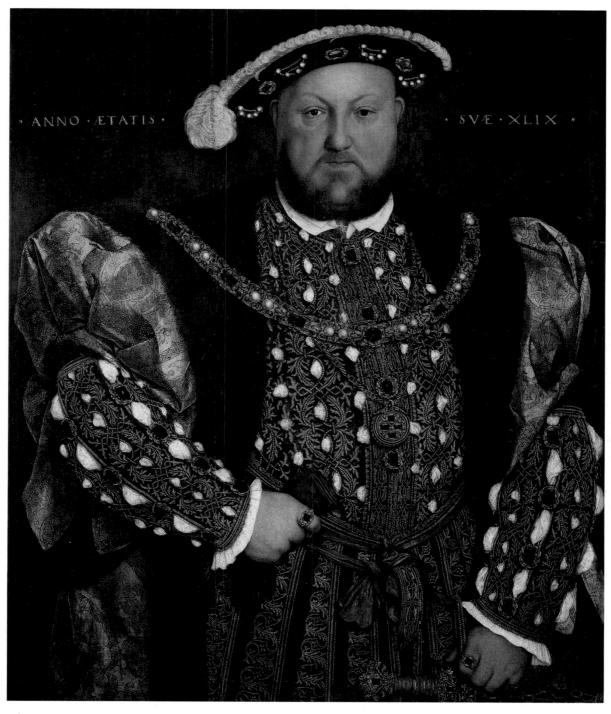

16–27 | Hans Holbein the Younger HENRY VIII 1540. Oil on wood panel, $32\frac{1}{2} \times 29\frac{1}{2}$ " (82.6 \times 75 cm). Galleria Nazionale d'Arte Antica, Rome.

16–28 | Attributed to Levina Bening Teerlinc PRINCESS ELIZABETH c. 1559. Oil on oak panel, $42\% \times 32\%''$ (109 × 81.8 cm). The Royal Collection, Windsor Castle, England. (RCIN 404444, OM 46 WC 2010)

French king Francis I and attempted to outdo him in every way, imitated French fashions and even copied the style of the French king's beard. Henry's huge frame—he was well over 6 feet tall and had a 54-inch waist—is covered by the latest style of dress: a short puffed-sleeve coat of heavy brocade trimmed in dark fur; a narrow, stiff white collar fastened at the front; and a doublet, encrusted with gemstones and gold braid, which was slit to expose his silk shirt. Holbein used the English king's great size to advantage for this official portrait, enhancing Henry's majestic figure with embroidered cloth, fur, and jewelry to create one of the most imposing images of

power in the history of art. He is dressed for his wedding to his fourth wife, Anne of Cleves, on April 5, 1540.

LEVINA BENING TEERLING. Holbein was not the highest-paid painter in Henry VIII's court. That status belonged to a Netherlandish woman, Levina Bening Teerlinc. Since Teerlinc worked in England for thirty years, her near-anonymity is an art-historical mystery. At Henry's invitation to become "King's Paintrix," she and her husband arrived in London in 1545 from Bruges, where her father was a leading manuscript illuminator. She maintained her court appointment

Art and Its Context

ARMOR FOR ROYAL GAMES

he medieval tradition of holding tilting, or jousting, competitions at English festivals and public celebrations continued during Renaissance times. Perhaps the most famous of these, the Accession Day Tilts, were held annually to celebrate the anniversary of Elizabeth 1's coronation. The gentlemen of the court, dressed in armor made especially for the occasion, held mock battles in the queen's honor. They rode their horses from opposite directions, trying to strike each other with long lances. Each pair of competitors made six passes and the judges rated their performances.

The elegant armor worn by George Clifford, third Earl of Cumberland, at the Accession Day Tilts has been preserved in the collection of the Metropolitan Museum of Art in New York. Tudor roses and back-to-back capital E's in honor of the queen decorate the armor's surface. As the Queen's Champion beginning in 1590, Clifford also wore her jeweled glove attached to his helmet as he met all comers in the tiltyard of Whitehall Palace in London.

Made by Jacob Halder in the royal armories at Greenwich, the 60-pound suit of armor is recorded in the sixteenth-century Almain Armourers' Album along with its "exchange pieces." These allowed the owner to vary his appearance by changing mitts, side pieces, or leg protectors, and also provided backup pieces if one were damaged.

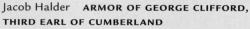

Made in the royal workshop at Greenwich, England. c. 1580-85. Steel and gold, height 5'9½" (1.77 m). The Metropolitan Museum of Art, New York.

Munsey Fund, 1932 (32.130.6)

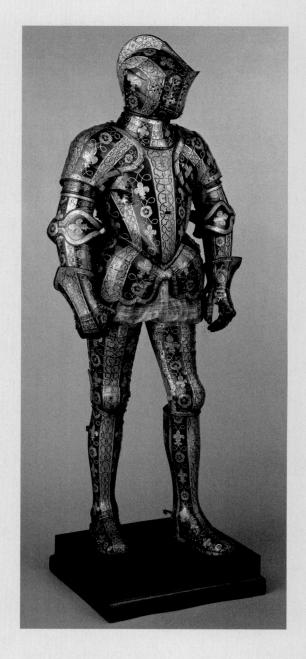

until her death about 1576, in the reign of Elizabeth I. Because Teerlinc was the granddaughter and daughter of Netherlandish manuscript illuminators, she is assumed to have painted miniature portraits or scenes on vellum and ivory. Certainly, she designed Elizabeth's first official seal of 1559, which included the queen's likeness. One life-size portrait frequently attributed to her—but by no means securely—depicts Elizabeth Tudor as a young princess (FIG. 16–28). Elizabeth's pearled cap, an adaptation of the so-

called French hood popularized by her mother, Anne Boleyn, is set back to expose her famous red hair. Her brocaded outer dress, worn over a rigid hoop, is split to expose an underskirt of cut velvet. Although her features are softened by youth and no doubt are idealized as well, her long, high-bridged nose and the fullness below her small lower lip give her a distinctive appearance. The prominently displayed books were no doubt included to signify Elizabeth's well-known love of learning.

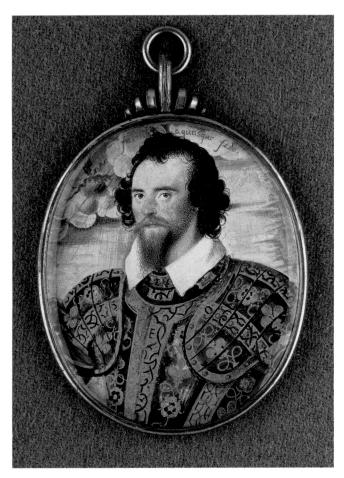

I6–29 | Nicholas Hilliard GEORGE CLIFFORD, THIRD EARL OF CUMBERLAND (1558–1605) c. 1595. Watercolor on vellum on card, oval $2\frac{1}{4} \times 2\frac{1}{16}$ " (7.1 \times 5.8 cm). The Nelson-Atkins Museum of Art, Kansas City, Missouri.

Gift of Mr. and Mrs. John W. Starr through the Starr Foundation. F58-60/188

NICHOLAS HILLIARD. In 1570, while Levina Teerlinc was still active at Elizabeth's court, Nicholas Hilliard (1547-1619) arrived in London from southwest England to pursue a career as a jeweler, goldsmith, and painter of miniatures. Hilliard never received a court appointment but worked instead on commission, creating miniature portraits of the queen and court notables, including GEORGE CLIFFORD, THIRD EARL OF CUMBERLAND (FIG. 16-29). Cumberland was a regular participant in the annual tilts and festivals celebrating the anniversary of Elizabeth I's ascent to the throne. In Hilliard's miniature, Cumberland wears a richly engraved and gold-inlaid suit of armor, forged for his first appearance, in 1583, at the tilts (see "Armor for Royal Games," page 607). Hilliard had a talent for giving his male subjects an appropriate air of courtly jauntiness. Cumberland, a man of about thirty with a stylish beard, mustache, and curled hair, is humanized by his direct gaze and unconcealed receding hairline. Cumberland's motto, "I bear lightning and water," is inscribed on a stormy sky, with a lightning bolt in the form of a caduceus (the classical staff with two entwined snakes), one of his emblems. After all, he was that remarkable Elizabethan type—a naval commander and a gentleman pirate.

Architecture

Henry VIII, as the newly declared head of the Church of England, sold or gave church land to favored courtiers. Many properties were bought by speculators who divided and resold them. To increase support for the Tudor dynasty, Henry and his successors also granted titles to rich landowners. To display their wealth and status, many of these newly created aristocrats embarked on extensive building projects. They built lavish country residences, which sometimes surpassed the French châteaux in size and grandeur. At this time, Elizabethan architecture still reflected the Perpendicular Gothic style (SEE FIG. 12–20), with its severe walls and broad expanses of glass, although designers modernized the forms by replacing medieval ornament with classical motifs copied from architectural handbooks and pattern books. The first architectural manual in English, published in 1563, was written by John Shute, one of the few builders who had spent time in Italy. But books by Flemish, French, and German architects were readily available. Most influential were the treatises on architectural design by the Italian architect Sebastiano Serlio.

HARDWICK HALL. One of the grandest of all the Elizabethan houses was HARDWICK HALL, the home of Elizabeth, Countess of Shrewsbury, known as "Bess of Hardwick" (FIG. 16–30). When she was in her seventies, the redoubtable countess—who inherited riches from all four of her deceased husbands—employed Robert Smythson (c. 1535–1614), England's first Renaissance professional architect, to build Hardwick Hall (1591–97).

Smythson's—and Bess's—plan for Hardwick was new. The medieval great hall became a two-story entrance hall, with rooms arranged symmetrically around it—a nod to classical balance. A sequence of rooms leads to a grand stair up to the Long Gallery and **HIGH GREAT CHAMBER** on the second floor (FIG. 16-31), where the countess received guests, entertained, and sometimes dined. The High Great Chamber was designed to display a set of six Brussels tapestries with the story of Ulysses. The room had enormous windows, ornate fireplaces, and a richly carved and painted plaster frieze around the room. The frieze, by the master Abraham Smith, depicts Diana and her maiden hunters in a forest where they pursue stags and boars. In the window bay, the frieze turns into an allegory on the seasons; Venus whipping Cupid represents spring, and the goddess Ceres, summer. Smith based his allegories on Flemish prints. Graphic arts transmitted images from artist to artist and country to country much as photography does today.

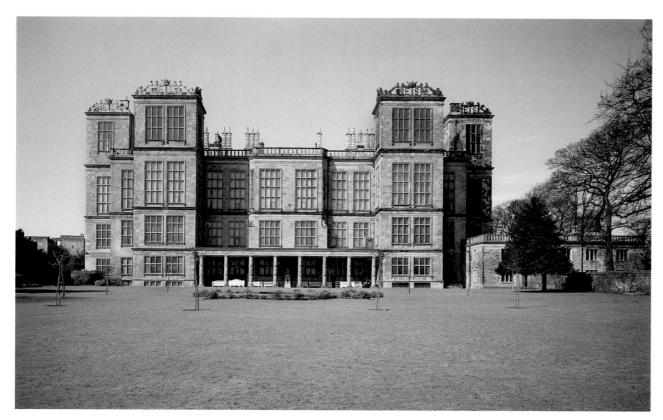

16–30 | Robert Smythson HARDWICK HALL, SHREWSBURY England. 1591–97.

Elizabeth, Countess of Shrewsbury, who commissioned Smythson, participated actively in the design of her houses. She embellished the roofline with her initials, ES, in letters 4 feet tall.

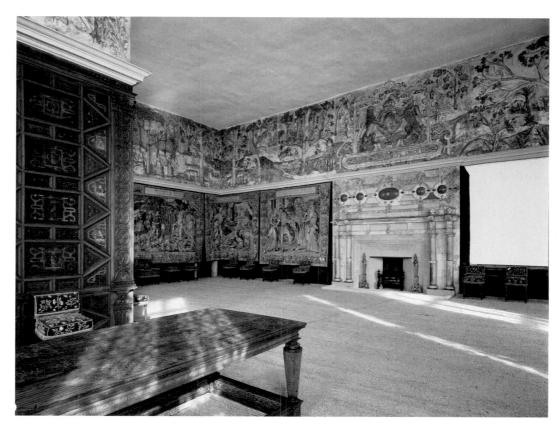

16–31 | Robert Smythson HIGH GREAT CHAMBER, HARDWICK HALL Shrewsbury, England. 1591–97. Brussels tapestries, 1550s; painted plaster sculpture by Abraham Smith.

IN PERSPECTIVE

In the sixteenth century people faced many challenges—political, religious, and aesthetic. Humanistic learning, based on the written word, was dominant—Germany was, after all, the home of the first printed book—and an increasingly literate public gained access not only to practical information but also to new ideas. Germany was also the center of the Reformation within the Christian Church. In many places, the reformers' zeal led to the destruction first of religious art and then sometimes of all the arts. People worshiped in stark shells of church buildings. With no call to paint religious themes, the artists found new themes and focused on worldly subjects, especially on portraits.

Artists were well aware of the new forces at work across the Alps in Italy, and study tours were an essential part of education. Traveling artists could copy ancient classical art in Rome, study mural painting in Florence, and admire the dazzling lush oil painting in Venice. The idea took hold that artists could express as much through painted, sculptural, and architectural forms as poets could with words or musicians with melody. The notion of divinely inspired creativity supplanted manual artistry.

Intense religiosity vied with materialistic enterprise early in the century. The crafts also emerged as splendid fine arts, as seen in pictorial tapestries, gold and silver show-piece tableware, and glazed ceramics, among other mediums. All the arts of personal display—cut velvet and brocade gowns and robes, chains and jewels of state—can be studied in portraits.

The Protestants carried on the tradition of using the visual arts to promote a cause, to educate, and to glorify with grand palaces and portraits—just as the Catholic Church had over the centuries used great church buildings and religious art for its didactic as well as aesthetic values. The effects of the Reformation and the Counter–Reformation would continue to reverberate in the arts of the following century throughout Europe and, across the Atlantic, in America.

VEIT STOSS
ANNUNCIATION AND
VIRGIN OF THE ROSARY
1517–18

Albrecht Dürer **SELF-PORTRAIT** 1500

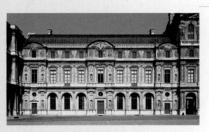

PIERRE LESCOT WEST WING. COUR CARRÉ, PALAIS DU LOUVRE, PARIS BEGUN 1546

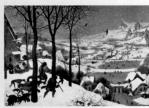

PIETER BRUEGEL THE ELDER
RETURN OF THE HUNTERS
1565

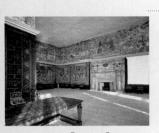

ROBERT SMYTHSON HIGH GREAT CHAMBER, HARDWICK HALL, SHREWSBURY, ENGLAND 1591–97

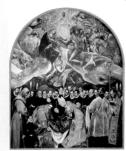

EL GRECO
BURIAL OF COUNT ORGAZ
1586

SIXTEENTH-CENTURY ART IN NORTHERN EUROPE AND THE IBERIAN PENINSULA

■ Luther Protests Church's Sale of

 Charles V Holy Roman Emperor 1519-56

■ First Circumnavigation of Earth 1522

Peasants' War 1524-26

Indulgences 1517

Charles V Orders Sack of Rome 1527

 Church of England Separates from Roman Church 1534

Council of Trent 1545-63

■ Elizabeth I Queen of England 1558-1603

Dutch Unite against Spanish Rule 1579

English Defeat Spanish Navy in Spanish Armada 1588

1580

1600

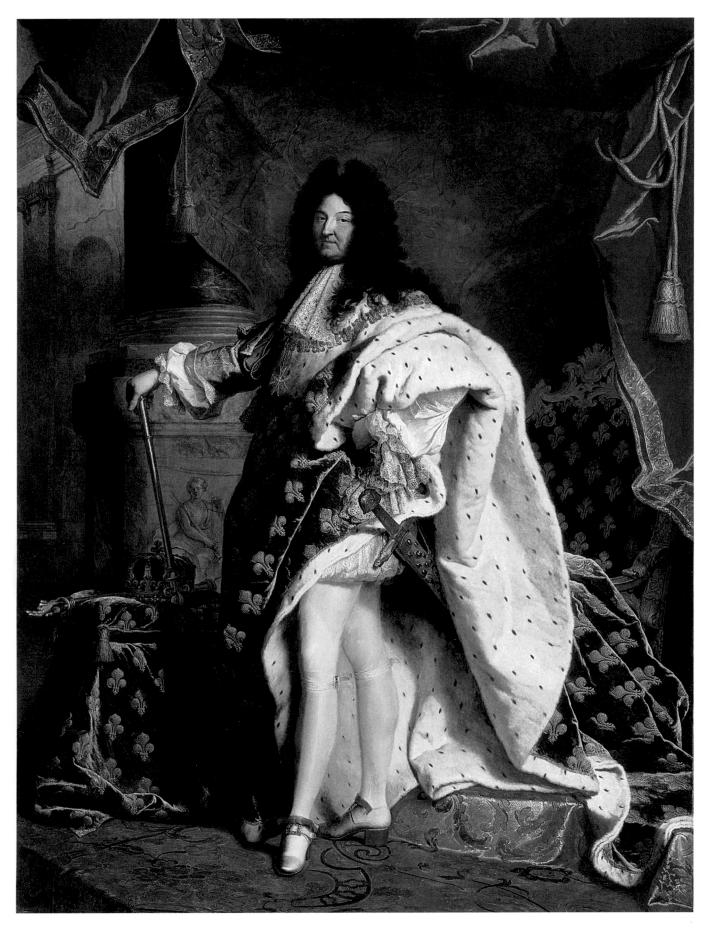

17–1 | Hyacinthe Rigaud Louis xiv 1701. Oil on canvas, $9'2'' \times 7'10\%''$ (2.19 \times 2.4 m). Musée du Louvre, Paris.

CHAPTER SEVENTEEN

BAROQUE ART

In Hyacinthe Rigaud's 1701 portrait of **LOUIS XIV** (FIG. 17–1), the richly costumed monarch known as *le Roi Soleil* ("the Sun King"; ruled 1643–1715) is presented to us by an unseen hand that pulls aside a huge billowing curtain.

17

portraits was not unusual, for the royal and aristocratic families of Europe were linked through marriage, and paintings made appropriate gifts for relatives. Rigaud's workshop produced between thirty and forty portraits a year. His

Showing off his elegant legs, of which he was very proud, the 63-year-old French monarch poses in an elaborate robe of state, decorated with gold *fleurs-de-lis* and white ermine, and he wears the red-heeled built-up shoes he had invented to compensate for his short stature. At first glance, the face under the huge wig seems almost incidental to the overall grandeur of the presentation. Yet the directness of Louis XIV's gaze makes him movingly human despite the pompous pose and the overwhelming magnificence that surrounds him. Rigaud's genius in portraiture was always to capture a good likeness while idealizing his subjects' less attractive features and giving minute attention to the virtuoso rendering of textures and materials of the costume and setting.

portraits varied in price according to whether the entire figure was painted from life or whether Rigaud merely added a portrait head to a stock figure in a composition he had designed for his workshop to execute.

Louis XIV had ordered this portrait as a gift for his grandson Philip, but when Rigaud finished the painting, Louis liked it so much that he kept it. Three years later, Louis ordered a copy from Rigaud to give his grandson, now King Philip V of Spain (ruled 1700–46). The request for copies of

Rigaud's long career spanned a time of great change in Western art. Not only did new manners of representation emerge, but, whereas art had once been under the patronage of the Church and the aristocracy, a kind of broad-based commercialism arose that was reflected both by portrait workshops such as Rigaud's and by the thousands of still-life and landscape painters producing works for the middle-class households that could now afford to decorate their homes. These changes of the seventeenth and eighteenth centuries—the Baroque period in Europe—took place in a cultural context in which individuals and organizations were grappling with the effects of religious upheaval, economic growth, colonial expansion, political turbulence, and a dramatic explosion of scientific knowledge.

- **THE BAROQUE PERIOD**
- ITALY | Architecture and Sculpture in Rome | Painting
- THE HABSBURG LANDS | Painting in Spain's Golden Age | Architecture in Spain and Austria
- FLANDERS AND THE NETHERLANDS | Flanders | The Dutch Republic
- FRANCE Architecture and Its Decoration at Versailles Painting
- ENGLAND | Architecture and Landscape Design | English Colonies in North America
- **IN PERSPECTIVE**

THE BAROQUE PERIOD

The word baroque was initially used in the late 1700s as a derogatory term to characterize the exuberant and extravagant aspects of some of the art of the preceding century and a half. Today, Baroque can designate certain formal characteristics of style, as well as refer to a period in the history of art lasting from the end of the sixteenth into the eighteenth century. Baroque style is characterized by an emotional rather than intellectual response to a work of art and by an interest in exploiting the dramatic moment through choice of subject and style. Artists created open compositions in which elements are placed or seem to move diagonally, expand upward, or overlap their supposed frames. Many artists developed a loose, free technique using rich colors and dramatic contrasts of light and dark, producing what one critic called an "absolute unity" of form. This unified concept extends to the more expansive unity between architecture, sculpture, and painting and the theatrical effects that could be created by what we would term a multimedia approach. Although many of the formal characteristics of the Baroque have been applied to other periods, like Hellenistic Greek styles, the term Baroque will be used here to refer to the complex of styles-including a more restrained, classical stream-that developed against the historical backdrop of the Counter-Reformation, the advancement of science, the expanding world of exploration and trade, and the rise of private patronage in the arts.

By the seventeenth century, the permanent division within Europe between Roman Catholicism and Protestantism had a critical effect on European art. As part of the Counter-Reformation program that came to fruition in the seventeenth century, the Church used art to encourage piety among the faithful and to persuade those it regarded as heretics to return to the fold. Patronage of art in Catholic as well as Protestant countries was spurred by economic growth that helped to support not only the aristocracy, but a large, affluent middle class eager to build and furnish fine houses and even palaces. Buildings ranged from magnificent churches and palaces to stage sets for plays and ballets, while painting and sculpture varied from large religious works and history paint-

ings to portraits, still lifes, and **genre** paintings (scenes of everyday life). At the same time, scientific advances compelled people to question their worldview. Of great importance was the growing understanding that Earth was not the center of the universe but was a planet revolving around the sun (see "Science and the Changing Worldview," page 616).

Within these historical parameters, artists achieved spectacular technical virtuosity and an impressive ability to produce for their patrons and the market. Painters manipulated their mediums from the thinnest glazes to heavy impasto (thickly applied pigments), taking pleasure in the very quality of the material. A desire for realism led some artists to reach for a verisimilitude that went against the idealization of classical and Renaissance styles. The English leader Oliver Cromwell supposedly demanded that his portrait be painted "warts and all." Leading artists such as Rubens and Rembrandt organized their studios into veritable picture factories. Artists were admired for the originality of a concept or design, and their shops produced paintings on demand—including copy after copy of popular themes or portraits. The respect for the "original," or first edition, is a modern concept.

The role of viewers also changed. Earlier, Renaissance painters and patrons had been fascinated with the visual possibilities of perspective, but even such displays as Mantegna's ceiling fresco at Mantua (SEE FIG. 14-34) remained an intellectual conceit. Seventeenth-century masters, on the other hand, treated viewers as participants in the artwork, and the space of the work included the world beyond the frame. In Catholic countries, representations of horrifying scenes of martyrdom or the passionate spiritual life of a mystic in religious ecstasy inspired a renewed faith (SEE FIG. 17-6). In Protestant countries, images of civic parades and city views inspired pride in accomplishment (SEE FIGS. 17-45, 17-49). Viewers participated in art like audiences in a theater vicariously but completely—as the work of art reached out visually and emotionally to draw them into its orbit. The seventeenth-century French critic Roger de Piles described this exchange when he wrote: "True painting . . . calls to us; and has so powerful an effect, that we cannot help coming near it, as if it had something to tell us" (quoted in Puttfarken, page 55).

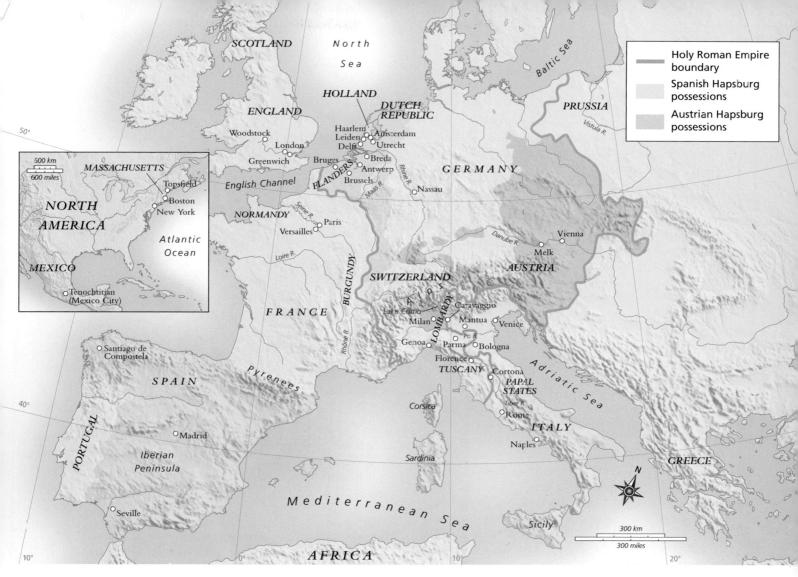

MAP 17-1 THE SEVENTEENTH CENTURY IN EUROPE AND NORTH AMERICA

Protestantism dominated in northern Europe, while Roman Catholicism remained strong after the Counter-Reformation in southern Europe.

ITALY

Italy in the seventeenth century remained a divided land in spite of a common history, language, and geography with borders defined by the seas. The Kingdom of Naples and Sicily was Spanish; the Papal States crossed the center; Venice maintained its independence as a republic; and the north remained divided among small principalities. In spite of religious wars raging in Germany and France, churchmen remained powerful patrons of the arts, especially as they recognized the visual arts' role in propaganda campaigns. The popes, cardinals, and their families turned to artists to enhance their status. Additionally, the Church had set down rules for art at the Council of Trent (1563) that went against the arcane, worldly, and often lascivious trends exploited by Mannerism. The clergy's call for clarity, simplicity, chaste subject matter, and the ability to rouse a very Catholic piety in the face of Protestant revolt found a response in the fresh approaches to subject matter and style offered by a new generation of artists.

Architecture and Sculpture in Rome

A major goal of the Counter-Reformation was to properly embellish the Church and its mother city. Pope Sixtus V (papacy 1585-90) had begun the renewal by cutting long straight avenues through the city to link the major pilgrimage churches with one another and with the main gates of Rome. Sixtus also ordered open spaces—piazzas—cleared in front of major churches, marking each site with an Egyptian obelisk. (His chief architect, Domenico Fontana, performed remarkable feats of engineering to move the huge monoliths.) In a practical vein, Sixtus also reopened one of the ancient aqueducts to stabilize the city's water supply. Unchallengeable power and vast financial resources were required to carry out such an extensive plan of urban renewal and to materially fashion Rome—which had been the victim of rapacity and neglect since the Middle Ages—once more into the center of spiritual and worldly power.

The Counter-Reformation popes had great wealth, although eventually they nearly bankrupted the Church with

ITALY

Science and Technology

SCIENCE AND THE CHANGING WORLDVIEW

nvestigations of the natural world that had begun during the Renaissance changed the way people of the seventeenth and eighteenth centuries—including artists—saw the world. Some of the new discoveries brought a sense of the grand scale of the universe, while others focused on the minute complexity of the microscopic world of nature. As frames of reference expanded and contracted, artists found new ways to mirror these changing perspectives in their own works.

The philosophers Francis Bacon (1561–1626) of England and René Descartes (1596–1650) of France established a new scientific method of studying the world by insisting on scrupulous objectivity and logical reasoning. Bacon proposed that facts be established by observation and tested by controlled experiments. Descartes argued for the deductive method of reasoning, in which a conclusion was arrived at logically from basic premises—the most fundamental example being "I think, therefore I am."

In 1543, the Polish scholar Nicolaus Copernicus (1473-1543) published On the Revolutions of the Heavenly Spheres, which contradicted the long-held view that Earth is the center of the universe (the Ptolemaic theory) by arguing that Earth and other planets revolve around the sun. The Church put the book on its Index of Prohibited Books in 1616, but Johannes Kepler (1571-1630) continued demonstrating that the planets revolve around the sun in elliptical orbits. Galileo Galilei (1564-1642), an astronomer, mathematician, and physicist, developed the telescope as a tool for observing the heavens. His findings provided further confirmation of the Copernican theory, but since the Church prohibited teaching that theory, Galileo was tried for heresy by the Inquisition and forced to recant his views. As the first person to see the craters of the moon through a telescope, Galileo began the exploration of space that eventually led humans to take their first steps on the moon in 1969.

Seventeenth-century science explored not only the vastness of outer space but also the smallest elements of inner space, thanks to the invention of the microscope by the Dutch lens maker and amateur scientist Antoni van Leeuwenhoek (1632–1723). Although embroiderers, textile inspectors, manuscript illuminators, and painters had long used magnifying glasses in their work, Leeuwenhoek perfected grinding techniques and increased the power of his lenses far beyond what those uses required. Ultimately, he was able to study the inner workings of plants and animals and even see microorganisms. Soon, scientists learned to draw, or depended on artists to draw, the images revealed by the microscope for further study

and publication. Not until the discovery of photography in the nineteenth century could scientists communicate their discoveries without an artist's help.

Maria Sibylla Merian PLATE 9 FROM DISSERTATION IN INSECT GENERATIONS AND METAMORPHOSIS IN SURINAM 1719. Hand-colored engraving, $18\% \times 13''$ (47.9×33 cm). National Museum of Women in the Arts, Washington, D.C. Gift of Wallace and Wilhelmina Holladay Collection, funds contributed by Mr. and Mrs. George G. Anderman and an anonymous donor (1976.56)

Maria Sibylla Merian (1647–1717) was unusual in making noteworthy contributions as both researcher and artist. German by birth and Dutch by training, Merian was once described by a Dutch contemporary as a painter of flowers, fruit, birds, worms, flies, mosquitoes, spiders, "and other filth." At the time, it was believed that insects emerged spontaneously from the soil, but Merian's research on the life cycles of insects proved otherwise, findings she published in 1679 and 1683 as The Wonderful Transformation of Caterpillars and (Their) Singular Plant Nourishment. In 1699, Amsterdam subsidized Merian's research on plants and insects in the Dutch colony of Surinam in South America; her results were published as Dissertation in Insect Generations and Metamorphosis in Surinam, illustrated with sixty large plates engraved after her watercolors. Each plate is scientifically precise, accurate, and informative, presenting insects in various stages of development, along with the plants they live on.

their building programs. Sixtus began to renovate the Vatican and its library. He completed the dome of Saint Peter's and built splendid palaces. The Renaissance ideal of the central-plan church continued to be used for the shrines of saints, but Counter-Reformation thinking called for churches with long, wide naves to accommodate large congregations assem-

bled to hear firm sermons as well as to participate in the Mass. In the sixteenth century, the decoration of new churches had been generally austere, but seventeenth- and eighteenth-century Catholic taste favored opulent and spectacular visual effects to heighten the emotional involvement of worshipers.

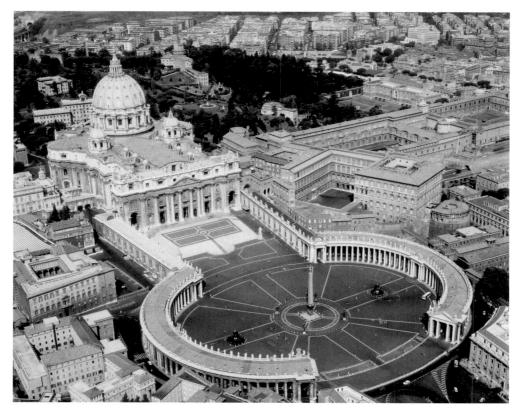

17–2 | SAINT PETER'S BASILICA AND PIAZZA, VATICAN, ROME Carlo Maderno, façade, 1607–26; Gianlorenzo Bernini, piazza design, c. 1656–57.

Perhaps only a Baroque artist of Bernini's talents could have unified the many artistic periods and styles that come together in Saint Peter's Basilica (starting with Bramante's original design for the building in the sixteenth century). The basilica in no way suggests a piecing together of parts made by different builders at different times but rather presents itself as a triumphal unity of all the parts in one coherent whole.

SAINT PETER'S BASILICA IN THE VATICAN. Half a century after Michelangelo had returned Saint Peter's Basilica to Bramante's original vision of a central-plan building, Pope Paul V (papacy 1605-21) commissioned Carlo Maderno (1556-1629) to provide the church with a longer nave and a new façade (FIG. 17-2). Construction began in 1607, and everything but the façade bell towers was completed by 1615 (see "Saint Peter's Basilica," Chapter 15, page 549). In essence, Maderno took the concept of Il Gesù's façade (SEE FIG. 15-31) and enlarged it to befit the most important church of the Catholic world. Maderno's façade for Saint Peter's "steps out" in three progressively projecting planes: from the corners to the doorways flanking the central entrance area, then the entrance area, then the central doorway itself. Similarly, the colossal orders connecting the first and second stories are flat pilasters at the corners but fully round columns where they flank the docrways. These columns support a continuous entablature that also steps out-following the columns-as it moves toward the central door. A triangular pediment provides vertical movement, as does the superimposition of pilasters on the relatively narrow attic story above the entablature.

When Maderno died in 1629, he was succeeded as Vatican architect by his collaborator of five years, Gianlorenzo Bernini (1598–1680). Gianlorenzo was taught by his father,

and part of his training involved sketching the Vatican collection of ancient sculpture, such as *Laocoön and His Sons* and the Farnese Hercules (see Introduction, Fig. 23), as well as the many examples of Renaissance painting in the papal palace. Throughout his life, Bernini admired antique art and, like other artists of this period, considered himself a classicist. Today, we not only appreciate his strong debt to the Renaissance tradition but also consider his art a breakthrough that takes us into a new, Baroque style.

When Urban VIII was elected pope in 1623, he unhesitatingly gave the young Bernini the demanding task of designing an enormous bronze baldachin, or canopy, for the high altar of Saint Peter's. The church was so large that a dramatic focus on the altar was essential. The resulting BALDACCHINO (FIG. 17–3), completed in 1633, stands almost 100 feet high and exemplifies the Baroque artists' desire to combine architecture and sculpture—and sometimes painting as well—so that works no longer fit into a single category or a single medium. The twisted columns symbolize the union of Old and New Testaments—the vine of the Eucharist climbing the columns of the Temple of Solomon. The fanciful Composite capitals, combining elements of both the Ionic and the Corinthian orders, support an entablature with a crowning element topped with an orb (a sphere representing the

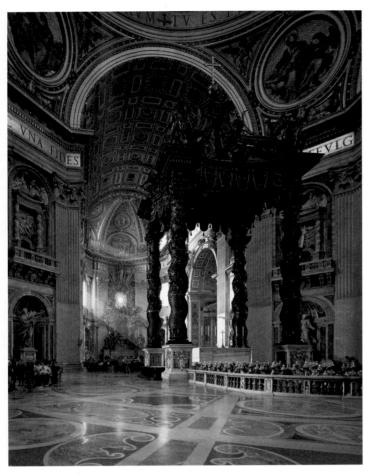

17–3 | Gianlorenzo Bernini BALDACCHINO 1624–33. Gilt bronze, height approx. 100' (30.48 m). Chair of Peter shrine, 1657–66. Gilt bronze, marble, stucco, and glass. Pier decorations, 1627–41. Gilt bronze and marble. Crossing, Saint Peter's Basilica, Vatican, Rome.

universe) and a cross (symbolizing the reign of Christ). Figures of angels and *putti* decorate the entablature, which is hung with tasseled panels in imitation of a cloth canopy. These symbolic elements, both architectural and sculptural, not only mark the site of the tomb of Saint Peter but also serve as a monument to Urban VIII and his family, the Barberini, whose emblems—including honeybees and suns on the tasseled panels, and laurel leaves on the climbing vines—are prominently displayed.

Between 1627 and 1641, Bernini and several other sculptors, again combining architecture and sculpture, rebuilt Bramante's crossing piers as giant reliquaries. Statues of saints Helena, Veronica, Andrew, and Longinus stand in niches below alcoves containing their relics, to the left and right of the *baldacchino*. Visible through the *baldacchino*'s columns in the apse of the church is another reliquary: the gilded stone, bronze, and stucco shrine made by Bernini between 1657 and 1666 for the ancient wooden throne thought to have

belonged to Saint Peter as the first bishop of Rome. The Chair of Peter symbolized the direct descent of Christian authority from Peter to the current pope, a belief rejected by Protestants and therefore deliberately emphasized in Counter-Reformation Catholicism. In Bernini's work, the chair is carried by four theologians and is lifted even farther by a surge of gilded clouds moving upward to the Holy Spirit, who materializes in the stained-glass window in the form of a dove surrounded by an oval of golden rays. Adoring, gilded angels and gilt-bronze rays fan out around the window and seem to extend the penetration of the natural light—and the Holy Spirit—into the apse of the church. The gilding also reflects the light back to the window, creating a dazzling, ethereal effect that the seventeenth century, with its interest in mystics and visions, would equate with the activation of divinity—and the sort of effect that present-day artists achieve by resorting to electric spotlights.

At approximately the same time that he was at work on the Chair of Peter, Bernini designed and supervised the building of a colonnade to form a huge double piazza in front of the entrance to Saint Peter's (SEE FIG. 17–2). The open space that he had to work with was irregular, and an Egyptian obelisk and a fountain already in place (part of

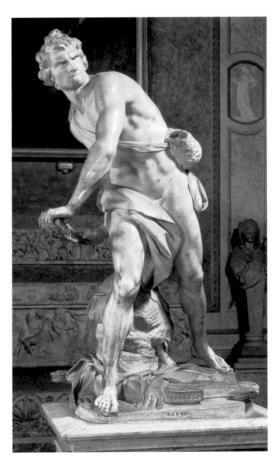

17–4 | Gianlorenzo Bernini DAVID 1623. Marble, height 5'7" (1.7 m). Galleria Borghese, Rome.

Sixtus V's plan for Rome) had to be incorporated into the overall plan. Bernini's remarkable design frames the oval piazza with two enormous curved porticoes, or covered walkways, supported by Doric columns. These curved porticoes are connected to two straight porticoes, which lead up a slight incline to the two ends of the church facade. Bernini spoke of his conception as representing the "motherly arms of the Church" reaching out to the world. He had intended to build a third section of the colonnade closing the side of the piazza facing the church so that pilgrims, after crossing the Tiber River bridge and passing through narrow streets, would suddenly emerge into the enormous open space before the church. Even without the final colonnade section, the great church, colonnade, and piazza with its towering obelisk and monumental fountains-Bernini added the second one to balance the first—are an awe-inspiring vision.

BERNINI AS SCULPTOR. Even after Bernini's appointment as Vatican architect in 1629, he was able to accept outside commissions by virtue of his large workshop. In fact, Bernini first became famous as a sculptor, and he continued to work as a sculptor throughout his career, for both the papacy and private clients. A man of many talents, he was also a painter and even a playwright—an interest that dovetailed with his genius for theatrical and dramatic aspects in his sculpture and architecture.

Bernini's **DAVID** (FIG. 17–4), made for a nephew of Pope Paul V in 1623, introduced a new type of three-dimensional composition that intrudes forcefully on the viewer's space. Inspired by the athletic figures Annibale Carracci had painted in the Farnese gallery some twenty years earlier (SEE, for example, the Giant preparing to heave a boulder at the far end of the gallery, FIG. 17-13), Bernini's David bends at the waist and twists far to one side, ready to launch the lethal rock. Unlike Michelangelo's cool and self-confident vouth (SEE FIG. 15-10), this more mature David, with his lean, sinewy body, is all tension and determination, a frame of mind emphasized by his ferocious expression, tightly clenched mouth, and straining muscles. Bernini's energetic, twisting figure includes the surrounding space as part of the composition by implying the presence of an unseen adversary somewhere behind the viewer. Thus, the viewer becomes part of the action that is taking place at that very moment. This immediacy, the emphasis on the climactic moment, and the inclusion of the viewer in the work of art represent an important new direction for art.

From 1642 until 1652, Bernini worked on the decoration of the funerary chapel of Venetian cardinal Federigo Cornaro (FIG. 17–5) in the Church of Santa Maria della Vittoria, designed by Carlo Maderno earlier in the century. Like Il Gesù (SEE FIG. 15–32), the church had a single nave with shallow side chapels. Santa Maria della Vittoria was built by the order of the Discalced (unshod) Carmelite Friars, and the chapel of the Cornaro family was dedicated to one of the

Sequencing Events GREAT ROYAL AND PAPAL PATRONS OF THE SEVENTEENTH CENTURY

1605-21	Pope Paul V (Borghese)
1623-44	Pope Urban VIII (Barberini)
1625-49	Charles I of England (Stuart)
1643 (61)-1715	Louis XIV of France (Bourbon)
1644-55	Pope Innocent X (Pamphili)
1621-65	Philip IV of Spain (Habsburg)
1655-67	Pope Alexander VII (Chigi)

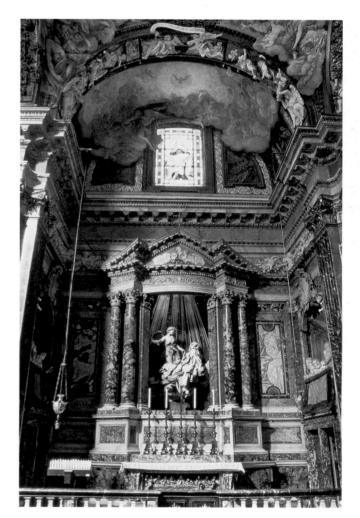

17-5 | Gianlorenzo Bernini CORNARO CHAPEL, CHURCH OF SANTA MARIA DELLA VITTORIA, ROME 1642-52.

order's great figures, the Spanish saint Teresa of Ávila, canonized only twenty years earlier. Bernini designed the chapel to be a rich and theatrical setting in which to portray an event in Teresa's life that contributed to her sainthood. To accomplish this, he covered the walls with colored marble panels

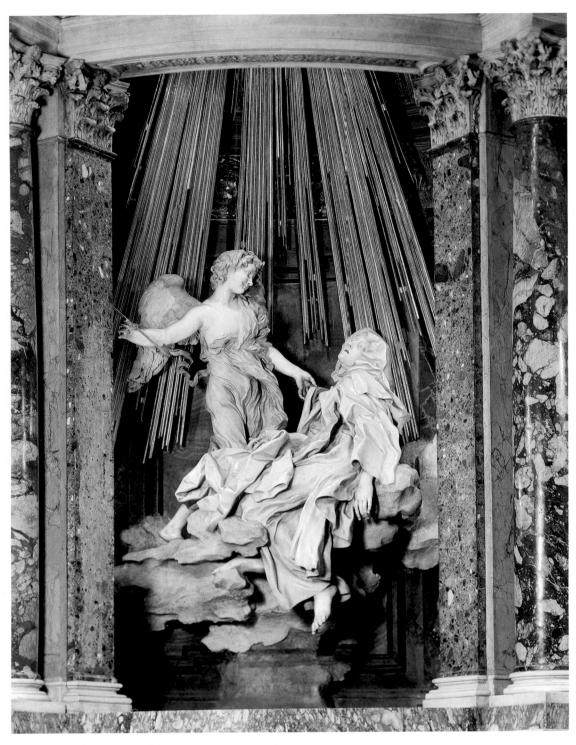

17–6 | Gianlorenzo Bernini SAINT TERESA OF ÁVILA IN ECSTASY
1645–52. Marble, height of the group 11′6″ (3.5 m). Cornaro Chapel, Church of Santa Maria della Vittoria, Rome.

and crowned them with a projecting cornice supported by marble pilasters.

In the center of the chapel and framed by columns in the huge oval niche above the altar, Bernini's marble group **SAINT TERESA OF ÁVILA IN ECSTASY (FIG. 17–6)** represents a vision described by the Spanish mystic in which an angel pierced her body repeatedly with an arrow, transporting her to a state of

indescribable pain, religious ecstasy, and a sense of oneness with God. Saint Teresa and the angel, who seem to float upward on moisture-laden stucco clouds, are cut from a heavy mass of solid marble supported on a hidden pedestal and by hidden metal bars sunk deep into the chapel wall. Bernini's skill at capturing the movements and emotions of these figures is matched by his virtuosity in simulating different textures

and colors in the pure white medium of marble; the angel's gauzy, clinging draperies seem silken in contrast with Teresa's heavy woolen robe, the habit of her order. Yet Bernini effectively used the configuration of the garment's folds to convey the swooning, sensuous body beneath, even though only Teresa's face, hands, and bare feet are actually visible.

As he would later do for the Chair of Peter (SEE FIG. 17-3), Bernini used a directed light source to announce the divine presence that enfolds the saint's ecstasy and spiritual martyrdom. Above the cornice on the back wall, the curved ceiling surrounds a concealed window that mysteriously illuminates the niche that houses Saint Teresa and dissolves the descending rays of gilt bronze, the solid marble figures, and the clouds on which they are suspended into a painterly vision. Kneeling at what appear to be prie-dieux on both sides of the chapel are marble portraits of Federigo, his deceased father (a Venetian doge), and six cardinals of the Cornaro family. The figures are informally posed and naturalistically portrayed. Two read from their prayer books, others exclaim at the miracle taking place in the light-infused realm above the altar, and one leans out from his seat, apparently to look at someone entering the chapel—perhaps the viewer, whose space these figures share. The frescoed vault, above, executed by another artist, depicts the dove of the Holy Spirit hovering over angels and stuccoed scenes of the saint's life.

Gianlorenzo Bernini was deeply religious and held fast to the tenets espoused by the Counter-Reformation. Although he created a "stage" for his subject, his purpose was not to produce a mere spectacle but to capture a critical, dramatic moment at its emotional and sensual height and by doing so guide the viewer to identify totally with the event—and perhaps be transformed in the process.

Bernini's complex, theatrical interplay of media—sculpture, architecture, and painting—and of the various levels of illusion in the chapel—divine, mystical, and actual—invite the beholder to identify with Teresa's experience. His brilliant solution to the problem of transfixing the momentary in physical materials was imitated by sculptors throughout Europe.

BORROMINI'S CHURCH OF SAN CARLO. The intersection of two of the wide straight avenues created by Pope Sixtus V inspired city planners to add a special emphasis, with fountains marking each of the four corners of the crossing. In 1634, the Trinitarian monks decided to build a new church at the site and awarded the commission for SAN CARLO ALLE QUATTRO FONTANE (Saint Charles at the Four Fountains) to Francesco Borromini (1599–1667). Borromini, a nephew of architect Carlo Maderno, had arrived in Rome in 1619 from northern Italy to enter his uncle's workshop. Later, he worked under Bernini's supervision on the decoration of Saint Peter's, and some details of the *Baldacchino*, as well as the structural engineering, are now attributed to him, but San Carlo was his first independent commission. Unfinished at

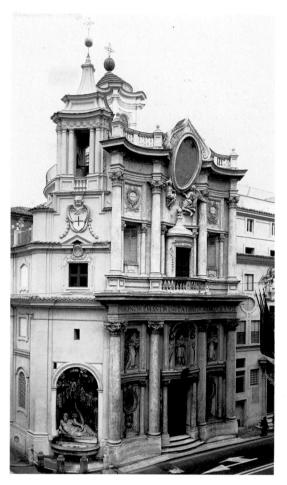

17-7 | Francesco Borromini FAÇADE, CHURCH OF SAN CARLO ALLE QUATTRO FONTANE, ROME 1665-67.

Borromini's death, the church was nevertheless completed according to his design.

San Carlo stands on a narrow piece of land, with one corner cut off to accommodate one of the four fountains that give the church its name (FIG. 17-7). To fit the irregular site, Borromini created an elongated central-plan interior space with undulating walls (FIG. 17-8), whose powerful, sweeping curves create an unexpected feeling of movement, as if the walls were heaving in and out. Robust pairs of columns support a massive entablature, over which an oval dome, supported on pendentives, seems to float. The coffers (inset panels in geometric shapes) filling the interior of the oval-shaped dome form an eccentric honeycomb of crosses, elongated hexagons, and octagons (FIG. 17-9). These coffers decrease sharply in size as they approach the apex, or highest point, where the dove of the Holy Spirit hovers in a climax that brings together geometry used in the chapel: oval, octagon, circle, and—very important—a triangle, symbol of the Trinity as well as of the church's patrons. The dome appears be shimmering and inflating, thanks to light sources placed in the lower coffers and the lantern.

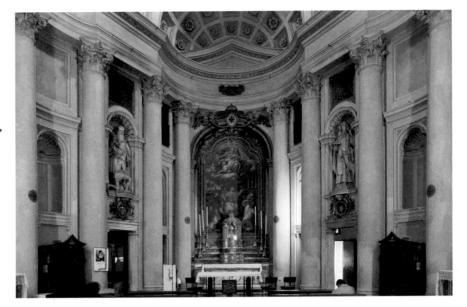

17-8 | Francesco Borromini
INTERIOR, CHURCH OF SAN
CARLO ALLE QUATTRO FONTANE,
ROME
1638-41

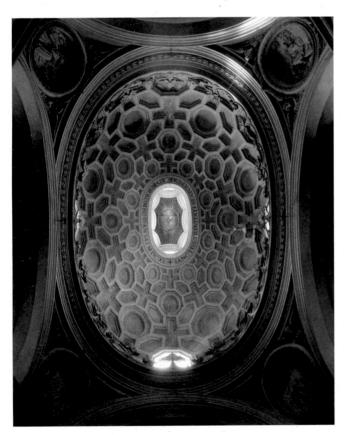

17-9 Dome interior, church of san carlo alle quattro fontane 1638-41.

It is difficult today to appreciate how audacious Borromini's design for this small church was. In it he abandoned the modular, additive system of planning taken for granted by every architect since Brunelleschi. He worked instead from an overriding geometrical scheme for the ideal, domed, central-plan church. Borromini looked at his buildings in

terms of geometrical units as a Gothic architect might, subdividing the units to obtain more complex, rational shapes. For example, the elongated, octagonal plan of San Carlo is composed of two triangles set base to base along the short axis of the plan (FIG. 17-10). This diamond shape is then subdivided into secondary triangular units made by calculating the distances between what will become the concave centers of the four major and five minor niches. Yet Borromini's conception of the whole is not medieval. The chapel is dominated horizontally by a classical entablature that breaks any surge upward toward the dome, allowing the eye to play with the rhythm of paired Corinthian columns. Borromini's treatment of the architectural elements as if they were malleable was also unprecedented. His contemporaries understood immediately what an extraordinary innovation the church represented; the Trinitarian monks who had commissioned it received requests for plans from visitors from all over Europe. Although Borromini's invention had little influence on the architecture of classically minded Rome, it was widely imitated in northern Italy and beyond the Alps.

Borromini's design for San Carlo's façade (SEE FIG. 17–7), done more than two decades later, was as innovative as his plan for its interior had been. He turned the building's front into an undulating, sculpture-filled screen punctuated with large columns and deep concave and convex niches that create dramatic effects of light and shadow. Borromini also gave his façade a strong vertical thrust in the center by placing over the tall doorway a statue-filled niche, then a windowed niche covered with a canopy, then a giant, forward-leaning cartouche held up by angels carved in such high relief that they appear to hover in front of the wall. The entire façade is crowned with a balustrade broken by the sharply pointed frame of the cartouche. Borromini's façade was enthusiastically imitated in northern Italy and especially in northern and eastern Europe.

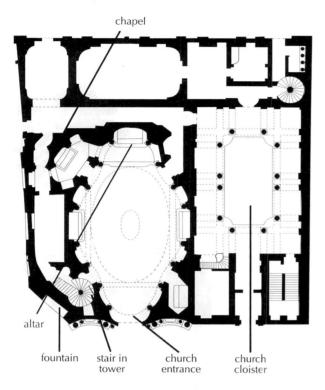

17-10 | Francesco Borromini PLAN OF THE CHURCH OF SAN CARLO ALLE QUATTRO FONTANE, ROME 1638-41.

PIAZZA NAVONA. Rome's PIAZZA NAVONA, a popular site for festivals and celebrations, became another center of urban renewal with the election of Innocent X as pope (papacy 1644–55). Both the palace and parish church of his family, the Pamphilis, fronted on the piazza, which had been the site of a stadium built by Emperor Domitian in 86 CE, and it still retains the shape of the ancient racetrack. The stadium, in ruins, had been used for festivals during the Middle Ages and as a marketplace since 1477. A modest shrine to Saint Agnes stood on the site of her martyrdom.

The Pamphilis enlarged their palace in 1644–50 and in 1652 decided to rebuild their parish church, the Church of Sant'Agnese (Saint Agnes). In 1653–57 Francesco Borromini took the commission, altered the interior, and designed the façade, conceiving a plan that unites church and piazza (FIG. 17–11). The façade sweeps inward from two flanking towers to a monumental portal approached by broad stairs. The inward curve of the façade brings the dome nearer the entrance than usual, making it clearly visible from the piazza. The templelike design of columns and pediment around the door also leads the eye to the steeply rising dome on its tall drum. As the pope had wished, the church truly dominates the urban space.

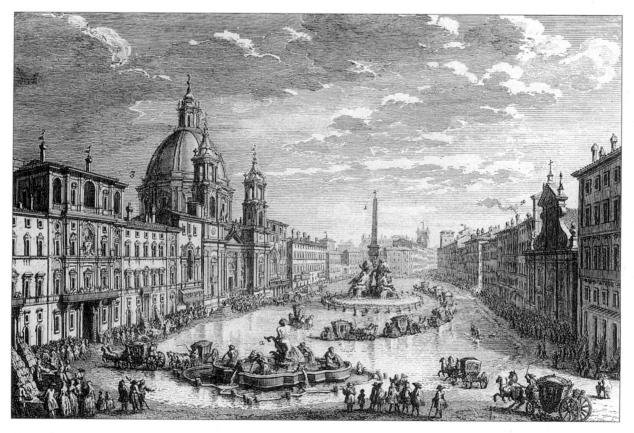

I7–II | PIAZZA NAVONA, ROME In the middle ground, Gianlorenzo Bernini's Four Rivers Fountain, 1648–51. To the left of the fountain, Franceso Borromini's Church of Sant'Agnese, 1653–57. In the foreground, Giacomo della Porta's fountain of 1576. Giuseppe Vasi, *The Flooding of the Piazza Navona*, 18th century, engraving.

The south end of the piazza was already graced by a 1576 fountain by Giacomo della Porta. The contest for a second monumental fountain in the center of the piazza was meant to celebrate the pope's redirection of one of Rome's main water supplies to the piazza. It was won by Borromini, who originated the fountain's theme of the Four Rivers and who brought in the water supply for it in 1647. Gianlorenzo Bernini, who had been publicly disgraced in 1646 when a bell tower he had begun for Saint Peter's threatened to collapse, had not been invited to compete for the fountain's design. However, after some skillful maneuvering, Pope Innocent X saw Bernini's model for the fountain and transferred the project to him the next year.

Bernini was at his most ingenious in fountain designs (FIG. 17–12). Executed in marble and travertine, a porous stone that is less costly and more easily worked than marble, the now famed FOUNTAIN OF THE FOUR RIVERS was completed in 1651. In the center a rocky hill seems to be suspended over an open grotto, within which a hidden collecting pool feeds streams of water signifying the four great rivers of the world. Above the streams recline colossal personifications of the four continents then recognized by contemporary geographers—the Nile (Africa), the Ganges (Asia), the Danube (Europe), and the Rio de la Plata (Americas). In the

center soars a towering ancient Roman imitation of an Egyptian obelisk that Bernini has crowned with a dove: a sign of peace and the Trinity but also the emblem of the pope's family. The towering complex is therefore a dual memorial to the might and reach of the papacy throughout the world as well as the power and status of the Pamphili.

Painting

Painting in seventeenth-century Italy followed one of two principal paths: the classicism of the Carracci or the naturalism of Caravaggio. Although the leading exponents of these paths were northern Italians—the Carracci family was from Bologna, and Caravaggio was apprenticed briefly in Milanthey were all eventually drawn to Rome, the center of power and patronage. The Carracci family as well as Caravaggio were schooled in northern Italian Renaissance realism, with its emphasis on chiaroscuro, as well as in Venetian color and sfumato. They painted with increased realism by using live models. The Carracci quite consciously rejected the difficulties of the Mannerist style and fused their northern roots with the central Italian Renaissance insistence on line (disegno), compositional structure, and figural solidity. They looked to Raphael, Michelangelo, and the models provided by classical sculpture for their ideal figural types. To their

17–12 | Gianlorenzo Bernini and His Shop FOUNTAIN OF THE FOUR RIVERS, THE GANGES (ASIA) 1648–51. Travertine and marble. Piazza Navona, Rome.

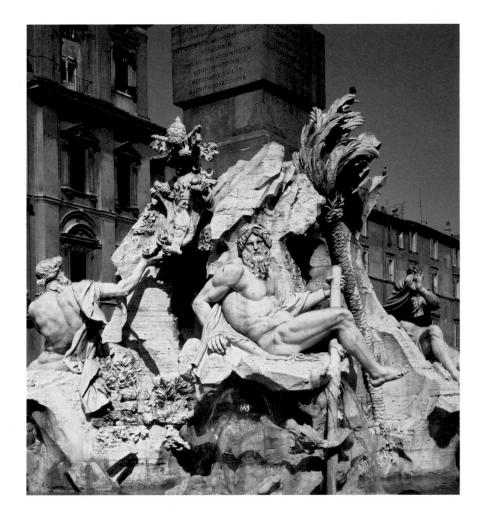

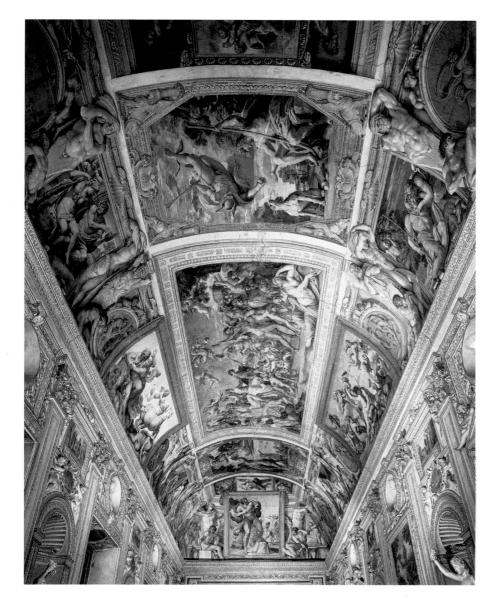

17–13 | Annibale Carracci CEILING OF GALLERY, PALAZZO FARNESE, ROME 1597–1601. Fresco, approx. $68 \times 21'$ $(20.7 \text{ m} \times 6.4 \text{ m})$

contemporaries, the Carraccis' dramatic but decorous style seemed, as one critic wrote, "to intuit the intentions of nature and thereby to close the gap between imagination and reality" (Minor, *Baroque and Rococo Art and Culture*, page 160). Caravaggio, on the other hand, satisfied the Baroque demand for drama and clarity by developing realism in a powerful new direction. He painted less than elevated subjects—the lowlife of Rome—and worked directly from his model without elaborate drawings and compositional notes. Unlike the Carracci, he claimed to ignore the masters. He intended to give the impression of immediacy, although he must have considered and adjusted his compositions carefully.

THE CARRACCI. The brothers Agostino (1557–1602) and Annibale Carracci (1560–1609) and their cousin Ludovico (1555–1619) shared a studio in Bologna. As their reevaluation of the High Renaissance masters attracted interest among their peers, they opened their doors to friends and students and then, in 1582, founded an art academy, where students

drew from live models and studied art theory, Renaissance painting, and antique classical sculpture. The Carracci placed a high value on accurate drawing, complex figure compositions, complicated narratives, and technical expertise in both oil and fresco painting. During its short life the academy had an impact on the development of the arts—and art education—through its insistence on both life drawing (to achieve naturalism) and aesthetic theory.

In 1595, Annibale was hired by the Cardinal Odoardo Farnese to decorate the principal rooms of his family's immense Roman palace. In the long *galleria* (gallery), to celebrate the wedding of Duke Ranuccio Farnese of Parma to the niece of the pope, the artist was requested to paint scenes of love based on Ovid's *Metamorphosis* (FIG. 17–13). Throughout their palace, the Farnese had an important collection of sculpture (see Introduction, Fig. 23). Undoubtedly, Annibale and Agostino, who assisted him, felt both inspiration and competition from the sculpture and architecture in the rooms below.

17–14 | Annibale Carracci LANDSCAPE WITH THE FLIGHT INTO EGYPT 1603–04. Oil on canvas, $48 \times 90\%$. Galleria Doria Pamphili, Rome.

The primary image, set in the center of the vault, is The Triumph of Bacchus and Ariadne, a joyous procession celebrating the wine god Bacchus's love for Ariadne, a woman whom he rescued after her lover, Theseus, abandoned her on the island of Naxos. Annibale combines the great tradition of ceiling painting of northern Italy—seen in the work of Mantegna and Correggio (FIGS. 14-34, 15-21)—with influences gained by his study of central Italian Renaissance painters and the classical heritage of Rome. Annibale organized his complex theme by using illusionistic devices to create multiple levels of reality. Gold-framed easel paintings called quadri riportati ("transported paintings") "rest" against the actual cornice of the vault and overlap "bronze" medallions that are flanked, in turn, by realistically colored ignudi, dramatically lit from below. The viewer is invited to compare the warm flesh tones of these youths, and their realistic poses, with the more idealized "painted" bodies in the framed scenes next to them. Above, paintings of stucco-colored sculptures of herms (plain shafts topped by human torsos) appear to support the painted framework of the vault, yet many of them also wear human expressions and seem to communicate with one another. Many of Annibale's motifs are inspired by Michelangelo's Sistine Chapel ceiling (FIG. 15–12). The figure types, true to their source, are heroic, muscular, and drawn with precise anatomical accuracy. But instead of Michelangelo's cool illumination and intellectual detachment, the Carracci ceiling glows with a warm light

that recalls the work of the Venetian painters Titian and Veronese and seems buoyant with optimism.

The ceiling was highly admired and became famous almost immediately. The Farnese family, proud of the gallery, generously allowed young artists to sketch the figures there, so that Carracci's masterpiece influenced Italian art well into the following century.

Among those present for the initial viewing of the galleria was the nephew of Pope Clement VIII, Pietro Aldobrandini, who subsequently commissioned the artist to decorate the six lunettes of his private chapel with scenes from the life of the Virgin, sometime between 1603 and 1604. LANDSCAPE WITH THE FLIGHT INTO EGYPT (FIG. 17–14), the largest of the six and one of only two that show Annibale's hand-probably occupied the position above the altar. In contrast to the dramatic figural compositions Annibale created for the Farnese gallery, the escape of the holy family is conceived within a contemplative pastoral landscape filled with golden light in the tradition of Venetian Renaissance painting (SEE FIG. 15-23). The design of the work and its affective spirit of melancholy result, however, in one of the fundamental exercises in Baroque classicism that would influence artists for generations to come. Here is nature ordered by man. Trees in the left foreground and right middle ground gracefully frame the scene; and the collection of ancient buildings in the center of the composition form a stable and protective canopy for the flight of the holy family. Space progresses gradually from foreground to background in diago-

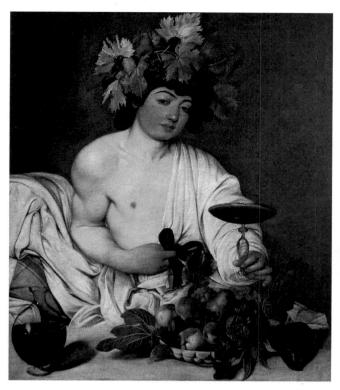

17–15 | Caravaggio **BACCHUS** 1595–96. Oil on canvas, $37 \times 33\%$ " (94 \times 85.1 cm). Galleria degli Uffizi, Florence.

nal movements that are indicated by people, animals, and architecture. Nothing is accidental, yet the whole appears unforced and entirely natural. The French painter Nicolas Poussin would soon learn lessons from Annibale's work (SEE FIG. 17–62).

CARAVAGGIO. A new powerful naturalism was introduced into painting by the Carracci's younger contemporary Michelangelo Merisi (1571–1610), known as "Caravaggio" after his family's home town in Lombardy. Lombard painters not only favored realistic art with careful drawing, they also had an interest in still life, which had been revived in the sixteenth century but was still unusual at the time. The young painter demonstrated those interests in his first known paintings when, late in 1592, he arrived in Rome from Milan and found work in the studio of the Cavaliere d'Arpino as a specialist painter of fruit and vegetables. When he began to paint on his own, he continued to paint still lifes but also included half-length figures, as in the BACCHUS (FIG. 17–15). By this time, his reputation had grown to the extent that an agent offered to market his pictures.

Caravaggio painted for a small circle of sophisticated Roman patrons. His subjects from this early period include still lifes and low-life scenes featuring fortune-tellers, cardsharps, and street urchins dressed as musicians or mythological figures like Bacchus. The figures in these pictures tend to be large, brightly lit, and set close to the picture plane. His important innovation was the decision to paint directly on the canvas. He

sketched out the figure with a sharp point—perhaps the end of his brush—and the marks can be seen through the paint. in *Bacchus*, Caravaggio painted what he saw: a slightly flabby, undressed youth. The parts of the skin that have been exposed to sun (hands and face) are darker in color than the rest of the body. His half-closed, slightly unfocused eyes look past the viewer even as he offers a glass filled with wine. Caravaggio's skill as a still-life painter is apparent in the bowl of half-rotten fruit and the decanter of wine on the table. Caravaggio's youth may appear to be simply a street tough masquerading as Bacchus, the classical god of wine; however, the painting may also have been meant as an allegory of the sins of lust and gluttony.

Most of Caravaggio's commissions after 1600 were religious, and reactions to them were mixed. On occasion, patrons rejected his powerful, sometimes brutal, naturalism as unsuitable to the subject's dignity. Critics differed as well. An early critic, the Spaniard Vincente Carducho, wrote in his *Dialogue on Painting* (Madrid, 1633) that Caravaggio was an "omen of the ruin and demise of painting" because he painted "with nothing but nature before him, which he simply copied in his amazing way" (Enggass and Brown, pages 173–74). Others recognized him as a great innovator who reintroduced realism into art and developed new, dramatic lighting effects. The art historian Giovanni Bellori, in his *Lives of the Painters* (1672), described Caravaggio's painting as

... reinforced throughout with bold shadows and a great deal of black to give relief to the forms. He went so far in this manner of working that he never brought his figures out into the daylight, but placed them in the dark brown atmosphere of a closed room, using a high light that descended vertically over the principal parts of the bodies while leaving the remainder in shadow in order to give force through a strong contrast of light and dark....

(Bellori, *Lives of the Painters*, Rome, 1672, in Enggass and Brown, page 79.)

Caravaggio's approach has been likened to the preaching of Filippo Neri (1515-95), the Counter-Reformation priest and mystic who founded a Roman religious group called the Congregation of the Oratory. Neri, called the Apostle of Rome and later canonized, focused his missionary efforts on ordinary people for whom he strove to make Christian history and doctrine understandable and meaningful. Caravaggio, too, interpreted his religious subjects directly and dramatically, combining intensely observed figures, poses, and expressions with strongly contrasting effects of light and color. His knowledge of Lombard painting, where the influence of Leonardo was strong, must have aided him in his development of the technique now known as tenebrism, in which forms emerge from a dark background into a strong light that often falls from a single source outside the painting. The effect is that of a modern spotlight.

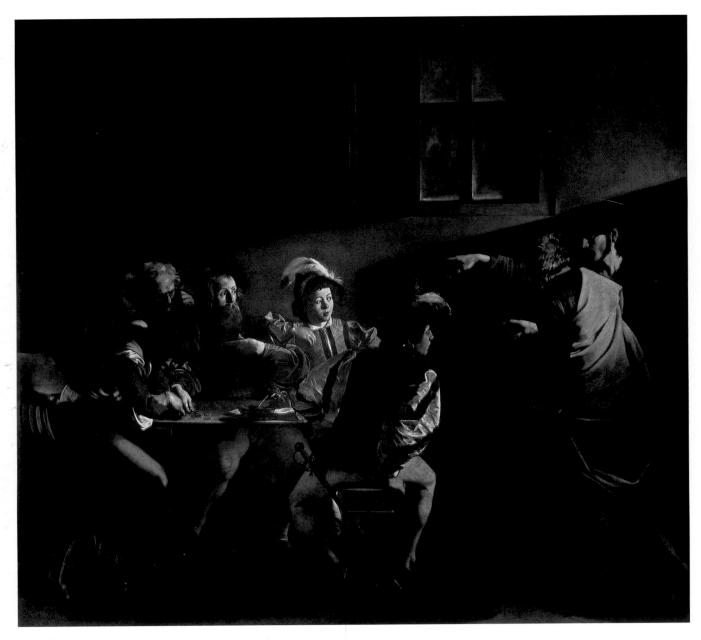

17–16 | Caravaggio THE CALLING OF SAINT MATTHEW 1599–1600. Oil on canvas, $10'7\%''\times 11'2''$ (3.24 \times 3.4 m). Contarelli Chapel, Church of San Luigi dei Francesi, Rome.

Caravaggio's first public commission, paintings for the Contarelli Chapel in the French community's Church of Saint Louis (Church of San Luigi dei Francesi), included **THE CALLING OF SAINT MATTHEW** (FIG. 17–16), painted about 1599–1600 and meant to suggest conversion, one of the tasks of the Church. The work is painted in oils. (Caravaggio had a very short apprenticeship and never seemed to have mastered the technique of fresco—nor, perhaps, skill in painting figures in depth.) The painting depicts Jesus calling Levi, the tax collector, to join his apostles (Mark 2:14). Levi sits at a table, counting out gold coins for a boy at the left, surrounded by overdressed young men in plumed hats, velvet doublets, and satin shirts. Nearly hidden behind the cloaked apostle Peter, at the right, the gaunt-

faced Jesus points dramatically at Levi, a gesture that is repeated by the tax collector's surprised response of pointing to himself. An intense raking light enters the painting from a high, unseen source at the right, above the altar, and spotlights the faces of the men. The viewpoint of the chapel visitor is the empty space across from Saint Matthew, so that she or he directly participates in the dramatic moment of conversion. For all of his realism and claims of independence, Caravaggio also used antique and Renaissance sources. Jesus's outstretched arm, for example, recalls God's gesture giving life to Adam in Michelangelo's *Creation of Adam* on the Sistine Chapel ceiling (SEE FIG. 15–14). It is now restated as Jesus's command to Levi to begin a new life by becoming his disciple Matthew.

The emotional power of Baroque realism combines with a solemn monumentality in Caravaggio's ENTOMBMENT (FIG. 17-17), painted in 1603-4 for a chapel in Santa Maria in Vallicella, the church of Neri's Congregation of the Oratory. With almost physical force, the size and immediacy of this painting strike the viewer, whose perspective is from within the burial pit into which Jesus's lifeless body is being lowered. The figures form a large off-center triangle, within which angular elements are repeated: the projecting edge of the stone slab; Jesus's bent legs; the akimbo arm, bunched coat, and knock-kneed stance of the man on the right; and even the spaces between the spread fingers of the raised hands. The Virgin and Mary Magdalen barely intrude on the scene, which, through the careful placing of the light, focuses on the dead Jesus, the sturdy-legged laborer supporting his body at the right, and the young John the Evangelist at the triangle's apex.

Despite the great esteem in which Caravaggio was held by some, especially the younger generation of artists, his violent temper repeatedly got him into trouble. During the last decade of his life, he was frequently arrested, generally for minor offenses such as street brawling. In 1606, however, he killed a man in a fight over a tennis match and had to flee Rome. He went first to Naples, then to Malta, finding work in both places. The Knights of Malta awarded him the cross of their religious and military order in July 1608, but in October he was imprisoned for insulting one of their number, and again he escaped and fled. The aggrieved knight's agents tracked him to Naples in the spring of 1610 and severely wounded him. The artist recovered and moved north to Port'Ercole, where he died of a fever on July 18, 1610, just short of his thirty-ninth birthday. Caravaggio's intense realism and tenebrist lighting influenced nearly every important European artist of the seventeenth century.

GENTILESCHI. One of Caravaggio's most successful Italian followers was Artemisia Gentileschi (1593-c. 1652/53), whose international reputation helped spread the Caravaggesque style beyond Rome. Born in Rome, Artemisia first studied and worked under her father, one of the early followers of Caravaggio. In 1616, she moved to Florence, where she worked for the grand duke of Tuscany and was elected, at the age of twenty-three, to the Florentine Academy of Design. As a resident of Florence, Artemisia was well aware of the city's identification with the Jewish hero David and heroine Judith (both subjects of sculpture by Donatello and Michelangelo), and she painted several versions of Judith triumphant over the Assyrian general Holofernes (FIG. 17-18). Artemisia brilliantly uses Baroque naturalism and tenebrist effects, dramatically showing Judith still holding the bloody sword and hiding the candle's light as her maid stuffs the general's head into a sack. Tension mounts-enhanced by the dramatic use of light—as the women listen for the sounds of guards.

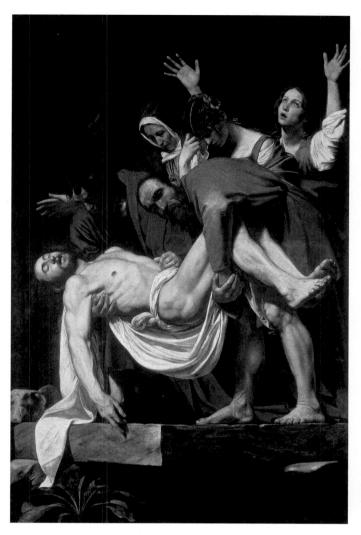

17–17 | Caravaggio ENTOMBMENT
Vittrici Chapel, Church of Santa Maria in Vallicella, Rome.
1603–4. Oil on canvas, 9′10½″ × 6′7½″ (3 × 2.03 m).
Musei Vaticani, Pinacoteca, Rome.

The Entombment was one of many paintings confiscated from Rome's churches and taken to Paris during the French occupation by Napoleon's troops in 1798 and 1808–14. It was one of the few to be returned after 1815 through the negotiations of Pius VII and his agents, who were assisted greatly by the Neoclassical sculptor Antonio Canova, a favorite of Napoleon. The decision was made not to return the works to their original churches and chapels but instead to assemble them in a gallery where the general public could enjoy them. Today, Caravaggio's painting is one of the most important in the collections of the Vatican Museums.

Religious subjects have dominated Western art since the medieval period. Beginning in the Renaissance, however, themes drawn from mythology, literature, daily life, and folklore began to play a significant role. Starting with Mannerism, and continuing into the Baroque period, artists and patrons delighted in iconography that was often complex and extremely subtle. A sourcebook, the *Iconologia*, by Cesare Ripa (1593), became an essential tool for creating and deciphering

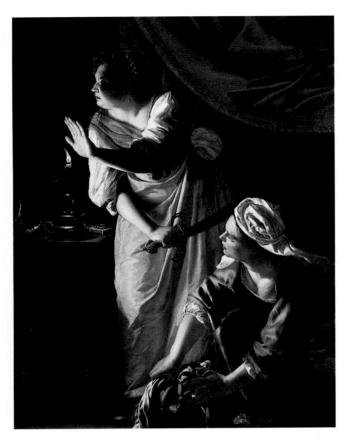

17–18 | Artemisia Gentileschi JUDITH AND MAIDSERVANT WITH THE HEAD OF HOLOFERNES
1625. Oil on canvas, $6'7_2'' \times 4'7''$ (1.84 × 1.41 m). The Detroit Institute of Arts.
Gift of Leslie H. Green, (52.253)

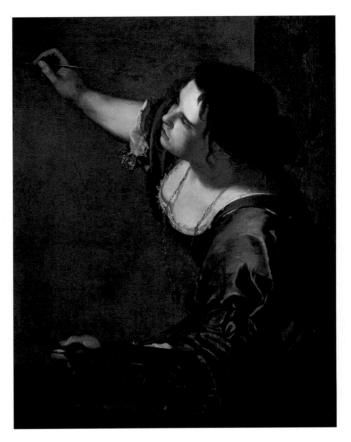

17–19 | Artemisia Gentileschi SELF-PORTRAIT AS THE ALLEGORY OF PAINTING 1630. Oil on canvas, $38 \times 29''$ (96.5×73.7 cm). The Royal Collection, Windsor Castle, England. (RCIN 405551, ML 49 BP 2652)

seventeenth- and eighteenth-century art. Painters and patrons turned to it when they needed detailed instruction or new ways to present a subject or person. Artemisia Gentileschi was no exception. In 1630, she painted SELF-PORTRAIT AS THE THE ALLEGORY OF PAINTING (FIG. 17-19), personified by a richly dressed woman with palette and brushes. The Iconologia's influence is revealed in the woman's gold necklace with its mask pendant. Ripa writes that the mask imitates the human face, as painting imitates nature, and the gold chain symbolizes "the continuity and interlocking nature of painting, each man learning from his master and continuing his master's achievements in the next generation" (cited in E. Maser, trans. no. 197). Artemisia may have painted her own features as the personification of painting, in which case she not only commemorates her profession but also pays tribute to those who came before.

FOLLOWERS OF THE CARRACCI. The Carracci had many Italian followers and students. Baroque classicism was preferred by patrons and artists for the altarpieces and murals required by the many new churches being built in Rome.

Giovanni Francesco Barbieri (1591-1666), called "Il Guercino" ("The Little Squinter"), responded to developments in classicism, and perhaps also to the work of Ludovico Carracci, during a brief sojourn in Rome in 1621-23. In Guercino's painting of Saint Luke Displaying a Painting of the Virgin (Introduction, Fig. 15) for the high altar of the Franciscan church in Reggio nell'Emilia, near Bologna, his palette has evolved from the pronounced chiaroscuro of his early work to the lighter colors of artists like Guido Reni (SEE FIG. 17-20). In keeping with the desire for greater naturalism and contemporary relevance in religious art, Luke turns to the viewer as if in the middle of a discussion about his painting of the Virgin and Child, a copy of a Byzantine icon believed by the Bolognese to have been painted by Luke himself. Although Protestants ridiculed the idea that paintings by Luke existed, Catholics staunchly defended their authenticity. Guercino's painting, then, is both an homage to the patron saint of painters and a defense of the miracle-working Madonna di San Luca in his hometown. The classical architecture and idealized figures typify Bolognese academic art.

The most important Italian Baroque classicist after Annibale Carracci was the Bolognese artist Guido Reni (1575–1642), who briefly studied at the Carracci academy in 1595. By 1620, Guido Reni had become the most popular painter in Italy.

In 1613-14, during a sojourn in Rome, Reni decorated the ceiling of a palace garden house (casino in Italian) in Rome with his most famous work, AURORA (FIG. 17–20). The fresco emulates the illusionistic mythological scenes in quadro riportato on the Farnese ceiling, although Reni made no effort to relate his painting's space to that of the room. Indeed, Aurora appears to be a framed oil painting incongruously attached to the ceiling. The composition itself, however, is Baroque classicism at its most lyrical. Framed by self-emanating golden light, Apollo, escorted by Cupid and the Seasons, drives the sun chariot. Ahead, the flying figure of Aurora, goddess of the dawn, leads Apollo's horses at a sharp diagonal over a dramatic Venetian sky. The measured, processional staging and idealized forms seem to have been derived from an antique relief, and the precise drawing owes much to Annibale Carracci and academic training. But the graceful figures, the harmonious rhythms of gesture and drapery, and the intense color are Reni's own, demonstrating his close study of models and his skillful combination of the real and ideal.

BAROQUE CEILINGS: CORTONA AND GAULLI. Theatricality, intricacy, and the opening of space reached an apogee in Baroque ceiling decoration. Baroque ceiling projects were complex constructions combining architecture, painting, and stucco sculpture. These grand illusionistic projects were car-

ried out on the domes and vaults of churches, civic buildings, palaces, and villas, and went far beyond even Michelangelo's Sistine Chapel ceiling (SEE FIG. 15–12) or Correggio's dome (SEE FIG. 15–21). In addition to using the device of the quadro riportate, Baroque ceiling painters were also concerned with achieving the drama of an immeasurable heaven that extended into vertiginous zones far beyond the limits of High Renaissance taste. To achieve this, they employed the system of quadratura (literally, "squaring" or "gridwork"): an architectural setting painted in meticulous perspective and usually requiring that it be viewed from a specific spot to achieve the effect of soaring space. The resulting viewpoint is called di sotto in su ("from below to above"), which we first saw, in a limited fashion, in Mantegna's ceiling (FIG. 14-34). Because it required such careful calculation, figure painters usually had specialists in quadratura paint the architectural frame for them.

Pietro Berretzini (1596–1669), called "Pietro da Cortona" after his hometown, carried the development of the Baroque ceiling away from classicism into a more strongly unified and illusionistic direction. Trained in Florence and inspired by Veronese's ceiling in the doge's palace, which he saw on a trip to Venice in 1637, the artist was commissioned in the early 1630s by the Barberini family of Pope UrbanVIII to decorate the ceiling of the audience hall of their Roman palace. A drawing by a Flemish artist visiting Rome, Lieven Cruyl (1640–c. 1720), gives us a view of the Barberini's huge palace, piazza, and the surrounding city. Bernini's Trident Fountain stands in the center of the piazza, and his scallop shell fountain can be seen at the right (FIG. 17–21).

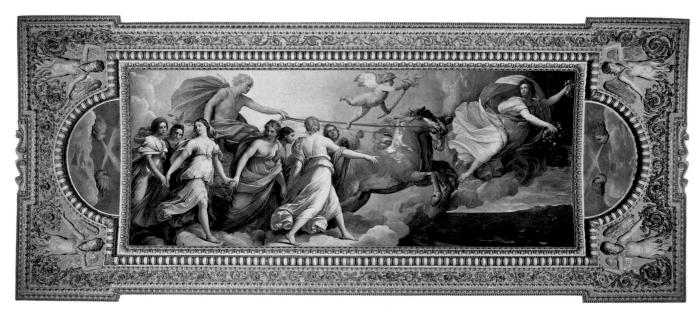

17–20 | Guido Reni AURORA Ceiling of the Garden House, Palazzo Rospigliosi-Palavacini, Rome. 1613–14. Fresco.

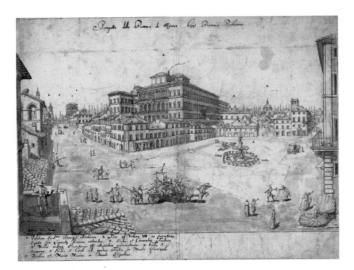

17–21 | BARBERINI PALACE AND SQUARE 1628–36. Drawing by Lieven Cruyl, 1665. Ink and chalk on paper, 15 × 19½" (38.2 × 49.4 cm). The Cleveland Museum of Art. Cleveland, Ohio. Dudley P. Allen Fund 1943.265.

Maderno, Bernini, and Borromini collaborated on the Barberini Palace between 1628 and 1636, and in the 1670s the structure underwent considerable remodeling. The original plan is unique, having no precedents or imitators in the history of Roman palaces. The structure appears as a single massive pile, but in fact it consists of a central reception block flanked by two residential wings and two magnificent staircases. Designed to house two sides of the family, the rooms are arranged in suites allowing visitors to move through them achieving increasing intimacy and privacy. Since Cruyl visited the city during Carnival, a Carnival float with musicians and actors takes center stage among the strollers. The Carnival floats are among the ephemera of art. (Today we might call them "performance art.") Cruyl, who includes his own image at the left, published his drawings as engravings, a set of fifteen plates called *Views of Rome*, in 1665.

Pietro's great fresco, **THE GLORIFICATION OF THE PAPACY OF URBAN VIII**, became a model for a succession of Baroque illusionistic palace ceilings throughout Europe (FIG. 17–22). Cortona structured his mythological scenes around a vault-like skeleton of architecture, painted in *quadratura* that appears to be attached to the actual cornice of the room. But in contrast to Annibale Carracci's neat separations and careful *quadro riportato* framing, Pietro's figures weave in and out of their setting in active and complex profusion; some rest on the actual cornice, while others float weightlessly against the sky. Instead of Annibale's warm, nearly even light, Pietro's dramatic illumination, with its bursts of brilliance alternating with deep shadows, fuses the ceiling into a dense but unified whole.

The subject is an elaborate allegory of the virtues of the pope. Just below the center of the vault, seated at the top of a pyramid of clouds and figures personifying Time and the Fates, Divine Providence (in gold against an open sky) gestures toward three giant bees surrounded by a huge laurel wreath (both Barberini emblems) carried by Faith, Hope, and Charity. Immortality offers a crown of stars, while other figures present the crossed keys and the triple-tiered crown of the papacy. Around these figures are scenes of Roman gods and goddesses, who demonstrate the pope's wisdom and virtue by triumphing over the vices. So complex was the imagery that a guide gave visitors an explanation, and one member of the household published a pamphlet, still in use today, explaining the painting.

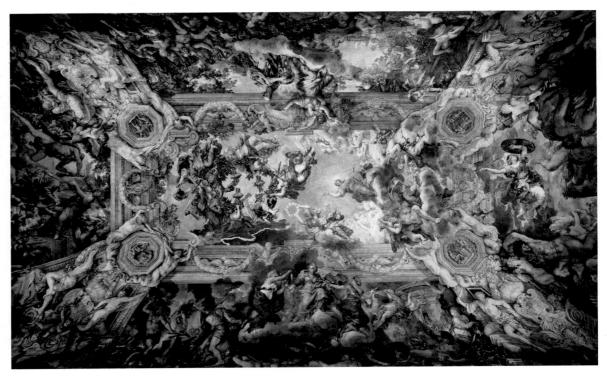

17–22 | Pietro da Cortona | THE GLORIFICATION OF THE PAPACY OF URBAN VIII Ceiling in the Gran Salone, Palazzo Barberini, Rome. 1632–39. Fresco.

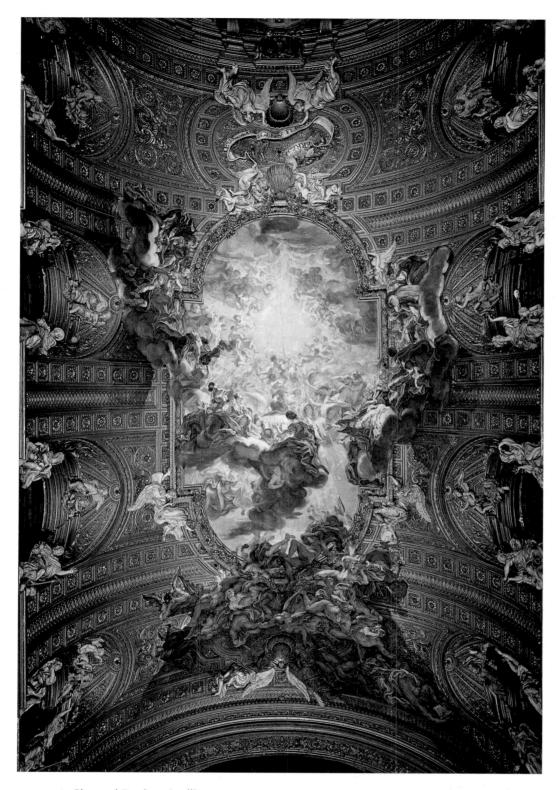

The most spectacular of all, and the ultimate illusionistic Baroque ceiling, is Gaulli's **THE TRIUMPH OF THE NAME OF JESUS AND THE FALL OF THE DAMNED** (FIG. 17–23), which fills the vault of the Jesuit church Il Gesù. In the 1560s, Giacomo da Vignola had designed an austere interior for Il Gesù,

but when the Jesuits renovated their church a century later, they commissioned a religious allegory to cover the nave's plain ceiling. Giovanni Battista Gaulli (1639–1709) designed and executed the spectacular illusion between 1672 and 1685, fusing sculpture and painting to eliminate any appearance of

architectural division. It is impossible to understand which figures are three-dimensional and which are painted, and some paintings are on real panels that extend over the actual architectural frame. Gaulli, who arrived in Rome from Genoa in 1657, had worked in his youth for Bernini, from whom he absorbed a taste for drama and for multimedia effects. The elderly Bernini, who worshiped daily at Il Gesù, may well have offered his personal advice to his former assistant, and Gaulli was certainly familiar with other illusionistic paintings in Rome as well, including Pietro da Cortona's Barberini ceiling.

Gaulli's astonishing creation went beyond anything that had preceded it in unifying architecture, sculpture, and painting. Every element is dedicated to creating the illusion that clouds and angels have floated down through an opening in the church's vault into the upper reaches of the nave. The extremely foreshortened figures are projected as if seen from below, and the whole composition is focused off-center on the golden aura around the letters IHS, the monogram of Jesus and the insignia of the Jesuits. The subject is, in fact, a Last Judgment, with the elect rising joyfully toward the name of God and the damned plummeting through the ceiling toward the nave floor. The sweeping inclusion in the work of the space of the nave, the powerful and exciting appeal to the viewer's emotions, and the nearly total unity of visual effect have never been surpassed.

THE HABSBURG LANDS

When the Holy Roman Emperor Charles V abdicated in 1556 (see Chapter 21), he left Spain and its American colonies, the Netherlands, Burgundy, Milan, and the Kingdom of Naples and Sicily to his son Philip II and the Holy Roman Empire (Germany and Austria) to his brother Ferdinand. Ferdinand and the Habsburg emperors who succeeded him ruled their territories from Vienna in Austria, but much of German-speaking Europe remained divided into small units in which local rulers decided on the religion of their territory. Catholicism prevailed in southern and western Germany and in Austria, while the north was Lutheran.

The Spanish Habsburg kings Philip III (ruled 1598-1621), Philip IV (ruled 1621-65), and Charles II (ruled 1665–1700) reigned over a weakening empire. After repeated local rebellions, Portugal reestablished its independence in 1640. The Kingdom of Naples remained in a constant state of unrest. After eighty years of war, the Protestant northern Netherlands—which had formed the United Dutch Republic-gained independence in 1648. Amsterdam grew into one of the wealthiest cities of Europe, and the Dutch Republic became an increasingly serious threat to Spanish trade and colonial possessions. The Catholic southern Netherlands (Flanders), discussed separately below, remained under Spanish and then Austrian Habsburg rule.

What had seemed an endless flow of gold and silver from the Americas to Spain diminished, as precious-metal production in Bolivia and Mexico lessened. Agriculture, industry, and trade at home also suffered. As they tried to defend the Roman Catholic Church and their empire on all fronts, the Spanish kings squandered their resources and finally went bankrupt in 1692. Nevertheless, despite the decline of the Habsburgs' Spanish empire, seventeenth-century writers and artists produced much of what is considered the greatest Spanish literature and art, and the century is often called the Spanish Golden Age.

Painting in Spain's Golden Age

The primary influence on Spanish painting in the fifteenth century had been the art of Flanders; in the sixteenth, it had been the art of Florence and Rome. Seventeenth-century Spanish painting, profoundly influenced by Caravaggio's powerful art, was characterized by an ecstatic religiosity combined with intense realism whose surface details emerge from the deep shadows of tenebrism. This influence is not surprising, since the Kingdom of Naples was ruled by Spanish monarchs, and contact between Naples and the Iberian peninsula was strong and productive.

Juan Sánchez Cotán. Late in the sixteenth century, Spanish artists developed a significant interest in paintings of artfully arranged objects rendered with intense attention to detail. Juan Sánchez Cotán (1561-1627) was one of the earliest painters of these pure still lifes in Spain. In STILL LIFE WITH

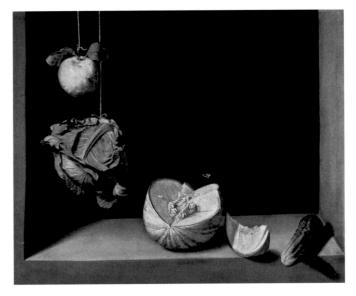

17-24 Juan Sánchez Cotán STILL LIFE WITH QUINCE, CABBAGE, MELON, AND CUCUMBER c. 1602. Oil on canvas, $27\% \times 33\%$ (68.8 \times 84.4 cm). San Diego Museum of Art.

Gift of Anne R. and Amy Putnam

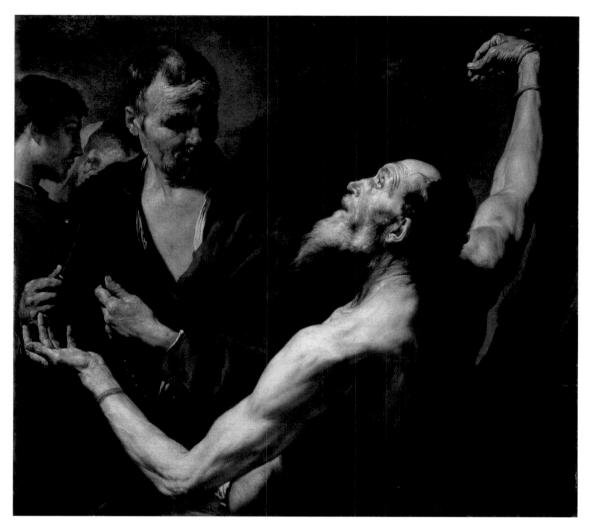

17–25 | Jusepe de Ribera MARTYRDOM OF SAINT BARTHOLOMEW 1634. Oil on canvas, $41\% \times 44\%$ (1.05 \times 1.14 m). National Gallery of Art, Washington, D.C. Gift of the 50th Anniversary Gift Committee (1990.137.1)

QUINCE, CABBAGE, MELON, AND CUCUMBER (FIG. 17–24), of about 1602, he plays off the irregular, curved shapes of the fruits and vegetables against the angular geometry of the ledge. His precisely ordered subjects—two of which are suspended from strings—form a long arc from the upper left to the lower right. It is not clear whether the seemingly airless space is a wall niche or a window ledge or why these objects have been arranged in this way. Set in a strong light against impenetrable darkness, this highly artificial arrangement portrayed in an intensely realistic manner suggests not only a fascination with spatial ambiguity but a contemplative sensibility and interest in the qualities of objects that look forward to the work of Zurbarán and Velázquez.

Jusepe de Ribera. José or Jusepe de Ribera (c. 1591–1652), born in Seville but living in Naples, has been claimed by both Spain and Italy; however, Naples was ruled by Spain, and in Italy he was known as "Lo Spagnoletto" ("the Little

Spaniard"). He combined the classical and Caravaggesque styles he had learned in Rome, and after settling in Naples in 1620, he created a new Neapolitan—and eventually Spanish—style. Ribera became the link extending from Caravaggio in Italy to the Spanish masters Zurbarán and Velázquez. Ribera was once thought to epitomize Spanish religiosity.

Scenes of martyrdom became popular as the church—aiming to draw people back to Catholicism—ordered art depicting heroic martyrs who had endured shocking torments as witness to their faith. Others, like Saint Teresa (SEE FIG. 17–6), reinforced the importance of personal religious experience and intuitive knowledge. A striking response to this call for relevance and passion is Ribera's painting of Saint Bartholomew, an apostle who was martyred by being skinned alive (FIG. 17–25). The bound Bartholomew looks heavenward as his executioner tests the knife that he will soon use on his still-living victim. Ribera has learned the lessons of Caravaggio well, as he highlights the intensely realistic aged

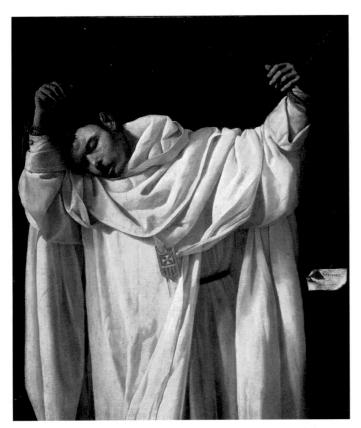

17–26 | Francisco de Zurbarán SAINT SERAPION 1628. Oil on canvas, $47\frac{1}{2} \times 40\frac{1}{4}$ " (120.7 \times 103.5 cm). Wadsworth Atheneum, Hartford, Connecticut. Ella Gallup Sumner and Mary Catlin Sumner Collection Fund

faces with the dramatic light of tenebrism and depicts the aging wrinkled flesh with almost painful naturalism. The compression of the figures into the foreground space heightens their immediacy and horror.

FRANCISCO DE ZURBARÁN. Equally horrifying in its depiction of martyrdom, but represented with understated control, is the 1628 painting of **SAINT SERAPION** (FIG. 17–26) by Francisco de Zurbarán (1598–1664). Little is known of his early years before 1625, but Zurbarán too came under the influence of the Caravaggesque taste prevalent in Seville, the major city in southwestern Spain. His own distinctive style incorporated a taste for abstract design, which some critics see as part of the heritage of centuries of Islamic Moorish occupation.

Zurbarán executed his major commissions for the monastic orders. In the painting shown here, he portrays the martyrdom of Serapion, who was a member of the thirteenth-century Mercedarians, a Spanish order founded to rescue the Christian prisoners of the Moors. Following the vows of his order, Serapion sacrificed himself in exchange for Christian captives. The dead man's pallor, his rough hands,

and the coarse ropes contrast with the off-white of his creased Mercedarian habit, its folds carefully arranged in a pattern of highlights and varying depths of shadow. The only colors are the red and gold of the insignia. This composition, almost timeless in its immobility, is like a tragic still life, a study of fabric and flesh.

DIEGO VELÁZQUEZ. Diego Rodríguez de Silva y Velázquez (1599-1660), the greatest painter to emerge from the Caravaggesque school of Seville, shared this fascination with objects. Velázquez entered Seville's painters' guild in 1617. Like Ribera, he began his career as a tenebrist and naturalist. During his early years, he painted figural works set in taverns, markets, and kitchens and emphasized still lifes of various foods and kitchen utensils. His early water carrier of SEVILLE (FIG. 17-27) is a study of surfaces and textures of the splendid ceramic pots that characterized folk art through the centuries. Velázquez was devoted to studying and sketching from life, and the man in the painting was a well-known Sevillian water seller. Like Sánchez Cotán, Velázquez arranged the elements of his paintings with almost mathematical rigor. The objects and figures allow the artist to exhibit his virtuosity in rendering sculptural volumes and contrasting textures illuminated by dramatic natural light. Light reacts to the surfaces: reflecting off the glazed waterpot at the left and the coarser clay jug in the foreground; being absorbed by the rough wool and dense velvet of the costumes; and reflecting, being refracted, and passing through the clear glass held by the man and through the waterdrops on the jug's surface.

In 1623, Velázquez moved to Madrid, where he became court painter to young King Philip IV, a prestigious position that he held until his death in 1660. The opportunity to study paintings in the royal collection, as well as to travel, enabled the development of his distinctive personal style. The Flemish painter Peter Paul Rubens (see pages 644–647), during a 1628–29 diplomatic visit to the Spanish court, convinced the king that Velázquez should visit Italy. Velázquez made two trips, the first in 1629–31 and a second in 1649–51. He was profoundly influenced by contemporary Italian painting, and on the first trip seems to have taken a special interest in narrative paintings with complex figure compositions.

Velázquez's Italian studies and his growing skill in composition are apparent in both figure and landscape painting. In **THE SURRENDER AT BREDA** (FIG. 17–28), painted in 1634–35, Velázquez treats the theme of triumph and conquest in an entirely new way—far removed from traditional gloating military propaganda. Years earlier, in 1625, the duke of Alba, the Spanish governor, had defeated the Dutch at Breda. In Velázquez's imagination, the opposing armies stand on a hilltop overlooking a vast valley where the city of Breda burns and soldiers are still deployed. The Dutch commander, Justin of Nassau, hands over the keys of Breda to the

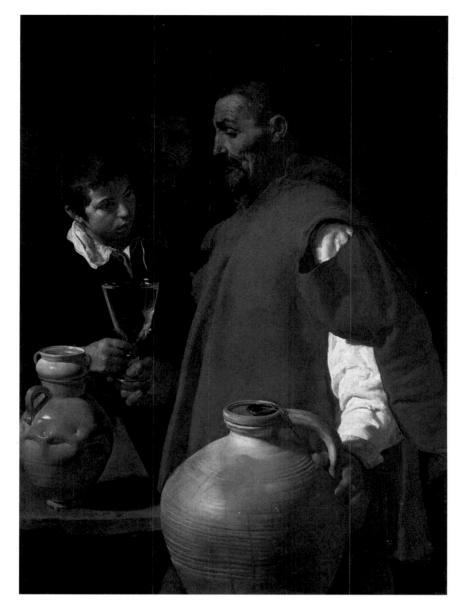

17–27 | Diego Velázquez | WATER CARRIER OF SEVILLE c. 1619. Oil on canvas, $41\% \times 31\%''$ (105.3 \times 80 cm). Victoria & Albert Museum, London.

In the hot climate of Seville, Spain, where this painting was made, water vendors walked the streets selling cool drinks from arge clay jars like the one in the foreground. In this scene, the clarity and purity of the water are proudly attested to by its seller, who offers the customer a sample poured into a glass goblet. The jug contents were usually flavored with the addition of a piece of fresh fruit or a sprinkle of aromatic herbs.

victorious Spanish commander, Ambrosio Spinola, the duke of Alba. The entire exchange seems extraordinarily gracious; the painting represents a courtly ideal of gentlemanly conduct. The victors stand at attention, holding their densely packed lances upright in a vertical pattern—giving the painting its popular name, "The Lances"—while the defeated Dutch, a motley group, stand out of order, with pikes and banners drooping. The painting is memorable as a work of

art, not as history. According to reports, no keys were involved and the Dutch were more presentable in appearance than the Spaniards. The victory was short-lived: The Dutch retook Breda in 1637.

In *The Surrender at Breda*, Velázquez displays his ability to arrange a large number of figures to tell a story effectively. A strong diagonal starting in the sword of the Dutch soldier in the lower left foreground and ending in the checked banner

on the upper right unites the composition and moves the viewer thematically from the defeated to the victorious soldiers. Portraitlike faces, meaningful gestures, and brilliant control of color and texture convince us of the reality of the scene. The landscape painting is almost startling. Across the huge canvas, Velázquez painted an entirely imaginary Netherlands in greens and blues worked with flowing, liquid brushstrokes. Luminosity is achieved by laying down a thick layer of lead white and then flowing the layers of color over it. The silvery light forms a background for dramatically silhouetted figures and weapons. Velázquez revealed a breadth and intensity unsurpassed in his century; his painting has inspired modern artists such as Manet and Picasso.

Although complex compositions became characteristic of many of Velázquez's paintings, perhaps his most striking and enigmatic work is the enormous multiple portrait, nearly 10½ feet tall and over 9 feet wide, known as **LAS MENINAS** (THE MAIDS OF HONOR) (FIG. 17–29). Painted in 1656, near the end of the artist's life, this painting continues to challenge the viewer and stimulate debate. Like Caravaggio's *Entombment* (SEE FIG. 17–17), it draws the viewer directly into its action, for in one interpretation, the viewer is apparently standing in the space occupied by King Philip and the queen, whose reflections can be seen in the large mirror on the back

wall. (Others say the mirror reflects the canvas on which Velázquez is working.) The central focus, however, is not on the royal couple or on the artist but on the 5-year-old *infanta* (princess) Margarita, who is surrounded by her attendants, most of whom are identifiable portraits.

The cleaning of *Las Meninas* in 1984 revealed much about Velázquez's methods. He used a minimum of underdrawing, building up his forms with layers of loosely applied paint and finishing off the surfaces with dashing highlights in white, lemon yellow, and pale orange. Velázquez tried to depict the optical properties of light rather than using it to model volumes in the classical time-honored manner. While his technique captures the appearance of light on surfaces, at close inspection his forms dissolve into a maze of individual strokes of paint.

No consensus exists today on the meaning of this monumental painting. Yes, it is a royal portrait; it is also a self-portrait of Velázquez standing at his easel. But more than that, Las Meninas seems to have been a personal statement. Throughout his life, Velázquez had sought respect and acclaim for himself and for the art of painting. Here, dressed as a courtier, the Order of Santiago on his chest (added later) and the keys of the palace in his sash, Velázquez proclaimed the dignity and importance of painting as one of the liberal arts.

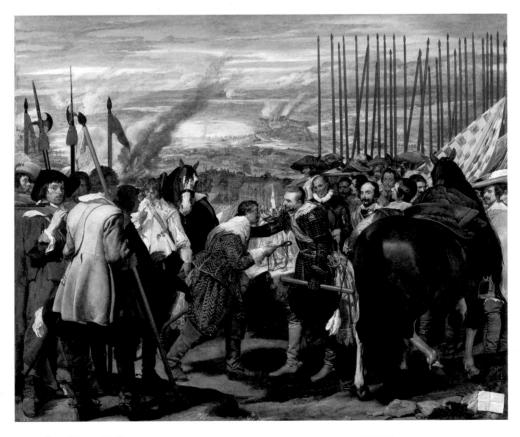

17–28 | Diego Velázquez | THE SURRENDER AT BREDA (THE LANCES) 1634–35. Oil on canvas, $10'\%'' \times 12'\%''$ (3.07 \times 3.67 m). Museo del Prado, Madrid.

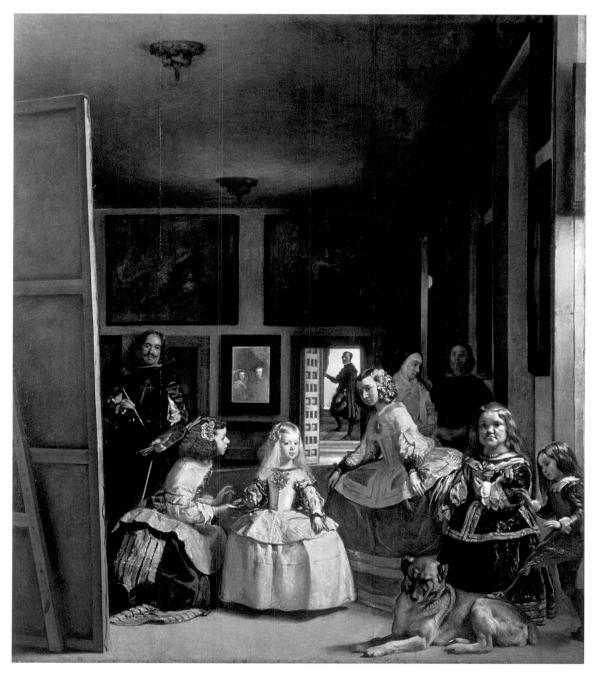

17–29 | Diego Velázquez LAS MENINAS (THE MAIDS OF HONOR) 1656. Oil on canvas, 10′5″ × 9′½″ (3.18 × 2.76 m). Museo del Prado, Madrid.

BARTOLOMÉ ESTEBAN MURILLO. The Madrid of Velázquez was the center of Spanish art; Seville declined after an outbreak of plague in 1649. Still living and working in Seville, however, was Bartolomé Esteban Murillo (1617–82). Seville was a center for trade with the Spanish colonies, where Murillo's work had a profound influence on art and religious iconography. Many patrons wanted images of the Virgin Mary and especially of the Immaculate Conception, the controversial idea that Mary was born free from original sin. Although the Immaculate Conception became Catholic dogma only in

1854, the concept, as well as devotion to Mary, was widespread during the seventeenth and eighteenth centuries.

Counter-Reformation authorities provided specific instructions for artists painting the Virgin: Mary was to be dressed in blue and white, her hands folded in prayer, as she is carried upward by angels, sometimes in large flocks. She may be surrounded by an unearthly light ("clothed in the sun") and may stand on a crescent moon in reference to the woman of the apocalypse. Angels often carry palms and symbols of the Virgin, such as a mirror, a fountain, roses, and lilies, and

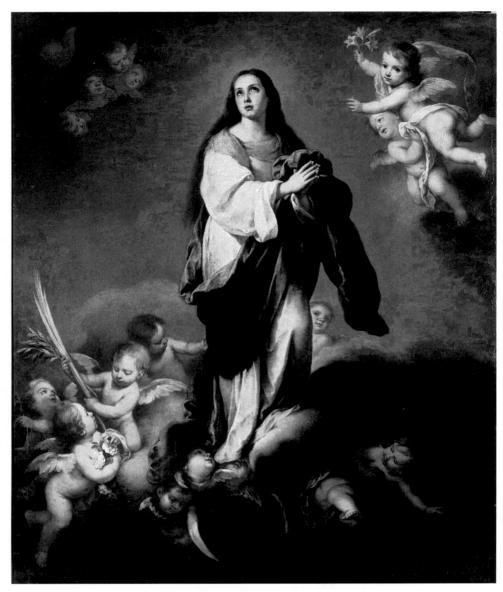

I7–30 | Bartolomé Esteban Murillo THE IMMACULATE CONCEPTION c. 1645–50. Oil on canvas, $7'8'' \times 6'5''$ (2.35 \times 1.96 m). State Hermitage Museum, St. Petersburg, Russia.

they may vanquish the serpent, Satan. Today, Murillo's paintings are admired for his skill as a draftsman and colorist. His version of ideal beauty—in Mary, Jesus, or the cherubs that surround Mary—is never cloying. The Church exported many paintings by Murillo, Zurbarán, and others to the New World. When the native population began to visualize the Christian story, paintings such as Murillo's **THE IMMACULATE CONCEPTION** provided the imagery (FIG. 17–30).

Architecture in Spain and Austria

THE CATHEDRAL OF SANTIAGO DE COMPOSTELA. Turning away from the severity displayed in the sixteenth-century El Escorial monastery-palace (SEE FIG. 16–19), Spanish architects again embraced the lavish decoration that had characterized

their art since the fourteenth century. The profusion of ornament typical of Moorish and Gothic architecture in Spain swept back into fashion, first in huge retablos (altarpieces), then in portals (main doors often embellished with sculpture), and finally in entire buildings.

In the seventeenth century, the role of Saint James as patron saint of Spain was challenged by the supporters of Saint Teresa of Ávila and then by supporters of Saint Michael, Saint Joseph, and other popular saints. It became important to the archbishop and other leaders in Santiago de Compostela, where the Cathedral of Saint James was located, to establish their primacy. They reinforced their efforts to revitalize the yearly pilgrimage to the city, undertaken by Spaniards since the ninth century, and used architecture as part of their campaign.

Renewed interest in pilgrimages to the shrines of saints in the seventeenth century brought an influx of pilgrims, and consequently financial security, to the city and the church. The cathedral chapter ordered a façade of almost unparalleled splendor to be added to the twelfth-century pilgrimage church (FIG. 17–31). The twelfth-century portal had already been closed with doors in the sixteenth century and a staircase built that incorporated the western crypt. A south tower was built in 1667–80 and then later copied as the north tower.

The last man to serve as architect and director of works, Fernando Casas y Nóvoas (active 1711–49), tied the disparate elements together at the west—towers, portal, stairs—in a grand design focused on a veritable wall of glass, popularly called "The Mirror." His design culminates in a freestanding gable soaring above the roof, visually linking the towers, and framing a statue of Saint James. The extreme simplicity of the cloister walls and the archbishop's palace at each side of the portal heighten the dazzling effect of this enormous expanse of glass windows, glittering jewel-like in their intricately carved granite frame.

THE BENEDICTINE ABBEY, MELK. The arts suffered in seventeenth-century Germanic lands, including Austria, during and after the Protestant Reformation. Wars over religion ravaged the land. When peace finally returned in the eighteenth cen-

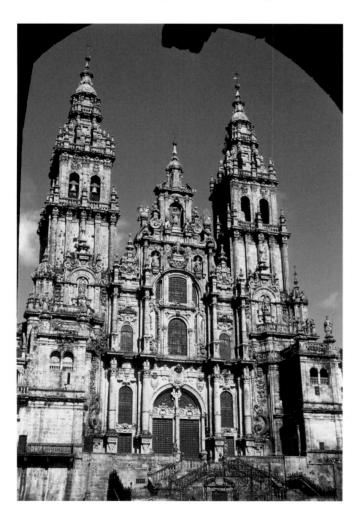

Sequencing Events KEY SCIENTIFIC AND MATHEMATICAL DISCOVERIES IN THE SEVENTEENTH CENTURY

1609, 1619	Johannes Kepler (Germany) publishes his three laws of planetary motion
1619	William Harvey (England) announces discovery of the circulation of the blood
1643	Evangelista Torricelli (Italy) invents barometer
1654	Blaise Pascal and Pierre de Fermat (France) develop the theory of probability
1675	Ole Romer (Denmark) establishes that light travels at a determined speed
1687	Isaac Newton (England) publishes his laws of gravity and motion

tury, Catholic Austria and Bavaria (southern Germany) saw a remarkable burst of building activity, including the creation and refurbishing of churches and palaces with exuberant interior decoration. Emperor Charles VI (ruled 1711–40) inspired building in his capital, Vienna, and throughout Austria.

17–31 WEST FAÇADE, CATHEDRAL OF SAINT JAMES, SANTIAGO DE COMPOSTELA, SPAIN.

South tower 1667-1680; north tower and central block finished mid-18th century by Fernando de Casas y Nóvoas.

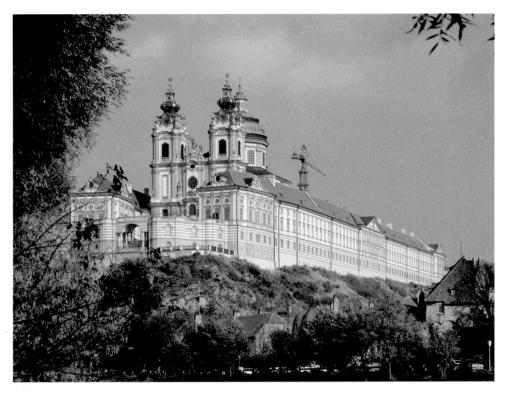

17–32 | Jakob Prandtauer | **BENEDICTINE MONASTERY CHURCH, MELK** Austria. 1702–36 and later.

Church architecture looked to Italian Baroque developments, which were then added to German medieval forms such as tall bell towers. With these elements, German Baroque architects gave their churches an especially strong vertical emphasis. One of the most imposing buildings of this period is the Benedictine Abbey of Melk, built high on a promontory overlooking the Danube River on a site where there had been a Benedictine monastery since the eleventh century. The complex combines church, monastery, library, and—true to the Benedictine tradition of hospitality—guest quarters that evolved into a splendid palace to house the traveling court (FIG. 17–32). The architect, Jakob Prandtauer (1660–1726), oversaw its construction from 1702 until his death in 1726. The buildings were finished in 1749.

Seen from the river, the monastery appears to be a huge twin-towered church, but it is in fact a complex of buildings. Two long (1,050 feet) parallel wings flank the church; one contains a great hall and the other, the monastery's library. The wings are joined by a curving building and terrace overlooking the river in front of the church. Large windows and open galleries take advantage of the river view. Colossal pilasters and high, bulbous-domed towers emphasize the building's verticality. Its grand and palacelike appearance is a reminder that the monastery was an ancient foundation enjoying imperial patronage.

Spectacular as it is, even the Danube River view does not prepare one for the interior of the church (FIG. 17–33). People descending the spiral staircase from the hall and

library emerge into an amazing yellow and pink confection. Every surface moves. Huge deep red pilasters support a massive undulating entablature. They establish the semblance of a wall behind which the chapels, galleries, and screens curve and disappear in a maze of gilded sculpture. Light from huge clerestory windows, reminiscent of ancient Roman architecture, enhance the effect of detachment. One cannot distinguish actual from fictive architecture. Figures seem to spill out over the architecture which—as in Gaulli's ceiling for Il Gesù (SEE FIG. 17–23)—sometimes is actually built and sometimes is fiction. Overhead white, gold, and pastel colors cause the frescoed vault to seem to float upward, detached from architecture below. The painting is the work of the first great Austrian Baroque muralist, Johann Michael Rottmayr (c. 1654–1750).

FLANDERS AND THE NETHERLANDS

After a period of relative autonomy from 1598 to 1621 under a Habsburg regent, Flanders, the southern—and predominantly Catholic—part of the Netherlands, returned to direct Spanish rule. Led by the nobleman Prince William of Orange, the Netherlands' Protestant northern provinces (present-day Holland) rebelled against Spain in 1568. The seven provinces joined together as the United Provinces in 1579 and began the long struggle for independence, achieved in the seventeenth century. The king of Spain considered the Dutch heretical rebels, but finally the Dutch prevailed. In

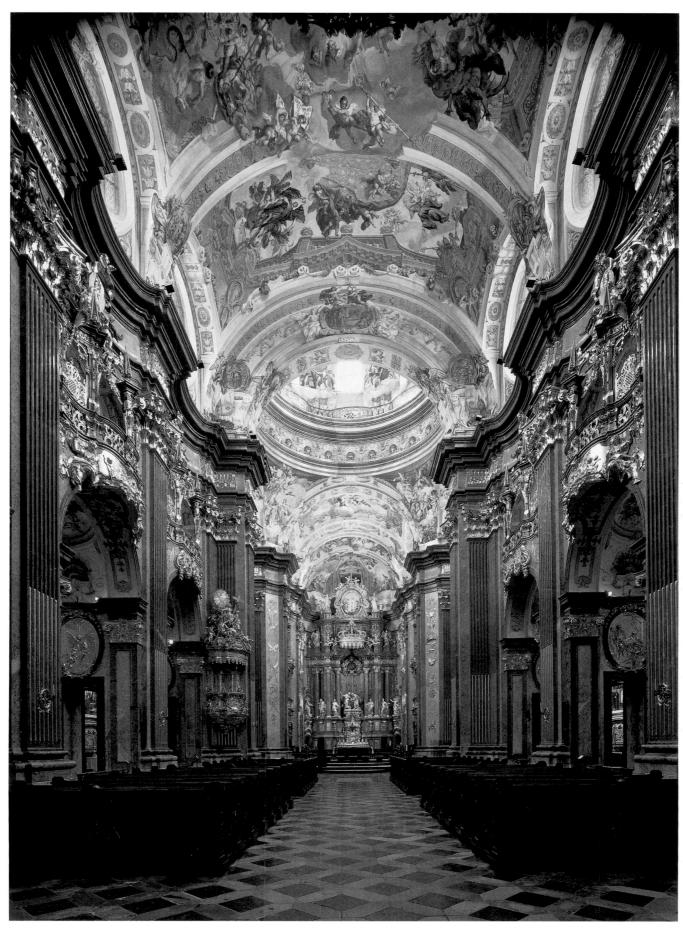

17–33 | INTERIOR, BENEDICTINE MONASTERY CHURCH, MELK Austria. Completed after 1738, after designs by Prandtauer, Antonio Beduzzi, and Joseph Munggenast.

1648, the United Provinces joined emissaries from Spain, the Vatican, the Holy Roman Empire, and France on equal footing in peace negotiations. The resulting Peace of Westphalia recognized the independence of the northern Netherlands.

Flanders

With the southern Netherlands remaining under Catholic Habsburg rule, churches were restored and important commissions went to religious subject matter. As Antwerp, the capital city and major arts center of the southern Netherlands, gradually recovered from the turmoil of the religious wars, artists of great talent flourished there. Painters like Peter Paul Rubens and Anthony Van Dyck established international reputations that brought them important commissions from foreign as well as local patrons.

Rubens. Peter Paul Rubens (1577–1640), whose painting has become synonymous with Flemish Baroque art, was born in Germany, where his father, a Protestant, had fled from his native Antwerp to escape religious persecution. In 1587, after her husband's death, Rubens's mother and her children returned to Antwerp and to Catholicism. Rubens decided in his late teens to become an artist and at age twenty-one was accepted into the Antwerp painters' guild, a testament to his energy, intelligence, and skill. Shortly thereafter, in 1600,

Rubens left for Italy. In Venice, Rubens's work came to the attention of the duke of Mantua, who offered him a court post. His activities on behalf of the duke over the next eight years did much to prepare him for the rest of his long and successful career. Surprisingly, other than designs for court entertainments and occasional portraits, the duke never acquired an original painting by Rubens. Instead, he had him copy famous paintings in collections all over Italy to add to the ducal collection.

Rubens visited every major Italian city, went to Madrid as the duke's emissary, and spent two extended periods in Rome, where he studied the great works of Roman antiquity and the Italian Renaissance. While in Italy, Rubens studied the paintings of two contemporaries, Caravaggio and Annibale Carracci. Hearing of Caravaggio's death in 1610, Rubens encouraged the duke of Mantua to buy the artist's *Death of the Virgin*, which the patron had rejected because of the shocking realism. The duke eventually bought the painting.

In 1608, Rubens returned to Antwerp, where he accepted employment by the Habsburg governors of Flanders, Archduke Albert and Princess Isabella Clara Eugenia, the daughter of Philip II. Shortly after his return he married and in 1611 built a house, studio, and garden in Antwerp (FIG. 17–34). Rubens lived in a large typical Flemish house. He added a studio in the

17–34 Peter Paul Rubens RUBENS HOUSE
Built 1610–15. Looking toward the garden: house at left, studio at right. From an engraving of 1684. British Museum, London. The house was restored and opened as a museum in 1946.

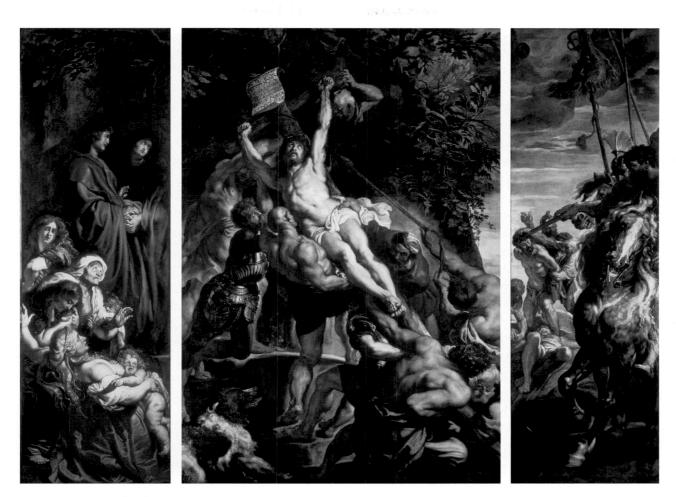

Italian manner across a courtyard, joining the two buildings by a second-floor gallery over the entrance portal. Beyond the courtyard lay the large formal garden, laid out in symmetrical beds. The living room permitted access to a gallery overlooking Rubens's huge studio, a room designed to accommodate large paintings and to house what became virtually a painting factory. The large arched windows provided ample light for the single, two-story room, and a large door permitted the assistants to move finished paintings out to their designated owners. Across the courtyard, one can see the architectural features of the garden, which inspired the architecture of the painting *Garden of Love* (SEE FIG. 17–37).

Rubens's first major commission in Antwerp was a large canvas triptych for the main altar of the Church of Saint Walpurga, **THE RAISING OF THE CROSS** (FIG. 17–35), painted in 1610–11. Rubens continued the Flemish tradition of uniting the triptych by extending the central action and the landscape through all three panels (see Rogier van der Weyden's Last Judgment Altarpiece, FIG. 13–16). At the center, Herculean figures strain to haul upright the wooden cross with Jesus already stretched upon it. At the left, the followers of Jesus join in mourning, and at the right, indifferent soldiers

supervise the execution. All the drama and intense emotion of Caravaggio and the virtuoso technique of Annibale Carracci are transformed and reinterpreted according to Rubens's own unique ideal of thematic and formal unity. The heroic nude figures, dramatic lighting effects, dynamic diagonal composition, and intense emotions show his debt to Italian art, but the rich colors and surface realism, with minute attention given to varied textures and forms, belong to his native Flemish tradition.

Rubens had created a powerful, expressive visual language that was as appropriate for the secular rulers who engaged him as it was for the Catholic Church. Moreover, his intelligence, courtly manners, and personal charm made him a valuable and trusted courtier to his royal patrons, who included Philip IV of Spain, Queen–Regent Marie de' Medici of France, and Charles I of England. In 1621, Marie de' Medici, who had been regent for her son Louis XIII, asked Rubens to paint the story of her life, to glorify her role in ruling France, and also to commemorate the founding of the new Bourbon royal dynasty. In twenty–four paintings, Rubens portrayed Marie's life and political career as one continuous triumph overseen by the ancient gods of Greece and Rome.

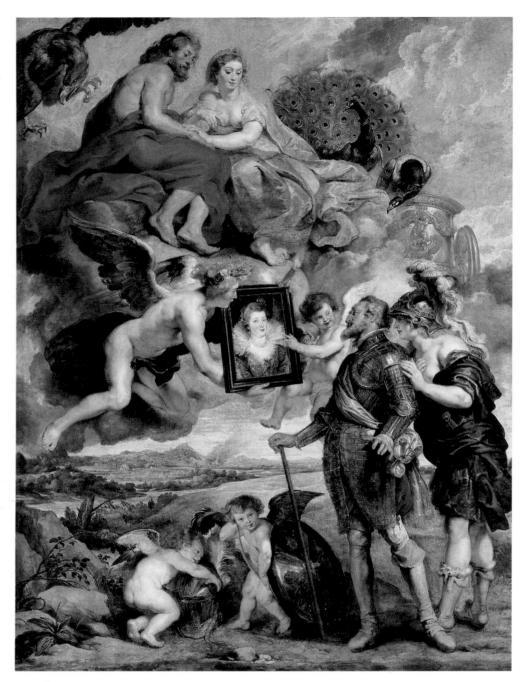

17–36 | Peter Paul Rubens | HENRI IV RECEIVING THE PORTRAIT OF MARIE DE' MEDICI 1621–25. Oil on canvas, $12'111\%'' \times 9'81\%'' (3.94 \times 2.95 \text{ m})$. Musée du Louvre, Paris.

In the painting depicting the royal engagement (FIG. 17–36), Henri IV falls in love at once with Marie's portrait, shown to him—at the exact center of the composition—by Cupid and Hymen, the god of marriage, while the supreme Roman god, Jupiter, and his wife, Juno, look down from the clouds. Henri, wearing his steel breastplate and silhouetted against a landscape in which the smoke of a battle lingers in the distance, is encouraged by a personification of France to abandon war for love, as *putti* play with the rest of his armor. The ripe colors, multiple tex-

tures, and dramatic diagonals give a sustained visual excitement to these enormous canvases, making them not only important works of art but also political propaganda of the highest order.

In 1630, while Rubens was in England on a peace mission, Charles I knighted him and commissioned him to decorate the ceiling of the new Banqueting House at Whitehall Palace, London (SEE FIG. 17–65). There, he painted the apotheosis of James I (Charles's father) and the glorification of the Stuart dynasty.

For all the grandeur of his commissioned paintings, Rubens was a sensitive, innovative painter, as the works he created for his own pleasure clearly demonstrate. His greatest joys seem to have been his home in Antwerp and his home in the country, Castle Steen, a working farm with gardens, fields, woods, and streams.

In GARDEN OF LOVE—a garden reminiscent of his own—Rubens may have portrayed his second wife, Helene Fourment, as the leading lady among a crowd of beauties (FIG. 17–37). Putti encourage the lovers, and one pushes a hesitant young woman into the garden. The couple joins the ladies and gentlemen who are already enjoying the pleasures of nature. The sculpture and architectural setting recall Italian Mannerist conceits. For example, the nymph presses water from her breasts to create the fountain. Herms flank the entrance and columns banded with rough-hewn rings support the pavilion that forms the entrance to the grotto of Venus. All is lush color, shimmering satin, falling water, and sunset sky—the visual and tactile effects so appreciated by seventeenth-century viewers achieved through masterful brushwork.

To satisfy his clients all over Europe, Rubens employed dozens of assistants, many of whom were, or became, important painters in their own right. Using workshop assistants was standard practice for a major artist, but Rubens was par-

ticularly methodical, training or hiring specialists in costumes, still lifes, landscapes, portraiture, and animal painting who together could complete a work from his detailed sketches. Among his friends and collaborators were Anthony Van Dyck and his friend and neighbor Jan Brueghel.

PORTRAITS AND STILL LIFES. One of Rubens's collaborators, Anthony Van Dyck (1599–1641), had an illustrious independent career as a portraitist. Son of an Antwerp silk merchant, he was listed as a pupil of the dean of Antwerp's Guild of Saint Luke at age 10. He had his own studio and roster of pupils at age 16 but was not made a member of the guild until 1618, the year after he began his association with Rubens as a painter of heads. The need to blend his work seamlessly with that of Rubens enhanced Van Dyck's technical skill; his independent work shows an elegance and aristocratic refinement that seems to express his own character. After a trip to the English court of James I (ruled 1603-25) in 1620, Van Dyck traveled to Italy and worked as a portrait painter for seven years before returning to Antwerp. In 1632, he returned to England as the court painter to Charles I (ruled 1625-49), by whom he was knighted and given a studio, a summer home, and a large salary.

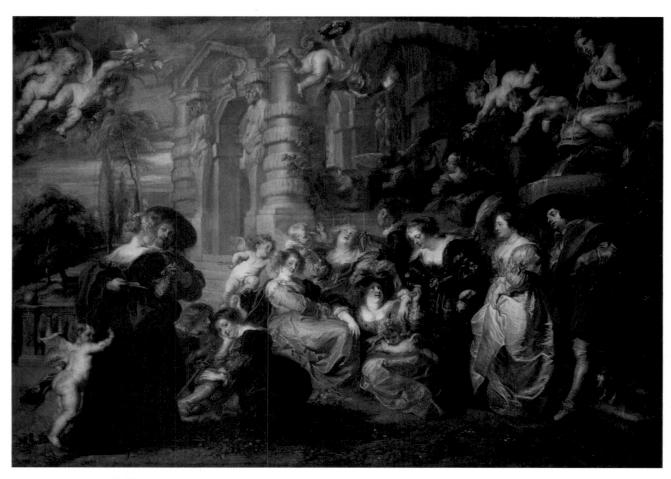

17–37 Peter Paul Rubens GARDEN OF LOVE 1630–32. Oil on canvas, $6'6'' \times 9'3\%''$ (1.98 \times 2.83 m). Museo del Prado, Madrid.

I7-38 | Anthony Van Dyck CHARLES I AT THE HUNT 1635. Oil on canvas, 8'11" × 6'11" (2.75 × 2.14 m). Musée du Louvre, Paris.

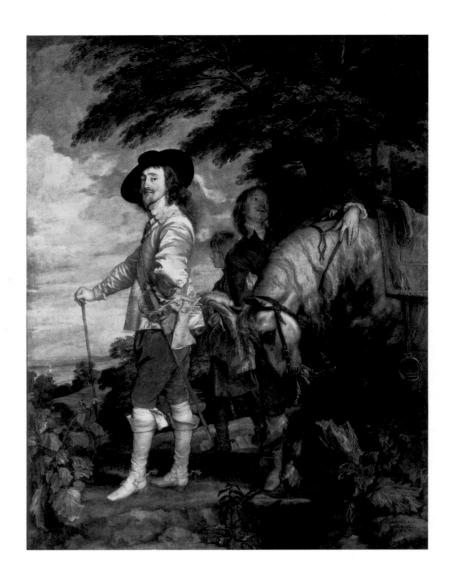

Van Dyck's many portraits of the royal family provide a sympathetic record of their features. In **CHARLES I AT THE HUNT** (FIG. 17–38), of 1635, Van Dyck was able, by clever manipulation of the setting, to portray the king truthfully and yet as a quietly imposing figure. Dressed casually for the hunt and standing on a bluff overlooking a distant view (a device used by Rubens to enhance the stature of Henry IV; SEE FIG. 17–36), Charles is shown as being taller than his pages and even than his horse, since its head is down and its heavy body is partly off the canvas. The viewer's gaze is diverted from the king's delicate and rather short frame to his pleasant features, framed by his jauntily cocked cavalier's hat. As if in decorous homage, the tree branches bow gracefully toward him, echoing the circular lines of the hat.

Yet another painter working with Rubens, Jan Brueghel (1568–1625), specialized in settings rather than portraits. Jan was the son of Pieter Bruegel the Elder; recall that Jan added the "h" to the family name (see Chapter 16). Brueghel and Rubens's allegories of the five senses—five paintings illustrating sight, hearing, touch, taste, and smell—in effect invited the viewer to wander in an imaginary space and to enjoy an amazing collection of works of art and scientific equipment

(see Brueghel and Rubens's *Allegory of Sight*, page 650). This remarkable painting is a display, a virtual inventory, and a summary of the wealth, scholarship, and connoisseurship created through the patronage of the Habsburg rulers of the Spanish Netherlands.

Our term still life for paintings of artfully arranged objects on a table comes from the Dutch stilleven, a word coined about 1650. The Antwerp artist Clara Peeters (1594-c. 1657) specialized in still-life tabletop arrangements. She was a precocious young woman whose career seems to have begun before she was fourteen. Of some fifty paintings now attributed to her (of which more than thirty are signed), many are of the type called "breakfast pieces," showing a table set for a meal of bread and fruit. Peeters was one of the first artists to combine flowers and food in a single painting, as in her STILL LIFE WITH FLOWERS, GOBLET, DRIED FRUIT, AND PRETZELS (FIG. 17-39), of 1611. Peeters arranged rich tableware and food against neutral, almost black backgrounds, the better to emphasize the fall of light over the contrasting surface textures. In a display of decorative arts that must have appealed to her clients, the luxurious goblet and bowl contrast with simple stoneware and pewter, as do the delicate

17–39 | Clara Peeters STILL LIFE WITH FLOWERS, GOBLET, DRIED FRUIT, AND PRETZELS 1611. Oil on panel, $20\% \times 28\%$ (52 × 73 cm). Museo del Prado, Madrid.

Like many breakfast pieces, this painting features a pile of pretzels among the elegant tablewares. The salty, twisted bread was called pretzel (from the Latin pretiola, meaning "small reward") because it was invented by southern German monks to reward children who had learned their prayers: The twisted shape represented the crossed arms of a child praying.

flowers with the homey pretzels. The pretzels, piled high on the pewter tray, are a particularly interesting Baroque element, with their complex multiple curves.

The Dutch Republic

The House of Orange was not notable for its patronage of the arts, but patronage improved significantly under Prince Frederick Henry (ruled 1625-47), and Dutch artists found many other eager patrons among the prosperous middle class in Amsterdam, Leiden, Haarlem, Delft, and Utrecht. The Hague was the capital city and the preferred residence of the House of Orange, but Amsterdam was the true center of power, because of its sea trade and the enterprise of its merchants, who made the city an international commercial center. The Dutch delighted in depictions of themselves and their country—the landscape, cities, and domestic life—not to mention beautiful and interesting objects to be seen in still-life paintings and interior scenes or exotic things (like the Farnese Hercules admired by Dutch travelers in Rome; see Introduction, Fig. 24). A well-educated people, the Dutch were also fascinated by history, mythology, the Bible, new scientific discoveries, commercial expansion abroad, and colonial exploration.

Visitors to the Netherlands in the seventeenth century noted the popularity of art among merchants and working people. Peter Mundy, an English traveler, wrote in 1640 that even butchers, bakers, shoemakers, and blacksmiths had pictures in their houses and shops. This taste for art stimulated a free market for paintings that functioned like other commodity markets. Artists had to compete to capture the interest of the public by painting on speculation. Naturally, specialists in particularly popular types of images were likely to be financially successful, and what most Dutch patrons wanted were paintings of themselves, their country, their homes, and the life around them. The demand for art gave rise to an active market for the graphic arts, both for original compositions and for copies of paintings, since one copperplate could produce hundreds of impressions, and worn-out plates could be reworked and used again.

THE INFLUENCE OF ITALY. Hendrik Goltzius (1558–1617) from Haarlem, the finest engraver in the Netherlands, perhaps in Europe, had visited Florence and Rome in 1590–91. His engravings of antiquities and of Mannerist paintings, which he made on his return, were widely circulated and introduced many people to Italian art (see Introduction, Fig. 24). The fascination continued. Flemish travelers like Leiven Cruyl (1640–1720) published engravings of the views of Rome he made in 1665 (SEE FIG. 17–21).

Hendrick ter Brugghen (1588-1629) had spent time in Rome, perhaps between 1608 and 1614, where he must have seen Caravaggio's works and became an enthusiastic follower. On his return home, in 1616, he entered the Utrecht painters' guild, bringing Caravaggio's style into the Netherlands. Ter Brugghen's SAINT SEBASTIAN TENDED BY SAINT IRENE introduced the Netherlandish painters to the new art of Baroque Italy (FIG. 17-40). The suffering and recovery of Saint Sebastian was equated to the Crucifixion and Resurrection of Christ. The sickly gray-green flesh of the nearly dead saint, set in an almost monochromatic palette, contrasts with the brilliant red and gold brocade of his garmentactually the cope of the bishop of Utrecht, which survived the destruction by Protestants and became a symbol of Catholicism in Utrecht. The saint is a heroic figure: His strong, youthful body is still bound to the stake. But Saint Irene (the patron saint of nurses) carefully removes one of the arrows that pierce him, and her maid is about to untie his wrists. In a typically Baroque manner, the powerful diagonal created by Saint Sebastian's left arm dislodges him from the triangular stability of the group: His corpse is in transition and will soon fall forward. The immediacy and emotional effectiveness of the work are further strenghtened by setting all the figures in the foreground plane, an effect strangthened by the low horizon line. The use of tenebrism and dramatic light effects, and realism recalling Caravaggio, made an impact on the Dutch artists who had not had the opportunity to travel to Italy. Rembrandt, Vermeer, and Rubens all admired ter Brugghen's painting.

THE OBJECT SPEAKS

BRUEGHEL AND RUBENS'S ALLEGORY OF SIGHT

n 1599, the Spanish Habsburg princess Isabel Clara Eugenia married the Austrian Habsburg archduke Albert, uniting two branches of the family. Together they ruled the Habsburg Netherlands for the king of Spain. They were patrons of the arts and sciences and friends of artists-especially Peter Paul Rubens. Their interests and generous patronage were abundantly displayed in five allegorical paintings of the senses by Rubens and Jan Brueghel. The two artists were neighbors and frequently collaborated; Rubens painted the figures, and Brueghel created the settings. Such collaboration between major artists was not unusual in Antwerp.

Of the five paintings, the **ALLEGORY OF SIGHT** is the most splendid: It is like an illustrated catalog of the ducal collection.

Gathered in a huge vaulted room are paintings, sculpture, furniture, objects in gold and silver, and scientific equipmentall under the magnificent double-headed eagle emblems of the Habsburgs. We explore the painting inch by inch, as if reading a book or scanning a palace inventory. There on the table are Brueghel's copies of Rubens's portraits of Archduke Albert and Princess Isabel Clara Eugenia; another portrait of the duke rests on the floor. Besides the portraits, we can find Rubens's Daniel in the Lions' Den (upper left corner), The Lion and Tiger Hunt (top center), and The Drunken Silenus (lower right), as well as the Madonna and Child in a Wreath of Flowers (far right), a popular seventeenth-century subject, for which Rubens painted the Madonna and Brueghel created the wreath. Brueghel

also included Raphael's Saint Cecilia (behind the globe) and Titian's Venus and Psyche (over the door).

In the foreground, the classical goddess Venus, attended by Cupid (both painted by Rubens), has put aside her mirror to contemplate a painting of Christ Healing the Blind. She is surrounded by the equipment needed to see and to study: The huge globe at the right and the armillary sphere with its gleaming rings at the upper left-the Earth and the solar system-symbolize the extent of humanistic learning, an image that speaks to viewers of our day as clearly as it did to those of its own. The books and prints, ruler, compasses, magnifying glass, and the more complex astrolabe, telescope, and eyeglasses may also refer to spiritual blindness-to those who look but do not see.

Jan Brueghel and Peter Paul Rubens AlleGORY OF SIGHT From Allegories of the Five Senses. c. 1617–18. Oil on wood panel, $25\% \times 43''$ (65 \times 109 cm). Museo del Prado, Madrid.

17–40 | Hendrick ter Brugghen SAINT SEBASTIAN TENDED BY SAINT IRENE 1625. Oil on canvas, 58½ × 47½" (149.6 × 120 cm). Allen Memorial Art Museum, Oberlin College, Ohio.

PORTRAITS. Dutch Baroque portraiture took many forms, ranging from single portraits in sparsely furnished settings to allegorical depictions of people in elaborate costumes surrounded by appropriate symbols. Although the accurate portrayal of facial features and costumes was the most important gauge of a portrait's success, the best painters went beyond pure description to convey a sense of mood or emotion in the sitter. (We cannot know if it was an accurate representation of their personality in the modern sense, however.) Group portraiture documenting the membership of corporate organizations was a Dutch specialty. These large canvases, filled with many individuals who shared the cost of the commission, challenged

painters to present a coherent, interesting composition that nevertheless gave equal attention to each individual portrait.

Frans Hals (c. 1581/85–1666), the leading painter of Haarlem, developed a style grounded in the Netherlandish love of realism and inspired by the Caravaggesque style introduced by artists such as ter Brugghen. Like Velázquez, he tried to re-create the optical effects of light on the shapes and textures of objects. He painted boldly, with slashing strokes and angular patches of paint. When his work is seen at a distance, however, all the colors merge into solid forms over which a flickering light seems to move. In Hals's hands, this seemingly effortless technique suggests a boundless joy in life.

In his painting **CATHARINA HOOFT AND HER NURSE** (FIG. 17–41), of about 1620, Hals captured the vitality of a gesture and a fleeting moment in time. While the portrait records for posterity the great pride of the parents in their child, the painting also records their wealth in its study of rich fabrics, laces, and expensive toys (a golden rattle). Hals depicted the heartwarming delight of a child, who seems to be acknowledging the viewer as a loving family member while her doting nurse tries to distract her with an apple.

In contrast to this intimate individual portrait are Hals's official group portraits, such as his **OFFICERS OF THE HAARLEM MILITIA COMPANY OF SAINT ADRIAN (FIG. 17–42),** of about 1627. Less imaginative artists had arranged their sitters in neat rows to depict every face clearly. Instead, Hals's dynamic composition turned the group portrait into a lively social event. The composition is based on a strong underlying geometry of diagonal lines—gestures, banners, and sashes—balanced by the stabilizing perpendiculars of table, window, tall glass, and striped banner. The black suits and hats make the white ruffs and sashes of rose, white, and blue even more brilliant.

The company, made up of several guard units, was charged with the military protection of Haarlem. Officers came from the upper middle class and held their commissions for three years, whereas the ordinary guards were tradespeople and craftworkers. Each company was organized like a guild, under the patronage of a saint. When the men were not on war alert, the company functioned as a fraternal order, holding archery competitions, taking part in city processions, and maintaining an altar in the local church (SEE ALSO FIG. 17–45.)

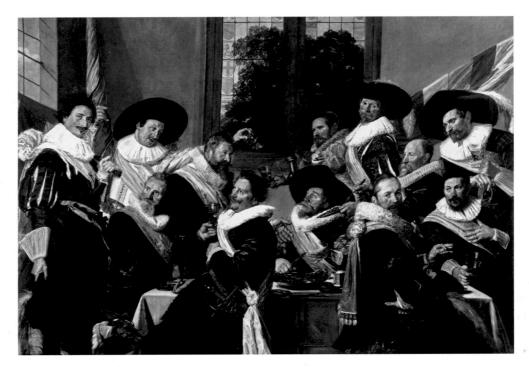

17–42 Frans Hals OFFICERS OF THE HAARLEM MILITIA COMPANY OF SAINT ADRIAN c. 1627. Oil on canvas, $6' \times 8'8''$ (1.83 \times 2.67 m). Frans Halsmuseum, Haarlem.

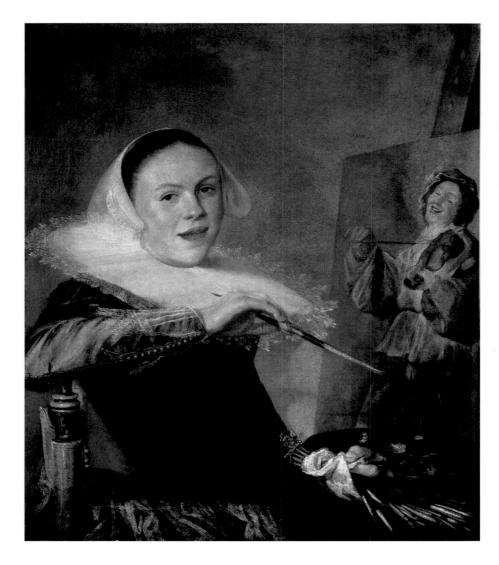

17–43 | Judith Leyster

SELF-PORTRAIT

1635. Oil on canvas, 29% × 25%"

(72.3 × 65.3 cm). National Gallery of Art, Washington, D.C.

Gift of Mr. and Mrs. Robert Woods Bliss.

A painting long praised as one of Hals's finest works was recently discovered to be by Judith Leyster (c. 1609-60), Hals's contemporary. A cleaning uncovered her distinctive signature, the monogram IL with a star, which refers to her surname, meaning "pole star." Leyster's work shows clear echoes of her exposure to the Utrecht painters who had enthusiastically adopted Caravaggio's realism, dramatic tenebrist lighting effects, large figures pressed into the foreground plane, and, especially, theatrically presented themes. Since in 1631 Leyster signed as a witness at the baptism in Haarlem of one of Hals's children, it is assumed they were close; she may also have worked in Hals's shop. She entered Haarlem's Guild of Saint Luke in 1633, which allowed her to take pupils into her studio, and her competitive relationship with Frans Hals around that time is made clear by the complaint she lodged against him in 1635 for luring away one of her apprentices.

Leyster is known primarily for her informal scenes of daily life, which often carry an underlying moralistic theme. In her lively **SELF-PORTRAIT** of 1635 (FIG. 17–43), the artist has paused momentarily in her work to look back, as if the viewer had just entered the room. Her elegant dress and the

fine chair in which she sits are symbols of her success as an artist whose popularity was based on the very type of painting underway on her easel. (One critic has suggested that her subject—a man playing a violin—may be a visual pun on the painter with palette and brush.) Leyster's understanding of light and texture is truly remarkable. The brushwork she used to depict her own flesh and delicate ruff is finer than Hals's technique and forms an interesting contrast to the broad strokes of thick paint used to create her full, stiff skirt. She further emphasized the difference between her portrait and her painting by executing the image on her easel in lighter tones and soft, loose brushwork. The narrow range of colors sensitively dispersed in the composition and the warm spotlighting are typical of Leyster's mature style.

REMBRANDT VAN RIJN. The most important painter working in Amsterdam in the seventeenth century was Rembrandt van Rijn (1606–69). Rembrandt, one of nine children born in Leiden to a miller and his wife, enrolled at the University of Leiden in 1620 at age 14 but chose instead to study painting with a local artist. Later he studied briefly under

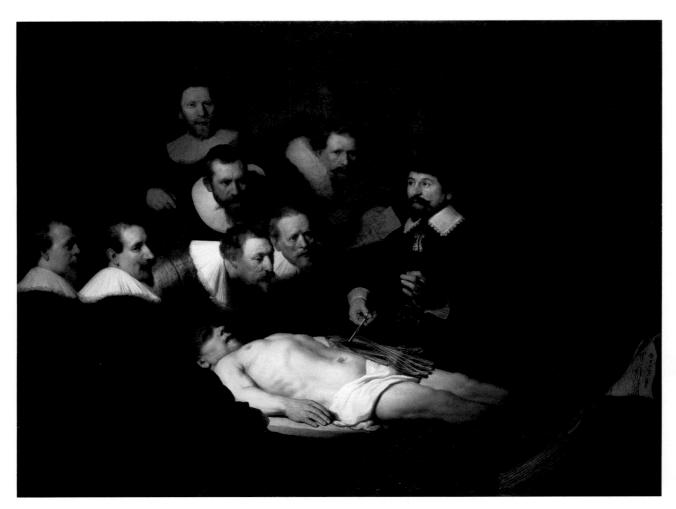

17–44 Rembrandt van Rijn THE ANATOMY LESSON OF DR. NICOLAES TULP 1632. Oil on canvas, $5'3\%'' \times 7'1\%''$ (1.6 \times 2.1 m). Mauritshuis, The Hague, Netherlands.

Pieter Lastman (1583–1633), the principal painter in Amsterdam at the time. From Lastman, a history painter who had worked in Rome, Rembrandt learned the new styles developed in Rome by Annibale Carracci and Caravaggio: naturalism, drama, and extreme tenebrism. He was back in Leiden by 1626, painting religious and historical scenes as well as fantasy portraits from models likely drawn from his family and acquaintances. Late in 1631 he returned to Amsterdam to work primarily as a portrait painter, although he continued to paint a wide range of narrative themes and landscapes.

In his first group portrait, **THE ANATOMY LESSON OF DR. NICOLAES TULP** (FIG. 17-44) of 1632, Rembrandt combined his scientific and humanistic interests. Frans Hals had activated the group portrait rather than conceiving it as a simple reproduction of figures and faces; Rembrandt transformed it into a dramatic narrative scene. Doctor Tulp, who was head of the surgeons' guild from 1628 to 1653, sits right of center, and the other doctors gather around to observe the cadaver and listen to the famed anatomist. Rembrandt built his composition on a sharp diagonal that pierces space from right to left, uniting the cadaver on the table, the calculated

arrangement of speaker and listeners, and the open book into a climactic event. Rembrandt makes effective use of Caravaggio's tenebrist technique. The figures emerge from a dark and undefined ambience with their faces framed by brilliant white ruffs. Radiant light from an unknown source streams down on the juxtaposed arms and hands, as Dr. Tulp flexes his own left hand to demonstrate the action of the cadaver's arm muscles. Unseen by the viewers are the illustrations of the huge book. It must be an edition of Andreas Vesalius's study of human anatomy, published in Basel in 1543, which was the first attempt at accurate anatomical illustrations in print. Rembrandt's painting has been seen as an homage to Vesalius and to science, as well as a portrait of the members of the Amsterdam surgeons' guild.

Prolific and popular with Amsterdam clientele, Rembrandt ran a busy studio producing works that sold for high prices. The prodigious output of his large workshop and of many followers who imitated his manner has made it difficult for scholars to define his body of work, and many paintings by students and assistants formerly attributed to Rembrandt have recently been assigned to other artists. Rembrandt's

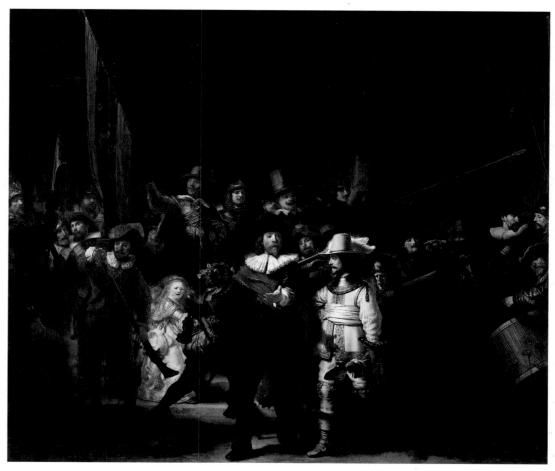

17–45 | Rembrandt van Rijn CAPTAIN FRANS BANNING COCQ MUSTERING HIS COMPANY (THE NIGHT WATCH)
1642. Oil on canvas, $11'11'' \times 14'4''$ (3.63 \times 4.37 m). (Cut down from the original size.) Rijksmuseum, Amsterdam.

mature work reflected his cosmopolitan city environment, his study of science and nature, and the broadening of his artistic vocabulary by the study of Italian Renaissance art, chiefly from engravings and paintings. Thanks to prints imported by the busy Amsterdam art market, he could study such works as Leonardo's *Last Supper* (see Introduction, Fig. 18).

In 1642, Rembrandt was one of several artists commissioned by a wealthy civic-guard company to create large group portraits of its members for its new meeting hall. The result, **CAPTAIN FRANS BANNING COCQ MUSTERING HIS COMPANY** (FIG. 17–45), carries the idea of the group portrait as drama even further. Because of the dense layer of grime and darkened varnish on it and its dark background architecture, this painting was once thought to be a night scene and was therefore called "The Night Watch." After cleaning and restoration in 1975–76 it now exhibits a natural golden light that sets after the palette of rich colors—browns, blues, olive green, orange, and red—around a central core of lemon yellow in the costume of a lieutenant. To the dramatic group composition, showing a company forming for a parade in an Amsterdam street, Rembrandt added several colorful but

seemingly unnecessary figures. While the officers stride purposefully forward, the rest of the men and several mischievous children mill about. The radiant young girl in the left middle ground, carrying a chicken and wearing a money pouch, may be a pun on the kind of guns (klower) that gave the name (the Kloveniers) to the company. Chicken legs with claws (klauw in Dutch) also are part of their coat of arms. She may stand as a kind of symbolic mascot of the militia company.

In his enthusiasm for printmaking as an important art form with its own aesthetic qualities, Rembrandt was remarkably like Albrecht Dürer (SEE FIGS. 16–9, 16–10). He focused on etching, which uses acid to inscribe a design on metal plates. His earliest etchings date from 1627. About a decade later, he began to experiment with making additions to his compositions in the **drypoint** technique, in which the artist uses a sharp needle to scratch shallow lines in a plate. Because etching and drypoint allow the artist to work directly on the plate, the style of the finished print can have the relatively free and spontaneous character of a drawing. Rembrandt's commitment to the full exploitation of the medium is indicated by the fact that in these works he alone

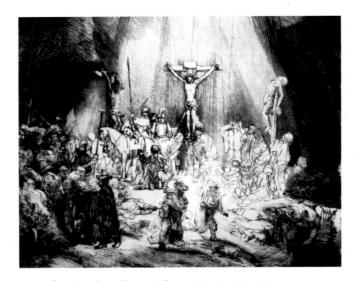

17–46 | Rembrandt van Rijn THREE CROSSES (FIRST STATE) 1653. Drypoint and etching, $15\% \times 17\%$ (38.5 \times 45 cm). Rijksmuseum, Amsterdam.

Rembrandt experienced a deep religious faith that was based on his personal study of the Bible. His deep consideration of the meaning of the life of Christ can be studied in a series of prints, THREE CROSSES, that comes down to us in five states, or stages, of the creative and printing process. (Only the first and fourth are reproduced here.) Rembrandt tried to capture the moment described in the Gospels when, during the Crucifixion, darkness covered the Earth and Jesus cried out, "Father, into thy hands I commend my spirit." In the first state (FIG. 17-46), the centurion kneels in front of the cross while other terrified people run from the scene. The Virgin Mary and John share the light flooding down from heaven. By the fourth state (FIG. 17-47), Rembrandt has completely reworked and reinterpreted the theme. In each version, the shattered hill of Golgotha dominates the foreground, but now a mass of vertical lines, echoing the rigid body of Jesus, fills the space, obliterates the shower of light, and virtually eliminates the former image, including even Mary and Jesus's friends. The horseman holding a lance now faces Jesus. Compared with the first state, the composition is more compact, the individual elements are simplified, and the emotions are intensified. The first state is a detailed rendering of the scene in realistic terms; the fourth state, a reduction of the event to its essence. The composition revolves in an oval of half-light around the base of the cross, and the viewer's attention is drawn to the figures of Jesus and the people, in mute confrontation. In Three Crosses, Rembrandt defined the mystery of Christianity in Jesus's sacrifice, presented in realistic terms but as something beyond rational

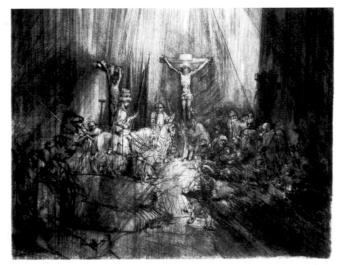

17–47 | Rembrandt van Rijn THREE CROSSES (FOURTH STATE)
1653. Drypoint and etching, $15\% \times 17\%$ " (38.5 × 45 cm). The Metropolitan Museum of Art, New York.
Gift of Felix M. Warburg and his family, 1941 (41.1.33)

explanation. In Rembrandt's late works, realism relates to the spirit of inner meaning, not of surface details. The eternal battles of dark and light, doom and salvation, evil and good—all seem to be waged anew.

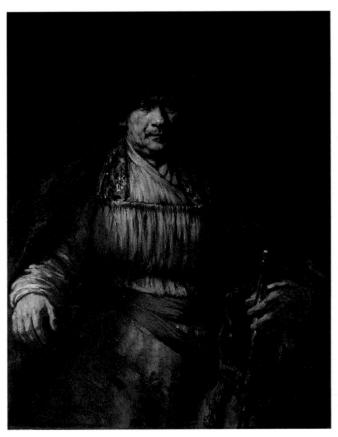

17–48 | Rembrandt van Rijn SELF-PORTRAIT 1658. Oil on canvas, $52\% \times 40\%$ (133.6 \times 103.8 cm). The Frick Collection, New York.

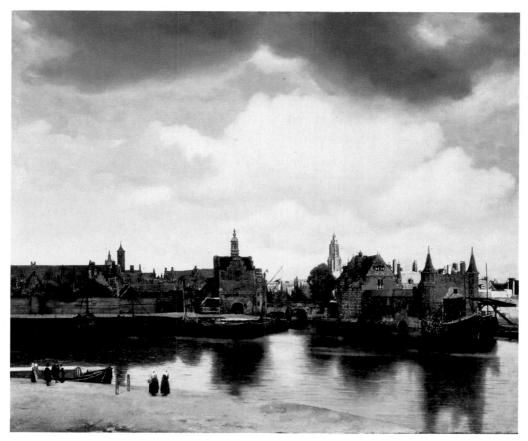

17–49 \perp Jan Vermeer VIEW OF DELFT c. 1662. Oil on canvas, $38\% \times 46\%''$ (97.8 \times 117.5 cm). Mauritshuis, The Hague. The Johan Maurits van Nassau Foundation.

As he aged Rembrandt painted ever more brilliantly, varying textures and paint from the thinnest glazes to thick impasto, creating a rich luminous chiaroscuro, ranging from deepest shadow to brilliant highlights in a dazzling display of gold, red, and chestnut brown. His sensitivity to the human condition is perhaps nowhere more powerfully expressed than in his late self-portraits which became more searching as the artist aged. Distilling a lifetime of study and contemplation, he expressed an internalized spirituality new in the history of art. In this **SELF-PORTRAIT** of 1658 (FIG 17-48), the artist assumes a regal pose, at ease with arms and legs spread and holding a staff as if it were a baton of command. Yet his face and eyes seem weary, and we know that fortune no longer smiled on him (he had to declare bankruptcy that same year). A few well-placed brush strokes suggest the physical tension in the fingers and the weariness of the deep-set eyes. Mercilessly analytical, the portrait depicts the furrowed brow, sagging flesh, and prematurely aged face of one who has suffered deeply but still retains his dignity.

Jan (Johannes) Vermeer. One of the most intriguing Dutch artists of this period is Jan (Johannes) Vermeer (1632–75), who was also an innkeeper and art dealer. He entered the Delft

artists' guild in 1653 and painted only for local patrons. Meticulous in his technique, with a unique compositional approach and painting style, Vermeer produced fewer than forty canvases that can be securely attributed to him; and the more these paintings are studied, the more questions arise about the artist's life and his methods. Vermeer's view of DELFT (FIG. 17-49), for example, is no simple cityscape. Although the artist convinces the viewer of its authenticity, he does not paint a photographic reproduction of the scene; Vermeer moves buildings around to create an ideal composition. He endows the city with a timeless stability by a stress on horizontal lines, the careful placement of buildings, the quiet atmosphere, and the clear, even light that seems to emerge from beneath low-lying clouds. Vermeer may have experimented with the mechanical device known as the camera obscura (see Chapter 30), not as a method of reproducing the image but as another tool in the visual analysis of the landscape. The camera obscura would have enhanced optical distortions that led to the "beading" of highlights (seen here on the harbored ships and dark gray architecture), which creates the illusion of brilliant light but does not dissolve the underlying form.

Vermeer seemed to favor enigmatic scenes of women in their homes, alone or with a servant, who are occupied with some cultivated activity, such as writing, reading letters, or playing a musical instrument. Most of his accepted works are of a similar type—quiet interior scenes, low-key in color, and asymmetrical but strongly geometric in organization. Vermeer achieved his effects through a consistent architectonic construction of space in which every object adds to the clarity and balance of the composition. An even light from a window often gives solidity to the figures and objects in a room.

All emotion is subdued, as Vermeer evokes the stillness of meditation. Even the brushwork is so controlled that it becomes invisible, except when he paints reflected light as tiny droplets of color.

In **woman holding a Balance** (FIG. 17–50), perfect equilibrium creates a monumental composition and a moment of supreme stillness. The woman contemplates the balance and so calls our attention to the act of weighing and

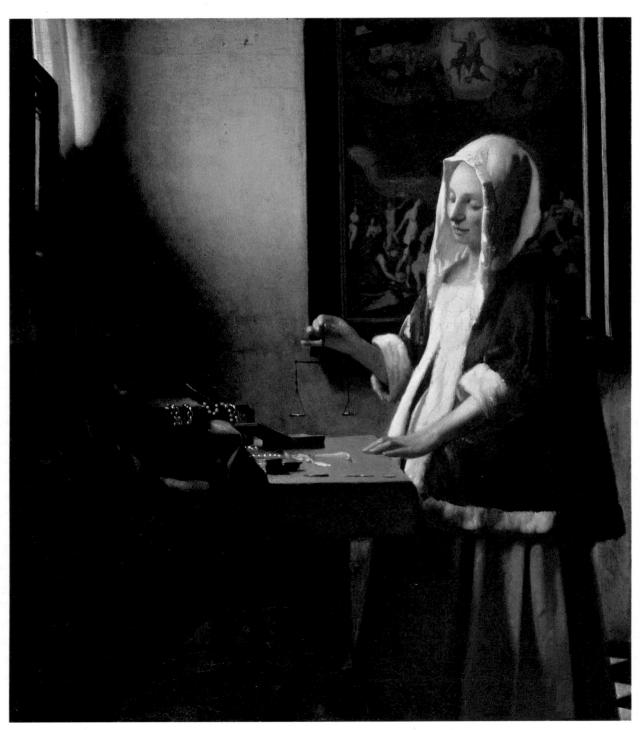

17–50 | Jan Vermeer WOMAN HOLDING A BALANCE c. 1664. Oil on canvas, $15\% \times 14''$ (39 \times 35 cm). National Gallery of Art, Washington, D.C. Widener Collection (1942.9.97)

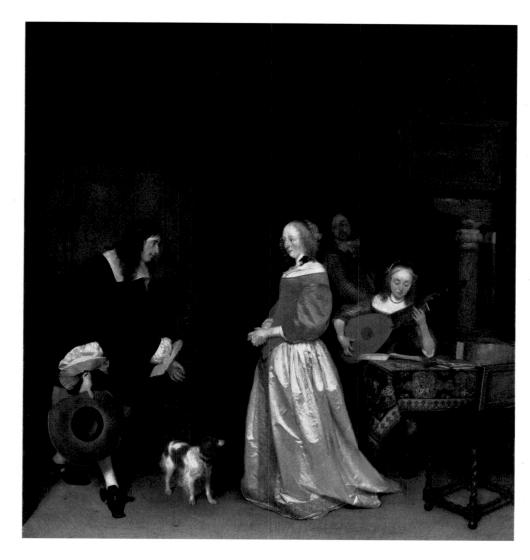

17–51 | Gerard ter Borch
THE SUITOR'S VISIT
c. 1658. Oil on canvas,
32½ × 29½" (82.6 × 75.3 cm).
National Gallery of Art,
Washington, D.C.
Andrew W. Mellon Collection
(1937.1.58).

judging. Her hand and the scale are central, but directly over her head, on the wall of the room, an image of Christ in a gold aureole appears in a large painting of the Last Judgment. Thus, Vermeer's painting becomes a metaphor for eternal judgment. The woman's moment of quiet introspection before she touches the gold or pearls, shimmering with the reflected light from the window, also recalls the *vanitas* theme of the transience of life, allowing the painter to comment on the ephemeral quality of material things.

LIFE IN THE CITY, GENRE SCENES. Continuing a long Netherlandish tradition, genre paintings of the Baroque period—generally painted for private patrons and depicting scenes of contemporary daily life—were often laden with symbolic references, although their meaning is not always clear. A clean house might indicate a virtuous housewife and mother while a messy household suggested laziness and the sin of sloth. Ladies dressing in front of mirrors certainly could be succumbing to vanity, and drinking parties led to overindulgence and lust.

One of the most refined of the genre painters was Gerard ter Borch (1617-81). In his painting traditionally known as THE SUITOR'S VISIT (FIG. 17-51), from about 1658, a welldressed man bows gracefully to an elegant woman arrayed in white satin, who stands in a sumptuously furnished room in which another woman plays a lute. Another man, in front of a fireplace, turns to observe the newcomer. The painting appears to represent a prosperous gentleman paying a call on a lady of equal social status, possibly a courtship scene. The dog in the painting and the musician seem to be simply part of the scene, but we are already familiar with the dog as a symbol of fidelity, and stringed instruments were said to symbolize, through their tuning, the harmony of souls and thus, possibly, a loving relationship. On the other hand, it has been suggested that the theme is not so innocent: that the gestures here suggest a liaison. The dog could be interpreted sexually, as sniffing around, and the music making could be associated with sensory pleasure. Ter Borch was renowned for his exquisite rendition of lace, velvet, and especially satin, and such wealth could be seen as a symbol of excess. One critic has

even suggested that the white satin is a metaphor for the women's skin. If there is a moral lesson, it is presented discreetly and ambiguously.

Another important genre painter is Jan Steen (1626–79), whose larger brushstrokes contrast with the meticulous treatment of ter Borch. Steen painted over 800 (mostly undated) works but never achieved financial success. Most of his scenes used everyday life to portray moral tales, illustrate proverbs and folk sayings, or make puns to amuse the spectator. Steen moved about the country for most of his life, and from 1670 until his death he kept a tavern in Leiden. He probably found inspiration and models all about him. Early in his career Steen was influenced by Frans Hals, and his work, in turn, influenced a school, or circle of artists working in a related style, of Dutch artists who emulated his ever-changing style and subjects. Steen could be very summary or extremely detailed in his treatment of forms. His paintings of often riotous and disorderly interiors gave rise to the saying "a Jan Steen household."

Jan Steen's paintings of children are especially remarkable, for he captured not only their childish physiques but also their fleeting moods and expressions with rapid and fluid brushstrokes. His ability to capture such transitory dispositions was well expressed in his painting **THE DRAWING LESSON** (Introduction, Fig. 17). Here, youthful apprentices—a boy and a well-dressed young woman—observe the master artist correct an example of drawing, a skill widely believed to be the foundation of art. The studio is cluttered with all the supplies the artists need. On the floor at the lower right, objects such as a lute, wine jug, book, and skull also remind the viewer of the transitory nature of life in spite of the permanence art may seem to offer.

Emanuel de Witte (1617-92) of Rotterdam specialized in architectural interiors, first in Delft in 1640 and then in Amsterdam after settling there permanently in 1652. Although many of his interiors were composites of features from several locations combined in one idealized architectural view, de Witte also painted faithful "portraits" of actual buildings. One of these is his PORTUGUESE SYNAGOGUE, AMSTERDAM (FIG. 17-52), of 1680. The synagogue, which still stands and is one of the most impressive buildings in Amsterdam, is shown here as a rectangular hall divided into one wide central aisle with narrow side aisles, each covered with a wooden barrel vault resting on lintels supported by columns. De Witte's shift of the viewpoint slightly to one side has created an interesting spatial composition, and strong contrasts of light and shade add dramatic movement to the simple interior. The caped figure in the foreground and the dogs provide a sense of scale for the architecture and add human interest.

Today, the painting is interesting both as a record of seventeenth-century synagogue architecture and as evidence of Dutch religious tolerance in an age when Jews were often persecuted. Ousted from Spain and Portugal in the late fifteenth and early sixteenth centuries, many Jews had settled first in

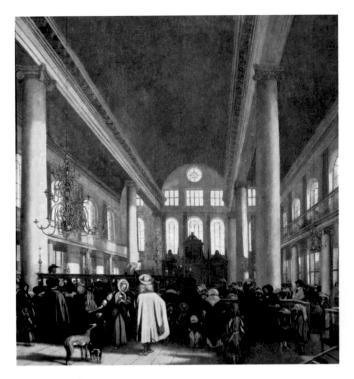

17–52 | Emanuel de Witte PORTUGUESE SYNAGOGUE, AMSTERDAM 1680. Oil on canvas, $43\frac{1}{2} \times 39$ " (110.5 × 99.1 cm).

1680. Oil on canvas, $43\% \times 39''$ (110.5 × 99.1 cm). Rijksmuseum, Amsterdam. Architect Daniel Stalpaert built the synagogue in 1670–75.

Flanders and then in the Netherlands. The Jews in Amsterdam enjoyed religious and personal freedom, and their synagogue was considered one of the outstanding sights of the city.

LANDSCAPE. The Dutch loved the landscapes and vast skies of their own country, but those who painted them were not slaves to nature as they found it: The concept was foreign to this time period. The artists constructed and refined their work in the confines of their studio and were never afraid to remake a scene by rearranging, adding, or subtracting to give their compositions formal organization or a desired mood. Starting in the 1620s, view painters generally adhered to a convention in which little color was used beyond browns, grays, and beiges. After 1650, they tended to be more individualistic in their styles, but nearly all brought a broader range of colors into play. One continuing motif was the emphasis on cloud-filled expanses of sky dominating a relatively narrow horizontal band of earth below. Painters specialized in the sea, the countryside, the city, and its buildings. Paintings of architectural interiors also became popular and seem to have been painted for their own beauty, just as exterior views of the land, cities, and harbors were.

The Haarlem landscape specialist Jacob van Ruisdael (1628/29–82), whose popularity drew many pupils to his workshop, was especially adept at both the invention of

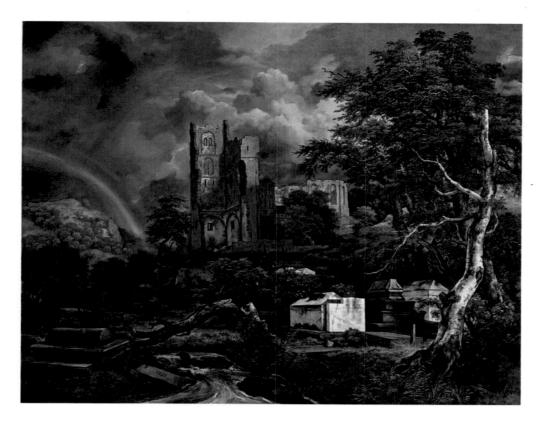

17–53 | Jacob van Ruisdael THE JEWISH CEMETERY 1655–60. Oil on canvas, 4' 6" × 6'2½" (1.42 × 1.89 m). The Detroit Institute of Arts. Gift of Julius H. Haass in memory of his brother Dr. Ernest W. Haass (24.3)

dramatic compositions and the projection of moods in his canvases. His **JEWISH CEMETERY** (FIG. 17–53), of 1655–60, is a thought-provoking view of silent tombs, crumbling ruins, and stormy landscape, with a rainbow set against dark, scudding clouds. Ruisdael was greatly concerned with spiritual meanings of the landscape, which he expressed in his choice of such environmental factors as the time of day, the weather, the appearance of the sky, or the abstract patterning of sun and shade. The barren tree points its branches at the tombs. Here the tombs, ruins, and fallen and blasted trees suggest an allegory of transience. The melancholy mood is mitigated by the rainbow, a traditional symbol of renewal and hope.

STILL LIFES AND FLOWER PIECES. The Dutch were so proud of their artists' still-life paintings that they presented one (a flower piece by Rachel Ruysch) to the French queen Marie de' Medici when she made a state visit to Amsterdam. A still-life painting might carry moralizing connotations and commonly had a *vanitas* theme, reminding viewers of the transience of life, material possessions, and even art.

One of the first Dutch still-life painters was Pieter Claesz (1596/97–1660) of Haarlem, who, like the Antwerp artist Clara Peeters, painted "breakfast pieces," that is, a meal of bread, fruits, and nuts. In subtle, nearly monochromatic paintings, such as **STILL LIFE WITH A WATCH** (FIG. 17–54), Claesz seems to give life to inanimate objects. He organizes dishes in diagonal positions to give a strong sense of space, and he gives the maximum contrast of textures within a color scheme of

white, grays, and browns. The brilliant yellow lemon provides visual excitement with its rough curling peel, juicy flesh, and soft pulpy inner skin. The tilted silver tazza contrasts with the half-filled glass that becomes a towering monumental presence and permits Claesz to display his skill at transparencies

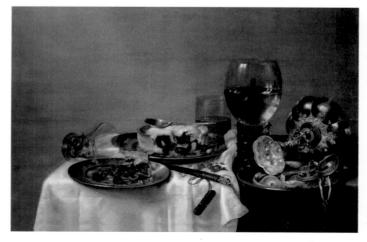

17–54 | Pieter Claesz STILL LIFE WITH A WATCH 1636. Oil on panel, Royal Picture Gallery, Maurithuis, The Hague.

The heavy round glass is a Roemer, an inexpensive, everyday item, as are the pewter plates. The gilt cup (tazza) was a typical ornamental piece. Painters owned and shared such valuable props, and this and other show pieces appear in many paintings.

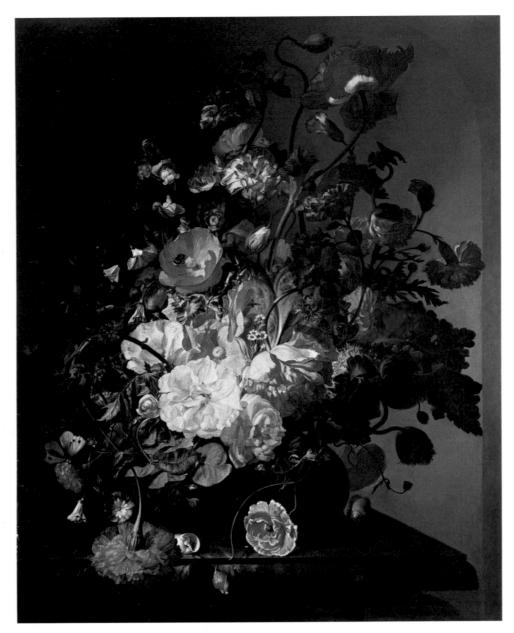

and reflections. No longer are inanimate objects represented for their symbolic value as in fifteenth-century Flemish painting, yet meaning is not entirely lost, for such paintings suggest the prosperity of Claesz's patrons. The food might be simple, but the lemon is a luxury imported from Mediterranean lands, and the silver ornamental cup graced the tables of only the wealthy. Finally, the meticulously painted time-piece suggests a deeper meaning—perhaps human achievement in science and technology, or perhaps it also becomes a *vanitas* symbol of the inexorable passage of time and the fleet-

ing life of human beings, thoughts also suggested by the interrupted breakfast.

Still-life paintings in which cut-flower arrangements predominate are referred to simply as "flower pieces." Significant advances were made in botany during the seventeenth century through the application of orderly scientific methods and objective observation (see "Science and the Changing Worldview," page 616). The Dutch were major growers and exporters of flowers, especially tulips, which appear in nearly every flower piece in dozens of exquisite

variations. The Dutch tradition of flower painting peaked in the long career of Rachel Ruysch (1664–1750) of Amsterdam. Her flower pieces were highly prized for their sensitive, free-form arrangements and their unusual and beautiful color harmonies. During her seventy-year career, she became one of the most sought-after and highest-paid still-life painters in Europe—her paintings brought twice what Rembrandt's did.

In her **FLOWER STILL LIFE** (FIG. 17–55), painted after 1700, Ruysch placed the container at the center of the canvas's width, then created an asymmetrical floral arrangement of pale oranges, pinks, and yellows rising from lower left to top right of the picture, offset by the strong diagonal of the tabletop. To further balance the painting, she placed highlighted blossoms and leaves against the dark left half of the canvas and silhouetted them against the light wall area on the right. Ruysch often emphasized the beauty of curving flower stems and enlivened her compositions with interesting additions, such as casually placed pieces of fruit or insects, in this case a large gray moth (lower left) and two snail shells.

Flower painting, a much-admired specialty in the seventeenth- and eighteenth-century Netherlands, was almost never a straightforward depiction of actual fresh flowers. Instead, artists made color sketches of fresh examples of each type of flower and studied scientifically accurate color illustrations in botanical publications. Using their sketches and notebooks, in the studio they would compose bouquets of perfect specimens of a variety of flowers that could never be found blooming at the same time. The short life of blooming flowers was a poignant reminder of the fleeting nature of beauty and of human life.

FRANCE

The early seventeenth century in France was marked by almost continuous foreign and civil wars. The assassination of King Henri IV in 1610 left France in the hands of the queen, Marie de' Medici (regency 1610–17; SEE FIG. 17–36), as regent for her 9-year-old son, Louis XIII (ruled 1610–43). When Louis came of age, the brilliant and unscrupulous Cardinal Richelieu became chief minister and set about increasing the power of the Crown at the expense of the French nobility. The death of Louis XIII again left France with a child king, the five-year-old Louis XIV (ruled 1643–1715). His mother, Anne of Austria, became regent, with the assistance of another powerful minister, Cardinal Mazarin. At Mazarin's death in 1661, Louis XIV (SEE FIG. 17–1) began his long personal reign, assisted by yet another able minister, Jean–Baptiste Colbert.

An absolute monarch whose reign was the longest in European history, Louis XIV expanded royal art patronage, making the French court the envy of every ruler in Europe. The arts, like everything else, came under royal control. In 1635, Cardinal Richelieu had founded the French Royal Academy, directing the members to compile a definitive dictionary and grammar of the French language. In 1648, the Royal Academy of Painting and Sculpture was founded, which, as reorganized by Colbert in 1663, maintained strict control over the arts (see "Grading the Old Masters," page 669). Although it was not the first European arts academy, none before it had exerted such dictatorial authority—an authority that lasted in France until the late nineteenth century. Membership in the academy assured an artist of royal and civic commissions and financial success, but many talented artists did well outside it.

Architecture and Its Decoration at Versailles

French architecture developed along classical lines in the second half of the seventeenth century under the influence of François Mansart (1598–1666) and Louis Le Vau (1612–70). When the Royal Academy of Architecture was founded in 1671, its members developed guidelines for architectural design based on the belief that mathematics was the true basis of beauty. Their chief sources for ideal models were the books of Vitruvius and Palladio (see Chapter 15).

In 1668, Louis XIV began to enlarge the small château built by Louis XIII at Versailles, not far from Paris. Louis moved to the palace in 1682 and eventually required his court to live in Versailles; 5,000 aristocrats lived in the palace itself, together with 14,000 servants and military staff members. The town had another 30,000 residents, most of whom were employed by the palace. The designers of the palace and park complex at Versailles (FIG. 17-56) were Le Vau, Charles Le Brun (1619-90), who oversaw the interior decoration, and André Le Nôtre (1613-1700), who planned the gardens (see "French Baroque Garden Design," page 666). For both political and sentimental reasons, the old Versailles château was left standing, and the new building went up around it. This project consisted of two phases: the first additions by Le Vau, begun in 1668; and an enlargement completed after Le Vau's death by his successor, Jules Hardouin-Mansart (1646–1708), from 1670 to 1685.

Hardouin-Mansart was responsible for the addition of the long lateral wings and the renovation of Le Vau's central block on the garden side to match these wings (FIG. 17–57). The three-story elevation has a lightly rusticated ground floor, a main floor lined with enormous arched windows separated by Ionic pilasters, an attic level whose rectangular windows are also flanked by pilasters, and a flat, terraced roof. The overall design is a sensitive balance of horizontals and verticals relieved by a restrained overlay of regularly spaced projecting blocks with open, colonnaded porches.

In his renovation of Le Vau's center-block façade, Hardouin-Mansart enclosed the previously open gallery on the main level, creating the famed **HALL OF MIRRORS** (FIG. 17–58), which is about 240 feet (73 meters) long and

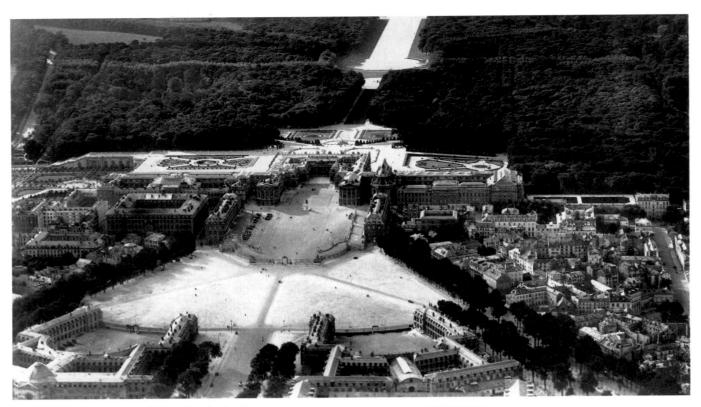

17–56 | Louis Le Vau and Jules Hardouin-Mansart PALAIS DE VERSAILLES, VERSAILLES France. 1668–85. Gardens by André Le Nôtre.

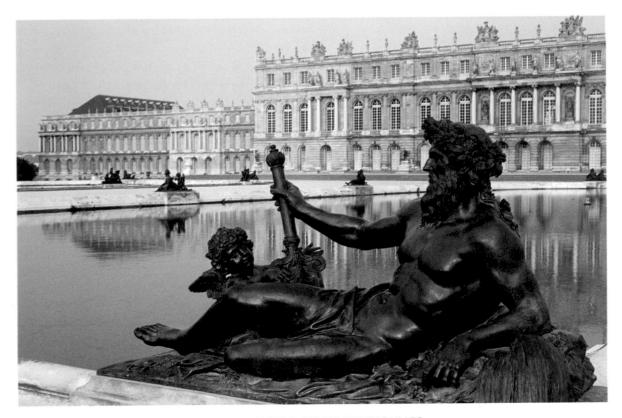

17-57 CENTRAL BLOCK OF THE GARDEN FAÇADE, PALAIS DE VERSAILLES

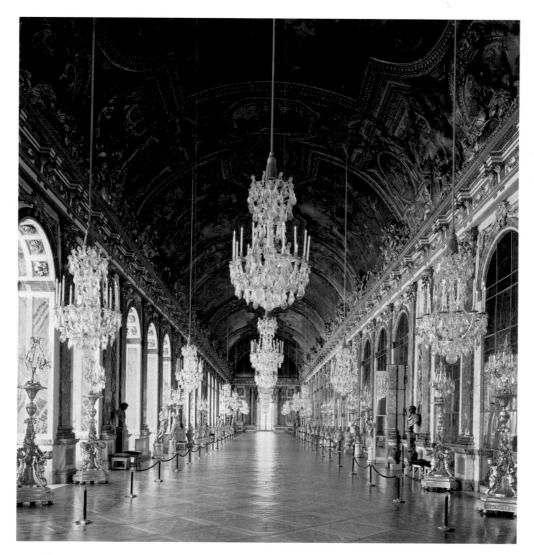

17–58 | Jules Hardouin-Mansart and Charles Le Brun HALL OF MIRRORS, PALAIS DE VER-SAILLES

Begun 1678. Length approx. 240' (73 cm).

In the seventeenth century, mirrors and clear window glass were enormously expensive. To furnish the Hall of Mirrors, hundreds of glass panels of manageable size had to be assembled into the proper shape and attached to one another with glazing bars, which became part of the decorative pattern of the vast room.

47 feet (13 meters) high. He achieved architectural symmetry and extraordinary effects by lining the interior wall opposite the windows with Venetian glass mirrors the same size and shape as the arched windows. (Mirrors were tiny and extremely expensive in the seventeenth century, and these huge walls of glass were created by fitting eighteen-inch panels together.) The mirrors reflect the natural light from the windows and give the impression of an even larger space; at night, the reflections of flickering candles must have turned the mirrored gallery into a veritable painting in which the king and courtiers saw themselves as they promenaded. Inspired by Carracci's Farnese ceiling (SEE FIG. 17–13), Le Brun decorated the vaulted ceiling with paintings (on canvas, which is more stable in the damp northern climate) glorify-

ing the reign of Louis XIV and Louis's military triumphs, assisted by the classical gods. In 1642, he had studied in Italy, where he came under the influence of the classical style of his compatriot Nicolas Poussin (discussed later in this chapter). As "First Painter to the King" and director of the Royal Academy, Le Brun controlled art education and patronage from 1661/63 until his death in 1690. He tempered the more exuberant Baroque ceilings he had seen in Rome with Poussin's classicism to produce spectacular decorations for the king. The underlying theme for the design and decoration of the palace was the glorification of the king as Apollo the Sun God, with whom Louis identified. Louis XIV thought of the duties of kingship, including its pageantry, as a solemn performance, so it is most appropriate that Rigaud's portrait

Elements of Architecture

FRENCH BAROQUE GARDEN DESIGN

ealthy landowners commissioned garden designers to transform their large properties into gardens extending over many acres. The challenge for garden designers was to unify diverse elements-buildings, pools, monuments, plantings, natural land formations-into a coherent whole. At Versailles, André Le Nôtre imposed order upon the vast expanses of palace gardens and park by using broad, straight avenues radiating from a series of round focal points. He succeeded so thoroughly that his plan inspired generations of urban designers as well as landscape architects.

In Le Nôtre's hands, the palace terrain became an extraordinary work of art and a visual delight for its inhabitants. Neatly contained stretches of lawn and broad,

straight vistas seemed to stretch to the horizon, while the formal gardens became an exercise in precise geometry. The Versailles gardens are classically harmonious in their symmetrical, geometric design but Baroque in their vast size and extension into the surrounding countryside, where the gardens thickened into woods cut by straight avenues.

The most formal gardens lay nearest the palace, and plantings became progressively less elaborate and larger in scale as the distance from the palace increased. Broad, intersecting paths separated reflecting pools and planting beds, which are called embroidered **parterres** for their colorful patterns of flowers outlined with trimmed hedges. After the formal zone of parterres came lawns, large fountains on terraces, and trees planted in thickets to conceal features such as an open-air ballroom and a colonnade. Statues carved by at least seventy sculptors also adorned the park. A mile-long canal, crossed by a sec-

Louis Le Vau and André Le Nôtre PLAN OF THE PALAIS DE VERSAILLES Versailles, France. c. 1661-1785. Drawing by Leland M. Roth after Delagrive's engraving of 1746.

ond canal nearly as large, marked the main axis of the garden. Fourteen waterwheels brought the water from the river to supply the canals and the park's 1,400 fountains. Only the fountains near the palace played all day; the others were turned on only when the king approached.

At the north of the secondary canal, a smaller pavilion-palace, the Trianon, was built in 1669. To satisfy the king's love of flowers year-round, the gardens of the Trianon were bedded out with blooming plants from the south, shipped in by the French navy. Even in midwinter, the king and his guests could stroll through a summer garden. The head gardener is said to have had nearly 2 million flowerpots at his disposal. In the eighteenth century, Louis XV added greenhouses and a botanical garden. The facilities of the fruit and vegetable garden that supplied the palace in 1677–83 today house the National School of Horticulture.

presents him on a raised, stagelike platform, with a theatrical curtain (SEE FIG. 17–1). Versailles was the splendid stage on which the king played this grandiose drama.

In the seventeenth century, French taste in sculpture tended to favor classicizing works inspired by antiquity and the Italian Renaissance. A highly favored sculptor in this classical style, François Girardon (1628–1715) had studied the monuments of classical antiquity in Rome in the 1640s.

He had worked with Le Vau and Le Brun before he began working to decorate Versailles. In keeping with the repeated identification of Louis XIV with Apollo, Girardon created the sculpture group **APOLLO ATTENDED BY THE NYMPHS OF THETIS** (FIG. 17–59), executed about 1666–75, for the central niche of the so-called Grotto of Thetis—a formal, triplearched pavilion named after a sea nymph beloved by the Sun God. In Girardon's circular grouping, Apollo, after his

long journey across the heavens, is attended by the graceful nymphs of Thetis. As in classical or Renaissance sculpture, the composition is best understood from a fixed viewpoint. The original setting was destroyed in 1684, and in 1776, Louis XVI had the painter Hubert Robert design a "natural" rocky cavern for Girardon's sculpture.

Painting

The lingering Mannerism of the sixteenth century in France gave way as early as the 1620s to Baroque classicism and Caravaggism—the use of strong chiaroscuro (tenebrism) and raking light—and the placement of large-scale figures in the foreground. Later in the century, under the control of the academy and inspired by studies of the classics and the surviving antiquities in Rome, French painting was dominated by the classical influences propounded by Le Brun.

THE INFLUENCE OF CARAVAGGIO. One of Caravaggio's most important followers in France, Georges de La Tour (1593-1652) received major royal and ducal commissions and became court painter to Louis XIII in 1639. La Tour may have traveled to Italy in 1614-16, and in the 1620s he almost certainly visited the Netherlands, where Caravaggio's style was being enthusiastically emulated. Like Caravaggio, La Tour filled the foreground of his canvases with monumental figures, but in place of Caravaggio's detailed naturalism he used a simplified setting and a light source within the picture so intense that it often seems to be his real subject. La Tour painted Mary Magdalen many times. In MARY MAGDALEN WITH THE SMOKING FLAME (FIG. 17-60), as in many of his paintings, the light emanates from a candle. The hand and skull, symbols of mortality, act as devices to establish a foreground plane, and the compression of the figure within the pictorial space lends a sense of intimacy. The light is the unifying element of the painting and conveys the somber mood. Mary Magdalen has put aside her rich clothing and jewels and meditates on the frailty and vanity of human life. She sighs, and the candle flickers.

Something of this same feeling of timelessness pervades the paintings of the Le Nain brothers, Antoine (c. 1588–1648), Louis (c. 1593–1648), and Mathieu (1607–1677). Although the brothers were working in Paris by about 1630, little else is known about their lives and careers. Because they collaborated closely with each other, art historians have only recently begun to distinguish their individual styles. They painted genre scenes imbued with a strange sense of foreboding and enigmatic meaning. **THE VILLAGE PIPER (FIG. 17–61)** of 1642, by Antoine Le Nain, is typical of the brothers' work. Peasant children gather around the figure of a flute player. The simple homespun garments and undefined setting turn the painting into a study in neutral colors and rough textures, with soft young

17-59 | François Girardon APOLLO ATTENDED BY THE NYMPHS OF THETIS

From the Grotto of Thetis, Palais de Versailles, Versailles, France. c. 1666-75. Marble, life-size. Grotto by Hubert Robert in 1776; sculpture reinstalled in a different configuration in 1778.

faces that contrast with the old man, who seems lost in his simple music. Why the brothers chose to paint these peasants and who bought the paintings are questions still not resolved.

The Classical Landscape: Poussin and Claude Lorrain. The painters Nicolas Poussin (1594–1665) and Claude Gellée (called "Claude Lorrain" or simply "Claude" 1600, 820

lée (called "Claude Lorrain" or simply "Claude," 1600–82) pursued their careers in Italy although they usually worked for French patrons. They perfected the ideal "classical" landscape and profoundly influenced painters for the next two centuries. Poussin and Claude were classicists in that they organized natural elements and figures into idealized compositions. Both were influenced by Annibale Carracci and to some extent by Venetian painting, yet each evolved an unmistakable personal style that conveyed an entirely different mood from that of their sources and from each other.

Nicolas Poussin, born in Normandy, settled in Paris, where his career as a painter was unremarkable. Determined to go to Rome, he finally arrived there in 1624. The Barberini became his foremost patrons, and Bernini considered Poussin to be one of the greatest painters in Rome. Poussin's landscapes with figures are the epitome of the orderly, arranged, classical landscape. In his LANDSCAPE WITH SAINT JOHN ON PATMOS (FIG. 17–62), from 1640, Poussin created a consistent perspective progression from the picture plane back into the distance through a clearly defined foreground, middle ground, and background. These zones are

17–60 | Georges de La Tour MARY MAGDALEN WITH THE SMOKING FLAME c. 1640. Oil on canvas, $46\% \times 36\%$ (117 \times 91.8 cm). Los Angeles County Museum of Art. Gift of the Ahmanson Foundation (M. 77.73)

marked by alternating sunlight and shade, as well as by architectural elements. Surrounded by the huge, tumbled ruins of ancient Rome—and by extension all earthly empires—Saint John writes the Book of Revelation, describing the end of the world, the Last Judgment, and the Second Coming of Christ: a renewal of life suggested by the flourishing vegetation. This grand theme is represented in the highly intellectualized format of Poussin's classical composition. In the middle distance are a ruined temple and an obelisk, and the round building in the distant city is

Hadrian's Tomb, which Poussin knew from Rome. Precisely placed trees, hills, mountains, water, and even clouds take on a solidity of form that seems almost as structural as architecture. The reclining evangelist and the eagle, his symbol, seem immobile—locked into this perfect landscape. The triumph of the rational mind takes on moral overtones. The subject of Poussin's painting is not the story of John the Evangelist but rather the balance and order of nature.

In the second half of the seventeenth century, the French Academy took Poussin's paintings and notes on

Defining Art

GRADING THE OLD MASTERS

he members of the French Royal Academy of Painting and Sculpture considered ancient classical art to be the standard by which contemporary art should be judged. By the 1680s, however, younger artists of the academy began to argue that modern art might equal and even surpass the art of the ancients—a radical thought that sparked controversy.

A debate arose over the relative merits of drawing and color in painting. The conservatives argued that drawing was superior to color because drawing appealed to the mind while color appealed to the senses. They saw Nicolas Poussin as embodying perfectly the classical principles of subject and design. But the young artists who admired the vivid colors of Titian, Veronese, and Rubens claimed that painting should deceive the eye, and since color achieves this deception more convincingly than drawing, application of color should be valued over drawing. Adherents to the two positions were called poussinistes (in honor of Poussin) and rubénistes (for Rubens).

The portrait painter and critic Roger de Piles (1635–1709) took up the cause of the *rubénistes* in a series of pamphlets. In *The Principles of Painting*, Piles evaluated the most important painters on a scale of 0 to 20 in four categories. He gave no score higher than 72 (18 in each category), since no mortal artist could achieve perfection. Caravaggio received the lowest grade, a 0 in expression and 6 in drawing for a low of 28, while Michelangelo and Leonardo both got a 4 in color and Rembrandt a 6 in drawing.

Most of the painters we have studied don't do very well. Raphael and Rubens get 65 points, Van Dyck comes close with 55. Poussin and Titian earn 53 and 51, while Rembrandt slips by with 50. Leonardo da Vinci gets 49, and Michelangelo and Dürer with 37 and Caravaggio with 28 all are resounding failures in Piles's view.

17–61 | Antoine Le Nain THE VILLAGE PIPER 1642. Oil on copper, $8\% \times 11\%''$ (21.3 \times 29.2 cm). Detroit Institute of Arts.

painting as a final authority. From then on, whether as a model to be followed or one to be reacted against, Poussin influenced French art.

When Claude Lorrain went to Rome in 1613, he first studied with Agostino Tassi, an assistant of Guercino and a specialist in architectural painting. Claude, however, preferred landscape. He sketched outdoors for days at a time, then returned to his studio to compose his paintings. Claude was fascinated with light, and his works are often studies of the effect of the rising or setting sun on colors and the atmosphere. A favorite and much imitated device was to place one or two large objects in the foreground—a tree, building, or hill—past which the viewer's eye enters the scene and proceeds, often by zigzag paths, into the distance.

Claude used this compositional device to great effect in paintings such as **EMBARKATION OF THE QUEEN OF SHEBA** (FIG. 17–63). Instead of balanced, symmetrically placed elements, Claude leads the viewer into the painting in a zigzag fashion. A ruined building with Corinthian cornice and columns frames the composition at the left; light catching the seashore leads the eye to the right, where a handsome palace with a grand double staircase and garden with trees establishes a middle ground. Across the water the sails and rigging of ships provide extra visual interest. More distant still are the

harbor fortification with town and lighthouse and finally the breakwater (at the left). On the horizon the sun illuminates the clouds in a clearing sky and catches the waves to make a glowing sea path to shore. The small figures—workers and onlookers in the foreground, the queen and her courtiers waiting on the quay and about to board—seem incidental, added to give the painting a subject. Claude's meticulous one-point perspective focuses on the sun with the same driving force with which earlier painters focused on Christ and the saints.

HYACINTHE RIGAUD. Hyacinthe Rigaud (1659–1743), trained by his painter father, won the Royal Academy's prestigious Prix de Rome in 1682, which would have paid his expenses for study at the Academy's villa in Rome. Rigaud rejected the prize, however, and opened his own Paris studio. After painting a portrait of Louis XIV's brother in 1688, he became a favorite of the king himself. His representation of the monarch (SEE FIG. 17–1) reveals a more extravagant style than the restrained classicism of Le Brun. In fact, Louis favored a more theatrical presentation for himself and his court, and Rigaud's representation of the Sun King embodies official portraiture as the height of royal propaganda.

17–62 Nicolas Poussin LANDSCAPE WITH SAINT JOHN ON PATMOS 1640. Oil on canvas, $40 \times 53\%$ " (101.8 \times 136.3 cm). The Art Institute of Chicago. A. A. Munger Collection, 1930.500

17–63 | Claude Lorrain **EMBARKATION OF THE QUEEN OF SHEBA** 1648. Oil on canvas, 4' $10'' \times 6'$ 4'' (1.48 \times 1.93 m). National Gallery, London. Reproduced by courtesy of the Trustees of the National Gallery, London

ENGLAND

England and Scotland were joined in 1603 with the ascent to the English throne of James VI of Scotland, who reigned over Great Britain as James I (ruled 1603–25). James increased royal patronage of British artists, especially in literature and architecture. William Shakespeare wrote *Macbeth*, featuring the king's legendary ancestor Banquo, in tribute to the new royal family, and the play was performed at court in December 1606.

Although James's son Charles I was an important collector and patron of painting, religious and political tensions that erupted into civil wars cost Charles his throne and his life in 1649. A succession of republican and monarchical rulers who alternately supported Protestantism or Catholicism followed, until the Catholic king James II was deposed in the Glorious Revolution of 1689 by his Protestant son-in-law and daughter, William and Mary. After Mary's death in 1694, William (the Dutch great-grandson of William of Orange, who had led the Netherlands' independence movement) ruled on his own until his death in 1702. He was succeeded by Mary's sister Anne (ruled 1702–14).

Architecture and Landscape Design

In sculpture and painting, the English court patronized foreign artists. The field of architecture, however, was dominated in the seventeenth century by the Englishmen Inigo Jones, Christopher Wren, and Nicholas Hawkmoor. They replaced the country's long-lived Gothic style with a classical one and were followed in a more Baroque mode by another English architect, John Vanbrugh. Major changes in landscape architecture took place during the eighteenth century, led by the innovative designer Lancelot "Capability" Brown.

INIGO JONES. In the early seventeenth century, the architect Inigo Jones (1573–1652) introduced his version of Renaissance classicism—an architectural design based on the style of the architect Andrea Palladio—into England. Jones had studied Palladio's work in Venice, and he filled his copy of Palladio's Four Books of Architecture (which has been preserved) with notes. Appointed surveyor-general in 1615, Jones was commissioned to design the Queen's House in Greenwich and the Banqueting House for the royal palace of Whitehall.

The BANQUETING HOUSE, WHITEHALL PALACE (FIG. 17-64), built in 1619-22 to replace an earlier hall destroyed by fire, was used for court ceremonies and entertainments such as the popular masques—dance-dramas combining theater, music, and dance in a spectacle in which professional actors, courtiers, and even members of the royal family participated. The west front shown here, consisting of what appears to be two upper stories with superimposed Ionic and Composite orders raised over a plain basement level, exemplifies the understated elegance of Jones's interpretation of Palladian design. Pilasters flank the end bays, and engaged columns subtly emphasize the three bays at the center. These vertical elements are repeated in the balustrade along the roofline. A rhythmic effect was created in varying window treatments from triangular and segmental (semicircular) pediments on the first level to cornices with volute (scroll-form) brackets on the second. The sculpted garlands just below the roofline add an unexpected decorative touch, as does the use of a different-color stone-pale golden, light brown, and white-for each story (no longer visible after the building was refaced in uniformly white Portland stone).

Although the exterior suggests two stories, the interior of the Banqueting House (FIG. 17–65) is actually one large hall divided by a balcony, with antechambers at each end. Ionic pilasters suggest a colonnade but do not impinge on the ideal, double-cube space, which measures 55 feet in width by 110 feet in length by 55 feet in height. In 1630, Charles I commissioned Peter Paul Rubens to decorate the ceiling. Jones had divided the flat ceiling into nine compartments, for which Rubens painted canvases glorifying the reign of James I. Installed in 1635, the paintings show the triumph of the Stu-

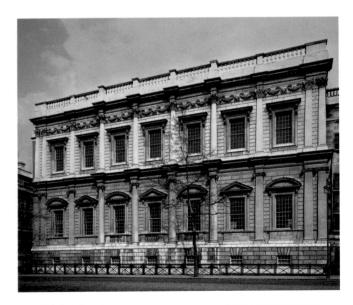

17–64 | Inigo Jones BANQUETING HOUSE, WHITEHALL PALACE
London. 1619–22.

art dynasty with the king carried to heaven in clouds of glory. The large rectangular panel beyond it depicts the birth of the new nation, flanked by allegorical paintings of heroic strength and virtue overcoming vice. In the long paintings on each side, *putti* holding the fruits of the Earth symbolize the peace and prosperity of England and Scotland under Stuart rule. So proud was Charles of the result that, rather than allow the smoke of candles and torches to harm the ceiling decoration, he moved evening entertainments to an adjacent pavilion.

CHRISTOPHER WREN. After Jones's death, English architecture was dominated by Christopher Wren (1632–1723). Wren began his professional career in 1659 as a professor of astronomy; architecture was a sideline until 1665, when he traveled to France to further his education. While there, he met with French architects and with Bernini, who was in Paris to consult on his designs for the Louvre. Wren returned to England with architectural books, engravings, and a greatly increased admiration for French classical Baroque design. In 1669, he was made surveyor–general, the position once held by Inigo Jones; in 1673, he was knighted.

After the Great Fire of 1666 demolished central London, Wren was continuously involved in rebuilding the city. He built more than fifty Baroque churches. His major project from 1675 to 1710, however, was the rebuilding of SAINT PAUL'S CATHEDRAL (FIG. 17-66). Attempts to salvage the burned-out medieval church on the site failed, and a new cathedral was needed. Wren's famous second design for Saint Paul's (which survives in the so-called Great Model of 1672-73) was for a centrally planned building with a great dome in the manner of Bramante's plan for Saint Peter's. This was rejected, but Wren ultimately succeeded both in satisfying Reformation tastes for a basilica and in retaining the unity inherent in the dome. Saint Paul's has a long nave and equally long sanctuary articulated by small, domed bays. Semicircular, colonnaded porticoes open into short transepts that compress themselves against the crossing, where the dome rises 633 feet from ground level. Wren's dome for Saint Paul's has an interior masonry vault with an oculus and an exterior sheathing of lead-covered wood but also has a brick cone rising from the inner oculus to support a tall lantern. (The ingenuity of the design and engineering remind one that Wren was mathematician and professor of astronomy at Oxford.) The columns surrounding the drum on the exterior recall Bramante's Tempietto in Rome (SEE FIG. 15-17), although Wren never went to Italy and knew Italian architecture only from books.

On the façade of Saint Paul's, two stages of paired Corinthian columns support a carved pediment. The deep-set porticoes and columned pavilions atop the towers create dramatic areas of light and shadow. Not only the huge size of the cathedral but also its triumphant verticality, complexity of form, and chiaroscuro effects make it a major monument of the English Baroque. Wren recognized the importance of the

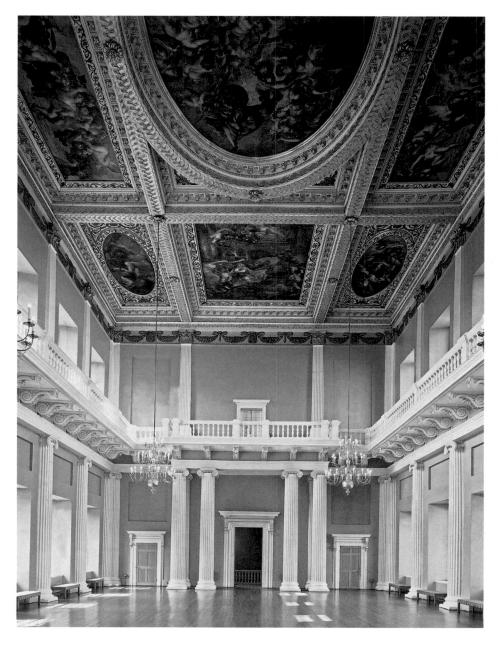

17–65 INTERIOR, BANQUETING HOUSE, WHITEHALL PALACE
Ceiling paintings of the apotheosis of King James and the glorification of the Stuart monarchy by Peter Paul Rubens. 1630–35.

building. On the simple marble slab that forms his tomb in the crypt of the cathedral, he had engraved: "If you want to see his memorial, look around you."

BLENHEIM PALACE. Like Wren, Sir John Vanbrugh (1664–1726) came late to architecture. His heavy, angular style, utterly unlike Wren's, was well suited to buildings intended to express power and domination. Wren's assistant Nicholas Hawksmoor (1661–1736) also worked in a bolder style. Perhaps the most important achievement of the two was BLENHEIM PALACE (FIG. 17–67), built in two phases (1705–12 and 1715–25) in Woodstock, just northwest of London. Van-

brugh was an amateur, a soldier and playwright whose architectural designs are indeed theatrical. Hawksmoor was an established professional who understood building and engineering. The two combined to create the imposing and impractical monument to the glory of England—an architectural challenge to Louis XIV and Versailles. Built by Queen Anne, with funds from Parliament, for John Churchill, duke of Marlborough, after his 1704 victory over the armies of Louis XIV at Blenheim, the palace was made a national monument as well as the residence of the dukes of Marlborough. Except for the formal gardens at each side of the center block, the informal and natural landscaping is the work of

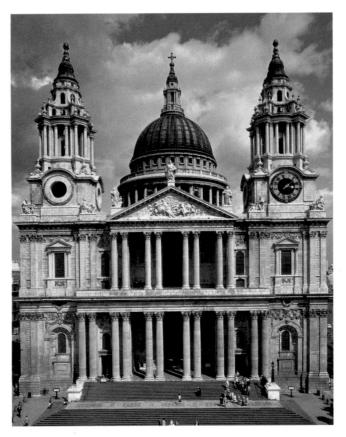

17–66 | Christopher Wren SAINT PAUL'S CATHEDRAL, LONDON
Designed 1673, built 1675–1710.

Lancelot "Capability" Brown. Blenheim's enormous size and symmetrical plan, with service and stable wings flanking an entrance court, recall Versailles as they reach out to encompass the surrounding terrain.

Blenheim's grounds originally comprised a practical kitchen garden, an avenue of elm trees, and another garden. In the 1760s, the grounds were redesigned by Lancelot "Capability" Brown (1716-83) according to his radical new style now called, appropriately, "landscape architecture." In contrast to the geometric rigor of the French and Italian gardens, Brown's designs appeared to be both informal and natural. The "natural" appearance was created by feats of engineering, as the land was reformed to create views inspired by the paintings of Claude Lorrain. In order to accomplish this at Blenheim, Brown dammed the small river flowing by the palace to form two lakes and a rockwork cascade, then created sweeping lawns and vistas with artfully arranged trees. (Gardeners and their patrons thought of the future, as they planted trees that they would never see grow to maturity.) The formal gardens in the French style now seen at each side of Blenheim's center block were added in the twentieth century.

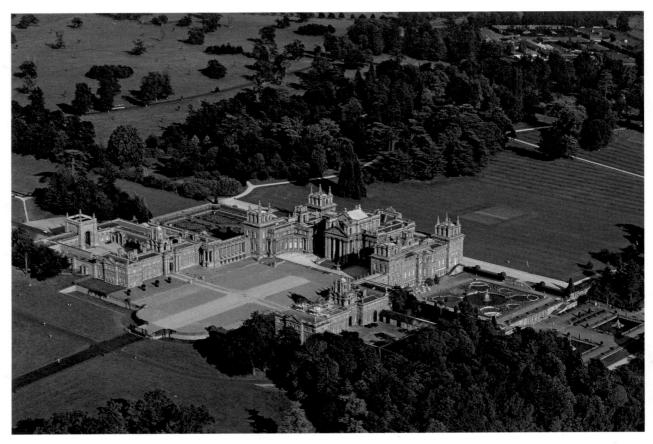

17–67 | John Vanbrugh BLENHEIM PALACE, WOODSTOCK Oxfordshire, England. 1705–12 and 1715–25.

English Colonies in North America

In the seventeenth century, the art of North America reflected the tastes of the European rulers—England on the East Coast, France in Canada and Louisiana, Spain in the Southwest. Not surprisingly, much of the colonial art was the work of immigrant artists, and styles often lagged behind the European mainstream. The rigors of colonial life meant that few people could afford to think of fine houses and art collections. Furthermore, the Puritans, religious dissenters who had left England and settled in the Northeast beginning in 1620, wanted simple, functional buildings for homes and churches. Architecture and crafts responded more quickly than sculpture and painting in the development of native styles. Although by the last decades of the seventeenth century a market for fine furniture and portraits had developed, native artists of outstanding talent often found it advantageous to resettle in Europe.

ARCHITECTURE. Early architecture in the British North American colonies was derived from European timber construction. Wood, so easily obtained in the Northeast, was used to create the same kinds of houses and churches then being built in rural England (as well as in Holland and France, which also had colonies in North America). In seventeenthcentury New England, many buildings reflected the adapta-

Sequencing Works of Art	
1645-52	Gianlorenzo Bernini, Saint Teresa of Ávila in Ecstasy
1648	Claude Lorrain, Embarkation of the Queen of Sheba
1656	Diego Velázquez, Las Meninas
c. 1656-57	Gianlorenzo Bernini, piazza design for Saint Peter's, Rome
1658	Rembrandt van Rijn, Self-Portrait

tion of contemporary English country buildings, which were appropriate to the severe North American winters-framedtimber construction with steep roofs, massive central fireplaces and chimneys, overhanging upper stories, and small windows with tiny panes of glass or parchment screens. Following a time-honored tradition, walls consisted of wooden frames filled with wattle and daub (woven branches packed with clay) or brick in more expensive homes. Instead of leaving this construction exposed, as was common in Europe, colonists usually weatherproofed it with horizontal plank siding, called clapboard. The PARSON CAPEN HOUSE in Topsfield, Massachusetts (FIG. 17-68), built in 1683, is a well-preserved example. The earliest homes generally consisted of a single

17–68 PARSON CAPEN HOUSE Topsfield, Massachusetts. 1683.

17–69 | Anonymous ("Freake Painter") MRS. FREAKE AND BABY MARY c. 1674. Oil on canvas, $42\% \times 36\%$ " (108 \times 92.1 cm). Worcester Museum of Art, Worcester, Massachusetts. Gift of Mr. and Mrs. Albert W. Rice

"great room" and fireplace, but the Capen House has two stories, each with two rooms flanking the central fireplace and chimney. The main fireplace was the center of domestic life; all the cooking was done there, and the firelight provided illumination for reading and sewing.

PAINTING. Painting and sculpture had to wait for more settled and affluent times in the eastern seacoast colonies. For a long time, the only works of sculpture were carved or engraved tombstones. Painting, too, was sponsored as a necessary part of family record keeping, and portraits done by itinerant "face painters," called **limners**, have a charm and sincerity that appeal to the modern eye. The anonymous painter of MRS. FREAKE AND BABY MARY (FIG. 17–69), dated about 1674, seems to have known Dutch portraiture, probably

through engraved copies that were imported and sold in the colonies. Even though the "Freake Painter" was clearly self-taught and lacked skills in illusionistic, three-dimensional composition, emotionally this portrait has much in common with Frans Hals's *Catharina Hooft and Her Nurse* (SEE FIG. 17–41). Maternal pride in an infant and hope for her future are universal ideals that apply to little Mary as well as to Catharina, even though their worlds were far apart.

IN PERSPECTIVE

Cataclysmic forces unleashed in the sixteenth century came to fruition in the arts only in the seventeenth century, as political and religious factions attacked each other with lethal fanaticism and enlisted art—as well as God—on their side. Spectacular visions, brilliant state portraits, and grandiose palaces and churches proclaimed the power of church and state. In papal Rome, Bernini, Borromini, and Gaulli worked their visual magic while Caravaggio revolutionized painting with his new naturalism. In Spain, France, and England, artists such as Rigaud and Van Dyck created portraits that were miracles of royal propaganda while Velázquez and Rubens glorified political and military victories.

Florence, Venice, and even Antwerp lost their economic and hence cultural advantage while papal Rome, Louis XIV's Paris and Versailles, and the commercial center of Amsterdam became the economic engines of the arts. In the Protestant countries, religious art was replaced by secular subject matter and a strong realistic style as the arts found a new economic basis—the open art market. Artists like Vermeer or Ruisdael painted themes considered "lesser" by the critics but with sales in mind: still lifes, landscapes, and scenes of daily life. As the universities became the centers of intellectual life, curriculum changed from religion and philosophy to science and mathematics. Artists like Maria Sibylla Merian joined scientists in the exploration and recording of nature, and Rembrandt probed the human mind and spirit.

Trade became global, and fortunes were to be made as ships replaced the overland routes between Europe and Asia and new trade routes crossed the Atlantic. The fascinating phenomenon today referred to as "core and periphery"—cultural transference between colonial power and colony—is epitomized by the comparison of two portraits, Hals's *Catharina Hooft* and the "Freake Painter's" *Baby Mary*—as a new art center arose in the New World.

PEETERS

STILL LIFE WITH FLOWERS, GOBLET,

DRIED FRUIT AND PRETZLES

1611

BERNINI
BALDACCHINO
SAINT PETER'S BASILICA, VATICAN
1624–1633

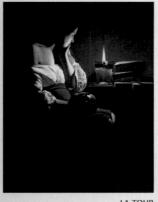

LA TOUR
MARY MAGDALEN WITH
THE SMOKING FLAME
C. 1640

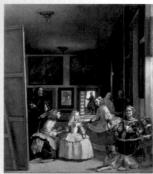

VELAZQUEZ LAS MENINAS 1656

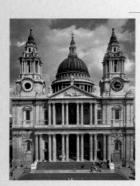

WREN

ST. PAUL'S CATHEDRAL

DESIGNED 1673

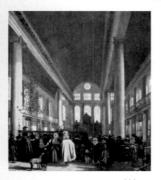

DE WITTE
PORTUGUESE SYNAGOGUE, AMSTERDAM
1680

BAROQUE ART

- Thirty Year's War 1618-48
 - Mayflower Lands in North America 1620
 - Galileo Forced to Recant 1633
 - **Louis XIV of France Ruled** 1643–1715
 - French Royal Academy of Painting and Sculpture 1648
 - Spanish Habsburgs Recognize
 Independence of United Provinces
 1648
 - Charles I of England Beheaded;
 England a Commonwealth 1649
 - Restoration of Charles II and Monarchy in England 1660
 - Great Fire of London 1666
 - French Royal Academy of Architecture 1671

- Newton Publishes Laws of Gravity and Motion 1687
- Glorious Revolution in England 1689
- Steam Engine Invented 1698

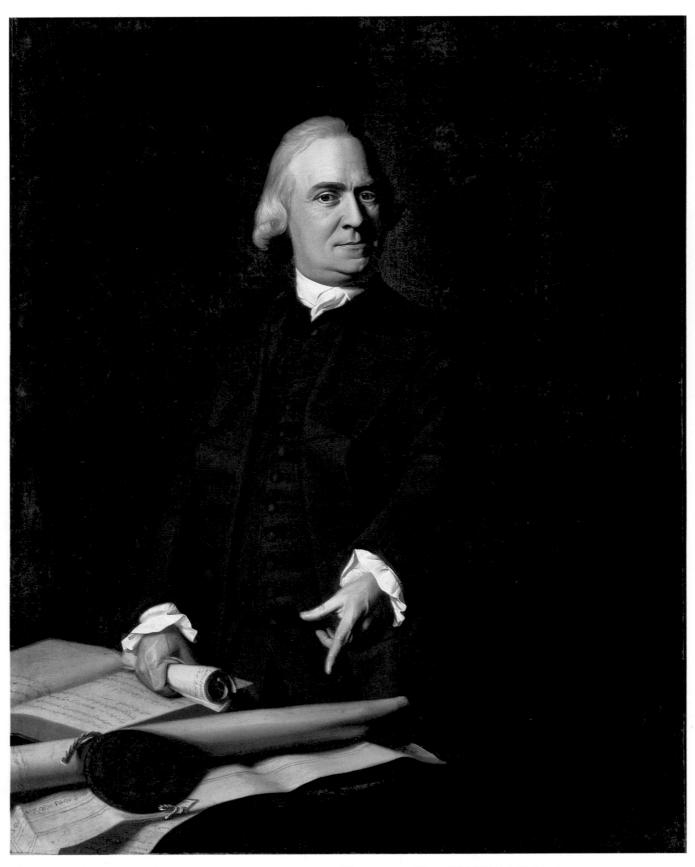

18–1 | **John Singleton Copley SAMUEL ADAMS** c. 1770–72. Oil on canvas, $50 \times 40''$ (127 \times 102.2 cm). Museum of Fine Arts, Boston. Deposited by the City of Boston

EIGHTEENTH-CENTURY ART IN EUROPE AND THE AMERICAS

On March 5, 1770, a street fight broke out between several dozen residents of Boston and a squad of British soldiers. The British fired into the crowd, killing three men and wounding eight others, two of whom later died. Dubbed

the Boston Massacre by anti-British patriots, the event was one of many that led to the Revolutionary War of 1775–83, which won independence from Britain for the thirteen American colonies.

The day after the Boston Massacre, Samuel Adams, a member of the Massachusetts legislature, demanded that the royal governor, Thomas Hutchinson, expel British troops from the city—a confrontation that Boston painter John Singleton Copley immortalized in oil paint (FIG. 18–1). Adams, conservatively dressed in a brown suit and waistcoat, stands before a table and looks sternly out at the viewer, who occupies the place of Governor Hutchinson. With his left hand, Adams points to the charter and seal granted to Massachu-

18

setts by King William and Queen Mary; in his right, he grasps a petition prepared by the aggrieved citizens of Boston.

The vivid realism of Copley's style makes the life-size figure of Adams seem almost to be

standing before us. Adams's head and hands, dramatically lit, surge out of the darkness with a sense of immediacy appropriate to the urgency of his errand. The legislator's defiant stance and emphatic gesture convey the moral force of his demands, which are impelled not by emotion but by reason. The charter to which he points insists on the rule of law, and the faintly visible classical columns behind him connote republican virtue and rationality—important values of the Enlightenment, the major philosophical movement of eighteenth-century Europe as well as Colonial America. Enlightenment political philosophy provided the ideological basis for the American Revolution, which Adams ardently supported.

- **THE ENLIGHTENMENT AND ITS REVOLUTIONS**
- THE ROCOCO STYLE IN EUROPE | Architecture and Its Decoration in Germany and Austria | Painting and Sculpture in France
- ITALY AND THE CLASSICAL REVIVAL | Italian Portraits and Views | Neoclassicism in Rome: The Albani-Winckelmann Influence
- REVIVALS AND EARLY ROMANTICISM IN BRITAIN | Classical Revival in Architecture and Landscaping | Gothic Revival in Architecture and Its Decoration | Neoclassicism in Architecture and the Decorative Arts | Painting
- LATER EIGHTEENTH-CENTURY ART IN FRANCE | Architecture | Painting and Sculpture
- EIGHTEENTH-CENTURY ART OF THE AMERICAS | New Spain | North America
- IN PERSPECTIVE

THE ENLIGHTENMENT AND ITS REVOLUTIONS

The eighteenth century marks a great divide in Western history. When the century opened, the West was still semifeudal economically and politically. Wealth and power were centered in an aristocratic elite, who owned or controlled the land worked by the largest and poorest class, the farmers. In between was a small middle class composed of doctors, lawyers, shopkeepers, artisans, and merchants—most of whom depended for their livelihood on the patronage of the rich. Only those involved in overseas trade operated outside the agrarian system, but even they aspired to membership in the landed aristocracy.

By the end of the century, the situation had changed dramatically. A new source of wealth—industrial manufacture—was then developing, and social visionaries expected industry not only to expand the middle class but also to provide a better material existence for all classes, an interest that extended beyond purely economic concerns. What became known as the Industrial Revolution was complemented by a revolution in politics, spurred by a new philosophy that conceived of all white men (some thinkers included women and racial or ethnic minorities) as deserving of equal rights and opportunities. The American Revolution of 1776 and the French Revolution of 1789 were the seismic results of this dramatically new concept.

Developments in politics and economics were themselves manifestations of a broader philosophical revolution: the Enlightenment. The Enlightenment was a radically new synthesis of ideas about humanity, reason, nature, and God that had arisen during classical Greek and Roman times and during the Renaissance. What distinguished the Enlightenment proper from its antecedents was the late seventeenthand early eighteenth-century thinkers' generally optimistic view that humanity and its institutions could be reformed, if not perfected. Bernard de Fontenelle, a French popularizer of seventeenth-century scientific discoveries, writing in 1702, anticipated "a century which will become more enlightened

day by day, so that all previous centuries will be lost in darkness by comparison." At the end of the seventeenth and beginning of the eighteenth century, such hopes were expressed by a handful of people; after 1740, the number and power of such voices grew, so that their views increasingly dominated every sphere of intellectual life, including that of the European courts. The most prominent and influential of these thinkers, called *philosophes* (to distinguish their practical concerns from the purely academic ones of philosophers), included Jean-Jacques Rousseau, Denis Diderot, Thomas Jefferson, Benjamin Franklin, and Immanuel Kant.

The philosophes and their supporters did not agree on all matters. Perhaps the matter that most unified these thinkers was the question of the purpose of humanity. Rejecting conventional notions that men and women were here to serve God or the ruling class, the philosophes insisted that humans were born to serve themselves, to pursue their own happiness and fulfillment. The purpose of the state, they agreed, was to facilitate this pursuit. Despite the pessimism of some and the reservations of others, Enlightenment thinkers were generally optimistic that men and women, when set free from their political and religious shackles, could be expected to act both rationally and morally. Thus, in pursuing their own happiness, they would promote the happiness of others.

The new emphasis on rationality proceeded in part from new mathematical and scientific discoveries by such thinkers as René Descartes, Gottfried Wilhelm von Leibnitz, Blaise Pascal, and, perhaps most significantly, Isaac Newton. Newton brought a new emphasis on empirical proof to his scientific studies and rejected the supernatural realm as a basis for theory. Fellow Englishman John Locke transferred this empiricism to his consideration of human society, concluding that ideas and behavior are not inborn or predetermined by God but rather the result of perception and experience. Each individual was born a blank slate with certain basic rights that a government was obligated to protect.

Thus, most Enlightenment thinkers saw nature as both rational and good. The natural world, whether a pure mecha-

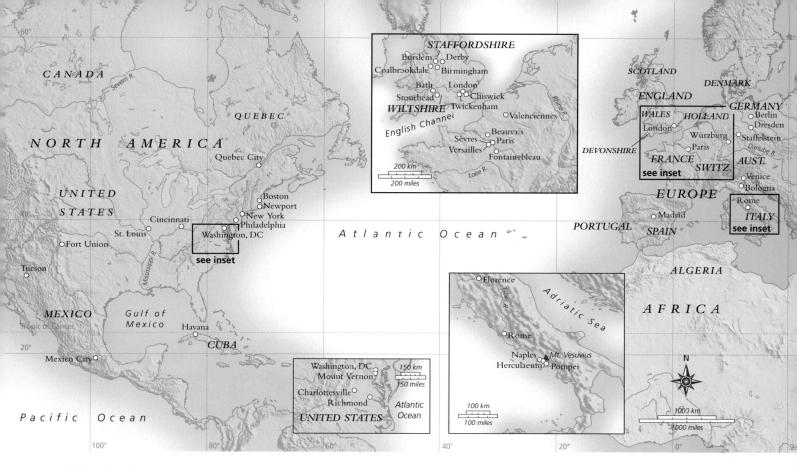

MAP 18-1 | EUROPE AND NORTH AMERICA IN THE EIGHTEENTH CENTURY

During the eighteenth century, three major artistic styles—Rococo, Neoclassicism, and Romanticism—flourished in Europe and North America.

nism or the creation of a beneficent deity, was amenable to human understanding and, therefore, control. Once the laws governing the natural and human realms were determined, they could be harnessed for our greater happiness. From this concept flowed the inextricably intertwined industrial and political revolutions that marked the end of the century. Before the Enlightenment took hold, however, most of aristocratic Europe had a fling with the art style known as Rococo, a sensuous variation on the preceding Baroque.

THE ROCOCO STYLE IN EUROPE

The term *Rococo* was coined by critics who combined the Portuguese word *barroco* (which refers to an irregularly shaped pearl and may be the source of the word *baroque*) and the French word *rocaille* (the artificial shell or rock ornament popular for gardens) to describe the refined, fanciful, and often playful style that became fashionable in France at the end of the seventeenth century and spread throughout Europe in the eighteenth century. This was the favored style of an aristocracy that devoted itself to the enjoyment of superficial pleasures, including witty conversation, cultivated artifice, and playful sensuality. The Rococo style is

characterized by pastel colors, delicately curving forms, dainty figures, and a lighthearted mood. It may be seen partly as a reaction at all levels of society, even among kings and bishops, against the art identified with the formality and rigidity of seventeenth-century court life. The movement began in French architectural decoration at the end of Louis XIV's reign (ruled 1643-1715) and quickly spread across Europe (MAP 18-1). The Duke of Orléans, regent for the boy-king Louis XV (ruled 1715-74), made his home in Paris, and the rest of the court—delighted to escape the palace at Versailles—also moved there and built elegant town houses (in French, hôtel), whose smaller rooms dictated new designs for layout, furniture, and décor. They became the lavish settings for intimate and fashionable intellectual gatherings and entertainments, called salons, that were hosted by accomplished, educated women of the upper class whose names are still known today—Mesdames de Staël, de La Fayette, de Sévigné, and du Châtelet being among the most familiar. The SALON DE LA PRINCESSE in THE HÔTEL DE SOUBISE in Paris (FIG. 18-2), designed by Germain Boffrand (1667-1754) beginning in 1732, is typical of the delicacy and lightness seen in French Rococo hôtel design during the 1730s.

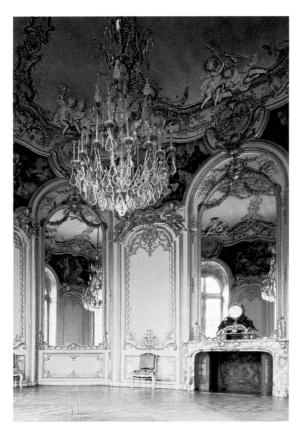

18-2 | Germain Boffrand SALON DE LA PRINCESSE, HÔTEL DE SOUBISE
Paris, France. Begun 1732.

Library, Getty Research, Institute, Los Angeles. Wim Swaan Photograph Collection (96, p.21)

> 18-3 | Johann Balthasar Neumann KAISERSAAL (IMPERIAL HALL), RESIDENZ, WÜRZBURG

Bavaria, Germany. 1719-44. Fresco by Giovanni Battista Tiepolo. 1751-52 (SEE FIG. 18-4). Typical Rococo elements in architectural decoration were **arabesques** (characterized by flowing lines and swirling shapes), S-shapes, C-shapes, reverse–C-shapes, volutes, and naturalistic plant forms. The glitter of silver or gold against expanses of white or pastel color, the visual confusion of mirror reflections, delicate ornament in sculpted stucco, carved wood panels called *boiseries*, and inlaid wood designs on furniture and floors were all part of the new look. In residential settings, pictorial themes were often taken from classical love stories, and sculpted ornaments were rarely devoid of *putti*, cupids, and clouds.

Architecture and Its Decoration in Germany and Austria

After the end of the War of the Spanish Succession in 1714, rulers in central Europe felt the need to replace damaged buildings and display their power and wealth more impressively. Interior designs for some of these new palaces and churches, though based on traditional Baroque plans, were also animated by the Rococo spirit, especially in Germany and Austria. In occasional small-scale buildings, the Rococo style was successfully applied to architectural planning as well.

THE RESIDENZ AT WÜRZBURG. The first major architectural project influenced by the new Rococo style was the Resi-

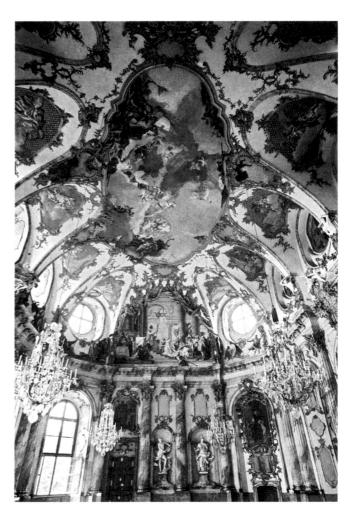

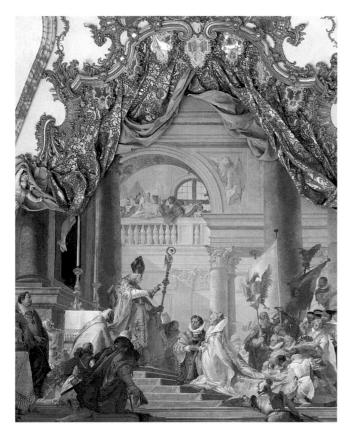

18–4 | Giovanni Battista Tiepolo THE MARRIAGE OF THE EMPEROR FREDERICK AND BEATRICE OF BURGUNDY Fresco in the Kaisersaal (Imperial Hall), Residenz. Würzburg, Germany. 1751–52.

denz, a splendid palace that Johann Balthasar Neumann (1687–1753) designed for the prince-bishop of Würzburg from 1719 to 1744. The oval KAISERSAAL, or Imperial Hall (FIG. 18–3), illustrates Neumann's great triumph in planning and decoration. Although the clarity of the plan, the size and proportions of the marble columns, and the large windows recall the Hall of Mirrors at Versailles (SEE FIG. 14–23), the decoration of the Kaisersaal, with its white-and-gold color scheme and its profusion of delicately curved forms, embodies the Rococo spirit. Here we see the earliest development of Neumann's aesthetic of interior design that culminated in his final project, the Church of the Vierzehnheiligen (Fourteen Auxiliary Saints) near Staffelstein (SEE FIG. 18–7).

Neumann's collaborator on the Residenz was the Venetian painter Giovanni Battista Tiepolo (1696–1770), who began to work there in 1750. Venice by the early eighteenth century had surpassed Rome as an artistic center, and Tiepolo gained international acclaim for his confident and optimistic expression of the illusionistic fresco painting pioneered by sixteenth-century Venetians such as Veronese (SEE PAGE 570). Tiepolo filled the niches in the Kaisersaal with frescoes—three scenes glorifying the twelfth-century crusader-emperor Frederick Barbarossa, who had been an early patron of the bishop of Würzburg—in a superb example of his architectural painting. THE MARRIAGE OF THE EMPEROR FREDERICK

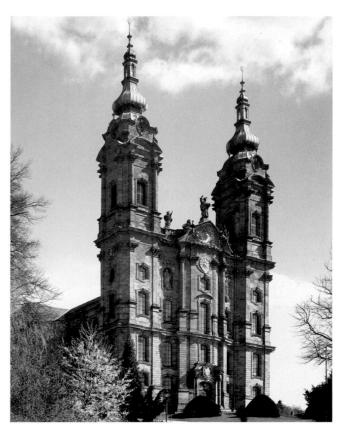

18–5 | Johann Balthasar Neumann CHURCH OF THE VIERZEHNHEILIGEN
Near Staffelstein, Germany. 1743–72.

AND BEATRICE OF BURGUNDY (FIG. 18–4) is presented as if it were theater, with painted and gilded stucco curtains drawn back to reveal the sumptuous costumes and splendid setting of an imperial wedding. Like Veronese's grand conceptions, Tiepolo's spectacle is populated with an assortment of character types, presented in dazzling light and sun-drenched colors with the assured hand of a virtuoso. Against the opulence of their surroundings, these heroic figures behave with the utmost decorum and, the artist suggests, nobility of purpose. The pale colors and elaborately cascading draperies they wear foreshadow the emerging Rococo style.

ROCOCO CHURCH DECORATION. ROCOCO decoration in Germany was as often religious as secular. One of the many opulent Rococo churches still standing in Germany and Austria is that of the CHURCH OF THE VIERZEHNHEILIGEN, or "Fourteen Auxiliary Saints" (FIG. 18–5), which Neumann began in 1743. The exterior shows an early Rococo style, with its gently bulging central pavilion and delicately arched windows. The façade offers only a foretaste of the overall plan (FIG. 18–6), which is based on six interpenetrating oval spaces of varying sizes around a domed ovoid center. The plan recalls Borromini's Baroque design of the Church of San Carlo alle Quattro Fontane (SEE FIG. 17–10), but surpasses it in airy lightness. On the interior of the nave (FIG. 18–7), the Rococo love of

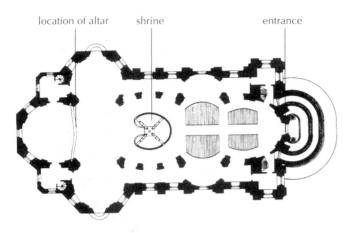

18–6 \parallel plan of the church of the vierzehnheiligen c. 1743.

undulating surfaces with overlays of decoration creates a visionary world where flat wall surfaces scarcely exist. Instead, the viewer is surrounded by clusters of pilasters and engaged columns interspersed with two levels of arched openings to the side aisles and large clerestory windows illuminating the gold and white of the interior. The foliage of the fanciful capitals is repeated in arabesques, wreaths, and the ornamented frames of the irregular panels that line the vault. What Neumann had begun in the Kaisersaal at Würzburg he brought to full fruition here in the ebullient sense of spiritual uplift achieved by the complete integration of architecture and decoration.

Rococo Painting and Sculpture in France

The death of the Sun King in 1715 brought important changes to French court life, and to art. The formality and seriousness that Louis XIV encouraged gave way to an increased devotion to pleasure, frivolity, and sensuality. As nobles forsook Versailles for pleasure palaces in the city such as the Hôtel de Soubise, artists decorated their salons with works that moved away from Academic precedent into realms redolent with casualness and fantasy. The Rococo style of painting and sculpture that French artists created reverberated across Europe until the rise of Neoclassicism in the 1760s brought Greece and Rome back in favor.

WATTEAU. The originator of the French Rococo style in painting, Jean-Antoine Watteau (1684–1721), was also its greatest exponent. Born in the provincial town of Valenciennes, Watteau around 1702 came to Paris, where he studied Rubens's Medici cycle (SEE FIG. 17–36), then displayed in the Luxembourg Palace, and the paintings and drawings of sixteenth-century Venetians such as Giorgione (SEE FIG. 15–23), which he saw in a Parisian private collection. After perfecting a graceful personal style informed by the fluent brushwork and rich colors of Rubens and the Venetians, Watteau created a new type of painting when he submitted his official examination canvas, PILGRIMAGE TO THE ISLAND OF CYTHERA (FIG.

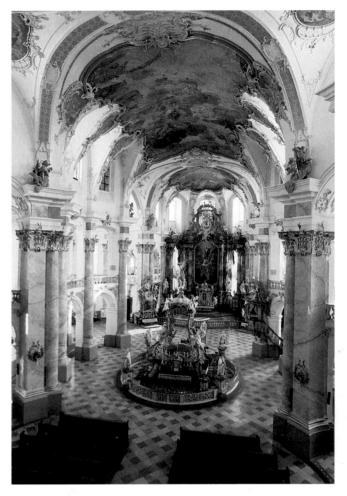

18—7 | Johann Balthasar Neumann INTERIOR, CHURCH OF THE VIERZEHNHEILIGEN 1743–72.

In the center of the nave of the Church of the Vierzehnheiligen (Fourteen Auxiliary Saints), an elaborate shrine was built over the spot where, in the fifteenth century, a shepherd had visions of the Christ Child surrounded by saints. The saints came to be known as the Holy Helpers because they assisted people in need.

18–8), for admission to membership in the Royal Academy of Painting and Sculpture in 1717 (see "Academies and Academy Exhibitions," page 686). The work so impressed the academicians that they created a new category of subject matter to accommodate it: the *fête galante*, or elegant outdoor entertainment. Watteau's painting depicts a dream world in which beautifully dressed couples, accompanied by *putti*, conclude their day's romantic adventures on the mythical island of love sacred to Venus, whose garlanded statue appears at the extreme right. The verdant landscape would never soil the characters' exquisite satins and velvets, nor would a summer shower ever threaten them. This kind of idyllic vision, with its overtones of wistful melancholy, had a powerful attraction in early eighteenth-century Paris and soon charmed most of Europe.

Tragically, Watteau died from tuberculosis when still in his thirties. During his final illness, while staying with the art dealer Edme-François Gersaint, he painted a signboard for Gersaint's shop (FIG. 18–9). The dealer later wrote that

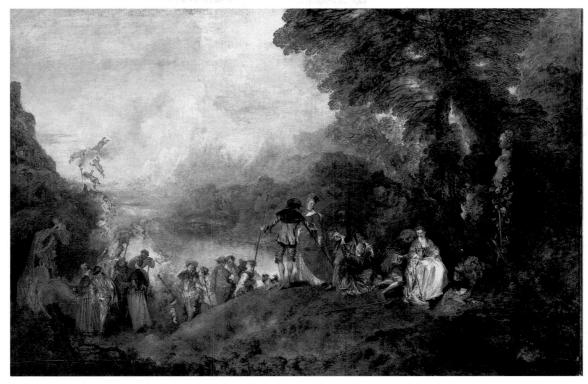

18–8 | Jean-Antoine Watteau PILGRIMAGE TO THE ISLAND OF CYTHERA 1717. Oil on canvas, $4'3'' \times 6'4\%''$ (1.3 \times 1.9 m). Musée du Louvre, Paris.

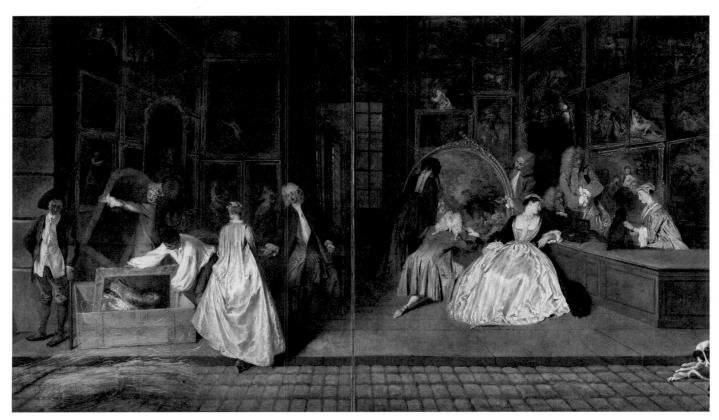

18–9 | Jean-Antoine Watteau | THE SIGNBOARD OF GERSAINT c. 1721. Oil on canvas, $5'4'' \times 10'1''$ (1.62 \times 3.06 m). Stiftung Preussische Schlössen und Gärten Berlin-Brandenburg, Schloss Charlottenburg.

Watteau's signboard painting was designed for the Paris art gallery of Edme-François Gersaint, who introduced to France the English idea of selling paintings by catalogue. The systematic listing of works for sale gave the name of the artist and the title, the medium, and the dimensions of each work of art. The shop depicted on the signboard is not Gersaint's but an ideal gallery visited by elegant and cultivated patrons. The sign was so admired that Gersaint sold it only fifteen days after it was installed. Later it was cut down the middle and each half was framed separately, which resulted in the loss of some canvas along the sides of each section. The painting was restored and its two halves reunited in the twentieth century.

Defining Art

ACADEMIES AND ACADEMY EXHIBITIONS

uring the seventeenth century, the French government founded a number of royal academies for the support and instruction of students in literature, painting and sculpture, music and dance, and architecture. In 1664, the Royal Academy of Painting and Sculpture began to mount occasional exhibitions of their members' recent work. These exhibitions came to be known as Salons because for much of the eighteenth century they were held in the Salon Carré in the Palace of the Louvre. Beginning in 1737, the Salons were held every other year, with a jury of members selecting the works to be shown. Illustrated here is a view of the Salon of 1787, with its typical floor-to-ceiling hanging of paintings. As the only public art exhibitions of any importance in Paris, the Salons were enormously influential in establishing officially approved styles and in molding public taste, and they helped consolidate the Royal Academy's dictatorial control over the production of art.

Among the most influential ideas promoted by the academy was that **history painting** (based on historical, mythological, or biblical narratives and generally conveying a high moral or intellectual idea) was the most important form of pictorial art, followed in prestige by landscape painting, portraiture, genre painting, and still life. As a result, most ambitious French artists of the later seventeenth and eighteenth centuries sought recognition as history painters, and devoted considerable effort to the creation of large-scale history paintings for the Salon. Several examples are visible in the upper registers of the illustrated view of the Salon of 1787, although the painting at the center is a portrait—Élisabeth Vigée-Lebrun's *Portrait of Marie Antoinette and Her Children* (SEE FIG. 18–38), doubtless given pride of place because it depicts members of the royal family.

In recognition of the importance of Rome as a training ground for artists—especially those aspiring to master history painting, which often treated subjects from ancient history or mythology—the French Royal Academy of Painting and Sculpture opened a branch there in 1666. The competitive Prix de Rome, or Rome Prize, was also established, which permitted the winners to study in Rome for three to five years. A similar prize was established by the French Royal Academy of Architecture in 1720.

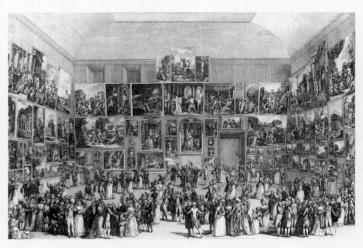

Piero Antonio Martini THE SALON OF 1787 1787. Engraving.

Many Western cultural capitals emulated the French model and opened academies of their own. Academies were established in Berlin in 1696, Dresden in 1705, London in 1768, Boston in 1780, Mexico City in 1785, and New York in 1802.

In France, the Revolution of 1789 brought a number of changes to the Royal Academy. In 1791, the jury system was abolished as a relic of the monarchy, and the Salon was democratically opened to all artists. In 1793, all of the royal academies were disbanded and, in 1795, reconstituted as the newly founded Institut de France, which was to administer the art school—the École des Beaux-Arts—and sponsor the Salon exhibitions. The number of would-be exhibitors was soon so large that it became necessary to reintroduce some screening procedure, and so the jury system was revived. In 1816, with the restoration of the monarchy following the defeat of Napoleon, the division of the Institut de France dedicated to painting and sculpture was renamed the Académie des Beaux-Arts, and thus the old academy was in effect restored.

Watteau had completed the painting in eight days, working only in the mornings because of his failing health. When the sign was installed, it was greeted with almost universal admiration, and Gersaint sold it shortly afterward.

The painting shows an art gallery filled with paintings from the Venetian and Netherlandish schools that Watteau admired. Indeed, the glowing satins and silks of the women's gowns pay homage to artists such as Gerard Ter Borch (SEE FIG. 17–51). The visitors to the gallery are elegant ladies and gentlemen, at ease in these surroundings and apparently

knowledgeable about paintings. Thus, they create an atmosphere of aristocratic sophistication. At the left, a woman in shimmering pink satin steps across the threshold, ignoring her companion's outstretched hand to look at the two porters packing. While one holds a mirror, the other carefully lowers into the wooden case a portrait of Louis XIV, which may be a reference to the name of Gersaint's shop, Au Grand Monarque ("At the Sign of the Great King"). It also suggests the passage of time, for Louis had died six years earlier. Other elements in the work also gently suggest transience. On the

left, the clock positioned directly over the king's portrait, surmounted by an allegorical figure of Fame and sheltering a pair of lovers, is a traditional *memento mori*, a reminder of mortality. The figures on it suggest that both love and fame are subject to the depredations of time. Well-established *vanitas* emblems are the straw (in the foreground), so easily destroyed, and the young woman gazing into the mirror (set next to a vanity case on the counter), for mirrors and images of young women looking at their reflections were time-honored symbols of the fragility of human life. Notably, the two gentlemen at the end of the counter also appear to gaze at the mirror, and are thus also implicated in the *vanitas* theme. The dying Watteau certainly knew how ephemeral life is, and no Western artist ever expressed the fleeting nature of human happiness with greater subtlety.

BOUCHER. The artist most closely associated today with Parisian Rococo painting at its height is François Boucher (1703–70). The son of a minor painter, Boucher in 1723 entered the workshop of an engraver. The young man's skill drew the attention of a devotee of Watteau, who hired Boucher to reproduce Watteau's paintings in his collection, an event that firmly established the direction of Boucher's career.

After studying at the French Academy in Rome from 1727 to 1731, Boucher settled in Paris and became an academician. Soon his life and career were intimately bound up with two women: The first was his artistically talented wife,

Marie-Jeanne Buseau, who was a frequent model as well as a studio assistant to her husband. The other was Louis XV's mistress, Madame de Pompadour, who became his major patron and supporter. Pompadour was an amateur artist herself and took lessons from Boucher in printmaking. After Boucher received his first royal commission in 1735, he worked almost continuously to decorate the royal residences at Versailles and Fontainebleau. In 1755, he was made chief inspector at the Gobelins Tapestry Manufactory, and he provided designs to it and to the Sèvres porcelain and Beauvais tapestry manufactories, all of which produced furnishings for the king. In 1765, Boucher became First Painter to the King. While he painted a number of fine portraits and scenes of daily life, Boucher is best known for his mythological scenes, in which gods, goddesses, and putti-generally nude except for strategically placed draperies-frolic or relax in natural settings. Among Boucher's most impressive mythological paintings is the **TRIUMPH OF VENUS** (FIG. 18–10). The goddess of love appears near the center of the composition, resting on silks and satins in a giant shell, pulled through the water by dolphins, and accompanied by burly Tritons and voluptuous sea nymphs, one of whom offers her a shell filled with pearls. In the sky above hover several putti, some of them carrying a shiny scarf that billows above Venus like a huge banner. In contrast to Watteau's wistful fêtes gallantes, Boucher's work creates a robust world of sensual pleasure recalling the style of Rubens (SEE FIG. 17-36), but Boucher's

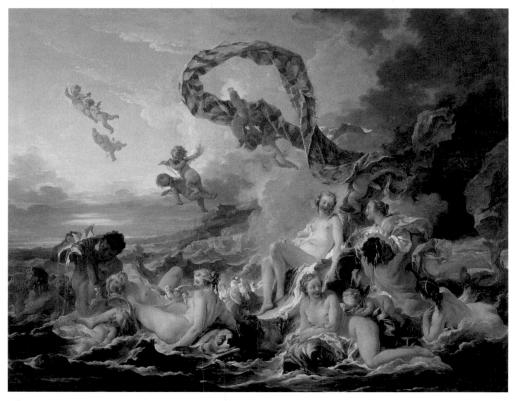

18–10 | François Boucher TRIUMPH OF VENUS 1740. Oil on canvas, $4'3\%'' \times 5'3\%''$ (1.3 \times 1.62 m). Nationalmuseum, Stockholm.

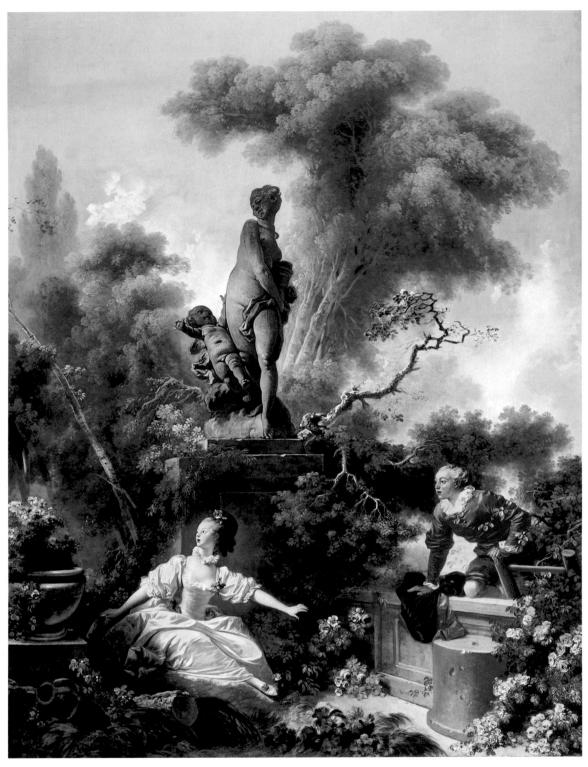

more charming and frivolous touches are distinctively Rococo.

FRAGONARD. The last noteworthy master of French Rococo painting, Jean-Honoré Fragonard (1732–1806) studied with Boucher, who encouraged Fragonard to enter the competition for the Prix de Rome, the three-to-five-year

scholarship awarded to the top students in painting and sculpture graduating from the French Academy's art school. Fragonard won the prize in 1752 and spent 1756–61 in Italy, but not until 1765 was he finally accepted as a member of the Royal Academy. Fragonard catered to the tastes of an aristocratic clientele, and he began to fill the vacuum left by Boucher's death in 1770 as a decorator of interiors.

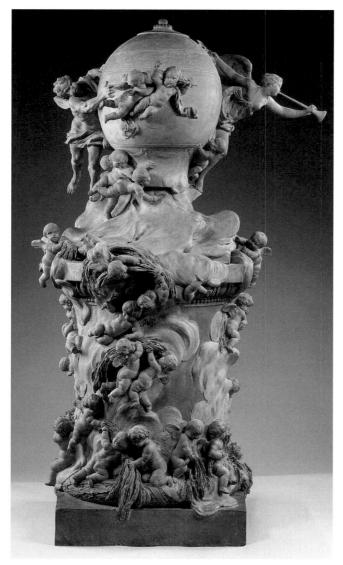

18–12 | Clodion THE INVENTION OF THE BALLOON 1784. Terra-cotta model for a monument, height 43½" (110.5 cm). The Metropolitan Museum of Art, New York. Rogers Fund and Frederick R. Harris Gift, 1944 (44.21a b)

Clodion had a long career as a sculptor in the exuberant, Rococo manner seen in this work commemorating the 1783 invention of the hot-air balloon. During the austere revolutionary period of the First Republic (1792–95), he became one of the few Rococo artists to adopt successfully the more acceptable Neoclassical manner. In 1806, he was commissioned by Napoleon to provide the relief sculpture for two Paris monuments, the Vendôme Column and the Carrousel Arch near the Louvre.

Fragonard produced fourteen canvases commissioned around 1771 by Madame du Barry, Louis XV's last mistress, to decorate her château. These marvelously free and seemingly spontaneous visions of lovers explode in color and luxuriant vegetation. **THE MEETING** (FIG. 18–11) shows a secret encounter between a young man and his sweetheart, who looks anxiously over her shoulder to be sure she has not been followed, and clutches the letter that arranged the tryst. The rapid brushwork that distinguishes Fragonard's technique is at its freest and most lavish here. The entertaining subject mat-

Sequencing Works of Art 1717 Watteau, Pilgrimage to the Island of Cythera 1724 Plan of Chiswick House c. 1730 Carriera, Charles Sackville, 2nd Duke of Dorset 1739 Chardin, The Governess 1770-72 Copley, Samuel Adams 1771-73 Fragonard, The Meeting 1781 Fuseli, The Nightmare 1787-93 Canova, Cupid and Psyche

ter, bright colors, and lush painting style typify the Rococo. Fragonard lived for more than thirty years after completing this work, long enough to see the Rococo lose its relevance in the newly complicated world of revolutionary France.

CLODION. In the last quarter of the eighteenth century, French art generally moved away from the Rococo style and toward Neoclassicism. But one sculptor who clung to Rococo up to the threshold of the French Revolution in 1789 was Claude Michel, known as Clodion (1738-1814). His major output consisted of playful, erotic tabletop sculpture, mainly in uncolored terra cotta. Typical of Clodion's Rococo designs is the terra-cotta model he submitted to win a 1784 royal commission for a large monument to the invention of the hot-air balloon (FIG. 18-12). Although Clodion's enchanting piece may today seem inappropriate to commemorate a technological achievement, hot-air balloons then were elaborately decorated with painted Rococo scenes, gold braid, and tassels. Clodion's balloon, decorated with bands of classical ornament, rises from a columnar launching pad in billowing clouds of smoke, assisted at the left by a puffing wind god with butterfly wings and heralded at the right by a trumpeting Victory A few putti stoke the fire basket that provided the hot air on which the balloon ascended as others gather reeds for fuel and fly up toward them.

ITALY AND THE CLASSICAL REVIVAL

From the late 1600s until well into the nineteenth century, the education of a wealthy young northern European or American gentleman—and increasingly over that period, gentlewoman—was completed on the **Grand Tour**, a prolonged visit to the major cultural sites of southern Europe. Accompanied by a tutor and an entourage of servants, the young man

Art and Its Context

WOMEN AND ACADEMIES

Ithough several women were made members of the European academies of art before the eighteenth century, their inclusion amounted to little more than honorary recognition of their achievements. In France, Louis XIV had proclaimed in the founding address of the Royal Academy that its intention was to reward all worthy artists, "without regard to the difference of sex," but this resolve was not put into practice. Only seven women gained the title of Academician between 1648 and 1706, the year the Royal Academy declared itself closed to women. Nevertheless, four more women had been admitted to the cademy by 1770, when the men became worried that women members would become "too numerous," and declared four women members to be the limit at any one time. Young women were not admitted to the academy school nor allowed to compete for academy prizes, both of which were nearly indispensable for professional success.

Women fared even worse at London's Royal Academy. After the Swiss painters Mary Moser and Angelica Kauffmann were named as founding members in 1768, no other women were elected until 1922, and then only as associates. Johann Zoffany's 1771–72 portrait of the London academicians shows the men grouped around a male nude model, along with the academy's study collection of classical statues and plaster copies. Propriety prohibited the presence of women in this setting (women were not allowed to see or work from the male nude), so Zoffany painted Moser's and Kauffmann's portraits on the wall. In more formal portraits of the academy, however, the two women were included.

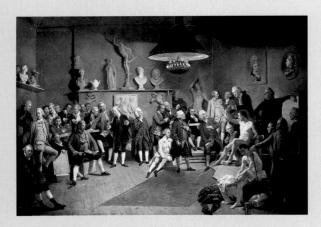

Johann Zoffany ACADEMICIANS OF THE ROYAL ACADEMY

1771–72. Oil on canvas, $47\% \times 59\%''$ (120.6 \times 151.2 cm). The Royal Collection, Windsor Castle, Windsor, England.

or woman began in Paris, moved on to southern France to visit a number of well-preserved Roman buildings and monuments there, then headed to Venice, Florence, Naples, and Rome. As repository of the classical and the Renaissance pasts, Italy was the focus of the Grand Tour and provided inspiration for the most characteristic style to prevail during the Enlightenment, Neoclassicism. Neoclassicism (neo means "new") presents classical subject matter—mythological or historical in a style derived from classical Greek and Roman sources. While some Neoclassical art was conceived to please the senses, most of it was intended to teach moral lessons. In its didactic manifestations—usually history paintings—Neoclassicism was an important means for conveying Enlightenment ideals such as courage and patriotism. It arose, in part, in reaction to the perceived frivolity and excess of the Rococo. Most Enlightenment thinkers held Greece and Rome in high regard as fonts of democracy and secular government, and the Neoclassical artists likewise revived classical stories and styles in an effort to instill those virtues.

Beginning in 1738, extraordinary archaeological discoveries made at two sites near Naples also excited renewed interest in classical art and artifacts. Herculaneum and Pompeii, two prosperous Roman towns buried in 79 CE by the sudden volcanic eruption of Mount Vesuvius, offered sensational new material for study and speculation. Numerous illustrated books on these discoveries circulated throughout Europe and America, fueling public fascination with the ancient world and contributing to a taste for the Neoclassical style.

Italian Portraits and Views

Most educated Europeans regarded Italy as the wellspring of Western culture, where Roman and Renaissance art flour-ished in the past and a great many artists still practiced. The studios of important Italian artists were required stops on the Grand Tour, and collectors avidly bought portraits and land-scapes that could boast an Italian connection.

CARRIERA. Wealthy northern European visitors to Italy often sat for portraits by Italian artists. Rosalba Carriera (1675–1757), the leading portraitist in Venice during the first half of the eighteenth century, began her career designing lace patterns and painting miniature portraits on the ivory lids of snuffboxes. By the early eighteenth century she was making portraits with pastels, crayons of pulverized pigment bound to a chalk base by weak gum water. A versatile medium, pastel can be employed in a sketchy manner to create a vivacious and fleeting effect or can be blended through rubbing to produce a highly finished image. Carriera's pastels earned her honorary membership in Rome's Academy of Saint Luke in 1705, and she later was admitted to the academies in Bologna and Florence. In 1720 she traveled to Paris, where she made a pastel portrait of the young Louis XV and was elected to the Royal Academy of Painting and Sculpture,

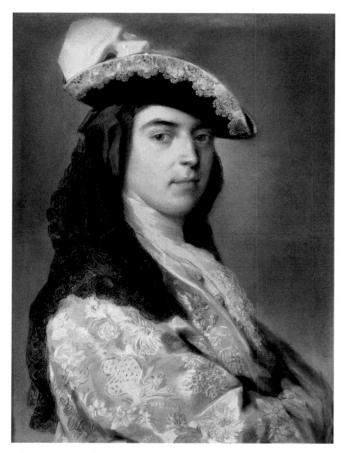

18–13 | Rosalba Carriera CHARLES SACKVILLE, 2ND DUKE OF DORSET c. 1730. Pastel on paper, $25 \times 19''$ (63.5 \times 48.3 cm). Private collection.

despite the 1706 rule forbidding the admission of any more women (see "Women and Academies," facing page). Returning to Italy in 1721, Carriera spent much of the rest of her career in Venice, where she produced sensitive portraits of distinguished sitters such as the British aristocrat Charles Sackville (FIG. 18–13).

CANALETTO. Even more than portraits of themselves, visitors to Italy on the Grand Tour desired paintings and prints of city views, which they collected largely as fond reminders of their travels. These city views were two types: the capriccio ("caprice;" plural capricci), in which the artist mixed actual features, especially ruins, into imaginatively pleasing compositions; and the veduta ("view;" plural vedute), a naturalistic rendering of a well-known tourist attraction, which often took the form of a panoramic view that was meticulously detailed, topographically accurate, and populated with a host of contemporary figures engaged in typical activities. The Venetian artist Giovanni Antonio Canal, called Canaletto (1697–1768), became so popular among British clients for his vedute that his dealer arranged for him to work from 1746 to 1755 in England, where he painted topographic views of London and the surrounding countryside, giving impetus to a school of English landscape painting.

In 1762, the English king George III purchased Canaletto's **SANTI GIOVANNI E PAOLO AND THE MONUMENT TO BARTOLOMMEO COLLEONI** (FIG. 18–14), painted probably in 1735–38. The Venetian square, with its famous fifteenth-century equestrian monument by Verrocchio (SEE FIG. 14–16),

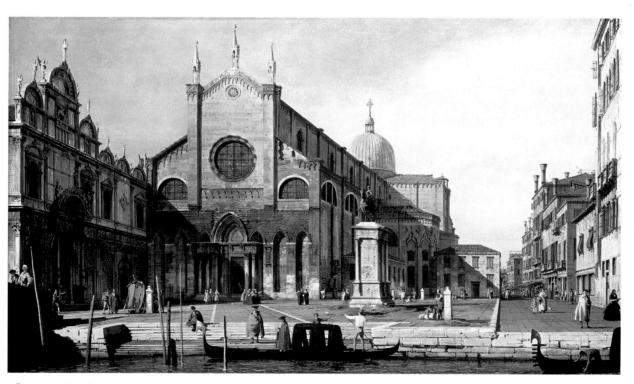

I8–I4 | Canaletto SANTI GIOVANNI E PAOLO AND THE MONUMENT TO BARTOLOMMEO COLLEONI c. 1735–38. Oil on canvas, $18\% \times 30\%$ " (46×78.4 cm). The Royal Collection, Windsor Castle, Windsor, England.

is shown as if the viewer were in a gondola on a nearby canal. The roofline of the large church of Santi Giovanni e Paolo behind the monument creates a powerful orthogonal that draws the viewer's eye toward the vanishing point at the lower right. Many of Canaletto's views, like this one, are topographically correct. In others he rearranged the buildings to tighten the composition, even occasionally adding features to produce a *capriccio*.

PIRANESI. Very different are the Roman views of Giovanni Battista Piranesi (1720-78), one of the century's greatest printmakers. Trained in Venice as an architect, Piranesi went to Rome in 1740. After studying etching, he began in 1743 to produce portfolios of prints, and in 1761 he established his own publishing house. Piranesi created numerous vedute of ancient Roman ruins, crumbling and overgrown with vegetation, and exemplary of the new taste for the picturesque, which contemporary British theorists defined as a quality seen in a landscape (actual or depicted) with an aesthetically pleasing irregularity in its shapes, composition, and lighting. Piranesi's fame today rests primarily, however, on a series of capricci: his Carcerci d'invenzione (Imaginary Prisons), which he began etching in 1741 and published in their definitive form in 1761. Recent discoveries at Herculaneum and Pompeii stimulated Piranesi's and his patrons' interest in Roman ruins—a major source of inspiration for the Carceri.

Informed both by his careful study of ancient Roman urban architecture and his knowledge of Baroque stage set design, Piranesi's Carceri, such as THE LION BAS-RELIEF (FIG. 18–15), depict vast, gloomy spaces spanned by the remnants of monumental vaults and filled with mazes of stairways and catwalks traversed by tiny human figures. Throughout Piranesi's series, motifs such as barred windows, dangling ropes and tackle, and the occasional torture device generate a sinister mood, but the overall effect created by the immense interiors and dwarfed figures is that of the sublime, an awesome, nearly terrifying experience of vastness described by the British writer Edmund Burke in his influential essay A Philosophical Enquiry into the Origin of our Ideas of the Sublime and the Beautiful (1756). Through their evocation of the sublime, which would later engage Romantic painters such as Joseph Mallord William Turner, and more fundamentally due to their powerfully imaginative qualities, Piranesi's Carceri are an early manifestation of Romanticism.

Neoclassicism in Rome: The Albani-Winckelmann Influence

A notable sponsor of the classical revival was Cardinal Alessandro Albani (1692–1779), who amassed a huge collection of antique sculpture, sarcophagi, **intaglios** (objects in which the design is carved out of the surface), cameos, and vases. In 1760–61, he built a villa just outside Rome to house

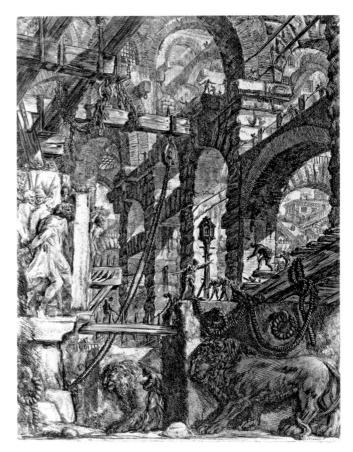

Plate V from the series Carceri d'invenzione (Imaginary Prisons). 1761. Etching and engraving, $21\% \times 16\%$ (56.2 \times 41.1 cm). The Fine Arts Museums of San Francisco.

Achenbach Foundation for the Graphic Arts purchase 1969.32.7.5

This print owes its name to the shadowy bas-reliefs of lions carved on the pedestals of a foreground stairway. At the left side of the composition is a brightly lit fragment of another ancient bas-relief showing a bound captive being paraded past spear-bearing Roman soldiers. Art nistorians have noted that this carved captive and another glimosed to his right are the only prisoners actually pictured in Piranesi's print; the other human figures seem to be contemporary visitors to this fantastic ancient space, gesticulating with wonder at its sublime marvels.

and display his holdings, and the Villa Albani became one of the most important stops on the Grand Tour. The villa was more than a museum, however; it was also a kind of shop, where many of the items he sold to satisfy the growing craze for antiquities were faked or heavily restored by artisans working in the cardinal's employ.

Albani's credentials as the foremost expert on classical art were solidified when he hired as his secretary and librarian Johann Joachim Winckelmann (1717–68), the leading theoretician of Neoclassicism. The Prussian-born Winckelmann had become an advocate of classical art while working in Dresden, where the French Rococo style he deplored was fashionable. In 1755, he published a pamphlet, *Thoughts on the*

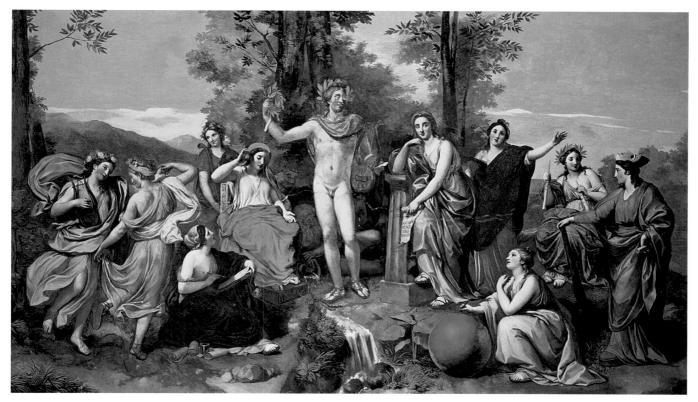

18–16 | Anton Raphael Mengs PARNASSUS Ceiling fresco in the Villa Albani, Rome. 1761.

Imitation of Greek Works in Painting and Sculpture, in which he attacked the Rococo as decadent and argued that only by imitating Greek art could modern artists become great again. Winckelmann imagined that the temperate climate and natural ways of the Greeks had perfected their bodies and made their artists more sensitive to certain general ideas of what constitutes true and lasting beauty. Shortly after publishing this pamphlet, Winckelmann moved to Rome, where in 1758 he went to work for Albani. In 1764 he published the second of his widely influential treatises, *The History of Ancient Art*, which many consider the beginning of modern art history. There he analyzed the history of art in terms of a logical succession of period styles, an approach which later became the norm for art history books (including this one).

MENGS. Winckelmann's closest friend and colleague in Rome was a fellow German, Anton Raphael Mengs (1728–79). Winckelmann's employer, Cardinal Albani, commissioned Mengs to create a painting for the ceiling of the great gallery in his new villa. The PARNASSUS ceiling (FIG. 18–16), from 1761, is usually considered the first true Neoclassical painting, though to most modern eyes the poses in the work seem forced and the atmosphere overly idealized. The scene takes place on Mount Parnassus in central Greece, which the ancients believed to be sacred to Apollo (the god of poetry, music, and the arts) and the nine Muses (female

personifications of artistic inspiration). At the center of the composition is Apollo, his pose modeled on that of the famous *Apollo Belvedere*, an ancient marble statue in the Vatican collection. Mengs's Apollo holds a lyre and a laurel branch, symbol of artistic accomplishment. Next to him, resting on a Doric column, is Mnemosyne, the mother of the Muses, who are shown in the surrounding space practicing the various arts. Inspired by relief sculpture he had studied at Herculaneum, Mengs arranged the figures in a generally symmetrical, pyramidal composition parallel to the picture plane. Winckelmann, not surprisingly, praised the work for achieving the "noble simplicity and calm grandeur" that he had found in Greek originals. Shortly after completing this work Mengs left for Spain, where he served as court painter until 1777.

CANOVA. The aesthetic ideals of the Albani-Winckelmann circle soon affected contemporary Roman sculptors, who remained committed to this paradigm for the next 100 years. The leading Neoclassical sculptor of the late eighteenth and early nineteenth centuries was Antonio Canova (1757–1822). Born near Venice into a family of stonemasons, Canova in 1781 settled in Rome, where under the guidance of the Scottish painter Gavin Hamilton (1723–98) he adopted the Neoclassical style and quickly became the most sought-after European sculptor of the period.

Canova specialized in two types of work: grand public monuments for Europe's leaders, and erotic mythological subjects, such as **CUPID AND PSYCHE** (FIG. 18–17), for the pleasure of private collectors. Cupid and Psyche illustrates the love story of Cupid, Venus's son, and Psyche, a beautiful mortal who had aroused the goddess's jealousy. Venus casts Psyche into a deathlike sleep; moved by Cupid's grief and love for her, the sky god Jupiter (the Roman name for the Greek Zeus) takes pity on the pair and gives Psyche immortality. In this sculpture, Canova chose the most emotional and tender moment in the story, when Cupid revives the lifeless Psyche with a kiss. Here Canova combined a Rococo interest in eroticism with a more typically Neoclassical appeal to the combined senses of sight and touch. Because the lovers gently caress each other, the viewer is tempted to run his or her fingers over the graceful contours of their cool, languorous limbs.

REVIVALS AND EARLY ROMANTICISM IN BRITAIN

British tourists and artists in Italy became the leading supporters of Neoclassicism partly because they had been prepared for it by the architectural revival of Renaissance classicism in their homeland earlier in the century. While the terms Rococo and Neoclassicism identify distinct artistic styles—the one complex and sensuous, the other more simple and restrained—a third term applied to later eighteenth-century art, *Romanticism*, describes not only a style but also an attitude. Romanticism is chiefly concerned with imagination

and the emotions, and it is often understood as a reaction against the Enlightenment focus on rationality. Romanticism celebrates the individual and the subjective rather than the universal and the objective. The movement takes its name from the romances—novellas, stories, and poems written in Romance (Latin-derived) languages—that provided many of its themes. Thus, the term Romantic suggests something fantastic or novelistic, perhaps set in a remote time or place, infused by a poetic or even melancholic spirit. One of the best examples of early Romanticism in literature is The Sorrows of Young Werther by Johann Wolfgang von Goethe (1749-1832), in which a sensitive, outcast young man fails at love and kills himself. Goethe believed that the artist's principal duty was to communicate feeling to the audience, rather than to entertain or to recall ancient virtues; this soon became a basic precept of the Romantic movement.

Neoclassicism and Romanticism existed side by side in the later eighteenth and early nineteenth centuries. Indeed, because a sense of remoteness in time or place characterizes both Neoclassical and Romantic art, some scholars argue that Neoclassicism is a subcategory of Romanticism.

Classical Revival in Architecture and Landscaping

Just as the Rococo was emerging in France, a group of British professional architects and wealthy amateurs led by the Scot Colen Campbell (1676–1729) took a stance against what they saw as the immoral extravagance of the Italian Baroque. As a moral corrective, they advocated a return to the austerity and simplicity found in the architecture of Andrea Palladio.

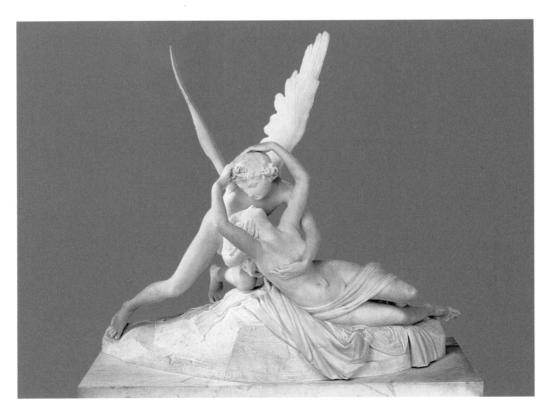

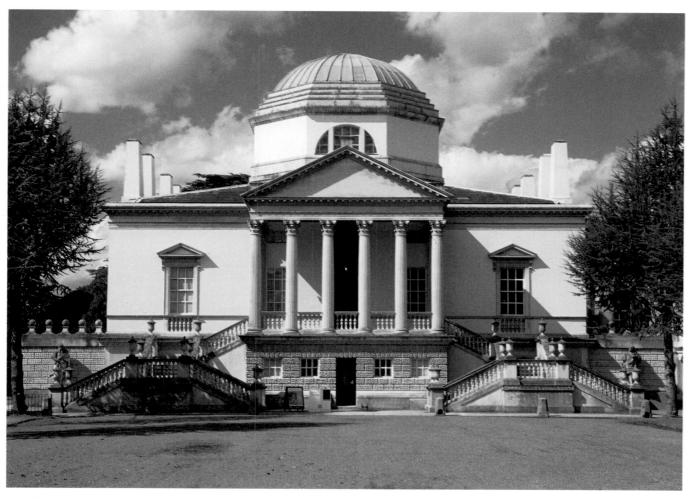

18–18 | Richard Boyle (Lord Burlington) CHISWICK HOUSE
West London, England. 1724–29. Interior decoration (1726–29) and new gardens (1730–40) by William Kent.

CHISWICK HOUSE. The most famous product of this group was **CHISWICK HOUSE** (FIG. 18–18), designed in 1724 by its owner, Richard Boyle, the third Earl of Burlington (1695-1753). Burlington sought out Palladio's architecture in Italy, especially his Villa Rotunda (SEE FIG. 15-47), which inspired Burlington's plan for Chiswick House. The building plan (FIG. 18-19) shares the bilateral symmetry of Palladio's villa, although its central core is octagonal rather than round and there are only two entrances. The main entrance, flanked now by matching staircases, is a Roman temple front, a flattering reference to the building's inhabitant. Chiswick's elevation is characteristically Palladian, with a main floor resting on a basement, and tall rectangular windows with triangular pediments. The result is a lucid evocation of Palladio's design, with few but crisp details that seem perfectly suited to the refined proportions of the whole.

In Rome, Burlington had persuaded the English expatriate William Kent (1685–1748) to return to London as his collaborator. Kent designed Chiswick's surprisingly ornate interior as well as the grounds, the latter in a style that became known throughout Europe as the English landscape

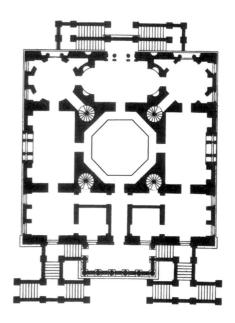

18–19 PLAN OF CHISWICK HOUSE 1724.

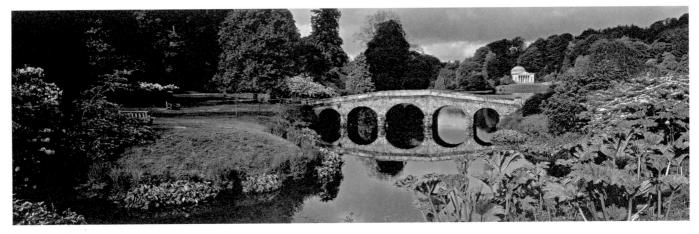

18–20 Henry Flitcroft and Henry Hoare THE PARK AT STOURHEAD Wiltshire, England. Laid out 1743; executed 1744–65, with continuing additions.

garden. Kent's garden, in contrast to the regularity and rigid formality of Baroque gardens (SEE FIG. 17–56), featured winding paths, a lake with a cascade, irregular plantings of shrubs, and other effects imitating the appearance of the natural rural landscape. The English landscape garden was another indication of the growing Enlightenment emphasis on the natural.

STOURHEAD. Following Kent's lead, landscape architecture flourished in the hands of such designers as Lancelot ("Capa-

bility") Brown (1716–83) (SEE FIG. 17–67) and Henry Flitcroft (1697–1769). In the 1740s the banker Henry Hoare began redesigning the grounds of his estate at Stourhead in Wiltshire (FIG. 18–20) with the assistance of Flitcroft, a protégé of Burlington. The resulting gardens at Stourhead carried Kent's ideas much further. Stourhead is, in effect, an exposition of the picturesque, with orchestrated views dotted with Greek– and Roman–style temples, grottoes, copies of antique statues, and such added delights as a rural cottage, a Chinese bridge, a Gothic spire, and a Turkish tent. In the view illustrated here, a

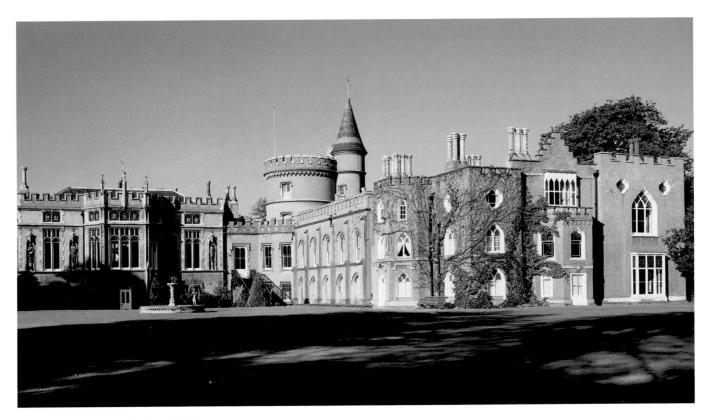

18–21 Horace Walpole and others STRAWBERRY HILL Twickenham, England. 1749–76.

replica of the Pantheon in Rome is just visible across a carefully placed lake. While the nostalgic evocation of an idyllic classical past recalls the work of the seventeenth-century French landscape painter Claude Lorrain (SEE FIG. 17–63), who had found a large market in Britain, the exotic elements here are an early indication of the Romantic taste for the strange and the novel. The garden is therefore an interesting mixture of the Neoclassical and the Romantic. For a wall inside the house, Hoare commissioned Mengs to paint *The Meeting of Antony and Cleopatra*, a work that similarly combines classical history with an exotic, Romantic subject.

Gothic Revival in Architecture and Its Decoration

Alongside the British classical revival of the mid-eighteenth century came a revival of the Gothic style, a manifestation of architectural Romanticism that spread to other nations after 1800. An early advocate of the Gothic revival was the conservative politician and author Horace Walpole (1717–97), who shortly before 1750 decided to remodel his house, called **STRAWBERRY HILL**, in the Gothic manner (FIG. 18–21). Gothic renovations were commonly performed in Britain before this date, but only to buildings that dated from the medieval period. Working with a number of friends and architects, Walpole spent nearly thirty years, from 1749 to 1776, transforming his home into a Gothic castle complete with **crenellated battlements** (alternating high and low sections of a wall, giving a notched appearance and creating permanent defensive shields), tracery windows, and turrets.

The interior, too, was totally changed. One of the first rooms Walpole redesigned, with the help of amateurs John Chute (1701-76) and Richard Bentley (1708-82), was the library (FIG. 18-22). Here the three turned for inspiration to illustrations in the antiquarian books that the library housed. For the bookcases, they adapted designs from London's old Saint Paul's Cathedral, which had been destroyed in the Great Fire of 1666. Prints depicting two medieval tombs inspired the chimneypiece. For the ceiling, Walpole incorporated a number of coats of arms of his ancestors—real and imaginary. The reference to fictional relatives offers a clue to Walpole's motives in choosing the medieval style. Walpole meant his house to suggest a castle out of the medievalizing Romantic fiction that he himself was writing. In 1764, he published The Castle of Otranto, a Romantic story set in the Middle Ages that helped launch the craze for the Gothic novel. Sir Walter Scott would later achieve fame as the best exponent of the genre in his novels Ivanhoe (1819) and Kenilworth (1821).

Neoclassicism in Architecture and the Decorative Arts

The vogue for classical things spread to most of the arts in late eighteenth-century England, as patrons regarded Greece and Rome as impeccable pedigree for their buildings, uten-

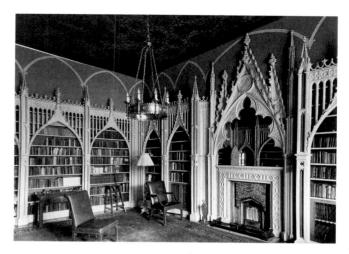

18–22 | Horace Walpole, John Chute, and Richard Bentley LIBRARY, STRAWBERRY HILL After 1754.

sils, poetry, and even clothing fashions. Alexander Pope translated Homer, and wrote his own poetry in iambic pentameter, a style based on the heroic couplets of Latin poets. Women often donned white muslin gowns in order to make themselves resemble classical statues.

ADAM: SYON HOUSE. The most important British contribution to Neoclassicism was a style of interior decoration developed by the Scottish architect Robert Adam (1728-92). On his Grand Tour in 1754-58, during which he joined Albani's circle of Neoclassicists, Adam largely ignored the civic architecture that had interested British classicists such as Burlington and focused instead on the applied ornament of Roman domestic architecture. When he returned to London to set up an architectural firm, he brought with him a complete inventory of decorative motifs, which he then modified in pursuit of a picturesque elegance. His stated aim to "transfuse the beautiful spirit of antiquity with novelty and variety" met with considerable opposition from the Palladian architectural establishment, but it proved ideally suited both to the evolving taste of wealthy clients and to the imperial aspirations of the new king, George III (ruled 1760-1820). In 1761, George appointed Adam and Adam's rival William Chambers (1723–96) as joint Architects of the King's Works.

Adam achieved wide renown for his interior renovations, such as those he carried out between 1760 and 1769 for the Duke of Northumberland at his country estate, Syon, near London. The opulent colored marbles, gilded relief panels, classical statues, spirals, garlands, rosettes, and gilded moldings in the anteroom (FIG. 18–23) are luxuriously profuse yet are restrained by the strong geometric order imposed on them and by the plain wall and ceiling surfaces. Adam's preference for bright pastel grounds and

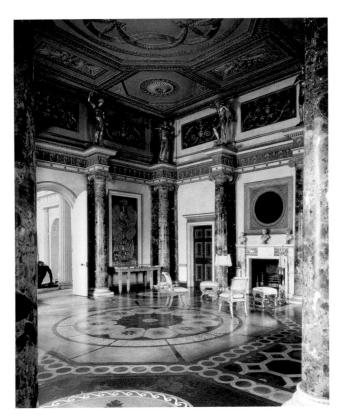

18–23 ∣ Robert Adam ANTEROOM, SYON HOUSE Middlesex, England. 1760–69.

Adam's conviction that it was acceptable to modify details of the classical orders was generally opposed by the British architectural establishment. As a result of that opposition, Adam was never elected to the Royal Academy.

small-scale decorative elements derives both from the Rococo (SEE FIG. 18–5), and from the recently uncovered ruins of Pompeii.

WEDGWOOD. Such interiors were designed partly as settings for the art collections of British aristocrats, which included antiquities as well as a range of Neoclassical painting, sculpture, and decorative ware (see "Georgian Silver," page 700). The most successful producer of Neoclassical decorative art was Josiah Wedgwood (1730-95). In 1769, near his native village of Burslem, he opened a pottery factory called Etruria after the ancient Etruscan civilization in central Italy known for its pottery. This production-line shop had several divisions, each with its own kilns (firing ovens) and workers trained in individual specialties. In the mid-1770s Wedgwood, a talented chemist, perfected a fine-grained, unglazed, colored pottery, which he called jasperware. The most popular of his jasperware featured white figures against a blue ground, like that in THE APOTHEOSIS OF HOMER (FIG. 18-24). The relief on the front of the vase was designed by the sculptor John Flaxman, Jr. (1755-1826), who worked for Wedgwood from 1775 to 1787. Flaxman based the scene on a book illustration documenting a classical Greek vase in the

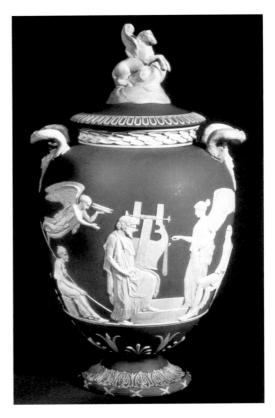

18–24 | Josiah Wedgwood | VASE: THE APOTHEOSIS OF HOMER

Made at the Wedgwood Etruria factory, Staffordshire, England. 1786. White jasper body with a mid-blue dip and white relief, height 18" (45.7 cm). Relief of *The Apotheosis of Homer* adapted from plaque by John Flaxman, Jr. 1778. Trustees of the Wedgwood Museum, Barlaston, Staffordshire, England.

collection of William Hamilton (1730–1803), a leading collector of antiquities and one of Wedgwood's major patrons. Flaxman's design simplified the original according to the prevailing idealized notion of Greek art and the demands of mass production.

The socially conscious Wedgwood—who epitomized Enlightenment thinking—established a village for his employees and cared deeply about every aspect of their living conditions. He was also active in the organized international effort to halt the African slave trade and abolish slavery. To publicize the abolitionist cause, Wedgwood asked the sculptor William Hackwood (c. 1757-1839) to design an emblem for the British Committee to Abolish the Slave Trade, formed in 1787. The compelling image Hackwood created was a small medallion of black-and-white jasperware, cut like a cameo in the likeness of an African man kneeling in chains, with the legend "Am I Not a Man and a Brother?" (FIG. 18-25). Wedgwood sent copies of the medallion to Benjamin Franklin, the president of the Philadelphia Abolition Society, and to others in the abolitionist movement. Later, those active in the women's suffrage movement in the United States adapted the image by representing a woman in chains with the motto "Am I Not a Woman and a Sister?"

to complete his Palladian house, which is visible out the window.

The loveless couple who will be sacrificed to this deal sit on the couch at the left. While the young Squanderfield vainly admires himself in the mirror, his unhappy fiancée is already being wooed by lawyer Silvertongue, who suggestively sharpens his pen. The next five scenes show the progressively disastrous results of such a union, culminating in the young lord's murder of Silvertongue and the subsequent suicide of his wife.

Stylistically, Hogarth's works combine the additive approach of seventeenth-century Dutch genre painters with the elegance and casual poses of the Rococo. Hogarth wanted to please and entertain his audience as much as educate them. He also hoped to create a distinctively English style of painting, free of obscure mythological references and encouraging the self-improvement in viewers that would lead to the progress of society. In this way he opposed both the frivolous Rococo and the at-times abstruse and remote Neoclassicism. By at least one measure, he was a success: His work became so popular that in 1745 he was able to give up portraiture, which he considered a deplorable form of vanity.

PORTRAITURE. A generation younger than Hogarth, Sir Joshua Reynolds (1723–92) specialized in the very form of painting—portraiture—that the moralistic Hogarth despised. After studying Renaissance art in Italy, Reynolds settled in London in 1753 and worked vigorously to educate artists and patrons to appreciate classical history painting. In 1768 he was appointed the first president of the Royal Academy (see "Academies and Academy Exhibitions," page 686). Reynolds's Fifteen Discourses to the Royal Academy (1769–90) set out his theories on art: Artists should follow the rules derived from studying the great masters of the past, especially those who worked in the classical tradition; art should generalize to create the universal rather than the particular; and the highest kind of art is history painting.

Because British patrons preferred portraits of themselves to scenes of classical history, Reynolds attempted to elevate portraiture to the level of history painting by giving it a historical or mythological veneer. A good example of this ambitious type of portraiture, a form of Baroque classicism that Reynolds called the Grand Manner, is LADY SARAH BUN-BURY SACRIFICING TO THE GRACES (FIG. 18-27). Dressed in a classicizing costume, Bunbury plays the part of a Roman priestess making a sacrifice to the personifications of female beauty, the Three Graces. The figure is further aggrandized through the use of the monumental classical pier and arch behind her, the emphatic classical contrapposto (Italian for "set against"; used to describe the twisted pose resulting from parts of the body set in opposition to each other around a central axis), and the large scale of the canvas. Such works were intended for the public rooms, halls, and stairways of aristocratic residences.

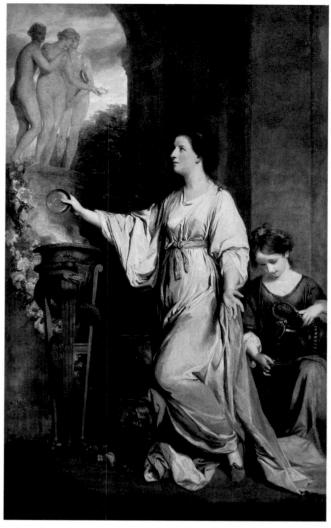

18–27 Joshua Reynolds LADY SARAH BUNBURY SACRIFICING TO THE GRACES 1765. Oil on canvas, $7'10'' \times 5'$ (2.42 × 1.53 m).

The Art Institute of Chicago.

Mr. and Mrs. W. W. Kimball Collection, 1922.4468

Lady Bunbury was one of the great beauties of her era. A few years before this painting was done, she turned down a request of marriage from George III.

A number of British patrons, however, remained committed to the kind of portraiture Van Dyck had brought to England in the 1620s, which had featured more informal poses against natural vistas. Thomas Gainsborough (1727–88) achieved great success with this mode when he moved to Bath in 1759 to cater to the rich and fashionable people who had begun going there in great numbers. A good example of his mature style is the **PORTRAIT OF MRS. RICHARD BRINSLEY SHERIDAN** (FIG. 18–28) which shows the professional singer (the wife of a celebrated playwright) seated informally cutdoors. The sloping view into the distance and the use of a tree to frame the sitter's head appear borrowed directly from Van Dyck (SEE FIG. 17–38). But Gainsborough modernized the formula not simply through his lighter, Rococo palette and

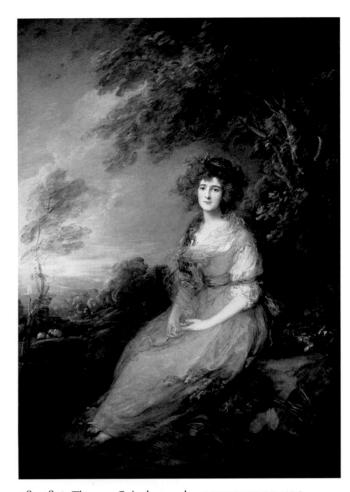

18–28 | Thomas Gainsborough PORTRAIT OF MRS. RICHARD BRINSLEY SHERIDAN 1785–87. Oil on canvas, $7'2\%'' \times 5'\%''$ (2.2 × 1.54 m). National Gallery of Art, Washington, D.C. Andrew W. Mellon Collection (1937.1.92)

feathery brushwork but also by integrating the woman into the landscape, thus identifying her with it. The effect is especially noticeable in the way her windblown hair matches the tree foliage overhead. The work thereby manifests one of the new values of the Enlightenment: the emphasis on nature and the natural as the sources of goodness and beauty.

THE ROMANCE OF SCIENCE. We see Enlightenment fascination with developments in the natural sciences in the dramatic depiction of AN EXPERIMENT ON A BIRD IN THE AIR-PUMP (FIG. 18–29) by Joseph Wright of Derby (1734–97). Trained as a portrait painter, Wright made the Grand Tour in 1773–75 and then returned to the English Midlands to paint local society. Many of those he painted were the self-made entrepreneurs of the first wave of the Industrial Revolution, which was centered in the Midlands in towns such as Birmingham. Wright belonged to the Lunar Society, a group of industrialists (including Wedgwood), mercantilists, and progressive nobles who met in Derby. As part of the society's attempts to popularize science, Wright painted a series of "entertaining" scenes of scientific experiments.

The second half of the eighteenth century was an age of rapid technological advances (see "Iron as a Building Material," page 705), and the development of the air pump was among the many innovative scientific developments of the time. Although it was employed primarily to study the property of gases, it was also widely used to promote the public's interest in science because of its dramatic possibilities. In the experiment shown here, air was pumped out of the large glass bowl until the small bird inside collapsed from lack of oxy-

18–29 | Joseph Wright AN EXPERIMENT ON A BIRD IN THE AIR-PUMP 1768. Oil on canvas, $6\times8'$ (1.82 \times 2.43 m). The National Gallery, London.

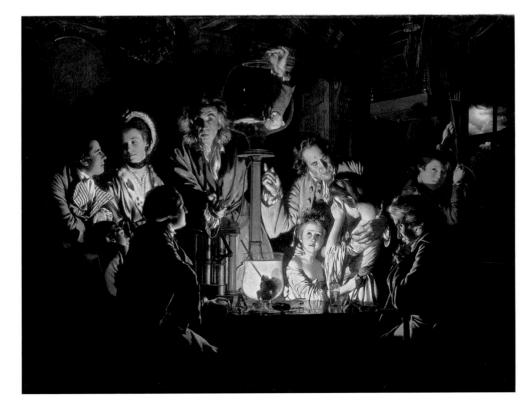

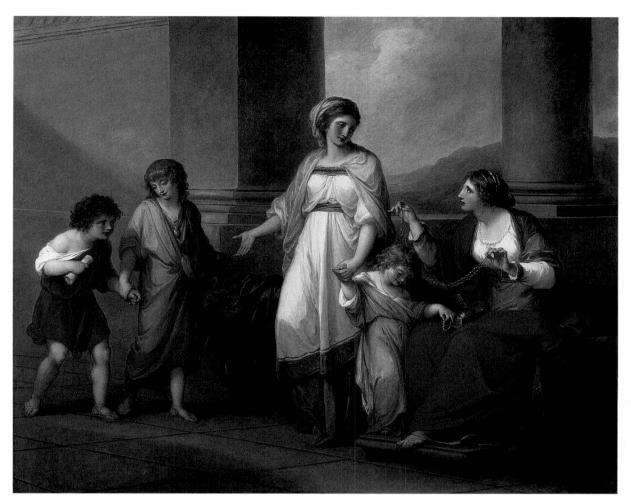

18–30 $\,\,$ Angelica Kauffmann CORNELIA POINTING TO HER CHILDREN AS HER TREASURES c. 1785. Oil on canvas, 40 \times 50" (101.6 \times 127 cm). Virginia Museum of Fine Arts, Richmond, Virginia. The Adolph D. and Wilkins C. Williams Fund

gen; before the animal died, air was reintroduced by a simple mechanism at the top of the bowl. In front of an audience of adults and children, a lecturer prepares to reintroduce air into the glass receiver. Near the window at right, a boy stands ready to lower a cage when the bird revives. (The moon visible out the window is a reference to the Lunar Society.) By delaying the reintroduction of air, the scientist has created considerable suspense, as the reactions of the two girls indicate. Their father, a voice of reason, attempts to dispel their fears. The dramatic lighting, stylistically derived from the Baroque religious paintings of Caravaggio and his followers (SEE FIG. 17–60) but here applied to a secular subject, not only underscores the life-and-death issue of the bird's fate but also suggests that science brings light into a world of darkness and ignorance.

HISTORY PAINTING. European academies had long considered history painting as the highest form of artistic endeavor, but British patrons were reluctant to purchase such works from native artists. Instead, they favored Italian paintings bought on the Grand Tour or acquired through agents in

Italy. Thus, the arrival in London in 1766 of the Italian-trained Swiss history painter Angelica Kauffmann (1741–1807) greatly encouraged those artists in London aspiring to success as history painters. She was welcomed immediately into Joshua Reynolds's inner circle and in 1768 was one of two women artists named among the founding members of the Royal Academy (see "Women and Academies," page 690).

Kauffmann had assisted her father on church murals and was already accepting portrait commissions at age fifteen. She first encountered the new classicism in Rome, where she painted Johann Winckelmann's portrait, and where she was elected to the Academy of Saint Luke. In a move unusual for a woman—most eighteenth-century women artists specialized in portraiture or still life—Kauffmann embarked on an independent career as a history painter. In London, where she lived from 1766 to 1781, she produced numerous history paintings, many of them with subjects drawn from classical antiquity. Kauffmann painted **CORNELIA POINTING TO HER CHILDREN AS HER TREASURES** (FIG. 18–30) for an English patron after returning to Italy. The story takes place in the

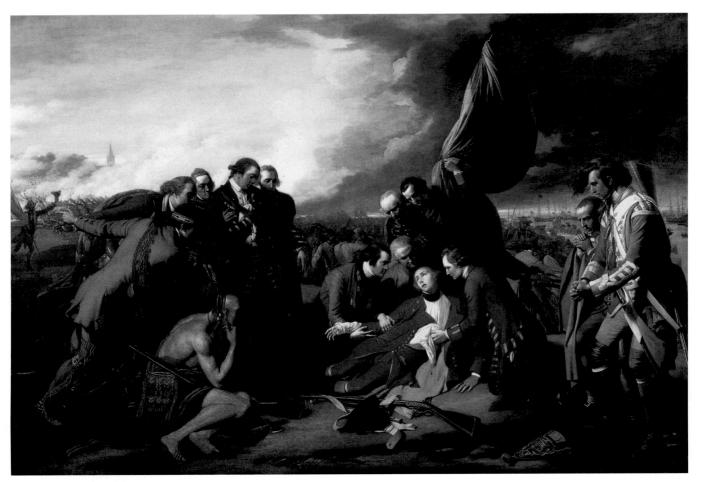

18–31 \dagger Benjamin West THE DEATH OF GENERAL WOLFE 1770. Oil on canvas, $4'11\%'' \times 7'$ (1.51 \times 2.14 m). The National Gallery of Canada, Ottawa.

Transfer from the Canadian War Memorials, 1921 (Gift of the 2nd Duke of Westminster, Eaton Hall, Cheshire, 1918)

The famous Shakespearean actor David Garrick was so moved by this painting that he enacted an impromptu interpretation of the dying Wolfe in front of the work when it was exhibited by the Royal Academy. The mid-eighteenth-century revival of interest in Shakespeare's more dramatic plays, in which Garrick played a leading role, was both a manifestation of and a major factor in the rise of Romantic taste in Britain.

second century BCE, during the republican era of Rome. A woman visitor has been showing Cornelia her jewels and then requests to see those of her hostess. In response, Cornelia shows her daughter and two sons and says, "These are my most precious jewels." Cornelia exemplifies the "good mother," a popular subject among later eighteenth-century history painters who, in the reforming spirit of the Enlightenment, often depicted subjects that would teach lessons in virtue. The value of Cornelia's maternal dedication is emphasized by the fact that under her loving care, the sons, Tiberius and Gaius Gracchus, grew up to be political reformers. Although the setting of Kauffmann's work is as severely simple as the message, the effect of the whole is softened by the warm, subdued lighting and by the tranquil grace of the leading characters.

Kauffmann's devotion to Neoclassical history painting was at first shared by her American-born friend Benjamin

West (1738–1820), who, after studying in Philadelphia, left for Rome in 1759. There he met Winckelmann and became a student of Mengs. In 1763, West moved permanently to London, where he specialized in Neoclassical history paintings. In 1768, he became a founding member of the Royal Academy. Two years later, he shocked Reynolds and his other academic friends with his painting **THE DEATH OF GENERAL WOLFE** (FIG. 18–31) because rather than clothing the figures in ancient garb in accordance with the tenets of Neoclassicism, he chose to depict them in modern dress. When Reynolds learned what West was planning to do, he begged him not to continue this aberration of "taste." George III informed West he would not buy a painting with British heroes in modern dress.

West's painting glorifies the British General James Wolfe, who had died in 1759 in a British victory over the French for the control of Quebec during the Seven Years' War (1756-63). West depicted Wolfe in his red uniform expiring in the arms of his comrades under a cloud-swept sky, rather than at the base of a tree, surrounded by two or three attendants—the actual situation of his death. Thus, though West's painting is naturalistic, it is not an objective document, nor was it intended to be; West employed the Grand Manner, which Reynolds promulgated in his Discourses, to celebrate the valor of the fallen hero, the loyalty of the British soldiers, and the justice of their cause. To indicate the North American setting, West also included at the left a Native American warrior who contemplates the fallen Wolfe—another fiction, since the Native Americans in this battle fought on the side of the French. The dramatic illumination increases the emotional intensity of the scene, as do the poses of Wolfe's attendants, arranged to suggest a Lamentation over the dead Christ. Extending the analogy, the British flag above Wolfe replaces the Christian cross. Just as Christ died for humanity, Wolfe sacrificed himself for the good of the State.

The Death of General Wolfe enjoyed such an enthusiastic reception by the British public that Reynolds apologized to West, and the king was among four patrons to commission replicas. West's innovative decision to depict a modern historical subject in the Grand Manner established the general format for the depiction of contemporary historical events for all European artists in the later eighteenth and early nineteenth centuries. And the emotional intensity of his image helped launch the Romantic movement in British painting.

ROMANTIC PAINTING. The Enlightenment's faith in reason and empirical knowledge, dramatized in such works of art as Joseph Wright's *An Experiment on a Bird in the Air-Pump* (SEE FIG. 18–29), was countered by Romanticism's celebration of the emotions and subjective forms of experience. Many Romantic artists glorified the irrational side of human nature that the Enlightenment sought to deny.

One such Romantic was John Henry Fuseli (1741–1825), who arrived in London from his native Switzerland in 1764. Trained in theology, philosophy, and the Neoclassical aesthetics of Winckelmann (whose writings he translated into English), Fuseli quickly became a member of the London intellectual elite. Joshua Reynolds encouraged Fuseli to become an artist, and in 1770 Fuseli left to study in Rome, where he spent most of the next eight years. Fuseli's encounter with ancient Roman sculpture and the painting of Michelangelo led him to develop a powerfully expressive style based on these sources rather than on the ancient Greek works admired by Winckelmann.

Back in London, Fuseli established himself as a history painter specializing in dramatic subjects drawn from such authors as Homer, Dante, Shakespeare, and Milton. Rejecting the Enlightenment emphasis on science and reason, Fuseli often depicted supernatural and irrational subjects, as in his

Elements of Architecture IRON AS A BUILDING MATERIAL

n 1779, Abraham Darby III built a bridge over the Severn River at Coalbrookdale in England-a town typical of the new industrial environment, with factories and workers' housing filling the valley. The bridge itself is important because it represents the first use of structural metal on a large scale, with iron replacing the heavy, hand-cut stone voussoirs used to construct earlier bridges. Five pairs of cast-iron, semicircular arches form a strong, economical hundred-foot span. In functional architecture such as this bridge, the available technology, the properties of the material, and the requirements of engineering ir large part determine form and often produce an unintended and revolutionary new aesthetic. Here, the use of metal at last made possible the light, open, skeletal structure desired by builders since the twelfth century. Cast iron was quickly adopted by builders, giving rise to such architectural feats as the soaring train stations of the nineteenth century and leading ultimately to such marvels as the Eiffel Tower.

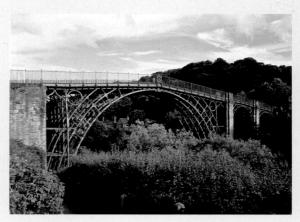

Abraham Darby III SEVERN RIVER BRIDGE Coalbrookdale, England. 1779.

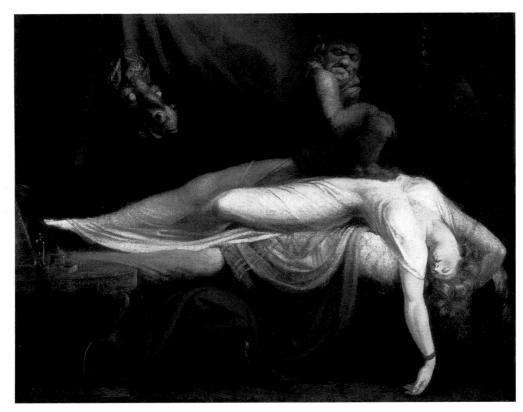

Fuseli was not popular with the English critics. One writer said Fuseli's 1780 entry in the London Royal Academy exhibition "ought to be destroyed," and Horace Walpole called another painting in 1785 "shockingly mad, mad, mad, madder than ever." Even after achieving the highest official acknowledgment of his talents, Fuseli was called the Wild Swiss and Painter to the Devil. But the public appreciated his work, and *The Nightmare*, exhibited at the Academy in 1782, was repeated in at least three more versions and its imagery disseminated by means of prints published by commercial engravers. One of these prints would one day hang in the office of the Austrian psychoanalyst Sigmund Freud, who believed that dreams were manifestations of the dreamer's repressed desires.

most famous work, THE NIGHTMARE (FIG. 18-32). In this painting, Fuseli depicts a somnolent white-clad woman, sprawled across a divan, who is oppressed by an erotic dream caused by an incubus (or mara, an evil spirit), the gruesome demon sitting on her chest. According to legend, the incubus was believed to steal upon sleeping women and have intercourse with them—a subject Fuseli also depicted in other works. Adding to the erotic suggestiveness of The Nightmare is the horse with phosphorescent eyes that thrusts its head into the room through a curtain at the left. This was the first of at least four versions of the theme Fuseli would paint. His motives are perhaps revealed by the portrait on the back of the canvas, which may be that of Anna Landolt. Fuseli had met her in Zürich in the winter of 1778-79 and had fallen in love with her. Too poor to propose marriage to her, he did not declare his feelings, but after his return to London he wrote to her uncle that she could not marry another because they had made love in one of his dreams and she therefore belonged to him. The painting may be an illustration of that dream.

Also opposed to the Enlightenment emphasis on reason and artistically inspired by Michelangelo was Fuseli's friend William Blake (1757–1827), a highly original poet, painter, and printmaker. Trained as an engraver, Blake enrolled briefly at the Royal Academy, where he was subjected to the teachings of Reynolds. The experience convinced him that all rules hinder rather than aid creativity, and he became a lifelong advocate of unfettered imagination. For Blake, imagination offered access to the higher realm of the spirit, while reason could only provide information about the lower world of matter.

Deeply concerned with the problem of good and evil, Blake developed an idiosyncratic form of Christian belief and drew on elements from the Bible, Greek mythology, and British legend to create his own mythology. The "prophetic books" that he designed and printed in the mid-1790s combined poetry and imagery dealing with themes of spiritual crisis and redemption. Their dominant characters include Urizen ("your reason"), the negative embodiment of ratio-

nalistic thought and repressive authority; Orc, the manifestation of energy, both creative and destructive; and Los, the artist, whose task is to create form out of chaos.

Thematically related to the prophetic books are an independent series of twelve large color prints that Blake executed for the most part in 1795, including the awe-inspiring **ELOHIM CREATING ADAM** (FIG. 18–33). The sculpturesque volumes and muscular physiques of the figures reveal the influence of Michelangelo, whose works Blake admired in reproduction, and the subject invites direct comparison with Michelangelo's famous Creation of Adam on the ceiling of the Sistine Chapel (SEE FIG. 15-14). But while Michelangelo, with humanist optimism, viewed the Creation as a positive act, Blake presents it in negative terms. In Blake's print, a giant worm, symbolizing matter, encircles the lower body of Adam, who, with an anguished expression, stretches out on the ground like the crucified Christ. Above him, the winged Elohim (Elohim is one of the Hebrew names for God) appears anxious, even desperate—quite unlike the confident deity pictured by Michelangelo. For Blake, the Creation is tragic because it submits the spiritual human to the fallen state of a material existence. Blake's fraught and gloomy image challenges the viewer to recognize his or her fallen nature and seek to transcend it.

LATER EIGHTEENTH-CENTURY ART IN FRANCE

The late eighteenth century in France witnessed the fading fortunes of the Rococo under the impact of Enlightenment ideas, Neoclassicism, and the gathering clouds of revolution. These new currents led artists away from the Rococo's breezy if entertaining subjects and toward art that was more edifying or inspiring. Architects hewed a line closer to Roman sources, while painters and sculptors increasingly embraced either a down-to-earth naturalism or didactic narratives. The era also saw the rise of the most important exponent of Neoclassicism in painting, Jacques-Louis David.

Architecture

French architects of the late eighteenth century generally considered classicism not one of many alternative styles but *the* single, true style. In the increasingly secular, Enlightenment-oriented culture of the period, the Rococo seemed frivolous, the Baroque was associated (rightly or wrongly) with corrupt and scheming Roman Catholicism, while the Gothic called up the superstitions of the medieval period. In order to achieve greatness, many believed along with Winckelmann that "imitation of the ancients" was the key to success. He wrote in *Reflections on the Imitation of Greek Works*, "Good

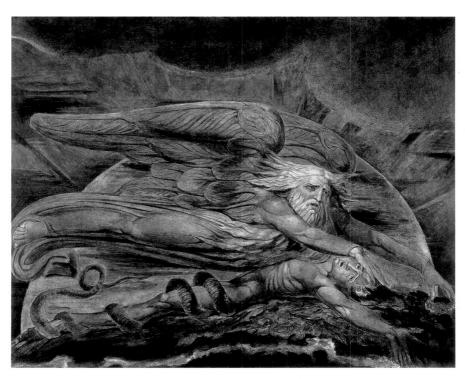

18–33 | William Blake ELOHIM CREATING ADAM 1795. Color print finished in pen and watercolor, $17\times21\%$ (43.1 \times 53.6 cm). Tate Gallery, London.

Made through a monotype process, Blake's large color prints of 1795 combine printing with painting and drawing. To make them, the artist first laid down his colors (possibly oil paint) on heavy paperboard. From the painted board Blake then pulled a few impressions, usually three, on separate sheets of paper. These impressions would vary in effect, with the first having fuller and deeper colors than the subsequent ones. Blake then finished each print by hand, using watercolor and pen and ink.

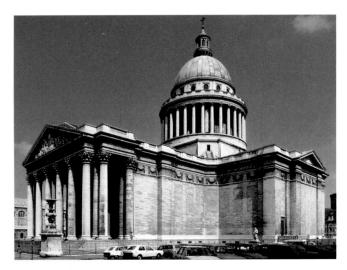

18–34 | Jacques-Germain Soufflot PANTHÉON (CHURCH OF SAINTE-GENEVIÈVE)
Paris. 1755–92.

This building has a strange history. Before it was completed, the Revolutionary government in control of Paris confiscated all religious properties to raise desperately needed public funds. Instead of selling Sainte-Geneviève, however, they voted in 1791 to make it the Temple of Fame for the burial of Heroes of Liberty. Under Napoleon I (ruled 1799-1814), the building was resanctified as a Catholic church and was again used as such under King Louis-Philippe (ruled 1830-48) and Napoleon III (ruled 1852-70). Then it was permanently designated a nondenominational lay temple. In 1851, the building was used as a physics laboratory. Here the French physicist Jean-Bernard Foucault suspended his now-famous pendulum on the interior of the high crossing dome and by measuring the path of the pendulum's swing proved his theory that the earth rotated on its axis in a counter-clockwise motion. In 1995, the ashes of Marie Curie, who had won the Nobel Prize in chemistry in 1911, were moved into this "memorial to the great men of France," making her the first woman to be enshrined there.

taste, which is becoming more prevalent throughout the world, had its origins under the skies of Greece." Original examples of Greek art were mostly inaccessible because the region was then dominated by the Ottoman Turks; but Roman art, its nearest equivalent, was close at hand.

The leading Neoclassical architect was Jacques-Germain Soufflot (1713-80); his Church of Sainte-Geneviève (FIG. 18-34), known today as the PANTHÉON, is the most typical Neoclassical building. Here Soufflot attempted to integrate three traditions: the kind of Roman architecture he had seen on his two trips to Italy; French and English Baroque classicism; and the Palladian style being revived at the time in England. The façade, with its huge portico, is modeled directly on ancient Roman temples. The dome, on the other hand, was inspired by several seventeenth-century examples, including Wren's Saint Paul's in London (SEE FIG. 17-66). Finally, the radical geometry of its plan (FIG. 18-35), a central-plan Greek cross, owes as much to Burlington's Chiswick House (SEE FIG. 18–19) as it does to Christian tradition. Note that he replaced the interlocking ovals and bulges of the Rococo with clear and pure rectangles, squares, and circles. Soufflot also seems to have been inspired by the plain, undecorated surfaces Burlington used in his home. The result is a building that attempts to maintain and develop the historical continuity of the classical tradition.

Painting and Sculpture

While French painters such as Boucher, Fragonard, and their followers continued to work in the Rococo style in the later decades of the eighteenth century, a strong reaction against the Rococo had set in by the 1760s. A leading detractor of the Rococo was Denis Diderot (1713–84), an Enlightenment figure whom many consider the founder of modern art criticism. In 1759, Diderot began to write reviews of the official Salon for a periodic newsletter for wealthy subscribers. Diderot believed that it was art's proper function to "inspire virtue and purify manners." He therefore criticized the adherents of the Rococo, whose characteristic works he con-

I8-35 | SECTION AND PLAN OF THE PANTHÉON (CHURCH OF SAINTE-GENEVIÈVE)

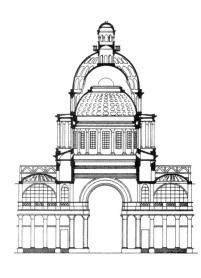

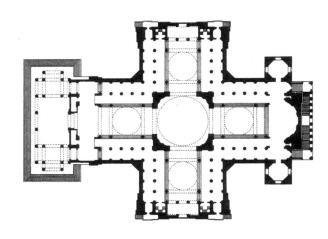

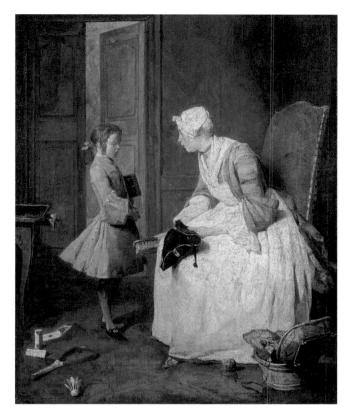

18–36 | Jean-Siméon Chardin THE GOVERNESS 1739. Oil on canvas, $18\frac{1}{8} \times 14\frac{1}{4}$ " (46 \times 37.5 cm). National Gallery of Canada, Ottawa. Purchase, 1956

Chardin was one of the first French artists to treat the lives of women and children with sympathy and to honor the dignity of women's work in his portrayals of young mothers, governesses, and kitchen maids. Shown at the Salon of 1739, *The Governess* was praised by contemporary critics, one of whom noted "the graciousness, sweetness, and restraint that the governess maintains in her discipline of the young man about his dirtiness, disorder, and neglect; his attention, shame, and remorse; all are expressed with great simplicity."

sidered frivolous at best and immoral at worst. Diderot's most notable accomplishment was editing, in collaboration with Jean le Rond d'Alembert, the *Encyclopédie* (1751–77), a thirty-two-volume compendium of knowledge and opinion that served as an archive of Enlightenment thought in fields as diverse as agriculture, aesthetics, and penology.

CHARDIN. Diderot found in Jean-Siméon Chardin (1699-1779) an artist to his liking. A painter whose output was limited essentially to still lifes and quiet domestic scenes, Chardin tended to work on a small scale, meticulously and slowly. As early as the 1730s, Chardin began to create moral genre pictures in the tradition of seventeenth-century Dutch genre paintings, which focused on simple, mildly touching scenes of everyday middle-class life. One such picture, THE GOVERNESS (FIG. 18-36), shows a finely dressed boy, with books under his arm, who listens to his governess as she prepares to brush his tricorn (three-cornered) hat. Scattered on the floor behind him are a racquet, a shuttlecock, and playing cards, evoking the childish pleasures that the boy leaves behind as he prepares to go to his studies and, ultimately, to a life of responsible adulthood. The work equally encourages benevolent exercise of authority, and willing submission to it.

GREUZE. Diderot's highest praise went to Jean-Baptiste Greuze (1725–1805)—which is hardly surprising, because Greuze's major source of inspiration came from the kind of middle-class drama that Diderot had inaugurated with his plays of the late 1750s. In addition to comedy and tragedy, Diderot thought the range of theatrical works should include a "middle tragedy" that taught useful lessons to the public with clear, simple stories of ordinary life. Greuze's domestic genre paintings, such as **THE DRUNKEN COBBLER** (FIG. 18–37),

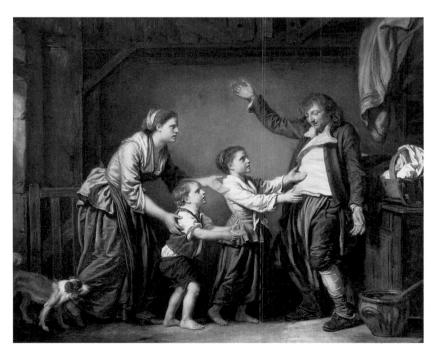

18–37 | Jean-Baptiste Greuze
THE DRUNKEN COBBLER
1780–85. Oil on canvas, 29 ½ × 36 ½"
(75.2 × 92.4 cm). Portland Art Museum,
Portland, Oregon.

Gift of Marion Bowles Hollis

In 1769, Greuze submitted a classical history painting to the Salon and requested the French Academy to change his official status from genre painter to the higher rank of history painter. The work was accepted but the request was refused. Greuze was so angry that he did not again exhibit at the Salon until 1800, preferring to show his works privately or in exhibitions sponsored by other organizations than the academy.

became the visual counterparts of that new theatrical form, which later became known as melodrama. On a shallow, stagelike space and under a dramatic spotlight, a drunken father returns home to his angry wife and hungry children. The gestures of the children make clear that he has spent the family's grocery money on drink. In other paintings, Greuze offered wives and children similar lessons in how not to behave.

VIGÉE-LEBRUN. French portrait painters before the Revolution of 1789 moved toward naturalistic poses and more everyday settings. Elegant informality continued to be featured, but new themes were introduced, figures tended to be larger and more robust, and compositional arrangements were more stable. Many leading portraitists were women. The

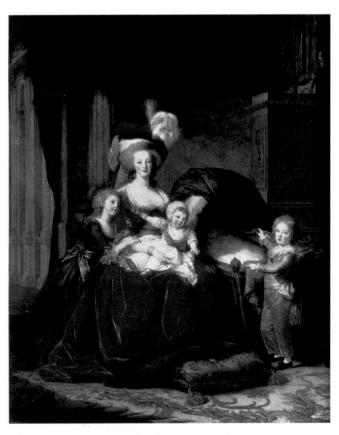

18–38 | Marie-Louise-Élisabeth Vigée-Lebrun

PORTRAIT OF MARIE ANTOINETTE WITH HER CHILDREN

1787. Oil on canvas, 9'½" × 7'½" (2.75 × 2.15 m).

Musée National du Château de Versailles.

As the favorite painter to the queen, Vigée-Lebrun escaped from Paris with her daughter on the eve of the Revolution of 1789 and fled to Rome. After a very successful self-exile working in Italy, Austria, Russia, and England, the artist finally resettled in Paris in 1805 and again became popular with Parisian art patrons. Over her long career, she painted about 800 portraits in a vibrant style that changed very little over the decades.

most famous was Marie-Louise-Élisabeth Vigée-Lebrun (1755-1842), who in the 1780s became Queen Marie Antoinette's favorite painter. In 1787, she portrayed the queen with her children (FIG. 18-38), in conformity with the Enlightenment theme of the "good mother," already seen in Angelica Kauffmann's painting of Cornelia (SEE FIG. 18–30). The portrait of the queen as a kindly, stabilizing presence for her offspring was meant to counter her public image as selfish, extravagant, and immoral. The princess leans affectionately against her mother, proof of the queen's natural goodness. In a further attempt to gain the viewer's sympathy, the little dauphin—the eldest son and heir to a throne he would never ascend—points to the empty cradle of a recently deceased sibling. The image also alludes to the well-known allegory of Abundance, suggesting the peace and prosperity of society under the reign of her husband, Louis XVI, who began his rule in 1774 but fell victim to revolutionary turmoil and was executed in 1792.

In 1783, Vigée-Lebrun was elected to one of the four places in the French Academy available to women. Also elected that year was Adélaïde Labille-Guiard (1749-1803), who in 1790 successfully petitioned to end the restriction on women. Labille-Guiard's commitment to increasing the number of women painters in France is evident in a selfportrait with two pupils that she submitted to the Salon of 1785. The monumental image of the artist at her easel (FIG. 18-39) was also meant to answer the sexist rumors that her paintings and those by Vigée-Lebrun had actually been painted by men. In a witty role reversal, the only male in this work is her muse—her father, whose bust is behind her. While the self-portrait flatters the painter's conventional feminine charms in a manner generally consistent with the Rococo tradition, a comparison with similar images of women by artists such as Fragonard (SEE FIG. 18-11) reveals the more monumental female type Labille-Guiard favored, in keeping with her conception of women as important contributors to national life, which is an Enlightenment impulse. The solid pyramidal arrangement of the three women adds to the effect.

DAVID. The most important French Neoclassical painter of the era was Jacques-Louis David (1748–1825), who dominated French art during the Revolution and subsequent reign of Napoleon. In 1774, David won the Prix de Rome and spent six years there, studying antique sculpture and assimilating the principles of Neoclassicism. After his return, he produced a series of severely undecorated, anti-Rococo paintings that extolled the antique virtues of stoicism, masculinity, and patriotism. In a career that rode the cresting waves of the Revolution, David was the dominant artist in France for over twenty years, creating memorable paintings and training the next generation.

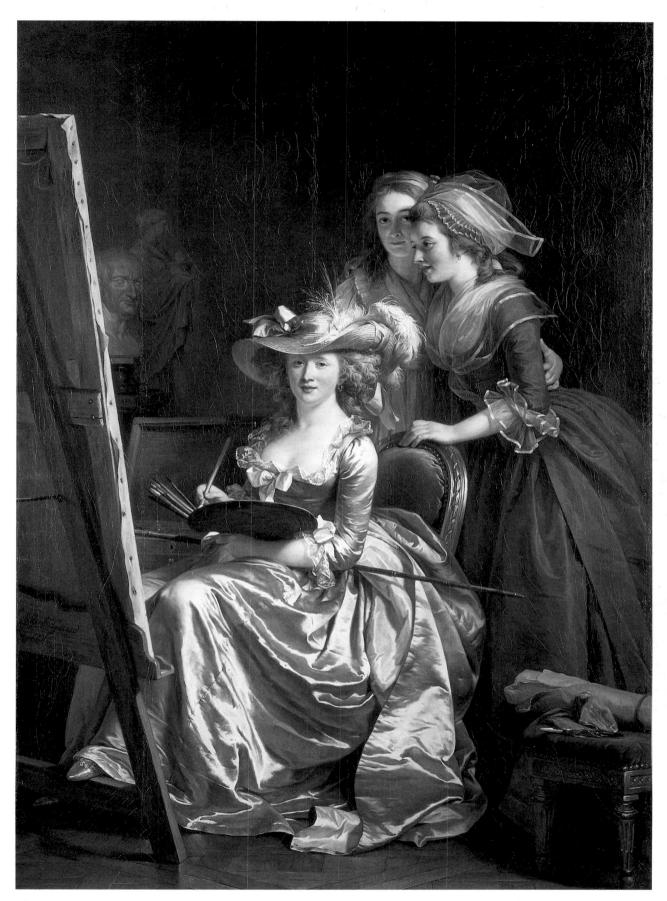

18–39 | Adélaïde Labille-Guiard | SELF-PORTRAIT WITH TWO PUPILS 1785. Oil on canvas, $6'11'' \times 4'11 \%''$ (2.11 \times 1.51 m). The Metropolitan Museum of Art, New York. Gift of Julia A. Berwind, 1953 (53.225.5)

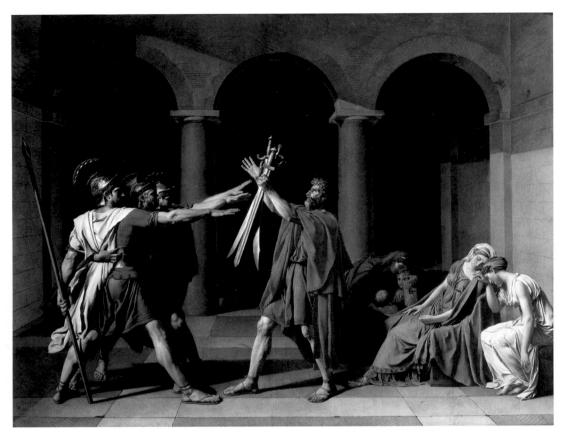

18–40 | Jacques-Louis David OATH OF THE HORATII 1784–85. Oil on canvas, 10'8½" × 14'(3.26 × 4.27 m). Musée du Louvre, Paris.

The most famous and influential of these works was the **OATH OF THE HORATII** (FIG. 18–40), of 1784–85. A royal commission, the work reflects the taste and values of Louis XVI, who along with his minister of the arts, Count d'Angiviller, was sympathetic to the Enlightenment. Following Diderot's lead, d'Angiviller and the king believed art should improve public morals. Among his first official acts, d'Angiviller banned indecent nudity from the Salon of 1775 and commissioned a series of didactic history paintings. David's commission in 1784 was part of that general program.

This work was inspired by Pierre Corneille's seventeenth-century drama *Horace*, which was itself based on ancient Roman historical texts, although the patriotic oath-taking incident depicted by David is found in none of these sources and seems to have been his own invention. The story concerns an episode from the seventh century BCE when Rome and its rival Alba, a neighboring city-state, agreed to settle a border dispute and avert a war by means of a battle to the death between the three sons of Horace (the Horatii), representing Rome, and the three Curatii, representing Alba. In David's painting, which he set in an austere Roman interior, the triplet Horatii stand with arms outstretched toward their father, who holds up the swords on which the young men pledge to fight to the death for

Rome. In contrast to the upright, muscular angularity of the men is a group of limp and weeping women and frightened children at the right. The women are upset not simply because the Horatii might die but also because one of them (Sabina, in the center) is a sister of the Curatii, married to one of the Horatii, and another (Camilla, at the far right) is engaged to one of the Curatii. David's composition, which spatially separates the men from the women and children through the use of the framing background arches, effectively contrasts the men's stoic willingness to sacrifice themselves for the state with the women's emotional commitment to family ties.

David's painting soon became an emblem of the French Revolution of 1789, which, ironically, precipitated the downfall of the monarchy that had commissioned the work. The painting's lesson in the sacrifices required for the good of the state effectively captured the mood of the leaders of the new French Republic established in 1792, as the revolutionaries abolished the monarchy, extinguished titles of nobility, took education out of the hands of the Church, and wrote a declaration of human rights. David sympathized with all of these causes. He joined the leftist Jacobin party, and they in turn appointed him national minister of the arts when they achieved power in 1792.

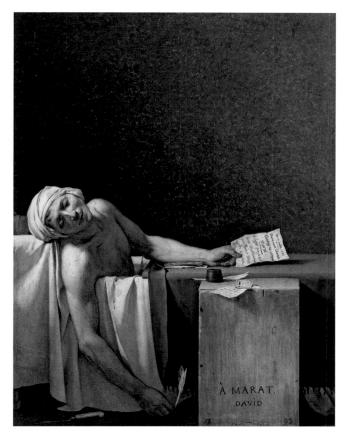

In 1793, David was elected a deputy to the National Convention and was named propaganda minister and director of public festivals. Because he supported Robespierre and the Reign of Terror, he was twice imprisoned after its demise in 1794, albeit under lenient circumstances that allowed him to continue painting.

David's greatest painting commemorates the death of one of the Jacobin leaders, Jean-Paul Marat (FIG. 18-41). A radical journalist, Marat lived simply among the packing cases that he used as furniture, writing pamphlets that urged the abolition of aristocratic privilege. A young supporter of an opposition party, Charlotte Corday, saw Marat as partly responsible for the 1792 riots in which hundreds of political prisoners deemed sympathetic to the king were killed. She decided that Marat should pay for his actions. Because Marat suffered from a painful skin ailment, he conducted his official business sitting in a medicinal bath. After using a ruse to gain entry to his house, Corday stabbed him, dropped her knife, and fled. Instead of handling the event in a sensational manner as Greuze might have, David played down the drama and showed us its quiet, still aftermath: the dead Marat slumped in his bathtub, a towel wrapped around his head, his right hand still holding a quill pen, his left hand grasping the letter Corday handed him on her entry. The simple wood block at the right, which Marat used as a desk, becomes his tombstone, inscribed with the painter's dedication. David combined his

reductive Neoclassical style with a dramatic naturalism to liken Marat to a martyred saint. Marat's dangling right arm echoes that of Christ in both Michelangelo's Sistine *Pietà* and Caravaggio's *Entombment* (SEE FIGS. 15–9 AND 17–17), making Marat a Christ-like figure who has given his life for a greater cause—in this case not religious but political.

The Revolution degenerated into mob rule in 1793–94, as various political parties ruthlessly executed thousands of their opponents in what became known as the Reign of Terror. David himself, as a member of the Jacobins, served a two-week term as president, during which he signed several arrest warrants. When the Jacobins lost power in 1794, David was twice imprisoned, but he later emerged as a partisan of Napoleon and reestablished his career at the pinnacle of French art.

GIRODET-TRIOSON. A charismatic and influential teacher, David trained most of the important French painters who emerged in the 1790s and early 1800s. The lessons of David's teaching are evident, for example, in the **PORTRAIT OF JEAN-BAPTISTE BELLEY** (FIG. 18–42) by Anne-Louis Girodet-Trioson (1767–1824). Stylistically, the work combines a

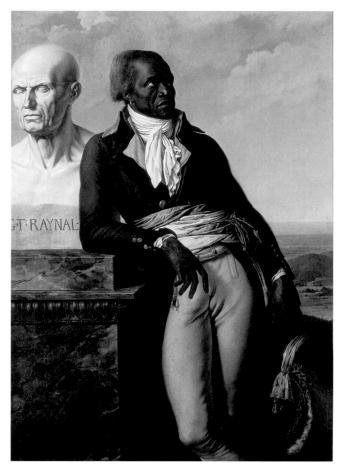

18–42 | Anne-Louis Girodet-Trioson PORTRAIT OF JEAN-BAPTISTE BELLEY

1797. Oil on canvas, $5'2\%'' \times 3'8\%''$ (1.59 \times 1.13 m). Musée National du Château de Versailles.

graceful pose recalling a classical sculpture with the kind of descriptive naturalism found in David's *Marat*. The work also has a significant political dimension. The Senegal-born Belley (1747?–1805) was a former slave sent by the colony of Saint-Domingue (now Haiti) as a representative to the French Convention. In 1794, he led the successful legislative campaign to abolish slavery in the colonies and grant black people full citizenship. Belley leans casually on a pedestal with the bust of the abbot Guillaume Raynal (1713–96), the French philosophe whose 1770 book condemning slavery had prepared the way for such legislation. (Unfortunately, in 1801 Napoleon reestablished slavery in the Caribbean Islands.) Girodet's portrait is therefore more of a tribute to the egalitarian principles of Raynal and Belley than it is a conventional portrait meant to flatter a sitter.

HOUDON. The heroes of the Enlightenment found their sculptor in Jean-Antoine Houdon (1741–1828), who combined naturalism with Neoclassicism in a way that influenced public monuments until the twentieth century. Houdon studied in Italy between 1764 and 1768 after winning the Prix de Rome. His commitment to a Neoclassical style began

during his stay in Rome, where he came into contact with some of the leading artists and theorists of the movement. Houdon carved busts and full-length statues of many important figures of his era, such as Diderot, Voltaire, Jean-Jacques Rousseau, Catherine the Great, Thomas Jefferson, Benjamin Franklin, Lafayette, and Napoleon. On the basis of his bust of Benjamin Franklin, Houdon was commissioned by the Virginia state legislature to do a portrait of its native son George Washington. Houdon traveled to the United States in 1785 to make a cast of Washington's features and a bust in plaster. He then executed a life-size marble figure in Paris (FIG. 18-43). For this work, Houdon combined contemporary naturalism with the new classicism that many were beginning to identify with republican politics. Although the military leader of the American Revolution of 1776 is dressed in his general's uniform, Washington's serene expression and relaxed contrapposto pose derive from sculpted images of classical athletes. Washington's left hand rests on a fasces, a bundle of rods tied together with an axe face, used in Roman times as a symbol of authority. The thirteen rods bound together are also a reference to the union formed by the original states. Attached to the fasces are a sword of war and a plowshare of

18–43 | Jean-Antoine Houdon GEORGE WASHINGTON 1788–92. Marble, height 6'2" (1.9 m). State Capitol, Richmond, Virginia.

The plow blade behind Washington alludes to Cincinnatus, a Roman soldier of the fifth century BCE who was appointed dictator and dispatched to defeat the Aequi, who had besieged a Roman army. After the victory, Cincinnatus resigned the dictatorship and returned to his farm. Washington's contemporaries compared him with Cincinnatus because, after leading the Americans to victory over the British, he resigned his commission and went back to farming rather than seeking political power. Just below Washington's waistcoat hangs the badge of the Society of the Cincinnati, founded in 1783 by the officers of the disbanding Continental Army who were returning to their peacetime occupations. Washington lived in retirement at his Mount Vernon, Virginia, plantation for five years before his 1789 election as the first president of the United States.

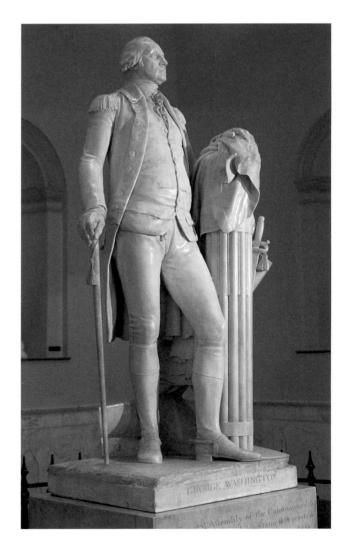

peace. Houdon's studio turned out a regular supply of replicas of such works as part of the cult of great men promoted by Enlightenment thinkers as models for all humanity.

EIGHTEENTH-CENTURY ART OF THE AMERICAS

New Spain

In the wake of the Spanish conquest of central and south America, the conquerors suppressed local beliefs and practices and imposed Roman Catholicism throughout Spanish America. Native American temples were torn down, and churches were erected in their place. The early work of conversion fell to Franciscan, Dominican, and Augustinian religious orders. Several missionaries were so appalled by the conquerors' treatment of the people they called Indians that they petitioned the Spanish king to improve their conditions.

In the course of the Native Americans' conversion to Roman Catholicism, their own symbolism was to some extent absorbed into Christian symbolism. This process can be seen in the huge early colonial atrial crosses, so called because they were located in church atriums, where large numbers of converts gathered for education in the new faith. Missionaries recruited Native American sculptors to carve these crosses. One sixteenth-century ATRIAL CROSS, now in the Basilica of Guadalupe near Mexico City, suggests pre-Hispanic sculpture in its stark form and rich surface symbols in low relief, even though the individual images were probably copied from illustrated books that the missionaries brought (FIG. 18-44). The work is made from two large blocks of stone that are entirely covered with images known as the Arms of Christ, the "weapons" Christ used to defeat the devil. Jesus's Crown of Thorns hangs like a necklace around the cross bar, and with the Holy Shroud, which also wraps the arms, it frames the image of the Holy Face (the impression on the cloth Veronica used to wipe Jesus's face). Blood gushes forth where nails pierce the ends of the cross. Symbols of regeneration, such as winged cherub heads and pomegranates, surround the inscription at the top.

The cross itself suggests an ancient Mesoamerican symbol, the Tree of Life. The image of blood sacrifice also resonates with indigenous beliefs. The cross is composed of many individual elements that seem compressed to make a shape other than their own, the dense low relief combining into a single massive form. Simplified traditional Christian imagery is clearly visible in the work, although it may not yet have had much meaning or emotional resonance for the artists who put it there.

Converts in Mexico gained their own patron saint after the Virgin Mary was believed to have appeared as an Indian to an Indian named Juan Diego in 1531. Mary is said to have asked that a church be built on a hill where an

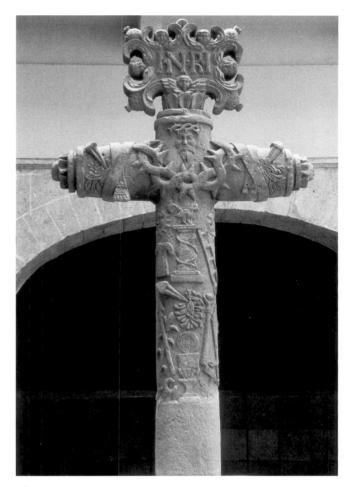

18–44 | ATRIAL CROSS Before 1556. Stone, height 11′ 3″ (3.45 m). Chapel of the Indians, Basilica of Guadalupe, Mexico City.

Aztec mother goddess had once been worshiped. As evidence of this vision, Juan Diego brought the archbishop flowers that the Virgin had caused to bloom, wrapped in a cloak. When Juan Diego opened his bundle, the cloak bore the image of a dark-skinned Mary, an image that, light-skinned, was popular in Spain and known as the Virgin of the Immaculate Conception. The site of the vision was renamed Guadalupe after Our Lady of Guadalupe in Spain, and it became a venerated pilgrimage center. In 1754, the pope declared the Virgin of Guadalupe the patron saint of the Americas, seen here (FIG. 18–45) in a 1779 work by Sebastian Salcedo.

Spanish colonial builders quite naturally tried to replicate the architecture of their native country in their adopted lands. In the colonies of North America's Southwest, the builders of one of the finest examples of mission architecture, **SAN XAVIER DEL BAC**, near Tucson, Arizona (FIG. 18–46), looked to Spain for its inspiration. The Jesuit priest Eusebio Kino (1644–1711) began laying the foundations in 1700, using stone quarried locally by Native Americans of the Pima nation. The desert

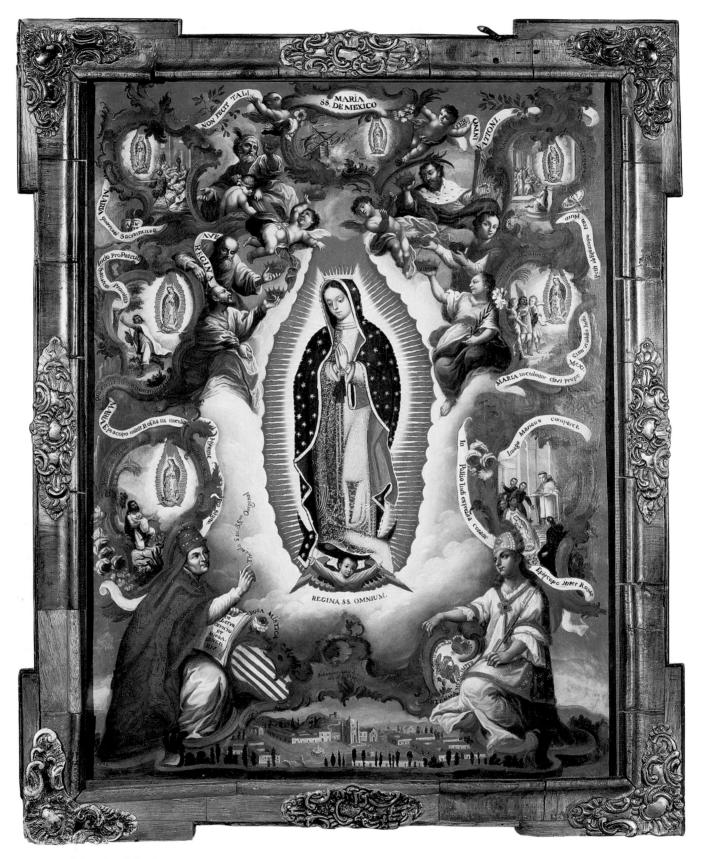

18–45 | Sebastian Salcedo OUR LADY OF GUADALUPE 1779. Oil on panel and copper, $25 \times 19''$ (63.5 \times 48.3 cm). Denver Art Museum.

At the bottom right is the female personification of New Spain (Mexico) and at the left is Pope Benedict XIV (papacy 1740-58), who in 1754 declared the Virgin of Guadalupe to be the patroness of the Americas. Between the figures, the sanctuary of Guadalupe in Mexico can be seen in the distance. The four small scenes circling the Virgin represent the story of Juan Diego, and at the top, three scenes depict Mary's miracles. The six figures above the Virgin represent Old Testament prophets and patriarchs and New Testament apostles and saints.

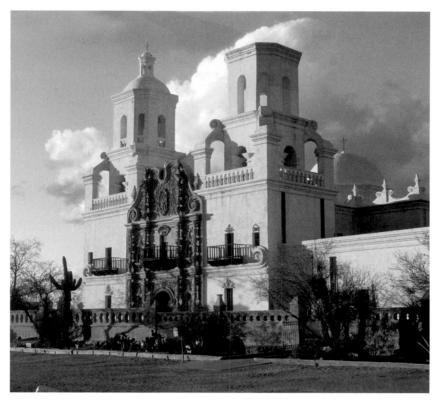

18–46 | MISSION SAN XAVIER DEL BAC Near Tucson, Arizona. 1784–97.

site had already been laid out with irrigation ditches, and Father Kino wrote in his reports that there would be running water in every room and workshop of the new mission, but the building never proceeded. The mission site was turned over to the Franciscans in 1768, after King Charles III ousted the Jesuit order from Spain and asserted royal control over Spanish churches. Father Kino's vision was realized by the Spanish Franciscan missionary and builder Juan Bautista Velderrain (d. 1790), who arrived at the mission in 1776.

The huge church, 99 feet long with a domed crossing and flanking bell towers, was unusual for the area since it was built of brick and mortar rather than adobe, which is made of earth and straw. The basic structure was finished by the time of Valderrain's death in 1790, and the exterior decoration was completed by 1797 under the supervision of his successor.

Although San Xavier is far from a copy, the focus on the central entrance area, with its Spanish Baroque decoration, is clearly in the tradition of the earlier work of Pedro de Ribera in Madrid. The mission was dedicated to Francis Xavier, whose statue once stood at the apex of the portal decoration. In the niches are statues of four female saints tentatively indentified as Lucy, Cecilia, Barbara, and Catherine of Siena. Hidden in the sculpted mass is one humorous element: a cat confronting a mouse, which inspired a local Pima saying: "When the cat catches the mouse, the end of the world will come" (cited in Chinn and McCarty, page 12).

North America

Eighteenth-century art by the white inhabitants of North America remained largely dependent on the styles of the European countries—Britain, France, and Spain—that had colonized the continent. Throughout the century, easier and more frequent travel across the Atlantic contributed to the assimilation of the European styles, but in general North American art lagged behind the European mainstream. In the early eighteenth century, the colonies grew rapidly in population, and rising prosperity led to an increased demand among the wealthy for fine works of art and architecture. (Apart from gravestone reliefs, sculpture was all but unknown.) Initially this demand was met by European immigrants who came to work in the colonies, but by the middle of the century a number of native-born American artists were also achieving professional success.

ARCHITECTURE. Professional architects, as we know them today, did not exist in the American colonies; rather, most fine houses and important public buildings were designed by amateur architects, sometimes called gentlemen-architects, who had the means and leisure to acquire and read books on architectural theory and the principles of design. These amateurs usually adapted, and sometimes copied outright, their building designs from the illustrated books of the sixteenth-century Italian architect Andrea Palladio (see Chapter 15) or the published designs of his English followers such as Inigo

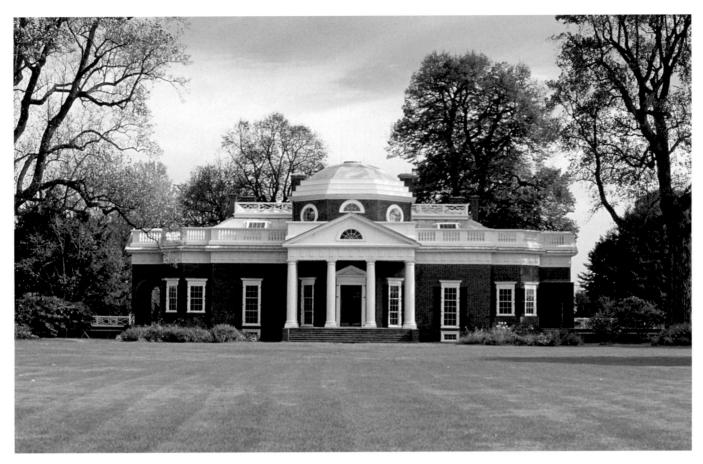

18–47 | Thomas Jefferson MONTICELLO Charlottesville, Virginia. 1769–82, 1796–1809.

Jones, who had introduced the Palladian style to England in the seventeenth century.

The tremendously accomplished Thomas Jefferson (1743–1826), principal author of the Declaration of Independence, governor of Virginia (1779-81), American minister to France (1785-89), second vice president (1797-1801), and third president of the United States (1801-09), was also a gentleman-architect. While serving in France, Jefferson was asked by the Virginia legislature to procure a design for the new state capitol in Richmond. In consultation with the French archaeologist and Neoclassical architect Charles-Louis Clérisseau (1721–1820), Jefferson produced a design for the capitol based on an ancient Roman temple. Jefferson's political convictions led him to this choice: He felt that the United States, having won its independence from Britain, should also free itself from the influence of British architecture and turn for inspiration to the buildings of republican Rome, which provided an ancient example of a representative, rather than monarchical, form of government. Jefferson's Virginia State Capitol (1785-89) thus adapted the Roman temple form to symbolize the values of American democracy, republicanism, and humanism, and inaugurated Neoclassicism as the official style of governmental architecture in the United States. In

succeeding decades most other state and federal government buildings, such as the U. S. Capitol in Washington, D.C. (SEE FIG. 19–22), were built in the Neoclassical style.

Prior to his sojourn in France, Jefferson had between 1769 and 1782 designed and built, near Charlottesville, Virginia, a mountaintop home he called **MONTICELLO** (Italian for "little mountain") (FIG. 18-47), in a style based on eighteenth-century English Palladian models. In a second building campaign at Monticello (1796-1809) following his return from France, Jefferson enlarged the house and redesigned its brick and wood exterior so that its two stories would appear to be one, in the manner then fashionable for Parisian houses. He accented the entrance and garden façades by means of porticoes capped by triangular pediments, and he unified the exterior by means of a continuous Doric entablature and balustrade. Behind the garden portico rises a hexagonal drum, its walls pierced by white-framed oculi and supporting a saucer dome. The combination of pedimented portico fronting a domed space derives from the most famous of all ancient Roman temples, the Pantheon (second-century CE), also quoted in Palladio's Villa Rotonda and Burlington's Chiswick House (FIGS. 15-47, 18-18), and imparts to Monticello a distinctively Neoclassical note.

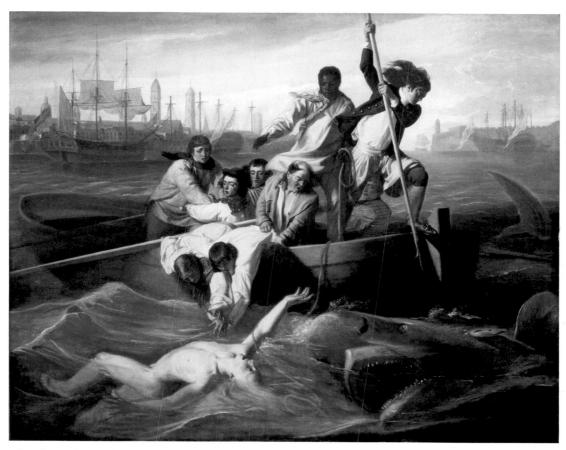

18–48 † John Singleton Copley **WATSON AND THE SHARK** 1778. Oil on canvas, $5'10\%''\times7'6\%''$ (1.82 \times 2.29 m). National Gallery of Art, Washington, D.C.

Ferdinand Lammot Belin Fund.

PAINTING. Most painters in England's American colonies relied on native talents rather than formal training. Portraiture dominated the market in the increasingly prosperous colonies, and portraitists studied engravings to learn figure poses and backdrops. The American-born Benjamin West, a member of the Royal Academy in London from 1768, encouraged colonial artists to travel to Europe for study; the most ambitious artists accepted his invitation.

John Singleton Copley (1738–1815) grew up to be colonial America's first native-born artist of genius. Copley's sources of inspiration were meager—principally his stepfather's collection of engravings—but his work was already drawing attention when he was 15 years old. Key to Copley's success was his intuitive understanding of his upper-class clientele. They valued not only his excellent technique, which equaled that of European artists, but also his ability to dignify them while recording their features with unflinching realism, as seen in his powerful portrait of *Samuel Adams* (SEE FIG. 18–1).

Copley's talents so outdistanced those of his colonial contemporaries that the artist aspired to a larger reputation. In 1766, he sent a portrait of his half brother to an exhibition in London, where it received a favorable critical response.

Benjamin West, the expatriate artist from Pennsylvania, encouraged Copley to study in Europe. At that time, family ties kept him from following the advice, but the impending Revolutionary War soon caused him to reconsider. In 1773, rebellious colonists dressed as Native Americans boarded a ship and threw its cargo of tea into Boston Harbor to protest the British East India Company's monopoly and the tax imposed on tea by the colonial government—an event known as the Boston Tea Party.

The shipment of tea belonged to Copley's merchant father-in-law, Richard Clarke. Copley was thus torn between two circles: his affluent pro-British in-laws and clients, and his radical friends, including Paul Revere, John Hancock, and Samuel Adams. Reluctant to take sides, Copley sailed in June 1774 for Europe, visiting Italy and settling in London, where his family joined him. Like West, he never returned to his native country.

In London, Copley established himself as a portraitist and painter of modern history in the vein of West. His most distinctive effort in the latter arena was **WATSON AND THE SHARK** (FIG. 18–48), commissioned by Brook Watson, a wealthy London merchant and Tory politician. Copley's 1778 painting dramatizes a 1749 episode during which the 14-year-old Watson, while swimming in the harbor of Havana,

was attacked by a shark and lost part of his right leg before being rescued by his comrades. Against the backdrop of a view of the Havana harbor, Copley deployed his foreground figures in a pyramidal composition inspired by classical prototypes. As the ferocious shark rushes on the helpless, naked Watson, a harpooner at the rescue boat's prow raises his spear for the kill. At the left, two of Watson's mates lean out and strain to reach him while the others in the boat look on in alarm. Prominent among these is a black man at the apex of the pyramid, who holds a rope that curls over Watson's extended right arm, connecting him to the boat and symbolizing his impending rescue.

While many have seen the black figure simply as a servant waiting to hand the rope to one of his white masters, art historians have also interpreted his presence in political terms. Watson's fateful swim in Havana Harbor occurred while he was working in the transatlantic shipping trade, one aspect of which involved the shipment of slaves from Africa to the West Indies. At the time Watson commissioned Copley's painting, a debate raged in Parliament not only over the Americans' recent Declaration of Independence, but also over the slave trade. Watson and other Tories opposed American independence and highlighted the hypocrisy of American calls for freedom from the British Crown while the colonists continued to deny freedom to African slaves. Furthermore, during the Revolutionary War the British used slavery to their advantage by promising freedom to every runaway American slave who joined the British army or navy.

Copley's painting, its subject doubtless dictated by Watson, therefore could be interpreted as a demonstration of Tory sympathy for the plight of the American slaves (though it should be noted that Watson ultimately did not support the outright abolition of slavery but rather gradual emancipation). In the context of Tory opposition to American independence, the shark-infested waters could symbolize the colonies themselves, a breeding ground of dangerous revolutionary ideas, while Watson's severed leg could stand for the dismemberment of the British Empire through the loss of its American colonies. Further connecting Watson, slavery, and the American colonies was the slavers' practice of throwing dead slaves overboard to the sharks during the journey from Africa to America. Yet Watson himself, through his involvement in the slave trade, had acted like a devouring shark and Copley represents him, metaphorically, as a victim of divine wrath (symbolized by the attacking shark) whose suffering redeems his guilty past. Significantly, Watson's arm reaches not toward his white comrades but toward the black man, whose reciprocal gesture seems to confer forgiveness.

The chaotic and uncertain mood of *Watson and the Shark* speaks of Romanticism, the movement that began in the late eighteenth century and would increasingly dominate the early nineteenth as the social forces unleashed by the Enlightenment and industrialization took hold across the Western world.

IN PERSPECTIVE

The eighteenth century in the West began under the sunny skies of the Rococo, as court artists decorated the salons of aristocrats with paintings that portrayed a life of ease. These works, whether by Tiepolo, Watteau, or Fragonard, generally took the aristocracy itself as subject matter, and depicted them in relaxed poses not based on classical norms, frolicking or relaxing in lush settings. The Rococo building style, initiated by Johan Balthasar Neumann in Bavaria, is a sensuous version of the Baroque. Spaces consist of complex, interpenetrating circles and ovals, with delicately scaled decoration.

The intellectual movement known as the Enlightenment influenced both society and art beginning in the middle years of the century. Based on scientific research rather than traditional belief, this movement led directly to the concept of universal human rights that many countries still aspire to today. Denis Diderot and others urged artists to work for the common good, and this encouraged artists such as Vigée–Lebrun to paint portraits in a down-to-earth style. Others, such as Wright, glorified science, and still others, such as Hogarth and Greuze, criticized aspects of the culture in the hope of improving it.

The discovery of the ruins of Pompeii and Herculaneum helped to set off the Neoclassical movement just after midcentury. Neoclassical painters such as David and Kauffmann, and sculptors such as Canova, rebelled against the entertaining Rococo and created art based on inspiring classical stories, with figure poses modeled after Roman reliefs in clear, evenly lit compositions. Neoclassicism also infused architecture with new, simpler designs based on Renaissance or Roman models. Leading architects included Jefferson, Boyle, Adam, and Soufflot.

Near the end of the century, the Romantic movement began to flower in England. Walpole redesigned Strawberry Hill to capture the flavor of the Middle Ages, Blake reinterpreted the Bible in his highly imaginative way, and John Henry Fuseli painted his nightmares. This movement, based on dreams, fantasies, and literature, would reach its height in the next century.

The eighteenth century ended in the smoke of the French Revolution, with Neoclassicism and incipient Romanticism the dominant movements.

WATTEAU
PILGRIMAGE TO THE ISLAND
OF CYTHERA
1717

CHARDIN
THE GOVERNESS
1739

CHURCH OF THE VIERZEHNHEILIGEN 1743-72

WRIGHT
AN EXPERIMENT ON A BIRD
IN THE AIR-PUMP
1768

OUR LADY OF GUADALUPE
1779

WEDGWOOD VASE 1786

EIGHTEENTH-CENTURY ART IN EUROPE AND THE AMERICAS

1700

1720

1740

1760

1780

1800

- Louis XIV of France Dies 1715
- Louis XV Rules France 1715-74

Seven Years' War 1756-63

- Women Were Founding Members of English Royal Academy 1768
- Louis XVI Rules France 1774-92
- American Revolution Begins 1776

■ French Revolution Begins 1789

19–1 | Gustave Eiffel EIFFEL TOWER Paris. 1887-89.

CHAPTER NINETEEN

NINETEENTH-CENTURY ART IN EUROPE AND THE UNITED STATES

"We writers, painters, sculptors, architects, and devoted lovers of the beauty of Paris . . . do protest with all our strength and all our indignation . . . against the erection, in the very heart of our capital, of the useless and monstrous

Eiffel Tower, which public spitefulness . . . has already baptized, 'the Tower of Babel.' "With these words, published in *Le Temps* on February 14, 1887, a group of conservative artists announced their strong opposition to the immense iron tower just beginning to be built on the River Seine. The work of the engineer Gustave Eiffel (1832–1923), the 300-meter (984-foot) tower would upon its completion be the tallest structure in the world, dwarfing even the Egyptian pyramids and Gothic cathedrals.

The EIFFEL TOWER (FIG. 19–1) was the main attraction of the 1889 Universal Exposition, one of several large fairs

19

staged in Europe and the United States during the late nineteenth century to showcase the latest international advances in science and industry, while also displaying both fine and applied arts. But because Eiffel's marvel lacked architec-

tural antecedents and did not conceal its construction, detractors saw it as an ugly, overblown work of engineering. For its admirers, however, it achieved a new kind of beauty derived from modern science and was an exhilarating symbol of technological innovation and human aspiration. One French poet called it "an iron witness raised by humanity into the azure sky to bear witness to its unwavering determination to reach the heavens and establish itself there." Perhaps more than any other monument, the Eiffel Tower embodies the nineteenth-century belief in the progress and ultimate perfection of civilization through science and technology.

- EUROPE AND THE UNITED STATES IN THE NINETEENTH CENTURY
- EARLY NINETEENTH-CENTURY ART: NEOCLASSICISM AND ROMANTICISM | Neoclassicism and Romanticism in France | Romantic Sculpture in France and Beyond | Romanticism in Spain: Goya | Romantic Landscape Painting | Orientalism | Revival Styles in Architecture Before 1850
- ART IN THE SECOND HALF OF THE NINETEENTH CENTURY | Early Photography in Europe | New Materials and Technology in Architecture at Midcentury | French Academic Art and Architecture | Realism | Late Nineteenth-Century Art in Britain | Impressionism
- THE BIRTH OF MODERN ART | Post-Impressionism | Symbolism in Painting | Late Nineteenth-Century French Sculpture | Art Nouveau | Late-Century Photography | Architecture
- IN PERSPECTIVE

EUROPE AND THE UNITED STATES IN THE NINETEENTH CENTURY

The Enlightenment set in motion powerful forces that would dramatically transform life in Europe and the United States during the nineteenth century. Great advances in manufacturing, transportation, and communications created new products for consumers and new wealth for entrepreneurs, fueling the rise of urban centers and improving living conditions for many (SEE MAP 19–1). But this so-called Industrial Revolution also condemned masses of workers to poverty and catalyzed new political movements for social reform. Animating these developments was the widespread belief in "progress" and the ultimate perfectibility of human civilization—a belief rooted deeply in Enlightenment thought (Chapter 18).

The Industrial Revolution had begun in eighteenth-century Britain, where the new coal-fired steam engine ran such innovations in manufacturing as the steam-powered loom. Increasing demands for coal and iron necessitated improvements in mining, metallurgy, and transportation. Subsequent development of the locomotive and steamship in turn facilitated the shipment of raw materials and merchandise, made passenger travel easier, and encouraged the growth of new cities.

Displaced from their small farms and traditional cottage industries by technological developments in agriculture and manufacturing, the rural poor moved to the new factory and mining towns in search of employment, and industrial laborers—many of them women and children—suffered miserable working and living conditions. Although new government regulations led to improvements during the second half of the nineteenth century, socialist movements condemned the exploitation of laborers by capitalist factory owners and advocated communal or state ownership of the means of production and distribution. The most radical of these movements was communism, which called for the abolition of private property.

Efforts at social reform reached a peak in 1848, as workers' revolts broke out in several European capitals. In that year, Karl Marx and Friedrich Engels also published the *Communist Manifesto*, which predicted the violent overthrow of the bourgeoisie (middle class) by the proletariat (working class) and the creation of a classless society. At the same time, the Americans Lucretia Mott and Elizabeth Cady Stanton organized the country's first women's rights convention, in Seneca Falls, New York. They called for the equality of women and men before the law, property rights for married women, the acceptance of women into institutions of higher education, the admission of women to all trades and professions, equal pay for equal work, and women's suffrage.

Continuing scientific discoveries led to the telegraph, telephone, and radio. By the end of the nineteenth century, electricity powered lighting, motors, trams, and railways in most European and American cities. Developments in chemistry created many new products, such as aspirin, disinfectants, photographic chemicals, and explosives. The new material of steel, an alloy of iron and carbon, was lighter, harder, and more malleable than iron, and replaced it in heavy construction and transportation. In medicine and public health, Louis Pasteur's purification of beverages through heat (pasteurization) and the development of vaccines, sterilization, and antiseptics led to a dramatic decline in death rates all over the Western world.

Some scientific discoveries challenged traditional religious beliefs and affected social philosophy. Geologists concluded that the earth was far older than the estimated 6,000 years sometimes claimed for it by biblical literalists. Contrary to the biblical account of creation, Charles Darwin proposed that all life evolved from a common ancestor and changed through genetic mutation and natural selection. Religious conservatives attacked Darwin's account of evolution, which seemed to deny the divine creation of humans and even the existence of God. Some of Darwin's supporters, however, suggested that "survival of the fittest" had advanced the human race, with certain types of people—particularly the

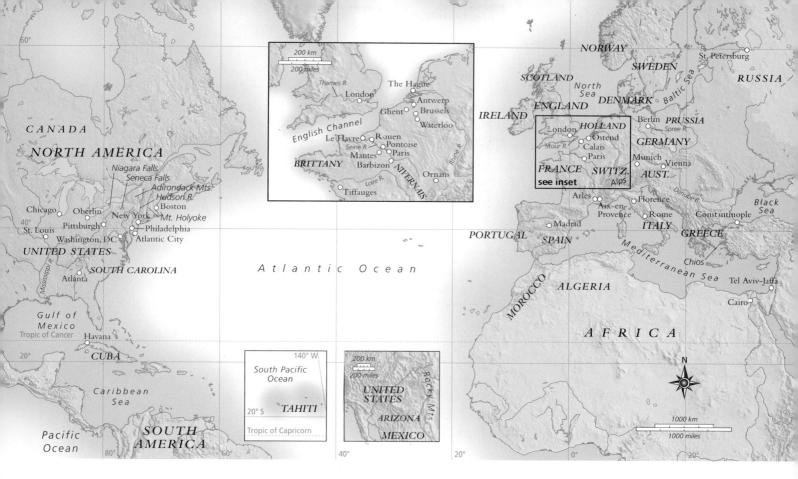

 ${
m MAP~I9}{=}{
m I}$ ${
m \mid }$ europe and the united states in the nineteenth century

Europe took the lead in industrialization, and France became the cultural beacon of the Western world.

Anglo-Saxon upper classes—achieving the pinnacle of social evolution. "Social Darwinism" provided a rationalization for the "natural" existence of a less "evolved" working class and a justification for British and American colonization of "underdeveloped" parts of the world.

The nineteenth century also witnessed the rise of imperialism. To create new markets for their products and to secure access to cheap raw materials and cheap labor, European nations established colonies in most of Africa and nearly a third of Asia. Colonial rule brought some technological improvements to non-Western regions but also threatened traditional native cultures and suppressed the economic development of the colonized areas.

As the power of both the Church and the Crown declined in the nineteenth century, so did their influence over artistic production. In their place, the capitalist bourgeoisie, nation-states, and national academies became major patrons of the arts. Large annual exhibitions in European and American cultural centers took on increasing importance as a means for artists to show their work, win prizes, attract buyers, and gain commissions. Art criticism proliferated in mass-printed periodicals, helping both to make and to break artis-

tic careers. And, in the later decades of the century, commercial art dealers gained in importance as marketers of both old and new art.

EARLY NINETEENTH-CENTURY ART: NEOCLASSICISM AND ROMANTICISM

Both Neoclassicism and Romanticism (see Chapter 18) remained vital in early nineteenth-century European and American art. Neoclassicism survived past the middle of the century in both architecture and sculpture, as patrons and creators held to the belief that recalling Greece and Rome ensured a connection to democracy. Neoclassical painters tended to dominate academies, where teachers urged students to learn from artique sculpture and great artists of the past such as Raphael. Most academicians regarded art as a repository of tradition in changing times, a way to access what was universal, abiding, and beautiful. They still hoped that art could inspire viewers to virtue and taste.

Romanticism took a variety of forms in the early decades, but the emphasis everywhere moved away from the

universal toward the personal, away from thought and toward feeling. Romantics respected the Enlightenment but regarded it as too narrowly focused on rationality, encouraging a certain coldness and detachment. Enlightenment rule by reason had, after all, led to the Reign of Terror in France. Humans are not only creatures of reason, the Romantics argued: Humans also possess deep and not always rational longings for self-expression, understanding, and identification with their fellows. The Romantic tools of feeling and imagination seemed the most appropriate aids to reach these goals. Thus Neoclassical art, embodied in the sandal-shod heroes of The Oath of the Horatii, seemed unconnected to the issues of the day. Many Romantic paintings and sculptures featured dramatic or emotional subject matter drawn from literature, the landscape, current events, or the artist's own imagination. In architecture, Romantics broadened the vocabulary of historical allusion that the Neoclassicists had pioneered: If recalling Rome instilled one set of feelings, then recourse to other periods could stimulate other kinds of sentiments. Ideally, each building type could use the style most appropriate to the personal wish of the patron.

Neoclassicism and Romanticism in France

The undisputed capital of the nineteenth-century Western art world was Paris. The École des Beaux-Arts attracted students from all over Europe and the Americas, as did the ateliers (studios) of Parisian academic artists who offered private instruction. Virtually every ambitious nineteenth-century artist aimed to exhibit in the Paris Salon, to receive positive reviews from the Parisian critics, and to find favor with the French art-buying public.

Conservative juries controlled the Salon exhibitions, however, and from the 1830s onward they routinely rejected paintings and sculpture that did not conform to the academic standards of slick technique, mildly idealized subject matter, and engaging, anecdotal story lines. As the century wore on, progressive and independent artists ceased submitting to the Salon and organized private exhibitions to present their work directly to the public without the intervention of a jury. The most famous of these was the first exhibition of the Impressionists, held in Paris in 1874.

DAVID AND HIS STUDENTS. With the rise of Napoleon, Jacques-Louis David reestablished his dominant position as chief arbiter of French painting. David saw in the general his best hope for realization of his Enlightenment-oriented political goals, and Napoleon saw in the artist a tested propagandist for revolutionary values. As Napoleon gained power and took his crusade across Europe, reforming law codes and abolishing aristocratic privilege, he commissioned David and his students to document his deeds. David's new artistic task, the glorification of Napoleon, appeared in an early, idealized portrait of Napoleon leading his troops across the Alps into

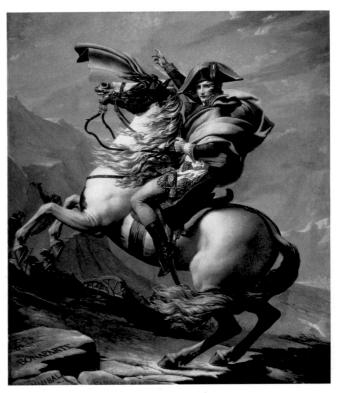

19–2 | Jacques-Louis David NAPOLEON CROSSING THE SAINT-BERNARD

1800–1801. Oil on canvas, $8'11''\times7'7''$ (2.7×2.3 m). Musée National du Château de la Malmaison, Rueil-Malmaison.

David flattered Napoleon by reminding the viewer of two other great generals from history who had accomplished this difficult feat—Charlemagne and Hannibal—by etching the names of all three in the rock in the lower left.

Italy in 1800 (FIG. 19–2). Napoleon—who actually made the crossing on a donkey—is shown calmly astride a rearing horse, exhorting us to follow him. His windblown cloak, an extension of his arm, suggests that Napoleon directs the winds as well. While Neoclassical in the firmness of its drawing, the work also takes stylistic inspiration from the Baroque—for example, in the dramatic diagonal composition used instead of the classical pyramid of the *Oath of the Horatii* (SEE FIG. 18–40). When Napoleon fell from power in 1814, David went into exile in Brussels, where he died in 1825.

Antoine-Jean Gros (1771–1835), who began to work in David's studio as a teenager, eventually vied with his master for commissions from Napoleon. Gros traveled with Napoleon in Italy in 1797 and later became an official chronicler of Napoleon's military campaigns. His painting NAPOLEON IN THE PLAGUE HOUSE AT JAFFA (FIG. 19–3) is an idealized account of an actual incident: During Napoleon's campaign against the Ottoman Turks in 1799, bubonic plague broke out among his troops. Napoleon decided to quiet the fears of the healthy by visiting the sick and dying, who were housed in a converted mosque in the Palestinian town of Jaffa (Palestine was then part of the Ottoman

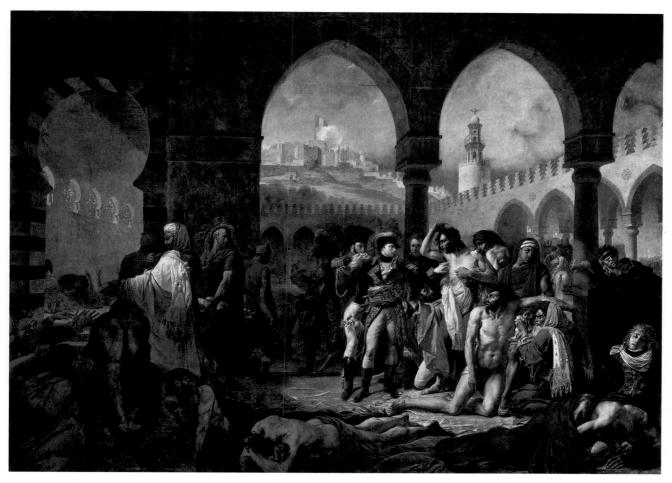

19–3 | Antoine-Jean Gros NAPOLEON IN THE PLAGUE HOUSE AT JAFFA 1804. Oil on canvas, $17'5'' \times 23'7''$ (5.32 \times 7.2 m). Musée du Louvre, Paris.

Empire). The format of the painting—a shallow stage and a series of arcades behind the main actors—is inspired by David's *Oath of the Horatii*. The overall effect is Romantic, however, not simply because of the dramatic lighting and the wealth of emotionally stimulating elements, both exotic and horrific, but also because the main action is meant to incite veneration rather than republican virtue. At the center of a small group of soldiers and a doctor, Napoleon calmly reaches toward the sores of one of the victims—the image of a Christ-like figure healing the sick with his touch is consciously intended to promote him as semidivine. Not surprisingly, Gros gives no hint of the event's cruel historical aftermath: Two months later, Napoleon ordered the remaining sick to be poisoned.

Jean-Auguste-Dominique Ingres (1780–1867) represents the Neoclassical wing of David's legacy, but Ingres significantly broadened both the sources and techniques of Neoclassicism. Inspired more by Raphael than by antique art, Ingres emulated the Renaissance artist's precise drawing, formal idealization, classical composition, and graceful lyricism, but interpreted them in a personal manner. Ingres won the

Prix de Rome and lived in Italy from 1806 to 1824, returning to serve as director of the French Academy in Rome from 1835 to 1841. As a teacher and theorist, Ingres became the most influential artist of his time.

Although Ingres, like David, fervently desired acceptance as a history painter, his paintings of literary subjects and contemporary history were less successful than his erotically charged portraits of women and female nudes, especially his numerous representations of the odalisque, a female slave or concubine in a sultan's harem. In LARGE ODALISQUE (FIG. 19-4), the cool gaze this odalisque levels at her master, while turning her naked body away from what we assume is his gaze, makes her simultaneously erotic and aloof. The cool blues of the couch and the curtain at the right heighten the effect of the woman's warm skin, while the tight angularity of the crumpled sheets accentuates the languid, sensual contours of her form. Although Ingres's commitment to fluid line and elegant postures was grounded in his Neoclassical training, he treated some Romantic themes, such as the odalisque, in an anticlassical fashion. Here the elongation of the woman's back (she seems to have several extra vertebrae), the widening of her hip, and her

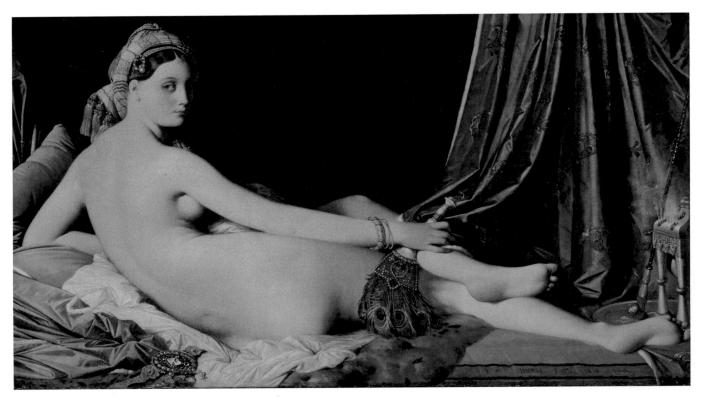

Jean-Auguste-Dominique Ingres LARGE ODALISQUE 1814. Oil on canvas, approx. $35 \times 64''$ (88.9 \times 162.5 m). Musée du Louvre, Paris.

During Napoleon's campaigns against the British in North Africa, the French discovered the exotic Near East. Upper-middleclass European men were particularly attracted to the institution of the harem, partly as a reaction against the egalitarian demands of women of their class that had been unleashed by the French Revolution.

tiny, boneless feet are anatomically incorrect but aesthetically compelling.

Although Ingres complained that making portraits was a "considerable waste of time," he was unparalleled in rendering a physical likeness and the material qualities of clothing, hairstyles, and jewelry. In addition to polished life-size oil portraits, Ingres produced—usually in just a day—small portrait drawings that are extraordinarily fresh and lively. The exquisite POR-TRAIT OF MADAME DESIRÉ RAOUL-ROCHETTE (FIG. 19-5) is a flattering yet credible interpretation of the relaxed and elegant sitter. With her gloved right hand Madame Raoul-Rochette has removed her left-hand glove, simultaneously drawing attention to her social status (gloves traditionally were worn by members of the European upper class, who did not work with their hands) and her marital status (on her left hand is a wedding band). Her shiny taffeta dress, with its fashionably high waist and puffed sleeves, is rendered with deft yet light strokes that suggest more than they describe. Greater emphasis is given to her refined face and elaborate coiffure, which Ingres has drawn precisely and modeled subtly through light and shade.

FRENCH ROMANTIC PAINTING. Romanticism, already anticipated in French painting during Napoleon's reign, flowered during the royal restoration that lasted from 1815 to 1830.

French Romantic painters took further the innovations of David's pupils as they based their art more on imagination and feeling than on Neoclassical reason. The French Romantics painted literary subjects as expressions of imagination, and current events as vehicles of feeling. They depicted these subjects using loose, fluid brushwork, strong colors, complex and off-balance compositions, powerful contrasts of light and dark, and expressive poses and gestures.

Théodore Géricault (1791-1824) was the leading innovator of early French Romanticism, though his career was cut short by early death. After a brief stay in Rome in 1816-17, where he discovered Michelangelo, Géricault returned to Paris determined to paint a great contemporary history painting. He chose for his subject the scandalous and sensational shipwreck of the Medusa (see "Raft of the 'Medusa,"" page 730). In 1816, the ship of French colonists headed for Senegal ran aground near its destination; its captain was an incompetent aristocrat appointed by the newly restored monarchy for political reasons. Because there were insufficient lifeboats, a raft was hastily built for 152 of the passengers and crew, while the captain and his officers took the seaworthy boats. Too heavy to pull to shore, the raft was set adrift. When it was found thirteen days later, only fifteen people remained alive, having survived their last several days on

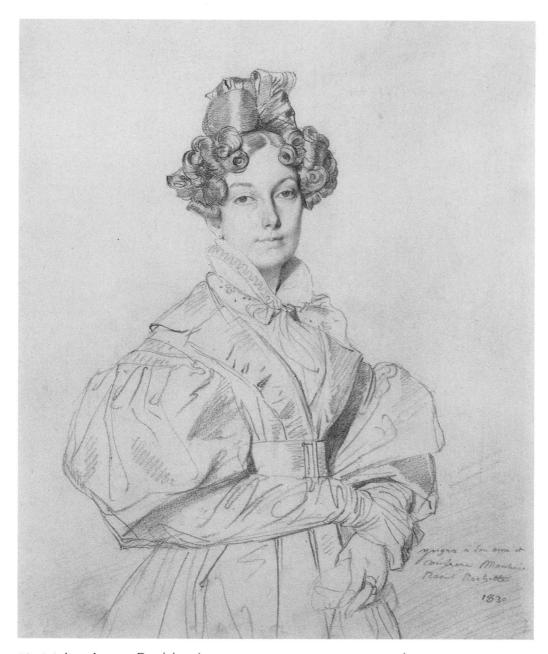

19–5 | Jean-Auguste-Dominique Ingres PORTRAIT OF MADAME DESIRÉ RAOUL-ROCHETTE 1830. Graphite on paper, $12\% \times 9\%''$ (32.2 \times 24.1 cm). The Cleveland Museum of Art, Cleveland, Ohio.

Purchase from the J. H. Wade Fund (1927.437)

Madame Raoul-Rochette (1790–1878), née Antoinette-Claude Houdon, was the youngest daughter of the famous Neoclassical sculptor Jean-Antoine Houdon (SEE FIG. 18–43). In 1810, at the age of 20, she married Desiré Raoul-Rochette, a noted archaeologist, who later became the secretary of the Academy of Fine Arts and a close friend of Ingres. Ingres's drawing of Madame Rochette is inscribed to her husband, whose portrait Ingres also drew around the same time.

human flesh. Géricault chose to depict the moment when the survivors first spot their rescue ship.

At the Salon of 1819 the painting caused a great deal of controversy. Most contemporary French critics interpreted the painting as political commentary, with liberals praising it for exposing a difficult issue and royalists condemning it as closer to sensational journalism than art. Such a large, multifigured composition might normally be expected to portray a mythological

or historic subject with a recognizable hero; this work, in contrast, showed a recent sensational event with no hero except the anonymous sufferers who desperately plead for rescue. Rather than offering a heroic narrative, the work engages the sympathy of anyone who has ever felt lost. Because the monarchy refused to buy the canvas, Géricault exhibited it commercially on a two-year tour of Ireland and England, where the London exhibition attracted more than 50,000 paying visitors.

THE OBJECT SPEAKS

RAFT OF THE "MEDUSA"

héodore Géricault's monumental Raft of the "Medusa" is a history painting that speaks powerfully through a composition in which the victims' largely nude, muscular bodies are organized on crossed diagonals. The diagonal that begins in the lower left and extends to the waving figures registers their rising hopes. The diagonal that begins with the dead man in the lower right and extends through the mast and billowing sail, however, directs our attention to a huge wave. The rescue of the men is not yet assured. They remain tensely suspended between salvation and death. Significantly, the "hopeful" diagonal in Géricault's painting terminates in the vigorous figure of a black man, a survivor named Jean Charles, and it may therefore carry political meaning. By placing him at the top of the pyramid of survivors and giving him the power to save his comrades by signaling to the rescue ship, Géricault suggests metaphorically that freedom for all of humanity will only occur when the most oppressed member of society is emancipated.

Géricault's work was the culmination of extensive study and experimentation. An early pen drawing depicts the survivors' hopeful response to the appearance of the rescue ship on the horizon at the extreme left. Their excitement is in contrast with the mournful scene of a man grieving over a dead youth on the right side of the raft. A later pen-andwash drawing reverses the composition, creates greater unity among the figures, and establishes the modeling of their bodies through light and shade. These developments look ahead to the final composition of the *Raft of the "Medusa,"* but the

study still lacks the figures of the black man at the apex of the painting and the dead bodies at the extreme left and lower right, which fill out the composition's base.

Géricault also made separate studies of many of the figures, as well as studies of actual corpses, severed heads, and dissected limbs supplied to him by friends who worked at a nearby hospital. For several months, according to Géricault's biographer. "his studio was a kind of morgue. He kept cadavers there until they were half-decomposed, and insisted on working in this charnel-house atmosphere. ..." However, Géricault did not use cadavers directly in the Raft of the "Medusa." To execute the final painting, he traced the outline of his composition onto a large canvas, then painted each body directly from a living model, gradually

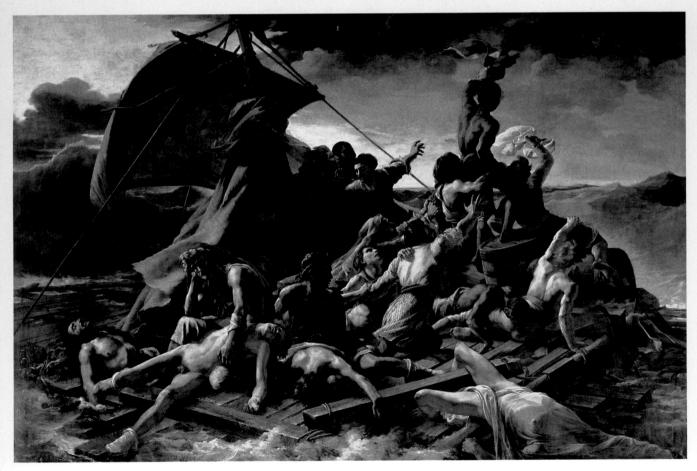

Théodore Géricault RAFT OF THE "MEDUSA" 1818–19. Oil on canvas, $16'1'' \times 23'6''$ (4.9×7.16 m). Musée du Louvre, Paris.

building up his composition figure by figure. He seems, rather, to have kept the corpses in his studio only to create an atmosphere of death that would provide him with a more authentic understanding of his subject.

Nevertheless, Géricault did not depict the actual physical condition of the survivors on the raft: exhausted, emaciated, sunburned, and close to death. Instead, following the dictates of the Grand Manner, he gave his men athletic bodies and vigorous poses, evoking the work of Michelangelo and Rubens (Chapters 15 and 17). He did this to generalize and ennoble his subject, elevating it above the particulars of a specific shipwreck so that it could speak to us of more fundamental conflicts: humanity against nature, hope against despair, life against death.

THE SIGHTING OF THE "ARGUS" (TOP) 1818.

Pen and ink on paper, $13\frac{1}{4} \times 16\frac{1}{8}$ " (34.9 \times 41 cm). Musée des Beaux-Arts, Lille.

THE SIGHTING OF THE "ARGUS" (MIDDLE) 1818.

Pen and ink, sepia wash on paper, $8\,\% \times 11\,\%''$ (20.6 \times 28.6 cm). Musée des Beaux-Arts, Rouen.

STUDY OF HANDS AND FEET (BOTTOM) 1818–19.

Oil on canvas, $20 \frac{1}{2} \times 25''$ (52 × 64 cm). Musée Fabre, Montpellier.

Technique

LITHOGRAPHY

ithography, invented in the mid-1790s, is based on the natural antagonism between oil and water. The artist draws on a flat surface—traditionally, fine-grained stone—with a greasy, crayonlike instrument. The stone's surface is wiped with water, then with an oil-based ink. The ink adheres to the greasy areas but not to the damp ones. A sheet of paper is laid face down on the inked stone, which is passed through a flatbed press. Holding a scraper, the lithographer applies light pressure from above as the stone and paper pass under the scraper, transferring ink from stone to paper, thus making lithography a direct method of creating a printed image. Francisco Goya, Théodore Géricault, Eugène Delacroix, Honoré Daumier, and Henri de Toulouse-Lautrec used the medium to great effect.

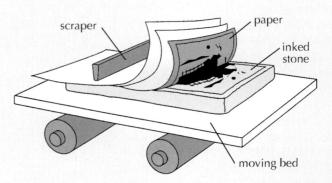

Diagram of lithographic press

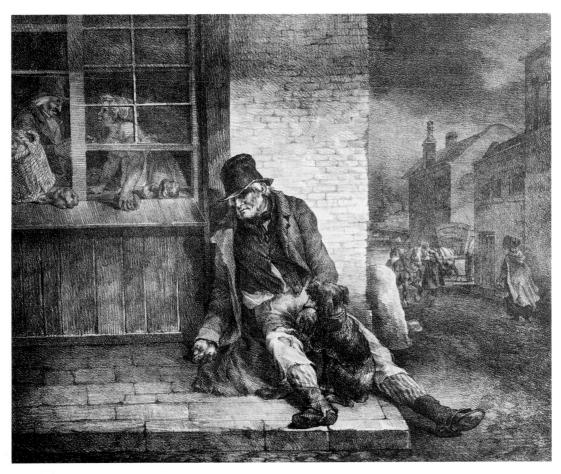

19–6 | Théodore Géricault PITY THE SORROWS OF A POOR OLD MAN 1821. Lithograph, $12.5 \times 14.8''$ (31.6×37.6 cm). Yale University Art Gallery, New Haven, Connecticut. Gift of Charles Y. Lazarus, B.A. 1936

One of the first artists to use the recently invented medium of lithography to create fine art prints, Géricault published his thirteen lithographs of *Various Subjects Drawn from Life and on Stone* in London in 1821. The title of *Pity the Sorrcws of a Poor Old Man* comes from a popular English nursery rhyme of the period that began: "Pity the sorrows of a poor old man whose trembling limbs have borne him to your door. . . ."

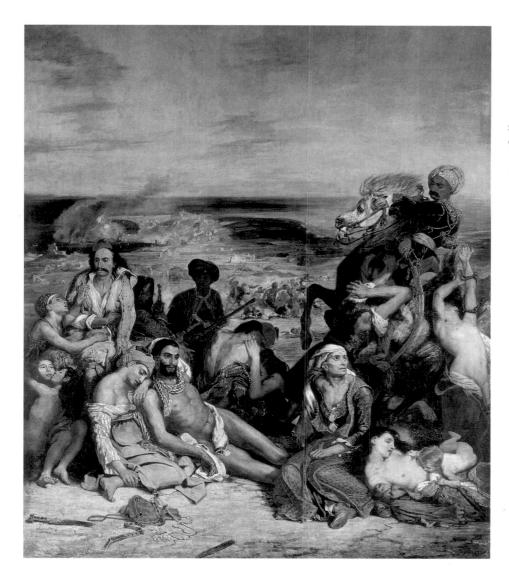

19-7 | Eugène Delacroix SCENES FROM THE MASSACRE AT CHIOS 1822-24. Oil on canvas, 13′ 10″ × 11′ 7″ (4.22 × 3.53 m). Musée du Louvre, Paris.

While in Britain, Géricault turned from Romantic history painting to the depiction of the urban poor in a series of lithographs (see "Lithography," facing page) entitled *Various Subjects Drawn from Life and on Stone*. PITY THE SORROWS OF A POOR OLD MAN (FIG. 19–6) depicts a haggard beggar, slumping against a wall and limply extending an open hand. Through the window above him, we see a baker who ignores the hungry man's plight and prepares to pass a loaf of bread to a paying customer. Although the subject's appeal to the emptions is Romantic, the print does not preach or sentimentalize. Viewers are invited to draw their own conclusions.

More insistent on the use of imagination was Eugène Delacroix (1798–1863), the most important Romantic after Géricault's early death. Stendhal (pen name of the French poet Henri Beyle) wrote, "Romanticism in all the arts is what represents the men of today and not the men of those remote, heroic times which probably never existed anyway." Delacroix fits the

description as well as any artist. Like Géricault, Delacroix depicted victims and antiheroes. One of his first paintings exhibited at a Salon was scenes from the massacre at CHIOS (FIG. 19-7), an event even more terrible than the shipwreck of the Medusa. In 1822, during the Greeks' struggle for independence from the Turks, the Turkish fleet stopped at the peaceful island of Chios and took revenge by killing about 20,000 of the 100,000 inhabitants and selling the rest into slavery in North Africa. Delacroix based his painting on journalistic reports, eyewitness accounts, and study of Greek and Turkish costumes. The painting is an image of savage violence and utter hopelessness—the entire foreground is given over to exhausted victims awaiting their fate—paradoxically made seductive through its opulent display of handsome bodies and colorful costumes. The Greek struggle for independence engaged the minds of many during that period, and it led the Romantic poet Lord Byron to enlist on the Greek side and give his life.

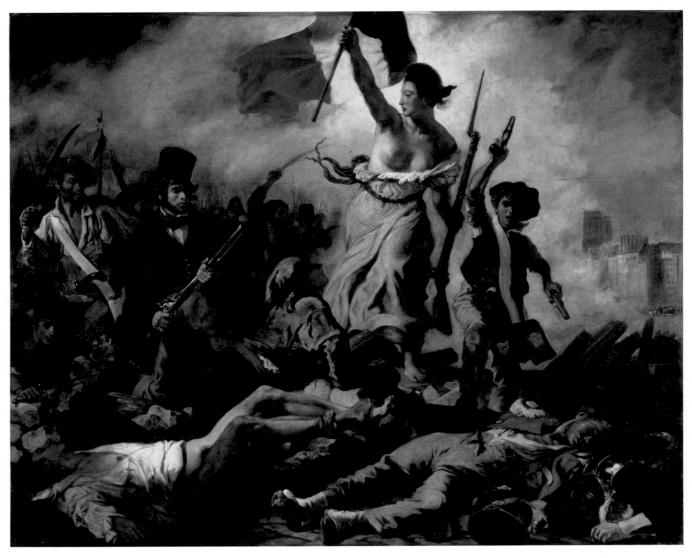

19–8 | Eugène Delacroix LIBERTY LEADING THE PEOPLE: JULY 28, 1830 1830. Oil on canvas, 8' $6\%'' \times 10'$ 8'' $(260 \times 325 \text{ cm})$. Musée du Louvre, Paris.

The work that brought Delacroix the most renown was LIBERTY LEADING THE PEOPLE: JULY 28, 1830 (FIG. 19-8), which summed up for many the destiny of France after the fall of Napoleon. When Napoleon was defeated in 1815, the victorious neighboring nations reimposed a monarchy on France under Louis XVIII, brother of the last pre-Revolutionary monarch. The king's power was limited by a constitution and a parliament, but the government became more conservative as years passed, and undid many of the Revolutionary reforms. Louis's successor Charles X reinstated press censorship, returned education to Catholic Church control, and limited voting rights. This led to a massive uprising over three days in July 1830 that overthrew the Bourbon monarchical line, replacing Charles with a more moderate king from the Orleanist line who promised to abide by a constitution. The term "July Monarchy" captures its initially mild-mannered character. Delacroix memorialized the revolt in this large painting a few months after it took place.

The work reports and departs from facts in ways that are typically Romantic. The Revolutionaries were indeed a motley crew of students, craft workers, day laborers, and even children and top-hatted lawyers. They stumble forward through the smoke of battle, crossing a barricade of refuse and dead bodies. This much of the work is plausibly accurate. Their leader, however, is the energetic flag-bearing allegorical figure of Liberty, personified by the muscular woman who carries the Revolutionary flag in one hand and a bayoneted rifle in the other. Delacroix took a classical allegorical figure and placed her, weapon and all, in the thick of battle. Like most Romantic paintings, the work is obviously not a mere transcription of an actual event. Rather, the artist applied his imagination to the story and created a work that, while not exactly faithful to fact, is indeed faithful to the emotional climate of the moment as the artist felt it. This was the essence of Romanticism.

Romantic Sculpture in France and Beyond

Romanticism gained general acceptance in France after the July Monarchy was established, bringing with it a new era of middle-class taste. This shift is most evident in sculpture, where a number of practitioners turned away from Neoclassical principles to more dramatic themes and approaches.

Early in the July Monarchy, the minister of the interior decided, as an act of national reconciliation, to complete the triumphal arch on the Champs-Elysées in Paris, which Napoleon had begun in 1806. François Rude (1784–1855) received the commission to decorate the main arcade to commemorate the volunteer army that had halted a Prussian invasion in 1792–93. Beneath the urgent exhortations of the winged figure of Liberty, the volunteers surge forward, some nude, some in classical armor (FIG. 19–9). Despite such Necclassical elements, the effect is Romantic. The crowded, excited grouping so stirred the patriotism of French spectators that it quickly became known as **THE MARSEILLAISE**, the name of the French national anthem written in the same year, 1792.

Marble sculpture remained closer to Neoclassical norms until after 1850, when Romanticism began to infect it. The American sculptor Edmonia Lewis (1845–c. 1911) was a leader in this tendency. Born in New York State to a Chippewa mother and an African American father and originally named Wildfire, Lewis was orphaned at the age of four and raised by her mother's family. As a teenager, with the help of abolitionists, she attended Oberlin College, the first college in the United States to grant degrees to women, then moved to Boston. Her highly successful busts and medallions of abolitionist leaders and Civil War heroes financed her move to Rome in 1867.

Galvanized by the struggle of newly freed slaves for equality, Lewis created **FOREVER FREE** (FIG. 19–10) as a memorial of the Emancipation Proclamation. The kneeling figure prays thankfully, while the standing man seems to dance on the ball that once bound his ankle as he raises the broken chain to the sky. In true Romantic fashion, Lewis's enthusiasm for the cause outran her financial abilities, so that she had to borrow money

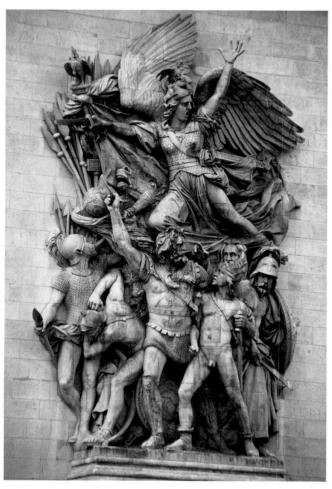

I9-9 François Rude DEPARTURE OF THE VOLUNTEERS
OF 1792 (THE MARSEILLAISE)

1833-36. Limestone, height approx. 42' (12.8 m). Arc de Triomphe, Place de l'Étoile, Paris.

19–10 | Edmonia Lewis **FOREVER FREE** 1867. Marble, $41\% \times 22 \times 17''$ (104.8 \times 55 \times 43.2 cm). Howard University Art Gallery, Washington, D.C.

to pay for the marble. Lewis sent this work back to Boston hoping that a subscription drive among abolitionists would redeem her loan. The effort was only partially successful, but her steady income from the sale of medallions eventually paid it off.

Romanticism in Spain: Goya

In the career of Francisco Goya y Lucientes (1746–1828), we see the birth of Romanticism in a single lifetime. In the 1770s and 1780s he was a court painter, making tapestry designs in a style based on the Rococo. The dawn of the French Revolution filled him with hope, as he belonged to an intellectual circle that was nourished by Enlightenment ideas. After the early years of the French Revolution, however, Spanish king Charles IV reinstituted the Inquisition, stopped most of the French-inspired reforms, and even halted the entry of French books into Spain. Goya responded to this new situation with Los Caprichos (The Caprices), a folio of eighty etchings produced between 1796 and 1798 whose overall theme is suggested by THE SLEEP OF REASON PRO-DUCES MONSTERS (FIG. 19–11). The print shows a slumbering personification of Reason, behind whom lurk the dark creatures of the night—owls, bats, and a cat—that are let loose when Reason sleeps. The rest of the Caprichos enumerate the specific follies of Spanish life that Goya and his circle considered monstrous. Goya hoped the series would show Spanish people the errors of their ways and reawaken reason. He even tried to sell the etchings, as Hogarth had done in England, but they only aroused controversy with his royal patrons. In order to deflect blame from himself, he made the metal plates an elaborate gift to the king. The disturbing quality of Goya's portrait of human folly suggests he was already beginning to feel the despair that would dominate his later work.

Goya's large portrait of the FAMILY OF CHARLES IV (FIG. 19–12) expresses some of the alienation that he felt. The work openly acknowledges the influence of Velázquez's earlier royal portrait Las Meninas (SEE FIG. 17-29) by placing the painter behind the easel on the left, just as Velázquez had. The artist somehow managed to make his patrons appear faintly ridiculous: The bloated and dazed king, chest full of medals, standing before another relative who appears to have seen a ghost; the double-chinned queen, who stares obliquely out (she was then having an open affair with the prime minister); her eldest daughter, to the left, stares into space next to another older relative who seems quizzically surprised by the attention. One French art critic described this frightened bunch as "The corner baker and his family after they have won the lottery." Yet the royal family seem to have been perfectly satisfied with Goya's realistic rather than flattering depiction of them. Indeed, if everyone was in fact posed in those positions, with the artist to one side, they must have all been admiring themselves in a huge mirror. As the authority of the Spanish aristocracy was crumbling, this complex rendition may have been the only possible type of royal portrait.

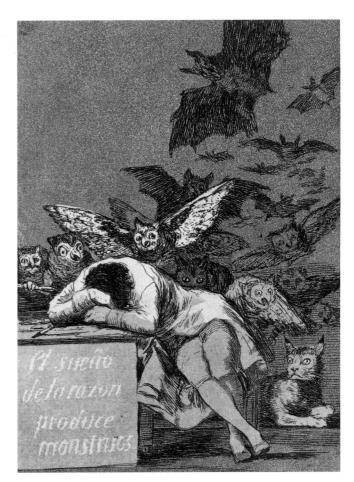

19–11 | Francisco Goya | THE SLEEP OF REASON PRODUCES MONSTERS,

No. 43 from Los Caprichos (The Caprices). 1796-98; published 1799. Etching and aquatint, $8 \frac{1}{2} \times 6^{\prime\prime}$ (21.6 \times 15.2 cm). Courtesy of the Hispanic Society of America, New York.

After printing about 300 sets of this series, Goya offered them for sale in 1799. He withdrew them from sale two days later without explanation. Historians believe that he was probably warned by the Church that if he did not he might have to appear before the Inquisition because of the unflattering portrayal of the Church in some of the etchings. In 1803 Goya donated the plates to the Royal Printing Office.

In 1808 Napoleon conquered Spain and placed on its throne his brother Joseph Bonaparte. Many Spanish citizens, including Goya, welcomed the French at first because of the reforms they inaugurated, including a new, more liberal constitution. On May 2, 1808, however, a rumor spread in Madrid that the French planned to kill the royal family. The populace rose up, and a day of bloody street fighting ensued, followed by mass arrests. Hundreds of Spanish people were herded into a convent, and a French firing squad executed these helpless prisoners in the predawn hours of May 3. Goya commemorated the event in a painting (FIG. 19-13) that, like Delacroix's Massacre at Chios (SEE FIG. 19-7), focuses on victims and antiheroes, the most prominent of which is a Christ-like figure in white. Everything about this work is Romantic: the sensational current event, the loose brushwork, the poses based on reality, the off-balance composition, the dramatic lighting. But

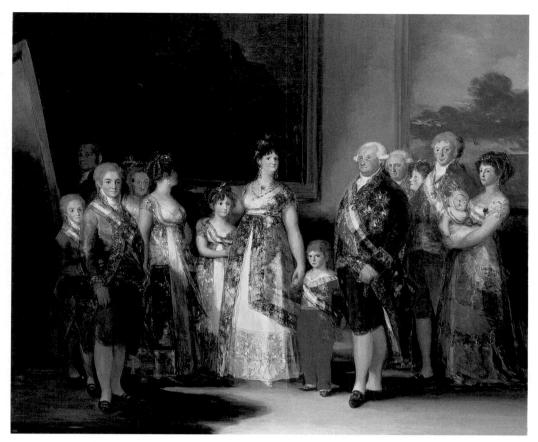

19–12 | Francisco Goya FAMILY OF CHARLES IV 1800. Oil on canvas, $9'12'' \times 11'$ (2.79 \times 3.36 m). Museo del Prado, Madrid.

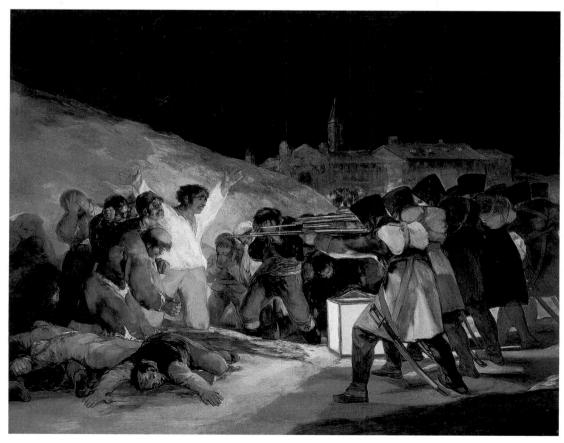

19–14 | Caspar David Friedrich NEBEL (FOG) 1807. Oil on canvas, $13\,\%\times20\,\%''$ (34.5 \times 52 cm). Neue Pinakothek, Munich.

Goya's work is less an indictment of the French than of the faceless and mechanical forces of war itself, blindly destroying defenseless humanity. When asked why he painted such a brutal scene, Goya responded: "To warn men never to do it again."

Soon after the Spanish monarchy was restored, Ferdinand VII (ruled 1808; 1814–33) abolished the new constitution and reinstated the Inquisition, which the French had banned. In 1815 Goya was himself called before the Inquisition for the alleged obscenity of an earlier painting of a female nude. Though found innocent, Goya gave up hope in human progress and retired to his home outside Madrid, where he vented his disillusionment in the series of nightmarish "black paintings" he did on its walls. He spent the last four years of his life in exile in France.

Romantic Landscape Painting

The Romantic vision of nature differed radically from that of the Enlightenment. Following the lead of Isaac Newton, most Enlightenment thinkers viewed nature as something orderly, predictable, and subject to laws that humans can discern by observation, and thus can control. It follows that the Enlightenment produced very few landscape artists. In contrast, most Romantics saw nature as ever-changing, unpredictable, more powerful than people, and even indifferent to them. Moreover, the many aspects of nature make an analog to the many types and moods of humans. Thus the Romantics found nature awesome, fascinating, or delightful; artists in many countries studied it in depth and put their feelings about it into works.

FRIEDRICH. The German Romantic painter Caspar David Friedrich (1774-1840) saw in nature a vehicle of intense personal feeling. He received early encouragement from poet Johann Wolfgang von Goethe to make landscape the principal subject of his art. In his early life Friedrich was also influenced by the writings and teachings of Gotthard Kosegarten, a Lutheran pastor and poet from his district who taught that we can see the divine in a personal experience of nature. If God's holy book was the Bible, just as important was God's "Book of Nature." Friedrich studied at the academies of Copenhagen and Dresden and settled in the latter city. Throughout his career, he not only sketched in nature, but also took long walks. Later, in the studio, he synthesized his sketches with his memories and feelings in order to create paintings such as **NEBEL (FOG)** (FIG. 19–14). Here we see a mysteriously quiet seacoast, where some passengers in a small

boat row out to a larger one. Fog has drawn a veil over most of the details of this landscape, but such facts matter much less to Friedrich than the overall mood, which is hushed and solemn. This place resembles none that we can visit, because the artist invented it based on his sketches and memories. He wrote, "Close your physical eyes in order that you may first see your painting with your spiritual eye. Then bring to the light of day what you have seen in the darkness so that it can affect others." We are left wondering about the possible reasons for this journey: Escape is one possibility; so is a more symbolic reading, such as death, or, in common parlance, passage to the other side.

TURNER. Friedrich's English contemporary Joseph Mallord William Turner (1775–1851) devoted much of his early work to the Romantic theme of nature as a cataclysmic force that overwhelms human beings and their creations. Turner entered the Royal Academy in 1789, was elected a full academician at the unusually young age of twenty-seven, and later became a professor in the Royal Academy school. During the 1790s, Turner helped revolutionize the British watercolor tradition by rejecting underpainting and topographic accuracy in favor of a freer application of paint and more generalized atmospheric effects. By the late 1790s, Turner was also exhibiting large-scale oil paintings of grand natural scenes and historical subjects.

Turner's **snowstorm**: **HANNIBAL AND HIS ARMY CROSS-ING THE ALPS** (FIG. 19–15) epitomizes the Romantic view of awesome nature, as an enormous vortex of wind, mist, and

Sequencing Events THE BEGINNINGS OF MODERN FRANCE	
1789	French Revolution begins
1792	Monarchy abolished, First Republic established
1804-1814	First Empire, rule of Napoleon I
1814–1830	Restoration of monarchy, reigns of Louis XVIII and Charles X
1830-1848	July Monarchy
1848-1852	Second Republic
1852-1870	Second Empire, reign of Napoleon III
1870	Third Republic established

snow threatens to annihilate the soldiers below it and even to obliterate the sun. Barely discernible in the distance is the figure of the Carthaginian general Hannibal, who, mounted on an elephant, led his troops through the Alps to defeat Roman armies in 218 BCE. Turner probably intended this painting as an allegory of the Napoleonic Wars—Napoleon himself had crossed the Alps, an event celebrated in Jacques-Louis David's Napoleon Crossing the Saint-Bernard (SEE FIG. 19–2). But while David's painting, which Turner saw in Paris in 1802, depicts Napoleon as a powerful figure who seems to command not only his troops but also nature itself, Turner reduced Hannibal to a speck on the horizon and showed his troops

19–15 | Joseph Mallord William Turner SNOWSTORM: HANNIBAL AND HIS ARMY CROSSING THE ALPS 1812. Oil on canvas, $4'9'' \times 7'9'' (1.46 \times 2.39 \text{ m})$. The Tate Gallery, London.

threatened by a cataclysmic storm, as if foretelling their eventual defeat. In 1814, just two years after the exhibition of Turner's painting, Napoleon suffered a decisive loss to his European opponents and met final defeat at Waterloo in 1815.

Closer to home both physically and temporally, Turner based another thrilling work on a tragic fire that severely damaged London's ancient Parliament building, an important national monument. Most of the complex was erected in the eleventh century and had witnessed some of the most dramatic events in English history, but the fire that broke out on October 16, 1834, completely destroyed the House of Lords and left the Commons unusable because its roof fell in. Contemporary accounts tell of flames lighting the night sky, and hundreds of spectators gathering in boats on the Thames and along the shore to witness the cataclysm. Turner himself hurriedly sketched watercolors at the scene and within a few months made a large painting, THE BURNING OF THE HOUSE OF LORDS AND COMMONS, 16TH OCTOBER 1834 (FIG. 19–16).

More faithful to feeling than to fact, the work accurately depicts the crowds and the bridge but greatly exaggerates the size of the fire. Turner's main interest was in capturing the feelings attending the loss of one of England's most historic structures, and in order to do this he resorted to some of the loosest and most painterly brushwork ever seen in Western art up to that time. In those years, the Parliament was in the midst of reforming its electoral districts in order to broaden its political base and equalize representation. The Reform Bill of 1832 was a landmark in this democratic quest, but Turner's painting points out that Mother Nature often has the last word, thwarting or hindering even our most noble aspirations.

Both this work and *Hannibal Crossing the Alps* partake of the sublime, an aesthetic category beloved of some Romantic artists. According to Edmund Burke, who defined it in a 1756 essay (see Chapter 18), when we witness something that instills fascination mixed with fear, or if we stand in the presence of something far larger than ourselves, we may have sublime feelings. Turner focused his vision on this aspect of nature.

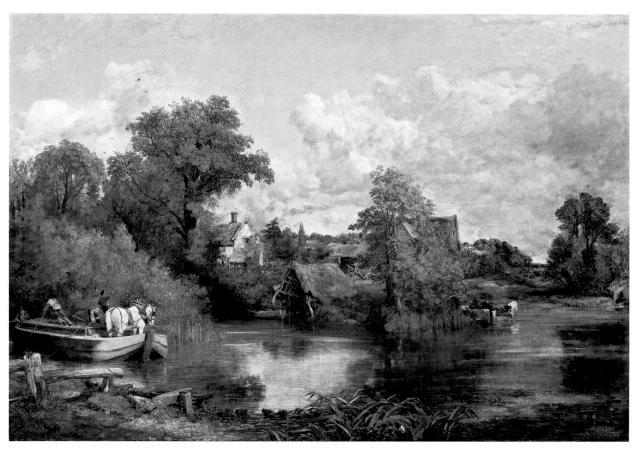

19–17 | John Constable THE WHITE HORSE 1819. Oil on canvas, $4'3 \frac{1}{4}'' \times 6'2\frac{1}{8}''$ (1.31 \times 1.88 m). The Frick Collection, New York.

CONSTABLE. If Turner's works epitomize the theatrical side of Romantic landscape painting, those of his compatriot John Constable (1776-1837) capture a calmer mood with unprecedented spontaneity and freshness. The son of a successful miller, Constable declared that the landscape of his youth in southern England had made him a painter even before he ever picked up a brush. Although he was trained at the Royal Academy, he was most influenced by the British topographic watercolor tradition of the late eighteenth century and by the example of seventeenth-century Dutch landscapists (SEE FIG. 17-62). After moving to London in 1816, he dedicated himself to painting monumental views of the agricultural landscape of his youth. So convinced was he that artists should study nature afresh that he opposed the establishment of the English National Gallery of Art in 1832; he thought it might unduly distract painters.

THE WHITE HORSE (FIG. 19–17), a typical work of Constable's maturity, depicts a fresh early summer day in the Stour River valley after the passing of a storm. Sunlight glistens off the water and foliage, an effect Constable achieved through tiny dabs of white paint. In the lower left, a farmer and his helpers ferry a workhorse across the river. Such elements were never invented by Constable, who among the Romantics stays closest to fact. His goal was rather to capture the time of day, the humidity in the air, and the smell of wet

earth. He once said that he wanted to paint the landscape as if no one had ever painted it before. In order to capture faithfully his initial sensation, he frequently used unmixed dabs of pure color on his canvases, a technique which later influenced artists on both sides of the English Channel.

THE BARBIZON SCHOOL AND DAUBIGNY. Constable's first critical success came not in England but at the Paris Salon of 1824, where one of his landscapes won a gold medal. His example inspired a group of French landscape painters that emerged in the 1830s and became known as the Barbizon School because a number of them lived in the rural town of Barbizon in the forest of Fontainebleau, near Paris. One of these artists was Charles-François Daubigny (1817-78), whose close observations of nature helped pave the way for Impressionism later in the century. Daubigny loved to travel up and down the River Seine, where he was among the first to make an entire painting outdoors, on the spot (FIG. 19-18). He even bought a boat and made it into a floating studio in order to facilitate his quest. THE BARGES has yet more of the spontaneous look that Constable treasured, and indeed Daubigny was criticized for not filtering his art enough through the imagination. Or, as one critic tellingly wrote in 1861, "He should not content himself with a mere impression" of a scene.

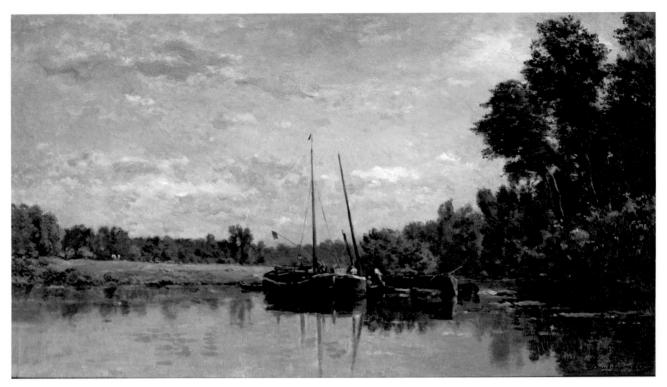

19–18 | Charles-François Daubigny LES PÉNICHES (THE BARGES) 1865. Oil on canvas, 15 \times 26" (38 \times 67 cm). Musée du Louvre, Paris. Legs Thomy Thiery, 1902. R.F. 1362

COLE. If we place Romantic landscape artists on a continuum, with those favoring imagination and feeling at one end (Friedrich and Turner) and partisans of down-to-earth sensation on the other (Constable and the Barbizon School), we

will find the middle ground occupied by American painters such as Thomas Cole (1801–48). He emigrated from England to the United States at seventeen and by 1820 was working as an itinerant portrait painter. On trips around New York, Cole

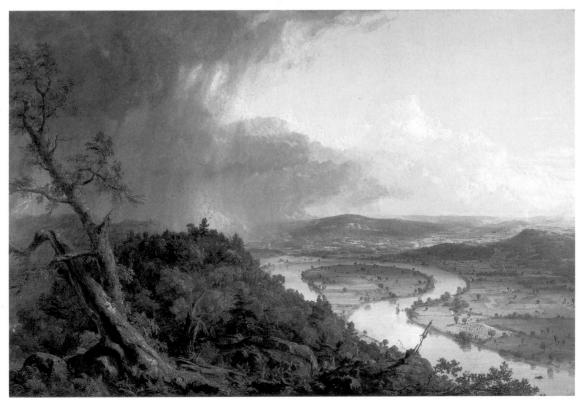

19–19 | Thomas Cole **THE OXBOW** 1836. Oil on canvas, $51\% \times 76''$ (1.31 \times 1.94 m). The Metropolitan Museum of Art, New York. Gift of Mrs. Russell Sage, 1908 (08.228).

sketched and painted the landscape, which quickly became his chief interest, and his paintings launched what became known as the Hudson River School. With the help of a patron, Cole traveled in Europe between 1829 and 1832. In the mid-1830s, Cole went on a sketching trip that resulted in THE OXBOW (FIG. 19-19), which he painted for exhibition at the National Academy of Design in New York. He believed that a too-close focus on factual accuracy was murderous to art, so he made paintings months after his sketches were complete, the better, he said, for memory to "draw a veil" over the scene. Cole considered The Oxbow one of his "view" paintings, which were usually small, although this one is monumental. The scale suits the dramatic view from the top of Mount Holyoke in western Massachusetts across a spectacular oxbow-shaped bend in the Connecticut River. To Cole, such ancient geological formations constituted America's "antiquities." The work's title tells us that it depicts an actual spot, but the artist orchestrated the scene in order to convey his interpretation of its grandeur. He exaggerated the steepness of the mountain, and set the scene below a dramatic sky. Along a great sweeping arc produced by the departing dark clouds and the edge of the mountain, Cole contrasts the two sides of the American landscape: its dense, stormy wilderness and its congenial, pastoral valleys. The fading storm suggests that the wild will eventually give way to the civilized.

Orientalism

European art patrons during the Romantic period not only wanted landscapes depicting areas that they knew; part of the Romantic urge is to stimulate the imagination through escape to new places, the more exotic the better. Some artists traveled the world in order to fill this need. This Romantic fascination with foreign cultures dates as far back as Napoleon's 1798 invasion of Egypt, which had the goal not only of conquest but also of study of that culture. After Napoleon's fall, the Restoration government continued to send study missions to Egypt and the Mideast, and published between 1809 and 1822 the twenty-four volume Description de l'Egypte, which recorded copious information about the people, lands, and culture of that area. Artists soon began painting subjects set in those foreign lands, whether they had been there or not. Gros, for example, never went to Jaffa but still he painted Napoleon in the Plague House (SEE FIG. 19-3). Ingres likewise never ventured farther away than Italy but scored a great success with his Large Odalisque (SEE FIG. 19–4), a portrait of a harem girl. The vogue for Oriental subjects, as they were called, engaged artists of both Romantic and Neoclassical persuasions.

ROBERTS. One of the first professional European artists to actually travel to the Mideast was the Scottish landscape painter David Roberts (1796–1864), whose background is notable for a lack of academic training. Rather, he learned

Sequencing Works of Art	
1830	Delacroix, Liberty Leading the People: July 28, 1830
1834	Turner, The Burning of the House of Lords and Commons, 16th October 1834
1836	Cole, The Oxbow
1836–60	Barry and Pugin, Houses of Parliament, London
1837	Daguerre, The Artist's Studio.

painting as an apprentice theater set designer. His wanderlust was probably awakened by an early assignment to paint sets for Mozart's comic opera set in Turkey, *The Abduction from the Seraglio*, in 1827. Roberts went to Spain and Morocco in 1832–33, returning to exhibit paintings, watercolors, and lithographs of the scenes he witnessed. (Eugène Delacroix also went to Morocco at the same time, though not in Roberts's company.) Emboldened by the success of that first trip, Roberts then set off for the Holy Land in 1838, and on his return he created a series of works, among them **GATEWAY TO THE GREAT TEMPLE AT BAALBEK** (FIG. 19–20).

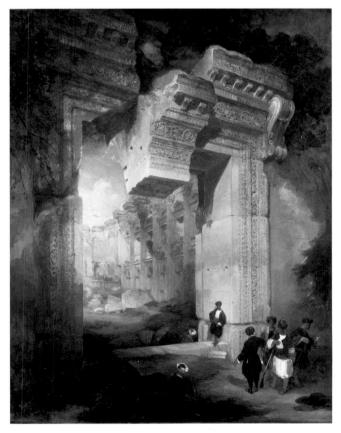

19–20 \bot David Roberts GATEWAY TO THE GREAT TEMPLE AT BAALBEK 1841. Oil on canvas, 75×62 cm. Royal Academy of Arts, London.

This painting shows both the pleasures and pitfalls of the Orientalist movement. Views of ancient ruins fed the fashion for the picturesque in European viewers, and Roberts focused on those aspects of life in the lands he visited. Here we see a ruined Roman temple doorway in Lebanon, its keystone perched precariously. Later photographs document this curious feature of this most impressive building, which was later restored. Like most Orientalists, however, Roberts painted only "exotic" people in his works, not the Western members of his party. When this painting was turned into a lithograph for sale as part of a set, it was inscribed as follows: "These beautiful structures carry with them regret that such proud relics of genius should be in the hands of a people incapable of appreciating their merits and consequently heedless of their complete destruction."

GÉRÔME. The example of Roberts suggests that Orientalist paintings give us a selective view of the lands the artists visited, calculated to pique curiosity while allowing Western viewers to remain convinced of their cultural superiority, if indeed they felt it. Most Orientalists depicted either the spectacular sights or the carefully selected everyday scenes of the Mideast. The most prolific Orientalist in the latter category was Jean-León Gérôme (1824–1904). Gérôme went to Constantinople in 1853, the first of many trips to Asia Minor and Egypt. CAFE HOUSE, CAIRO (FIG. 19–21) shows the results of the artist's classical training under an academic master: The figures are tightly rendered, the poses believable, their scaling in space perfectly appropriate. Many Orientalist paintings tended to show Middle Eastern people as sultry and sexual (as in the Odalisque of Ingres) or prone to violence. This

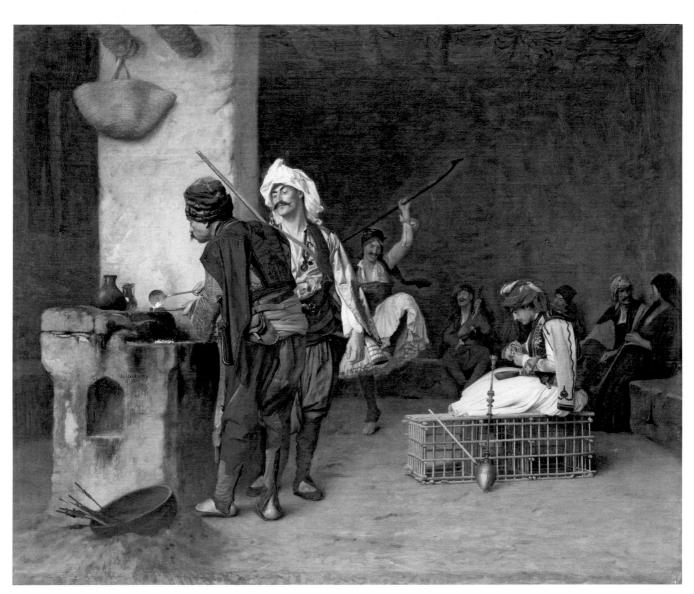

19–22 Benjamin Henry Latrobe
U.S. CAPITOL
Washington, D.C. c. 1808. Engraving by
T. Sutherland, 1825. New York Public
Library. I. N. Phelps Stokes Collection, Myriam and
Ira Wallach Division of Art, Prints, and Photographs

work shows a group of mercenaries in a coffee house using the heat of the fireplace to melt metal for bullets. Orientalist subjects remained attractive to artists and patrons through most of the nineteenth century, as European nations colonized the Mideast and other parts of the world. In addition to his Orientalist scenes, Gérôme was an accomplished painter of Neoclassical subjects. He remained active until the end of the century.

Revival Styles in Architecture Before 1850

Both Neoclassicism and Romanticism motivated architects in the early nineteenth century, and many architects worked in either mode, depending on the task at hand. Necclassicism, which evoked both Greek democracy and Roman republicanism, became the favored style for government buildings in the United States. In Europe, many different kinds of public institutions, including art museums, were built in the Neoclassical style.

NEOCLASSICAL STYLE. The most significant and symbolic Neoclassical edifice in Washington, D.C. was the U.S. Capitol, initially designed in 1792 by William Thornton (1759-1828), an amateur architect. His monumental plan featured a large dome over a temple front flanked by two wings to accommodate the House of Representatives and the Senate. In 1803, President Thomas Jefferson, also an amateur architect, hired a British-trained professional, Benjamin Henry Latrobe (1764–1820), to oversee the actual construction of the Capitol. Latrobe modified Thornton's design by adding a grand staircase and Corinthian colonnade on the east front (FIG. 19-22). After the British gutted the building in the War of 1812, Latrobe repaired the wings and designed a higher dome. Seeking new symbolic forms for the nation within the traditional classical vocabulary, Latrobe also created for the interior a variation on the Corinthian order by substituting indigenous plants—corn (FIG. 19-23) and tobacco-for the Corinthian order's acanthus leaves

19–23 | Giuseppe Franzoni CORNCOB CAPITAL Sculpted for the U.S. Capitol. 1809.

19–24 | Karl Friedrich Schinkel ALTES MUSEUM Berlin. 1822–30.

19–25 | Charles Barry and Augustus Welby Northmore Pugin HOUSES OF PARLIAMENT London, England. 1836–60. Royal Commission on the Historical Monuments of England, London.

Pugin published two influential books in 1836 and 1841, in which he argued that the Gothic style of Westminster Abbey was the embodiment of true English genius. In his view, the Greek and Roman classical orders were stone replications of earlier wooden forms and therefore fell short of the true principles of stone construction.

(see Introduction, Fig. 3). Latrobe resigned in 1817, and the reconstruction was completed under Charles Bulfinch (1763–1844). A major renovation begun in 1850 brought the building closer to its present form.

Many European capitals in the early nineteenth century erected museums in the Neoclassical style—which, being derived chiefly from Greek and Roman religious architecture, positioned the new buildings as temples of culture. The most influential of these was the **ALTES** ("Old") **MUSEUM** in Berlin, designed in 1822 by Karl Friedrich Schinkel (1781–1841) and built between 1824 and 1830 (FIG. 19–24). Commissioned to

display the royal art collection, the Altes Museum was built on an island in the Spree River in the heart of the capital, directly across from the Baroque royal palace. The museum's imposing façade consists of a screen of eighteen Ionic columns, raised on a platform with a central staircase. Attentive to the problem of lighting artworks on both the ground and the upper floors, Schinkel created interior courtyards on either side of a central rotunda, tall windows on the museum's outer walls to provide natural illumination, and partition walls perpendicular to the windows to eliminate glare on the varnished surfaces of the paintings on display.

19–26 ↑ Richard Upjohn **TRINITY CHURCH** New York City. 1839–46.

GOTHIC PRIDE. Schinkel also created numerous Gothic architectural designs, which many Germans considered an expression of national genius. Meanwhile, the British claimed the Gothic as part of *their* patrimony and erected a plethora of Gothic revival buildings in the nineteenth century, the most famous being the HOUSES OF PARLIAMENT (FIG. 19–25). After Parliament's Westminster Palace burned in 1834 in the fire so memorably painted by Turner, the government opened a competition for a new building designed in the English Perpendicular Gothic style, to be consistent with the neighboring Westminster Abbey, the thirteenth-century church where English monarchs are crowned.

Charles Barry (1795–1860) and Augustus Welby Northmore Pugin (1812–52) won the commission. Barry was responsible for the basic plan, whose symmetry suggests the balance of powers of the British system; Pugin provided the intricate Gothic decoration laid over Barry's essentially classical plan. The leading advocate of Gothic architecture in his era, Pugin in 1836 published *Contrasts*, which unfavorably compared the troubled modern era of materialism and mechanization with the Middle Ages, which he represented as an idyllic epoch of deep spirituality and satisfying handcraft. For Pugin, Gothic was not a style but a principle, like classicism. The Gothic, he insisted, embodied two "great rules" of architecture: "first that there should be no features about a build-

ing which are not necessary for convenience, construction or propriety; second, that all ornament should consist of enrichment of the essential structure of the building."

In nineteenth-century Europe and the United States, many architects used the Gothic style because of its religious associations, especially for Roman Catholic, Anglican, and Episcopalian churches. The British-born American architect Richard Upjohn (1802–78) designed many of the most important Gothic revival churches in the United States, including **TRINITY CHURCH** in New York (FIG. 19–26). With its tall spire, long nave, and squared-off chancel, Trinity quotes the early fourteenth-century British Gothic style particularly dear to Anglicans and Episcopalians. Every detail is historically accurate, although the vaults are of plaster, not masonry. The stained-glass windows above the altar were among the earliest in the United States.

ART IN THE SECOND HALF OF THE NINETEENTH CENTURY

The second half of the nineteenth century has been called the positivist age, an age of faith in the positive consequences of close observation of the natural and human realms. The term positivism was used by the French philosopher Auguste Comte (1798-1857) during the 1830s to describe what he saw as the final stage in the development of philosophy, in which all knowledge would derive from the objectivity of science and scientific methods. Just as scientists had determined through observation the laws of motion and gravity, so might social scientists—Comte invented this term—deduce the laws underlying human culture. Metaphysical and theological speculation were practically useless in this new era, he wrote in The Nature and Importance of Positive Philosophy. "The mind has given up the vain search after Absolute notions, the origin and destination of the universe, and the causes of phenomena, and applies itself to the study of their laws. . . . Reason and observation, duly combined are the means of this knowledge." In the second half of the century, the term positivism came to be applied widely to any expression of the new emphasis on objectivity.

In the visual arts, the positivist spirit is most obvious in the decline of Romanticism in favor of the accurate and apparently objective description of the ordinary, observable world. Positivist thinking is evident in the new movement of Realism in painting, and in many other artistic developments of the period after 1850—from the development of photography, capable of recording nature with unprecedented accuracy, to the highly descriptive style of academic art, to Impressionism's almost scientific emphasis on the optical properties of light and color. In architecture, the application of new technologies also led at the century's end to the abandonment of historical styles and ornamentation in favor of a more direct or "realistic" expression of structure and materials.

Early Photography in Europe

A prime expression of the new, positivist interest in descriptive accuracy spurred by Comte's philosophy was the development of photography. Photography as we know it emerged around 1840, but since the late Renaissance, artists and others had been seeking a mechanical method for exactly recording or rendering a scene. One early device was the camera obscura (Latin, meaning "dark chamber"), which consists of a darkened room or box with a lens through which light passes, projecting onto the opposite wall or box side an upside-down image of the scene, which an artist can trace. By the seventeenth century a small, portable camera obscura, or camera, had become standard equipment for many landscape painters. Photography developed essentially as a way to fix—that is, to make permanent—the images produced by a camera obscura on light-sensitive material.

19–27 | Louis-Jacques-Mandé Daguerre THE ARTIST'S STUDIO 1837. Daguerreotype, $6\frac{1}{2} \times 8\frac{1}{2}$ " (16.5 \times 21.6 cm). Société Française de Photographie, Paris.

STILL LIFE AND ALLEGORY. The first person to "fix" a photographic image was the painter Louis-Jacques-Mandé Daguerre (1787–1851), who guarded his patents so jealously that the earliest photographs are still called daguerreotypes. Using the most advanced lenses to project a scene onto a treated metal plate for twenty to thirty minutes yielded what seemed a perfect reproduction of the visible world. Daguerre's photograph of his studio tabletop (FIG. 19–27) retains the conventions of the still life that Daguerre practiced in his own painting, but the camera accurately captured the look of the drawing, the plaster cast, the curtain, and the wicker-covered bottle. Improvements in photography over the next twenty years gave better lenses, smaller cameras, and shorter exposure times, so that by the mid-nineteenth century portrait photography was widely practiced in many cities.

The acceptance of photography as an art form alongside painting or sculpture took much longer, however. Among the first photographers to argue for its artistic legitimacy was Oscar Rejlander (1813-75) of Sweden, who had studied painting in Rome before settling in England. He first took up photography in the early 1850s as an aid for painting but was soon attempting to create photographic equivalents of the painted and engraved moral allegories so popular in Britain since the time of Hogarth (SEE FIG. 18-26). In 1857 he produced his most famous work, THE TWO PATHS OF LIFE (FIG. 19-28), by combining thirty negatives. This allegory of Good and Evil, work and idleness, was loosely based on Raphael's School of Athens (SEE FIG. 15-6). At the center, an old sage ushers two young men into life. The serene youth on the right turns toward personifications of Religion, Charity, Industry, and other virtues, while his counterpart eagerly responds to the enticements of pleasure. The figures on the left Rejlander described as personifications of "Gambling, Wine, Licentiousness and other Vices, ending in Suicide, Insanity, and Death." In the lower center, with a drapery over her head, is the hopeful figure of "Repentance." Although Queen Victoria

19–28 | Oscar Rejlander THE TWO PATHS OF LIFE 1857. Combination albumen print, 16 × 31" (41 × 79.5 cm). George Eastman House, Rochester, New York.

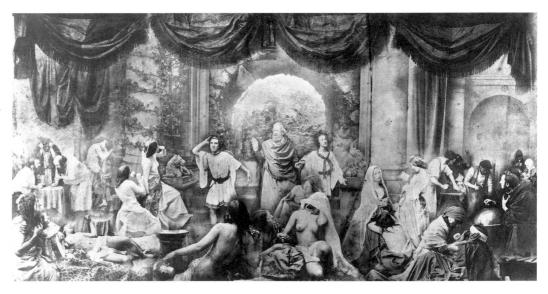

19–29 | Julia Margaret Cameron PORTRAIT OF THOMAS CARLYLE

1867. Silver print, $10 \times 8''$ (25.4 \times 20.3 cm). The Royal Photographic Society, Collection at National Museum of Photography, Film, and Television, England.

purchased a copy of *The Two Paths of Life* for her husband, it was not generally well received as art. One typical response was that "mechanical contrivances" could not produce works of "high art," a persistent criticism of photography.

PORTRAITURE. The most creative early portrait photographer was Julia Margaret Cameron (1815-79), who received her first camera as a gift from her daughters when she was forty-nine. Cameron's principal subjects were the great men and women of British arts, letters, and sciences, many of whom had long been family friends. Cameron's work was more personal and less dependent on existing forms than Rejlander's. Like many of Cameron's portraits, that of the famous British historian Thomas Carlyle is deliberately slightly out of focus (FIG. 19-29). Cameron was consciously rejecting the sharp stylistic precision of popular portrait photography, which she felt accentuated the merely physical attributes and neglected a subject's inner character. By blurring the details she sought to call attention to the light that suffused her subjects—a metaphor for creative genius—and to their thoughtful, often inspired expressions. In her autobiography Cameron said: "When I have had such men before my camera my whole soul has endeavored to do its duty towards them in recording faithfully the greatness of the inner as well as the features of the outer man."

The Frenchman Gaspard-Félix Tournachon, known as Nadar (1820–1910), applied photography to an even more ambitious goal, initially adopting the medium in 1849 as an aid in realizing the "Panthéon-Nadar," a series of lithographs

intended to include the faces of all the well-known Parisians of the day. Nadar quickly saw both the documentary and the commercial potential of the photograph, and in 1853 opened a portrait studio that became a meeting place for many of the great intellectuals and artists of the period. The first exhibition of Impressionist art was held there in 1874.

A realist in the tradition inaugurated by Daguerre, Nadar embraced photography because of its ability to capture people and their surroundings exactly: He took the first aerial photographs of Paris (from a hot-air balloon equipped with a darkroom), photographed the city's catacombs and sewers, produced a series on typical Parisians, and attempted to record all the leading figures of French culture. As we see in his portrait of the poet Charles Baudelaire (FIG. 19–30), Nadar avoided props and formal poses in favor of informal

19–30 Nadar (Gaspard-Félix Tournachon)
PORTRAIT OF CHARLES BAUDELAIRE
1863. Silver print. Caisse Nationale des Monuments Historiques et des Sites, Paris.

The year this photograph was taken, Baudelaire published "The Painter of Modern Life," a newspaper article in which he called on artists to provide an accurate and insightful portrait of the times. The idea may have come from Nadar, who had been trying to do just that for some time. Although Baudelaire never wrote about the photographic work of his friend Nadar, he was highly critical of the vogue for photography and of its influence on the visual arts. In his Salon review of 1859 he said: "The exclusive taste for the True... oppresses and stifles the taste of the Beautiful.... In matters of painting and sculpture, the present-day *Credo* of the sophisticated is this: 'I believe in Nature.... I believe that Art is, and cannot be other than, the exact reproduction of Nature....' A vengeful God has given ear to the prayers of this multitude. Daguerre is his Messiah."

19–31 | Joseph Paxton CRYSTAL PALACE London. 1850–51. Iron, glass, and wood.

ones determined by the sitters themselves. His goal was not so much an interpretation as a factual record of a sitter's characteristic appearance and demeanor.

New Materials and Technology in Architecture at Midcentury

The positivist faith in technological progress as the key to human progress spawned world's fairs that celebrated advances in industry and technology. The first of these fairs, the London Great Exhibition of 1851, introduced new building techniques that would eventually lead to the development of Modern architecture.

The revolutionary construction of the CRYSTAL PALACE (FIG. 19-31), created for the London Great Exhibition by Joseph Paxton (1803-65), featured a structural skeleton of cast iron that held iron-framed glass panes measuring 49 by 30 inches, the largest size that could then be mass-produced. Prefabricated wooden ribs and bars supported the panes. The triple-tiered edifice was the largest space ever enclosed up to that time—1,851 feet long, covering more than 18 acres, and providing for almost a million square feet of exhibition space. The central vaulted transept—based on the new cast-iron railway stations—rose 108 feet to accommodate a row of elms dear to Prince Albert, the husband of Queen Victoria. Although everyone agreed that the Crystal Palace was a technological marvel, most architects and critics, still wedded to Neoclassicism and Romanticism, considered it a work of engineering rather than legitimate architecture because it

made no clear allusion to any past style. Some observers, however, were more forward-looking. One visitor called it a revolution in architecture from which a new style would emerge.

We see a less reverent attitude toward technological progress in the first attempt to incorporate structural iron into architecture proper: the **BIBLIOTHÈQUE SAINTE-GENEVIÈVE** (FIG. 19–32), a library in Paris designed by Henri Labrouste (1801–75). Conventionally trained at the École des Beaux-Arts and employed as one of its professors, Labrouste was something of a radical in his desire to reconcile the École's conservative design principles with the technological innovations of industrial engineers. Although reluctant to promote this goal in his teaching, he clearly pursued it in his practice.

Because of the Bibliothèque Sainte-Geneviève's educational function, Labrouste wanted the building to suggest the course of both learning and technology. The window arches on the exterior have panels with the names of 810 important contributors to Western thought from its religious origins to the positivist present, arranged chronologically from Moses to the Swedish chemist Jöns Jakob Berzelius. The exterior's stripped-down Renaissance style reflects the belief that the modern era of learning dates from that period. The move from outside to inside subtly outlines the general evolution of architectural techniques. The exterior of the library features the most ancient of permanent building materials, cut stone, which was considered the only construction material "noble" enough for a serious building. The columns in the entrance

19-32 | Henri Labrouste READING ROOM, BIBLIOTHÈQUE SAINTE-GENEVIÈVE Paris. 1843-50.

hall are solid masonry with cast-iron decorative elements. In the main reading room, however, cast iron plays an undisguised structural role. Slender iron columns—cast to resemble the most ornamental Roman order, the Corinthian—support two parallel barrel vaults. The columns stand on tall concrete pedestals, a reminder that modern construction technology rests on the accomplishments of the Romans, who perfected the use of concrete. The design of the delicate floral cast-iron ribs in the vaults is borrowed from the Renaissance architectural vocabulary.

French Academic Art and Architecture

The Académie des Beaux-Arts and its official art school, the École des Beaux-Arts, exerted a powerful influence over the visual arts in France throughout the nineteenth century. Academic artists controlled the Salon juries, and major public commissions routinely went to academic architects, painters, and sculptors.

GARNIER: THE OPÉRA. Unlike Labrouste in the Bibliothèque Sainte-Geneviève, most later nineteenth-century architects trained at the École des Beaux-Arts worked in a style known as historicism, an elaboration on earlier Noclassical and Romantic revivals. Historicists were expected to be aware of the whole sweep of architectural history. They often combined historical allusions to different periods in a single building. They typically used iron only as an internal support for conventional materials, as in the case of the OPÉRA, the Paris opera house (FIG. 19-33) designed by Charles Garnier (1825-98). The Opéra was a focal point of a thorough urban redevelopment plan begun under Naroleon III by Georges-Eugène Haussmann (1809-91) in the 1850s. After riots in 1848 devastated some of the city's central neighborhoods, the city leaders engaged Haussnann to rebuild the city and redraw the street map. Haussmann's project swept away the narrow, winding, medieval stræts with their historic buildings, replacing them with new buildings

19-33 | Charles Garnier THE OPÉRA Paris. 1861-74.

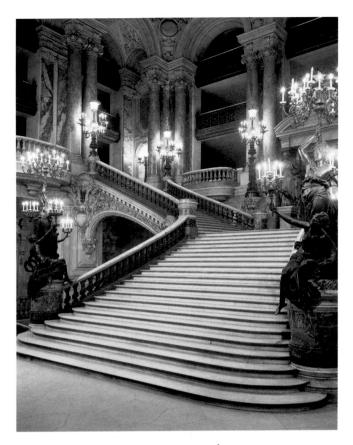

19-34 GRAND STAIRCASE, THE OPÉRA

The bronze figures holding the lights on the staircase are by Marcello, the pseudonym used by Adèle d'Affry (1836-79), the duchess Castiglione Colonna, as a precaution against the male chauvinism of the contemporary art world.

along wide, straight, tree-lined avenues that were more propitious for horse-drawn carriages, for strollers, and for suppressing future riots.

Set in one of these new intersections and carefully hiding its cast-iron frame, Garnier's design is a masterpiece of historicism based mostly on the Baroque style, here revived in order to recall that earlier period of France's greatness. The massive façade, featuring a row of paired columns above an arcade, is essentially a heavily ornamented, Baroque version of the seventeenth-century wing of the Louvre, an association meant to suggest the continuity of the French nation and to flatter Emperor Napoleon III by comparing him favorably with King Louis XIV. The luxuriant treatment of form, in conjunction with the building's primary function as a place of entertainment, was intended to celebrate the devotion to wealth and pleasure that characterized the period. The ornate architectural style was also appropriate for the home of that most flamboyant musical form, the opera.

The inside of what some critics called the "temple of pleasure" (FIG. 19–34) was even more opulent, with neo-Baroque sculptural groupings; heavy, gilded decoration; and a lavish mix of expensive, polychromed materials. The highlight of the interior was not the spectacle onstage so much as the

one on the great, sweeping Baroque staircase, where various members of the Paris elite—from old nobility to newly wealthy industrialists—could display themselves, the men in tailcoats accompanying women in bustles and long trains. As Garnier himself said, the purpose of the Opéra was to fulfill the most basic of human desires: to hear, to see, and to be seen.

CARPEAUX. Jean-Baptiste Carpeaux (1827–75), who had studied at the École des Beaux-Arts under the Romantic sculptor François Rude (SEE FIG. 19–9), was commissioned to carve one of the large sculptural groups for the façade of Garnier's Opéra (illustrated here in a plaster version). In this work, **THE DANCE** (FIG. 19–35), a winged personification of Dance, a slender male carrying a tambourine, leaps up joyfully in the midst of a compact, entwined group of mostly nude female dancers, embodying the theme of uninhibited Dionysian revelry. The erotic implication of this wild dance is revealed by the presence in the background of a satyr, a mythological creature known for its lascivious appetites.

Carpeaux's group upset many Parisians because he had not smoothed and generalized the bodies as Neoclassical

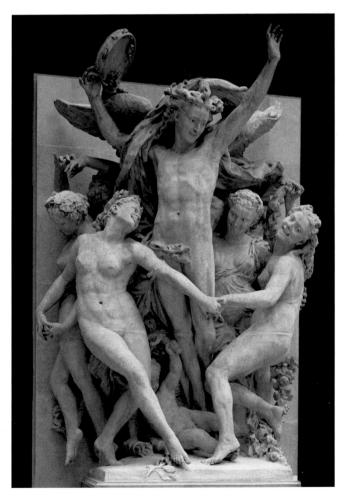

19–35 | Jean-Baptiste Carpeaux THE DANCE 1867–68. Plaster, height approx. 15′ (4.6 m). Musée de l'Opéra, Paris.

sculptors such as Canova had done (SEE FIG. 18–17). Although the figures are idealized, their detailed musculature and bone structure (observe the knees and elbows, for example) make them appear to belong more to the real world than to the ideal one. Carpeaux's handling of the body and its parts has therefore been labeled realistic.

Carpeaux's unwillingness to idealize physical details was symptomatic of an important shift in French academic art in the second half of the nineteenth century. Although the influence of photography on the taste of the period has sometimes been cited as the probable cause of this change, both photography and the new exactitude in academic art were simply manifestations of the increasingly positivist values of the era. These values were particularly evident among the bankers and businesspeople who came to dominate French society and politics in the years after 1830. As patrons, these practical leaders of commerce were generally less interested in art that idealized than in art that brought the ideal down to earth.

CABANEL. We see the effect of this new taste on painters in **THE BIRTH OF VENUS** by Alexandre Cabanel (1823–89), one of the leading academic artists (FIG. 19–36). He won the Prix de Rome in 1845 after studying with an academic master, and won top honors at the Salon three times in the 1860s and

1870s. The mythological subject of this work is venerable in Western art and engaged many artists as far back as Raphael. Cabanel depicted Venus borne along on the waves, accompanied by a group of putti, some of whom blow on conch shells. His ultra-skillful painting style is based on Neoclassical techniques and shows Cabanel's mastery of anatomy, flesh tones, and the surface of the sea. The image has a strong erotic charge, though, in the arched back and hooded eyelids of Venus. Thus is the goddess of love rendered as earthy as a pinup picture. This combination of mythological pedigree and physical appeal proved irresistible to Napoleon III, who bought The Birth of Venus for his private collection. Alert readers will notice that our illustration of this work is credited to more than one artist. This anomaly is explained in "How to Be a Famous Artist in the Nineteenth Century" (page 754), which explores some ways in which successful artists bolstered their careers during that period.

Realism

The European national academies retained official control over both the teaching and the display of art in the second half of the nineteenth century. The academicians that populated the Salon juries in those years rewarded artists who painted in an acceptable style that showed the proper technical polish and appropriate subject matter. These artists all

Technique

HOW TO BE A FAMOUS ARTIST IN THE NINETEENTH CENTURY

ince artists generally make unique, handcrafted objects, keeping their work visible to large numbers of people can be difficult, especially in modern times when most forms of entertainment are mass produced. Since at least the time of Hogarth in the eighteenth century, artists have resorted to engravings to disseminate large editions of their works. Hogarth did this with several print series, as we saw in Chapter 18. Francisco Goya sold many copies of his print series *Los Caprichos* (SEE FIG. 19–11) in both France and Spain. Both of these artists created prints because they wanted to send a message to the general public.

Works that won prizes or created controversy were often engraved for large-scale reproduction. Artists generally hired specialists to render their work in the new medium, and sold the prints at bookstores or magazine stands. J. M. W. Turner did this more often than most artists; he used a team of engravers to capture on paper the delicate tonal shadings of his works, such as HANNIBAL CROSSING THE ALPS, which was engraved by one of his favorites, John Cousen. Engraved editions might run

into the low hundreds before the repeated pressing took its toll on image quality. The arrival of steel plates in the 1820s made much larger editions possible: Those more durable surfaces could print up to 10,000 copies without loss of quality, though few artists experienced such demand.

One of the canniest self-marketers of the century was Alexandre Cabanel. After Napoleon III bought *The Birth of Venus*, the artist sold the reproduction rights to the art dealer Adolphe Goupil, who in turn hired artists to create at least two smaller-scale copies of the work (one of which is FIG. 19–36). After the original creator approved the copies and signed them, the dealer used them as models for engravers who cut the steel plates. The dealer then sold the smaller versions of the work.

The technological advances that made possible the mass reproduction of photographs changed this equation radically near the end of the century. The expense of hand-carving an engraving plate soon became prohibitive, and artists began to hope that publicity in newspapers or magazines might do for them what printed editions had done in the past.

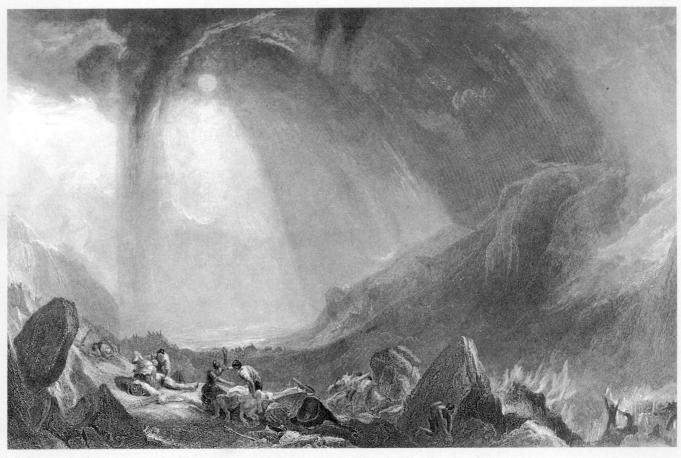

John Cousen, after J. M. W. Turner HANNIBAL CROSSING THE ALPS
1859. Engraving on paper. Tate Gallery, London. Transferred from British Museum.
T06314

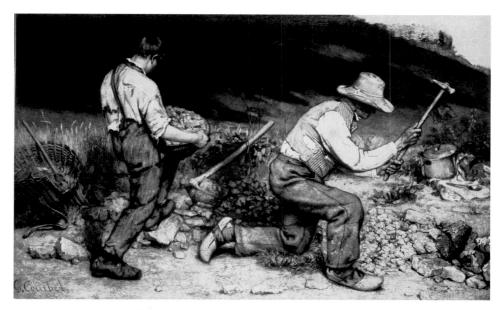

enjoyed successful careers during their day, creating works based on history, mythology, or picturesque genre, but they are mostly forgotten now because most of their work was simply not innovative. Rather, their art catered to the taste of most Salon visitors, who during the rapid social changes that transformed modern society looked to art for the reassurance of a comforting subject well painted.

In the middle nineteenth century, however, some artists rejected the precepts of the Salon in favor of a belief that art should faithfully record ordinary life. Most had not read Auguste Comte, but they joined in the new spirit of objectivity. In the years after 1850, some of the work produced by these independent-minded landscape and figure painters was labeled Realism, reflecting their positivist belief that art should show the "unvarnished truth." Some of these realists took up subjects that were generally regarded as not important enough for a serious work of art, and as a result they tended to get bad reviews in the press. But as we look back at the decades surrounding the middle of that century, we see that the realists were creating the most innovative and challenging work.

The political backdrop of the rise of Realism was defined by the Revolution of 1848 in France, when an uneasy coalition of socialists, anarchists, and workers overthrew the July Monarchy. The revolts began in February of that year, initially over government corruption and narrow voting rights, but they soon spread to a dozen major cities across Europe. The revolts led in France to the installation of Napoleon III (nephew of Bonaparte) as emperor under a new constitution with broadened suffrage rights, but still much social unease. Napoleon III soon acted to redraw the Paris street maps, as we have seen, to help prevent future revolts.

The Realist movement had a close parallel in literature of the time. Emile Zola, Charles Dickens, Honoré de Balzac, and others wrote novels that focused close attention on the urban lower classes. Zola, in particular, seemed to adhere to positivist beliefs in social science, as he said that he envisioned his novels as scientific experiments: He set his characters loose in an environment to see how they might interact with each other.

REALIST PAINTING IN FRANCE. The social radical Gustave Courbet (1819–77) was inspired by the events of 1848 to turn his attention to poor and ordinary people. Born and raised in Ornans near the Swiss border and largely self-taught as an artist, he moved to Paris in 1839. The street fighting of 1848 seems to have radicalized him. He told one newspaper in 1851 that he was "not only a Socialist but a democrat and a Republican: in a word, a supporter of the whole Revolution." Courbet proclaimed his new political commitment in three large paintings he submitted to the Salon of 1850–51.

One of these, **THE STONE BREAKERS** (FIG. 19–37), is a large painting showing two haggard men laboring to produce gravel used for roadbeds. In a letter he wrote while working on the painting, Courbet described its origins and considered its message:

[N]ear Maisières [in the vicinity of Ornans], I stopped to consider two men breaking stones on the highway. It's rare to meet the most complete expression of poverty, so an idea for a picture came to me on the spot. I made an appointment with them at my studio for the next day. . . . On the one side is an old man, seventy. . . . On the other side is a young fellow . . . in his filthy tattered shirt. . . . Alas, in labor such as this, one's life begins that way, and it ends the same way.

To contemporary viewers, this large painting of workers on the lowest social level seemed to dignify the revolutionaries of 1848. Courbet's friend, the anarchist philosopher Pierre-Joseph Proudhon, in 1865 called *The Stone Breakers* the first socialist picture ever painted, "a satire on our industrial civilization, which continually invents wonderful machines to perform all kinds of labor . . . yet is unable to liberate man from the most backbreaking toil." And Courbet himself, in a letter of the following year, referred to the painting as a depiction of "injustice."

Courbet's representation of The Stone Breakers on an 8½-foot-wide canvas testified in a provocative way to the painter's respect for ordinary people. In French art before 1848, such people usually had been shown only in modestly scaled paintings, while monumental canvases had been reserved for heroic subjects and pictures of the powerful. Immediately after completing The Stone Breakers, Courbet began work on an even larger canvas, roughly 10 by 21 feet, focusing on another scene of ordinary life: the funeral of an unnamed bourgeois citizen of Ornans. A BURIAL AT ORNANS (FIG. 19-38), also exhibited at the Salon of 1850-51, was attacked by conservative critics, who objected to its presentation of a mundane provincial funeral on a scale normally reserved for the depiction of a major historical event. They also faulted its disrespect for conventional compositional standards: Instead of arranging figures in a pyramid that would indicate a hierarchy of importance, Courbet lined them up in rows across the picture plane—an arrangement he considered more democratic. Critics also noted that the work contains no suggestion of an afterlife; rather it presents death and burial as mere physical facts, as a positivist might regard them. The painter's political convictions are especially evident in the individual attention and sympathetic treatment he accords the ordinary citizens of Ornans, many of them the artist's friends and family members. Courbet seems to have enjoyed the controversy: When some of his works were refused by the jury for a special Salon at the International Exposition of 1855, he rented a building near the fair's Pavilion of Art and installed a show of his own works which he called the Pavilion of Realism.

Similar accusations of political radicalism were made against Jean-François Millet (1814–75), though with less justification. The artist grew up on a farm and, despite living in Paris between 1837 and 1848, never felt comfortable in the city. The 1848 Revolution's preoccupation with ordinary people led Millet to focus on peasant life, only a marginal concern in his early work, and his support of the revolution earned him a state commission that allowed him to move from Paris to the village of Barbizon. After settling there in 1849, he devoted his art almost exclusively to the difficulties and simple pleasures of rural existence.

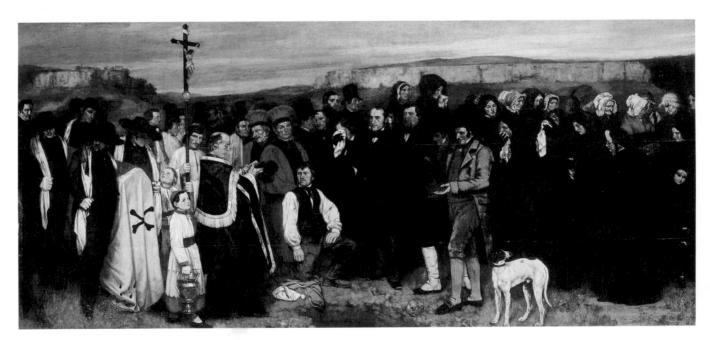

19–38 | Gustave Courbet A BURIAL AT ORNANS 1849. Oil on canvas, $10'3\,\%''\times21'9''$ (3.1 \times 6.6 m). Musée d'Orsay, Par s.

A Burial at Ornans was inspired by the 1848 funeral of Courbet's maternal grand-ather, Jean-Antoine Oudot, a veteran of the Revolution of 1793. The painting is not meant as a record of that particular funeral, however, since Oudot is shown alive in profile at the extreme left of the canvas, his image adapted by Courbet from an earlier portrait. The two men to the right of the open grave, dressed not in contemporary but in late eighteenth-century clothing, are also revolutionaries of Oudot's generation, and their proximity to the grave suggests that one of their peers is being buried. Courbet's picture may be interpreted as linking the revolutions of 1793 and 1848, both of which sought to advance the cause of democracy in France.

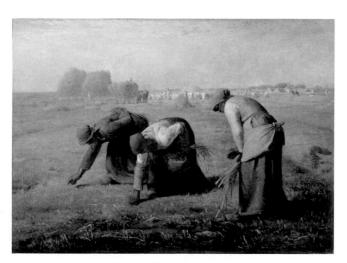

19–39 $\,\,$ Jean-François Millet $\,\,$ THE GLEANERS 1857. Oil on canvas, 33 $\,\times$ 44" (83.8 $\,\times$ 111.8 cm). Musée d'Orsay, Paris.

Among the best known of Millet's mature works is **THE GLEANERS** (FIG. 19–39), which shows three women gathering grain at harvest time. The warm colors and slightly hazy atmosphere are soothing, but the scene is one of extreme poverty. Gleaning, or the gathering of the grains left over after the harvest, was a form of relief offered to the rural poor. It required hours of backbreaking work to gather enough wheat to produce a single loaf of bread. When the painting was shown in 1857, a number of critics thought Millet was

attempting to rekindle the sympathies and passions of 1848, and he was therefore labeled a realist and even a socialist. Although Millet did not harbor such beliefs, his works aroused suspicion and controversy.

The kind of work produced in the 1830s and 1840s by the Barbizon School (SEE FIG. 19–18) became increasingly popular with Parisian critics and collectors after 1850, largely because of the radically changed conditions of Parisian life. Between 1831 and 1851 the city's population doubled, then the massive renovations of the entire city led by Haussmann transformed Paris from a collection of small neighborhoods to a modern, crowded, noisy, and fast–paced metropolis. Another factor in the appeal of images of peaceful country life was the widespread uneasiness over the political and social effects of the Revolution of 1848, and fear of further disruptions.

Soothing images of the rural landscape became a specialty of Jean-Baptiste-Camille Corot (1796–1875), who during the early decades of his career had painted not only historical landscapes with subjects drawn from the Bible and classical history, but also ordinary country scenes similar to those depicted by the Barbizon School. Ironically, just as popular taste was beginning to favor the latter kind of work, Corot around 1850 moved on to a new kind of landscape painting that mixed naturalistic subject matter with Romantic, poetic effects. A fine example is **FIRST LEAVES, NEAR MANTES** (FIG. 19–40), an idyllic image of budding green foliage in a warm, misty wood. The

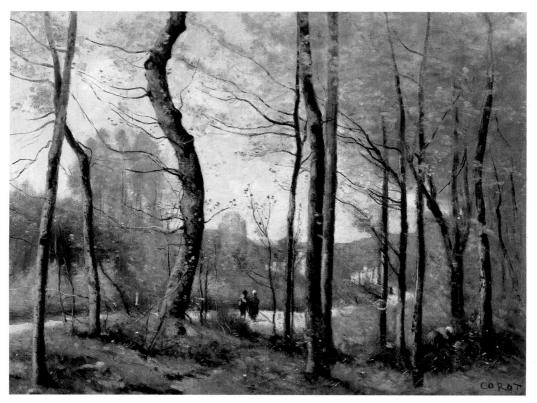

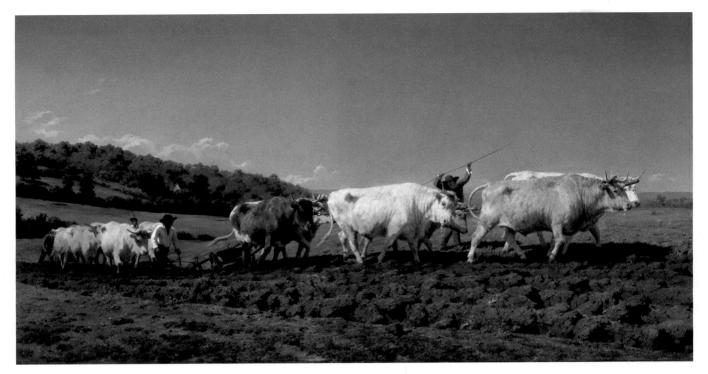

19–41 | Rosa Bonheur PLOWING IN THE NIVERNAIS: THE DRESSING OF THE VINES 1849. Oil on canvas, $5'9'' \times 8'8''$ (1.8 \times 2.6 m). Musée d'Orsay, Paris.

Bonheur was often compared with George Sand, a contemporary woman writer who adopted a male name as well as male dress. Sand devoted several of her novels to the humble life of farmers and peasants. Critics at the time noted that *Plowing in the Nivernais* may have been inspired by a passage in Sand's *The Devil's Pond* (1846) that begins: "But what caught my attention was a truly beautiful sight, a noble subject for a painter. At the far end of the flat ploughland, a handsome young man was driving a magnificent team [of] oxen."

feathery brushwork in the grasses and leaves infuses the painting with a soft, dreamy atmosphere that is counterbalanced by the solidly modeled tree trunks in the foreground, which create a firm sense of structure. Beyond the trees, a dirt road meanders toward the village in the background. Two rustic figures travel along the road at the lower center, while another figure labors in the woods at the lower right. Corot invites us to identify with these figures and to share imaginatively in their simple and unhurried rural existence.

Among the period's most popular painters of farm life was Rosa Bonheur (1822–99), whose commitment to rural subjects was partly the result of her aversion to Paris, where she had been raised. Bonheur's success in what was then a male domain owed much to the socialist convictions of her parents, who belonged to a radical utopian sect founded by the Comte de Saint-Simon (1760–1825), which believed not only in the equality of women but also in a future female Messiah. Bonheur's father, a drawing teacher, provided most of her artistic training.

Bonheur devoted herself to painting her beloved farm animals with complete accuracy, increasing her knowledge by reading zoology books and making detailed studies in stockyards and slaughterhouses. (To gain access to these all-male preserves, Bonheur got police permission to dress in men's clothing.) Her professional breakthrough came at the Salon

of 1848, where she showed eight paintings and won a firstclass medal. Shortly after, she received a government commission to paint PLOWING IN THE NIVERNAIS: THE DRESSING OF THE VINES (FIG. 19-41), a monumental composition featuring one of her favorite animals, the ox. The powerful beasts, anonymous workers, and fertile soil offer a reassuring image of the continuity of agrarian life. The stately movement of people and animals reflects the kind of carefully balanced compositional schemes taught in the academy and echoes scenes of processions found in classical art. The painting's compositional harmony—the shape of the hill is answered by and continued in the general profile of the oxen and their handler on the right—as well as its smooth illusionism and conservative theme were very appealing to the taste of the times. Her workers are far less pathetic than those of Courbet or Millet. Bonheur became so famous that in 1865 she received France's highest award, membership in the Legion of Honor, becoming the first woman to be awarded its Grand Cross.

Millet, Courbet, Bonheur, and the other Realists who emerged in the 1850s are sometimes referred to as the "Generation of 1848." Because of his sympathy with working-class people, Honoré Daumier (1808–79) is also grouped with this generation. Unlike Courbet and the others, however, Daumier often depicted urban scenes, as in his famous early lith-

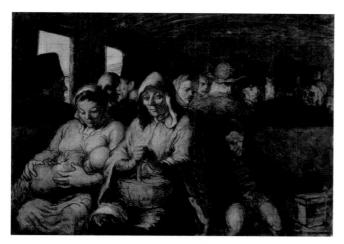

I9–42 | Honoré Daumier THE THIRD-CLASS CARRIAGE c. 1862. Oil on canvas, $25\% \times 35\%$ " (65.4 \times 90.2 cm). The National Gallery of Canada, Ottawa. Purchase, 1946

Although he devoted himself seriously to oil painting during the later decades of his life, Daumier was known to the Parisian public primarily as a lithographer whose cartoons and caricatures appeared regularly in the press. Early in his career he drew antimonarchist caricatures critical of King Louis-Philippe, but censorship laws imposed in 1835 obliged him to focus on social and cultural themes of a nonpolitical nature.

ograph Rue Transnonain, Le 15 Avril 1834 (see Introduction, FIG. 13) and his later oil painting THE THIRD-CLASS CARRIAGE (FIG. 19–42). The painting depicts the interior of one of the large, horse-drawn buses that transported Parisians along one of the new boulevards Haussmann had introduced as part of the city's redevelopment. Daumier places the viewer in the poor section of the bus, opposite a serene grandmother, her daughter, and her two grandchildren. Although there is a great sense of intimacy and unity among these people, they are physically and mentally separated from the upper- and

middle-class passengers, whose heads appear behind them. By portraying the lower classes as hardworking and earnest, the work humanizes them in a way similar to that of the novels of Charles Dickens.

REALISM OUTSIDE FRANCE. Following the French lead, artists of other nations also embraced Realism in the period after 1850 as the social effects of urbanization and industrialization began to take hold in their countries. In Russia, Realism developed in relation to a new concern for the peasantry. In 1861 the czar abolished serfdom, emancipating Russia's peasants from the virtual slavery they had endured on the large estates of the aristocracy. Two years later a group of painters inspired by the emancipation declared allegiance both to the peasant cause and to freedom from the St. Petersburg Academy of Art, which had controlled Russian art since 1754. Rejecting what they considered the escapist, "art for art's sake" aesthetics of the Academy, the members of the group dedicated themselves to a socially useful Realism. Committed to bringing art to the people in traveling exhibitions, they called themselves the Wanderers. By the late 1870s members of the group, like their counterparts in music and literature, had also joined a nationalistic movement to reassert what they considered to be an authentic Russian culture rooted in the traditions of the peasantry, rejecting the Western European customs that had long predominated among the Russian aristocracy.

Ilya Repin (1844–1930), who attended the St. Petersburg Academy and won a scholarship to study in Paris, joined the Wanderers in 1878 after his return to Russia. Repin painted a series of works illustrating the social injustices then prevailing in his homeland, including **BARGEHAULERS ON THE VOLGA** (FIG. 19–43). The painting features a group of wretchedly dressed peasants condemned to the brutal work

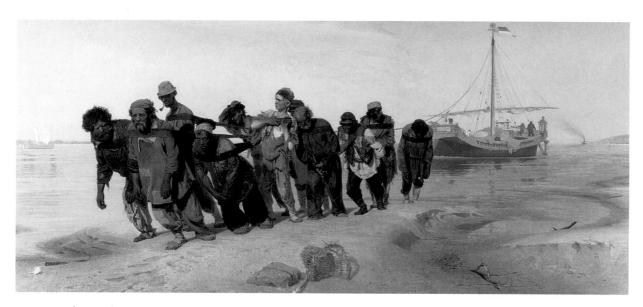

19–43 | Ilya Repin BARGEHAULERS ON THE VOLGA 1870–73. Oil on canvas, $4'3\%'' \times 9'3''$ (1.3 \times 2.81 m). State Russian Museum, St. Petersburg.

of pulling ships up the Volga River. To heighten our sympathy for these workers, Repin placed a youth in the center of the group, a young man who will soon look as old and tired as his companions unless something is done to rescue him. In this way, the painting is a cry for action.

The most uncompromising American Realist of the era, Thomas Eakins (1844–1916), was also criticized for selecting controversial subjects. Born in Philadelphia, Eakins trained at the Pennsylvania Academy of the Fine Arts, but since he regarded the training in anatomy as not rigorous enough—lacking realism, as he might have put it—he supplemented his training at the Jefferson Medical College nearby. He later studied at the École des Beaux-Arts in Paris, then spent six months in Spain, where he encountered the profound realism of Jusepe de Ribera and Diego Velázquez (SEE FIGS. 17–25, 17–27). After he returned to Philadelphia in 1870, he specialized in frank portraits and scenes of everyday life whose lack of conventional charm generated little popular interest. But he was a charismatic and influential teacher, and was soon appointed director of the Pennsylvania Academy.

One work of his did attract attention of a negative kind: THE GROSS CLINIC (FIG. 19-44) was severely criticized and was refused exhibition space at the 1876 Philadelphia Centennial because the jury apparently did not regard surgery as a fit subject for art. The painting shows Dr. Samuel David Gross performing an operation with young medical students looking on. The representatives of science—a young medical student, the doctor, and his assistants—are all highlighted. This dramatic use of light, inspired by Rembrandt and the Spanish Baroque masters Eakins admired, is not meant to stir emotions but to make a point: Amid the darkness of ignorance and fear, modern science shines the light of knowledge. The light in the center falls not on the doctor's face but on his forehead—on his mind. The French poet and art critic Charles Baudelaire had called as far back as 1846 for artists to depict "The Heroism of Modern Life," and turn away from the historical or the imaginary. He wrote, "There are such things as modern beauty and modern heroism." Though Eakins most likely had not read Baudelaire's call, he did see Dr. Gross as a hero and depicted him memorably. For many years the painting hung not in an art gallery but at the Jefferson Medical College.

A few years later, Eakins's commitment to the unvarnished truth proved costly in his career. When he removed the loincloth from a male nude model in a mixed life-drawing class, the scandalized Academy board gave him the choice of changing his teaching methods or resigning. He resigned. This step did not remove Realism from the Academy curriculum, however, as we shall see in the next chapter.

His compatriot Winslow Homer (1836–1910) believed that unadorned realism was the most appropriate style for American-type democratic values. The Boston-born Homer began his career in 1857 as a freelance illustrator for popular

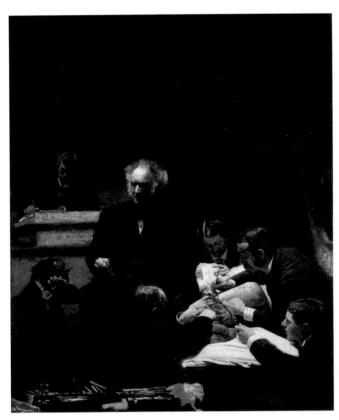

19–44 Thomas Eakins THE GROSS CLINIC 1875. Oil on canvas, $8' \times 6'5''$ (2.44 \times 1.98 m). Jefferson Medical College of Thomas Jefferson University, Philadelphia.

Eakins, who taught anatomy and figure drawing at the Pennsylvania Academy of the Fine Arts, disapproved of the academic technique of drawing from plaster casts. In 1879 he said, "At best, they are only imitations, and an imitation of an imitation cannot have so much life as an imitation of nature itself." He added, "The Greeks did not study the antique . . . the draped figures in the Parthenon pediment were modeled from life, undoubtedly."

periodicals such as Harper's Weekly, which sent him to cover the Civil War in 1862. In 1866-67 Homer spent ten months in France, where the Realist art he saw may have inspired the rural subjects he painted when he returned. His commitment to depicting common people deepened after he spent 1881-82 in a tiny English fishing village on the rugged North Sea coast. The strength of character of the people there so inspired him that he turned from idyllic subjects to more dramatic themes involving the heroic human struggle against natural adversity. In England, he was particularly impressed with the breeches buoy, a mechanical apparatus used to rescue those aboard foundering ships. During the summer of 1883 Homer made sketches of a breeches buoy imported by the lifesaving crew in Atlantic City, New Jersey. The following year Homer painted THE LIFE LINE (FIG. 19-45), which depicts a coast guardsman using the breeches buoy to rescue an unconscious woman and is a testament not simply to human bravery but also to ingenuity.

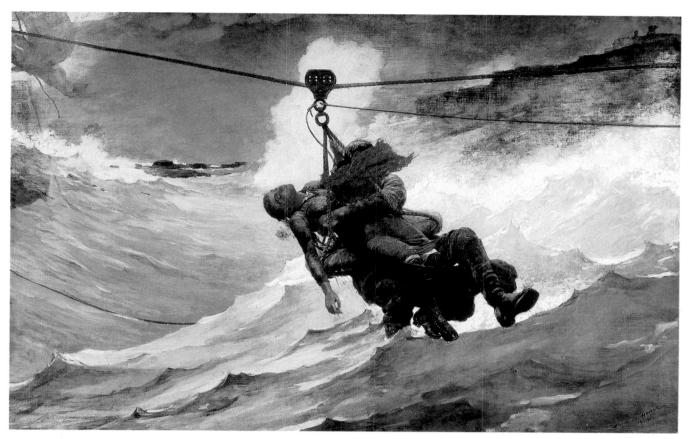

19–45 Winslow Homer **THE LINE** 1884. Oil on canvas, $28\frac{1}{4} \times 44\frac{1}{8}$ " (73 \times 113.3 cm). Philadelphia Museum of Art. The George W. Elkins Collection.

In the early sketches for this work, the man's face was visible. The decision to cover it focuses more attention not only on the victim but also on the true hero, the mechanical apparatus known as the breeches buoy.

Late Nineteenth-Century Art in Britain

The parliamentary reforms of the 1830s made England a more flexible society, better able to deal with the social pressures that industrialization and urbanization caused. Though it had its share of political agitation, the country was spared the worst violence of the 1848 revolts. Likewise, Realist currents were few, and they were tied to an effort to reform English art that looked back to the social concern of Hogarth. In 1848 seven young London artists formed the Pre-Raphaelite Brotherhood in response to what they considered the misguided practices of contemporary British art. Instead of the Raphaelesque conventions taught at the Royal Academy, the Pre-Raphaelites advocated the naturalistic approach of certain early Renaissance masters, especially those of northern Europe. They advocated as well a moral approach to art, in keeping with what they saw as a long tradition in Britain.

HUNT. The combination of didacticism and naturalism that characterized the first phase of the movement is best represented in the work of one of its leaders, William Holman Hunt (1827–1910), for whom moral truth and visual accuracy were synonymous. A well-known painting by this academically trained artist is **THE HIRELING SHEPHERD**

(FIG. 19–46). Hunt painted the landscape portions of the composition outdoors, an innovative approach at the time, leaving space for the figures, which he painted in his London studio. The work depicts a farmhand neglecting his duties to flirt with a woman while pretending to discuss a death's-head moth that he holds in his hand. Meanwhile, some of his

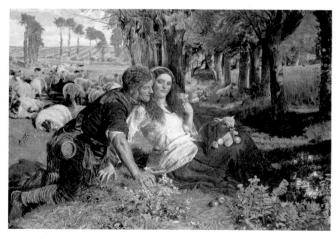

employer's sheep are wandering into an adjacent field, where they may become sick or die from eating green corn. Hunt later explained that he meant to satirize pastors who instead of tending their flock waste time discussing what he considered irrelevant theological questions. The work is certainly an allegory fashioned after one of the parables of Jesus about good and bad shepherds (John 10:11-13). The painting can also be seen as a moral lesson on the perils of temptation. The woman is cast as a latter-day Eve, as she feeds an apple—a reference to humankind's fall from grace—to the lamb on her lap and distracts the shepherd from his duty.

MORRIS AND THE ARTS AND CRAFTS MOVEMENT. socialist values of the Revolution of 1848 had their strongest impact on English arts in the field of interior design. William Morris (1834-1896) worked briefly as a painter under the influence of the Pre-Raphaelites before turning his attention to interior design and decoration. Morris's interest in handcrafts developed in the context of a widespread reaction against the gaudy design of industrially produced goods that began with the Crystal Palace exhibition of 1851. Unable to find satisfactory furnishings for his new home after his marriage in 1859, Morris designed and made them himself with the help of friends. He then founded a decorating firm to produce a full range of medieval-inspired objects. Although many of the furnishings offered by Morris & Company were expensive, one-of-a-kind items, others, such as the rushseated chair illustrated here (FIG. 19-47), were cheap and simple, intended to provide a handcrafted alternative to the vulgar excess characteristic of industrial furniture. Concerned with creating a "total" environment, Morris and his colleagues designed not only furniture but also stained glass, tiles, wallpaper, and fabrics, such as the PEACOCK AND **DRAGON CURTAIN** seen in the background of FIGURE 19–47.

Morris inspired what became known as the Arts and Crafts movement. His aim was to benefit not just a wealthy few but society as a whole. He rebelled against the common Western notion, in effect since the Renaissance, that art was a highly specialized product made by a uniquely gifted person for sale at a high price to a wealthy individual for a private possession. Rather, he hoped to usher in a new era of art by the people and for the people. As he said in the hundreds of lectures he began delivering in 1877, "I do not want art for a few, any more than education for a few, or freedom for a few." A socialist, Morris had serious doubts about mass production not only because he found its products ugly but also because of its deadening influence on the industrial worker, forced to work ten- to twelve-hour days at repetitive tasks. With craftwork, he maintained, the laborer retains the satisfaction of seeing a project through to completion. He was inspired by the popular and mostly anonymous artists of the Middle Ages, but he also dreamed of a Utopian future without class

19-47 FOREGROUND: Philip Webb SINGLE CHAIR FROM THE SUSSEX RANGE

In production from c. 1865. Ebonized wood with rush seat, $33 \times 16\% \times 14$ " (83.8 × 42 × 35.6 cm). Manufactured by Morris & Company. William Morris Gallery (London Borough of Waltham Forest).

BACKGROUND: William Morris PEACOCK AND DRAGON CURTAIN

1878. Handloomed jacquard-woven woolen twill, 12'10 ½" \times 11'5 ½" (3.96 \times 3.53 m). Manufactured at Queen Square and later at Merton Abbey. Victoria & Albert Museum,

Morris and his principal furniture designer, Philip Webb (1831-1915), adapted the Sussex Range from traditional rushseated chairs of the Sussex region. The handwoven curtain in the background is typical of Morris's fabric design in its use of flat patterning that affirms the two-dimensional character of the textile medium. The pattern's prolific organic motifs and soothing blue and green hues-the decorative counterpart to those of naturalistic landscape painting—were meant to provide relief from the stresses of modern urban existence.

envy and where everyone embellished their lives with some form of art.

WHISTLER. Not all of those who participated in the revival of the decorative arts were committed to improving the conditions of modern life. Many saw in the Arts and Crafts revival simply another way to satisfy an elitist taste for beauty. Among these was the American expatriate James Abbott McNeill Whistler (1834-1903), who not only devoted attention to the rooms and walls where art is hung, but also participated in

controversies that laid important groundwork for the art of the next century. After flunking out of West Point in the early 1850s, Whistler studied art in Paris, where he came under the influence of the Realists, and painted seascapes with Courbet. After settling in London in 1859, his thought evolved away from Realism, and he began to conceive of aesthetic values as independent of any other social fact. That is, he believed that the mere arrangement of a room or a painting can be aesthetically pleasing in itself, no matter what it contains or depicts. He was among the first to hang his works in a gallery in a single row, rebelling against the "stacked" array of most art exhibitions since the seventeenth century. He also occasionally designed rooms to hold his works, mindful of the total harmony of a space.

His ideas about what makes a successful work of art proved equally revolutionary. He was among the first to collect Japanese art, finding there fascinating patterns of pure decoration that delighted his eye although he understood nothing of the subject matter. By the middle of the 1860s he was titling his works "Symphony" and "Arrangement," hinting that just as a symphony can be a pleasing composition of sound, so a painting can be a pleasing arrangement of form, regardless of its subject. He made several landscapes with the musical title "Nocturne," and when he exhibited some of these in 1877, he drew a negative review from England's leading art critic John Ruskin, a supporter of the Pre-Raphaelites who defended the moral intentions of those artists. Whistler's work seemed to have no such purpose, so Ruskin wondered in print how an artist could "demand 200 guineas for flinging a pot of paint in the public's face."

The most controversial painting in Whistler's show was NOCTURNE IN BLACK AND GOLD, THE FALLING ROCKET (FIG. 19-48), and it precipitated one of the most important court cases in Western art history. The work is a night scene painted in restricted tonalities that looks at first like a completely abstract painting, meaning that it does not represent observable aspects of nature. In fact, Whistler depicted a fireworks show over a lake at nearby Cremorne Gardens, with viewers dimly recognizable in the foreground. Calling the work a "Nocturne" recalled the piano pieces of Romantic composer Frederic Chopin, though Whistler was less interested in Romantic feeling than in pursuing the parallel between art and music. After reading Ruskin's review, Whistler sued the critic for libel and the case went to trial (see "Art on Trial in 1877"). On the witness stand, the artist defended his view that art has no higher purpose than creating visual delight; he further claimed that art need not have a subject matter at all in order to be successful. While Whistler never made a completely abstract painting, his theories became an important part of the justification for abstract art in the next century.

Defining Art ART ON TRIAL IN 1877

his is a partial transcript of Whistler's testimony at the libel trial that he initiated against the art critic John Ruskin. Whistler's responses often provoked laughter, and the judge at one point threatened to clear the courtroom.

- Q: What is your definition of a Nocturne?
- A: I have, perhaps, meant rather to indicate an artistic interest alone in the work, divesting the picture from any outside sort of interest which might have been otherwise attached to it. It is an arrangement of line, form, and color first . . . The *Nocturne in Black and Goid* [SEE FIG. 30-48] is a night piece, and represents the fireworks at Cremorne.
- Q: Not a view of Cremorne?
- A: If it were called a view of Cremorne, it would certainly bring about nothing but disappointment on the part of beholders. It is an artistic arrangement. It was marked 200 guineas . . .
- Q: I suppose you are willing to admit that your pictures exhibit some eccentricities; you have been told that over and over again?
- A: Yes, very often.
- Q: You send them to the gallery to invite the admiration of the public?
- A: That would be such a vast absurdity on my part that I don't think I could.
- Q: Did it take you much time to paint the *Nocturne in Black and Gold?* How soon did you knock it off?
- A: I knocked it off in possibly a couple of days; one day to do the work, and another to finish it.
- Q: And that was the labor for which you asked 200 guineas?
- A: No, it was for the knowledge gained through a lifetime.

The judge ruled in Whistler's favor; Ruskin had indeed libeled him. But he awarded Whistler damages of only one half of one cent. Since in those days the person who brought the suit had to pay all the court costs, the case ended up bankrupting the artist.

19-48 James Abbott McNeill Whistler NOCTURNE IN BLACK AND GOLD, THE FALLING ROCKET 1875. Oil on panel, $23\frac{3}{4} \times 18\frac{3}{8}$ " $(60.2 \times 46.7 \text{ cm})$. Detroit Institute of Arts, Detroit, Michigan. 46.309

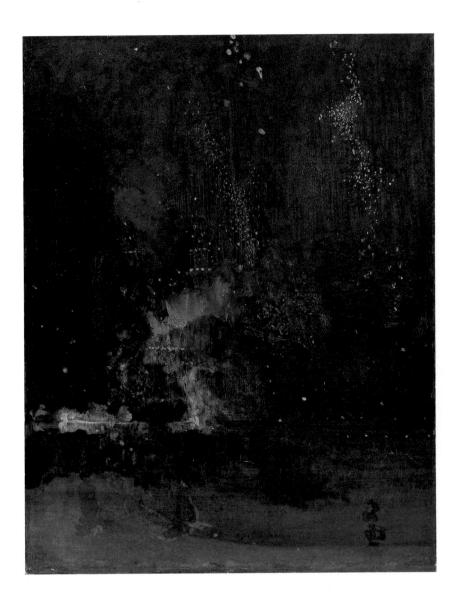

Impressionism

While the leading British artists were moving away from the naturalism advocated by the original Pre-Raphaelite Brotherhood, their French counterparts were pushing the French Realist tradition into new territory. The generation that matured around 1870 began as followers of Realism or the Barbizon School but soon moved to more modern subjects: leisure, the upper middle class, and the city. Although many of these artists specialized in paintings of the countryside, their point of view was usually that of a city person on holiday.

In April 1874, a number of these artists, including Paul Cézanne, Edgar Degas, Claude Monet, Berthe Morisot, Camille Pissarro, and Pierre-Auguste Renoir, exhibited together in Paris as the Société Anonyme des Artistes Peintres, Sculpteurs, Graveurs, etc. (Corporation of Artists Painters, Sculptors, Engravers, etc.). The mastermind of this arrangement was Pissarro, a devotee of anarchist philosophies. Anarchists such as Proudhon urged citizens to band together into voluntary associations for mutual aid instead of relying on the state for such functions as banking and policing. Pissarro envisioned the Société as such a mutual aid group in opposition to the state-funded Salons. While the Impressionists became the best-known members that are remembered today, at the time the group consisted of artists who worked in various styles. All thirty participants agreed not to submit anything that year to the Salon, which had in the past often rejected their works; hence, their exhibition was a declaration of independence from the Academy and a bid to gain the attention of the public without the intervention of a jury. While the exhibition received some positive reviews, it was attacked by most critics. Louis Leroy, writing in the comic journal Charivari, seized on the title of a painting by Monet, Impression, Sunrise (1873), and dubbed the entire exhibition "impressionist." While Leroy used the word to attack the seemingly haphazard technique and unfinished look of some of the paintings, Monet and many of his colleagues were

pleased to accept the label, which spoke to their concern for capturing an instantaneous impression of a scene in nature. Seven more Impressionist exhibitions followed between 1876 and 1886, with the membership of the group varying slightly on each occasion; only Pissarro participated in all eight shows. The exhibitions of the Impressionists inspired other artists to organize alternatives to the Salon, a development that by the end of the century ended the French Academy's centuries—old stranglehold on the display of art and thus on artistic standards.

MANET. Frustration among progressive artists with the exclusionary practices of the Salon jury had been mounting in the decades preceding the first Impressionist exhibition. Such discontent reached a fever pitch in 1863 when the jury turned down nearly 3,000 works submitted to the Salon, leading to a storm of protest. In response, Napoleon III tried to mediate in the dispute by ordering an exhibition of the refused work called the *Salon des Refusés* ("Salon of the Rejected Ones").

Featured in it was a painting by Édouard Manet (1832–83), LE DÉJEUNER SUR L'HERBE OF THE LUNCHEON ON THE GRASS (FIG. 19–49), which scandalized contemporary viewers and helped to establish Manet as a radical artist. Within a few years, many of the future Impressionists would gather around Manet and follow his lead in challenging academic conventions.

A well-born Parisian who had studied in the early 1850s with the progressive academician Thomas Couture (1815–79), Manet had by the early 1860s developed a strong commitment to Realism, largely as a result of his friendship with the poet Baudelaire (SEE FIG. 19–30). In his article "The Painter of Modern Life," Baudelaire called for an artist who would be the painter of contemporary manners, "the painter of the passing moment and all the suggestions of eternity that it contains." Manet seems to have responded to Baudelaire's call in painting *Le Déjeuner sur l'Herbe*, which proved deeply offensive to both the academic establishment and the average Salon–goer. Most disturbing to contemporary viewers was the "immorality" of Manet's theme: a suburban picnic

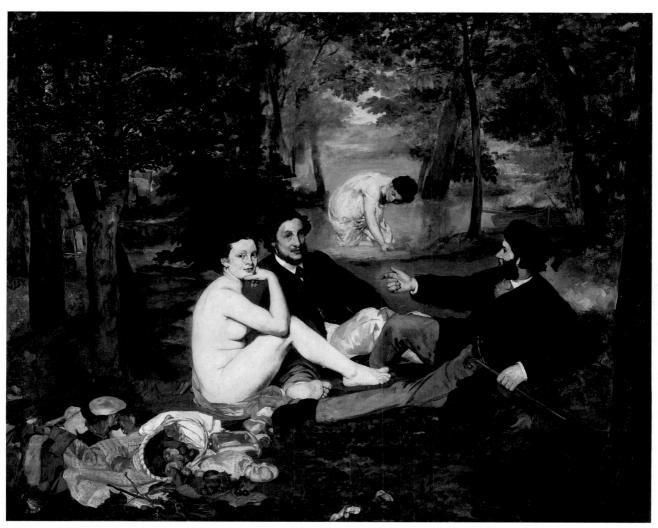

19–49 Édouard Manet LE DÉJEUNER SUR L'HERBE (THE LUNCHEON ON THE GRASS) 1863. Oil on canvas, $7' \times 8'8''$ (2.13 \times 2.64 m). Musée d'Orsay, Paris.

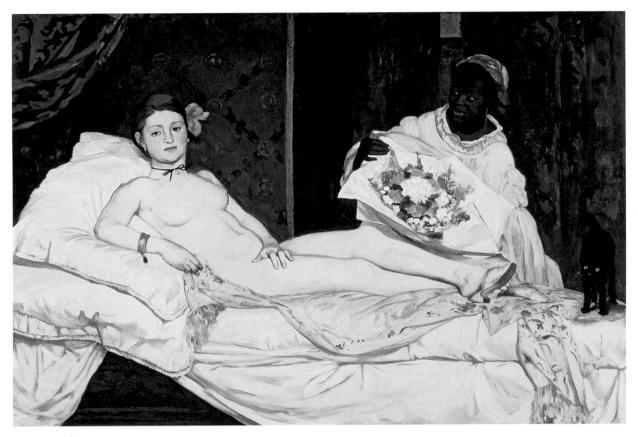

19–50 | Édouard Manet OLYMPIA 1863. Oil on canvas, $4'3'' \times 6'2 \%''$ (1.31 \times 1.91 m). Musée du Louvre, Paris.

featuring a scantily clad bathing woman in the background and, in the foreground, a completely naked woman, seated alongside two fully clothed, upper-class men. Manet's scandalized audience assumed that these women were prostitutes and that the well-dressed men were their clients. What was most shocking about this work was its modernity, presenting nudity in the context of contemporary life. In contrast, one of the paintings that gathered most renown at the official Salon in that year was Alexandre Cabanel's *Birth of Venus* (SEE FIG. 19–36), which, because it presented nudity in a more acceptable classical environment, was favorably reviewed and quickly entered the collection of Napoleon III.

Manet apparently conceived of *Le Déjeuner sur l'Herbe* as a modern version of a famous Venetian Renaissance painting in the Louvre, the *Pastoral Concert*, then believed to be by Giorgione but now attributed to both Titian and Giorgione (SEE FIG. 15–24). Manet also adapted for his composition a group of river gods and a nymph from an engraving by Marcantonio Raimondi based on Raphael's *The Judgment of Paris*—an image that, in turn, looked back to classical reliefs. With its deliberate allusions to Renaissance artworks, Manet's painting addresses the history of art and Manet's relationship to it. To a viewer who has in mind the traditional perspective and the rounded modeling of forms of the two Renaissance works,

the stark lighting of Manet's nude and the flat, cutout quality of his figures become all the more shocking. In this way, Manet emphasized his own radical innovations.

The intended meaning of *Le Déjeuner* remains a matter of considerable debate. Some see it as a portrayal of modern alienation, for the figures in Manet's painting fail to connect with one another psychologically. Although the man on the right seems to gesture toward his companions, the other man gazes off absently, while the nude turns her attention away from them and to the viewer. Moreover, her gaze makes us conscious of our role as outside observers; we, too, are estranged. Manet's rejection of warm colors for a scheme of cool blues and greens plays an important role, as do his flat, sharply outlined figures, which seem starkly lit because of the near absence of modeling. The figures are not integrated with their natural surroundings, as in the *Pastoral Concert*, but seem to stand out sharply against them, as if seated before a painted backdrop.

Shortly after completing *Le Déjeuner sur l'Herbe*, Manet painted **OLYMPIA** (FIG. 19–50), whose title alluded to a socially ambitious prostitute of the same name in a novel and play by Alexandre Dumas *fils* (the younger). Like *Le Déjeuner sur l'Herbe*, Manet's *Olympia* was based on a Venetian Renaissance source, Titian's *Venus of Urbino* (SEE FIG. 15–26), which Manet had earlier copied in Florence. At first, Manet's paint-

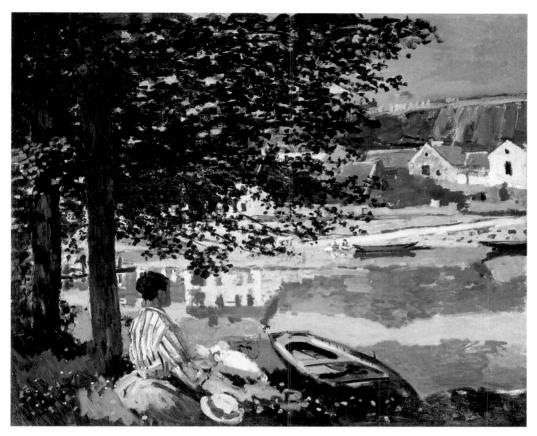

19–51 | Claude Monet ON THE BANK OF THE SEINE, BENNECOURT 1868. Oil on canvas, $32 \times 39 \%$ (81.5 \times 100.7 cm). Art Institute of Chicago. Potter Palmer Collection, 1922.427

ing appears to pay homage to Titian's in its subject matter (the Titian painting was then believed to be the portrait of a Venetian courtesan) and composition. However, Manet made his modern counterpart the very antithesis of the Titian. Whereas Titian's female is curvaceous and softly rounded, Manet's is angular and flattened. Whereas Titian's looks lovingly at the male spectator, Manet's appears coldly indifferent. Our relationship with Olympia is underscored by the reaction of her cat, who—unlike the sleeping dog in the Titian arches its back at us. Finally, instead of looking up at us, Olympia stares down on us, indicating that she is in the position of power and that we are subordinate, akin to the black servant at the foot of the bed who brings her a bouquet of flowers. In reversing the Titian, Manet in effect subverted the entire tradition of the accommodating female nude. Not surprisingly, conservative critics vilified the Olympia when it was displayed at the Salon of 1865.

Manet generally submitted his work to every Salon, but when he had a number of rejections in 1867, he did as Courbet had done in 1855: He rented a hall nearby and staged a solo exhibition. This made Manet the unofficial leader of a group of progressive artists and writers who gathered at the Café Guerbois in the Montmartre district of Paris. Among the artists who frequented the café were Degas,

Monet, Pissarro, and Renoir, who would soon exhibit together as the Impressionists. With the exception of Degas, who, like Manet, remained a studio painter, these artists began to paint outdoors, *en plein air* ("in the open air"), in an effort to record directly the fleeting effects of light and atmosphere. (*Plein air* painting was greatly facilitated by the invention in 1841 of tin tubes for oil paint.)

MONET. Claude Monet (1840–1926) was probably the purest exponent of Impressionism. Born in Paris but raised in the port city of Le Havre, Monet trained briefly with an academic teacher but soon forsook the studio to paint outdoors. He befriended the Barbizon School artist Daubigny (SEE FIG. 19-18), who urged him to "be faithful to his impression," and guided the younger artist to create his own floating studio on a boat. Many of Monet's early works include expanses of water, such as on the bank of the seine, bennecourt (FIG. 19-51). Monet's effort to capture the intense brightness of the sunlight led to the creation of this work, which one critic complained made his eyes hurt. Monet applied the flat expanses of pure color to the canvas unmixed, directly out of the tube, and he avoided underpainting his canvases in brown, as the academics taught. This is a solitary figure in a landscape, but it is not a Romantic vision. Monet visited

England in 1870 and saw the extremely painterly works by Turner, such as *The Burning of the Houses of Lords and Commons* (SEE FIG. 19–16). While Turner's brushwork may have influenced some of Monet's later landscapes, Monet did not share the older artist's commitment to feeling or to narrative. He said simply, "The Romantics have had their day." Instead he painted simple moments, capturing the play of light quickly before it changed.

In the 1870s, Monet moved further away from his Barbizon sources and began painting more urban subjects, such as the St. Lazare railway station (FIG. 19–52). This was a new structure, made of steel and glass, and Monet was fascinated by the way light descended through the glass ceiling and filtered through the steam from the trains parked beneath. He set up his easel in the station (to the consternation of the station manager), and painted twelve different views of the canopy under differing light conditions. The railroad was at that time a modern conveyance, bringing hordes of people from the countryside into the center of Paris. Monet had no interest in the human drama of the arrivals and departures, but rather he

focused on the evanescent qualities of the light in the context of modern urban haste.

Monet carried out his quest to record the shifting play of light on the surface of objects and the effect of that light on the eye without concern for the physical character or any symbolic importance of the objects he represented. The American painter Lilla Cabot Perry, who befriended Monet in his later years, recalled him telling her:

When you go out to paint, try to forget what objects you have before you—a tree, a house, a field, or whatever. Merely think, Here is a little square of blue, here an oblong of pink, here a streak of yellow, and paint it just as it looks to you, the exact color and shape, until it gives your own naive impression of the scene before you.

Perry also reported that Monet

said he wished he had been born blind and then had suddenly gained his sight so that he could have begun to paint in this way without knowing what the objects were that he saw before him. He held that the first real look at the motif was likely to be the truest and most unprejudiced one....

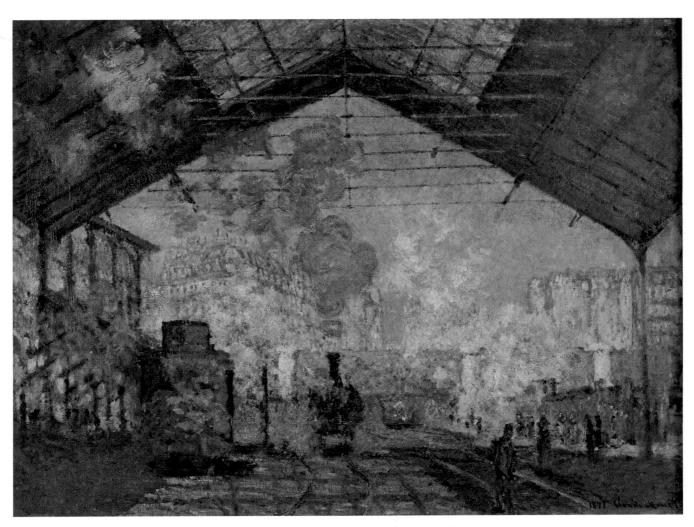

19–52 | Claude Monet | GARE ST-LAZARE | 1877. Oil on canvas, $29\% \times 50''$ (75.5 \times 104 cm). Musée d'Orsay, Paris. Photo: Erich Lessing/Art Resource, NY

Two important ideas are expressed here. One is that a quickly painted oil sketch most accurately records a landscape's general appearance. This view had been a part of academic training since the late eighteenth century, but such sketches were considered merely part of the preparation for a finished work. In essence Monet attempted to raise these traditional "sketch aesthetics" to the same level as a completed painting. As a result, the major criticism at the time was that his paintings were not "finished." The second idea is a more modern one, that an artist can see a subject freshly, without preconceptions or traditional filters. This was an inheritance of the Barbizon painters, and it led the Impressionists to paint subjects that had not been painted before. They sought subject matter that lacked the traditional markers of appropriateness: symbolic content, historical allusion, or narrative meanings. Instead they painted modern urban and suburban life in a way that captured its fastchanging character.

In the 1880s and 1890s, Monet focused his vision yet more intently, taking the idea of a series of works to other outdoor subjects: grain stacks, rows of poplar trees against the sky, and the cathedral at Rouen (FIG. 19–53). He painted the cathedral not because he suddenly discovered religion late in life, but because he found the church's undulating stone surface a laboratory of natural light effects, which he could paint without worrying much about perspective. He especially focused on the content of the shadows in the façade's deep niches, where he sometimes found iridescent overtones created by afterimages on his retina.

COUNTRY AND CITY IN PLEIN AIR. Although he painted during the 1870s in a style similar to Monet's, Camille Pissarro (1830–1903) identified more strongly with peasants and rural laborers. Born in the Danish West Indies to a French family and raised near Paris, Pissarro studied art in that city during the 1850s and early 1860s. After assimilating the influences of both Corot and Courbet, Pissarro embraced Impressionism in 1870, when both he and Monet were living in London to escape the Franco-Prussian War. There, they worked closely together, dedicating themselves, as Pissarro later recalled, to "plein air light and fugitive effects." The result, for both painters, was a lightening of color and a loosening of the way they handled paint.

Following his return to France, Pissarro settled in Pontoise, a small, hilly village northwest of Paris that retained a thoroughly rural character. There he worked for much of the 1870s in a style close to that of Monet, using high-keyed color and short brushstrokes to capture fleeting qualities of light and atmosphere. Rather than the vacationer's landscapes that Monet favored, however, Pissarro chose agrarian themes such as orchards and tilled fields. In the late 1870s his painting tended toward greater visual and material complexity.

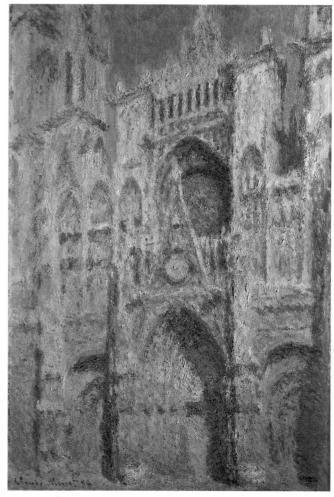

19–53 | Claude Monet ROUEN CATHEDRAL: THE PORTAL (IN SUN) 1894. Oil on canvas, $39\% \times 26''$ (99.7 \times 66 cm). The Metropolitan Museum of Art, New York. Theodore M. Davis Collection, Bequest of Theodore M. Davis, 1915 (30.95.250)

Monet painted more than thirty views of the façade of Rouen Cathedral. He probably began each canvas during two stays in Rouen in early 1892 and early 1893, observing his subject from a second-story window across the street. He then finished the whole series in his studio at Giverny. In these paintings Monet continued to pursue his Impressionist aim of capturing fleeting effects of light and atmosphere, but his extensive reworking of them in the studio produced pictures far more carefully orchestrated and laboriously executed than his earlier, more spontaneously painted *plein air* canvases.

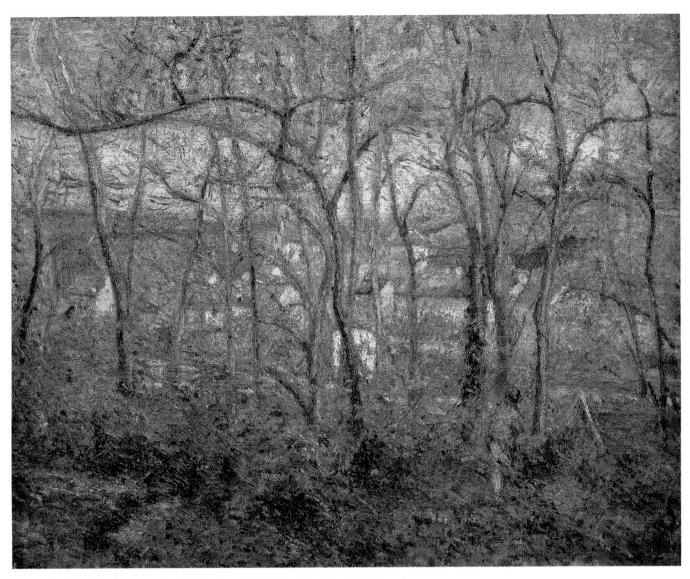

19–54 | Camille Pissarro WOODED LANDSCAPE AT L'HERMITAGE, PONTOISE 1878. Oil on canvas, $18\frac{5}{16} \times 22\frac{7}{16}$ " (46.5 × 56 cm). The Nelson-Atkins Museum of Art, Kansas City, Missouri. Gift of Dr. and Mrs. Nicholas S. Pickard

wooded Landscape at L'Hermitage, Pontoise (FIG. 19–54) reflects the continuing influence of Corot (SEE FIG. 19–40) in its composition of foreground trees that screen the view of a rural path and village and in its inclusion of a rustic figure at the lower right. Pissarro uses a brighter and more variegated palette than Corot, however, and he applies his paint more thickly, through a multitude of dabs, flecks, and short brushstrokes. One hostile critic remarked, accurately but painfully, "Corot, Corot, what crimes are committed in your name!"

More typical of the Impressionists in his proclivity for painting scenes of upper-middle-class recreation was Pierre-Auguste Renoir (1841–1919), who met Monet at the École des Beaux-Arts in 1862. Despite his early predilection for figure painting in a softened, Courbet-like mode, Renoir was encouraged by his more forceful friend Monet to create pleasant, light-filled landscapes, which were painted outdoors. By

the mid-1870s Renoir was combining Monet's style in the rendering of natural light with his own taste for the figure.

MOULIN DE LA GALETTE (FIG. 19–55), for example, features dancers dappled in bright afternoon sunlight. The Moulin de la Galette (the "Pancake Mill"), in the Montmartre section of Paris, was an old-fashioned Sunday afternoon dance hall, which during good weather made use of its open courtyard. Renoir has glamorized its working-class clientele by replacing them with his young artist friends and their models. Frequently seen in Renoir's work of the period, these attractive people are shown in attitudes of relaxed congeniality, smiling, dancing, and chatting. The innocence of their flirtations is underscored by the children in the lower left, while the ease of their relations is emphasized by the relaxed informality of the composition itself. The painting is knit together not by figural arrangement but by the overall mood, the sunlight falling through the

trees, and the way Renoir's soft brushwork weaves his blues and purples through the crowd and across the canvas. This idyllic image of a carefree age of innocence, a kind of paradise, nicely encapsulates Renoir's essential notion of art: "For me a picture should be a pleasant thing, joyful and pretty—yes pretty! There are quite enough unpleasant things in life without the need for us to manufacture more."

URBAN ANGLES. Subjects of urban leisure also attracted Edgar Degas (1834–1917), but he did not share the *plein air* Impressionists' interest in outdoor light effects. Instead, Degas composed his pictures in the studio from working drawings—a traditional academic procedure. Degas had in fact received rigorous academic training at the École des Beaux-Arts in the mid-1850s and subsequently spent three years in Italy studying the Old Masters. Firm drawing and careful composition remained central features of his art for the duration of his career, setting it apart from the more spontaneously executed pictures of the *plein air* painters.

The son of a Parisian banker, Degas was closer to Manet than to other Impressionists in age and social background. He

was also the most well trained in a traditional sense, having studied with a pupil of Ingres and having made numerous copies of masterworks in museums (a typical way for students to learn in those days). After a period of painting psychologically probing portraits of friends and relatives, Degas became convinced that traditional painting had no future, so he turned in the 1870s to more modern subjects such as the racetrack, music hall, opera, and ballet. Composing his ballet scenes from carefully observed studies of rehearsals and performances, Degas, in effect, arranged his own visual choreography. THE REHEARSAL ON STAGE (FIG. 19-56), for example, is not a factual record of something seen but a careful contrivance, intended to delight the eye. The rehearsal is viewed from an opera box close to the stage, creating an abrupt foreshortening of the scene emphasized by the dark scrolls of the bass viols that jut up from the lower left. His work shows two new important influences: The angular viewpoint in this and many other works shows his knowledge of Japanese prints, which he collected, and the seemingly arbitrary cropping of figures (seen here at the left) shows the influence of photography, which he also practiced. His work diverges significantly

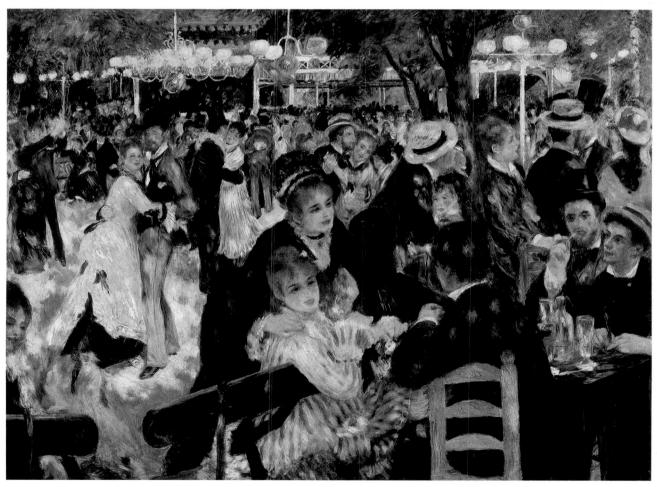

19–55 | Pierre-Auguste Renoir MOULIN DE LA GALETTE 1876. Oil on canvas, 4'3½" × 5'9" (1.31 × 1.75 m). Musée d'Orsay, Paris.

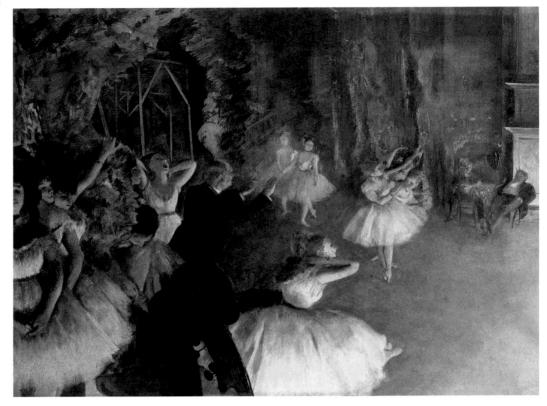

In the right background of Degas's picture sit two well-dressed, middle-aged men, each probably a "protector" (lover) of one of the dancers. Because ballerinas generally came from lower-class families and exhibited their scantily clad bodies in public—something that "respectable" bourgeois women did not do—they were widely assumed to be sexually available, and they often attracted the attentions of wealthy men willing to support them in exchange for sexual favors. Several of Degas's ballet pictures also include one or more of the dancers' mothers, who would accompany their daughters to rehearsals and performances in order to safeguard their virtue.

from that of the other Impressionists in these compositional techniques and also in his subjects, which are mostly indoors under artificial light. But the Realist novelist Edmond de Goncourt, a friend of most of the Impressionists, said that Degas was most able to capture "the soul of modern life."

We see similarly jarring angles in contemporary urban views in the art of Gustave Caillebotte (1848–1894), a friend of Degas who helped organize some of the Impressionist exhibitions and bought works from them when they needed financial assistance. Private study with an academic teacher qualified him for the École des Beaux-Arts, but he never attended. Rather, Caillebotte was fascinated by the new urban geometry that modern construction and Haussmann's new street grid produced. His **PARIS STREET, RAINY DAY** (FIG. 19–57) shows an unconventional and offhand composition similar to those of Degas, but with a gaping hole in the center where the street rushes away into seeming infinity. This is a typically open intersection that Haussmann's carving-up of Paris produced, here portrayed in somewhat exaggerated perspective. The figure at the right is cropped and crowded in

with two others in one half of the canvas, delineated by a lamppost; the other half is mostly building façades and a rain-soaked stone street. Caillebotte's painting technique owed little to Monet's pure colors, but his subjects and compositions remain jarringly modern.

UPPER-CLASS LIVES. Another artist who showed with the Impressionists was the American expatriate Mary Cassatt (1844–1926). Born near Pittsburgh to a well-to-do family, Cassatt studied at the Pennsylvania Academy of the Fine Arts in Philadelphia between 1861 and 1865 and then moved to Paris for further academic training. She lived in France for most of the rest of her life. The realism of the figure paintings she exhibited at the Salons of the early and middle 1870s attracted the attention of Degas, who invited her to participate in the fourth Impressionist exhibition, in 1879. Although she, like Degas, remained a studio painter, disinterested in plein air painting, her distaste for what she called the tyranny of the Salon jury system made her one of the group's staunchest supporters.

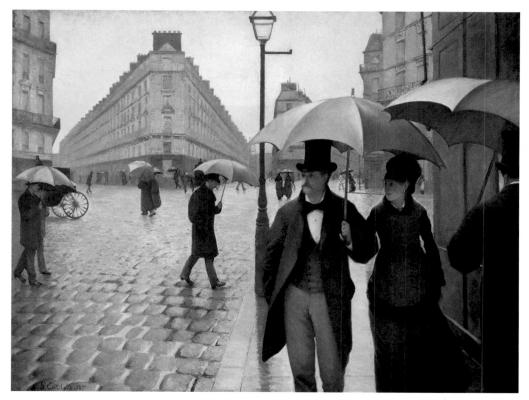

19–57 | Gustave Caillebotte PARIS STREET, RAINY DAY 1877. Oil on canvas, $83\frac{1}{2} \times 108\frac{3}{4}''$ (212.2 \times 276.2 cm). The Art Institute of Chicago. Part of the Charles H. and Mary F. S. Worcester Fund

Cassatt focused her work on the world to which she had access: the domestic and social life of well-off women. One of the paintings she exhibited in 1879 was **WOMAN IN A LOGE** (FIG. 19–58). The painting's bright and luminous color, fluent brushwork, and urban subject were no doubt chosen partly to demonstrate her solidarity with her new associates. (Renoir had exhibited a very similar image of a woman at the opera in 1874.) Reflected in the mirror behind the smiling woman are other operagoers, some with opera glasses trained not on the stage but on the crowd around them, scanning it for other elegant socialites. As Charles Garnier had noted, his new Opéra (SEE FIG. 19–34) made an ideal backdrop for just this kind of display.

19–58 | Mary Cassatt **WOMAN IN A LOGE** 1879. Oil on canvas, $31\% \times 23''$ (80.3×58.4 cm). Philadelphia Museum of Art. Bequest of Charlotte Dorrance Wright

Long known as *Lydia in a Loge, Wearing a Pearl Necklace*, this painting was believed to portray Cassatt's sister, Lydia, who came to live with her in 1877 and posed for many of her works. The young, redhaired sitter does not resemble the older, dark-haired Lydia, however, and was probably a professional model whose name has not been recorded. The painting is now known by the title it had when shown at the fourth Impressionist exhibition in 1879.

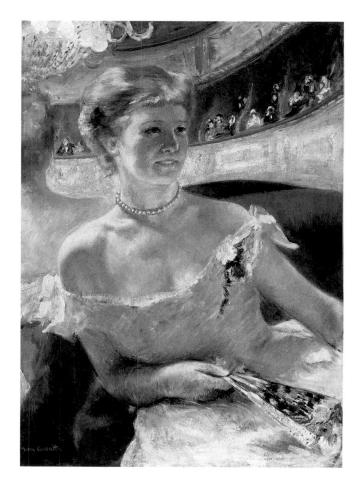

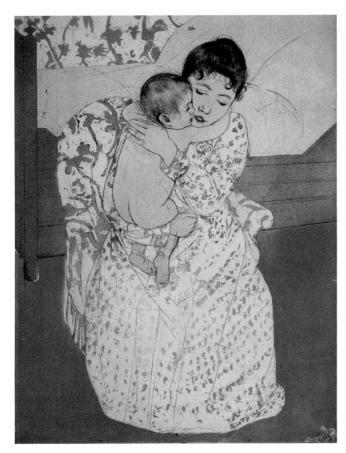

19–59 | Mary Cassatt MATERNAL CARESS 1891. Drypoint, soft-ground etching, and aquatint on paper, $14\frac{1}{4}\times10\frac{1}{4}$ " (37.5 \times 27.3 cm). National Gallery of Art, Washington, D.C. Chester Dale Collection (1963.10.255)

Her later work shows the influence of Japanese prints, as the artist began endowing her compositions with more solid forms in off-balance compositions (FIG. 19–59). The clashing patterns in the mother's dress and the chair, with the tipped "horizon" line from the bed seen at an angle, testify to this influence. Though she lived as an expatriate, Cassatt retained her connections with upper-class society back in the United States, and when her friends and relatives came to visit she encouraged them to buy works by the Impressionists, thus creating a market for their work in the United States before one developed in France itself.

Cassatt decided early to have a career as a professional artist, but Berthe Morisot (1841–95) came to that decision only after years in the amateur role then conventional for women. Morisot and her sister, Edma, copied paintings in the Louvre and studied under several different teachers, including Corot, in the late 1850s and early 1860s. The sisters showed in the five Salons between 1864 and 1868, the year they met Manet. In 1869 Edma married and, following the traditional course, gave up painting to devote herself to domestic duties. Berthe, on the other hand, continued painting, even after her 1874 marriage to Manet's brother, Eugène, and the birth of

their daughter in 1879. Morisot sent nine works to the first exhibition of the Impressionists in 1874 and showed in all but one of their subsequent exhibitions.

Like Cassatt, Morisot dedicated her art to the lives of bourgeois women, which she depicted in a style that became increasingly loose and painterly over the course of the 1870s. In works such as **SUMMER'S DAY** (FIG. 19–60), Morisot pushed the "sketch aesthetics" of Impressionism almost to their limit, dissolving her forms into a flurry of feathery brushstrokes. Originally exhibited in the fifth Impressionist exhibition in 1880 under the title *The Lake of the Bois du Boulogne*, Morisot's picture is typically Impressionist in its depiction of modern urban leisure in a large park on the fashionable west side of Paris. As the women apparently ride in a ferry between tiny islands in the largest of the park's lakes, the viewer occupies a seat opposite them and is invited to share their enjoyment of the delicious weather and pleasant surroundings.

LATER MANET. Although he never exhibited with the Impressionists, preferring to submit his pictures to the official Salons where he had only limited success, Édouard Manet nevertheless in the 1870s followed their lead by lightening his palette, loosening his brushwork, and confronting modern life in a more direct manner than he had in *Le Déjeuner sur l'Herbe* and *Olympia*, both of which maintained a dialogue with the art of the past. But complicating Manet's apparent acceptance of the Impressionist viewpoint was his commitment, conscious or not, to counter Impressionism's essentially optimistic interpretation of modern life with a more pessimistic (we might say Realist) one.

Manet's last major painting, A BAR AT THE FOLIES-BERGÈRE (FIG. 19-61), for example, contradicts the happy aura of works such as Moulin de la Galette (SEE FIG. 19-55) and Woman in a Loge (SEE FIG. 19-58). In the center of the painting stands one of the barmaids at the Folies-Bergère, a large nightclub with bars arranged around a theater that offered circus, musical, and vaudeville acts. Reflected in the mirror behind her is some of the elegant crowd, who are entertained by a trapeze act. (The legs of one of the performers can be seen in the upper left.) On the marble bartop Manet has spread a glorious still life of liquor bottles, tangerines, and flowers, associated not only with the pleasures for which the Folies-Bergère was famous but also with the barmaid herself, whose wide hips, strong neck, and closely combed golden hair are echoed in the champagne bottles. The barmaid's demeanor, however, refutes these associations. Manet puts the viewer directly in front of her, in the position of her customer. She neither smiles at this customer, as her male patrons and employers expected her to do, nor gives the slightest hint of recognition. She appears instead to be self-absorbed and slightly depressed, perfunctory in the manner of the many shallow interactions that urban life enables. But in the mirror

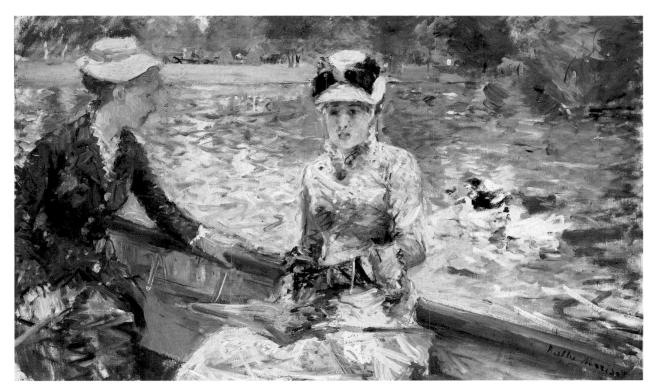

19–60 | Berthe Morisot SUMMER'S DAY 1879. Oil on canvas, 17 % \times 29 %" (45.7 \times 75.2 cm). The National Gallery, London. Lane Bequest, 1917

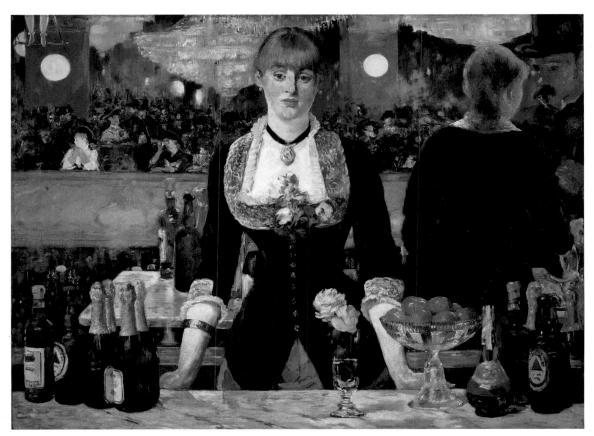

behind her, her reflection and that of her customer tell a different story. In this reflection, which Manet has curiously shifted to the right as if the mirror were placed at an angle, the barmaid leans toward the patron, whose intent gaze she appears to meet; the physical and psychological distance between them has vanished. Exactly what Manet meant to suggest by this juxtaposition has been much debated. One possibility is that he wanted to contrast the longing for happiness and intimacy, reflected miragelike in the mirror, with the disappointing reality of ordinary existence that directly confronts the viewer of the painting.

THE BIRTH OF MODERN ART

Manet and the Impressionists are generally regarded as the initiators of Modern art, a many-faceted movement that began probably in the 1860s and lasted for just over a hundred years. Rather than a cohesive movement with specific stylistic characteristics (such as the Rococo, for example), Modern art is distinguished primarily by a rejection of the traditions of art that had been handed down since the Renaissance. This traditional legacy came to artists in the form of customs, techniques, conventions, and rules. Custom dictated, for example, that artists paint with oil on canvas, using their brushes in certain ways, or that they cast public monuments in bronze. Techniques formed the principal subject of art instruction, such as one-point perspective and figure drawing from the nude. Conventions are the often unspoken agreements between artists and viewers, which, for example, lead Western viewers to see three-dimensional space in a painting's flat surface or to regard large works as more important than small ones. Rules are more stringent prohibitions, such as obscenity laws, which can invoke penalties. Far from being restrictive, this network of traditions defined Western art for about 400 years, giving artists a scope in which to operate and a set of values by which viewers could judge their products. Before Modern art, most innovation took place within the tradition.

Yet in the second half of the nineteenth century, artists began seriously and systematically to question that traditional legacy. They did this for various reasons, which some artists spoke about and others acted on unconsciously. Some thought that the tradition was simply used up and that nothing more could be said with it. Others regarded the tradition as irrelevant to the fast-changing world of urbanization and industrialization of that period. Claude Monet, for example, disregarded his academic teacher when he urged the class to think of Greek sculpture every time they saw a nude. Monet had serious doubts about the relevance of Greek sculpture to modern life. Some artists (probably a minority) were natural rebels who generally believed in opposing authority. The rise of photography was another important impetus to experimentation in art: Why perfect ancient methods of rendering

a subject when a machine could do it almost as well? Whatever the reason, Modern artists rejected not only the tradition but also the superstructure that came with it in the form of academic training, Salon exhibitions, and the taste of most of the art-viewing public. This choice was a costly one for many of them, who could have had much more lucrative careers if they had created their art in more acceptable modes.

A deeper cause of Modern art was the modernization of society. The Industrial Revolution created a new public for art in the urban middle classes who flocked to the Salons in search of culture. As we have seen, their taste was cautious and conservative, favoring Academic artists such as Bouguereau, Carpeaux, and Cabanel. Modern artists had little interest in catering to this clientele, and preferred to carry out and exhibit their experiments in realms outside the norm.

In place of the "official" art culture, Modern artists created what has been called an avant-garde. The term was initially used in a military context, designating the forward units of an advancing army that scouted territory which the rest of the troops would soon occupy. This term thus captures the forward-looking aspect of Modern art, and the belief that Modernists are working ahead of the public's ability to comprehend. As an art-world social group, the avant-garde consisted of Modern artists, along with a few collectors, art critics, and art dealers who followed the latest developments and found them stimulating. These two concepts, the rejection of tradition and the avant-garde, are most important for understanding Modern art.

Despite the angry protestations of conservative critics, the rejection of tradition did not happen all at once. In fact, the Modern art movement unfolded in a gradual and even logical way, as artists questioned and threw out one rule after another in succeeding decades. Modernism was not revolutionary but rather evolutionary. The Realists shunned traditional narrative content and properly "dignified" subject matter. The Impressionists also did that, and in addition they broke the convention that separated sketch from finished work. Although they seemed radical to some at the time, both of these movements left large parts of the tradition perfectly intact. After Impressionism began to run its course in the middle 1880s, other movements came along to challenge other aspects of the tradition. To these artists and movements we turn next.

Post-Impressionism

The English critic Roger Fry coined the term *Post-Impressionism* in 1910 to identify a broad reaction against Impressionism in avant-garde painting of the late nineteenth and early twentieth centuries. Art historians recognize Paul Cézanne (1839–1906), Georges Seurat (1859–1891), Vincent van Gogh (1853–1890), and Paul Gauguin (1848–1903) as the principal Post-Impressionist artists. Each of these painters moved through an Impressionist phase, and each continued to use in his mature work the bright Impressionist palette. But each came also to reject

Impressionism's emphasis on the spontaneous recording of light and color. Some sought to create art with a greater degree of formal order and structure; others moved further from Impressionism and developed more abstract styles that would prove highly influential for the development of Modern painting in the early twentieth century.

CÉZANNE. No artist had a greater impact on the next generation of Modern painters than Cézanne, who enjoyed little professional success until the last few years of his life, when younger artists and critics began to recognize the innovative qualities of his art. The son of a prosperous banker in the southern French city of Aix-en-Provence, Cézanne studied art first in Aix and then in Paris, where he participated in the circle of Realist artists around Manet. Cézanne's early pictures, somber in color and coarsely painted, often depicted Romantic themes of drama and violence, and were consistently rejected by the Salon.

In the early 1870s Cézanne changed his style under the influence of Pissarro and adopted the bright palette, broken brushwork, and everyday subject matter of Impressionism. Like the Impressionists, with whom he exhibited in 1874 and 1877, Cézanne now dedicated himself to the objective transcription of what he called his "sensations" of nature. Unlike the Impressionists, however, he did not seek to capture transi-

Sequencing Works of Art			
1884	Homer, The Life Line		
1884-86	Seurat, A Sunday Afternoon on the Island of La Grande Jatte		
1884-89	Rodin, Burghers of Calais		
1885-87	Cézanne, Mont Sainte-Victoire		
1887-89	Eiffel, Eiffel Tower, Paris		
1889	van Gogh, The Starry Night		

tory effects of light and atmosphere but rather to create a sense of order in nature through a methodical application of color that merged drawing and modeling into a single process. His professed aim was to "make of Impressionism something solid and durable, like the art of the museums."

Cézanne's tireless pursuit of this goal is exemplified in his paintings of Mont Sainte-Victoire, a prominent mountain near his home in Aix that he depicted about thirty times in oil from the mid-1880s to his death. The version here (FIG. 19–62) shows the mountain rising above the Arc Valley, which is dotted with houses and trees and is traversed at the far right by an aqueduct. Framing the scene at the left is an

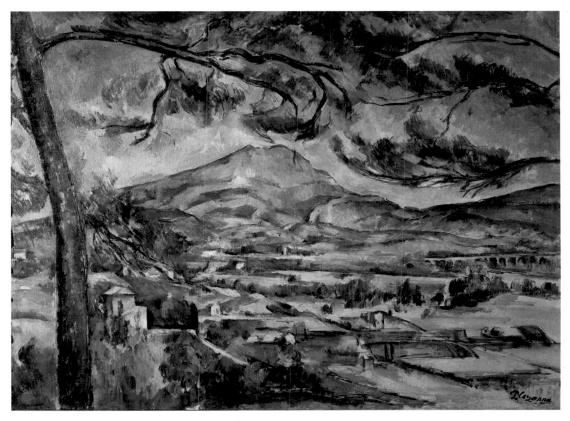

19–62 | Paul Cézanne MONT SAINTE-VICTOIRE c. 1885–87. Oil on canvas, $25 \frac{1}{2} \times 32^{\prime\prime}$ (64.8 \times 92.3 cm). Courtauld Institute of Art Gallery, London. (P.1934.SC.55)

evergreen tree, which echoes the contours of the mountains, creating visual harmony between the two principal elements of the composition. The even lighting, still atmosphere, and absence of human activity in the landscape communicate a sense of timeless endurance, at odds with the Impressionists' interest in capturing a momentary aspect of the everchanging world.

Cézanne's paint handling is more deliberate and constructive than the Impressionists' spontaneous and comparatively random brushwork. His strokes, which vary from short, parallel hatchings to sketchy lines to broader swaths of flat color, not only record his "sensations" of nature but also weave every element of the landscape together into a unified surface design. That surface design coexists with the effect of spatial recession that the composition simultaneously creates, generating a fruitful tension between the illusion of three dimensions "behind" the picture plane and the physical reality of its two-dimensional surface. On the one hand, recession into depth is suggested by elements such as the foreground tree, a **repoussoir** (French for "something that pushes back") that helps draw the eye into the valley and toward the distant mountain range, and by the gradual transition from the saturated greens and orange-yellows of the foreground to the softer blues and pinks in the mountain, which create an effect of atmospheric perspective. On the other hand, this illusion of consistent recession into depth is challenged by the inclusion of blues, pinks, and reds in the foreground foliage, which relate the foreground forms to the background mountain and sky, and by the tree branches in the sky, which follow the contours of the mountain, making the peak appear nearer and binding it to the foreground plane. Contemporary photographs of this same location reveal that Cézanne composed his paintings not according to how the scene looked. Nor did

he alter the fact to fit his feeling, as a Romantic might. Rather, he depicted the scene in accordance with the harmony that the composition of the painting itself demanded. This proved a tremendously fruitful idea for future artists.

Spatial ambiguities of a different sort appear in Cézanne's late still lifes, in which many of the objects seem incorrectly drawn. In STILL LIFE WITH BASKET OF APPLES (FIG. 19-63), for example, the right side of the table is higher than the left, the wine bottle has two different silhouettes, and the pastries on the plate next to it are tilted upward while the apples below seem to be viewed head-on. Such apparent inaccuracies are not evidence of Cézanne's incompetence, however, but of his willful disregard for the rules of traditional scientific perspective. Although scientific perspective mandates that the eye of the artist (and hence the viewer) occupy a fixed point relative to the scene being observed (see "Brunelleschi, Alberti, and Renaissance Perspective," page 492), Cézanne studies different objects in a painting from slightly different positions. Most of us, after all, when examining a scene, turn our head or move our bodies in order to take it all in. This composition as a whole, assembled from multiple sightings of its various elements, is complex and dynamic and even seems on the verge of collapse. The pastries look as if they could levitate, the bottle tilts precariously, the fruit basket appears ready to spill its contents, and only the folds and small tucks in the white cloth seem to prevent the apples from cascading to the floor. All of these physical improbabilities are designed, however, to serve the larger visual logic of the painting as a work of art, characterized by Cézanne as "something other than reality"-not a direct representation of nature but "a construction after nature." As with his landscapes, the distinction is a crucial one that later artists would exploit.

19–63 | Paul Cézanne STILL LIFE WITH BASKET OF APPLES 1890–94. Oil on canvas, $24 \% \times 31''$ (62.5 \times 79.5 cm). The Art Institute of Chicago. Helen Birch Bartlett Memorial Collection

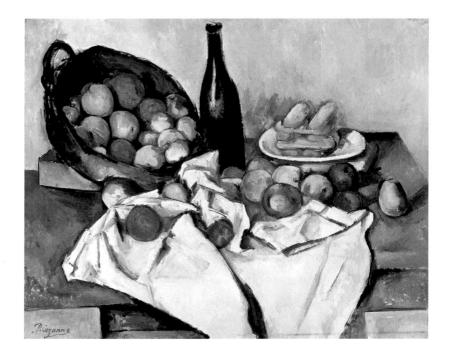

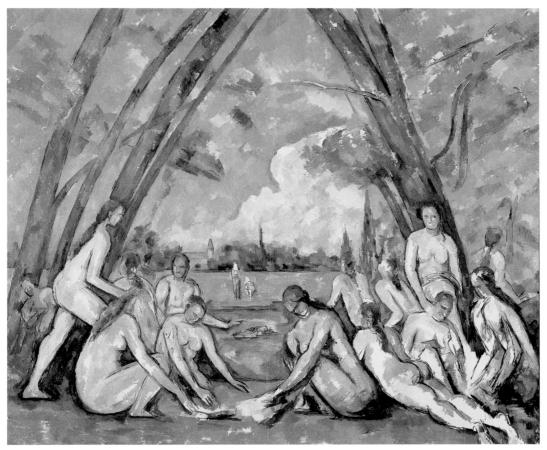

19–64 | Paul Cézanne THE LARGE BATHERS 1906. Oil on canvas, $6'10'' \times 8'2''$ (2.08 \times 2.49 m). Philadelphia Museum of Art. The W. P. Wilstach Collection

Toward the end of his life, Cézanne's constructions after nature became increasingly abstract, as we see in the monumental THE LARGE BATHERS (FIG. 19-64), probably begun in the last year of his life, and left unfinished. This canvas, the largest Cézanne ever painted, culminated his involvement with the subject of nude bathers in nature, a theme he had admired in the Old Masters and had depicted on numerous earlier occasions. Unlike his predecessors, however, Cézanne did not usually paint directly from models but instead worked from earlier drawings, photographs, and memory. As a result, his bathers do not appear lifelike but have simplified, schematic forms. In The Large Bathers, the bodies cluster in two pyramidal groups at the left and right sides of the painting, beneath a canopy of trees that opens in the middle onto a triangular expanse of water, landscape, and sky. The figures assume motionless, statuesque poses (the crouching figure at the left quotes the Hellenistic Crouching Venus that Cézanne had copied in the Louvre) and seem to exist in a timeless realm, unlike the bathers of Manet (SEE FIG. 19-49), who clearly inhabit the modern world. Emphasizing the scene's serene remoteness from everyday life, the simplified yet resonant palette of blues and greens, ochers and roses, laid down in large patches over a white ground, suffuses the picture with light. Despite its unfinished state, The Large Bathers stands as a

grand summation of Cézanne's art. His conception of the canvas as a separate realm from reality, requiring its own rules of composition, is his chief legacy to Modern art.

SEURAT. Georges Seurat was another artist who, like Cézanne, adapted Impressionist discoveries to the creation of an art of greater structure and monumentality. Born in Paris and trained at the École des Beaux-Arts, Seurat became devoted to classical aesthetics, which he combined with a rigorous study of optics and color theory, especially the "law of the simultaneous contrast of colors," first formulated by Michel-Eugène Chevreul in the 1820s. Chevreul's law holds that adjacent objects not only cast reflections of their own color onto their neighbors but also create in them the effect of their complementary color. Thus, when a blue object is set next to a yellow one, the eye will detect a trace of purple, the complement of yellow, and in the yellow object a trace of orange, the complement of blue.

The Impressionists knew of Chevreul's law but had not applied it systematically. Seurat, however, approached color as a scientist might. He calculated exactly which hues should be combined, in what proportion, to produce the effect of a particular color. He then set these hues down in dots of pure color, next to one another, in what came to be known by the

various names of *divisionism* (the term preferred by Seurat), *pointillism*, and *Neo-Impressionism*. In theory, these juxtaposed dots would merge in the viewer's eye to produce the impression of other colors, which would be perceived as more luminous and intense than the same hues mixed on the palette. In Seurat's work, however, this optical mixture is never complete, for his dots of color are large enough to remain separate in the eye, giving his pictures a grainy appearance the artist liked because it better showed the underlying order of his work.

Seurat's best-known work is **A SUNDAY AFTERNOON ON THE ISLAND OF LA GRANDE JATTE** (FIG. 19–65), which he first exhibited at the eighth and final Impressionist exhibition in 1886. The theme of weekend leisure is typically Impressionist, but the rigorous divisionist technique, the stiff formality of the figures, and the highly calculated geometry of the composition produce a solemn, abstract effect quite at odds with the casual naturalism of earlier Impressionism. Seurat's picture in fact depicts a contemporary subject in a highly formal style recalling much older art, such as that of the ancient Egyptians.

From its first appearance, A Sunday Afternoon on the Island of La Grande Jatte has generated conflicting interpretations. Contemporary accounts of the island indicate that on Sundays it was noisy, littered, and chaotic. By painting it the way he did, Seurat may have intended to show how tranquil it should be. It is more likely that he was satirizing the Parisian middle class, since like Pissarro he was a devotee of anarchist beliefs and made cartoons for anarchist magazines at that time.

VAN GOGH. Among the many artists to experiment with divisionism was the Dutch painter Vincent van Gogh, who took divisionism and Impressionism and made of them a highly expressive personal style. The oldest son of a Protestant minister van Gogh worked as an art dealer, teacher, and evangelist before deciding in 1880 to become an artist. After brief periods of study in Brussels, The Hague, and Antwerp, he moved in 1886 to Paris, where he discovered the work of the Impressionists and Post-Impressionists. Van Gogh quickly adapted Seurat's divisionism, but rather than laying his paint

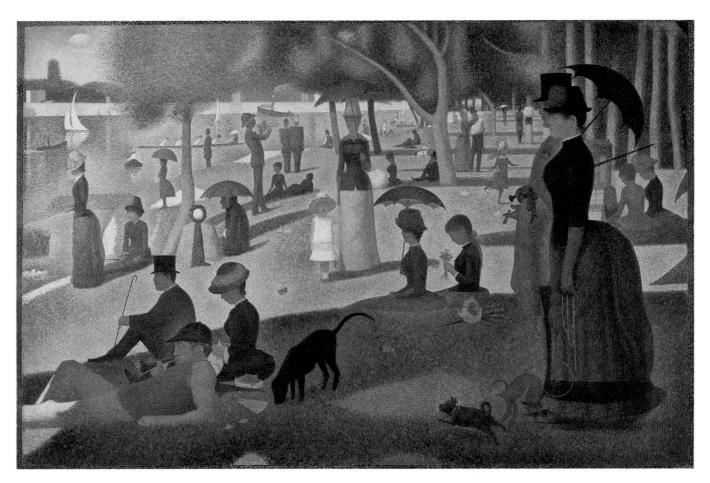

19–65 | Georges Seurat A SUNDAY AFTERNOON ON THE ISLAND OF LA GRANDE JATTE 1884–86. Oil on canvas, $6'9\frac{1}{2}''\times10'1\frac{1}{4}''$ (2.07 \times 3.08 m). The Art Institute of Chicago. Helen Birch Bartlett Memorial Collection

Although the painting is highly stylized and carefully composed, it has a strong basis in factual observation. Seurat spent months visiting the island, making small studies, drawings, and oil paintings of the light and the people he found there. All of the characters in the final painting, including the woman with the monkey, were based on his observations at the site.

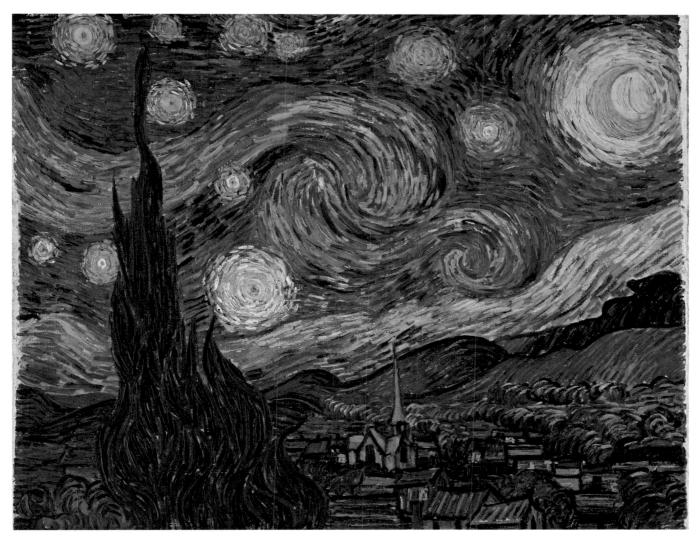

down regularly in dots, he typically applied it freely in multidirectional dashes of impasto (thick applications of pigment), which gave his pictures a greater sense of physical energy and a palpable surface texture.

Van Gogh was a socialist who believed that modern life, with its constant social change and focus on progress and success, alienated people from each other and themselves (see "Modern Artists and World Cultures," page 782). His own paintings are efforts to establish empathy between artist and viewer, thereby overcoming some of the emotional barrenness that he felt modern society created. In a steady and prolific output over ten years, he communicated his emotional state in paintings that contributed significantly to the emergence of the Expressionistic tradition, in which the intensity of an artist's feelings overrides fidelity to the actual appearance of things. For example, he once described his working method in a letter to his brother:

I should like to paint the portrait of an artist friend who dreams great dreams, who works as the nightingale sings, because it is his nature. This man will be fair-haired. I should like to put my appreciation, the love I have for him, into the picture. So I will paint him as he is, as faithfully as I can—to begin with. But that is not the end of the picture. To finish it, I shall be an obstinate colorist. I shall exaggerate the fairness of the hair, arrive at tones of orange, chrome, pale yellow. Behind the head—instead of painting the ordinary wall of the shabby apartment, I shall paint infinity, I shall do a simple background of the richest, most intense blue that I can contrive, and by this simple combination, the shining fair head against this rich blue background, I shall obtain a mysterious effect, like a star in the deep blue sky.

One of the earliest and most famous examples of Expressionism is **THE STARRY NIGHT** (FIG. 19–66), which van Gogh painted from imagination and memory as well as

Art in Its Context

MODERN ARTISTS AND WORLD CULTURES

on-Western art has been a constant influence on a great deal of Modern art. In some respects this is logical, because if artists regard their own tradition as outmoded or in need of reform, they may naturally look to other cultures for inspiration. Artistic interest in foreign cultures is certairly not new—the Orientalists, for example, visited many countries—but unlike previous cultural interactions, Modern artists were open to stylistic influence from nearly every inhabited continent.

The first wave of such influence was from Japan, beginning shortly after the U.S. Navy forcibly opened that country to Western trade and diplomacy in 1853.

Two years later, France, England, Russia, and the United States signed trade agreements that permitted regular exchange of goods. The first Japanese art to engage the attention of Modern artists was a sketchbook called *Manga* by Hokusai (1760–1849), which several Parisian artists eagerly passed around. Soon it became fashionable for people connected to the art world to collect Japanese objects for their homes. Édouard Manet, for example, painted a portrait of Emile Zola at his desk along with a Japanese screen and some prints that he owned. The Paris International Exposition of 1867 hosted the first exhibit of Japanese prints on the continent.

Soon, Japanese lacquers, fans, bronzes, hanging scrolls, kimonos, ceramics, illustrated books, and *ukiyo-e* (prints of the "floating world," the realm of geishas and popular entertainment) began to appear in Western European specialty shops, art galleries, and even some department stores. French interest in Japan and its arts reached such proportions by 1872 that the art critic Philippe Burty gave it a name: *japonisme*.

Japanese art profoundly influenced Western painting, print-making, applied arts, and eventually architecture. The tendency toward simplicity, flatness, and the decorative evident in much painting and graphic art in the West between roughly 1860 and 1900 is probably the most characteristic result of that influence. Nevertheless, its impact was extraordinarily diverse. What individual artists took from the Japanese depended on their own interests. Thus, Whistler found encouragement for his decorative conception of art, while Edgar Degas discovered both realistic subjects and interesting compositional arrangements, and those interested in the reform of late nineteenth-century industrial design found in Japanese objects both fine craft and a smooth elegance lacking in the West. Vincent van Gogh enjoyed the bold design and handcrafted quality of Japanese prints. He both owned and copied Japanese prints, as the accompanying illustrations show.

Other artists saw in non-Western cultures not only new art styles, but also alternatives to Western civilization. Many Modern artists embraced preindustrial cultures, often naively, in a search for what was "primitive" and hence purer. Paul Gauguin's attitude was among the most enthusiastic of these, but primitivism remained an important influence on Modern art well into the twentieth century.

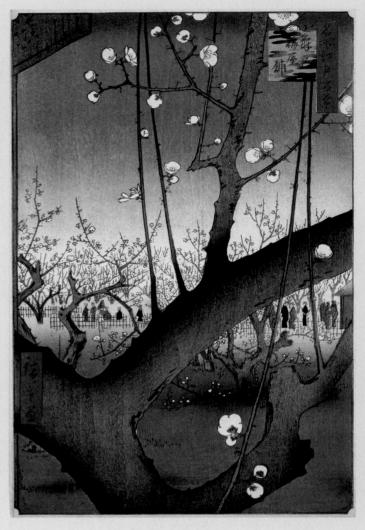

Hiroshige PLUM ORCHARD, KAMEIDO 1857. From *One Hundred Famous Views of Edo*. Woodblock print, $13\frac{7}{4} \times 8\frac{7}{4}$ " (33.6 \times 47 cm). The Brooklyn Museum, New York.

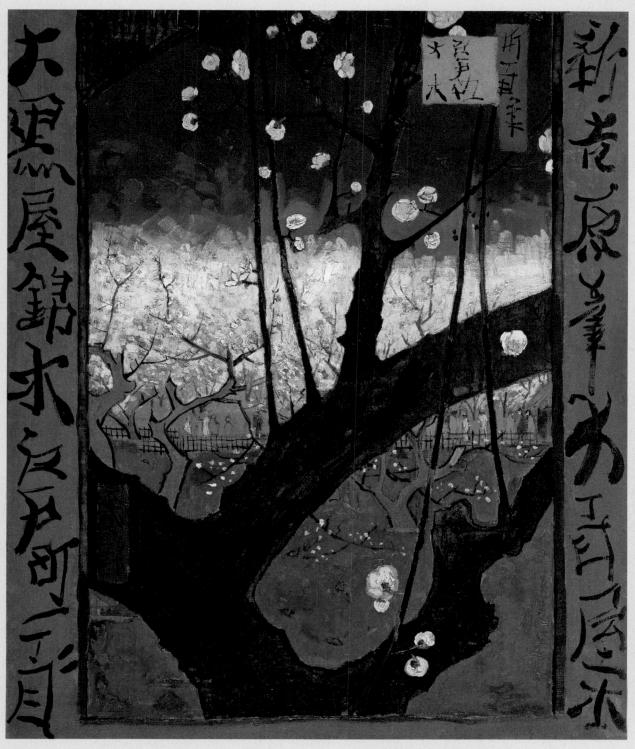

Vincent van Gogh JAPONAISERIE: FLOWERING PLUM TREE 1887. Oil on canvas, $21\frac{1}{2} \times 18$ " (54.6 \times 45.7 cm). Vincent van Gogh Museum, Amsterdam.

observation. Above the quiet town the sky pulsates with celestial rhythms and blazes with exploding stars. Van Gogh may have subscribed to the then-popular theory that after death people journey to a star, where they continue their lives. Contemplating immortality in a letter, van Gogh wrote: "Just as we take the train to get to Tarascon or Rouen, we take death to reach a star." The idea is given visible form in this painting by the cypress tree, a traditional symbol of both death and eternal life, which dramatically rises to link the terrestrial and celestial realms. The brightest star in the sky is actually a planet, Venus, which is associated with love. It is possible that the picture's extraordinary excitement also expresses van Gogh's euphoric hope of gaining the companionship that had eluded him on earth. The painting is a riot of brushwork, as rail-like strokes of intense color writhe across its surface. If the traditional function of brushwork is to describe a subject, van Gogh surpassed this and made brushwork more immediately expressive of the artist's feelings than any previous painter in the Western tradition. During the last year and a half of his life he experienced repeated psychological crises that lasted for days or weeks. While they were raging, he wanted to hurt himself and he heard loud noises in his head, but he could not paint. The stress and burden of these attacks led him into a mental asylum and eventually to his suicide in July 1890.

GAUGUIN. In painting from his imagination rather than from nature in The Starry Night, van Gogh was perhaps following the advice of his friend Gauguin, who had once counseled another colleague, "Don't paint from nature too much. Art is an abstraction. Derive this abstraction from nature while dreaming before it, and think more of the creation that will result." Gauguin's own mature work was even more abstract than van Gogh's, and, like Cézanne's, it laid important foundations for the development of nonrepresentational art in the twentieth century. Born in Paris to a Peruvian mother and a radical French journalist father, Gauguin lived in Peru from infancy until the age of seven; this experience, together with his service in the Merchant Marine in his youth, may have awakened in him the wanderlust that marked his artistic life. During the 1870s and early 1880s Gauguin enjoyed a comfortable bourgeois life as a stockbroker and painted in his spare time under the tutelage of Pissarro. Between 1880 and 1886, he exhibited in the final four Impressionist exhibitions. In 1883, Gauguin lost his job during a stock market crash; three years later he abandoned his wife and five children to pursue a full-time painting career. Gauguin knew firsthand the business-oriented culture of the day, and he came to despise it, at one point dismissing capitalism in a letter to a friend as "the European struggle for money." Disgusted by what he considered the corruption of urban civilization and seeking a more "primitive" existence,

Gauguin lived for extended periods in the French province of Brittany between 1886 and 1891, traveled to Panama and Martinique in 1887, spent two months in Arles with van Gogh in 1888, and then in 1891 sailed for Tahiti, a French colony in the South Pacific. After a final sojourn in France in 1893–95, Gauguin returned to the Pacific, where he died in 1903.

Gauguin's mature style was inspired by such nonacademic sources as medieval stained glass, folk art, and Japanese prints, and it featured simplified drawing, flattened space, and antinaturalistic color. Gauguin rejected Impressionism because it neglected subjective feelings and "the mysterious centers of thought." Gauguin called his anti-Impressionist style synthetism, because it synthesized observation of the subject in nature with the artist's feelings about that subject, expressed through abstracted line, shape, space, and color. Very much a product of such synthesis is MAHANA NO ATUA (DAY **OF THE GOD)** (FIG. 19–67), which, despite its Tahitian subject, was painted in France during one of his return trips home from the South Pacific. Gauguin had gone to Tahiti hoping to find an unspoiled paradise where he could live and work cheaply and "naturally." What he discovered, instead, was a thoroughly colonized country whose native culture was rapidly disappearing under the pressures of Westernization. In his paintings, Gauguin ignored this reality and depicted the Edenic ideal in his imagination, as seen in Mahana no atua, with its bright colors, stable composition, and appealing subject matter.

Gauguin divided Mahana no atua into three horizontal zones in styles of increasing abstraction. The upper zone, painted in the most realistic manner, centers around the statue of a god, behind which extends a beach landscape populated by Tahitians. This god was not local to Tahiti; it is Gauguin's version of a Javanese figure that he saw illustrated in a magazine. In the middle zone, directly beneath the statue, three figures occupy a beach divided into several bands of antinaturalistic color. The central female bather dips her feet in the water and looks out at the viewer, while on either side of her two figures recline in fetuslike postures—perhaps symbolizing birth, life, and death. Filling the bottom zone of the canvas is a strikingly abstract pool whose surface does not reflect what is above it but instead offers a dazzling array of bright colors, arranged in a puzzlelike pattern of flat, curvilinear shapes. By reflecting a strange and unexpected reality exactly where we expect to see a mirror image of the familiar world, this magic pool seems the perfect symbol of Gauguin's desire to evoke "the mysterious centers of thought." Gauguin's chief groundbreaking innovation was his use of color not to describe a subject, but to express his feelings. Like many of Gauguin's works, Mahana no atua is enigmatic and suggestive of unstated meanings that cannot be literally represented but only evoked indirectly through abstract pictorial means.

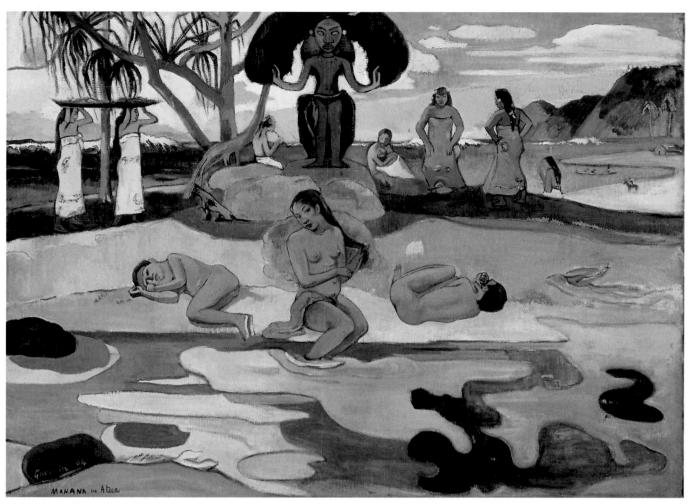

19–67 | Paul Gauguin MAHANA NO ATUA (DAY OF THE GOD) 1894. Oil on canvas, $27 \% \times 35 \%$ " (69.5 \times 90.5 cm). The Art Institute of Chicago. Helen Birch Bartlett Memorial Collection (1926.198)

Symbolism in Painting

Gauguin's suggestiveness is characteristic of Symbolism, an international movement in late nineteenth-century art and literature of which he was a recognized leader. Like the Romantics before them, the Symbolists opposed the values of rationalism and material progress that dominated modern Western culture and instead explored the nonmaterial realms of emotion, imagination, and spirituality. Ultimately the Symbolists sought a deeper and more mysterious reality than the one we encounter in everyday life, which they conveyed not through traditional iconography but through ambiguous subject matter and formal stylization suggestive of hidden and elusive meanings. Instead of objectively representing the world, they transformed appearances in order to give pictorial form to psychic experience, and they often compared their works to dreams. It seems hardly coincidental that Sigmund Freud, who compared artistic creation to the process of dreaming, wrote his pioneering The Interpretation of Dreams (1900) during the Symbolist period.

The Symbolist movement in painting closely parallels a similar one in literature, led by poets and art critics such as Maurice Maeterlinck, Jean Moréas, Joris-Karl Huysmans, and Paul Verlaine. Pronouncing themselves disgusted with the alleged materialism of contemporary society, they too retreated into fantasy worlds that they conjured from their imaginations. The purpose of a work of art, they wrote, was to serve as an evacuation hoist, lifting us out of our grimy present reality into a world of dreams and hallucinations. Maeterlinck wrote an extended poem about a forbidden medieval love affair, Pelleas and Melisande, in which the action takes place mostly at night, and Melisande's long yellow hair both illuminates some scenes and symbolizes her sexuality (composer Claude Debussy would turn this poem into a Symbolist opera in 1901). Huysmans' short novel Against the Grain (A Rebours) has a single character, an aristocrat named Des Esseintes, who locks himself away from the world because "Imagination could easily be substituted for the vulgar realities of things." Even nature was boring to the

Symbolists. Reversing Monet's criticism of the Romantics, Des Esseintes mused: "Nature had had her day, as he put it. By the disgusting sameness of her landscapes and skies, she had once and for all wearied the considerate patience of aesthetes." Instead, the truly sensitive person must take refuge in artworks "steeped in ancient dreams or antique corruptions, far removed from the manner of our present day."

EUROPEAN SYMBOLISTS. A dreamlike atmosphere pervades the later work of Gustave Moreau (1826–98), an older academic artist whom the Symbolists recognized as a precursor. The Symbolists particularly admired Moreau's renditions of the biblical Salome, the young Judaean princess who, at the instigation of her mother, Herodias, performed an erotic dance before her stepfather, Herod, and demanded in return the head of John the Baptist (Mark 6:21–28). In **THE APPARI**-

TION (FIG. 19–68), exhibited at the Salon of 1876, the seductive Salome confronts a vision of the saint's severed head, which hovers open-eyed in midair, simultaneously dripping blood and radiating holy light. Moreau depicted this macabre subject and its exotic architectural setting in elaborate linear detail with touches of jewel-like color. His style creates an atmosphere of voluptuous decadence that amplifies Salome's role as the archetypal *femme fatale*, the "fatal woman" who tempts and destroys her male victim—a fantasy that haunted the imagination of countless male Symbolists, perhaps partly in response to late nineteenth-century feminism.

A younger artist who embraced Symbolism was Odilon Redon (1840–1916). Although he exhibited with the Impressionists in 1886, he diverged from their artistic goals by using nature as a point of departure for fantastic visions tinged with loneliness and melancholy. For the first twenty-

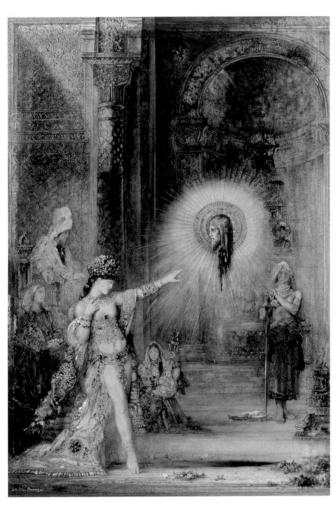

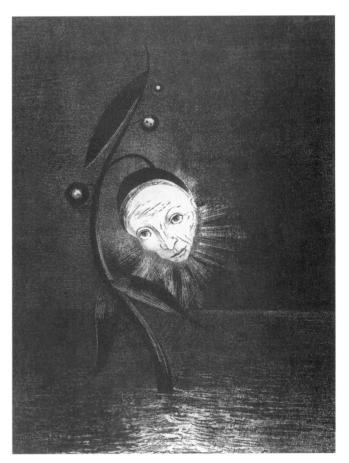

19–69 \perp Odilon Redon The Marsh Flower, a sad and human face

Plate 2 from *Homage to Goya*. 1885. Lithograph, $10\,\% \times 8'' \ (27.5 \times 20.3 \ cm)$. The Museum of Modern Art, New York. Abby Aldrich Rockefeller Purchase Fund

Fascinated by the science of biology, Redon based his strange hybrid creatures on the close study of living organisms. His aim, as he wrote in his journal, was "to make improbable beings live, like human beings, according to the laws of probability by putting . . . the logic of the visible at the service of the invisible."

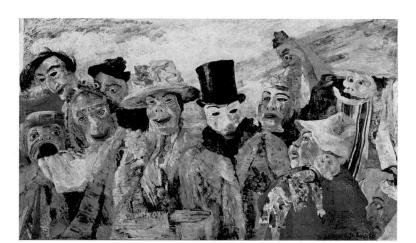

19–70 | James Ensor THE INTRIGUE 1890. Oil on canvas, $35 \frac{1}{2} \times 59$ " (90.3 \times 150 cm). Koninklijk Museum voor Schone Kunsten, Antwerp. © Ensor / Licensed by VAGA, New York, New York

five years of his career, Redon created moody images in black-and-white charcoal drawings that he referred to as *Noirs* ("Blacks"). He also made highly imaginative etchings and lithographs, such as **THE MARSH FLOWER**, **A SAD AND HUMAN FACE** (FIG. 19–69), one of many bizarre human-vegetal hybrids Redon invented. It should hardly surprise us that the fictional character Des Esseintes loved Redon, and in Huysmans' *Against the Grain* he spent an entire day looking at Redon's prints and dark charcoal drawings: "These designs were beyond anything imaginable; they leaped, for the most part, beyond the limits of painting and introduced a fantasy that was unique, the fantasy of a diseased and delirious mind."

Like the Impressionists, the Symbolists staged art exhibitions outside the normal venues of the day, but they cared less about attracting the general public. Instead of hiring a hall, printing a program, and charging a small admission fee as the Impressionists had done, the Symbolists showed modest exhibitions in more out-of-the-way places. For example, during the 1889 Universal Exposition, which marked the debut of the Eiffel Tower (SEE FIG. 19–1), they hung some works in a café a few blocks away from the grounds; the show passed almost unnoticed in the press.

Symbolism originated in France but had a profound impact on the avant-garde in other countries, where it often merged with Expressionist tendencies. Such a melding of Symbolism and Expressionism is evident in the work of the Belgian painter and printmaker James Ensor (1860-1949), who, except for four years of study at the Brussels Academy, spent his life in the coastal resort town of Ostend. Like Redon, Ensor derived his weird and anxious visions from the observation of the real world-often from the grotesque papier-mâché masks that his family sold during the annual pre-Lenten carnival, one of Ostend's main holidays. In paintings such as THE INTRIGUE (FIG. 19-70), these disturbing masks seem to come to life and reveal rather than hide the character of the people wearing them—comical, stupid, and hideous. The acidic colors increase the sense of caricature, as does the crude handling of form. The rough paint is both

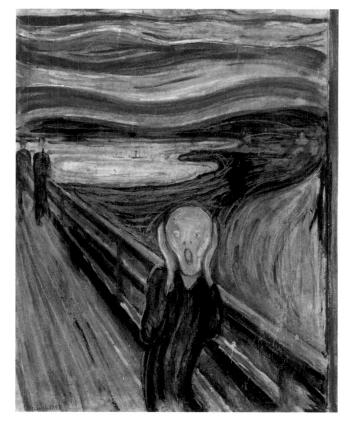

19–71 | Edvard Munch THE SCREAM 1893. Tempera and casein on cardboard, $36 \times 29''$ (91.3 \times 73.7 cm). Nasjonalgalleriet, Oslo, Norway.

expressive and Expressionistic: Its lack of subtlety well characterizes the subjects, while its almost violent application directly records Ensor's feelings toward them.

The sense of powerful emotion that pervades Ensor's work is even more evident in that of his Norwegian contemporary Edvard Munch (1863–1944). Munch's most famous work, **THE SCREAM** (FIG. 19–71), is an unforgettable image of modern alienation that merges Symbolist suggestiveness with

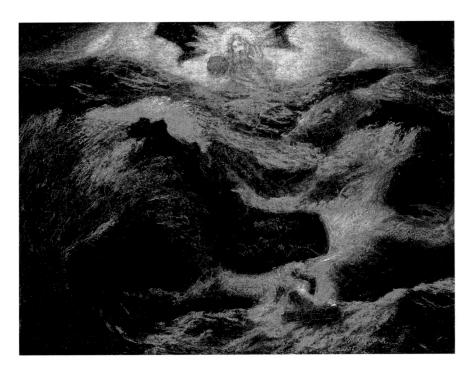

19–72 | Albert Pinkham Ryder JONAH

c. 1885. Oil on canvas, mounted on fiberboard, $27\% \times 34\%$ " (69.2 \times 87.3 cm). Smithsonian American Art Museum, Smithsonian Institution, Washington, D.C. Gift of John Gellatly, (1929.6.98)

Expressionist intensity of feeling. Munch recorded the painting's genesis in his diary: "One evening I was walking along a path; the city was on one side, and the fjord below. I was tired and ill. . . . I sensed a shriek passing through nature. . . . I painted this picture, painted the clouds as actual blood." In the painting itself, however, the figure is on a bridge and the scream emanates from him. Although he vainly attempts to shut out its sound by covering his ears, the scream fills the landscape with clouds of "actual blood." The overwhelming anxiety that sought release in this primal scream was chiefly a dread of death, as the sky and the figure's skull-like head suggest, but the setting of the picture also suggests a fear of open spaces. The expressive abstraction of form and color in the painting reflects the influence of Gauguin and his Scandinavian followers, whose work Munch had encountered shortly before he painted The Scream.

AMERICAN SYMBOLISTS. Some American artists of the late nineteenth century turned their backs on modern reality and, like their European Symbolist counterparts, escaped into the realms of myth, fantasy, and imagination. Some were also attracted to traditional literary, historical, and religious subjects, which they treated in unconventional ways to give them new meaning, as Albert Pinkham Ryder (1847–1917) did in his highly expressive interpretation of JONAH (FIG. 19–72).

Ryder moved from Massachusetts to New York City around 1870 and studied at the National Academy of Design. Although he traveled to Europe four times between 1877 and 1896, he seems to have been mostly unaffected by both the old and modern works he saw there. His mature painting style was an extremely personal one, as were his working

methods. Ryder would paint and repaint the same canvas over a period of several years, loading glazes one on top of another to a depth of a quarter inch or more, mixing in with his oils such substances as varnish, bitumen, and candle wax. Due to chemical reactions between his materials and the uneven drying times of the layers of paint, most of Ryder's pictures have become darkened and severely cracked.

In *Jonah*, Ryder depicted the moment when the terrified Old Testament prophet, thrown overboard by his shipmates, was about to be consumed by a great fish. Appearing above in a blaze of holy light is God, shown as a bearded old man who holds the orb of divine power and makes a gesture of blessing, as if promising Jonah's eventual redemption. Both the subject—being overwhelmed by hostile nature—and its dramatic treatment through dynamic curves and sharp contrasts of light and dark are characteristically Romantic. The broad, generalized handling of the violent sea is particularly reminiscent of Turner (SEE FIGS. 19–15, 19–16), one of the few European artists whose work Ryder is known to have admired.

Vividly imagined biblical subjects became a specialty of Henry Ossawa Tanner (1859–1937), the most successful African American painter of the late nineteenth and early twentieth centuries. The son of a bishop in the African Methodist Episcopal Church, Tanner grew up in Philadelphia, sporadically studied art under Thomas Eakins at the Pennsylvania Academy of the Fine Arts between 1879 and 1885, then worked as a photographer and drawing teacher in Atlanta. In 1891 he moved to Paris for further academic training. In the early 1890s Tanner painted a few African American genre subjects but ultimately turned to biblical painting in order to make his art serve religion.

Tanner's **THE RESURRECTION OF LAZARUS** (FIG. 19–73) received a favorable critical reception at the Paris Salon of 1897 and was purchased by the Musée du Luxembourg, the museum for living artists. The subject is the biblical story in which Jesus went to the tomb of his friend Lazarus, who had been dead for four days, and revived him with the words "Lazarus, come forth" (John 11:1–44). Tanner shows the moment following the miracle, as Jesus stands before the amazed onlookers and gestures toward Lazarus, who begins to rise from his tomb. The limited palette of browns and golds, reminiscent of Rembrandt but more intense, is appropriate for the somber burial cave. It also has the expressive effect of unifying the astonished witnesses in their recognition that a miracle has indeed occurred.

Late Nineteenth-Century French Sculpture

RODIN. The most successful and influential European sculptor of the late nineteenth century was Auguste Rod:n (1840–1917), whose work embodies some of the contemporary Symbolist and Expressionist currents. The public was much more prepared to accept his style, however, than that of the Symbolists. Born in Paris and trained as a decorative craftworker, Rodin failed on three occasions to gain entrance to the École des Beaux-Arts and consequently spent the first twenty years of his career as an assistant to other sculptors and

decorators. After an 1875 trip to Italy, where he saw the sculpture of Donatello and Michelangelo, Rodin developed his mature style of vigorously modeled figures in unconventional poses, which were simultaneously scorned by academic critics and admired by the general public.

Rodin's status as a major sculptor was confirmed in 1884, when he won a competition for the BURGHERS OF CALAIS (FIG. 19-74), commissioned to commemorate an event from the Hundred Years' War. In 1347 Edward III of England had offered to spare the besieged city of Calais if six leading citizens (or burghers)—dressed only in sackcloth with rope halters and carrying the keys to the city—would surrender to him for execution. Rodin shows the six volunteers preparing to give themselves over to what they assume will be their deaths. The Calais commissioners were not pleased with Rodin's conception of the event. Instead of calm, idealized heroes, Rodin presented ordinary-looking men in various attitudes of resignation and despair. He exaggerated their facial expressions, expressively lengthened their arms, greatly enlarged their hands and feet, and swathed them in heavy fabric, showing not only how they may have looked but how they must have felt as they forced themselves to take one difficult step after another. Rodin's willingness to szylize the human body for expressive purposes was a revolutionary move that opened the way for the more radical innovations of later sculptors.

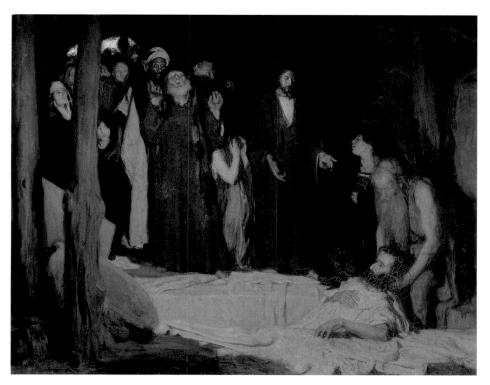

19–73 | Henry Ossawa Tanner THE RESURRECTION OF LAZARUS 1896. Oil on canvas, $37\% \times 47\%$ (94.9 × 121.4 cm). Musée d'Orsay, Paris.

Tanner believed that biblical stories could illustrate the struggles and hopes of contemporary African Americans. He may have depicted the resurrection of Lazarus because many black preachers made a connection between the story's themes of redemption and rebirth and the Emancipation Proclamation of 1863, which freed black slaves and gave them a new life.

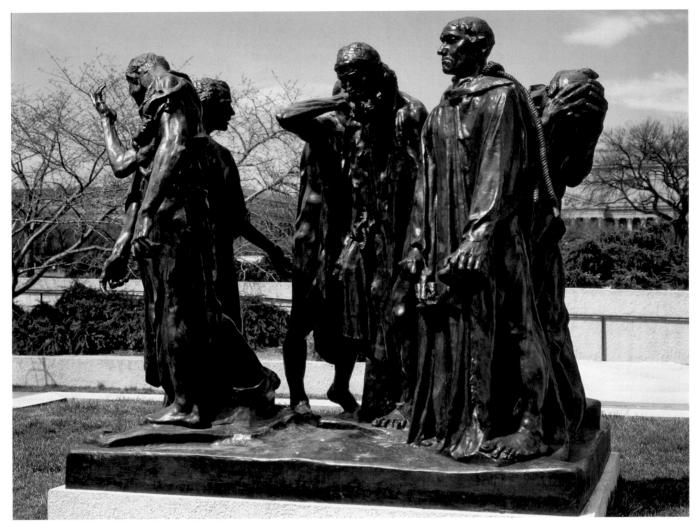

19–74 | Auguste Rodin BURGHERS OF CALAIS 1884–89. Bronze, $6'10\%'' \times 7'11'' \times 6'6''$ (2.1 \times 2.4 \times 2 m). Hirshhorn Museum and Sculpture Garden, Smithsonian Institution, Washington, D.C. Gift of Joseph H. Hirshhorn, 1966

Nor were the commissioners pleased with Rodin's plan to display the group on a low pedestal. Rodin felt that the usual placement of such figures on an elevated pedestal suggested that only higher, superior humans are capable of heroic action. By placing the figures nearly at street level, Rodin hoped to convey to viewers that ordinary people, too, are capable of noble acts. Rodin's removal of public sculpture from a high to a low pedestal would lead, in the twentieth century, to the elimination of the pedestal itself and to the presentation of sculpture in the "real" space of the viewer.

CLAUDEL. An assistant in Rodin's studio who worked on the *Burghers of Calais* was Camille Claudel (1864–1943), whose accomplishments as a sculptor were long overshadowed by the dramatic story of her life. Claudel began to study

sculpture in 1879 and became Rodin's pupil four years later. After she started working in his studio, she also became his mistress, and their often stormy relationship lasted fifteen years. Both during and after her association with Rodin, Claucel enjoyed independent professional success, but she also suffered from psychological problems that eventually overtook her, and she spent the last thirty years of her life in a mer.tal asylum.

Among Claudel's most celebrated works is **THE WALTZ** (FIG. 19–75), which exists in several versions made between 1892 and 1905. The sculpture depicts a dancing couple, the man unclothed and the woman seminude, her lower body enveloped in a long, flowing gown. In Claudel's original conception, both figures were entirely nude, but she had to add drapery to the female figure after an inspector from the Ministry of the Beaux-Arts found the pairing of the nude

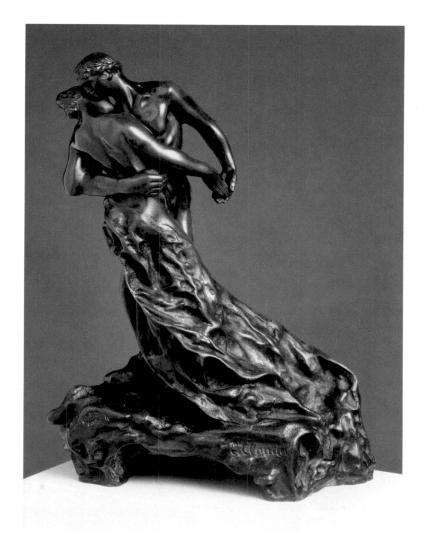

19–75 | Camille Claudel THE WALTZ 1892–1905. Bronze, 91/8" (25 cm). Neue Pinakothek, Munich.

French composer Claude Debussy, a close friend of Claudel, displayed a cast of this sculpture on his piano. Debussy acknowledged the influence of art and literature on his musical innovations.

bodies indecent and recommended against a state commission for a marble version of the work. After Claudel added drapery, the same inspector endorsed the commission, but it was never carried out. Instead, Claudel modified *The Waltz* further and had it cast in bronze.

In this work, Claudel succeeded in conveying an illusion of fluent motion as the dancing partners whirl in space, propelled by the rhythm of the music. The spiraling motion of the couple, enhanced by the woman's flowing gown, encourages the observer to view the piece from all sides, increasing its dynamic effect. Despite the physical closeness of the dancers there is little actual physical contact between them, and their facial expressions reveal no passion or sexual desire. After violating decency standards with her first version of *The Waltz*, Claudel perhaps sought in this new rendition to portray love as a union more spiritual than physical.

Art Nouveau

The swirling mass of drapery in Claudel's Waltz has a stylistic affinity with Art Nouveau (French for "new art"), a movement launched in the early 1890s that for more than a decade permeated all aspects of European art, architecture, and design. Like the contemporary Symbolists, the practitioners of Art Nouveau largely rejected the values of modern industrial society and sought new aesthetic forms that would retain a preindustrial sense of beauty while also appearing fresh and innovative. They drew particular inspiration from nature, especially from organisms such as vines, snakes, flowers, and winged insects, whose delicate and sinuous forms were the basis of their graceful and attenuated linear designs. Following from this commitment to organic principles, they also sought to harmonize all aspects of design into a beautiful whole, as found in nature itself.

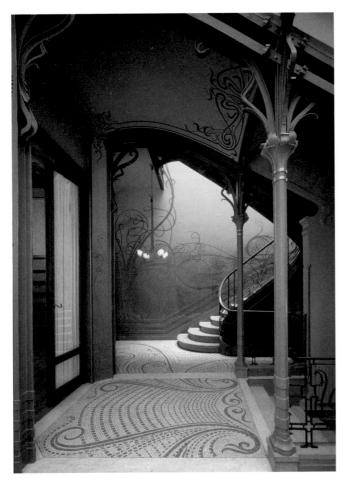

19–76 | Victor Horta STAIRWAY, TASSEL HOUSE Brussels. 1892–93.

HORTA AND VAN DE VELDE. The artist most responsible for introducing the Art Nouveau style in architecture was the Belgian, Victor Horta (1861–1947). Trained at the academies in Ghent and Brussels, Horta worked in the office of a Neoclassical architect in Brussels for six years before opening his own practice in 1890. In 1892 he received his first important commission, a private residence in Brussels for a Professor Tassel. The result, especially the house's entry hall and staircase (FIG. 19-76), was strikingly original. The ironwork, wall decoration, and floor tile were all designed in an intricate series of long, graceful curves. Although Horta's sources are still a matter of debate, he apparently was much impressed with the stylized linear graphics of the English Arts and Crafts movement of the 1880s. Horta's concern for integrating the various arts into a more unified whole, like his reliance on a refined decorative line, derived largely from English reformers.

Horta's contemporary and compatriot Henry van de Velde (1863–1957) brought the Art Nouveau style into nearly all of the decorative arts. He studied at the Belgian National Academy in Antwerp, then went to Paris where he saw the Post-Impressionist art of Seurat and others. After a period making divisionist works in the late 1880s, his reading

of William Morris's socialist theories of art (see page 1022) convinced him that he should devote his creative energies toward art that everyone can see. From that moment he focused his efforts on useful objects. After designing a house for his family in 1895, he proceeded to create the rugs, furniture, utensils, wallpaper, and even his wife's dresses. He wrote in an exhibition catalogue near the same time, "The hope of a happy and egalitarian future lies behind these new decorative works." His design office in Brussels became a beehive of activity, and he argued against historicism in architecture and in favor of art for all. When the grocery firm Tropon approached him with a commission for a new advertising campaign, van de Velde created the first integrated marketing program in the history of design (FIG. 19-77). The abstract ovoid module that forms the center of this poster became the company's logo, and was featured on all of its products, as well as its stationery, advertising, and delivery vehicles.

GAUDÍ AND KLIMT. The application of graceful linear arabesques to all aspects of design, evident in the entry hall of the Tassel House, began a vogue that spread across Europe. In Spain, where the style was called *Modernismo*, the major practitioner was the Catalan architect Antonio Gaudí i Cornet

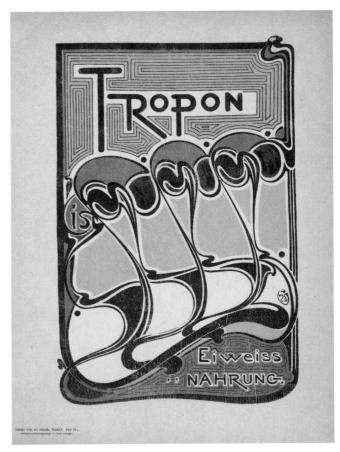

19–77 | Henry van de Velde **TROPON** 1898. Color lithograph, $12\,\% \times 8''$ (31 \times 20 cm). Fine Arts Museums of San Francisco.

Achenbach Foundation for the Graphic Arts Purchase, 1976.1.361

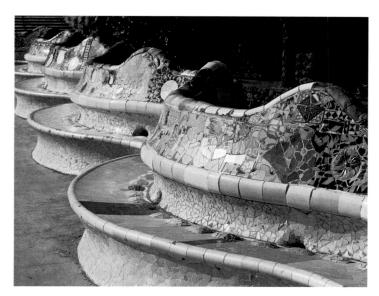

19–78 \perp Antonio Gaudí SERPENTINE BENCH, GÜELL PARK Barcelona. 1900–14.

(1852–1926). Gaudí attempted to integrate natural forms into his buildings and into daily life. For a public plaza on the outskirts of Barcelona, he combined architecture and sculpture in a continuous, serpentine bench that also is a boundary

wall (FIG. 19–78). Its surface is a glittering mosaic of broken pottery and tiles in homage to the long tradition of ceramic work in Spain.

In Austria, Art Nouveau was referred to as *Sezessionstil* because of its association with the Vienna Secession, one of several such groups formed in the late nineteenth century by progressive artists who seceded from conservative academic associations to form more liberal exhibiting bodies. The Vienna Secession's first president, Gustav Klimt (1862–1918), led a faction within the group dedicated to a richly decorative art and architecture that would offer an escape from the drab, ordinary world.

Between 1907 and 1908 Klimt perfected what is called his golden style, seen in **THE KISS** (FIG. 19–79), where a couple embrace in a golden aura. The representational elements here are subservient to the decorative ones, which are characteristically Art Nouveau in their intricate, ornamental quality. Not evident at first glance is the tension in the couple's physical relationship, most noticeable in the way that the woman's head is forced uncomfortably against her shoulder. That they kneel dangerously close to the edge of a precipice further unsettles the initial impression for those willing to look further into the beautiful surface.

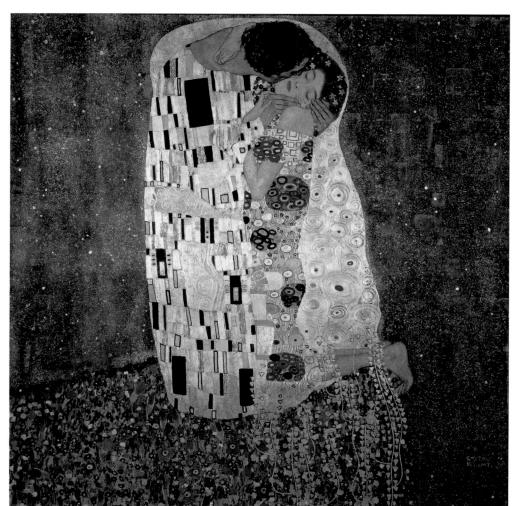

19-79 | Gustav Klimt THE KISS 1907-8. Oil on canvas, 5' 10¾" × 6' (1.8 × 1.83 m). Österreichische Nationalbibliothek, Vienna.

The Secession was part of a generational revolt expressed in art, politics, literature, and the sciences. The Viennese physician Sigmund Freud, founder of psychoanalysis, may be considered part of this larger cultural movement, one of whose major aims was, according to the architect Otto Wagner, "to show modern man his true face."

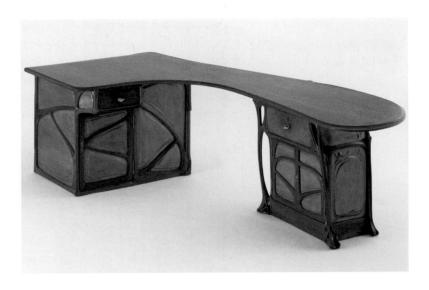

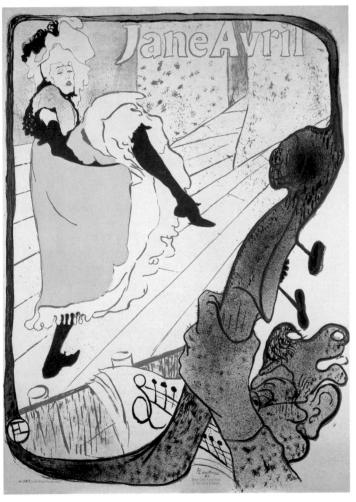

19–81 | Henri de Toulouse-Lautrec JANE AVRIL 1893. Lithograph, $50 \frac{1}{2} \times 37''$ (129 \times 94 cm). San Diego Museum of Art. Gift of the Baldwin M. Baldwin Foundation (1987.32)

GUIMARD AND TOULOUSE-LAUTREC. In France, Art Nouveau was also sometimes known as *Style Guimard* after its leading French practitioner, Hector Guimard (1867–1942). Guimard worked in an eclectic manner during the early 1890s, but in 1895 he met and was influenced by Horta. He went on to design the famous Art Nouveau-style entrances for the Paris Métro (subway) and devoted considerable effort to interior design and furnishings, such as the desk he made for himself (FIG. 19–80). Instead of a static and stable object, Guimard handcrafted an asymmetrical, organic entity that seems to undulate and grow.

We see the influence of the Art Nouveau style on the century's best-known poster designer, Henri de Toulouse-Lautrec (1864–1901). Born into an aristocratic family in the south of France, Lautrec suffered from a genetic disorder and childhood accidents that left him physically handicapped and short in height. Extremely gifted artistically, he moved to Paris in 1882 and had private academic training before discovering the work of Degas, which greatly influenced his own development. He also discovered Montmartre, a lower-class entertainment district of Paris, and soon joined its population of bohemian artists. From the late 1880s Lautrec dedicated himself to depicting the social life of the Parisian cafés, theaters, dance halls, and brothels—many of them in Montmartre—that he himself frequented.

Among these images were thirty lithographic posters Lautrec designed between 1891 and 1901 as advertisements for popular night spots and entertainers. His portrayal of the café dancer Jane Avril (FIG. 19–81) demonstrates the remarkable originality that Lautrec brought to an essentially commercial project. The composition juxtaposes the dynamic figure of Avril dancing onstage at the upper left with the cropped image of a bass viol player and the scroll of his instrument at the lower right. The bold foreshortening of the stage and the prominent placement of the bass in the foreground both suggest the influence of Degas, who employed

similar devices (SEE FIG. 19–56). Lautrec departs radically from Degas's naturalism, however, particularly in his imaginative extension of each end of the bass viol's head into a curving frame that encapsulates Avril and connects her visually with her musical accompaniment. Also antinaturalistic are the radical simplification of form, suppression of modeling, flattening of space, and integration of blank paper into the composition, all of which suggest the influence of Japanese woodblock prints. Meanwhile, the emphasis on curving lines and the harmonization of the lettering with the rest of the design are characteristic of Art Nouveau.

Late-Century Photography

Despite the efforts of Rejlander, Cameron, and others to win recognition for photography as an art form (SEE FIGS. 19–28, 19–29), the medium was still generally regarded as a "handmaiden to the arts," as poet Charles Baudelaire put it. Painters such as Ingres, Delacroix, and Courbet had used photographs in place of posed models for some of their paintings, and photographers were widely accepted as portraitists or journalists, but dominant opinion still held back from accepting them as artists. Their efforts to gain legitimacy led to the rise of an international movement known as *Pictorialism*, in which photographers sought to create images whose aesthetic qualities matched those of Modern painting, drawing, and printmaking. The principal debate among Pictorialists was over

the degree of manipulation a photographer could engage in. Some photographers urged combining negatives into a print, as Rejlander had done, while others, who called themselves Naturalists or straight photographers, preferred composing a single negative while standing behind the camera and then printing it with minimal manipulation.

PHOTOGRAPHY AS ART. The leader of the Naturalist faction of Pictorialism was Peter Henry Emerson (1856-1936), though he later recanted some of his early positions. Born in Cuba, he lived there until age 13 when his family moved to London. He originally trained as a doctor and had a small medical practice until the lure of art overtook him in the middle 1880s. His early efforts at photographing the landscape convinced him that photography was an art form "superior to etching, woodcutting, and charcoal drawing," as he put it in his 1886 book Photography: A Pictorial Art. His work from this period shows him capturing poetic effects in interestingly off-balance compositions (FIG. 19-82). This work shows both his flair for composition and his devotion to print quality, which he regarded as crucial to photography's acceptance as an art form. He urged photographers to use the platinum process, in which the printing paper is coated with platinum dust, an exceptionally sensitive surface that can faithfully transmit very subtle tonal gradations. (Most art photographers used this process until World War I pushed

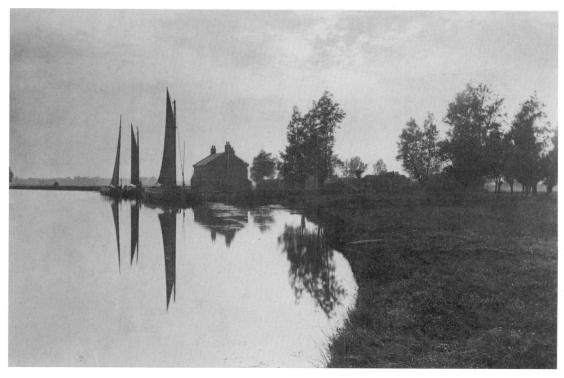

19–82 | Peter Emerson | CANTLEY: WHERRIES WAITING FOR THE TURN OF THE TIDE 1886. Platinum print, $7\% \times 11\%$ (18.7 \times 28.4 cm). George Eastman House, Rochester, New York. Gift of William C. Emerson. GEH NEG: 5894. Obj no. 79:4333:0001

the price of platinum to impractical levels.) Ironically enough, a meeting with James McNeill Whistler in 1895 caused Emerson to radically alter his belief that photography was an art. After seeing Whistler's Nocturnes (SEE FIG. 19–48) and Japanese prints, Emerson came to believe that photography was only a mechanical process that could not equal the direct inspiration of an artist. However, before his resignation from the Photographic Society he gave a great deal of recognition to photographers, and his aesthetic of straight photography dominated the practice of art photographers until well into the next century.

PHOTOGRAPHY AS ACTIVISM. The urban photographs of Jacob Riis (1849–1914) offer a harsh contrast to the essentially aesthetic views of Emerson. A reformer who aimed to galvanize public concern for the unfortunate poor, Riis saw photography not as an artistic medium but as a means of bringing about social change. Riis immigrated to New York City from Denmark in 1870 and was hired as a police reporter for the *New York Tribune*. He quickly established himself as a maverick among his colleagues by actually investigating slum life himself rather than merely rewriting police reports. Riis's contact with the poor convinced him that crime, poverty, and ignorance were largely environmental problems that resulted from, rather than caused, harsh slum conditions. He believed that if Americans knew the truth about slum life, they would support reforms.

Riis turned to photography in 1887 to document slum conditions, and three years later published his photographs in a groundbreaking study, *How the Other Half Lives*. The illustrations were accompanied by texts that described their circumstances in matter-of-fact terms. Riis said he found the poor, immigrant family shown in **TENEMENT INTERIOR IN POVERTY GAP: AN ENGLISH COAL-HEAVER'S HOME** (FIG. 19–83) when he visited a house where a woman had been killed by her drunken, abusive husband:

The family in the picture lived above the rooms where the dead woman lay on a bed of straw, overrun by rats. . . . A patched and shaky stairway led up to their one bare and miserable room. . . . A heap of old rags, in which the baby slept serenely, served as the common sleeping-bunk of father, mother, and children—two bright and pretty girls, singularly out of keeping in their clean, if coarse, dresses, with their surroundings. . . . The mother, a pleasant-faced woman, was cheerful, even light-hearted. Her smile seemed the most sadly hopeless of all in the utter wretchedness of the place.

What comes through clearly in the photograph is the family's attempt to maintain a clean, orderly life despite the rats and the chaotic behavior of their neighbors. The broom behind the older girl implies as much, as does the caring way the father holds his youngest daughter. Riis shows that such slum dwellers are decent people who deserve better.

19-83 | Jacob Riis | Tenement Interior in Poverty Gap: an english coal-heaver's home

c. 1889. Museum of the City of New York.

The Jacob A. Riis Collection

During the late nineteenth and early twentieth centuries, American social and business life operated under the British sociologist Herbert Spencer's theory of Social Darwinism, which in essence held that only the fittest will survive. Riis saw this theory as merely an excuse for neglecting social problems.

Architecture

The history of late nineteenth-century architecture is a story of the impact of modern conditions and materials on the still-healthy Beaux-Arts historicist tradition. Unlike painting and sculpture, where antiacademic impulses gained force after 1880, in architecture the search for modern styles occurred somewhat later and met with considerably more resistance. As the École des Beaux-Arts in Paris was rapidly losing its leadership in figurative art education, it was becoming the central training ground for both European and American architects. The center of innovation in late-century architecture was in the American Midwest.

WORLD'S COLUMBIAN EXHIBITION, CHICAGO. Richard Morris Hunt (1827–95) in 1846 became the first American to study architecture at the École des Beaux-Arts. Extraordinarily skilled in Beaux-Arts historicism and determined to raise the standards of American architecture, he built in every accepted style, including Gothic, French classicist, and Italian Renaissance. After the Civil War, Hunt built many lavish mansions emulating aristocratic European models for the growing class of wealthy Eastern industrialists and financiers.

Late in his career, Hunt participated in a grand project with more democratic aims: He was head of the board of architects for the 1893 World's Columbian Exposition in Chicago, organized to commemorate the 400th anniversary

Elements of Architecture

THE CITY PARK

arks originated during the second millennium BCE in China and the Near East as enclosed hunting reserves for kings and the nobility. In Europe from the Middle Ages through the eighteenth century, they remained private recreation grounds for the privileged. The first urban park intended for the public was in Munich, Germany, laid out by Friedrich Ludwig von Sckell in 1789–95 in the picturesque style of an English landscape garden (SEE FIG. 18–20), with irregular lakes, gently sloping hills, broad meadows, and paths meandering through wooded areas.

Increased crowding and pollution during the Industrial Revolution prompted outcries for large public parks whose greenery would help purify the air and whose open spaces would provide city dwellers of all classes with a place for healthful recreation and relaxation. Numerous municipal parks were built in Britain during the 1830s and 1840s and in Paris during the 1850s and 1860s, when Georges-Eugène Haussmann redesigned the former royal hunting forests of the Bois de Boulogne and the Bois de Vincennes in the English style favored by the emperor.

In American cities before 1857, the only outdoor spaces for the public were small squares found between certain intersections, and larger gardens, such as the Boston Public Garden. Neither kind of space filled the growing need for varied recreational facilities. For a time, naturalistically landscaped suburban cemeteries became popular sites for strolling, picnicking, and even horse racing—an incongruous use that strikingly demonstrated the need for urban recreation parks.

The rapid growth of Manhattan spurred civic leaders to set aside parkland while open space still existed. The city purchased an 843-acre tract in the center of the island and in 1857 announced a competition for its design as Central Park. The competition required that designs include a parade ground,

playgrounds, a site for an exhibition or concert hall, sites for a fountain and for a viewing tower, a flower garden, a pond for ice skating, and four east-west cross streets so that the park would not interfere with the city's vehicular traffic.

The latter condition was pivotal to the winning design, drawn up by architect Calvert Vaux (1824–95) and park superintendent Frederick Law Olmsted (1822–1903), who sank the crosstown roads in trenches hidden below the surface of the park and designed separate routes for carriages, horseback riders, and pedestrians.

Central Park contains some formal elements, such as the stately tree-lined Mall leading to the classically styled Bethesda Terrace and Fountain, but its designers believed that the "park of any great city [should be] an antithesis to its bustling, paved, rectangular, walled-in streets." Accordingly, Olmsted and Vaux followed the English tradition by designing Central Park in a naturalistic manner based on irregularities in topography and plantings. Where the land was low, they further depressed it, installing drainage tiles and carving out ponds and meadows. They planted clumps of trees to contrast with open spaces, and they emphasized natural outcroppings of schist to provide elements of dramatic, rocky scenery. They arranged walking trails, bridle paths, and carriage drives to provide a series of changing vistas. An existing reservoir divided the park into two sections. Olmsted and Vaux developed the southern half more completely and located most of the sporting facilities and amenities there, while they treated the northern half more as a nature preserve. Substantially completed by the end of the Civil War, Central Park was a tremendous success and launched a movement to build similar parks in cities across the United States and to conserve wilderness areas and establish national parks.

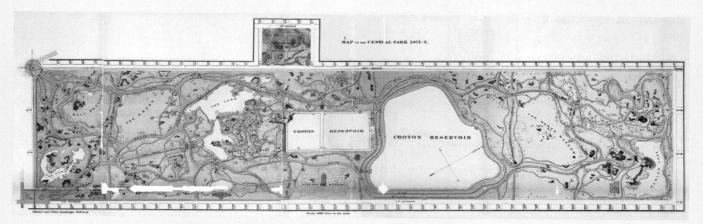

Frederick Law Olmsted and Calvert Vaux MAP OF CENTRAL PARK, NEW YORK CITY 1858–1880. Revised and extended park layout as shown in a map of 1873.

The rectangular water tanks in the middle of the park were later removed and replaced by a large, elliptical meadow known as the Great Lawn.

of Columbus's arrival in the Americas. The board abandoned the metal-and-glass architecture of earlier world's fairs (SEE FIG. 19–31) in favor of the appearance of what it called "permanent buildings—a dream city." (The buildings were actually temporary ones composed of staff, a mixture of plaster and fibrous materials.) To create a sense of unity for all the exposition's major buildings, the board designated a single, classical style associated with both the birth of democracy in ancient Greece and the imperial power of ancient Rome, reflecting the United States' pride in its democratic institutions and emergence as a world power. Hunt's design for the Administration Building at the end of the Court of Honor (FIG. 19–84) was in the Renaissance classicist mode used by earlier American architects for civic buildings (SEE FIG. 19–22).

The World's Columbian Exposition also provided a model for the American city of the future—reassurance that it could be clean, spacious, carefully planned, and classically beautiful, in contrast to the ill-planned, sooty, and overcrowded American urban centers rapidly emerging in the late nineteenth century. Frederick Law Olmsted, the designer of New York's Central Park (see "The City Park," page 797), was principally responsible for the landscape design of the Chicago exposition. He converted the marshy lakefront into lagoons, canals, ponds, and islands, some laid out formally, as in the Court of Honor, others informally, as in the section containing national and state pavilions. After the fair closed and most of its buildings were taken down, Olmsted's land-scape art remained for succeeding generations to enjoy.

THE CHICAGO SCHOOL: THE FIRST SKYSCRAPERS. The second American architect to study at the École des Beaux-Arts was Henry Hobson Richardson (1838-86). Born in Louisiana and schooled at Harvard, Richardson returned from Paris in 1865 and settled in New York. Like Hunt, he worked in a variety of styles, but he became famous for a simplified Romanesque style known as Richardsonian Romanesque. His best-known building was probably the MARSHALL FIELD WHOLESALE STORE in Chicago (FIG. 19–85). Although it is reminiscent of Renaissance palaces in form and of Romanesque churches in its heavy stonework and arches, it has no precise historical antecedents. Instead, Richardson took a fresh approach to the design of this modern commercial building. Applied ornament is all but eliminated in favor of the intrinsic appeal of the rough stone and the subtle harmony between the dark red granite facing of the base and the red sandstone of the upper stories. The solid corner piers, the vertical structural supports, give way to the regular rhythm of the broad arches of the middle floors, which are doubled in the smaller arches above, then doubled again in the rectangular windows of the attic. The integrated mass of the whole is completed in the crisp line of the simple cornice at the top.

Richardson's plain, sturdy building was a revelation to the young architects of Chicago then engaged in rebuilding the city after the disastrous fire of 1871 and helped shape a distinctly American architecture. About this time, new technology for making inexpensive steel (an alloy of iron, carbon, and other materials) brought architecture entirely new structural possibilities. The first structural use of steel in the internal skeleton of a building was made in Chicago by William Le Baron Jenney (1832-1907), and his example was soon followed by the younger architects who became known as the Chicago School. These architects saw in the stronger, lighter material the answer to both their search for an independent style and their clients' desire for taller buildings. The rapidly rising cost of commercial urban property made tall buildings more efficient; the first electric elevator, dating from 1889, made them possible.

Equipped with steel and with the improved passenger elevators, driven by new economic considerations, and inspired by Richardson's departure from Beaux-Arts historicism, the Chicago School architects produced a new kind of building—the skyscraper—and a new style of architecture. A fine early example of their work, and evidence of its rapid spread throughout the Midwest, is Louis Sullivan's WAIN-WRIGHT BUILDING in St. Louis, Missouri (FIG. 19-86). The Boston-born Sullivan (1856-1924) had studied for a year at the Massachusetts Institute of Technology (MIT), home of the United States' first architecture program, and equally briefly at the École des Beaux-Arts, where he seems to have developed his lifelong distaste for historicism. He settled in Chicago in 1875, partly because of the building boom there that had followed the fire of 1871, and in 1883 he entered into a partnership with the Danish-born engineer Dankmar Adler (1844-1900).

Sullivan's first major skyscraper, the Wainwright Building has a U-shaped plan that provides an interior light well for the illumination of inside offices. The ground floor, designed to house shops, has wide plate-glass windows for the display of merchandise. The second story, or mezzanine, also features large windows for the illumination of the shop offices. Above the mezzanine rise seven identical floors of offices, lit by rectangular windows. An attic story houses the building's mechanical plant and utilities. Forming a crown to the building, this richly decorated attic is wrapped in a foliate frieze of high-relief terra cotta, punctuated by bull's-eye windows, and capped by a thick cornice slab.

The Wainwright Building thus features a clearly articulated, tripartite design in which the different character of each of the building's parts is expressed through its outward appearance. This illustrates Sullivan's philosophy of functionalism, summed up in his famous motto, "Form follows function," which holds that the function of a building should dictate its design. But Sullivan did not design the Wainwright Building along strictly functional lines; he also took expres-

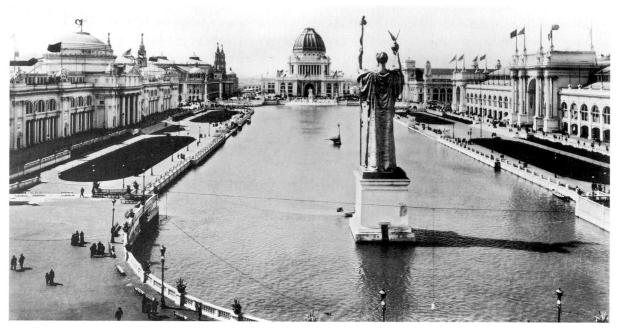

19–84 COURT OF HONOR, WORLD'S COLUMBIAN EXPOSITION Chicago. 1893. View from the east.

Surrounding the Court of Honor were, from left to right, the Agriculture Building by McKim, Mead, and White; the Administration Building by Richard Morris Hunt; and the Manufactures and Liberal Arts Building by George B. Post. The architectural ensemble was collectively called The White City, a nickname by which the exposition was also popularly known. The statue in the foreground is *The Republic* by Daniel Chester French.

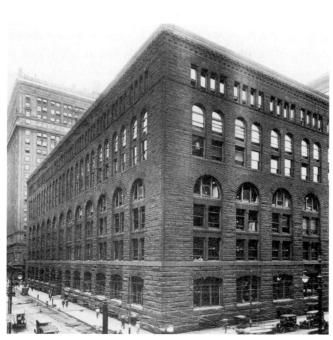

19–85 | Henry Hobson Richardson MARSHALL FIELD WHOLESALE STORE
Chicago. 1885–87. Demolished c. 1935.

sive considerations into account. The thick corner piers, for example, are not structurally necessary since the building is supported by a steel-frame skeleton, but they serve to emphasize its vertical thrust. Likewise, the thinner piers between the office windows, which rise uninterruptedly from the third

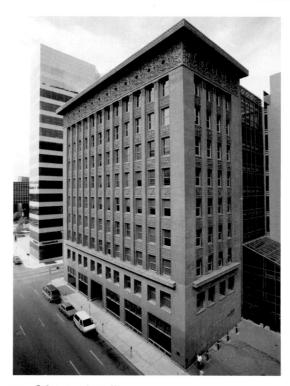

19–86 | Louis Sullivan WAINWRIGHT BUILDING St. Louis, Missouri. 1890–91.

story to the attic, echo and reinforce the dominant verticality. Sullivan emphasized verticality in the Wainwright Building not out of functional concerns but rather out of emotional ones. A tall office building, in his words, "must be every inch a proud and soaring thing, rising in sheer exultation."

In the Wainwright Building that exultation culminates in the rich vegetative ornament that swirls around the crown of the building, serving a decorative function very much like that of the foliated capital of a classical column. The tripartite structure of the building itself suggests the classical column with its base, shaft, and capital, reflecting the lingering influence of classical design principles even on an architect as opposed to historicism as Sullivan. It would remain for the Modern architects of the early twentieth century to break free from tradition entirely and pioneer an architectural aesthetic that was entirely new.

IN PERSPECTIVE

As the nineteenth century began, Neoclassicism and Romanticism were principal movements in Western art, with the former dominant in the academies and Salons, while the latter led the way in innovations. Romantics favored landscape, literature, or recent dramatic events as subjects, and rendered them in off-balance compositions that often featured loose, painterly brushwork.

The Realist movement that emerged in the late 1840s baffled most of the public with its deadpan renditions of common subjects such as rural labor. Yet the movement was the most innovative of the time, and its quasi-scientific accuracy led to Impressionism in the 1860s. Building on the Realism of Courbet and the Romantic-Realist landscapes of the Barbizon School, the Impressionists painted the landscape

in pure, unmixed colors and loose brushwork as they tried to capture the fleeting play of light over their subjects. Soon the Impressionists also painted the bustling urban life of the newly redesigned Paris streets. Both Realism and Impressionism partook of the spirit of positivism, the intellectual movement begun by Auguste Comte that favored direct observation over philosophical speculation and imaginative flights. The new art of photography also seemed to embody the positivist spirit, with its apparently seamless translation of reality onto a negative.

The Impressionists are generally regarded as the founders of Modern art, which generally rejected traditional rules. This earned them the scorn of much of the public: The Industrial Revolution had created an atmosphere of rapid social change that led the new middle-class art viewers to crave comforting, traditional subjects rendered with polished technique. Modern artists seceded from these demands, and functioned within a narrow social context of critics and collectors called the avant-garde.

As Impressionism reached its limits in the middle 1880s, Modern artists went in several directions. Post-Impressionists built directly on the preceding movement, taking it into greater formal organization or personal expression. Symbolists took refuge from the changing world in the misty realm of imagination, while Art Nouveau reinvested the design disciplines with organic shapes. In architecture, revivalism and historicism early in the century were displaced by technological innovations at midcentury that eventually led to the modern skyscraper.

Goya FAMILY OF CHARLES IV 1800

Barry and Pugin HOUSES OF PARLIAMENT 1836–60

BONHEUR PLOWING IN THE NIVERNAIS 1849

CAMERON

PORTRAIT OF THOMAS CARLYLE

1867

RODIN BURGHERS OF CALAIS 1884–89

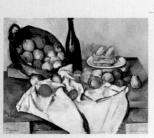

CÉZANNE

STILL LIFE WITH BASKET OF APPLES

1890-94

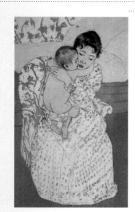

CASSATT

MATERNAL CARESS

1891

NINETEENTH-CENTURY ART IN EUROPE AND THE UNITED STATES

■ Napoleon Crowned Emperor of France 1804

1800

1820

1860

1880

- Battle of Waterloo 1815
- July Monarchy 1830-48
- Beginning of Modern Photography
 c. 1840
- Revolution in France; Marx and Engels Publish Communist Manifesto; Women's Right Convention,
 Seneca Falls, NY 1848
- London Great Exhibition 1851
- American Civil War 1861-65

- Paris Universal Exposition 1889
- World's Columbian Exposition, Chicago 1893

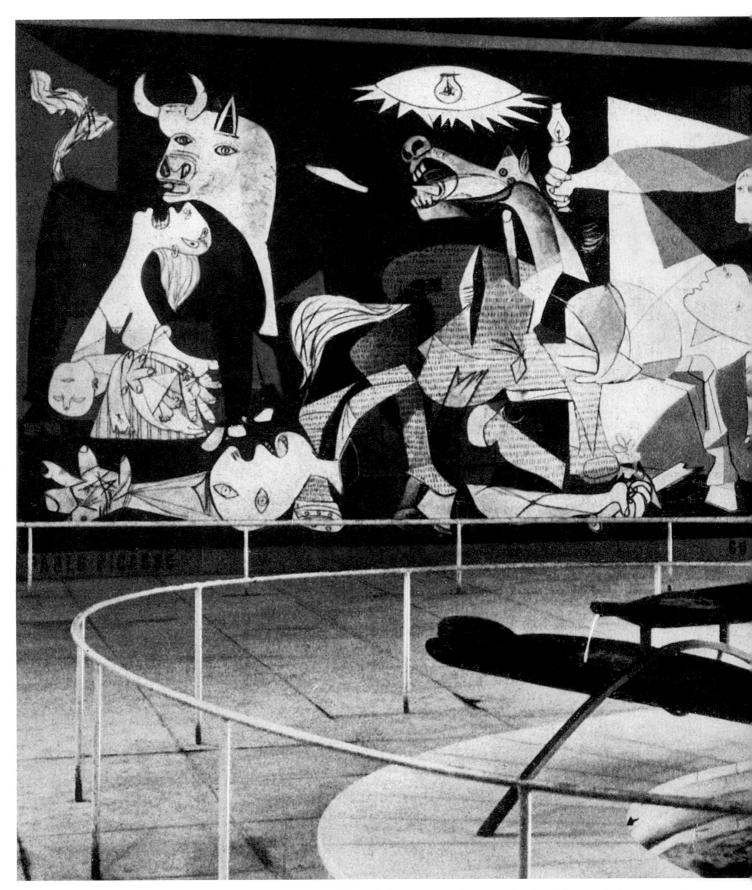

20–I | Pablo Picasso GUERNICA 1937. Oil on canvas, $11'6'' \times 25'8''$ (3.5 \times 7.8 m). Museo Nacional Centro de Arte Reina Sofía, Madrid. On permanent loan from the Museo del Prado, Madrid. Shown installed in the Spanish Pavilion of the Paris Exposition, 1937. In the foreground: Alexander Calder's *Fontaine de Mercure*. 1937. Mercury, sheet metal, wire rod, pitch, and paint, $44 \times 115 \times 77''$ (122 \times 292 \times 196 cm). Fundacio Joan Miró, Barcelona.

CHAPTER TWENTY

MODERN ART IN EUROPE AND THE AMERICAS, 1900–1945

20

In April 1937, during the Spanish Civil War, German pilots flying for Spanish fascist leader General Francisco Franco targeted the Basque city of Guernica. This act, the world's first intentional mass bombing of civilians, killed more than 1,600 people and shocked

the world. The Spanish artist Pablo Picasso, living in Paris at the time, reacted to the massacre by painting **GUERNICA**, a stark, hallucinatory nightmare that became a powerful symbol of the brutality of war (FIG. 20–1).

Focusing on the victims, Picasso restricted his palette to black, gray, and white—the tones of the newspaper photographs that publicized the atrocity. Expressively distorted women, one holding a dead child and another trapped in a burning house, wail in desolation at the carnage. A screaming horse, an image of betrayed innocence, represents the suffering Spanish Republic, while a bull symbolizes either Franco or Spain. An electric light and a woman holding a lantern suggest Picasso's desire to reveal the event in all its horror.

The work excited widespread admiration when exhibited later that year in the Spanish Pavilion of the International Exposition in Paris because the artist used the language of Modern art to comment in a heartfelt manner on what seemed an international scandal. However, when World War II broke out a few years later, the tactic of bombing civilians became a common strategy that all sides adopted.

- EUROPE AND THE AMERICAS IN THE EARLY TWENTIETH CENTURY
- EARLY MODERN ART IN EUROPE | The Fauves: Wild Beasts Of Color | "The Bridge" and Primitivism | Independent Expressionists |

 Spiritualism of the Blue Rider | Cubism in Europe: Exploding the Still Life | Extensions of Cubism | Toward Abstraction in Sculpture | Dada
- EARLY MODERN ART IN THE AMERICAS | Modernist Tendencies in the United States | Modernism Breaks Out in Latin America | Canada
- EARLY MODERN ARCHITECTURE | European Modernism | American Modern Architecture
- ART BETWEEN THE WARS | Utilitarian Art Forms in Russia | Rationalism in the Netherlands | Bauhaus Art in Germany | Art and Politics | Surrealists Rearrange Our Minds
- IN PERSPECTIVE

EUROPE AND THE AMERICAS IN THE EARLY TWENTIETH CENTURY

Just as we ponder Guernica within the context of the Spanish Civil War, so too must we consider the backdrop of politics, war, and technological change to understand other twentieth-century art. As that century dawned, many Europeans and Americans believed optimistically that human society would "advance" through the spread of democracy, capitalism, and technological innovation. By 1906 representative governments existed in the United States and every major European nation (SEE MAP 20-1), and Western power grew through colonialism across Africa, Asia, the Caribbean, and the Pacific. The competitive nature of both colonialism and capitalism created great instability in Europe, however, and countries joined together in rival political alliances. World War I erupted in August 1914, initially pitting Britain, France, and Russia (the Allies) against Germany and Austria (the Central Powers). U.S. troops entered the war in 1917 and contributed to an Allied victory the following year.

World War I significantly transformed European politics and economics, especially in Russia, which became the world's first Communist nation in 1917 when a popular revolution brought the Bolshevik ("Majority") Communist Party of Vladimir Lenin to power. In 1922 the Soviet Union, a Communist state encompassing Russia and neighboring areas, was created. A revolution in Mexico (1910–1917) also overthrew an oppressive government.

The United States emerged from the war as the economic leader of the West, and economic recovery followed in Western Europe, but the 1929 New York stock market crash plunged the West into the Great Depression. In 1933, President Franklin D. Roosevelt responded with the New Deal, an ambitious welfare program meant to provide jobs and stimulate the American economy, and Britain and France also instituted state welfare policies during the 1930s. Elsewhere in Europe, the economic crisis brought to power right-wing totalitarian regimes: Benito Mussolini had already become

the fascist dictator of Italy in the mid-1920s; he was followed in Germany in 1933 by the Nazi leader Adolf Hitler. In Spain, General Francisco Franco consolidated his power by 1939 after his victory in the Spanish Civil War. Meanwhile, in the Soviet Union, Joseph Stalin (who had succeeded Lenin in 1924) established his authoritarian rule through the execution or imprisonment of millions of his political opponents.

The Western world of the early twentieth century was rocked by advances in technology, science, and psychology that undercut traditional beliefs and created new ways of seeing and understanding the world. Naming just a few of the technological innovations will help establish their reach: electrification, radio, automobiles, airplanes, movies, radar, and assembly-line production. Technology led both to better medicines for prolonging life and to more efficient warfare, which shortened it.

The stable and orderly Newtonian world of science was replaced with the more dynamic and unpredictable theory of relativity that German physicist Albert Einstein largely pioneered. His great innovation was to discover that matter is not stable at the atomic level. Rather, what we formerly took to be solid matter is only another form of energy, similar to gravity or light but much more powerful than either. He likewise altered our previous conceptions of space and time in a three-dimensional universe. After Einstein, it made more sense to see space and time as relative to each other: What time it is depends on where you are and how fast you are moving.

At the same time, new theories and discoveries in psychology altered how humans viewed themselves. In 1900, Austrian psychiatrist Sigmund Freud published *The Interpretation of Dreams*, which posited that our behavior is often motivated by powerful forces that are below our level of awareness. The human unconscious, as he described it, has strong urges for love and power that we simply cannot act upon if society is to remain peaceful and whole. Our psychic lives are not wholly, or even usually, guided by reason alone, but often by these urges that we may be unaware of. Thus we are always attempting to strike a balance between our rational

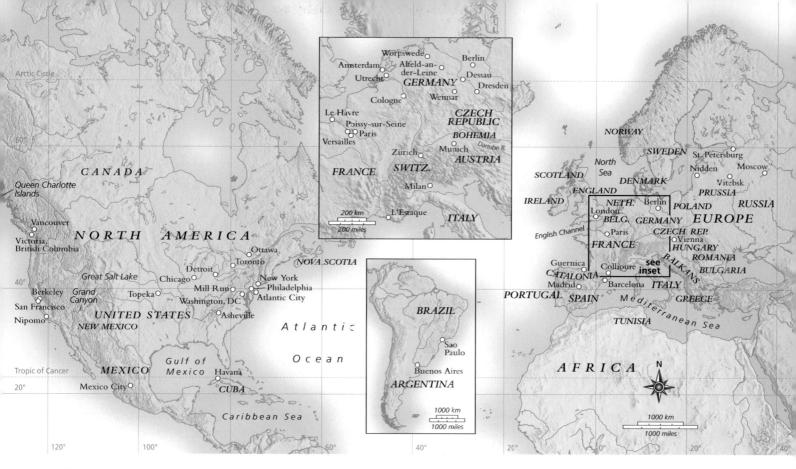

MAP 20-I | EUROPE AND NORTH AMERICA, 1900-50

Through the end of World War II, Western Europe was home to the many forms of Modernism.

and irrational sides, often erring on one side or the other. Also in 1900, Russian scientist Ivan Pavlov began feeding dogs just after ringing a bell. Soon the dogs salivated not at the sight of food but at the sound of the bell. The discovery that these "conditioned reflexes" also exist in humans showed that if we manage the external stimuli we can control people's appetites. Political leaders of all stripes soon took advantage of this fact. As a consequence of all these events and discoveries, the old view that humans were created in the image of God took a severe beating.

EARLY MODERN ART IN EUROPE

Modern artists also invented myriad new ways of seeing our world. Most artists did not read physics or psychology, but they lived in the same world that was being transformed by these two fields. The Modernist urge to question and overthrow tradition was fertilized and encouraged by the constant change in the surrounding society. Modern art in the early twentieth century was still mostly controversial and much criticized for being either a publicity stunt, childish,

untrained, or politically subversive. Most often, none of these criticisms was true. Rather, Modern art is an outgrowth of modern society. Just as modern society valued innovation and invention, so did the art world. The plethora of new products that industry gave us is paralleled in the panoply of new styles of Modern art that we will be examining here.

The Fauves: Wild Beasts of Color

The Salon system still operated in France, but the ranks of artists dissatisfied with its conservative precepts swelled. These malcontents early in the century launched the Salon d'Automne ("Autumn Salon") in opposition to the official one that took place in the spring. The Autumn Salons had liberal juries where artists of all stripes exhibited, including Realists, Impressionists, Post-Impressionists, Symbolists, and even bad academic artists. The first Modern movement of the twentieth century made its debut in this salon's disorderly halls. Reviewing the 1905 Salon d'Automne, critic Louis Vauxcelles referred to some young painters as fauves ("wild beasts")—a term that captured the explosive colors and impulsive brushwork that characterized their pictures. Their

leaders—André Derain (1880–1954), Maurice de Vlaminck (1876–1958), and Henri Matisse (1869–1954)—advanced the colorist tradition in modern French painting, which they dated from the work of Eugène Delacroix (SEE FIGS. 19–7, 19–8) and which included that of the Impressionists and Post-Impressionists such as Gauguin and van Gogh. The Fauves took further the expressive power of color and brushwork that the latter two especially pioneered.

Among the first major Fauve works were paintings that Derain and Matisse made in 1905 in Collioure, a Mediterranean port. Derain's **MOUNTAINS AT COLLIOURE** (FIG. 20–2) exemplifies so-called mixed-technique Fauvism, in which short strokes of pure color, derived from the work of van Gogh and Seurat (SEE FIG. 19–65), are combined with curvilinear planes of flat color, inspired by Gauguin's paintings and Art Nouveau decorative arts (SEE FIG. 19–77). Derain's assertive colors, which he likened to "sticks of dynamite," do not record what he actually saw in the landscape but rather generate their own purely artistic energy as they express the artist's intense feeling about what he saw. The stark juxtaposi-

tions of complementary hues—green leaves next to red tree trunks, red-orange mountainsides against blue-shaded slopes—create what Derain called "deliberate disharmonies." Equally interested in such deliberate disharmonies was Matisse, whose **THE WOMAN WITH THE HAT** (FIG. 20–3) sparked controversy at the 1905 Salon d'Automne—not because of its fairly conventional subject, but because of the way its subject was depicted: with crude drawing, sketchy brushwork, and wildly arbitrary colors that create a harsh and dissonant effect.

Matisse soon settled into a style with less fevered brushwork but color regions just as vivid. **THE JOY OF LIFE (FIG. 20–4)** depicts nudes in attitudes close to traditional studio poses, but the landscape is intensely bright. He defended his aims in a 1908 pamphlet called *Notes of a Painter:* "What I am after, above all, is expression," he wrote. In the past, an artist might express feeling through the figure poses or facial expressions that the characters in the painting had. But now, he wrote, "The whole arrangement of my picture is expressive. The place occupied by figures or objects, the empty spaces around them, the proportions, everything plays a part."

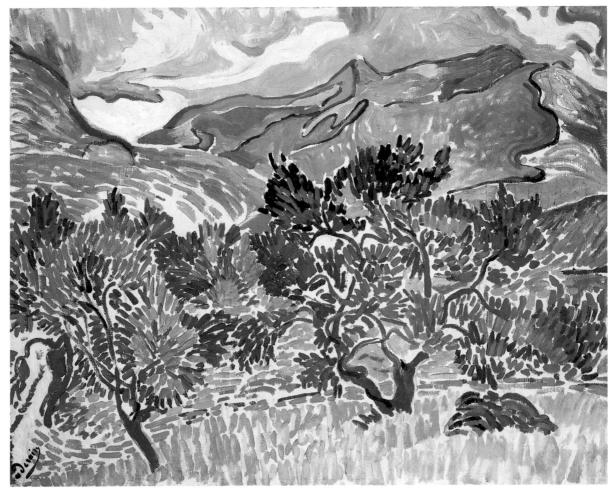

20–2 | André Derain MOUNTAINS AT COLLIOURE 1905. Oil on canvas, $32\times39\%''$ (81.5 \times 100 cm). National Gallery of Art, Washington, D.C. John Hay Whitney Collection

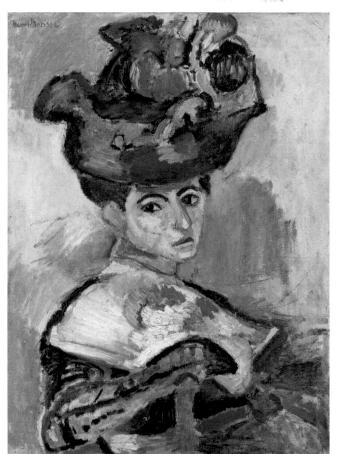

20–3 † Henri Matisse THE WOMAN WITH THE HAT 1905. Oil on canvas, $31\% \times 23\%''$ (80.6×59.7 cm). San Francisco Museum of Modern Art.

Bequest of Elise S. Haas

Both *The Woman with the Hat* and *The Joy of Life* (FIG. 20-4) were originally owned by the brother and sister Leo and Gertrude Stein, important American patrons of European avant-garde art in the early twentieth century. They hung their collection in their Paris apartment, where they hosted an informal salon that attracted many leading literary, musical, and artistic figures, including Matisse and Picasso. In 1913 Leo moved to Italy while Gertrude remained in Paris, pursuing a career as a Modernist writer and continuing to host a salon with her companion, Alice B. Toklas.

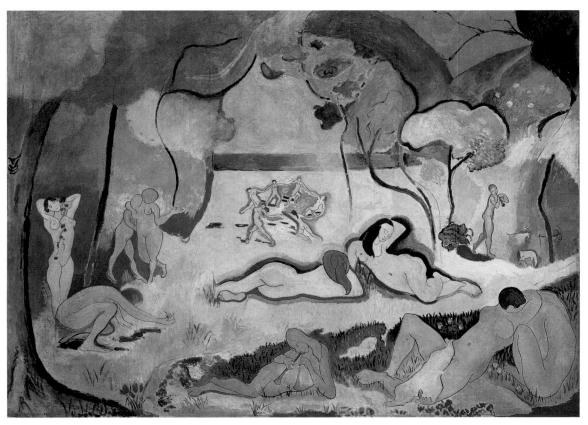

And the colors that he used? "The chief aim of color should be to serve expression as well as possible." We see in *The Joy of Life* that he also radically simplified the forms, both of the trees and of the bodies. The purpose of this step was to avoid overloading the viewer with excess details. A viewer may become absorbed in the leaves or the clouds, for example, and lose the overall feeling of the work. Matisse wrote, "All that is not useful in the picture is detrimental. A work of art must be harmonious in its entirety; for superfluous details would, in the mind of the beholder, encroach upon the essential elements." Far from the "wild beast" that his detractors saw, Matisse was a thoughtful innovator rather than a radical. The feelings that he communicated were mostly positive and pleasant, making his paintings, as he said, "something like a good armchair in which to rest from physical fatigue."

"The Bridge" and Primitivism

In northern Europe, the Expressionist tradition of artists such as van Gogh and Ensor expanded as younger artists used abstracted forms and colors to communicate more complicated emotional and spiritual states. Prominent in German Expressionist art was *Die Brücke* ("The Bridge"), which formed in Dresden in 1905 when four architecture students—Fritz Bleyl (1880–1966), Erich Heckel (1883–1970), Ernst Ludwig Kirchner (1880–1938), and Karl Schmidt-Rottluff (1884–1976)—decided to devote themselves to painting and to form an exhibiting group. Other German and European artists later joined the group, which endured until 1913. Die Brücke was named for a passage in Friedrich Nietzsche's *Thus Spake Zarathustra* (1883) that spoke of contemporary humanity's potential to be the evolutionary "bridge" to a more perfect being of the future.

The artists hoped that The Bridge would become a gathering place for "all revolutionary and surging elements," in opposition to the dominant culture, which they saw as "pale, overbred, and decadent," according to written testimony from one of the leaders. Among their favorite motifs were nudes in nature, such as we see in Schmidt-Rottluff's THREE NUDES-DUNE PICTURE FROM NIDDEN (FIG. 20-5), which shows three simplified female nudes formally integrated with their landscape. The style is purposefully simple and direct, and is a good example of Modernist Primitivism, which drew its inspiration from the non-Western arts of Africa, Pre-Columbian America, and Oceania. The bold stylization typical of such art offered a compelling alternative to the sophisticated illusionism that the Modern artists rejected, and it also provided them formal models to adapt. Many Modernists also believed that immersion in non-Western aesthetics gave them access to a more authentic state of being, uncorrupted by civilization and filled with primal spiritual energies. Nudism was also a growing cultural trend in Germany in those years, as city-dwellers forsook the urban environment to frolic outdoors and reconnect with nature.

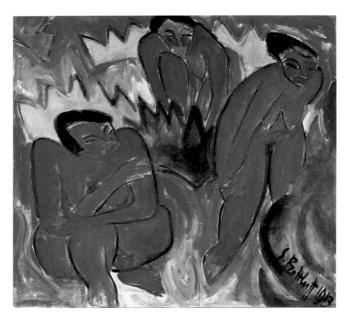

20–5 | Karl Schmidt-Rottluff

THREE NUDES—DUNE PICTURE FROM NIDDEN

1913. Oil on canvas, 38 % × 41 ½" (98 × 106 cm). Staatliche

Museen zu Berlin, Preussischer Kulturbesitz, Nationalgalerie.

The group member most systematically committed to Primitivism was Emil Nolde (1867–1956), who was invited to join The Bridge in 1906. Originally trained in industrial design, he had studied with a private academic painting teacher in Paris for a few months in 1900, but he never painted as he was taught. Rather, Nolde regularly visited

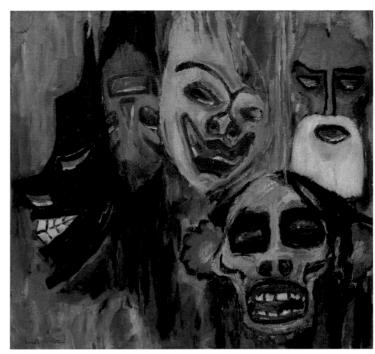

20–6 | Emil Nolde MASKS 1911. Oil on canvas, $28\frac{1}{4} \times 30\frac{1}{2}$ " (73.03 × 77.47 cm). Nelson-Atk ns Museum, Kansas City, Missouri. Gift of the Friends of Art, 5490. © Artists Rights Society (ARS), New York

20–7 | Erich Heckel CROUCHING WOMAN 1912. Painted linden wood, $11\% \times 6\% \times 3\%$ " (30 × 17 × 10 cm). Estate of Erich Heckel, Hemmenhofen am Bodensee, Germany.

ethnographic museums to study the arts of tribal cultures from Africa and Oceania, and he was greatly stimulated by the radical simplifications and forceful presence of figural arts that he saw there. One result of his research was MASKS (FIG. 20-8). Here he used the garish colors and fevered brushwork of Expressionism to depict some of the masks that he sketched in the museum. If a traditional still life is a careful composition of pleasant items on a well-lit tabletop, surely this work is a brisk riposte. The masks hang in an indefinite pictorial space, presenting a lurid and grotesque appearance. On the eve of World War I, Nolde accompanied a German scientific expedition that traveled to New Guinea via Asia and the Palau Islands. In the preface to an unfinished book that he intended to write about his travels, he explained what attracted an artist from the supposedly "advanced" European civilization to the arts of Oceania: "Absolute originality, the

intense and often grotesque expression of power and life in very simple forms—that may be why we like these works of native art." Nolde was never exactly a joiner, so he stopped frequenting The Bridge studio in 1907 but remained on good terms with the members thereafter.

Several Bridge members also made their own "primitive" sculpture. Heckel's **CROUCHING WOMAN** (FIG. 20–7) is crudely carved in wood with hacking strokes, rejecting the classical tradition of marble and bronze and suggesting the desire to return to nature depicted in Schmidt-Rottluff's *Three Nudes*.

During the summers, members of The Bridge did return to nature, visiting remote areas of northern Germany, but in 1911 they moved to Berlin—perhaps preferring to imagine the simple life. Ironically, their images of cities, especially Berlin, offer powerful arguments against living there. Particularly critical of urban life are the street scenes of Kirchner, such as **STREET, BERLIN** (FIG. 20–8). Dominating the left half of the painting, two prostitutes—their professions advertised by their large feathered hats and fur-trimmed coats—strut past well-dressed bourgeois men, their potential clients.

20–8 | Ernst Ludwig Kirchner STREET, BERLIN 1913. Oil on canvas, $47\% \times 35\%$ " (120.6 \times 91 cm). The Museum of Modern Art, New York. Purchase (274.39)

20–9 | Käthe Kollwitz | THE OUTBREAK From the *Peasants' War* series. 1903. Etching, $20 \times 23\%''$ (50.7×59.2 cm). Kupferstichkabinett, Staatliche Museen zu Berlin, Preussischer Kulturbesitz.

The women and men appear as artificial and dehumanized figures, with masklike faces and stiff gestures. Their bodies crowd tegether, but they are psychologically distant from one another, victims of modern urban alienation. The harsh colors, tilted perspective, and angular lines register Kirchner's Expressionistic response to the subject.

Independent Expressionists

While the members of The Bridge sought to further their artistic aims collectively, many Expressionists in Germanspeaking countries worked independently. One, Käthe Kollwitz (1867–1945), was committed to causes of the working class and pursued social change primarily through printmaking because of its potential to reach a wide audience. Between 1902 and 1908 she produced the *Peasants' War* series, seven etchings that depict in an exaggerated and intense fashion events in a sixteenth-century rebellion. **THE OUTBREAK** (FIG. 20–9) shows the peasants' built-up fury from

20–IO | Paula Modersohn-Becker SELF-PORTRAIT WITH AN AMBER NECKLACE

1906. Oil on canvas, $24 \times 19 \%$ " (61 \times 50 cm). Öffentliche Kunstsammlung Basel, Kunstmuseum, Basel, Switzerland.

years of mistreatment exploding against their oppressors, a lesson in the power of group action. Kollwitz said that she herself was the model for the leader of the revolt, Black Anna, who raises her hands to signal the attack. Her arms silhouetted against the sky, and the crowded mass of workers with their farm tools, form a jumbled and chaotic picture of a time of upheaval.

Paula Modersohn-Becker (1876–1907), like Kollwitz, studied at the Berlin School of Art for Women, then moved in 1898 to Worpswede, a rustic artists' retreat in northern Germany. Dissatisfied with the Worpswede artists' naturalistic approach to rural life, after 1900 she made four trips to Paris to assimilate recent developments in Post-Impressionist painting. Her **SELF-PORTRAIT WITH AN AMBER NECKLACE** (FIG. 20–10) testifies to the inspiration she found in the work of Paul Gauguin (SEE FIG. 19–67). Her simplified shapes and crude outlines are similar to those in Schmidt-Rottluff's *Three Nudes* (FIG. 20–5), but her muted palette avoided his

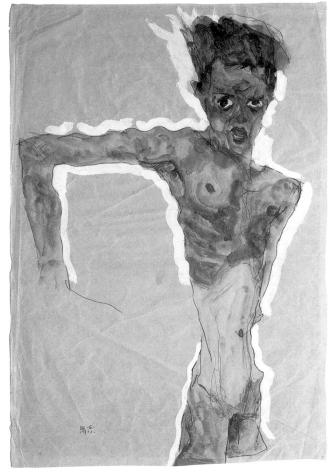

20–II | Egon Schiele SELF-PORTRAIT NUDE 1911. Gouache and pencil on paper, $20\frac{1}{4} \times 13\frac{1}{4}$ " (51.4 \times 35 cm). The Metropolitan Museum of Art, New York. Bequest of Scofield Thayer, 1982 (1984.433.298)

intense colors. By presenting herself against a screen of flowering plants and tenderly holding a flower that echoes the shape and color of her breasts, she appears as a natural being in tune with her surroundings, as in the nudist paintings by members of The Bridge.

Adding - prison

In contrast to Modersohn-Becker's gentle self-portrait, one by Austrian Egon Schiele (1890-1918) conveys physical and psychological torment (FIG. 20-II). Schiele's father had suffered from untreated syphilis and died insane when Egon was fourteen, leaving his son with an abiding link between sex, suffering, and death. In numerous drawings and watercolors, Schiele represented women in sexually explicit poses that emphasize the animal nature of the human body, and his self-portraits reveal deep ambivalence toward the sexual content of both his art and his life. In SELF-PORTRAIT NUDE, the artist stares at the viewer with an anguished expression, his emaciated body stretched into an uncomfortable pose. The absent right hand suggests amputation, and the unarticulated genital region, castration. The missing body parts have been interpreted as the artist's symbolic self-punishment for indulgence in masturbation, then commonly believed to lead to insanity.

Spiritualism of the Blue Rider

Members of *Der Blaue Reiter* ("The Blue Rider") harbored more spiritual intentions that led one member to produce some of the first completely abstract paintings. The group was named for a popular image of a blue knight, the Saint George on the city emblem of Moscow, which many believed would be the world's capital during Christ's 1,000-year reign on earth following the Apocalypse prophesied by Saint John. The Blue Rider formed in Munich around the painters Vasily Kandinsky (1866–1944), a Russian from Moscow, and Franz Marc (1880–1916), a native of Munich, who both considered blue the color of spirituality. Its first exhibition, in December 1911, featured fourteen very diverse artists, whose subjects and styles ranged widely, from naive realism to radical abstraction.

During the early years of his career, Franz Marc moved from a Barbizon-inspired landscape style to a colorful form of Expressionism influenced by the Fauves. By 1911 he was painting animals rather than people because he felt that animals enjoyed a purer, more spiritual relationship to nature than did humans; he rendered these animals in bold, near-primary colors. In his **THE LARGE BLUE HORSES** (FIG. 20–12), the animals merge into a homogenous unit, the fluid contours of which reflect the harmony of their collective existence and echo the lines of the hills behind them, suggesting that they are also in harmony with their surroundings. The pure, strong colors reflect their uncomplicated yet intense experience of the world as Marc enviously imagined it.

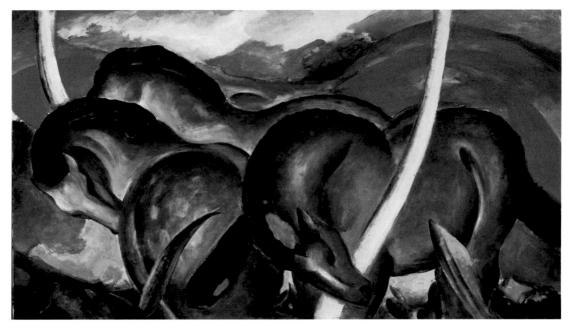

20–I2 | Franz Marc | THE LARGE BLUE HORSES | 1911. Oil on canvas, $3'5\%'' \times 5'11\%''$ (1.05 \times 1.81 m). Walker Art Center, Minneapolis. Gift of T. B. Walker Collection, Gilbert M. Walter Fund, 1942

20–I3 | Vasily Kandinsky THE BLUE MOUNTAIN (DER BLAUE BERG) 1908–09. Oil on canvas, $41\frac{1}{4} \times 38''$ (106×96.6 cm). Guggenheim Museum, New York. Gift of Solomon R. Guggenheim, 1941.41.505. Vasily Kandinsky © 2007

© Artists Rights Society (ARS), New York/ADAGP, Paris

The most radical of the Expressionists was also the best read. Born into a wealthy family and trained originally as a lawyer, Kandinsky was headed for a career as a law school professor in Moscow when he began to frequent exhibitions of Modern art during trips to Germany. After procuring private art instruction, he threw over the idea of a conventional career, settled in Munich in 1896, and began painting.

His early works make frequent reference to Russian folk culture, a "primitive" type of society that inspired him. His 1909 work **THE BLUE MOUNTAIN** (FIG. 20–13) shows two horsemen, rendered in the style of Russian folk art, before a looming peak in his favorite color. The flatness of the work and the carefully parallel brushstrokes show influence from Gauguin and Cézanne. Many of his works feature riders; Kandinsky had in mind the horsemen of the Apocalypse who usher in the end of the world before its final transformation at the end of time.

Kandinsky's study of Whistler's work (SEE FIG. 19–48) also led him to see that the arts of painting and music were related: Just as the composer organizes sound, a painter organizes color and form. This insight was the most direct cause of Kandinsky's contribution to the history of Western art. His musical explorations led him to the work of the Austrian composer Arnold Schoenberg, who in the years surrounding 1910 was taking one of the most momentous steps in musical history. All Western music since antiquity was based on the arrangement of notes into scales, or modes (such as today's common major and minor), and composers could choose the scale they wanted for expressive reasons. Particularly since the Baroque period, each of the notes in any given scale had a role to play, and these roles operated in a clear hierarchy that served

to reinforce what became known as the "tonal center," a kind of home base or place of repose in the musical composition. Schoenberg's great departure was to eliminate the tonal center and treat all tones equally, denying the listener any place of repose and instead prolonging the tension (and thus, he felt, the expression) indefinitely. Kandinsky contacted the composer and was delighted to find out that he also painted in an Expressionist style. Kandinsky asked himself: If music can do without a tonal center, can art do without subject matter?

He found it difficult to paint a completely abstract painting, just as it is difficult to sing without a tonal scale. He gave his works musical titles, such as "Composition" and "Improvisation," and he made his paintings respond to his inner state rather than an external stimulus. Sometime in 1910, art historians generally agree, Kandinsky made his first abstract work. A typical work from this period is **IMPROVISATION 28** (FIG. 20–14). This work retains a vestige of the landscape; Kandinsky found references to nature the hardest to transcend. But the work takes us into a vortex of color, line, and shape. If we recognize buildings or mountains or faces in the work, then perhaps we are seeing in the old way, looking for correspondences between the painting and the world where

none are intended. Rather, the artist would have us look at the painting as if we were hearing a symphony, responding instinctively and spentaneously to this or that passage, and then to the total experience. Kandinsky further explained the musical analogy in a short book about his working methods called *Concerning the Spiritual in Art:* "Color directly influences the soul. Color is the keyboard, the eyes are the hammers, the soul is the piano with many strings. The artist is the hand that plays, touching one key or another purposively, to cause vibrations in the soul."

Kandinsky saw his art as part of a wider political program in opposition to the materialism of Western society. Art's traditional focus on accurate rendering of the physical world is a basically materialistic quest, he thought. Art should not depend so much on mere physical reality. He hoped that his paintings would lead humanity toward a deeper awareness of spirituality and the inner world.

The Swiss-born Paul Klee (1879–1940) participated in the second Blue Rider exhibition of 1912, but his involvement with the group was never more than tangential. A 1914 trip to Tunisia, rather than the Blue Rider, inspired Klee's interest in the expressive potential of color. On his return,

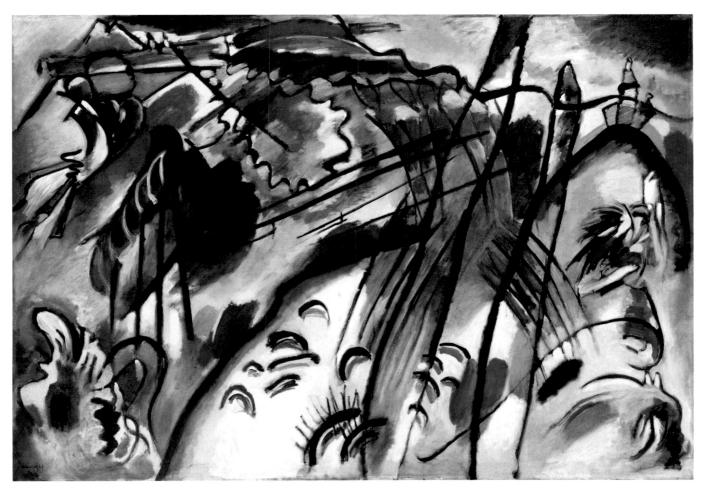

20–I4 | Vasily Kandinsky IMPROVISATION 28 (SECOND VERSION) 1912. Oil on canvas, $43\% \times 63\%$ ". Guggenheim Museum, New York. Gift, Solomon R. Guggenheim. 37.239. Vasily Kandinsky © 2003 Artists Rights Society (ARS), New York/ADAGP, Paris

20–15 | Paul Klee

HAMMAMET WITH ITS MOSQUE
1914. Watercolor and pencil on
two sheets of laid paper mounted
on cardboard, 8 1/8 × 7 1/8"
(20.6 × 19.7 cm). The Metropolitan Museum of Art, New York.
The Berggruen Klee Collection, 1984
(1984,315.4)

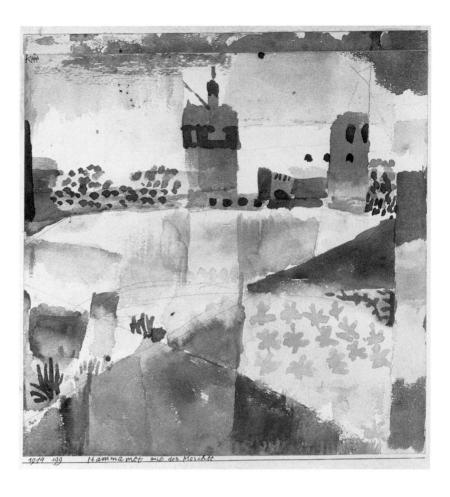

Klee painted watercolors based on his memories of North Africa, including **HAMMAMET WITH ITS MOSQUE** (FIG. 20–15). The play between geometric composition and irregular brushstrokes is reminiscent of Cézanne's work, which Klee had recently seen. The luminous colors and delicate **washes**, or applications of dilute watercolor, result in a gently shimmering effect. The subtle modulations of red across the bottom, especially, are positively melodic. Klee, who played the violin and belonged to a musical family, seems to have wanted to use color the way a musician would use sound, not to describe appearances but to evoke subtle nuances of feeling.

Cubism in Europe: Exploding the Still Life

Of all Modern art movements created before World War I, Cubism probably had the most influence on later artists. The joint invention of Pablo Picasso (1881–1973) and Georges Braque (1882–1963), the Cubist style proved a fruitful launching pad for both artists, allowing each to comment on modern life and to investigate how we perceive the world.

Picasso's Early Art. Born in Málaga, Spain, Picasso was a child prodigy as an artist. During his teenage years at the National Academy in Madrid, he made highly polished works that portended a bright future, had he stayed on a conservative

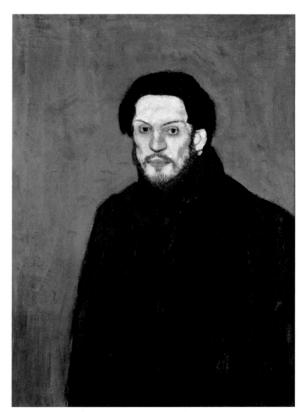

20–16 | Pablo Picasso SELF-PORTRAIT 1901. Oil on canvas, $31\% \times 23\%$ " (81×60 cm). Musée Picasso, Paris.

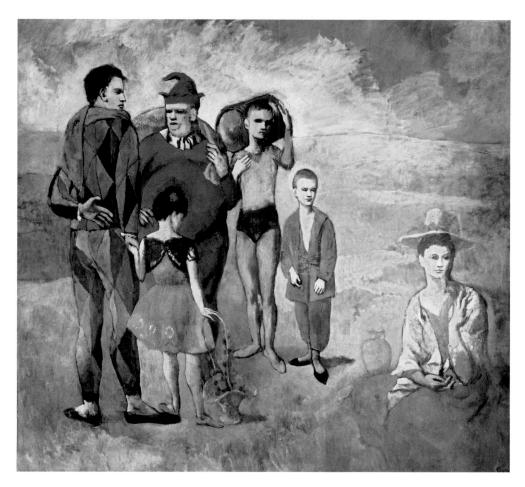

20–17 | Pablo Picasso

FAMILY OF SALTIMBANQUES

1905. Oil on canvas,
6'11¼" × 7'6½" (2.1 × 2.3 m).

National Gallery of Art,
Washington, D.C.

Chester Dale Collection

artistic path. But his restless temperament led him to Barcelona in 1899, where he involved himself in avant-garde circles.

During this time Picasso was attracted to the socially conscious nineteenth-century French painting that included Daumier (SEE FIG. 19–42) and Toulouse-Lautrec (SEE FIG. 19–81). In what is known as his Blue Period, he painted the outcasts of Paris and Barcelona in weary poses, using a coldly expressive blue, likely chosen for its associations with melancholy. These paintings seem to have been motivated by Picasso's political sensitivity to those he considered victims of modern capitalist society, which eventually led him to join the Communist Party. They also reflect his own unhappiness, hinted at in his 1901 **SELF-PORTRAIT** (FIG. 20–16), which reveals his familiarity with cold, hunger, and disappointment.

In search of a more vital art environment, Picasso moved to Paris in 1904. There his personal circumstances greatly improved. He gained a circle of supportive friends among the avant-garde, and his work attracted several important collectors. His works from the end of 1904 through 1905, known collectively as the Rose Period because of the introduction of that color into his palette, show the last vestiges of his earlier despair. During the Rose Period, Picasso was preoccupied with the subject of traveling acrobats, *saltimbanques*, whose rootless and insecure existence on the margins of society was

similar to the one he too had known. Picasso rarely depicted them performing but preferred to show them at rest, as in **FAMILY OF SALTIMBANQUES** (FIG. 20–17). In this mysterious composition, six figures inhabit a barren landscape painted in warm tones of beige and rose sketchily brushed over a blue ground. Five of the figures cluster together in the left two-thirds of the picture while the sixth, a seated woman, curiously detached, occupies her own space in the lower right. All of the *saltimbanques* seem psychologically withdrawn and uncommunicative, as silent as the empty landscape they occupy.

Soon his encounters with non-Western art in Paris museums would prove decisive in his career. In 1906 the Louvre installed a newly acquired collection of sixth- and fifth-century BCE sculpture from the Iberian Peninsula (present-day Spain and Portugal). Picasso identified these ancient Iberian figures with the stoic dignity of the villagers in the province of his birth. Even more important, he made repeated visits to the ethnographic museum where African art from France's colonies was displayed. While he never took the time to study the cultures where the art originated, Picasso was greatly stimulated by the expressive power and formal novelty of the African masks that he saw. Since African art was relatively inexpensive, he also bought several pieces and kept them in his studio.

20–18 | Pablo Picasso

LES DEMOISELLES D'AVIGNON

(THE YOUNG LADIES OF AVIGNON)

1907. Oil on canvas, 8' × 7'8"

(2.43 × 2.33 m). The Museum of Modern Art, New York.

Acquired through the Lillie P. Bliss Bequest, (333.1939)

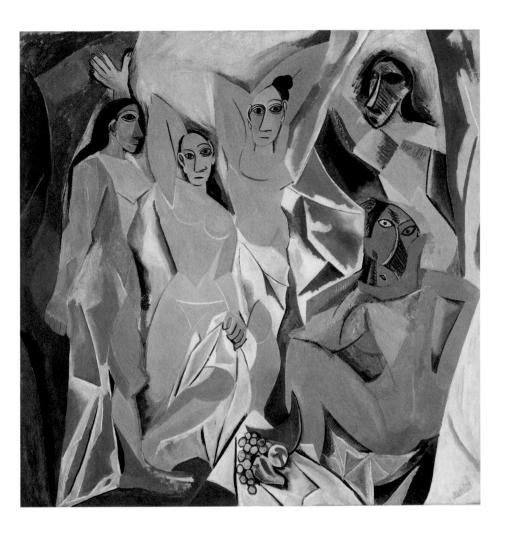

The result of these encounters burst into view in Picasso's large 1907 work LES DEMOISELLES D'AVIGNON (THE YOUNG LADIES OF AVIGNON) (FIG. 20-18). The Iberian influence is seen specifically in the faces of the three leftmost figures, with their simplified features and wide, almond-shaped eyes. The faces of the two right-hand figures, painted in a radically different style, were inspired by African art. Given the then-dominant condescending attitudes toward such allegedly "primitive" cultures, Picasso's wholesale adoption and adaptation of their styles for a large, multifigured painting—as opposed to a still life or a small genre work—was a culturally rebellious thing to do. Such sympathy with non-Western styles paralleled his political beliefs at the time, as he flirted with anarchist theories. Along with its bold embrace of non-Western art, the controversial subject matter of the work is prostitutes. The term demoiselles, meaning "young ladies," is a euphemism for prostitutes, and Avignon refers not to the French town but to a narrow street in the red-light district of Barcelona.

We see the African influence not only in their masklike faces, but also in the handling of their forms in space. The women in the painting are flattened and fractured into sharp curves and angles. The space they inhabit is equally fractured and convulsive. The central pair of *demoiselles* raise their arms

in a traditional gesture of accessibility but contradict it with their hard, piercing gazes and firm mouths. Even the fruit displayed in the foreground, a symbol of female sexuality, seems hard and dangerous. Women, Picasso suggests, are not the gentle and passive creatures that men would like them to be. With this viewpoint he contradicts practically the entire tradition of erotic imagery since the Renaissance. Likewise, his treatment of space shatters the orderly perspective also inherited from that period.

Most of Picasso's friends were horrified by his new work. Matisse, for example, accused Picasso of making a joke of Modern art and threatened to break off their friendship. But one artist, Georges Braque, responded positively, and he saw in *Les Demoiselles d'Avignon* a potential that Picasso probably had not fully intended. Picasso used broken and distorted forms expressionistically, to convey his view of women, which some feminists have derided as misogynist. But what secured Picasso's place at the forefront of the Parisian avant-garde was the revolution in form that *Les Demoiselles d'Avignon* inaugurated. Braque responded eagerly to Picasso's formal innovations and set out, alongside Picasso, to develop them. The work was the seedbed for the Cubist style, which came in two phases, Analytic and Synthetic.

ANALYTIC CUBISM. Georges Braque was born a year after Picasso, near Le Havre, France, where he trained to become a house decorator like his father and grandfather. In 1900 he moved to Paris. The Fauve paintings in the 1905 Salon d'Automne so impressed him that he began to paint brightly colored landscapes, but it was the 1907 Cézanne retrospective that established his future course. Picasso's *Demoiselles* sharpened his interest in altered form and compressed space and emboldened Braque to make his own advances on Cézanne's late direction.

Braque's 1908 HOUSES AT L'ESTAQUE (FIG. 20–19) reveals the emergence of early Cubism. Inspired by Cézanne's example, Braque reduced nature's many colors to its essential browns and greens and eliminated detail to emphasize basic geometric forms. Arranging the buildings into an approximate pyramid, he pushed those in the distance closer to the foreground, so the viewer looks *up* the plane of the canvas more than into it. The painting is less a Cézannesque study of nature than an attempt to translate nature's complexity into an independent, aesthetically satisfying whole.

Braque submitted *Houses at L'Estaque* to the 1908 Autumn Salon, but the jury, which included Matisse, rejected it—Matisse dismissively referring to Braque's "little cubes." Thus, the name *Cubism* was born.

Braque's early Cubist work helped point Picasso in a new artistic direction. By the end of 1908 the two artists had

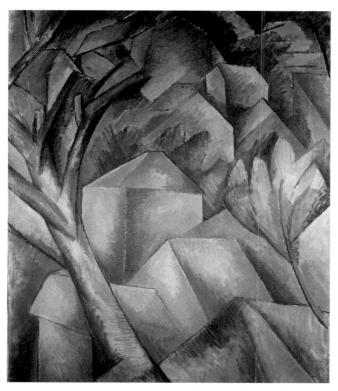

20–19 | Georges Braque HOUSES AT L'ESTAQUE 1908. Oil on canvas, $36\% \times 23\%$ " (73×59.5 cm). Kunstmuseum, Bern, Switzerland. Collection Hermann and Magrit Rupf-Stiftung

begun an intimate working relationship that lasted until Braque went off to war in 1914. "We were like two mountain climbers roped together," Braque later said. The move toward simplification begun in Braque's landscapes in 1908 continued in the moderately scaled still lifes the two artists produced over the next two and a half years. In Braque's VIOLIN AND PALETTE (FIG. 20–20), the gradual abstraction of deep

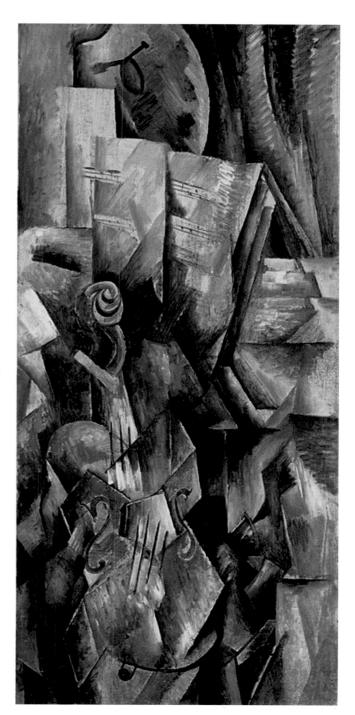

20–20 | Georges Braque VIOLIN AND PALETTE 1909–10. Oil on canvas, $36\% \times 16\%$ (91.8 \times 42.9 cm). Solomon R. Guggenheim Museum, New York. (54.1412)

space and recognizable subject matter is well under way. The still-life items are not arranged in illusionistic depth but are pushed close to the picture plane in a shallow space. Braque knit the various elements together into a single shifting surface of forms and colors. In some areas of the painting, these formal elements have lost not only their natural spatial relations but their identities as well. Where representational motifs remain—the violin, for example—Braque fragmented them to facilitate their integration into the whole.

Braque's and Picasso's paintings of 1909 and 1910 initiated what is known as Analytic Cubism because of the way the artists broke objects into parts as if to analyze them. The works of 1911 and early 1912 are also grouped under the Analytic label, although they reflect a different approach to the breaking up of forms. Instead of simply fracturing an object, Picasso and Braque picked it apart and rearranged its elements. In this way, Analytic Cubism resembles the actual process of perception. When we look at an object, we are likely to examine it from various angles and then reassemble our glances into a whole in our brain. Picasso and Braque shattered their subjects into jagged forms analogous to momentary, partial glances, but they reassembled the pieces according not to the laws of reality but to those of aesthetic composition. Remnants of the subject Picasso worked from are evident throughout MA JOLIE (FIG. 20-21), for example, but any attempt to reconstruct that subject—a woman with a stringed instrument—would be misguided because the subject provided only the raw material for a formal arrangement.

The inscription of the title on the work offers a joke at the expense of baffled viewers (of which there were probably very many). *Ma Jolie* means "My Pretty One," which was also the name of a popular song. Our first impulse might be to wonder what exactly is pictured on the canvas, and to that unspoken question, Picasso provided a sarcastic answer: "It's My Pretty One!"

A subtle tension between order and disorder is maintained throughout this painting. For example, the shifting effect of the surface, a delicately patterned texture of grays and browns, is given regularity through the use of short, horizontal brushstrokes. Similarly, with the linear elements, strict horizontals and verticals dominate, although many irregular curves and angles are also to be found. The combination of horizontal brushwork and right angles firmly establishes a grid that effectively counteracts the surface flux. Moreover, the repetition of certain diagonals and the relative lack of details in the upper left and upper right create a pyramidal shape. Thus, what at first may seem a random assemblage of lines and muted colors turns out to be a well-organized unit. The aesthetic satisfaction of such a work depends on the way chaos seems to resolve itself into order.

Synthetic Cubism. Works such as *Ma Jolie* brought Picasso and Braque to the brink of total abstraction, but in the spring

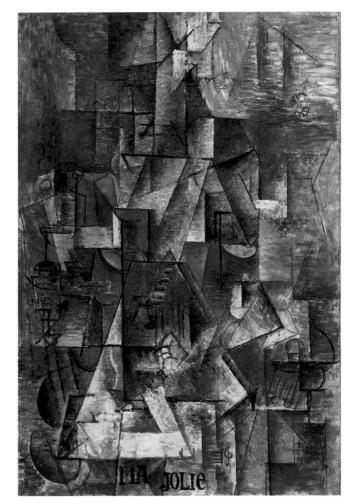

20–21 | Pablo Picasso MA JOLIE 1911–12. Oil on canvas, $39\% \times 25\%''$ (100 \times 65.4 cm). The Museum of Modern Art, New York. Acquired through the Lillie P. Bliss Bequest (176.1945)

In 1923 Picasso said, "Cubism is no different from any other school of painting. The same principles and the same elements are common to all. The fact that for a long time Cubism has not been understood . . . means nothing. I do not read English, . . . [but] this does not mean that the English language does not exist, and why should I blame anybody . . . but myself if I cannot understand [it]?"

of 1912 they pulled back and began to create works that suggested more clearly discernible subjects. Neither artist wanted to break the link to reality; Picasso once said that there was no such thing as perfectly abstract art, because, he said, "You have to start somewhere." This second major phase of Cubism is known as Synthetic Cubism because of the way the artists created motifs by combining simpler elements, as in a chemical synthesis. Picasso's **GLASS AND BOTTLE OF SUZE** (FIG. 20–22), like many of the works he and Braque created from 1912 to 1914, is a *collage* (from the French *coller*, meaning "to glue"), a work composed of separate elements pasted together. At the center, newsprint and construction paper are assembled to suggest a

tray or round table supporting a glass and a bottle of liquor with an actual label. Around this arrangement Picasso pasted larger pieces of newspaper and wallpaper. The composition of this work is Cubist, as jagged shapes overlap in a shallow space. The elements together evoke not only a place—a bar—but also an activity: the viewer alone with a newspaper, enjoying a quiet drink. However, the newspaper clippings deal with the First Balkan War of 1912–13, which contributed to the outbreak of World War I. Picasso may have wanted to underline the disorder in his art by comparing it with the disorder then building in the world.

Picasso soon extended the principle of collage to produce revolutionary Synthetic Cubist sculpture, such as **MANDOLIN AND CLARINET** (FIG. 20–23). Composed of wood scraps, the sculpture suggests the typical Cubist subject of two musical instruments at right angles to each other. Sculpture has traditionally been either carved, modeled, or cast, but Picasso invented a new method here. In works such as this Picasso introduced the revolutionary technique of **assemblage**, giving sculptors the option not only of carving or modeling but also of constructing their works out of found

Seq	uencing	Works	of Art

1903	Stieglitz, The Flatiron Building
1905	Matisse, The Woman with the Hat
1906-1909	Wright, Robie House
1907	Picasso, Les Demoiselles d'Avignon Sloan, Election Night
1908–1912	Brancusi, The Magic Bird

objects and unconventional materials. Another innovative feature of assemblage was the introduction of space into the interior of the sculpture. We see how the parts of the sculpture do not fit perfectly together, leaving gaps and holes. Moreover, the white central piece describes a semicircle that juts outward toward the viewer. Thus the sculpture creates volume through contained space rather than mass alone. This innovation reversed the traditional conception of sculpture as a solid surrounded by a void.

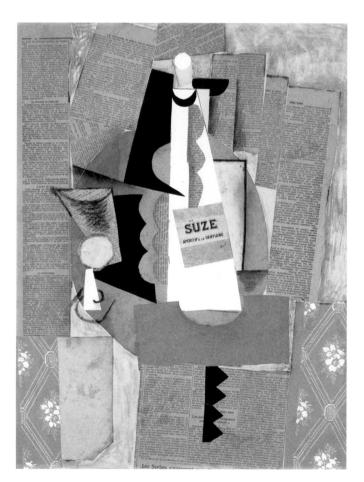

20–22 | Pablo Picasso GLASS AND BOTTLE OF SUZE 1912. Pasted paper, gouache, and charcoal, $25\% \times 19\%$ (65.4 \times 50.2 cm). Washington University Gallery of Art, St. Louis, Missouri.

University Purchase, Kende Sale Fund, 1946

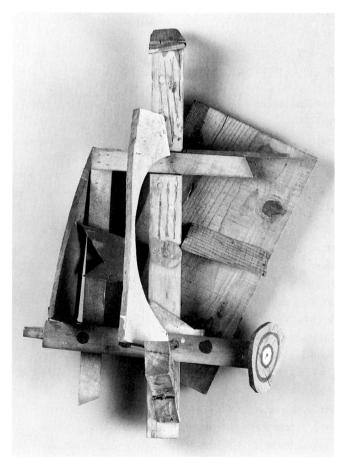

20–23 | Pablo Picasso MANDOLIN AND CLARINET 1913. Construction of painted wood with pencil marks, $22\% \times 14\% \times 9''$ (58 \times 36 \times 23 cm). Musée Picasso, Paris.

20–24 | Robert Delaunay **HOMAGE TO BLÉRIOT**1914. Tempera on canvas, 8'2½" × 8'3"
(2.5 × 2.51 m). Öffentliche
Kunstsammlung Basel, Kunstmuseum,
Basel, Switzerland.

Emanuel Hoffman Foundation

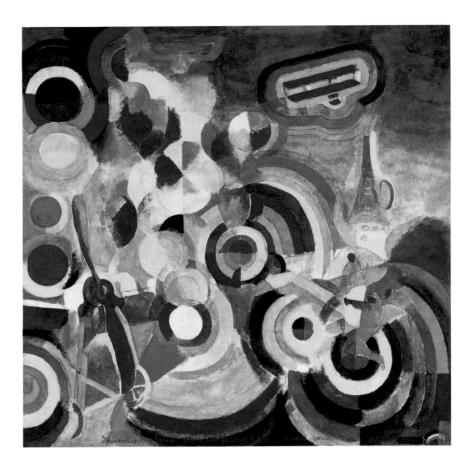

Extensions of Cubism

As the various phases of Cubism emerged from the studios of Braque and Picasso, it became clear to the art world that something of great significance was happening. Artists in many countries used various aspects of the Cubist style to create works that significantly broadened the message of Cubism beyond the studio-based aesthetic of its inventors.

FRENCH EXTENSIONS. Robert Delaunay (1885–1941) and his wife, the Ukrainian-born Sonia Delaunay-Terk (b. Sonia Stern, 1885–1979), took monochromatic, static, Analytic Cubism into a new, wholly different direction. Neo-Impressionism and Fauvism influenced Robert's early painting, and his interest in the spirituality of color led him to participate in Blue Rider exhibitions. Beginning in 1910, he fused Fauvist color with Analytic Cubist form in works celebrating the modern city and modern technology. One of these, HOMAGE TO BLÉRIOT (FIG. 20-24), pays tribute to the French pilot who in 1909 was the first to fly across the English Channel. One of Blériot's early airplanes, in the upper right, and the Eiffel Tower, below it, symbolized technological and social progress, and the crossing of the Channel expressed the hope of a new, unified world without national antagonisms. The brightly colored circular forms that fill the canvas suggest both the movement of the propeller on the left and the blazing sun, as well as the great rose windows of Gothic cathedrals. By combining images of progressive science with those of divinity, Delaunay suggested that progress is part of God's divine plan. The ecstatic painting thus synthesizes not only Fauvist color and Cubist form but also religion and modern technology.

The critic Guillaume Apollinaire labeled Sonia and Robert's style Orphism for its affinities with Orpheus, the legendary Greek poet whose lute playing charmed wild beasts, implying an analogy between their painting and music. They preferred to think of their work in terms of "simultaneity," a complicated concept based on Michel-Eugène Chevreul's law of the simultaneous contrast of colors. Simultaneity for Sonia and Robert connoted the collapse of spatial distance and temporal sequence into the simultaneous "here and now" and the creation of harmonic unity out of elements normally considered disharmonious. The simultaneity that they envisioned captured the new, faster pace of life made possible by airplanes, telephones, and automobiles.

Sonia produced innovative paintings along with Robert, but she also devoted much of her career to fabric and clothing design. She pioneered new clothing patterns based on Modern painting and used them in garments that she called Simultaneous Dresses. Her greatest critical success came in 1925 at the International Exposition of Modern Decorative and Industrial Arts, for which she decorated a Citroën sports

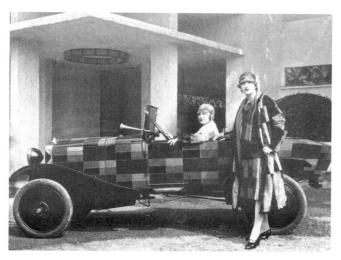

20–25 | Sonia Delaunay-Terk CLOTHES AND CUSTOMIZED CITROËN B-12 (EXPO 1925 MANNEQUINS AVEC AUTO) From Maison de la Mode, 1925.

Delaunay-Terk's clothing and fabric designs were displayed at the 1925 International Exposition of Modern Decorative and Industrial Arts in Paris. The term *Art Deco* was coined to describe the kind of geometric style influenced by Cubism and abstract art evident in many of the works on display, which included clocks, furniture, and wallpaper.

car to match one of her ensembles (FIG. 20–25), suggesting that her bold geometric designs were an expression of the new automobile age. Sonia chose that particular car because it was produced cheaply for a mass market, and she had also recently brought out inexpensive ready-to-wear clothing. Moreover, the small three-seater was specifically designed to appeal to the "new woman," who, like the artist herself, was less tied to home and family and less dependent on men than her predecessors. Regrettably, only black-and-white photos exist of these creations.

Similarly fascinated by technology was Fernand Léger (1881–1955), who developed a version of Cubism based on machine forms. Léger painted in a nearly abstract Cubist style as early as 1911, but his artistic development was redirected by his wartime experience. Drafted into the French army, he was almost killed in a poison gas attack; the experience led him to see more beauty in everyday objects, even machine-made ones. **THREE WOMEN** (FIG. 20–26) is a machine-age version of the French odalisque tradition that dates back to Ingres (SEE FIG. 19–4). The picture space is shallow and compressed but less radically shattered than Analytic Cubist works. The women, arranged within a geometric grid, stare out blankly at us, embodying a quality of classical calm. Léger's women have identical faces, and their bodies seem assembled from

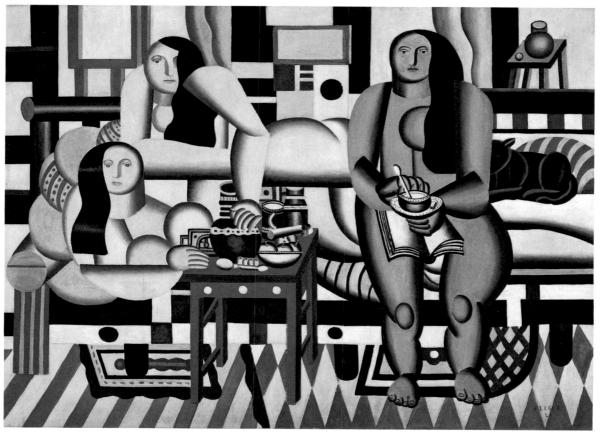

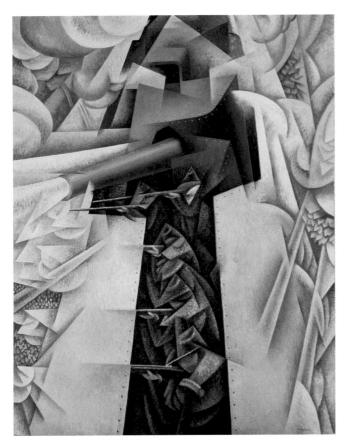

20–27 | Gino Severini ARMORED TRAIN IN ACTION 1915. Oil on canvas, $45\% \times 34\%$ (115.8 \times 88.5 cm). The Museum of Modern Art, New York. Gift of Richard S. Zeisler. 287.86

standardized, interchangeable metal parts. The bright, exuberant colors and patterns that surround them suggest a positive vision of an orderly industrial society.

ITALIAN EXTENSIONS. Italian Futurism emerged on February 20, 1909, when the controversial Milanese poet and literary magazine editor Filippo Marinetti (1876–1944) published his "Foundation and Manifesto of Futurism" in a Paris newspaper. An outspoken attack against everything old, dull, "feminine," and safe, Marinetti's manifesto promoted the exhilarating "masculine" experiences of warfare and reckless speed. Futurism aimed both to free Italy from its past and to promote a new taste for the thrilling speed, energy, and power of modern technology and modern urban life.

In April 1911, five Milanese artists issued the "Technical Manifesto" of Futurist painting, in which they boldly declared that "all subjects previously used must be swept aside in order to express our whirling life of steel, of pride, of fever, and of speed." Some members of the group took a trip to Paris to prepare for a Futurist exhibition in 1912, and when they saw Cubist works there they realized that the style could be harnessed to express their love of machines, speed, and war.

Among the signers of the manifesto, Gino Severini (1883–1966) most consistently expressed the radical Futurist idea that war was a cleansing agent for humanity. He lived in Paris from 1906, where he focused special attention on the work of Seurat. Invited to sign the Technical Manifesto while living in Paris, he served as an intermediary between the Futurists based in Italy and the French avant–garde. In his 1915 work **ARMORED TRAIN IN ACTION** (FIG. 20–27), we see the artist's interest in Seurat's Post–Impressionism in the small strokes of bright color that enliven the surface of the work. He also uses the compressed picture space and jagged forms of Cubism to describe a tumultuous scene of smoke, violence, and cannon blasts issuing from the speeding train. The viewpoint in this painting is similarly dizzying, as if we are flying above in an airplane.

In 1912 the Futurist painter Umberto Boccioni (1882–1916) took up sculpture, and his "Technical Manifesto of Futurist Sculpture" called for a "sculpture of environment" in which closed outlines would be broken open and sculptural forms integrated with surrounding space. If traditional sculpture represented things at rest, Futurist sculpture should concern itself with motion. His major sculptural work, **UNIQUE FORMS OF CONTINUITY IN SPACE** (FIG. 20–28), presents an armless nude figure in full, powerful stride. The contours of the muscular body flutter and flow into the surrounding space, expressing the figure's great velocity and vitality as it rushes forward, a stirring symbol of the brave new Futurist world. This brave new world included World War I, which the Futurists enthusiastically supported. Boccioni enlisted immediately, and lost his life in combat.

Russian Extensions. At the beginning of the century, art societies in St. Petersburg and Moscow began showing works by Impressionist and Post-Impressionist artists. In addition, some important Russian art collectors in both cities bought Modern artworks and opened their homes to artists. These two factors made it possible for Russians to be aware of most of the latest developments in the rest of Europe. By 1912, several Russians were painting in a style they called Cubo-Futurism for its combination of those two movements. Soon Russian artists took Cubism into completely abstract realms.

The leader in this new movement was Kazimir Malevich (1878–1935), who emerged after 1915 as the leading figure in the Moscow avant-garde. According to his later reminiscences, "in the year 1913, in my desperate attempt to free art from the burden of the object, I took refuge in the square form and exhibited a picture which consisted of nothing more than a black square on a white field." He used this large canvas as a backdrop for a performance of Mikhail Matiushin's new opera, *Victory Over the Sun*, in that year. Malevich exhibited thirtynine works in this radically new vein at the "Last Futurist Exhibition of Paintings: 0.10," held in St. Petersburg in the winter of 1915–16. One work, **SUPREMATIST PAINTING** (EIGHT RED RECTANGLES) (FIG. 20–29), consists simply of

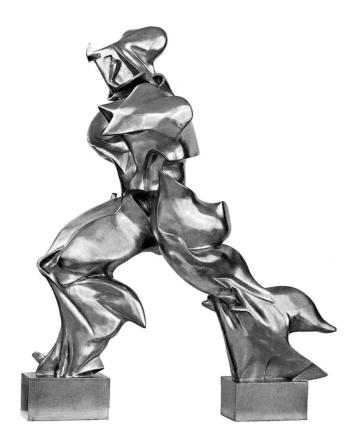

20–28 | Umberto Boccioni UNIQUE FORMS OF CONTINUITY IN SPACE 1913. Bronze, $43\% \times 34\% \times 15\%$ (111 \times 89 \times 40 cm). The Museum of Modern Art, New York. Acquired through the Lillie P. Bliss Bequest, (231.1948)

Boccioni and the Futurist architect Antonio Sant'Elia were both killed in World War I. The Futurists had ardently promoted Italiar entry into the war on the side of France and England. After the war Marinetti's movement, still committed to nationalism and militarism, supported the rise of fascism under Benito Mussolini, although a number of the original members of the group rejected this direction.

eight red rectangles arranged diagonally on a white painted ground. Malevich called this art Suprematism, short for "the supremacy of pure feeling in creative art" motivated by "a pure feeling for plastic [that is, formal] values." By eliminating objects and focusing entirely on formal issues, Malevich intended to "liberate" the essential beauty of all great art.

While Malevich was launching an art that transcended the present, Vladimir Tatlin (1885–1953) was opening a very different direction for Russian art, inspired by Synthetic Cubism. In April 1914, Tatlin went to Paris specifically to visit Picasso's studio. Tatlin was most impressed by the Synthetic Cubist sculpture he saw there, such as *Mandolin and Clarinet* (SEE FIG. 20–23), and began to produce innovative nonrepresentational relief sculptures constructed of various materials, including metal, glass, plaster, asphalt, wire, and wood. These "Counter-Reliefs," as he called them, were based on the conviction that each material generates its own repertory of forms and colors. Partly because he wanted to place "real

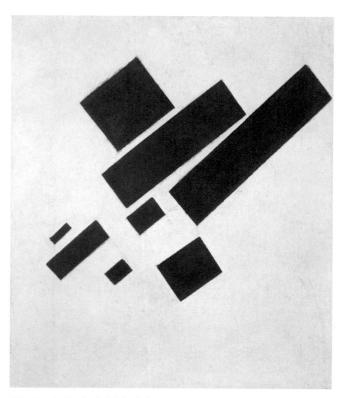

20–29 | Kazimir Malevich SUPREMATIST PAINTING (EIGHT RED RECTANGLES) 1915. Oil on canvas, $22\frac{1}{2} \times 18\frac{7}{8}$ " (57 × 48 cm). Stedelijk Museum, Amsterdam.

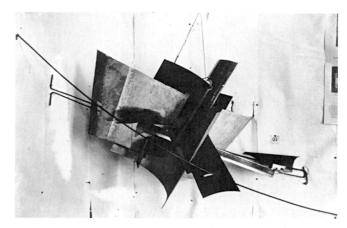

20–30 | Vladimir Tatlin | CORNER COUNTER-RELIEF 1915. Mixed media, $31\frac{1}{2} \times 59 \times 29\frac{1}{2}$ " (80 × 150 × 75 cm). Present whereabouts unknown.

© Estate of Vladimir Tat in/RAO Moscow/Licensed by VAGA, New York, NY

materials in real space" and because he thought the usual placement on the wall tended to flatten his reliefs, Tatlin began at the "0.10" exhibition of 1915–16 to suspend them across the upper corners of rooms (FIG. 20–30)—the usual location for the traditional Russian religious pictures known as icons. In effect, these Counter–Reliefs were intended to replace the old symbol of Russian faith with one dedicated to respect for modern and industrial materials.

20–31 Liubov Popova

ARCHITECTONIC PAINTING

1917. Oil on canvas, 29 ½ × 21"

(75.57 × 53.34 cm). Los Angeles County

Museum of Art.

Purchased with funds provided by the Estate of Hans G. M. de
Schulthess and the David E. Bright Bequest. 87.49

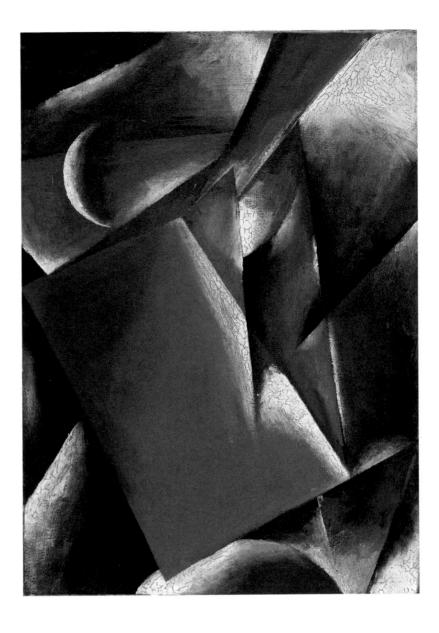

The Suprematist movement attracted many women, the most radical of whom was Liubov Popova (1889–1924). Born into a wealthy family, she studied Modern art in Paris in 1912–13. On her return to Russia she gravitated toward the Suprematists, and she made her first completely abstract Cubist works in 1916. She titled all of these works **ARCHITEC-TONIC PAINTING** (FIG. 20–31). They are more dynamic than those of Malevich, as their forms are modeled and seem to jut into our space. The title alludes to the combination of two-and three-dimensional forms that she attempted to capture in the shallow space of Cubism. The bright colors contribute to the dynamic space that the work creates: Warm colors, such as red and orange, seem to advance toward the viewer, while cool ones (blue and black) recede.

The Russian avant-garde enthusiastically supported the Russian Revolution when it broke out in 1917. They thought that their new form of art was appropriate for the new type of Russian citizen that would emerge from the ashes of the Czarist dictatorship.

Toward Abstraction in Sculpture

Sculpture underwent a revolution as profound as that of painting in the years prior to World War I. Some of the innovations were carried out by artists such as Erich Heckel (SEE FIG. 20-7), who gouged and chopped his sculptures in an Expressionist fashion, and Picasso (FIG. 20-23), who invented constructed sculpture. The sculptor most devoted to making abstract threedimensional objects was the Romanian Constantin Brancusi (1876-1957). Brancusi settled in Paris in 1904 and was immediately captivated by non-Western art. He admired the simplification of forms that he found in the art of many of those cultures because he thought that the artists who made them were intent on capturing the "essence" of the subject. This search for an essence seemed the opposite of the Western tradition after Michelangelo, which he thought focused too much attention on the superficial appearance. He wrote, "What is real is not the external form but the essence of things. Starting from this truth it is impossible for anyone to express anything essentially real by imitating its exterior surface."

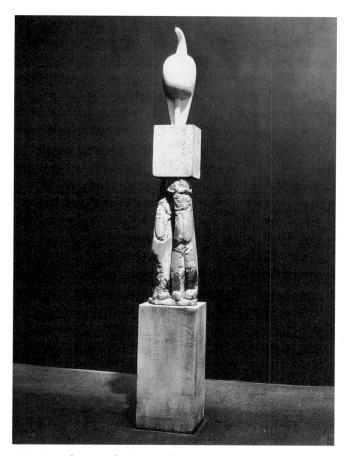

20–32 | Constantin Brancusi MAGIC BIRD 1908–12. White marble, height 22" (55.8 cm), on three-part limestone pedestal, height 5'10" (1.78 m), of which the middle part is the *Double Caryatid* (c. 1908); overall 7'8" \times 12 $\frac{1}{2}$ " \times 10 $\frac{1}{2}$ " (237 \times 32 \times 27 cm). The Museum of Modern Art, New York. Katherine S. Dreier Bequest

Brancusi's works tend to focus on two subjects, each of profound symbolic significance: the bird and the egg. The bird symbolized for him the human urge to transcend gravity and earthbound existence. We see in MAGIC BIRD (FIG. 20-32) that the avian form rises majestically above the figural masses below. The sculpture was inspired by Igor Stravinsky's orchestral piece The Firebird, a ballet based on a Russian folk tale that Brancusi saw in 1910. In the ballet, Prince Ivan rescues himself and a princess from an evil sorcerer and his monsters by waving one of the Firebird's feathers. The Firebird then leads Ivan to the hidden egg that holds the evil sorcerer's spirit, and she tells him to break it. When he does, the sorcerer vanishes. The upper part of the sculpture is the Firebird, who in the ballet has bright red plumage. Brancusi made her sleek and abstract. Below are struggling human masses that symbolize the sorcerer's assistants.

For Brancusi, the egg symbolized birth or rebirth and the potential for growth and development. He saw egg shapes as perfect, organic ovals that contain all possible life forms. In **THE NEWBORN** (FIG. 20–33), he charmingly conflated the egg shape with that of a shrieking infant's head. Both infants and eggs, after all, represent a life span in prototype. Perhaps its cry is the primal shout of the baby as it leaves the womb and enters a new (and for Brancusi, more problematic) level of existence.

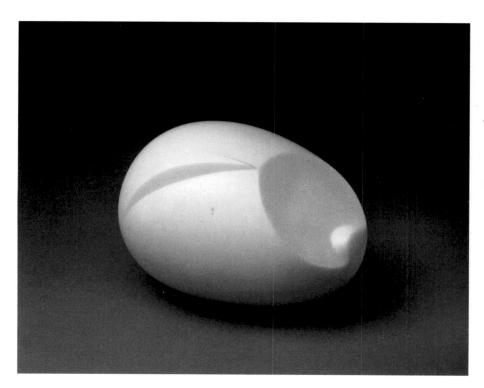

20–33 | Constantin Brancusi THE NEWBORN
1915. Marble, $5\% \times 8\% \times 5\%$ (14.6 \times 21 \times 14.8 cm). Philadelphia Museum of Art.
Louise and Walter Arensberg Collection.
1950.134.10. Artists Rights Society

Dada

When the Great War broke out in August 1914, most European leaders thought it would be over by Christmas. Each side reassured its population that the efficiency and bravery of its soldiers would ensure a speedy resolution and that Europe could then resume its onward march of progress. Yet these hopes proved illusory in the extreme. World War I was by far the most brutal in human history up to that time, as the allegedly advanced societies hurled themselves at each other. A casualty list provides some indication of the human toll: Germany suffered 850,000 dead; France lost 700,000; Great Britain, 400,000. Large as they are, these numbers cover only the Western front, and only the single year 1916. The conflict, which was supposed to end quickly and gloriously, settled into a vicious stalemate on all fronts, as each side deployed the latest technology for killing: machine guns, flame throwers, fighter aircraft, poison gas. On the home front, governments assumed unheard-of powers over industry and labor in order to manage the war effort. Citizens saw propaganda campaigns, war profiteering masquerading as patriotism, and food rationing. Disgust with the

KARAWANE
jolitanto bambla o falli bambla
grossiga m pla habla horem
sigla goramen
higo bloiko russula huju
holioka holiala
anlogo bung
blago bung
blago bung
boeso fataka
a sa sa
schampa wulla wussa ólobo
hej tatta görem
eschipe zunbada
mulubu ssubudu ulum ssubudu
tumba ba- umf
kusagauma
ba- umf

20–34 Hugo ball reciting the sound poem "karawane"

Photographed at the Cabaret Voltaire, Zürich, 1916.

conflict would eventually spring up on many fronts, but the first artistic movement to react against the slaughter and its moral quandaries was Dada. If the goal of Modern art was questioning and overthrowing the traditions of art, the Dadaists went further and questioned art itself.

Hugo Ball and the Cabaret Voltaire. The movement began with the opening of the Cabaret Voltaire in Zürich, Switzerland, on February 5, 1916. The cabaret's founders, German actor and poet Hugo Ball (1886–1927) and his companion, Emmy Hennings (d.1949), a nightclub singer, had moved to neutral Switzerland after World War I broke out. Their cabaret was inspired by the bohemian artists' cafés they had known in Berlin and Munich, and it attracted avant-garde writers and artists of various nationalities who shared their disgust with contemporary culture, which they blamed for the war.

Ball's performance while reciting one of his sound poems, "KARAWANE" (FIG. 20-34), reflects the iconoclastic spirit of the Cabaret Voltaire. His legs and body encased in blue cardboard tubes, his head surmounted by a white-andblue "witch doctor's hat," as he called it, and his shoulders covered with a huge, gold-painted cardboard collar that flapped when he moved his arms, he slowly and solemnly recited the poem, which consisted of nonsensical sounds. As was typical of Dada, this performance involved two both critical and playful aims. One goal was to retreat into sounds alone and thus renounce "the language devastated and made impossible by journalism." Another end was simply to amuse his audience by introducing the healthy play of children back into what he considered overly restrained adult lives. The flexibility of interpretation inherent in Dada extended to its name, which, according to one account, was chosen at random from a dictionary. In German the term signifies baby talk; in French it means "hobbyhorse"; in Romanian and Russian, "yes, yes"; in the Kru African dialect, "the tail of a sacred cow." The name, and therefore the movement, could be defined as the individual wished.

DUCHAMP. French artist Marcel Duchamp (1887–1968) created the most shocking Dada works. He was also influential in spreading Dada to the United States after he moved to New York to escape the war in Europe. In Paris, Duchamp had experimented successfully with Cubism before abandoning painting, which he came to consider a mindless activity. By the time he arrived in New York, Duchamp believed that art should appeal to the intellect rather than the senses. Duchamp's cerebral approach is exemplified in his **readymades**, which were ordinary manufactured objects transformed into artworks simply through the decision of the artist. The most notorious readymade was **FOUNTAIN** (FIG. **20–35**), a porcelain urinal turned 90 degrees and signed with the pseudonym "R. Mutt," a play on the name of the fixture's

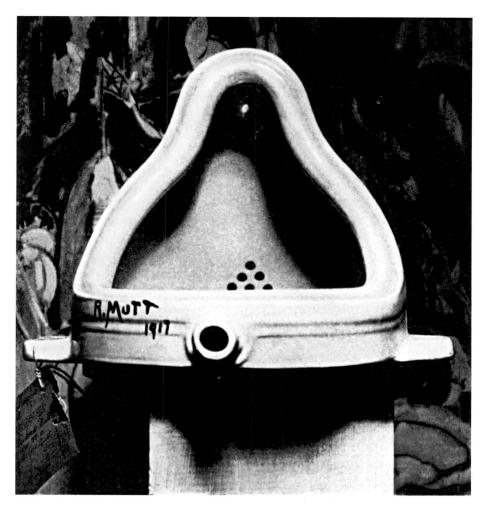

20–35 | Marcel Duchamp FOUNTAIN
1917. Porcelain plumbing fixture and enamel paint, height 24%" (62.5 cm).
Photograph by Alfred Stieglitz. Philadelphia Museum of Art.
Louise and Walter Arensberg Collection (1998–74–1)

Stieglitz's photograph is the only known image of Duchamp's original *Fountain*, which mysteriously disappeared after it was rejected by the jury of the American Society of Independent Artists exhibition. Duchamp later produced several more versions of *Fourtain* by simply buying new urinals and signing them "R. Mutt/1917."

manufacturer, the J. L. Mott Iron Works. Duchamp submitted Fountain anonymously in 1917 to the first annual exhibition of the American Society of Independent Artists, which was committed to staging a large, unjuried show, open to any artist who paid a \$6 entry fee. Duchamp, a founding member of the society and the head of the show's hanging committee, entered Fountain partly to test just how open the society was. A majority of the society's directors declared that Fountain was not a work of art, and, moreover, was indecent, so the piece was refused. The decision did not surprise Duchamp, who immediately resigned from the society.

A small journal that Duchamp helped to found published an unsigned editorial on the Mutt case refuting the charge of immorality and wryly noting: "The only works of art America has given are her plumbing and bridges." In a more serious vein, the editorial added: "Whether Mr. Mutt with his own hands made the fountain or not has no importance. He CHOSE it. He took an ordinary article of life, placed it so that its useful significance disappeared under the new title and point of view—created a new thought for that object." *Fountain* is a masterpiece of philosophical investigation, a conundrum on a tabletop that quietly explodes some

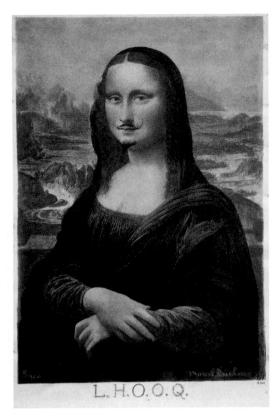

20–36 | Marcel Duchamp L.H.O.O.Q. 1919. Pencil on reproduction of Leonardo's *Mona Lisa*. $7\frac{1}{4} \times 4\frac{1}{4}$ " (19.7 × 12.1 cm). Philadelphia Museum of Art. Louise and Walter Arensberg Collection

of our most cherished notions. If a work of art is supposed to be a hand-made product, crafted (and signed) by the creator, this work is neither. If a work of art is supposed to have meaningful form, this work is formed to catch excretions. If a work of art is supposed to show the results of the artist's years of training and study, this work shows only the results of a trip to the hardware store. Duchamp's radical gesture was one of the most important advances of Modern art.

Equally challenging in a slightly different direction is L.H.O.O.Q. (FIG. 20-36). Duchamp bought a postcard reproduction of Leonardo's Mona Lisa (SEE FIG. 15-4), drew a mustache and beard on the famous face, and signed it with his name. He called this piece not a readymade but an "assisted readymade," in which the artist takes a common object and "assists" it with some alteration. Like Fountain, this work challenges preconceived notions with tremendous irreverence. Yet here the target is somewhat different. If one purpose of art is to contribute to civilization by creating objects of beauty, how can artists do this in the face of the unprecedented brutality of the war? Why would an artist want to contribute to the civilization that brought us such carnage? Duchamp's contribution to civilization is to ridicule its hypocrisies. One of the founders of the Dada movement put it succinctly: "Dada was born of disgust." In the face of poison gas attacks that caused thousands of casualties in a single day,

perhaps the most reasonable response is one that scales similar heights of ridiculousness.

Duchamp made only a few readymades. In fact, he created very little art at all after about 1922, when he devoted himself mostly to chess. Asked his occupation, he usually said, "retired artist"; his influence, however, made itself felt in many other Modern art movements for the rest of the century.

BERLIN DADA. Dada soon spread to other countries. Early in 1917 Hugo Ball and the Romanian-born poet Tristan Tzara (1896–1963) organized the Galerie Dada. Tzara also edited the magazine *Dada*, which soon attracted the attention of like-minded men and women in various European capitals. The movement spread farther when members of Ball's circle returned to their respective homelands after the war. Richard Huelsenbeck (1892–1974) brought Dada to Germany, where he helped form the Club Dada in Berlin in April 1918.

One distinctive feature of Berlin Dada was the amount of visual art it produced, while Dada elsewhere tended to be

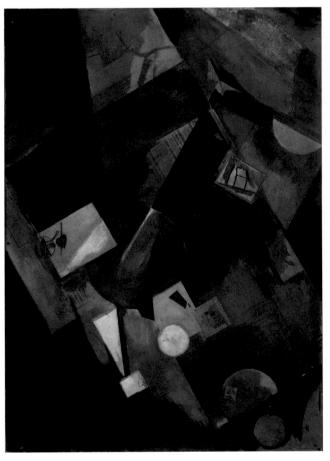

20–37 | Kurt Schwitters **MERZBILD 5B (PICTURE-RED-HEART-CHURCH)**April 26, 1919. Collage, tempera, and crayon on cardboard, 32% " $\times 23\%$ " (83.4 \times 60.3 cm). Guggenheim Museum. 52.1325. Kurt Schwitters © 2003 Artists Rights Society (ARS), New York/VG Bild-Kunst, Bonn

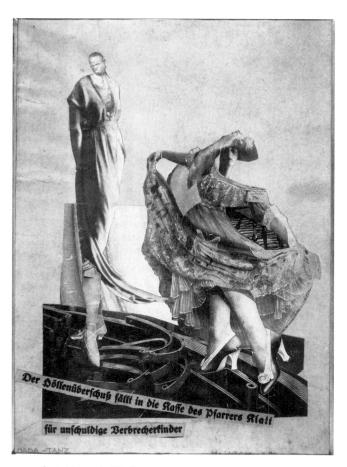

20–38 | Hannah Höch DADA DANCE 1922. Photomontage, $12\% \times 9\%$ (32 \times 23 cm). Israel Museum, Jerusalem. Arturo Schwartz Collection of Dada and Surrealist Art

more literary. Berlin Dada members especially favored collage and photomontage (a photograph created from many smaller photographs arranged in a composition), one of whose leading practitioners was Kurt Schwitters (1887-1948). After study at the Dresden academy, Schwitters painted in an Expressionist style until an important 1919 meeting with Huelsenbeck and other Dadaists. Probably the best example of a Dada collage was created in 1918 by Jean Arp, who dropped torn scraps of paper on a canvas and glued them down where they fell; in contrast, Schwitters used pieces of trash that he found in streets and parks to make images of subtle poetry (FIG. 20-37). Schwitters called each of these works Merzbild, or Merz picture, using an invented term that he claimed meant "garbage" or "rejects." He layered items such as rail tickets, postage stamps, ration coupens, and beer labels together with painted or drawn surfaces, because, he said, refuse deserves equal rights along with paint. The detritus he used was the mass-produced refuse of modern society. In the present work we see several fragments of this type, along with a newspaper page of telling significance. It is a clipping from February 1919 that describes some of the postwar disorder of defeated Germany, as a short-lived socialist republic in Bremen was brutally overthrown by conservative forces. Schwitters thus took the collage of Synthetic Cubism and broadened its image vocabulary in order to make pointed political statements.

Hannah Höch (1889-1978) was among the best exponents of photomontage. Between 1916 and 1926, Höch worked for Berlin's largest publishing house, producing decorative border patterns and writing articles on crafts for a domestically oriented magazine, and many of her photomontages focus on women's issues. Although the status of women improved in Germany after the war, and the "new woman" was much discussed in the German news media, Höch's contribution to this discussion was largely critical. In works such as DADA DANCE (FIG. 20-38), she seems to ridicule the way changing fashions establish standards of beauty that women, regardless of their natural appearance, must observe. On the right is an odd composite figure, wearing high-fashion shoes and dress, in a ridiculously elegant pose. The taller figure, with a small, black African head, looks down on her with a pained expression. For Höch, as for many in the Modernist era, Africa represented what was natural, so Höch presumably meant to contrast natural elegance with its foolish, overly cultivated counterpart. The work's message is not immediately evident, however; nor is it spelled out clearly by the text, which reads: "The excess of Hell falls into the coffers of Pastor Klatt for innocent children of criminals." Many Dadaists valued such purposeful obscurity, a fact which made them good candidates for the Surrealist movement after it began in the mid-1920s.

EARLY MODERN ART IN THE AMERICAS

Artists in the United States were closest to the European innovations, adapting and adopting many of them within a few years of their appearance, but the penetration of Modern art elsewhere in the Americas was uneven. The reasons varied with each region: Canadians had few artistic contacts with Europe; many Mexicans were ideologically opposed to Modern art; South America was far enough away that a time lag took effect. In each case, Modern art took a form different from what unfolded in Europe. If there is a common thread uniting all these regions, it is self-exploration. That is, in many countries artists put the vocabulary of Modern art into the service of a search for cultural roots; they explored the new styles as they also searched for ways to embody their cultural identity.

Modernist Tendencies in the United States

When Modern art was first exhibited in the United States, it competed with a still-vital American Realist tradition that was fundamentally opposed to the abstract styles of painters such as Kandinsky, Delaunay, and Malevich. In the opening decade of the twentieth century, a vigorous Realist movement coalesced in New York City around the charismatic

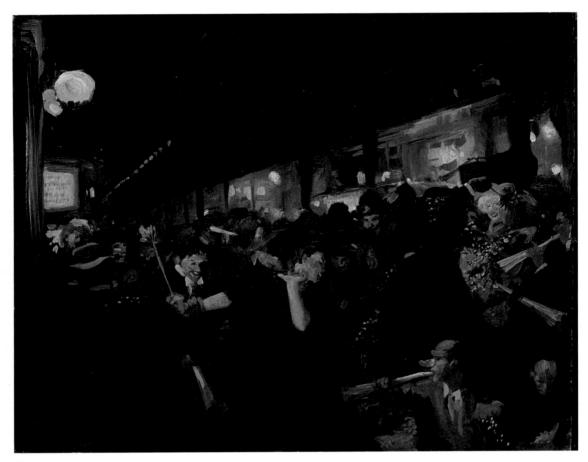

20–39 \perp John Sloan ELECTION NIGHT 1907. Oil on canvas, $26\% \times 32\%''$ (67×82 cm). Memorial Art Gallery of the University of Rochester, Rochester, New York, Marion Stratton Gould Fund. 41.33.

painter and teacher Robert Henri (1865–1929). Speaking out against both the academic conventions of "beautiful" subject matter and the Impressionistic style then dominating American art, Henri told his students: "Paint what you see. Paint what is real to you."

THE ASHCAN SCHOOL. In 1908, Henri organized an exhibition of artists who came to be known as The Eight, four of whom were former newspaper illustrators. The show was a gesture of protest against the conservative exhibition policies of the National Academy of Design, the American counterpart of the French École des Beaux-Arts. Because they depicted scenes of often gritty urban life in New York City, five of The Eight became part of what was later dubbed the Ashcan School.

Several members of the Ashcan School studied at the Pennsylvania Academy, where a Realist tradition that Thomas Eakins established (SEE FIG. 19–44) remained active. Most characteristic of this school is John Sloan (1871–1951), whose **ELECTION NIGHT** (FIG. 20–39) embodies many of the group's concerns. The artist went out into the street during a postelection victory celebration and made a sheaf of quick drawings that he then turned into this painting. The work retains the feel of a spontaneous sketch, with its rough, painterly surface. Members

of the group were criticized, as the Impressionists had been before them, for exhibiting unfinished works. Sloan was an avid socialist who made illustrations for several leftist magazines in those years, but he used his painting for a broader purpose: to record the passing show of humanity in its beautiful as well as grimy aspects. This work seems to record the latter category, as some of the revelers look ridiculous in their false noses as they blow on huge trumpets. In the first decade of the twentieth century, the Ashcan School was the most Modern art movement in the United States.

STIEGLITZ'S GALLERY. The chief proponent of European Modern art in the United States was the photographer Alfred Stieglitz, who in the years before World War I worked to foster the American recognition of European Modernism and to support its independent development by Americans. Like Peter Emerson before him (SEE FIG. 19–82), Stieglitz sought recognition for photography as a creative art form on a par with painting, drawing, and printmaking. Born in New Jersey to a wealthy German immigrant family, Stieglitz was educated in the early 1880s at the Technische Hochschule in Berlin, where he discovered photography and quickly recognized its artistic potential. In 1890 Stieglitz began to photograph New York City street scenes with one of the new high-

speed, handheld cameras (the most popular of which, the Kodak, was invented in 1888), which permitted him to "await the moment when everything is in balance" and capture it. He sent one of his early photos to Emerson, who published it in his magazine. Stieglitz promoted his views through an organization called the Photo-Secession, founded in 1902, and two years later he opened a gallery at 291 Fifth Avenue, soon known simply as "291," which exhibited Modern art as well as photography to help break the barrier between the two. In the years around 1910, Stieglitz's gallery became the American focal point not only for the advancement of photographic art but also for the larger cause of European Modernism. Even more important, Stieglitz also exhibited young American artists beginning to experiment with Modernist expression.

In his own art, Stieglitz used his camera to capture poetic moments in the midst of urban life, as we see in **THE FLAT-IRON BUILDING** (FIG. 20–40). Usually Stieglitz's poetic moments were fascinating formal compositions that he framed, rather than documents of human interaction. The tree trunk in the right finds an echo in the grove farther back, and also in the wedge-shaped building that gave the work its title. An arc of chairs behind a low wall seems to encircle both the building and the trees. The entire scene is bathed in winter's cloudy light, which the artist finely controlled through careful exposure, exacting darkroom treatment, and handcrafted printing. Like Emerson, Stieglitz was a devotee of straight photography. Stieglitz's magazine Camera Work, where this image was published in 1903, was among the highest-quality art publications in existence at that time.

THE ARMORY SHOW. The turning point for Modern art in the United States was the 1913 exhibition known as the Armory Show. It was assembled by one of The Eight, Arthur B. Davies (1862-1928), to demonstrate how outmoded were the views of the National Academy of Design. Unhappily for the Ashcan School, the Armory Show also demonstrated how out of fashion their Realistic approach was. Of the more than 1,300 works in the show, only about a quarter were by Europeans, but those works drew all the attention. Critics claimed that Matisse, Kandinsky, Braque, Duchamp, and Brancusi were the agents of "universal anarchy." The academic painter Kenyon Cox called them mere savages. When a selection of works continued on to Chicago, civic leaders there called for a morals commission to investigate the show. Faculty and students at the School of the Art Institute were so enraged they hanged Matisse in effigy.

A number of younger artists, however, responded positively and sought to assimilate the most recent developments from Europe. The issue of Realism versus academicism, so critical before 1913, suddenly seemed inconsequential. For the first time in their history, American artists at home began fighting their provincial status.

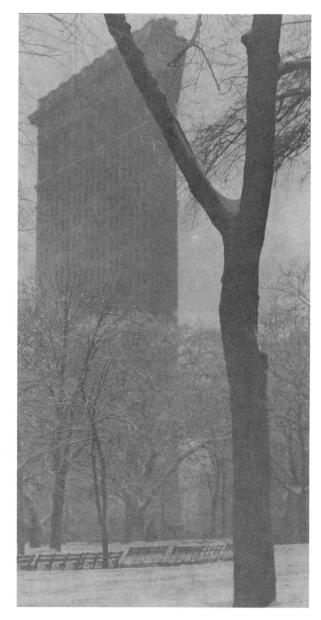

20–40 | Alfred Stieglitz | THE FLATIRON BUILDING 1903. Photogravure, $6\frac{11}{16} \times 3\frac{1}{16}$ " (17 \times 8.4 cm) mounted. Metropolitan Museum of Art, New York, Gift of J. B. Neumann, 1958 (58.577.37).

Among the pioneers of American Modernism who exhibited at the Armory Show was Marsden Hartley (1877–1943), who was also a regular exhibitor at Stieglitz's 291 gallery. Between 1912 and 1915 Hartley lived mostly abroad, first in Paris, where he discovered Cubism, then in Berlin, where he was drawn to the colorful, spiritually oriented Expressionism of Kandinsky. Around the beginning of World War I, Hartley merged these influences into the powerfully original style seen in his *Portrait of a German Officer* (see "*Portrait of a German Officer*," page 832). a tightly arranged composition of boldly colored shapes and patterns, interspersed with numbers, letters, and fragments of German military imagery that refer symbolically to its subject.

THE OBJECT SPEAKS

PORTRAIT OF A GERMAN OFFICER

arsden Hartley's modernist painting Portrait of a German Officer does not literally represent its subject but speaks symbolically of it through the use of numbers, letters, and fragments of German military paraphernalia and insignia. While living in Berlin in 1914, the homosexual Hartley became enamored of a young Prussian lieutenant, Karl von Freyburg, whom he later described in a letter to his dealer, Alfred Stieglitz, as "in every way a perfect being-physically, spiritually and mentally, beautifully balanced-24 years young. . . . ' Freyburg's death at the front in October 1914 devastated Hartley, and he mourned the fallen officer through painting.

The black background of *Portrait of a German Officer* serves formally to heighten the intensity of its colors and expressively to create a solemn, funereal mood. The symbolic references to Freyburg include his initials ("Kv.F"), his age ("24"), his regiment number ("4"), epaulettes, lance tips, and the Iron Cross he was awarded the day before he was killed. The cursive "E" may refer to Hartley himself, whose given name was Edmund.

Even the seemingly abstract, geometric patterns have symbolic meaning. The black-and-white checkerboard evokes Freyburg's love of chess. The blue-and-white diamond pattern comes from the flag of Bavaria. The black-and-white stripes are those of the historic flag of Prussia. And the red, white, and black bands constitute the flag of the German Empire, adopted in 1871.

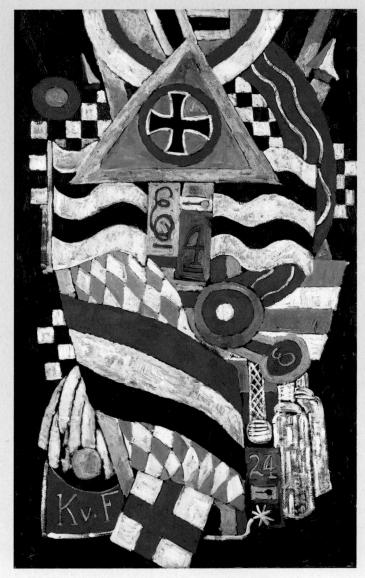

Marsden Hartley **PORTRAIT OF A GERMAN OFFICER** 1914. Oil on canvas, $68\frac{1}{4} \times 41\frac{3}{6}$ " (1.78 \times 1.05 m). The Metropolitan Museum of Art, New York. The Alfred Stieglitz Collection, 1949 (49.70.42)

Home-Grown Modernists. In some ways the most original of the early Modernists in the United States was Arthur Dove (1880-1946). Dove went to Europe in 1907-09, where he studied the work of the Fauves and exhibited at the Autumn Salon. After returning home, he isolated himself and began making abstract studies from nature around the same time as Vasily Kandinsky, though the two were unaware of each other. His series of works called NATURE SYMBOLIZED (FIG. 20-41) is a remarkable set of small works in which the artist made visual equivalents for natural phenomena such as rivers, trees, and breezes. While Kandinsky focused on his inner life and tried to shut out the external world, Dove rendered in abstract terms his experience in the landscape. A reader of the American philosopher Ralph Waldo Emerson, Dove liked to say that he had "no background except perhaps the woods, running streams, hunting, fishing, camping, the sky." In 1912 he bought a chicken farm in Connecticut so that he could stay close to nature and not have to depend on art sales for his livelihood. Dove is a minor master, an American-type individualist even in an avant-garde context; he worked outside the mainstream and cared little for how his work was received.

Stieglitz reserved his strongest professional and personal commitment at 291 for Georgia O'Keeffe (1887–1986). Born in rural Wisconsin, O'Keeffe studied and taught art sporadically between 1905 and 1915, when a New York friend showed Stieglitz some of O'Keeffe's abstract charcoal drawings. On seeing them, Stieglitz is reported to have said, "At last, a woman on paper!" Stieglitz included O'Keeffe's work in a small group show at 291 in the spring of 1916 and gave her a solo exhibition the following year. One male critic wrote that O'Keeffe, with her organic abstractions, had "found expression in delicately veiled symbolism for 'what every woman knows' but what women heretofore kept to themselves." This was the beginning of much written criticism that focused on the artist's gender, to which O'Keeffe strongly objected. She wanted to be considered an artist, not a woman artist.

O'Keeffe went to New York in 1918, and she and Stieglitz married in 1924. In 1925 Stieglitz introduced O'Keeffe's innovative, close-up images of flowers, which remain among her best-known subjects (see Fig. 5, Introduction). That same year, O'Keeffe began to paint New York skyscrapers, which artists and critics of the period recognized as an embodiment of American inventiveness and productive energy. O'Keeffe's skyscraper paintings are not unambiguous celebrations of lofty buildings, however. She often depicted them from a low vantage point so that they appear to loom ominously over the viewer, as in CITY NIGHT (FIG. 20-42), whose dark tonalities, stark forms, and exaggerated perspective may produce a sense of menace or claustrophobia. The painting seems to reflect O'Keeffe's own growing perception of the city as too confining. In 1929, she began to spend her summers in New Mexico and moved there permanently after Stieglitz's death.

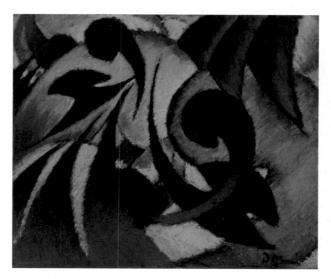

20–41 | Arthur Dove NATURE SYMBOLIZED NO. 2 c. 1911. Pastel on paper, $18 \times 21\%$ (45.8×55 cm). The Art Institute of Chicago.

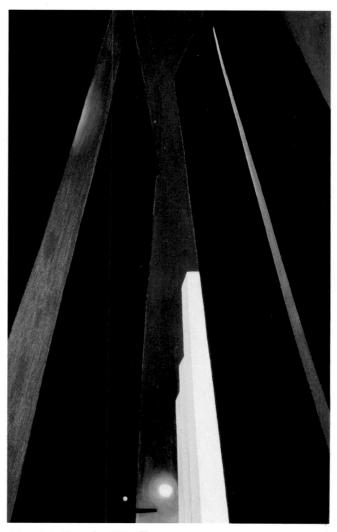

20–42 | Georgia O'Keeffe CITY NIGHT 1926. Oil on canvas, $48 \times 30''$ (123 \times 76.9 cm). Minneapolis Institute of Arts.

Modernism Breaks Out in Latin America

Academic values dominated Latin American art during the nineteenth century, as artists and patrons mostly went to Paris in search of training or works to decorate their houses. At the time of World War I, the most radical artists in most countries practiced a pleasant form of Impressionism that focused on the local landscape or traditional customs. After the war, when artists who had studied abroad returned with visions of Cubism or Expressionism, they caused a jolt similar to that of the Armory Show in the United States. Yet Latin American Modernists did not merely imitate Europe-based Modern styles, as they might imitate clothing fashions or technology. Latin American artists put the Modern language to use in exploring ethnic, national, or continental identity.

BRAZIL. The year 1922 marked the centenary of Brazil's independence from Portugal, and the avant-garde in Sao Paulo celebrated with Modern Art Week. It was time for Brazil to declare its artistic independence as well, and so the event gathered avant-garde poets, dancers, and musicians as well as visual artists. The week had an undeniable confrontational character. Poets penned new lines making fun of their elders, and dancers enacted Modern versions of indigenous rituals. Composer Heitor Villa-Lobos (1887–1959) appeared on stage in a bathrobe and slippers to play new music based on Afro-Brazilian rhythms.

Sao Paulo poet Oswald de Andrade, a planner of Modern Art Week, wrote the *Anthropophagic Manifesto* in 1928 that proposed a radical solution to the most urgent problem: What would be Brazil's relationship to European culture? He wrote that Brazilians should do with European culture what the ancient Brazilian natives did to the arriving Portuguese explorers as often as they could: Eat them. The relationship of Brazil to Europe would be one of cannibalism, or *anthropophagia*. Brazilians would gobble up European culture, ingest it, and let it strengthen Brazilianness.

The painter who most closely embodies this irreverent ideal is Tarsila do Amaral (1887-1974), a daughter of the coffee-planting aristocracy who studied in Europe with Fernand Léger, among others (SEE FIG. 20-26). Her work ABA-PORÚ (THE ONE WHO EATS) shows what might happen if Léger were taken out into the fresh air (FIG. 20-43). The work also shows influence of Brancusi's smooth abstractions (SEE FIG. 20–33), which Tarsila collected. But she purposely inserted "tropical" clichés into this work, in the form of the cactus and the lemon-slice sun. The subject matter is a cannibal who seems to sit and reflect on life. If we Brazilians are cannibals, the work seems to say, well then, let us be cannibals. Or, as Andrade put it in one of his manifestos: "Carnival in Rio is the religious outpouring of our race. Richard Wagner yields to the samba. Barbaric but ours. We have a dual heritage: the jungle and the school."

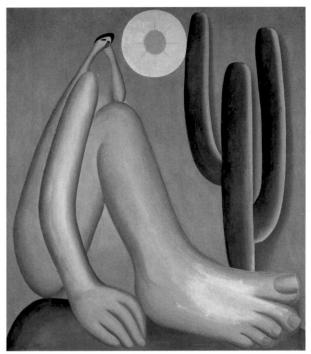

20–43 | Tarsila do Amaral

ABAPORÚ (THE ONE WHO EATS)

1928. Oil on canvas, 34" × 29" (86.4 × 73.7 cm).

Museo de Arte Latinoamericano, Buenos Aires.

Courtesy of Guilherme Augusto do Amaral / Malba-Coleccion Constantini,

Buenos Aires

ARGENTINA. In Argentina, the first exhibition of Cubist art in 1924 had a curious reception. On the first day of the show, the country's president came to visit, all by himself, to see the latest novelty. Later that evening at the official opening, a disturbance broke out that forced the gallery to close. These facts are signs of Argentina's "idiosyncratic modernity," wrote Xul Solar, the leading avant–garde artist. Argentina was at that time among the world's wealthiest nations, made rich on exports of beef and grain. It was also among the most cosmopolitan, with over 90 percent of the population of European descent, about half of them born in Europe. Buenos Aires saw itself as an outpost of Paris or Madrid.

Xul Solar (b. Alejandro Schultz Solari, 1887–1963) took the pseudonym in order to name himself after sunlight–Xul is the Latin *lux*, "light," spelled backward. He lived for twelve years in Europe, where he spent as much time studying art as the arcane mysticisms of the Jewish Kabbalah, the Chinese I Ching, tarot cards, and astrology. On his return in 1924, he altered his piano so that it showed colors instead of playing notes, and he invented two new languages that synthesized European and indigenous tongues. His paintings were little-known in his time because they are mostly small watercolors that he rarely exhibited (FIG. 20–44). The style of these works is most indebted to the Expressionist Paul Klee (SEE FIG. 20–15) but with important differences that reflect Xul's mystical proclivities. The central figure has catlike whiskers, lending it a mysterious air that the half-closed green eyes

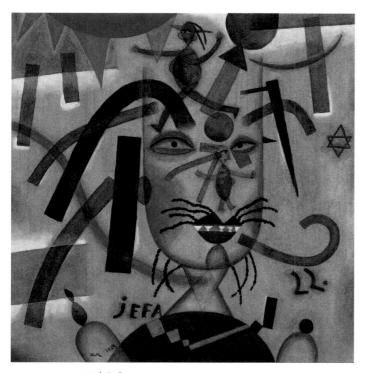

20–44 † Xul Solar JEFA (PATRONESS) 1923. Watercolor on paper, set on cardboard, $10\,\%''\times10\,\%''$ (26 \times 26 cm). Museum of Fine Arts, Houston. Museum purchase with funds provided by the Latin American Experience Gala and Auction 2005 343

support. The shallow composition is crisscrossed with lines of varying thickness which tend to go to or from the head, perhaps indicating directions of thought. An arrow at the top center connects the head to a blue orb symbolizing the universe, between a sun and crescent moon. Two smaller figures seem able to walk forward or backward with equal ease. A star of David at the right sits below a truncated Christian cross in the upper corner. This female feline is a mysterious but seemingly all-knowing being, which is now the artist regarded himself. Xul received the most support for his art from the literary magazine *Martín Fierro*, where the author Jorge Luis Borges worked. The magazine promoted avantgarde nationalism, Borges wrote, "believ[ing] in the importance of the intellectual contribution of the Americas, after taking a scissors to each and every umbilical cord."

CUBA. The avant-garde in Cuba in the 1920s was the most interdisciplinary, consisting of anthropologists, poets, composers, and even a few scientists. They gathered into a group in Havana that called itself "The Minority." Their 1927 manifesto pronounced itself opposed to government corruption, "Yankee imperialism," and dictatorships on any continent. Visual artists were urged to embrace not only new art, but, more important, popular art: to make Modern art that is rooted on Cuban soil. The artist who did this the most consistently over the years was Amelia Peláez (1896–1968). Shortly after the manifesto appeared, she had a seven-year stay in Paris where she studied with Alexandra Exter, a Russ-

ian artist allied with the Suprematists. On her return home in 1934, she joined the anthropologist Lydia Cabrera in studying Cuban popular and folk arts. Her paintings focus on the woman's realm of the Cuban domestic interior with a distinct national orientation (FIG. 20–45). The overall pictorial organization of this work is Cubist, as the flattened forms overlap in compressed pictorial space. We recognize in the work a mirror, a tabletop, and local hibiscus flowers, but these are embroidered by abstract patterns in pure color with heavy black outlining. This feature would be recognizable to any Cuban as a reinterpretation of the fan-shaped stained-glass windows that decorate a great many Cuban homes.

MEXICO. Art culture in Mexico was decisively shaped by the revolution of 1910–1917, which overthrew a dictatorship and established in his place a more democratic regime. Most postrevolutionary government officials believed that the more abstract forms of Modern art would not serve the people's needs because they are incomprehensible to the public. The Ministry of Education instead hired artists to paint murals in public buildings in a readily recognizable style. This movement of muralism will be discussed later, in the context of art for social change.

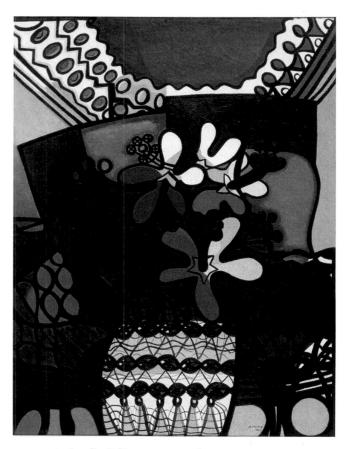

20–45 | Amelia Peláez MARPACÍFICO (HIBISCUS) 1943. Oil on canvas, $45\% \times 35''$ (115.6 \times 88.9 cm). Art Museum of the Americas, Washington, D.C. Gift of IBM

20–46 | Frida Kahlo
THE TWO FRIDAS
1939. Oil on canvas.
5′8½" × 5′8½" (1.74 × 1.74 m).
Museo de Arte Moderno, Instituto
Nacional de Bellas Artes, Mexico
City.

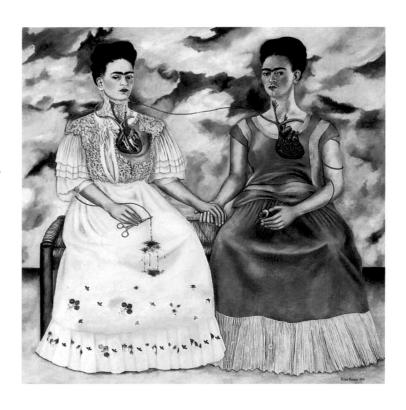

Some artists who did not participate in the mural program created highly individual styles with little or no connection to European Modernism. One of these was Frida Kahlo (1907-1954), who based her autobiographical art on traditional Mexican folk painting (FIG. 20-46). THE TWO FRIDAS shows a double image of the artist that expresses the split in her identity between European and Mexican (she was born of a German father and a part-indigenous Mexican mother). The European Frida on the left wears a Victorian dress while the Frida on the right wears Mexican peasant clothing. This latter Frida holds in her lap a piece of pre-Columbian sculpture, a small head of an indigenous god connected to a blood vessel that passes through the hearts of both Fridas. This vessel ends in the lap of the European Frida, who holds a forceps to try to stop its bleeding. The artist suffered a broken pelvis in a bus accident when she was 17, and faced a lifetime of surgical operations. The work alludes to that personal pain, as well as to the Aztec custom of human sacrifice by heart removal. The value of Kahlo's art, apart from its memorable self-expression, lies in how it investigates and lays bare larger issues of identity. This work focuses most on the mixed heritage of Latin America; others deal more directly with sexuality, feminine identity, and gender equality, all in the context of Kahlo's own life.

Canada

Canadian artists of the nineteenth century, like their counterparts in the United States, generally worked in styles derived from European art. A number of Canadians studied in Paris during the late nineteenth century, some of them mastering

academic realism and painting figurative and genre subjects, others developing tame versions of Impressionism and Post-Impressionism that they applied to landscape painting. Back in Canada, several of the most advanced painters in 1907 formed the Canadian Art Club, an exhibiting society based in Toronto, Ontario.

LANDSCAPE AND IDENTITY. In the early 1910s, a younger group of Toronto artists, many of whom worked for the same commercial art firm, became friends and began to go on weekend sketching trips together. They adopted the rugged landscape of the Canadian north as their principal subject and presented their art as an expression of Canadian national identity, despite its stylistic debt to European Post-Impressionism. A key figure in this development was Tom Thomson (1877-1917), who beginning in 1912 spent the warm months of each year in Algonquin Provincial Park, a large forest reserve 180 miles north of Toronto. There he made numerous small, swiftly painted, oil-on-board sketches that were the basis for full-size paintings he executed in his studio during the winter. A sketch made in the spring of 1916 led to THE JACK PINE (FIG. 20–47). The tightly organized composition features a stylized pine tree rising from a rocky foreground and silhouetted against a luminous background of lake and sky, horizontally divided by cold blue hills. The glowing colors and thick brushwork suggest the influence of Post-Impressionism, while the sinuous shapes and overall decorative effect reveal a debt to Art Nouveau. The painting's arresting beauty and reverential mood, suggesting a divine presence in the lonely northern landscape, have made

it an icon of Canadian art and, for many, a symbol of the nation itself.

NATIVE AMERICAN INFLUENCE. Three years after Thomson's tragic 1917 death by drowning in an Algonquin Park lake, several of his former colleagues formed an exhibiting society called the Group of Seven, which regularly invited other likeminded artists to exhibit with them. One was the West Coast artist Emily Carr (1871–1945), who first met members of the group on a trip to Toronto in 1927. Born in Victoria, British Columbia, Carr studied art in San Francisco (1890-93), England (1899-1904), and Paris (1910-11), where she assimilated the lessons of Post-Impressionism and Fauvism. Between 1906 and 1913 she lived in Vancouver, where she became a founding member of the British Columbia Society of Art. On a 1907 trip to Alaska she was taken with the monumental carved poles of Northwest Coast Native Americans and resolved to document these "real art treasures of a passing race." Over the next twenty-three years Carr visited more than thirty native village sites across British Columbia, making drawings and watercolors as the basis for oil paintings. After a commercially unsuccessful exhibition of her Native American subjects in 1913, Carr returned to Victoria and opened a boardinghouse. Running this business left little time for art, and for the next fifteen years she hardly painted. Her life changed dramatically in 1927 when she was invited to participate in an exhibition of West Coast art at the National Gallery of Canada in Ottawa, Ontario. It was on her trip east to attend the show's opening that she met members of the Group of Seven, whose example and encouragement rekindled her interest in painting.

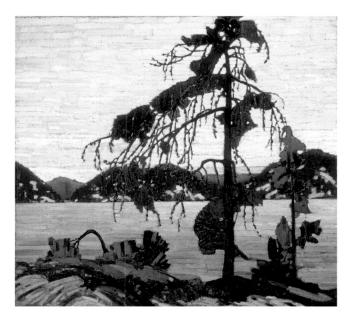

20–47 † Tom Thomson **THE JACK PINE** 1916–17. Oil on canvas, $49\% \times 54\%$ " (127.9 \times 139.8 cm). National Gallery of Canada, Ottawa, Ontario. Purchase, 1918.

Under the influence of the Group of Seven, Carr developed a dramatic and powerfully sculptural style full of dark and brooding energy. An impressive example of such work is **BIG RAVEN** (FIG. 20–48), which Carr based on a watercolor she made in 1912 in an abandoned village in the Queen Charlotte Islands. There she discovered a carved raven raised on a pole, the surviving member of a pair that had marked a mortuary house. While in her autobiography Carr described the raven as "old and rotting," in her painting the bird appears strong and majestic, thrusting dynamically above the swirling

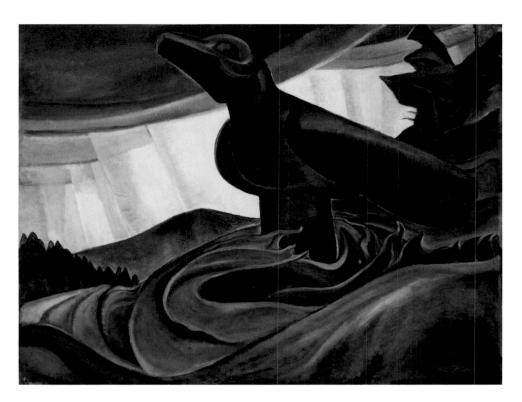

20–48 | Emily Carr

BIG RAVEN

1931. Oil on canvas, 34 × 44%"
(87.3 × 114.4 cm).

The Vancouver Art Gallery,
Vancouver, B.C.

Emily Carr Trust (VAG 42.3.11)

vegetation, a symbol of enduring spiritual power. Through its focus on a Native American artifact set in a recognizably northwestern Canadian landscape, Carr's *Big Raven* may be interpreted, like the paintings of the Group of Seven, as an assertion of national pride.

EARLY MODERN ARCHITECTURE

New industrial materials and advances in engineering enabled twentieth-century architects to create unprecedented architectural forms that responded to the changing needs of society. Just as Modern artists set aside the traditions of painting and sculpture, Modern architects rejected historical styles and emphasized simple, geometric forms and plain, undecorated surfaces.

European Modernism

In Europe, a stripped-down and severely geometric style of Modern architecture arose, partly in reaction against the ornamental excesses of Art Nouveau. A particularly harsh critic of Art Nouveau (known in Austria as *Sezessionstil*) was the Viennese writer and architect Adolf Loos (1870–1933). In the essay "Ornament and Crime" (1913), he insisted, "The evolution of a culture is synonymous with the removal of ornament from utilitarian objects." For Loos, ornament was a sign of a degenerate culture.

Exemplary of Loos's aesthetic is his **STEINER HOUSE** (FIG. 20–49), whose stucco-covered, reinforced-concrete construc-

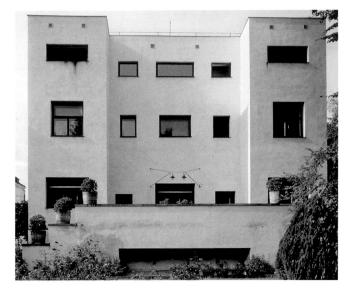

20–49 | Adolf Loos STEINER HOUSE Vienna. 1910.

tion lacks embellishment. The plain, rectangular windows are placed only according to interior needs. For Loos, the exterior's only function was to provide protection from the elements. A curved roof behind allows rain and snow to run off but, unlike the traditional pitched roof, creates no wasted space.

The purely functional exteriors of Loos's buildings qualify him as a founder of European Modern architecture. Another was the German Walter Gropius (1883–1969), who

20-50 | Walter Gropius and Adolf Meyer FAGUS SHOE FACTORY Alfeld-an-der-Leine, Germany. 1911-16.

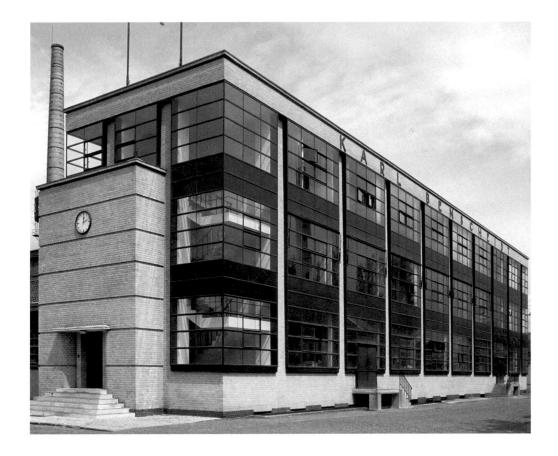

opened an office in 1910 with Adolf Meyer (1881–1929). Gropius's lectures on increasing workers' productivity by improving the workplace drew the attention of an industrialist who in 1911 commissioned him to design a factory for the **FAGUS SHOE COMPANY** (FIG. 20–50). This building represents the evolution of Modern architecture from the engineering advances of the nineteenth century. Unlike the Eiffel Tower or the Crystal Palace (SEE FIGS. 19–1, 19–31), it was conceived not to demonstrate advances or solve a problem but to function as a building. With it Gropius proclaimed that Modern architecture should make intelligent and sensitive use of what the engineer can provide.

To produce a purely functional building, Gropius gave the Fagus Factory façade no elaboration beyond that dictated by its construction methods. The slender brick piers along the outer walls mark the vertical members of the building's steel frame, and the horizontal bands of brickwork at the top and bottom, like the opaque panels between them, mark floors and ceilings. A curtain wall—an exterior wall that bears no weight but simply separates the inside from the outside—hangs over the frame, and it consists largely of glass. The corner piers standard in earlier buildings, here rendered unnecessary by the steel-frame skeleton, have been eliminated. The large windows both reveal the building's structure and flood the workplace with light. This building insists that good engineering is good architecture.

The most important French Modern architect was Le Corbusier (b. Charles-Édouard Jeanneret, 1887–1965), who developed several important concepts that influenced architects for the next half-century. His **VILLA SAVOYE** (FIG. 20–51), a private home outside Paris, is an icon of the

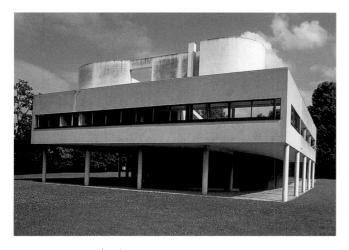

20–51 Le Corbusier VILLA SAVOYE Poissy-sur-Seine, France. 1929–30.

Located 30 miles outside of Paris, near Versailles, the Villa Savoye was designed as a weekend retreat. The owners, arriving from Paris, could drive right under the house, whose ground floor curves to accommodate the turning radius of an automobile and incorporates a three-car garage.

Sequencing Works of Art

1921	Léger, Le Grand Déjeuner
1922	Höch, Dada Dance
1926	O'Keeffe, City Night
1927	Mondrian, Composition with Yellow, Red, and Blue
1928	Tarsila do Amaral, <i>Abaporú</i>
1929-1930	Le Corbusier, Villa Savoye

International Style (see "The International Style," page 847). It is the best expression of his domino construction system, first elaborated in 1914, in which slabs of ferroconcrete (concrete reinforced with steel bars) were floated on six freestanding steel posts, placed at the positions of the six dots on a domino playing piece. Over the next decade the architect explored the possibilities of this structure and in 1926 published "The Five Points of a New Architecture," which argued for elevating houses above the ground on *pilotis* (freestanding posts); making roofs flat for use as terraces; using partition walls slotted between supports on the interior and curtain walls on the exterior to provide freedom of design; and using ribbon windows (windows that run the length of the wall). All of these became features of Modern buildings.

Le Corbusier applied these motifs in a distinctive fashion that combined two apparently opposed formal systems: the simplified Doric architecture of classical Greece and the clear precision of machinery. He referred to his Villa Savoye as a "machine for living," meaning that it should be as rationally designed as a car or an appliance. Such houses could be effectively placed in nature, as here, but they were meant to transcend it, as the elevation off the ground and pure white coloring suggest. The building appears to be a cube, but behind the ribbon windows, the façade is hollow on its two southfacing sides, allowing natural light to penetrate throughout.

American Modern Architecture

CONNECTION TO THE LAND. Many consider Frank Lloyd Wright (1867–1959), a pioneer of architectural Modernism, the greatest American architect of the twentieth century. Summers spent working on his uncle's farm in Wisconsin gave him a deep respect for nature, natural materials, and agrarian life. After briefly studying engineering at the University of Wisconsin, Wright apprenticed for a year with a Chicago architect, then spent the next five years with the firm of Dankmar Adler and Louis Sullivan (SEE FIG. 19–86), eventually becoming their chief drafter. In 1893, Wright opened his own office, specializing in domestic architecture. Seeking better ways to integrate house and site, he turned away from the traditional boxlike design and by 1900 was creating "organic" architecture that integrated a building with its natural surroundings.

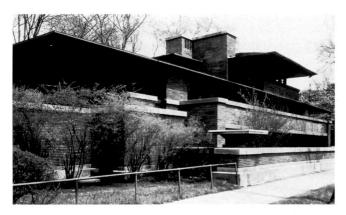

20–52 | Frank Lloyd Wright | FREDERICK C. ROBIE HOUSE Chicago. 1906–9.

This distinctive domestic architecture is known as the **Prairie style** because many of Wright's early houses were built in the Prairie States and were inspired by the horizontal character of the prairie itself. Its most famous expression is the **FREDERICK C. ROBIE HOUSE** (FIG. 20–52), which, typical of the style, is organized around a central chimney that marks the hearth as the physical and psychological center of the home. From the chimney mass, dramatically cantilevered (see "Space-Spanning Construction Devices," page xxix, Starter Kit) roofs and terraces radiate outward into the surrounding

environment, echoing the horizontality of the prairie even as they provide a powerful sense of shelter for the family within. The windows are arranged in long rows and deeply embedded into the brick walls, adding to the fortresslike quality of the building's central mass.

The horizontal emphasis of the exterior continues inside, especially in the main living level-one long space divided into living and dining areas by a freestanding fireplace. The free flow of interior space that Wright sought was partly inspired by traditional Japanese domestic architecture, which uses screens rather than heavy walls to partition space. In his quest to achieve organic unity among all parts of the house, Wright integrated lighting and heating into the ceiling and floor and designed built-in bookcases, shelves, and storage drawers. He also incorporated freestanding furniture of his own design, such as the dining room set seen in FIGURE 20-53. The chairs feature a strikingly modern, machine-cut geometric design that harmonizes with the rest of the house. Their high backs were intended to create around the dining table the intimate effect of a room within a room. Wright also designed the table with a view to promoting intimacy: Because he felt that candles and bouquets running down the center of the table formed a barrier between people seated on either side, he integrated lighting features and flower holders into the posts near each of the table's corners.

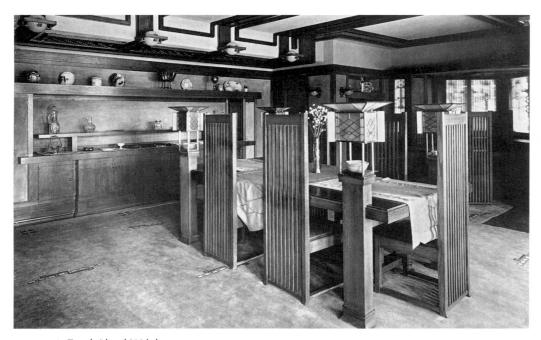

20–53 Frank Lloyd Wright DINING ROOM, FREDERICK C. ROBIE HOUSE

In 1897 Wright helped found the Chicago Arts and Crafts Society, an outgrowth of the movement begun in England by William Morris (Chapter 19). But whereas Morris's English predecessors looked nostalgically back to the Middle Ages and rejected machine production, Wright did not. He detested standardization, but he thought the machine could produce beautiful and affordable objects. The chairs seen here, for example, were built of rectilinear, machine-cut pieces. Wright, a conservationist, favored such rectilinear forms in part because they could be cut with a minimum of wasted lumber.

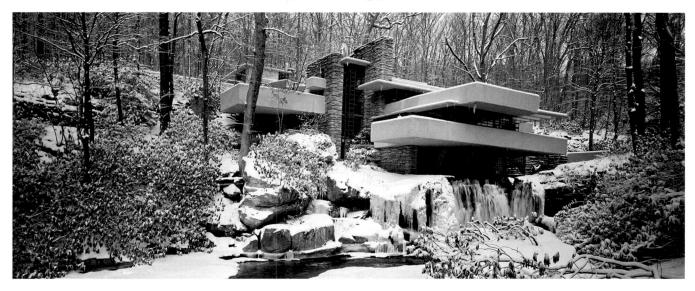

20–54 ∣ Frank Lloyd Wright EDGAR KAUFMANN HOUSE, FALLINGWATER Mill Run, Pennsylvania. 1937.

Wright had an uneasy relationship with Modernism as it developed in Europe. Though he routinely used modern building materials (concrete, glass, steel), he always sought ways to keep his buildings connected to the earth and organic realities. The machine aesthetic of Le Corbusier and Gropius held no interest for him. To keep this organic connection, he often used brick, wood, or local stone, items that more orthodox Modernists shunned because they spoke of the past.

FALLINGWATER (FIG. 20-54), in rural Pennsylvania, is perhaps the best-known expression of Wright's conviction that buildings ought to be not simply on the landscape but in it. The house was commissioned by Edgar Kaufmann, a Pittsburgh department store owner, to replace a family summer cottage, on a site that featured a waterfall into a pool where the children played. To Kaufmann's great surprise, Wright decided to build the house into the cliff over the pool, allowing the waterfall to flow around and under the house. A large boulder where the family had sunbathed was built into the house as the hearthstone of the fireplace. In a dramatic move that engineering experts questioned, Wright cantilevered a series of broad concrete terraces out from the cliffside, echoing the great slabs of rock below. The house is further tied to its site through materials. Although the terraces are poured concrete, the wood and stone used elsewhere are either from the site or in harmony with it. Such houses do not simply testify to the ideal of living in harmony with nature but declare war on the modern industrial city. When asked what could be done to improve the city, Wright responded: "Tear it down."

We see a still stronger connection to the land, in combination with a dose of Modernist Primitivism, in the architec-

ture of Mary Colter (1869–1958), which developed separately from that of Wright at about the same time. Born in Pittsburgh and educated at the California School of Design in San Francisco, she spent most of her career as architect and decorator for the Fred Harvey Company, a tourism firm active throughout the Southwest. Colter was an avid student of Native American arts, especially the architecture of the Hopi and Pueblo peoples, and her buildings quoted liberally from those traditions. She designed several visitor facilities at Grand Canyon National Park, of which the most dramatic is the **LOOKOUT STUDIO** (FIG. 20–55). The foundation of this building is natural rock, and most of the walls are built from stones quarried nearby. The building incorporates the edge of the canyon rim and natural rock outcrops into its design,

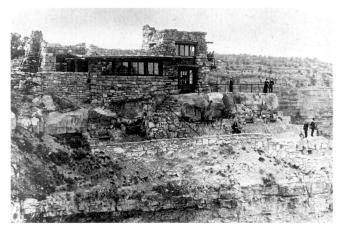

20–55 | Mary Colter LOOKOUT STUDIO Grand Canyon National Park, Arizona. 1914. Photo Grand Canyon National Park Museum Collection

Elements of Architecture

THE SKYSCRAPER

he evolution of the skyscraper depended on the development of these essentials: metal beams and girders for the structural-support skeleton; the separation of the building-support structure from the enclosing layer (the cladding); fireproofing materials and measures; elevators; and plumbing, central heating, artificial lighting, and ventilation systems. First-generation skyscrapers, built between about 1880 and 1900, were concentrated in the Midwest, especially in Chicago and St. Louis (SEE FIG. 19-86). Second-generation skyscrapers, with more than twenty stories, date from 1895. At first the tall buildings were freestanding towers, sometimes with a base, like the Woolworth Building of 1911-13 (SEE FIG. 20-56). New York City's Building Zone Resolution of 1916 introduced mandatory setbacks-recessions from the groundlevel building line-to ensure light and ventilation of adjacent elevator sites. Built in 1931, the 1,250-foot setback form of the Empire shafts State Building, diagrammed here, is thoroughly modern in hav-(layer two) ing a streamlined exterior-its cladding is in Art Deco style (SEE FIG. 20-25, caption)—that conceals the great complexity of the internal structure and mechanisms that make its height possible. The Empire State Building is still one of the tallest buildings stairwells in the world. (layer one) masonry wall beam girder cladding concrete flooring heat setbacks source

which is intended to facilitate contemplation of the spectacular view across the canyon. The roofline of the structure is also irregular, like the surrounding canyon wall. Inside, she used huge bare logs for most of the structural supports, between raw stone walls. All of these features can also be found in Hopi architecture. The sole concessions to modernity are in the liberal use of glass and a flat cement floor over the stone foundation. Her work on hotels and railroad sta-

tions throughout the Southwest helped to establish a distinctive identity for architecture of that region.

THE AMERICAN SKYSCRAPER. After 1900, New York City assumed leadership in the development of the skyscraper, whose soaring height was made possible by the use of the steel-frame skeleton for structural support and other advances in engineering and technology (see "The Skyscraper," above).

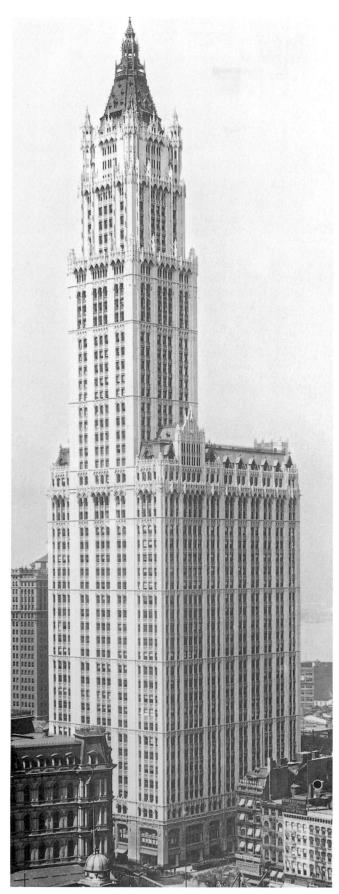

20–56 | Cass Gilbert woolworth building New York. 1911–13.

© Collection of the New York Historical Society, New York

New York clients rejected the innovative style of Louis Sullivan and other Chicago architects for the historicist approach still in favor in the East, as seen in the **woolworth Building** (FIG. 20–56), designed by the Minnesota-based Cass Gilbert (1859–1934). When completed, at 792 feet and 55 floors, it was the world's tallest building. Its Gothic-style external details, inspired by the soaring towers of latemedieval churches, resonated well with the United States' increasing worship of business. Gilbert explained that he wished to make something "spiritual" of what others called his "Cathedral of Commerce."

ART BETWEEN THE WARS

World War I had a profound effect on Europe's artists and architects. While the Dadaists responded sarcastically to the unprecedented destruction, some sought in the war's ashes the basis for a new, more secure civilization. The onset of the Great Depression in 1929 also motivated many artists to try to find ways to serve society. In general, a great deal of art produced between 1919 and 1939 in Europe and North America is connected in some way with the hope for a better and more just world, rather than primarily serving self-expression or the investigation of aesthetics.

Utilitarian Art Forms in Russia

In the 1917 Russian Revolution, the radical socialist Bolsheviks overthrew the czar, took Russia out of the world war, and turned to winning an internal civil war that lasted until 1920. Most of the Russian avant-garde enthusiastically supported the Bolsheviks, who in turn supported them.

Constructivism. The case of Aleksandr Rodchenko (1891–1956) is fairly representative. An early associate of Malevich and Popova (SEE FIGS. 20–29, 20–31), Rodchenko initially used drafting tools to make abstract drawings. The Suprematist phase of his career culminated in a 1921 exhibition where he showed three large flat, monochromatic panels painted in red, yellow, and blue, which he titled *Last Painting* (they are unfortunately lost). After making this work, he renounced painting as a basically selfish activity and condemned self-expression as socially irresponsible.

In the same year he helped launch a group known as the Constructivists, who were committed to quitting the studio and going "into the factory, where the real body of life is made." In place of artists dedicated to expressing themselves or exploring aesthetic issues, politically committed artists would create useful objects and promote the aims of society. Rodchenko came to believe that painting and sculpture did not contribute enough to practical needs, so after 1921 he began to make photographs, posters, books, textiles, and theater sets that would promote the egalitarian ends of the new Soviet society.

In 1925 Rodchenko designed a model workers' club for the Soviet Pavilion at the Paris International Exposition of Modern Decorative and Industrial Arts (FIG. 20–57). Although Rodchenko said such a club "must be built for amusement and relaxation," the space was essentially a reading room dedicated to the proper training of the Soviet mind. Designed for simplicity of use and ease of construction, the furniture was made of wood because Soviet industry was best equipped for mass production in that material. The design of the chairs is not strictly utilitarian, however. Their high, straight backs were meant to promote a physical and moral posture of uprightness among the workers.

Not all Modernists in Soviet Russia were willing to give up traditional art forms. El Lissitzky (1890–1941), for one, attempted to fit the formalism of Malevich to the new imperative that art be useful to the social order. After the revolution, Lissitzky was invited to teach architecture and graphic arts at the Vitebsk School of Fine Arts and came

20–57 Aleksandr Rodchenko

VIEW OF THE WORKERS' CLUB

Exhibited at the International Exposition of Modern

Decorative and Industrial Arts, Paris. 1925.

Rodchenko-Stepanova Archive, Moscow.

Art ©Estate of Aleksandr Rodchenko/RAO, Moscow / VAGA, New York

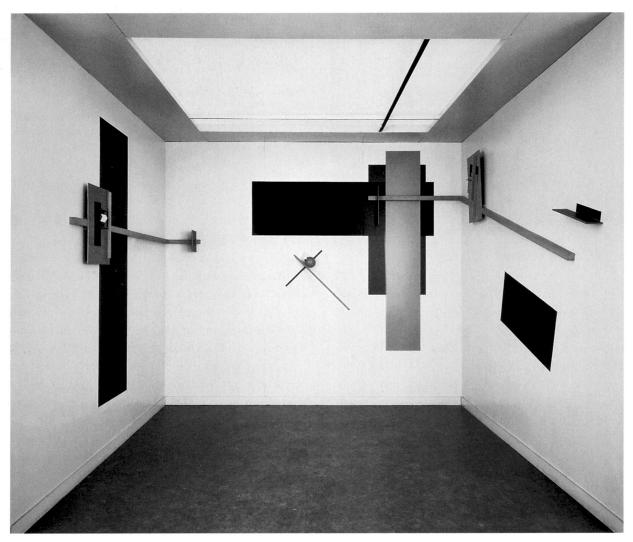

20–58 | El Lissitzky PROUN SPACE Created for the Great Berlin Art Exhibition. 1923, reconstruction 1965. Stedelijk Van Abbemuseum, Eindhoven, the Netherlands.

under the influence of Malevich, who also taught there. By 1919 he was using Malevich's Suprematist vocabulary for propaganda posters and for the new type of art work he called the Proun (pronounced "pro-oon"), possibly an acronym for the Russian proekt utverzhdenya novogo ("project for the affirmation of the new"). Most Prouns were paintings or prints, but a few were spaces (FIG. 20-58) that qualify as early examples of installation art—artworks created for a specific site, especially a gallery or outdoor area, that create a total environment. Lissitzky rejected conventional painting tools as too personal and imprecise and produced his Prouns with the aid of mechanical instruments. Their engineered look was meant to encourage precise thinking among the public. Like many other Soviet artists of the late 1920s, Lissitzky grew disillusioned with the power of formalist art to communicate broadly and turned to more utilitarian projects—architectural design and typography, in particular and he began to produce, along with Rodchenko and others, propaganda photographs and photomontages.

Socialist Realism. The move away from abstraction was led by a group of Realists, deeply antagonistic to the avant-garde, who banded together in 1922 to form the Association of Artists of Revolutionary Russia (AKhRR) to promote a clear, representational approach to depicting workers, peasants, revolutionary activists, and, in particular, the life and history of the Red Army. Remembering fondly both the Realism and social radicalism of Gustave Courbet (SEE FIG. 19–37), they created huge, dramatic canvases and statues on heroic or inspirational themes in an effort to appeal to the people more directly than they thought Modern art could. By depicting workers and peasants in a heroic manner, they believed they could help build the Soviet state. Their work established the basis for the Socialist Realism instituted by Stalin after he took control of the arts in 1932.

One of the sculptors who worked in this official style was Vera Mukhina (1889–1953), who is best known for her **WORKER AND COLLECTIVE FARM WOMAN** (FIG. 20–59), a colossal stainless-steel sculpture made for the Soviet Pavilion at the Paris Universal Exposition of 1937. The powerfully built male factory worker and female farm laborer hold aloft their respective tools, a hammer and a sickle, to mimic the appearance of these implements on the Soviet flag. The two figures are shown as equal partners striding purposefully into the future, their determined faces looking forward and upward. The dramatic, windblown drapery and the forward propulsion of their diagonal poses enhance the sense of vigorous idealism.

Rationalism in the Netherlands

If Lissitzky's goal was nothing less than reform of human thought through art, a contemporary Dutch movement attempted the same thing using even more simplified means.

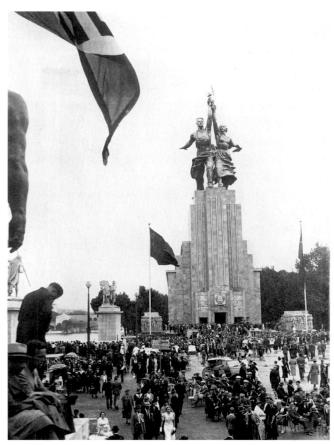

20–59 | Vera Mukhina

WORKER AND COLLECTIVE FARM WOMAN

Sculpture for the Soviet Pavilion, Paris Universal Exposition.
1937. Stainless steel, height approx. 78′ (23.8 m).

Art © Estate of Vera Mukhina / RAO, Moscow / VAGA, New York

The Dutch counterpart to Lissitzky's inspirational formalism was a group known as *de Stijl* ("The Style"), whose leading artist was Piet Mondrian (1872–1944). The turning point in Mondrian's life came in 1912, when he went to Paris and encountered Analytic Cubism. After assimilating its influence he gradually moved from radical abstractions of landscape and architecture to a simple, austere form of geometric art inspired by them. In the Netherlands during World War I, he met Theo van Doesburg (1883–1931), another painter who shared his artistic views. In 1917 van Doesburg started a magazine, *De Stijl*, which became the focal point of a Dutch movement of artists, architects, and designers. The title of the magazine is instructive: These artists did not work in a style, they worked in *The Style*.

Animating the de Stijl movement was the conviction that there are two kinds of beauty: a sensual or subjective one and a higher, rational, objective, "universal" kind. In his mature works, Mondrian sought the essence of the second kind, eliminating representational elements because of their subjective associations and curves because of their sensual appeal.

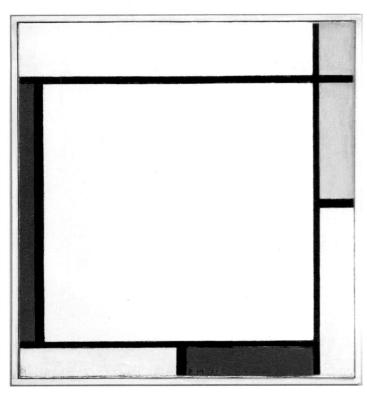

20-60 | Piet Mondrian (1872-1944)

COMPOSITION WITH YELLOW, RED, AND BLUE, 1927.

Oil on canvas, $14\% \times 13\%''$ (37.8 × 34.9 cm).

The Menil Collection, Houston.

© 2008 Mondrian/Holtzman Trust c/o HCR International, Warrenton, VA, USA.

Mondrian so disliked the sight of nature, whose irregularities he held largely accountable for humanity's problems, that when seated at a restaurant table with a view of the outdoors, he would ask to be moved.

In this he was following the lead of the theosophist mystic and mathematician M. H. J. Schoenmaekers, who in the 1915 book *New Image of the World* urged thoughtful people "to penetrate nature in such a way that the inner construction of reality is revealed to us." That inner construction, Schoenmaekers wrote, consists of a balance of opposing forces, such as heat and cold, male and female, order and disorder. Moreover, he wrote, artists can help us visualize this inner construction by making completely abstract paintings out of horizontals, verticals, and primary colors only. These words found a ready audience in Mondrian, who had joined the Theosophical Society in 1909 and was already headed toward abstraction in his art. During the war, Mondrian and Schoenmaekers both lived in Amsterdam and shared many visits and conversations.

From about 1920 on, Mondrian's paintings, such as **COMPOSITION WITH YELLOW**, **RED**, **AND BLUE** (FIG. 20–60), all employ the same essential formal vocabulary: the three primary hues (red, yellow, and blue), the three neutrals (white, gray, and black), and horizontal and vertical lines. The two linear directions are meant to symbolize the harmony of a series of opposites, including male versus female, individual versus society, and spiritual versus material. For Mondrian the essence of higher beauty was resolved conflict, what he called dynamic equilibrium. Here, in a typical composition, Mondrian achieved this equilibrium through the precise arrangement of color areas of different size, shape, and "weight," asymmetrically grouped around the edges of a canvas whose

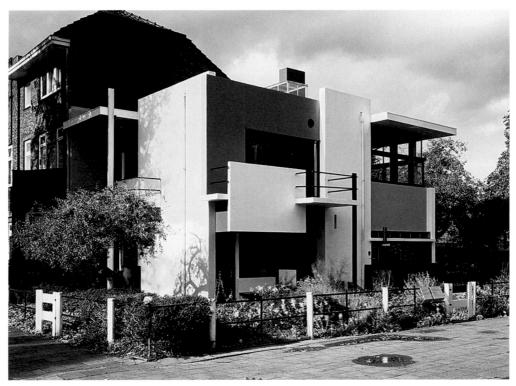

20–61 | Gerrit Rietveld SCHRÖDER HOUSE Utrecht, the Netherlands. 1925.

center is dominated by a large area of white. The ultimate purpose of such a painting is to demonstrate a universal style with applications beyond the realm of art. Like Art Nouveau, de Stijl wished to redecorate the world. But Mondrian and his colleagues rejected the organic style of Art Nouveau, believing that nature's example encourages "primitive animal instincts." If, instead, we live in an environment designed according to the rules of "universal beauty," we, like our art, will be balanced, our natural instincts "purified." Mondrian hoped to be the world's last artist: He thought that art had provided humanity with something lacking in daily life and that, if beauty were in every aspect of our lives, we would have no need for art.

The architect and designer Gerrit Rietveld (1888–1964) took de Stijl into the third dimension. His **schröder house** in Utrecht is an important example of the Modern architecture that came to be known as the International Style (see "The International Style," this page). Rietveld applied Mondrian's principle of a dynamic equilibrium to the entire house. The radically asymmetrical exterior (FIG. 20–61) is composed of interlocking gray and white planes of varying sizes, combined with horizontal and vertical accents in primary colors and black. His "RED-BLUE" CHAIR is shown here in the interior (FIG. 20–62), where sliding partitions allow modifications in the spaces used for sleeping, working, and entertaining. These innovative wall partitions were the idea of the patron, Truus Schröder-Schräder, a widowed interior designer. Though wealthy, Schröder-Schräder wanted her

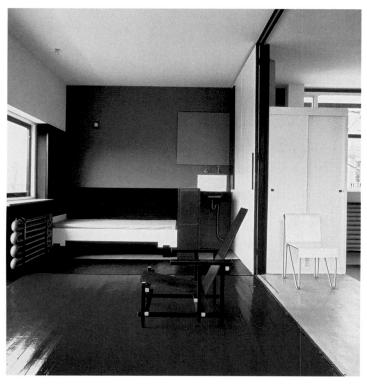

20–62 \perp Interior, schröder house, with "red-blue" chair. 1925.

Elements of Architecture THE INTERNATIONAL STYLE

fter World War I, increased exchanges between Modern architects led to the development of a common formal language, transcending national boundaries, which came to be known as the International Style. The term gained wide currency as a result of a 1932 exhibition at the Museum of Modern Art in New York, "The International Style: Architecture since 1922," organized by the architectural historian Henry-Russell Hitchcock and the architect and curator Philip Johnson. Hitchcock and Johnson identified three fundamental principles of the style.

The first principle was "the conception of architecture as volume rather than mass." The use of a structural skeleton of steel and ferroconcrete made it possible to eliminate load-bearing walls on both the exterior and interior. The building could now be wrapped in a skin of glass, metal, or masonry, creating an effect of enclosed space (volume) rather than dense material (mass). Interiors could now feature open, free-flowing plans providing maximum flexibility in the use of space.

The second principle was "regularity rather than symmetry as the chief means of ordering design." Regular distribution of structural supports and the use of standard building parts promoted rectangular regularity rather than the balanced axial symmetry of classical architecture. The avoidance of classical balance also encouraged an asymmetrical disposition of the building's components.

The third principle was the rejection of "arbitrary applied decoration." The new architecture depended on the intrinsic elegance of its materials and the formal arrangement of its elements to produce harmonious aesthetic effects.

The style or ginated in the Netherlands, France, and Germany and by the end of the 1920s had spread to other industrialized countries. Important influences on the International Style included Cubism, the abstract geometry of de Stijl, the work of Frank Lloyd Wright, and the prewar experiments in industrial architecture of Germans such as Walter Gropius. The first concentrated manifestation of the trend came in 1927 at the Deutscher Werkbund's Weissenhofsiedlung exhibition in Stuttgart, Germany, directed by Mies van der Rohe, an architect who, like Gropius, was associated with the Bauhaus in Germany (see p. 848). This permanent exhibition included modern houses by, among others, Mies, Gropius, and Le Corbusier. Its aim was to present models using new technologies and without reference to historical styles. All of the buildings featured flat roofs, plain walls, and asymmetrical openings, and almost all of them were rectilinear in shape.

The concepts of the International Style remained influential in architecture until the 1970s, particularly in the United States, where numerous European architects, including Mies and Gropius, settled in the 1930s. Even Frank Lloyd Wright, an individualist who professed to disdain the work of his European colleagues, adopted elements of the International Style in his later buildings, such as Fallingwater (SEE FIG. 20–54).

home to suggest not luxury but elegant austerity, with the basic necessities sleekly integrated into a meticulously restrained whole.

Bauhaus Art in Germany

The machine-made look of the buildings and furnishings of de Stijl proved anathema to the designers of the Bauhaus, who wanted to reinvigorate industry through craft. The Bauhaus ("House of Building") was the brainchild of Walter Gropius, an early devotee of the Arts and Crafts movement who believed that mass production destroyed art. He admired the spirit of the medieval building guilds—the *Bauhütten*—that had built the great German cathedrals, and he sought to revive and commit that spirit to the reconciliation of Modern art with industry by synthesizing the efforts of architects, artists, and designers and craft workers. The Bauhaus was formed in 1919, when Gropius convinced the authorities of Weimar, Germany, to allow him to combine the city's schools of art and craft. The Bauhaus moved to Dessau in 1925 and then to Berlin in 1932.

Although Gropius's "Bauhaus Manifesto" of 1919 declared that "the ultimate goal of all artistic activity is the building," the school offered no formal training in architecture until 1927. Gropius thought students would be ready for architecture only after they had completed the required preliminary course and received full training in the crafts taught in the Bauhaus workshops. These included making pottery, metalwork, textiles, stained glass, furniture, wood carvings, and wall paintings. In 1922 Gropius implemented a new emphasis on industrial design, and the next year brought on the Hungarian-born László Moholy-Nagy (1895–1946) to reorient the workshops toward the creation of sleek, func-

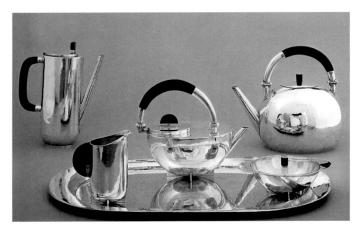

20–63 | Marianne Brandt COFFEE AND TEA SERVICE 1924. Silver and ebony, with Plexiglas cover for sugar bowl. Bauhaus Archiv, Berlin.

The lid of Marianne Brandt's sugar bowl is made of Plexiglas, reflecting the Bauhaus's interest in incorporating the latest advances in materials and technology into the manufacture of utilitarian objects.

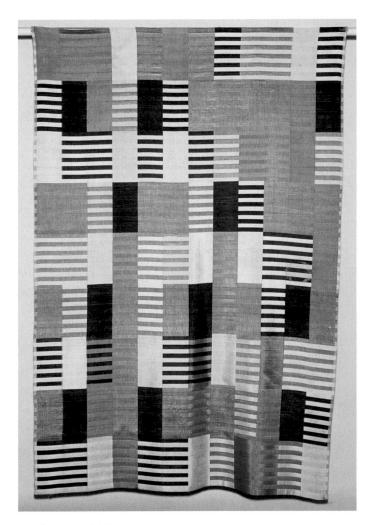

20–64 | Anni Albers **WALL HANGING** 1926. Silk, two-ply weave, $5'11\%'' \times 3'11\%''$ (1.83 \times 1.22 m). Busch-Reisinger Museum, Harvard University, Cambridge, Massachusetts
Association Fund.

Following the closure of the Bauhaus in 1933 by the Nazis, Anni Albers and her husband, Josef, immigrated to the United States, where they became influential teachers at the newly founded Black Mountain College in Asheville, North Carolina. Anni Albers exerted a powerful influence on the development of fiber art in the United States through her exhibitions, her teaching, and her many publications, including the books *On Designing* (1959) and *On Weaving* (1965).

tional designs suitable for mass production. The elegant tea and coffee service (FIG. 20–63) by Marianne Brandt (1893–1983), for example, though handcrafted in silver, was a prototype for mass production in a cheaper metal such as nickel silver. After the Bauhaus moved to Dessau, Brandt designed several innovative lighting fixtures and table lamps that went into mass production, earning much-needed revenue for the school. After Moholy-Nagy's departure in 1928 (the same year Gropius left), she directed the metal workshop for a year before leaving the Bauhaus herself.

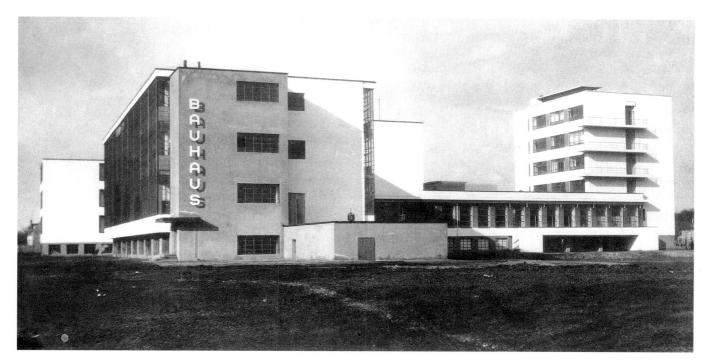

20–65 | Walter Gropius BAUHAUS BUILDING Dessau, Germany. 1925–26. View from northwest.

One of the enduring contributions of the Bauhaus was graphic design. The sans-serif letters of the building's sign not only harmonize with the architecture's clean lines but also communicate the Bauhaus commitment to modernity. Sans-serif typography (that is, a typeface without serifs, the short lines at the end of the strokes of a letter) had been in use only since the early nineteenth century, and a host of new sans-serif typefaces was created in the 1920s.

As a woman holding her own in the otherwise all-male metals workshop, Brandt was an exceptional figure at the Bauhaus. Although women were admitted to the school on an equal basis with men, Gropius opposed their education as architects and channeled them into workshops that he deemed appropriate for their gender, namely pottery and textiles. One of the most talented members of the textile workshop was the Berlin-born Anni Albers (b. Annelise Fleischmann, 1899-1994), who arrived at the school in 1922 and three years later married Josef Albers (1888-1976), a Bauhaus graduate and professor. Obliged to enter the textiles workshop rather than the painting studio, Anni Albers set out to make "pictorial" weavings that would equal paintings as fine (as opposed to applied) art. Albers's wall hangings, such as the one shown in FIGURE 20-64, were intended to aesthetically enhance the interior of a modern building in the same way an abstract painting would. The decentralized, rectilinear design reflects the influence of de Stijl, while acknowledging weaving as a process of structural organization.

Albers's intention was "to let threads be articulate . . . and find a form for themselves to no other end than their own orchestration." Numerous other Bauhaus works reveal a similarly "honest" attitude toward materials, including Gropius's design for the new Dessau Bauhaus, built in 1925–26. The building frankly acknowledges the reinforced concrete, steel,

and glass of which it is built but is not strictly utilitarian. Gropius, influenced by de Stijl, used asymmetrical balancing of the three large, cubical structural elements to convey the dynamic quality of modern life (FIG. 20–65). The expressive glass-panel wall that wraps around two sides of the workshop wing of the building recalls the glass wall of the Fagus Shoe Factory (SEE FIG. 20–50) and sheds natural light on the workshops inside. The raised parapet below the workshop windows demonstrates the ability of modern engineering methods to create light, airy spaces unlike the heavy spaces of past styles.

After the Bauhaus moved to Berlin in 1932, it lasted only one more year before Adolf Hitler forced its closure (see "Suppression of the Avant-Garde in Nazi Germany," page 850). Hitler objected to Modern art on two grounds: first, that it was cosmopolitan and not nationalistic enough; second, that it was unduly influenced by Jews. Only the first of these has a shred of truth; as grounds for censorship, neither is rational.

Art and Politics

Many art movements of the interwar period had a goal of improving the world somehow, but a few of them were more directly linked to political realities in their respective countries. These more politically oriented movements took a slightly different form in each region, in styles ranging from realism to abstraction.

Defining Art

SUPPRESSION OF THE AVANT-GARDE IN NAZI GERMANY

he 1930s in Germany witnessed a serious political reaction against avant-garde art and, eventually, a concerted effort to suppress it. One of the principal targets was the Bauhaus. Through much of the 1920s, the Bauhaus, where such luminaries as Paul Klee, Vasily Kandinsky, Josef Albers, and Ludwig Mies van der Rohe taught, had struggled against an increasingly hostile and reactionary political climate. As early as 1924 conservatives accused the Bauhaus of being not only educationally unsound but also politically subversive. To avoid having the school shut down by the opposition, Gropius moved it to Dessau in 1925, at the invitation of Dessau's liberal mayor, but he left the school soon after the relocation. His successors faced increasing political pressure, as the school was a prime center of Modernist practice, and the Bauhaus was again forced to move in 1932, this time to Berlin.

After Adolf Hitler came to power in 1933, the Nazi party mounted an aggressive campaign against Modern art. In his youth Hitler himself had been a mediocre landscape painter, and he had developed an intense hatred of the avant-garde. During the first year of his regime, the Bauhaus was forced to close for good. A number of the artists, designers, and architects who had been on its faculty—including Albers, Gropius, and Mies—migrated to the United States.

The Nazis also launched attacks against the German Expressionists, whose often intense depictions of German soldiers defeated in World War I and of the economic depression following the war were considered unpatriotic. Most of all, the treatment of the human form in these works, such as the Expression-

istic exaggeration of facial features, was deemed offensive. The works of these and other artists were removed from museums, while the artists themselves were subjected to public ridicule and often forbidden to buy canvas or paint.

As a final move against the avant-garde, the Nazi leadership organized in 1937 a notorious exhibition of banned works. The "Degenerate Art" exhibition was intended to erase Modernism once and for all from the artistic life of the nation. Seeking to brand all the advanced movements of art as sick and degenerate, it presented Modern artworks as specimens of pathology; the organizers printed derisive slogans and comments to that effect on the gallery walls (see illustration). The 650 paintings, sculpture, prints, and books confiscated from German public museums were viewed by 2 million people in the four months the exhibition was on view in Munich and by another million during its subsequent three-year tour of German cities.

By the time World War II broke out, the authorities had confiscated countless works from all over the country. Most were publicly burned, though the Nazi officials sold much of the looted art at public auction in Switzerland to obtain foreign currency.

The bl ndness of the Nazi regime even kept it from recognizing some of its friends. Expressionist Emil Nolde (SEE FIG. 20-6) joined the Danish section of the Nazi party in 1932, but still his works were confiscated and he was forbidden from painting. Among the other artists crushed by the Nazi suppression was Ernst Ludwig Kirchner, whose *Street*, *Berlin* (SEE FIG. 20-8) was included in the "Degenerate Art" exhibit. The state's open animosity was a factor in his suicide in 1938.

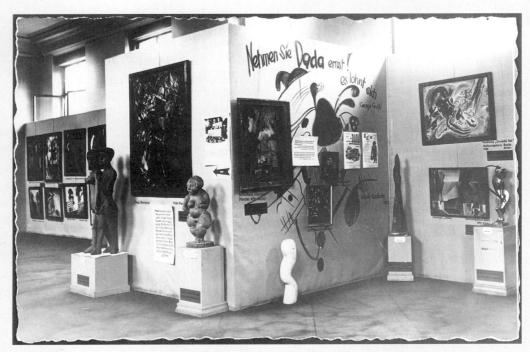

THE DADA WALL IN ROOM 3 OF THE "DEGENERATE ART" (ENTARTETE KUNST) EXHIBITION Munich. 1937.

Art © Estate of George Grosz/Licensed by VAGA, New York, N.Y.

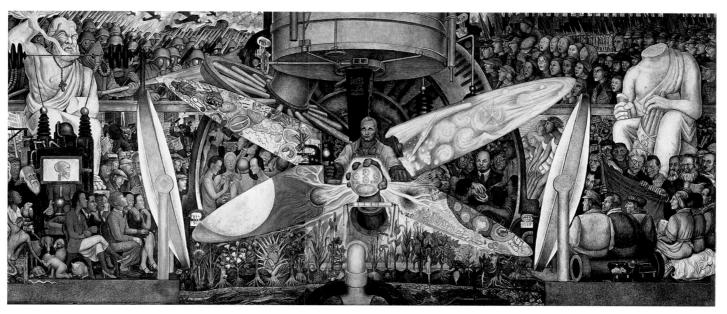

20–66 | Diego Rivera MAN, CONTROLLER OF THE UNIVERSE 1934. Fresco, $15'11'' \times 37'6''$ (4.85 \times 11.45 m). Museo del Palacio de Bellas Artes, Mexico City.

PAINTING FOR THE PEOPLE IN MEXICO. The Mexican Revolution of 1910 overthrew the thirty-five-year-long dictatorship of General Porfirio Díaz and was followed by ten years of political instability. In 1920 the reformist president Álvaro Obregón came to power and restored political order. As part of their revolt against the old regime, the leaders of the new government found ways to put art in the service of the people and the just-completed revolution. Obregón's government commissioned artists to decorate public buildings with murals celebrating the history, life, and work of the Mexican people.

Prominent in the new Mexican mural movement was Diego Rivera (1886–1957), a child prodigy who had enrolled in Mexico City's Academia de San Carlos at age 11. From 1911 to 1919 Rivera lived in Paris, where he befriended Picasso and worked in a Synthetic Cubist style. In 1919 he met David Siqueiros (1896-1974), another future Mexican muralist. They began to discuss Mexico's need for a national and revolutionary art. Siqueiros was violently opposed to Modern art, which he dismissed as "intellectual masturbation." It would be better, Rivera and Siqueiros thought, to make art in public places so that it could not be bought or sold, and to make it in a recognizable style. In this way, art could serve the people. In 1920–21 Rivera traveled in Italy to study its great Renaissance frescoes, then he visited ancient indigenous sites in Mexico that also had large mural paintings. The Mexican mural movement was indebted to both traditions.

One of Rivera's best murals (FIG. 20–66) was originally planned for New York City. Between 1930 and 1934 Rivera

worked in the United States, painting murals in San Francisco, Detroit, and New York. In 1933 the Rockefeller family commissioned him to paint a mural for the lobby of the RCA Building in Rockefeller Center, a fresco on the theme "Man at the Crossroads Looking with Hope and High Vision to the Choosing of a New and Better Future." When Rivera, a Communist, proposed including a portrait of Lenin in the mural, the Rockefellers objected. Rivera offered to add heads of Abraham Lincoln and some abolitionists, but the offer was refused. The Rockefellers canceled his commission, paid him his fee, and had the unfinished mural destroyed.

In response to what he called an "act of cultural vandalism," Rivera re-created the mural in the Palacio de Bellas Artes in Mexico City, under the new title MAN, CONTROLLER OF THE UNIVERSE. At the center of the mural, the clear-eyed young figure in overalls represents Man, who symbolically controls the universe through the manipulation of technology. Crossing behind him are two great ellipses that represent, respectively, the microcosm of living organisms as seen through the microscope at Man's right hand, and the macrocosm of outer space as viewed through the giant telescope above his head. Below, fruits and vegetables rise from the earth as a result of his agricultural efforts. To Man's left (the viewer's right), Lenin joins the hands of several workers of different races. To Man's right, decadent capitalists debauch themselves in a nightclub, directly beneath the disease-causing cells in the ellipse. (Rivera included in this section a portrait of the bespectacled John D. Rockefeller Jr.) The wings of the mural feature, to Man's left, the workers of the world embracing socialism, and, to Man's right, the capitalist world, which is cursed by militarism and labor

unrest. The work of the muralists on government buildings in Mexico influenced art in the United States, as the Federal government also engaged in a program during the Depression to hire American artists to decorate public buildings with murals (see "Federal Patronage for American Art during the Depression," page 854).

THE HARLEM RENAISSANCE. Between the two world wars, hundreds of thousands of African Americans migrated from the rural, mostly agricultural South to the urban, industrialized North, fleeing racial and economic oppression and seeking greater social and economic opportunity. This transition gave rise to the so-called New Negro movement, which encouraged African Americans to become politically progressive and racially conscious. The New Negro movement in turn stimulated a flowering of black art and culture known as the Harlem Renaissance, because its capital was in Manhattan's Harlem district, which had the country's largest concentration of African Americans. The cultural flowering encouraged musicians such as Duke Ellington, novelists such as Jean Toomer, and poets such as Langston Hughes. The intellectual leader of the Harlem Renaissance was Alain Locke (1886-1954), a critic and philosophy professor who argued that black artists should seek their artistic roots in the traditional arts of Africa rather than in the art of white America or Europe.

The first black artist to answer Locke's call was Aaron Douglas (1898–1979), a native of Topeka, Kansas, who moved to New York City in 1925 and rapidly developed an abstracted style influenced by African art. In paintings such as **ASPECTS OF NEGRO LIFE: FROM SLAVERY THROUGH RECONSTRUCTION** (FIG. 20–67), Douglas used schematic figures, sil-

houetted in profile with the eye rendered frontally as in ancient Egyptian reliefs and frescoes, and he limited his palette to a few subtle hues, varying in value from light to dark and sometimes organized abstractly into concentric bands that suggest musical rhythms or spiritual emanations. This work, painted for the Harlem branch of the New York Public Library under the sponsorship of the Public Works of Art Project, was intended to awaken in African Americans a sense of their place in history. At the right, Southern black people celebrate the Emancipation Proclamation of 1863, which freed the slaves. Concentric circles issue from the Proclamation, which is read by a figure in the foreground. At the center of the composition, an orator symbolizing black leaders of the Reconstruction era urges black freedmen, some still picking cotton, to cast their ballots in the box before him, while he points to a silhouette of the Capitol on a distant hill. Concentric circles highlight the ballot in his hand. In the left background, Union soldiers depart from the South at the close of Reconstruction, as the fearsome Ku Klux Klan, hooded and on horseback, invades from the left. Despite this negative image, the heroic orator at the center of Douglas's panel remains the focus of the composition, inspiring contemporary viewers to continue the struggle to improve the lot of African Americans.

The career of sculptor Augusta Savage (1892–1962) reflects the difficulties that many African Americans faced. She studied at Cooper Union in New York, but her first application for study in Europe in 1923 was turned down because of her race. Her letter of protest was eloquent but ultimately futile: "Democracy is a strange thing. My brother was good enough to be accepted in one of the regiments that

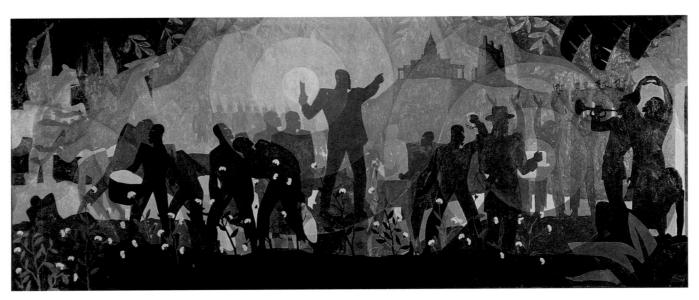

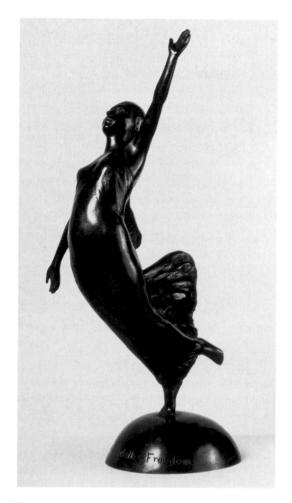

20–68 | Augusta Savage LA CITADELLE: FREEDOM 1930. Bronze, $14\frac{1}{2} \times 7 \times 6''$ (35.6 \times 17.8 \times 15.2 cm). Howard University Art Collection, Washington, D.C.

saw service in France during the war, but it seems his sister is not good enough to be a guest of the country for which he fought." On another occasion she was accepted but was unable to raise the money for passage. Finally in 1930 her efforts paid off, and she studied portraiture at La Grande Chaumière in Paris. On her return she sculpted portraits of many black leaders, such as Marcus Garvey and W. E. B. DuBois. Though she disagreed with Locke about the relevance of the tribal arts of Africa for contemporary artists, she devoted a great deal of time to the study of black history and was particularly stimulated by the story of Haiti, the black republic that achieved independence in 1804 after a slave revolt. One of her sculptures, LA CITADELLE: FREEDOM, combines her historical research with her interest in the human form (FIG. 20-68). La Citadelle is a castle that one of Haiti's first leaders erected, in imitation of the executive mansions of other countries. To her its very existence symbolized freedom and equality for blacks. Poised on the toes of one foot, the figure seems to fly through the air.

Sequencing Events WAR AND REVOLUTION IN THE EARLY 20TH CENTURY

exican Revolution
ninese Revolution; Republic founded nder Sun Yat-sen
orld War I
ussian Revolution
oviet Union created
tler becomes chancellor of Germany
utbreak of Spanish Civil War
orld War II

The private art school that she established in a basement eventually received Federal funding in 1935 as part of the Works Progress Administration (see "Federal Patronage for American Art during the Depression," page 854), and it became the Harlem Community Art Center, one of a hundred such centers across the country. Hers was the largest center, and it soon became much more than an art studio: poets, composers, dancers, and historians gathered there to discuss cultural issues and investigate and interpret black history.

The best-known artist to emerge from the Harlem Community Art Center was Jacob Lawrence (1917–2000). He devoted much of his early work to the depiction of black history, which he carefully researched and then recounted through narrative painting series comprising dozens of small panels, each accompanied by a text. He claimed that a single work was insufficient to capture the full import of the stories he researched. The themes of his painting series include the history of Harlem and the lives of abolitionist John Brown and Haitian revolutionary leader Toussaint L'Ouverture. In 1940-41, Lawrence created his most expansive set, THE MIGRATION OF THE NEGRO, whose sixty panels chronicle the exodus of African Americans from the rural South to the urban North-an exodus that had brought Lawrence's own parents from South Carolina to Atlantic City, New Jersey, where he was born. The first panel (FIG. 20-69), set in the South, depicts a train station filled with black migrants who stream through portals labeled with the names of Northern and Midwestern cities. The boldly abstracted style, with its simple shapes and bright, flat colors, suggests the influence of Cubism; but a more likely source is Lawrence's own study of the African art that also influenced Cubism. He later also illustrated books by Harlem Renaissance authors.

Art and its Context

FEDERAL PATRONAGE FOR AMERICAN ART DURING THE DEPRESSION

resident Franklin D. Roosevelt's New Deal, programs to provide relief for the unemployed and to revive the nation's economy during the Great Depression, included several initiatives to give work to American artists. The Public Works of Art Project (PWAP), set up in late 1933 to employ needy artists, was in existence for only five months but supported the activity of 4,000 artists, who produced more than 15,000 works. The Section of Painting and Sculpture in the Treasury Department, established in October 1934 and lasting until 1943, commissioned murals and sculpture for public buildings but was not a relief program; artists were paid only if their designs were accepted. These programs were influenced by the Mexican government's postrevolutionary mural painting program. The Federal Art Project (FAP) of the Works Progress Administration (WPA), which ran from 1935 to 1943, succeeded the PWAP in providing relief to unemployed artists. The most important work-relief agency of the Depression era, the WPA employed more than 6 million workers by 1943. Its programs to support the arts included the Federal Theater Project and the Federal Writers' Project as well as the Federal Art Project. About 10,000 artists participated in the FAP, producing a staggering amount of art, including about 108,000 paintings, 18,000 works of sculpture, 2,500 murals, and thousands of prints, photographs, and posters. Because it was paid for by the government, all this art became public property. The murals and large works of sculpture, commissioned for public buildings such as train stations, schools, hospitals, and post offices, reached a particularly wide audience.

To build public support for federal assistance to those in need, the government, through the Resettlement Agency (RA) and Farm Security Administration (FSA), hired photographers to document the problems of farmers, then supplied these photographs, with captions, free to newspapers and magazines. A leading RA/FSA photographer between 1935 and 1939 was the San Francisco-based Dorothea Lange (1895-1965). Many of her photographs document the plight of migrant farm laborers who had flooded California looking for work after fleeing the Dust Bowl conditions on the Great Plains. MIGRANT MOTHER, NIPOMO, CALIFORNIA pictures Florence Thompson, the 32year-old mother of seven children, who had gone to a pea-picking camp but found no work because the peas had frozen on the vines. The tired mother, with her knit brow and her hand on her mouth, seems to capture the fears of an entire population of disenfranchised people.

During the Depression, the Federal Art Project paid a generous average salary of about \$20 a week (a salesclerk at Woolworth's earned only about \$11), allowing painters and sculptors to devote themselves full-time to art and to think of themselves as professionals in a way few had been able to do before 1935. New York City's painters, in particular, began to develop a group identity, largely because they now had time to meet and discuss art in the bars and coffeehouses of Greenwich Village, the city's answer to the cafés that played such an important role in the life of artists in Paris. Finally, the FAP gave New York's art community a sense that high culture was important in the United States. The FAP's monetary support and its professional consequences would prove crucial to the artists later known as the Abstract Expressionists, who made important innovations after 1945.

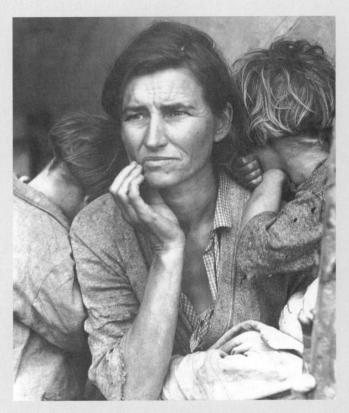

Dorothea Lange MIGRANT MOTHER, NIPOMO, CALIFORNIA February 1936. Gelatin-silver print. Library of Congress, Washington, D.C

Sculpture and Freedom. During the 1930s, totalitarian regimes increased pressure on Modern artists. In Russia, the leaders of the Communist Party promoted only Socialist Realism (SEE FIG. 20–59), and it became an official style early in the decade. Party leaders routinely denounced any sort of Modern tendencies in the arts, including music and drama,

on the grounds that Modern art was too individualistic and not understandable by the general public. Many of the pioneering Modernists, such as Popova and Rodchenko (SEE FIGS. 20–31, 20–57), were relatively unaffected by this, because they had already moved toward designing posters, furniture, and other useful objects. But Modernists who

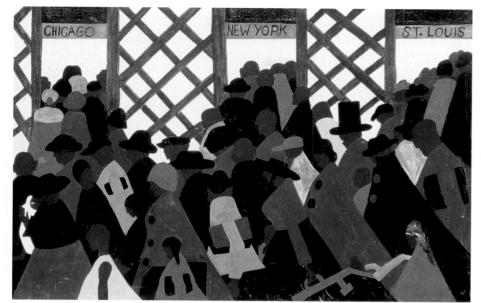

20-69 | Jacob Lawrence DURING THE WORLD WAR THERE WAS A GREAT MIGRATION NORTH BY SOUTHERN NEGROES

Panel 1 from *The Migration of the Negro*. 1940–41. Tempera on masonite, $12\times18''$ (30.5 \times 45.7 cm). The Phillips Collection, Washington, D.C.

This is the first image in Lawrence's sixty-panel cycle that tells the story of the migration of Southern American blacks to the industrialized North in the decades between the two world wars. The Harlem writer Alain Locke brought the series to the attention of Edith Halpert, a white New York art dealer, who arranged for the publication of several of its pane s in the November 1941 issue of Fortune magazine and who showed the entire series the same year at her Downtown Gallery. Thus, at age 23, Lawrence became the first African American artist to gain acclaim from whites in the segregated New York art world. The next year, the Migration series was jointly acquired by the Phillips Collection in Washington, D.C., and the Museum of Modern Art in New York, each of which purchased thirty paintings.

wanted to continue the Suprematist line, despite their continuing support of the Communist revolution, found themselves without opportunities to exhibit and at times were actively persecuted. Likewise, when the Nazi party took power in Germany, energetic suppression of Modernism in the arts followed shortly thereafter (see "Suppression of the Avant-Garde in Nazi Germany," page 850).

European abstract artists had gathered in 1931 to form the Abstraction-Creation group, and two years later they announced opposition to totalitarian control as the central principle behind their union: "The second issue of Abstraction-Creation appears at a time when, under all regimes, in some countries more effectively than others, but everywhere, free thought is fiercely opposed. . . . We place this issue under the banner of a total opposition to all oppression, of whatever kind it may be." The group numbered about fifty active members and a few hundred more associates, working in many modes of Modern art from Cubism to Neo-Plasticism, but the most innovative of them were sculptors. These artists were investigating the allusive power of biomorphic forms, that is, forms based on or resembling forms found in nature. Picasso too embraced such forms in his anti-Fascist protest work Guernica (SEE FIG. 20-1).

An early leader in biomorphic sculpture was Barbara Hepworth (1903–1975). After study at the Leeds School of Art, she joined Abstraction–Creation in 1933, and she later helped to form Unit One, a similarly oriented group of English artists. Hepworth was among the first to pierce her sculpture with holes, so that air and light pass through (FIG. 20–70). This strategy differs from that of assemblage, in which the pieces assembled create spaces and voids (SEE FIG. 20–23).

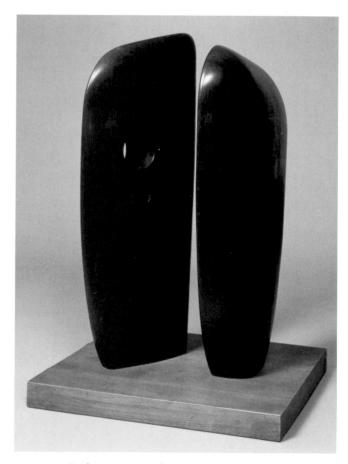

20–70 | Barbara Hepworth FORMS IN ECHELON 1938. Wood, $42\frac{1}{2}\times23\frac{1}{3}\times28$ " (108 \times 60 \times 71 cm). Tate Gallery, London.

Presented by the artist 1964 $\mbox{@}$ Bowness, Hepworth Estate

FORMS IN ECHELON consists of two pieces whose shape, while not obviously representational, is highly suggestive of organic forms, perhaps weathered stones or fingers or the backs of insects. The artist rarely stated her intentions in creating these shapes, beyond merely saying that they are organic. She hoped that viewers would let their eyes play across them, letting imagination generate associations and meanings. The two parts stand in a relationship to each other that is similarly unstated but potentially full of significance.

Her compatriot Henry Moore (1898–1986) developed the idea of the pierced work in abstractions that were more obviously based on the human form. After serving in World War I, including being gassed at the battle of Cambrai, Moore studied sculpture at the Leeds School of Art and the Royal College of Art. The African, Oceanic, and Pre-Columbian art he saw at the British Museum had a more powerful impact on his developing aesthetic than the tradition-oriented curriculum at the college. In the simplified forms of these non-Western art works he discovered an intense vitality that interested him far more than the refinement of the Renaissance tradition. Moreover, he saw in non-Western art a respect for the inherent qualities of materials such as stone or wood. He

never joined Abstraction-Creation, but he was a founder of Unit One. In most of his own works of the 1920s and 1930s, Moore practiced direct carving in stone and wood and pursued the ideal of truth to material as he created new images of humans.

A central subject in Moore's art is the reclining female figure, such as **RECUMBENT FIGURE** (FIG. 20-71), whose massive, simplified forms recall Pre-Columbian art. Specifically, Moore was inspired by the chacmool, a reclining human form that occurs frequently in Toltec and Maya art. The carving reveals Moore's sensitivity to the inherent qualities of the stone, whose natural striations harmonize with the sinuous surfaces of the design. Moore sought out remote quarries and extracted stone from sites that interested him, always insisting that each work he created be labeled with the specific type of stone he used. While certain elements of the body are clearly defined, such as the head and breasts, and the supporting elbow and raised knee, other parts flow together into an undulating mass more suggestive of a hilly landscape than of a human body. An open cavity penetrates the torso, emphasizing the relationship of solid and void fundamental to Moore's art. The sculptor wrote in 1937, "A hole

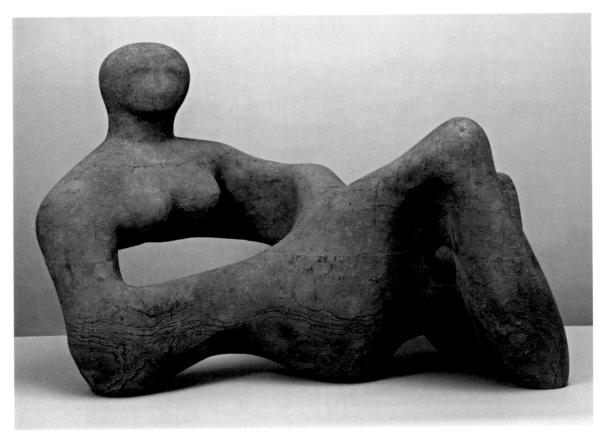

20–71 Henry Moore RECUMBENT FIGURE 1938. Hornton stone, $35 \times 52 \times 29''$ (88.9 \times 132.7 \times 73.7 cm). Tate Gallery, London.

Originally carved for the garden of the architect Serge Chermayeff in Sussex, Moore's sculpture was situated next to a low-lying Modernist building with an open view of the gently rolling landscape. "My figure looked out across a great sweep of the Downs, and her gaze gathered in the horizon," Moore later recalled. "The sculpture had no specific relationship to the architecture. It had its own identity and did not *need* to be on Chermayeff's terrace, but it so to speak *enjoyed* being there, and I think it introduced a humanizing element; it became a mediator between modern house and ageless land."

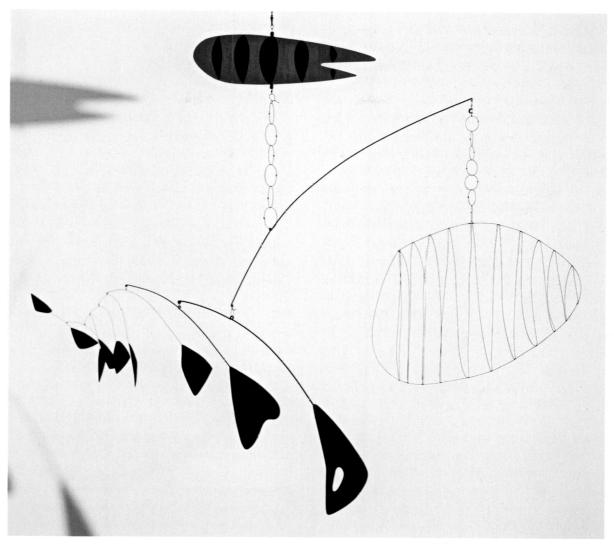

20–72 | Alexander Calder LOBSTER TRAP AND FISH TAIL 1939. Hanging mobile: painted steel wire and sheet aluminum, approx. $8'6'' \times 9'6''$ (2.6 \times 2.9 m). The Museum of Modern Art, New York. Commissioned by the Advisory Committee for the stairwell of the Museum (590.139.a–d)

can itself have as much shape-meaning as a solid mass." Moore also remarked on "the mystery of the hole—the mysterious fascination of caves in hillsides and cliffs," identifying the landscape as a source of inspiration for his hollowing out of the human body.

If the Italian Futurists suggested motion in their paintings and sculpture, Alexander Calder (1898–1976) made biomorphic works of sculpture that actually move. Calder's kinetic works, meaning works containing parts that move, unfix the traditional stability and timelessness of art and invest it with vital qualities of mutability and unpredictability. Born in Philadelphia and trained in both engineering and painting, Calder went to Paris in 1926 and became friendly with several abstract artists, joining Abstraction–Creation in time for the second issue of their journal. On a 1930 visit to Mondrian's studio, he had been impressed by the rectangles of colored paper that the painter had tacked up everywhere on the walls. What would it look like, Calder wondered, if the flat shapes were moving freely in space, interacting in not just

two but three dimensions? The question inspired Calder to begin creating sculpture with moving parts, known as mobiles. Calder's LOBSTER TRAP AND FISH TAIL (FIG. 20–72) features delicately balanced elements that spin and bob in response to shifting currents of air. At first, the work seems almost completely abstract, but Calder's title works on our imagination, helping us find the oval trap awaiting unwary crustaceans and the delicate wires at the right that suggest the backbone of a fish. The term *mobile*, which in French means "moving body" as well as "motive," or "driving force," came from Calder's friend Marcel Duchamp, who no doubt relished the double meaning of the word.

Surrealists Rearrange Our Minds

The entire history of the interwar period is the appropriate backdrop for the 1924 founding of the Surrealist movement. Led by French writer André Breton (1896–1966), the Surrealists attacked the rational emphasis of Western culture. They were as disillusioned as the Dadaists had been before them,

and indeed, many Surrealists had participated in that earlier movement. The problem, Breton wrote in 1934, is that "We still live under the rule of logic." European civilization emphasizes science, progress, comfort, and success. These values are not wrong in themselves, but in Europe they were pursued with blind fervor, and to the detriment of other values such as fantasy, imagination, and play. The results were obvious to the most casual observer: Europe experienced the unprecedented horrors of World War I, as science was applied to killing. And moreover, Europe was in danger again, they thought, from the rise of fascist regimes in Spain, Germany, and Italy, as those regimes intently snuffed out all opposition.

A participant in the Paris Dada movement, Breton became dissatisfied with the seemingly nonsensical activities of his colleagues and set out to make something more programmatic out of Dada's somewhat unfocused bitterness. In 1924 he published the first "Manifesto of Surrealism," outlining his view of Freud's theory that the human psyche is a battleground where the rational, civilized forces of the conscious mind struggle against the irrational, instinctual urges of the unconscious. The way to improve civilization, Breton argued, does not lie in strengthening the repressive forces of reason, but in freeing the individual to experience and safely express forbidden desires and urges. Artists are uniquely positioned to facilitate these explorations, because, he thought, coming face to face with one's inner demons in an art context may prevent our letting them loose in the real world. The Surrealists developed a number of techniques for liberating the unconscious, including dream analysis, free association, automatic writing, word games, and hypnotic trances. Their aim was to help people discover the more intense reality, or "surreality," that lay beyond the narrow rational notions of what is real.

AUTOMATISM. Surrealist painters employed a variety of manual techniques, known collectively as automatism, which were designed to release art from conscious control and thus produce new and surprising forms. Particularly inventive in his use of automatism was Max Ernst (1891–1976), a self-taught German artist who helped organize a Dada movement in Cologne and later moved to Paris, where he joined Breton's circle. In 1925 Ernst discovered the automatist technique of frottage, in which the artist rubs a pencil or crayon across a piece of paper placed on a textured surface. The resulting imprints stimulated Ernst's imagination, and he discovered in them fantastic creatures, plants, and landscapes, which he articulated through additional drawing. Ernst adapted the frottage technique to painting through grattage, creating patterns by scraping off layers of paint from a canvas laid over a textured surface. He then would extract representational forms from the patterns through overpainting. One result of this technique is THE HORDE (FIG. 20-73), a nightmarish scene of a group of monsters, seemingly made out of wood, who advance against some unseen opponent. Like

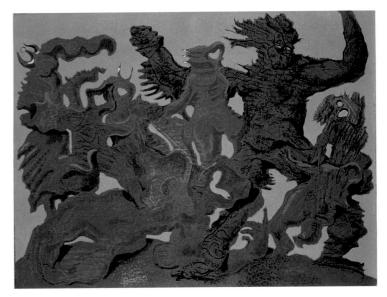

20–73 | Max Ernst **THE HORDE** 1927. Oil on canvas, $44\frac{7}{8} \times 57\frac{7}{2}$ " (114 \times 146.1 cm). Stedelijk Museum, Amsterdam.

much of Ernst's work of the period, this frightening image seems to resonate with the violence of World War I—which he experienced firsthand in the German army—and also to foretell the coming of another terrible European conflict.

UNEXPECTED JUXTAPOSITIONS. Even more carefully executed are the paintings of Salvador Dalí (1904–89). Trained at the San Fernando Academy of Fine Arts in Madrid, where he mastered the traditional methods of illusionistic representation, Dalí traveled to Paris in 1928 where he met the Surrealists. By the next year Dalí had converted fully to the movement and was welcomed officially into it. Dalí's contribution to Surrealist theory was the "paranoid-critical method," in which the sane person cultivates the ability of the paranoid to misread ordinary appearances and become liberated from the shackles of conventional thought. He hoped that the paranoid-critical method would take an equal place in Western culture along with the scientific method for the analysis of reality.

Dalí's paintings generally deal with sexual urges of various kinds (FIG. 20–74). In the BIRTH OF LIQUID DESIRES, we see a woman in a white gown embracing a hermaphroditic figure (one which has both male and female organs). This figure half-kneels on a classical pedestal, its foot in a bowl that a partially hidden figure fills with a liquid, while on its head sits a long loaf of French bread. (Merely describing this piece provides a challenge to logic.) Out of the head a thick black cloud representing a dream emerges below a mysterious cabinet. In one of the recesses of the cloud, the artist inscribed in small print a nonsense phrase: "Consign: to waste the total slate?" The artist said that he arrived at his imagery by carefully writing down his nightmares and merely painting what his fantasy-laden mind conjured up. In this way, the work ful-

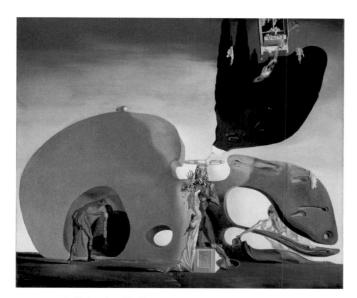

20–74 | Salvador Dalí BIRTH OF LIQUID DESIRES 1931–32. Oil and collage on canvas, $37\% \times 44\%$ (96.1 \times 112.3 cm). Guggenheim Museum, New York. Peggy Guggenheim Collection. 76.2553 PG 100. © 2003 Salvador Dalí, Cala-Salvador Dalí Foundation/Artists Rights Society (ARS), New York, N.Y.

fills the Surrealist goal, set out in the first "Manifesto of Surrealism," of expressing "the true process of thought, free from the exercise of reason and from any aesthetic or moral purpose." The composition is dominated by a large yellow bio-

morphic form whose shape might suggest a monster facing right, a painter's palette, or a violin (which might in turn suggest a woman's body). A shadow looms over the yellow form, which probably represents the artist's father, with whom Dalí had a tense relationship. There are many other ways to interpret this work, depending on the personality and mental state of the viewer. Others, for example, may see the cave at the left as the most significant motif. The half-shod figure who enters the cave may be regressing toward the womb, a metaphor for incest. Thus, perhaps, the central pair represents an incestuous union. Another line of analysis is to focus on the work's quotations from previous art. Some of these include, besides the classical pedestal and the palette, the pitcher pouring the liquid, a quote from a Dutch genre work by Vermeer (see Chapter 17), and the top of the cloud, which transcribes a portion of a work by the Swiss-German symbolist painter Arnold Böcklin. Dalí's tense relationship with his father is expressed in his uneasy juxtaposition of quotes from his artistic elders.

This absurd yet compelling work typifies the Surrealist interest in unexpected juxtapositions of disparate realities. When created with actual rather than represented objects and materials, the strategy produced disquieting assemblages such as **OBJECT (LE DÉJEUNER EN FOURRURE)** (FIG. 20–75), by Meret Oppenheim (1913–85), a Swiss artist who was one of the few female participants in the Surrealist movement.

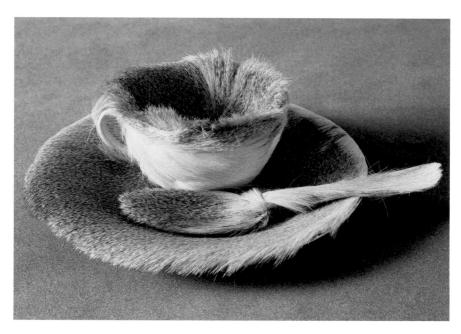

20-75 | Meret Oppenheim OBJECT (LE DÉJEUNER EN FOURRURE) (LUNCHEON IN FUR)

1936. Fur-covered cup, diameter 4%" (10.9 cm); fur-covered saucer, diameter 9%" (23.7 cm); fur-covered spoon, length 8" (20.2 cm); overall height, 2%" (7.3 cm). The Museum of Modern Art, New York.

Oppenheim's *Object* was inspired by a café conversation with Picasso about her designs for jewelry made of fur-lined metal tubing. When Picasso remarked that one could cover just about anything with fur, Oppenheim replied, "Even this cup and saucer."

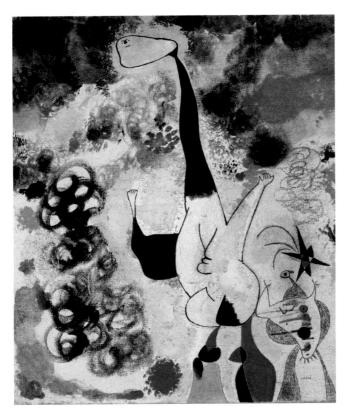

20-76 Joan Miró SHOOTING STAR 1938. Oil on canvas, $25\% \times 21\%$ (65.2 \times 54.4 cm). National Gallery of Art, Washington D.C.

Gift of Joseph H. Hazen (1970.36.1). Image © 2006 Board of Trustees, National Gallery of Art, Washington, D.C.

Consisting of a cup, saucer, and spoon covered with the fur of a Chinese gazelle, Oppenheim's work transforms implements normally used for drinking tea into a hairy ensemble that simultaneously attracts and repels the viewer.

BIOMORPHIC ABSTRACTION. The painter who made the most from biomorphic abstraction was Joan Miró, who exhibited with the Surrealists from the beginning of the movement. He arrived at his shapes by doodling, as shoot-ING STAR shows (FIG. 20-76). The Surrealists believed that through the accidents of doodling, we might relax our rational control and draw something that bubbles up from our unconscious. Miró usually doodled on the canvas, then examined his product to see what shapes it suggested, then applied more lines and colors to bring out what lay hidden. In an indefinite space influenced by Cubism, the star of the work's title seems to fly off toward the lower right, though the central figure could also be a deformed star. Other forms suggestive of birds' heads or flowers prance across the surface of this work, which looks improvised. Indeed, Miró painted in such a way that his forms appear to be taking shape before our eyes; their identity is in flux just as our thought process is itself always in flux. Miró was fascinated by the art of children, which he regarded as spontaneous and expressive; though he had been well-trained as an artist, he made it a goal to forget his learning in order to recover the freshness of childhood. We see that childlike quality here as well.

If the art world was full of schemes to improve civilization during the 1930s, obviously none of them functioned as the creators hoped; Europe hurtled once again toward war as the decade closed. A great many artists left Europe for the Americas, redrawing the map of artistic innovation.

IN PERSPECTIVE

The early twentieth century saw a systematic undermining of the traditional rules of Western art, as artists overthrew longheld conventions in a series of movements that flowered before 1920: Fauvists and Expressionists attacked traditional notions of pictorial representation through color and brushwork, culminating in completely abstract paintings by 1910. Cubists created influential new methods of composition in both painting and sculpture. Futurists embodied "the beauty of speed" in new ways, and Suprematists combined Cubist picture space with complete abstraction. During World War I, Dada asked the most radical questions about the nature of art itself. As part of a program of challenging the norms, many Modern artists looked to non-Western cultures for stylistic cues. Modern architecture also took definite form in buildings that used only the modern materials of concrete, glass, and steel, without decoration or reference to any past style.

Modern art arrived somewhat later to the Americas, but artists on those continents also pursued Modernist techniques, often coupling their experiments in form with efforts to uncover national or cultural identity.

In the period between the wars, many artists gave their art a deeper social relevance. Some reacted to the slaughter of World War I, others to social inequalities of various kinds, while still others combated fascism. Constructivists in Russia after the Communist Revolution united Modern styles with practical needs. Socialist Realists and Mexican muralists retreated from the more radical innovations of Modernism in order to communicate with the masses, often through art in public places. Bauhaus artists turned modern mass production toward a harmonious and beautiful home environment for consumers. Dutch painters and architects of de Stijl created art that they hoped would purify the human mind through use of pure colors and simple forms. Harlem Renaissance artists raised awareness of African American culture, some using Modernist techniques, and some looking past them back to African tribal arts. The Abstraction-Creation group used organic abstraction as part of a campaign against fascist regimes, which usually censored Modern art. Surrealists sought various ways to liberate the unconscious mind, based on their reading of Freud's psychology, in an effort to reorient Western culture toward fantasy.

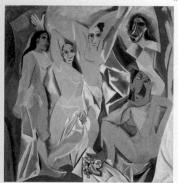

Picasso Les demoiselles d'avignon 1907

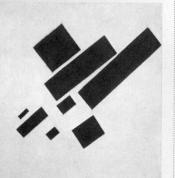

MALEVICH SUPREMATIST PAINTING 1915

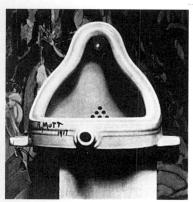

DUCHAMP FOUNTAIN 1917

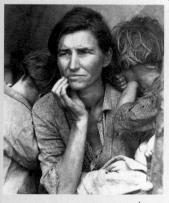

MIGRANT MOTHER,
NIPOMO, CALIFORNIA
1936

LAWRENCE MIGRATION SERIES 1940-41

GROPIUS **BAUHAUS** 1925–26

PELÁEZ MARPACÍFICO (HIBISCUS) 1943

MODERN ART IN EUROPE AND THE AMERICAS, 1900–1945

■ Wright Brothers' First Flight 1903

- First Flight Across English Channel
- Messican Revolution 1910-17
- ▼ First Balkan War 1912-13
- **World War I** 1914-18
- Russian Revolution 1917
- Soviet Union Formed 1922
- Stalin Comes to Power 1924
- Great Depression Begins 1929
- New Deal in U.S.; Hitler Comes to Power in Germany 1933
- ▼ First Analog Computer 1935
- World War II 1939-45
- First Digital Computer 1939
- Atomic Bomb Dropped on Hiroshima and Nagasaki 1945

2I-I | Jannis Kounellis UNTITLED (12 HORSES) 1969. Installation, Galleria L'Attico, Rome.

CHAPTER TWENTY-ONE

THE INTERNATIONAL SCENE SINCE 1945

21

Visitors to the 1969 Jannis Kounellis exhibition at the Galleria L'Attico in Rome did not see paintings, sculpture, drawings, or any other objects

made by the artist. Instead, they encountered twelve live horses of different breeds and colors tethered with halters to the gallery walls (FIG. 21–1). Following the example of Marcel Duchamp (SEE FIG. 20–36), Kounellis did not create a new object but took existing entities (in this case, living ones), placed them in an art context, and designated them a work of art. This particular work existed only as long as the horses remained "installed" in the gallery (three days) and could not be bought or sold. By placing unsalable works in the exhibition space, Kounellis, who harbored leftist political views, challenged "the ideological and economic interests that are the foundations of a gallery."

Kounellis did not intend simply to criticize the capitalist values of the art market; he also wanted to create a memorable work that would generate a rich variety of interpretations. He used horses because they evoke energy and strength and have art-historical associations with equestrian statuary and portraits of mounted heroes and rulers (SEE FIG. 14–14, 14–16, 19–2). One critic wrote that Kounellis's horses "had only to stand in place to confirm their stature as an attribute of Europe personified" and saw them as symbols of "the heritage accumulated over great distances of time, and of the

urgent need for freedom in the present moment." Another felt the installation conveyed "something of the quality of an anxiety dream." Still another suggested that Kounellis was actually mocking art by "treating the exhibition space as if it were a stable," which brought to mind one of the first-century emperor Caligula's "most insulting acts: making a horse a member of the Roman Senate."

However we interpret Kounellis's work, it stimulates our imaginations even as it defies our normal expectations of a work of art and—like much innovative art since World War II—causes us to question the nature of art itself.

CHAPTER-AT-A-GLANCE

- **THE WORLD SINCE 1945**
- POSTWAR EUROPEAN ART | Figural Artists | Abstraction and Art Informel
- ABSTRACT EXPRESSIONISM | The Formative Phase | Action Painting | Color Field Painting | Sculpture of the New York School
- EXPERIMENTS WITH FORM IN BUENOS AIRES | Concrete-Invention | Madí
- POSTWAR PHOTOGRAPHY | New Documentary Slants | The Modernist Heritage
- MOVING INTO THE REAL WORLD | Assemblage | Happenings | Pop Art
- THE FINAL ASSAULT ON CONVENTION, 1960–1975 | Op Art and Minimal Art | Arte Povera: Impoverished Art | Conceptual and Performance Art | Earthworks and Site-Specific Sculpture | Feminist Art
- ARCHITECTURE: FROM MODERN TO POSTMODERN | Midcentury Modernist Architecture | Postmodern Architecture
- POSTMODERN ART | The Critique of Originality | Telling Stories with Paint | Finding New Meanings in Shapes | High Tech and Deconstructive Architecture | New Statements in New Media
- IN PERSPECTIVE

THE WORLD SINCE 1945

The United States and the Soviet Union emerged from World War II as the world's most powerful nations and soon were engaged in the "cold war." The Soviets set up communist governments in Eastern Europe and supported the development of communism elsewhere. The United States, through financial aid and political support, sought to contain the spread of communism in Western Europe, Japan, Latin America, and other parts of the developing world. A second huge communist nation emerged in 1949 when Mao Zedong established the People's Republic of China. The United States tried to prevent the spread of communism in Asia by intervening in the Korean War (1950–53) and in the Vietnam War (1965–75).

The United States and the Soviet Union built massive nuclear arsenals aimed at each other, effectively deterring either from attacking for fear of a devastating retaliation. The cold war ended in the late 1980s, when the Soviet leader Mikhail Gorbachev signed a nuclear-arms reduction treaty with the United States and instituted economic and political reforms designed to foster free enterprise and democracy.

The dissolution of the Soviet Union soon followed and gave rise to numerous independent republics.

While the Soviet Union and the United States vied for world leadership, the old European states gave up their empires, often after massive resistance by the colonized peoples. The British led the way by withdrawing from India in 1947. Other European nations gradually granted independence to colonies in Asia and Africa, which entered the United Nations as a Third World bloc not aligned with either side in the cold war. Despite the efforts of the United Nations, deepseated ethnic and religious hatreds have continued to spark violent conflicts around the world—in countries such as Pakistan, India, South Africa, Somalia, Ethiopia, Rwanda, the former Yugoslavia, and states throughout the Middle East. Escalating the sense of tension around the globe were the devastating terrorist attacks of September 11, 2001, on the World Trade Center and the Pentagon in the United States, and the controversial U.S.-led wars in Afghanistan and Iraq that followed.

A great many Modern artists since 1945 have used their art to comment on the state of the world, and the growth and

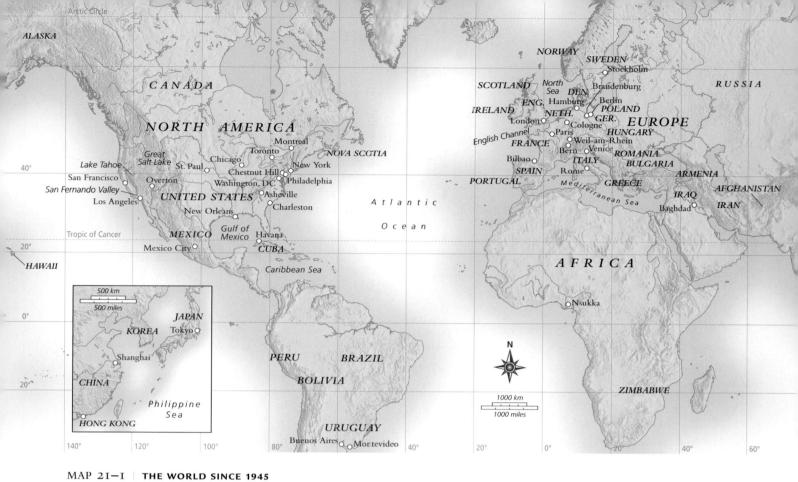

The distribution of cultural sites expands to cover the world.

proliferation of mass media after World War II made everyone better informed, including artists. In the decade following the war, many artists' reflections on the state of humanity paralleled the Existentialist philosophy developed primarily by Jean-Paul Sartre and Albert Camus. Existentialism started from the position that there was no God, no supreme being, no absolute, no "transpersonal entity." Modern science and the twentieth century's multiple disasters seemed to prove that God must be absent, leaving humans "condemned to be free," as Sartre put it. Existentialists reflected a great deal on the implications of this fact for each person. Since there is no God, the self is not a "soul" or even a stable entity but rather a process in constant evolution as each of us establishes an identity and responds to our world. Sartre's principal philosophical work, Being and Nothingness, postulated that human beings are responsible for the world they have created, yet they are also free to decide how to act in it. In this situation, the most valuable art offers sincere individual testimony about life, honest sharing of personal insight about existence.

The assault on tradition that has marked Modern art from its inception continued, but with a slightly different focus. Most Modern artists thought less about questioning Renaissance-based rules because traditional styles of painting and sculpture had receded into the historical distance. Rather, many artists embraced a related quest: investigation of the nature of art. That is, they created works as experiments in form or challenges to the boundaries of art. What arose was a Tradition of the New, as Modern questioning grew more implanted in art institutions such as schools and museums and less controversial among the public.

The most important art-world watershed came sometime in the late 1970s, when the Modern movement seemed to exhaust the search for conventions to attack. The basic conditions and forces that undergirded Modern art also disappeared or evolved, leading to what we call the Postmodern period. Postmodern artists largely gave up the quest for formal novelty, and likewise the avant-garde lost its distinct identity as a social group. Instead there arose a plurality of styles in a more globalized art world, where artists found novel ways of exploring their identity and commenting about issues such as race, gender, the environment, and globalization itself.

POSTWAR EUROPEAN ART

The devastation of Europe in World War II far exceeded the toll of the first conflict: Defeated Germany lost 5 million dead, less than the 6 million Jews that Nazis had murdered in concentration camps, and far less than Russia's 20 million war casualties. Poland lost 20 percent of its population. At war's end, the total number of refugees and displaced persons across the continent amounted to 40 million. Two years after the end of hostilities, French industry was producing only 35 percent of its 1939 total. Looking at the condition of Europe in the same year, Winston Churchill described the extent of the catastrophe: "What is Europe now? A rubble heap, a charnel house, a breeding ground of pestilence and hate."

Most European artists in the immediate postwar period used their art to come to terms in some way with what they had experienced. There were many debates about how best to do this: Some urged figural styles, others proposed abstract art.

Figural Artists

For many artists, figuration was a way to keep one's art close to the human condition, to preserve a connection to humanity, or to express some kinship with the wounded, the displaced, and the dead. Swiss-born Alberto Giacometti (1901-1966) did this most memorably in sculpture (FIG. 21-2). He had worked in an abstract mode related to biomorphic Surrealism in the 1930s, but the war caused a crisis for him. Abstract art was merely "decorator stuff," he said, irrelevant to postwar humanity. So after the war he began sculpting in plaster from live models. The figures he produced were the antithesis of the classical ideal: thin, fragile, and lumpy, their surfaces rough and crude. Jean-Paul Sartre wrote that Giacometti's figures reminded him of "the fleshless martyrs of Buchenwald [concentration camp]." Yet they bravely occupy their limited space, and they even seem to ascend. Their frail nobility offers us a poignant vision of a way of "being in the world," to use a phrase dear to Existentialists. These slight individuals seemed to embody Sartre's view of the human condition. He wrote that Giacometti's figures are "between nothingness and being."

English artist Francis Bacon (1909–92) captured more of the horror and less of the ascent in his figural paintings. While working as an interior decorator, Bacon taught himself to paint in about 1930 but produced few pictures until the early 1940s, when the onset of World War II crystallized his harsh view of the world. He served as an air raid warden during the conflict, seeing that his neighbors got to safety during Nazi bombing attacks. His style draws on the Expressionist work of Vincent van Gogh (SEE FIG. 19–66) and Edvard Munch (SEE FIG. 19–71), as well as on Picasso's figure paintings. His subject matter comes from a wide variety of sources, including post–Renaissance Western art. **HEAD SURROUNDED BY SIDES OF BEEF** (FIG. 21–3), for example, is inspired by Diego

2I–2 | Alberto Giacometti **CITY SQUARE** 1948. Bronze, $8\frac{1}{2} \times 25\frac{3}{8} \times 17\frac{1}{4}$ " (21.6 × 64.5 × 43.8 cm). The Museum of Modern Art, New York. Purchase (337.1949)

21–3 | Francis Bacon | HEAD SURROUNDED BY SIDES OF BEEF 1954. Oil on canvas, $50\frac{1}{4} \times 48''$ (129 \times 122 cm). The Art Institute of Chicago. Harriott A. Fox Fund

Velázquez's *Pope Innocent X* (1650), a solid and imperious figure that Bacon transformed into an anguished, insubstantial man howling in a black void. The feeling is also reminiscent of Munch's *The Scream*, but Bacon's pope is enclosed in a claustrephobic box that contains his frightful cries. The figure's terror is magnified by the sides of beef behind him, quoted from a Rembrandt painting. (Bacon said that slaughterhouses and meat brought to his mind the Crucifixion.) Bacon's pope seems to show that humanity's claim to a divine connection is illusory at best. The artist wrote, "I hope to make the best human cry in painting . . . to remake the violence of reality itself."

The French painter Jean Dubuffet (1901-85) developed a distinctive form of Expressionism inspired by what he called art brut ("raw art")—the work of children and the insane—which he considered uncontaminated by Western culture. The war provoked a crisis of values, he thought. Certain old beliefs—that humans are fit to be masters of nature. that the world responds to reason and analysis—have been proved wrong. In the 1951 lecture "Anticultural Positions," he expressed deep disillusionment with those traditional notions and urged artists to reject "civilization." In a postwar version of Modernist Primitivism, he embraced art by the insane and funded a society to study and collect it. In his own art, at times he applied paint mixed with tar, sand, and mud, using his fingers and ordinary kitchen utensils, in a deliberately crude and spontaneous style that imitated art brut. In the early 1950s, he began to mix oil paint with new, fast-drying industrial enamels, laying them over a preliminary base of still-wet oils. The result was a texture of fissures and crackles that suggests organic surfaces, like those of cow with the **SUBTILE NOSE** (FIG. 21–4). Dubuffet observed that "the sight of that animal affords me an inexhaustible feeling of wellbeing because of the aura of calm and serenity it gives off." The animal seems completely content and focused on its "subtile" nose, which appears to twitch just slightly, perhaps at the scent of some grassy morsel.

Abstraction and Art Informel

Dubuffet's celebration of crude, basic forms of self-expression, including graffiti, contributed to the emergence of the most distinctive postwar European artistic approach: Art Informel ("formless art"), which was sometimes also called tachisme (tache is French for "spot" or "stain"). Art Informel was promoted by French critic Michel Tapié (1909-87), who opposed geometric formalism as the proper response to the horrors of World War II. He insisted that Dada and the two world wars had discredited all notions of humanity as reasonable, thus clearing the way for a new and more authentic concept of the species that locates the origins of human expression in the simple, honest mark. Most practitioners of Art Informel worked abstractly, in part because the prewar totalitarian regimes despised abstraction. Moreover, many artists favored abstraction because it was cosmopolitan, not rooted in any of the nationalisms that had fueled the century's bloody conflicts.

The principal founder of *Art Informel* was Wolfgang Schulze, called Wols (1913–1951), who lived through some of Europe's dislocations. Born in Germany, the resolutely anti-Nazi artist left his homeland as soon as Hitler took power. He settled in Paris, where he knew many Modern artists, and took up a career as a photographer, with his work featured in international fashion magazines such as *Vogue* and *Harper's Bazaar*. When France was overrun in the Nazi invasion, he

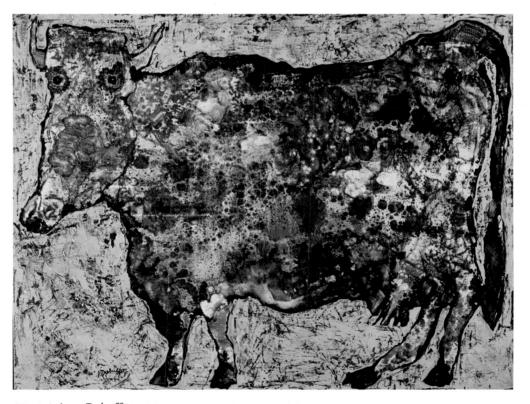

fled to Spain, where he was arrested and his passport confiscated. Deported from Spain in 1940, he lived the rest of the war as a stateless person in a refugee camp in southern France. When the war ended he settled in Paris and took up art again, painting in an abstract style (FIG. 21–5). He applied

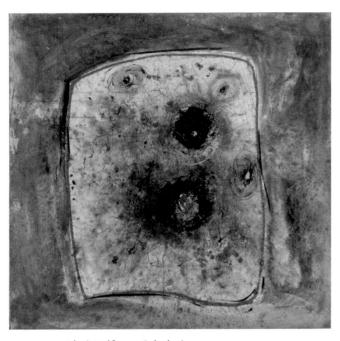

21–5 | Wols (Wolfgang Schulze) PAINTING 1944–45. Oil on canvas, 31% \times 32" (81 \times 81.1 cm). The Museum of Modern Art, New York. Gift of D. and J. de Menil Fund (29.1956) / Otto Wols © 2007 Artists Rights Society (ARS), New York

paint with whatever was at hand, sometimes allowing it to drip and run. Sometimes he threw paint at the canvas, then scraped the surfaces with a knife. These techniques are his own elaborations of Surrealist automatism. The resulting works often resemble cells or bacterial growths, with a disease-ridden or violent appearance. His experiences convinced him that humanity was no more noble than any other life form, however lowly or lofty. Sartre wrote about Wols and gave him money for his resettlement, but the artist's difficult history and complicated personal temperament led him to live carelessly, and he died of food poisoning in 1951.

If Art Informel expanded the range of materials that artists could apply to a canvas, Alberto Burri (1915–1995) used this more ample vocabulary in tellingly symbolic ways. A surgeon in the Italian army during the war, Burri was captured and spent most of the conflict in a POW camp in Texas. There he taught himself to paint with whatever was at hand, a trait that marked the rest of his career. Repatriated in 1945, he began to create works using red paint along with the burlap sacks that held donated foodstuffs that Italy received during its reconstruction (FIG. 21–6). The artist rarely spoke of his work, but the burlap seems to signify the bandages he used as a surgeon, and the red paint, the blood that flowed from unseen injuries. The English art critic Herbert Read, one of Burri's early supporters, wrote of him, "Burri is defiant in the face of chaos. He tries to face the wounds of Europe and heal them."

21–6 | Alberto Burri COMPOSITION (COMPOSIZIONE) 1953. Oil, gold paint, and glue on burlap and canvas, 33 % × 39 ½" (86 × 100 cm). Solomon R. Guggenheim Museum, New York. FN53.1364

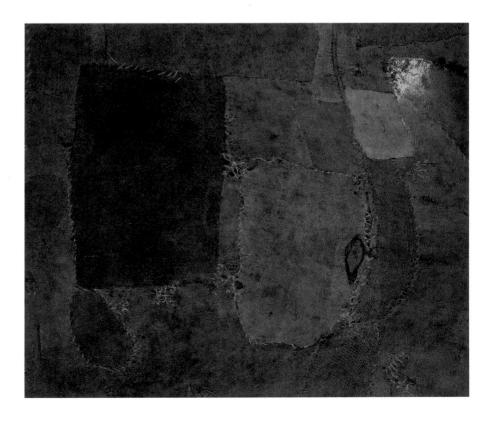

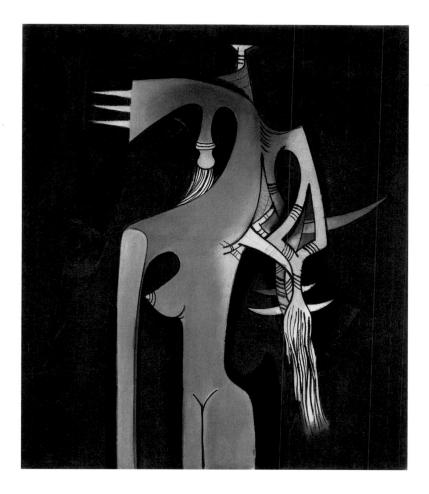

21–7 Wifredo Lam ZAMBEZIA, ZAMBEZIA 1950. O l on canvas, $49\% \times 43\%$ (125 \times 110 cm). Solomon R. Guggenheim Museum, New York. Gift, Mr. Joseph Cantor, 1974.2095. Wifredo Lam © 2007 Artists Rights Soc ety (ARS), New York / ADAGP, Paris

ABSTRACT EXPRESSIONISM

The rise of fascism and the outbreak of World War II led many leading European artists and writers to move to the United States. By 1941, André Breton, Salvador Dalí, Fernand Léger, Piet Mondrian, and Max Ernst were living in New York, where they had a strong impact on the art scene. American abstract artists were most deeply affected by the ideas of the Surrealists, from which they evolved Abstract Expressionism, a wide variety of work produced in New York between 1940 and roughly 1960. This movement pioneered many innovations, in materials used, methods of application, compositional structures, and the sizes of the resulting works. Abstract Expressionism is also known as the New York School, a more neutral label many art historians prefer.

The Formative Phase

The earliest Abstract Expressionists found inspiration in Cubist formalism and Surrealist automatism, two very different strands of Modernism. But whereas European Surrealists had derived their notion of the unconscious from Sigmund Freud, many of the Americans subscribed to the thinking of Swiss psychoanalyst Carl Jung (1875–1961). Jung's theory of the collective unconscious holds that beneath one's private memories lies a storehouse of feelings and symbolic associations common to all humans. Abstract Expressionists, dissatis-

fied with what they considered the provincialism of American art in the 1930s, sought the universal themes within themselves.

SPIRITUAL HERITAGE. One of the first artists to bring these influences together was Cuban artist Wifredo Lam (1902-1980), who turned them into art that supported the struggle against colonialism. Of mixed Chinese, Spanish, and African descent, he studied at the National Academy in Havana before settling in Paris. There he became friendly with both Picasso and the Surrealists, and his work began to reflect these influences. The Nazi invasion of France forced him to return to his homeland, on the same boat with Surrealist leader André Breton. While Breton continued on to New York, Lam remained in Havana and began investigating his Afro-Cuban heritage in the company of anthropologist Lydia Cabrera and novelist Alejo Carpentier. Lam's work from the late 1940s shows strong influence of Afro-Cuban art forms associated with santería, an indigenous form of polytheistic spirituality. Unlike European Primitivists, who adapted art forms foreign to them without necessarily studying their meanings, Lam reconnected with his own heritage and used it in works that often have an anticolonial subtext. ZAMBEZIA, ZAMBEZIA, for example (FIG. 21-7), shows overlapping planes and shallow spaces reminiscent of Joan Miró

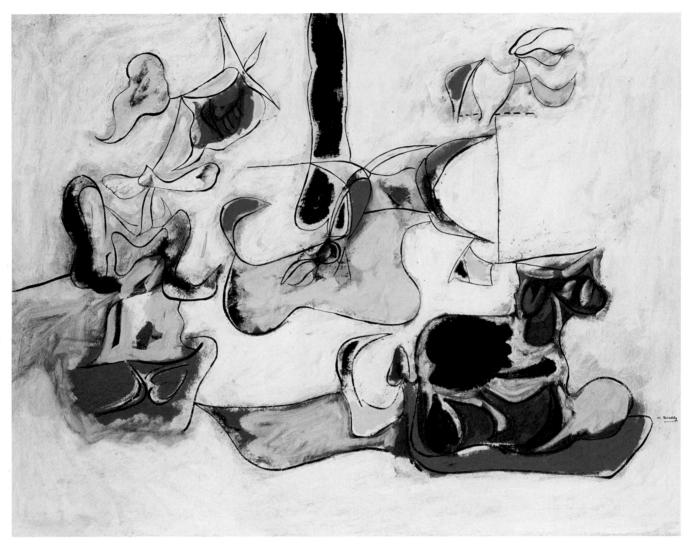

21–8 | Arshile Gorky GARDEN IN SOCHI c. 1943. Oil on canvas, $31 \times 39''$ (78.7×99.1 cm). The Museum of Modern Art, New York. Acquired through the Lillie P. Bliss Bequest (492.1969)

Born Vosdanig Adoian in Turkish Armenia, Arshile Gorky adopted his new Russian-sounding name (*Gorky* is Russian for "bitter") after settling in New York in 1925. Insecure about his Armenian origins and hoping to impress his American colleagues, Gorky often gave his birthplace as Kazan, Russia, and on one occasion claimed to be a cousin of the famous Russian writer Maksim Gorky—apparently unaware that this was the pen name of Aleksey Peshkov. Related to Gorky's fabrication of a Russian background is his naming of *Garden in Sochi* for a Russian town rather than the Armenian village of Khorkom that actually inspired it.

(SEE FIG. 20–76), but here the forms are derived from Afro-Cuban religious implements used in rituals. The central figure is a composite deity of *santería*. The title is an early colonial name for Zimbabwe in East Africa. At that time this region was still a colony known as Rhodesia, but it was also a source for slaves brought to Cuba. Lam said, "I wanted with all my heart to paint the drama of my country . . . In this way I could act as a Trojan horse spewing forth hallucinating figures with the power to surprise, to disturb the dreams of the exploiters."

Arshile Gorky (1904–48) took the Cubist-Surrealist style further into spontaneous improvisation. He was born in Armenia and immigrated to the United States in 1920 fol-

lowing Turkey's brutal eviction of its Armenian population, which caused the death of Gorky's mother. Converging in Gorky's mature work were his childhood memories of Armenia, which provided his primary subject matter; his interest in Surrealism; and his attraction to Jungian ideas. These factors came together in the early 1940s in a series of paintings that Gorky called **GARDEN IN SOCHI** after the Russian resort or: the Black Sea but that were actually inspired by Gorky's father's garden in his native Khorkom, Armenia (FIG. 21–8). According to Gorky, this garden was known as the Garden of Wish Fulfillment. It contained a rock upon which village women, including his mother, rubbed their bare breasts for the granting of wishes; above the rock stood a

"Holy Tree" to which people tied strips of clothing. Gorky's painting includes the highly abstracted images of a barebreasted woman at the left, a tree trunk at the upper center, and perhaps pennants of cloth at the upper right. The out-ofscale yellow shoes below the tree may refer to "the beautiful Armenian slippers" that Gorky and his father had worn in Khorkom. Knowledge of such autobiographical details is not necessary, however, to appreciate the painting's expressive effect, for the fluid, biomorphic forms—derived from Miró (SEE FIG. 20-76)—suggest vital life forces and signal Gorky's evocation of not only his own past but also an ancient, universal, unconscious identification with the earth. Despite their improvisational appearance, Gorky's paintings were based on detailed preparatory drawings—he wanted his paintings to touch his viewers deeply and to be formally beautiful, like the drawings of Ingres and Matisse.

PRIMORDIAL IMAGERY. Jackson Pollock (1912–56), the most famous of the Jung-influenced Abstract Expressionists, rejected this European tradition of aesthetic refinement—what he referred to as "French cooking"—for cruder, rougher formal values identified with the Wyoming frontier country of his birth. Pollock went to New York in 1930 and studied at the Art Students League and later with the Mexican muralist David Siqueiros. Self-destructive and alcoholic, Pollock entered Jungian psychotherapy in 1939. Because Pollock was reluctant to talk about his problems, the therapist engaged him through his art, analyzing in terms of Jungian symbolism the drawings Pollock brought in each week.

The therapy had little apparent effect on Pollock's personal problems, but it greatly affected his art. He gained a new vocabulary of symbols and a belief in Jung's notion that artistic images that tap into primordial human consciousness can have a positive psychological effect on viewers, even if they do not understand the imagery. In paintings such as MALE AND FEMALE (FIG. 21-9), Pollock covered the surface of the painting with symbols he ostensibly retrieved from his unconscious through automatism. Underneath them is a firm compositional structure of strong vertical elements flanking a central rectangle—evidence, according to Pollock's therapist, of the healthy, stable adult psyche in which male and female elements are integrated. Such elements are balanced throughout the painting and within the forms suggesting two facing figures. Each figure combines soft, curving shapes suggestive of femininity with firmer, angular ones that connote masculinity. The sexual identity of both figures is therefore ambiguous; each seems to be both male and female. The painting and the two figures within it represent not only the union of Jung's anima (the female principle in the male) and animus (the male principle in the female) but also that of Pollock and his then lover, Lee Krasner (1908-84), a painter (SEE FIG. 21–12) with whom he had an intense relationship and whom he would marry in 1945.

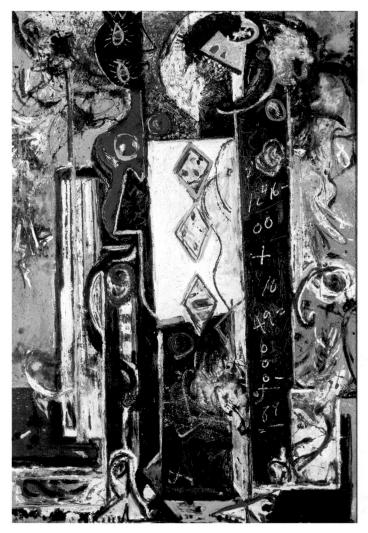

21–9 | Jackson Pollock MALE AND FEMALE 1942. Oil on canvas, $6'1\,\%''\times4'1''$ (1.86 \times 1.24 m). Philadelphia Museum of Art. Gift of Mr. and Mrs. Gates Lloyd

The reds and yellows used here, like the diamond shapes featured at the center, were inspired by Southwestern Native American art. Native Americans, like other so-called primitive peoples, were believed to have direct access to the collective unconscious and were therefore much studied by Surrealists and early members of the New York School, including Pollock and his psychiatrist.

Action Painting

In the late 1940s, Pollock liberated his earlier automatism in large canvases that evolved into a completely abstract welter that seemed to capture the controlled disorder of a frenzied dance. This forcefully improvisational style came to be known as *action painting*. The term was coined by art critic Harold Rosenberg (1906–78) in his 1952- essay "The American Action Painters," in which he claimed: "At a certain moment the canvas began to appear to one American painter after another as an arena in which to act—rather than a space in which to reproduce, redesign, analyze, or 'express' an object, actual or imagined. What was to go on the canvas was not a

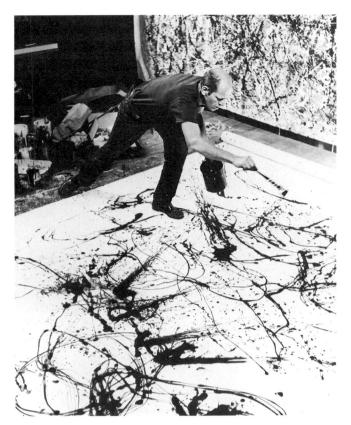

21–10 | Hans Namuth PHOTOGRAPH OF JACKSON POLLOCK PAINTING
The Springs, New York. 1950.

picture but an event." Although he did not mention them by name, Rosenberg was referring primarily to Pollock and to Pollock's chief rival for leadership of the New York School, Willem de Kooning (1904–97). It was Pollock, said de Kooning, who "broke the ice."

EXPLODING HIERARCHY. Beginning in the fall of 1946, Pollock worked in a renovated barn, where he placed his canvases on the floor so that he could work on them from all four sides. He also began to employ enamel house paints along with conventional oils, dripping them onto his canvases with sticks and brushes, using a variety of fluid arm and wrist movements (FIG. 21-10). As a student, he had experimented with spraying and dripping industrial paints during his studies with Siqueiros. He was also, according to his wife, a "jazz addict" who would spend hours listening to the explosively improvised belop of Charlie Parker and Dizzy Gillespie. In addition, visits to the Natural History Museum allowed him to witness Navajo sand painting, a healing ritual in which a shaman pours colored sand on the floor in symbolic patterns. All of these sources help us to understand where Pollock's art came from, but they do not explain the power of the works he created from them, which engulf the viewer's entire field of vision (FIG. 21-11). AUTUMN RHYTHM and other works by Pollock from this period innovate in many ways. Besides the novel method of paint application shown in the photo, the works show no trace of the Cubist picture space, Picasso's chief legacy to Modern art. Following from this, the composition lacks hierarchical arrangement, as almost every area of the work is equally energized. In addition, the work shows

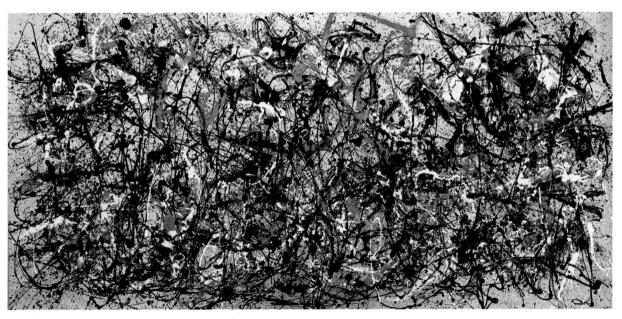

2I–II | Jackson Pollock AUTUMN RHYTHM (NUMBER 30) 1950. Oil on canvas, 8'9" × 17'3" (2.66 × 5.25 m). The Metropolitan Museum of Art, New York. George A. Hearn Fund, 1957 (57.92)

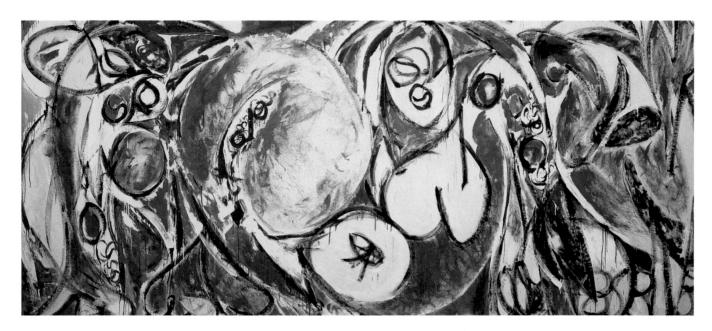

2I—I2 | Lee Krasner THE SEASONS
1957. Oil on canvas, $7'8\frac{y''}{4} \times 16'11\frac{y''}{4}$ (2.36 × 5.18 m). Whitney Museum of American Art, New York.
Purchased with funds from Frances and Sydney Lewis (by exchange), the Mrs. Percy Uris Purchase Fund, and the Painting and Sculpture Committee (87.7)

clearly its process of making; we could literally retrace most of the artist's steps around the canvas. Finally, the work embodies a new level of physical involvement of the artist with his product. These paintings rank, along with certain works by Kandinsky (FIG. 20–14), Picasso (FIG. 20–18), and Duchamp (FIG. 20–36), among the most important breakthroughs of Modern art. As innovative as they are in a formal sense, these works also speak for the times. Pollock said in a radio interview that he was creating for "the age of the airplane, the atom bomb, and the radio," and the works do seem to embody something of the tensions of the Cold War period, as each side silently threatened the other with instant annihilation.

Painting from Harmony, Painting from Doubt. Lee Krasner (1908–84), who had studied in New York with the German expatriate teacher and abstract painter Hans Hofmann (1880–1966), produced fully nonrepresentational work several years before Pollock did. After she began living with him in 1942, however, she virtually stopped painting to devote herself to the conventional role of a supportive wife. Following the couple's move to Long Island in 1945, she set up a small studio in a guest bedroom, where she produced small, tight, gestural paintings similar in composition to Pollock's but lacking their sense of freedom. After Pollock's death in an automobile crash in 1956, Krasner took over his studio and produced large, dazzling gestural paintings, known as the *Earth Green* series, which marked her emergence from her husband's shadow. Works such as **THE SEASONS** (FIG. 21–12) feature bold, sweeping curves

that express not only her new sense of liberation but also her identification with the forces of nature in the bursting, rounded forms and springlike colors. "Painting, for me, when it really 'happens' is as miraculous as any natural phenomenon," said Krasner, suggesting an attitude similar to that of Pollock, who found "pure harmony" in the act of painting.

By contrast, Willem de Kooning insisted that "Art never seems to make me peaceful or pure." An immigrant from the Netherlands, de Kooning in the 1930s became friendly with several Modern painters but resisted the shift to Jungian Surrealism. For him it was more important to record honestly and passionately his sense of the world around him, which was never simple or certain. "I work out of doubt," he once remarked. During the 1940s he expressed his nervous uncertainty in the agitated way he handled paint itself. We see these autobiographical urges in action paintings such as ASHEVILLE (FIG. 21–13). De Kooning was less radical than Pollock in that he still used brushes and an easel, but the work shares the sense of urgent improvisation that typifies the style. The dominant rhythm of this work is controlled by the brushstrokes in black (including paint drips) that define jagged blocks. Some passages suggest fleshy body parts or eyes, but they are created by natural arm movements or gestures with the brush. The work's title is the name of the town in North Carolina near where Black Mountain College is located, a small college where de Kooning taught in the summer of 1948. Existentialist-oriented art critics see in these works an artist offering a rich glimpse of his own self, captured in a moment. If Sartre was correct in saying that there are no absolutes anymore,

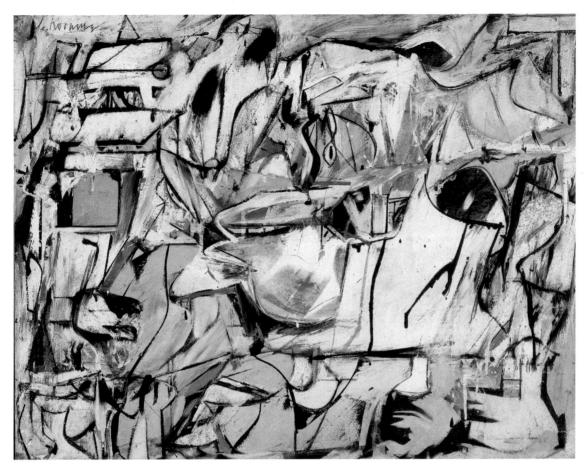

21–13 | Willem de Kooning ASHEVILLE 1948. Oil and enamel on cardboard, $25\% \times 31\%$ (64.6 \times 80.7 cm). Phillips Collection, Washington, D.C. © The Willem de Kooning Foundation / Artists Rights Society (ARS), New York

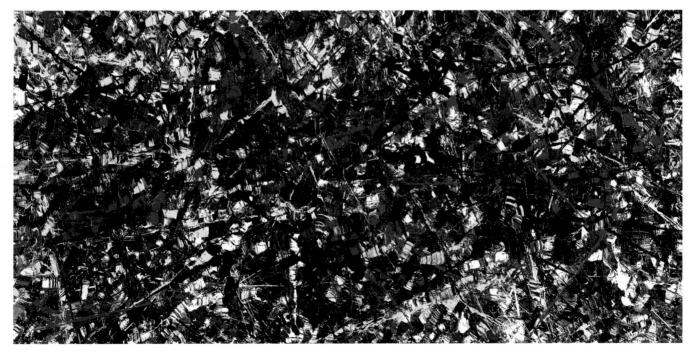

2I–I4 | Jean-Paul Riopelle KNIGHT WATCH 1953. Oil on canvas, $38 \times 76\%''$ (96.6 \times 194.8 cm). The National Gallery of Canada, Ottawa, Ontario.

then all we really have is our selves as a reference point. Sartre held that people create their own identities through the decisions that they make, day by day, rather than through realization of some inner destiny or essence. If so, autobiographical works such as this are valuable because they offer us a condensation of the artist's self, built up in paint through a process of steps and decisions that this work makes obvious. Such was certainly the artist's goal.

ACTION PAINTING EXTENDS ITSELF. Action painting soon influenced artists in Canada and in Europe. One participant in this broad movement was the French Canadian painter Jean-Paul Riopelle (1923–2002), who settled in Paris in 1947. In his native Montreal, Riopelle had participated in the activities of *Les Automatistes* ("The Automatists"), who applied the Surrealist technique of automatism to the creation of abstract paintings. In the early 1950s, he began to squeeze blobs of paint directly onto the canvas and then spread them with a palette knife to create an "all-over" pattern of bright color patches, suggestive of broken shards of stained glass, and often traversed, as in KNIGHT WATCH (FIG. 21–14), by a network of spidery lines.

Helen Frankenthaler (b. 1928) visited Pollock's studio in 1951 and went on to create a more lyrical version of action painting that had an important influence on later artists. Like Pollock, she worked on the floor, but rather than flinging paint she poured it out in thin washes (FIG. 21–15). She also

used unprimed canvas, so that the paint soaked into the fabric rather than sitting on the surface. She typically began a work with some aesthetic question, but soon the process of creation became a self-expressive act as well. She described her working method in an interview (Artforum, October 1965): "I will sometimes start a picture feeling, What will happen if I work with three blues . . . ? And very often midway through the picture I have to change the basis of the experience. Or I add and add to the canvas. . . . When I say gesture, my gesture. I mean what my mark is. I think there is something now that I am still working out in paint; it is a struggle for me to both discard and retain what is gestural and personal." In MOUN-TAINS AND SEA, she poured several colors, then outlined some of them in charcoal. The result reminded her of the coast of Nova Scotia where she frequently went to sketch, so the title of the work, applied later, alludes to this.

Color Field Painting

New York School artists used abstract means to express various sorts of emotional states, not all of them as urgent or improvisatory as that of the action painters. A group known as Color Field painters also developed out of the biomorphic Surrealism of Gorky and Lam, but they moved in a different direction. Responding in part to what they saw as a spiritual problem in modern society, they created works that use large, flat areas of color to evoke transcendent moods of contemplation.

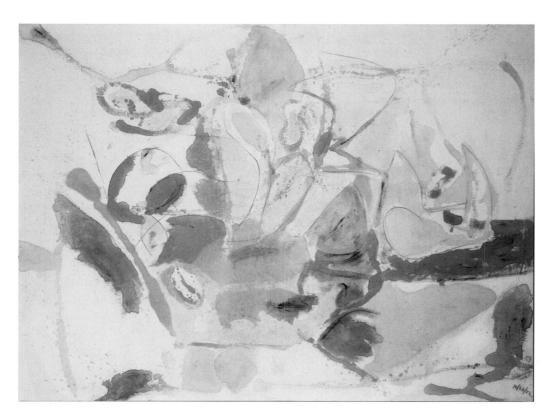

21–15 | Helen Frankenthaler MOUNTAINS AND SEA 1952. Oil and charcoal on canvas, 7'2¾" × 9'8¾" (2.2 × 2.95 m). Collection of the artist on extended loan to the National Gallery of Art, Washington, D.C.

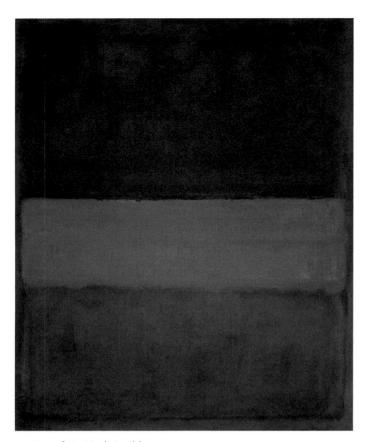

21–16 | Mark Rothko No. 61, BROWN, BLUE, BROWN ON BLUE 1953. Oil on canvas, $9'7\frac{3}{4}'' \times 7'7\frac{3}{4}'' (2.94 \times 2.32 \text{ m})$. The Museum of Contemporary Art, Los Angeles. The Panza Collection

THE DIVIDED INDIVIDUAL. Mark Rothko's (1903–1970) mature paintings typically feature two to four soft-edged rectangular blocks of color hovering one above another against a monochrome ground. In works such as BROWN, BLUE, BROWN ON BLUE (FIG. 21-16) Rothko sought to bring together the two divergent human tendencies that German philosopher Friedrich Nietzsche called the Dionysian and the Apollonian. The rich color represents the emotional, instinctual, or Dionysian element (after Dionysus, the Greek god of wine, the harvest, and inspiration), whereas the simple compositional structure is its rational, disciplined, or Apollonian counterpart (after Apollo, the Greek god of light, music, and truth). However, Rothko was convinced of Nietzsche's contention that the modern individual was "tragically divided," so his paintings are never completely unified but remain a collection of separate parts. What gives this fragmentation its particular force is that these elements offer an abstraction of the human form. In Brown, Blue, Brown on Blue, as elsewhere, the three blocks approximate the human division of head, torso, and legs. The vertical paintings, usually somewhat taller than the adult viewer, thus present the viewer with a kind of amplified mirror image of the divided self. The dark tonalities that Rothko increasingly featured in

his work emphasize the tragic implications of this division. The best of his mature paintings maintain a tension between the harmony they seem to seek and the fragmentation they regretfully acknowledge.

THE INDIVIDUAL AND THE SUBLIME. Barnett Newman also developed a distinctive nonrepresentational art to address modern humanity's existential condition, declaring his "subject matter" to be "[t]he self, terrible and constant." Newman specialized in monochrome canvases with one or more vertical lines, or "zips," dividing the surface, as in VIR HEROICUS SUBLIMIS (FIG. 21-17), whose Latin title means "Man, Heroic and Sublime." Newman often painted large works that engulf the viewer with color. He hoped to provide a modern experience of the sublime, as artists of the past such as Turner had done (SEE FIG. 19-15), but through abstract means which are not attached to any kind of scenery. Newman wondered whether modern science had demystified the world so much that people had lost the ability to sense the sublime. Jung wrote in Modern Man in Search of a Soul that the urge for the sublime was indeed frustrated in the modern era, and this led people to engage in war and slaughter as a perverse, negative substitute. Newman's own study of non-Western mythology convinced him that the sublime feelings are basic to most of the world's religions, yet modern Christianity seemed devoted to worldly goals such as material success and getting along well with others. The most popular minister of that period, the New York-based Dr. Norman Vincent Peale, achieved bestseller status with faith-based books such as The Power of Positive Thinking. Newman saw this as superficial. Writing about his art in the third person in an essay called "The Plasmic Image," he said: "The present painter is concerned not with his own feelings or with the mystery of his own personality but with the penetration into the world of mystery. His imagination is therefore attempting to dig into metaphysical secrets. To that extent his art is concerned with the sublime."

Sculpture of the New York School

Most sculptural media resist the spontaneous handling that painters such as Pollock developed, but some sculptors still took the New York School into the third dimension by using abstract means to transmit meanings and emotional states. The most important of these, David Smith (1906–1965) and Louise Nevelson (1899–1988), were first trained as painters, and their work retained important links to that medium.

WORKING WITH METAL. Smith gained metalworking skills at 19 as a welder and riveter at an automobile plant in his native Indiana. He first studied painting but turned to sculpture in the early 1930s after seeing reproductions of welded metal sculptures by Picasso and others. After World War II, Smith defied the traditional values of vertical, monolithic sculpture by welding horizontally formatted,

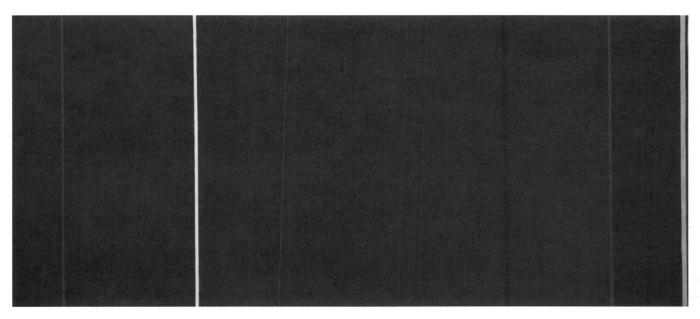

2I–I7 $^{\parallel}$ Barnett Newman VIR HEROICUS SUBLIMIS 1950–51. Oil on canvas, $7'11\frac{y_8''}{8} \times 17'9\frac{y_4''}{4} (2.42 \times 5.41 \text{ m})$. The Museum of Modern Art, New York. Gift of Mr. and Mrs. Ben Heller

open-form pieces that resemble drawings in space. A fine example is **HUDSON RIVER LANDSCAPE** (FIG. 21–18), whose fluent metal calligraphy, reminiscent of Pollock's poured lines of paint, was inspired by views from a train window of the rolling topography of upstate New York. Like many of his works from this period, the piece is meant to be seen from the front, like a painting.

During the last five years of his life, Smith turned from nature-based themes to formalism—a shift partly inspired by his discovery of the expressive properties of stainless steel. Smith explored both its relative lightness and the beauty of its polished surfaces in the *Cubi* series, monumental combinations of geometric units inspired by and offering homage to the formalism of Cubism. Like the Analytic Cubist works of

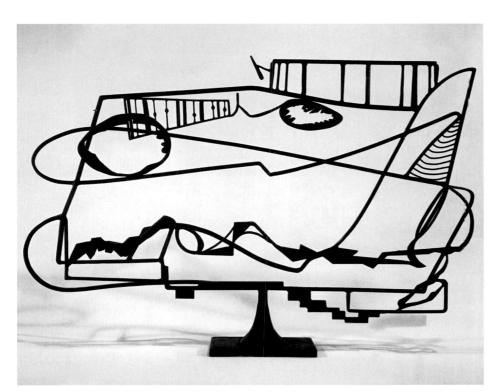

21–18 | David Smith

HUDSON RIVER LANDSCAPE

1951. Welded steel,

49 × 73¾ × 16½"

(127 × 187 × 42.1 cm).

Whitney Museum of American Art,
New York.

Art © Estate of David Smith/Licensed by

VAGA, New York, N.Y.

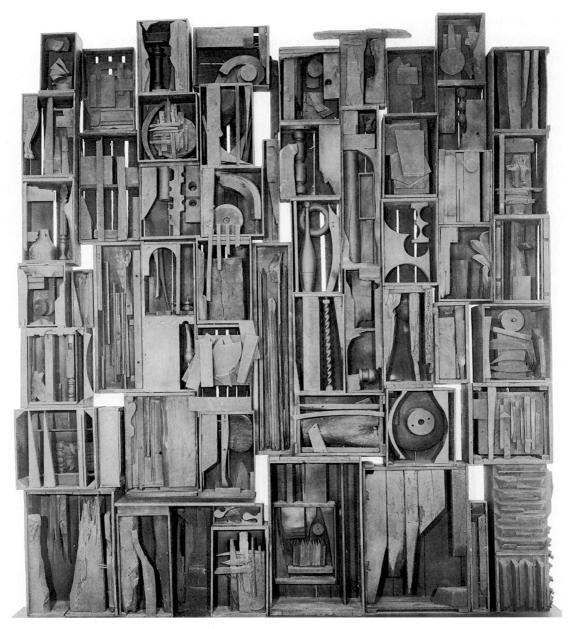

21–19 | Louise Nevelson SKY CATHEDRAL 1958. Assemblage of wood construction, painted black, $11'3\%'' \times 10'\%'' \times 1'6''$ (3.44 \times 3.05 \times 0.46 m). The Museum of Modern Art, New York. Gift of Mr. and Mrs. Mildwoff

Braque and Picasso (SEE FIG. 20–21), *Cubi XIX* (see Fig. 6, Introduction) presents a finely tuned balance of elements that, though firmly welded together, seems ready to collapse at the slightest provocation. The viewer's aesthetic pleasure depends on this tension and on the dynamic curvilinear patterns formed by the play of light over the sculpture's burnished surfaces. The *Cubi* works were meant to be seen outdoors, not only because of the effect of sunlight but also because of the way natural shapes and colors complement the inorganic ones.

WORKING WITH WOOD. While many sculptors of the New York School shared Smith's devotion to welded metal, some

continued to work with more traditional materials, such as wood. Wood became the signature medium of Louise Nevelson (1899–1988), a Russian immigrant who gained intimacy with the material as a child in Maine, where her father ran a lumberyard. After studying painting with Hans Hofmann, who introduced her to the formal language of Cubism, Nevelson turned to sculpture around 1940, working first in a biomorphic mode reminiscent of Henry Moore (SEE FIG. 20–71) before discovering her talent for evoking ancient ruins, monuments, and royal personages through assemblage.

Nevelson's most famous works are the wall-scale assemblages she began to produce in the late 1950s out of stacked packing boxes, which she filled with carefully and

sensitively arranged Analytic Cubist-style compositions of chair legs, broom handles, cabinet doors, spindles, and other wooden objects. She painted her assemblages a matte black to obscure the identity of the individual elements, to formally integrate them, and to provide an element of mystery. One of her first wall assemblages was **SKY CATHEDRAL** (FIG. 21–19), which Nevelson believed could transform an ordinary space into another, higher realm—just as the prosaic elements she worked with had themselves been changed. To add a further poetic dimension, Nevelson first displayed *Sky Cathedral* bathed in soft blue light, like moonlight.

EXPERIMENTS WITH FORM IN BUENOS AIRES

Uruguayan and Argentine artists were as innovative as their counterparts from the New York School but in a completely different direction. Starting from the geometric abstraction of Mondrian (SEE FIG. 20–60), they pioneered a range of new techniques in abstract painting and sculpture. They gathered in Buenos Aires immediately after the war, where they formed the groups Arte Concreto-Invención and Madí. Like

the Abstraction-Creation group in Europe (see Chapter 20), the South Americans were also motivated by antifascism: Ruling Argentina at that time was Juan Perón, who admired Italian dictator Mussolini and professed a profound dislike of Modern art.

The forerunner of the Latin American experiments was the Uruguayan Joaquín Torres-García (1874-1949), who established what he called a "School of the South" in Montevideo, Uruguay's capital. He had spent forty-three years in Europe and participated in several abstract art groups. His own art was also rooted in Pre-Columbian indigenous art forms of the Inca, especially their masonry buildings. He regarded ancient American cultures as a fertile bed of ideas similar to how Europeans might regard ancient Greek art: an important traditional source for later innovation. Torres-García also noticed that the patterns of stone in Inca architecture resembled the abstract paintings of Mondrian and others, a fact that he took as support for the universal validity of abstract art. His paintings (FIG. 21-20) combine ideas gleaned from Mondrian with Pre-Columbian patterns in a style he called Constructive Universalism. A tireless educator, he taught hundreds of students, formed several magazines, and even hosted a radio show.

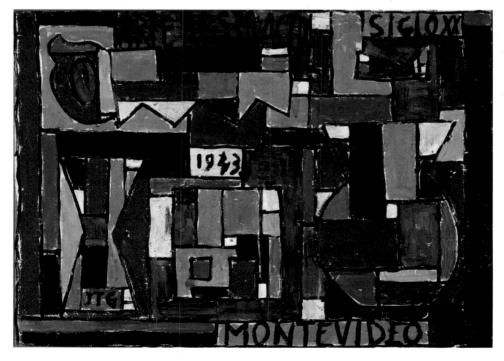

Gift of Mr. and Mrs. Armand J. Castellani, 1979, Artists Rights Society (ARS), New York

Concrete-Invention

After visiting Torres-García and taking in his polemical materials in the years just after World War II, younger artists in Buenos Aires moved their art even further away from representation. Mondrian, after all, was still representing a cosmic order, and Torres-García owed some of his forms to ancient stone walls. They called their group "Concrete" in order to avoid the term abstract, which might mean that their art was abstracted from something else. Rather, they stressed their own "Invention" of new forms. Their first important discovery was the shaped canvas (FIG. 21-21), here in a version by Raúl Lozza (b. 1911). The artist's goal was not to picture or represent anything, nor was it to transcribe or symbolize his emotional state. The work should exist without reference to any other reality. Art with a representational agenda, even a hidden one, is harmful because it "tends to sap the mental strength of viewers, leaving them unaware of their true powers," according to one of the group's manifestos. Representational art makes viewers into passive spec-

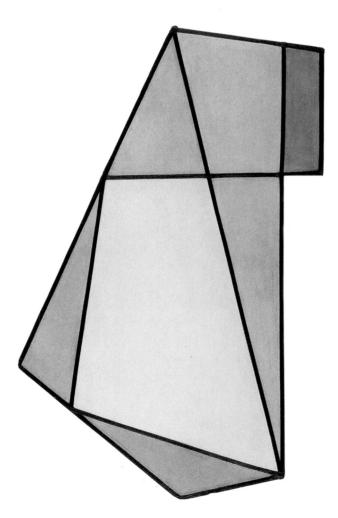

2I–2I | Raul Lozza ANALYTICAL STRUCUTURE 1946. Oil and ribbon on wood, $20\frac{1}{2} \times 11\frac{1}{8}$ " (52.1 \times 32.5 cm). Galerie von Bartha, Basel. Artists Rights Society (ARS), New York

tators. Rather, Lozza invented these forms without any preconceived notion so that the viewer could experience the forms merely as forms. Conforming the creations to a rectangular format limits the artist's scope of invention. Moreover, a shaped canvas was necessary because a rectangular or square painting might still be readable as a "picture" of something. Straight edges are necessary because curved ones might remind viewers of some organic shape. The surface is completely smooth because showing brushwork would point the viewer's attention away from the work itself and toward the artist. Lozza, who made leftist political cartoons in the 1930s, hoped that viewers would grasp their "true powers" after seeing these works and be more inclined to invent something in their own lives.

Madí

The next aesthetic question follows logically from Lozza's work, and it led to another important innovation: If the artist's goal is to invent new forms, why limit oneself to paint on a flat surface? Can artists invent in entirely new media? These questions first occurred to Gyula Kosice (b. 1924), and they led him to split from Concrete-Invention and form Madí in 1946. (The name, pronounced "mah-DEE," is a nonsense word.) This group, which included poets and composers as well as painters, rejected many of the previous limitations of their media. Madí poets arranged words on the page in visual patterns rather than verses; composers threw out the Western harmonic system, as Schoenberg had done earlier (see Chapter 20). After painting shaped canvases and experimenting with sculpture that moved, Kosice in 1946 was the first to make a sculpture out of neon lights (FIG. 21-22). As in Lozza's analytical strucuture, the shapes are intended to be completely abstract, but here they are also immaterial, since they consist of neon gas agitated to a glow by electricity. Color is not something that the artist applied to the work, but rather it exists in the tube and in the air surrounding it. The artists of Madí and Concrete-Invention exhibited widely over the next two decades, and helped establish a strong current of geometric abstraction in Latin American art, which at times converged with later European and North American developments.

POSTWAR PHOTOGRAPHY

Documentary photography, which flourished under New Deal patronage in the 1930s (see page 854), went into eclipse following the withdrawal of government support during World War II. Meanwhile, photojournalism, which burgeoned in the 1930s with the appearance of large-format picture magazines such as *Life*, grew in importance during the postwar decades. Fashion periodicals such as *Vogue* and *Harper's Bazaar* also provided work for professional photographers and stimulated the development of color photography.

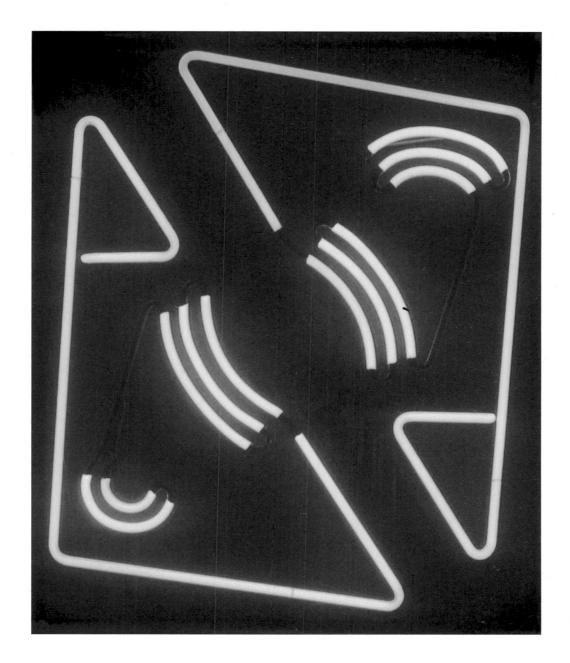

21–22 | Gyula Kosice MADÍ LUMINOUS STRUCTURE "F" 1946. Neon gas tube, $20\% \times 15\% \times 7\%$ " ($55 \times 40 \times 18$ cm). Collection of the artist.

New Documentary Slants

Many photographers took on commercial assignments to earn a living while producing independent work more expressive of their personal concerns and aesthetic interests. An important noncommercial trend that emerged in the 1950s was a new form of documentary photography that rejected traditional aesthetic standards to survey in a raw and unsentimental manner what one writer called the "social landscape." The founder of this mode was the Swiss-born Robert Frank (b. 1924). Frustrated by the pressure and banality of news and fashion assignments, Frank went to

Peru and Bolivia in 1948 to photograph the lives of poor people. Four years later he made another photo suite on Welsh coal miners at work. He applied successfully for a Guggenheim Fellowship in 1955 to finance a yearlong photographic tour of the United States. From more than 28,000 images, he selected 83 for a book published first in France as Les Américains in 1958 and a year later in an Englishlanguage edition as *The Americans*, with an introduction by the Beat writer Jack Kerouac (1922–69). Many of the images in the book combine unmistakable social comment with formal interest in composition. The perfect symmetry of

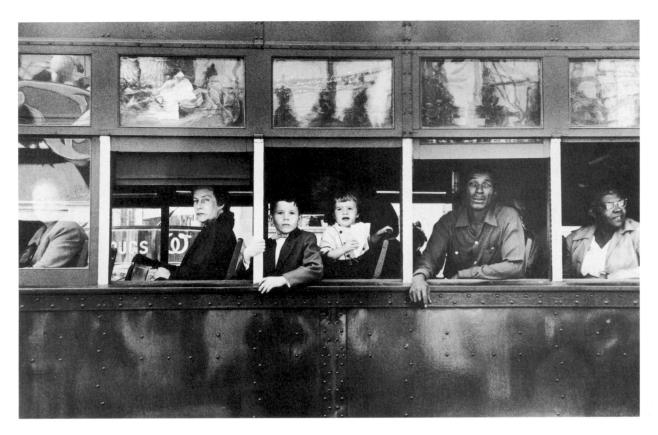

21–23 | Robert Frank TROLLEY, NEW ORLEANS 1955–56. Gelatin-silver print, $9\times13''$ (23×33 cm). The Art Institute of Chicago.

trolley, New ORLEANS (FIG. 21–23), for example, ironically underscores the racial segregation that it documents: White passengers sit in the front of the trolley, African Americans in the back, according to the laws of many Southern states before the civil rights movement forced changes. At the same time, the rectangular frames of the trolley windows isolate the individuals looking through them, evoking a sense of urban alienation. The rectangles in various formats also echo the shape of the picture itself, and the top row presents ghostly reflections that could be photographs in themselves.

In her complete preoccupation with subject matter, Diane Arbus (1923–71), even more than Frank, rejected the concept of the elegant photograph, discarding the niceties of conventional art photography (FIG. 21–24). She developed this approach partly in reaction to her experience as a fashion photographer during the 1950s—she and her husband, Allan Arbus, had been *Seventeen* magazine's favorite cover photographers—but mostly because she did not want formal concerns to distract viewers from her compelling, often disturbing subjects. Her innovative treatment of the photographic process created some of the sense of unease. She moved beyond the boundaries of what had been acceptable subject matter, photographing nudists and people with physical deformities or people otherwise on the fringes of society.

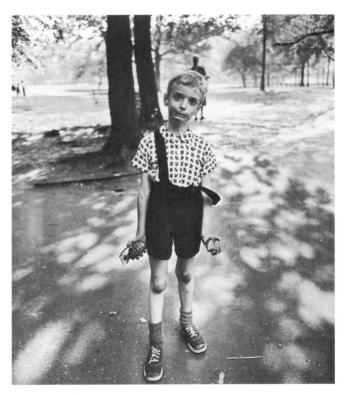

21–24 | Diane Arbus CHILD WITH TOY HAND GRENADE 1962. Gelatin-silver print, $8\frac{1}{4} \times 7\frac{1}{4}$ " (21 × 18.4 cm). The Museum of Modern Art, New York.

21–25 | Minor White CAPITOL REEF, UTAH
1962. Gelatin-silver print. The Museum of Modern Art, New York.
Purchase. Courtesy © The Minor White Archive, Princeton, New Jersey

She also usually allowed these subjects to sense the presence of the camera, allowing the subject to look back at us. This memorably broke down the distance between viewer and subject.

The Modernist Heritage

Other postwar photographers remained largely aloof from the social landscape and worked at expanding the Modernist line of Emerson and Stieglitz. A leading practitioner of this mode was Minor White (1908-76), whose aesthetically beautiful photographs were also meant to be forms of mystical expression, vehicles of self-discovery and spiritual enlightenment. Using a large-format camera, White focused sharply on weathered rocks (FIG. 21-25), swirling waves, frosted windowpanes, peeling paint, and similar "found" subjects that, as enigmatic photographic images, could serve as abstract visual equivalents for inner emotional states. In the late 1940s, White began showing his works in numbered sequences rather than as isolated individual images, thereby hoping to build a mood over a series of pictures. He experimented with infrared film in the middle 1950s, photographing light invisible to the naked eye in an effort to make his photos transcend physical reality. He also worked to advance photography as an art form, founding and then editing Aperture magazine from 1952 to 1975.

MOVING INTO THE REAL WORLD

The next generation of artists, who reached maturity in the 1950s, looked for new ways to link their art to the real world. One reason for this was a rebellion against their immediate forebears. New York School artists, after all, were studiobased. Despite their innovative techniques and formats, they used traditional media: paint, canvas, metal, wood. Perhaps the next goal should be to move beyond the studio. Moreover, younger artists saw the New York School as very serious, their brows darkened by the war and Existentialism, as they tried to flesh out their deeper selves in their work or heal a crisis of human spirituality. Members of the younger generation did not experience the war as adults, so it had less impact on their consciousness. Rather, as the Western world healed from the war's destruction, they saw growing waves of material prosperity that they grappled with in their creations. Thus, the most innovative European and North American artists in the 1950s and early 1960s reintroduced the real world into art and often worked in a less serious and sometimes even playful mode. The movements that resulted were Assemblage, Happenings, and Pop Art.

Assemblage

The most important early influence on the move toward the real world was the composer John Cage (1912-1992). Along with Dada poet Hugo Ball and Surrealist leader André Breton, Cage is one of the most important nonvisual artists to influence the course of Modern art history. He studied composition during the war years with Arnold Schoenberg, whose rejection of the major and minor musical scales earlier in the century paralleled the rise of completely abstract art (see page 812). Cage's most important innovation in music was to open his works to the random sounds of noise that we all live with every day. For example, he created a piece for twelve radios, whose score consisted of instructions to twelve operators on how to turn their volume and tuning dials; naturally this piece sounded radically different at each new performance and in each new location. The composer did not express his own feelings in this work; rather, he set up a situation in which unpredictable events can happen. This method of creation was a logical outgrowth of his study of Zen Buddhism, which teaches that enlightenment can come at any time, from any sort of experience. Likewise, Assemblage artists gather seemingly random objects and put them together in unruly compositions, not in order to make a predetermined statement but rather to see what kind of meanings might emerge.

BETWEEN ART AND LIFE. Cage was teaching at Black Mountain College near Asheville, North Carolina, when he met his most precocious student, Robert Rauschenberg (b. 1925). Rauschenberg also studied painting with Willem de Kooning, who was on the faculty that year (see his *Asheville*, Fig. 21–13). Ever the

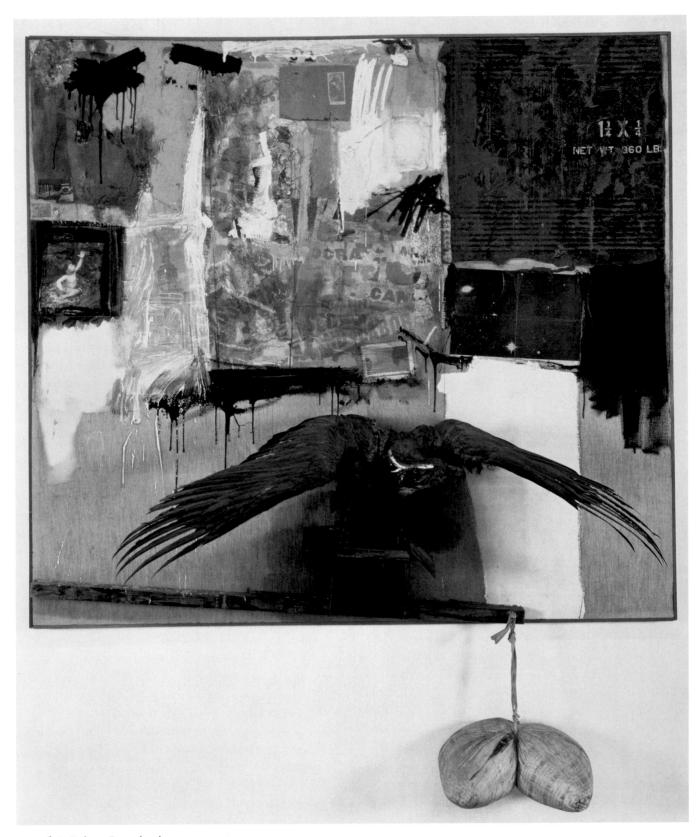

irreverent prankster, Rauschenberg asked for a drawing by the action painter and expressed his feeling about the older generation by erasing it (with de Kooning's permission). After a trip to Europe in 1948–49, where he saw work by Alberto Burri, among others (SEE FIG. 21–6), Rauschenberg began finding ways to "work in the gap between art and life," as he put it. In 1951, he exhibited a series of blank white paintings, so that the lights in the room and the shadows cast by viewers became the content of the canvases. This closely parallels a similar work by Cage from the same period, 4' 33" (four minutes thirty-three seconds), which calls for a player or players to sit silently on the stage at their instruments for that length of time, allowing any random sounds to become the work.

Between 1955 and 1960, Rauschenberg created his most important pieces, which he called *Combines* because they combined painting and sculpture. **CANYON**, for example (FIG. 21–26), features an assortment of family photographs, public imagery (such as the Statue of Liberty), fragments of political posters (in the center), and various objects salvaged from trash (the flattened steel drum at upper right) or purchased (the stuffed eagle). This agglomeration shares space with various patches of paint. The rich disorder in this work challenges the viewer to make sense of it. In fact, Rauschenberg meant his work to be open to various readings, so he assembled mate-

rial that each viewer might interpret differently. One could, for example, see the Statue of Liberty as a symbolic invitation to interpret the work freely. Or perhaps, covered as it is with paint applied in the manner of action painting, it symbolizes that style. Following Cage's ideas, Rauschenberg created a work of art that was to some extent beyond his control—a work of iconographic as well as formal disarray. Rauschenberg cheerfully accepted the chaos and unpredictability of modern urban experience and tried to find artistic metaphors for it. "I only consider myself successful," he said, "when I do something that resembles the lack of order I sense."

BETWEEN ABSTRACTION AND REPRESENTATION. Jasper Johns (b. 1930) integrated the real world in his work in order to ask more direct questions about the nature of art. He came to New York from South Carolina in 1948 and met Rauschenberg six years later. Unlike Rauschenberg's works, Johns's are controlled, emotionally cool, and highly cerebral. Inspired by the example of Marcel Duchamp (SEE FIG. 20–36), Johns produced conceptually puzzling works that seemed to bear on issues raised in contemporary art. Art critics, for example, had praised the evenly dispersed, "nonhierarchical" quality of so much Abstract Expressionist painting, particularly Pollock's. The target in TARGET WITH FOUR FACES (FIG. 21–27), an

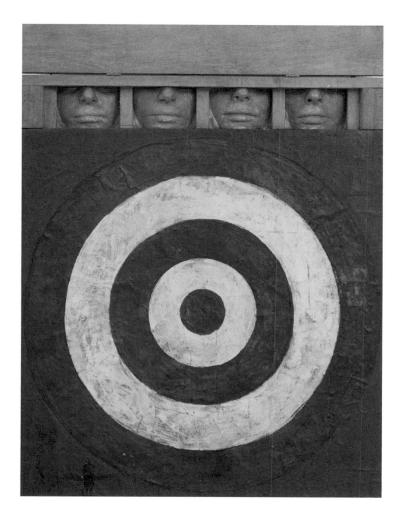

21–27 | Jasper Johns TARGET WITH FOUR FACES

1955. Assemblage: encaustic on newspaper and cloth over canvas, surmounted by four tinted plaster faces in wood box with hinged front; overall, with box open, $33\% \times 26 \times 3''$ (85.3 \times 66 \times 7.6 cm). The Museum of Modern Art, New York. Gift of Mr. and Mrs. Robert C. Scull, (8.1958) Art © Jasper Johns/Licensed by VAGA, New York, NY

emphatically hierarchical, organized image, can be seen as a critical comment on this discourse. The image also raises thorny questions about the difference between representation and abstraction. The target, although arguably a representation, is flat, whereas two-dimensional representational art usually creates the illusion of three-dimensional space. The target therefore occupies a troubling middle ground between the two kinds of painting then struggling for dominance in American art.

Johns, Cage, and Rauschenberg collaborated on several theatrical events in the late 1950s and early 1960s that may be the most perfect assemblages. Cage provided the music while Johns and Rauschenberg made sets and sometimes performed. Dancers came from the Merce Cunningham Dance Company, which specialized in making dance out of everyday actions such as waiting for a bus or reading a newspaper. Prior to the events, none of them informed the others of what they were going to do, or even for how long, so that the result was a multimedia evening of legendary unpredictability.

Happenings

Happenings resemble Assemblage in their incorporation of the real world, but Happenings are more scripted events that take place over a predetermined period of time. Many creators of Happenings acknowledged a debt to Jackson Pollock and his physical enactment of the work of art (SEE FIG. 21–10). If Pollock used his entire body with paint to create two-dimensional works, Happening artists used their bodies in the real world to create events.

THE GUTAI GROUP. The first Happenings took place in Japan, where recovery from war was closely supervised by American occupation. General Douglas MacArthur personally rewrote the Japanese constitution and directed a peaceful social revolution in order to transform postwar Japan into a Westernstyle nation. This naturally led to a radical collapse of old values that artists took advantage of. Some painters formed the Gutai group in 1954 to "pursue the possibilities of pure and creative activity with great energy," as their manifesto put it. Gutai organized outdoor installations, theatrical events, and dramatic displays of art making. The name of the movement means "embodiment," and most Gutai Happenings involved the artist performing some radical action. For example, one artist made paintings with his feet before an invited audience. Another made "drawings" by framing huge sheets of paper and walking through them. At the second Gutai Exhibition in 1956, Shozo Shimamoto (b. 1928) dressed in protective clothing and eyewear to produce HURLING COLORS (FIG. 21-28) by smashing bottles of paint on a canvas laid on the floor. This pushed Pollock's drip technique into the realm of a performance. Since there was practically no market for contemporary

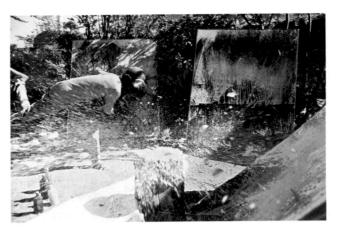

21–28 | Shozo Shimamoto HURLING COLORS
1956. Happening at the second Gutai Exhibition, Tokyo.

art in Japan at that time, the artists often destroyed their works after the Happening was over.

KAPROW. The leading creator of Happenings in the United States was Allan Kaprow (1927–2006), like the Assemblagists a student of John Cage. Kaprow's Happenings usually involved simple scripts that invited guests acted out. A particularly ambitious Kaprow Happening of the early 1960s was THE COURT-YARD (FIG. 21-29), staged on three consecutive nights in the skylight-covered courtyard of a run-down Greenwich Village hotel. At the center of the courtyard stood a 30-foot-high tar paper-covered "mountain." Spectators were handed brooms by two workers and invited to help clean the courtyard, which was filled with crumpled newspaper and bits of tin foil, the latter dropped from the windows above. The workers ascended ladders to dump the refuse into the top of the mountain, while a man on a bicycle rode through the crowd, ringing his handlebar bell. After a few moments, wild noises were heard from the mountain, which then erupted in an explosion of black crepe-paper balls. This was followed by a shower of dishes that broke on the courtyard floor, while noises and activity were heard from the windows above. Mattresses and cartons were lowered to the courtyard, which the workers carried to the top of the mountain and fashioned into an "altar-bed." A young woman, wearing a nightgown and carrying a transistor radio, then climbed to the top of the mountain and reclined on the mattresses. Two photographers entered, searching for the young woman. They ascended the ladder, took flash pictures of her, thanked her, and left. The Happening concluded with an "inverse mountain" descending to cover the young woman.

Although Kaprow argued that Happenings lacked literary content, *The Courtyard* was for him richly symbolic: The young woman in the nightgown, for example, was the "dream girl," the "embodiment of a number of old, archetypal symbols. She is the nature goddess (Mother Nature) . . . and Aphrodite (Miss America)." Kaprow admitted that "very

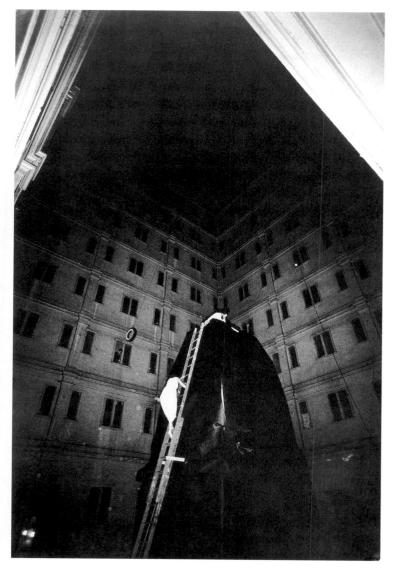

21–29 ↑ Allan Kaprow THE COURTYARD 1962. Happening at the Mills Hotel, New York.

few of the visitors got these implications out of *The Courtyard*," but he believed that many sensed at some level "there was something like that going on."

HUMOR HAPPENS. Two Happenings by European artists from 1960 captured the movement's more humorous side. In Europe, Happenings were called New Realism, a term coined by art critic Pierre Restany in that year. Restany wrote that after the New York School and *Art Informel*, the art of painting was over; there was nothing left to be done with it (he was neither the first nor the last to say this; painting keeps coming back from the dead, as we shall see). After painting will come real life, Restany wrote: "The passionate adventure of the real, perceived in itself . . . The New Realists consider the world a painting: a large, fundamental work of which they appropriate fragments."

Sequencing Works of Art

1944-45	Wols, Painting
1947	Lozza, Painting No. 99
1950	Lam, Zambezia, Zambezia
	Pollock, Autumn Rhythm
1951	Smith, Hudson River Landscape
1952	Frankenthaler, Mountains and Sea
1953	Rothko, No. 61, Brown, Blue, Brown on Blue
1955	Johns, Target with Four Faces

The French artist Yves Klein (1928–1962) arrived at Happenings after experimenting with both *Art Informel* and monochromatic abstract art. For his Happening **ANTHRO-POMETRIES OF THE BLUE PERIOD** (FIG. 21–30), Klein invited members of the Paris art world to watch him direct three nude female models covered in blue paint to press their bodies against large sheets of paper. The accompaniment consisted of a string orchestra playing one constant note. This was meant, in part, as a satire on the pretentiousness of action painting, especially Pollock's work on the floor of his studio. Klein wrote, "I dislike artists who empty themselves into their paintings. They spit out every rotten complexity as if relieving themselves, putting the burden on their viewers." He offered instead a sensuous and diverting display, leading to a work that he created without actually touching it himself.

The Swiss-born Jean Tinguely (1925–1991) made comical Assemblages out of machinery that amounted to Happenings when activated. He studied art in Switzerland during the war, where he got to know several leading Dadaists, including Kurt Schwitters (SEE FIG. 20–37). Among Tinguely's most ingenious contraptions were his *Metamatics*,

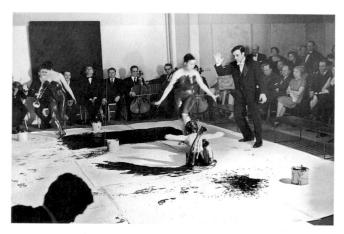

21–30 | Yves Klein ANTHROPOMÉTRIES OF THE BLUE PERIOD

1960. Performance at the Galerie Internationale d'Art Contemporain, Paris.

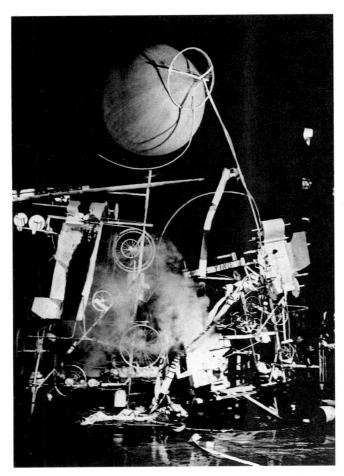

21–31 | Jean Tinguely HOMAGE TO NEW YORK 1960. Self-destroying sculpture in the garden of the Museum of Modern Art, New York.

machines with rolls of paper attached that produced abstract paintings by the yard. Viewers could turn on the machine, watch it run, and tear off the artworks it created. The satirical implication is that abstract art, which was supposed to powerfully express an artist's inner self, can be mass produced.

Happenings are generally scripted events, but when his largest machine once got out of control, it led to a Happening that made history. He designed HOMAGE TO NEW YORK (FIG. 21-31) for a special one-day exhibition in the sculpture garden of the Museum of Modern Art. He assembled the work from yards of metal tubing, several dozen bicycle and baby-carriage wheels, a washing-machine drum, an upright piano, a radio, several electric fans, a noisy old printing press, a bassinet, numerous small motors, two Metamatics, several bottles of chemical stinks, and various noisemakers—the whole ensemble painted white and topped by an inflated orange meteorological balloon. The machine was designed to destroy itself when activated. On the evening of March 17, 1960, before a distinguished group of guests, including New York governor Nelson A. Rockefeller, the work was plugged in. As smoke poured out of the machinery and covered the crowd, parts of the contraption broke free and scuttled off in various directions, sometimes frightening the onlookers. The Metamatics blew abstract art in their direction. A device meant to douse the burning piano—which kept playing only three notes—failed to work, and firefighters had to be called in. They extinguished the blaze and finished the work's destruction—to boos from the audience, who, except for the museum officials, had been delighted by the spectacle. The artist said the event was better than any he could have planned.

Pop Art

Between about 1955 and 1965, some artists made the move into the real world by borrowing mass-produced imagery, or using mass-production techniques in their art, in response to the growing presence of mass media in the prosperous postwar culture. The movement was almost immediately given the name Pop Art to distinguish it from Assemblage, in which artists also used real objects, only some of them mass produced. The exclusive use of mass-produced imagery or techniques gives Pop Art a slicker look than the other contemporary movements. The emotional tone of Pop Art tends to show a more ironic, cynical, or detached attitude, compared with the irreverence or humor of Assemblage and Happenings.

Pop Art had its widest flowering in the United States after about 1962, but the movement originated in England years earlier. The immediate backdrop for Pop Art is wildly increasing prosperity brought on by a postwar economic boom. The Marshall Plan funneled \$9.4 billion to Europe for reconstruction, and the infusion brought about an industrial rebound. By 1950, industrial output for Europe as a whole was one-third higher than it had been in 1939. In 1955, European unemployment was only 2 percent. In most European countries, the average citizen benefited from an unprecedented level of government benefits, including social security, national health insurance, unemployment benefits, and company pensions. In 1958, for the first time, more people crossed the Atlantic by air than by sea. When English Prime Minister Harold Macmillan ran for reelection in 1959, his slogan was "You never had it so good!" In such an environment, lonely Existentialism seemed completely discredited.

HAMILTON. In this setting, younger artists wondered what they should do. Some Londoners formed the Independent Group to discuss the function of art in a comfortable industrial society which seemed to lack nothing. The group consisted of a critic, two architects, two artists, a photographer, and a writer, and they periodically staged exhibitions at London's Institute of Contemporary Arts. The artist-member generally credited with pioneering the Pop Art style was Richard Hamilton (b. 1922). An apprentice industrial designer during the war, he was thrown out of the Royal Academy for having "low standards." He reasoned, penetratingly and correctly, that the modern mass culture of televi-

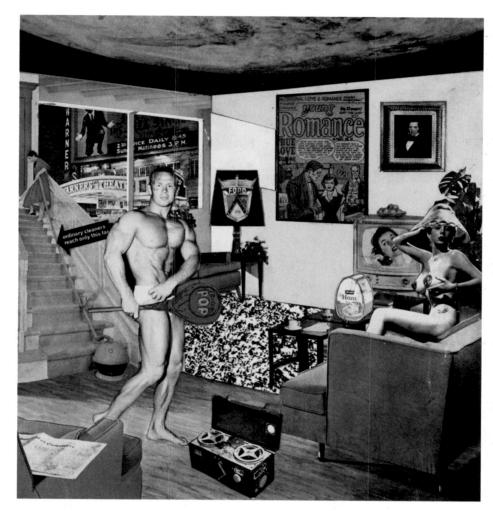

1955. Collage, $10\,\% \times 9\,\%$ " (26 \times 24.7 cm). Kunsthalle Tübingen, Germany. ARS/DACS

sion, movies, and media had taken over many of the previous functions of traditional art. For example, if in the past art showed us ideal beauty, today people see such things in advertising and pin-up photographs. If another function of art is to comment on society, then television news programs do that more vividly. If art has traditionally given us heroic narratives of larger-than-life figures, people today can see this at the movies. Finally, if art somehow symbolizes the times by its style, then car bodies and the latest consumer goods do this just as well.

Hamilton's answer was to make art that ironically used the same strategies as mass media. His 1955 collage has a long title borrowed from advertising slogans: JUST WHAT IS IT THAT MAKES TODAY'S HOMES SO DIFFERENT, SO APPEALING? (FIG. 21–32). Here we see a man and a woman—Hamilton called them Adam and Eve—in their domestic setting. To point out just a few of the details in this iconographically rich work: The home is populated with brand-name goods, most of them of American origin. Out the window is a movie theater showing *The Jazz Singer*, the 1927 film that was the first to integrate a spoken sound track. On the wall, occupying the

favored place above the TV set, is a portrait of John Ruskin. the moralistic art critic who had libeled James Whistler seventy years before (see "Art on Trial in 1877," page 763). The central male figure holds the huge sucker that gave the style its name: Art critic Lawrence Alloway referred to that Tootsie Pop when he called Hamilton's collage a work of Pop Art. The work illustrates modern comfort, progress, and success, using the imagery of the mass media themselves. The historical antecedents for this work are the Dada collages of Hannah Höch and others (SEE FIG. 20–38), but Hamilton's work uses later imagery and is less bitter. Like other British Pop artists, Hamilton was not alienated from popular culture; he respected it and worked with it. He later designed an album cover for The Beatles ("White Album," 1968), as did his fellow Pop artist Peter Blake ("Sgt. Pepper's Lonely Hearts Club Band," 1967).

WARHOL. American artists soon found their way to a yet slicker and simpler Pop Art style that uses more layers of irony. Andy Warhol (1928–1987) is a giant of Pop Art if only because he created memorably in many media. Moreover, his

best works conceal important insights behind their mass-produced surfaces. Trained initially as a commercial artist, he decided in 1960 to pursue a career as an artist along the general lines suggested by the work of Johns and Rauschenberg. He took as subjects the iconic images of American mass culture, such as film star Marilyn Monroe (FIG. 21–33). MARILYN DIPTYCH is one of the first in which Warhol turned from conventional painting to the assembly-line technique of silk-screening photographic images onto canvas. The method was quicker than painting by hand and thus more profitable, and Warhol could also produce many versions of the subject—all of which he considered good business. He established a workshop in 1965 to make his pieces, and called it ironically The Factory.

The subject of this work is also telling. Like many Americans, Warhol was fascinated by movie stars such as Marilyn Monroe, whose persona became even more compelling after

her apparent suicide in 1962, the event that prompted Warhol to begin painting her. The strip of pictures in this work suggests the sequential images of film, the medium that made Monroe famous. Some of these are in black-and-white and some in color, like her movies. The face Warhol portrays, taken from a publicity photograph, is not that of Monroe the person but of Monroe the star, since Warhol was interested in her public mask, not in her personality or character. He borrowed the diptych format from the icons of Christian saints he recalled from the Byzantine Catholic church he had attended as a youth. By symbolically treating the famous actress as a saint, Warhol shed light on his own fascination with fame.

Warhol's most penetrating works take the mass media themselves as subject (FIG. 21–34). BIRMINGHAM RACE RIOT deals with the civil rights protests that characterized that period, but Warhol is typically noncommittal in this work. He

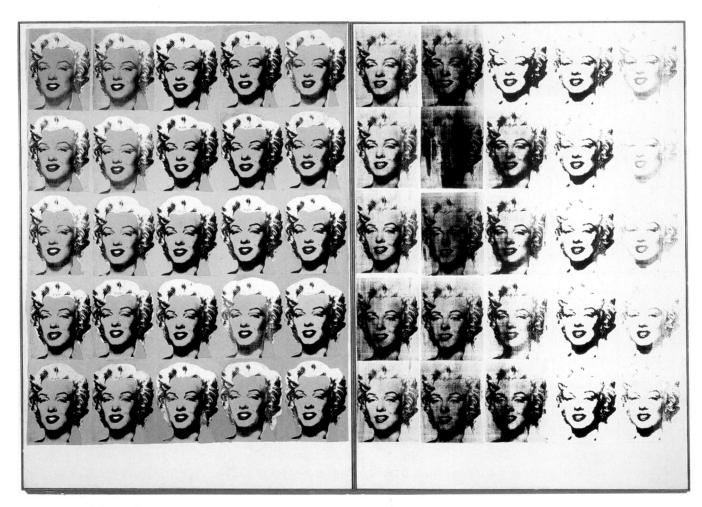

21–33 Andy Warhol MARILYN DIPTYCH 1962. Oil, acrylic, and silkscreen on enamel on canvas, two panels, each $6'10'' \times 4'9''$ (2.05 \times 1.44 m). Tate Gallery, London.

Warhol assumed that all Pop artists shared his affirmative view of ordinary culture. In his account of the beginnings of the Pop movement, he wrote: "The Pop artists did images that anybody walking down Broadway could recognize in a split second—comics, picnic tables, men's trousers, celebrities, shower curtains, refrigerators, Coke bottles—all the great modern things that the Abstract Expressionists tried so hard not to notice at all."

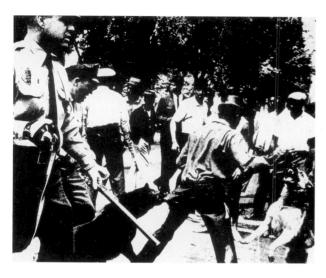

21–34 Andy Warhol BIRMINGHAM RACE RIOT 1964. Serigraph on Bristol board, with Japan paper borders, $20\times24''$ (50.9×60.8 cm). National Gallery of Canada, Ottawa. (No. 17242) Purchased 1973 / © 2007 Andy Warhol Foundation for the Visual Arts / SODRAC, Montreal / Artists Rights Society (ARS), New York, NY

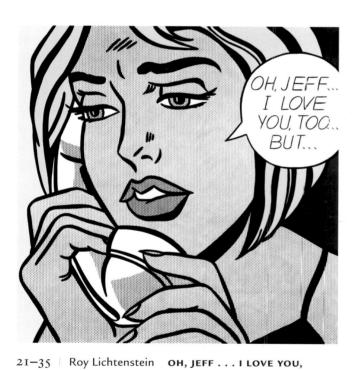

TOO...BUT... 1964. Oil and Magna on canvas, $48 \times 48''$ (122 \times 122 cm). Private collection.

took no position on the civil rights question but merely transcribed a media image from a popular magazine. Later versions of this work reproduced the photo dozens of times, as in the *Marilyn Diptych*. Warhol was among the first to notice that the mass media bring the whole world much closer to us, but they also enable us to observe the world in a detached fashion. Tragedies and disasters enter our living rooms every day,

but they come in a small box that we can turn on or off at will, making us voyeurs rather than participants. Moreover, the media repeat stories so often that we become desensitized to their impact. Warhol's works, through deadpan presentation and seemingly mindless repetition, make both of these points cogently. He also had a gift for aphorism that by itself might have guaranteed his fame. Nearly everyone has heard of his assertion that "In the future everybody will be worldfamous for fifteen minutes." He made a telling comment that speaks to a central dilemma of modern life: "All of my films are artificial, but then everything is sort of artificial. I don't know where the artificial stops and the real starts." Besides his art pieces and his films, Warhol also founded a magazine (Interview) and managed a highly influential rock band (The Velvet Underground). His influence outlasted Modern art itself, as we shall see.

LICHTENSTEIN. Roy Lichtenstein (1923–97) was among the first American artists to make art from the look as well as the subjects of popular culture. In 1961, while teaching at Rutgers University with Allan Kaprow, Lichtenstein began producing paintings whose imagery and style—featuring heavy black outlines, flat primary colors, and the Benday dots used to add tone in printing—were drawn from advertisements and cartoons. The most famous of these early works were based on panels from war and romance comic books, which Lichtenstein said he turned to for formal reasons. Although many assume that he merely copied from the comics, in fact he made numerous subtle yet important formal adjustments that tightened, clarified, and strengthened the final image. Nevertheless, most of the paintings retain a sense of the cartoon plots they draw on. OH, JEFF . . . I LOVE YOU, TOO . . . BUT . . . (FIG. 21-35), for example, compresses into a single frame the generic romance-comic story line, in which two people fall in love, face some sort of crisis that temporarily threatens their relationship, then live happily ever after. Lichtenstein's work plays an elaborate game with illusion and reality: We know that comic-book emotions are melodramatic and thus unreal, and yet he presents them vividly and almost reverently. He actually used a stencil to make sure that he got the Benday dots right. The issue of what is real and unreal in our media-saturated culture was just coming to awareness in the early 1960s; its increasing urgency since then has kept Pop Art relevant.

OLDENBURG. Swedish-born Claes Oldenburg (b. 1929) took both a more critical and a more humorous attitude toward his popular subjects than did Warhol and Lichtenstein. Oldenburg's humor is most evident in such large-scale public projects as his Lipstick Monument for his alma mater, Yale University (FIG. 21–36). Oldenburg created this work at the invitation of a group of graduate students in Yale's School of Architecture, who requested a monument to the "Second

21–36 | Claes Oldenburg **LIPSTICK (ASCENDING) ON CATERPILLAR TRACKS**1969, reworked 1974. Painted steel body, aluminum tube, and fiberglass tip, $21' \times 19' \ 5 \% \times 10' 11''$ (6.70 $\times 5.94 \times 3.33$ m). Yale University Art Gallery, New Haven, Connecticut.
Gift of Colossal Keepsake Corporation

American Revolution" of the late 1960s, which was marked by student demonstrations against the Vietnam War. By mounting a giant lipstick tube on tracks from a Caterpillar tractor, Oldenburg suggested a missile grounded in a tank, simultaneously subverting the warlike reference by casting the missile in the form of a feminine cosmetic with erotic overtones. Oldenburg thus urged his audience, in the vocabulary of the time, to "make love, not war." He also addressed the issue of "potency," both sexual and military, by giving the lipstick a balloonlike vinyl tip, which, after being pumped up with air, was meant to deflate slowly. (In fact, the pump was never installed and the drooping tip, vulnerable to vandalism, was soon replaced with a metal one.) Oldenburg and the students provocatively installed the monument on a plaza fronted by the Yale War Memorial and the president's office. The university, offended by the work's irreverent humor, had Oldenburg remove it the next year. In 1974 he reworked LIP- **STICK (ASCENDING) ON CATERPILLAR TRACKS** in the more permanent materials of fiberglass, aluminum, and steel and donated it to the university, which this time accepted it for the courtyard of Morse College.

THE FINAL ASSAULT ON CONVENTION, 1960–1975

If Pop artists happily engaged with the world of mass culture, other artists saw that movement as a distraction from the basic quest of Modern art: questioning and overthrowing the conventions of art itself. The era of 1960s and early 1970s was another period of intense experimentation, similar to the early twentieth century, when movements and styles proliferated and overlapped with each other. Various groups of artists on different continents attacked the rules from different angles. Though most of this art has no overt political dimension, the restless questioning by artists parallels the social upheavals that also marked that period. The years that saw the civil rights movement, massive rallies against the draft and the Vietnam War, and organized movements of environmentalism, feminism, and the Paris revolts of 1968, also saw artists making works that outdid the radicalism of even the Dadaists.

Op Art and Minimal Art

MATTER AS WAVE. Building on the Latin American tradition of geometric abstraction (SEE FIG. 21-21), some Venezuelan artists experimented with a new kind of motion in their art. We have already seen art that moves by Alexander Calder (SEE FIG. 20-72); Gyula Kosice in Argentina also made mobiles in the 1940s. Is it possible, some wondered, to have art that depends on motion by the spectator? In society, people are moving all the time, why not in the art gallery as well? Jesús Rafael Soto (1923-2005) created such works as far back as the 1950s (FIG. 21-37). TRANSFORMABLE HARMONY is a series of painted planes a few inches apart, attached together parallel to the wall. When a viewer passes by, the clashing lines set up patterns that seem to vibrate. Soto hoped that these vibrations generate enough interest on optical grounds alone, apart from any personal expression or symbolic meaning, to hold the viewer's contemplative attention. The moving patterns do not exist in the painted planes themselves but only on the viewer's retina; Soto said in 1965 that the form of his art is thus "dematerialized." Viewers passing by at different speeds, at different heights, will see somewhat different patterns. Every viewer with good enough eyesight will see the patterns, though, and their motion does not depend on the viewer's culture or level of education. Soto, a socialist, took pleasure in this egalitarian aspect of his art. Since the work depends primarily on optical phenomena, his art was dubbed (half in jest by a fan of Pop Art) "Op Art."

2I-37 | Jesús Rafael Soto | ARMONÍA TRANSFORMABLE (TRANSFORMABLE HARMONY)

1956. Plexiglass and acrylic on wood, $39\% \times 15\% \times 39\%$ " (100 \times 40 \times 100 cm). Art Museum of the Americas, Washington, D.C.

© Jesús Rafael Soto / Artists Rights Society (ARS), New York / ADAGP, Paris

English artist Bridget Riley (b. 1931) worked along a similar path in two-dimensional works (FIG. 21–38). CURRENT plays with the viewer's depth perception, as the narrow lines seem to describe wave patterns. Riley's art is based more on natural rhythms than that of Soto, and it also presumes a stationary viewer, but we soon discover as we look at this work that it is impossible to keep our eyes perfectly still. The lines seem to undulate, and the afterimages that develop in our retina create extraneous patterns. These optical phenomena create a new kind of visual immersion, perhaps admirably suited to a fast-paced existence.

MATTER AS MATTER. In its emphasis on hard-edged geometry, Op Art held a formal relationship to Minimalism, which emerged in the mid-1960s as the dominant mode of abstraction in New York. The Minimalists had no knowledge of the earlier Concrete-Invention group in Argentina, but they worked along a similar path. Minimalists sought to purge their art of everything that was not essential to art. They banished subjective gestures and personal feelings; negated representation, narrative, and metaphor; and focused exclusively on the artwork as a physical fact. They employed simple geometric forms with plain, unadorned surfaces and often used industrial techniques and materials to achieve an effect of complete impersonality. Canadian artist Jack Bush (1909–1977) once

said that his paintings are "something to look at, just with the eye, and react." This statement accurately describes part of the Minimalist program, but Bush retained something of a handmade look in his abstractions. Influenced by Helen Frankenthaler (SEE FIG. 21-15), he worked with thinned-down oils during the first half of the 1960s. Bush switched to acrylics in 1966, the year he painted TALL SPREAD (FIG. 21-39). In this large painting from Bush's Ladder series, a stack of color bars fills the right side of the canvas, held in place by a single green vertical stripe at the left. While the bands of the ladder alternate in value between dark and light, Bush chose their hues not according to any systematic logic but rather intuitively. Similarly, he avoided geometric regularity by varying the width of each band and leaning its top and bottom edges slightly off the horizontal. Bush's art retains the human touch in ways that American Minimalists worked hard to avoid.

21–38 | Bridget Riley CURRENT 1964. Synthetic polymer on board, $58\%'' \times 58\%''$ (148 \times 149 cm). The Museum of Modern Art, New York. Philip Johnson Fund (576.1964)

While the American popular media loved Op Art, most avant-garde critics detested it. Lucy Lippard, for example, called it "an art of little substance," depending "on purely technical knowledge of color and design theory which, when combined with a conventional geometric . . . framework, results in jazzily respectable jumping surfaces, and nothing more." For Lippard and like-minded New York critics, Op Art was too involved with investigating the processes of perception to qualify as serious art.

21–39 | Jack Bush TALL SPREAD 1966. Acrylic on canvas, 106 × 50" (271 × 127 cm). The National Gallery of Canada, Ottawa, Ontario. Purchase, 1966

The painter Frank Stella (b. 1936) inaugurated the Minimalist movement in the late 1950s through a series of large "Black Paintings," whose flat, symmetrical black enamel stripes, laid down on bare canvas with a house painter's brush, rejected the varied colors, spatial depth, asymmetrical compositions, and impulsive brushwork of action painters such as de Kooning. In 1960 Stella created a series of "Aluminum Paintings," using a metallic paint normally applied to radiators. He chose this paint because it "had a quality of repelling

21–40 | Frank Stella AVICENNA 1960. Aluminum paint on canvas, $6'2\%''\times6'$ (1.91 \times 1.85 m). The Menil Collection, Houston, Texas.

21–41 | Judd Foundation UNTITLED 1969. Anodized aluminum and blue Plexiglas, each $47\frac{1}{2} \times 59\frac{1}{8} \times 59\frac{1}{8}$ " (1.2 × 1.5 × 1.5 m); overall $47\frac{1}{2} \times 59\frac{1}{8} \times 278\frac{1}{2}$ " (1.2 × 1.5 × 7.7 m). The St. Louis Art Museum, St. Louis, Missouri. Purchase funds given by the Shoenberg Foundation, Inc. Art © Judd Foundation / Licensed by VAGA, New York, NY

the eye," and it created an even flatter, more abstract effect than had the "soft" black enamel. While the "Black Paintings" featured straight bands that either echoed the edges of the rectangular canvas or cut across them on the diagonal, in "Aluminum Paintings" such as AVICENNA (FIG. 21–40) Stella arrived at a more consistent fit between the shape of the support and the stripes painted on it by cutting notches out of the corners and the center of the canvas and making the stripes "jog" in response to these irregularities.

In these and subsequent series, Stella continually developed the possibilities of the shaped canvas that Argentine artists had pioneered. He used thick stretchers (the pieces of wood on which canvas is stretched) to give his works the appearance of slablike objects, which his friend Donald Judd (1928-94) recognized as suggesting sculpture. By the mid-1960s, Judd, trained as a painter, had decided that sculpture offered a better medium for creating the kind of pure, matter-of-fact art that he and Stella both sought. Rather than depicting shapes, as Stella did-which Judd thought still smacked of representation—Judd created actual shapes. In search of maximum simplicity and clarity, he evolved a formal vocabulary featuring identical rectangular units arranged in rows and constructed of industrial materials, especially galvanized iron, anodized aluminum, stainless steel, and Flexiglas. UNTITLED (FIG. 21-41) is a typical example of his mature work, which the artist did not make by hand but had fabricated according to his specifications. He faced the boxes with transparent Plexiglas to avoid any uncertainty about what might be inside. He arranged them in evenly spaced rows the most impersonal way to integrate them—and generally avoided sets of two or three because of their potential to be read as representative of something other than a row of boxes. Judd provided the viewer with a set of clear, self-contained

facts, setting the conceptual clarity and physical perfection of his art against the messy complexity of the real world.

Judd participated in protests against the Vietnam War and bought advertising space in newspapers to publicize that cause, but he felt that art should deal with aesthetic issues only. Some Minimalists struggled with the idea of banishing all personal meaning from their work, and in grappling with it they created innovative pieces. One of these is Eva Hesse (1936-1970), whose personal history kept influencing her creations. Born in Hamburg to German Jewish parents, Hesse narrowly escaped the Nazi Holocaust by immigrating with her family to New York City in 1939. After graduating from the Yale School of Art in 1959, she painted darkly Expressionistic self-portraits that reflected the emotional turbulence of her life. In 1964 she began to make completely abstract sculpture that adapted the vocabulary of Minimalism to a similarly self-expressive purpose. "For me ...," said Hesse, "art and life are inseparable. If I can name the content . . . it's the total absurdity of life." The "absurdity" that Hesse pursued in her last works was the complete denial of fixed form and scale, so vital to Minimalists such as Judd. Her ROPE PIECE (FIG. 21-42), for example, takes on a different shape and different dimensions each time it is installed. The work consists of several sections of rope, which Hesse and her assistant dipped in

21–42 | Eva Hesse ROPE PIECE 1969–70. Latex over rope, string, and wire; two strands, dimensions variable. Whitney Museum of American Art, New York.

Purchase, with funds from Eli and Edythe L. Broad, the Mrs. Percy Uris Purchase Fund, and the Painting and Sculpture Committee (88.17 a-b)

21–43 | Lygia Clark BICHO LC3 (PAN-CUBISME) 1970. Aluminum and metal, $9\times17\%\times15\%''$ (23 \times 45 \times 40 cm). Daros-Latinamerica, Zurich, Switzerland. Artists Rights Society (ARS), New York

latex, knotted and tangled, and then hung from wires attached to the ceiling. The resulting linear web extends into new territory the tradition of "drawing in space" practiced by David Smith and others (SEE FIG. 21–18). Much more than a welded sculpture, Hesse's *Rope Piece* resembles a three-dimensional version of a poured painting by Jackson Pollock, and, like Pollock's work, it achieves a sense of structure despite its chaotic appearance. If the Minimal art of Judd and Stella is rigorously shaped by the artist, Hesse allowed the natural force of gravity a much larger role.

Brazilian artists also explored the physical properties of materials, but in ways that brought viewers into the creative process. Lygia Clark (1920-1988) began as an abstract painter, but under the influence of the Madí group (SEE FIG. 21–22), she wondered how she could change the relationship of artist to viewer so that the viewer is not the mere recipient of the artist's invention. She hoped to create work that empowered viewers to cooperate in actually shaping her artworks. In the 1960s she made a series of works called **BICHOS** ("Beasts") from irregular flanges of metal, attached together with hinges in asymmetrical ways (FIG. 21-43). The Bichos have no inside or outside, no upside down or right side up. At first they appear to be endlessly manipulable, but it soon becomes clear that the complex system of hinges that she installed limits the possibilities, as if the Bicho itself has desires that no one foresaw. The construction of the piece combines with gravity and the intent of the viewer to determine its shape. When a spectator asked her once how and in what ways she could move a Bicho, Clark replied, "I don't know, neither do you, but he does."

Arte Povera: Impoverished Art

Many artists in the late 1960s used natural processes in their work in an effort to expand art's vocabulary beyond tradi-

tional materials and reconnect viewers with organic realities. The most cohesive movement in this direction was Arte Povera, formed in Italy in 1967 by several artists who had been reading the American philosopher John Dewey. His 1934 book Art as Experience made several claims that later artists would adapt to their own ends. Dewey's principal insight was that the aesthetic experience of a work of art is not so very different from any experience of any object: Viewers select aspects of an object to look at, and they compare what they see with their own mental directory of experiences formed over their lifetimes. Thus the "aesthetic moment" that artists hope for is built in the viewer's mind by the viewer and not, strictly speaking, by the artist. Moreover, everyone's aesthetic experience will be different because the receiving minds are all different. The Italian artists who read this book (in a 1962 translation by Umberto Eco) wondered if viewers might respond aesthetically to visual stimuli that the artist did not exactly create, but merely set into motion. They were most interested in natural processes because they thought that modern life was becoming too prepackaged and mediated, and they also hoped to rebel against the art market by making items (or starting processes) that would be difficult to buy and sell.

The Greek-born Jannis Kounellis (b. 1933) made this approach gloriously visible in his UNTITLED (12 HORSES) that began this chapter (FIG. 21-1). Viewers to the gallery got a multisensory experience whose "richness" depended in part on how often the horses were washed and the floor was cleaned. Their experience could also include some of the many symbolic meanings that people attach to horses, and the artist need not specify or discourage any of them. The possibilities of such encounters could prove liberating for artist and viewer alike. The term Arte Povera was coined by art critic Germano Celant, who said that these artists are trying to "abolish their function as artists" and "discover the magic and the marvelous in natural elements." Works by Arte Povera artists are "impoverished" in at least two ways: first, the use of natural processes reduces the presence of the artist's ego or personality; second, employing everyday materials removes some of the specialness that artworks have enjoyed for centuries.

Gilberto Zorio (b. 1944) worked a more subtle way when he bought a piece of industrial pipe over nine feet long, sliced it in half, and filled it with cobalt chloride (FIG. 21–44). The compound is highly sensitive to humidity, changing from pink to blue and back again. In a gallery setting, the color changes over the course of a day. In addition, the segment was long enough so that the humidity (and thus the color) might even vary along the length of the pipe. Thus the piece looks different depending on atmospheric conditions, and perhaps it helps make viewers more aware of their sensory surroundings. Other pieces by Zorio involved slowly evaporating salt water during a month-long exhibition; as the pool shrank, a field of crystals grew.

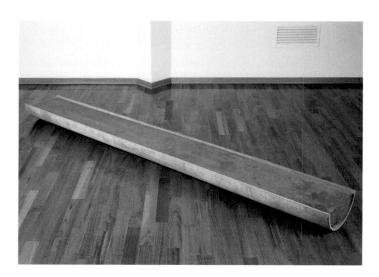

21–44 | Gilberto Zorio PINK-BLUE—PINK 1967. Semicylinder filled with cobalt chloride, $11\% \times 112\% \times 6''$ ($30 \times 285 \times 15$ cm). Galleria Civica d'Arte Moderna e Contemporanea, Torino, Italy.

Purchased by the Fondazione Guido ed Ettore De Fornaris from Pier Luigi Pero, Turin, 1985 / Artists Rights Society (ARS), New York / ADAGP, Paris

Mario Merz (1925–2003) was old enough to have experienced and rejected the expressive tendencies of *Art Informel*. He had participated in several shows as a painter, but his career as an abstract artist ended in 1962 when he bought every tube of paint at his local art store and applied them all to one canvas in a single day. His search for a more organic statement led him to the igloo, one of humanity's most prim-

Sequencing Works of Art		
1962	Arbus, Child with Toy Hand Grenade	
	Kaprow, The Courtyard	
1964	Warhol, Birmingham Race Riot	
	Riley, Current	
1965	Kosuth, One and Three Chairs	
1967	Zorio, Pink-Blue-Pink	
1969	Judd, Untitled	

itive structures. He made simple hemispheric frames out of metal, then covered them with what he called "shapeless" materials that lack substance: soil, glass, blobs of clay, or netting (FIG. 21-45). THE IGLOO symbolizes the human need for shelter and recalls how Eskimos live close to the earth. Merz also generally pierced his pieces with neon, in order, he said, to "energize them." The neon tubes might spell out political slogans of the day, or display simple mathematical facts such as 1 + 1 = 2. By such regressions, he hoped to arrive back at some originating point of thought, a degree zero of aesthetics. The Arte Povera artists were naturally accused of not making art; Merz's reply to this accusation was the most cogent and revealed their broader goal in terms derived from Dewey and Eco: "It is absurd to ask ourselves whether these forms are art or not: What we have to ask ourselves instead is whether they have some organic meaning or not."

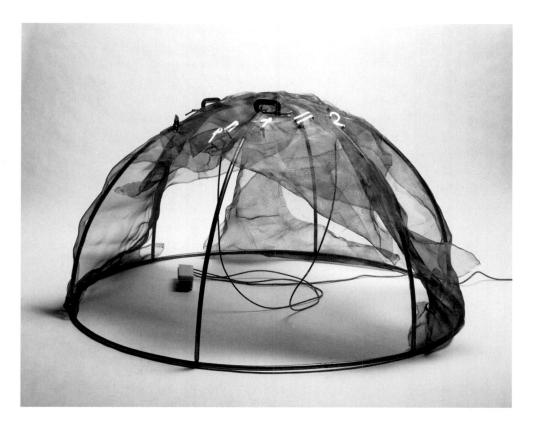

21–45 | Mario Merz IGLOO 1971. Steel tubes, neon tubing, wire mesh, transformer, C-clamps, $39\% \times 78\% \times 78\%$ (100 \times 200 \times 200 cm). Walker Art Center, Minneapolis T. B. Walker Acquisition Fund, 2001. (2001.64.1.19) / Artists Rights Society (ARS), New York

Conceptual and Performance Art

If the Minimalists and Arte Povera artists seemed radical, they were still at least making things: The artists who came to be known as Conceptualists pushed Minimalism to its logical extreme by eliminating the art object itself. Although the Conceptualists always produced something to look at, it was often only a printed statement, a set of directions, or a documentary photograph. The ultimate root of Conceptual art is Marcel Duchamp and his assertion that making art should be a mental, not a physical, activity. That is, every art object begins as an idea; carrying out the idea is a perfunctory affair. Conceptual art is based on the premise that if the idea is good, the art piece will also be good. This standard could apply to a great deal of art. For example, Michelangelo's work on the Sistine ceiling was very creative in envisioning the relationship between God and people in a new way. The idea of God reaching out to Adam was the masterpiece, and all he had to do was paint his idea. Many artists had a similar skill level at that time, but no one thought as creatively as Michelangelo did. By that reasoning, Michelangelo is a good Conceptual artist. In the 1960s, the Conceptual artist's quest was to do away with the valuable art object (to "dematerialize" it) while still exposing the artist's thought.

Deemphasizing the art object kept art from becoming simply another luxury item, a concern raised by the booming market for contemporary art that arose during the 1960s. Some artists did not want to make works that would sell in elite galleries and then decorate the homes of the wealthy. Others noticed that the governing boards of many museums consisted of corporate executives from companies that practiced discrimination or earned their money from warfare or exploiting natural resources. Artist groups picketed and protested outside most major museums in the late 1960s at one time or another. Making art that avoided the system became a priority for many.

The most prominent American Conceptual artist, Joseph Kosuth (b. 1945), abandoned painting in 1965 and began to work with language, under the influence of Duchamp and the linguistic philosopher Ludwig Wittgenstein (1889–1951). Kosuth believed that the use of language would direct art away from aesthetic concerns and toward philosophical speculation. His **ONE AND THREE CHAIRS** (FIG. 21–46) invites such speculation by presenting an actual chair, a full–scale black–and–white photograph of the same chair, and a dictionary definition of the word *chair*. The work thus leads the viewer from the physical chair to the purely linguistic ideal of "chairness" and invites the question of which is the most "real."

Many Conceptual artists used their bodies as an artistic medium and engaged in simple activities or performances that they considered works of art. Use of the body offered another alternative to object-oriented mediums like painting and sculpture, and it produced no salable artwork unless the artist's activity was recorded on film or video. One artist who

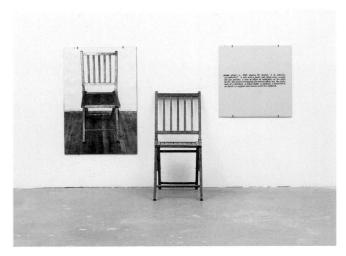

21–46 | Joseph Kosuth ONE AND THREE CHAIRS 1965. Wood folding chair, photograph of chair, and photographic enlargement of dictionary definition of chair; chair, $32\frac{1}{8} \times 14\frac{1}{8} \times 20\frac{1}{8}$ " (82.2 × 37.8 × 53 cm); photo panel, $36 \times 24\frac{1}{8}$ " (91.4 × 61.3 cm); text panel $24\frac{1}{8} \times 24\frac{1}{2}$ " (61.3 × 62.2 cm). The Museum of Modern Art, New York. Larry Aldrich Foundation Fund (383.1970 a-c)

used his body as an artistic medium in the late 1960s was the California-based Bruce Nauman (b. 1941). In 1966-67 he made a series of eleven color photographs based on wordplay and visual puns. In **SELF-PORTRAIT AS A FOUNTAIN** (FIG. 21–47), for example, the bare-chested artist tips his head back, spurts water into the air, and, in the spirit of Duchamp, designates himself a work of art. He is even a *Fountain*, naming himself after Duchamp's famous urinal.

Some of the most radical Conceptual and Performance art came out of Europe. As far back as 1960, Yves Klein helped initiate Performance art in his *Anthropometries of the Blue Period* (SEE FIG. 21–30). In the same year, Klein staged a more Conceptual show by leaving the gallery completely empty. He called this exhibition *The Void*, and art collectors could buy portions of the emptiness, parceled out in square meters. They had to pay with gold dust, which the artist threw into the Seine River. (There were several takers.)

Similarly subversive was the German artist Joseph Beuys, whose Performances had a ritualistic aspect and, often, a political message as well. Beuys met Happening artist Allan Kaprow in 1963 (SEE FIG. 21–29) and later testified to the importance of the encounter. Like a Happening, a Performance work is an event rather than an object, but Performance artists usually enact their pieces all alone. In 1965 Beuys swathed his head in honey and gold leaf, handicapped himself by attaching a large metal flange to one shoe, and hobbled around a gallery cradling a dead rabbit in his arms (FIG. 21–48). He stopped in front of each work in the gallery

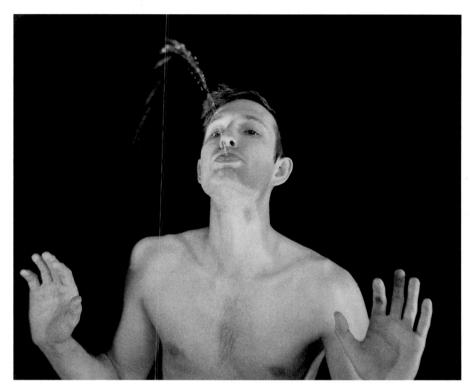

2I–47 | Bruce Nauman SELF-PORTRAIT AS A FOUNTAIN 1966–67. Color photograph, $19\frac{1}{4} \times 23\frac{1}{4}$ " (50.1 \times 60.3 cm). Courtesy Leo Castelli Gallery, New York

Regarding his works of the later 1960s, Nauman observed, "I was using my body as a piece of material and manipulating it. I think of it as going into the studio and being involved in some activity. Sometimes it works cut that the activity involves making something, and sometimes the activity itself is the piece."

and whispered to the animal the meaning of each, then touched its lifeless paw to the glass-coated surface. His radiant head was intended to make him seem a magical figure or a wizard, while the metal flange made him frail at the same time. HOW TO EXPLAIN PICTURES TO A DEAD HARE targets endless attempts to explain art (including perhaps this book!). Beuys said, "Even a dead animal preserves more powers of intuition than some human beings." Beuys's later work was more political: Invited to show at the prestigious Documenta show of European contemporary art in 1972, he set up a table and passed out literature from a political party that he founded, the Organization for Direct Democracy Through Referendum. He was fired from his teaching position at the Düsseldorf Academy that year for admitting 172 students to his classes, because, he said, everyone is an artist. One of his 1976 performances was to run for the German Senate (he lost). His expression of mythic meanings combined with political activism made him hugely influential on later European art.

Earthworks and Site-Specific Sculpture

Conceptual and Performance artists seemed to take art to its limits, but most of their events happened in a gallery or

21–49 | Michael Heizer **DOUBLE NEGATIVE** 1969–70. 240,000-ton displacement at Mormon Mesa, Overton, Nevada. $1,500 \times 50 \times 30'$ (457.2 \times 15.2 \times 9.1 m). Museum of Contemporary Art, Los Angeles. Gift of Virginia Dwan. Photograph courtesy the artist

museum. Some artists in the early 1970s wondered if art could do without those traditional settings entirely. Certainly art has been made in public places before, in ways that cannot be bought or sold, such as Mexican murals (SEE FIG. 20–66). But perhaps an artist could take the earth itself as a medium, and

shape a site or do something on it. Acting partly on the political impulse of getting away from the art market and partly on the Modern impulse to throw out conventions, a number of sculptors began to work outdoors, using raw materials found at the site to fashion **Earthworks**. They also pioneered a new category of art making called **site-specific sculpture**, which is designed for a particular location, often outdoors.

LARGE-SCALE EARTHWORKS. One of the leaders of the Earthworks movement was Michael Heizer (b. 1944), the California-born son of a specialist in Native American archaeology. Heizer moved to New York in 1966 but, disgusted by the growing emphasis on art as an investment, began to spend time in the Nevada desert and to create works there that could not easily be bought and sold and that required a considerable commitment of time from viewers. There, in 1969-70, Heizer hired bulldozers to produce his most famous work, **DOUBLE NEGATIVE** (FIG. 21-49). Using a simple Minimalist formal vocabulary, he made two gigantic cuts on opposite sides of a canyon wall at a remote location. To fully experience the work, the viewer needs to travel to Overton, Nevada, to walk into the 50-foot-deep channels and experience their huge scale, and to fly overhead to see the work from above.

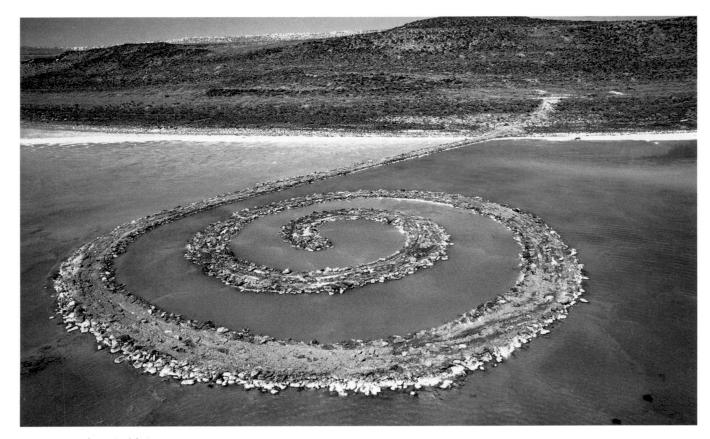

2I-50 | Robert Smithson SPIRAL JETTY
1969-70. Black rock, salt crystal, and earth spiral, length 1,500′ (457 m). Great Salt Lake, Utah.
Courtesy James Cohan Gallery, New York Art © Estate of Robert Smithson/Licensed by VAGA, New York, NY

More symbolic in intention was the work of another major Earthworks artist, Robert Smithson (1938-73), a New Jersey native who first traveled to the Nevada desert with Heizer in 1968. In his mature work, Smithson sought to illustrate the "ongoing dialectic" in nature between constructive forces—those that build and shape form—and destructive forces—those that destroy it. SPIRAL JETTY (FIG. 21-50), a 1,500-foot spiraling stone and earth platform extending into the Great Salt Lake in Utah, expresses these ideas. Smithson chose the lake because it recalls both the origins of life in the salty waters of the primordial ocean and also the end of life. One of the few organisms that live in the otherwise dead lake is an alga that sometimes gives it a red tinge, suggestive of blood. Smithson also liked the way the abandoned oil rigs that dot the lake's shores suggested both prehistoric dinosaurs and some vanished civilization. He used the spiral because it is the most fundamental shape in nature, appearing, for example, in galaxies, seashells, DNA molecules, and even salt crystals. Smithson also chose the spiral because, unlike Modernist squares, circles, and straight lines, it is a "dialectical" shape, one that opens and closes, curls and uncurls endlessly. It is an organic shape that also appears in rock art by various ancient peoples, where it transmits symbolic meanings unknown to us. More than any other shape, it suggested to him the perpetual coming and going of things. To allow the "ongoing dialectic" of construction and destruction to proceed, Smithson ordered that no maintenance be done on the work. Since he created it, the surrounding lake water has turned red and back to blue, risen up to drown the work, and revealed it again, covered with salt.

IMPERMANENT SITES. Strongly committed to the realization of temporary, site-specific artworks in both rural and urban settings are Christo and Jeanne-Claude, both born on June 13, 1935. Christo Javacheff (who uses only his first name) emigrated from his native Bulgaria to Paris in 1958, where he met Jeanne-Claude de Guillebon. His interest in "wrapping" (or otherwise defining) places or things in swaths of fabric soon became an obsession, and he began wrapping progressively larger items. Their first collaborative work, in 1961, was Stacked Oil Barrels and Dockside Packages at the port of Cologne, Germany. The pair moved to New York City in 1964. Four years later, Christo and Jeanne-Claude wrapped the Kunsthalle museum in Bern, Switzerland, and the following year they wrapped 1 million square feet of the Australian coastline. The artists pay all their own expenses, never accepting sponsors but rather raising funds through the sale of preparatory drawings of the intended project.

Their best-known work, **RUNNING FENCE** (FIG. 21–51), was a 24½-mile-long, 18-foot-high nylon fence that crossed two counties in northern California and extended into the Pacific Ocean. The artists chose the location in Sonoma and Marin counties for aesthetic reasons, as well as to call atten-

21-51 | Christo and Jeanne-Claude RUNNING FENCE 1972-76. Nylon fence, height 18' (5.50 m), length 24½ miles (40 km). Sonoma and Marin counties, California.

tion to the link between urban, suburban, and rural spaces. This concern with aesthetics is common to all their work, in which they reveal the beauty in various spaces. At the same time, the conflict and collaboration between the artists and various social groups open the workings of the political system to scrutiny and invest their work with a sense of social space. For example, Christo and Jeanne-Claude spent fortytwo months overcoming the resistance of county commissioners, half of whom were in favor of the project from the outset, as well as social and environmental organizations, before they could create Running Fence. Meanwhile, the project forged a community of supporters drawn from groups as diverse as college students, ranchers, lawyers, and artists. In a way, the fence broke down the social barriers among those people. The work remained in place for two weeks and then was taken down. Property owners whose land the work traversed could keep the materials.

Feminist Art

Feminist art emerged in the context of the Women's Liberation movement of the late 1960s and early 1970s, and it challenged one of the major unspoken conventions of the history of Western art including Modern art: the dominance of men. A major aim of feminist artists and their allies was increased recognition for the accomplishment of women artists, both past and present. As feminists examined the history of art, they found that women had contributed to most of the movements of Western art but were almost never mentioned in histories of art. Feminists also attacked the traditional Western hierarchy that placed "the arts" (painting, sculpture, architecture) at a level of achievement higher than "the crafts" (ceramics, textiles, jewelry-making). Since most craft media have been historically dominated by women, favoring art

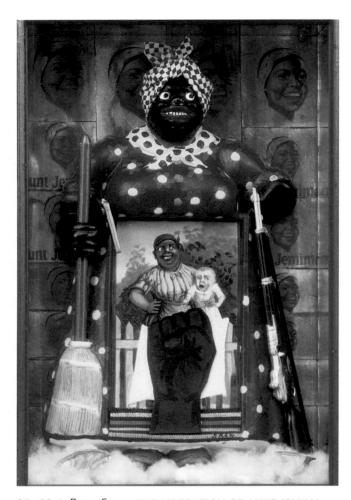

2I–52 Betye Saar THE LIBERATION OF AUNT JEMIMA 1972. Mixed media, $11\frac{1}{4} \times 11\frac{1}{8} \times 2\frac{1}{4}$ " (29.8 \times 30.3 \times 7), Berkeley Art Museum, University of California. Purchased with the aid of funds from the National Endowment for the Arts (selected by The Committee for the Acquisition of Afro-American Art)

over craft tends to relegate women's achievements to secondclass status. Thus early feminist art tended to elevate craft media.

Women artists faced considerable discrimination at that time (and they still do). A 1970 survey revealed that although women constituted half of the nation's practicing artists, only 18 percent of commercial New York galleries carried works by women. Of the 143 artists in the 1969 Whitney Annual (now the Whitney Biennial), one of the country's most prominent exhibitions of the work of living artists, only eight were women. The next year, the newly formed Ad Hoc Committee of Women Artists, disappointed by the lukewarm response of the Whitney's director to their concerns, staged a protest at the opening of the 1970 Annual. To focus more attention on women in the arts, feminist artists began organizing women's cooperative galleries.

ATTACKING STEREOTYPES. As feminist art critics scanned the horizon for contemporary women who were creating with insufficient recognition, they found a wealth of neg-

lected talent, such as the Los Angeles-based African American sculptor Betye Saar (b. 1926). She had been making assemblages for years that showed a political militancy rare in postwar American art. Several of her works in this medium reflect both feminist interests and the aims of the civil rights movement. Saar's best-known work, THE LIBERATION OF AUNT JEMIMA (FIG. 21-52), appropriates (borrows for Saar's own purposes) the derogatory stereotype of the cheerfully servile "mammy" and transforms it into an icon of militant black feminist power. Set against a background papered with the smiling advertising image of Aunt Jemima stands a note pad holder in the form of an Aunt Jemima. She holds a broom (whose handle is actually the pencil for the note pad) and pistol in one hand and a rifle in the other. In the place of the note pad is a picture of another jolly mammy holding a crying child identified by the artist as a mulatto, or person of mixed black and white ancestry. In front of this pair is a large clenched fist—a symbol of Black Power signaling African Americans' willingness to use force to achieve their aims. Saar's armed Jemima liberates herself not only from racial oppression but also from traditional gender roles that had long relegated black women to such subservient positions as domestic servant or mammy.

COLLABORATION. A younger artist who assumed a leading role in the feminist movement of the 1970s was Judy Chicago (b. 1939), whose The Dinner Party is perhaps the best-known work of feminist art created in that decade (see "The Dinner Party," page 906). Born Judy Cohen, she became Judy Gerowitz after her marriage and then in 1970 adopted the surname Chicago (from the city of her birth) to free herself from "all names imposed upon her through male social dominance." Originally a Minimalist sculptor, Chicago in the late 1960s began to make abstracted images of female genitalia designed to challenge the aesthetic standards of the male-dominated art world and to validate female experience. In 1970 she established the first feminist studio art course at Fresno State College (now California State University, Fresno). The next year, she moved to Los Angeles and joined with the painter Miriam Schapiro (b. 1923) to establish at the new California Institute of the Arts (CalArts) the Feminist Art Program, dedicated to training women artists.

During the first year of the program, Chicago and Schapiro led a team of twenty-one female students in the creation of *Womanhouse* (1971–72), a collaborative art environment set in a run-down Hollywood mansion, which the artists renovated and filled with installations that addressed women's issues. Schapiro's work for *Womanhouse*, created in collaboration with Sherry Brody, was *The Dollhouse*, a mixed-media construction featuring several miniature rooms adorned with richly patterned fabrics. Schapiro soon began to incorporate pieces of fabric into her acrylic paintings,

developing a type of work she called femmage (from female and collage). Schapiro's femmages, such as the exuberant PERSONAL APPEARANCE #3 (FIG. 21–53), celebrate traditional women's craftwork. After returning to New York from California in 1975, Schapiro became a leading figure in the Pattern and Decoration movement. Composed of both female and male artists, this movement sought to merge Modernist abstraction with ornamental motifs derived from women's craft, folk art, and a variety of non-Western sources in order to break down hierarchical distinctions among them.

RINGGOLD'S STORY QUILTS. African American artist Faith Ringgold (b. 1930) drew on the traditional American craft of quilt making and combined it with the rich heritage of African textiles to create memorable statements about American race relations. She began in the early 1970s to paint on soft fabrics rather than stretched canvases, and to frame her images with decorative quilted borders. Ringgold's mother, Willi Posey, a fashion designer and dressmaker, made these guilted borders until her death in 1981, after which Ringgold took responsibility for both the quilting and the painting. In 1977 Ringgold began writing her autobiography (We Flew Over the Bridge: The Memoirs of Faith Ringgold, 1995). Not immediately finding a publisher, she decided to write her stories on her quilts, and in the early 1980s inaugurated what became her signature medium: the story quilt.

Animated by a powerful feminist sensibility, Ringgold's story quilts are always narrated by women and usually address themes related to women's lives. A splendid example is TAR BEACH (FIG. 21-54), whose fictional narrator, 8year-old Cassie Louise Lightfoot, is based on the artist's childhood memories of growing up in Harlem. The "Tar Beach" of the title is the roof of the apartment building on which Ringgold's family, lacking air conditioning, would sleep on hot summer nights. Cassie describes sleeping on Tar Beach as a magical experience. As she lies on a blanket with her brother, she dreams that she can fly and possess everything over which she passes. Cassie can fly over the George Washington Bridge and make it hers; she can fly over the new union building and claim it for her father—a half-black, half-Native American man who helps construct skyscrapers but is prevented by his race from joining the union; she can fly over an ice cream factory to guarantee her mother "ice cream every night for dessert." Ringgold's colorful painting in the center of the quilt shows Cassie and her brother lying on a blanket at the lower right while their parents and two neighbors play cards at a table at center. Directly above the adults appears a second Cassie, magically flying over the George Washington Bridge against a star-dotted sky. Cassie's fantasy of achieving the impossible is charming but also delivers a serious message by remind-

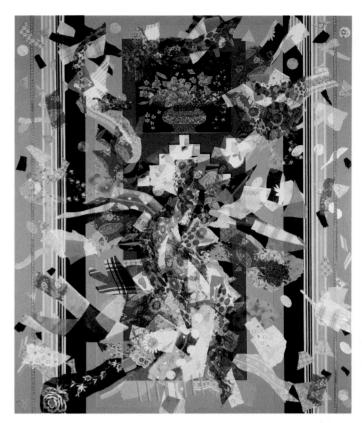

21–53 | Miriam Schapiro PERSONAL APPEARANCE #3 1973. Acrylic and fabric on canvas, $60 \times 50''$ (152.4 \times 127 cm). Private collection.

Schapiro championed the theory that women have a distinct artistic sensibility that can be distinguished from that of men and hence a specifically feminine aesthetic. During the late 1950s and 1960s she made explicitly female versions of the dominant Modernist styles, including reductive, hard-edged abstractions of the female form: large X-shapes with openings at their centers. In 1973 she created *Personal Appearance #3*, using underlying hard-edge rectangles and overlaying them with a collage of fabric and paper—materials associated with women's craftwork—the formal and emotional richness of which were meant to counter the Minimalist aesthetic of the 1960s, which Schapiro and other feminists considered typically male.

ing the viewer of the real social and economic limitations that African Americans have faced throughout American history.

IDENTIFICATION WITH NATURE. Many feminists, including Cuban-born Ana Mendieta (1948–85), celebrated the notion that women have a deeper identification with nature than do men. By 1972, Mendieta had rejected painting for Performance and body art. Influenced by Joseph Beuys but inspired by *santería*, the Afro-Cuban religion that Wifredo Lam had dealt with earlier (SEE FIG. 21–7), she produced ritualistic performances on film, as well as about 200 earth-and-body works, called *Silhouettes*, which she recorded in color photographs. Some were done in Mexico, and others, like the **TREE** OF LIFE series (FIG. 21–55), were set in Iowa, where she lived

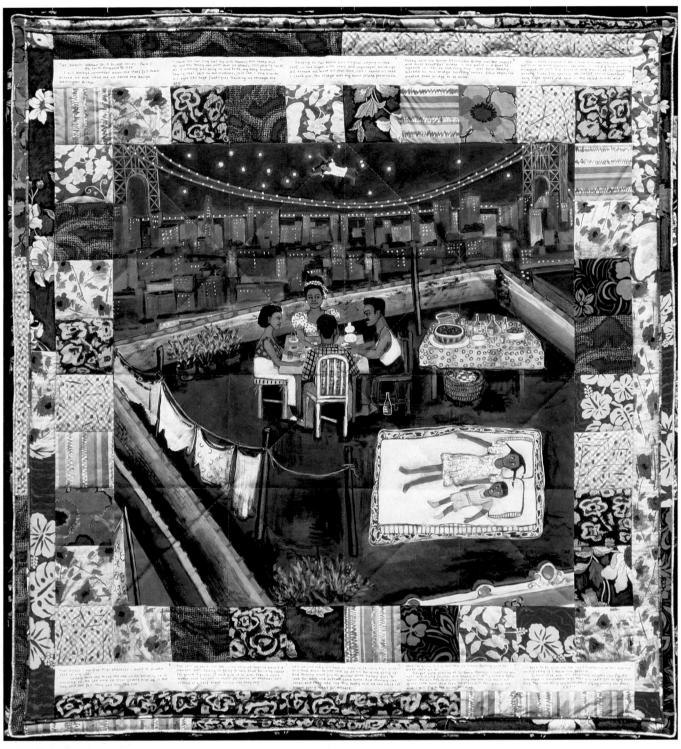

21–54 Faith Ringgold TAR BEACH (PART I FROM THE WOMAN ON A BRIDGE SERIES) 1988. Acrylic on canvas, bordered with printed, painted, quilted, and pieced cloth, $74\% \times 68\%$ (190.5 \times 174 cm). Guggenheim Museum, New York. Gift, Mr. and Mrs. Gus and Judith Lieber, 1988 (88.362)

after completing graduate study. In this work, Mendieta stands covered with mud, her arms upraised like a prehistoric goddess, appearing at one with nature, her "maternal source." Reconnecting with the maternal source in this and other works was a compensation for a major disruption of her childhood: Along with 14,000 other unaccompanied chil-

dren, Mendieta was sent away from her native country by her parents in 1961 as part of Operation Peter Pan, a cold war mission to rescue Cuban children from communism after the 1959 revolution. The feeling of personal dislocation that this caused would always haunt her art, leading her to imprint her body by various means in several locations.

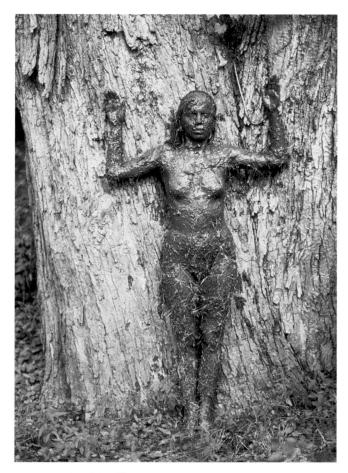

21–55 | Ana Mendieta UNTITLED WORK FROM THE TREE OF LIFE SERIES 1977. Color photograph, $20 \times 13 \,\%$ (50.8 \times 33.7 cm). Courtesy of Galerie Lelong, New York and the Estate of Ana Mendieta

ARCHITECTURE: FROM MODERN TO POSTMODERN

As in painting and sculpture, Modernism endured in architecture until the 1970s. The International Style, with its plainly visible structure and rejection of historicism, dominated new urban construction in much of the world after World War II. Several important International Style architects, such as Walter Gropius (SEE FIG. 20–65), migrated to the United States and assumed important positions in architecture schools where they trained a generation of like-minded designers.

Midcentury Modernist Architecture

The best examples of postwar International Style buildings were designed by Ludwig Mies van der Rohe (1886–1969), a former Bauhaus staff member and refugee from Nazi Germany (see Chapter 20). Whether designing schools, houses, or office buildings, Mies used the same simple, rectilinear vocabulary that for many came to personify the modern, efficient culture of postwar capitalism. The differences among his

buildings are to be found in their details. Because he had a large budget for the **SEAGRAM BUILDING** in New York City (FIG. 21–56), for instance, he used custom-made bronze (instead of standardized steel) beams on the exterior, an example of his love of elegant materials. Mies would have preferred to leave the internal steel structural supports visible, but building codes required him to encase them in concrete. The ornamental beams on the outside thus stand in for the functional beams inside, much as the shapes on the surface of a Stella painting refer to the structural frame that holds the canvas (SEE FIG. 21–40).

The dark glass and bronze were meant to give the Seagram Company a discreet and dignified image. The building's clean lines and crisp design seemed to epitomize the efficiency, standardization, and impersonality that had become synonymous with the modern corporation itself—which, in part, is why this particular style dominated corporate architecture after World War II. Such buildings were also economical to build. Mies believed that the industrial preoccupation with streamlined efficiency was the dominant value of the day and that the only legitimate architecture was one that expressed this modern spirit. Criticized for building glass boxes, Mies pointed out the subtle mathematical relations that exist between the various rectangles on his buildings, and retorted, "Less is more."

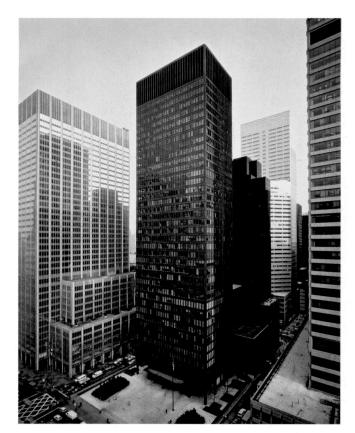

21–56 Ludwig Mies van der Rohe and Philip Johnson SEAGRAM BUILDING
New York. 1954–58.

THE OBJECT SPEAKS

THE DINNER PARTY

complex, mixed-medium installation that fills an entire room, Judy Chicago's THE DINNER PARTY takes advantage of feminist art research and speaks powerfully of the accomplishments of women throughout history. Five years of collaborative effort went into the creation of the work, involving hundreds of women and several men who volunteered their talents as ceramists, needleworkers, and china painters to realize Chicago's designs. The Dinner Party is composed of a large, triangular table, each side stretching 48 feet, which rests on a triangular platform covered with 2,300 triangular porcelain tiles. Chicago saw the equilateral triangle as a symbol of the equalized world sought by feminism, and she also identified it as one of the earliest symbols of the feminine. The porcelain "Heritage Floor" bears the names of 999 notable women from myth, legend, and history. Along each side of the triangular table, thirteen place settings each represent a famous woman. Chicago chose the number thirteen because it is the number of men who were present at the Last Supper

and also the number of witches in a coven, and therefore a symbol of occult female power. The thirty-nine women honored through the place settings include mythical ancient goddesses such as Ishtar, legendary figures such as the Amazon, and historical personages such as the Egyptian queen Hatshepsut, the Roman scholar Hypatia, the medieval French queen Eleanor of Aquitaine, the medieval French author Christine de Pisan (SEE FIG. 21, Introduction), the Italian Renaissance noblewoman Isabella d'Este (see page 558), the Italian Baroque painter Artemesia Gentileschi (SEE FIG. 17-19), the eighteenth-century English feminist writer Mary Wollstonecraft (shown here), the nineteenth-century American abolitionist Sojourner Truth, and the twentieth-century American painter Georgia O'Keeffe (SEE FIG. 20-42).

Each place setting features a 14-inchwide painted porcelain plate, ceramic flatware, a ceramic chalice with a gold interior, and an embroidered napkin, all set upon an elaborately decorated runner. The runners incorporate decorative motifs and techniques of stitching and weaving appropriate to the period with which each woman was associated. Most of the plates feature abstract designs based on female genitalia because, Chicago said, "that is all [the women at the table] had in common. . . . They were from different periods, classes, ethnicities, geographies, experiences, but what kept them within the same confined historical space" was the fact of their biological sex. Chicago thought it appropriate to represent the women through plates because they "had been swallowed up and obscured by history instead of being recognized and honored."

Chicago emphasized china painting and needlework in *The Dinner Party* to celebrate craft mediums traditionally practiced by women and to argue that they should be considered "high" art forms on a par with painting and sculpture. This argument complemented her larger aim of raising awareness of the many contributions women have made to history, thereby fostering women's empowerment in the present.

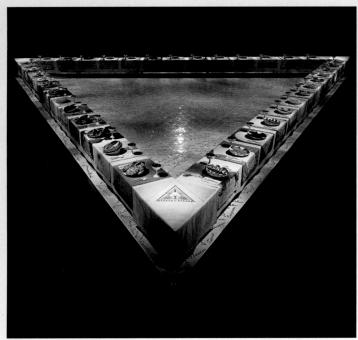

Judy Chicago **THE DINNER PARTY** 1974–79. Overall installation view. White tile floor inscribed in gold with 999 women's names; triangular table with painted porcelain, sculpted porcelain plates, and needlework, each side $48 \times 42 \times 3'$ ($14.6 \times 12.8 \times 1$ m). The Brooklyn Museum of Art. Gift of the Elizabeth A. Sackler Foundation (2002.10)

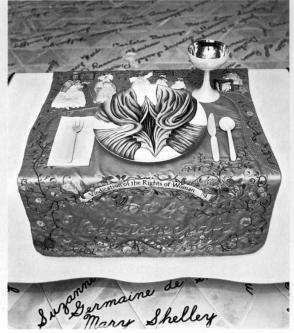

MARY WOLLSTONECRAFT
Place setting, detail of The Dinner Party

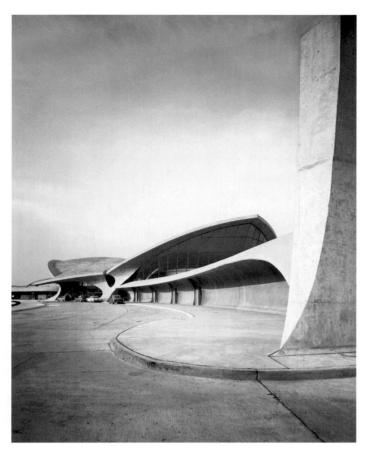

21–57 | Eero Saarinen TRANS WORLD AIRLINES TERMINAL, JOHN F. KENNEDY AIRPORT New York. 1956–62

In 2003 the National Trust for Historic Preservation added the TWA Terminal to its list of America's Eleven Most Endangered Historic Places due to plans by the building's owners, the Port Authority of New York and New Jersey, to demolish portions of the terminal and construct a large new terminal behind it, violating the integrity of Saarinen's design and rendering it useless as an aviation structure.

While Mies's pared-down, rectilinear idiom dominated skyscraper architecture into the 1970s, other building types invited more adventuresome Modernist designs that departed from the rational and impersonal principles of the International Style. A trend toward powerfully expressive, organic forms characterized the architecture of numerous buildings dedicated to religious or cultural functions. Such buildings remained Modernist in their unabashed use of massproduced materials and lack of historical references, but they showed a new exuberance in design. Expressive designs sometimes appeared also in commercial architecture, as in the remarkable TRANS WORLD AIRLINES (TWA) TERMINAL at John F. Kennedy Airport in New York City, by the Finnish-born American architect Eero Saarinen (1910-61). Seeking to evoke the excitement of air travel, Saarinen gave his building dynamically flowing interior spaces and covered it with two broad, winglike canopies of reinforced concrete that suggest a huge bird about to take flight (FIG. 21-57). Saarinen also designed all of the building's interior details-from ticket counters to telephone booths—to complement the gullwinged shell.

Modern architects of the post–World War II decades also sought fresh solutions to the persistent challenge of urban housing, which had engaged pioneers of the International Style such as Le Corbusier. The desire for economy led to an interest in the use of standard, prefabricated elements for the construction of both individual houses and larger residential complexes. An innovative example of the latter is HABITAT '67 (FIG. 21–58) by the Israeli-born Moshe Safdie (b. 1938). Built as a permanent exhibit for the 1967 World Exposition in Montreal, the complex consists of three stepped clusters of prefabricated concrete units attached to a zigzagging concrete frame that provides a series of elevated streets and shel-

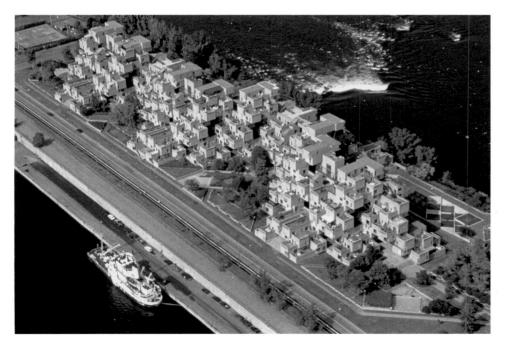

21–58 Moshe Safdie

HABITAT '67

Montreal, Quebec, Canada. 1967

World Exposition.

Growing up in Israel, Safdie spent his summers on a kibbutz, or collective farm. This experience partly inspired his plans for Habitat, which adapts aspects of traditional communal living to the social, economic, and technological realities of industrial society.

tered courtyards. By stacking units that contained their own support system, Safdie eliminated the need for an external skeletal frame and allowed for expansion of the complex simply through the addition of more units. An inspired alternative to the conventional high-rise apartment block, Habitat '67 offers greater visual and spatial variety, increased light and air to individual apartments, and a sense of community not often found in a big city housing project.

Postmodern Architecture

Historians trace the origin of Postmodernism in architecture to the work of the Philadelphian Robert Venturi (b. 1925) and his associates, who rejected the abstract purity of the International Style by incorporating into their designs elements drawn from vernacular (meaning popular, common, or ordinary) sources. Parodying Mies van der Rohe's famous aphorism "Less is more," Venturi claimed "Less is a bore" in his pioneering 1966 book Complexity and Contradiction in Architecture. The problem with Mies and the other Modernists, he argued, was their impractical unwillingness to accept the modern city for what it is: a complex, contradictory, and heterogeneous collection of "high" and "low" architectural forms. Acting on these impulses, Venturi engaged in practices that Modernists thought heretical: He layered his buildings with references to past styles and at times even applied decoration to them. Such moves were controversial at first, but they pointed a way to innovation that many would follow.

While writing Complexity and Contradiction in Architecture, Venturi designed a house for his mother (FIG. 21–59) that illustrated many of his new ideas. The building is both simple and complex. The shape of the façade returns to the archetypal "house" shape—evident in children's drawings—that Modernists from Rietveld (SEE FIG. 20–61) to Safdie had rejected because of its historical associations. Its vocabulary of triangles, squares, and circles is also elementary, although the shapes are arranged in a complex asym-

metry that skews the restful harmonies of Modernist design. The round molding over the door has no structural function, and is thus—gasp!—a decoration. The most disruptive element of the façade is the deep cleavage over the door, which opens to reveal a mysterious upper wall (which turns out to be a penthouse) and chimney top. On the inside, too, complexity and contradiction reign. The irregular floor plan (FIG. 21–60), especially evident in the odd stairway leading to the second floor, is further complicated by the unusual ceilings, some of which are partially covered by a barrel vault.

The Vanna Venturi House makes reference to a number of older buildings, from Michelangelo's Porta Pia in Rome to a nearby house designed by Venturi's mentor, Louis Kahn (1901-74). Although such allusions to architectural history were lost on the general public, they provided many architects, including Philip Johnson (1906-2005), with a path out of Modernism. Johnson's major contribution to Postmodernism is the AT&T CORPORATE HEADQUARTERS (now the Sony Building) in New York City (FIG. 21-61), an elegant, granite-clad skyscraper whose thirty-six oversized floors reach the height of an ordinary sixty-story building. The skyscraper makes gestures of accommodation to its surroundings: Its smooth, uncluttered surfaces match those of its International Style neighbors, while the classically symmetrical window groupings between vertical piers echo those in more conservative Manhattan skyscrapers built in the early to mid-1900s. What critics focused on, however, was the building's resemblance to a type of eighteenth-century furniture: the Chippendale highboy, a chest of drawers with a long-legged base. Johrson seems to have intended a pun on the terms highboy and high-rise. In addition, the round notch at the top of the building and the arched entryway at the base recall the coin slot and coin return of old pay telephones. Many critics were not amused by Johnson's effort to add a touch of humor to high architecture. His purpose, however, was less to poke fun at his client or his profession than to create an architecture that would appeal to the public and at the same time, like a fine piece of furniture, meet its deeper aesthetic needs with a formal, decorative elegance.

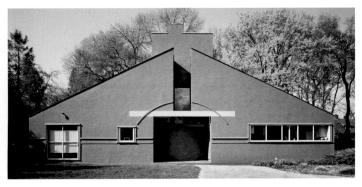

21–59 | Robert Venturi VANNA VENTURI HOUSE Chestnut Hill, Pennsylvania. 1961–64.

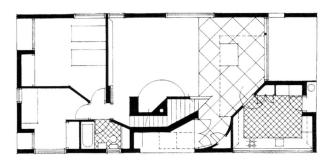

21–60 | GROUND-FLOOR PLAN OF THE VANNA VENTURI HOUSE

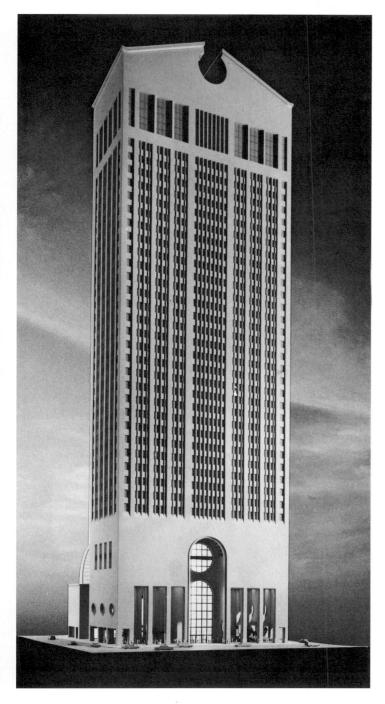

21–61 | Philip Johnson and John Burgee MODEL, AT&T CORPORATE HEADQUARTERS New York, 1978–83.

After collaborating on the Seagram Building (SEE FIG. 21–56) with Mies, who had long been his architectural idol, Johnson grew tired of the limited Modernist vocabulary. During the 1960s he experimented with a number of alternatives, especially a weighty, monumental style that looked back to nineteenth-century Neoclassicism. At the end of the 1970s he became fascinated with the new possibilities opened by Venturi's Postmodernism, which he found "absolutely delightful."

POSTMODERN ART

Observers disagree about the exact date, but most agree that sometime during the 1970s, the impulses that created Modern art exhausted themselves. If we think back to the key concepts that defined Modern art (see p. 776), we will see that they had evolved out of existence by the late 1970s. Moreover, the underlying social environment had evolved as well.

The quest to set aside conventions died a natural death when it seemed that all the rules had been broken. The radicalism of some Conceptual and site-specific works of the 1970s seemed to signal the end of an era. For example, an artist once announced a site-specific piece for a public park and unleashed tanks of colorless and odorless gases there; his piece was completely invisible. Another declared Lake Tahoe a work of art. Yet a third declared his own body a work of art and willed it to the Museum of Modern Art when he passes away (he is still alive). The Modernist questioning of conventions reached a point in the 1970s when there were no more conventions to question.

Likewise, the avant-garde has lost its distinctiveness as a source of innovation. In the past, it was a small group that cared about the innovations of a few artists, and it served as a support group for Modern artists such as Monet, Gauguin, Picasso, and Mondrian. As late as the 1950s, this group was still functioning much as it had in the 1880s. Helen Frankenthaler, in the same interview quoted earlier, described the scene in her day: "When we were all showing at Tibor de Nagy [Gallery] in the early fifties, none of us expected to sell pictures. A few people knew your work. There was a handful of people you could talk to in your studio, a small orbit." With the advent of Pop Art in the 1960s, the avant-garde came much more into the public eye. Andy Warhol was a celebrity (and he loved being one). Magazine coverage of contemporary art proliferated. Art schools began teaching Modern techniques instead of traditional ones. The spread of higher education (and the proliferation of art history courses) made the public for contemporary art much larger. All of these factors mean that innovation in the arts is not now confined to a small, select group; rather, a creative idea can now spring up almost anywhere.

Underlying the decline of the avant-garde is a larger social change: Just as Modern art arrived with the transition to an industrial society, Postmodern art is heralded by postindustrial society. Advanced capitalist societies today are based on information and services rather than industry, and these demand a relatively educated population that is flexible and tolerant. The values of Modern art (innovation, questioning of tradition, individual expression) have permeated this society. Most of us embrace the constant changes of our world. The media encourage this by treating each new consumer product as a revolution and rule-breaking as the norm. A telling moment came when a national chain of hamburger

stands adopted this slogan in the 1990s: "Sometimes you just gotta break the rules." In addition, Modern art itself is no longer controversial. The former rebels Gauguin, van Gogh, and Picasso are now the most expensive artists at auction. While the public still resists obscenity in art, most people tolerate what artists do, even when they do not understand it. Postmodern society has made the avant-garde a spent force by absorbing many of its values.

If the dominant tendency of Modern art was the questioning and rejection of tradition, finding a similar unifying concept for Postmodern art is difficult. In that sense, Postmodern art reflects our pluralistic and globalized society, in which innovation can happen anyplace. Since the demise of Modernism, the art world seems to be characterized much more by pluralism, in which a number of styles and trends coexist simultaneously. Postmodern artists generally avoid the Modernist goals of researching the qualities of their media or exploring aesthetic issues; first and foremost, they use art to comment on their world. Likewise, if Modern art was characterized by constant creation of new styles, Postmodern artists tend to revive previous styles and media, because they have discovered that referring to past art in a knowing fashion can add meaning to an artistic statement. Indeed, quotation of the past not only characterizes much Postmodern art and architecture; many of today's cultural products, such as movies, advertisements, and even political campaigns, make reference to past versions or even re-create them. We live in the age of the sequel, the knock-off, and the recycled character. In that sense, Andy Warhol's original insight ("I don't know where the artificial stops and the real starts") has become even more cogent. Though the definition of Postmodernism is still in dispute, we can point to a few trends that have motivated artists in this new period.

The Critique of Originality

Some of the first art to be called Postmodern questioned one of Modernism's basic notions, that an individual can create something totally original. If part of the heritage of Modern art is based on originality, Postmodern artists who criticize this notion ironically use the medium best known for truth and accuracy: the camera.

RECEIVED IDENTITY. Cindy Sherman (b. 1954), for example, made a series of works beginning in the late 1970s in which she posed her made-up self in settings that quote well-known plots of old movies (FIG. 21–62). In UNTITLED FILM STILL #21, she is the young girl who leaves the small town to find work in the big city. Other photos from the same series show her as the glamorous Southern belle, the hardworking housewife, or the teenager who waits by the phone for a call. All of these works examine the roles that our popular culture assigns to women, and Sherman shows that she understands them all very well and she plays them willingly. She seems to be saying

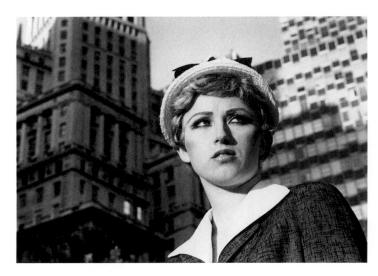

21–62 | Cindy Sherman UNTITLED FILM STILL #21 1978. Black-and-white photograph, $8\times10''$ (20.3×25.4 cm). Courtesy of the artist and Metro Pictures, New York

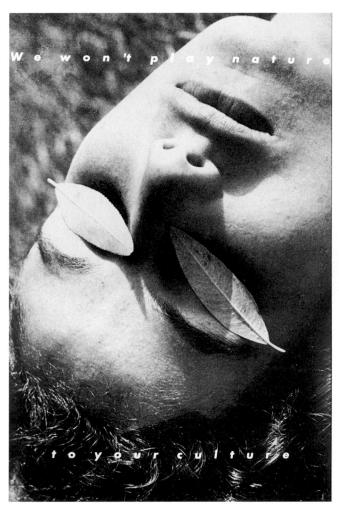

21–63 | Barbara Kruger WE WON'T PLAY NATURE TO YOUR CULTURE 1983. Photostat $6'1'' \times 4'1''$ (1.85 \times 1.24 m). Courtesy Mary Boone Gallery, New York

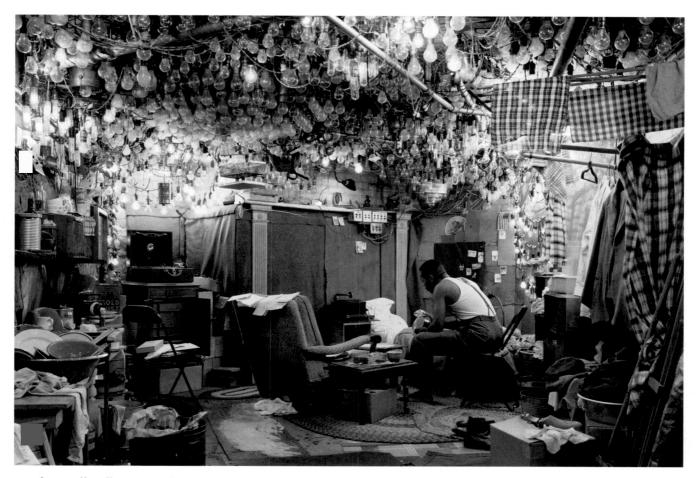

21–64 | Jeff Wall AFTER "INVISIBLE MAN" BY RALPH ELLISON, THE PREFACE 1999–2001. Edition of 2. Cibachrome transparency, aluminum light box, and fluorescent bulbs.

that her personality is the sum of all the movies that she has seen, and she does not know where the real Cindy Sherman starts and the one derived from movies stops. If this statement reminds us of Andy Warhol's confession about the real and the artificial, so much the better. The influence of popular culture on all of our identities has only intensified since he said it.

Barbara Kruger (b. 1945) makes a more militant point with slightly different media (FIG. 21–63). Her work quotes magazine advertising layouts, with a catchy photograph and a slogan inscribed, but the slogan talks back to the viewer with a confrontational sentence that sounds feminist. Women's curves have traditionally been seen as symbols for nature, but this work articulates a revolt against that role. This work is not an "original," but rather a piece of graphic design that can be reproduced. Kruger has worked in many other public media, including billboards and bus shelter posters, implanting her subversive messages directly in the flow of media and advertising.

CONSTRUCTED IDENTITY. If photography was traditionally a medium for the straightforward recording of reality ("The camera never lies"), many Postmodern photographers attack this notion by using the camera to photograph obviously set-

up situations. They show us that the camera can indeed be made to lie. Canadian artist Jeff Wall (b. 1946) creates detailed illusions that feel as if they could easily be documentary photographs, even as they seek to rival in visual impact large-scale history paintings from the past as well as glossy advertisements of the present. As an art history student in the 1970s, Wall was impressed by the way nineteenth-century artists such as Delacroix and Manet (see Chapter 19) adapted the conventions of history painting to the depiction of contemporary life. Since the late 1970s his own project has been to fashion a comparable grand-scale representation of the history of his own times, presented in the form of color transparencies mounted in large light boxes—a format borrowed from modern advertising and meant to give his art the same persuasive power.

Like a stage or movie director, Wall carefully designs the settings of his scenes and directs actors to play roles within them. He then shoots multiple photographs and combines them digitally to create the final transparency. To make AFTER "INVISIBLE MAN" BY RALPH ELLISON, THE PREFACE (FIG. 21–64), an especially elaborate composition, Wall spent eighteen months constructing the set and another three weeks shooting the single actor within it. The image vividly illustrates a well-known

passage from the classic 1952 novel by Ralph Ellison about a black man's search for fulfillment in modern America, which ends in disillusionment and retreat. Wall shows us the cellar room "warm and full of light," in which Ellison's narrator lives beneath 1,369 light bulbs. Powered by electricity stolen from the power company, these lights illuminate the truth of the character's existence: "Light confirms my reality, gives birth to my form. . . . Without light I am not only invisible but formless as well; and to be unaware of one's form is to live a death. . . . The truth is the light and the light is the truth." The artist mounts his work in large-scale light boxes the size of movie screens, to add yet another layer of quotation.

More recent photographers have continued the critique of originality by showing that photography is not merely a recorder of reality, but it also helps us construct our reality. There is no other way except through photography to establish the historical importance of Performance art or Earthworks, which are more remote for most viewers than famous museums. Likewise, photographs of artists at work also create mythology about them. The photographs of Jackson Pollock at work, for example, helped cement his reputation as a major

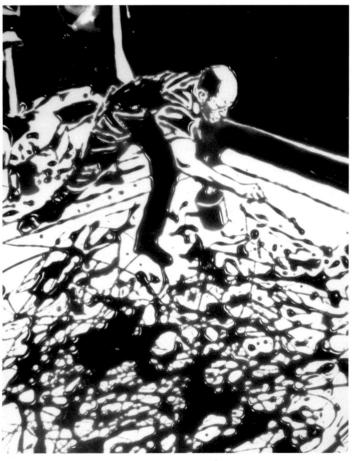

21-65 Vik Muniz Action Photo I (FROM "PICTURES OF CHOCOLATE")

1997. Dye destruction print, $59\,\% \times 46\,\%$ (152 \times 121 cm). Victoria & Albert Museum, London.

Art © Vik Muniz / Licensed by VAGA, New York, NY

Modern artist (SEE FIG. 21–10). Vik Muniz (b. 1961) re-creates famous photographs in surprising media and then photographs the result (FIG. 21–65). In **ACTION PHOTO 1**, Muniz splashed enough chocolate around so that he was able to make a passable copy of Hans Namuth's famous photo of Pollock at work. In order to make his version, Muniz had to develop the ability to match Pollock's famous drip technique of action painting (differing scales of the respective works complicated the task). After photographing his chocolate panel, he destroyed it, leaving the photograph as the completed work. The layers of reference in this work are numerous: It alludes to Muniz's skillful handling of the chocolate, the photo of Pollock, and to Pollock's actual painting. The latter is arguably the only "original" object in this work.

Andreas Gursky (b. 1955) photographs the spaces of contemporary society: stock exchanges, libraries, airports, designer stores, and, in the present example, a discount store (FIG. 21-66). This work may seem like a straight photograph, but in fact the artist shot several views and combined them with a digital photo editing program; he also altered the color scheme to give it more order. The store tried to create a perfect environment for shopping, and Gursky heightened the effect by smoothing out the dissonant shades, limiting the number of customers, and widening the perspective. He even placed the viewpoint high, as if we are "above the action," and added a reflective ceiling. All of these techniques are common in advertising photographs, which Gursky appropriates. An ironic fact about this particular work is that it belongs in the collection of a financial services company that invests in retail stores. A Postmodern method of discussing this work would be for the author to renounce originality and allow the owner of the work to speak in his place. Thus, let us invite the UBS publicity department to complete the story, from the company website: "Gursky's photographs refer to the structures and aesthetics of the consumerist world, in which context his series on the shop interior of the luxury brand Prada are, in their abstraction, as equally striking as the view into the interior of a 99 Cent store, one of Gursky's works in the UBS Art Collection. Whilst the Prada series could be linked to Color Field paintings, 99 Cent reminds one of pointillist or impressionist paintings, representing reality while melting light and color."

Telling Stories with Paint

Many in the art world thought that the art of painting was moribund in the last years of the Modern movement. Most innovations seemed to come from Performance, Conceptual, or feminist art, perhaps leaving painting as a historical relic. Such talk has proved completely untrue in the Postmodern period, as artists in many countries have gone back to the studio. There they have rediscovered the pleasures of storytelling through art. Principal influences include Joseph Beuys's political rituals and the self-examination that feminists practiced.

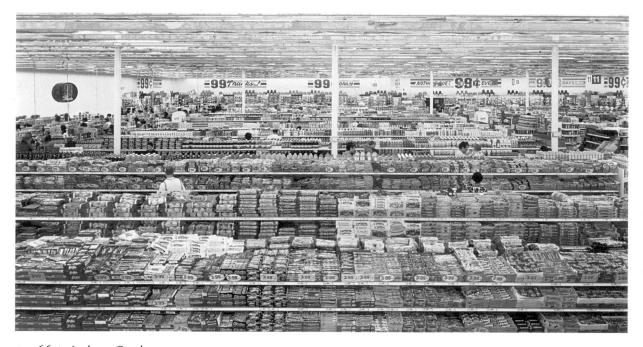

21–66 | Andreas Gursky 99 CENT 1999. C-print, $81\frac{1}{2} \times 132\frac{1}{8}$ " (207 \times 336.7 cm). GURA.PH.9529. Courtesy Matthew Marks Gallery, New York. © 2001 Andreas Gursky / Artists Rights Society (ARS), New York, NY

NEO-EXPRESSIONISM. One of the first Postmodern movements to arise in the late 1970s was Neo-Expressionism, a return to the Expressionist styles in which the artist tries to render his or her inner self more than the outward appearance of the subject matter at hand. In Germany, the revival of Expressionism took on political connotations because the work of the original Expressionists had been labeled degenerate and banned by the Nazis during the 1930s (see "The

Suppression of the Avant-Garde in Nazi Germany," page 850). The German Neo-Expressionist Anselm Kiefer (b. 1945) was born in the final weeks of World War II, and in his work he has sought to come to grips with his country's Nazi past—"to understand the madness." The burned and barren landscape in his **HEATH OF THE BRANDENBURG MARCH** (FIG. 21–67) evokes the ravages of war that the Brandenburg area, near Berlin, has frequently experienced, most recently in

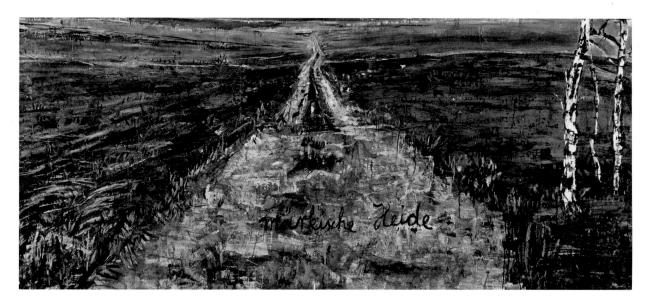

21–67 | Anselm Kiefer | HEATH OF THE BRANDENBURG MARCH 1974. Oil, acrylic, and shellac on burlap, $3'10\%'' \times 8'4''$ (1.18 \times 2.54 m). Stedelijk Van Abbemuseum, Eindhoven, the Netherlands.

Kiefer often incorporates words and phrases into his paintings that amplify their meaning. Here, the words märkische Heide ("March Heath") evoke an old patriotic tune of the Brandenburg region, "Märkische He de, märkische Sand," which Hitler's army adopted as a marching song.

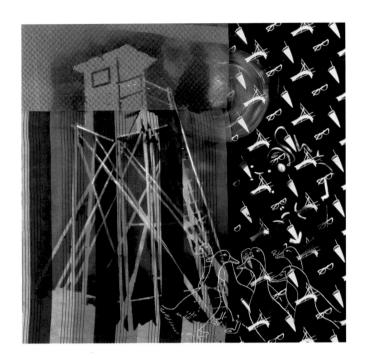

21–68 | Sigmar Polke RAISED CHAIR WITH GEESE 1987–88. Artificial resin and acrylic on various fabrics, $9'5\%'' \times 9'5\%'' (2.9 \times 2.9 \text{ m})$. The Art Institute of Chicago. Restricted gift in memory of Marshall Frankel; Wilson L. Mead Endowment (1990.81)

World War II. The road that lures us into the landscape, a standard device in nineteenth-century landscape paintings, here invites us into the region's dark past.

Kiefer's determination to deal with his country's troubled past was shaped in part by his study under Joseph Beuys (SEE FIG. 21-48) in the early 1970s. Another prominent Beuys student was Sigmar Polke (b. 1941), who grew up in Communist-controlled East Germany before moving at age 12 to West Germany. During the 1960s Polke made crude "capitalist realist" paintings that expressed a more critical view of consumer culture than did the generally celebratory work of the British and American Pop artists. Like them, Polke appropriated his images from the mass media. Polke later began to mix diverse images from different sources and paint them on unusual supports, such as printed fabrics, creating a complex, layered effect. RAISED CHAIR WITH GEESE (FIG. 21-68), for example, juxtaposes the silhouette of a watchtower with outlined figures of geese and a printed pattern of sunglasses, umbrellas, and folding chairs. The motif of the elevated hut generates many dark associations, ranging from the raised chair used by German fowl hunters (reinforced by the presence of the geese), to a sentry post for soldiers monitoring the border between East and West Germany, to a concentration camp watchtower. Set next to the decorative fabric

evocative of the beach, however, the tower also evokes the more pleasurable image of a raised lifeguard chair. Such lighter touches distinguish Polke's work in general from the unrelievedly serious efforts of Kiefer.

An American painter associated with the Neo-Expressionist movement was the tragically short-lived Jean-Michel Basquiat (1960-88), whose meteoric career ended with his death from a heroin overdose at age 27. The Brooklyn-born son of a Haitian father and a Puerto Rican mother, Basquiat was raised in middle-class comfort, against which he rebelled as a teenager. After quitting high school at 17, he left home to become a street artist, covering the walls of lower Manhattan with short and witty philosophical texts signed with the tag SAMO©. In 1980 Basquiat participated in the highly publicized "Times Square Show," which showcased the raw and aggressive styles of subway graffiti artists. The response to Basquiat's work encouraged him to begin painting professionally. Although he was untrained and wanted to make "paintings that look as if they were made by a child," Basquiat was a sophisticated artist. He carefully studied the Abstract

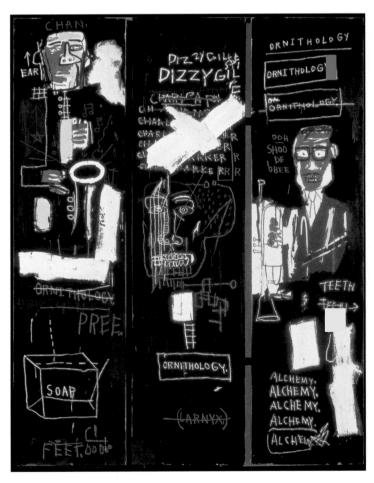

21–69 | Jean-Michel Basquiat HORN PLAYERS 1983. Acrylic and oil paintstick on canvas, three panels, overall $8'\times6'5''$ (2.44 \times 1.91 m). Broad Art Foundation, Santa Monica, California

Expressionists, the late paintings of Picasso, and Dubuffet (SEE FIG. 21–4), among others.

Basquiat's HORN PLAYERS (FIG. 21–69) portrays jazz musicians Charlie Parker (at the upper left) and Dizzy Gillespie (at center right) and includes numerous verbal references to their lives and music. The urgent paint handling and scrawled lettering seem genuinely Expressionist, conveying Basquiat's strong emotional connection to his subject (he avidly collected jazz records and considered Parker one of his personal heroes), as well as his passionate determination to make African American subject matter visible to his predominantly white audience. "Black people," said Basquiat, "are never portrayed realistically, not even portrayed, in Modern art, and I'm glad to do that."

NEW USES FOR OLD STYLES. In the Postmodern period, nearly every historical style is equally available for recycling by artists; Judith F. Baca (b. 1946) looked back to the Mexican mural movement (SEE FIG. 20–66) to recount from a new perspective the history of California (FIG. 21–70). Painted on a site controlled by the U.S. Army Corps of Engineers, Baca's GREAT WALL OF LOS ANGELES extends almost 2,500 feet along the wall of a drainage canal, making it the longest mural in the world. Its subject is the history of California, with an

Sequencing Works of Art

1978	Sherman, Untitled Film Stills
1981	Kapoor, As if to Celebrate
1982	Hammons, Higher Goals
1983	Basquiat, Horn Players
1986	Foster, Hong Kong and Shanghai Bank
1987-88	Polke, Raised Chair with Geese

emphasis on the role of ethnic minorities. The twentieth-century scenes include the deportation of Mexican American citizens during the Great Depression, the internment of Japanese American citizens during World War II, and residents' futile protests over the division of a Mexican American neighborhood by a new freeway. The mural concludes with more positive images of the opportunities minorities gained in the 1960s. Typical of Baca's public work, *The Great Wall of Los Angeles* was a group effort, involving professional artists and hundreds of young people who painted the mural under her direction.

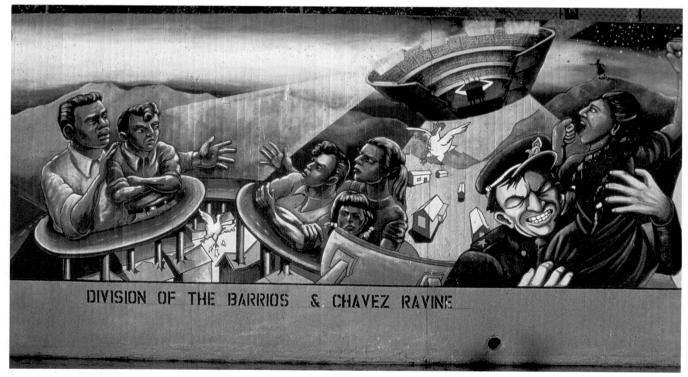

2I-7I | Jaune Quick-to-See Smith | THE RED MEAN: SELF PORTRAIT

1992. Acrylic, newspaper collage, and mixed media on canvas, $90\times60''$ (228.6 \times 154.4 cm). Smith College Museum of Art, Northhampton, Massachusetts.

Part gift from Janet Wright Ketcham, class of 1953, and part purchase from the Janet Wright Ketcham, class of 1953, Fund © Jaune Quick-to-See Smith

Native American artist Jaune Quick-to-See Smith (b. 1940) borrowed a well-known image by Leonardo da Vinci for her work **THE RED MEAN** (FIG. 21–71). She describes the work as a self-portrait, and indeed the center of the work has

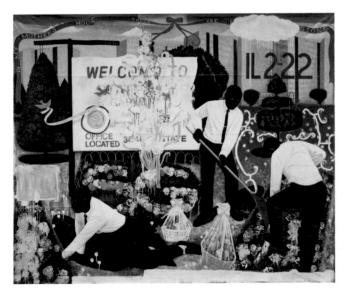

2I-72 | Kerry James Marshall MANY MANSIONS 1994. Acrylic on paper mounted on canvas, $114\frac{7}{4} \times 135\frac{7}{8}$ " (290 \times 343 cm). Art Institute of Chicago. Max V. Kohnstamm Fund, 1995.147 / Artists Rights Society (ARS), New York

a bumper sticker that reads "Made in the U.S.A." above an identification number. The central figure quotes Leonardo's *Vitruvian Man* (see "Vitruvian Man," page 535), but the message here is autobiographical. Leonardo inscribed the human form within perfect geometric shapes to emphasize the perfection of the human body, while Smith put her silhouette inside the red X that signifies nuclear radiation. This image alludes both to the uranium mines found on some Indian reservations and also to the fact that many have become temporary repositories for nuclear waste. The background of the work is a collage of Native American tribal newspapers. Her self-portrait thus includes her ethnic identity and life on the reservation as well as the history of Western art.

African American painter Kerry James Marshall (b. 1955) updates the pre-Modern genre of history paintings for the contemporary era. He grew up in public housing projects in Alabama and California, and in MANY MANSIONS (FIG. 21-72) he painted a visual essay on life in housing projects. In the background we see the huge buildings of Stateway Gardens, one of America's largest housing projects, located in Chicago. Many housing projects have the word "Gardens" in their names, and Marshall poses three well-dressed black men in the foreground, planting a garden in order to help create a sense of community. The three are arrayed in an off-center triangle that is based on Théodore Géricault's Raft of the "Medusa," a narrative work that Marshall admires (see "Raft of the 'Medusa,'" page 730). He told an interviewer from the PBS television network, "That whole genre of history painting, that grand narrative style of painting, was something that I really wanted to position my work in relation to." Thus he uses a reference to a past style to enrich his art. The work presents many sentimental touches as well, such as the red ribbon across the top with the altered quote from the Bible: "In my mother's house there are many mansions." Two bluebirds fly along at the left bearing another ribbon in their beaks. The overt cuteness of these features, together with the impossibly florid garden, lend the work an ironic touch. The inscription "IL2-22" is like an illustration number, reminding us that this work is only a version of its subject.

The paintings of Takashi Murakami (b. 1962) tie in closely with the popular culture of the artist's native Japan, but they are only one aspect of his voluminous output. EYE LOVE SUPERFLAT (FIG. 21–73) resembles at first glance a corporate logo. Four stylized eyes frame a monogram that symbolizes love on a field of stenciled floral patterns, all in garish colors. The eyes are rendered in a cute style that quotes the Japanese popular culture of manga (comics) and animated films. The Superflat of the title describes not only the lack of depth in this work but also Japanese culture as a whole, the artist says. Woodblock prints of the nineteenth century used flat patterns, as does much traditional Japanese art by painters such as Sesshu and Sotatsu. Murakami was trained in the traditional Japanese art techniques at Tokyo National Univer-

21–73 | Takashi Murakami EYE LOVE SUPERFLAT 2003. Acrylic on canvas mounted on wood, $23\frac{7}{2} \times 23\frac{7}{2}$ " (59.7 \times 59.7 cm). Marianne Boesky Gallery, New York. © 2003 Takashi Murakami / Kaikai Kiki Co., Ltd. All rights reserved.

sity, where he earned a doctoral degree. He claims that Japanese culture today is still characterized by flatness, now of PDAs, flat-screen televisions, and digital billboards. *Eye Love Superflat* looks reproducible because it is. The artist, whom *Wired* magazine referred to in 2003 as "the next Andy Warhol," leads a workshop called the Hiropon Factory that employs 25 assistants who craft his images into videos, T-

shirts, handbags, and dolls. His career is an excellent example of how the paradigm for artistic success in the Postmodern era has evolved away from the archetypal solitary genius of Modernism.

Finding New Meanings in Shapes

Sculpture reached its limits under the impact of the Minimalist movement, as artists such as Judd and others (SEE FIG. 21–41) used the most elementary structures to see if they could remove all symbolic or personal meanings. Postmodern sculptors have gradually reinvested their work with some of these resonances, and thus the last twenty years have witnessed a flowering of three-dimensional art.

Martin Puryear (b. 1941) had an early interest in biology that would shape his mature aesthetic. As a Peace Corps volunteer in Sierra Leone on the west coast of Africa, Puryear studied the traditional, preindustrial woodworking methods of local carpenters and artisans. In 1966 he moved to Stockholm, Sweden, to study printmaking and learn the techniques of Scandinavian cabinetmakers. Two years later he began graduate studies in sculpture at Yale, where he encountered the work of a number of visiting Minimalist sculptors. By the middle of the 1970s he had combined these formative influences into a distinctive personal style reminiscent, in its organic simplicity, of Constantin Brancusi (SEE FIG. 20-33). Puryear's PLENTY'S BOAST (FIG. 21-74) does not represent anything in particular but suggests any number of things, including a strange sea creature or a fantastic musical instrument. Perhaps the most obvious reference is to the horn of plenty evoked in the sculpture's title. But the cone is empty, implying an "empty boast"—another phrase suggested by the

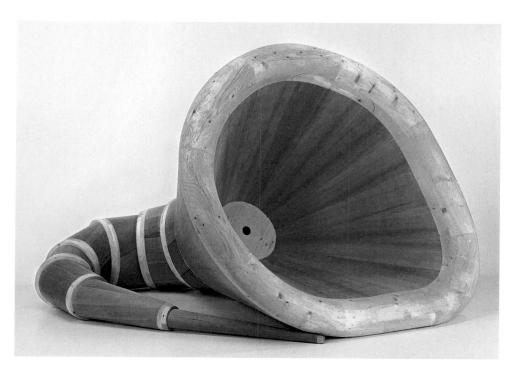

2I-74 | Martin Puryear

PLENTY'S BOAST

1994-95. Red cedar and pine,
68 × 83 × 118"

(172.7 × 210.8 × 299.7 cm).

The Nelson-Atkins Museum of
Art, Kansas City, Missouri.

Purchase of the Renee C. Crowell Trust
(F95-16 A-C)

title. Whatever associations one prefers, the beauty of the sculpture lies in its superb craft and its idiosyncratic yet elegant organic forms. Sounding like an early twentieth-century Modernist, Puryear said, "The task of any artist is to discover his own individuality at its deepest."

If Puryear explores the territory of the self, Bombayborn Anish Kapoor (b. 1954) makes reference to the culture of his native India (Fig. 21–75). His pieces refer to the fleshy curves of traditional Indian sculpture and the tall shapes of Hindu temples, without exactly quoting either. He later sprinkles pigment powder on most of his works for two reasons: first, because such powders are the purest colors available since they are not mixed with binders as paint is; second, because such sprinkling has a ritualistic overtone, as if sanctifying the object. This work's long title has a diaristic quality that also suggests enlightenment.

In contrast to Kapoor's contemporary spirituality, Rachel Whiteread (b. 1963) urges us to take a fresh look at everyday things by making casts of them. She has cast the insides of a closet, the rectangle of space under a chair, and the contents of a water tower, turning all of these barely noticed negative spaces into solid blocks. Her aesthetic is based in part on the Arte Povera movement (SEE FIGS. 21-44, 21-45), which similarly found meaning in everyday things. For an exhibition in Venice she made a cast of the space behind the books on her library shelf. Over the years these castings have grown more ambitious, culminating in the 1993 work HOUSE (FIG. 21-76), in which she cast the entire inside of a three-story townhouse in concrete. The work took on a political dimension, because it was the last home remaining from a Victorian-era terrace that was being removed to create a new green space. Whiteread intended the work both as a monument to the idea of home and as a political statement about "the state of housing in England; the ludicrous policy of knocking down homes like this and building badly designed tower blocks which themselves have to be knocked down after 20 years." Immediately upon its completion, House became the focus of public debate over not just its

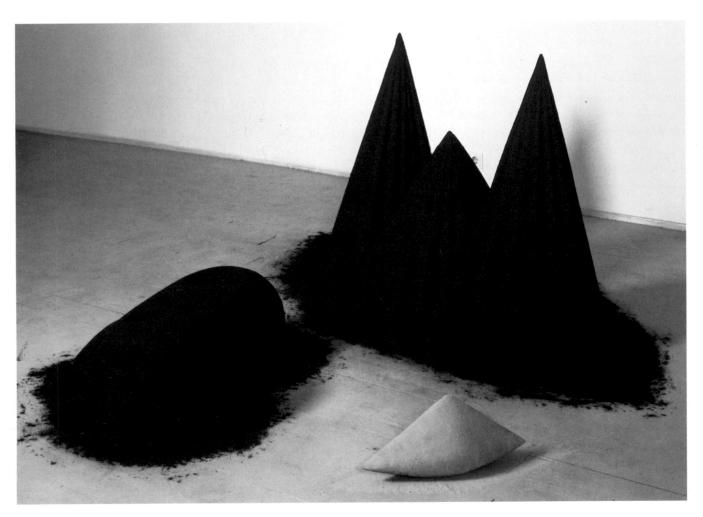

21–75 | Anish Kapoor AS IF TO CELEBRATE, I DISCOVERED A MOUNTAIN BLOOMING WITH RED FLOWERS 1981. Three drawings and sculpture with wood and various materials, height of tallest element, 38 1/2 (97 cm). Tate Gallery, London.

© Anish Kapoor

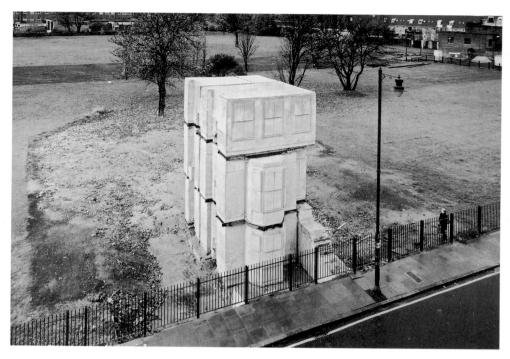

21–76 | Rachel Whiteread HOUSE
1993. Sprayed concrete. Corner of Grove and Roman roads, London; destroyed in 1994.
Commissioned by Artangel Trust and Beck's

artistic merits but also social issues such as housing, neighborhood life, and the authority of local planners. Intended to be temporary, Whiteread's work stood for less than three months before it, too, was demolished.

Modern sculpture since 1945 has generally neglected the human body, but many Postmodern sculptors have revived it because of its rich narrative possibilities. An important impetus for this renewed interest in the human form came with the AIDS crisis, which hit in the 1980s. The social agitation and medical controversy surrounding this disease gave many artists a new feeling that the human body is not only a means of storytelling but also a site of political struggle. The American sculptor Kiki Smith (b. 1954), who lost a sister to AIDS, has explored this territory in works such as **UNTITLED** (FIG. 21-77). This disturbing sculpture, made of red-stained, tissue-thin gampi paper, represents the flayed, bloodied, and crumpled skin of a male figure, torn into three pieces that hang limply from the wall. The body, once massive and vigorous, is now hollow and lifeless. This shattered, blood-red figure suggests a narrative too gruesome to contemplate but unfortunately not uncommon in present-day wars and terrorist attacks.

Postmodern sculptors may work in almost any medium that can be shaped in three dimensions. Ghana-born sculptor El Anatsui (b. 1944) was making wood carvings with a chainsaw when he began to notice the large quantities of liquor bottles in the trash in Nsukka, Nigeria, where he lives. He gathered several thousand of the aluminum tops, flattened

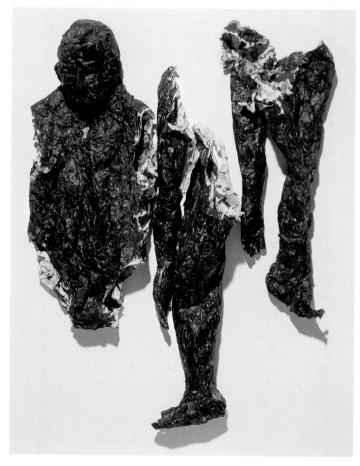

21–77 | Kiki Smith UNTITLED 1988. Ink on gampi paper, $48 \times 38 \times 7''$ (121.9 \times 96.5 \times 17.8 cm). The Art Institute of Chicago. Gift of Lannon Foundation (1997.121)

21–78 | El Anatsui AFTER KINGS 2005. Aluminum (liquor bottle tops) and copper wire, 88 × 70" (224 × 178 cm). Private Collection, Washington, D.C. Courtesy Skoto Gallery, New York. Artists Rights Society (ARS), New York

them, and stitched them together with copper wire to form large wall pieces such as AFTER KINGS (FIG. 21–78). The tops were chosen not only because they were plentiful but also because of symbolic meanings. He said, "To me, the bottle tops encapsulate the essence of the alcoholic drinks which were brought to Africa by Europeans as trade items at the time of the earliest contact between the two peoples. Almost all the brands I use are locally distilled. I now source the caps from around Nsukka, where I live and work. I don't see what I do as recycling. I transform the caps into something else." After Kings changes garbage into a form that resembles a traditional kente cloth from the Ashanti culture of Ghana. The kente cloth art form was originally for the nobility only, which helps to explain the title of the work.

The African tradition of making art from whatever is at hand also motivated the British-born Nigerian Chris Ofili (b. 1968) to attach elephant dung to the surface of a painting about Mary, the mother of Jesus. This work became highly controversial when the mayor of New York City tried to close a museum that exhibited it in 1999 (see "Recent Controversies Over Public Funding for the Arts," facing page).

High Tech and Deconstructive Architecture

Architecture has gone through a rebirth almost as dramatic as that of sculpture since the end of Modernism, as architects search restlessly for new support systems beyond the "glass box" of late Modernism (SEE FIG. 21–56). New three-dimensional digital graphics programs allow architects to visualize these new ideas quickly and easily, making possible many innovative building shapes.

HIGH TECH ARCHITECTURE. Even as Postmodernism flourished in the late 1970s and 1980s, High Tech challenged it as the dominant successor to an exhausted Modernism. Characterized by the use of advanced building technology and industrial materials, equipment, and components, High Tech architects experiment with new, more expressive ways of composing a building's mass and of incorporating service modules such as heating and electricity. Among the most spectacular examples of High Tech architecture is the HONG KONG & SHANGHAI BANK (FIG. 21-79) by Norman Foster (b. 1935). Invited by his client to design the most beautiful bank in the world, Foster spared no expense in the creation of this futuristic forty-seven-story skyscraper. The rectangular plan features service towers at the east and west ends, eliminating the central service core typical of earlier skyscrapers such as the Seagram Building. The load-bearing steel skeleton, composed of giant masts and girders, is on the exterior. The individual stories hang from this structure, allowing for uninterrupted façades and open working areas filled with natural

Defining Art

RECENT CONTROVERSIES OVER PUBLIC FUNDING FOR THE ARTS

hould public money support the creation or exhibition of art that some taxpayers might find indecent or offensive? This question became an issue of heated debate in 1989-90, when controversies arose around the work of the American photographers Robert Mapplethorpe and Andres Serrano (b. 1950), who had both received funding, directly or indirectly, from the National Endowment for the Arts (NEA). Serrano became notorious for a large color photograph, Piss Christ (1987), that shows a plastic crucifix immersed in the artist's urine. Although Serrano did not create that work using public money, he did receive a \$15,000 NEA grant in 1989 through the Southeastern Center for Contemporary Art (SECCA), which included Piss Christ in a group exhibition. Piss Christ came to the attention of the Reverend Donald Wildmon, leader of the American Family Association, who railed against it as "hate-filled, bigoted, anti-Christian, and obscene." Wildmon exhorted his followers to flood Congress and the NEA with letters of protest, and the attack on the NEA was quickly joined by conservative Republican politicians.

Amid the Serrano controversy, the Corcoran Gallery of Art in Washington, D.C., decided to cancel its showing of the NEA-funded Robert Mapplethorpe retrospective (organized by the Institute of Contemporary Art [ICA] in Philadelphia) because it included homoerotic and sadomasochistic images. Congress proceeded to cut NEA funding by \$45,000, equaling the \$15,000 SECCA grant to Serrano and the \$30,000 given to the ICA for the Mapplethorpe retrospective. It also added to the NEA guidelines a clause requiring that award decisions take into consideration "general standards of decency and respect for the diverse beliefs and values of the American public."

During the years of legal battle, the NEA underwent major restructuring under pressure from the Republican-controlled House of Representatives, some of whose members sought to eliminate the agency altogether. In 1996 Congress cut the NEA's budget by 40 percent, cut its staff in half, and replaced its seventeen discipline-based grant programs with four interdisciplinary funding categories. It also prohibited grants to individual artists in all areas except literature, making it impossible for visual artists in any medium to receive grants.

Another major controversy over the use of taxpayer money to support the display of provocative art erupted in the fall of 1999, when the Brooklyn Museum of Art opened the exhibition "Sensation: Young British Artists from the Saatchi Collection" in defiance of a threat from New York City mayor Rudolph Giuliani to eliminate city funding and evict the museum from its city-owned building if it persisted in showing work that he called "sick" and "disgusting." Giuliani and Catholic leaders took particular offense at Chris Ofili's THE HOLY VIRGIN MARY, a glittering painting of a stylized African Madonna with a breast made out of elephant dung, set against a background dotted with small photographic images of women's buttocks and genitalia. Ofili, a British-born black of Nigerian parentage who is himself Catholic, explained that he meant the painting to be a contemporary reworking of the traditional image of the Madonna surrounded

by naked *putti*, and that the elephant dung, used for numerous practical purposes by African cultures, represents fertility. Giuliani and his allies, nowever, considered the picture sacrilegious.

When in late September the Brooklyn Museum of Art refused to cancel the show, Giuliani withheld the city's monthly maintenance payment to the museum of \$497,554 and filed a suit in state court to revoke its lease. The museum responded with a federal lawsuit seeking an injunction against Giuliani's actions on the grounds that they violated the First Amendment. On November 1, the U.S. District Court for the Eastern District of New York barred Giuliani and the city from punishing or retaliating against the museum in any way for mounting the exhibition. While the mayor had argued that the city should not have to subsidize art that fosters religious intolerance, the court ruled that the government has "no legitimate interest in protecting any or all religions from views distasteful to them." Taxpayers, said the court, "subsidize all manner of views with which they do not agree," even those "they abhor."

Chris Ofili **THE HOLY VIRGIN MARY** 1996. Paper collage, oil paint, glitter, polyester resin, map pins, and elephant dung on linen, $7'11'' \times 5'11\%''$ (2.44 \times 1.83 cm). The Saatchi Gallery, London.

21–79 Norman Foster HONG KONG & SHANGHAI BANK Hong Kong. 1986.

light. The main banking hall, the lowest segment of the building, features a ten-story atrium space flooded by daylight refracted from motorized "sunscoops" at its apex, computer-programmed to track the sun and channel its rays into the building. The sole concession Foster's High Tech building makes to tradition are the two bronze lions that guard its public entrance—the only surviving elements from the bank's previous headquarters. A popular belief holds that touching the lions before entering the bank brings good luck.

DECONSTRUCTIVIST ARCHITECTURE. Deconstructivist architecture is a new tendency to disturb the traditional architectural values of harmony, unity, and stability through the use of skewed, distorted, and impure geometry. The principal influences on this movement are Suprematism and Constructivism, both Russian Modernist movements (SEE FIGS. 20–30, 20–58). Many architects since the 1980s have combined an awareness of these Russian sources with an interest in the theory of Deconstruction developed by French philosopher Jacques Derrida (1930–2004). Concerned mostly with the analysis of verbal texts, Derridean Deconstruction holds that no text possesses a single, intrinsic meaning. Rather, its meaning is always "intertextual"—a product of its relationship to other texts—and is always "decentered," or "dispersed" along

an infinite chain of linguistic signs, the meanings of which are themselves unstable. Deconstructivist architecture is, consequently, often "intertextual" in its use of design elements from other traditions, including Modernism, and "decentered" in its denial of a unified and stable form.

A prime example of Deconstructivist architecture is the **VITRA FIRE STATION** in Weil-am-Rhein, Germany (FIG. 21–80), by the Baghdad-born Zaha Hadid (b. 1950), who studied architecture in London and established her practice there in 1979. Stylistically influenced by the Suprematist paintings of Kasimir Malevich (SEE FIG. 20–29), the Vitra Fire Station features leaning, reinforced concrete walls that meet at unexpected angles and jut dramatically into space, denying any sense of unity while creating a feeling of dynamism appropriate to the building's function.

The Toronto-born, California-based Frank O. Gehry (b. 1929) creates unstable and Deconstructivist building masses using curved shapes far more exuberant than those of Modern architecture. He achieved his initial fame in the late 1970s with his inventive use of vernacular forms and cheap materials set into unstable and conflicted arrangements. After working during the 1980s in a more classically geometrical mode, in the 1990s Gehry developed a powerfully organic, sculptural style, most famously exemplified in his enormous GUGGENHEIM MUSEUM in Bilbao, Spain (FIG. 21-81). The building's complex steel skeleton is covered with a thin skin of silvery titanium that shimmers gold or silver depending on the light. Gehry's building resembles a living organism from most vantage points except the north, from which it resembles a giant ship, a reference to the shipbuilding so important to Bilbao. This building started a trend of adventurous design in art museums that continues today.

New Statements in New Media

The art of our own times is the most difficult to classify and analyze; we are still too close to the Postmodern trees to allow us to see the forest. Having pointed out in general terms a few trends that have developed in the last generation, we will close this book with a brief look at more recent art that is difficult to put into stylistic categories. The artists who created these seven works come from various continents and ethnic groups, reflecting today's globalized art world. Some of the creators focus on political issues; some are autobiographical or symbolic; some explore the new media that technology has given us.

SOCIAL CHANGE. A socially minded artist strongly committed to working in public is David Hammons (b. 1943), an outspoken critic of the gallery system. Lamenting the lack of challenging content in art shows, he says that the art world is "like Novocaine. It used to wake you up but now it puts you to sleep." Only street art, uncontaminated by commerce, he maintains,

21–80 | Zaha Hadid VITRA FIRE STATION Weil-am-Rhein, Germany. 1989–93.

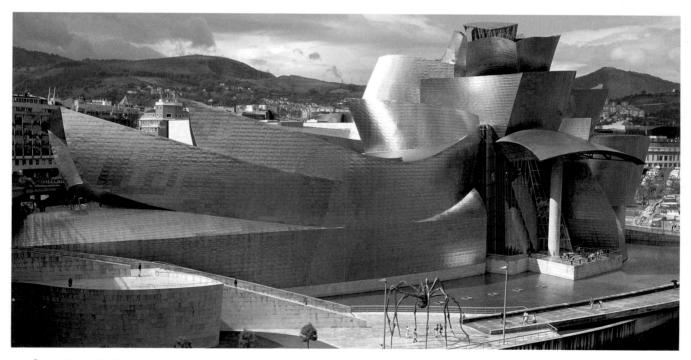

21–81 | Frank O. Gehry GUGGENHEIM MUSEUM Bilbao, Spain. 1993-97.

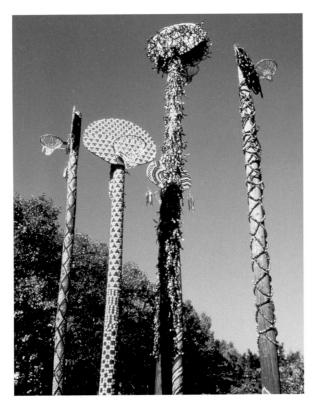

21–82 | David Hammons HIGHER GOALS 1982; shown installed in Brooklyn, New York, 1986. Five poles of mixed media, including basketball hoops and bottle caps, height of tallest pole 40' (11 m).

Courtesy of Artemis Greenberg Van Doren Gallery, New York

can still serve the function of jolting people awake. Hammons for the most part aims his work at his own African American community. His best-known creation is probably **HIGHER GOALS** (FIG. 21–82), which he produced in several versions between 1982 and 1986. This one, temporarily set up in a Brooklyn

park, has backboards and baskets set on telephone poles—a reference to communication—that rise as high as 35 feet. The poles are decorated with bottle caps, a substitute for the cowrie shells used not only in African design but also in some African cultures as money. Although the series may appear to honor the game of basketball, Hammons said it is "anti-basketball sculpture." "Basketball has become a problem in the black community because kids aren't getting an education. . . . It means you should have higher goals in life than basketball."

In their drive to bring about positive social change, some artists have created public works meant to provoke not only discussion but also tangible improvements. Notable examples are the REVIVAL FIELDS of Mel Chin (b. 1951), which are designed to restore the ecological health of contaminated land through the action of "hyperaccumulating" plants that absorb heavy metals from the soil. Chin created his first Revival Field near St. Paul, Minnesota, in the dangerously contaminated Pig's Eye Landfill (FIG. 21-83). He gave the work the cosmological form of a circle in a square (representing heaven and earth in Chinese iconography), divided into quarters by intersecting walkways. He seeded the inside of the circle with hyperaccumulating plants and the outside with nonaccumulating plants as a control. For three years the plants were harvested and replanted and toxic metals removed from the soil. Chin went on to create other Revival Fields elsewhere in the United States and Europe. "Rather than making a metaphorical work to express a problem," said Chin, "a work can . . . tackle a problem head-on. As an art form it extends the notion of art beyond a familiar objectcommodity status into the realm of process and public service." He has created a new kind of Earthwork (SEE FIGS. 21-49 to 21-51) that moves the focus away from aesthetic contemplation in favor of environmental activism.

21-83 | Mel Chin REVIVAL FIELD: PIG'S EYE LANDFILL

1991-93. St. Paul, Minnesota.

Although the *Revival Field* series serves the practical purpose of reclaiming a hazardous waste site through the use of plants that absorb toxic metals from the soil, Chin sought funding for his series not from the Environmental Protection Agency but from the National Endowment for the Arts. In 1990 his grant application, which had been approved by an NEA panel, was vetoed by NEA chair John E. Frohnmayer, who questioned the project's status as art. Frohnmayer reversed his decision after Chin eloquently compared *Revival Field* to a work of sculpture: "Soil is my marble. Plants are my chisel. Revived nature is my product. . . . This is responsibility and poetry."

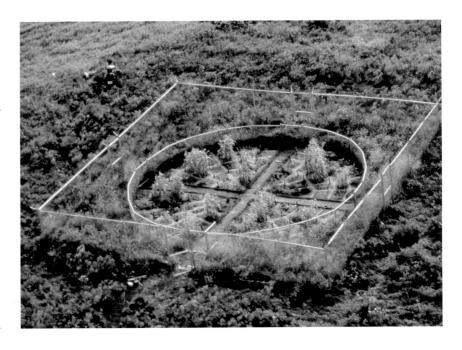

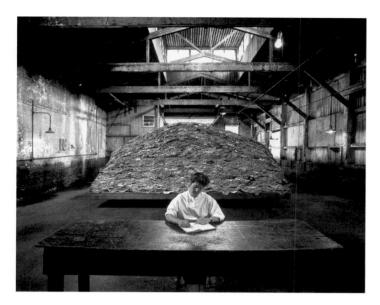

Social Observation. Visitors to the installation by Ann Hamilton (b. 1956) at the 1991 Spoleto Festival in Charleston, South Carolina, found an abandoned auto repair shop with a worker sitting at a table laboriously erasing pages from a book, before a huge pile of carefully folded blue clothing (FIG. 21-84). Taking a cue from the everyday aesthetics of John Dewey and Arte Povera, her installation allows historically specific readings that have a political subtext about aspects of American life neglected by most historians. The street outside was named for Eliza Lucas Pinckney, who in 1744 introduced to the American colonies the cultivation of indigo, the source of a blue dye used for blue-collar work clothes, among other things. The focal point of Hamilton's INDIGO BLUE was a pile of about 48,000 neatly folded work pants and shirts. However, Indigo Blue was more a tribute to the women who washed, ironed, and folded such clothes—in this case, Hamilton and a few women helpers, including her mother—than to the men who wore them. In front of the great mound of shirts and pants sat a performer erasing the contents of old history books—creating page space, Hamilton said, for the ordinary, working-class people usually omitted from conventional histories.

Landscape design has entered its Postmodern phase in the work of Ken Smith (b. 1953). When New York's Museum of Modern Art underwent an expansion in 2005, the curators decided to decorate some of the new roof space with landscape gardens. These spaces would not be accessible from inside the building, and hence the garden had to be maintenance-free. The concept was to decorate the roof so that the building would be less unsightly to the apartment dwellers living nearby. Smith created a humorously understated design

using plastic rocks, trees, and bushes set on gravel of various colors, all arranged in a camouflage pattern to "hide" the roof (FIG. 21–85). The curving plots also resemble the winding paths of New York's Central Park (see "The City Park," page 797), but on a smaller scale responding to the needs of the site. When some neighbors objected that the garden was completely fake, Smith responded that Central Park is fake also, since Olmsted leveled the area before planting anything. The way this work alludes to the past, and makes a joke out of the confusion of the real and unreal, mark it as a highly original piece of garden design, creative in a Postmodern sense.

A number of contemporary artists create installations with video, either using the video monitor itself as a visible part of their work or projecting video imagery onto walls, screens, or other surfaces. The pioneer of video as an artistic medium was the Korean-born Nam June Paik (1931–2006), who proclaimed that just "as collage technique replaced oil paint, the cathode ray [television] tube will replace the canvas." Strongly influenced by John Cage, Paik made experimental music in the late 1950s and early 1960s. He began working with modified television sets in 1963 and bought his first video camera in 1965. Paik worked with live, recorded, and computer-generated images displayed on video monitors of varying sizes, which he often combined into sculptural

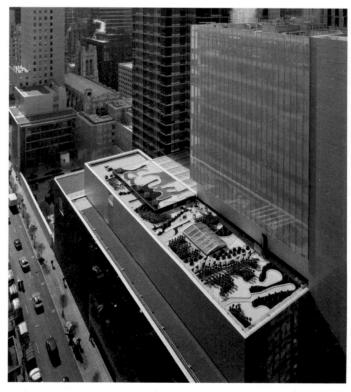

21-85 | Ken Smith, Landscape Architect MOMA ROOF GARDEN

2005. Outdoor garden at the Museum of Modern Art, New York. Photograph © Peter Mauss / ESTO / Artists Rights Society (ARS), New York

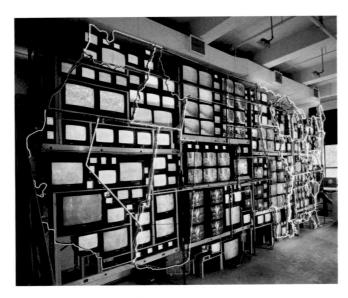

21-86 Nam June Paik ELECTRONIC SUPERHIGHWAY: CONTINENTAL U.S.

1995. Forty-seven-channel closed-circuit video installation with 313 monitors, neon, steel structure, color, and sound; approx. $15 \times 32 \times 4'$ ($4.57 \times 9.75 \times 1.2$ m).

Courtesy Holly Solomon Gallery, New York

ensembles such as **ELECTRONIC SUPERHIGHWAY: CONTINENTAL U.S.** (FIG. 21–86), a site-specific installation created for the Holly Solomon Gallery in New York. Stretching across an entire wall, the work featured a map of the continental United States outlined in neon and backed by video monitors perpetually flashing with color and movement and accompanied by sound. (Side walls featured Alaska and Hawaii.) The monitors within the borders of each state displayed images reflecting that state's culture and history, both past and recent. The only exception was New York State, whose monitors displayed live, closed-circuit images of the gallery visitors, placing them in the artwork and transforming them from passive spectators into active participants.

DIVISIONS, COMMONALITIES. The videos of Shirin Neshat (b. 1957) address universal themes within the specific context of present-day Islamic society. Neshat was studying art in California when revolution shook her native Iran in 1979. Returning to Iran in 1990 for the first time in twelve years, Neshat was shocked by the extent to which fundamentalist Islamic rule had transformed her homeland, particularly through the requirement that women appear in public veiled from head to foot in a *chador*, a square of fabric. Upon her return to the United States, Neshat began using the black *chador* as the central motif of her work.

In the late 1990s Neshat began to make visually arresting and poetically structured films and videos that offer subtle critiques of Islamic society. **FERVOR** (FIG. 21–87), in Neshat's words, "focuses on taboos regarding sexuality and desire" in Islamic society that "inhibit the contact between the sexes in

public. A simple gaze, for instance, is considered a sin..." Composed of two separate video channels projected simultaneously on two large, adjoining screens, Fervor presents a simple narrative. In the opening scene, a black-veiled woman and jacket-wearing man, viewed from above, cross paths in an open landscape. The viewer senses a sexual attraction between them, but they make no contact and go their separate ways. Later, they meet again while entering a public ceremony where men and women are divided by a large curtain. On a stage before the audience, a bearded man fervently recounts (in Farsi, without subtitles) a story adapted from the Koran about Yusuf (the biblical Joseph) and Zolikha. Zolikha attempts to seduce Yusuf (her husband's slave) and then, when he resists her advances, falsely accuses him of having seduced her. The speaker passionately urges his listeners to resist such sinful desires with all their might. As his tone intensifies and the audience begins to chant in response to his exhortations, the male and female protagonists grow increasingly anxious, and the woman eventually rises and exits hurriedly. Fervor ends with the man and woman passing each other in an alley, again without verbal or physical contact.

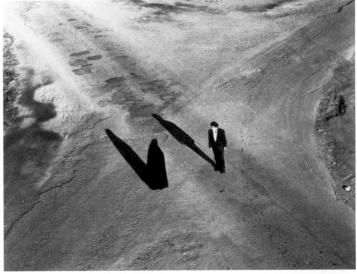

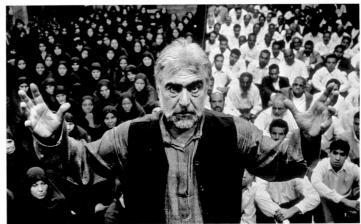

21–87 | Shirin Neshat PRODUCTION STILLS FROM "FERVOR"

2000. Video/sound installation with two channels of blackand-white video projected onto two screens, 10 minutes. Courtesy Barbara Gladstone Gallery, New York

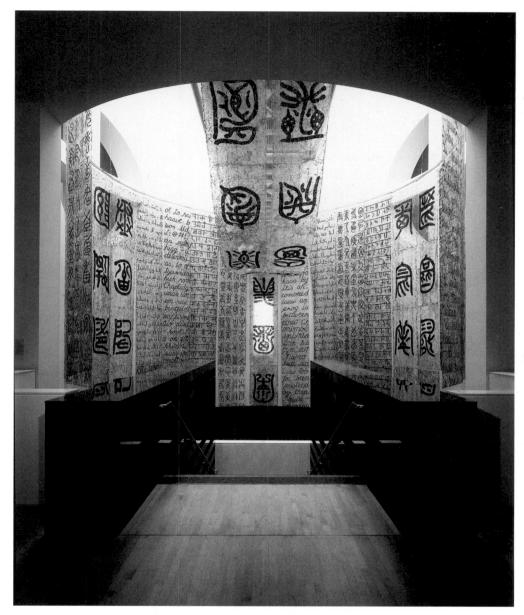

2I-88 | Wenda Gu UNITED NATIONS—BABEL OF THE MILLENNIUM
1999. Site-specific installation made of human hair, height 75′ (22.9 m); diameter 34′ (10.4 m). San Francisco Museum of Modern Art.
Fractional and promised gift of Viki and Kent Logan

While Neshat concentrates on dualisms and divisions—between East and West, male and female, individual desire and collective law—the Shanghai-born artist Wenda Gu (b. 1955) dedicates his art to bringing people together. Trained in traditional ink painting at China's National Academy of Fine Arts, Gu in the 1980s began to paint pseudo-characters—fake, Chinese-looking ideograms of his own invention. Although he later claimed that his intent was simply to "break through the control of tradition," the Chinese authorities feared that his work contained hidden political messages and did not permit his first solo exhibition to open in 1986. The next year Gu emigrated to the United States and in 1992 began his *United Nations* series, which he describes as an ongoing worldwide

art project. The series consists of site-specific installations or "monuments" made of human hair, which Gu collects from barbershops across the globe and presses or weaves into bricks, carpets, and curtains. Gu's "national" monuments—installed in such countries as Poland, Israel, and Taiwan—use hair collected within that country, addressing issues specific to that country. His "transnational" monuments address larger themes and blend hair collected from different countries as a metaphor for the mixture of races that the artist predicts will eventually unite humanity into "a brave new racial identity." Many of Gu's installations, such as UNITED NATIONS—BABEL OF THE MILLENNIUM (FIG. 21–88), also incorporate invented scripts based on Chinese, English, Hindi, and Arabic characters

that, by frustrating viewers' ability to read them, "evoke the limitations of human knowledge" and help prepare them for entry into an "unknown world."

In its ambitious attempt to address in artistic terms the issue of globalism that dominates discussions of contemporary economics, society, and culture, Gu's work is remarkably timely. Yet, like all important art, it is meant to speak not only to the present but also to the future, which will recognize it as part of the fundamental quest of artists throughout history to extend the boundaries of human perception, feeling, and thought and to express humanity's deepest wishes and most powerful dreams. "A great 'Utopia' of the unification of mankind probably can never exist in our reality," admits Gu, "but it is going to be fully realized in the art world."

IN PERSPECTIVE

Shortly after the end of the World War II in 1945, artistic innovation in the Western world was centered in Paris, New York, and Buenos Aires. The Paris artists reacted to the meltdown of European civilization that witnessed millions of deaths. The New York School pioneered Abstract Expressionism and Color Field painting, while the Buenos Aires groups worked abstractly with shaped canvases and neon.

From about 1955 to 1965, artists experimented with new ways of bringing their art into contact with the real world. Some created Assemblages of real objects in chaotic compositions; others carried out Happenings that involved staging events. The third and most important outgrowth of this trend was Pop Art, in which artists borrowed the techniques of mass media to comment on popular culture.

In the 1960s and early 1970s, artists made the final assault on traditions that date from the Renaissance. As in the early twentieth century, movements followed each other in quick succession, each claiming to be more radical than the last. Minimal artists eliminated personal feeling and all social reference from their work. Conceptual artists eliminated the art object itself in favor of informational documentation of their ideas. Performance artists refused to produce anything permanent at all. Arte Povera artists made works that depended on natural processes rather than the artist's decision to determine their form. Earthwork artists worked in remote locations directly on the surface of the land. Feminists assaulted the mostly unspoken tradition of male dominance. Some of these movements were influenced by the activism of the 1960s, while others shared in the widespread questioning of social norms that marked the period.

By the mid- to late 1970s, there seemed to be no traditional rules of art left to break. In addition, the avant-garde had all but ceased to exist as a group separate from society at large. As a result, most art produced since then has been called Postmodern, as artists ceased focusing on formal innovation and devoted more energy to reflection on our world. Architecture underwent a similar transition as Postmodern architects began to use decoration and historical reference once again.

And the history of art still unfolds. As Modern art restlessly investigated the boundaries of art, the Postmodern period has opened new possibilities for interaction with the audience. If we viewers are aware of art of the past, we will be able to appreciate the many varieties of creativity that await us in the future.

JOHNS
TARGET WITH FOUR FACES
1955

Krasner **THE SEASONS**1957

RILEY CURRENT 1964

CHRISTO AND JEANNE-CLAUDE
RUNNING FENCE
1972–76

FOSTER
HONG KONG & SHANGHAI BANK
1986

NESHAT
PRODUCTION STILLS
FROM "FERVOR"
2000

THE INTERNATIONAL SCENE SINCE 1945

- **World War II Ends** 1945
 - Britain Withdraws from India 1947
 - People's Republic of China Established 1949
 - Korean War 1950-53
 - Civil Rights Movement Begins in U.S 1954
 - USSR Launches First Satellite 1957
 - Human First Orbits Earth 1961
 - President John F. Kennedy Killed
 1963
 - U.S. Enters Vietnam War 1965
 - Montreal World Exposition 1967
 - Robert F. Kennedy and Martin Luther King, Jr., Killed 1968
 - First Moon Landing 1969
 - Stephen Hawkings Proposes Black Hole Theory 1974

- Chernobyl Nuclear Power Plant
 Disaster 1986
- Germany Reunited 1990
- USSR Disssolved 1991
- Advent of World Wide Web 1994
- Human Genome Sequence Decoded 2000
- World Trade Center Attack 2001
- U.S. War in Iraq 2003

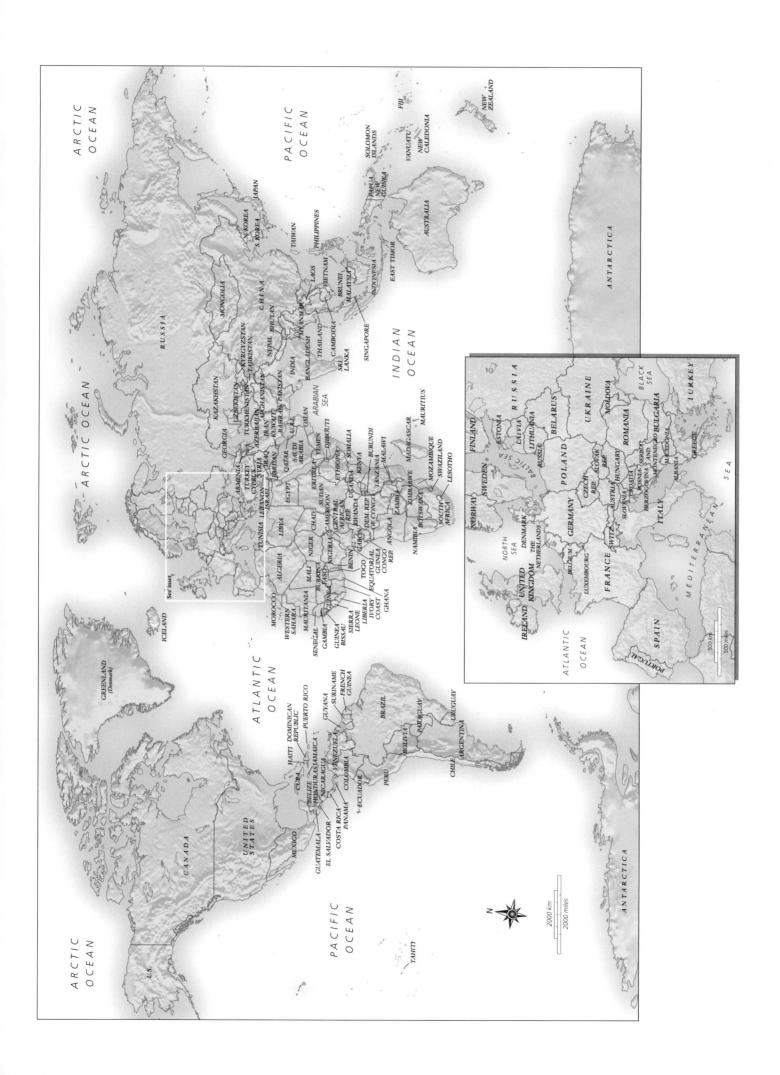

GLOSSARY

abacus The flat slab at the top of a **capital**, directly under the **entablature**.

absolute dating A method of assigning a precise historical date to periods and objects based on known and recorded events in the region as well as technically extracted physical evidence (such as carbon–14 disintegration). See also

radiometric dating, relative dating.

abstract, abstraction Any art that does not represent observable aspects of nature or transforms visible forms into a stylized image. Also: the formal qualities of this process.

acropolis The **citadel** of an ancient Greek city, located at its highest point and housing temples, a treasury, and sometimes a royal palace. The most famous is the Acropolis in Athens.

acroterion (acroteria) An ornament at the corner or peak of a roof.

adyton The back room of a Greek temple. At Delphi, the place where the **oracles** were delivered. More generally, a very private space or room.

aedicula (aediculae) A decorative architectural frame, usually found around a niche, door, or window. An aedicula is made up of a **pediment** and **entablature** supported by **columns** or **pilasters**.

agora An open space in a Greek town used as a central gathering place or market. See also forum.aisle Passage or open corridor of a church, hall,

or other building that parallels the main space, usually on both sides, and is delineated by a row, or **arcade**, of **columns** or piers. Called side aisles when they flank the **nave** of a church.

album A book consisting of a series of painting or prints (album leaves) mounted into book form

all'antica Meaning, "in the ancient manner." allegory In a work of art, an image (or images) that symbolically illustrates an idea, concept, or principle, often moral or religious.

alloy A mixture of metals; different metals melted together.

ambulatory The passage (walkway) around the **apse** in a basilican church or around the **central space in a central-plan building**.

amphiprostyle Term describing a building, usually a temple, with **porticoes** at each end but without **columns** along the other two sides.

amphora An ancient Greek jar for storing oil or wine, with an egg-shaped body and two curved handles.

aniconic A symbolic representation without images of human figures, very often found in Islamic art.

animal interlace Decoration made of interwoven animals or serpents, often found in Celtic and early medieval Northern European art.

ankh A looped cross signifying life, used by ancient Egyptians.

appropriation Term used to describe an artist's practice of borrowing from another source for a new work of art. While in previous centuries artists often copied one another's figures, motifs, or compositions, in modern times the sources for appropriation extend from material culture to works of art.

apse, apsidal A large semicircular or polygonal (and usually vaulted) niche protruding from the end wall of a building. In the Christian church, it contains the altar. Apsidal is an adjective describing the condition of having such a space.

arabesque A type of linear surface decoration based on foliage and **calligraphic** forms, usually characterized by flowing lines and swirling shapes.

arcade A series of **arches**, carried by **columns** or **piers** and supporting a common wall or lintel. In a blind arcade, the arches and supports are engaged (attached to the wall) and have a decorative function.

arch In architecture, a curved structural element that spans an open space. Built from wedgeshaped stone blocks called voussoirs, which, when placed together and held at the top by a trapezoidal keystone, form an effective spacespanning and weight-bearing unit. Requires buttresses at each side to contain the outward thrust caused by the weight of the structure. Corbel arch: arch or vault formed by courses of stones. each of which projects beyond the lower course until the space is enclosed; usually finished with a capstone. Horseshoe arch: an arch of more than a half-circle; typical of western Islamic architecture. Ogival arch: a pointed arch created by S curves. Relieving arch: an arch built into a heavy wall just above a post-and-lintel structure (such as a gate, door, or window) to help support the wall above by transferring the load to the side walls.

archaic smile The curved lips of an ancient Greek statue, usually interpreted as an attempt to animate the features.

architrave The bottom element in an entablature, beneath the frieze and the cornice.

art brut French for "raw art." Term introduced by Jean Dubuffet to denote the often vividly expressionistic art of children and the insane, which he considered uncontaminated by culture. articulated Joined; divided into units; in architecture, divided intoparts tomake spatial organiza-

tion intelligible.

ashlar A highly finished, precisely cut block of stone. When laid in even **courses**, ashlar masonry creates a uniform face with fine joints. Often used as a facing on the visible exterior of a building, especially as a veneer for the **façade**. Also called **dressed stone**.

assemblage Artwork created by gathering and manipulating two and/or three-dimensional found objects.

astragal A thin convex decorative **molding**, often found on classical **entablatures**, and usually decorated with a continuous row of beadlike circles.

atmospheric perspective See **perspective**. **atrial cross** The cross placed in the atrium of a church. In Colonial America, used to mark a gathering and teaching place.

atrium An unroofed interior courtyard or room in a Roman house, sometimes having a pool or garden, sometimes surrounded by columns. Also: the open courtyard in front of a Christian church; or an entrance area in modern architecture.

automatism A technique whereby the usual intellectual control of the artist over his or her brush or pencil is foregone. The artist's aim is to allow the subconscious to create the artwork without rational interference.

avant-garde Term derived from the French military word meaning "before the group," or "vanguard." Avant-garde denotes those artists or concepts of a strikingly new, experimental, or radical nature for the time.

baldachin A canopy (whether suspended from the ceiling, projecting from a wall, or supported by columns) placed over an honorific or sacred space such as a throne or church altar.

barrel vault See vault.

bar tracery See tracery.

bas-de-page French: bottom of the page; a term used in manuscript studies to indicate pictures below the text, literally at the bottom of the page.

base Any support. Also: masonry supporting a statue or the **shaft** of a **column**.

basilica A large rectangular building. Often built with a **clerestory**, side **aisles** separated from the center **nave** by **colonnades**, and an **apse** at one or both ends. Roman centers for administration, later adapted to Christian church use. Constantine's architects added a transverse aisle at the end of the nave called a **transept**.

bay A unit of space defined by architectural elements such as **columns**, **piers**, and walls.

beehive tomb A **corbel-vaulted** tomb, conical in shape like a beehive, and covered by an earthen mound

Benday dots In modern printing and typesetting, the individual dots that, together with many others, make up lettering and images. Often machine- or computer-generated, the dots are very small and closely spaced to give the effect of density and richness of tone.

bestiary A book describing characteristics, uses, and meaning illustrated by moralizing tales about real and imaginary animals, especially popular during the Middle Ages in western Europe.

biomorphic Adjective used to describe forms that resemble or suggest shapes found in nature.

black-figure A style or technique of ancient Greek pottery in which black figures are painted on a red clay ground. See also **red-figure**.

boss A decorative knoblike element. Bosses can be found in many places, such as at the intersection of a Gothic vault rib. Also buttonlike projections in decorations and metalwork.

bracket, bracketing An architectural element that projects from a wall to support a horizontal part of a building, such as beams or the eaves of a roof.

brandea An object, such as a linen strip, having contact with a relic and taking on the power of the relic.

buon fresco See fresco.

cairn A pile of stones or earth and stones that served both as a prehistoric burial site and as a marker of underground tombs.

calyx krater See krater.

came (cames) A lead strip used in the making of leaded or **stained-glass** windows. Cames have

an indented vertical groove on the sides into which the separate pieces of glass are fitted to hold the design together.

cameo Gemstone, clay, glass, or shell having layers of color, carved in **low relief** to create an image and ground of different colors.

camera obscura An early cameralike device used in the Renaissance and later for recording images of nature. Made from a dark box (or room) with a hole in one side (sometimes fitted with a lens), the camera obscura operates when bright light shines through the hole, casting an upside-down image of an object outside onto the inside wall of the box.

canon of proportions A set of ideal mathematical ratios in art based on measurements of the human body.

capital The sculpted block that tops a **column**. According to the conventions of the orders, capitals include different decorative elements. See **order**. Also: a historiated capital is one displaying a narrative.

capriccio A painting or print of a fantastic, imaginary landscape, usually with architecture.

capstone The final, topmost stone in a **corbel arch** or vault, which joins the sides and completes the structure.

cartoon A full-scale drawing used to transfer the outline of a design onto a surface (such as a wall, canvas,panel,or tapestry) to be painted, carved, or woven.

cartouche A frame for a **hieroglyphic** inscription formed by a rope design surrounding an oval space. Used to signify a sacred or honored name. Also: in architecture, a decorative device or plaque, usually with a plain center used for inscriptions or epitaphs.

caryatid A sculpture of a draped female figure acting as a column supporting an **entablature**.

catacomb A subterranean burial ground consisting of tunnels on different levels, having niches for urns and **sarcophagi** and often incorporating rooms (cubiculae).

cella The principal interior room at the center of a Greek or Roman temple within which the cult statue was usually housed. Also called the **naos**.

cenotaph A funerary monument commemorating an individual or group buried elsewhere.

centering A temporary structure that supports a masonry **arch** and **vault** or **dome** during construction until the mortar is fully dried and the masonry is self-sustaining.

centrally planned building Any structure designed with a primary central space surrounded by symmetrical areas on each side. For example, **Greek-cross plan** (equal-armed cross).

ceramics A general term covering all types of wares made from fired clay, including **porcelain** and **terra cotta**.

chasing Ornamentation made on metal by incising or hammering the surface.

chevron A decorative or heraldic motif of repeated Vs; a zigzag pattern.

chiaroscuro An Italian word designating the contrast of dark and light in a painting, drawing, or print. Chiaroscuro creates spatial depth and volumetric forms through gradations in the intensity of light and shadow.

chiton A thin sleeveless garment, fastened at

waist and shoulders, worn by men and women in ancient Greece.

clapboard Horizontal overlapping planks used as protective siding for buildings, particularly houses in North America.

clerestory The topmost zone of a wall with windows in a **basilica** extending above the **aisle** roofs. Provides direct light into the central interior space (the **nave**).

cloisonné An enamel technique in which metal wire or strips are affixed to the surface to form the design. The resulting areas (cloisons) are filled with enamel (colored glass).

cloister An open space, part of a monastery, surrounded by an **arcaded** or **colonnaded** walkway, often having a fountain and garden, and dedicated to nonliturgical activities and the secular life of the religious. Members of a cloistered order do not leave the monastery or interact with outsiders.

codex (codices) A book, or a group of **manuscript** pages (folios), held together by stitching or other binding on one side.

coffer A recessed decorative panel that is used to reduce the weight of and to decorate ceilings or **vaults**. The use of coffers is called coffering.

colonnade A row of **columns**, supporting a straight lintel (as in a **porch** or **portico**) or a series of arches (an **arcade**).

column An architectural element used for support and/or decoration. Consists of a rounded or polygonal vertical **shaft** placed on a **base** and topped by a decorative **capital**. In classical architecture, built in accordance with the rules of one of the architectural **orders**. Columns can be freestanding or attached to a background wall (**engaged**).

complementary color The primary and secondary colors across from each other on the color wheel (red and green, blue and orange, yellow and purple). When juxtaposed, the intensity of both colors increases. When mixed together, they negate each other to make a neutral graybrown.

Composite order See order.

connoisseurship A term derived from the French word connoisseur, meaning "an expert," and signifying the study and evaluation of art based primarily on formal, visual, and stylistic analysis. A connoisseur studies the style and technique of an object to deduce its relative quality and possible maker. This is done through visual association with other, similar objects and styles. See also **contextualism**: **formalism**.

contextualism An interpretive approach in art history that focuses on the culture surrounding an art object. Unlike **connoisseurship**, contextualism utilizes the literature, history, economics, and social developments (among other things) of a period, as well as the object itself, to explain the meaning of an artwork. See *also* **connoisseurship**.

contrapposto An Italian term mearing "set against," used to describe the twisted pose resulting from parts of the body set in opposition to each other around a central axis.

corbel, corbeling An early roofing and **arching** technique in which each course of stone projects slightly beyond the previous layer (a corbel) until the uppermost corbels meet. Results in a high, almost pointed **arch** or **vault**. A corbel table is a ledge supported by corbels.

corbeled vault See vault.

Corinthian order See order.

cornice The uppermost section of a Classical **entablature**. More generally, a horizontally projecting element found at the top of a building wall or **pedestal**. A raking cornice is formed by the junction of two slanted cornices, most often found in **pediments**.

course A horizontal layer of stone used in building.

crenellation Alternating high and low sections of a wall, giving a notched appearance and creating permanent defensive shields in the walls of fortified buildings.

crockets A stylized leaf used as decoration along the outer angle of spins, pinnacles, gables, and around **capitals** in Gothic architecture.

cuneiform An early form of writing with wedge-shaped marks impressed into wet clay with a stylus, primarily used by ancient Mesopotamians.

curtain wall A wall in a building that does not support any of the weight of the structure. Also: the freestanding outer wall of a castle, usually encircling the inner bailey (yard) and keep (primary defensive tower).

cyclopean construction or **masonry** A method of building using huge blocks of roughhewn stone. Any large-scale, monumental building project that impresses by sheer size. Named after the Cyclopes (sing. Cyclops) one-eyed giants of legendary strength in Greek myths.

cylinder seal A small cylindrical stone decorated with incised patterns. When rolled across soft clay or wax, the resulting raised pattern or design (relief) served in Mesopotamian and Indus Valley cultures as an identifying signature.

dado (dadoes) The lower part of a wall, differentiated in some way (by a **molding** or different coloring or paneling) from the upper section.

daguerreotype An early photographic process that makes a positive print on a light-sensitized copperplate; invented and marketed in 1839 by Louis-Jacques-Mandé Daguerre.

demotic writing The simplified form of ancient Egyptian hieratic writing, used primarily for administrative and private texts.

diptych Two panels of equal size (usually decorated with paintings or reliefs) hinged together.

dolmen A prehistoric structure made up of two or more large upright stones supporting a large, flat, horizontal slab or slabs.

dome A round vault, usually over a circular space. Consists of a curved masonry vault of shapes and cross sections that can vary from hemispherical to bulbous to ovoidal. May use a supporting vertical wall (drum), from which the vault springs, and may be crowned by an open space (oculus) and/or an exterior lantern. When a dome is built over a square space, an intermediate element is required to make the transition to a circular drum. There are two types: A dome on pendentives (spherical triangles) incorporates arched, sloping intermediate sections of wall that carry the weight and thrust of the dome to heavily buttressed supporting piers. A dome on squinches uses an arch built into the wall (squinch) in the upper corners of the space to carry the weight of the dome across the corners of the square space below. A half-dome or conch may cover a semicircular space.

urally heat resistant; the finished wares remain porous after firing unless **glazed**. Earthenware occurs in a range of earth-toned colors, from white and tan to gray and black, with tan predominating.

echinus A cushionlike circular element found below the **abacus** of a Doric **capital**. Also: a similarly shaped **molding** (usually with egg-and-dart motifs) underneath the **volutes** of an Ionic **capital**.

electron spin resonance techniques Method that uses magnetic field and microwave irradiation to date material such as tooth enamel and its surrounding soil.

emblema (emblemata) In a mosaic, the elaborate central motif on a floor, usually a self-contained unit done in a more refined manner, with smaller tesserae of both marble and semiprecious stones.

encaustic A painting technique using pigments mixed with hot wax as a medium.

engaged column A **column** attached to a wall. See also column.

engraving An intaglio printmaking process of inscribing an image, design, or letters onto a metal or wood surface from which a print is made. An engraving is usually drawn with a sharp implement (burin) directly onto the

surface of the plate. Also: the print made from this process

entablature In the Classical orders, the horizontal elements above the columns and capitals. The entablature consists of, from bottom to top, an architrave, a frieze, and a cornice.

entasis A slight swelling of the **shaft** of a Greek column. The optical illusion of entasis makes the column appear from afar to be straight.

exedra (exedrae) In architecture, a semicircular niche. On a small scale, often used as decoration, whereas larger exedrae can form interior spaces (such as an apse).

expressionism, expressionistic Terms describing a work of art in which forms are created primarily to evoke subjective emotions rather than to portray objective reality.

façade The face or front wall of a building.

faience Type of **ceramic** covered with colorful, opaque glazes that form a smooth, impermeable surface. First developed in ancient Egypt.

fête galante A subject in painting depicting well-dressed people at leisure in a park or country setting. It is most often associated with eighteenth-century French Rococo painting.

filigree Delicate, lacelike ornamental work.

fillet The flat ridge between the carved out flutes of a **column shaft**. See also **fluting**.

finial A knoblike architectural decoration usually found at the top point of a spire, pinnacle, canopy, or gable. Also found on furniture; also the ornamental top of a staff.

fluting In architecture, evenly spaced, rounded parallel vertical grooves **incised** on **shafts** of **columns** or columnar elements (such as **pilasters**).

foreshortening The illusion created on a flat surface in which figures and objects appear to recede or project sharply into space. Accomplished according to the rules of **perspective**.

formal analysis See formalism.

formalism, formalist An approach to the understanding, appreciation, and valuation of art based almost solely on considerations of form. This approach tends to regard an artwork as independent of its time and place of making. See also **connoisseurship**.

four-iwan mosque See iwan and mosque.

fresco A painting technique in which waterbased pigments are applied to a surface of wet plaster (called **buon fresco**). The color is absorbed by the plaster, becoming a permanent part of the wall. **Fresco secco** is created by painting on dried plaster, and the color may flake off. Murals made by both these techniques are called frescoes.

fresco secco See fresco.

frieze The middle element of an **entablature**, between the **architrave** and the **cornice**. Usually decorated with sculpture, painting, or **moldings**. Also: any continuous flat band with **relief sculpture** or painted decorations.

frottage A design produced by laying a piece of paper over a textured surface and rubbing with charcoal or other soft medium.

galleria See gallery.

gallery In church architecture, the story found above the side **aisles** of a church, usually open to and overlooking the nave. Also: in secular architecture, a long room, usually above the ground floor in a private house or a public building used for entertaining, exhibiting pictures, or promenading. *Also*: a building or hall in which art is displayed or sold. Also: **salleria**.

garbhagriha From the Sanskrit word meaning "womb chamber," a small room or shrine in a Hindu temple containing a holy image.

genre A type or category of artistic form, subject, technique, style, or medium. See also genre painting.

gesso A ground made from glue, gypsum, and/or chalk forming the ground of a wood panel or the priming layer of a canvas. Provides a smooth surface for painting.

gilding The application of paper-thin **gold leaf** or gold pigment to an object made from another medium (for example, a sculpture or painting). Usually used as a decorative finishing detail.

giornata (giornate) Adopted from the Italian term meaning "a day's work," a giornata is the section of a fresco plastered and painted in a single day.

glaze See glazing.

glazing An outermost layer of vitreous liquid (**glaze**) that, upon firing, renders **ceramics** waterproof and forms a decorative surface. In painting, a technique particularly used with oil mediums in which a transparent layer of paint (**glaze**) is laid over another, usually lighter, painted or glazed area.

gloss A type of clay **slip** used in **ceramics** by ancient Greeks and Romans that, when fired, imparts a colorful sheen to the surface.

golf foil A thin sheet of gold.

gold leaf Paper-thin sheets of hammered gold that are used in **gilding**. In some cases (such as Byzantine **icons**), also used as a ground for paintings.

Grand Manner An elevated style of painting popular in the eighteenth century in which the artist looked to the ancients and to the Renaissance for inspiration; for portraits as well as history painting, the artist would adopt the poses, compositions, and attitudes of Renaissance and antique models.

Grand Tour Popular during the eighteenth and nineteenth centuries, an extended tour of cultural sites in southern Europe intended to finish the education of a young upper-class person from Britain or North America.

grattage A pattern created by scraping off layers of paint from a canvas laid over a textured surface. See also **frottage**.

Greek-key pattern A continuous rectangular scroll often used as a decorative border. Also called a meander pattern

grid A system of regularly spaced horizontally and vertically crossed lines that gives regularity to an architectural plan. Also: in painting, a grid enables designs to be enlarged or transferred easily.

grisaille A style of monochromatic painting in shades of gray. Also: a painting made in this style.

groin vault See vault.

guild An association of craftspeople. The medieval guild had great economic power, as it set standards and controlled the selling and marketing of its members' products, and as it provided economic protection, group solidarity, and training in the craft to its members.

hall church A church with a **nave** and **aisles** of the same height, giving the impression of a large, open hall.

hemicycle A semicircular interior space or structure.

henge A circular area enclosed by stones or wood posts set up by Neolithic peoples. It is usually bounded by a ditch and raised embankment.

hieratic In painting and sculpture, a formalized style for representing rulers or sacred or priestly figures

hieratic scale The use of different sizes for significant or holy figures and those of the everyday world to indicate importance. The larger the figure, the greater the importance.

high relief Relief sculpture in which the image projects strongly from the background. See also **relief sculpture**.

himation In ancient Greece, a long loose outer garment.

historicism The strong consciousness of and attention to the institutions, themes, styles, and forms of the past, made accessible by historical research, textual study, and archaeology.

history painting Paintings based on historical, mythological, or biblical narratives. Once considered the noblest form of art, history paintings generally convey a high moral or intellectual idea and are often painted in a grand pictorial style.

hollow-casting See lost-wax casting.

hypostyle hall A large interior room characterized by many closely spaced **columns** that support its roof.

icon An image in any material representing a sacred figure or event in the Byzantine, and later in the Orthodox, Church. Icons were venerated by the faithful, who believed them to have miraculous powers to transmit messages to God.

iconoclasm The banning or destruction of images, especially icons and religious art. Iconoclasm in eighth- and ninth-century Byzantium and sixteenth-and seventeenth-century Protestant territories arose from differing beliefs about the power, meaning, function, and purpose of imagery in religion.

iconographic See iconography.

iconography The study of the significance and interpretation of the subject matter of art.

iconostasis The partition screen in a Byzantine or Orthodox church between the **sanctuary** (where the Mass is performed) and the body of the church (where the congregation assembles). The iconostasis displays **icons**.

idealism See idealization.

idealization A process in art through which artists strive to make their forms and figures attain perfection, based on pervading cultural values and/or their own mental image of beauty.

ignudi Heroic figures of nude young men.

illumination A painting on paper or parchment used as illustration and/or decoration for manuscripts or albums. Usually done in rich colors, often supplemented by gold and other precious materials. The illustrators are referred to as illuminators. Also: the technique of decorating manuscripts with such paintings.

impasto Thick applications of pigment that give a painting a palpable surface texture.

impost, impost block A block, serving to concentrate the weight above, imposed between the capital of a column and the springing of an arch above.

in antis Term used to describe the position of columns set between two walls, as in a portico or a cella

incising A technique in which a design or inscription is cut into a hard surface with a sharp instrument. Such a surface is said to be incised.

inlay To set pieces of a material or materials into a surface to form a design. Also: material used in or decoration formed by this technique.

installation art Artworks created for a specific site, especially a gallery or outdoor area, that create a total environment.

intaglio Term used for a technique in which the design is carved out of the surface of an object, such as an engraved seal stone. In the graphic arts, intaglio includes engraving, etching, and drypoint—all processes in which ink transfersto paper from incised, ink-filled lines cut into a metal plate.

intarsia Decoration formed through wood inlay. intuitive perspective See perspective. Ionic order See order.

iwan A large vaulted chamber in a mosque with a monumental arched opening on one side

jamb In architecture, the vertical element found on both sides of an opening in a wall, and supporting an arch or lintel.

japonisme A style in French and American nineteenth-century art that was highly influenced by Japanese art, especially prints.

jasperware A fine-grained, unglazed, white ceramic developed by Josiah Wedgwood, often colored by metallic oxides with the raised designs ramaining white.

joggled voussoirs Interlocking voussoirs in an arch or lintel, often of contrasting materials for col-

kantharos A type of Greek vase or goblet with two large handles and a wide mouth.

keystone The topmost voussoir at the center of an arch, and the last block to be placed. The pressure of this block holds the arch together. Often of a larger size and/or decorated.

kiln An oven designed to produce enough heat for the baking, or firing, of clay.

kinetic art Artwork that contains parts that can be moved either by hand, air, or motor.

kore (korai) An Archaic Greek statue of a young woman

kouros (kouroi) An Archaic Greek statue of a young man or boy

krater An ancient Greek vessel for mixing wine and water, with many subtypes that each have a distinctive shape. Calyx krater: a bell-shaped vessel

with handles near the base that resemble a flower calyx. Volute krater: a type of krater with handles shaped like scrolls.

kufic An ornamental, angular Arabic script.

kylix A shallow Greek vessel or cup, used for drinking, with a wide mouth and small handles near

lamassu Supernatural guardian-protector of ancient Near Eastern palaces and throne rooms, often represented sculpturally as a combination of the bearded head of a man, powerful body of a lion or bull, wings of an eagle, and the horned headdress of a god, and usually possessing five legs.

lancet A tall narrow window crowned by a sharply pointed arch, typically found in Gothic architecture.

lantern A turretlike structure situated on a roof, vault, or dome, with windows that allow light into the space below.

lekythos (lekythoi) A slim Greek oil vase with one handle and a narrow mouth.

limner An artist, particularly a portrait painter, in England during the sixteenth and seventeenth centuries and in New England during the seventeenth and eighteenth centuries.

lithograph See lithography.

lithography Process of making a print (lithograph) from a design drawn on a flat stone block with greasy crayon. Ink is applied to the wet stone and adheres only to the greasy areas of the cesign.

loggia Italian term for a covered open-air gallery. Often used as a corridor between buildings or around a courtyard, loggias usually have arcades or colonnades

lost-wax casting A method of casting metal, such as bronze, by a process in which a wax mold is covered with clay and plaster, then fired, melting the wax and leaving a hollow form. Molten metal is then poured into the hollow space and slowly cooled. When the hardened clay and plaster exterior shell is removed, a solid metal form remains to be smoothed and polished.

low relief Relief sculpture whose figures project slightly from the background. See also relief sculp-

lunette A semicircular wall area, framed by an arch over a door or window. Can be either plain or deco-

lusterware Ceramic pottery decorated with metallic glazes.

madrasa An Islamic institution of higher learning, where teaching is focused on theology and law.

maenad In ancient Greece, a female devotee of the wine god Dionysos who participated in orgiastic rituals. She is often depicted with swirling drapery to indicate wild movement or dance. (Also called a Bacchante, after Bacchus, the Roman name of Dionysos.)

majolica Pottery painted with a tin glaze that, when fired, gives a lustrous and colorful surface.

mandorla Light encircling, or emanating from, the entire figure of a sacred person.

manuscript A handwritten book or document. magsura An enclosure in a Muslim mosque, near the mihrab, designated for dignitaries.

martyrium (martyria) In Christian architecture, a church, chapel, or shrine built over the grave of a martyr or the site of a great miracle.

mastaba A flat-topped, one-story structure with slanted walls over an ancient Egyptian underground matte Term describing a smooth surface that is without shine or luster.

meander See Greek-key pattern.

medallion Any round ornament or decoration. Also: a large medal.

megalith A large stone used in prehistoric building. Megalithic architecture employs such stones.

megaron The main hall of a Mycenaean palace or grand house, having a columnar porch and a room with a central fireplace surrounded by four columns.

memento mori From Latin for "remember that you must die." An object, such as a skull or extinguished candle, typically found in a vanitas image, symbolizing the transience of life.

memory image An image that relies on the generic shapes and relationships that readily spring to mind at the mention of an object.

menorah A Jewish lamp-stand with seven or nine branches; the nine-branched menorah is used during the celebration of Hanukkah. Representations of the seven-branched menorah, once used in the Temple of Jerusalem, became a symbol of

metope The carved or painted rectangular panel between the triglyphs of a Doric frieze.

minbar A high platform or pulpit in a mosque. miniature Anything small. In painting, miniatures may be illustrations within albums or manuscripts or intimate portraits.

mirador In Spanish and Islamic palace architecture, a very large window or room with windows, and sometimes balconies, providing views to interior courtyards or the exterior landscape.

mithuna The amorous male and female couples in Buddhist sculpture, usually found at the entrance to a sacred building. The mithuna symbolize the harmony and fertility of life.

moat A large ditch or canal dug around a castle or fortress for military defense. When filled with water, the moat protects the walls of the building from direct attack.

mobile A sculpture made with parts suspended in such a way that they move in a current of air.

modeling In painting, the process of creating the illusion of three-dimensionality on a two-dimensional surface by use of light and shade. In sculpture, the process of molding a three-dimensional form out of a malleable substance.

molding A shaped or sculpted strip with varying contours and patterns. Used as decoration on architecture, furniture, frames, and other objects.

mortise-and-tenon joint A method of joining two elements. A projecting pin (tenon) on one element fits snugly into a hole designed for it (mortise) on the other. Such joints are very strong and flexible.

mosaic Images formed by small colored stone or glass pieces (tesserae), affixed to a hard, stable surface

mullion A slender vertical element or colonnette that divides a window into subsidiary sections.

mugarnas Small nichelike components stacked in tiers to fill the transition between differing vertical and horizontal planes.

naos The principal room in a temple or church. In ancient architecture, the cella. In a Byzantine church, the nave and sanctuary.

narthex The vestibule or entrance porch of a

naturalism, naturalistic A style of depiction that

seeks to imitate the appearance of nature. A naturalistic work appears to record the visible world.

nave The central space of a **basilica**, two or three stories high and usually flanked by **aisles**.

necking The molding at the top of the **shaft** of the **column**.

necropolis A large cemetery or burial area; literally a "city of the dead."

nemes headdress The royal headdress of Egypt.

niello A metal technique in which a black sulfur alloy is rubbed into fine lines engraved into a metal (usually gold or silver). When heated, the alloy becomes fused with the surrounding metal and provides contrasting detail.

nocturne A night scene in painting, usually lit by artificial illumination.

nonrepresentational art An **abstract** art that does not attempt to reproduce the appearance of objects, figures, or scenes in the natural world. Also called nonobjective art.

oculus (oculi) In architecture, a circular opening. Oculi are usually found either as windows or at the apex of a **dome**. When at the top of a dome, an oculus is either open to the sky or covered by a decorative exterior lantern.

ogee An S-shaped curve. See arch.

olpe Any Greek vase or jug without a spout.

one-point perspective See perspective.

opithodomos In greek temples, the entrance porch or room at the back.

oracle A person, usually a priest or priestess, who acts as a conduit for divine information. Also: the information itself or the place at which this information is communicated.

orant The representation of a standing figure praying with outstretched and upraised arms.

orchestra The circular performance area of an ancient Greek theater. In later architecture, the section of seats nearest the stage or the entire main floor of the theater.

order A system of proportions in Classical architecture that includes every aspect of the building's plan, elevation, and decorative system. Composite: a combination of the Ionic and the Corinthian orders. The capital combines acanthus leaves with volute scrolls. Corinthian: the most ornate of the orders the Corinthian includes a base, a fluted column shaft with a capital elaborately decorated with acanthus leaf carvings. Its entablature consists of an architrave decorated with moldings, a frieze often containing sculptured reliefs, and a cornice with dentils. Doric: the column shaft of the Doric order can be fluted or smooth-surfaced and has no base The Doric capital consists of an undecorated echinus and abacus. The Doric entablature has a plain architrave, a frieze with metopes and triglyphs, and a simple cornice. Ionic: the column of the Ionic order has a base, a fluted shaft, and a capital decorated with volutes. The Ionic entablature consists of an architrave of three panels and moldings, a frieze usually containing sculpted relief ornament, and a cornice with dentils. Tuscan: a variation of Doric characterized by a smooth-surfaced column shaft with a base, a plain architrave, and an undecorated frieze. A colossal order is any of the above built on a large scale, rising through several stories in height and often raised from the ground by a pedestal.

orthogonal Any line running back into the represented space of a picture perpendicular to the imagined picture plane. In linear perspective, all orthogonals converge at a single **vanishing point** in the

picture and are the basis for a **grid** that maps out the internal space of the image. An orthogonal plan is any plan for a building or city that is based exclusively on right angles, such as the grid plan of many modern cities.

palace complex A group of buildings used for living and governing by a ruler and his or her supporters, usually fortified.

palmette A fan-shaped ornament with radiating leaves

parapet A low wall at the edge of a balcony, bridge, roof, or other place from which there is a steep drop, built for safety. A parapet walk is the passageway, usually open, immediately behind the uppermost exterior wall or battlement of a fortified building.

parchment A writing surface made from treated skins of animals. Very fine parchment is known as vellum.

parterre An ornamental, highly regimented flowerbed. An element of the ornate gardens of seventeenth-century palaces and châteaux.

pastel Dry pigment, chalk, and gum in stick or crayon form. Also: a work of art made with pastels.

pedestal A platform or **base** supporting a sculpture or other monument. Also: the block found below the base of a Classical **column** (or **colon-nade**), serving to raise the entire element off the ground.

pediment A triangular gable found over major architectural elements such as Classical Greek **porticoes**, windows, or doors. Formed by an **entablature** and the ends of a sloping roof or a raking **cornice**. A similar architectural element: is often used decoratively above a door or window, sometimes with a curved upper **molding**. A broken pediment is a variation on the traditional pediment, with an open space at the center of the topmost angle and/or the horizontal cornice.

pendentive The concave triangular section of a **vault** that forms the transition between a square or polygonal space and the circular base of a **dome**.

peplos A loose outer garment worn by women of ancient Greece. A cloth rectangle fastened on the shoulders and belted below the bust or at the waist.

peripteral A term used to describe any building (or room) that is surrounded by a single row of columns. When such **columns** are engaged instead of freestanding, called pseudo-peripteral.

peristyle A surrounding **colonnade** in Greek architecture. A peristyle building is surrounded on the exterior by a colonnade. Also: a peristyle court is an open colonnaded courtyard, often having a pool and garden.

perspective A system for representing threedimensional space on a two-dimensional surface. Atmospheric perspective: A method of rendering the effect of spatial distance by subtle variations in color and clarity of representation. Intuitive perspective: A method of giving the impression of recession by visual instinct, not by the use of an overall system or program. Oblique perspective: An intuitive spatial system in which a building or room is placed with one corner in the picture plane, and the other parts of the structure recede to an imaginary vanishing point on its other side. Oblique perspective is not a comprehensive, mathematical system. One-point and multiple-point perspective (also called linear, scientific or mathematical perspective): A method of creating the illusion of threedimensional space on a two-dimensional surface by delineating a horizon line and multiple orthogonal

lines. These recede to meet at one or more points on the horizon (called **vanishing** points), giving the appearance of spatial depth. Called scientific or mathematical because its use requires some knowledge of geometry and mathematics, as well as optics. **Reverse perspective:** A Byzantine perspective theory in which the orthogonals or rays of sight do not converge on a vanishing point in the picture, but are thought to originate in the viewer's eye in front of the picture. Thus, in reverse perspective the image is constructed with orthogonals that diverge, giving a slightly tipped aspect to objects.

photomontage A photographic work created from many smaller photographs arranged (and often overlapping) in a composition.

picture plane The theoretical spatial plane corresponding with the actual surface of a painting.

picture stone A medieval northern European memorial stone covered with figural decoration. See also **rune stone**.

picturesque A term describing the taste for the familiar, the pleasant, and the pretty, popular in the eighteenth and nineteenth centuries in Europe. When contrasted with the sublime, the picturesque stood for all that was ordinary but pleasant.

piece-mold casting A casting technique in which the mold consists of several sections that are connected during the pouring of molten metal, usually bronze. After the cast form has hardened, the pieces of the mold are disassembled, leaving the completed object.

pier A masonry support made up of many stones, or rubble and concrete (in contrast to a column shaft which is formed from a single stone or a series of drums), often square or rectangular in plan, and capable of carrying very heavy architectural loads.

pietra serena A gray Tuscan limestone used in Florence.

pilaster An **engaged** columnar element that is rectangular in format and used for decoration in architecture.

pillar In architecture, any large, freestanding vertical element. Usually functions as an important weight-bearing unit in buildings.

plate tracery See tracery.

plinth The slablike base or pedestal of a column, statue, wall, building, or piece of furniture.

pluralism A social structure or goal that allows

members of diverse ethnic, racial, or other groups to exist peacefully within the society while continuing to practice the customs of their own divergent cultures. Also: an adjective describing the state of having many valid contemporary styles available at the same time to artists.

podium A raised platform that acts as the foundation for a building, or as a platform for a speaker.

polychrome See polychromy.

polyptych An altarpiece constructed from multiple panels, sometimes with hinges to allow for movable wings.

porch The covered entrance on the exterior of a building. With a row of **columns** or **colonnade**, also called a **portico**.

portal A grand entrance, door, or gate, usually to an important public building, and often decorated with sculpture.

portico In architecture, a projecting roof or porch supported by columns, often marking an entrance. See also porch.

post-and-lintel construction An architectural system of construction with two or more vertical ele-

ments (posts) supporting a horizontal element (lintel).

potassium-argon dating Technique used to measure the decay of a radioactive potassium isotope into a stable isotope of argon, an inert gas.

potsherd A broken piece of ceramic ware.

Praire Style A style of architecture initiated by the American Frank Lloyd Wright (1867-1959), in which he sought to integrate his structures in an "organic" way into the surrounding natural landscape, often having the lines of the building follow the horizontal contours of the land. Since Wright's early buildings were built in the Prairie States of the Midwest, this type of architecture became known as the Prairie Style.

primitivism The borrowing of subjects or forms usually from non-Western or prehistoric sources by Western artists. Originally practiced by Western artists as an attempt to infuse their work with the naturalistic and expressive qualities attributed to other cultures, especially colonized cultures, primitivism also borrowed from the art of children and the insane.

pronaos The enclosed vestibule of a Greek or Roman temple, found in front of the **cella** and marked by a row of **columns** at the entrance.

proscenium The stage of an ancient Greek or Roman theater. In modern theater, the area of the stage in front of the curtain. Also: the framing **arch** that separates a stage from the audience.

psalter In Jewish and Christian scripture, a book containing the psalms, or songs, attributed to King David.

punchwork Decorative designs that are stamped onto a surface, such as metal or leather, using a punch (a handheld metal implement).

putto (putti) A plump, naked little boy, often winged. In classical art, called a cupid; in Christian art, a cherub.

pylon A massive gateway formed by a pair of tapering walls of oblong shape. Erected by ancient Egyptians to mark the entrance to a temple complex.

qibla The mosque wall oriented toward Mecca indicated by the mihrab.

quatrefoil A four-lobed decorative pattern common in Gothic art and architecture.

quincunx A building in which five **domed** bays are arranged within a square, with a central unit and four corner units. (When the central unit has similar units extending from each side, the form becomes a **Greek cross**.)

quoin A stone, often extra large or decorated for emphasis, forming the corner of two walls. A vertical row of such stones is called quoining.

radiometric dating A method of dating prehistoric works of art made from organic materials, based on the rate of degeneration of radiocarbons in these materials. See also relative dating, absolute dating.

readymade An object from popular or material culture presented without further manipulation as an artwork by the artist.

realism In art, a term first used in Europe around 1850 to designate a kind of **naturalism** with a social or political message, which soon lost its didactic import and became synonymous with naturalism.

red-figure A style and technique of ancient Greek vase painting characterized by red clay-colored figures on a black background. (The figures are reversed against a painted ground and details are drawn, not engraved, as in black-figure style.) See also **black-figure**.

register A device used in systems of spatial definition. In painting, a register indicates the use of differing groundlines to differentiate layers of space within an image. In sculpture, the placement of self-contained bands of reliefs in a vertical arrangement. In printmaking, the marks at the edges used to align the print correctly on the page, especially in multiple-block color printing.

relief sculpture A three-dimensional image or design whose flat background surface is carved away to a certain depth, setting off the figure.
Called high or low (bas) relief depending upon the extent of projection of the image from the background. Called sunken relief when the image is carved below the original surface of the background, which is not cut away.

reliquary A container, often made of precious materials, used as a repository to protect and display sacred relics.

repoussé A technique of hammering metal from the back to create a protruding image. Elaborate reliefs are created with wooden armatures against which the metal sheets are pressed and hammered.

reverse perspective See perspective.

rhyton A vessel in the shape of a figure or an animal, used for drinking or pouring liquids on special occasions.

rib vault See vault.

ridgepole A longitudinal timber at the apex of a roof that supports the upper ends of the rafters.

rosette A round or oval ornament resembling a rose.

rotunda Any building (or part thereof) constructed in a circular (or sometimes polygonal) shape, usually producing a large open space crowned by a **dome**.

round arch See arch.

roundel Any element with a circular format, often placed as a decoration on the exterior of architecture.

rune stone A stone used in early medieval northern Europe as a commemorative monument, which is carved or inscribed with runes, a writing system used by early Germanic peoples.

running spirals A decorative motif based on the shape formed by a line making a continuous spiral.

rustication In building, the rough, irregular, and unfinished effect deliberately given to the exterior facing of a stone edifice. Rusticated stones are often large and used for decorative emphasis around doors or windows, or across the entire lower floors of a building. Also, masonry construction with conspicuous, often beveled joints.

salon A large room for entertaining guésts; a periodic social or intellectual gathering, often of prominent people; a hall or **gallery** for exhibiting works of art.

sanctuary A sacred or holy enclosure used for worship. In ancient Greece and Rome, consisted of one or more temples and an altar. In Christian architecture, the space around the altar in a church called the chancel or presbytery.

sarcophagus (sarcophagi) A stone coffin. Often rectangular and decorated with **relief sculpture**.

scarab In Egypt, a stylized dung beetle associated with the sun and the god Amun.

school of artists An art historical term describing a group of artists, usually working at the same time and sharing similar styles, influences, and ideals. The artists in a particular school may not

necessarily be directly associated with one another, unlike those in a workshop or **atelier**.

scribe A writer;a person who copies texts.

scriptorium (scriptoria) A room in a monastery for writing or copying manuscripts.

scroll painting A painting executed on a rolled support. Rollers at each end permit the horizontal scroll to be unrolled as it is studied or the vertical scroll to be hung for contemplation or decoration.

seals Personal emblems usually carved of stone in intaglio or relief and used to stamp a name or legend onto paper or silk. They traditionally employ the archaic characters appropriately known as "seal script," of the Zhou or Qin. Cut in stone, a seal may state a formal givem name, or it may state any of the numerous personal names that China's painters and writers adopted throughout their lives. A treasured work of art often bears not only the seal of its maker but also those of collectors and admirers through the centuries. In the Chinese view, these do not disfigure the work but add another layer of interest.

seraph (seraphim) An angel of the highest rank in the Christian hierarchy.

serdab In Egyptian tombs, the small room in which the ka statue was placed.

sfumato Italian term meaning "smoky," soft, and mellow. In painting, the effect of haze in an image. Resembling the color of the atmosphere at dusk, sfumato gives a smoky effect.

sgraffito Decoration made by incising or cutting away a surface layer of material to reveal a different color beneath.

shaft The main vertical section of a column between the capital and the base, usually circular in cross section.

shaftgrave A deep pit used for burial.

shoji A standing Japanese screen covered in translucent rice paper and used in interiors.

sinopia The preparatory design or underdrawing of a **fresco**. Also: a reddish chalklike earth pigment.

site-specific sculpture A sculpture commissioned and/or designed for a particular spot.

spandrel The area of wall adjoining the exterior curve of an arch between its **springing** and the **keystone**, or the area between two arches, as in an **arcade**.

springing The point at which the curve of an arch or vault meets with and rises from its support.

squinch An **arch** or lintel built across the upper corners of a square space, allowing a circular or polygonal **dome** to be more securely set above the walls.

stained glass Molten glass is given a color that becomes intrinsic to the material. Additional colors may be fused to the surface (flashing). Stained glass is most often used in windows, for which small pieces of differently colored glass are precisely cut and assembled into a design, held together by cames. Additional painted details may be added to create images.

stele (stelae) A stone slab placed vertically and decorated with inscriptions or reliefs. Used as a grave marker or memorial.

stereobate A foundation upon which a Classical temple stands.

still life A type of painting that has as its subject inanimate objects (such as food, dishes, fruit, or

stoa In Greek architecture, a long roofed walkway, usually having columns on one long side and a wall on the other.

stoneware A high-fired, vitrified, but opaque **ceramic** ware that is fired in the range of 1,100 to 1,200 degrees Celsius. At that temperature, particles of silica in the clay bodies fuse together so that the finished vessels are impervious to liguids, even without **glaze**. Stoneware pieces are glazed to enhance their aesthetic appeal and to aid in keeping them clean (since unglazed ceramics are easily soiled). Stoneware occurs in a range of earth-toned colors, from white and tan to gray and black, with light gray predominating. Chinese potters were the first in the world to produce stoneware, which they were able to make as early as the Shang dynasty.

stucco A mixture of lime, sand, and other ingredients into a material that can be easily molded or modeled. When dry, produces a very durable surface used for covering walls or for architectural sculpture and decoration.

stylobate In Classical architecture, the stone foundation on which a temple **colonnade** stands.

stylus An instrument with a pointed end (used for writing and printmaking), which makes a delicate line or scratch. Also: a special writing tool for **cuneiform** writing with one pointed end and one triangular wedge end.

sublime Adjective describing a concept, thing, or state of high spiritual, moral, or intellectual value; or something awe-inspiring. The sublime was a goal to which many nineteenth-century artists aspired in their artworks.

sunken relief See relief sculpture.

syncretism In religion or philosophy, the union of different ideas or principles.

tapestry Multicolored pictorial or decorative weaving meant to be hung on a wall or placed on furniture.

tempera A painting medium made by blending egg yolks with water, pigments, and occasionally other materials, such as glue.

tenebrism The use of strong **chiaroscuro** and artificially illuminated areas to create a dramatic contrast of light and dark in a painting.

terra cotta A medium made from clay fired over a low heat and sometimes left unglazed. Also: the orange-brown color typical of this medium.

tessera (tesserae) The small piece of stone, glass, or other object that is pieced together with many others to create a mosaic.

tetrarchy Four-man rule, as in the late Roman Empire, when four emperors shared power.

thatch A roof made of plant materials.

thermo-luminescence dating A technique that measures the irradiation of the crystal structure of material such as flint or pottery and the soil in which it is found, determined by luminescence produced when a sample is heated.

tholos A small, round building. Sometimes built underground, as in a Mycenaean tomb.

thrust The outward pressure caused by the weight of a vault and supported by buttressing. *See* **arch**.

tierceron In **vault** construction, a secondary rib that arcs from a **springing** point to the rib that runs

lengthwise through the vault, called the ridge rib.

tondo A painting or relief sculpture of circular

tondo A painting or **relief sculpture** of circular shape.

tracery Stonework or woodwork applied to wall surfaces or filling the open space of windows. In **plate tracery**, opening are cut through the wall. In **bar tracery**, **mullions** divide the space into vertical segments and form decorative patterns at the top of the opening or panel.

transept The arm of a cruciform church, perpendicular to the **nave**. The point where the nave and transept cross is called the crossing. Beyond the crossing lies the **sanctuary**, whether **apse**, choir, or chevet.

travertine A mineral building material similar to limestone, typically found in central Italy.

triglyph Rectangular block between the **metopes** of a **Doric frieze**. Identified by the three carved vertical grooves, which approximate the appearance of the end of a wooden beam.

triptych An artwork made up of three panels. The panels may be hinged together so the side segments (**wings**) fold over the central area.

trompe Poeil A manner of representation in which the appearance of natural space and objects is re-created with the express intention of fooling the eye of the viewer, who may be convinced that the subject actually exists as three-dimensional reality.

trumeau A column, pier, or post found at the center of a large portal or doorway, supporting the lintel.

tugra A calligraphic imperial monogram used in Ottoman courts.

Tuscan order See order.

twisted perspective A convention in art in which every aspect of a body or object is represented from its most characteristic viewpoint.

vanishing point In a perspective system, the point on the horizon line at which orthogonals meet. A complex system can have multiple vanishing points

vanitas An image, especially popular in Europe during the seventeenth century, in which all the objects symbolize the transience of life. Vanitas paintings are usually of still lifes or genre subjects.

vault An arched masonry structure that spans an interior space. Barrel or tunnel vault: an elongated or continuous semicircular vault, shaped like a half-cylinder. Corbeled vault: a vault made by projecting courses of stone. Groin or cross vault: a vault created by the intersection of two barrel vaults of equal size which creates four side compartments of identical size and shape. Quadrant or half-barrel vault: as the name suggests, a half-barrel vault. Rib vault: ribs (extra masonry) demarcate the junctions of a groin vault. Ribs may function to reinforce the groins or may be purely decorative. See also corbeling.

veduta (vedute) Italian for "vista" or "view." Paintings, drawings, or prints often of expansive city scenes or of harbors.

vellum A fine animal skin prepared for writing and painting. See also parchment

veneer In architecture, the exterior facing of a building, often in decorative patterns of fine stone or brick. In decorative arts, a thin exterior layer of finer material (such as rare wood, ivory, metal, and semi-precious stones) laid over the form.

verism A style in which artists concern themselves with capturing the exterior likeness of an object or person, usually by rendering its visible details in a finely executed, meticulous manner.

vihara From the Sanskrit term meaning "for wanderers." A vihara is, in general, a Buddhist monastery in India. It also signifies monks' cells and gathering places in such a monastery.

volute A spiral scroll, as seen on an Ionic capital.
 votive figure An image created as a devotional offering to a god or other deity.

voussoirs The oblong, wedge-shaped stone blocks used to build an **arch**. The topmost voussoir is called a **keystone**.

warp The vertical threads in a weaver's loom. Warp threads make up a fixed framework that provides the structure for the entire piece of cloth, and are thus cften thicker than weft threads. See also weft.

wash A diluted watercolor or ink. Often washes are applied to drawings or prints to add tone or touches of color.

wattle and daub A wall construction method combining upright branches, woven with twigs (wattles) and plastered or filled with clay or mud (daub).

weft The horizontal threads in a woven piece of cloth. Weft threads are woven at right angles to and through the warp threads to make up the bulk of the decorative pattern. In carpets, the weft is often completely covered or formed by the rows of trimmed knots that form the carpet's soft surface. See also warp.

white-ground A type of ancient Greek pottery in which the background color of the object is painted with a slip that turns white in the firing process. Figures and details were added by painting on or incising into this slip. White-ground wares were popular in the Classical period as funerary objects.

wing A side panel of a **triptych** or **polyptych** (usually found in pairs), which was hinged to fold over the central panel. Wings often held the depiction of the donors and/or subsidiary scenes relating to the central image.

woodblock print A print made from one or more carved wooden blocks. In Japan, woodblock prints were made using multiple blocks carved in relief, usually with a block for each color in the £nished print. See also woodcut.

woodcut A type of print made by carving a design into a wooden block. The ink is applied to the block with a roller. As the ink remains only on the raised areas between the carvedaway lines, these carvedaway areas and lines provide the white areas of the print. Also: the process by which the woodcut is made.

ziggurat In Mesopotamia, a tall stepped tower of earthen materials, often supporting a shrine.

BIBLIOGR APHY

Susan V. Craig

This bibliography is composed of books in English that are appropriate "further reading" titles. Most items on this list are available in good libraries, whether college, university, or public institutions. I have emphasized recently published works so that the research information would be current. There are three classifications of lisings: general surveys and art history reference tools, including journals and Internet directories; surveys of large periods that encompass multiple chapters (ancient art in the Western tradition, European medieval art, European Renaissance through eighteenth-century art, modern art in the West); and books for individual chapters 1 through 21.

General Art History Surveys and Reference

- Adams, Laurie Schneider. Art across Time. 2nd ed. New York: McGraw-Hill 2002
- Barnet, Sylvan. A Short Guide to Writing about Art. 8th ed. New York: Pearson/Longman, 2005.
- Boströöm, Antonia. Encyclopedia of Sculpture. 3 vols. New York: FitzroyDearborn, 2004.
- Broude, Norma, and Garrard, Mary D., eds. Feminism and Art History: Questioning the Litany. Icon Editions. New York: Harper & Row, 1982.
- Chadwick, Whitney. Women, Art, and Society. 3rd ed. New York: Thames and Hudson, 2002.
- Chilvers, Ian, ed. The Oxford Dictionary of Art. 3rd ed. New York: Oxford Univ. Press, 2004.
- Curl, James Stevens. A Dictionary of Architecture and Landscape Architecture. 2nd ed. Oxford: Oxford Univ. Press, 2006.
- Davies, Penelope J.E., et al. Janson's History of Art: The Western Tradition. 7th ed. Upper Saddle River, NJ: Prentice Hall, 2006.
- Dictionary of Art, The. 34 vols. New York: Grove's Dictionaries, 1996.
- Encyclopedia of World Art. 16 vols. New York: McGraw-Hill, 1972–83.
- Frank, Patrick, Duane Preble, and Sarah Preble. Preble's Artforms. 8th ed. Upper Saddle River, NJ: Prentice Hall, 2006.
- Gardner, Helen. Gardner's Art through the Ages. 12th ed. Ed. Fred S. Kleiner & Christin J. Manniya. Belmont, CA: Thomson/Wadsworth, 2005.
- Gaze, Delia, ed. Dictionary of Women Artists. 2 vols. London: Fitzroy Dearborn Publishers, 1997.
- Griffiths, Antony. Prints and Printmaking: An Introduction to the History and Techniques. 2nd ed. London: British Museum Press, 1996.
- Hadden, Peggy. The Quotable Artist. New York: Allworth Press, 2002.
- Hall, James. Illustrated Dictionary of Symbols in Eastern and Western Art. New York: Icon Editions, 1994.
- Holt, Elizabeth Gilmore, ed. A Documentary History of Art. 3 vols. New Haven: Yale Univ. Press, 1986.
- Honour, Hugh, and John Fleming. *The Visual Arts: A History*. 7th ed. Upper Saddle River, NJ: Prentice Hall, 2005.
- Hults, Linda C. The Print in the Western World: An Introductory History. Madison: Univ. of Wisconsin Press, 1996.
- Johnson, Paul. Art: A New History. New York: HarperCollins, 2003.
 Kaltenbach. G. E. Pronunciation Dictionary of Artists' Names. 3rd ed.
 Rev. Debra Edelstein. Boston: Little, Brown, and Co., 1993.
- Kemp, Martin. The Oxford History of Western Art. Oxford: Oxford Univ. Press, 2000.
- Kostof, Spiro. A History of Architecture: Settings and Rituals. 2nd ed. Rev. Greg Castillo. New York: Oxford Univ. Press, 1995.
- Mackenzie, Lynn. Non-Western Art: A Brief Guide. 2nd ed. Upper Saddle River, NJ: Prentice Hall, 2001.
- Marmor, Max, and Alex Ross, eds. Guide to the Literature of Art History 2. Chicago: American Library Association, 2005.
- Onians, John, ed. Atlas of World Art. New York: Oxford Univ. Press, 2004.
- Roberts, Helene, ed. Encyclopedia of Comparative Iconography: Themes Depicted in Works of Art. 2 vols. Chicago: Fitzroy Dearborn,
- Rogers, Elizabeth Barlow. Landscape Design: A Cultural and Architectural History. New York: Harry N. Abrams, 2001.
- Sayre, Henry M. Writing about Art. 5th ed. Upper Saddle River, NJ: Pearson/Prentice Hall, 2006.
- Sed-Rajna, Gabrielle. *Jewish Art*. Trans. Sara Friedman and Mira Reich. New York: Abrams, 1997.
- Slatkin, Wendy. Women Artists in History: From Antiquity to the Present. 4th ed. Upper Saddle River, NJ: Prentice Hall, 2000.
- Sutton, Ian. Western Architecture: From Ancient Greece to the Present. World of Art. New York: Thames and Hudson, 1999.

- Trachtenberg, Marvin, and Isabelle Hyman. Architecture: From Prehistory to Postmodernity. 2nd ed. Upper Saddle River, NJ: Prentice Hall. 2001.
- Tufts, Eleanor. Our Hidden Heritage: Five Centuries of Women Artists. New York: Paddington Press, 1974.
- West, Shearer. Portraiture. Oxford History of Art. Oxford: Oxford Univ. Press, 2004.
- Wilkins, David G., Bernard Schultz, and Katheryn M. Linduff. Art Past, Art Present. 5th ed. Upper Saddle River, NJ: Prentice Hall, 2005.
- Watkin, David. A History of Western Architecture. 4th ed. New York: Watson-Guptill Publications, 2005.

Art History Journals: A Select List of Current Titles

- African Arts. Quarterly. Los Angeles: Univ. of California at Los Angeles, James S. Coleman African Studies Center, 1967-
- American Art: The Journal of the Smithsonian American Art Museum. 3/year. Chicago: Univ. of Chicago Press, 1987–
- American Indian Art Magazine, Quarterly. Scottsdale, AZ: American Indian Art Inc, 1975-
- American Journal of Archaeology. Quarterly. Boston: Archaeological Institute of America, 1885–
- Antiquity: A Periodical of Archaeology. Quarterly. Cambridge, UK: Antiquity Publications Ltd, 1927-
- Apollo: The International Magazine of the Arts. Monthly. London: Apollo Magazine Ltd, 1925-
- Architectural History. Annually. Farnham, UK: Society of Architectural Historians of Great Britain, 1958–
- Archives of American Art Journal. Quarterly. Washington,
- D.C.:Archives of American Art, Smithsonian Institution, 1960-Archives of Asian Art. Annually. New York: Asia Society, 1945-
- Ars Orientalis: The Arts of Asia, Southeast Asia, and Islam. Annually. Ann Arbor: Univ. of Michigan Dept. of Art History, 1954-
- Art Bulletin. Quarterly. New York: College Art Association, 1913-Art History: Journal of the Association of Art Historians. 5/year. Oxford: Blackwell Publishing Ltd, 1978-
- Ant in America. Monthly. New York: Brant Publications Inc, 1913– Art Journal. Quarterly. New York: College Art Association, 1960– Ant Nexus. Quarterly. Bogata, Colombia: Arte en Colombia Ltda, 1976–
- Art Papers Magazine. Bi-monthly. Atlanta: Atlanta Art Papers Inc, 1976-
- Artforum International. 10/year. New York: Artforum International Magazine Inc, 1962-
- Artnews. 11/year. New York: Artnews LLC, 1902-
- Bulletin of the Metropolitan Museum of Art. Quarterly. New York: Metropolitan Museum of Art, 1905-.
- Burlington Magazine. Monthly. London: Burlington Magazine Publications Ltd, 1903-
- Dumbarton Oaks Papers. Annually. Locust Valley, NY: J. J. Augustin Inc, 1940-
- Flash Art International. Bimonthly. Trevi, Italy: Giancarlo Politi Editore, 1980-
- Gesta. Semiannually. New York: International Center of Medieval Art, 1963-
- History of Photography. Quarterly. Abingdon, UK: Taylor & Francis Ltd, 1976-
- International Review of African American Art. Quarterly. Hampton, VA: International Review of African American Art, 1976-
- Journal of Design History. Quarterly. Oxford: Oxford Univ. Press, 1988-
- Journal of Egyptian Archaeology. Annually. London: Egypt Exploration Society, 1914-
- Journal of Hellenic Studies. Annually. London: Society for the Promotion of Hellenic Studies, 1880-Journal of Roman Archaeology. Annually. Portsmouth, R.I: Journal of
- Roman Archaeology LLC, 1988– Journal of the Society of Architectural Historians. Quarterly. Chicago:
- Society of Architectural Historians, 1940– Journal of the Warburg and Courtauld Institutes. Annually. London:
- Warburg Institute, 1937-Leonardo: Art, Science and Technology. 6/year. Cambridge, MA: MIT
- Press, 1968-
- Marg. Quarterly. Mumbai, India: Scientific Publishers, 1946– Master Drawings. Quarterly. New York: Master Drawings Association, 1963–
- October. Cambridge, MA: MIT Press, 1976-
- Oxford Art Journal. 3/year. Oxford: Oxford Univ. Press, 1978– Parkett. 3/year. Züürich, Switzerland: Parkett Verlag AG, 1984–
- Print Quarterly. Quarterly. London: Print Quarterly Publications,

- Simiolus: Netherlands Quarterly for the History of Art. Quarterly. Apeldoorn, Netherlands: Stichting voor Nederlandse Kunsthistorische Publicaties. 1966-
- Woman's Art Journal. Semiannually. Philadelphia: Old City Publishing Inc, 1980-

Internet Directories for Art History Information ARCHITECTURE AND BUILDING

http://library.nevada.edu/arch/rsrce/webrsrce/contents.html

A directory of architecture websites collected by Jeanne Brown at the Univ. of Nevada at Las Vegas. Topical lists include architecture, building and construction, design, history, housing, planning, preservation, and landscape architecture. Most entries include a brief annotation and the last date the link was accessed by the compiler.

ART HISTORY RESOURCES ON THE WEB http://witcombe.sbc.edu/ARTHLinks.html

Authored by Christopher L. C. E. Witcombe of Sweet Briar College in Virginia since 1995, the site includes an impressive number of links for various art historical eras as well as links to research resources, museums, and galleries. The content is frequently undated.

ART IN FLUX: A DIRECTORY OF RESOURCES FOR RESEARCH IN CONTEMPORARY ART

http://www.boisestate.edu/art/artinflux/intro.html

Cheryl K. Shutleff of Boise State Univ. in Idaho has authored this directory, which includes sites selected according to their relevance to the study of national or international contemporary art and artists. The subsections include artists, museums, theory, reference, and links.

ARTCYCLOPEDIA: THE FINE ARTS SEARCH ENGINE

With over 2,100 art sites and 75,000 links, this is one of the most comprehensive web directories for artists and art topics.

The primary searching is by artist's name but access is also available by artistic movement, nation, timeline and medium.

MOTHER OF ALL ART HISTORY LINKS PAGES http://www.art-design.umich.edu/mother/

Maintained by the Dept. of the History of Art at the Univ. of Michigan, this directory covers art history departments, art museums, fine arts schools and departments as well as links to research resources. Each entry includes annotations.

VOICE OF THE SHUTTLE

http://vos.ucsb.edu

Sponsored by Univ. of California, Santa Barbara, this directory includes over 70 pages of links to humanities and humanities-related resources on the Internet. The structured guide includes specific sub-sections on architecture, on art (modern & contemporary), and on art history. Links usually include a one sentence explanation and the resource is frequently updated with new information.

YAHOO! ARTS>ART HISTORY

http://dir.yahoo.com/Arts/Art_History/

Another extensive directory of art links organized into subdivisions with one of the most extensive being "Periods and Movements." Links include the name of the site as well as a few words of explanation.

Ancient Art in the Western Tradition, General

- Amiet, Pierre. Art in the Ancient World: A Handbook of Styles and Forms. New York: Rizzoli, 1981.
- Beard, Mary, and John Henderson. Classical Art: From Greece to Rome. Oxford History of Art. Oxford: Oxford Univ. Press, 2001.
- Boardman, John. Oxford History of Classical Art. New York: Oxford Univ. Press, 2001.
- Chitham, Robert. The Classical Orders of Architecture. 2nd ed. Boston: Elsevier/Architectural Press, 2005.
- Ehrich, Robert W., ed. Chronologies in Old World Archaeology. 3rd ed. 2 vols. Chicago: Univ. of Chicago Press, 1992.
- Gerster, Georg. The Past from Above: Aerial Photographs of Archaeological Sites. Ed. Charlotte Trüümpler. Trans.
- Stewart Spencer. Los Angeles: The J. Paul Getty Museum, 2005. Groenewegen-Frankfort, H. A., and Bernard Ashmole. Art of the
- Ancient World: Painting, Pottery, Sculpture, Architecture from Egypt, Mesopotamia, Crete, Greece, and Rome. Library of Art History. Upper Saddle River, NJ: Prentice Hall, 1972.

- Haywood, John. The Penguin Historical Atlas of Ancient Civilizations. New York: Penguin, 2005.
- Lloyd, Seton, and Hans Wolfgang Muller. Ancient Architecture. New York: Rizzoli, 1986.
- Milleker, Elizabeth J., ed. *The Year One: Art of the Ancient World East* and West. New York: Metropolitan Museum of Art. 2000.
- Nagle, D. Brendan. The Ancient World: A Social and Cultural History. 6th ed. Upper Saddle River, NJ: Pearson Prentice Hall, 2006.
- Romer, John, and Elizabeth Romer. The Seven Wonders of the World: A History of the Modern Imagination. New York: Henry Holt, 1995.
- Saggs, H.W. F. Civilization before Greece and Rome. New Haven: Yale Univ. Press, 1989.
- Smith, William Stevenson. Interconnections in the Ancient Near East: A Study of the Relationships between the Arts of Egypt, the Aegean, and Western Asia. New Haven: Yale Univ. Press, 1965.
- Tadgell, Christopher. Imperial Form: From Achaemenid Iran to Augustan Rome. New York: Whitney Library of Design, 1998.
- ——. Origins: Egypt, West Asia and the Aegean. New York: Whitney Library of Design, 1998.
- Trigger, Bruce G. Understanding Early Civilizations: A Comparative Study. New York: Cambridge Univ. Press, 2003.
- Winckelmann, Johann Joachim. History of the Art of Antiquity. Trans. Harry Francis Mallgrave. Texts & Documents. Los Angeles: Getty Research Institute, 2006.
- Woodford, Susan. The Art of Greece and Rome. 2nd ed. New York: Cambridge Univ. Press, 2004.

European Medieval Art, General

- Backman, Clifford R. *The Worlds of Medieval Europe*. New York: Oxford Univ. Press, 2003.
- Bennett, Adelaide Louise, et al. Medieval Mastery: Book Illumination from Charlemagne to Charles the Bold: 800-1475. Trans. Lee Preedy and Greta Arblaster-Holmer. Turnhout: Brepols, 2002.
- Benton, Janetta Rebold. Art of the Middle Ages. World of Art. New York: Thames & Hudson, 2002.
- Binski, Paul. Painters. Medieval Craftsmen. London: British Museum Press, 1992.
- Brown, Sarah, and David O'Connor. *Glass-painters*. Medieval Craftsmen. London: British Museum Press, 1992.
- Calkins, Robert C. Medieval Architecture in Western Europe: From A.D. 300 to 1500. 1v. CD-ROM. New York: Oxford Univ. Press, 1998.
- Cherry, John F. *Goldsmiths*. Medieval Craftsmen. London: British Museum Press, 1992.
- Clark, William W., Medieval Cathedrals. Greenwood Guides to Historic Events of the Medieval World. Westport, CT: Greenwood Press, 2006.
- Coldstream, Nicola. Masons and Sculptors. Medieval Craftsmen. London: British Museum Press, 1991.
- ——. Medieval Architecture. Oxford History of Art. Oxford: Oxford Univ. Press, 2002.
- De Hamel, Christopher. Scribes and Illuminators. Medieval Craftsmen. London: British Museum Press, 1992.
- Duby, Georges. Art and Society in the Middle Ages. Trans. Jean Birrell. Malden, MA: Blackwell Publishers, 2000.
- —--. Sculpture: The Great Art of the Middle Ages from the Fifth to the Fifteenth Century. New York: Skira/Rizzoli, 1990.
 Eames, Elizabeth S. English Tilers. Medieval Craftsmen, London:
- British Museum Press, 1992.
 Fossier, Robert, ed. The Cambridge Illustrated History of the Middle
- Fossier, Robert, ed. Ine Cambridge Intistrated ristory of the Middle Ages. Trans. Janet Sondheimer & Sarah Hanbury Tenison. 3 vols. Cambridge, U.K.: Cambridge Univ. Press, 1986–97.
- Hurlimann, Martin, and Jean Bony. French Cathedrals. Rev. & enlg. London: Thames and Hudson, 1967.
- Jotischky, Andrew, and Caroline Susan Hull. The Penguin Historical Atlas of the Medieval World. New York: Penguin, 2005.
- Kenyon, John. Medieval Fortifications. Leicester: Leicester Univ. Press, 1990.
- Labarge, Margaret Wade. A Small Sound of the Trumpet: Women in Medieval Life. London: Hamilton, 1990.
- Pfaffenbichler, Matthias. Armourers. Medieval Craftsmen. London:
 British Museum Press, 1992.
 Rebold Benton, Janetta. Art of the Middle Ages. World of Art. New
- York: Thames & Hudson, 2002.
 Sekules, Veronica. Medieval Art. Oxford History of Art. New York:
- Sekules, Veronica. Medieval Art. Oxford History of Art. New York: Oxford Univ. Press, 2001.
- Snyder, James, Henry Luttikhuizen, and Dorothy Verkerk. Art of the Middle Ages. 2nd ed. Upper Saddle River, NJ: Prentice Hall, 2006.
- Staniland, Kay. Embroiderers. Medieval Craftsmen. London: British Museum Press, 1991.
- Stokstad, Marilyn. Medieval Art. 2nd ed. New York: Westview, 2004.

 ——. Medieval Castles. Greenwood Guides to Historic Events of the Medieval World. Westport, CT: Greenwood Press,
- Wixom, William D., ed. Mirror of the Medieval World. New York: Metropolitan Museum of Art, 1999.

European Renaissance through Eighteenth-Century Art, General

- Black, C. F., et al. *Cultural Atlas of the Renaissance*. New York: Prentice Hall General Reference, 1993.
- Blunt, Anthony. Art and Architecture in France, 1500–1700. 5th ed. Rev. Richard Beresford. Pelican History of Art. New Haven: Yale Univ. Press, 1999.
- Brown, Jonathan. *Painting in Spain: 1500–1700*. Pelican History of Art. New Haven: Yale Univ. Press, 1998.
- Cole, Bruce. Italian Art, 1250–1550: The Relation of Renaissance Art to Life and Society. New York: Harper & Row, 1987.
- Graham-Dixon, Andrew. Renaissance. Eerkeley: Univ. of California Press, 1999.
- Harbison, Craig. The Mirror of the Artisi: Northern Renaissance Art in Its Historical Context. Perspectives. New York: Abrams, 1995.
- Harris, Ann Sutherland. Seventeenth-Century Art & Architecture.

 Upper Saddle River, NJ: Pearson Prentice Hall, 2005
- Harrison, Charles, Paul Wood, and Jason Gaiger. Art in Theory 1648–1815: An Anthology of Changing Ideas. Oxford: Blackwell, 2000.
- Hartt, Frederick, and David G. Wilkins. History of Italian Renaissance Art: Painting, Sculpture, Architecture. 6th ed. Upper Saddle River, NJ: Prentice Hall, 2007.
- Jestaz, Bertrand. The Art of the Renaissance. Trans. I. Mark Paris. New York: Abrams, 1995.
- Levenson, Jay A., ed. Circa 1492: Art in the Age of Exploration. Washington: National Gallery of Art, 1991.
- McCorquodale, Charles. The Renaissance: European Painting, 1400–1600. London: Studio Editions, 1994.
- Minor, Vernon Hyde. Baroque & Rococo: Art & Culture. New York: Abrams, 1999. Murrav, Peter. Renaissance Architecture. History of World Architec-
- ture. Milan: Electa, 1985.
- Paoletti, John T., and Gary M. Radke. Art in Renaissance Italy. 3rd ed. Upper Saddle River, NJ: Prentice Hall, 2006.
- Ripa, Cesare. Baroque and Rococo Pictorial Imagery: The 1758-60 Hertel Edition of Ripa's 'Iconologia. Introd., transl., & commentaries Edward A. Maser. The Dover Pictorial Archives Series. New York: Dover Publications, 1991
- Smith, Jeffrey Chipps. *The Northern Renaissance*. Art & Ideas. New York: Phaidon Press, 2004.
- Stechow, Wolfgang. Northern Renaissance, 1400–1600: Sources and Documents. Upper Saddle River, NJ: Prentice Hall, 1966.
- Summerson, John. Architecture in Britain, 1530–1830. 9th ed. Yale Univ. Press Pelican History of Art. New Haven: Yale Univ. Press, 1993.
- Waterhouse, Ellis K. Painting in Britain, 1530 to 1790. 5th ed. Yale Univ. Press Pelican History of Art. New Haven: Yale Univ. Press. 1994.
- Whinney, Margaret Dickens. Sculpture in Britain: 1530–1830. 2nd ed. Rev. John Physick. Pelican History of Art. London: Penguin, 1988.

Modern Art in the West, General

- Arnason, H. Harvard. Histery of Modern Art: Painting, Sculpture, Architecture, Photography. 5th ed. Rev. Peter Kalb. Upper Saddle River, NI: Prentice Hall, 2004.
- Ballantyne, Andrew, ed. Architectures: Modernism and After. New Interventions in Art History, 3. Malden, MA: Blackwell, 2004. Barnitz, Jacqueline. Twentieth- Century Art of Latin America. Austin:
- Univ. of Texas Press, 2001. Bjelajac, David. *American Art: A Cultural History*. Rev. & exp. ed.
- Upper Saddle River, NJ: Prent.ce Hall, 2005.

 Bowness, Alan. Modern European Ast. World of Art. New York:
 Thames and Hudson. 1995.
- Brettell, Richard R. Modern Art, 1851–1929: Capitalism and Representation. Oxford History of Art. Oxford: Oxford Univ. Press, 1999.
- Chipp, Herschel Browning. Theories of Modern Art: A Source Book by Artists and Critics. California Studies in the History of Art. Berkeley: Univ. of California Press, 1984.
- Clarke, Graham. The Photograph. Oxford History of Art. Oxford: Oxford Univ. Press, 1997.
- Craven, David. Art and Revolution in Latin America, 1910-1990. New Haven: Yale Univ. Press, 2002.
- Craven, Wayne. American Art: History and Culture. Rev. ed. Boston: McGraw-Hill, 2003.
- Doordan, Dennis P. Tiventieth-Century Architecture. New York: Abrams, 2002.
- Doss, Erika. Twentieth-Century American Art. Oxford: Oxford Univ. Press, 2002.
- Edwards, Steve, and Paul Wood, eds. Art of the Avant-Gardes. Art of the 20th Century. New Haven: Yale Univ. Press in assoc. with the Open Univ., 2004.
- Foster, Hal, et al. Art Since 1900: Modernism, Antimodernism, Postmodernism. New York: Thames & Hudson, 2004.
- Gaiger, Jason, ed. Frameworks for Modern Art. Art of the 20th Century. New Haven: Yale Univ. Press in assoc. with the Open Univ., 2003.

- ——, and Paul Wood, eds. Art of the Twentieth Century: A Reader. New Haven: Yale Univ. Press, 2003
- Hamilton, George Heard. Painting and Sculpture in Europe, 1880–1940. 6th ed. Pelican History of Art. New Haven: Yale Univ. Press, 1993.
- Hummacher, A. M. Modern Sculpture: Tradition and Innovation. Enlg. ed. New York: Abrams, 1988.
- Harrison, Charles, and Paul Wood, eds. Art in Theory: 1900–2000: An Anthology of Changing Ideas. 2nd ed. Oxford: Blackwell, 2002.
- Hunter, Sam, John Jacobus, and Daniel Wheeler. Modern Art: Painting, Sculpture, Architecture, Photography. 3rd rev. & exp. ed. Upper Saddle River, NJ: Prentice Hall, 2004.
- Krauss, Rosalinde. Passages in Modern Sculpture. Cambridge, MA: MIT Press, 1977.
- Mancini, JoAnne Marie. Pre-Modernism: Art-World Change and American Culture from the Civil War to the Armory Show. Princeton: Princeton Univ. Press, 2005.
- Marien, Mary Warner. Photography: A Cultural History. New York: Harry N. Abrams, 2002.
- Meecham, Pam, and Julie Sheldon. Modern Art: A Critical Introduction. 2nd ed. New York: Routledge, 2005.
- Newlands, Anne. Canadian Art: From Its Beginnings to 2000. Willowdale, Ont.: Firefly Books, 2000.
- Harris, Ann Sutherland, and Linda Nochlin. Women Arists: 1550–1950. Los Angeles: Los Angeles County Museum of Art, 1976
- The Phaidon Atlas of Contemporary World Architecture. London: Phaidon, 2004.
- Powell, Richard J. Black Art: A Cultural History. 2nd ed. World of Art. New York: Thames and Hudson, 2002.
- Rosenblum, Naomi. A World History of Photography. 3rd ed. New York: Abbeville, 1997.
- Ruhrberg, Karl. Art of the 20th Century. Ed. Ingo E Walther. 2 vols. New York: Taschen, 1998
- Scully, Vincent Joseph. Modern Architecture and Other Essays. Princeton: Princeton Univ. Press, 2003
- Stiles, Kristine, and Peter Howard Selz. Theories and Documents of Contemporary Art: A Scurcebook of Artists' Writings. California Studies in the History of Art, 35. Berkeley: Univ. of California Press, 1996.
- Tafuri, Manfredo. Modern Architecture. History of World Architecture. 2 vols. New York: Electa/Rizzoli, 1986.
- Traba, Marta. Art of Latin America, 1900-1980. Washington, D.C.:Inter-American Development Bank, 1994.
- Upton, Dell. Architecture in the United States. Oxford History of Art. Oxford: Oxford Univ. Press. 1998.
- Wood, Paul, ed. Varieties of Modernism. Art of the 20th Century. New Haven: Yale Univ. Press in assoc. with the Open Univ., 2004.
- Woodham, Jonathan M. Twentieth Century Design. Oxford History of Art. Oxford: Oxford Univ. Press, 1997.

CHAPTER 1 Prehistoric Art in Europe

- Aujoulat, Norbert. Lascaux: Movement, Space, and Time. New York: H. N. Abrams, 2005.
- Bahn Paul G. The Cambridge Illustrated History of Prehistoric Art. Cambridge Illustrated History. Cambridge, U.K.: Cambridge Univ. Press. 1998.
- Bataille, Georges. The Cradle of Humanity: Prehistoric Art and Culture. Ed. and intro. Stuart Kendall. Trans. Michelle Kendall & Stuart Kendall. New York: Zone Books, 2005
- Berghaus, Gunter. New Perspectives on Prehistoric Art. Westport, CT: Praeger, 2004
- Chippindale, Christopher. Stonehenge Complete. 3rd ed. New York: Thames and Hudson, 2004.
- Clottes, Jean. Chauvet Cave: The Art of Earliest Times. Salt Lake City: Univ. of Utah Press, 2003.
- ——, and J. David Lewis-Williams. The Shamans of Prehistory: Trance and Magic in the Painted Caves. Trans. Sophie Hawkes. New York: Harry N. Abrams, 1998.
- Cunliffe, Barry W, ed. The Oxford Illustrated History of Prehistoric Europe. New York: Oxford Univ. Press, 2001.
- Forte, Maurizio, and Alberto Siliotti. Virtual Archaeology: Re-Creating Ancient Worlds. New York: Abrams, 1997.
- Freeman, Leslie G. Altamira Revisited and Other Essays on Early Art. Chicago: Institute for Prehistoric Investigation, 1987.
- Gowlett, John A. J. Ascent to Civilization: The Archaeology of Early Humans. 2nd ed. New York: McGraw-Hill, 1993.
- Guthrie, R. Dale. *The Nature of Paleolithic Art.* Chicago: Univ. of Chicago Press, 2005.
- Jope, E. M. Early Celtic art in the British Isles. 2 vols New York: Oxford Univ. Press, 2000.
 Lealon P. Schard F. and P. com Lewin. Oxidia. Prescriptoral Islands.
- Leakey, Richard E. and Roger Lewin. Origins Reconsidered: In Search of What Makes Us Human. New York: Doubleday, 1992.

- Leroi-Gourhan, Andréé. The Dawn of European Art: An Introduction to Paleolithic Cave Painting. Trans. Sara Champion. Cambridge, U.K.: Cambridge Univ. Press, 1982.
- Lewis-Williams, J. David. The Mind in the Cave: Consciousness and the Origins of Art. New York: Thames & Hudson, 2002.
- Marshack, Alexander. The Roots of Civilization: The Cognitive Beginnings of Man's First Art, Symbol, and Notation. New York: McGraw-Hill, 1972.
- Megaw, Ruth, and Vincent Megaw. Celtic Art: From Its Beginnings to the Book of Kells. Rev. and exp. ed. New York: Thames and Hudson, 2001.
- O'Kelly, Michael J. Newgrange: Archaeology, Art, and Legend. New Aspects of Antiquity. London: Thames and Hudson, 1982.
- Price, T. Douglas, and Gray M. Feinman. *Images of the Past*. 3rd ed. Mountain View, CA: Mayfield, 2000.
- Renfrew, Colin, ed. *The Megalithic Monuments of Western Europe*. London: Thames and Hudson, 1983.
- Ruspoli, Mario. The Cave of Lascaux: The Final Photographs. New York: Abrams, 1987.
- Sandars, N. K. Prehistoric Art in Europe. 2nd ed. Pelican History of Art. New Haven: Yale Univ. Press, 1992.
 Sura Ramos, Pedro A. The Cave of Altamira. Gen. Ed. Antonio Bel-
- tran. New York: Abrams, 1999.
 Sieveking Ann The Cave Artists Ancient People and Places vol
- Sieveking, Ann. *The Cave Artists*. Ancient People and Places, vol. 93. London: Thames and Hudson, 1979.
- White, Randall. Prehistoric Art: The Symbolic Journey of Humankind. New York: Harry N. Abrams, 2003.

CHAPTER 2 Art of the Ancient Near East

- Akurgal, Ekrem. Ancient Civilizations and Ruins of Turkey: From Prehistoric Times until the End of the Roman Empire. 5th ed. London: Kegan Paul, 2002.
- Aruz, Joan, ed. Art of the First Cities: The Third Millennium B.C. from the Mediterranean to the Indus. New York: Metropolitan Museum of Art, 2003.
- Bahrani, Zainab. The Graven Image: Representation in Babylonia and Assyria. Archaeology, Culture, and Society Series. Philadelphia: Univ. of Pennsylvania Press, 2003.
- Boardman, John. Persia and the West: An Archaeological Investigation of the Genesis of Achaemenid Art. New York: Thames & Hudson, 2000.
- Bottero, Jean. Everyday Life in Ancient Mesopotamia. Trans. Antonia Nevill. Baltimore, MD.: Johns Hopkins Univ. Press, 2001.
- Charvat, Petr. Mesopotamia before History. Rev. & updated ed. New York: Routledge, 2002.
- Collon, Dominque. Ancient Near Eastern Art. Berkeley: Univ. of California Press, 1995.
- Crawford, Harriet. Sumer and the Sumerians. 2nd ed. New York: Cambridge Univ. Press, 2004.
- Curtis, J.E., and J. E. Reade, eds. Art and Empire: Treasures from Assyria in the British Museum. New York: Metropolitan Museum of Art, 1995.
- Curtis, John, and Nigel Tallis, eds. Forgotten Empire: The World of Ancient Persia. Berkeley: Univ. of California Press, 2005.
- Downey, Susan B. Mesopotamian Religious Architecture: Alexander through the Parthians. Princeton: Princeton Univ. Press, 1988. Ferrier, R. W., ed. Arts of Persia. New Haven: Yale Univ. Press, 1989.
- Frankfort, Henri. The Art and Architecture of the Ancient Orient. 5th ed. Pelican History of Art. New Haven: Yale Univ. Press, 1996.
- Haywood, John. Ancient Civilizations of the Near East and Mediterranean. London: Cassell, 1997.
- Lloyd, Seton. Ancient Turkey: A Traveller's History of Anatolia. Berkeley: Univ. of California Press, 1989.
- Meyers, Eric M., ed. The Oxford Encyclopedia of Archaeology in the Near East. 5 vols. New York: Oxford Univ. Press, 1997.
- Moorey, P. R., S. Idols of the People: Miniature Images of Clay in the Ancient Near East. The Schweich Lectures of the British Academy; 2001. New York: Oxford Univ. Press, 2003.
- Polk, Milbry, and Angela M. H. Schuster. The Looting of the Inaq Museum, Baghdad: The Lost Legacy of Ancient Mesopotamia. New York: Harry N. Abrams, 2005.
- Reade, Julian. Assyrian Sculpture. Cambridge, MA: Harvard Univ. Press, 1999.
- Roaf, Michael. Cultural Atlas of Mesopotamia and the Ancient Near East. New York: Facts on File, 1990.
- Roux, Georges. Ancient Inaq. 3rd ed. London: Penguin, 1992.
 Zettler, Richard L., and Lee Horne, ed. Treasures from the Royal Tombs of Ur. Philadelphia: Univ. of Pennsylvania, Museum of Archaeology and Anthropology, 1998.

CHAPTER 3 Art of Ancient Egypt

- Arnold, Dieter. Temples of the Last Pharaohs. New York: Oxford Univ. Press, 1999.
- Arnold, Dorothea. When the Pyramids Were Built: Egyptian Art of the Old Kingdom. New York: Metropolitan Museum of Art, 1999.

- Baines, John, and Jaromíír Máálek. Cultural Atlas of Ancient Egypt. Rev. ed. New York: Facts on File, 2000.
- Brier, Bob. Egyptian Mummies: Unraveling the Secrets of an Ancient
- Casson, Lionel. Everyday Life in Ancient Egypt. Rev. & exp. ed. Baltimore, Md.: Johns Hopkins Univ. Press, 2001.
- Egyptian Art in the Age of the Pyramids. New York: Metropolitan Museum of Art, 1999.
- The Egyptian Book of the Dead: The Book of Going Forth by Day: Being the Papyrus of Ani (Royal Scribe of the Divine Offerings). Trans. Raymond O. Faulkner. 2nd rev. ed. San Francisco: Chronicle. 1998.
- Freed, Rita E. Sue D'Auria, and Yvonne J Markowitz. Pharaohs of the Sun: Akhenaten, Neferiti, Titankhamen. Boston: Museum of Fine Arts in assoc. with Bulfinch Press/Little, Brown and Co., 1999.
- Hawass, Zahi A. Tittankhamun and the Golden Age of the Pharaohs. Washington, D.C.: National Geographic, 2005.
- Johnson, Paul. The Civilization of Ancient Egypt. Updated ed. New York: HarperCollins, 1999.
- Kozloff, Arielle P., and Betsy M. Bryan. Egypt's Dazzling Sun: Amenhotep III and His World. Cleveland: Cleveland Museum of Art, 1992.
- Lehner, Mark. The Complete Pyramids: Solving the Ancient Mysteries. New York: Thames and Hudson, 1997.
- Máálek, Jaromir. Egypt: 4000 Years of Art. London: Phaidon, 2003.Pemberton, Delia. Ancient Egypt. Architectural Guides for Travelers. San Francisco: Chronicle, 1992.
- Robins, Gay. The Art of Ancient Egypt. Cambridge, MA: Harvard Univ. Press, 1997.
- Roehrig, Catharine H., Renee Dreyfus, and Cathleen A. Keller.

 Hatshepsut, from Queen to Pharaoh. New York: The Metropolitan Museum of Art, 2005.
- Russmann, Edna R. Egyptian Sculpture: Cairo and Luccor. Austin: Univ. of Texas Press, 1989.
- Smith, Craig B. How the Great Pyramid Was Built. Washington, D.C.: Smithsonian Books, 2004.
- Smith, W. Stevenson. The Art and Architecture of Ancient Egypt. 3rd ed. Rev. William Kelly Simpson. Pelican History of Art. New Haven: Yale Univ. Press, 1999.
- Strudwick, Nigel, and Helen Studwick. Thebes in Egypt: A Guide to the Tombs and Temples of Ancient Luxor. Ithaca, NY: Cornell Univ. Press, 1999.
- Thomas, Thelma K. Late Antique Egyptian Funerary Sculpture: Images for this World and for the Next. Princeton: Princeton Univ. Press, 2000.
- Tiradritti, Francesco. Ancient Egypt: Art, Architecture and History. Trans. Phil Goddard. London: British Museum, 2002.
- The Treasures of Ancient Egypt: From the Egyptian Museum in Cairo. New York: Rizzoli, 2003.
- Wilkinson, Richard H. The Complete Temples of Ancien: Egypt. New York: Thames & Hudson, 2000.
- ———. Reading Egyptian Art: A Hieroglyphic Guide to Ancient Egyptian Painting and Sculpture. London: Thames and Hudson, 1992.
- Ziegler, Cristiane, ed. *The Pharaohs*. New York: Rizzoli, 2002. Zivie-Coche, Christiane. *Sphinx: History of a Monument*. Trans. David Lorton, Ithaca. NY: Cornell Univ. Press. 2002.

CHAPTER 4 Aegean Art

- Barber, R. L. N. The Cyclades in the Bronze Age. Iowa City: Univ. of Iowa Press, 1987.
- Castleden, Rodney. The Knossos Labyrinth: A New View of the "Palace of Minos" at Knossos. London: Routledge, 1990.
- . Mycenaeans. New York: Routledge, 2005.
- Demargne, Pierre. The Birth of Greek Art. Trans. Stuart Gilbert & James Emmons. Arts of Mankind. New York: Golden, 1964.
- Dickinson. Oliver. The Aegean Bronze Age. Cambridge World
 Archaeology. Cambridge, U.K.: Cambridge Univ. Press, 1994.
- Doumas, Christos. *The Wall-Paintings of Thera*. 2nd ed. Trans. Alex Doumas. Athens: Kapon Editions, 1999.
- Fitton, J. Lesley. Cycladic Art. 2nd ed. London: British Museum, 1999.
- Getz-Gentle, Pat. Personal Styles in Early Cycladic Sculpture. Madison: Univ. of Wisconsin Press, 2001.
- Hamilakis, Yannis. ed. Labyrinth Revisited: Rethinking 'Minoan' Archaeology. Oxford: Oxbow, 2002.
- Higgins, Reynold. Minoan and Mycenean Art. Rev. ed. World of Art. New York: Thames and Hudson, 1997.
- Hitchcock, Louise. Minoan architecture: A Contextual Analysis. Studies in Mediterranean Archaeology and Literature, Pocket-Book, 155. Jonsered: P. ÅÅströöms Föörlag, 2000.
- Immerwahr, Sara Anderson. Aegean Painting in the Bronzε Age. University Park; Pennsylvania State Univ. Press, 1990.
- Preziosi, Donald, and Louise Hitchcock. Aggean Art and Architecture. Oxford History of Art. Oxford: Oxford Univ. Press, 1999.

CHAPTER 5 Art of Ancient Greece

- Barletta, Barbara A. The Origins of the Greek Architectural Orders. New York: Cambridge Univ. Press, 2001.
- Beard, Mary. The Parthenon. Cambridge, MA: Harvard Univ. Press, 2003.
- Belozerskaya, Marina, and Kenneth Lapatin. Ancient Greece: Art, Architecture, and History. Los Angeles: J. Paul Getty Museum, 2004.
- Boardman, John. Early Greek Vase Painting: 11th–6th Centuries

 B.C.: A Handbook. World of Art. London: Thames and Hudson,
 1998.
- Greek Sculpture: The Archaic Period: A Handbook. World of Art. New York: Thames and Hudson, 1991.
- Greek Sculpture: The Classical Period: A Handbook. London: Thames and Hudson, 1985.
- —. Greek Sculpture: The Late Classical Period and Sculpture in Colonies and Overseas. World of Art. New York: Thames and Hudson, 1995.
- The History of Greek Vases: Potters, Painters, and Pictures New York: Thames & Hudson, 2001.
- Burn, Lucilla. Hellenistic Art: From Alexander the Great to Augustus. London: British Museum Press, 2004.
- Camp, John M. The Athenian Agora: Excavations in the Heart of Classical Athens. New York: Thames and Hudson, 1986.
- Carpenter, Thomas H. Art and Myth in Ancient Greece: A Handbook.
 World of Art. London: Thames and Hudson, 1991.
- Clark, Andrew J., Maya Elston, Mary Louise Hart. Understanding Greek Vases: A Guide to Terms, Styles, and Techniques. Los Angeles: I. Paul Getty Museum. 2002.
- De Grummond, Nancy T. and Brunilde S. Ridgway. From Pergamon to Sperlonga: Sculpture in Context. Berkeley: Univ. of California Press, 2000.
- Donohue, A. A. Greek Sculpture and the Problem of Description. New York: Cambridge Univ. Press, 2005.
- Fullerton, Mark D. Greek Art. Cambridge, U.K.: Cambridge Univ.
- Hurwit, Jeffrey M. The Art and Culture of Early Greece 1100–480 B.C. Ithaca, NY: Cornell Univ. Press, 1985.
- ______, and Adam D. Newton. *The Acropolis in the Age of Pericles*. 1

 v. & CD-ROM, New York: Cambridge Univ. Press, 2004.
- Karakasi, Katerina. Archaic Korai. Los Angeles: The J. Paul Getty Museum, 2003.
- Lagerlof, Margaretha Rossholm. The Sculptures of the Parthenon:
 Aesthetics and Interpretation. New Haven:Yale Univ. Press, 2000.
- Lawrence, A. W. Greek Architecture. 5th ed. Rev. R. A. Tomlinson.
 Pelican History of Art. New Haven: Yale Univ. Press, 1996.
- Martin, Roland. Greek Architecture: Architecture of Crete, Greece, and the Greek World. History of World Architecture. New York: Electa/Rizzoli, 1988.
- Osborne, Robin. Archaic and Classical Greek Art. Oxford History of Art. Oxford: Oxford Univ. Press, 1998.
- Palagia, Olga. ed. Greek Sculpture: Function, Materials, and Techniques in the Archaic and Classical Periods. New York: Cambridge Univ. Press. 2006.
- ——, and J.J. Pollitt., eds. Personal Styles in Greek Sculpture. Yale Classical Studies, v. 30. New York: Cambridge Univ. Press, 1996.
- Pedley, John Griffiths, Greek Art and Archaeology. 3rd ed. Upper Saddle River: Prentice-Hall, 2002.
- Pollitt, J. J. The Art of Ancient Greece: Sources and Documents. 2nd ed. Cambridge, U.K.: Cambridge Univ. Press, 1990.
- Ridgway, Brunilde Sismondo. The Archaic Style in Greek Sculpture. 2nd ed. Chicago: Ares, 1993.
- ——. Fifth Century Styles in Greek Sculpture. Princeton: Princeton Univ. Press, 1981.
- —. Hellenistic Sculpture 1: The Styles of ca. 331–200 B.C. Wisconsin Studies in Classics. Madison: Univ. of Wisconsin Press, 1990.
- Stafford, Emma J. Life, Myth, and Art in Ancient Greece. Los Angeles: J. Paul Getty Museum, 2004.
- Stewart, Andrew F. Greek Sculpture: An Exploration. 2 vols. New Haven: Yale Univ. Press, 1990.
- Whitley, James. The Archaeology of Ancient Greece. New York: Cambridge Univ. Press, 2001.

CHAPTER 6 Etruscan and Roman Art

- Bianchi Bandinelli, Ranuccio. Rome: *The Centre of Power: Roman*Art to A.D. 200. Trans. Peter Green. Arts of Mankind. London:
 Thames and Hudson, 1970.
- —. Rome: The Late Empire: Roman Art A.D. 200–400. Trans. Peter Green. Arts of Mankind. New York: Braziller, 1971.
- Borrelli, Federica. *The Etruscans: Art, Architecture, and History.* Ed. Stefano Peccatori & Stefano Zuffi. Trans. Thomas Michael Hartmann. Los Angeles: J. Paul Getty Museum, 2004.

- Breeze, David John. Hadrian's Wall. 4th ed. London: Penguin, 2000. Brendel, Otto J. Etruscan Art. 2nd ed. Yale Univ. Press Pelican History Series, New Haven: Yale Univ. Press, 1995.
- Ciarallo, Annamaria, and Ernesto De Carolis, eds. Pompeii: Life in a Roman Town. Milan: Electa, 1999.
- Conlin, Diane Atnally. The Artists of the Ara Pacis: The Process of Hellenization in Roman Relief Sculpture. Studies in the History of Greece & Rome. Chapel Hill: Univ. of North Carolina Press,
- Cornell, Tim, and John Matthews. Atlas of the Roman World. New York: Facts on File, 1982.
- D'Ambra, Eve. Roman Art. Cambridge, U.K.: Cambridge Univ. Press, 1998.
- Elsner, Ja. Imperial Rome and Christian Triumph: The Art of the Roman Empire A.D. 100-450. Oxford History of Art. Oxford: Oxford Univ. Press, 1998
- Gabucci, Ada. Ancient Rome: Art, Architecture, and History. Eds. Stefano Peccatori & Stephano Zuffi. Trans. T. M. Hartman. Los Angeles, CA: J. Paul Getty Museum, 2002.
- -. ed. The Colosseum. Los Angeles, CA: J. Paul Getty Museum, 2002
- Grant, Michael. Art in the Roman Empire. London: Routledge, 1995.
- Guillaud, Jacqueline, and Maurice Guillaud. Frescoes in the Time of Pompeii. New York: Potter, 1990.
- Haynes, Sybille. Etruscan Civilization: A Cultural History. Los Angeles: J. Paul Getty Museum, 2000.
- Holloway, R. Ross. Constantine & Rome. New Haven: Yale Univ. Press, 2004.
- L'Orange, Hans Peter. The Roman Empire: Art Forms and Civic Life. New York: Rizzoli, 1985.
- MacDonald, William L. The Architecture of the Roman Empire: An Introductory Study. Rev. ed. Yale Publications in the History of Art. New Haven: Yale Univ. Press, 1982.
- The Pantheon: Design, Meaning, and Progeny. Cambridge, MA: Harvard Univ. Press, 1976.
- and John A. Pinto. Hadrian's Villa and Its Legacy. New Haven: Yale Univ. Press, 1995.
- Mazzoleni, Donatella. Domus: Wall Painting in the Roman Hou Los Angeles: J. Paul Getty Museum, 2004.
- Packer, James E., and Kevin Lee Sarring. The Forum of Trajan in Rome: A Study of the Monuments. California Studies in the History of Art, 31.2 vols., portfolio and microfiche. Berkeley: Univ. of California Press, 1997.
- Pollitt, J. J. The Art of Rome, c. 753 B.C.-337 A.D.: Sources and Documents. Upper Saddle River, NJ: Prentice Hall, 1966.
- Ramage, Nancy H., and Andrew Ramage. Roman Art: Romulus to Constantine. 4th ed. Upper Saddle River, NJ: Prentice Hall, 2004.
- Spivey, Nigel. Etruscan Art. World of Art. New York: Thames and Hudson, 1997.
- Stamper, John W. The Architecture of Roman Temples: The Republic to the Middle Empire. New York: Cambridge Univ. Press, 2005.
- Stewart, Peter. Roman Art. New York: Oxford Univ. Press, 2004. Statues in Roman Society: Representation and Response Oxford Studies in Ancient Culture and Representation. New
- York: Oxford Univ., 2003. Strong, Donald. Roman Art. 2nd ed. rev. & annotated, Ed. Roger Ling, Pelican History of Art, New Haven: Yale Univ. Pres
- Ward-Perkins, J. B. Roman Architecture. History of World Architecture. New York: Electa/Rizzoli, 1988.
- Roman Imperial Architecture. Pelican History of Art. New Haven: Yale Univ. Press, 1981.
- Wilson Jones, Mark. Principles of Roman Architecture. New Haven: Yale Univ. Press, 2000.

CHAPTER 7 Jewish, Early Christian, and Byzantine Art

- Age of Spirituality: Late Antique and Early Christian Art, Third to Seventh Century. New York: Metropolitan Museum of Art, 1979. Beckwith, John. The Art of Constantinople: An Introduction to Byzan-
- tine Art 330-1453, 2nd ed. London: Phaidon, 1968. -. Early Christian and Byzantine Art. 2nd ed. Pelican History of
- Art. Harmondsworth, UK: Penguin, 1979.
- Carr, Annemarie Weyl. Byzantine Illumination, 1150-1250: The Study of a Provincial Tradition. Chicago: Univ. of Chicago Press,
- Cioffarelli, Ada. Guide to the Catacombs of Rome and Its Surroundings. Rome: Bonsignori, 2000.
- Cormack, Robin. Byzantine Art. Oxford History of Art. Oxford: Oxford Univ. Press, 2000.
- Cutler, Anthony. The Hand of the Master: Craftsmanship, Ivory, and Society in Byzantium (9th-11th Centuries). Princeton: Princeton Univ. Press, 1994.
- Demus, Otto. The Mosaic Decoration of San Marco, Venice. Ed. Herbert L. Kessler. Chicago: Univ. of Chicago Press, 1988. Durand, Jannic. Byzantine Art. Paris: Terrail, 1999.
- Eastmond, Antony, and Liz James, ed. Icon and Word: The Power of

- Images in Byzantium: Studies Presented to Robin Cormack. Burlington, VT: Ashgate, 2003.
- Evans, Helen C., ed. Byzantium: Faith and Power (1261-1557). New York: Metropolitan Museum of Art, 2004.
- , and William D. Wixom, eds. Tae Glory of Byzantium: Art and Culture of the Middle Byzantine era, A.D. 843-1261. New York: Abrams, 1997.
- Fine, Steven. Art and Judaism in the Grece-Roman World: Toward a New Jewish Archaeology, New York: Cambridge Univ. Press, 2005.
- Gerstel, Sharon E. J. Beholding the Sacred Mysteries: Programs of the Byzantine Sanctuary. Monograph on the Fine Arts, 56. Seattle: Published by College Art Association in assoc. with Univ. of Washington Press, 1999.
- Grabar, Andréé. Byzantine Painting: Historical and Critical Study. Trans. Stuart Gilbert. New York: Rizzoli, 1979.
- Jensen, Robin Margaret. Understanding Early Christian Art. New York: Routledge, 2000.
- Kitzinger, Ernst. Byzantine Art in the Making: Main Lines of Stylistic Development in Mediterranean Art, 3rd-7th Century. Cambridge, MA: Harvard Univ Press, 1977
- Krautheimer, Richard, and Slobodan Curcic. Early Christian and Byzantine Architecture. 4th ed. Pelican History of Art. New Haven: Yale Univ. Press, 1992.
- Levine, Lee I. and Zeev Weiss, eds. From Dura to Sepphoris: Studies in Jewish Art and Society in Late Antiquity. Journal of Roman Archaeology: Supplementary Series, no. 40. Portsmouth, R.I.: Journal of Roman Archaeology, 2000.
- Lowden, John. Early Christian and Byzantine Art. Art & Ideas. London: Phaidon, 1997.
- Maguire, Henry. The Icons of Taeir Bodies: Saints and their Images in Byzantium. Princeton: Princeton Univ. Press, 1996.
- Mainstone, R. J. Hagia Sophia: Architecture, Structure and Liturgy of Justinian's Great Church. London: Thames and Hudson, 1988
- Mango, Cyril. Art of the Byzantine Empire, 312-1453: Sources and Documents, Upper Saddle River, NI: Prentice Hall, 1972.
- Mathew, Gervase. Byzantine Aesthetics. London: J. Murray, 1963. Mathews, Thomas P. Byzantiura: From Antiquity to the Renaissance. Perspectives. New York: Abrams, 1993.
- The Clash of Gods: A Reinterpretation of Early Christian Art. Rev. & exp. ed. Princeton: Princeton Univ. Press, 1999
- Milburn, R. L. P. Early Christian Art and Architecture. Berkeley. Univ. of California Press, 1988.
- Olin, Margaret. The Nation without Art: Examining Modern Discourses on Jewish Art. Lincoln: Univ. of Nebraska Press, 2001.
- Olsson, Birger and Magnus Zetterholm, eds. The Ancient Synagogue from Its Origins until 200 C.E.: Papers Presented at an International Conference at Lund University, October 14-17, 2001. Coniectanea Biblica: New Testament Series, 39. Stockholm: Almqvist & Wiksell International, 2003.
- Ousterhout, Robert. Master Builders of Byzantium. Princeton: Princeton Univ. Press, 1999.
- Rodley, Lyn. Byzantine Art and Architecture: An Introduction. Cambridge, U.K.: Cambridge Univ. Press, 1994.
- Rutgers, Leonard Victor. Subterranean Rome: In Search of the Roots of Christianity in the Catacom's of the Eternal City. Leuven: Peeters
- Tadgell, Christopher. Imperial Space: Rome, Constantinopie and the Early Church. New York: Whitney Library of Design, 1998.
- Teteriatnikov, Natalia. Mosaics of Hagia Sophia, Istanbul: The Fossati Restoration and the Work of the Byzantine Institute. Washington, D.C.: Dumbarton Oaks Research Library and Collection, 1998
- Tronzo, William. The Cultures of his Kingdom: Roger II and the Cappella Palatina in Palermo, Princeton: Princeton Univ. Press
- Vio, Ettore. St. Mark's: The Art and Architecture of Church and State in Venice. New York: Riversice Book Co., 2003.
- Webb, Matilda. The Churches and Catacombs of Early Christian Rome: A Comprehensive Guide. Brighton, UK: Sussex Academic Press. 2001.
- Weitzmann, Kurt. Late Antique and Early Christian Book Illumination. New York: Braziller, 1977.
- -. Place of Book Illumination in Byzantine Art. Princeton: Art Museum, Princeton Univ., 1975.
- Wharton, Annabel Jane. Refiguring the Post ClassicalCity: Dura Europe, Jerash, Jerusalem and Ravenna. New York: Cambridge Univ. Press, 1995.
- White, L. Michael. The Social Origins of Christian Architecture. 2 vols. Baltimore: Johns Hopkins Univ. Press, 1990.

CHAPTER 8 Islamic Art

- Al-Faruqi, Ismail R, and Lois Lamya'al Faruqi. Cultural Atlas of Islam. New York: Macmillan, 1986.
- Atasoy, Nurhan. Splendors of the Ottoman Sultans. Ed. and Trans Tulay Artan. Memphis, TN: Lithograph, 1992.
- Atil, Esin. The Age of Sultan Suleyman tue Magnificent. Washington, D.C.: National Gallery of Art, 1987.

- Baer, Eva. Islamic Ornament, New York: New York Univ. Press.
- Baker, Patricia L. Islam and the Religious Arts. New York: Continuum, 2004.
- Berry, Michael. Figurative Art in Medieval Islam and the Riddle of Bihzââd of Herâât (1465-1535). Paris: Flammarion, 2004.
- Blair, Sheila S., and Jonathan Bloom. The Art and Architecture of Islam 1250-1800. Pelicar. History of Art. New Haven: Yale Univ. Press. 1994.
- Carboni, Stefano, and David Whitehouse. Glass of the Sultans. New York: Metropolitan Museum of Art. 2001.
- Denny, Walter B. Iznik: The Artistry of Ottoman Ceramics. New York: Thames & Hudson, 2004.
- Dodds, Jerrilynn D., ed. al-Andalus: The Art of Islamic Spain. New York: Metropolitan Museum of Art, 1992.
- Ecker, Heather. Caliphs and Kings: The Art and Influence of Islamic Spain. Washington, D.C.: Arthur M. Sackler Gallery, Smithsonian Institution, 2004.
- Ettinghausen, Richard, Oleg Grabar, and Marilyn Jenkins-Madina. Islamic Art and Architecture, 650-1250. 2nd ed. Yale Univ. Press Pelican History of Art. New Haven: Yale Univ. Press, 2001. Reissue ed. 2003.
- Frishman, Martin, and Hasan-Uddin Khan. The Mosque: History, Architectural Development and Regional Diversity. London: Thames and Hudson, 1994.
- Grabar, Oleg. The Formation of Islamic Art. Rev. ed. New Haven: Yale Univ. Press. 1987.
- -. The Great Mosque of Is ahan. New York: New York Univ. Press, 1990.
- -. Mostly Miniatures: An Introduction to Persian Painting, Princeton: Princeton Univ. Press, 2000.
- , Mohammad al-Asad, Abeer Audeh, and Said Nuseibeh. The Shape of the Holy; Early Islamic Jerusalem. Princeton: Princeton Univ Press 1996
- H. llenbrand, Robert. Islamic Art and Architecture. World of Art. London: Thames and Hudson, 1999.
- Irwin, Robert, The Alhambra, Cambridge, MA: Harvard Univ. Press, 2004.
- Khatibi, Abdelkebir, and Mohammed Sijelmassi. The Splendour of Islamic Calligraphy. Rev. & exp. ed. New York: Thames and
- Komaroff, Linda, and Stefano Carboni, eds. The Legacy of Genghis Khan: Courtly Art and Culture in Western Asia, 1256- 1353. New York: Metropolitan Museum of Art, 2002.
- Lentz, Thomas W., and Glenn D. Lowry. Timur and the Princely Vision: Persian Art and Culture in the Fifteenth Century. Los Angeles: Los Angeles Ccunty Museum of Art, 1989.
- Necipo lu, Güülru. The Age of Sinan: Architectural Culture in the Ottoman Empire. Princeton: Princeton Univ. Press, 2005.
- Petruccioli, Attilio, and Khalil K. Pirani, eds. Understanding Islamic Architecture. New York: Routledge Curzon, 2002.
- Roxburgh, David J., ed. Turks: A Journey of a Thousand Years, 600-1600. London: Royal Academy of Arts, 2005.
- Sims, Eleanor, Boris I. Marshak, and Ernest J. Grube. Peerless Images: Persian Painting and Its Sources. New Haven: Yale Univ. Press, 2002.
- Stanley, Tim, Mariam Rosser-Owen, and Stephen Vernoit. Palace and Mosque: Islamic Art from the Middle East. London: V & A Publications, 2004.
- Steele, James. An Architecture for People: The Complete Works of Hassan Fathy. New York: Whitney Library of Design, 1997.
- Stierlin, Henri. Islamic Art and Architecture: From Isfahan to the Taj Mahal, New York: Thames & Hudson, 2002. Suhrawardy, Shahid. The Art of the Mussulmans in Spain. New York:
- Oxford Univ. Press, 2005. Tadgell, Christopher. Four Caliphates: The Formation and Development of
- the Islamic Tradition. London: Ellipsis, 1998 Ward, R. M. Islamic Metalwork. New York: Thames and Hudson,
- 1993. Watson, Oliver. Ceramics from Islamic Lands. New York: Thames &
- Hudson in assoc, with the al-Sabah Collection, Dar al-Athar al-Islamiyyah, Kuwait National Museum, 2004.

CHAPTER 9 Early Medieval Art in Europe

- A.exander, J. J. G. Medieval Illuminators and Their Methods of Work. New Haven: Yale Univ. Press, 1992.
- The Art of Medieval Spain, A.D. 500-1200. New York: Metropolitan Museum of Art, 1993.
- Backhouse, Janet, D. H. Turner, and Leslie Webster. The Golden Age of Anglo-Saxon Art, 966–1066.
 - Bloomington: Indiana Univ. Press, 1984.
- Bandman, Gunter. Early Medieval Architecture as Bearer of Meaning. New York: Columbia Univ. Press, 2005.
- Beckwith, John. Early Medieval Art: Carolingian, Ottonian Romanesque. World of Art. New York: Oxford Univ. Press.

- Calkins, Robert G. Illuminated Books of the Medieval Ages. Ithaca, NY: Cornell Univ. Press, 1983.
- Carver, Martin. Sutton Hoo: A Seventh-Century Princely Burial Ground and Its Context. London: British Museum Press, 2005.
- Davis-Weyer, Caecilia. Early Medieval Art, 300–1150: Sources and Documents. Upper Saddle River, NJ: Prentice Hall, 1971.
- Diebold, William J. Word and Image: An Introduction to Early Medieval Art. Boulder, CO: Westview Press, 2000.
- Dodwell, C. R., Pictorial Arts of the West 800–1200. Yale Univ. Press Pelican History of Art. New Haven: Yale Univ. Press, 1993.
- Farr, Carol. The Book of Kells: Its Function and Audience. London: British Library, 1997.
- Fernie, E. C. The Architecture of the Anglo-Saxons. London: Batsford, 1983.
- Fitzhugh, William W., and Elisabeth I. Ward, eds. Vikings: The North Atlantic Saga. Washington, D.C.: Smithsonian Institution Press, 2000.
- Harbison. Peter. The Golden Age of Irish Art: The Medieval Achievement, 600–1200. London: Thames and Hudson, 1998.
- Henderson, George. From Durrow to Kells: The Insular Gospel-Books, 650–800. London: Thames and Hudson, 1987.
- Horn, Walter W., and Ernest Born. Plan of Saint Gall: A Study of the Architecture and Economy of and Life in a Paradigmatic Carolingian Monastery. California Studies in the History of Art, 19. 3 vols. Berkeley: Univ. of California Press, 1979.
- Lasko, Peter. Ars Sacra, 800–1200. 2nd ed. Pelican History of Art. New Haven: Yale Univ. Press, 1994.
- McClendon, Charles B. The Origins of Medieval Architecture: Building in Europe, A.D 600-900. New Haven: Yale Univ. Press, 2005.
- Mayr-Harting, Henry. Ottoman Book Illumination: An Historical Study. 2nd rev. ed. 2 vols. London: Harvey Miller, 1999.
- Mentréé, Mireille. Illuminated Manuscripts of Medieval Spain. New York: Thames and Hudson, 1996.
- Nees, Lawrence. Early Medieval Art. Oxford History of Art. Oxford: Oxford Univ. Press, 2002.
- Nordenfalk, Carl Adam Johan. Early Medieval Book Illumination. New York: Rizzoli, 1988.
- Richardson, Hilary, and John Scarry. An Introduction to Irish High Crosses. Dublin: Mercier, 1990.
- Crosses. Dublin: Mercier, 1990.

 Stalley, R.A. Early Medieval Architecture. Oxford History of Art.
 Oxford: Oxford Univ. Press, 1999.
- Wickham, Chris. Framing the Early Middle Ages: Europe and the Mediterranean 400-800. New York: Oxford Univ. Press, 2005.
- Williams, John, ed. Imaging the Early Medieval Bible. The Penn State Series in the History of the Book. University Park: Pennsylvania State Univ. Press, 1999.
- Wilson, David M. Anglo-Saxon Art: From the Seventh Century to the Norman Conquest. London: Thames and Hudson, 1984.
- —, and Ole Klindt-Jensen. Viking Art. 2nd ed. Minneapolis: Univ. of Minnesota Press, 1980.

CHAPTER 10 Romanesque Art

- Armi, C. Edson. Design and Construction in Romanesque Architecture: First Romanesque Architecture and the Pointed Arch in Burgundy and Northern Italy. New York: Cambridge Univ. Press, 2004.
- Barral i Altet, Xavier. The Romanesque: Towns, Cathedrals and Monasteries. Taschen's World Architecture. New York: Taschen, 1998.
- Cahn, Walter. Romanesque Manuscripts: The Twelfth Century. A Survey of Manuscripts Illuminated in France. 2 vols. London: H. Miller, 1996.
- "Cloister Symposium, 1972" in Gesta, v.12 #1/2, 1973, pgs. v-132.
- Davis-Weyer, Caecilia. Early Medieval Art, 300–1150. Sources and Documents. Upper Saddle River, NJ: Prentice Hall, 1971.
- Dimier, Anselme. Stones Laid before the Lord: A History of Monastic Architecture. Trans. Gilchrist Lavigne. Cistercian Studies Series, no. 152. Kalamazoo, MI: Cistercian Publications, 1999.
- Evans, Joan. Cluniac Art of the Romanesque Period. Cambridge, U.K.: Cambridge Univ. Press, 1950.
- Fergusson, Peter. Architecture of Solitude: Cistercian Abbeys in Twelfth-Century England. Princeton: Princeton Univ. Press, 1984.
- Forsyth, Ilene H. The Throne of Wisdom: Wood Sculptures of the Madonna in Romanesque France. Princeton: Princeton Univ. Press, 1972.
- Gaud, Henri, and Jean-Franççois Leroux-Dhuys.

 Cistercian Abbeys: History and Architecture. Kööln: Köönnemann,
 1998
- Hawthorne, John G. and Cyril S. Smith, eds. On Divers Arts: The Treatise of Theophilus. New York: Dover Press, 1979.
- Hearn, M. F. Romanesque Sculpture: The Revival of Monumental Stone Sculptures in the Eleventh and Twelfth Centuries. Ithaca, NY: Cornell Univ. Press, 1981.
- Hicks, Carola. The Bayeux Tapestry: The Life Story of a Masterpiece. London: Chatto & Windus, 2006
- Kubach, Hans Erich. Romanesque Architecture. History of World Architecture. New York: Electa/Rizzoli, 1988.
- Mââle, Emile. Religious Art in France, the Twelfth Century: A Study of

- the Origins of Medieval Iconography. Bollingen Series. Princeton: Princeton Univ. Press, 1978.
- Minne-Sèève, Viviane, and Hervéé Kergall. Romanzsque and Gothic France: Architecture and Sculpture. Trans. Jack Hawkes & Lory Frankel. New York: Harry N. Abrams, 2000.
- O'Neill, John Philip, ed. *Enamels of Limoges: 1100-1350.Tians.* Sophie Hawkes, Joachim Neugroschel, & Patricia Stirneman. New York: Metropolitan Museum of Art, 1996.
- Petzold, Andreas, Romanesque Art. Perspectives. New York: Abrams 1995.
- Radding, Charles M., and William W. Clark. Medieval Architecture, Medieval Learning: Builders and Masters in the Age of Romanesque and Gothic. New Haven: Yale Univ. Press, 1992.
- Schapiro, Meyer. The Romanesque Sculpture of Moissac. New York: Braziller. 1985.
- Seidel, Linda. Legends in Limestone: Lazarus, Gislebertus, and the Cathedral of Autun. Chicago: Univ. of Chicago Press, 1999.
- Stones, Alison, Jeanne Krochalis, Paula Gerson, and Annie Shaver-Crandell. The Pilgrim's Guide: A Critical Edition. 2 vols. London: Harvey Miller, 1998.
- Swanson, R. N. The Twelfth-Century Renaissance. Manchester: Manchester Univ. Press, 1999.
- Toman, Rolf,ed. Romanesque: Architecture, Sculpture, Painting. Trans. Fiona Hulse & Ian Macmillan. Kööln: Köönemann, 1997.
- The Year 1200. 2 vols. New York: Metropolitan Museum of Art, 1970
- Zarnecki, George, Janet Holt, and Tristam Holland, eds. English Romanesque Art, 1066–1200. London: Weidenfeld and Nicolson, 1984.

Chapter 11 Gothic Art of the Twelfth and Thirteenth Centuries

- Armi, C. Edson. The "Headmaster" of Chartres and the Origins of "Gothic" Sculpture. University Park: Pennsylvan: a State Univ. Press, 1994.
- Binding, Güünther. High Gothic: The Age of the Great Cathedrals. Taschen's World Architecture. London: Taschen, 1999.
- Binski, Paul. Becket's Crown: Art and Imagination in Gothic England 1170-1350. New Haven: Yale Univ. Press, 2004.
- Bony, Jean. French Gothic Architecture of the 12th and 13th Centuries. California Studies in the History of Art. Berkeley: Univ. of California Press, 1983.
- Camille, Michael. Gothic Art: Glorious Visions. Perspectives. New York: Abrams, 1996.
- Cennini, Cennino. The Crafisman's Handbook (Il libro dell'arte). Trans. D.V. Thompson. New York: Dover, 1954.
- Crosby, Sumner McKnight. The Royal Abbey of Saint-Denis from Its Beginnings to the Death of Suger, 475–1151.Yale Publications in the History of Art. New Haven:Yale Univ. Press, 1987.
- Erlande-Brandenburg, Alain. Gothic Art. Trans. I. Mark Paris. New York: Abrams, 1989.
- ----. Notre-Dame de Paris. New York: Abrams, 1998.
- Favier, Jean. The World of Chartres. Trans. Francisca Garvie. New York: Abrams. 1990.
- Frankl, Paul. Gothic Architecture. Rev. Paul Crossley. Yale Univ. Press Pelican History of Art. New Haven: Yale Univ. Press, 2000.
- Frisch, Teresa G. Gothic Art, 1140–c.1450: Sources and Documents.

 Upper Saddle River, NJ: Prentice Hall, 1971.
- Grodecki, Louis, and Catherine Brisac. Gothic Staited Glass, 1200–1300. Ithaca. NY: Cornell Univ. Press, 1985.
- Kren, Thomas, and Mark Evans, eds. A Masterpiece Reconstructed: The Hours of Louis XII. Los Angeles: The J. Paul Getty Museum, 2005.
- Moskowitz, Anita Fiderer. Nicola & Giovanni Pisano: The Pulpits: Pious Devotion, Pious Diversion. London: Harvey Miller Publishers, 2005.
- Murray, Stephen. Notre-Dame, Cathedral of Amiens: The Power of Change in Gothic. New York: Cambridge Univ. Press, 1996.
- Nussbaum, Norbert. German Gothic Church Architecture. Trans. Scott Kleager. New Haven: Yale Univ. Press, 2000.
- Panofsky, Erwin. Abbot Suger on the Abbey Church of St.-Denis and Its Art Treasures, 2nd ed. Ed. Gerda Panofsky-Soergel. Princeton: Princeton Univ. Press, 1979.
- Gothic Architecture and Scholasticism. Latrobe, FA: Archabbey
 1951
- Parry, Stan. Great Gothic Cathedrals of France. New York: Viking Studio, 2001.
- Sauerlander, Willibald. Gothic Sculpture in France, 1140–1270. Trans.

 Janet Sandheimer. London: Thames and Hudson, 1972.
- Scott, Robert A. The Gothic Enterprise: A Guide to Understanding the Medieval Cathedral. Berkeley: Univ. of California Press, 2003.
- Simsom Otto Georg von. The Gothic Cathedral: Origins of Gothic Architecture and the Medieval Concept of Order. 3rd ed. Bollingen Series. Princeton: Princeton Univ. Press, 1988.
- Smart, Alastair. The Dawn of Italian Painting, 1250–1400. Ithaca. NY: Cornell Univ. Press, 1978.

- Suckale, Robert, and Matthias Weniger. Painting of the Gothic Era. Ed. Ingo F. Walther. New York: Taschen, 1999.
- Villard, de Honnecourt. The Sketchbook of Villard de Honnecourt. Ed. Theodore Bowie. Bloomington: Indiana Univ., 1960.
- Wieck, Roger S. Time Sanctified: The Book of Hours in Medieval Art and Life. New York: Braziller, 1988.
- Williamson, Paul. Gothic Sculpture 1140–1300. Pelican History of Art. New Haven: Yale Univ. Press, 1995.

Chapter 12 Fourteenth Century Art in Europe

- Alexander, Jonathan, and Paul Binski, eds. Age of Chivalry: Art in Plantagenet England, 1200–1400. London: Royal Academy of Arts, 1987.
- Art from the Court of Burgundy: The Patronage of Phillip the Bold and John the Fearless 1364-1419. Cleveland: The Cleveland Museum of Art, 2004.
- Backhouse, Janet. Illumination from Books of Hours. London: British Library, 2004.
- Boehm, Barbara Drake, and Jifiii Fajt, eds. Prague: The Crown of Bohemia, 1347-1437. New York: Metropolitan Museum of Art, 2005.
- Bony, Jean. The English Decorated Style: Gothic Architecture Transformed, 1250-1350. The Wrightsman Lecture, 10th. Oxford: Phaidon Press Limited, 1979.
- Borsook, Eve. The Mural Painters of Tuscary: From Cimabue to Andrea del Sarto. 2nd ed. rev. & enlg. Oxford Studies in the History of Art and Architecture. Oxford: Clarendon Press 1980.
- Branner, Robert. St. Louis and the Court Style in Gothic Architecture Studies in Architecture, v. 7. London, A. Zwemmer, 1965.
- Bruzelius, Caroline Astrid. The 13th-Century Church at St-Denis. Yale Publications in the History of Art, 33. New Haven: Yale University Press, 1985.
- Fajt, Jifiii, ed. Magister Theodoricus, Court Painter to Emperor Charles IV:The Pictorial Decoration of the Shrines at Karlstejn Castle. Prague: National Gallery, 1998.
- Ladis, Andrew. ed, The Arena Chapel and the Genius of Giotto: Padua. Giotto and the World of Early Italian Art, 2. New York: Garland Pub., 1998.
- Moskowitz, Anita Fiderer. *Italian Gothic Sculpture: c. 1250-c. 1400*. New York: Cambridge Univ. Press, 2001.
- Norman, Diana, ed. Siena, Florence, and Padua: Art, Society, and Religion 1280-1400. 2 vols. New Haven: Yale Univ. Press in assoc. with the Open Univ., 1995.
- Paolucci, Antonio. The Origins of Renaissance Art: The Baptistry Doors, Florence. Trans. Franççoise Pouncey Chiarini. New York: George Braziller, 1996.
- George Braziller, 1996.

 Poeschke, Joachim. *Italian Frescoes, the Age of Giotto, 1280-1400*.

 New York: Abbeville Press, 2005.
- Welch, Evelyn S. Art in Renaissance Italy, 1350-1500. New Ed. Oxford: Oxford Univ. Press, 2000.
- White, John. Art and Architecture in Italy, 1250 to 1400. 3rd ed. Pelican History of Art. Harmondsworth, UK: Penguin, 1993.
- Wieck, Roger S. Painted Prayers: The Book of Hours in Medieval and Renaissance Art. New York: George Braziller in assoc. with the Pierpont Morgan Library, 1997.

Chapter 13 Fifteenth-Century Art in Northern Europe and the Iberian Peninsula

- Baxandall, Michael. The Limewood Sculptors of Renaissance Germany New Haven Yale Univ. Press, 1980.
- Blum, Shirley. Early Netherlandish Triptychs: A Study in Patronage California Studies in the History of Art.
- Berkeley: Univ. of California Press, 1969.
- Borchert, Till-Holger. Age of Van Eyck: The Mediterranean World and Early Netherlandish Painting, 1430-1530. New York: Thames & Hudson, 2002.
- Cavallo, Adolph S. The Unicorn Tapestries at the Metropolitan Museum of Art. New York: The Museum, 1998.
- Chastel, Andrèè. French Art: The Renaissance, 1430–1620. Paris: Flammarion, 1995.
- Dhanens, Elisabeth. Van Eyck: The Ghent Altarpiece. New York: Viking Press, 1973.
- Flanders in the Fifteenth Century: Art and Civilization. Detroit: Detroit Institute of Arts, 1960. Füüssel, Stephan, Gutenbere and the Impact of Printing. Trans. Dou
- Füüssel, Stephan. Gutenberg and the Impact of Printing. Trans. Douglas Martin. Burlington, VT: Ashgate Pub., 2005.
- Kuskin, William, ed. Caxton's Trace: Studies in the History of English Printing. Notre Dame, IN: Univ. of Notre Dame Press, 2006.
- Lane, Barbara G. The Altar and the Altarpiece: Sacramental Themes in Early Netherlandish Painting, New York: Harper & Row, 1984.
 Marks, Richard, and Paul Williamson, eds. Gothic: Art for England
- 1400-1547. London: V & A, 2003. Meiss, Millard. French Painting in the Time of Jean de Berry: The Limbourgs and their Contemporaries. 2 vols. New York: G. Braziller, 1974
- Müüller, Theodor. Sculpture in the Netherlands, Germany, France, and Spain: 1400–1500. Trans. Elaine & William Robson Scott. Pel-

- Harmondsworth, Eng.: Penguin, 1966.
- Päächt, Otto. Early Netherlandish Painting: From Rogier van der Weyden to Gerard David. Ed. Monika Rosenauer. Trans. David Britt. London: Harvey Miller, 1997.
- Panofsky, Erwin. Early Netherlandish Painting. Its Origins and Character. 2 vols. Cambridge, MA: Harvard Univ. Press, 1966.
- Parshall, Peter W. and Rainer Schoch. Origins of European Printmaking: Fifteenth-Century Woodcuts and their Public. Washington, D.C.: National Gallery of Art, 2005.
- Plummer, John. The Last Flowering: French Painting in Manuscripts, 1420–1530, from American Collections. New York: Pierpont Morgan Library, 1982.
- Scott, Kathleen L. Later Gothic Manuscripts, 1390–1490. A Survey of Manuscripts Illuminated in the British Isles, 6. 2 vols. London: H. Miller, 1996.
- Snyder, James. Northern Renaissance Art: Painting, Sculpture, the Graphic Arts from 1350 to 1575, 2nd.ed Rev. Larry Silver and Henry Luttikhuizen. Upper Saddle River, NJ: Prentice Hall, 2005.
- Vos, Dirk de. The Flemish Primitives: The Masterpieces. Princeton: Princeton Univ. Press, 2002.
- Zuffi, Stefano. European Art of the Fifteenth Century. Trans. Brian D. Phillips. Art through the Centuries. Los Angeles: J. Paul Getty Museum, 2005.

Chapter 14 Renaissance Art in Fifteenth-Century Italy

- Adams, Laurie Schneider. Italian Renaissance Art. Boulder, CO: Westwiew Press 2001
- Ahl, Diane Cole, ed. *The Cambridge Companion to Masaccio*. New York: Cambridge Univ. Press, 2002.
- Alexander, J.J.G. The Painted Page: Italian Renaissance Book Illumination, 1450–1550. Munich: Prestel, 1994.
- tion, 1450–1550. Munich: Prestel, 1994.

 Ames-Lewis, Francis. Drawing in Early Renaissance Italy. 2nd ed.

 New Haven: Yale Univ. Press, 2000.
- —. The Intellectual Life of the Early Renaissance Artist. New Haven: Yale Univ. Press, 2000.
- Baxandall, Michael. Painting and Experience in Fifteenth-Century Italy: A Primer in the Social History of Pictorial style. Oxford: Clarendon, 1972.
- Boskovits, Miklóós. *Italian Paintings of the Fifteenth Century*. The Collections of the National Gallery of Art. Washington, D.C.: National Gallery of Art, 2003.
- Botticelli and Filippino: Passion and Grace in Fifteenth-Century Florentine Painting. Milano: Skira, 2004.
- Brown, Patricia Fortini. Art and Life in Renaissance Venice. Perspectives. New York: Harry N. Abrams, 1997.
- Reissued. Upper Saddle River, NJ: Prentice Hall, 2006. Christianity and the Renaissance: Image and Religious Imagination in
- the Quattrocento. Syracuse, NY: Syracuse Univ. Press, 1990.
 Christiansen, Keith, Laurence B. Kanter, and Carl Brandon
 Strehlke. Painting in Renaissance Siena, 1420–1500. New York:
 Metropolitan Museum of Art. 1988.
- Christine, de Pisan. The Book of the City of Ladies. Trans. Rosalind Brown-Grant. London: Penguin Books, 1999.
- Gilbert, Creighton, ed. Italian Art, 1400–1500: Sources and Documents. Evanston: Northwestern Univ. Press, 1992.
- Heydenreich, Ludwig Heinrich. Architecture in Italy, 1400–1500.
 Rev. Paul Davies. Pelican History of Art. New Haven: Yale
 Univ. Press. 1996.
- Hind, Arthur M. An Introduction to a History of Woodcut. New York: Dover, 1963.
- Huizinga, Johan. The Autumn of the Middle Ages. Trans. Rodney J. Payton & Ulrich Mammitzsch. Chicago: Univ. of Chicago Press, 1996.
- Hyman, Timothy. Sienese Painting: The Art of a City-Republic (1278-1477). World of Art. New York: Thames & Hudson, 2003.
- King, Ross. Brunelleschi's Dome: How a Renaissance Genius Reinvented Architecture. New York: Walker & Co., 2000.
- Lavin, Marilyn Aronberg, ed. Piero della Francesca and his Legacy. Studies in the History of Art, 48: Symposium Papers, 28. Washington, D.C.: National Gallery of Art, 1995.
- Levey, Michael. Early Renaissance. Harmondsworth, UK: Penguin, 1967.
- Päächt, Otto. Venetian Painting in the 15th Century: Jacopo, Gentile and Giovanni Bellini and Andrea Mantegna. Ed. Margareta Vyoral-Tschapka & Michael Päächt. Trans. Fiona Elliott. London: Harvey Miller Pub., 2003.
- Partridge, Loren W. The Art of Renaissance Rome, 1400-1600. Perspectives. New York: Harry N. Abrams, 1996. Reissue Ed. Upper Saddle River, NJ: Prentice Hall, 2006.
- Poeschke, Joachim. Donatello and his World: Sculpture of the Italian Renaissance. Trans. Russell Stockman. New York: H. N. Abrams, 1993.
- Randolph, Adrian W. B., Engaging Symbols: Gender, Politics, and Public Art in Fifteenth-Century Florence. New Haven: Yale Univ. Press, 2002.
- Seymour, Charles. Sculpture in Italy 1400–1500. Pelican History of Art. Harmondsworth, UK: Penguin, 1966.

- Troncelliti, Latifah. The Two Parallel Realities of Alberti and Cennini: The Power of Writing and the Visual Arts in the Italian Quattrocento. Studies in Italian Literature, v. 14. Lewiston, N.Y. Edwin Mellen Press, 2004.
- Turner, Richard. Renaissance Florence: The Invention of a New Art. Perspectives. New York: Abrams, 1997. Reissue ed. Upper Saddle River, NJ: Prentice Hall, 2006.
- Walker, Paul Robert. The Feud that Sparked the Renaissance: Hou Brunelleschi and Ghiberti Changed the Art World. New York: William Morrow, 2002.
- Welch, Evelyn S. Art and Society in Italy, 1350–1500. Oxford History of Art. Oxford: Oxford Univ. Press, 1997.

Chapter 15 Sixteenth-Century Art in Italy

- Acidini Luchinat, Cristina, et al. The Medici, Michelangele, & the Art of Late Renaissance Florence. New Haven: Yale Univ. Press, 2002.
- Andrews, Lew. Story and Space in Renaissance Art: The Rebirth of Continuous Narrative. New York: Cambridge Univ. Press, 1995.
- Bambach, Carmen. Drawing and Painting in The Italian Renaissance Workshop: Theory and Practice, 1339–1600. Cambridge, U.K.: Cambridge Univ. Press, 1999.
- Barriault, Anne B., ed. *Readirg Vasari*. London: Philip Wilson in assoc. with the Georgia Museum of Art, 2005.
- Brown, Patricia Fortini. Art and Life in Renaissance Venice. Perspectives. New York: Abrams, 1997.
- Burroughs, Charles. The Italian Renaussance Palace Facade: Structures of Authority, Surfaces of Sense. Cambridge, U.K.: Cambridge Univ. Press, 2002.
- Cellini, Benvenuto. My Life. Trans. & notes Julia Conaway Bondanella & Peter Bondanella. Oxford World's Classics. New York: Oxford Univ. Press, 2002.
- Chastel, Andréé. The Age of Humanism: Europe, 1480–1530. Trans. Katherine M. Delavenay & E. M. Gwyer. London: Thames and Hudson, 1963.
- Chelazzi Dini, Giulietta, Alessandro Angelini, and Bernardina Sani Sienese Painting: From Duccio to the Birth of the Baroque. New York: Abrams, 1998.
- Cole, Alison. Virtue and Magnificence: Art of the Italian Renaissance Courts. Perspectives. New York: Abrams, 1995. Reissue ed. Art of the Italian Courts. Prespectives. Upper Saddle River, NJ: Prentice Hall, 2006.
- Dixon, Annette, ed. Women Who Ru'ed: Queens, Godáesses, Amazons in Renaissance and Baroque Art. Ann Arbor: Univ. of Michigan Museum of Art, 2002.
- Franklin. David, ed. Leonardo da Vinci, Michelangelo, and the Renaissance in Florence. Ottawa: National Gallery of Canada in assoc. with Yale Univ. Press, 2005.
- Freedberg, S. J. Painting in Italy, 1500 to 1600. 3rd ed.
 Pelican History of Art. New Haven: Yale Univ. Press, 1993.
- Goffen, Rona. Renaissance Rivals: Michelangelo, Leonardo, Raphael,
 Titian. New Haven: Yale Univ. Press, 2002.
 Gröössinger, Christa. Picturing Women in Late Medieval and Renais-
- sance Art. New York: St. Martin's Press, 1997.
 Hall, Marcia B. After Raphael: Painting in Central Italy in the Six-
- teenth Century. New York: Cambridge Univ. Press, 1999.

 ——., ed. The Cambridge Companion to Raphael. New York:
- Cambridge Univ. Press, 2005.
 Hollingsworth, Mary. Patrenage in Sixteenth Century Italy. London: Murray, 1996.
- Hopkins, Andrew. Italian Architecture: From Michelangelo to Borromini. World of Art. New York: Thames & Hudson, 2002.
- Hughes, Anthony, Michelangelo, London: Phaidon, 1997.
- Huse, Norbert, and Wolfgang Wolters. Art of Renaissance Venice: Architecture, Sculpture and Painting, 1460–1590. Trans. Edmund Jephcott. Chicago: Univ. of Chicago Press, 1990.
- Jacobs, Fredrika Herman. Defining the Renaissance Virtuosa: Women Artists and the Language of Art History and Criticism. Cambridge, U.K.: Cambridge Univ. Press, 1997.
- Joannides, Paul. Titian to 1518: The Assumption of Genius. New Haven: Yale Univ. Press, 2001.
- King, Ross. Michelangelo & the Pope's Ceiling. New York: Walker & Company, 2003.
- Klein, Robert, and Henri Zerner. Italian Art, 1500–1600: Sources and Documents. Upper Saddle River, NJ: Prentice Hall, 1966. Kliemann, Julian-Matthias, and Michael Rohlmann, Italian Fres-
- Kliemann, Julian-Matthias, and Michael Rohlmann, Italian Frescoes: High Renaissance and Manaerism, 1510-1600. Trans. Steven Lindberg. New York: Abbeville Press, 2004.
- Landau, David, and Peter Parshall. *The Renaissance Print:* 1470–1550. New Haven: Yale Univ. Press, 1994.
- Lieberman, Ralph. Renaissance Architecture in Venice, 1450–1540.

 New York: Abbeville, 1982.
- Lotz, Wolfgang. Architecture in Italy, 1500–1600. Rev. Deborah Howard. Pelican History of Art. New Haven: Yale Univ. Press, 1995.
- Manca, Joseph. Moral Essays on the High Renaissance: Art in Italy in the Age of Michelangelo. Lanham, MD: Univ. Press of America, 2001.

- Mann, Nicholas, and Luke Syson, eds. The Image of the Individual: Portraits in the Renaissance. London: British Museum Press, 1998.
- Meilman, Patricia, ed. The Cambridge Companion to Titian. New York: Cambridge Univ. Press, 2004
- Mitrovic, Branko. Learning from Palladio. New York: W.W. Norton, 2004.
- Murray Linda. The High Renaissance and Mannerism: Italy, the North and Spain, 1500–1600. World of Art. London: Thames and Hudson, 1995.
- Olson, Roberta J. M. Italian Renaissance Sculpture. World of Art. New York: Thames and Hudson, 1992.
- Partridge, Loren W. The Art of Renaissance Rome, 1400–1600. New York: Abrams, 1996.
- Pietrangeli, Carlo, et al. The Sistine Chapel: The Art, the History, and the Restoration. New York: Harmony, 1986.
- Pilliod, Elizabeth. Pontormo, Bronzino, Allori: A Genealogy of Florentine Art. New Haven: Yale Univ. Press, 2001.
- Poeschke, Joachim. Michelangelo and his World: Sculpture of the Italian Renaissance. Trans. Russell Stockman. New York: Harry N. Abrams, 1996.
- Pope-Hennessy, Sir John. Italian High Renaissance and Baroque Sculpture. 3rd ed. Oxford: Phaidon, 1986.
- Rosand, David. Painting in Cinquecento Venice: Titian, Veronese, Tintoretto. Rev. ed. Cambridge, U.K.: Cambridge Univ. Press, 1997.
- Rowe, Colin, and Leon Satkowski. *Italian Architecture of the 16th Century*. New York: Princeton Architectural Press, 2002.
- Rowland, Ingrid D. The Culture of the High Renaissance: Ancients and Moderns in Sixteenth Century Rome. Cambridge, U.K.: Cambridge Univ. Press, 1998.
- Shearman, John. Mannerism. Harmondsworth, UK:
- Penguin, 1967. Reissue ed. New York: Penguin Books, 1990.Vasari, Giorgio. The Lives of the Artists. Trans. Julia Cor.away Bondanella & Peter Bondanella. New York: Oxford Univ. Press, 1991
- Verheyen, Egon. The Paintings in the Studiolo of Isabella d'Este at Mantua. Monographs on Archaeology and Fine Arts. New York: New York Univ. Press, 1971.
- Williams, Robert. Art, Theory, and Culture in Sixteenth-Century Italy: From Techne to Metateche. Cambridge, U.K.: Cambridge Univ. Press, 1997.

Chapter 16 Sixteenth-Century Art in Northern Europe and the Iberian Peninsula

- Bartrum, Giulia. Albrecht Düürer and his Legacy: The Graphic Work of a Renaissance Artist. London: British Museum Press, 2002.
- Bartrum, Giulia. German Renaissance Prints 1490-1550. London: British Museum Press, 1995.
- Buck, Stephanie, and Jochen Sander. Hans Holbein the Younger: Painter at the Court of Henry VIII. Trans. Rachel Esner & Beverley Jackson. New York: Thames & Hudson, 2004.
- Chapuis, Julien. Tilman Riemenschneider: Master Sculptor of the Late Middle Ages. Washington, D.C.: National Gallery of Art, 1999.
- Cloulas, Ivan, and Michèèle Bimbenet-Privat. Treasures of the French Renaissance. Trans. John Goodman. New York: Harry N Abrams, 1998.
- Davies, David, and John H. Elliott. *El Greco*. London: National Gallery, 2003.
- Dixon, Laurinda. Bosch. Art & Ideas. New York: Phaidon, 2003.
 Foister, Susan. Holbein and England. New Haven:
 Published for Paul Mellon Centre for Studies in British Art by
- Yale Univ. Press, 2004.

 Hayum, Andréé. The Isenheim Altarpiece: God's Medicine and the Painter's Vision. Princeton Essays on the Arts. Princeton:
- Princeton Univ. Press, 1989.

 Hearn, Karen, ed. Dynasties: Painting in Tudor and Jecobean England, 1530-1630. New York: Rizzoli, 1996.
- Koerner, Joseph Leo. *The Reformation of the Image*. Chicago: Univ. of Chicago Press, 2004.
- Kubler, George. Building the Escorial. Princeton: Princeton Univ. Press, 1982.
- Osten, Gert von der, and Horst Vey. Painting and Sculpture in Germany and the Netherlands, 1500–1600. Pelican History of Art. Harmondsworth, UK: Penguin, 1969.
- Price, David Hotchkiss. Albrecht Düürer's Renaissance: Humanism, Reformation, and the Art of Faith. Studies in Medieval and Early Modern Civilization. Ann Arbor: Univ. of Michigan Press, 2003
- Roberts-Jones, Philippe, and Francoise Roberts-Jones. Pieter Bruegel. New York: Harry N. Abrams, 2002.
- Smith, Jeffrey Chipps. Nuremberg, a Renaissance City. 1500–1618.
 Austin: Huntington Art Gallery, Univ. of Texas, 1983.
- Strong, Roy C. Artists of the Tidor Court: The Portrait Miniature Rediscovered, 1520–1620. London: Victoria and Albert Museum. 1983.
- The Word Made Image: Religion, Art, and Architecture in Spain and

- Spanish America, 1500-1600. Fenway Court, 28. Boston: Published by the Trustees of the Isabella Stewart Gardner Museum. 1998.
- Wheeler, Daniel. *The Chateaux of France*. New York: Vendome Press, 1979.
- Zerner, Henri. Renaissance Art in France: The Invention of Classicism. Paris: Flammarion, 2003.
- Zorach, Rebecca. Blood, Milk, Ink, Gold: Abundance and Excess in the French Renaissance. Chicago: Univ. of Chicago Press, 2005.

CHAPTER 17 Baroque Art

- Adams, Laurie Schneider. Key Monuments of the Baroque. Boulder, CO: Westview Press, 2000.
- The Age of Caravaggio. New York: Metropolitan Museum of Art, 1985.
- Allen, Christopher. French Painting in the Golden Age. World of Art. New York: Thames & Hudson, 2003.
- Alpers, Svetlana. The Making of Rubens. New Haven: Yale Univ. Press, 1995.
- Barberini, Maria Giulia, et al. Life and the Arts in the Baroque Palaces of Rome: Ambiente Barocco. Eds. Stefanie Walker and Frederick Hammond. New Haven: Published for the Bard Graduate Center for Studies in the Decorative Arts, New York by Yale Univ. Press, 1999.
- Blankert, Albert. Rembrandt: A Genius and his Impact. Melbourne: National Gallery of Victoria, 1997.
- Boucher, Bruce. Italian Baroque Sculpture. World of Art. New York: Thames and Hudson, 1998.
- Brown, Beverly Louise, ed. *The Genius of Rome, 1592-1623*. London: Royal Academy of Arts, 2001.
- Careri, Giovanni. Baroques. Tran. Alexandra Bonfante-Warren. Princeton: Princeton Univ. Press, 2003.
- Chong, Alan, and Wouter Kloek. Still-Life Paintings from the Netherlands, 1550-1720. Zwolle: Waanders Publishers, 1999.
- Franits, Wayne E. Dutch Seventeenth-Century Genre Painting: Its Stylistic and Thematic Evolution. New Haven: Yale Univ. Press, 2004.
- Harbison, Robert. Reflections on Baroque. Chicago: Univ. of
 Chicago Press. 2000.
- Kiers, Judikje, and Fieke Tissink. Golden Age of Dutch Art: Painting, Sculpture, Decorative Art. London: Thames and Hudson, 2000.
- Lagerlof, Margaretha Rossholm. Ideal Landscape: Annibale Caracci, Nicolas Poussin, and Claude Lorrain. New Haven: Yale Univ. Press, 1990.
- McPhee, Sarah. Bernini and the Bell Towers: Architecture and Politics at the Vatican. New Haven: Yale Univ. Press, 2002.
- Millon, Henry A., ed. The Triumph of the Baroque: Architecture in Europe, 1600-1750. New York: Rizzoli, 1999.
- Morrissey, Jake. The Genius in the Design: Bernini, Borromini, and the Rivalry that Transformed Rome. New York: William Morrow, 2005.
- Slive, Seymour. Dutch Painting 1600–1800. Pelican History of Art. New Haven: Yale Univ. Press, 1995.
- Stratton, Suzanne L., ed. The Cambridge Companion to Veláázquez. New York: Cambridge Univ. Press, 2002.
- Summerson, John. Inigo Jones. New Haven: Published for the Paul Mellon Centre for Studies in British Art by Yale Univ. Press, 2000.
- Vlieghe, Hans. Flemish Art and Architecture, 1585–1700. Pelican History of Art. New Haven: Yale Univ. Press, 1998. Reissue ed. 2004
- Wheelock Jr., Arthur K. Flemish Paintings of the Seventeenth Century. Washington, D.C.: National Gallery of Art, 2005.
- Wittkower, Rudolf. Art and Architecture in Italy, 1600 to 1750. 3 vols. 4th ed. Rev. Joseph Connors & Jennifer Montague. Pelican History of Art. New Haven: Yale Univ. Press, 1999.
- Zega, Andrew, and Bernd H. Dams. Palaces of the Sun King: Versailles, Trianon, Marly: The Chââteaux of Louis XIV. New York: Bizzoli, 2002.

Chapter 18 Eighteenth-Century Art in Europe and the Americas

- Bailey, Colin B., Philip Conisbee, and Thomas W. Gaehtgens. The Age of Watteau, Chardin, and Fragonard: Masterpieces of French Genre Painting. New Haven: Yale Univ. Press in assoc. with the National Gallery of Canada, Ottawa, 2003.
- Boime, Albert. Art in an Age of Revolution, 1750–1800. Chicago: Univ. of Chicago Press, 1987.
- Bowron, Edgar Peters, and Joseph J. Rishel, eds. Art in Rome in the Eighteenth Century. London: Merrell, 2000.
- Craske, Matthew. Art in Europe, 1700–1830: A History of the Visual Arts in an Era of Unprecedented Urban Economic Growth. Oxford History of Art. Oxford: Oxford Univ. Press, 1997.
- Goodman, Elise, ed. Art and Culture in the Eighteenth Century: New Dimensions and Multiple Perspectives. Studies in Eighteenth-Century Art and Culture. Newark: Univ. of Delaware Press, 2001 Irwin, David G. Neoclassicism. Art & Ideas. London: Phaidon, 1997.

- Jarrasséé, Dominique. 18th-Century French Painting. Trans. Murray Wyllie. Paris: Terrail, 1999.
- Kalnein, Wend von. Architecture in France in the Eighteenth Century. Trans. David Britt. Pelican History of Art. New Haven: Yale Univ. Press, 1995.
- Levey, Michael. Painting in Eighteenth-Century Venice. 3rd ed. New Haven: Yale Univ. Press, 1994.
- Lewis, Michael J. *The Gothic Revival*. World of Art. New York: Thames & Hudson, 2002.
- Lovell, Margaretta M. Art in a Season of Revolution: Fainters, Artisans, and Patrons in Early America. Early American Studies. Philadelphia: Univ. of Pennsylvania Press, 2005.
- Monneret, Sophie. David and Neo-Classicism. Trans. Chris Miller & Peter Snowdon. Paris: Terrail, 1999.
- Montgomery, Charles E, and Patrick E. Kane, eds. American Art, 1750–1800: Towards Independence. Eoston: New York Graphic Society, 1976.
- Poulet, Anne L. Jean-Antoine Houdon: Sculptor of the Enlightenment. Washington, D.C.: National Gallery of Art, 2003.
- Summerson, John. Architecture of the Eighteenth Century. World of Art. New York: Thames and Hudson, 1986.
- Wilton, Andrew, and Ilaria Bignamini, eds. Grand Tour: The Lure of Italy in the Eighteenth Century. London: Tate Gallery, 1996.
- Young, Hilary, ed. *The Genius of Wedgwood*. London:Victoria & Albert Museum, 1995.

Chapter 19 Nineteenth-Century Art in Europe and the United States

- Adams, Steven. The Barbizon School and the Origins of Impressionism London: Phaidon, 1994.
- Bajac, Quentin. The Invention of Photography. Discoveries. New York: Harry N. Abrams, 2002.
- Barger, M. Susan, and William B. White. The Daguerreotype: Nineteenth-Century Technology and Modern Science. Washington, D.C.: Smithsonian Institution, 1991.
- Benjamin, Roger. Orientalist Aesthetics: Art, Colonialism, and French North Africa, 1880-1930. Berkeley: Univ. of California Press, 2003.
- Bergdoll, Barry. European Architecture, 1750-1890. Oxford History of Art. New York: Oxford Univ. Press, 2000.
- Blakesley, Rosalind P. Russian Genre Painting in the Nineteenth Century. Oxford Historical Monographs. New York: Oxford Univ. Press, 2000.
- Blüühm, Andreas, and Louise Lippincott. Light!: The Industrial Age 1750-1900: Art & Science, Technology & Society. New York: Thames & Hudson, 2001.
- Boime, Albert. Art in an Age of Bonapartism, 1800–1815. Chicago: Univ. of Chicago Press, 1990.
- Boime, Albert. Art in an Age of Counterrevolution, 1815–1848. Chicago: Univ. of Chicago Press, 2004.
- Butler, Ruth, and Suzanne G. Lindsay. European Sculpture of the Nineteenth Century. The Collections of the National Gallery of Art Systematic Catalogue. Washington, D.C.: National Gallery of Art. 2000.
- Callen, Anthea. The Art of Impressionism: Painting Technique & the Making of Modernity. New Haven: Yale Univ. Press, 2000.
- Chu, Petra ten-Doesschate. Nineteenth Century European Art. New York: Abrams, 2003.
- Denis, Rafael Cardoso, and Colin Trodd. Art and the Academy in the Nineteenth Century. New Brunswick, NJ: Rutgers Univ. Press, 2000.
- Eisenman, Stephen. Nineteenth Century Art: A Critical History. 2nd ed. New York: Thames and Hudson, 2002.
- Eitner, Lorenz. Nineteenth Century European Painting: David to Cezanne. Rev. ed. Boulder: Westview Press, 2002.
- Frazier, Nancy. Louis Sullivan and the Chicago School. New York: Knickerbocker Press, 1998.
- Fried, Michael. Manet's Modernism, or, The Face of Painting in the 1860s. Chicago: Univ. of Chicago Press, 1996.
- Gerdts, William H. American Impressionism. 2nd ed. New York: Abbeville, 2001.
- Greenhalgh, Paul, ed. Art nouveau, 1890-1914. London: V&A Publications, 2000.
- Grigsby, Darcy Grimaldo. Extremities: Painting Empire in Post-Revolutionary France. New Haven: Yale Univ. Press, 2002.
 Groseclose, Barbara. Nineteenth-Century American Art. Oxford His-
- Groseclose, Barbara. Nineteenth-Century American Art. Oxford History of Art. Oxford: Oxford Univ. Press, 2000.
- Harrison, Charles, Paul Wood, and Jason Gaiger. Art in Theory 1815–1900: An Anthology of Changing Ideas. Oxford: Blackwell, 1998.
- Herrmann, Luke. Nineteenth Century British Painting. London: Giles de la Mare, 2000.
- Hirsh, Sharon L. Symbolism and Modern Urban Society. New York: Cambridge Univ. Press, 2004.
- Holt, Elizabeth Gilmore, ed. The Expanding World of Art, 1874–1902. New Haven: Yale Univ. Press, 1988.
- Kaplan, Wendy. The Arts & Crafts Movement in Europe & America: Design for the Modern World. New York: Thames & Hudson in assoc, with the Los Angeles County Museum of Art, 2004.

- Kapos, Martha, ed. The Post-Impressionists: A Retrospective. New York: Hugh Lauter Levin Associates, 1993.
- Kendall, Richard. Degas: Beyond Impressionism. London: National Gallery Publications, 1996.
- Lambourne, Lionel. Japonisme: Cultural Crossings between Japan and the West. New York: Phaidon, 2005.
- Lemoine, Bertrand. Architecture in France, 1800–1900. Trans.
 Alexandra Bonfante-Warren. New York: Harry N. Abrams,
 1998.
- Lochnan, Katharine Jordan. Timer Whistler Monet. London: Tate Publishing in assoc. with the Art Gallery of Ontario, 2004.
- Noon, Patrick J. Crossing the Channel: British and French Painting in the age of Romanticism. London: Tate Pub., 2003.
- Pissarro, Joachim. Pioneering Modern Painting: Céézanne & Pissarro 1865-1885, New York: Museum of Modern Art, 2005
- Rodner, William S. J.M. W. Turner: Romantic Painter of the Industrial Revolution. Berkeley: Univ. of California Press, 1997.
- Rosenblum, Robert, and H. W. Janson. 19th Century Art. Rev. & updated ed. Upper Saddle River, NJ: Pearson Prentice Hall, 2005.
- Rubin, James H. Impressionism. Art & Ideas. London: Phaidon, 1999.
- Rybczynski, Witold. A Clearing in the Distance: Frederick Law Olmsted and America in the Nineteenth Century. New York: Scribner, 1999.
- Smith, Paul. Seurat and the Avant-Garde. New Haven: Yale Univ. Press, 1997.
- Thomson, Belinda. Impressionism: Origins, Practice, Reception. Thames & Hudson World of Art. New York: Thames & Hudson, 2000.
- Twyman, Michael. Breaking the Mould: The First Hundred Years of Lithography. The Panizzi Lectures, 2000. London: British Library, 2001.
- Vaughan, William, and Francoise Cachin. Arts of the 19th Century. 2 vols. New York: Abrams, 1998.
- Werner, Marcia. Pre-Raphaelite Painting and Nineteenth-Century Realism. New York: Cambridge Univ. Press, 2005.
- Zemel, Carol M. Van Gogh's Progress: Utopia, Modernity, and Late-Nineteenth-Century Art. California Studies in the History of Art, 36. Berkeley: Univ. of California Press, 1997.

Chapter 20 Modern Art In Europe And The Americas

- Ades, Dawn, comp. Art and Power: Europe under the Dictators, 1930-45. Stuttgart, Germany: Oktagon in assoc. with Hayward Gallery, 1995.
- Antliff, Mark, and Patricia Leighten. Cubism and Culture. World of Art. London: Thames & Hudson, 2001.
- Bailey, David A. Rhapsodies in Black: Art of the Harlem Renaissance London: Hayward Gallery, 1997.
- Balken, Debra Bricker. Debating American Modernism: Stieglitz, Duchamp, and the New York Avant-Garde. New York: American Federation of Arts, 2003.
- Barron, Stephanie, ed. Degenerate Art: The Fate of the Avant-Garde in Nazi Germany. Los Angeles: Los Angeles County Museum of Art, 1991.
- Barron, Stephanie, and Wolf-Dieter Dube, eds. German Expressionism: Art and Society. New York: Rizzoli, 1997.
- Bochner, Jay. An American Lens: Scenes from Alfred Stieglitz's New York Secession. Cambridge, MA: MIT Press, 2005.
- Bohn, Willard. The Rise of Surrealism: Cubism, Dada, and the Pursuit of the Marvelous. Albany: State Univ. of New York Press, 2002.
- Bowlt, John E., and Evgeniia Petrova, eds. Painting Revolution: Kandinsky, Malevich and the Russian Avant-Garde. Bethesda, MD: Foundation for International Arts and Education, 2000.
- Bown, Matthew Cullerne. Socialist Realist Painting. New Haven: Yale Univ. Press, 1998.
- Brown, Milton. Story of the Armory Show: The 1913 Exhibition That Changed American Art. 2nd ed. New York: Abbeville, 1988.
- Chassey, Eric de, ed. American art: 1908-1947, from Winslow Homer to Jackson Pollock: Trans. Jane McDonald. Paris: Reunion des Musees Nationaux, 2001.
- Corn, Wanda M. The Great American Thing: Modern Art and National Identity, 1915–1935. Berkeley: Univ. of California Press, 1999.
- Curtis, Penelope. Sculpture 1900–1945: After Rodin. Oxford History of Art. Oxford: Oxford Univ. Press, 1999.
- Elger, Dietmar. Expressionism: A Revolution in German Art. Ed. Ingo F. Walther. Trans. Hugh Beyer. New York: Taschen, 1998.
- Fer, Briony. On Abstract Art. New Haven: Yale Univ., 1997.
 Fletcher, Valerie J. Crosscurrents of Modernism: Four Latin American
 Pioneers: Diego Rivera, Joaquiín Torres-Garciía, Wifredo Lam,
 Matta. Washington, D.C.: Hirshhorn Museum and Sculpture
- Garden in assoc, with the Smithsonian Institution Press, 1992. Folgarait, Leonard. Mural Painting and Social Revolution in Mexico, 1920-1940: Art of the New Order. New York: Cambridge Univ. Press, 1998.
- Forgáács, Eva. *The Bauhaus Idea and Bauhaus Politics*. Trans. John Báátki. New York: Central European Univ. Press, 1995.
- Frank, Patrick. Los Artistas del Pueblo: Prints and Workers' Culture in

- Buenos Aires, 1917-1935. Albuquerque: Univ. of New Mexico Press, 2006.
- Grant, Kim. Surrealism and the Visual Arts: Theory and Reception. New York: Cambridge Univ. Press, 2005.
- Green, Christopher. Art in France: 1900–1940. Pelican History of Art. New Haven: Yale Univ. Press, 2000. Reissue ed. 2003.
- Haiko, Peter, ed. Architecture of the Early XX Century. Trans. Gordon Clough. New York: Rizzoli, 1989.
- Harris, Jonathan. Federal Art and National Culture: The Politics of Identity in New Deal America. Cambridge Studies in American Visual Culture. New York: Cambridge Univ. Press, 1995.
- Harrison, Charles, Francis Frascina, and Gill Perry. Primitivism, Cubism, Abstraction: The Early Twentieth Century. New Haven: Yale Univ. Press, 1993.
- Haskell, Barbara. *The American Century: Art & Culture, 1900–1950.*New York: Whitney Museum of American Art, 1999.
- Herbert, James D. Fauve Painting: The Making of Cultural Politics. New Haven: Yale Univ. Press, 1992.
- Hill, Charles C. The Group of Seven: Art for a Nation. Toronto: National Gallery of Canada, 1995.
- Karmel, Pepe. Picasso and the Invention of Cubism. New Haven: Yale Univ. Press, 2003.
- Lista, Giovanni. Futurism. Trans. Susan Wise. Paris: Terrail, 2001.
 McCarter, Robert, ed. On and by Frank Lloyd Wright: A Primer of Architectural Principles. New York: Phaidon Press, 2005.
- Moudry, Roberta, ed. The American Skyscraper: Cultural Histories. New York: Cambridge Univ. Press, 2005.
- Rickey, George. Constructivism: Origins and Evolution. Rev. ed. New York: G. Braziller, 1995.
- Taylor, Brandon. Collage: The Making of Modern Art. London: Thames & Hudson, 2004.
- Weston, Richard. Modernism. London: Phaidon, 1996.
- White, Michael. De Stijl and Dutch Modernism. Critical Perspectives in Art History. New York: Manchester Univ. Press, 2003.
- Whitfield, Sarah. Fauvism. World of Art. New York: Thames and Hudson, 1996.
- Whitford, Frank. Bauhaus. World of Art. London: Thames and Hudson, 1984.
- Zurier, Rebecca, Robert W. Snyder, and Virginia M. Mecklenburg. Metropolitan Lives: The Ashcan Artists and Their New York. Washington, D.C.: National Museum of American Art, 1995.

Chapter 21 The International Scene Since 1945

- Alberro, Alexander, and Blake Stimson, eds. Conceptual Art: A Critical Anthology. Cambridge, MA: MIT Press, 1999.
- Archer, Michael. Art Since 1960. 2nd ed. World of Art. New York: Thames and Hudson, 2002.
- Atkins. Robert. Artspeak: A Guide to Contemporary Ideas, Movements, and Buzzwords. 2nd ed. New York: Abbeville, 1997.
- Ault, Julie. Art Matters: How the Culture Wars Changed America. Ed. Brian Wallis, Marianne Weems, & Philip Yenawine. New York: New York Univ. Press, 1999.
- Battcock, Gregory. Minimal Art: A Critical Anthology. Berkeley: Univ. of California Press, 1995.
- Beardsley, John. Earthworks and Beyond: Contemporary Art in the Landscape. 3rd ed. New York: Abbeville, 1998.

- Bird, Jon, and Michael Newman, eds. Rewriting Conceptual Art. Critical Views. London: Reaktion, 1999.
- Bishop, Claire. Installation Art: A Critical History. New York: Routledge, 2005.
- Blais, Joline, and Jon Ippolito. At the Ege of Art. London: Thames & Hudson, 2006.
- Buchloh, Benjamin H. D. Neo-Avantgarde and Culture Industry: Essays on European and American Art from 1955 to 1975. Cambridge, MA: MIT Press, 2000.
- Carlebach, Michael L. American Photojournalism Comes of Age. Washington, D.C.: Smithsonian Institution Press, 1997.
- Causey, Andrew. Sculpture since 1945. Oxford History of Art Oxford: Oxford Univ. Press. 1993.
- Corris, Michael, ed. Conceptual Art: Theory, Myth, and Practice. New York: Cambridge Univ. Press, 2004.
- Craven, David. Abstract Expressionism as Cultural Critique: Dissent during the McCarthy Period. Cambridge Studies in American Visual Culture. New York: Cambridge Univ. Press, 1999.
- Day, Holliday T. Crossoads of American Sculpture: David Smith, George Rickey, John Chareberlain, Robert Indiana, William T. Wiley, Bruce Nauman. Indianapolis, IN: Indianapolis Museum of Art, 2000.
- De Oliveira, Nicolas, Nicola Oxley, and Michael Petry. Installation Art in the New Millennium: The Empire of the Senses. New York: Thames & Hudson, 2003.
- De Salvo, Donna M., ed. *Open Systems: Rethinking Art c. 1970.* London: Tate, 2005.
- Fabozzi, Paul E Artists, Critiss, Context: Readings In and Around American Art Sinze 1945. Upper Saddle River, NJ: Prentice Hall, 2002.
- Fineberg, Jonathan David. Art Since 1940: Strategies of Being. 2nd ed. New York: Abrams, 2000.
- Flood, Richard, and Frances Morris Zero to Infinity: Arte Povera 1962-1972. Minneapol:s, MN: Walker Art Center, 2001.
- Follin, Frances. Embodied Visions: Bridget Riley, Op Art and the Sixties. London: Thames & Hudson, 2004.
- Ghirardo, Diane. Architecture after Medernism. World of Art. New York: Thames and Hudson, 1996.
- Goldberg, Roselee. Performance Art. From Futurism to the Present.
- Rev. ed. World of Art. London: Thames and Hudson, 2001. Goldstein, Ann. A Minimal Future?: An as Object 1958-1968. Los
- Angeles: Museum of Contemporary Art, 2004. Grande, John K. Art Nature Dialogues: Interviews with Environmental Artists. Albany: State Univ. of New York Press, 2004.
- Grosenick, Uta, and Burkhard Riemschneider, eds. Art at the Turn of the Millennium. New York: Taschen, 1999.
- Grunenberg, Christoph, ed. Summer of Love: Art of the Psychedelic Era. London: Tare. 2005
- Herskovic, Marika, ed. American Abstract Expressionism of the 1950s: An Illustrated Survey: With Artists' Statements, Artwork and Biographies. New York: New York School Press, 2003.
- Hitchcock, Henry Russell, and Philip Johnson. The International Style. New York: W.W. Norton, 1995.
- Hopkins, David. After Modern Art. 1945–2000. Oxford History of Art. Oxford: Oxford Univ. Press, 2000.
- Jencks, Charles. The New Faradigm in Architecture: The Language of Post-Modernism. New Haven: Yale Univ. Press, 2002.

- Jodidio, Philip. New Forms: Architecture in the 1990s. New York: Taschen, 2001.
- Johnson, Deborah, and Wendy Oliver, eds. Women Making Art: Women in the Visual, Literary, and Performing Arts Since 1960. Eruptions, vol. 7. New York: Peter Lang, 2001.
- Jones, Caroline A. Machine in the Studio: Constructing the Postwar American Artist. Chicago: Univ. of Chicago Press, 1996.
- Joselit, David. American Art Since 1945. World of Art. London: Thames and Hudson, 2003.
- Katzenstein, Inéés, ed. Listen, Here, Nowl: Argentine art of the 1960s: Writings of the Avant-Garde. New York: Museum of Modern Art. 2004.
- Legault, Rééjean, and Sarah Williams Goldhagen, eds. Anxious Modernisms: Experimentation in Postwar Architectural Culture. Montrééal: Canadian Centre for Architecture. 2000
- Lucie-Smith, Edward. Movements in Art since 1945. World of Art. London: Thames and Hudson. 2001.
- Madoff, Steven Henry, ed. Pop Art: A Critical History. The Documents of Twentieth Century Art. Berkeley: Univ. of California Press 1997
- Moos, David, ed. The Shape of Colour: Excursions in Colour Field Art, 1950-2005. Toronto: Art Gallery of Ontario, 2005.
- Paul, Christiane. Digital Art. World of Art. London: Thames and Hudson 2003
- Phillips, Lisa. The American Century: Art and Culture, 1950–2000. New York: Whitney Museum of American Art. 1999.
- Ratcliff, Carter. The Fate of a Gesture: Jackson Pollock and Postwar American Art. New York: Farrar, Straus, Giroux, 1996.
- Reckitt, Helena, ed. *Art and Feminism*. Themes and Movements. London: Phaidon, 2001.
- Risatti, Howard, ed. Postmodern Perspectives: Issues in Contemporary Art. 2nd ed. Upper Saddle River, NJ: Prentice Hall. 1998.
- Robertson, Jean, and Craig McDaniel. *Themes of Contemporary Art: Visual Art after 1980.* New York: Oxford Univ. Press, 2005.
- Robinson, Hilary, ed. Feminism-Art-Theory: An Anthology, 1968-2000. Malden, MA: Blackwell Publishers, 2001.
- Rorimer, Anne. New Art in the 60s and 70s: Redefining Reality. New York: Thames & Hudson, 2001.
- Rush, Michael. New Media in Late 20th-Century Art. World of Art.
- London: Thames and Hudson, 1999.
 ——. Video Art. New York: Thames & Hudson, 2003.
- Sandler, Irving. Art of the Postmodern Era: From the Late 1960s to the Early 1990s. New York: Icon Editions, 1996.
- Shohat, Ella. Talking Visions: Multicultural Feminism in a Transnational Age. Documentary Sources in Contemporary Art, 5. New York: New Museum of Contemporary Art, 1998.
- Sylvester, David. About Modern Art. 2nd ed. New Haven: Yale Univ. Press, 2001.
- Waldman, Diane. Collage, Assemblage, and the Found Object. New York: Abrams, 1992.
- Weintraub, Linda, Arthur Danto, and Thomas McEvilley. Art on the Edge and Over: Searching for Art's Meaning in Contemporary Socicty, 1970s–1990s. Litchfield, CT: Art Insights, 1996.

CREDITS

CREDITS AND COPYRIGHTS

The Authors and Publishers wish to thank the libraries, museums, galleries, and private collections for permitting the reproduction of works of art in their collections. Sources not included in the captions are gratefully acknowledged below. In addition, the Editors are gratefull to the following correspondents: Barbara Nagelsmith, Paris; Elizabeth Meryman, New York; Achim Bednorz, Cologne; Carla Bertini, Rome; Angela Anderson, London; Kostas Kontos, Athens.

Introduction

1 Roger Wood, London Corbis / Bettmann; 2 The Art Institute of Chicago. Wirt D. Walker Fund. 1949.585 Photograph © 2005, The Art Institute of Chicago. All Rights Reserved; 3 John Decopoulos; 4 University of Arizona, Museum of Art; 5 The University of Arizona Museum of Art. © 2007 The Georgia O'Keeffe Foundation / Artists Rights Society (ARS), New York; 6 Art Resource, NY; 7 Art Resource, NY; 8 Derechos reservados © Museo Nacional Del Prado - Madrid; 9 M. Sari / Musei Vaticani / SCALA Art Resource, NY; 10 Art Resource, NY; 11 SCALA Art Resource, NY; 12 Erich Lessing / Art Resource, NY; 13 Spencer Museum of Art, The University of Kansas; 14 The Nelson-Atkins Museum of Art, Kansas City, Missouri. Purchase, F83-55. Photograph by Mel McLean; 15 Spencer Museum of Art, The University of Kansas: Museum Purchase: Peter T. Bohan Art Acquisition Fund; 16 The J. Paul Getty Museum, Los Angeles; 17 Ghigo Roli / Index Ricerca Iconografica; 18 Robert Lehman Collection, 1975 (1975.1.794) Photograph © 1983 The Metropolitan Museum of Art; 19 Birmingham Museums and Art Gallery, Birmingham, England, U.K.; 20 By permission of The British Library; 21 Courtesy of the Freer Gallery of Art, Smithsonian Institution, Washington, D.C. F1904.61; 22 SCALA Art Resource, NY: 23 Victoria & Albert Museum, London / Art Resource, NY; BOX Catherine Ursillo / Photo Researchers, Inc.; BOX Frank Fournier.

Chapter 12

12-1, 12-2, 12-3, 12-5 Achim Bednorz; 12-4 © Guide Gallimard Florence, Illustration by Pilippe Biard; 12-6 Tosi Index Ricerca Iconografica; 12-7 Cimabue (Cenni di Pepi) Index Ricerca Iconografica, 12-8 Galleria degli Uffizi; 12-9, 12-10 Alinari / Art Resource, NY; 12 11Piero Codato / Canali Photobank; 12-12 Canali Photobank; 12-13 Thames & Hudson International, Ltd; 12-14 Photograph © Board of Trustees, National Gallery of Art, Washington, D.C.; 12-14, 12-16, 12-17 Scala Art Resource, NY;12-15 Canali Photobank; 12-16 Mario Quattrone / IKONA; 12-18 M. Beck-Coppola / Art Resource / Musee du Louvre; 12-19 Photography © 1991 The Metropolitan Museum of Art; 12-20 The Walters Art Museum, Baltimore; 12-21 Photograph © 1981 The Metropolitan Museum of Art; 12-23 Jan Gloc; 12-24, 12-25 © Radovnn Bocek; BOX: Canali Photobank; BOX: Alinari / Art Resource, NY.

Chapter 13

13-1, 13-4, 13-12, 13-16 Erich Lessing / Art Resource, NY; 13-2 SCALA Art Resource, NY; 13-3 Reunion des Musees Nationaux / Art Resource, NY; 13-5L Giradon / Art Resource, NY; 13-5R SCALA Art Resource, NY; 13-6 R.G. Ojeda / Art Resource, NY; 13-7 Bildarchiv der Osterreichische Nationalbibliothek; 13-8 Photograph © 1998 The Metropolitan Museum of Art, NY; 13-9 Kunsthistorisches Museum, Vienna; 13-10 Photograph © 1996 The Metropolitan Museum of Art, NY; 13-11 © National Gallery, London; 13-12 Photograph © Board of Trustees, National Gallery of Art, Washington, D.C.; 13-13 © National Gallery, London; 13-14 © Museo Nacional Del Prado; 13-19 Photograph © 1993 The Metropolitan Museum of Art, NY; 13-19 Speltdoorn Musees Royaux des Beaux-Arts de Belgique; 13-20 Galleria degli Uffizi; 13-22 Joerg P. Anders / Art Resource /Bildarchiv Preussischer Kulturbesitz; 13-23, 13-24, 13-25 Achim Bednorz: 13-26 SCALA Art Resource, NY; 13-27 Musee d'art et d'histoire, Geneve; 13-28 John Rylands University Library of Manchester; 13-30 Photograph © 1997 The Metropolitan Museum of Art, NY; 13-31 The Pierpont Morgan Library / Art Resource, NY; BOX: H. Martaans, Bruges / Brugge; BOX: Bibliotheque Nationale de France.

Chapter 14

14-1, 14-39 © National Gallery, London; 14-2 Photo Nimitallah / Art Resource, NY; 14-6, 14-7, 14-9, 14-12,

14-13, 14-15, 14-30, 14-32, 14-40 Achim Bednorz; 14-8 Cantarelli / Index Ricerca Iconografica; 14-10 Canali Photobank; 14-11 Museo Nazionale del Bargello, Florence / Canali Photobank; 14-12 Nimatallah / Art Resource, NY; 14-14 © Piazza del Santo, Padua, Italy The Bridgeman Art Library; 14-16, 14-21 Er:ch Lessing / Art Resource, NY; 14-16 Art Resource, NY; 14-17 SCALA Art Resource, NY; 14-18 Cincinnati Art Museum, Ohio; 14-14 Sta. Maria Novella, Florence / Canali Photobank; 14-20, 14-22 Studio Mario Quattrone; 14-23, 14-26, 14-27, 14-33, 14-37, BOX: Scala Art Resource, NY: 14-24 Canali Photobank; 14-25 Alinari /Art Resource, NY; 14-28, 14-29, BOX: Nicolo Orsi Battaglini / Art Resource, NY; 14-34 @ Canali Photobank; 14-36 Orsi Battaglini / Index Ricerca Iconografica; 14-39 Galleria degli Uffizi, Florence Canali Photobank; 14-41 Galleria Dell'Accademia, Venice Cameraphoto Arte di Codato G.P. & C.snc; 14-44 Campolini / Art Resource, NY; 14-43 © The Frick Collection, NY; BOX: Art Resource / The Pierpont Morgan Library; BOX: The J. Paul Getty Museum; BOX: SCALA Art Resource, NY: BOX: Canali Photobank

Chapter 15

15-1, 15-6, 15-8 Musei Vaticani; 15-2 Studio Mario Quattrone; 15-3 @ National Gallery, London; 15-4 Lewandowski / LeMage / Art Resource, NY; 15-5 Photograph © Board of Trustees, National Gallery of Art, Washington, D.C.; 15-7 Alinari / Art Resource, NY; 15-9, 15-14, 15-29, 15-34, 15-42 Canali Photobank; 15-10, 15-20, 15-21, 15-27, 15-31, BOX: SCALA Art Resource, NY; 15-11 Zigrossi Bracchetti / Vatican Musei / IKONA; 15-12 AKG-Images; 15-15 Hirmer Fotoarchiv; 15-16 © Raffaello Bencini / Ikona; 15-17, 15-47, BOX: Achim Bednorz; 15-18, BOX: @ Alinari / Ikona; 15-19 SuperStock, Inc.; 15-22 Ikona; 15-23 Cameraphoto / Art Resource, NY; 15-24 Musee du Louvre / RMN Reunion des Musees Nationaux / Erich Lessing / Art Resource, NY; 15-25 Embassy of Italy; 15-26 Summerfield / Galleria degli Uffizi, Florence / Index Ricerca Iconografica; 15-28 A. Braccetti - P. Zigrossi / Musei Vaticani; 15-30 Alinari Art Resource, NY; 15-33 Index Ricerca Iconografica; 15-35 Galleria degli Uffizi; 15-36 Photograph © 1990 The Metropoligan Museum of Art; 15-37 © National Gallery, London; 15-38 Photo Joseph Zehavi / Art Resource, NY;15-39 © 2005 Museum of Fine Arts, Boston. All Rights Reserved; 15-39 Photograph © 2007 Museum of Fine Arts, Boston; 15-40, 15-41, BOX: Kunsthistorisches Museum, Vienna; 15-43 Cameraphoto / Art Resource, NY; 15-44 Erich Lessing / Art Resource, NY; 15-45 © Bildarchiv Monheim GmbH / Alamy.

Chapter 16

16-1V & A Picture Library; 16-2, 16-3, 16-16, 16-22, 16-26 Erich Lessing / Art Resource, NY; 16-4 Photo O. Zimmermann; 16-5 Musee d'Unterlinden; 16-6 Germanisches Nationalmuseum Nurnberg; 16-7 SCALA / Alte Pinakothek, Munich / Art Resource, NY; 16-8 Laurie Platt Winfrey, Inc. / The Metrpolitan Museum of Art, NY; 16-9 Los Angeles County Museum of Art / Culver Pictures, Inc.; 16-10, 16-12 Alte Pinakothek, Munich. Bayerische Staatsgemaldesammlungen, Neue Pinakothek Munich; 21-11 Photograph © Board of Trustees, National Gallery of Art, Washington, D.C.; 16-13 Reunion des Musees Natinaux/Art Resource, NY; 16-14 @ GlobalQuest Photography / L. B. Foy; 16-15 Giraudon / The Bridgeman Art Library International; 21-17 Musee du Louvre / RMN Reunion des Musees Nationaux SCALA Art Resource, NY; 16-20 Photograph © 2007 The Metropolitan Museum of Art, NY; 16-21 Photo Oronoz. Derechos reservados © Museo Nacional Del Prado; 16-22, BOX: SCALA Art Resource, NY; 16-24 Martin Buhler / Kunstmuseum Basel; 16-25 Musees Royaux des Beaux-Arts de Belgique; 16-27 Index Ricerca Iconografica; 16-28 The Royal Collection © 2008, Her Majesty Queen Elizabeth II; 16-29 The Nelson-Atkins Museum of Art; 16-30 © Hardwick Hall, Derbyshire, UK / The Bridgeman Art Library; 16-31 A.F. Kersting; BOX: Photograph © 2007 The Metropolitan Museum of Art.

Chapter 17

17-1 Herve Lewandowski / Louvre, Paris / Reunion des Musees Nationaux / Art Resource, NY; 17-2 © Alinari Archives / Corbis; 17-3, 17-8, 17-9, 17-14 Achim Bednorz; 17-4 SCALA Art Resource, NY; 17-5 Adros Studio Fotografia; 17-6, 17-16, 17-17 Canali Photobank; 17-7 IKONA; 17-10 Allen Memorial Art Museum; 17-

11 Joseph Martin / akg-images; 17-12 Vincenzo Pirozzi / IKONA; 17-13 Canali Photobank; 17-15 Dagli Orti / The Art Archive; 17-18 Detroit Institute of Arts; 17-19 The Royal Collection © 2007, Her Majesty Queen Elizabeth II. Photo by A. C. Cooper Ltd.; 17-20 Casino Rospigliosi / Canali Photobank; 17-21 © The Cleveland Museum of Art, Dudley P. Allen Fund. 1943.265a; 17-22 Palazzo Barberini, Italy / Canali Photobank; 17-23 SCALA / Il Gesu, Rome, Italy / Art Resource, NY; 17-24 San Diego Museum of Art; 17-24 Markus Bassler / Bildarchiv Monheim GmbH / Alamy Images; 17-25 Bob Grove / Photograph © Board of Trustees, National Gallery of Art, Washington, D.C.; 17–26 Wadsworth Atheneum; 17–27 V & A Picture Library; 17–28, 17–29 Derechos reservados © Museo Nacional Del Prado; 17-30 The State Hermitage Museum; 17-31 Courtesy of Marilyn Stokstad, Private Collection; 17–32, 17–37, 17–54 Erich Lessing / Art Resource, NY; 17-33 Jakob Prandtauer / Achim Bednorz; 17-35 Institut Royal du Patrimoine Artistique (IRPA-KIK) © IRI Brussels; 17-36, 17-38 © Reunion des Musee © IRPA-KIK, Nationaux / Art Resource, NY; 17-39 Ashmolean Museum, Oxford, England; 17-41 Art Resource Miscum, Oxford, England, 17-41 Art Resource / Bildarchiv Preussischer Kulturbesitz; 17-42 Frans Hals Museum De Hallen; 17-43, 17-77 Photograph © Board of Trustees, National Gallery of Art, Washington, D.C.; 22-44, BOX: SCALA Art Resource, NY; 17-45, 17-46, 17-52 Publis SCALA Art Resource, NY; 17-45, 17-46, 17-52 Publis SCALA Art Resource, NY; 17-45, 17-46, 17-54 Publis SCALA Art Resource, NY; 17-45, 17-46, 17-17-52 Rijksmuseum, Amsterdam; 17-47 Photograph © 2007 The Metropolitan Museum of Art; 17-48 Frick Art Reference Library / The Frick Collection, NY; 17-49 Stichting Vrienden van Het Mauritshuis; 17-50, 17-51 Richard Carafelli / Photograph © Board of Trustees, National Gallery of Art, Washington, D.C.; 17-53 Detroit Institute of Arts; 17-55 The Toledo Museum of Art; 17-56, 17-67 Altitude / Yann Arthus Bertrand; 17-57 Hugh Rooney / Eye Ubiquitos / Corbis-NY; 17-58 © Marc Deville / Corbis; 17-59 © Peter Willi / Superstock; 17-60 Photograph © 2000 Museum Associates/LACMA. All Rights Reserved; 17-61 Photo © 2004, Detroit Institute of Arts; 17-62 Photograph © 2007, The Art Institute of Chicago. All Rights Reserved; 17-63 © National Gallery, London; 17-64, 17-66 A.F. Kersting; 17-65 Inigo Jones / Historic Royal Palaces Enterprises Ltd; 17-68 Janet Urso @ bimmy.com; 17-69 Worcester Museum of Art. Gift of Mr. and Mrs. Albert W. Rice; BOX: National Museum of Women In the Arts

Chapter 18

18-1 Photograph © 2007 Museum of Fine Arts, Boston; 18-2 Wim Swaan / The Getty Research; 18-3 Martin von Wagner Museum der Universitat Wurzburg Antikensammlung; 18-4, 18-5, 18-18 © Achim Bednorz, Koln; 18-7 Picture Press Bild - und Textagentur GmbH, Munich, Germany; 18-8 Gerard Blott / Reunion des Musees Nationaux / Art Resource, NY; 18-9 Erich Lessing / Art Resource, NY; 18-10 National Museum of Stockholm; 18-11 Frick Art Reference Library; 18-12 Photograph © 1990 The Metropolitan Museum of Art; 18-13 John Hammond / National Trust Photographic Library, England; 18-14 The Royal Collection © 2008, Her Majesty Queen Elizabeth II; 18-15 Fine Arts Museums of San Francisco; 18-16 IKONA; 18-17 C. Jean Art Resource, NY; 18-20 Palazzo Barberini, Galleria Nazionale d' Arte Antica / Canali Photobank: 18-21 English Heritage / National Monuments Record / © Crown copyright; 18-22 A.F. Kersting; 18-23 Richard Bryant / Arcaid; 18-24, 18-25 Courtesy Wedgwood Museum Trust Limited, Barlaston, Staffordshire; 18-26, 18-29 © National Gallery, London; 18-27 Photograph © 2007, The Art Institute of Chicago. All Rights Reserved; 18-28 Photograph © Board of Trustees, National Gallery of Art, Washington, D.C. 18-30 Katherine Wetzel / Virginia Museum of Fine Arts, Richmond; 18-31, 18-36 National Gallery of Canada, Ottawa; 18-32 The Detroit Institute of Arts; 18-33 Tate; 18-34 French Government Tourist Office; 18-37 Portland Art Museum; 18-38 Caisse Nationale des Monuments Historique et des Sites, Paris; 18-39 Photograph © 1980 The Metropolitan Museum of Art; 18-40 © Reunion des Musees Nationaux, Paris, France / Art Resource, NY; 18-41 Cussac / Musees Royaux des Beaux-Arts de Belgique; 18-42 Musee National du Chateau de Versailles / Art Resource / Reunion des Musees Nationaux; 18-43 The Library of Virginia; 18-45 Denver Art Museum; 18-47 © David R. Frazier Photolibrary, Inc. / Alamy Images; 18-48 Photograph © 2006 Board of Trustees, National Gallery of Art, Washington, D.C.; BOX: National Museum of Women in the Arts, Washington, DC; BOX: Courtesy of Philip Pocock; BOX: The Royal Collection © 2006, Her Majesty Queen Elizabeth II; BOX: British Embassy.

Chapter 19

19-1 Lauros-Giraudon / Art Resource, NY; 19-2, 19-3, 19-4, 19-8 RMN Reunion des Musees Nationaux / Art Resource, NY; 19-5 The Cleveland Museum of Art; 19-6 Yale University Art Gallery; 19-7 Getty Images - Stockbyte; 19-9 © Bernard Boutrit / Woodfin Camp and Associates, Inc; 19-10 Gregory; 19-11 Courtesy of the Hispanic Society of America; 19-12 © Museo Nacional Del Prado / Erich Lessing / Art Resource, NY; 19-13 Oronoz / © Museo Nacional Del Prado; 19-14 Osterreichische Galerie im Belvedere, Vienna; 19-15 Tate Gallery / Art Resource. NY; 30-16 Photo by Graydon Wood, 1988; 19-17 Frick Art Reference Library; 19-18, 19-32, 19-35, 19-52 Erich Lessing / Art Resource, NY; 19-19 Photograph © 1995 The Metropolitan Museum of Art; 19-20 © The Royal Academy of Arts; 19-21 Photograph © 1997 The Metropolitan Museum of Art, NY; 19-22, 19-24 The New York Public Library / Art Resource, NY; 19-26 © Leo Sorel; 19-27 Societe Française de Photographie; 19-28, 19-82 George Eastman House; 19-29 Science & Society Picture Library; 19-30 Caisse Nationale des Monuments Historique et des Sites, Paris; 19-31 V & A Images / Victoria and Albert Museum; 19-33 Roger-Viollet Agence Photographique, 19-34 Giraudon / Art Resource, NY; 19-36 © 2006 Dahesh Museum of Art, NY. All Rights Reserved; 19-37 Bridgeman Art Library; 19-38, 19-39, 19-49, 19-55, 19-73, BOXES: RMN Reunion des Musees Nationaux Art Resource, NY; 19-40 The Carnegie Museum of Art, Pittsburgh; 19-41 Gerard Blot / Art Resource / Musee d'Orsay; 19-42 © 1922 The Metropolitan Museum of Art, NY; 19-43 © State Russian Museum / CORBIS. All Rights Reserved; 19-44 Thomas Jefferson University; 19-44 The Bridgeman Art Library; 19-45 Philadelphia Museum of Art; 19-46 Manchester City Art Galleries; 19-47 William Morris Gallery; 19-48 Photograph © 1988 The Detroit Institute of Arts; 19-50 RMN Reunion des Musees Nationaux/Art Resource, NY / © 2007 Edouard Manet/ARS,NY; 19-51 Photography © The Art Institute of Chicago; 19-53 Photograph © 2007 The Metropolitan Museum of Art; 19-53 Photograph © 1996 The Metropolitan Museum of Art; 19-54 The Nelson-Atkins Museum of Art; 19-56 $\@ifnextchar[{\@model{O}}{\@model{O}}$ 1980 The Metropolitan Museum of Art; 19-57 Photography © The Art Institute of Chicago; 19-58 Philadelphia Museum of Art; 19-59 Dean Beasom / Photograph © Board of Trustees, National Gallery of Art, Washington, D.C.; 19-60 © National Gallery, London; 19-61 John Webb / Courtauld Institute of Art: 19-62 The Samuel Courtauld Trust / Courtauld Institute of Art Gallery; 19-63 Photograph © 2007, The Art Institute of Chicago. All Rights Reserved; 19-64 Philadelphia Museum of Art; 19-65 Photograph © 2006, The Art Institute of Chicago. All Rights Reserved. 19-66 Photograph © 2000 The Museum of Modern Art, New York / Art Resource, NY; 19-67 Photograph © 2007, The Art Institute of Chicago. All Rights Reserved; 19-68 J. G. Berizzi / Art Resource / RMN Reunion des Musees Nationaux. France; 19-69 The Museum of Modern Art / Licensed by Scala Art Resource, NY; 19-70 Koninklijk Museum voor Schone Kunsten, Antwerp / © 2007 ARS, NY / SABAM, Brussels; 19-71 J. Lathion / © Nasjonal galleriet / © 2007 ARS,NY / ADAGP, Paris; 19-72 Art Resource, NY / Smithsonian American Art Museum; 19-74 Hirshhorn / Smithsonian; 19-75 Bayerische Staatsgemaldesammlungen, Neue Pinakothek, Munich; 19-76 Ch. Bastin & J. Evrard / © ARS,NY / SOFAM, Brussels; 19-77 Fine Arts Museums of San Francisco; 19-78 Corbis/Bettmann; 19-79 Bildarchiv der Osterreichische Nationalbibliothek; 30-80 Digital image © The Museum of Modern Art / Licensed by SCALA Art Resource, NY; 19-81 San Diego Museum of Art; 19-83 Museum of the City of NY; 19-84 © Corbis. All Rights Reserved; 19-85 Library of Congress. 19-86 © Art on file / Louis H. Sullivan / Corbis-NY; BOX: Musee Fabre; BOX: City of NY, Department of Parks; BOX: Tate Gallery / Art Resource, New York; BOX: The Brooklyn Museum of Art / Central Photo Archive; BOX:Van Gogh Museum Enterprises.

Chapter 20

20-1 New York Public Library / Art Resource, NY; 20-2 Photograph © Board of Trustees, National Gallery of Art, Washington, D.C.; 20-3 San Francisco Museum of Modern Art / © Succession H. Matisse, Paris / ARS,NY / Photo: Ben Blackwell; 20-4 © 1995 the Barnes Foundation / 2008 Succession H. Matisse, Paris / ARS,NY; 20-5 Staatliche Museen zu Berlin, Preussischer Kulturbesitz, Nationalgalerie / Art Resource, NY; 20-6 Photograph by Jamison Miller; 20-8 Digital Image © The Museum of Modern Art / Licensed by SCALA Art Resource, NY; 20-9 © 2007 ARS, NY / Art Resource / Bildarchiv

Preussischer Kulturbesiz; 20-10 Martin Buhler / Kunstmuseum; 20-11 Photograph © 2007 The Metropolitan Museum of Art, NY; 20-12 Walker Art Center, Minneapolis; 20-13 The Solomon R. Guggenheim Museum, NY / © 2008 ARS, NY; 20-14 The Solomon R. Guggenheim Museum, NY / © 2008 ARS, NY; 20-15 Photograph © The Metropolitan Museum of Art / © ARS, NY /VG Bild-Kunst, Bonn; 20-16 RMN Reunion des Musees Nationaux / Art Resource, NY / © 2008 Estate of Pablo Picasso / © ARS, NY; 20-17 Photograph © Board of Trustees, National Gallery of Art, Washington, D.C.; 20-18 Museum of Modern Art / Licensed by SCALA Art Resource, NY / © 2007 Estate of Pablo Picasso / © ARS, NY; 20-19 Peter Lauri / Kunstmuseum Bern; 20-20 The Solomon R. Guggenheim Museum George Braque © 2002 ARS, NY / ADAGP, Paris; 20-21 Art Resource, NY / © 2007 Estate of Pablo Picasso ARS, NY; 20-22 © 2007 Estate of Pablo Picasso / ARS, NY; 20-23 RMN Reunion des Musees Nationaux / Art Resource, NY / © 2008 Estate of Pablo Picasso / ARS. NY; 20-24, 20-25 Emanuel Hoffman Foundation. Kunstsammlung Basel, Switzerland / © L & M Services, B.V. Amsterdam, 20031010; 20-26 Museum of Modern Art / Licensed by SCALA Art Resource, NY; 20-27 Digital Image © The Museum of Modern Art / Licensed by Scala / Art Resource, NY; 20-28 Art Resource, NY; 20-29 Stedelijk Museum Amsterdam; 20-30 © Estate of Vladimir Tatlin / RAO Moscow / Licensed by VAGA, NY; 20-30 Annely Juda Fine Art; 20-31 Photograph ©2006 Museum Associates / LACMA; 20-35 © Philadelphia Museum of Art: The Louise and Walter Arensberg Collection, 1950. 1998-74-1 / © 2007 ARS, NY ADAGP, Paris / Succession Marcel Duchamp; 20-36 Lynn Rosenthal, 1998 / Philadelphia Museum of Art / © 2006 ARS, NY; 20-37 Solomon R. Guggenheim Museum, NY © 2008 ARS, NY; 20-39 Photo by James Via; 20-40 Photograph © 2000 The Metropolitan Museum of Art, NY; 20-41 Photography © The Art Institute of Chicago; 20-42 The Minneapolis Institute of Arts / © 2008 The Georgia O'Keeffe Foundation / ARS, NY: 20-43 Guilherme Augusto do Amaral / Malba-Coleccion Costanini, Buenos Aires; 20-44 The Museum of Fine Arts, Houston; 20-45 Art Museum of the Americas; 20-46 Bob Schalkwijk / © 2001 Banco de Mexico Diego Rivera & Frida Kahlo Museums Trust. Av. Cinco de Mayo No. 2, Col. Centro, Del. Cuauhtemoc 06059, Mexico, D.F. Reproduction authorized by the Instituto Nacional de Bellas Artes y Literatura / Art Resource, NY; 20-47 National Gallery of Canada; 20-48 Trevor Mills / Vancouver Art Gallery; 20-49 Gerald Zugmann Fotographie KEG; 20-50 Vanni / Art Resource, NY; 20-51 Anthony Scibilia / Art Resource, NY / © 2001 ARS, NY / ADAGP, Paris / FLC; 20-52 Heidrich Blessing / Chicago Historical Society; 20-53 David R. Phillips / Chicago Architecture Foundation; 20-54 Fallingwater; 20-55 Sante Fe Railroad; 20-56 Cas Gilbert / The New-York Historical Society; 20-57 © Estate of Aleksandr Rodchenko / RAO Moscow Licensed by VAGA, NY: 20-58 Van Abbemuseum: 20-59 Estate of Vera Mukhina; 20-60 Hickey-Robertson / The Menil Collection, Houston. © 2008 Mondrian / Holtzman Trust c/o HCR International, Warrenton, VA; 20-61 Florian Monheim / Artur Architekturbilder Agentur GmbH; 20-62 Jannes Linders Photography; 20-63 Fred Kraus / Bauhausarchiv-Museum fur Gestaltung; 20-64 Michael Nedzweski / The Busch-Reisinger Museum / © President and Fellows of Harvard College, Massachusetts; 20-65 The Museum of Modern Art/Licensed by SCALA Art Resource, NY; 20-66 © Banco de Mexico Trust Reproduction authorized by the Instituto Nacional de Bellas Artes y Literatura. Palacio de Bellas Artes, Mexico City; 20-67 Schomburg Center for Research in Black Culture, New York Public Library / Art Resource, NY; 20-68 Howard University Libraries; 20-69 © 2007 ARS, NY; 20-70 Tate Gallery, London / Art Resource, NY; 20-71 The Henry Moore Foundation / Tate Picture Gallery; 20-72 The Museum of Modern Art / Licensed by SCALA Art Resource, NY / © 2007 ARS, NY; 20-73 Stedelijk Museum, Amsterdam; 20-74 The Solomon R. Guggenheim Foundation, NY / © 2008 ARS, NY; 20-75 The Museum of Modern Art / Licensed by SCALA Art Resource, NY / © 2006 ARS, NY; 20-76 Image © 2006 Board of Trustees, National Gallery of Art, Washington; BOX: Photograph © 1986 The Metropolitan Museum of Art; BOX: Akademie der Kunste/Archiv Bildende Kunst; BOX: Courtesy of the Library of Congress.

Chapter 21

21-1 Claudio Abate / Index Ricerca Iconografica; 21-4, 21-24 Museum of Modern Art / Licensed by SCALA

Art Resource, NY; 21-5 Digital Image © The Museum of Modern Art / Licensed by SCALA Art Resource, NY; 21-6 Solomon R. Guggenheim Museum, NY; 21-7 Solomon R. Guggenheim Museum, NY / © 2008 ARS, NY; 21-8 Art Resource, NY; 21-9 © ARS, NY; 21-10 Hans Namuth Ltd; 21-11 Photograph © 1993 The Metropolitan Museum of Art. NY / © 2007 The Pollock-Krasner Foundation / ARS, NY; 21-12 Geoffrey Clements / © 1997 Whitney Museum of American Art, NY / © 2007 ARS, NY; 21-13 © The Phillips Collection, Washington, DC; 21-14 National Gallery of Canada; 21-15 Photograph © Board of Trustees, National Gallery of Art, Washington, DC; 21-16 Valerie Walker / Museum of Contemporary Art, Chicago / @ ARS, NY; 21-17 The Museum of Modern Art / Licensed by SCALA Art Resource, NY / © 2007 ARS, NY; 21-18 Whitney Museum of American Art, NY / © Estate of David Smith / Licensed by VAGA, NY; 21-20 Albright-Knox Art Gallery / © 2008 ARS, NY; 21-21 Galerie von Bartha; 21-22 Gyula Kosice; 21-23 Photograph © 2004, The Art Institute of Chicago. All Rights Reserved; 21-25 © The Minor White Archive, Princeton, NJ Museum of Modern Art / Licensed by SCALA Art Resource, NY; 21-26 Sonnabend Gallery / Art © Robert Rauschenberg / Licensed by VAGA, NY; 21-27 Digital Image © The Museum of Modern Art / Licensed by SCALA Art Resource, NY / © Jasper Johns / Licensed by VAGA, NY; 21-28 Marilyn Stokstad / Courtesy of Shozo Shimamoto; 21-29 Marilyn Stokstad / Lawrence Shustack; 21-30 Harry Shunk; 21-31 Digital Image © Museum of Modern Art / Licensed by SCALA Art Resource, NY / © 2003 ARS, NY / ADAGP, Paris; 21-32 Kunsthalle Tubingen, Sammlung G.F. Zundel / © 2007 ARS, NY / DACS, London; 21-33 © 2003 Andy Warhol Foundation for the Visual Arts / ARS, New York / (TM) 2002 Marilyn Monroe LLC under license authorized by CMG Worldwide Inc., Indianapolis, Indiana 46256 USA www.MarilynMonroe.com; 21-34 photo © National Gallery of Canada, Ottawa / © 2008 Andy Warhol Foundation for the Visual Arts / ARS, NY SODRAC Montreal; 21-35 © Estate of Roy Lichtenstein; 21-36 Yale University Art Gallery; 21-37 Art Museum of the Americas: Art © Estate of Iesus Rafael Soto / Licensed by VAGA, NY; 21-38 Philip Johnson Fund / Museum of Modern Art / Licensed by SCALA Art Resource, NY; 21-39 National Gallery of Canada; 21-40 The Menil Collection, Houston / © ARS, NY; 21-42 Geoffrey Clements / Collection of the Whitney Museum of American Art, NY; 21-43 Photo by Peter Schaelchli, Zurich; 21-44 Gongella / Ikona; 21-45 Walker Art Center, T.B. Walker Acquisition Fund, 2001; 21-46 Museum of Modern Art /Licensed by SCALA Art Resource, NY / © 2006 ARS, NY; 21-47 Eric Pollitzer / Leo Castelli Gallery, NY / © 2007 ARS, NY; 21-48 © Ute Klophaus / VG Bild-Kunst, Bonn / © ARS, NY; 32-49 Venuri, Scott Brown & Associates, Inc; 21-50 Gianfranco Gorgoni / VAGA; 21-51 Wolfgang Volz; 21-52 Benjamin Blackwell / University of CA / Berkeley Art Museum; 21-53 Robert Hickerson; 21-54 Solomon R. Guggenheim Museum, NY / Photo © Faith Ringgold: 21-55 Galerie Lelong; 21-56 Andrew Garn; 21-57 Ezra Stoller / Esto Photographics, Inc; 21-58 Courtesy Moshe Safdie and Associates; 21-59 Matt Wargo / VSBA; 21-61 Richard Payne, FAIA; 21-62 Cindy Sherman / Metro Pictures; 21-63 Mary Boone Gallery; 21-64 Jeff Wall / Marian Goodman Gallery; 21-65 V & A Images / © Vic Muniz and the Estate of Hans Namuth / VAGA, NY DACS, London 2006; 21-66 Matthew Marks Gallery, NY / Monika Spruth Galerie, Cologne / © 2001 Andreas Gursky; 21-67 Van Abbemuseum / © 2007 The Estate of Anseim Kiefer / ARS, NY; 21-68 Photograph © 2007, The Art Institute of Chicago. All Rights Reserved; 21-69 © 2007 ARS, NY / ADAGP, Paris; 21-70 Tujunga Wash Flood Control Channel SPARC / Social and Public Art Resource Center; 21-71 Smith College Museum of Art; 21-72 Photography © The Art Institute of Chicago; 21-73 KaiKai Kiki Co., Ltd; 21-74 Robert Newcombe Nelson-Atkins Museum of Art; 21-75 Tate Gallery, London / Art Resource, NY; 21-77 Susan Einstein / © 2000, The Art Institute of Chicago; 21-78 Skoto Gallery; 21-79 Ian Lambot / Foster and Partners; 21-80 Richard Bryant Esto Photographics, Inc; 21-81 © AAD Worldwide Travel Images / Alamy; 21-82 Jack Tilton Gallery, NY; 21-83 Mel Chin; 21-84 William H. Struhs; 21-85 © Peter Mauss / Esto; 21-86 Holly Solomon Gallery; 21-87 © 2000 Shirin Neshat. Photo: Larry Barns / Barbara Gladstone Gallery; 21-88 San Francisco Museum of Modern Art; BOX: Photograph © Donald Woodman / © 2005 Judy Chicago / ARS, NY.

INDEX

Annunication, Mérode Altarpiece, Triptych of the Italic page numbers refer to illustrations Isenheim Altarpiece (Grünewald), 581-582, 582, (Campin), 457, 458, 467-468, 467 583, 584 and maps. Annunciation and Virgin of the Rosary (Stoss), 581, Last Judgment Altarpiece (Weyden), 472-473, A Anthropométries of the Blue Period (Klein), 887, 887 Maestà Altarpiece (Duccio di Buoninsegna), 437, Abaporú (The One Who Eats) (Amaral), 834, 834 Anthropophagic Manifesto (Andrade), 834 437, 438, 439, 440 Abstract art, xxxv Antwerp, sixteenth century, 601-604 Mérode Altarpiece (Triptych of the Annunication) art informel, 867-868 Apollinaire, Guillaume, 820 (Campin), 457, 458, 467-468, 467 biomorphic forms, 855-857, 855, 856, 857, Apollo Attended by the Nymphs of Thetis (Girardon), Portinari Altarpiece (Goes), 476-477, 477, 479, 860,860 666-667, 667 Apotheosis of Homer, The (Flaxman), 698, 698 sculpture, 824-825, 825 terminology, 461, 461 Abstract Art in Five Tones and Complementaries (Tor-Apparition (Moreau), 786, 786 Altdorfer, Albrecht, Danube Landscape, 588, 589 res-García), 879, 879 Apple Cup, silver (Krug?), 584, 584 Altes Museum (Schinkel), Berlin, 746, 746 Abstract Expressionism, 869–879, 869–878 Arabesques, 682 Amaral, Tarsila do, Abaporú (The One Who Abstraction-Creation group, 855 Arbus, Allan, 882 Eats),834, 834 Academicians of the Royal Academy (Zoffany), 690, Arbus, Diane, Child with Toy Hand Grenade, 882, America federal patronage of art, 854 Académie des Beaux-Arts, 686, 751 Arc de Triomphe, Paris, Departure of the Volunteers Gothic Revival in, 747, 747 Academies, 663, 686, 690 of 1792 (The Marseillaise) (Rude), 735, 735 Industrial Revolution, 724-725 Action painting (gesturalism), 871-875, 871-875 Arches map of, in the nineteenth century, 725 Action Photo I (from "Pictures of Chocolate") corbel, 446 Modern art in, 829-833, 830-833 (Muniz), 912, 912 nodding agee, 446 Neoclassicism in, 717-720, 718, 719, 735-736, Acts of the Apostles series, 538, 538 Architectonic Painting (Popova), 824, 824 Adam, Robert, Anteroom, Syon House, England, Architecture twentieth century in, 804-805 697-698, 698 American, early, 675-676, 675 American art Adam and Eve (Dürer), 586, 586 American Gothic Revival, 747, 747 Abstract Expressionism, 869-879, 869-878 American Modern, 839-843, 840-843, 905, Adams, Samuel, 678, 679 architecture, early, 675-676, 675 Adler, Dankmar, 798, 839 905, 907-908, 907 architecture, Gothic Revival, 747, 747 American Neoclassicism, 717-718, 718, Aedicula, 505 architecture, Modern, 839-843, 840-843, 905, Aerial (atmospheric) perspective, 456 745-746, 745 907-908, 907 Aesthetics, xxxvii-xxxviii American nineteenth century, 796, 798-800, architecture, Neoclassicism, 717-718, 718, African American artists 799 745-746, 745 Douglas, Aaron, 852, 852 American Postmodern, 908, 908 architecture, nineteenth century, 796, 798-800, Harlem Renaissance, 852-853, 852, 853, 855 Art Nouveau, 792, 792 Baroque, Austrian, 641-642, 642, 643 Lawrence, Jacob, 853, 855 architecture, Postmodern, 908, 908 Baroque, English, 671-674, 672, 673, 674 Lewis, Edmonia, 735-736, 735 Armory Show, 831 Marshall, Kerry James, 916, 916 Baroque, French, 663-667, 664-667 Ashcan School, 830 Puryear, Martin, 917-918, 917 Baroque, Italian, 615-624, 617-624 Harlem Renaissance, 852-853, 852, 853, 855 Baroque, Spanish, 640-641, 641 Ringgold, Faith, 903, 904 landscape painting, 742-743, 742 bridges, 705, 705 Saar, Betye, 902, 902 Modern art, 829-833, 830-833 Savage, Augusta, 852-853, 853 Deconstructivist, 922, 923 New York School, 869–879, 869–878 Tanner, Henry Ossawa, 788–789, 789 de Stijl, 846, 847 painting, early, 676, 676 After "Invisible Man" by Ralph Ellison, the Preface English Baroque, 671-674, 672, 673, 674 painting, Neoclassicism, 719-720, 719 English Classical Revival, 694-697, 695, 696 (Wall), 911-912, 911 painting, Neo-Expressionism, 913-915, 913, English fourteenth century, 446-448, 447 After Kings (Anatsui), 920, 920 914 English Gothic Revival, 697, 697, 746, 747 Albani, Alessandro, 692 painting, Realism, 760, 760, 761 English Neoclassicism, 697-698, 698 Albarello, Renaissance jar, 504, 504 painting, Romantic landscape, 742-743, 742 English Renaissance, 608, 609 Albers, Anni, Wall hanging, 848, 849 painting, Symbolists, 788–789, 788, 789 European Modern, 838-839, 838, 839 Albers, Josef, 849 Pop art, 888-892, 889-892 flamboyant-style, 480-481, 481 Alberti, Leon Battista, 494 sculpture, Neoclassicism, 735-736, 735 On Architecture, 547 French Baroque, 663-667, 664-667 skyscrapers, 798, 842-843, 842, 843, 905, 905, French Neoclassicism, 707-708, 708 On Painting, 492 908, 909 Palazzo Rucellai, 497-498, 497 French nineteenth century, 750-751, 751 American Revolution, 679, 680 French Renaissance, 590-593, 591, 592, 593 Aldobrandini, Pietro, 626 Americans, The (Frank), 881 German Neoclassicism, 746, 746 Alexander VI, pope, 541 Analytic Cubism, 816-818, 817, 818 German Rococo, 682-684, 682, 683, 684 Allegory, 520 Allegory of Good Government in the City and in the Anastaise, illuminator, 462, 463 Gothic Revival, American, 747, 747 Anatomy Lesson of Dr. Nicolaes Tulp, The (Rem-Gothic Revival, English, 697, 697, 746, 747 Country (A. Lorenzetti), 441-442, 441 brandt), 654, 654 Allegory of Sight, from Allegories of the Five Senses High Tech, 920, 922, 922 Anatsui, El, 919 International style, 847, 905 (Brueghel and Rubens), 648, 650, 650 Allegory with Venus and Cupid (Bronzino), After Kings, 920, 920 Italian, Baroque, 615-624, 617-624 Italian, fourteenth century, 427-429, 427, 428, Andachtsbilder, 450 565–566, *565* Andrade, Oswald de, 834 429 Alma-Tadema, Lawrence, Pheidias and the Frieze of Angelico, Fra (Guido di Pietro da Mugello), Italian, Renaissance, 491-498, 492-497, the Parthenon, Athens, xliii, xliii 510-512, 511, 512, 514-517, 515, 516, 523, Annunciation, 508, 509 Altarpiece of the Holy Blood (Riemenschneider), Anguissola, Sofonisba, Self-Portrait, 566-567, 567 524, 547-550, 548, 549, 550 580, 580 landscape, 694-697, 695, 696, 925, 925 Annunciation (Angelico), 508, 509 Altars and altarpieces

Annunciation, Book of Hours of Jeanne d'Evreux

Annunciation, Ghent Altarpiece (Jan and Hubert van

(Pucelle), 442-443, 443

Eyck), 454, 455

Modern, 838-843, 838-843, 905, 905,

Neoclassicism, American, 717-718, 718,

907-908, 907

745-746, 745

Chartreuse de Champmol (Broederlam),

Ghent Altarpiece (Jan and Hubert van Eyck),

458-460, 459, 460

454, 455, 468, 469

Neoclassicism, English, 697-698, 698 Astronomy, or Venus Urania (Giovanni da Barozzi, Giacomo. See Vignola Neoclassicism, French, 707-708, 708 Bologna), 568, 568 Barry, Charles, Houses of Parliament, London, Neoclassicism, German, 746, 746 AT&T Corporate Headquarters (Johnson and 746, 747 nineteenth century use of new materials and Burgee), New York City, 908, 909 Barry, Madame du, 689 methods, 750-751 Ateliers 726 Bartolomeo, Michelozzo di. See Michelozzo di Postmodern, 908, 908 Athanadoros, Laocoön and His Sons, xxxvii, xxxvii Bartolomeo Prairie style, 840 Atmospheric (aerial) perspective, 456 Bas-de-page, 443 Renaissance, early, 491-498, 492-497, Atrial crosses, 715, 715 Basquiat, Jean-Michel, Horn Players, 914-915, 914 510-512, 511, 512, 514-517, 515, 516, 523, Attack on the Castle of Love, jewelry box lid, 444, Bateman, Ann, 700 445 Bateman, Hester, 700 Renaissance, English, 608, 609 Aurora (Reni), 631, 631 Bateman, Peter, 700 Renaissance, French, 590-593, 591, 592, 592 Austria Renaissance, High, 547-550, 548, 549, 550 Battista Sforza and Federico da Montefeltro (Piero architecture, Baroque, 641-642, 642, 643 Renaissance, Spanish, 595, 595 architecture, Rococo, 682-684, 682, 683, 684 della Francesca), 513-514, 513, 514 Rococo, 682-684, 682, 683, 684 Art Nouveau in, 793, 793 Battle of San Romano, The (Uccello), 488-489. skyscrapers, 798, 842-843, 842, 843, 905, 905, Steiner House (Loos), 838, 838 489-490 908, 909 Automatism, 858, 875 Battle of the Nudes (Pollaiuolo), 504, 595 Spanish Baroque, 640-641, 641 Autumn Rhythm (Number 30) (Pollock), 872-873, Baudelaire, Charles, 749-750, 749, 765 Spanish Renaissance, 595, 595 872 Bauhaus art, 848-849, 848, 849, 850 Architecture, elements of Autumn Salons, 805-806 Bauhaus Building (Gropius), Dessau, Germany, International style, 847 Avant-garde, use of term, 776 849, 849, 850 iron, use of, 705 Avicenna (Stella), 894-895, 894 Bautista de Toledo, Juan, El Escorial, Madrid, 595, parks, 797, 797 595 Saint Peter's basilica plans, 549, 549 Beautiful style, 449-450, 483 В skyscrapers, 842, 842 "Beautiful" Virgin and Child, Sternberk, 450, 451 Baca, Judith F., Division of the Barrios, from Great Argentina, Cubism in, 834-835, 835 Belgium, Art Nouveau in, 792, 792 Wall of Los Angeles, 915, 915 Aristotle, xxxiv, 529, 536 Bellini, Gentile, Procession of the Relic of the True Bacchus (Caravaggio), 627, 627 Cross before the Church of Saint Mark, 524, Armonía Transformable (Transformable Harmony) Bacci Chapel, San Francesco church, Arezzo, (Soto), 892, 893 524 512-513, 512 Armor, for English royal games, 607, 607 Bellini, Giovanni Bacon, Francis, 616 Armored Train in Action (Severini), 822, 822 Saint Francis in Ecstasy, 525, 526 Bacon, Francis (20th century artist), Head Sur-Armory Show, 831 Virgin and Child Enthroned with Saints Francis, rounded by Sides of Beef, 866, 866 Arnolfini, Giovanni, 469-470, 471 John the Baptist, Job, Dominic, Sebastian, and Baerze, Jacques de, 459 Arp, Jean, 829 Louis of Toulouse, 524-525, 525 Baldacchino, 617 Bellini, Jacopa, 524 Arruda, Diogo de, Convent of Christ, Tomar, Baldacchino (Bernini), 617-618, 618 Portugal, 594, 594 Bellori, Giovanni, 627 Art Baldachin, 617 Benday dots, 891 Ball, Hugo, 828, 883 brut, 867 Benedictine Abbey of Melk (Prandtauer), Austria, 'Karawane," 826, 826 conceptual, 898-899, 898, 899 641-642, 642, 643 Banker and His Wife, The (Van Reymerswaele), criticism, 725 Bentley, Richard, 697 defined, xxxiii 601-602, 601 Berlin Banqueting House (Jones), Whitehall Palace, Lonhistory, xlvi-xlvii Altes Museum (Schinkel), Berlin, 746, 746 human figure as beauty and ideal, xxxvi-xxxvii don, 672, 672, 673 Dadaism, 828-829, 828, 829 Bar at the Folies-Eergère, A (Manet), 774, 775, 776 impoverished (povera), 896-897, 897 Bernini, Gianlorenzo informel, 867-868 Barberini palace and square (Cruyl), 631, 632 Baldacchino, 617-618, 618 modes of representation, xxxiii-xxxviii Barbieri, Giovanni Francesco, 630 Cornaro Chapel, Santa Maria della Vittoria nature of, xxxiii Barbizon School, 741 church, 619-620, 619 patrons and collectors, role of, xliii-xlvi Bargehaulers on the Volga (Repin), 759-760, 759 David, 618, 619 performance, 898-899, 898, 899 Barges, The (Daubigny), 741, 742 Fountain of the Four Rivers, 623, 624, 624 reasons for having, xxxviii-xl Baroque, use of term, 614 Saint Peter's Basilica piazza design, 617-619, search for meaning and, xxxviii-xxxix Baroque art social context and, xxxix-xl architecture, Austrian, 641-642, 642, 643 Saint Teresa of Ávila in Ecstasy, 620-621, 620 sociopolitical intentions, xl architecture, English, 671-674, 672, 673, 674 Berrettini, Pietro. See Pietro da Cortona viewers, responsibilities of, xlvii architecture, French, 663-667, 664-667 Bertoldo di Giovanni, 539 Art as Experience (Dewey), 896 architecture, Italian, 615-624, 617-624 Bestiary, 464 Art Deco, use of term, 821 architecture, Spanish, 640-641, 641 Betrayal and Arrest of Christ, Book of Hours of Jeanne Arte Concreto-Invención, 879 Flemish, 644-649, 644-649 d'Evreux (Pucelle), 442-443, 443 Arte povera, 896-897, 897 painting, Dutch, 649, 651-663, 651-663 Beuys, Joseph, How to Explain Pictures to a Dead Art for art's sake theory, xlvi painting, French, 667-670, 668-671 Hare, 898-899, 899 Artists painting, Italian, 624-634, 625-633 Bible, Gutenberg, 485 how to be famous nineteenth century, 754 painting, Spanish, 634-640, 634-640 Bibliothèque Sainte-Geneviève (Labrouste), Paris, who are, xl-xliii sculpture, Italian, 615, 618, 619-621, 619 750-751, 751 Artist's Studio, The (Daguerre), 748, 748 Bicho LC3 (Pan-Cubisme) (Clark), 896, 896 Baroque period Art Nouveau, 791-795, 792, 793, 794 in the colonies in North America, 675-676 Big Raven (Carr), 837-838, 837 Arts and Crafts movement, 762 description of, 614 Bilbao, Spain, Guggenheim Museum, Solomon R. Ashcan School, 830 in En gland, 671-674 (Gehry), 922, 923 Asheville (de Kooning), 873, 874, 875 in Flanders, 644-649 Biomorphic forms, 855-857, 855, 856, 857, 860, As If to Celebrate, I Discovered a Mountain Blooming in France, 663-670 with Red Flowers (Kapoor), 918, 918 in Italy, 615-634 Birmingham Race Riot (Warhol), 890-891, 891 Aspects of Negro Life: From Slavery through Reconmap of Europe and North America in. 615 Birth of Liquid Desires, The (Dalí), 858-859, 859 struction (Douglas), 852, 852 in the Netherlands/United Dutch Republic, Birth of Venus, The (Botticelli), 521-522, 521 Assemblage, 883-886, 884, 885 Birth of Venus, The (Cabanel), 753, 753 Association of Artists of Revolutionary Russia science and worldview in, 616 (AKhRR), 845 Black Death, 424, 426, 445

in Spain, 634-642

style of, 614

Assumption of the Virgin (Correggio), 550–551, 551

Blake, William, 706

Habitat '67 (Safdie), Montreal, 907-908, 907 Brooklyn Museum of Art, "Sensation" exhibition, Elohim Creating Adam, 707, 707 modern art in, 836-838, 837 Blenheim Palace (Vanbrugh), England, 673-674, Canaletto (Giovanni Antonio Canal), Santi Gio-Brown, Blue, Brown on Blue (Rothko), 876, 876 vanni e Paolo and the Monument to Bartolom-Brown, Lancelot, 696 Bleyl, Fritz, 808 meo Colleoni, 691-692, 691 Brueghel, Jan, 604 Blue Mountain (Kandinsky), 812, 812 Allegory of Sight, from Allegories of the Five Canova, Antonio, 693 Der Blaue Reiter), Cupid and Psyche, 694, 694 Blue Rider (Senses, 648, 650, 650 811-814, 812, 813, 814 Canterbury Tales, The (Chaucer), 431, 445, 486, 486 Bruegel the Elder, Pieter, 598, 602 Boccaccio, Giovanni Cantley: Wherries Waiting for the Turn of the Tide The Fall of Icarus, 603, 603 Concerning Famous Women, 461, 462, 462 (Emerson), 795, 795 Return of the Hunters, 603-604, 604 The Decameron, 431 Brunelleschi, Filippo, 492 Canvas painting, 552 Boccioni, Umberto, Unique Forms of Canyon (Rauschenberg), 884, 885 Capponi chapel, Santa Felicità church, Flo-Continuity in Space, 822, 823 Capitoline Hill, 558 rence, 562, 563 Boffrand, Germain, Salon de la Princesse, Hôtel Capitol Reef, Utah (White), 883, 883 Florence Cathedral dome, 428, 428, 429, Capponi chapel, Santa Felicità church, Florence, de Soubise, Paris, 681, 682 493-494, 493 Bohier, Thomas, 590, 592 Foundling Hospital, 494, 496, 496 Bonheur, Rosa, Plowing in the Nivernais: The Dress-Capriccio, 691 San Lorenzo church, 494-495, 494, 495 ing of the Vines, 758, 758 Caprichos (Caprices), Los (Goya), 736, 736 Buenos Aires, experiments with form in, Bonheur de Vivre, Le (The Joy of Life) (Matisse), 806, Captain Frans Banning Cocq Mustering His Com-879-880, 879, 880, 881 pany (The Night Watch) (Rembrandt), 655, 807,808 Buffalmacco(?), The Triumph of Death, Cam-Book of Hours of Jeanne d'Evreux (Pucelle), 655 posanto, Pisa, 426, 426 442-443, 443 Caravaggio (Michelangelo Merisi), 667 Buon fresco, 439 Book of the City of Ladies, The (Christine de Pizan), Buontalenti, Bernardo, The Great Grotto, Boboli Bacchus, 627, 627 Calling of Saint Matthew, 628, 628 Gardens, Florence, 547, 547 Book of the Courtier, The (Castigione), 510 Death of the Virgin,644 Burgee, John, AT&T Corporate Headquarters, Books, printing of, 485-486, 522 Entombment, 629, 629 New York City, 908, 909 Borromini, Francesco Carducho, Vincente, 627 Burghers of Calais (Rodin), 789-790, 790 San Carlo alle Quattro Fontane church, 621-622, Carlyle, Thomas, 749, 749 Burgundy, dukes of, dates for, 463 621, 622, 623 Carpeaux, Jean-Baptiste, The Dance, 752-753, 752 Burial at Ornans, A (Courbet), 756, 756 Sant'Agnese church, 623, 623 Carr, Emily, Big Raven, 837-838, 837 Burial of Count Orgaz (El Greco), 596, 597 Bosch, Hieronymus, Garden of Earthly Delights, Carracci, Agostino, 625 Burins, 485 598-599, 599 Carracci, Annibale Burke, Edmund, 692 Bosses, 446 Landscape with Flight into Egypt, 626-627, 626 Burlington, Lord (Richard Boyle), Chiswick Boston Massacre, 679 Palazzo Farnese, 548, 548, 550, 625-627, 625, House, England, 695-696, 695 Boston Tea Party, 719 Burning of the House of Lords and Commons, 16th Botticello, Sandro Carracci, Ludovico, 625, 630 October 1834, The (Turner), 740, 740 The Birth of Venus, 521-522, 521 Carriera, Rosalba, Charles Sackville, 2nd Duke of Burri, Alberto, Composition, 868, 868 The Mystic Nativity, 522-523, 523 Dorset, 690-691, 691 Burrows, Alice, 700 Primavera (Spring), 520-521, 520 Carthusians, 458-459 Burrows, George, 700 Boucher, François, Triumph of Venus, 687-688, 687 Cartoon, 534, 538 Burty, Philippe, 782 Bourgot, illuminator, 462 Cartouches, 548 Buseau, Marie-Jeanne, 687 Bouts, Dirck Casa y Nóvoas, Fernando, 641 Bush, Jack, Tall Spread, 893, 894 Justice of Otto III, 475-476, 476 Cassatt, Mary, 772 Buxheim Saint Christopher, woodcut, 484, 484 Maternal Caress, 774, 774 Wrongful Execution of the Count, 475-476, 476 Woman in a Loge, 773, 773 Bramante, Donato, 536 Castagno, Andrea del, The Last Supper, 508, 510, Saint Peter's basilica, plan for, 549, Cabanel, Alexandre, 754 549 The Birth of Venus, 753, 753 Castiglione, Baldassare, The Book of the Courtier, Tempietto, San Pietro church, Rome, 547-548, Cabaret Voltaire, 826 Ca D'Oro (House of Gold), Contarini Palace, Castle of Otranto, The (Walpole), 697 Brancacci Chapel, Santa Maria del Carmine Catharina Hooft and Her Nurse (Hals), 652, 652 Venice, 523, 524 church, Florence, 506-508, 507, 508, 509 Cafe House, Cairo (Casting Bullets) (Gérôme), Cathedrals. See under name of Brancusi, Constantin, 824 744-745, 744 Catholicism, 604 Magic Bird, 825, 825 Cage, John, 883 Caxton, William, 485-486 Newborn, 825, 825 Caillebotte, Gustave, Paris Street, Rainy Day, 772, Celant, Germano, 896 Cellini, Benvenuto, Saltcellar of King Francis I, Brandt, Marianne, 849 Calder, Alexander, Lobster Trap and Fish Tail, 857, Coffee and tea service, 848, 848 567-568, 567 Cenami, Giovanna, 469-470, 471 Braque, Georges Central Park (Olmsted and Vaux), New York City, Calling of Saint Matthew, The (Caravaggio), 628, Analytic Cubism, 816-818, 817, 818 797, 797 Houses at L'Estaque, 817, 817 Calvin, John, 578, 590 Ceramics Violin and Palette, 817-818, 817 See also Pottery Cambio, Arnolfo di, Florence Cathedral, 428, 428, Brazil, Modern art in, 834, 834 Italian Renaissance, 504, 504 429 Breton, André, 857-858, 869, 883 Cameos, 692, 698 Cézanne, Paul, 764 Briconnet, Catherine, 592 Camera obscura, 748 The Large Bathers, 779, 779 Bridge (Die Brücke), 808–810, 808, 809 Mont Sainte-Victoire, 777-778, 777 Camera Picta, Ducal Palace, Mantua, Italy, 516, Bridges, iron, 705, 705 Still Life with Basket of Apples, 778, 778 Britain. See England; English art Cameron, Julia Margaret, Portrait of Thomas Carlyle, Chacmools, 856 Brody, Sherry, The Dollhouse, 902 748, 749 Chambers, William, 697 Campbell, Scot Colen, 694 Chardin, Jean-Siméon, The Governess, 709, 709 Broederlam, Melchior, Champmol Altarpiece, 459-460, 459 Campin, Robert Charles I, king of England, 645, 646, 647-648, Bronze work, Renaissance, 499-501, 500, 501 Flemish City, A, 457, 458 671,672 Bronzino (Agnolo di Cosimo), 564 Mérode Altarpiece (Triptych of the Annunication), Charles I at the Hunt (Van Dyck), 647-648, 648 457, 458, 467-468, 467 Charles II, king of Spain, 634 Allegory with Venus and Cupid, 565-566, 565 Charles IV, Holy Roman emperor, 448, 449

Portrait of a Young Man, 564, 564

Canada

Charles IV, king of Spain, 736, 737 Clouet, Jean, Francis I, 590, 590 Cromwell, Oliver, 614 Charles IV, king of France, 442, 448 Clovio, Giulio, Farnese Heurs, 566, 566 Crouching Woman (Heckel), 809, 809 Charles V, Holy Roman emperor, 530, 531, 555. Coeur, Jacques, 481 Cruyl, Lieven, 649 578, 634 Coffee and tea service (Brandt), 848, 848 Barberini palace and square, 631, 632 Charles V, king of France, 457, 462, 463 Coffers, 506 Crystal Palace (Paxton), London, 750, 750 Charles VI, Holy Roman emperor, 641 Colbert, Jean-Baptiste, 663 Cuba, Modern art in, 835, 835 Charles VI, king of France, 479 Cole, Thomas, 742 Cubism Charles VII, king of France, 479 The Oxbow, 742, 743 analytic, 816-818, 817, 818 Charles V Triumphing Over Fury (Leoni), Collage, 818, 829 French, 820-822, 820, 821 xxxvi-xxxvii, xxxvi, 578 Colleoni, Bartolommeo, 503, 503 Italian, 822, 822, 823 Charles Sackville, 2nd Duke of Dorset (Carriera), Colonna, Francesco de, Hypnerotomachia Poliphili, Picasso, work of, 814-816, 814, 815, 816, 690-691, 691 Garden of Love page, 522, 522 818-819, 818, 819 Chartreuse de Champmol, Dijon, France, Color, complementary, 779 Russian, 822-824, 823, 824 458–460, 459, 460 Color field painting, 875-876, 876, 877 synthetic, 818-819, 818, 819 Chasing, 700 Colter, Mary, Lookout Studio, Grand Canyon Cubi XIX (Smith), xxxv, xxxv, 877-878 Château of Chenonceau, 590-591, 591, 592 National Park, Arizona, 841-842, 841 Cubo-Futurism, 822 Châtelet, Madame du, 681 Communist Manifesto (Marx and Engels), 724 Cupid and Psyche (Canova), 694, 694 Chaucer, Geoffrey, The Canterbury Tales, 431, 445, Complementary color, 779 Current (Riley), 893, 893 486, 486 Complexity and Contradiction in Architecture (Ven-Curtain wall, 839 Chenonceau, Château of, 590-591, 591, 592 turi), 908 Chevreul, Michel-Eugène, 779 Composition (Burri), 868, 868 Chiaroscuro, 534 Composition with Yellow, Red, and Blue (Mondrian), Dada Dance (Höch), 829, 829 Chicago 846-847, 846 Dadaism, 826-829, 826-829 Frederick C. Robi House (Wright), Chicago, Comte, Auguste, 747 Daddi, Bernardo, 437 840-841, 840 Conceptual art, 898-899, 898, 899 Madonna and Child, 422, 423 Marshall Field Wholesale Store (Richardson), Concerning Famous Women (Boccaccio), 461, 462, Daguerre, Louis-Jacques-Mandé, The 798. 799 462 World's Columbian Exposition (Hunt), 796, Artist's Studio, 748, 748 Concerning the Spiritual in Art (Kandinsky), 813 Daguerreotypes, 748 798, 799 Connoisseurship, xlvi Dalí, Salvador, 869 Chicago, Judy, The Dinner Party, 902, 906, 906 Constable, John, The White Horse, 741, 741 The Birth of Liquid Desires, 858-859, 859 Chicago School, 798-800 Constructive Universalism, 879 Chichester-Constable chasuble, 445-446, 446 Dance, The (Carpeaux), 752-753, 752 Constructivism, 843-845, 844 Danube Landscape (Altdorfer), 588, 589 Chihuly, Dale, Violet Persian Set with Red Lip Contarini, Marino, 523 Darby, Abraham III, Severn River Bridge, Eng-Wraps, xli, xli Contextualism, xlvi-xlvii land, 705, 705 Child with Toy Hand Grenade (Arbus), 882, 882 Contrapposto, 701 Darwin, Charles, 724-725 Chin, Mel, Revival Fields, 924, 924 Convent of Christ, Tomar, Portugal, 594, 594 Daubigny, Charles-François, The Barges, 741, 742 Chiswick House (Lord Burlington), England, Cooke, Elizabeth, 7002 695-696, 695 Daumier, Honoré Cope of the Order of the Golden Fleece, Flemish, Christianity, schisms, 424, 517 Rue Transonain, Le 15 Avril 1834, xl, xl, 759 466, 466 Third-Class Carriage, 759, 759 Christine de Pizan, 462 Copernicus, Nicolaus, 616 The Book of the City of Ladies, 431 David, Jacques-Louis, 710 Copley, John Singleton Death of Marat, 713, 713 Christine de Pizan Presenting Her Book to the Queen Samuel Adams, 678, 679, 719 Napoleon Crossing the Saint-Bernard, 726, 726 of France, xlv, xlv Watson and the Shark, 719-720, 719 Oath of the Horatii, 712, 712 Christo (Christo Javacheff), Running Fence, 901, Corbel arch, 446 David (Bernini), 618, 619 Cornaro Chapel (Bernini), Santa Maria della Vit-Christus, Petrus, A Goldsmith (Saint Eligius?) in His toria church, Rome, 619-620, 619 David (Donatello), 501-502, 501 Corncob Capital, U.S. Capitol (Franzoni), Shop, 474, 475 David (Michelangelo), 540, 541 Churches 745-746, 745 Davies, Arthur B., 831 See also under name of Cornelia Pointing to Her Children as Her Treasures Death of General Wolfe (West), 704-705, 704 Greek-cross plan, 549 (Kauffmann), 703-704, 703 Death of Marat (David), 713, 713 Latin-cross plan, 515, 515, 517, 549 Corner Counter-Relief (Tatlin), 823, 823 Decameron, The (Boccaccio), 431 Chute, John, 697 Cornithian capital, xxxiv, xxxiv Deconstructivist architecture, 922, 922 Cimabue (Cenni di Pepi), Virgin and Child Corot, Jean-Baptiste-Camille, First Leaves, Near Decorated style, 446 Enthroned, 431, 432 Mantes, 757-758, 757 Deesis, 468 Cione, Berici di, Palazzo della Signoria, Florence, Correggio (Antonio Allegri), Assumption of the Vir-Degas, Edgar, 764 427, 427 gin, 550-551, 551 The Rehearsal on Stage, 771-772, 772 City Night (O'Keeffe), 833, 833 Council of Trent, 557, 615 Degenerate Art exhibition, Munich, 850 City Square (Giacometti), 866, 866 Counter-Reformation, 530, 557-562, 614, De Kooning, Willem, 872 Claesz, Pieter, Still Life with a Watch, 661-662, 661 615-616 Asheville, 873, 874, 875 Clapboard, 675 Courbet, Gustave Delacroix, Eugène Clark, Lygia, Bicho LC3 (Pan-Cubisme), 896, 896 A Burial at Ornans, 756, 756 Liberty Leading the People, July 28, 1830, 734, Classical Revival The Stone Breakers, 755-756, 755 in England, 694-697 Cour Carré, Louvre (Lescot), Paris, 593, 593 Scenes from the Massacre at Chios, 733, 733 in Italy, 690-694, 691, 692, 693 Courtly love, 444 De La Tour, Georges, Mary Magdalen with the Classicism, French architecture, 707-708, 708 Court (Rayonnant) style, 442 Smoking Flame, 667, 668 Claude Lorrain. See Lorrain, Claude (Claude Courtyard, The (Kaprow), 886-887, 887 Delaunay, Robert, Homage to Blériot, 820, 820 Gellé) Cousen, John, Hanniba! Crossing the Alps, 754, 754 Delaunay-Terk, Sonia, Clothes and customized Claudel, Camille, The Waltz, 790-791, Couture, Thomas, 765 Citroën, 820-821, 821 791 Cow with the Subtile Nose (Dubuffet), 867, 867 Delivery of the Keys to Saint Peter (Perugino), 492, Clement VI, pope, 448 Cox, Kenyon, 831 492, 517-518, 518 Clement VII, pope, 531, 537, 538, 541, 557 Cranach the Elder, Lucas, Nymph of the Spring, Della Porta, Giacomo, 560 Clifford, George, 3rd Earl of Cumberland, 607, 587-588, 588 fountain, 623, 624 607, 608, 608 Creation of Adam (Michelangelo), 541, 544, 544 Il Gesù church, 561-562, 561 Clodion (Claude Michel), The Invention of the Bal-Crenellated battlements, 697 de l'Orme, Philibert, 591

Crockets, 446, 480

loon, 689, 689

Demoiselles d'Avignon, Les (Picasso), 816, 816

map of, in the Enlightenment, 681 Eight, The, 830 Departure of the Volunteers of 1792 (The Marseillaise) map of, in the fourteenth century, 425 Einstein, Albert, 804 (Rude), Arc de Triomphe, Paris, 735, 735 Electronic Superhighway: Continental U.S. (Paik), map of, in the nineteenth century, 725 Deposition (Weyden), 470-472, 472 map of, in the Renaissance, 457, 531, 579 925-926, 926 Depression of 1929, 804, 854 map of, in the twentieth century, 805 El Escorial (Bautista and Herrera), Madrid, 595, Derain, André, Mountains at Collioure, 806, 806 postwar art, 866–868 Der Blaue Reiter, 811-814, 812, 813, 814 595 twentieth century in, 804-805 El Greco (Domenikos Theotokopoulos), 596 Derrida, Jacques, xlvii, 922 Exeter Cathedral, England, 446-447, 447 Burial of Count Orgaz, 596, 597 Descartes, René, 616, 680 Experiment on a Bird in the Air-Pump, An (Wright), View of Toledo, 597-598, 597 de Stijl, 845-848, 846, 847 Election Night (Sloan), 830, 830 702-703, 702 Dewey, John, 896 Expressionism, 781, 810-811, 810, 811 Elizabeth, countess of Shrewsbury, 608, 609 De Witte, Emanuel, Portuguese Synagogue, Amster-Abstract, 869-879, 869-878 Elizabeth I, queen of England, 604, 606, 607 dam, 660, 660 Elohim Creating Adam (Blake), 707, 707 Neo-, 913-915, 913, 914 Diary (Shimomura), xl, xl Expulsion from Paradise (Masaccio), 506, 508 Embarkation of the Queen of Sheba, (Lorrain), 670, Diderot, Denis, 680, 708-709 Evck, Jan van. See Van Eyck, Jan Die Brücke (the Bridge), 808-810, 808, 809 Eye Love Superflat (Murakami), 916-917, 917 Embroidery, opus anglicanum, 445–446, 446 Dietrich II, 415 Emerson, Peter Henry, 795-796 Dijon, France, Chartreuse de Champmol, Cantley: Wherries Waiting for the Turn of the Tide, 458-460, 459, 460 Fagus Shoe Company (Gropius and Meyer), Ger-Dinner Party, The (Chicago), 902, 906, 906 many, 838-839, 838 Photography: A Pictorial Art, 795 Diptychs, 461 Fallingwater, Kaufmann House (Wright), Mill Encyclopédie (Diderot), 709 Marilyn Diptych (Warhol), 890, 890 Run, Pennsylvania, 841, 841 Melun Diptych (Fouquet), 479-480, 480 Ende, 462 Fall of Icarus, The (Bruegel the Elder), 603, 603 Engels, Friedrich, 724 Divisionism, 780 Fall of the Giants (Romano), 550, 550 England Dollhouse, The (Schapiro and Brody), 902 Family of Charles IV (Goya), 736, 737 Baroque period in, 671–674 Dome of Florence Cathedral, 428, 428, 429, Family of Saltimbanques (Picasso), 815, 815 Classical Revival in, 694-697 493-494, 493 Farnese, Alessandro, 548, 557, 561, 566 Gothic Revival in, 697 Dominicans, 425 Farnese Hercules, xlvi, xlvii Industrial Revolution, 724-725 Domino construction system, 839 Farnese Hours (Clovio), 566, 566 National Gallery of Art, 741 Donatello Fauvism, 805-808, 806, 807 David, 501-502, 501 Neoclassicism in, 697-698 Feast in the House of Levi (Veronese), 570, 571 Renaissance in, 604-609 equestrian monument of Erasmo da Narni, Federal Art Project (FAP), 854 English art 501, 502-503 Federico da Montefeltro, 490, 510-514, 513, 514, architecture, Baroque, 671-674, 672, 673, 674 Mary Magdalen, 502, 503 architecture, fourteenth century, 446-448, 447 536 real name of, 499 Feminist art, 901-904, 902-905 architecture, Gothic Revival, 697, 697, 746, Saint George, 499, 499 Femmage, 903 Double Negative (Heizer), 900, 900 747 Ferdinand VII, king of Spain, 738 architecture, Neoclassicism, 697-698, 698 Douglas, Aaron, Aspects of Negro Life: From Slavery architecture, Renaissance, 608, 609 Ferdinand of Aragon, 595 through Reconstruction, 852, 852 architecture and landscape architecture, Classi-Fervor (Neshat), 926, 926 Dove, Arthur, Nature Symbolized No. 2, 833, 833 Fête galante, 684 Drawing Lesson, The (Steen), xli, xlii, 660 cal Revival, 694-697, 695, 696 Fiber arts, Flemish, 464-466, 465, 466 armor for royal games, 607, 607 Drums, octagonal base, 493 Fifteen Discourses to the Royal Academy (Reynolds), embroidery, fourteenth century, 445-446, 446 Drunken Cobbler (Greuze), 709-710, 709 Georgian silver, 700, 700 701 Drypoint technique, 655-656 Figural art, 866-867, 866 Dubuffet, Jean, Cow with the Subtile Nose, 867, 867 landscape garden, 694-697, 696 painting, late nineteenth century, 761-762, 761 Fiorentino, Rosso, 591 Ducal Palace, Mantua, Italy, 516, 517 First Leaves, Near Mantes (Corot), 757-758, 757 Ducal Palace, Urbino, Italy, 510-512, 511, 512 painting, Neoclassicism, 699, 701-707, 699, Flamboyant-style architecture, 480-481, 481 Duccio di Buoninsegna, Maestà Altarpiece, 437, painting, Renaissance, 605-608, 605, 606, 608 Flanders, 456, 644-649, 644-649 437, 438, 439, 440 painting, Romanticism, 705-707, 706, 707 Flatiron Building, The (Stieglitz), 831, 831 Duchamp, Marcel, 857 Flaxman, John, Jr., 698 painting, Romantic landscape, 739-741, Fountain, 826-828, 827 Flemish art LHOOQ, 828, 828 fiber arts, 464-466, 465, 466 wedgwood, 698, 698, 699 Duke of Berry at Table, from Très Riches Heures manuscripts, illuminated, 458, 460-464, 462, Engravings, 485 (Limbourg brothers), 457, 458 463, 464 Enlightenment Dürer, Albrecht, 584, 655 painting, 466-479, 467, 469, 470-479 description of, 680-681 Adam and Eve, 586, 586 painting, Baroque, 644-649, 644-649 map of Europe and North America, 681 Four Apostles, 586-587, 587 tapestry, 464-465, 465 science and, 680, 702, 724 Four Horsemen of the Apocalypse, 585, 585 Flitcroft, Henry, Stourhead park, Wiltshire, Eng-Ensor, James, The Intrigue, 787, 787 Melencolia I, 576, 577-578 land, 696-697, 696 Entombment (Caravaggio), 629, 629 Self-Portrait, 585, 585 Florence, 491 Entombment (Pontormo), 563, 563 Dutch art, Baroque painting, 649, 651-663, architecture, Renaissance, 493-498, 493-497 Epidauros, theater in, Corinthian capital from, 651-662 Brancacci Chapel, Santa Maria del Carmine Dutch Visitors to Rome Looking at the Farnese Herxxxiv, xxxiv church, 506-508, 507, 508, 509 Equestrian monument of Bartolommeo Colleoni cules (Goltzius), xlvii, xlvii (Verrocchio), 503, 503 Capponi chapel, Santa Felicità church, Florence, 562, 563 Equestrian monument of Erasmo da Narni Cathedral Dome, 428, 428, 429, 493-494, 493 (Donatello), 501, 502-503 Foundling Hospital, 494, 496, 496 Eakins, Thomas, The Gross Clinic, 760, 760 Erasmo da Narni, 501, 502 Great Grotto (Buontalenti), Boboli Gardens, Earthworks, modern, 899-901, 900, 901 Erasmus, Desiderius, 578 547, 547 Eco, Umberto, 896 Ernst, Max, 869 Orsanmichele Tabernacle, 422, 423-424, The Horde, 858, 858 École des Beaux-Arts, 686, 726, 750, 751, 796 498-499, 498 Étienne Chevalier and Saint Stephen (Fouquet), Edict of Nantes, 590 painting, 429, 431-437, 432, 433, 435, 436 479-480, 480 Edward I, king of England, 445 painting, Renaissance, 504-510, 505-510 Edward III, king of England, 445, 789 Europe Palazzo della Signoria (Cione and Talenti), 427, Edward VI, king of England, 604 See also under specific country map of, in Baroque period, 615

Eiffel, Gustave, Eiffel Tower, Paris, 722, 723

Palazzo Medici-Riccardi, 495, 495, 497, 497 painting, fifteenth century, 479-480, 480 Self-Portrait as the Allegory of Painting, 630, 630 Palazzo Rucellai, 497-498, 497 painting, Neoclassicism. 709-714, 709-713, George III, king of England, 908, 691, 697, 704 San Giovanni baptistry, 428-429, 430, 726-728, 726-729 George Clifford, 3rd Earl of Cumberland (Hilliard). 499-501, 500 painting, Realism, 755-759, 755-759 608, 608 San Lorenzo church, 494-495, 494, 495 painting, Renaissance, 590, 590 George Washington (Houdon), 714-715, 714 sculpture, Renaissance, 498-504, 498-503 painting, Rococo, 685, 685, 686-689, 687 Georgian silver, 700, 700 Flower Piece with Curtain (Van der Spelt and Van painting, Romanticism, 728-734, 730-734 Géricault, Théodore, 728-729 Mieris), xxxiii, xxxiii Salons, 681, 686, 726 Pity the Sorrows of a Poor Old Man, 732, 733 Flower Still Life (Ruysch), 662, 663 sculpture, fourteenth century, 443-444, 444, Raft of the "Medusa," 728, 730-731, 730, 731 Fontainebleau, France, Chamber of the Duchess German art of Étampes, 591-592, sculpture, Neoclassicism, 714-715, 714 See also Holy Roman Empire sculpture, nineteenth century, 752-753, 752, architecture, Modern, 838-839, 838 Fontana, Domenico, 615 789–791, 7*90,* 7*91* architecture, Neoclassicism, 746, 746 Fontana, Lavinia, Noli Me Tangere, 568-569, 569 sculpture, Rococo, 689, 689 architecture, Rococo, 682-684, 682, 683, 684 Fontenelle, Bernard de, 680 sculpture, Romanticism, 735, 735 Bauhaus art, 848–849, 848, 849, 850 Foreshortening, 492 Frencia Revolution, 680, 712-713 Dadaism, 828-829, 828, 829 Forever Free (Lewis), 735-736, 735 French Royal Academy of Painting and Sculpture, Der Blaue Reiter, 811–814, 812, 813, 814 Forms in Echelon (Hepworth), 855-856, 855 Die Brücke (the Bridge), 808–810, 808, 809 Foster, Norman, Hong Kong & Shanghai Bank, Frescoes metalwork, 584, 584 Hong Kong, 920, 922, 922 buon, 439 Nazi suppression of, 850 Foundling Hospital (Brunelleschi), 494, 496, 496 Italian Renaissance, 505-510, 506-510 Neo-Expressionism, 913-915, 913, 914 Fountain (Duchamp), 826-828, 827 Sala della Pace, Siena, 440, 441 painting, expressionism, 810-811, 810, 811 Fountain of the Four Rivers (Bernini), 623, 624, Scrovegni (Arena) Chapel, Padua, 433-437, painting, Renaissance, 581-588, 582-589 624 435, 436 painting, Romantic landscape, 738-739, 738 Fouquet, Jean secco, 439 sculpture, Renaissance, 579-581, 580, 581 Étienne Chevalier and Saint Stephen, Melun Diptych, technique, 439 sculpture, Rococo, 683-684, 684 479-480, 480 Freud, Sigmund, xlvi, 785, 804, 858 Germany Virgin and Child, Melun Diptych, 479-480, 480 Friedrich, Caspar David, Nebel (Fog), 738-739, See also Holy Roman Empire Four Apostles (Dürer), 586-587, 587 738 Bauhaus Building, Dessau, 849, 849, 850 Four Crowned Martyrs, The (Nanni di Banco), Frottage, 858 Fagus Shoe Company (Gropius and Meyer). Orsanmichele church, 498-499, 498 Fry, Roger, 776 838–839, 838 Four Horsemen of the Apocalypse (Dürer), 585, 585 Furniture Nazis, 804, 850 Four Winds publishing house, 598, 602 Art Nouveau, 792-793, 793, 794, 794 Renaissance in, 579–588 Fra Angelico. See Angelico, Fra (Guido di Pietro Morris & Company, 762, 762 Gérôme, Jean-León, Cafe House, Cairo (Casting da Mugello) Fuseli, John Henry (Füssli, Johann Bullets), 744-745, 744 Fragonard, Jean-Honoré, 688 Heinrich), The Nightmare, 705-706, 706 Ghent Altarpiece (Jan and Hubert van Evck), 454, The Meeting, 688, 689 Futurism, in Italy, 822, 822, 823 France Gherardini del Giocondo, Lisa, 534 G Baroque period in, 663-670 Ghiberti, Lorenzo, San Giovanni baptistry, door ducal courts, 457-466 Gainsborough, Thomas, Portrait of Mrs. Richard panels, 499-501, 500 Neoclassicism in, 707-715, 726-728 Brinsley Sheridan, 701-702, 702 Ghirlandaio, Domenico, 539 Renaissance in, 479–481, 590–593 Galileo Galilei, 616 frescoes for Sassetti Chapel, 518, 519-520, 519 Rococo style in, 684-689 Galleria, 625 The Nativity and Adoration of the Shepherds, Galmeton, Richard de, 446 Romanticism in, 728-734 519-520, 519 Francis I, king of France, 567, 590, 591, 592, 593 Garden in Sochi (Gorky), 870-871, 870 real name of, 518 Francis I (Clouet), 590, 590 Garden of Earthly Delights (Bosch), 598-599, 599 Giacometti, Alberto, City Square, 866, 866 Franciscans, 425 Garden of Love (Rubens), 647, 647 Gilbert, Cass, Woolworth Building, New York Franco, Francisco, 803, 804 Garden of Love page from, Hypnerotomachia Poliphili City, 843, 843 Frank, Robert (Colonna), 522, 522 Giorgione (Giorgio da Castelfranco) The Americans, 881 Gardens The Pastoral Concert, 554, 554 Trolley, New Orleans, 882, 882 English landscape, 695-696, 695 The Tempest, 552-553, 553 Frankenthaler, Helen, Mountains and Sea, 875, 875 French Baroque. 666, 666 Giornata, 439, 508 Franklin, Benjamin, 680, 698 French Renaissance, 593 Giotto di Bondone, 424 Franzoni, Giuseppe, Corncob Capital, U.S. Capi-Great Grotto (Buontalenti), Boboli Gardens, frescoes, Scrovegni (Arena) Chapel, Padua, tol, 745-746, 745 Florence, 547, 547 433-437, 435, 436 Frederick C. Robi House (Wright), Chicago, landscape, 925, 925 Lamentation, 434, 436, 437 840-841, 840 Gare St. Lazare (Monet), 768-769, 768 Marriage at Cana, Raising of Lazarus, Resurrection Freer, Charles Lang, xlv-xlvi Garnier, Charles, Opéra, Paris, 751-752, 751, 752 and Noli Me Tangere and Lamentation, French art Gates of Paradise, San Giovanni baptistry, Flo-Scrovegni (Arena) Chapel, Padua, 434, 436 academic, 751-753 rence, 499-500, 500 Virgin and Child Enthroned, 431-432, 433 academies, 663, 669, 686 Gateway to the Great Temple at Baalbek (Roberts), Giovane, Palma, 557 architecture, Baroque, 663-667, 664-667 743-744, 743 Giovanni da Bologna (Jean de Boulogne or architecture, Modern, 839, 839 Gaudí i Cornet, Antonio, Serpentine bench, Giambologna), Astronomy, or Venus Urania, architecture, Neoclassicism, 707-708, 708 792-793, 793 568, 568 architecture, nineteenth century, 750-751, 751 Gauguin, Paul, 776 Girardon, François, Apollo Attended by the Nymphs architecture, Renaissance, 590-593, 591, 592, Mahana no atua Day of the God), 784, 785 of Thetis, 666-667, 667 Gaulli, Giovanni Battista, The Triumph of the Name Girodet-Trioson, Anne-Louis, Portrait of Jean-Bap-Art Nouveau, 794-795, 794 of Jesus and the Fall of the Damned, 633-634, tiste Belley, 713-714, 713 Cubism, 820-822, 820, 821 633 Giuliani, Rudolph, 921 flamboyant style, 480-481 Gehry, Frank, Guggenheim Museum, Solomon Glass and Bottle of Suze (Picasso), 818-319, 819 garden design, Baroque, 666, 666 R., Bilbao, Spain, 922, 923 Gleaners, The (Millet), 757, 757 manuscripts, fourteenth century illuminated, Genre, 614, 659-660 Glorification of the Papacy of Urban VIII (Pietro da 442-443, 443 Gentileschi, Artemisia Cortona), 632, 632 painting, Baroque, 667-670, 668-671 Judith and Maidservant with the Head of Goes, Hugo van der, Portinari Altarpiece, 476-477,

Holofernes, 629, 630

painting, Fauvism, 805-808, 806, 807

477, 479, 479

Het Schilderbock (The Painter's Book) (Van Mander), Guido di Pietro. See Angelico, Fra (Guido di Goethe, Johann Wolfgang von, 694 Pietro da Mugello) Goldsmith (Saint Eligius?) in His Shop, A (Chris-Higher Goals (Hammons), 922, 924, 924 Guilds, 425, 466 tus), 474, 475 High Tech architecture, 920, 922, 922 women in, 462 Gold work, Mannerism, 567-568, 567, 568 Hilliard, Nicholas, George Clifford, 3rd Earl of Cum-Goltzius, Hendrick, 598, 649 Guimard, Hector, Desk, 794, 794 berland, 608, 608 Gursky, Andreas, 99 Cent, 912, 913 Dutch Visitors to Rome Looking at the Farnese Hireling Shepherd, The (Hunt), 761-762, 761 Gutai group, 886 Hercules, xlvii, xlvii Hiroshige, Utagawa, One Hundred Views of Edo: Gonçalves, Nuño, Saint Vincent with the Portuguese Gutenberg, Johann, 485 Plum Orchard, Kameido, 782, 782 Royal Family from Altarpiece of Saint Vincent, Historicism, 751 482-483, 483 History of Ancient Art, The (Winckelmann), 693 Gonzaga, Federigo II, 550 History paintings Gonzaga, Lodovico, 514, 517 Habitat '67 (Safdie), Montreal, Canada, 907-908, defined, 686 Gorky, Arshile, Garden in Sochi, 870-871, 870 English Neoclassicism, 703-705, 703, 704 Gossaert, Jan, 598, 599 Habsburg Empire, 634 Hitchcock, Henry-Russell, 847 Saint Luke Painting the Virgin Mary, 600–601, Hackwood, William, "Am I Not a Man and a Hitler, Adolph, 804, 849, 850 Brother?" jasperware, 698, 699 Hoare, Henry, Stourhead park, Wiltshire, England, Hadid, Zaha, Vitra Fire Station, Germany, 922, Gothic art 696-697, 696 architecture, American Gothic Revival, 747, 923 Höch, Hannah, Dada Dance, 829, 829 Hagenauer, Nikolaus, Saint Anthony Enthroned between Saints Augustine and Jerome, 581, 582 Hofmann, Hans, 873 architecture, English Gothic Revival, 697, 697, Hogarth, William, 754 Hagesandros, Laocoön and His Sons, xxxvii, xxxvii 746,749 Halder, Jacob, Armor of George Clifford, 607, 607 The Marriage Contract, from Marriage à la Mode, international, 458, 462-463, 483 Hall of Mirrors (Le Brun and Hardouin-Mansart), 699, 699, 701 Goujon, Jean, 593 Holbein the Younger, Hans, Henry VIII, 605-606, Versailles, 663, 665, 665 Governess, The (Chardin), 709, 709 605 Hals, Frans, 651 Goya, Francisco Holy Cross church, Schwäbisch Gmünd, Ger-Catharina Hooft and Her Nurse, 652, 652 Caprichos (Caprices), Los, 736, 736, 754 Officers of the Haarlem Militia Company of Saint many, 448-449, 448 Family of Charles IV, 736, 737 Holy Roman Empire, 334, 344 The Sleep of Reason Produces Monsters, 736, Adrian, 652, 652 See also German art; Germany Hamilton, Ann, Indigo Blue, 925, 925 736 Hamilton, Gavin, 693 architecture, fourteenth century, 448-449, 448, Third of May, 1808, 736, 737, 738 Hamilton, Richard, 888 449 Graffiti, 914 Just What Is It that Makes Today's Home so Differfifteenth century, 483, 484 Grand Canyon National Park, Arizona, Lookout metalwork, 584, 584 ent, so Appealing?, 889, 889 Studio (Colter), 841-842, 841 painting, fourteenth century, 449-450, 450, 451 Grand Manner, 701, 705 Hamilton, William, 698 painting, Renaissance, 581-588, 582-589 Hammamet with its Mosque (Klee), 814, 814 Grand Tour, 689–694 Renaissance (early) in, 483 Hammons, David, Higher Goals, 922, 924, 924 Graphic arts Hampton, James, Throne of the Third Heaven of the sculpture, Renaissance, 579-581, 580, 581 Art Nouveau, 791-795, 792, 793, 794 Holy Virgin Mary (Ofili), 920, 921, 921 Renaissance, 484-486 Nations' Millennium General Assembly, Homage to Blériot (Delaunay), 820, 820 xxxviii-xxxix, xxxviii Grattage, 858 Hannibal Crossing the Alps (Cousen), 754, 754 Homage to New York (Tinguely), 888, 888 Great Grotto (Buontalenti), Boboli Gardens, Homer, 697 Happenings, 886-888, 886, 887, 888 Florence, 547, 547 Hardouin-Mansart, Jules, Palais de Versailles, 663, Homer, Winslow, The Life Line, 760, 761 Great Schism, 424, 517 Hong Kong & Shanghai Bank (Foster), Hong Great Sphinx, Egypt, xxxii, xxii 664, 665–667, 665, 666, 667 Kong, 920, 922, 922 Great Wall of Los Angeles, The Division of the Barrios Hardwick Hall (Smythson), Shrewsbury, England, Horde, The (Ernst), 858, 858 608, 609 (Baca), 915, 915 Harlem Renaissance, 852-853, 852, 853, 855 Horn Players (Basquiat), 914-915, 914 Greco, El (Domenikos Theotokopoulos), 596 Horta, Victor, Stairway, Tassel House, Brussels, 792, Harmony in Blue and Gold, Peacock Room, for Burial of Count Orgaz, 596, 597 Frederick Levland (Whistler), xlv-x.vi, xlv View of Toledo, 597-598, 597 Houdon, Jean-Antoine, George Washington, Greek-cross plan churches, 549 Hartley, Marsden, Portrait of a German Officer, 831, 714-715, 714 832.832 Greek manner, 429, 431 Haussmann, Georges-Eugène, 751, 757, 797 Hours of Mary of Burgundy (Mary of Burgundy Greuze, Jean-Baptiste, The Drunken Cobbler, Head Surrounded by Sides of Beef (Bacon), 866, 866 Painter), Mary at Her Devotions from, 709-710, 709 Heath of the Brandenburg March (Kiefer), 913-914, 463-464, 464 Grisaille, 434, 442, 447, 473 House (Whiteread), 918-919, 919 Gropius, Walter, 848 Houses at L'Estaque (Braque), 817, 817 Heckel, Erich, Crouching Woman, 809, 809 Bauhaus Building, Dessau, Germany, 849, 849, House of Jacques Coeur, Bourges, France, 481, Heizer, Michael, Double Negative, 900, 900 Fagus Shoe Company, 838-839, 838 Hemicycles, 560 Gros, Antoine-Jean, Napoleon in the Plague House at Houses of Parliament (Barry and Pugin), London, Hendrick III of Nassau, 598, 599 Hennings, Emmy, 826 746,747 Jaffa, 726-727, 727 How the Other Half Lives (Riis), 796 Henri, Robert, 830 Gross Clinic, The (Eakins), 760, 760 Henri IV Receiving the Portrait of Marie de' Medici How to Explain Pictures to a Dead Hare (Beuys), Grottos, French, 593 898-899, 899 (Rubens), 646, 646 Group of Seven, 837 Henry II, king of France, 590 Hudson River Landscape (Smith), 877, 877 Grünewald, Matthias, Isenheim Altarpiece, 581-582, Huelsenbeck, Richard, 828 Henry III, king of England, 446 582, 583, 584 Henry III, king of France, 590 Humanism, 424-425, 456-457, 490-491 Gu, Wenda, United Nations-Babel of the Millen-Hundred Years' War, 424, 442, 445, 789 Henry IV, king of France, 590, 663 nium, 927-928, 927 Güas, Juan, San Juan de Los Reyes church, Toledo, Henry VI, king of England, 479 Hunt, Richard Morris, World's Columbian Exposition, Chicago, 796, 798, 799 Henry VIII, king of England, 578, 604, 605–606 Spain, 482, 482 Hunt, William Holman, The Hireling Shepherd, Henry VIII (Holbein), 605-605, 605 Guda, 462 761-762, 761 Hepworth, Barbara, Forms in Echelon, 855-856, Guercino (Giovanni Francesco Barbieri), Hunt of the Unicorn tapestry, 464-465, 465 855 Saint Luke Displaying a Painting of the Virgin, Hurling Colors (Shimamoto), 886, 886 Herculaneum, 690 xli, xli, 630 Guernica (Picasso), 802-803, 803 Hus, John, 424, 452 Hercules and Antaeus (Pollaiuolo), 503-504, 503 Herrera, Juan de, El Escorial, Madrid, 595, 595 Huysmans, Joris-Karl, 785 Guggenheim Museum, Solomon R. (Gehry),

Hesse, Eva, Rope Piece, 895-896, 895

Hypnerotomachia Poliphili (Colonna), 522, 522

Bilbao, Spain, 922, 923

1	painting, Renaissance (High), 532, 533,	Improvisation No. 28 (Second Version), 813, 813
Iconoclasm, 579	534–539, <i>534–538</i> , 541–544, <i>542</i> , <i>543</i> , <i>544</i> ,	Kant, Immanuel, 680
Iconography, xxxvii	550–556, <i>550–557</i>	Kapoor, Anish, As If to Celebrate,
Iconologia (Ripa), 629–630	sculpture, Baroque, 615, 618, 619–621, 619	I Discovered a Mountain Blooming with Red
Idealism, xxxiv	sculpture, Neoclassicism, 693–694, 694	Flowers, 918, 918
Igloo (Merz), 897, 897	sculpture, Renaissance (early), 498–504, 498–503	Kaprow, Allan, <i>The Courtyard</i> , 886–887, 887
Ignatius of Loyola, 558, 561		"Karawane" (Ball), 826, 826
Ignudi, 541, 544, 626	sculpture, Renaissance (High), 539–541, <i>539</i> , <i>540</i> , 544–547, <i>545</i> , <i>546</i> , <i>547</i>	Kauffmann, Angelica, 690
Il Gesù church (Vignola and della Porta), 561–562, 561	Italy	Cornelia Pointing to Her Children as Her Treasure 703–704, 703
Illuminated manuscripts. See Manuscripts, illumi-	Baroque period in, 615–634	Kaufmann, Edgar, 841
nated	Grand Tour, 689–694	Kaufmann House (Wright), Mill Run, Pennsylva
Immaculate Conception, The (Murillo), 639–640,	maps of, in Renaissance, 491, 531	nia, 841, <i>841</i>
640	Neoclassicism in, 690-694, 691, 692, 693, 694	Kent, William, 695-696
Impasto, 614	Ivory	Kepler, Johannes, 616
Impost blocks, 494	French fourteenth century, 444, 444	Kerouac, Jack, 881
Impressionism	1	Khafre, sculpture of, xxxii, xxxii
angles, 771–772, 771	J	Kiefer, Anselm, Heath of the Brandenburg March,
Cassatt, 772–774, 773, 774	Jack Pine (Thomson), 836–837, 837	913–914, <i>913</i>
exhibitions, 764	Jacob and Esau, Gates of Paradise (Ghiberti),	Kilns, 698
Manet, 765–767, 765, 766, 774, 775, 776	500–501, <i>500</i> James I, king of England, 647, 671, 672	Kinetic works, 857
Monet, 767–769, 767, 768, 769	Jane Avril (Toulouse-Lautrec), 794–795, 794	Kino, Eusebio, 715, 717 Kirchner, Ernst Ludwig, 850
Morisot, 774, <i>775</i> plein air, 769–771	Jan van Eyck. See Van Eyck, Jan	Street, Berlin, 809–810, 809
Post-, 776–784, 777–785	Japonaiserie: Flowering Plum Tree (Van Gogh), 782,	Kiss, The (Klimt), 793, 793
use of word, 764–765	783	Klee, Paul, 813
Impoverished (povera) art, 896–897, 897	Japonisme, 782	Hammamet with its Mosque, 814, 814
Improvisation No. 28 (Second Version) (Kandinsky),	Jasperware, 698, <i>699</i>	Klein, Yves
813, 813	Jean, duke of Berry, 460	Anthropométries of the Blue Period, 887, 887
Indigo Blue (Hamilton), 925, 925	Jean de Marville, 460	The Void, 898
Industrial Revolution, 680	Jean le Noir, 462	Klimt, Gustav, The Kiss, 793, 793
description of, 724-725	Jeanne-Claude (de Guillebon), Running Fence,	Knights of Christ, Tomar, Portugal, 594, 594
map of Europe and America in the nineteenth	901, 901	Knight Watch (Riopelle), 874, 875
century, 725	Jeanne d'Evreux, 442–443, 444	Kollwitz, Käthe Schmidt, The Outbreak, 810–811,
Ingres, Jean-Auguste-Dominique	Jeanneret, Charles-Édouard. <i>See</i> Le Corbusier	810
Large Odalisque, 727–728, 728	Jefa (Patroness) (Xul Solar), 834–835, 835	Kosice, Gyula, Madí Luminous Structure "F," 880, 881
Portrait of Madame Desiré Raoul-Rochette, 728, 729	Jefferson, Thomas, 680, 745	Kosuth, Joseph, One and Three Chairs, 898, 898
Innocent X, pope, 623	Monticello, Virginia, 718, 718	Kounellis, Jannis, 896
Installation art, 845	Jenney, William Le Baron, 798	Untitled (12 Horses), 862–863, 863–864
Intaglios, 485, 692	Jesuits, 558, 561	Krasner, Lee, The Seasons, 873, 873
Intarsia, 511	Jewish art, synagogues, 660, 660	Krug, Hans, Apple Cup, 584, 584
International Gothic art, 458, 462–463, 483	Jewish Cemetery, The (Ruisdael), 660-661, 661	Kruger, Barbara, We Won't Play Nature to Your Cul-
International style, 847, 905	Joan of Arc, 479	ture, 910, 911
Interpretation of Dreams, The (Freud), 785, 804	John, duke of Berry, 457, 458, 461	
Intonaco, 533	Johns, Jaspar, Target with Four Faces, 885–886, 885	L
Intrigue, The (Ensor), 787, 787	Johnson, Philip, 847	Labille-Guiard, Adélaïde, Self-Portrait with Two
Intuitive perspective, 456	AT&T Corporate Headquarters,	Pupils, 710, 711
Invention of the Balloon, The (Clodion), 689, 689	New York City, 908, 909 Seagram Buildir:g, New York City, 905, 905	Labrouste, Henri, Bibliothèque Sainte-Geneviève, Paris, 750–751, 751
Iron bridges, 705, 705	Jonah (Ryder), 788, 788	La Citadelle: Freedom (Savage), 853, 853
Isabella, queen of Castile, 481–482, 595	Jones, Inigo, 671	Lady Sarah Bunbury Sacrificing to the Graces
Isabella d'Este, 555, 558	Banqueting House, Whitehall Palace, London,	(Reynolds), 701, 701
Isabella d'Este (Titian), 558, 558	672, 672, 673	La Fayette, Madame de, 681
Isenheim Altarpiece (Grünewald), 581–582, 582,	Joseph and Potiphar's Wife (Properzia de' Rossi),	Lam, Wifredo, Zambezia, Zambezia, 869-870, 869
<i>583</i> , 584	552, <i>552</i>	Lamentation (Giotto di Bondone), 434, 436, 437
Italian art	Joy of Life, The (Le Bonheu [*] de Vivre) (Matisse), 806,	Landscape
architecture, Baroque, 615–624, 617–624 architecture, fourteenth century, 427–429, 427,	807, 808	English garden, 694–697, 695, 696
428, 429	Judd, Donald, Untitled, 894, 895	French Baroque, 666, 666
architecture, Renaissance (early), 491–498,	Judith and Maidservant with the Head of Holofernes (Gentileschi), 629, 630	Landscape architecture, 694–697, <i>695</i> , <i>696</i> , <i>925</i> , 925
492–497, 510–512, <i>511</i> , <i>512</i> , 514–517, <i>515</i> ,	Julius II, pope, 529, 530, 536, 541, 547, 548, 549	
516, 523, 524	Jung, Carl, 869, 876	Landscape painting
architecture, Renaissance (High), 547–550,	Justice of Otto III (Bouts), 475–476, 476	American, 742–743, <i>742</i> Canadian, 836–837, <i>837</i>
548, 549, 550	Just What Is It that Makes Today's Home so Different,	Dutch, 660–661, 661
ceramics, 504, 504	so Appealing? (Hamilton), 889, 889	English, 739–741, 739–741
Cubism and Futurism, 822, 822, 823	11 8 (French, 667–670, 670, 671
painting, Baroque, 624-634, 625-633	K	German, 588, 589, 738–739, 738
painting, fourteenth century, 429, 431-437,	Kahlo, Frida, The Two Fridas, 836, 836	Romantic, 738–743, 738–742
432, 433, 435, 436	Kahn, Louis, 908	Landscape with Flight into Egypt (Carracci),
painting, Neoclassicism, 690–694, <i>691</i> , <i>692</i> ,	Kaisersaal (Imperial Hall), Residenz (Neumann),	626–627, 626
693	Germany, 682–683, <i>682</i> , <i>683</i>	Landscape with Saint John on Patmos (Poussin),
painting, Renaissance (early), 504–510,	Kandinsky, Vasily, 811	667–668, 670, 670
506–510, 512–514, 512, 513, 514, 517–523, 518–523, 524–525, 524, 525, 526	Blue Mountain, 812, 812	Lange, Dorothea, Migrant Mother, Nipomo,
<i>518–523</i> , 524–525, <i>524</i> , <i>525</i> , <i>526</i>	Concerning the Spiritual in Art, 813	California, 854, 854

Mandolin and Clarinet (Picasso), 819, 819 Linear perspective (one-point or mathemati-Lantern, 494 Manet Édouard cal), 489, 491, 492, 517 Laocoön and His Sons (Hagesandros, Polydoros, and Lion Bas-Relief, The (Piranesi), 692, 692 A Bar at the Folies-Bergère, 774, 775, 776 Athanadoros), xxxvii, xxxvii Le Déjeuner sur l'Herbe (Luncheon on the Grass), Large Bathers, The (Cézanne), 779, 779 Lippi, Filippino, Brancacci Chapel, Santa Maria 765–766, 765 Large Blue Horses, The (Marc), 811, 812 del Carmine church, 506 Olympia, 766–767, 766 Lipstick (Ascending) on Caterpillar Tracks (Olden-Large Odalisque (Ingres), 727-728, 728 Man in a Red Turban (Jan van Eyck), 468-469, 470 burg), 892, 892 Las Meninas (The Maids of Honor) (Velázquez), Mannerism Lissitzky, El, 844 638, 639 defined, 562-563 Last Judgment (Michelangelo), 558, 559, 560 Proun space, 844, 845 Lithography, 732 goldwork, 567-568, 567, 568 Last Judgment Altarpiece (Weyden), 472-473, 473 manuscripts, 566, 566 Lives of the Most Excellent Italian Architects, Lastman, Pieter, 654 Painters, and Sculptors (Vasari), xlvi, 490, 531, Last Supper, The (Castagno), 508, 510, 510 painting, 563-566, 563, 564, 565, 567, 568-569, 569 Last Supper, The (Leonardo), xlii, xlii, 532, 533, Mansart, François, 663 Lobster Trap and Fish Tail (Calder), 857, 857 Mansart, Jules. See Hardouin-Mansart, Jules Locke, Alain, 852 Last Supper, The (Rembrandt), xlii-xliii, xliii Mantegna, Andrea, 524 Last Supper, The (Tintoretto), 571-572, 571 Locke, John, 680 Loggia, 423, 497 frescoes in Camera Picta, Ducal Palace, Man-Last Supper from Altarpiece of the Holy Blood tua. Italy. 516, 517 (Riemenschneider), 580, 580 of the Lancers, 427, 427, 519 Latin-cross plan churches, 515, 515, 517, 549 London Mantua, Italy Banqueting House (Jones), Whitehall Palace, architecture in, 514-517 Latrobe, Benjamin Henry, U.S. Capitol, 745-746, Ducal Palace, 516, 517 672, 672, 673 Palazzo del Tè (Romano), 550, 550 Crystal Palace (Paxton), 750, 750 Laurana, Luciano, Ducal Palace, 510-512, 511, Sant'Andrea church, 514-515, 515, 517 Great Exhibition of 1851, 750-751 512 Manuel I, king of Portugal, 594 Houses of Parliament (Barry and Pugin), 746, Lawrence, Jacob, The Migration of the Negro, 853, Manueline style, 594 747 Le Bonheur de Vivre (The Joy of Life) (Matisse), 806, Royal Academy, 690 Manuscripts, illuminated Saint Paul's Cathedral (Wren), 672-673, 674 Flemish, 458, 460-464, 462, 463, 464 fourteenth century, French, 442-443, 443 Le Brun, Charles, Hall of Mirrors, Versailles, 663, Lookout Studio, Grand Canyon National Park, Renaissance, 484-486, 522 Arizona (Colter), 841-842, 841 665, 665 Le Corbusier, Villa Savoye, France, 839, 839 Loos, Adolf, Steiner House, Vienna, 838, 838 Manuscripts, Mannerism, 566, 566 Manuzio, Aldo (Aldus Manutius), 522 Le Déjeuner sur l'Herbe (Manet), 765-766, 766 Lorenzetti, Ambrogio, 426 Many Mansions (Marshall), 916, 916 Allegory of Good Government in the City and in Leeuwenhoek, Antoni van, 616 Mapplethorpe, Robert, 921 Léger, Fernand, 869 the Country, 441-442, 441 Sala della Pace, fresco series, 440, 441 Maps Three Women, 821-822, 821 Leibnitz, Gottfried Wilhelm von, 680 Lorenzo the Magnificent. See Medici, Lorenzo de' of America in the nineteenth century, 725 of Europe in Baroque period, 615 (the Magnificent) Le Nain, Antoine, The Village Piper, 667, 669 of Europe in the Enlightenment, 681 Lorrain, Claude (Claude Gellé), 667 Le Nain, Louis, 667 Embarkation of the Queen of Sheba, 670, 671 of Europe in fourteenth century, 425 Le Nain, Mathieu, 667 of Europe in the nineteenth century, 725 Louis XI, king of France, 479 Lenin, Vladimir, 804 of Europe in the Renaissance, 457, 491, 531, Louis XIII, king of France, 663, 667 Le Nôtre, André, 663, 666 Leo X, pope, 536–538, 538, 541, 590 579 Louis XIV, king of France, 613, 663, 670, 681, of Europe in the twentieth century, 805 Leonardo da Vinci, xxxv, 669 684, 690, 752 Louis XIV (Rigaud), 612, 613, 670 of Italy in the Renaissance, 491 The Last Supper, xlii, xlii, 532, 533, 534 of North America in Baroque period, 615 Louis XV, king of France, 666, 681, 687, 689, Mona Lisa, 534-535, 534 of North America in Enlightenment, 681 Virgin and Saint Anne with the Christ Child and 690 of North America in the twentieth century, the Young John the Baptist, 534, 534 Louis XVI, king of France, 710, 712 Louis of Anjou, 457 Vitruvian Man, 535, 535 of the world, since 1945, 865 Louvre, palais du (Lescot), Paris, 593, 593 Leoni, Leone, Charles V Triumphing Over Fury, xxxvi-xxxvii, xxxvi, 578 Lozza, Raúl, Painting #99, 880, 880 Marat, Jean-Paul, 713, 713 Marc, Franz, The Large Blue Horses, 811, Luncheon on the Grass (Manet), 765-766, 765 Leroy, Louis, 764 Lescot, Pierre, Louvre, palais du, 593, 593 Lunettes, 468 Margaret of Austria, 558 Luther, Martin, 578, 586, 587 Les Demoiselles d'Avignon (The Young Ladies of Marie Antoinette, queen of France, 710, 710 Avignon) (Picasso), 816, 816 Marilyn Diptych (Warhol), 890, 890 Lessing, xxxviii Marinetti, Filippo, 822 Maderno, Carlo, Saint Peter's basilica, plan for, Lesyngham, Robert, 447 549, 549, 617, 617 Marpacífico (Hibiscus) (Peláez), 835, 835 Le Vau, Louis, Palais de Versailles, 663, 664, Marriage at Cana, Raising of Lazarus, Resurrection 665-667, 665, 666, 667 Madí, 879, 880 and Noli Me Tangere and Lamentation (Giotto Lewis, Edmonia, Forever Free, 735-736, 735 Madí Luminous Structure "F" (Kosice), 880, 881 di Bondone), 434, 436 Madonna and Child (Daddi), 422, 423 Leyland, Frederick, xlv Marriage Contract, from Marriage à la Mode (Hoga-Madonna with the Long Neck (Parmigianino), 564, Leyster, Judith, Self-Portrait, 653, 653 rth), 699, 699, 701 LHOOQ (Duchamp), 828, 828 Liberation of Aunt Jemima (Saar), 902, 902 Madrid, El Escorial (Bautista and Herrera), 595, Marriage of the Emperor Frederick and Beatrice of Burgundy, The (Tiepolo), 683, 683 Liberty Leading the People, July 28, 1830 (Delacroix), 734, 734 Maestà Altarpiece (Duccio di Buoninsegna), 437, Marseillaise, Departure of the Volunteers of 1792 (Rude), Arc de Triomphe, Paris, 735, 735 Lichtenstein, Roy, Oh Jeff...I Love You, Too...But..., 437, 438, 439, 440 Magic Bird (Brancusi), 825, 825 Marshall, Kerry James, Many Mansions, 916, 916 891, 891 Mahana no atua (Day of the God) (Gauguin), 784, Marshall Field Wholesale Store (Richardson), Life Line, The (Homer), 760, 761 Life of John the Baptist (A. Pisano), panel doors, Chicago, 798, 799 785 Marsh Flower, a Sad and Human Face, The (Redon), Majolica, 467 428-429, 430 786-787, 786 Limbourg brothers, 461 Ma Jolie (Picasso), 818, 818 Male and Female (Pollock), 871, 871 Martyrdom of Saint Bartholomew (Ribera), 635-636, January, The Duke of Berry at Table, Très Riches Heures, 457, 458 Malevich, Kazimir, Suprematist Painting (Eight Red 635 Martyrdom of Saint Ursula (Memling), 478, 478 February, Life in the Country, Très Riches Heures, Rectangles), 822-823, 823

Man, Controller of the Universe (Rivera), 851-852,

851

Martyria 549

Mary I, queen of England, 604

Limners, 676

462-463, 463

Meyer, Adolf, Fagus Shoe Company, 838-839, Rouen Cathedral: The Portal (in Sun), 769, 769 gundy (Mary of Burgundy Painter), Montbaston, Jeanne de, 462 463-464, 464 Meyer, Adolf, Fagus Shoe Company, 838-839, Montefeltro, Federico da, 490, 510-514, 513, 514, Mary Magdalen (Donatello), 502, 503 536 Mary Magdalen with the Smoking Flame, (De La Michelangelo Buonarroti, 669 Monticello (Jefferson), Virginia, 718, 718 Tour), 667, 668 Creation of Adam, 541, 544, 544 Montreal, Canada, Habitat '67 (Safdie), 907-908, Mary of Burgundy Painter, Mary at Her Devotions David, 540, 541 from Hours of Mary of Burgundy, 463-464, Last Judgment, 558, 559, 560 Mont Sainte-Victoire (Cézanne), 777-778, 777 464 Medici Chapel, 545-547, 546 Moore, Henry, Recumbent Figure, 856-857, 856 Mary of Hungary, 558, 602 Moses, 545, 545 Moreau, Gustave, Apparition, 786, 786 Marx, Karl, xlvi, 724 Pietà, 539-541, 539 Morisot, Berthe, 764 Masaccio Rondanini Pietà, 560, 560 Summer's Day, 774, 775 Brancacci Chapel, Santa Maria del Carmine Saint Peter's basilica, plan for, 549, 549, 560, Morisot, Edma, 774 church, 506-508, 507, 508, 509 Morley, Elizabeth, 700 Expulsion from Paradise, 506, 508 Sistine Chapel, 541, 542, 543, 544, 544 Morris, William, Peacock and Dragon curtain, 762, real name of, 505 Michelozzo di Bartolomeo 762 Tribute Money, 506-508, 509 Cathedral Dome, 494, 495 Morris & Company, 762, 762 Trinity with the Virgin, Saint John the Evangelist, Palazzo Medici-Riccardi, 495, 495, 497, 497 Moser, Mary, 690 and Donors, 505-506, 506 Mies van der Rohe, Ludwig, 850 Moses (Michelangelo), 545, 545 Masks (Nolde), 808-809, 808 Seagram Building, New York City, 905, 905 Mott, Lucretia, 724 Masolino, Brancacci Chapel, Santa Maria del Migrant Mother, Nipomo, California (Lange), 854, Moulin de la Galette (Renoir), 770-771, 771 Carmine church, 506, 507 Mountains and Sea (Frankenthaler), 875, 875 Master of Flémalle. See Campin, Robert Migration of the Negro, The (Lawrence), 853, 855 Mountains at Collioure (Derain), 806, 806 Master Theodoric, Saint Luke, 449-450, 450 Milan, Santa Maria delle Grazie monastery, 532, Mrs Freake and Baby Mary (anonymous), 676, 676 Maternal Caress (Cassatt), 774, 774 533, 534 Mukhina, Vera, Worker and Collective Farm Woman, Mathematical perspective (one-point or Millet, Jean-François, 756 845, 845 linear), 489, 491, 492, 505, 517 The Gleaners, 757, 757 Munch, Edvard, The Scream, 787-788, 787 Matisse, Henri Mill Run, Pennsylvania, Fallingwater, Kaufmann Muniz, Vik, Action Photo I (from "Pictures of Choco-Le Bonheur de Vivre (The Joy of Life), 806, 807, House (Wright), 841, 841 late"), 912, 912 808 Minimalism, 892-896 Murakami, Takashi, Eye Love Superflat, 916-917, The Woman with the Hat, 806, 807 Miraculous Draft of Fishes (Raphael), 538-539, 538 Mazarin, Cardinal, 663 Miraculous Draft of Fishes (Witz), 483, 484 Murals, Italian Renaissance, 505-510, 506-510 Medallion, 496, 496 Miró, Joan, Shooting Star, 860, 860 Murillo, Bartolomé Esteban, The Immaculate Con-Medici, Catherine de, 590, 591, 592, 645, 646, Mobiles, 857 ception, 639-640, 640 Modern art Museum of Modern Art, New York City Medici, Cosimo de' (the Elder), 493, 495, 497, American, 829-833, 830-833 International style, 847 508, 514 in architecture, 838-843, 838-843, 905, 905, landscape architecture, 925, 925 Medici, Giovanni de Bicci de', 494, 536-538, 538 907-908, 907 Mussolini, Benito, 804 Medici, Giulio de', 537, 538, 545 Argentina, 834–835, 835 Mysticism, 450, 452 Medici, Lorenzo de' (the Magnificent), 490, 491, Art Nouveau, 791-795, 792, 793, 794 Mystic Nativity (Botticelli), 522-523, 523 521, 539, 545 Bauhaus art in Germany, 848-849, 848, 849, Medici Chapel, 545-547, 546 850 Medici family, 491, 493, 520, 545 birth of, 776 Nadar (Gaspard-Félix Tournachon), Portrait of Medici Palace Courtyard, 497, 497 Blue Rider (Der Blaue Reiter), 811-814, 812, Charles Baudelaire, 749-750, 749 Medici-Riccardi palace, 495, 495, 497, 497 813, 814 Namuth, Hans, Photograph of Jackson Pollock Medici Venus, statue, xxxvi, xxxvi Brazilian, 834, 834 painting, 872 Meeting, The (Fragonard), 688, 689 Canadian, 836-837, 837 Nanni di Banco, The Four Crowned Martyrs, Melencolia I (Dürer), 576, 577-578 Constructivism, 843-845, 844 Orsanmichele church, 498-499, 498 Melun Diptych (Fouquet), 479-480, 480 Cuban, 835, 835 Napoleon, 736 Memento mori, 687 Cubism, 814-824, 814-824 Napoleon III, 751, 752, 753, 755, 765 Memling, Hans Dadaism, 826-829, 826-829 Napoleon Crossing the Saint-Bernard (David), 726, Martyrdom of Saint Ursula, 478, 478 expressionism, 810-811, 810, 811 Saint Ursula reliquary, 478, 478, 479 Fauvism, 805-808, 806, 807 Napoleon in the Plague House at Jaffa (Gros), Mendieta, Ana Harlem Renaissance, 852-853, 852, 853, 855 726-727, 727 Silhouettes, 903 National Academy of Design, 830 International style, 847 Untitled work from the Tree of Life series, Mexican, 835-836, 836 National Endowment for the Arts (NEA), 921 903-904. 905 Nazi suppression of, 850 Native American art Mengs, Anton Raphael, Parnassus, 693, 693 primitivism and the Bridge (Die Brücke), influence on Emily Carr, 837, 837 Merian, Maria Sibylla, Wonderful Transformation of 808-810, 808, 809 Modern, 916, 916 Caterpillars and (Their) Singular Plant Nourish-Rationalism, 845-848, 846, 847 Spanish art, influence of, 715, 715, 716, 717, ment, 616, 616 sculpture, abstraction, 824-825, 825 Mérode Altarpiece (Triptych of the Annunication) Socialist Realism, 845, 845 Nativity and Adoration of the Shepherds, The (Campin), 457, 458, 467-468, 467 Surrealism, 857-860, 858, 859, 860 (Ghirlandaio), 519-520, 519 Merz, Mario, Igloo, 897, 897 Modernismo, 792 Nativity with Prophets Isaiah and Ezekiel, Maestà Merzbild 5B (Picture-Red-Heart-Church) (Schwit-Modersohn-Becker, Paula, Self-Portrait with an Altarpiece (Duccio di Buoninsegna), 439, ters), 828, 829 Amber Necklace, 810, 811 440 Metalwork Moholy-Nagy, László, 848 Naturalism, xxxiii-xxxiv English armor for royal games, 607, 607 Mona Lisa (Leonardo), 534-535, 534 Nature and Importance of Positive Philosophy, The engraving, 485 Mondrian, Piet, 845, 869 (Comte), 747 Georgian silver, 700, 700 Composition with Yellow, Red, and Blue, 846-847, Nature Symbolized No. 2 (Dove), 833, 833 German, 584, 584 846 Nauman, Bruce, Self-Portrait as a Fountain, 898, New York School, 876-878, 877 Monet, Claude, 764 Mexican art Gare St. Lazare, 768-769, 768 Nazis, 804, 850 interwar years, 851-852, 851 On the Bank of the Seine, Bennecourt, 767-768, Nebel (Fog) (Friedrich), 738-739, 738 Modern art, 835-836, 836 767 Neoclassicism

Mary at Her Devotions from Hours of Mary of Bur-

Florentine fourteenth century, 429, 431-437, Officers of the Haarlem Militia Company of Saint architecture, American, 717-718, 718, 432, 433, 435, 436 Adrian (Hals), 652, 652 745-746, 745 Ofili, Chris, Holy Virgin Mary, 920, 921, 921 French Baroque, 667–670, 668–671 architecture, English, 697-698, 698 French Neoclassicism, 709–714, 709–713, architecture, French, 707-708, 708 Oh Jeff...I Love You, Too...But..., (Lichtenstein), 726-728, 726-729 891, 891 architecture, German, 746, 746 French Realism, 755-759, 755-759 defined, 899, 725 O'Keeffe, Georgia French Renaissance, 590, 590 City Night, 833, 833 in the nineteenth century, 725 French Rococo, 684, 685, 686-689, 688 painting, American, 719-720, 719 Red Canna, xxxv, xxxv French Romanticism, 728-734 730-734 painting, English, 699, 699, 701-707, 701-707 Oldenburg, Claes, 891 Lipstick (Ascending) on Caterpillar Tracks, 892, genre, 614, 659-660 painting, French, 726-728, 726-729 German Expressionism, 781, 810-811, 810, painting, Italian, 690-694, 691, 692, 693 Old Sacristy, San Lorenzo Church (Brunelleschi), in Rome, 692-694, 693, 694 German Renaissance, 581–589, 582–589 Florence, 494, 494 sculpture, American, 735-736, 735 Harlem Renaissance, 852-853, 852, 853, 855 sculpture, Italian, 693-694, 693 Olmsted, Frederick Law Central Park, New York City, 797, 797 history, 686 Neo-Expressionism, 913-915, 913, 914 Impressionism, 764–776, 764–775 World's Columbian Exposition, Chicago, 798 Neo-Impressionism, 780 Olympia (Manet), 766-767, 766 Italian Baroque, 624-634, 625-633 Neoplatonists, 493 Italian Neoclassicism, 690-694, 691, 692, 693 One and Three Chairs (Kosuth), 898, 898 Neri, Filippo, 627 Italian Renaissance, 504-510, 504-510, One Hundred Views of Edo: Plum Orchard, Kameido Neshat, Shirin, Fervor, 926, 926 512–514, *512*, *513*, *514*, 517–523, *518–523*, (Hiroshige), 782, 782 Netherlands One-point perspective (linear or mathematical), 524–525, 524, 525, 526, 532, 533, 534–539, Baroque painting, 649-663, 651-663 *534*–*538*, 541–544, *542*, *543*, *544*, 550–556, 489, 491, 492, 505, 517 Rationalism, 845-848, 846, 847 Renaissance painting, 598-604, 599-604 550-557 On the Bank of the Seine, Bennecourt (Monet), lithography, 732 767-768, 767 Schröder House (Rietveld), 846, 847-848, 847 Mannerism, 563-566, 563, 564, 565, 567, Op Art, 892-896 Neumann, Johann Balthasar Opéra (Garnier), Paris, 751-752, 751, 752 568-569, *569* Church of the Vierzehnheiligen, 683-684, 683, Neoclassicism, American, 719-720, 719 Oppenheim, Meret, Object (Le Déjeuner en fourrure) (Luncheon in Fur), 859-860, 859 Neoclassicism, English, 699, 701-707, 699, Kaisersaal (Imperial Hall), Residenz, Germany, 701-707 682-683, 682, 683 Opus anglicanum, 445-446, 446 Neoclassicism, French, 709-714, 709-713, Nevelson, Louise, 876, 878 Orcagna (Andrea di Cione) 726-728, 726-729 Florence Cathedral, 428, 428, 429 Sky Cathedral, 878, 879 Neoclassicism, Italian, 690-694, 691, 692, 693 Orsanmichele Tabernacle, 422, 423-424 Newborn (Brancusi), 825, 825 Neo-Expressionism, 913-915, 913, 914 Newman, Barnett, Vir Heroicus Sublimis, 876, 877 Orgaz, Count, 596, 597 Netherlands, Renaissance, 598-604, 599-604 Orientalism, 743-745, 743, 744 New Negro movement, 852 oil and tempera, 466, 504-510, 506-510, 532, Orsanmichele Tabernacle, 422, 423-424 New Realism, 887 Orsanmichele, 423-424, 498-499 552-556, 553-557 Newton, Isaac, 680 oil painting in Venice, 569-572, 570, 571 New York City Orthogonals, 492 Orientalism, 743-745, 743, 744 Otto III, Holy Roman emperor, 475, 476 See also Museum of Modern Art pastels, 690 Our Lady of Guadalupe (Salcedo), 715, 716 Abstract Expressionism, 869-879, 869-878 Outbreak, The (Kollwitz), 810-811, 810 plein air, 769–771 Ashcan School, 830 Post-Impressionism, 776-784, 777-785 Oval plate (Palissy), 593, 593 AT&T Corporate Headquarters (Johnson and primitivism, 808-810, 808, 809 Burgee), 908, 909 Oxbow, The (Cole), 742, 743 Realism, American, 760, 760, 761 Central Park (Olmsted and Vaux), 797, 797 Realism, French, 755–759, 755–759 Seagram Building (Mies van der Rohe and Realism, Russian, 759-760, 759 Johnson), New York City, 905, 905 Padua, Italy, frescoes, Scrovegni (Arena) Chapel, Renaissance, early, 504-510, 506-510, skyscrapers, 842–843, 842, 843, 905, 905, 908, 433-437, 435, 436 Paik, Nam June, Electronic Superhighway: Continen-512-514, 512, 513, 514, 517-523, 518-523, Trans World Airlines Terminal (Saarinen), John 524–525, *524*, *525*, *526* tal U.S., 925-926, 926 Renaissance, English, 605-608, 605, 606, F. Kennedy Airport, 907, 907 See also Landscape painting; Murals; Portraiture 608 Trinity Church (Upjohn), 747, 747 Abstract Expressionism, 869-876, 869-877 Renaissance, French, 590, 590 Woolworth Building, 843, 843 Renaissance, German, 581–588, *582–589* Action (gesturalism), 871-875, 872, 873, 874, New York School, 869-879, 869-878 Renaissance, High, 532, 533, 534-539, 875 Nietzsche, Friedrich, 876 *534–538*, 541–544, *542*, *543*, *544*, 550–556, Nightmare, The (Fuseli), 706, 706 American early, 676, 676 American Neoclassicism, 719-720, 719 99 Cent (Gursky), 912, 913 Renaissance, Netherlands, 598-604, 599-604 American Realism, 760, 760, 761 Nocturne in Black and Gold, the Falling Rocket Baroque, Flemish, 644-649, 644-649 Renaissance, Spanish, 595-598, 596, 597 (Whistler), 763, 764 Rococo, French, 684, 685, 686–689, 688 Baroque, French, 667-670, 668-671 Nocturnes, 763 Romanticism, English, 705-707, 706, 707 Baroque, Italian, 624-634, 625-633 Nolde, Emil, 850 Romanticism, French, 728-734 730-734 Baroque, Spanish, 634-640, 634-640 Masks, 808-809, 808 Romanticism, Spanish, 736, 736, 737, 738 on canvas, 552 Noli Me Tangere (Fontana), 568-569, 569 Russian Realism, 759–760, 759 color field, 875-876, 876, 877 Normandy, Saint-Maclou church, 480-481, 481 Spanish Baroque, 634-640 634-640 Cubism, 814-824, 814-824 North America Spanish Renaissance, 595–598, 596, 597 Der Blaue Reiter, 811-814, 812, 813, 814 map of, in Baroque period, 615 Spanish Romanticism, 736, 736, 737, 738 Die Brücke, 808-810, 808, 809 map of, in Enlightenment, 681 English late nineteenth century, 761-762, 761 Symbolism, 785–789, 786–789 map of, in the twentieth century, 805 Painting (Wols), 868, 868 Nymph of the Spring (Cranach the Elder), English Neoclassicism, 699, 701-707, 699, Painting #99 (Lozza), 880, 880 701-707 587-588, 588 English Renaissance, 605-608, 605, 606, Palace(s) Banqueting House (Jones), Whitehall Palace, English Romanticism, 705–707, 706, 707 London, 672, 672, 673 Oath of the Horatii (David), 712, 712 Blenheim (Vanbrugh), England, 673-674, 674 Expressionism, 781, 810-811, 810, 811

Fauvism, 805-808, 806, 807

Flemish, 466–479, 467, 469, 470–479

Flemish Baroque, 644–649, 644–649

Ca D'Oro (House of Gold), Contarini Palace,

Château of Chenonceau, 590-591, 591, 592

Venice, 523, 524

Oculus, 494

Odalisque, 727

Object (Le Déjeuner en fourrure) (Luncheon in Fur)

(Oppenheim), 859-860, 859

della Signoria (Cione and Talenti), Florence, American government, 854 Battista Sforza and Federico da Montefeltro, 427, 427 Baroque period and, 614, 645 513-514, 513, 514 Ducal Palace, Mantua, Italy, 516, 517 collectors and museums as, xlvi Recognition and Proving of the True Cross, 512, Ducal Palace, Urbino, Italy, 510-512, 511, 512 controveries over public funding, 921 513 El Escorial (Bautista and Herrera), Madrid, defined, xliiii Pietà (Michelangelo), 539-541, 539 595, 595 in France, 479, 590, 592 Pietà (Titan and Giovane), 556, 557 Farnese, Rome, 548, 548, 550, 625-627, 625. individuals as, xlv-xlvi, 545, 633, 648 Pietra serena, 494, 496, 546 626 in Italy, 490, 493, 504, 531, 545 Pietro da Cortona (Pietro Berrettini), 631 Fontainebleau, France, Chamber of the in the Netherlands, 598 Glorification of the Papacy of Urban VIII, 632, 632 popes who were, 531, 541 Duchess of Étampes, 591–592, 592 Piles, Roger de, 614 Louvre (Lescot), Paris, 593, 593 in Spain, 595 Principles of Painting, 669 Medici-Riccardi, 495, 495, 497, 497 women as, 558, 592 Pilgrimage to the Island of Cythera, The (Watteau), Residenz (Neumann), Germany, 682-683, 682, Pattern and Decoration movement, 903 684, 685 Paul III, pope, 541, 548, 557, 558, 561 Pink-Blue-Pink (Zorio), 896, 897 Rucellai, Florence, 497-498, 497 Paul V, pope, 617 Piranesi, Giovanni Battista, The Lion Bas-Relief, Salon de la Princesse (Boffrand), Hôtel de Paxton, Joseph, Crystal Palace, London, 750, 750 692, 692 Soubise, 681, 682 Peacock and Dragon curtain (Morris), 762, 762 Pisano, Andrea, 426 Versailles, 663, 664, 665–667, 665, 666, 667 Peeters, Clara, Still Life with Flowers, Goblet, Dried Life of John the Baptist, panel doors, 428-429, Palazzo della Signoria (Cione and Talenti), Flo-Fruit, and Pretzels, 643-649, 649 430 rence, 427, 427 Peláez, Amelia, Marpacífico (Hibiscus), 835, 835 Pissarro, Camille, 764, 765, 769 Palazzo del Tè (Romano), Mantua, 550, 550 Performance art, 898-899. 898, 899 Wooded Landscape at l'Hermitage, Pontoise, 770, Palazzo Farnese, Rome, 548, 548, 550, 625-627, Perpendicular style, 446-447 770 625, 626 Piss Christ (Serrano), 921 atmospheric (aerial) perspective, 456 Palazzo Medici-Riccardi, 495, 495, 497, 497 intuitive, 456 Pity the Sorrows of a Poor Old Man (Géricault), Palazzo Rucellai, Florence, 497-498, 497 Perry, Lilla Cabot, 768 732, 733 Palissy, Bernard, 593, 593 Personal Appearance #3 (Schapiro), 903, 903 Plato, xxxiv, 493, 529, 536 Palladio (Andrea di Pietro della Gondola), 694, Perspective, one-point (linear or mathematical), Plein air painting, 769-771 489, 491, 492, 505, 517 Plenty's Boast (Puryear), 917–918, 917 Four Books of Architecture, 574, 671 Perugino Plowing in the Nivernais: The Dressing of the Vines San Giorgio Maggiore church, Venice, 572, Delivery of the Keys to Saint Peter, 492, 492, (Bonheur), 758, 758 573, 573 517-518, 518 Pluralism, 910 Villa Rotunda, 574, 574 real name of, 517 Poesie (painted poems), 552 Panofsky, Erwin, 577 Pesaro, Jacopo, 554 Pointillism, 780 Panthéon (Soufflot), Sainte-Geneviève, Paris, 708, Pesaro Madonna (Titian), 554-556, 555 Polke, Sigmar, Raised Chair with Geese, 914, 914 Petrarch, 424, 431, 456, 514 Pollaiuolo, Antonio del Papacy Pheidias and the Frieze of the Parthenon, Athens Battle of the Nudes, 504, 505 See also under name of pope (Alma-Tadema), xliii, xliii Hercules and Antaeus, 503-504, 503 list of popes who were patrons of the arts, 531, Philip II, king of Spain, 578, 595, 596, 634 Pollock, Jackson, 912 Philip III, king of Spain, 734 Autumn Rhythm (Number 30), 872–873, 872 Paris Philip IV, king of Spain, 634, 636, 638, 645 Male and Female, 871, 871 Bibliothèque Sainte-Geneviève (Labrouste), Philip V, king of Spain, 613 Namuth's photograph of Pollock painting, 872 750-751, 751 Philip the Bold, duke of Burgundy, 457, 458, 460 Polydoros, Laocoön and His Sons, xxxvii, xxxvii Departure of the Volunteers of 1792 (The Marseil-Philip the Fair, 598 Polyptych, 461 laise) (Rude), Arc de Triomphe, Paris, 735, Philip the Good, duke of Burgundy, 455, 457, 466 Pompadour, Madame de, 687 Philosophical Enquiry into the Origin of Our Ideas of Pompeii, 690 École des Beaux-Arts, 686, 726, 750, 751, 796 the Sublime and the Beautiful, A (Burke), 692 Pontormo, Jacopo da, Entombment, 563, 563 Eiffel Tower, Paris, 722, 723 Photography Pop art, 888–892, 889–892 Louvre, palais du (Lescot), 593, 593 early, 748-750, 748, 749 Pope, Alexander, 697 Opéra, (Garnier), 751-752, 751, 752 late nineteenth century, 795-796, 795, 796 Pope Leo X with Cardinals Giulio de' Medici and Panthéon, Sainte-Geneviève (Soufflot), 708, Modernism, 831, 831 Luigi de' Rossi (Raphael), 537-538, 538 postwar, 880-883, 882, 883 Popova, Liubov, Architectonic Painting, 824, 824 Paris Street, Rainy Day (Caillebotte), 772, 773 Photography: A Pictorial Art (Emerson), 795 Portinari Altarpiece (Goes), 476-477, 477, 479, 479 Parks Photojournalism, 880 Portrait of a German Officer (Hartley), 831, 832, 832 Central Park, New York City, 797, 797 Photomontages, Dadaism, 828, 829, 829 Portrait of a Lady (Weyden), 474, 474 early designs, 797 Photo-Secession, 831 Portrait of a Young Man (Bronzino), 564, 565 Stourhead park (Flitcroft and Hoare), Wiltshire, Piazza Navona, Rome, 623-624, 623 Portrait of Charles Baudelaire (Nadar), 749-750, 749 England, 696-697, 696 Picasso, Pablo, 814 Portrait of Giovanni Arnolfini and His Wife, Giovanna Parler, Heinrich, Church of the Holy Cross, Analytic Cubism, 816-818, 818 Cenami (Jan van Eyck), 469-470, 471 Portrait of Jean-Baptiste Belley (Girodet-Trioson), 448-449, 448 Blue Period, 815 Parler, Peter Family of Saltimbanques, 815, 815 713-714, 713 Church of the Holy Cross, 448-449, 448 Glass and Bottle of Suzz, 818-819, 819 Portrait of Madame Desiré Raoul-Rochette (Ingres), Saint Wenceslas Chapel, 449, 449 Guernica, 802-803, 803 728, 729 Parmigianino (Francesco Mazzola), Madonna with Iberian Period, 815-816 Portrait of Marie Antoinette with Her Children the Long Neck, 564, 564 Les Demoiselles d'Avignon (The Young Ladies of (Vigée-Lebrun), 686, 710, 710 Parnassus (Mengs), 693, 693 Avignon), 816, 816 Portrait of Mrs. Richard Brinsley Sheridan (Gainsbor-Parrhasios, xxxiii Ma Jolie, 818, 818 ough), 701–702, 702 Parson Capen House, Massachusetts, 675-676, Mandolin and Clarinet, 819, 819 Portrait of Thomas Carlyle (Cameron), 749, 749 675 Rose Period, 815 Portrait sculpture, Italian Neoclassicism, 690-694, Parterres, 666 Self-Portrait, 814, 815 691, 692, 693 Synthetic Cubism, 818-819, 819 Pascal, Blaise, 680 Portraiture Pastels, 690 Pictorialism, 795 Baroque, 647–648, 648 Pastoral Concert, The (Giorgione and Titian), 554, Picturesque, 692 Dutch Baroque, 651-652, 652, 653 554 Piero della Francesca English, 605–607, 605, 606 Patrons of art Bacci Chapel, San Francesco church, Arezzo, English Neoclassicism, 701-702, 701, 702 See also under name of 512-513, 512 Flemish, 468–469, 470, 474, 474

High, 532, 533, 534-539, 534-538, 541-544, French, 590, 590 Rationalism, 845-848, 846, 847 542, 543, 544, 550-556, 550-557 photography, 749-750, 749 Rauschenberg, Robert, 883 Netherlands, 598-604, 599-604 Canyon, 884, 885 Portugal, Renaissance in, 481-483, 594 one-point perspective (linear or mathematical), Portuguese Synagogue, Amsterdam (de Witte), 660, Rayonnant (Court) style, 442 489, 491, 492, 505, 517 660 Read, Herbert, 868 Readymades, 826, 828 Spanish, 595-598, 596, 597 Positivism, 747 Renaissance sculpture Post-Impressionism Cézanne, 777–779, 777, 778, 779 early, 498-504, 498-503 American, 760, 760, 761 German, 579-581, 580, 581 French, 755–759, 755–759 Gauguin, 784, 785 Seurat, 779-780, 780 High, 539-541, 539, 540, 544-547, 545, 546, New, 887 547 use of term, 776 in the nineteenth century, 753, 755 Van Gogh, 780–781, 781, 783, 784 Portuguese, 594, 594 Russian, 759-760, 759 Reni, Guido, Aurora, 631, 631 Socialist, 845, 845 Postmodern art, 909 use of term, xxxiii-xxxiv, 747 Renoir, Pierre-Auguste, 764 architecture, 908, 908 Moulin de la Galette, 770-771, 771 architecture, Deconstructivist, 922, 923 Recognition and Proving of the True Cross (Piero della Repin, Ilya, Bargehaulers on the Volga, 759-760, 759 Francesca), 512, 513 architecture, High Tech, 920, 922, 922 Recumbent Figure (Moore), 856-857, 856 Repoussoir, 778 European art, 866-868, 866-868 Residenz, Kaisersaal (Imperial Hall) (Neumann), identity, 910-912, 910, 911, 912 Red Canna (O'Keeffe), xxxv, xxxv Neo-Expressionism, 913-915, 913, 914 Red Mean: Self Portrait (Smith), 916, 916 Germany, 682-683, 682, 683 Restany, Pierre, 887 Redon, Odilon, The Marsh Flower, a Sad and new types of media, 922, 924-928, 924-927 Resurrection of Lazarus, The (Tanner), 789, 789 Human Face, 786-787, 786 new uses for old styles, 915-917, 915, 916, 917 Return of the Hunters, The (Bruegel the Elder), Reformation, 530, 578-579, 591, 598 shapes, new meanings in, 917-920, 917-920 Registers, 434 603-604, 604 use of term, 865 Revival Fields (Chin), 924, 924 Rehearsal on Stage, The (Degas), 771-772, 772 Pottery, Wedgwood, 698, 698 Reynolds, Joshua, Lady Sarah Bunbury Sacrificing to Rejlander, Oscar, The Tivo Paths of Life, 748-749, Poussin, Nicolas, Landscape with Saint John on Patthe Graces, 701, 701 mos, 667-668, 670, 671 Ribera, Jusepe de, Martyrdom of Saint Bartholomew, Rembrandt van Rijn, xli, 653, 669 Poussinistes, 669 635-636, 635 The Anatomy Lesson of Dr. Nicolaes Tulp, 654, Prague, Saint Wenceslas Chapel, 449, 449 Richardson, Henry Hobson, Marshall Field Prairie style, 840 Wholesale Store, Chicago, 798, 799 Captain Frans Banning Cocq Mustering His Prandtauer, Jakob, Benedictine Abbey of Melk, Company (The Night Watch), 655, Richelieu, Cardinal, 663 Austria, 641-642, 641, 642 Riemenschneider Tilman, 579 Predella, 439, 461 Primaticcio, Francesco, Chamber of the Duchess Altarpiece of the Holy Blood, 580, 580 The Last Supper, xlii-xliii, xliii Self-Portrait, 656, 657 Rietveld, Gerrit, Schröder House, Netherlands, of Étampes, Fontainebleau, France, 591-592, 846, 847-848, 847 Three Crosses, 656, 656 Rigaud, Hyacinthe, Louis XIV, 612, 613, 670 Renaissance Primavera (Botticelli), 520-521, 520 artists, changing status of, 531-532 Riis, Jacob Primitivism, 808-810, 808, 809 How the Other Half Lives, 796 Princess Elizabeth (Teerlinc), 606, 607 book printing, 522 ceramics, 504, 504 Tenement Interior in Poverty Gap: An English Princess from the Land of Porcelain (Whistler), xlv Coal-Heaver's Home, 796, 796 development and meaning of, 456 Printing, 485-486, 522, 530 in England, 604-609 Riley, Bridget, Current, 893, 893 Printmaking, 484, 584-587 Ringgold, Faith, Tar Beach, 903, 904 Prix de Rome, 686 fiber arts, 464-466, 465, 466 Riopelle, Jean-Paul, Knight Watch, 874, 875 in Flanders, 466-479 Procession of the Relic of the True Cross before the Ripa, Cesare, 629-630 Church of Saint Mark (Gentile Bellini), 524, in France, 479-481, 590-593 Rivera, Diego, Man, Controller of the Universe, in Germany, 579-588 graphic arts, 484-486 851-852, 851 Properzia de' Rossi, Joseph and Potiphar's Wife, 552, Robbia, Andrea della, 496 in Holy Roman Empire, 483 552 Robbia, Luca della, 504 in Italy, 488-525, 532-556 Proun space (Lissitzky), 844, 845 Roberts, David, Gateway to the Great Temple at Protestantism, 557, 578, 590, 598 Mannerism, 562-569 Baalbek, 743-744, 743 manuscripts, illuminated, 454-455, 472-474 Pucelle, Jean, Book of Hours of Jeanne d'Evreux, Robin, Pierre (?), Saint-Maclou church, maps of Europe in, 457, 491, 531, 579 442-443, 443 Normandy, France, 480-481, 481 Pugin, Augustus Welby Northmore, Houses of metalwork, 607, 607 Robusti, Jacopo. See Tintoretto Parliament, London, 746, 747 in the Netherlands, 598-604 Robusti, Marietta, 572 patrons of the arts, 490, 493, 504, 531, 541, Punchwork, 439 Puryear, Martin, Plenty's Boast, 917-918, 917 545, 590, 592 Rockefeller family, 851 Putti, 514, 517, 541, 554, 565, 646, 647, 682, 684, in Portugal, 481-483, 594 Rococo academies, 686, 690 printmaking, 484-486, 584-587 in Spain, 481-483, 595-598 in France, 684-689 Q tapestry, 464-465, 465 in Germany and Austria, 682-684 timelines, 563, 601 Grand Tour, 689-694 Quadratura, 631 Salons, 681, 686 women artists, 462, 532 Quadro riportato, 631 Renaissance architecture timeline, 689 Quoins, 548 early, 491-498, 492-497, 510-512, 511, 512, use of term, 681 514-517, 515, 516, 523, 524 Rococo style architecture, 682-684, 682, 683, 684 Raft of the "Medusa," (Géricault), 728, 730-731, English, 608, 609 French, 590-593, 591, 592, 593 defined, 681, 682 730, 731 painting, French, 684, 685, 686-689, 687, 688 High, 547-550, 548, 549, 550 Raised Chair with Geese (Polke), 914, 914 Raising of the Cross, The (Rubens), 645, 645 Spanish, 595, 595 painting, German, 683, *683* sculpture, French, 689, 689 Raphael Renaissance painting sculpture, German, 683-684, 683 Miraculous Draft of Fishes, 538-539, 538 early, 504-510, 506-510, 512-514, 512, 513, 514, 517–523, 518–523, 524–525, 524, 525, Rodchenko, Aleksandr, Workers' Club, 843-844, Pope Leo X with Cardinals Giulio de' Medici and Luigi de' Rossi, 536-538, 538 Rodin, Auguste, Burghers of Calais, 789-790, 790 English, 605-609, 605, 606, 608 School of Athens, 529, 536, 537 Rogier van der Weyden. See Weyden, The Small Cowper Madonna, 536, 536 French, 590, 590

German, 518-588, 582-589

Rogier van der

Stanza della Segnatura, 528–529, 529–530, 536

Rolin, Nicolas, 472, 473 Saint Anthony Enthroned between Saints Augustine Santa Maria della Vittoria church, Rome, 619, 619 Romano, Giulio, 591 and Jerome (Hagenauer), 581, 582 Santa Maria delle Grazie monastery, Milan, Italy, Palazzo del Tè, Mantua, 550, 550 Saint-Denis, abbey church, France, 444, 444 532, 533, 534 Romanticism Saint Francis in Ecstasy (Giovanni Bellini), 525, 526 Santi Giovanni e Paolo and the Monument to Bar-English painting, 705-707, 706, 707 Sainte-Geneviève, Panthéon (Soufflot), Paris, 708, tolommeo Colleoni (Canaletto), 691-692, 691 French painting, 728-734, 730-734 708 Sartre, Jean-Paul, 864, 865 French sculpture, 735, 735 Saint George (Donatello), 499, 499 Sassetti Chapel, Florence, 518, 519-520, 519 landscape painting, 738-743, 738-742 Saint James cathedral, Santiago de Compostela, Saussure, Ferdinand de, xlvii in the nineteenth century, 725-726 Spain, 640-641, 641 Savage, Augusta, 852 Spanish painting, 736, 736, 737, 738 St. Louis, Missouri, Wainwright Building (Sulli-La Citadelle: Freedom, 853, 853 use of term, 694 van), 798-800, 799 Savonarola, Girolamo, 522, 539 Rome Saint Luke (Master Theodoric), 449-450, 450 Scenes from the Massacre at Chios, (Delacroix), 733. See also Saint Peter's basilica; Vatican Saint Luke Displaying a Painting of the Virgin (Guer-733 Capitoline Hill, 558 cino), xli, xli, 630 Schapiro, Miriam Cornaro Chapel (Bernini), Santa Maria della Saint Luke Painting the Virgir Mary (Gossaert), The Dollhouse, 902 Vittoria church, 619-620, 619 600-601, 600 Personal Appearance #3, 903, 903 Il Gesù church (Vignola and della Porta), Saint-Maclou church, Normandy, France, Schiele, Egon, Self-Portrait Nude, 811, 811 561-562, 561 480-481, 481 Schinkel, Karl Friedrich, Altes Museum, Berlin, Neoclassicism in, 692-694, 693, 694 Saint Paul's Cathedral (Wren), London, 672-673, 746. 746 Palazzo Farnese, 548, 548, 550, 625-627, 625, 674 Schmidt-Rottluff, Three Nudes-Dune Picture from 626 Saint Peter's basilica Nidden, 808, 808 Piazza Navona, 623-624, 623 Bernini's plan, 617-619, 617, 618 Schongauer, Martin, Temptation of Saint Anthony, in the Renaissance, 517 Bramante's plan, 549, 549 484-485, *485* sack of, 531 Maderno's plan, 549, 549, 617, 617 School of Athens (Raphael), 529, 536, 537 San Carlo alle Quattro Fontane church Michelangelo's plan, 549, 549, 560, 560 Schröder House (Rietveld), Netherlands, 846, (Borromini), 621-622, 621, 622, 623 old, 549, 549 847-848, 847 Tempietto, San Pietro church, 547-548, Saint Sebastian Tended by Saint Irene (Ter Brug-Schröder-Schräder, Truus, 847–848 ghen), 649, 651 Schulze, Wolfgang. See Wols Rondanini Pietà (Michelangelo), 560, 560 Saint Serapion (Zurbarán), 636, 636 Schwitters, Kurt, Merzbild 5B (Picture-Red-Heart-Roosevelt, Franklin D., 854 Saint-Simon, comte de, 758 Church), 828, 829 Rope Piece (Hesse), 895-896, 895 Saint Teresa of Ávila, 619 Science Rosenberg, Harold, 871–872 Saint Teresa of Ávila in Ecstasy (Bernini), 620-621, Baroque period and, 616 Rossellino, Bernardo, 497 620 Enlightenment and, 680, 702, 724 Rossi, Luigi de', 537, 538 Sckell, Ludwig von, 797 Saint Ursula reliquary (Memling), 478, 478, 479 Rothko, Mark, Brown, Blue, Brown on Blue, 876, Saint Vincent with the Portuguese Royal Family from Scott, Walter, 697 876 Altarpiece of Saint Vincent (Gonçalves), Scream, The (Munch), 787-788, 787 Rouen Cathedral: The Portal (in Sun) (Monet), 769, 482–483, 483 Scrovegni (Arena) Chapel, Padua, 433-437, 435, 769 Saint Wenceslas Chapel (P. Parler), Prague, 449, 436 Rousseau, Jean-Jacques, 680 449 Sculpture Sala della Pace, fresco series (Lorenzetti), Siena, Rubénistes, 669 Abstract, 824-825, 825 Rubens, Peter Paul, 669 440, 441 American Neoclassicism, 735–736, 735 Allegory of Sight, from Allegories of the Five Salcedo, Sebastian, Our Lady of Guadalupe, 715, Baroque, Italian, 615, 618, 619-621, 619 Senses, 648, 650, 650 716 biomorphic forms, 855-857, 855, 856, 857 Garden of Love, 647, 647 Salimbeni, Lionardo Bartolini, 489-490, 493 French fourteenth century, 443-444, 444, 445 Henri IV Receiving the Portrait of Marie de' Salon d'Automne, 805-805 French Neoclassicism, 714-715, 714 Medici, 646, 646 Salon de la Princesse (Boffrand), Hôtel de French nineteenth century, 752-753, 752, house of, 644-645, 644 Soubise, Paris, 681, 682 789–791, 790, 791 The Raising of the Cross, 645, 645 Salon des Refusés, 765 French Rococo, 689, *689* Rucellai, Giovanni, 490, 497 Salon of 1787 (Martini), 686, 686 French Romanticism, 735, 735 Rude, François, Departure of the Volunteers of 1792 Salons, 681, 686, 726 German Rococo, 683–684, 683 (The Marseillaise), Arc de Triomphe, Paris, Saltcellar of King Francis I (Cellini), 567-568, 567 German Renaissance, 579–581, 580 581 735, 735 Samuel Adams (Copley), 678, 679, 719 Harlem Renaissance, 852-853, 853 Rue Transonain, Le 15 Avril 1834 (Daumier), xl, xl, San Carlo alle Quattro Fontane church (Borro-Italian Baroque, 615, 618, 619-621, 619 mini), 621-622, 621, 622, 623 Italian Neoclassicism, 693-694, 694 Ruisdael, Jacob van, The Jewish Cemetery, Sánchez Cotán, Juan, Still Life with Quince, Cab-Italian Renaissance, 498-504, 498-503, 660-661, 661 bage, Melon, and Cucumber, 634-635, 634 539-541, 539, 540, 544-547, 545, 546, 547 Running Fence (Christo and Jeanne-Claude), 901, San Francesco church, Bacci Chapel, Arezzo, Neoclassicism, American, 735–736, 735 901 512-513, 512 Neoclassicism, French, 714-715, 714 Ruskin, John, 763 Sangallo the Younger, Antonio da, Palazzo Far-Neoclassicism, Italian, 693-694, 694 Russian art nese, Rome, 548, 548, 550 New York School, 876–878, 877, 878 Constructivism, 843-845, 844 San Giorgio Maggiore church, Venice, 572, 573, Portuguese, Renaissance, 594, 594 Cubism and Futurism, 822-824, 823, 824 573 Renaissance, early, 498–504, 498–503 painting, Realism, 759-760, 759 San Giovanni baptistry, Florence, 428-429, 430, Renaissance, German, 579-581, 580, 581 Socialist Realism, 845, 845 499-501, 500 Renaissance, High, 539-541, 539, 540, Rusticated stone blocks, 497 San Juan de Los Reyes church, Toledo, Spain, 482, 544-547, 545, 546, 547 Ruysch, Rachel, Flower Still Life, 662, 663 Renaissance, Portuguese, 594, 594 Ryder, Albert Pinkham, Jonah, 788, 788 San Lorenzo church, Florence, 494–495, 494, 495 Rococo, French, 689, 689 San Pietro church, Rome, 547-548, 548 Rococo, German, 683-684, 683 Sant'Agnese church, Rome, 623, 623 Romanticism, French, 735, 735 Saar, Betye, Liberation of Aunt Jemima, 902, 902 Sant'Andrea church, Mantua, Italy, 514-515, 515, site-specific, 899-901, 900, 901 Saarinen, Eero, Trans World Airlines Terminal, Seagram Building (Mies van der Rohe and John-John F. Kennedy Airport, New York City, Sant'Elia, Antonio, 823 son), New York City, 905, 905 Santa Felicità church, Florence, 562, 563 Seasons, The (Krasner), 873, 873 Safdie, Moshe, Habitat '67, Montreal, Canada, Santa Maria del Carmine church, Brancacci Secco, 439 907-908, 907 Chapel, Florence, 506-508, 507, 508, 509 Self-Portrait (Anguissola), 566-567, 567

Synagogues, Portuguese Synagogue, Amsterdam, 660, Self-Portrait (Dürer), 585, 585 Société Anonyme des Artistes Peintres, Sculpteurs, Graveurs, Etc., 764 660 Self-Portrait (Leyster), 653, 653 Synthetic Cubism, 818-819, 819 Society of Jesus, 557-558 Self-Portrait (Picasso), 814, 815 Synthetism, 784 Sorel, Agnès, 479 Self-Portrait (Rembrandt), 656, 657 Soto, Jesús Rafael, Armonía Transformable Syon House (Adam), England, 697-698, 698 Self-Portrait (Van Hemessen), 602, 602 Self-Portrait as a Fountain (Nauman), 898, 899 (Transformable Harmony), 892, 893 Self-Portrait as the Allegory of Painting (Gentileschi), Soufflot, Jacques-Germain, Panthéon, Sainte-Tachisme, 867 Geneviève, Paris, 708, 708 630, 630 Talenti, Francesco, Florence Cathedral, 428, 428, Self-Portrait Nude (Schiele), 811, 811 Spain Baroque period in, 634-641 Self-Portrait with an Amber Necklace (Modersohn-Civil War in, 803 Talenti, Simone, Palazzo della Signoria, Florence, Becker), 810, 811 Self-Portrait with Two Pupils (Labille-Guiard), 710, colonies in America, 715-717 427, 427 Tall Spread (Bush), 893, 894 Guggenheim Museum, Solomon R. (Gehry), 711 Tanner, Henry Ossawa, 788 Seraphim, 525 Bilbao, Spain, 922, 923 Renaissance in, 481-483, 595-598 Resurrection of Lazarus, The, 789, 789 Serlio, Sebastiano, 608 Serpentine bench (Gaudí i Cornet), 792-793, 793 Romanticism in, 736, 736, 737, 738 Tapestry Flemish, 464–465, 465 Spanish art Serrano, Andres, Piss Christ, 921 Renaissance, 538-539, 538 architecture, Baroque, 641-642, 642, 643 Seurat, Georges, 776, 779 A Sunday Afternoon on the Island of La Grande architecture, Renaissance, 595, 595 Tapié, Michel, 867 Art Nouveau (Modernismo), 792-793, 793 Target with Four Faces (Johns), 885-886, 885 Jatte, 780, 780 Tassel House, Stairway (Horta), Brussels, 792, 792 Flemish art, 481-482 Seven Years' War, 704 Tatlin, Vladimir, Corner Counter-Relief, 823, 823 influence of, on Native American art, 715, 715, Severini, Gino, Armored Train in Action, 822, 822 716, 717, 717 Teerlinc, Levina Bening, Princess Elizabeth, 606, Severn River Bridge (Darby III), England, 705, painting, Baroque, 634-640, 634-640 705 painting, Renaissance, 595-598, 596, 597 Tempera, 466, 532 Sévigné, Madame de, 681 Tempest, The (Giorgione), 552-553, 553 painting, Romanticism, 736, 736, 737, 738 Sezessionstil, 793, 838 Tempietto, San Pietro church, Rome, 547-548, Sforza, Battista, 512, 513-514, 513, 514 Sphinx, Great Sphinx, Egypt, xxxii, xxxii Sforza, Ludovico, 532, 533, 534 Spiral Jetty (Smithson), 900, 901 Temptation of Saint Anthony (Schongauer), Staël, Madame de, 681 Sfumato, 535, 551, 624 Stairway (Horta), Tassel House, Brussels, 792, 484-485, 485 Sgraffito, 497 Sherman, Cindy, Untitled Film Still #21, 910-911, Tenement Interior in Poverty Gap: An English Coal-792 Heaver's Home (Riis), 796, 796 Stalin, Joseph, 804 Ter Borch, Gerard, The Suitor's Visit, 659-660, 659 Shimamoto, Shozo, Hurling Colors, 886, 886 Stanton, Elizabeth Cady, 724 Stanza della Segnatura, 528-529, 529-530, 536 Ter Brugghen, Hendrick, Saint Sebastian Tended by Shimomura, Roger, Diary, xl, xl Starry Night, The (Van Gogh), 781, 781, 784 Saint Irene, 649, 651 Shooting Star (Miró), 860, 860 Terra-cotta, 504 Shrewsbury, England, Hardwick Hall (Smythson), Statues. See Sculpture Textiles, Flemish, 464-466, 465, 466 608, 609 Steel, early use of, 798 Thamyris from Concerning Famous Women (Boccac-Shute, John, 608 Steen, Jan, The Drawing Lesson, xli, xlii, 660 Steiner House (Loos), Vienna, 838, 838 cio), 462, 462 Sienese painting, 437, 437, 438, 439, 440, Third-Class Carriage (Daumier), 759, 759 Stella, Frank, Avicenna, 894-895, 894 441-442 Stieglitz, Alfred, 830, 833 Third of May, 1808 (Goya), 736, 737, 738 Signboard of Gersaint (Watteau), 684, 685, 686-687 Silver, Georgian, 700, 700 The Flatiron Building, 831, 831 Thomas of Witney, Exeter Cathedral, England, Still Life with a Watch (Claesz), 661-662, 661 446-448, 447 Sinopia, 439 Thomson, Tom, Jack Pine, 836-837, 837 Siqueiros, David Alfaro, 851, 871 Still Life with Basket of Apples (Cézanne), 778, 778 Thornton, William, United States Capitol, Wash-Still Life with Flowers, Goblet, Dried Fruit, and Pret-Sistine Chapel, Vatican zels (Peeters), 648-649, 649 ington, D.C., 745, 745 Delivery of the Keys to Saint Peter (Perugino), Thoughts on the Imitation of Greek Works in Painting 492, 492, 517-518, 518 Still Life with Quince, Cabbage, Melon, and Cucumber and Sculpture (Winckelmann), 692-693, Last Judgment, 558, 559, 560 (Sánchez Cotán), 634-635, 634 Stone Breakers, The (Courbet), 755-756, 755 Michelangelo's work on, 541, 542, 543, 544, Three Crosses (Rembrandt), 656, 656 Stoss, Veit, Annunciation and Virgin of the Rosary, Site-specific sculpture, 899–901, 900, 901 Three Nudes-Dune Picture from Nidden (Schmidt-581, 581 Rottluff), 808, 808 Stourhead park (Flitcroft and Hoare), Wiltshire, Sixtus IV, pope, 517, 520 Sixtus V, pope, 541, 615, 616, 621 Three Women (Léger), 821-822, 821 England, 696-697, 696 Throne of the Third Heaven of the Nations' Millen-Strawberry Hill (Walpole), England, 696, 697, 697 Sky Cathedral (Nevelson), 878, 879 Skyscrapers, 798, 842-843, 842, 843, 905, 905, Street, Berlin (Kirchner), 809-810, 809 nium General Assembly (Hampton), Studiolo (study) of Federico da Montefeltro, xxxviii-xxxix, xxxviii 908, 909 Sleep of Reason Produces Monsters, The (Goya), 736, Ducal Palace, Urbino, Italy, 511-512, 512 Tiepolo, Giovanni Battista, The Marriage of the Emperor Frederick and Beatrice of Burgundy, Style Guimard, 794 Sloan, John, Election Night, 830, 830 Sublime, 692 683, 683 Succulent (Weston), xxxiv, xxxv Tiercerons, 446 Sluter, Claus, Well of Moses, 460, 460 Suitor's Visit, The (Ter Borch), 659-660, 659 Tinguely, Jean Small Cowper Madonna, The (Raphael), 536, Homage to New York, 888, 888 536 Sullivan, Louis, 839 Wainwright Building, St. Louis, Missouri, Metamatics, 887-888 Smith, David, 876 Tintoretto (Jacopo Robusti), Last Supper, The, Cubi XIX, xxxv, xxxv, 877–878 798-800, 799 571-572, 571 Summer's Day (B. Morisot), 774, 775 Hudson River Landscape, 877, 877 Titian (Tiziano Vecelli), 553, 669 Smith, Jaune Quick-to-See, The Red Mean: Self Sunday Afternoon on the Island of La Grande Jatte, Isabella d'Este, 558, 558 Portrait, 916, 916 A (Seurat), 780, 780 Suprematism, 824 Pastoral Concert, The, 554, 554 Smith, Ken, Landscape Architect, 925, 925 Pesaro Madonna, 554-556, 555 Suprematist Painting (Eight Red Rectangles) Smith, Kiki, Untitled, 919, 919 Smithson, Robert, Spiral Jetty, 900, 901 (Malevich), 822-823, 823 Pietà, 556, 557 Venus of Urbino, 556, 556 Surrealism, 857-860, 858, 859, 860 Smythson, Robert, Hardwick Hall, Shrewsbury, England, 608, 609 Surrender at Breda (Velázquez), 636-638, 638 Toledo, Spain, San Juan de Los Reyes church, 482, Sussex chair (Webb), 762, 762 Snowstorm: Hannibal and His Army Crossing the Alps (Turner), 739-740, 739 Switzerland, 483 Torres-García, Joaquín, Abstract Art in Five Tones Symbolism, 785-789, 786-789 and Complementaries, 879, 879

Socialist Realism, 845, 845

Toulouse-Lautrec, Henri de, Jane Avril, 794-795, Van Doesburg, Theo, 845 View of Delft (Vermeer), 657, 657 Van Dyck, Anthony, Charles I at the Hunt, View of Toledo (El Greco), 597-598, 597 Transformable Harmony (Soto), 892, 893 647-648, 648 Vigée-Lebrun, Marie-Louise-Élisabeth, Portrait of Van Eyck, Hubert, Ghent Altarpiece, 454, 455, 468, Trans World Airlines Terminal (Saarinen), John F. Marie Antoinette with Her Children, 686. 710, Kennedy Airport, New York City, 907, 907 469 Très Riches Heures (Limbourg brothers) Van Eyck, Jan Vignola (Giacomo Barozzi), Il Gesù church. January, The Duke of Berry at Table, 457, 458 Ghent Altarpiece, 454, 455, 468, 469 561-562, 561 February, Life in the Country, 462-463, 463 Man in a Red Turban, 468-469, 470 Village Piper, The (A. Le Nain), 667, 669 Tribute Money (Masaccio), 506-508, 509 Portrait of Giovanni Arnolfini and His Wife, Gio-Villa Rotunda (Palladio), 574, 574 Trinity Church (Upjohn), New York City, 747, vanna Cenami, 469-470, 471 Villa Savoye (Le Corbusier), France, 839, 839 Van Gogh, Vincent, 776, 780 Violet Persian Set with Red Lip Wraps (Chihuly), Trinity with the Virgin, Saint John the Evangelist, and Japonaiserie: Flowering Plum Tree, 782, 783 Donors (Masaccio), 505-506, 506 The Starry Night, 781, 781, 784 Violin and Palette (Braque), 817-818, 817 Triptych, 461 Van Hemessen, Caterina, Self-Portrait, 602, 602 Virgin and Child (Fouquet), 479-480, 480 Garden of Earthly Delights (Bosch), 598-599, Virgin and Child, Saint-Denis, abbey church, Vanishing point, 492, 507 599 Van Mander, Carel, 598 France, 444, 444 Mérode Altarpiece (Triptych of the Annunication) Van Mieris, Frans, Flower Piece with Curtain, xxxiii, Virgin and Child Enthroned (Cimabue), 431, 432 (Campin), 457, 458, 467-468, 467 xxxiii Virgin and Child Enthroned (Giotto di Bondone), Portinari Altarpiece (Goes), 476-477, 477, 479, Vanna Venturi House (Venturi), 908, 908 431-432, 433 Van Reymerswaele, Marinus, The Banker and His Virgin and Child Enthroned with Saints Francis, John The Raising of the Cross (Rubens), 645, 645 Wife, 601-602, 601 the Baptist, Job, Dominic, Sebastian, and Louis of Triumph of Death (Buffalmacco?), Camposanto, Vasari, Giorgio, xlvi, 432, 490, 495, 531, 552, 566, Toulouse (Giovanni Bellini), 524-525, 525 Pisa, 426, 426 Virgin and Child in Majesty, Maestà Altarpiece (Duc-Triumph of the Name of Jesus and the Fall of the Vases and vessels, Wedgwood, 698, 698 cio di Buoninsegna), 437, 437, 438 Damned, The (Gaulli), 633-634, 633 Vatican Virgin and Saint Anne with the Christ Child and the Triumph of Venice (Veronese), xxxix-xl, xxxix Pietà (Michelangelo), 539-541, 539 Young John the Baptist (Leonardo), 534, Triumph of Venus (Boucher), 687-688, 687 Saint Peter's basilica, 549, 549, 560, 560, 534 Triumphs, The (Petrarch), 431, 514 617-619, 617, 618 Vir Heroicus Sublimis (Newman), 876, 877 Trolley, New Orleans, (Frank), 882, 882 Stanza della Segnatura, 528–529, 529–530, 536 Vitra Fire Station (Hadid), Germany, 922, 923 Trompe l'oeil, 505, 511, 536, 541, 550, 582 Vatican, Sistine Chapel Vitruvian Man (Leonardo), 535, 535 Delivery of the Keys to Saint Peter (Perugino), 492, 492, 517–518, 518 Tropon (Van de Velde), 792, 792 Vitruvius, 535, 547 Turner, Joseph Mallord William, 754 Vlaminck, Maurice de, 806 The Burning of the House of Lords and Commons, Last Judgment, 558, 559, 560 Void, The (Klein), 898 16th October 1834, 740, 740 Michelangelo's work on, 541, 542, 543, 544, Voussoirs, 705 Snowstorm: Hannibal and His Army Crossing the Alps, 739-740, 739 Vaux, Calvert, Central Park, New York City, 797, Two Fridas, The (Kahlo), 836, 836 797 Wa:nwright Building (Sullivan), St. Louis, Mis-Two Paths of Life, The (Rejlander), 748-749, 748 Vauxcelles, Louis, 805 souri, 798-800, 799 Tzara, Tristan, 828 Vedute, 691, 692 Wall, Jeff, After "Invisible Man" by Ralph Ellison, the Velázquez, Diego Preface, 911-912, 911 Las Meninas (The Maids of Honor), 638, 639 Wall hanging (Albers), 848, 849 Uccello, Paolo, The Battle of San Romano, Surrender at Breda, 636-638, 638 Wall paintings. See Murals 488-489, 489-490 Water Carrier of Seville, 636, 637 Walpole, Horace, Strawberry Hill, England, 696, Unicorn Is Found at the Fountain from Hunt of the Velderrain, Juan Bautista, 717 697, 697 Unicorn tapestry, 464-465, 465 Venice Walter of Memburg, 446 Unique Forms of Continuity in Space (Boccioni), architecture, 523-524, 524, 572, 573-574, 573, Waltz, The (Claudel), 790-791, 791 822, 823 Warhol, Andy, 889 United Nations—Babel of the Millennium (Gu), oil painting in, 569-572, 570, 571 Birmingham Race Riot, 890-891, 891 927-928, 928 Renaissance oil painting, 524-525, 524, 525, Marilyn Diptych, 890, 890 United States. See American art 552-556, *553-557* Washington, D.C., United States Capitol United States Capitol (Latrobe), Washington, Venturi, Robert (Latrobe), 745-746, 745 D.C., 745-746, 745 Complexity and Contradiction in Architecture, 908 Washington, George, 714, 714 Unit One, 855, 856 Vanna Venturi House, 908, 908 Water Carrier of Seville (Velázquez), 636, 637 Universal Exposition (1889), 723 Venus of Urbino (Titian), 556, 556 Watson and the Shark (Copley), 719-720, 719 Untitled (Judd), 894, 895 Venus Urania (Giovanni da Bologna), 568, 568 Watteau, Jean-Antoine Untitled (Smith), 919, 919 Vermeer, Jan (Johannes) The Pilgrimage to the Island of Cythera, 684, Untitled Film Still #21 (Sherman), 910-911, 910 View of Delft, 657, 657 Untitled (12 Horses) (Kounellis), 862-863, Woman Holding a Balance, 658-659, 658 The Signboard of Gersaint, 684, 685, 686-687 863-864, 896 Veronese (Paolo Caliari), 569 Wattle and daub, 675-676 Untitled work from the Tree of Life series Feast in the House of Levi, 570, 571 Webb, Philip, Sussex chair, 762, 762 (Mendieta), 903-904, 905 The Triumph of Venice, xxxix-xl, xxxix Wedgwood, Josiah, pottery, 698, 698, 699 Upjohn, Richard, Trinity Church, New York City, Verrocchio, Andrea del, 532 Well of Moses (Sluter), 460, 460 747, 747 Equestrian monument of Bartolommeo West, Benjamin, The Death of General Wolfe, Urban VIII, pope, 617, 618 Colleoni, 503, 503 704-705, 704 Urbino, Italy Versailles, palais de (Le Vau and Hardouin-Weston, Edward, Succulent, xxxiv, xxxv architecture in, 510-512 Mansart), 663, 664, 665-667, 665, 666, 667 We Won't Play Nature to Your Culture (Kruger), 910, Ducal Palace, 510-512, 511, 512 Hall of Mirrors (Le Brun and Hardouinpainting, 512-514, 512, 513, 514 Mansart), 663, 665, 665 Weyden, Rogier van der plan of, 666, 666 Deposition, 470-472, 472 Vesperbild, Germany, 450, 452, 452 Last Judgment Altarpiece, 472-473, 473 Vanbrugh, John, Blenheim Palace, England, Vessels. See Vases and vessels Portrait of a Lady, 474, 474 673-674, 674 Victoria, queen of England, 750 Whistler, James Abbott McNeill, 762 Van der Spelt, Adriaen, Flower Piece with Curtain, Vienna, Steiner House (Loos), 838, 838 Harmony in Blue and Gold, Peacock Room, for

Vierzehnheiligen church (Neumann), Germany,

683-684, 683, 684

xxxiii, xxxiii

Van de Velde, Henry, Tropon, 792, 792

Frederick Leyland, xlv-xlvi, xlv

lawsuit, 763

Nocturne in Black and Gold, the Falling Rocket,

Princess from the Land of Porcelain, xlv White, Minor, Capitol Reef, Utah, 883, 883 Whitehall Palace, Banqueting House (Jones), London, 672, 672, 673

White Horse (Constable), 741, 741

Whiteread, Rachel, House, 918-919, 919

Wildom, Donald, 921

William of Orange, 642, 671

Winckelmann, Johann Joachim, 692-693, 704, 707-708

Wittgenstein, Ludwig, 898

Witz, Konrad, Miraculous Draft of Fishes, 483, 484 Wols (Wolfgang Schulze), 867

Painting, 868, 868

Woman Holding a Balance (Vermeer), 658-659, 658

Womanhouse, 902

Woman in a Loge (Cassatt), 773, 773

Woman with the Hat, The (Matisse), 806, 807

Women

academies and, 690

African American artists, 735-736, 735, 902-903, 902, 904

Baroque artists, 616, 616, 629-630, 630, 648-649, 649, 653, 653, 662, 663

feminist art, 901-904, 902-905

Georgian silver artists, 700, 700

in guilds, 462

as patrons of the arts, 558, 592

Renaissance artists, 462, 532, 566-569

salons and role of, 681

Women artists

Albers, Anni, 848, 849

Amaral, Tarsila do, 834, 834

Anastaise, 462, 463

Anguissola, Sofonisba, 566-567, 567

Arbus, Diane, 882-883, 882

Baca, Judith F., 915, 915

Bateman, Ann, 700

Bateman, Hester, 700

Bonheur, Rosa, 758, 758

Bourgot, 462

Brandt, Marianne, 848-849, 848

Brody, Sherry, 902

Burrows, Alice, 700

Cameron, Julia Margaret, 749, 749

Carr, Emily, 837-838, 837

Carriera, Rosalba, 690-691, 691

Cassatt, Mary, 772-774, 773, 774

Chicago, Judy, 902, 906, 906

Christine de Pizan, xlv, xlv, 431, 462

Clark, Lygia, 896, 896

Claudel, Camille, 790-791, 791

Colter, Mary, 841-842, 841

Cooke, Elizabeth, 700

Delaunay-Terk, Sonia, 820-821, 821

Ende, 462

Fontana, Lavinia, 568-569, 569

Frankenthaler, Helen, 875, 875

Gentileschi, Artemisia, 629-630, 630

Girodet-Trioson, Anne-Louis, 713-714, 713 Guda, nun, 462

Hamilton, Ann. 925, 925

Hepworth, Barbara, 855-856, 855

Hesse, Eva, 895-896, 895

Höch, Hannah, 829, 829

Kahlo, Frida, 836, 836

Kauffmann, Angelica, 690, 703-704, 703

Kollwitz, Käthe Schmidt, 810-811, 810

Krasner, Lee, 873, 873

Kruger, Barbara, 910, 911

Labille-Guiard, Adélaïde, 710, 711

Lewis, Edmonia, 735–736, 735

Leyster, Judith, 653, 653

Lin, Maya Ying, xliv, xliv

Mendieta, Ana, 903-904, 905

Merian, Maria Sibylla, 616, 616

Modersohn-Becker, Paula, 810, 811

Montbaston, Jeanne de, 462

Morisot, Berthe, 764, 774, 775

Morisot, Edma, 774

Morley, Elizabeth, 700

Moser, Mary, 690 Mukhina, Vera, 845, 845

Neshat, Shirin, 926, 926 Nevelson, Louise, 876, 878-879, 878

O'Keeffe, Georgia, xxxv, xxxv, 833, 833

Oppenheim, Meret, 859-860, 859

Peeters, Clara, 648-649, 649

Peláez, Amelia, 835, 835 Pompadour, Madame de, 687

Popova, Liubov, 824, 824

Properzia de' Rossi, 552, 552

Riley, Bridget, 893, 893

Ringgold, Faith, 903, 904

Robusti, Marietta, 572

Ruysch, Rachel, 662, 663

Saar, Betye, 902, 902

Savage, Augusta, 852-853, 853

Schapiro, Miriam, 902-903, 903 Sherman, Cindy, 910-911, 910

Smith, Jaune Quick-to-See, 916, 916

Smith, Kiki, 919, 919

Teerlinc, Levina Bening, 606-607, 606

Van Hemessen, Caterina, 602, 602

Vigée-Lebrun, Marie-Louise-Élisabeth, 686, 710, 710

Whiteread, Rachel, 918-919, 919

Wonderful Transformation of Caterpillars and (Their) Singular Plant Nourishment, (Merian), 616, 616

Wood, New York School, 878-879, 878

Woodblocks, 485

Woodcuts, 485, 522, 585-587, 585, 586, 587

Wooded Landscape at l'Hermitage, Pontoise (Pissarro),

Woolworth Building (Gilbert), New York City, 843, 843

Worker and Collective Farm Woman (Mukhina), 845, 845

Workers' Club (Rodchenko), 843-844, 844

World, since 1945, 864–865

map of, 865

World's Columbian Exposition (Hunt), Chicago, 796, 798, 799

World War I, 804, 826

World War II, 804

Wren, Christopher, Saint Paul's Cathedral, London, 672-673, 674

Wright, Frank Lloyd, 839

Fallingwater, Kaufmann House, Mill Run,

Pennsylvania, 841, 841

Frederick C. Robi House, Chicago, 840-841, 840

Wright, Joseph, Experiment on a Bird in the Air-Pump, An, 702-703, 702

Wrongful Execution of the Count (Bouts), 475-476,

Würzburg, Germany, Kaisersaal (Imperial Hall), Residenz (Neumann), 682-683, 682, 683

X, Y, Z

Xul Solar (Alejandro Schultz Solari), Jefa (Patroness), 834-835, 835

Zambezia, Zambezia (Lam), 869-870, 869

Zeuxis, xxxiii

Zoffany, Johann, Academicians of the Royal Academy,

690, 690 Zorio, Gilberto, Pink-Blue-Pink, 896, 897 Zurbarán, Francisco de, Saint Serapion, 636, 636